THE LIMITS OF ART

A CRITIC'S ANTHOLOGY OF WESTERN LITERATURE

Collected and Edited by
HUNTINGTON CAIRNS

MJF BOOKS
NEW YORK

Published by MJF Books
Fine Communications
Two Lincoln Square
60 West 66th Street
New York, NY 10023

ISBN 1-56731-162-8

10 9 8 7 6 5 4 3 2 1

TO THE MEMORY
OF
MARY MELLON
1904–1946

Εἰ καὶ ἄπιστα κλύουσι, λέγω τάδε· φημὶ γὰρ ἤδη
τέχνης εὑρῆσθαι τέρματα τῆσδε σαφῆ
χειρὸς ὑφ’ ὑμετέρης· ἀνυπέρβλητος δὲ πέπηγεν
οὖρος. ἀμώμητον δ’ οὐδὲν ἔγεντο βροτοῖς.

This I say, even though they that hear believe not: I declare
that the clear limits of this art have been found under my
hand, and the goal is set that may not be overpassed, though
there is no human work with which fault may not be found.

PARRHASIUS

PREFACE

THIS WORK presents selections of poetry and prose that have been held by competent critics to touch, in one way or another, the limits of art. That is to say, the selections have been pronounced perfect or the greatest of their kind. With each selection there is printed the judgment of the critic. I have thus, in the compilation of the work, employed a method the opposite of that used in the conventional anthology. My starting point was neither the poet nor the poem, but the critic; the volume therefore differs from the customary anthology of selections from standard authors. The work of a recognized writer is not included here unless in the considered judgment of a responsible critic it is, in some sense, superlative.

It should also be remarked that this volume brings criticism itself to the bar of judgment. Here is what criticism has held, at various times and places since its beginnings in ancient Greece, to be supreme in poetry or prose. I venture to think that on the whole its estimates have been sound. I have asked only that the critic's appreciation of his selection be in terms of its value as poetry or prose, and that there be a basis for believing he is competent to make the estimate. Where a critic has a long-established reputation I have attempted no careful weighing of his position, although, in the course of editing, I may have rejected many of his judgments. Coleridge, of course, I have admitted without hesitation, although there are those who now deny that he is a critic at all; however, I have included none of his appreciations which rest upon the circumstances that the poems promote a virtuous life or a sound view of religion. I should add that American and German critics are so hesitant to cite examples of excellence that their literatures are perhaps not as widely represented here as they deserve. This characteristic may possibly be the product of local conditions, as it is in Germany, where the taught tradition of the university seminars forbids the use of superlatives; but it is also individual, as we can see in the frugality with which such well qualified critics as W. P. Ker and Oliver Elton engage in the practice.

It will be seen from the book's epigraph that I have borrowed the phrase the "limits of art" from the Greek Anthology; it suggests both the idea of perfection and the idea of greatness, a distinction recognized long ago by Longinus, when he remarked on the difference between the flawless and the sublime. Criticism unfortunately has not arrived at any generally accepted understanding of either idea. Nevertheless,

it has been the practice of nearly every important critic, from ancient to modern times, to apply these ideas to concrete examples. Perhaps the most satisfactory approaches are still Aristotle's conception that a poem is perfect when it cannot be added to or subtracted from, and Longinus' view that a poem is great when it transports or overwhelms the reader. There is, of course, the further limit, the requirement discussed by Aristotle, that art must discover the universal, that which is enduring and essential. It is the essence of the critical function to judge literature; when the critic is in the presence of poetry or prose that is wholly excellent, it would seem that he violates no sound canon when he pronounces it so. Art is wayward and baffling, it tends always to escape the rigid formula; it is however possible to contrast, to search for, the specific qualities that give literature its character. When the critic who does this has also knowledge and a sense of form we find, as we can see from Saintsbury's *History of Criticism*, that we have described the practice and equipment of all great critics in the history of the craft. If the critic goes further and states why the arrangement of a handful of words in a certain order possesses excellence, he is also discharging a legitimate function of criticism. "To like and dislike rightly," Bosanquet once wrote, "is the goal of all culture worth the name." Why are the first four words of the *Republic* pleasing to the ear, if placed in one order, as Plato discovered, and displeasing if placed in another? In the present work, when the critic has attempted to answer this difficult question, I have allowed him the additional space for his exposition; but that task, unluckily, is one that the critic too often sidesteps.

In all cases save two—Walpole's letter to the Rev. William Cole and Cowper's to the Rev. John Newton—every extract has been specified by the critic; for that reason many of them are of a fragmentary nature. If the critic gave his approbation to a single verse and not to the whole poem, I have not attempted to enlarge the area of his selection. Similarly, if he has designated Homer or Shakespeare or Dante as the first poet of the world and has not exhibited a passage to enforce his estimate, I have not printed his views nor attempted to make his opinion more particular by extracting an example of quotable length. Dryden thought that the English language reached its highest perfection in Beaumont and Fletcher; Shelley believed that the truth and splendor of Plato's imagery and the melody of his language were the most intense that it was possible to conceive; but they were not specific and their judgments are thus omitted from this volume. The reader should not assume, therefore, that because a passage is not specified in the context of the criticism quoted in its support that it is not specified by the critic at all. In the few cases where the criticism has not been definite I have turned to other sources, as, for example, to the authorized

life of Tennyson for his favorite Virgilian lines to associate with the general tribute

> Wielder of the stateliest measure
> ever moulded by the lips of man.

Considerations of space have sometimes compelled me to make a choice where the critic has given more than one example of perfection or greatness. In one instance I have ventured to shorten a passage: the *De Corona* extract from Demosthenes, which is supported by Lord Brougham's famous judgment. Some poems, of course, because of their length, I have not been able to present. Gautier, for example, insisted that Alfred de Vigny's *Eloa* was the most beautiful and the most perfect poem in the French language; while present-day taste undoubtedly would not accept this estimate, it is with regret that I have been forced to omit the poem.

I have not hesitated to print extracts that are no more than a sentence or even a phrase. However, it may well be that some emotional association is involved in the critic's choice of the single word or two. Henry James' selection, for example, of "summer afternoon", as the most beautiful phrase in the English language probably carries a personal connotation. It is significant that in *The Portrait of a Lady*, when Isabel Archer and Gilbert Osmond are engaged, the most that Osmond can promise is that life for them will be "one long summer afternoon". In any event, the element of the personal is here too plainly present and I have therefore excluded such examples.

Although the volume to a degree exhibits some of the vagaries in the history of taste, that aspect is largely fortuitous. My intention has been to include only such passages as informed criticism would be inclined to rank at the highest level, whatever the period of the critic—such passages, that is, as have come to my notice, for an anthology of this nature can of course lay no claim to completeness. I must add that my inclusion of a passage does not necessarily imply an endorsement of the degree of the critic's enthusiasm, although it does imply a recognition of the merits of his selection and of his own authority to speak in the particular case; I doubt, for example, that any critic of standing today would concur in Johnson's estimate of the Congreve passage; nevertheless, that it is a great passage I think scarcely anyone would deny.

For the most part I have avoided the appraisal of the biographer, on the ground that his enthusiasm for his subject is likely to prompt him to excessive judgment. Nevertheless, on several occasions I have admitted criticism written by the author in praise of his own work; but in all instances the opinions are not incompatible with the estimates of other good critics. Many of the passages could have been supported by additional critical statements, but a mere repetition of authority seemed

to serve no purpose. I have attempted everywhere to exclude the rhetorical superlative as exemplified by the otherwise excellent criticism of Hazlitt.

The passages have been uniformly printed in the language that evoked the critic's praise; to do otherwise would amount to a misrepresentation. However, translations have been provided in all cases save that of La Harpe. As a substitute for a translation of La Harpe's *La Prophétie de Cazotte* I have appended Saintsbury's witty condensation, with its supplementary information. The translations which have been made especially for this work are intended as no more than literal versions of the original. Occasionally, as in the Balzac passage, the criticism stresses not the original language but the general character of the piece; in those instances the extracts are printed only in translation. Where translations themselves have been the object of the critic's praise, as in the case of Chapman's rendering of Homer, the selected passage is included under the translator's name, and is followed by the original text for the convenience of the reader.

HUNTINGTON CAIRNS

National Gallery of Art
Washington, D. C.

ACKNOWLEDGMENTS

THE EDITOR wishes to express his appreciation for special assistance on editorial problems from many sources. He is particularly indebted to the following: the late Dr. Joseph Quincy Adams, Mabel A. Barry, René Batigne, Ruth E. Carlson, Mary Elizabeth Charlton, Frances Cheney, Marie Compton, A. D. Emmart, Dr. Elio Gianturco, Edith Hamilton, Dr. George N. Henning, Burnley Hodgson, Macgill James, Dean Martin McGuire, Dr. James G. McManaway, David Mearns, Elizabeth Mongan, Christopher Saintsbury, John H. Scarff, Fern Rusk Shapley, Katherine Shepard, Everett E. Smith, E. Millicent Sowerby, Charles C. Stotler, L. O. Teach and John Walker. The editor wishes to thank Miss Kay Becker, of the Catholic University of America, Washington, D. C., and Professor John B. McDiarmid, of the Johns Hopkins University, Baltimore, Md., for undertaking the task of reading the proofs of the Greek passages, and Professor Leonard Dean, of Tulane University, New Orleans, La., for reading the proofs of the Chaucer selections. The epigraph from Parrhasius was translated by the late Professor J. W. Mackail.

The following libraries have been of assistance in making source material available: Boston Public Library, Boston, Mass.; Bryn Mawr College Library, Bryn Mawr, Pa.; Catholic University Library, Washington, D. C.; University of Chicago Library, Chicago, Ill.; Columbia University Library, New York, N. Y.; District of Columbia Library, Washington, D. C.; George Washington University Library, Washington, D. C.; Grosvenor Library, Buffalo, N. Y.; Harvard College Library, Cambridge, Mass.; Lehigh University Library, Bethlehem, Pa.; Library of Congress, Washington, D. C.; National Gallery of Art Library, Washington, D. C.; Peabody Institute Library, Baltimore, Md.; University of Pennsylvania Library, Philadelphia, Pa.; Princeton University Library, Princeton, N. J.; University of Rochester Library, Rochester, N. Y.; Smithsonian Institution Library, Washington, D. C.; U. S. Department of Justice Library, Washington, D. C.; University of Virginia Library, Charlottesville, Va.; Yale University Library, New Haven, Conn.

For permission to use the copyrighted material included in this work acknowledgment is made to the following publishers and others: from Henry Adams Bellows' translation of the *Poetic Edda*, by permission of the American-Scandinavian Foundation, New York; Aldous Huxley's translation of Mallarmé's "L'Après-midi d'un faune", by permission of

Basil Blackwell & Mott, Ltd., Oxford; from L. P. Wilkinson's *Horace and his Lyric Poetry,* published by the Cambridge University Press, by permission; from R. C. Jebb's translation of Sophocles' *Oedipus at Colonus,* by permission of The Cambridge University Press; from George Thomson's translation of Aeschylus' *Oresteia,* by permission of The Cambridge University Press; from J. T. Sheppard's translation of Sophocles' *Oedipus Tyrannus,* by permission of The Cambridge University Press; from E. M. W. Tillyard, *Poetry Direct and Oblique* (1945), by permission of Chatto & Windus, London; from John Addington Symonds' translation of "The Confession of Golias", in *Wine, Women and Song* (The Mediaeval Library, published in England by Chatto & Windus, in the United States by The Oxford University Press) by permission of Chatto & Windus, London; from Robert Bridges, *Ibant Obscuri,* by permission of The Clarendon Press, Oxford; from A. O. Prickard's translation of Longinus' *On the Sublime,* by permission of The Clarendon Press, Oxford; translation of Pericles' Funeral Oration from Sir Alfred Zimmern's *The Greek Commonwealth,* by permission of The Clarendon Press, Oxford; extracts reprinted from Mary M. Colum, *From These Roots,* by permission of Columbia University Press, New York; a translation by Malcolm Cowley from La Fontaine's "Adonis", by permission of Malcolm Cowley; from *Catullus,* translated by Horace Gregory; copyright 1931, by Covici-Friede, Inc.; by special permission of Crown Publishers; from Gladys M. Turquet's translation of Joachim Du Bellay's *La Deffense et illustration de la langue française,* by permission of J. M. Dent & Sons Ltd., London; from Anatole France, *On Life and Letters,* by permission of Dodd, Mead & Company, Inc.; Arthur Symons' translation of Mallarmé's "Hérodiade", from *The Poems of Arthur Symons,* used by permission of Dodd, Mead and Company, Inc.; Arthur Symons' translation of "Clair de Lune" by Paul Verlaine, reprinted by permission of Dodd, Mead & Company, Inc.; Arthur Symons' translation of Paul Verlaine's "Chanson d'Automne", reprinted by permission of Dodd, Mead & Company, Inc.; from Rudyard Kipling's poems: "Danny Deever" from *Departmental Ditties and Barrack-room Ballads,* by Rudyard Kipling, copyright 1899, reprinted by permission of Mrs. G. Bambridge and Doubleday, Doran and Company, Inc.; "Recessional" from *The Five Nations,* by Rudyard Kipling, copyright 1903, reprinted by permission of Mrs. G. Bambridge and Doubleday, Doran and Company, Inc.; "An Only Son", "The Coward", "The Beginner", "Common Form", "A Dead Statesman", "Salonikan Grave", from *The Years Between,* by Rudyard Kipling, copyright 1904, reprinted by permission of Mrs. G. Bambridge and Doubleday, Doran and Company, Inc.; from J. G. Legge, *Chanticleer* (1935), by permission of E. P. Dutton & Co., Inc., New York, publisher in the United States; from Samuel Butler's translation of Homer's *Iliad,* by permission of E. P. Dutton & Co., Inc.,

New York, publisher in the United States; from E. J. Trechmann's translation of C.-A. Sainte-Beuve's *Causeries du lundi,* by permission of E. P. Dutton & Co., Inc., New York, publisher in the United States; from Hilaire Belloc, *Avril* (1904), by permission of E. P. Dutton & Co., Inc., New York, publisher in the United States; from Sir Frank Marzial's translation of Geoffroi de Villehardouin's *La Conquête de Constantinople* (Everyman's Library) by permission of E. P. Dutton & Co., Inc., New York, publisher in the United States; from E. B. Pusey's translation of the *Confessions of St. Augustine* (Everyman's Library) by permission of E. P. Dutton & Co., Inc., New York, publisher in the United States; extracts taken from the *Nibelungenlied,* translated by Margaret Armour (Everyman's Library), published by E. P. Dutton & Co., Inc., New York; extracts taken from *Anglo-Saxon Poetry,* by R. K. Gordon, published by E. P. Dutton & Co., Inc., New York; from *The Collected Essays and Papers of George Saintsbury,* by permission of E. P. Dutton & Co., Inc., New York, publisher in the United States; Horace's "Celebration for Neptune", translated by Roselle Mercier Montgomery; reprinted from *Forum* by permission of the Events Publishing Company, Inc.; from George Frederic Lees' translation of Rimbaud's "A Season in Hell" by permission of The Fortune Press, London; from A. R. Waller's translation of Molière's *Tartuffe,* reprinted by permission from *Molière—Complete Works in French and English* (8 Vols. Cr. 8vo, cloth) published by John Grant, Edinburgh; from Henry Thomas' translation of Lope de Vega's *The Star of Seville,* by permission of The Gregynog Press, Newtown, Montgomeryshire, England; from Joan Redfern's translation of *History of Italian Literature* by Francesco De Sanctis, by permission of Harcourt, Brace and Company, Inc., New York; from T. S. Eliot's "The Love Song of J. Alfred Prufrock", from *Collected Poems,* by permission of Harcourt, Brace and Company, Inc.; Louis Untermeyer's translation of Heine's "Ein Fichtenbaum Steht Einsam" from *Heinrich Heine: Paradox and Poet,* Volume 2, by Louis Untermeyer, copyright 1937, by Harcourt, Brace and Company, Inc.; from Aldous Huxley, *Texts & Pretexts* (1933), by permission of Harper & Brothers, New York; poems and prose extracts from Algernon Charles Swinburne, *Collected Poetical Works,* by permission of Harper & Brothers, New York; Sir William Watson's "Hymn to the Sea", from *The Poems of Sir William Watson, 1878–19,* by permission of George G. Harrap & Company Limited, London; texts and translations reprinted by permission of the publishers from the Loeb Classical Library: from Aeschylus, *The Persians,* translated by Herbert Weir-Smyth; from Aristotle, *Metaphysics,* translated by Hugh Tredennick; from Aristotle, *Art of Rhetoric,* translated by J. H. Freese; from Cicero, *Pro Archia Poeta,* translated by N. H. Watts; from Demosthenes, *De Corona,* translated by C. A. and J. H. Vince; from Euripides, *Daughters of Troy,* translated by Arthur S. Way;

from Herodotus, translated by A. D. Godley; from Hesiod, translated by H. G. Evelyn-White; from Homer, the *Iliad*, translated by A. T. Murray; from Homer, the *Odyssey*, translated by A. T. Murray; from Horace, *Odes*, translated by C. E. Bennett; from Isocrates, *Areopagiticus*, translated by George Norlin; from Longinus, translated by W. Hamilton Fyfe; from Lucian, translated by A. M. Harmon; from Lucretius, translated by W. H. D. Rouse; from Pindar, translated by Sir John Sandys; from Plato, the *Apology* and *Crito*, translated by H. N. Fowler; from Seneca, *Medea*, translated by Frank Justus Miller; from Sextus Propertius, translated by H. E. Butler; from Sophocles, *Ajax*, *Electra* and *Oedipus at Colonus*, translated by F. Storr; from Tacitus, *Agricola*, translated by Maurice Hutton; from Tacitus, *Annals*, translated by John Jackson; from Theocritus, *Idylls*, translated by J. M. Edmonds; from Virgil, *Aeneid* and *Georgics*, translated by H. R. Fairclough; Cambridge, Mass.; Harvard University Press; extracts reprinted by permission of the publishers from Gilbert Murray—*The Classical Tradition in Poetry*, Cambridge, Mass.; Harvard University Press, 1927; J. B. Leishman's translation of "Der Blinde Sänger" from *The Select Poems of Friedrich Hölderlin*, by permission of The Hogarth Press, London; from Norman Macleod's *German Lyric Poetry* (1930) by permission of The Hogarth Press, London; Norman Cameron's translation of Rimbaud's "Bateau Ivre", by permission of The Hogarth Press, London; from Helen Waddell, *The Wandering Scholars* (1927) and *Mediaeval Latin Lyrics* (1929), by permission of Constable and Company, Ltd., London, and published in the United States by Henry Holt and Company; from Henry Adams, *Mont-Saint-Michel and Chartres*, by permission of Houghton Mifflin Company, Boston; from Amy Lowell, *Six French Poets* (1915), by permission of Houghton Mifflin Company, Boston; from Charles Eliot Norton's translation of Dante's *Divine Comedy*, by permission of Houghton Mifflin Company, Boston; from *The Trophies* (translation of *Les Trophées* of José-Maria de Heredia) by John Hervey, The John Day Company, New York, 1929; from C. K. Scott Moncrieff's *The Letters of Abelard and Heloise*, by permission of Alfred A. Knopf, Inc., New York; from Maurice Baring, *Have You Anything to Declare?* by permission of Alfred A. Knopf, Inc., New York; Emily Dickinson, "The Chariot", from *The Poems of Emily Dickinson*, edited by Martha Dickinson Bianchi and Alfred Leete Hampson, reprinted by permission of Little, Brown & Company, Boston; translations from *The Poems of Victor Hugo* (1909), by permission of Little, Brown & Company, Boston; from Jacques Chevalier, *Pascal*, translated by Lilian A. Clare, by permission of Longmans, Green & Co., Inc., New York; from J. W. Mackail, *Lectures on Greek Poetry* (1910) by permission of Longmans, Green & Co., Inc., New York; from J. W. Mackail, *Studies in Humanism* (1938) by permission of Longmans, Green & Co., Inc., New York; translations by

Andrew Lang from *The Poetical Works of Andrew Lang*, by permission of Longmans, Green & Co., Inc., New York and London, and the representatives of the late Andrew Lang; from J. S. Phillimore's translation of Sophocles' *Antigone*, by permission of Longmans, Green & Co., Inc., New York; from W. Rhys Roberts' translation of Dionysius of Halicarnassus, *De Compositione Verborum*, by permission of Macmillan & Co., Ltd., London; from John Morley, *Voltaire* (1903), by permission of Macmillan & Co., Ltd., London; from F. W. H. Myers, *Essays Classical and Modern*, by permission of Macmillan & Co., Ltd., London; from J. A. K. Thomson, *The Greek Tradition* (1915), by permission of The Macmillan Company, New York; from W. B. Yeats, *Essays* (1924), by permission of The Macmillan Company, New York, and The Macmillan Company of Canada, Ltd.; from *Theocritus, Bion and Moschus*, translated by Andrew Lang (1889), by permission of The Macmillan Company, publishers; from Edith Sitwell, *A Poet's Notebook*, by permission of Miss Sitwell and Macmillan & Co., Ltd., London; from W. B. Yeats, *Autobiography* (1938), by permission of The Macmillan Company, publishers; from A. E. Housman's *The Name and Nature of Poetry* (1933), by permission of The Macmillan Company, publishers; from *Pierre de Ronsard: Sonnets pour Hélène* (1934), by Humbert Wolfe, by permission of The Macmillan Company, publishers; from W. B. Yeats, *Collected Poems* (1933), by permission of The Macmillan Company, publishers; from the Globe Edition of the *Works of Geoffrey Chaucer*, edited by A. W. Pollard and others (1898), by permission of The Macmillan Company, publishers; Wallace Fowlie's translation of Rimbaud's "Mémoire", by permission of J. Laughlin, New Directions, New York; from Edith Sitwell, *The Pleasures of Poetry*, by permission of W. W. Norton & Company, Inc.; from T. E. Shaw's translation of Homer's *Odyssey*, by permission of Oxford University Press, New York; from Lytton Strachey, *Landmarks in French Literature* (1923), by permission of Oxford University Press, London; "The Leaden Echo and the Golden Echo", from *The Poems of Gerard Manley Hopkins*, by permission of Oxford University Press, London, and the poet's family; from Bonamy Dobrée, *Variety of Ways* (1932), by permission of Oxford University Press; from James Rhoades' translation of Virgil's *Aeneid*, by permission of Oxford University Press; from Sir William Marris' translations of the *Iliad* and *Catullus*, by permission of Sir William Marris and the Oxford University Press; from Anna Maria Armi's translation of Petrarch, by permission of Pantheon Books Inc., New York; from translations by J. A. Carlyle, Thomas Okey and P. H. Wicksteed of Dante's *The Divine Comedy*, by permission of Random House, Inc., (The Modern Library) New York; from Charles M. Doughty, *Travels in Arabia Deserta* (1888) by permission of Random House, Inc., New York; song from W. S. Gilbert's *Pinafore*, by permission of Random House, Inc., New York; from W. D. Ross's

CONTENTS

xxiv

xxvi

xxvii

xxviii

xxix

xxxiii

xxxix

xl

xliii

xliv

THE LIMITS OF ART

HOMER

DATES UNKNOWN

SING, O MUSE

Μῆνιν ἄειδε, θεά, Πηληϊάδεω Ἀχιλῆος,
οὐλομένην, ἣ μυρί' Ἀχαιοῖς ἄλγε' ἔθηκεν,
πολλὰς δ' ἰφθίμους ψυχὰς "Αϊδι προΐαψεν
ἡρώων, αὐτοὺς δὲ ἑλώρια τεῦχε κύνεσσιν
οἰωνοῖσί τε πᾶσι — Διὸς δ' ἐτελείετο βουλή —
ἐξ οὗ δὴ ταπρῶτα διαστήτην ἐρίσαντε
Ἀτρεΐδης τε, ἄναξ ἀνδρῶν, καὶ δῖος Ἀχιλλεύς.

Of Peleus' son, Achilles, sing, O Muse,
The vengeance, deep and deadly; whence to Greece
Unnumber'd ills arose; which many a soul
Of mighty warriors to the viewless shades
Untimely sent; they on the battle plain
Unburied lay, a prey to rav'ning dogs,
And carrion birds; but so had Jove decreed,
From that sad day when first in wordy war,
The mighty Agamemnon, King of men,
Confronted stood by Peleus' godlike son.

Iliad, i, 1-7
Translated by Edward Earl of Derby

THE MAN OF MANY DEVICES

"Ανδρα μοι ἔννεπε, Μοῦσα, πολύτροπον, ὃς μάλα πολλὰ
πλάγχθη, ἐπεὶ Τροίης ἱερὸν πτολίεθρον ἔπερσεν·
πολλῶν δ' ἀνθρώπων ἴδεν ἄστεα, καὶ νόον ἔγνω·
πολλὰ δ' ὅγ' ἐν πόντῳ πάθεν ἄλγεα ὃν κατὰ θυμόν,
ἀρνύμενος ἥν τε ψυχὴν καὶ νόστον ἑταίρων.
ἀλλ' οὐδ' ὣς ἑτάρους ἐρρύσατο, ἱέμενός περ·
αὐτῶν γὰρ σφετέρῃσιν ἀτασθαλίῃσιν ὄλοντο
νήπιοι, οἳ κατὰ βοῦς Ὑπερίονος Ἠελίοιο
ἤσθιον· αὐτὰρ ὁ τοῖσιν ἀφείλετο νόστιμον ἦμαρ.
τῶν ἁμόθεν γε, θεά, θύγατερ Διός, εἰπὲ καὶ ἡμῖν.

Tell me, O Muse, of the man of many devices, who wandered full
many ways after he had sacked the sacred citadel of Troy. Many were
the men whose cities he saw and whose mind he learned, aye, and many

3

the woes he suffered in his heart upon the sea, seeking to win his own life and the return of his comrades. Yet even so he saved not his comrades, though he desired it sore, for through their own blind folly they perished—fools, who devoured the kine of Helios Hyperion; but he took from them the day of their returning. Of these things, goddess, daughter of Zeus, beginning where thou wilt, tell thou even unto us.

<div align="right">

Odyssey, i, 1-10
Translated by A. T. Murray

</div>

Has he not in the very few lines that open both his poems not only followed but, I may say, established the law which should govern the writing of exordiums?

<div align="right">

QUINTILIAN
Institutio Oratoria, x, 1, 48

</div>

HOMER

DATES UNKNOWN

THETIS TO ACHILLES

Τέκνον, τί κλαίεις; τί δέ σε φρένας ἵκετο πένθος;
ἐξαύδα, μὴ κεῦθε νόῳ ἵνα εἴδομεν ἄμφω.

My son, why are you weeping? What is it that grieves you? Keep it not from me, but tell me, that we may know it together.

<div align="right">

Iliad, i, 362-63
Translated by Samuel Butler

</div>

῏Ω μοι, τέκνον ἐμόν, τί νύ σ' ἔτρεφον, αἰνὰ τεκοῦσα;
αἴθ' ὄφελες παρὰ νηυσὶν ἀδάκρυτος καὶ ἀπήμων
ἧσθαι· ἐπεί νύ τοι αἶσα μίνυνθά περ, οὔτι μάλα δήν·
νῦν δ' ἄμα τ' ὠκύμορος καὶ ὀϊζυρὸς περὶ πάντων
ἔπλεο· τῷ σε κακῇ αἴσῃ τέκον ἐν μεγάροισιν.
τοῦτο δέ τοι ἐρέουσα ἔπος Διῒ τερπικεραύνῳ,
εἶμ' αὐτὴ πρὸς ῎Ολυμπον ἀγάννιφον, αἴ κε πίθηται.
ἀλλὰ σὺ μὲν νῦν νηυσὶ παρήμενος ὠκυπόροισιν,
μήνι' Ἀχαιοῖσιν, πολέμου δ' ἀποπαύεο πάμπαν.
Ζεὺς γὰρ ἐς Ὠκεανὸν μετ' ἀμύμονας Αἰθιοπῆας
χθιζὸς ἔβη κατὰ δαῖτα, θεοὶ δ' ἄμα πάντες ἕποντο·
δωδεκάτῃ δέ τοι αὖτις ἐλεύσεται Οὐλυμπόνδε.

<div align="center">

4

</div>

καὶ τότ' ἔπειτά μοι εἶμι Διὸς ποτὶ χαλκοβατὲς δῶ,
καί μιν γουνάσομαι, καί μιν πείσεσθαι ὀίω.

My son, woe is me that I should have borne or suckled you. Would indeed that you had lived your span free from all sorrow at your ships, for it is all too brief; alas, that you should be at once short of life and long of sorrow above your peers. Woe, therefore, was the hour in which I bore you. Nevertheless I will go to the snowy heights of Olympus, and tell this tale to Zeus, if he will hear our prayer. Meanwhile stay where you are with your ships, nurse your anger against the Achaeans, and hold aloof from fight. For Zeus went yesterday to Oceanus to a feast among the Ethiopians, and the other gods went with him. He will return to Olympus twelve days hence. I will then go to his mansion paved with bronze and will beseech him, nor do I doubt that I shall be able to persuade him.

Iliad, i, 414-27
Translated by Samuel Butler

There is nothing more moving in literature than the speeches of Thetis to Achilles her son; she knowing what his doom is to be.

MAURICE BARING
Have You Anything to Declare? (1936)

HOMER

DATES UNKNOWN

ZEUS ON OLYMPUS

Ἦ, καὶ κυανέῃσιν ἐπ' ὀφρύσι νεῦσε Κρονίων·
ἀμβρόσιαι δ' ἄρα χαῖται ἐπερρώσαντο ἄνακτος
κρατὸς ἀπ' ἀθανάτοιο· μέγαν δ' ἐλέλιξεν Ὄλυμπον.

The son of Cronos spake, and bowed his dark brow in assent, and the ambrosial locks waved from the king's immortal head; and he made great Olympus to quake.

Iliad, i, 528-30
Translated by A. T. Murray

5

VENUS THE GODDESS

Dixit et avertens rosea cervice refulsit,
ambrosiaeque comae divinum vertice odorem
spiravere; pedes vestis defluxit ad imos,
et vera incessu patuit dea.

She spake, and as she turned away, her roseate neck flashed bright.
From her head her ambrosial tresses breathed celestial fragrance; down
to her feet fell her raiment, and in her step she was revealed, a very
goddess.

Aeneid, i, 402-05
Translated by H. R. Fairclough

*Homer is in his province, when he is describing a battle or a multitude,
a hero or a god. Virgil is never better pleased than when he is in his
elysium, or copying out an entertaining picture. Homer's epithets gener-
ally mark out what is great; Virgil's what is agreeable. Nothing can be
more magnificent than the figure Jupiter makes in the first Iliad, nor
more charming than that of Venus in the first Aeneid.*

JOSEPH ADDISON
The Spectator (June 28, 1712)

HOMER

D A T E S U N K N O W N

THE ELDERS OF TROY BEHOLD HELEN

' Οὐ νέμεσις Τρῶας καὶ ἐϋκνήμιδας ᾿Αχαιοὺς
τοιῇδ᾽ ἀμφὶ γυναικὶ πολὺν χρόνον ἄλγεα πάσχειν·
αἰνῶς ἀθανάτῃσι θεῇς εἰς ὦπα ἔοικεν.'

' 'Tis no marvel', one to other said,
'The valiant Trojans and the well-greav'd Greeks
For beauty such as this should long endure
The toils of war; for goddess-like she seems.'

Iliad, iii, 156-58
Translated by Edward Earl of Derby

6

What is said of Helen by Priam and the old men of his council is generally thought to give us the highest possible idea of that fatal beauty.

On the Sublime and Beautiful (1756)

HOMER

DATES UNKNOWN

GENERATIONS OF MEN

Οἴη περ φύλλων γενεή, τοιήδε καὶ ἀνδρῶν.

Even as the generations of leaves, so are also those of men.

Iliad, vi, 146

One thing most beautiful was uttered by the man of Chios.

SEMONIDES
Fragment 29 D

HOMER

DATES UNKNOWN

A SLEEP OF BRONZE

Καὶ τόγε χειρὶ λαβὼν εὐρυκρείων 'Αγαμέμνων,
ἕλκ' ἐπὶ οἷ μεμαώς, ὥστε λῖς· ἐκ δ' ἄρα χειρὸς
σπάσσατο· τὸν δ' ἄορι πλῆξ' αὐχένα, λῦσε δὲ γυῖα.
ὣς ὁ μὲν αὖθι πεσὼν κοιμήσατο χάλκεον ὕπνον,
οἰκτρός, ἀπὸ μνηστῆς ἀλόχου, ἀστοῖσιν ἀρήγων,
κουριδίης, ἧς οὔτι χάριν ἴδε, πολλὰ δ' ἔδωκεν·

Then wide-ruling Agamemnon seized the spear in his hand and drew it toward him furiously like a lion, and pulled it from the hand of Iphidamas, and smote him on the neck with his sword and loosed his limbs. So there he fell, and slept a sleep of bronze, unhappy youth, far from his wedded wife, bearing aid to his townsfolk—far from the bride of whom he had known no joy, yet much had he given for her.

Iliad, xi, 238-43
Translated by A. T. Murray

7

This grace and this charm of life glimpsed in the very shadow of death, this final smile for all that one has loved and is going to leave, Homer has first understood its infinite sadness and has made it a necessary element of heroic poetry. But in him this human tenderness is always associated with the highest and most manly inspirations. We pass from one to the other without surprise, though with profound emotion. It is humanity in its completeness, at the same time grand and feeble, mingling the fury of combat with the tenderest memories, humanity summed up in a few contrasts, as simple as they are sublime.

<div align="right">

MAURICE CROISET
Histoire de la littérature grecque (1928)

</div>

HOMER

DATES UNKNOWN

DEAD IS PATROCLUS

Εἷος ὃ ταῦθ' ὥρμαινε κατὰ φρένα καὶ κατὰ θυμόν,
τόφρα οἱ ἐγγύθεν ἦλθεν ἀγαυοῦ Νέστορος υἱὸς
δάκρυα θερμὰ χέων, φάτο δ' ἀγγελίην ἀλεγεινήν·
' Ὤ μοι, Πηλέος υἱὲ δαΐφρονος, ἦ μάλα λυγρῆς
πεύσεαι ἀγγελίης, ἣ μὴ ὤφελλε γενέσθαι.
κεῖται Πάτροκλος, νέκυος δὲ δὴ ἀμφιμάχονται
γυμνοῦ· ἀτὰρ τά γε τεύχε' ἔχει κορυθαίολος Ἕκτωρ.'

> Thus while he thinks, Antilochus appears,
> And tells the melancholy tale with tears.
> "Sad tydings, son of Peleus! thou must hear;
> And wretched I, th' unwilling messenger!
> Dead is Patroclus! For his corps they fight;
> His naked corps: his arms are Hector's right."

<div align="right">

Iliad, xviii, 15-21
Translated by Alexander Pope

</div>

BATTLE OF THE CURETES AND AETOLIANS

Κουρῆτές τ' ἐμάχοντο καὶ Αἰτωλοὶ μενεχάρμαι
ἀμφὶ πόλιν Καλυδῶνα, καὶ ἀλλήλους ἐνάριζον·
Αἰτωλοὶ μέν, ἀμυνόμενοι Καλυδῶνος ἐραννῆς·

Κουρῆτες δέ, διαπραθέειν μεμαῶτες Ἄρηϊ.
καὶ γὰρ τοῖσι κακὸν χρυσόθρονος Ἄρτεμις ὦρσεν,
χωσαμένη, ὅ οἱ οὔτι θαλύσια γουνῷ ἀλωῆς
Οἰνεὺς ῥέξ᾽· ἄλλοι δὲ θεοὶ δαίνυνθ᾽ ἑκατόμβας·
οἴῃ δ᾽ οὐκ ἔρρεξε Διὸς κούρῃ μεγάλοιο,
ἢ λάθετ᾽, ἢ οὐκ ἐνόησεν· ἀάσατο δὲ μέγα θυμῷ.
ἡ δὲ χολωσαμένη, δῖον γένος, Ἰοχέαιρα,
ὦρσεν ἔπι χλούνην σῦν ἄγριον, ἀργιόδοντα,
ὃς κακὰ πόλλ᾽ ἔρδεσκεν ἔθων Οἰνῆος ἀλωήν·
πολλὰ δ᾽ ὅγε προθέλυμνα χαμαὶ βάλε δένδρεα μακρά,
αὐτῇσιν ῥίζῃσι καὶ αὐτοῖς ἄνθεσι μήλων.
τὸν δ᾽ υἱὸς Οἰνῆος ἀπέκτεινεν Μελέαγρος,
πολλέων ἐκ πολίων θηρήτορας ἄνδρας ἀγείρας
καὶ κύνας· οὐ μὲν γάρ κ᾽ ἐδάμη παύροισι βροτοῖσιν·
τόσσος ἔην, πολλοὺς δὲ πυρῆς ἐπέβησ᾽ ἀλεγεινῆς.
ἡ δ᾽ ἀμφ᾽ αὐτῷ θῆκε πολὺν κέλαδον καὶ ἀϋτήν,
ἀμφὶ συὸς κεφαλῇ καὶ δέρματι λαχνήεντι,
Κουρήτων τε μεσηγὺ καὶ Αἰτωλῶν μεγαθύμων.
ὄφρα μὲν οὖν Μελέαγρος Ἀρηΐφιλος πολέμιζεν,
τόφρα δὲ Κουρήτεσσι κακῶς ἦν· οὐδ᾽ ἐδύναντο
τείχεος ἔκτοσθεν μίμνειν, πολέες περ ἐόντες.
ἀλλ᾽ ὅτε δὴ Μελέαγρον ἔδυ χόλος, ὅς τε καὶ ἄλλων
οἰδάνει ἐν στήθεσσι νόον πύκα περ φρονεόντων·
ἤτοι ὁ μητρὶ φίλῃ Ἀλθαίῃ χωόμενος κῆρ,
κεῖτο παρὰ μνηστῇ ἀλόχῳ, καλῇ Κλεοπάτρῃ,
κούρῃ Μαρπήσσης καλλισφύρου Εὐηνίνης,
Ἰδέω θ᾽, ὃς κάρτιστος ἐπιχθονίων γένετ᾽ ἀνδρῶν
τῶν τότε — καί ῥα ἄνακτος ἐναντίον εἵλετο τόξον
Φοίβου Ἀπόλλωνος, καλλισφύρου εἵνεκα νύμφης·
τὴν δὲ τότ᾽ ἐν μεγάροισι πατὴρ καὶ πότνια μήτηρ
Ἀλκυόνην καλέεσκον ἐπώνυμον, οὕνεκ᾽ ἄρ᾽ αὐτῆς
μήτηρ, Ἀλκυόνος πολυπενθέος οἶτον ἔχουσα,
κλαῖ᾽, ὅτε μιν ἑκάεργος ἀνήρπασε Φοῖβος Ἀπόλλων—
τῇ ὅγε παρκατέλεκτο, χόλον θυμαλγέα πέσσων,
ἐξ ἀρέων μητρὸς κεχολωμένος, ἥ ῥα θεοῖσιν
πόλλ᾽ ἀχέουσ᾽ ἠρᾶτο κασιγνήτοιο φόνοιο·
πολλὰ δὲ καὶ γαῖαν πολυφόρβην χερσὶν ἀλοία,
κικλήσκουσ᾽ Ἀΐδην καὶ ἐπαινὴν Περσεφόνειαν,
πρόχνυ καθεζομένη, δεύοντο δὲ δάκρυσι κόλποι,
παιδὶ δόμεν θάνατον· τῆς δ᾽ ἠεροφοῖτις Ἐριννὺς
ἔκλυεν ἐξ Ἐρέβευσφιν, ἀμείλιχον ἦτορ ἔχουσα·
τῶν δὲ τάχ᾽ ἀμφὶ πύλας ὅμαδος καὶ δοῦπος ὀρώρει,
πύργων βαλλομένων· τὸν δὲ λίσσοντο γέροντες
Αἰτωλῶν, πέμπον δὲ θεῶν ἱερῆας ἀρίστους,

9

ἐξελθεῖν καὶ ἀμῦναι, ὑποσχόμενοι μέγα δῶρον.
ὁππόθι πιότατον πεδίον Καλυδῶνος ἐραννῆς,
ἔνθα μιν ἤνωγον τέμενος περικαλλὲς ἑλέσθαι,
πεντηκοντόγυον· τὸ μὲν ἥμισυ, οἰνοπέδοιο,
ἥμισυ δέ, ψιλὴν ἄροσιν πεδίοιο ταμέσθαι.
πολλὰ δέ μιν λιτάνευε γέρων ἱππηλάτα Οἰνεύς,
οὐδοῦ ἐπεμβεβαὼς ὑψηρεφέος θαλάμοιο,
σείων κολλητὰς σανίδας, γουνούμενος υἱόν·
πολλὰ δὲ τόνγε κασίγνηται καὶ πότνια μήτηρ
ἐλλίσσονθ', ὁ δὲ μᾶλλον ἀναίνετο· πολλὰ δ' ἑταῖροι,
οἵ οἱ κεδνότατοι καὶ φίλτατοι ἦσαν ἁπάντων·
ἀλλ' οὐδ' ὣς τοῦ θυμὸν ἐνὶ στήθεσσιν ἔπειθον,
πρίν γ' ὅτε δὴ θάλαμος πύκα βάλλετο· τοὶ δ' ἐπὶ πύργων
βαῖνον Κουρῆτες,, καὶ ἐνέπρηθον μέγα ἄστυ.
καὶ τότε δὴ Μελέαγρον ἐΰζωνος παράκοιτις
λίσσετ' ὀδυρομένη, καί οἱ κατέλεξεν ἅπαντα
κήδε', ὅσ' ἀνθρώποισι πέλει, τῶν ἄστυ ἁλώῃ·
ἄνδρας μὲν κτείνουσι, πόλιν δέ τε πῦρ ἀμαθύνει,
τέκνα δέ τ' ἄλλοι ἄγουσι, βαθυζώνους τε γυναῖκας.
τοῦ δ' ὠρίνετο θυμὸς ἀκούοντος κακὰ ἔργα·
βῆ δ' ἰέναι, χροΐ δ' ἔντε ἐδύσετο παμφανόωντα.
ὣς ὁ μὲν Αἰτωλοῖσιν ἀπήμυνεν κακὸν ἦμαρ,
εἴξας ᾧ θυμῷ· τῷ δ' οὐκέτι δῶρ' ἐτέλεσσαν
πολλά τε καὶ χαρίεντα, κακὸν δ' ἤμυνε καὶ οὕτως.
ἀλλὰ σὺ μή τοι ταῦτα νόει φρεσί, μηδέ σε δαίμων
ἐνταῦθα τρέψειε, φίλος· χαλπὸν δέ κεν εἴη
νηυσὶν καιομένῃσιν ἀμυνέμεν· ἀλλ' ἐπὶ δώροις
ἔρχεο· ἶσον γάρ σε θεῷ τίσουσιν Ἀχαιοί·
εἰ δέ κ' ἄτερ δώρων πόλεμον φθισήνορα δύῃς,
οὐκέθ' ὁμῶς τιμῆς ἔσεαι, πόλεμόν περ ἀλαλκών.'

"Where Calydon on rocky mountains stands
Once fought th' Ætolian and Curetian bands;
To guard it those, to conquer, these advance;
And mutual deaths were dealt with mutual chance.
The silver Cynthia bade contention rise,
In vengeance of neglected sacrifice;
On Œneus' fields she sent a monstrous boar,
That levell'd harvests, and whole forests tore:
This beast (when many a chief his tusks had slain)
Great Meleager stretch'd along the plain.
Then, for his spoils, a new debate arose,
The neighbour nations thence commencing foes.
Strong as they were, the bold Curetes fail'd,

While Meleager's thund'ring arm prevail'd:
Till rage at length inflam'd his lofty breast
(For rage invades the wisest and the best).
 "Curs'd by Althæa, to his wrath he yields,
And in his wife's embrace forgets the fields.
(She from Marpessa sprung, divinely fair,
And matchless Idas, more than man in war;
The god of day ador'd the mother's charms;
Against the god the father bent his arms:
Th' afflicted pair, their sorrows to proclaim,
From Cleopatra chang'd this daughter's name,
And call'd Alcyone; a name to show
The father's grief, the mourning mother's woe.)
To her the chief retir'd from stern debate,
But found no peace from fierce Althæa's hate:
Althæa's hate th' unhappy warrior drew,
Whose luckless hand his royal uncle slew;
She beat the ground, and call'd the pow'rs beneath
On her own son to wreak her brother's death:
Hell heard her curses from the realms profound,
And the red fiends that walk the nightly round.
In vain Ætolia her deliv'rer waits,
War shakes her walls, and thunders at her gates.
She sent embassadors, a chosen band,
Priests of the gods, and elders of the land;
Besought the chief to save the sinking state;
Their pray'rs were urgent, and their proffers great:
(Full fifty acres of the richest ground,
Half pasture green, and half with vin'yards crown'd.)
His suppliant father, aged Œneus, came;
His sisters follow'd; ev'n the vengeful dame,
Althæa sues; his friends before him fall:
He stands relentless, and rejects 'em all.
Mean while the victor's shouts ascend the skies;
The walls are scal'd; the rolling flames arise;
At length his wife (a form divine) appears,
With piercing cries, and supplicating tears:
She paints the horrors of a conquer'd town,
The heroes slain, the palaces o'erthrown,
The matrons ravish'd, the whole race enslav'd:
The warrior heard, he vanquish'd, and he sav'd.
Th' Ætolians, long disdain'd, now took their turn,
And left the chief their broken faith to mourn.
Learn hence, betimes to curb pernicious ire,
Nor stay, till yonder fleets ascend in fire:

11

Accept the presents; draw thy conqu'ring sword;
And be amongst our guardian gods ador'd."

<div align="right">

Iliad, ix, 529-605
Translated by Alexander Pope

</div>

*Who can recount more succinctly than the character who announces
the death of Patroclus, or more forcefully than he who describes the
fight between the Curetes and the Aetolians?*

<div align="right">

QUINTILIAN
Institutio Oratoria, x, 1, 49

</div>

H O M E R

D A T E S U N K N O W N

AJAX PRAYS FOR LIGHT

'Ήέρι γὰρ κατέχονται ὁμῶς αὐτοί τε καὶ ἵπποι.
Ζεῦ πάτερ, ἀλλὰ σὺ ῥῦσαι ὑπ' ἠέρος υἶας 'Αχαιῶν,
ποίησον δ' αἴθρην, δὸς δ' ὀφθαλμοῖσιν ἰδέσθαι·
ἐν δὲ φάει καὶ ὄλεσσον, ἐπεί νύ τοι εὔαδεν οὕτως.

A veil of cloud
O'er men and horses all around is spread.
O Father Jove, from o'er the sons of Greece
Remove this cloudy darkness; clear the sky,
That we may see our fate, and die at least,
If such thy will, in th' open light of day.

<div align="right">

Iliad, xvii, 644-47
Translated by Edward Earl of Derby

</div>

*Perhaps I shall not seem wearisome, comrade, if I quote to you one
other passage from the poet, this time on a human theme, that you may
learn how he accustoms his readers to enter with him into majesties
which are more than human. . . . Here is the very truth of the passion
of Ajax: he does not pray to live—such a petition were too humble for
the hero—but when in impracticable darkness he could dispose his
valour to no good purpose, chafing that he stands idle for the battle, he
prays for light at the speediest, sure of finding therein at the worst a
burial worthy of his valour, even if Zeus be arrayed against him.*

<div align="right">

LONGINUS
On the Sublime, ix
Translated by A. O. Prickard

</div>

12

No one has understood better than Longinus [in his comment on the passion of Ajax] the fine economy of heavenly assistance and virtue in great men.

CHARLES DE SAINT-ÉVREMOND
Réflexions sur nos traducteurs (1705)

HOMER

DATES UNKNOWN

ACHILLES' SHOUT

Ἡ μὲν ἄρ' ὣς εἰποῦσ' ἀπέβη πόδας ὠκέα ᵗΙρις·
αὐτὰρ Ἀχιλλεὺς ὧρτο Διῒ φίλος· ἀμφὶ δ' Ἀθήνη
ὤμοις ἰφθίμοισι βάλ' αἰγίδα θυσσανόεσσαν·
ἀμφὶ δέ οἱ κεφαλῇ νέφος ἔστεφε δῖα θεάων
χρύσεον, ἐκ δ' αὐτοῦ δαῖε φλόγα παμφανόωσαν.
ὡς δ' ὅτε καπνὸς ἰὼν ἐξ ἄστεος αἰθέρ' ἵκηται,
τηλόθεν ἐκ νήσου, τὴν δήϊοι ἀμφιμάχονται,
οἵτε πανημέριοι στυγερῷ κρίνονται Ἄρηϊ
ἄστεος ἐκ σφετέρου· ἅμα δ' ἠελίῳ καταδύντι
πυρσοί τε φλεγέθουσιν ἐπήτριμοι, ὑψόσε δ' αὐγὴ
γίγνεται ἀΐσσουσα, περικτιόνεσσιν ἰδέσθαι,
αἴ κέν πως σὺν νηυσὶν ἄρης ἀλκτῆρες ἵκωνται·
ὣς ἀπ' Ἀχιλλῆος κεφαλῆς σέλας αἰθέρ' ἵκανεν.
στῆ δ' ἐπὶ τάφρον ἰὼν ἀπὸ τείχεος· οὐδ' ἐς Ἀχαιοὺς
μίσγετο· μητρὸς γὰρ πυκινὴν ὠπίζετ' ἐφετμήν.
ἔνθα στὰς ἤϋσ'· ἀπάτερθε δὲ Παλλὰς Ἀθήνη
φθέγξατ'· ἀτὰρ Τρώεσσιν ἐν ἄσπετον ὦρσε κυδοιμόν.
ὡς δ' ὅτ' ἀριζήλη φωνή, ὅτε τ' ἴαχε σάλπιγξ
ἄστυ περιπλομένων δηΐων ὕπο θυμοραϊστέων,
ὣς τότ' ἀριζήλη φωνὴ γένετ' Αἰακίδαο.
οἱ δ' ὡς οὖν ἄϊον ὄπα χάλκεον Αἰακίδαο,
πᾶσιν ὀρίνθη θυμός· ἀτὰρ καλλίτριχες ἵπποι
ἂψ ὄχεα τρόπεον· ὄσσοντο γὰρ ἄλγεα θυμῷ.
ἡνίοχοι δ' ἔκπληγεν, ἐπεὶ ἴδον ἀκάματον πῦρ
δεινὸν ὑπὲρ κεφαλῆς μεγαθύμου Πηλείωνος
δαιόμενον· τὸ δὲ δαῖε θεὰ γλαυκῶπις Ἀθήνη.
τρὶς μὲν ὑπὲρ τάφρου μεγάλ' ἴαχε δῖος Ἀχιλλεύς,
τρὶς δὲ κυκήθησαν Τρῶες, κλειτοί τ' ἐπίκουροι.
ἔνθα δὲ καὶ τότ' ὄλοντο δυώδεκα φῶτες ἄριστοι
ἀμφὶ σφοῖς ὀχέεσσι καὶ ἔγχεσιν.

13

So saying, light-foot Iris pass'd away.
Then rose Achilles dear to Zeus; and round
The warrior's puissant shoulders Pallas flung
Her fringed aegis, and around his head
The glorious goddess wreath'd a golden cloud,
And from it lighted an all-shining flame.
As when a smoke from a city goes to heaven
Far off from out an island girt by foes,
All day the men contend in grievous war
From their own city, but with set of sun
Their fires flame thickly, and aloft the glare
Flies streaming, if perchance the neighbors round
May see, and sail to help them in the war;
So from his head the splendour went to heaven.
From wall to dyke he stept, he stood, nor join'd
The Achaeans—honouring his wise mother's word—
There standing, shouted, and Pallas far away
Call'd; and a boundless panic shook the foe.
For like the clear voice when a trumpet shrills,
Blown by the fierce beleaguerers of a town,
So rang the clear voice of Æákidês;
And when the brazen cry of Æákidês
Was heard among the Trojans, all their hearts
Were troubled, and the full-maned horses whirl'd
The chariots backward, knowing griefs at hand;
And sheer-astounded were the charioteers
To see the dread, unweariable fire
That always o'er the great Peleion's head
Burn'd, for the bright-eyed goddess made it burn.
Thrice from the dyke he sent his mighty shout,
Thrice backward reel'd the Trojans and allies;
And there and then twelve of their noblest died
Among their spears and chariots.

<div align="right">Iliad, xviii, 202-31

Translated by Alfred Lord Tennyson</div>

*Though having now so excellent a plea for leaving the army, and though
aware of the early death that awaited him if he stayed, he disdains to
profit by the evasion. We see him still living in the tented field, and
generously unable to desert those who had so insultingly deserted* HIM.
*We see him in a dignified retirement, fulfilling all the duties of religion,
friendship, hospitality; and, like an accomplished man of taste, culti-
vating the arts of peace. We see him so far surrendering his wrath to
the earnest persuasion of friendship, that he comes forth at a critical
moment for the Greeks to save them from ruin. What are his arms? He*

has none at all. Simply by his voice he changes the face of the battle. He shouts, and nations fly from the sound. Never but once again is such a shout recorded by a poet—

> He call'd so loud, that all the hollow Deep
> Of Hell resounded.*

Who called? THAT *shout was the shout of an archangel.*

<div align="right">

THOMAS DE QUINCEY
Homer and the Homeridæ (1841)

</div>

HOMER

D A T E S U N K N O W N

PATROCLUS

Τόν ῥ' ἤτοι μὲν ἔπεμπε σὺν ἵπποισιν καὶ ὄχεσφιν
ἐς πόλεμον, οὐδ' αὖτις ἐδέξατο νοστήσαντα.

He had sent him out with horses and chariots into battle, but his return he was not to welcome.

<div align="right">

Iliad, xviii, 237-38
Translated by Samuel Butler

</div>

No more beautiful ending can be imagined for the PATROKLEIA.

<div align="right">

ULRICH VON WILAMOWITZ-MOELLENDORFF
Die Ilias und Homer (1916)

</div>

HOMER

D A T E S U N K N O W N

THE THUNDER OF ZEUS

Δεινὸν δὲ βρόντησε πατὴρ ἀνδρῶν τε θεῶν τε
ὑψόθεν· αὐτὰρ ἔνερθε Ποσειδάων ἐτίναξεν
γαῖαν ἀπειρεσίην, ὀρέων τ' αἰπεινὰ κάρηνα.

* Milton, *Paradise Lost*, i, 314.

πάντες δ' ἐσσείοντο πόδες πολυπίδακος Ἴδης
καὶ κορυφαί, Τρώων τε πόλις καὶ νῆες Ἀχαιῶν.
ἔδδεισεν δ' ὑπένερθεν ἄναξ ἐνέρων, Ἀϊδωνεύς,
δείσας δ' ἐκ θρόνου ἆλτο καὶ ἴαχε, μή οἱ ὕπερθεν
γαῖαν ἀναρρήξειε Ποσειδάων ἐνοσίχθων,
οἰκία δὲ θνητοῖσι καὶ ἀθανάτοισι φανείη
σμερδαλέ', εὐρώεντα, τάτε στυγέουσι θεοί περ.
τόσσος ἄρα κτύπος ὦρτο θεῶν ἔριδι ξυνιόντων.

From the heights the Sire of gods
And men rolled dreadful thunder; and beneath
Poseidon made the infinite earth to quake,
And the steep mountain-summits: all the roots
Of many-fountained Ida and all her peaks,
The Trojans' city and the Achæans' ships
Were shaken. Hades, lord of shades below,
Was scared, and leapt in terror from his throne
And screamed for fear Poseidon earthquake-lord
Should burst apart the earth above his head,
And his abode be bared before the eyes
Of mortals and immortals—his abode
Ghastly and dank, which e'en the gods abhor.
So huge arose the clash of battling gods.

Iliad, xx, 56-66
Translated by Sir William Marris

*This passage has been quoted by all critics as the utmost effort of the
sublime. The Greek verses are admirable: they present successively the
thunder of Jupiter, the trident of Neptune, and the shriek of Pluto.
You imagine that you hear the thunder's roar reverberating through
all the valleys of Ida.*

Δεινὸν δ' ἐβρόντησε πατὴρ ἀνδρῶν τε θεῶν τε.

*The sounds of the words which occur in this line are a good imitation
of the peals of thunder, divided, as it were, by intervals of silence,
ων, τε, ων, τε. Thus does the voice of heaven, in a tempest, alternately
rise and fall in the recesses of the forests. A sudden and painful silence,
vague and fantastic images, rapidly succeed the tumult of the first
movements. After Pluto's shriek you feel as if you had entered the empire
of death; the expressions of Homer drop their force and coloring, while
a multitude of hissings imitate the murmur of the inarticulate voices
of the shades.*

F. R. CHATEAUBRIAND
Génie du Christianisme (1802)
Translated by Charles I. White

DATES UNKNOWN

ACHILLES REFUSES TO SPARE
LYCAON'S LIFE

'Νήπιε, μή μοι ἄποινα πιφαύσκεο, μηδ' ἀγόρευε.
πρὶν μὲν γὰρ Πάτροκλον ἐπισπεῖν αἴσιμον ἦμαρ,
τόφρα τί μοι πεφιδέσθαι ἐνὶ φρεσὶ φίλτερον ἦεν
Τρώων, καὶ πολλοὺς ζωοὺς ἕλον, ἠδ' ἐπέρασσα·
νῦν δ' οὐκ ἔσθ', ὅςτις θάνατον φύγῃ, ὅν κε θεός γε
Ἰλίου, προπάροιθεν ἐμῆς ἐν χερσὶ βάλῃσιν,
καὶ πάντων Τρώων, πέρι δ' αὖ Πριάμοιό γε παίδων.
ἀλλά, φίλος, θάνε καὶ σύ. τίη ὀλοφύρεαι οὕτως;
κάτθανε καὶ Πάτροκλος, ὅπερ σέο πολλὸν ἀμείνων.
οὐχ ὁράᾳς, οἷος κἀγὼ καλός τε μέγας τε;
πατρὸς δ' εἴμ' ἀγαθοῖο, θεὰ δέ με γείνατο μήτηρ·
ἀλλ' ἔπι τοι καὶ ἐμοὶ θάνατος καὶ Μοῖρα κραταιή —
ἔσσεται ἢ ἠώς, ἢ δείλη, ἢ μέσον ἦμαρ —
ὁππότε τις καὶ ἐμεῖο Ἄρει ἐκ θυμὸν ἕληται,
ἢ ὅγε δουρὶ βαλών, ἢ ἀπὸ νευρῆφιν ὀϊστῷ.'
 Ὣς φάτο· τοῦ δ' αὐτοῦ λύτο γούνατα καὶ φίλον ἦτορ·
ἔγχος μέν ῥ' ἀφέηκεν, ὁ δ' ἕζετο χεῖρε πετάσσας
ἀμφοτέρας. Ἀχιλλεὺς δὲ ἐρυσσάμενος ξίφος ὀξύ,
τύψε κατὰ κληῖδα παρ' αὐχένα· πᾶν δέ οἱ εἴσω
δῦ ξίφος ἄμφηκες· ὁ δ' ἄρα πρηνὴς ἐπὶ γαίῃ
κεῖτο ταθείς, ἐκ δ' αἷμα μέλαν ῥέε, δεῦε δὲ γαῖαν.
τὸν δ' Ἀχιλεὺς ποταμόνδε, λαβὼν ποδός, ἧκε φέρεσθαι,
καί οἱ ἐπευχόμενος ἔπεα πτερόεντ' ἀγόρευεν·
 ' Ἐνταυθοῖ νῦν κεῖσο μετ' ἰχθύσιν, οἵ σ' ὠτειλὴν
αἷμ' ἀπολιχμήσονται ἀκηδέες· οὐδέ σε μήτηρ
ἐνθεμένη λεχέεσσιν γοήσεται· ἀλλὰ Σκάμανδρος
οἴσει δινήεις εἴσω ἁλὸς εὐρέα κόλπον.
θρώσκων τις κατὰ κῦμα μέλαιναν φρῖχ' ὑπαΐξει
ἰχθύς, ὅς κε φάγῃσι Λυκάονος ἀργέτα δημόν.
φθείρεσθ', εἰς ὅ κεν ἄστυ κιχείομεν Ἰλίου ἱρῆς,
ὑμεῖς μὲν φεύγοντες, ἐγὼ δ' ὄπιθεν κεραΐζων.
οὐδ' ὑμῖν ποταμός περ ἐΰρροος ἀργυροδίνης
ἀρκέσει, ᾧ δὴ δηθὰ πολέας ἱερεύετε ταύρους,
ζωοὺς δ' ἐν δίνῃσι καθίετε μώνυχας ἵππους.
ἀλλὰ καὶ ὣς ὀλέεσθε κακὸν μόρον, εἰς ὅ κεν πάντες
τίσετε Πατρόκλοιο φόνον καὶ λοιγὸν Ἀχαιῶν,
οὓς ἐπὶ νηυσὶ θοῇσιν ἐπέφνετε, νόσφιν ἐμεῖο.'

"Fool, tender not ransom to me, neither make harangue. Until Patroclus met his day of fate, even till then was it more pleasing to me to spare the Trojans, and full many I took alive and sold oversea; but now is there not one that shall escape death, whomsoever before the walls of Ilios God shall deliver into my hands—aye, not one among all the Trojans, and least of all among the sons of Priam. Nay, friend, do thou too die; why lamentest thou thus? Patroclus also died, who was better far than thou. And seest thou not what manner of man am I, how comely and how tall? A good man was my father, and a goddess the mother that bare me; yet over me too hang death and mighty fate. There shall come a dawn or eve or mid-day, when my life too shall some man take in battle, whether he smite me with cast of the spear, or with an arrow from the string."

So spake he, and the other's knees were loosened where he was and his heart was melted. The spear he let go, but crouched with both hands outstretched. But Achilles drew his sharp sword and smote him upon the collar-bone beside the neck, and all the two-edged sword sank in; and prone upon the earth he lay outstretched, and the dark blood flowed forth and wetted the ground. Him then Achilles seized by the foot and flung into the river to go his way, and vaunting over him he spake winged words:

"Lie there now among the fishes that shall lick the blood from thy wound, nor reck aught of thee, neither shall thy mother lay thee on a Lier and make lament; nay, eddying Scamander shall bear thee into the broad gulf of the sea. Many a fish as he leapeth amid the waves, shall dart up beneath the black ripple to eat the white fat of Lycaon. So perish ye, till we be come to the city of sacred Ilios, ye in flight, and I making havoc in your rear. Not even the fair-flowing river with his silver eddies shall aught avail you, albeit to him, I wean, ye have long time been wont to sacrifice bulls full many, and to cast single-hooved horses while yet they lived, into his eddies. Howbeit even so shall ye perish by an evil fate, till ye have all paid the price for the slaying of Patroclus and for the woe of the Achaeans, whom by the swift ships ye slew while I tarried afar."

<div align="right">

Iliad, xxi, 99-135
Translated by A. T. Murray

</div>

There is nothing more terrible in literature than the simple words of Achillês to Lycaon, which send a shiver down my spine whenever I read them. I noticed in the happy days when we used to read Homer together in Greek, without translating at all, that the general mood of the company was the schoolboy's high spirits, with continual banter and jest, but whenever one of these great things came in, a sudden

silence fell. They never failed to feel them, although a schoolboy cannot understand them as a man of wider experience can.

W. H. D. ROUSE
The Story of Achilles (1938)

HOMER

DATES UNKNOWN

ANDROMACHE ON ASTYANAX'S LOSS OF HECTOR

ˁΗμαρ δ' ὀρφανικὸν παναφήλικα παῖδα τίθησι·

Thee lost, he loses all, of father, both,
And equal playmate in one day depriv'd.

Iliad, xxii, 490
Translated by William Cowper

HELEN UNREPROACHED BY HECTOR

'Αλλ' οὔ πω σεῦ ἄκουσα κακὸν ἔπος οὐδ' ἀσύφηλον·
ἀλλ' εἴ τίς με καὶ ἄλλος ἐνὶ μεγάροισιν ἐνίπτοι
δαέρων ἢ γαλόων ἢ εἰνατέρων ἐυπέπλων,
ἢ ἑκυρή (ἑκυρὸς δὲ πατὴρ ὣς ἤπιος αἰεί),
ἀλλὰ σὺ τόν γ' ἐπέεσσι παραιφάμενος κατέρυκες
σῇ τ' ἀγανοφροσύνῃ καὶ σοῖς ἀγανοῖς ἐπέεσσι.

Yet never heard I once hard speech from thee,
Or taunt morose; but if it ever chanc'd
That male or female of thy father's house
Blam'd me, and even if herself the queen
(For in the king, whate'er befell, I found
Always a father), thou hast interpos'd
Thy gentle temper and thy gentle speech
To soothe them.

Iliad, xxiv, 767-72
Translated by William Cowper

Surely, in delicate touches of pathos Homer excels all poets.

SAMUEL ROGERS
Recollections of the Table-Talk of Samuel Rogers (1856)

HOMER

DATES UNKNOWN

THE SHADE OF PATROCLUS

Ἐν καθαρῷ, ὅθι κύματ' ἐπὶ ἠϊόνος κλύζεσκον·
εὖτε τὸν ὕπνος ἔμαρπτε, λύων μελεδήματα θυμοῦ,
νήδυμος ἀμφιχυθείς· μάλα γὰρ κάμε φαίδιμα γυῖα
Ἕκτορ' ἐπαΐσσων προτὶ Ἴλιον ἠνεμόεσσαν.
ἦλθε δ' ἐπὶ ψυχὴ Πατροκλῆος δειλοῖο,
πάντ' αὐτῷ, μέγεθός τε καὶ ὄμματα κάλ', εἰκυῖα,
καὶ φωνήν, καὶ τοῖα περὶ χροΐ εἵματα ἔστο·
στῆ δ' ἄρ' ὑπὲρ κεφαλῆς, καί μιν πρὸς μῦθον ἔειπεν·
 ' Εὕδεις, αὐτὰρ ἐμεῖο λελασμένος ἔπλευ, Ἀχιλλεῦ;
οὐ μέν μευ ζώοντος ἀκήδεις, ἀλλὰ θανόντος·
θάπτε με ὅττι τάχιστα, πύλας Ἀΐδαο περήσω.
τῆλέ με εἴργουσι ψυχαί, εἴδωλα καμόντων,
οὐδέ μέ πω μίσγεσθαι ὑπὲρ ποταμοῖο ἐῶσιν·
ἀλλ' αὔτως ἀλάλημαι ἀν' εὐρυπυλὲς Ἄϊδος δῶ.
καί μοι δὸς τὴν χεῖρ', ὀλοφύρομαι· οὐ γὰρ ἔτ' αὖτις
νίσομαι ἐξ Ἀΐδαο, ἐπήν με πυρὸς λελάχητε.
οὐ μὲν γὰρ ζωοί γε φίλων ἀπάνευθεν ἑταίρων
βουλὰς ἑζόμενοι βουλεύσομεν·'

In a clear space he lay,
Where broke the waves, continuous, on the beach.
There, circumfus'd around him, gentle sleep,
Lulling the sorrows of his heart to rest,
O'ercame his senses; for the hot pursuit
Of Hector round the breezy heights of Troy
His active limbs had wearied: as he slept,
Sudden appear'd Patroclus' mournful shade,
His very self; his height, and beauteous eyes,
And voice; the very garb he wont to wear:
Above his head it stood, and thus it spoke:
 'Sleep'st thou, Achilles, mindless of thy friend,
Neglecting, not the living, but the dead?
Hasten my fun'ral rites, that I may pass
Through Hades' gloomy gates; ere those be done,
The spirits and spectres of departed men
Drive me far from them, nor allow to cross
Th' abhorrèd river; but forlorn and sad
I wander through the wide-spread realms of night.

And give me now thy hand, whereon to weep;
For never more, when laid upon the pyre,
Shall I return from Hades; never more,
Apart from all our comrades, shall we two,
As friends, sweet counsel take.'

Iliad, xxiii, 61-79
Translated by Edward Earl of Derby

That well-known passage, one of the sweetest and most pathetic, as I think, in the whole range of poetry.

JOHN KEBLE
Lectures on Poetry (1832-41)
Translated by Edward K. Francis

HOMER

DATES UNKNOWN

PRIAM'S PRAYER TO ACHILLES

Μνῆσαι πατρὸς σοῖο, θεοῖς ἐπιείκελ' Ἀχιλλεῦ,
τηλίκου, ὥςπερ ἐγών, ὀλοῷ ἐπὶ γήραος οὐδῷ.
καὶ μέν που κεῖνον περιναιέται ἀμφὶς ἐόντες
τείρουσ', οὐδέ τίς ἔστιν ἀρὴν καὶ λοιγὸν ἀμῦναι·
ἀλλ' ἤτοι κεῖνός γε, σέθεν ζώοντος ἀκούων,
χαίρει τ' ἐν θυμῷ, ἐπί τ' ἔλπεται ἤματα πάντα
ὄψεσθαι φίλον υἱόν, ἀπὸ Τροίηθε μολόντα.
αὐτὰρ ἐγὼ πανάποτμος, ἐπεὶ τέκον υἷας ἀρίστους
Τροίῃ ἐν εὐρείῃ, τῶν δ' οὔτινά φημι λελεῖφθαι.
πεντήκοντά μοι ἦσαν, ὅτ' ἤλυθον υἷες Ἀχαιῶν·
ἐννεακαίδεκα μέν μοι ἰῆς ἐκ νηδύος ἦσαν,
τοὺς δ' ἄλλους μοι ἔτικτον ἐνὶ μεγάροισι γυναῖκες.
τῶν μὲν πολλῶν θοῦρος Ἄρης ὑπὸ γούνατ' ἔλυσεν·
ὃς δέ μοι οἶος ἔην, εἴρυτο δὲ ἄστυ καὶ αὐτούς,
τὸν σὺ πρώην κτεῖνας, ἀμυνόμενον περὶ πάτρης,
Ἕκτορα· τοῦ νῦν εἵνεχ' ἱκάνω νῆας Ἀχαιῶν,
λυσόμενος παρὰ σεῖο, φέρω δ' ἀπερείσι' ἄποινα.
ἀλλ' αἰδεῖο θεούς, Ἀχιλεῦ, αὐτόν τ' ἐλέησον,
μνησάμενος σοῦ πατρός· ἐγὼ δ' ἐλεεινότερός περ,
ἔτλην δ', οἷ' οὔπω τις ἐπιχθόνιος βροτὸς ἄλλος,
ἀνδρὸς παιδοφόνοιο ποτὶ στόμα χεῖρ' ὀρέγεσθαι.

'O God-like Achilles, thy father call to remembrance,
How he is halting as I, i' the dark'ning doorway of old age,
And desolately liveth, while all they that dwell about him
Vex him, nor hath he one from their violence to defend him:
Yet but an heareth he aught of thee, thy wellbeing in life,
Then he rejoiceth an' all his days are glad with a good hope
Soon to behold thee again, his son safe home from the warfare.
But most hapless am I, for I had sons numerous and brave
In wide Troy; where bē they now? scarce is one o' them left.
They were fifty the day ye arriv'd hither out of Achaia,
Nineteen royally born princes from one mother only,
While the others women of my house had borne me; of all these
Truly the greater part hath Ares in grim battle unstrung.
But hé, who was alone the city's lov'd guardian and stay,
Few days since thou slew'st him alas! his country defending,
Hector, for whose sake am I‑come to the ships of Achaia
His body dear to redeem, offering thee a ransom abundant.
O God-like Achilles, have fear o' the gods, pity him too,
Thy sire also remember, having yet more pity on mé,
Who now stoop me beneath what dread deed mortal ever dar'd,
Raising the hand that slew his son pitiably to kiss it.'

<div align="right">Iliad, xxiv, 486-506

Translated by Robert Bridges</div>

What peroration can ever match the prayers of Priam to Achilles?

<div align="right">QUINTILIAN

Institutio Oratoria, x, 1, 50</div>

HOMER

DATES UNKNOWN

ONCE HAPPY

Καὶ σέ, γέρον, τὸ πρὶν μὲν ἀκούομεν ὄλβιον εἶναι.

It is said, old man, that thou also wert happy once.

<div align="right">Iliad, xxiv, 543

Translated by J. A. K. Thomson</div>

What array of words could say so much? One has to go to the DIVINE
COMEDY *to match it, the words of Beatrice to Dante in the Earthly Para-*

dise: 'Knewest thou not that here man is happy?' *Nausicaa says to Odysseus, her last words,*

FAREWELL, STRANGER GUEST. THAT EVEN IN YOUR OWN LAND YOU MAY REMEMBER ME! FOR THOU OWEST THE PRICE OF THY LIFE TO ME, THE FIRST.

That is all she says. It is so wonderful in its delicacy, that the answer of Odysseus, though a masterpiece of tact, jars a little, as it could not but jar, no answer being really possible. Only the very greatest poets can do this kind of thing. Ophelia's 'No more but so?' may be set beside Nausicaa's farewell. The critic is afraid to touch words like these, they are so alive and sensitive. They are as full of mysterious meaning as life itself. Shakespeare is a great master in this kind of simplicity. But the Greeks are nearly all masters in it. It is only achieved by a perfect skill in the use of language.

<div align="right">

J. A. K. THOMSON
The Greek Tradition (1915)

</div>

HOMER

DATES UNKNOWN

THE BURIAL OF HECTOR

Ὣς οἵγ' ἀμφίεπον τάφον Ἕκτορος ἱπποδάμοιο.

Thus they conducted the funeral of horse-taming Hector.

<div align="right">

Iliad, xxiv, 804

</div>

I cannot take my leave of this noble poem, without expressing how much I am struck with this plain conclusion of it. It is like the exit of a great man out of company whom he has entertained magnificently; neither pompous nor familiar; not contemptuous, yet without much ceremony. I recollect nothing, among the works of mere man, that exemplifies so strongly the true style of great antiquity.

<div align="right">

WILLIAM COWPER
The Iliad of Homer (1791)

</div>

HOMER

DATES UNKNOWN

OLYMPUS

Ἡ μὲν ἄρ' ὣς εἰποῦσ' ἀπέβη γλαυκῶπις Ἀθήνη
Οὔλυμπόνδ', ὅθι φασὶ θεῶν ἕδος ἀσφαλὲς αἰεὶ
ἔμμεναι· οὔτ' ἀνέμοισι τινάσσεται, οὔτε ποτ' ὄμβρῳ
δεύεται, οὔτε χιὼν ἐπιπίλναται· ἀλλὰ μάλ' αἴθρη
πέπταται ἀνέφελος, λευκὴ δ' ἐπιδέδρομεν αἴγλη.
τῷ ἔνι τέρπονται μάκαρες θεοὶ ἤματα πάντα.
ἔνθ' ἀπέβη Γλαυκῶπις, ἐπεὶ διεπέφραδε κούρῃ.

Having thus fulfilled her purpose Athene went away to Olympus where
evermore they say the seat of the gods stays sure: for the winds shake it
not, nor is it wetted by rain, nor approached by any snow. All around
stretches the cloudless firmament, and a white glory of sunlight is dif-
fused about its walls. There the blessed gods are happy all their days:
and thither, accordingly, repaired the grey-eyed One after clearly im-
parting her message to the maiden.

Odyssey, vi, 41-47
Translated by T. E. Shaw

Nothing can excel the harmony of these passages, and the poetry*
they contain is equally perfect.

WALTER SAVAGE LANDOR
Imaginary Conversations, Abbé Delille and Landor (1824-9)

HOMER

DATES UNKNOWN

ODYSSEUS' MOTHER SPEAKS TO HIM
IN HADES

Οὔτε μέ γ' ἐν μεγάροισιν ἐΰσκοπος Ἰοχέαιρα
οἷς ἀγανοῖς βελέεσσιν ἐποιχομένη κατέπεφνεν,
οὔτε τις οὖν μοι νοῦσος ἐπήλυθεν, ἥτε μάλιστα

* For the other passage cited by Landor (*Odyssey*, xi, 198-203) see the
extract immediately following.

24

τηκεδόνι στυγερῇ μελέων ἐξείλετο θυμόν·
ἀλλά με σός τε πόθος, σά τε μήδεα, φαίδιμ' 'Οδυσσεῦ,
σή τ' ἀγανοφροσύνη μελιηδέα θυμὸν ἀπηύρα.

Neither did the keen-sighted archer goddess assail me in my halls with her gentle shafts, and slay me, nor did any disease come upon me, such as oftenest through grievous wasting takes the spirit from the limbs; nay, it was longing for thee, and for thy counsels, glorious Odysseus, and for thy tender-heartedness, that robbed me of honey-sweet life.

<div align="right">

Odyssey, xi, 198-203
Translated by A. T. Murray

</div>

No words that men can any more set side by side can ever affect the mind again like some of the great passages of Homer. For in them it seems as if all that makes life precious were in the act of being created at once and together—language itself, and the first emotions, and the inconceivable charm of song. When we hear one single sentence of Anticleia's answer, as she begins—

οὔτ' ἔμεγ' ἐν μεγαροῖσιν ἐΰσκοπος ἰοχέαιρα—

what words can express the sense which we receive of an effortless and absolute sublimity, the feeling of morning freshness and elemental power, the delight which is to all other intellectual delights what youth is to all other joys? And what a language! which has written, as it were, of itself those last two words for the poet, which offers them as the fruit of its inmost structure and the bloom of its early day! Beside speech like this Virgil's seems elaborate, and Dante's crabbed, and Shakespeare's barbarous. There never has been, there never will be, a language like the dead Greek.

<div align="right">

F. W. H. MYERS
Essays Classical and Modern (1921)

</div>

HOMER

DATES UNKNOWN

THE SILENCE OF AJAX

Αἱ δ' ἄλλαι ψυχαὶ νεκύων κατατεθνηώτων
ἕστασαν ἀχνύμεναι, εἴροντο δὲ κήδε' ἑκάστη.
οἴη δ' Αἴαντος ψυχὴ Τελαμωνιάδαο
νόσφιν ἀφεστήκει, κεχολωμένη εἵνεκα νίκης,

25

τήν μιν ἐγὼ νίκησα, δικαζόμενος παρὰ νηυσίν,
τεύχεσιν ἀμφ' Ἀχιλῆος· ἔθηκε δὲ πότνια μήτηρ.
[παῖδες δὲ Τρώων δίκασαν καὶ Παλλὰς Ἀθήνη.]
ὡς δὴ μὴ ὄφελον νικᾶν τοιῷδ' ἐπ' ἀέθλῳ·
τοίην γὰρ κεφαλὴν ἕνεκ' αὐτῶν γαῖα κατέσχεν,
Αἴανθ', ὃς πέρι μὲν εἶδος, πέρι δ' ἔργα τέτυκτο
τῶν ἄλλων Δαναῶν, μετ' ἀμύμονα Πηλείωνα.
τὸν μὲν ἐγὼν ἐπέεσσι προςηύδων μειλιχίοισιν·

Αἶαν, παῖ Τελαμῶνος ἀμύμονος, οὐκ ἄρ' ἔμελλες
οὐδὲ θανὼν λήσεσθαι ἐμοὶ χόλου, εἵνεκα τευχέων
οὐλομένων; τὰ δὲ πῆμα θεοὶ θέσαν Ἀργείοισιν.
τοῖος γάρ σφιν πύργος ἀπώλεο· σεῖο δ' Ἀχαιοὶ
ἶσον Ἀχιλλῆος κεφαλῇ Πηληϊάδαο,
ἀχνύμεθα φθιμένοιο διαμπερές· οὐδέ τις ἄλλος
αἴτιος, ἀλλὰ Ζεὺς Δαναῶν στρατὸν αἰχμητάων
ἐκπάγλως ἤχθηρε· τεῒν δ' ἐπὶ μοῖραν ἔθηκεν.
ἀλλ' ἄγε δεῦρο, ἄναξ, ἵν' ἔπος καὶ μῦθον ἀκούσῃς
ἡμέτερον· δάμασον δὲ μένος καὶ ἀγήνορα θυμόν.

Ὣς ἐφάμην· ὁ δέ μ' οὐδὲν ἀμείβετο, βῆ δὲ μετ' ἄλλας
ψυχὰς εἰς Ἔρεβος νεκύων κατατεθνηώτων.

There hung about me others of the departed, each sadly asking news of his loved ones. Only the spirit of Aias the son of Telamon kept aloof, he being yet vexed with me for that I had been preferred before him when by the ships we disputed the harness of Achilles, the arms which his Goddess-mother had set as prize, and which the sons of the Trojans and Pallas Athene adjudged. Would I had not won that victory, since by it earth closed above so excellent a head. Verily, in sheer beauty of form and for prowess, great Aias stood out above every Danaan, the noble son of Peleus excepted. So to him I spoke very gently, thus: 'Lord Aias, son of great Telamon, can you not even in death forget your anger against me over those cursed arms? Surely the Gods meant them as a plague upon the Argives. What a tower fell in your fall! For you we Argives mourn as for our lost crown, Achilles; because you died. Prime cause of it was Zeus, who in his terrible hatred of the Danaan chivalry laid upon you their guilty desert. I pray you, King, draw near to hear the things we say. Vail your fierce pride of heart.' So I appealed, but he answered not a word: only went away towards Erebus with other spirits of the departed dead.

<div align="right">Odyssey, xi, 541-64

Translated by T. E. Shaw</div>

Thus it is that, without any utterance, a notion, unclothed and unsup-ported, often moves our wonder, because the very thought is great: the

silence of Ajax in the book of the Lower World is great, and more
sublime than any words.

LONGINUS
On the Sublime, **ix**
Translated by A. O. Prickard

H O M E R

D A T E S U N K N O W N

THE SOUND OF FOOTSTEPS

Τὼ δ' αὖτ' ἐν κλισίῃ 'Οδυσσεὺς καὶ δῖος ὑφορβὸς
ἐντύνοντο ἄριστον ἅμ' ἠοῖ' κειαμένω πῦρ,
ἔκπεμψάν τε νομῆας ἅμ' ἀγρομένοισι σύεσσιν·
Τηλέμαχον δὲ περίσσαινον κύνες ὑλακόμωροι,
οὐδ' ὕλαον προςιόντα. νόησε δὲ δῖος 'Οδυσσεὺς
σαίνοντάς τε κύνας, περί τε κτύπος ἦλθε ποδοῖιν.
αἶψα δ' ἄρ' Εὔμαιον ἔπεα πτερόεντα προςηύδα·

Εὔμαι', ἦ μάλα τίς τοι ἐλεύσεται ἐνθάδ' ἑταῖρος,
ἦ καὶ γνώριμος ἄλλος, ἐπεὶ κύνες οὐχ' ὑλάουσιν,
ἀλλὰ περισσαίνουσι· ποδῶν δ' ὑπὸ δοῦπον ἀκούω.

Οὔπω πᾶν εἴρητο ἔπος, ὅτε οἱ φίλος υἱὸς
ἔστη ἐνὶ προθύροισι· ταφὼν δ' ἀνόρουσε συβώτης·
ἐκ δ' ἄρα οἱ χειρῶν πέσον ἄγγεα, τοῖς ἐπονεῖτο,
κιρνὰς αἴθοπα οἶνον. ὁ δ' ἀντίος ἦλθεν ἄνακτος·
κύσσε δέ μιν κεφαλήν τε καὶ ἄμφω φάεα καλά,
χεῖράς τ' ἀμφοτέρας· θαλερὸν δέ οἱ ἔκπεσε δάκρυ.

Meanwhile the two in the hut, Odysseus and the goodly swineherd, had kindled a fire, and were making ready their breakfast at dawn, and had sent forth the herdsmen with the droves of swine; but around Telemachus the baying hounds fawned, and barked not as he drew near. And goodly Odysseus noted the fawning of the hounds, and the sound of footsteps fell upon his ears; and straightway he spoke to Eumaeus winged words:

"Eumaeus, surely some comrade of thine will be coming, or at least some one thou knowest, for the hounds do not bark, but fawn about him, and I hear the sound of footsteps."

Not yet was the word fully uttered, when his own dear son stood in the doorway. In amazement up sprang the swineherd, and from his

27

hands the vessels fell with which he was busied as he mixed the flaming
wine. And he went to meet his lord, and kissed his head and both his
beautiful eyes and his two hands, and a big tear fell from him.

<div align="right">

Odyssey, xvi, 1-16
Translated by A. T. Murray

</div>

*We find Odysseus tarrying in the swineherd's hut and about to break
his fast at dawn, as they used to do in ancient days. Telemachus then
appears in sight, returning from his sojourn in the Peloponnese. Trifling
incidents of everyday life as these are, they are inimitably portrayed.
. . . Everybody would, I am sure, testify that these lines cast a spell
of enchantment on the ear, and rank second to no poetry whatsoever,
however exquisite it may be.*

<div align="right">

DIONYSIUS OF HALICARNASSUS
De Compositione Verborum, iii
Translated by W. Rhys Roberts

</div>

HOMER

DATES UNKNOWN

WISE PENELOPE

'Ως δ' ὅτε Πανδαρέου κούρη, χλωρηῒς 'Αηδών,
καλὸν ἀείδῃσιν, ἔαρος νέον ἱσταμένοιο,
δενδρέων ἐν πετάλοισι καθεζομένη πυκινοῖσιν,
ἥτε θαμὰ τρωπῶσα χέει πολυηχέα φωνήν,
παῖδ' ὀλοφυρομένη ῎Ιτυλον φίλον, ὅν ποτε χαλκῷ
κτεῖνε δι' ἀφραδίας, κοῦρον Ζήθοιο ἄνακτος·
ὣς καὶ ἐμοὶ δίχα θυμὸς ὀρώρεται ἔνθα καὶ ἔνθα,
ἠὲ μένω, παρὰ παιδί, καὶ ἔμπεδα πάντα φυλάσσω,
κτῆσιν ἐμήν, δμωάς τε καὶ ὑψηρεφὲς μέγα δῶμα,
εὐνήν τ' αἰδομένη πόσιος, δήμοιό τε φῆμιν·
ἢ ἤδη ἅμ' ἕπωμαι 'Αχαιῶν ὅςτις ἄριστος
μνᾶται ἐνὶ μεγάροισι, πορὼν ἀπερείσια ἕδνα.

Even as when the daughter of Pandareus, the nightingale of the green-
wood, sings sweetly, when spring is newly come, as she sits perched
amid the thick leafage of the trees, and with many trilling notes pours
forth her rich voice in wailing for her child, dear Itylus, whom she had
one day slain with the sword unwittingly, Itylus, the son of king Zethus;
even so my heart sways to and fro in doubt, whether to abide with my

son and keep all things safe, my possessions, my slaves, and my great, high-roofed house, respecting the bed of my husband and the voice of the people, or to go now with him whosoever is best of the Achaeans, who woos me in the halls and offers bride-gifts past counting.

<div align="right">

Odyssey, xix, 518-29
Translated by A. T. Murray

</div>

A perfect miracle of language.

<div align="right">

J. W. MACKAIL
Lectures on Greek Poetry (1910)

</div>

HOMER

DATES UNKNOWN

ODYSSEUS AND PENELOPE MEET

Γρηῦς δ' εἰς ὑπερῷ' ἀνεβήσατο καγχαλόωσα,
δεσποίνῃ ἐρέουσα φίλον πόσιν ἔνδον ἐόντα·
γούνατα δ' ἐρρώσαντο, πόδες δ' ὑπερικταίνοντο·
στῆ δ' ἄρ' ὑπὲρ κεφαλῆς, καί μιν πρὸς μῦθον ἔειπεν·
Ἔγρεο, Πηνελόπεια, φίλον τέκος, ὄφρα ἴδηαι
ὀφθαλμοῖσι τεοῖσι, τάτ' ἔλδεαι ἤματα πάντα·
ἦλθ' Ὀδυσσεύς, καὶ οἶκον ἱκάνεται, ὀψέ περ ἐλθών·
μνηστῆρας δ' ἔκτεινεν ἀγήνορας, οἵτε οἱ οἶκον
κήδεσκον, καὶ κτήματ' ἔδον, βιόωντό τε παῖδα.
 Τὴν δ' αὖτε προσέειπε περίφρων Πηνελόπεια·
μαῖα φίλη, μάργην σε θεοὶ θέσαν· οἵτε δύνανται
ἄφρονα ποιῆσαι καὶ ἐπίφρονά περ μάλ' ἐόντα,
καί τε χαλιφρονέοντα σαοφροσύνης ἐπέβησαν·
οἵ σέ περ ἔβλαψαν· πρὶν δὲ φρένας αἰσίμη ἦσθα.
τίπτε με λωβεύεις, πολυπενθέα θυμὸν ἔχουσαν,
ταῦτα παρὲξ ἐρέουσα, καὶ ἐξ ὕπνου μ' ἀνεγείρεις
ἡδέος, ὅς μ' ἐπέδησε φίλα βλέφαρ' ἀμφικαλύψας;
οὐ γάρ πω τοιόνδε κατέδραθον, ἐξ οὗ Ὀδυσσεὺς
ᾤχετ', ἐποψόμενος Κακοΐλιον οὐκ ὀνομαστήν.
ἀλλ' ἄγε νῦν κατάβηθι, καὶ ἄψ ἔρχευ μεγαρόνδε.
εἰ γάρ τίς μ' ἄλλη γε γυναικῶν, αἵ μοι ἔασιν,
ταῦτ' ἐλθοῦσ' ἤγγειλε, καὶ ἐξ ὕπνου μ' ἀνέγειρεν,
τῷ κε τάχα στυγερῶς μιν ἐγὼν ἀπέπεμψα νέεσθαι
αὖτις ἔσω μέγαρον· σὲ δὲ τοῦτό γε γῆρας ὀνήσει.
 Τὴν δ' αὖτε προσέειπε φίλη τροφὸς Εὐρύκλεια·

<div align="center">

29

</div>

οὔτι σε λωβεύω, τέκνον φίλον· ἀλλ' ἔτυμόν τοι
ἦλθ' Ὀδυσσεύς, καὶ οἶκον ἱκάνεται, ὡς ἀγορεύω,
ὁ ξεῖνος, τὸν πάντες ἀτίμων ἐν μεγάροισιν.
Τηλέμαχος δ' ἄρα μιν πάλαι ᾔδεεν ἔνδον ἐόντα,
ἀλλὰ σαοφροσύνῃσι νοήματα πατρὸς ἔκευθεν,
ὄφρ' ἀνδρῶν τίσαιτο βίην ὑπερηνορεόντων.
 Ὣς ἔφαθ'· ἡ δ' ἐχάρη, καὶ ἀπὸ λέκτροιο θοροῦσα
γρηῒ περιπλέχθη, βλεφάρων δ' ἀπὸ δάκρυον ἧκεν·
καί μιν φωνήσασ' ἔπεα πτερόεντα προσηύδα·
 Εἰ δ', ἄγε δή μοι, μαῖα φίλη, νημερτὲς ἔνισπε,
εἰ ἐτεὸν δὴ οἶκον ἱκάνεται, ὡς ἀγορεύεις,
ὅππως δὴ μνηστῆρσιν ἀναιδέσι χεῖρας ἐφῆκεν,
μοῦνος ἐών, οἱ δ' αἰὲν ἀολλέες ἔνδον ἔμιμνον.
 Τὴν δ' αὖτε προσέειπε φίλη τροφὸς Εὐρύκλεια·
οὐκ ἴδον, οὐ πυθόμην, ἀλλὰ στόνον οἶον ἄκουον
κτεινομένων· ἡμεῖς δὲ μυχῷ θαλάμων εὐπήκτων
ἥμεθ' ἀτυζόμεναι, σανίδες δ' ἔχον εὖ ἀραρυῖαι,
πρίν γ' ὅτε δή με σὸς υἱὸς ἀπὸ μεγάροιο κάλεσσεν
Τηλέμαχος· τὸν γάρ ῥα πατὴρ προέηκε καλέσσαι.
εὗρον ἔπειτ' Ὀδυσῆα μετὰ κταμένοισι νέκυσσιν
ἑσταόθ'· οἱ δέ μιν ἀμφί, κραταίπεδον οὖδας ἔχοντες,
κεῖατ' ἐπ' ἀλλήλοισιν· ἰδοῦσά κε θυμὸν ἰάνθης.
νῦν δ' οἱ μὲν δὴ πάντες ἐπ' αὐλείῃσι θύρῃσιν
ἀθρόοι· αὐτὰρ ὁ δῶμα θεειοῦται περικαλλές,
πῦρ μέγα κειάμενος· σὲ δέ με προέηκε καλέσσαι.
ἀλλ' ἕπευ, ὄφρα σφῶϊν ἐϋφροσύνης ἐπιβῆτον
ἀμφοτέρω φίλον ἦτορ, ἐπεὶ κακὰ πολλὰ πέποσθε.
νῦν δ' ἤδη τόδε μακρὸν ἐέλδωρ ἐκτετέλεσται·
ἦλθε μὲν αὐτὸς ζωὸς ἐφέστιος, εὗρε δὲ καὶ σέ,
καὶ παῖδ' ἐν μεγάροισι· κακῶς δ' οἵπερ μιν ἔρεζον
μνηστῆρες, τοὺς πάντας ἐτίσατο ᾧ ἐνὶ οἴκῳ.
 Τὴν δ' αὖτε προσέειπε περίφρων Πηνελόπεια·
μαῖα φίλη, μήπω μέγ' ἐπεύχεο καγχαλόωσα.
οἶσθα γὰρ ὡς ἀσπαστὸς ἐνὶ μεγάροισι φανείη
πᾶσι, μάλιστα δ' ἐμοί τε καὶ υἱέϊ, τὸν τεκόμεσθα·
ἀλλ' οὐκ ἔσθ' ὅδε μῦθος ἐτήτυμος, ὡς ἀγορεύεις·
ἀλλά τις ἀθανάτων κτεῖνε μνηστῆρας ἀγαυούς,
ὕβριν ἀγασσάμενος θυμαλγέα καὶ κακὰ ἔργα.
οὔτινα γὰρ τίεσκον ἐπιχθονίων ἀνθρώπων,
οὐ κακόν, οὐδὲ μὲν ἐσθλόν, ὅτις σφέας εἰσαφίκοιτο·
τῷ δι' ἀτασθαλίας ἔπαθον κακόν· αὐτὰρ Ὀδυσσεὺς
ὤλεσε τηλοῦ νόστον Ἀχαΐδος, ὤλετο δ' αὐτός.
 Τὴν δ' ἠμείβετ' ἔπειτα φίλη τροφὸς Εὐρύκλεια·
τέκνον ἐμόν, ποῖόν σε ἔπος φύγεν ἕρκος ὀδόντων,

30

ἢ πόσιν, ἔνδον ἐόντα παρ' ἐσχάρη, οὔποτ' ἔφησθα
οἴκαδ' ἐλεύσεσθαι· θυμὸς δέ τοι αἰὲν ἄπιστος.
ἀλλ' ἄγε τοι καὶ σῆμα ἀριφραδὲς ἄλλο τι εἴπω,
οὐλήν, τήν ποτέ μιν σῦς ἤλασε λευκῷ ὀδόντι.
τὴν ἀπονίζουσα φρασάμην· ἔθελον δέ σοὶ αὐτῇ
εἰπέμεν· ἀλλά με κεῖνος ἑλὼν ἐπὶ μάστακα χερσίν,
οὐκ ἔα εἰπέμεναι, πολυϊδρείῃσι νόοιο.
ἀλλ' ἕπευ· αὐτὰρ ἐγὼ ἐμέθεν περιδώσομαι αὐτῆς,
αἴ κέν σ' ἐξαπάφω, κτεῖναί μ' οἰκτίστῳ ὀλέθρῳ.
 Τὴν δ' ἠμείβετ' ἔπειτα περίφρων Πηνελόπεια·
μαῖα φίλη, χαλεπόν σε θεῶν αἰειγενετάων
δήνεα εἴρυσθαι, μάλα περ πολύϊδριν ἐοῦσαν·
ἀλλ' ἔμπης ἴομεν μετὰ παῖδ' ἐμόν, ὄφρα ἴδωμαι
ἄνδρας μνηστῆρας τεθνηότας, ἠδ' ὅς ἔπεφνεν.
 Ὣς φαμένη, κατέβαιν' ὑπερώϊα· πολλὰ δέ οἱ κῆρ
ὥρμαιν', ἢ ἀπάνευθε φίλον πόσιν ἐξερεείνοι,
ἢ παρστᾶσα κύσειε κάρη καὶ χεῖρε λαβοῦσα.
ἡ δ' ἐπεὶ εἰσῆλθεν, καὶ ὑπέρβη λάϊνον οὐδόν,
ἕζετ' ἔπειτ' Ὀδυσῆος ἐναντίον, ἐν πυρὸς αὐγῇ,
τοίχου τοῦ ἑτέρου· ὁ δ' ἄρα πρὸς κίονα μακρὴν
ἧστο κάτω ὁρόων, ποτιδέγμενος, εἴ τί μιν εἴποι
ἰφθίμη παράκοιτις, ἐπεὶ ἴδεν ὀφθαλμοῖσιν.
ἡ δ' ἄνεω δὴν ἧστο, τάφος δέ οἱ ἦτορ ἵκανεν·
ὄψει δ' ἄλλοτε μέν μιν ἐνωπαδίως ἐσίδεσκεν,
ἄλλοτε δ' ἀγνώσασκε, κακὰ χροῒ εἵματ' ἔχοντα.
Τηλέμαχος δ' ἐνένιπεν, ἔπος τ' ἔφατ', ἔκ τ' ὀνόμαζεν.
 Μῆτερ ἐμή, δύσμητερ, ἀπηνέα θυμὸν ἔχουσα,
τίφθ' οὕτω πατρὸς νοσφίζεαι, οὐδὲ παρ' αὐτὸν
ἑζομένη μύθοισιν ἀνείρεαι, οὐδὲ μεταλλᾷς;
οὐ μέν κ' ἄλλη γ' ὧδε γυνὴ τετληότι θυμῷ
ἀνδρὸς ἀφεσταίη, ὅς οἱ κακὰ πολλὰ μογήσας
ἔλθοι ἐεικοστῷ ἔτεϊ ἐς πατρίδα γαῖαν·
σοὶ δ' αἰεὶ κραδίη στερεωτέρη ἐστὶ λίθοιο.
 Τὸν δ' αὖτε προσέειπε περίφρων Πηνελόπεια·
τέκνον ἐμόν, θυμός μοι ἐνὶ στήθεσσι τέθηπεν·
οὐδέ τι προσφάσθαι δύναμαι ἔπος, οὐδ' ἐρέεσθαι,
οὐδ' εἰς ὦπα ἰδέσθαι ἐναντίον. εἰ δ' ἐτεὸν δὴ
ἔστ' Ὀδυσεύς, καὶ οἶκον ἱκάνεται, ἦ μάλα νῶϊ
γνωσόμεθ' ἀλλήλων καὶ λώϊον· ἔστι γὰρ ἡμῖν
σήμαθ', ἃ δὴ καὶ νῶϊ κεκρυμμένα ἴδμεν ἀπ' ἄλλων.
 Ὣς φάτο· μείδησεν δὲ πολύτλας δῖος Ὀδυσσεύς,
αἶψα δὲ Τηλέμαχον ἔπεα πτερόεντα προσηύδα·
 Τηλέμαχ' ἤτοι μητέρ' ἐνὶ μεγάροισιν ἔασον
πειράζειν ἐμέθεν· τάχα δὲ φράσεται καὶ ἄρειον.

31

νῦν δ' ὅττι ῥυπόω, κακὰ δὲ χροΐ εἵματα εἷμαι,
τούνεκ' ἀτιμάζει με, καὶ οὔπω φησὶ τὸν εἶναι.
ἡμεῖς δὲ φραζώμεθ', ὅπως ὄχ' ἄριστα γένηται.
καὶ γάρ τίς θ' ἕνα φῶτα κατακτείνας ἐνὶ δήμῳ,
ᾧ μὴ πολλοὶ ἔωσιν ἀοσσητῆρες ὀπίσσω,
φεύγει, πηούς τε προλιπὼν καὶ πατρίδα γαῖαν·
ἡμεῖς δ' ἕρμα πόληος ἀπέκταμεν, οἳ μέγ' ἄριστοι
κούρων εἰν Ἰθάκῃ· τάδε σε φράζεσθαι ἄνωγα.
 Τὸν δ' αὖ Τηλέμαχος πεπνυμένος ἀντίον ηὖδα·
αὐτὸς ταῦτά γε λεῦσσε, πάτερ φίλε· σὴν γὰρ ἀρίστην
μῆτιν ἐπ' ἀνθρώπους φάσ' ἔμμεναι, οὐδέ κέ τίς τοι
ἄλλος ἀνὴρ ἐρίσειε καταθνητῶν ἀνθρώπων.
[ἡμεῖς δ' ἐμμεμαῶτες ἅμ' ἑψόμεθ', οὐδέ τί φημι
ἀλκῆς δευήσεσθαι, ὅση δύναμίς γε πάρεστιν.]
 Τὸν δ' ἀπαμειβόμενος προσέφη πολύμητις Ὀδυσσεύς·
τοιγὰρ ἐγὼν ἐρέω, ὥς μοι δοκεῖ εἶναι ἄριστα.
πρῶτα μὲν ἂρ λούσασθε, καὶ ἀμφιέσασθε χιτῶνας,
δμῳὰς δ' ἐν μεγάροισιν ἀνώγετε εἵμαθ' ἑλέσθαι·
αὐτὰρ θεῖος ἀοιδός, ἔχων φόρμιγγα λίγειαν,
ἡμῖν ἡγείσθω φιλοπαίγμονος ὀρχηθμοῖο,
ὥς κέν τις φαίη γάμον ἔμμεναι, ἐκτὸς ἀκούων,
ἢ ἂν' ὁδὸν στείχων, ἢ οἳ περιναιετάουσιν·
μὴ πρόσθε κλέος εὐρὺ φόνου κατὰ ἄστυ γένηται
ἀνδρῶν μνηστήρων, πρίν γ' ἡμέας ἐλθέμεν ἔξω
ἀγρὸν ἐς ἡμέτερον πολυδένδρεον· ἔνθα δ' ἔπειτα
φρασσόμεθ' ὅττι κε κέρδος Ὀλύμπιος ἐγγυαλίξῃ.
 Ὣς ἔφαθ'· οἱ δ' ἄρα τοῦ μάλα μὲν κλύον, ἠδ' ἐπίθοντο
πρῶτα μὲν οὖν λούσαντο, καὶ ἀμφιέσαντο χιτῶνας·
ὅπλισθεν δὲ γυναῖκες· ὁ δ' εἵλετο θεῖος ἀοιδὸς
φόρμιγγα γλαφυρήν, ἐν δέ σφισιν ἵμερον ὦρσεν
μολπῆς τε γλυκερῆς καὶ ἀμύμονος ὀρχηθμοῖο.
τοῖσιν δὲ μέγα δῶμα περιστεναχίζετο ποσσὶν
ἀνδρῶν παιζόντων, καλλιζώνων τε γυναικῶν.
ὧδε δέ τις εἴπεσκε, δόμων ἔκτοσθεν ἀκούων·
 Ἦ μάλα δή τις ἔγημε πολυμνήστην βασίλειαν·
σχετλίη, οὐδ' ἔτλη πόσιος οὗ κουριδίοιο
εἴρυσθαι μέγα δῶμα διαμπερές, ἕως ἵκοιτο.
 Ὣς ἄρα τις εἴπεσκε· τὰ δ' οὐκ ἴσαν, ὡς ἐτέτυκτο.
αὐτὰρ Ὀδυσσῆα μεγαλήτορα ᾧ ἐνὶ οἴκῳ
Εὐρυνόμη ταμίη λοῦσεν, καὶ χρῖσεν ἐλαίῳ·
ἀμφὶ δέ μιν φᾶρος καλὸν βάλεν ἠδὲ χιτῶνα·
αὐτὰρ κὰκ κεφαλῆς χεῦεν πολὺ κάλλος Ἀθήνη,
μείζονά τ' εἰσιδέειν καὶ πάσσονα· κὰδ δὲ κάρητος
οὔλας ἧκε κόμας, ὑακινθίνῳ ἄνθει ὁμοίας.

ὡς δ' ὅτε τις χρυσὸν περιχεύεται ἀργύρῳ ἀνὴρ
ἴδρις, ὃν Ἥφαιστος δέδαεν καὶ Παλλὰς Ἀθήνη
τέχνην παντοίην, χαρίεντα δὲ ἔργα τελείει,
ὣς μὲν τῷ περίχευε χάριν κεφαλῇ τε καὶ ὤμοις.
ἐκ δ' ἀσαμίνθου βῆ, δέμας ἀθανάτοισιν ὅμοιος·
ἂψ δ' αὖτις κατ' ἄρ' ἕζετ' ἐπὶ θρόνου, ἔνθεν ἀνέστη,
ἀντίον ἧς ἀλόχου, καί μιν πρὸς μῦθον ἔειπεν·
Δαιμονίη, περὶ σοίγε γυναικῶν θηλυτεράων
κῆρ ἀτέραμνον ἔθηκαν Ὀλύμπια δώματ' ἔχοντες·
οὐ μέν κ' ἄλλη γ' ὧδε γυνὴ τετληότι θυμῷ
ἀνδρὸς ἀφεσταίη, ὅς οἱ κακὰ πολλὰ μογήσας
ἔλθοι ἐεικοστῷ ἔτεϊ ἐς πατρίδα γαῖαν.—
ἀλλ' ἄγε μοι, μαῖα, στόρεσον λέχος, ὄφρα καὶ αὐτὸς
λέξομαι· ἦ γὰρ τῇγε σιδήρεος ἐν φρεσὶ θυμός.
Τὸν δ' αὖτε προσέειπε περίφρων Πηνελόπεια·
δαιμόνι', οὔτ' ἄρ τι μεγαλίζομαι, οὔτ' ἀθερίζω,
οὔτε λίην ἄγαμαι· μάλα δ' εὖ οἶδ', οἷος ἔησθα,
ἐξ Ἰθάκης ἐπὶ νηὸς ἰὼν δολιχηρέτμοιο.—
ἀλλ' ἄγε οἱ στόρεσον πυκινὸν λέχος, Εὐρύκλεια,
ἐκτὸς ἐϋσταθέος θαλάμου, τόν ῥ' αὐτὸς ἐποίει·
ἔνθα οἱ ἐκθεῖσαι πυκινὸν λέχος, ἐμβάλετ' εὐνήν,
κώεα καὶ χλαίνας καὶ ῥήγεα σιγαλόεντα.
Ὣς ἄρ' ἔφη, πόσιος πειρωμένη· αὐτὰρ Ὀδυσσεὺς
ὀχθήσας ἄλοχον προσεφώνεε, κέδν' εἰδυῖαν·
Ὦ γύναι, ἦ μάλα τοῦτο ἔπος θυμαλγὲς ἔειπες·
τίς δέ μοι ἄλλοσε θῆκε λέχος; χαλεπὸν δέ κεν εἴη,
καὶ μάλ' ἐπισταμένῳ, ὅτε μὴ θεὸς αὐτὸς ἐπελθὼν
ῥηϊδίως ἐθέλων θείη ἄλλῃ ἐνὶ χώρῃ·
ἀνδρῶν δ' οὔ κέν τις ζωὸς βροτός, οὐδὲ μάλ' ἡβῶν,
ῥεῖα μετοχλίσσειεν, ἐπεὶ μέγα σῆμα τέτυκται
ἐν λέχει ἀσκητῷ· τὸ δ' ἐγὼ κάμον, οὐδέ τις ἄλλος.
θάμνος ἔφυ τανύφυλλος ἐλαίης ἕρκεος ἐντός,
ἀκμηνός, θαλέθων· πάχετος δ' ἦν, ἠΰτε κίων.
τῷ δ' ἐγὼ ἀμφιβαλὼν θάλαμον δέμον, ὄφρ' ἐτέλεσσα
πυκνῇσιν λιθάδεσσι, καὶ εὖ καθύπερθεν ἔρεψα·
κολλητὰς δ' ἐπέθηκα θύρας, πυκινῶς ἀραρυίας.
καὶ τότ' ἔπειτ' ἀπέκοψα κόμην τανυφύλλου ἐλαίης·
κορμὸν δ' ἐκ ῥίζης προταμών, ἀμφέξεσα χαλκῷ
εὖ καὶ ἐπισταμένως, καὶ ἐπὶ στάθμην ἴθυνα,
ἑρμῖν', ἀσκήσας· τέτρηνα δὲ πάντα τερέτρῳ.
ἐκ δὲ τοῦ ἀρχόμενος λέχος ἔξεον, ὄφρ' ἐτέλεσσα
δαιδάλλων χρυσῷ τε καὶ ἀργύρῳ ἠδ' ἐλέφαντι·
ἐν δ' ἐτάνυσσα ἱμάντα βοός, φοίνικι φαεινόν.
οὕτω τοι τόδε σῆμα πιφαύσκομαι· οὐδέ τι οἶδα,

εἴ μοι ἔτ' ἔμπεδόν ἐστι, γύναι, λέχος, ἠέ τις ἤδη
ἀνδρῶν ἄλλοσε θῆκε, ταμὼν ὕπο πυθμέν' ἐλαίης.

Ὣς φάτο· τῆς δ' αὐτοῦ λύτο γούνατα καὶ φίλον ἦτορ,
σήματ' ἀναγνούσης, τά οἱ ἔμπεδα πέφραδ' Ὀδυσσεύς·
δακρύσασα δ' ἔπειτ' ἰθὺς δράμεν, ἀμφὶ δὲ χεῖρας
δειρῇ βάλλ' Ὀδυσῆϊ, κάρη δ' ἔκυσ', ἠδὲ προσηύδα·

Μή μοι, Ὀδυσσεῦ, σκύζευ, ἐπεί τά περ ἄλλα μάλιστα
ἀνθρώπων πέπνυσο· θεοὶ δ' ὤπαζον ὀϊζύν,
οἳ νῶϊν ἀγάσαντο παρ' ἀλλήλοισι μένοντε
ἥβης ταρπῆναι, καὶ γήραος οὐδὸν ἱκέσθαι.
αὐτὰρ μὴ νῦν μοι τόδε χώεο, μηδὲ νεμέσσα,
οὕνεκά σ' οὐ τὸ πρῶτον, ἐπεὶ ἴδον, ὧδ' ἀγάπησα.
αἰεὶ γάρ μοι θυμὸς ἐνὶ στήθεσσι φίλοισιν
ἐρρίγει, μήτις με βροτῶν ἀπάφοιτ' ἐπέεσσιν
ἐλθών· πολλοὶ γὰρ κακὰ κέρδεα βουλεύουσιν.
οὐδέ κεν Ἀργείη Ἑλένη, Διὸς ἐκγεγαυῖα,
ἀνδρὶ παρ' ἀλλοδαπῷ ἐμίγη φιλότητι καὶ εὐνῇ,
εἰ ᾔδη, ὅ μιν αὖτις Ἀρήϊοι υἷες Ἀχαιῶν
ἀξέμεναι οἴκόνδε φίλην ἐς πατρίδ' ἔμελλον.
τὴν δ' ἤτοι ῥέξαι θεὸς ὤρορεν ἔργον ἀεικές·
τὴν δ' ἄτην οὐ πρόσθεν ἑῷ ἐγκάτθετο θυμῷ
λυγρήν, ἐξ ἧς πρῶτα καὶ ἡμέας ἵκετο πένθος.
νῦν δ', ἐπεὶ ἤδη σήματ' ἀριφραδέα κατέλεξας
εὐνῆς ἡμετέρης, ἣν οὐ βροτὸς ἄλλος ὀπώπει,
ἀλλ' οἶοι, σύ τ' ἐγώ τε, καὶ ἀμφίπολος μία μούνη,
Ἀκτορίς, ἥν μοι δῶκε πατὴρ ἔτι δεῦρο κιούσῃ,
ἣ νῶϊν εἴρυτο θύρας πυκινοῦ θαλάμοιο,
πείθεις δή μευ θυμόν, ἀπηνέα περ μάλ' ἐόντα.

Ὣς φάτο· τῷ δ' ἔτι μᾶλλον ὑφ' ἵμερον ὦρσε γόοιο.
κλαῖε δ' ἔχων ἄλοχον θυμαρέα, κέδν' εἰδυῖαν.
ὡς δ' ὅτ' ἂν ἀσπάσιος γῆ νηχομένοισι φανήῃ,
ὧντε Ποσειδάων εὐεργέα νῆ' ἐνὶ πόντῳ
ῥαίσῃ, ἐπειγομένην ἀνέμῳ καὶ κύματι πηγῷ·
παῦροι δ' ἐξέφυγον πολιῆς ἁλὸς ἤπειρόνδε
νηχόμενοι, πολλὴ δὲ περὶ χροῒ τέτροφεν ἅλμη·
ἀσπάσιοι δ' ἐπέβαν γαίης, κακότητα φυγόντες·
ὣς ἄρα τῇ ἀσπαστὸς ἔην πόσις εἰσοροώσῃ·
δειρῆς δ' οὔπω πάμπαν ἀφίετο πήχεε λευκώ.
καὶ νύ κ' ὀδυρομένοισι φάνη ῥοδοδάκτυλος Ἠώς,
εἰ μὴ ἄρ' ἄλλ' ἐνόησε θεὰ γλαυκῶπις Ἀθήνη.
νύκτα μὲν ἐν περάτῃ δολιχὴν σχέθεν, Ἠῶ δ' αὖτε
ῥύσατ' ἐπ' Ὠκεανῷ χρυσόθρονον, οὐδ' ἔα ἵππους
ζεύγνυσθ' ὠκύποδας, φάος ἀνθρώποισι φέροντας,
Λάμπον καὶ Φαέθονθ', οἵτ' Ἠῶ πῶλοι ἄγουσιν.

34

καὶ τότ' ἄρ' ἣν ἄλοχον προσέφη πολύμητις Ὀδυσσεύς·
Ὦ γύναι, οὐ γάρ πω πάντων ἐπὶ πείρατ' ἀέθλων
ἤλθομεν, ἀλλ' ἔτ' ὄπισθεν ἀμέτρητος πόνος ἔσται,
πολλὸς καὶ χαλεπός, τὸν ἐμὲ χρὴ πάντα τελέσσαι.
ὣς γάρ μοι ψυχὴ μαντεύσατο Τειρεσίαο
ἤματι τῷ, ὅτε δὴ κατέβην δόμον Ἄϊδος εἴσω,
νόστον ἑταίροισιν διζήμενος ἠδ' ἐμοὶ αὐτῷ.
ἀλλ' ἔρχευ, λέκτρονδ' ἴομεν, γύναι, ὄφρα καὶ ἤδη
ὕπνῳ ὕπο γλυκερῷ ταρπώμεθα κοιμηθέντε.

Τὸν δ' αὖτε προσέειπε περίφρων Πηνελόπεια·
εὐνὴ μὲν δὴ σοίγε τότ' ἔσσεται, ὁππότε θυμῷ
σῷ ἐθέλῃς, ἐπεὶ ἄρ σε θεοὶ ποίησαν ἱκέσθαι
οἶκον ἐϋκτίμενον καὶ σὴν ἐς πατρίδα γαῖαν.
ἀλλ' ἐπεὶ ἐφράσθης, καί τοι θεὸς ἔμβαλε θυμῷ,
εἴπ' ἄγε μοι τὸν ἄεθλον, ἐπεὶ καὶ ὄπισθεν ὀΐω,
πεύσομαι· αὐτίκα δ' ἐστὶ δαήμεναι οὔτι χέρειον.

Τὴν δ' ἀπαμειβόμενος προσέφη πολύμητις Ὀδυσσεύς·
δαιμονίη, τί τ' ἄρ' αὖ με μάλ' ὀτρύνουσα κελεύεις
εἰπέμεν; αὐτὰρ ἐγὼ μυθήσομαι, οὐδ' ἐπικεύσω.
οὐ μέν τοι θυμὸς κεχαρήσεται· οὐδὲ γὰρ αὐτὸς
χαίρω· ἐπεὶ μάλα πολλὰ βροτῶν ἐπὶ ἄστε' ἄνωγεν
ἐλθεῖν, ἐν χείρεσσιν ἔχοντ' εὐῆρες ἐρετμόν,
εἰσόκε τοὺς ἀφίκωμαι, οἳ οὐκ ἴσασι θάλασσαν
ἀνέρες, οὐδέ θ' ἅλεσσι μεμιγμένον εἶδαρ ἔδουσιν·
οὐδ' ἄρα τοίγ' ἴσασι νέας φοινικοπαρῄους,
οὐδ' εὐήρε' ἐρετμά, τάτε πτερὰ νηυσὶ πέλονται.
σῆμα δέ μοι τόδ' ἔειπεν ἀριφραδές, οὐδέ σε κεύσω·
ὁππότε κεν δή μοι ξυμβλήμενος ἄλλος ὁδίτης
φήῃ, ἀθηρηλοιγὸν ἔχειν ἀνὰ φαιδίμῳ ὤμῳ,
καὶ τότε μ' ἐν γαίῃ πήξαντ' ἐκέλευεν ἐρετμόν,
ἔρξανθ' ἱερὰ καλὰ Ποσειδάωνι ἄνακτι,
ἀρνειόν, ταῦρόν τε, συῶν τ' ἐπιβήτορα κάπρον,
οἴκαδ' ἀποστείχειν, ἔρδειν θ' ἱερὰς ἑκατόμβας
ἀθανάτοισι θεοῖσι, τοὶ οὐρανὸν εὐρὺν ἔχουσιν,
πᾶσι μάλ' ἑξείης· θάνατος δέ μοι ἐξ ἁλὸς αὐτῷ
ἀβληχρὸς μάλα τοῖος ἐλεύσεται, ὅς κέ με πέφνῃ
γήρᾳ ὕπο λιπαρῷ ἀρημένον· ἀμφὶ δὲ λαοὶ
ὄλβιοι ἔσσονται· τάδε μοι φάτο πάντα τελεῖσθαι.

Τὸν δ' αὖτε προσέειπε περίφρων Πηνελόπεια·
εἰ μὲν δὴ γῆράς γε θεοὶ τελέουσιν ἄρειον,
ἐλπωρή τοι ἔπειτα κακῶν ὑπάλυξιν ἔσεσθαι.

Ὣς οἱ μὲν τοιαῦτα πρὸς ἀλλήλους ἀγόρευον.
τόφρα δ' ἄρ' Εὐρυνόμη τε ἰδὲ τροφὸς ἔντυον εὐνὴν
ἐσθῆτος μαλακῆς, δαΐδων ὕπο λαμπομενάων.

αὐτὰρ ἐπεὶ στόρεσαν πυκινὸν λέχος ἐγκονέουσαι,
γρηῦς μὲν κείουσα πάλιν οἶκόνδε βεβήκει·
τοῖσιν δ' Εὐρυνόμη θαλαμηπόλος ἡγεμόνευεν
ἐρχομένοισι λέχοσδε, δάος μετὰ χερσὶν ἔχουσα·
ἐς θάλαμον δ' ἀγαγοῦσα, πάλιν κίεν· οἱ μὲν ἔπειτα
ἀσπάσιοι λέκτροιο παλαιοῦ θεσμὸν ἵκοντο.
Αὐτὰρ Τηλέμαχος καὶ βουκόλος ἠδὲ συβώτης
παῦσαν ἄρ' ὀρχηθμοῖο πόδας, παῦσαν δὲ γυναῖκας·
αὐτοὶ δ' εὐνάζοντο κατὰ μέγαρα σκιόεντα.
Τὼ δ' ἐπεὶ οὖν φιλότητος ἐταρπήτην ἐρατεινῆς,
τερπέσθην μύθοισι, πρὸς ἀλλήλους ἐνέποντε·
ἡ μέν, ὅσ' ἐν μεγάροισιν ἀνέσχετο δῖα γυναικῶν,
ἀνδρῶν μνηστήρων ἐσορῶσ' ἀΐδηλον ὅμιλον,
οἳ ἕθεν εἵνεκα πολλά, βόας καὶ ἴφια μῆλα,
ἔσφαζον· πολλὸς δὲ πίθων ἠφύσσετο οἶνος.
αὐτὰρ ὁ Διογενὴς Ὀδυσσεύς, ὅσα κήδε' ἔθηκεν
ἀνθρώποις, ὅσα τ' αὐτὸς ὀϊζύσας ἐμόγησεν,
πάντ' ἔλεγ'· ἡ δ' ἄρ' ἐτέρπετ' ἀκούουσ', οὐδέ οἱ ὕπνος
πίπτειν ἐπὶ βλεφάροισι, πάρος καταλέξαι ἅπαντα.
Ἤρξατο δ', ὡς πρῶτον Κίκονας δάμασ'· αὐτὰρ ἔπειτα
ἦλθ' ἐς Λωτοφάγων ἀνδρῶν πίειραν ἄρουραν·
ἠδ' ὅσα Κύκλωψ ἔρξε, καὶ ὡς ἀπετίσατο ποινὴν
ἰφθίμων ἑτάρων, οὓς ἤσθιεν, οὐδ' ἐλέαιρεν·
ἠδ' ὡς Αἴολον ἵκεθ', ὅ μιν πρόφρων ὑπέδεκτο,
καὶ πέμπ'· οὐδέ πω αἶσα φίλην ἐς πατρίδ' ἱκέσθαι
ἦην, ἀλλά μιν αὖτις ἀναρπάξασα θύελλα
πόντον ἐπ' ἰχθυόεντα φέρεν μεγάλα στενάχοντα.
ἠδ' ὡς Τηλέπυλον Λαιστρυγονίην ἀφίκανεν,
οἳ νῆάς τ' ὄλεσαν καὶ ἐϋκνήμιδος ἑταίρους
[πάντας· Ὀδυσσεὺς δ' οἶος ὑπέκφυγε νηὶ μελαίνη·]
καὶ Κίρκης κατέλεξε δόλον, πολυμηχανίην τε·
ἠδ' ὡς εἰς Ἀΐδεω δόμον ἤλυθεν εὐρώεντα,
ψυχῇ χρησόμενος Θηβαίου Τειρεσίαο,
νηὶ πολυκληῖδι, καὶ εἴσιδε πάντας ἑταίρους,
μητέρα θ', ἥ μιν ἔτικτε, καὶ ἔτρεφε τυτθὸν ἐόντα·
ἠδ' ὡς Σειρήνων ἀδινάων φθόγγον ἄκουσεν·
ὥς θ' ἵκετο Πλαγκτὰς πέτρας, δεινήν τε Χάρυβδιν,
Σκύλλην θ', ἣν οὔ πώποτ' ἀκήριοι ἄνδρες ἄλυξαν·
ἠδ' ὡς Ἠελίοιο βόας κατέπεφνον ἑταῖροι·
ἠδ' ὡς νῆα θοὴν ἔβαλε ψολόεντι κεραυνῷ
Ζεὺς ὑψιβρεμέτης· ἀπὸ δ' ἔφθιθεν ἐσθλοὶ ἑταῖροι
πάντες ὁμῶς, αὐτὸ δὲ κακὰς ὑπὸ κῆρας ἄλυξεν·
ὥς θ' ἵκετ' Ὠγυγίην νῆσον, νύμφην τε Καλυψώ,
ἣ δή μιν κατέρυκε, λιλαιομένη πόσιν εἶναι,

ἐν σπέσσι γλαφυροῖσι, καὶ ἔτρεφεν, ἠδὲ ἔφασκεν
θήσειν ἀθάνατον καὶ ἀγήραον ἤματα πάντα·
ἀλλὰ τῷ οὔποτε θυμὸν ἐνὶ στήθεσσιν ἔπειθεν·
ἠδ' ὡς ἐς Φαίηκας ἀφίκετο, πολλὰ μογήσας,
οἳ δή μιν περὶ κῆρι, θεὸν ὥς, τιμήσαντο,
καὶ πέμψαν σὺν νηΐ φίλην ἐς πατρίδα γαῖαν,
χαλκόν τε χρυσόν τε ἅλις, ἐσθῆτά τε δόντες.
τοῦτ' ἄρα δεύτατον εἶπεν ἔπος, ὅτε οἱ γλυκὺς ὕπνος
λυσιμελὴς ἐπόρουσε, λύων μελεδήματα θυμοῦ.
 Ἡ δ' αὖτ' ἄλλ' ἐνόησε θεὰ γλαυκῶπις Ἀθήνη·
ὁππότε δή ῥ' Ὀδυσῆα ἐέλπετο ὃν κατὰ θυμὸν
εὐνῆς ἧς ἀλόχου ταρπήμεναι ἠδὲ καὶ ὕπνου,
αὐτίκ' ἀπ' Ὠκεανοῦ χρυσόθρονον Ἠριγένειαν
ὦρσεν, ἵν' ἀνθρώποισι φόως φέροι· ὦρτο δ' Ὀδυσσεὺς
εὐνῆς ἐκ μαλακῆς, ἀλόχῳ δ' ἐπὶ μῦθον ἔτελλεν·
 Ὦ γύναι, ἤδη μὲν πολέων κεκορήμεθ' ἀέθλων
ἀμφοτέρω, σὺ μὲν ἐνθάδ' ἐμὸν πολυκήδεα νόστον
κλαίουσ'· αὐτὰρ ἐμὲ Ζεὺς ἄλγεσι καὶ θεοὶ ἄλλοι
ἱέμενον πεδάασκον ἐμῆς ἀπὸ πατρίδος αἴης·
νῦν δ' ἐπεὶ ἀμφοτέρω πολυήρατον ἱκόμεθ' εὐνήν,
κτήματα μέν, τά μοί ἐστι, κομιζέμεν ἐν μεγάροισιν·
μῆλα δ', ἅ μοι μνηστῆρες ὑπερφίαλοι κατέκειραν,
πολλὰ μὲν αὐτὸς ἐγὼ λήΐσσομαι, ἄλλα δ' Ἀχαιοὶ
δώσουσ', εἰσόκε πάντας ἐνιπλήσωσιν ἐπαύλους.
ἀλλ' ἤτοι μὲν ἐγὼ πολυδένδρεον ἀγρὸν ἔπειμι,
ὀψόμενος πατέρ' ἐσθλόν, ὅ μοι πυκινῶς ἀκάχηται·
σοὶ δέ, γύναι, τάδ' ἐπιτέλλω, πινυτῇ περ ἐούσῃ·
αὐτίκα γὰρ φάτις εἶσιν ἅμ' ἠελίῳ ἀνιόντι
ἀνδρῶν μνηστήρων, οὓς ἔκτανον ἐν μεγάροισιν·
εἰς ὑπερῷ' ἀναβᾶσα σὺν ἀμφιπόλοισι γυναιξίν,
ἧσθαι, μηδέ τινα προτιόσσεο, μηδ' ἐρέεινε.
 Ἦ ῥα, καὶ ἀμφ' ὤμοισιν ἐδύσατο τεύχεα καλά·
ὦρσε δὲ Τηλέμαχον καὶ βουκόλον ἠδὲ συβώτην,
πάντας δ' ἔντε' ἄνωγεν Ἀρήϊα χερσὶν ἑλέσθαι.
οἱ δέ οἱ οὐκ ἀπίθησαν, ἐθωρήσσοντο δὲ χαλκῷ·
ὤϊξαν δὲ θύρας, ἐκ δ' ἤϊον· ἦρχε δ' Ὀδυσσεύς.
ἤδη μὲν φάος ἦεν ἐπὶ χθόνα· τοὺς δ' ἄρ' Ἀθήνη
νυκτὶ κατακρύψασα θοῶς ἐξῆγε πόληος.

Then the old dame went up to the upper chamber, laughing aloud, to tell her mistress that her dear husband was in the house. Her knees moved nimbly, but her feet trotted along beneath her; and she stood above her lady's head, and spoke to her, and said:

"Awake, Penelope, dear child, that with thine own eyes thou mayest

see what thou desirest all thy days. Odysseus is here, and has come home, late though his coming has been, and has slain the proud wooers who vexed his house, and devoured his substance, and oppressed his son."

Then wise Penelope answered her: "Dear nurse, the gods have made thee mad, they who can make foolish even one who is full wise, and set the simple-minded in the paths of understanding; it is they that have marred thy wits, though heretofore thou wast sound of mind. Why dost thou mock me, who have a heart full of sorrow, to tell me this wild tale, and dost rouse me out of slumber, the sweet slumber that bound me and enfolded my eyelids? For never yet have I slept so sound since the day when Odysseus went forth to see evil Ilios that should not be named. Nay come now, go down and back to the women's hall, for if any other of the women that are mine had come and told me this, and had roused me out of sleep, straightway would I have sent her back in sorry wise to return again to the hall, but to thee old age shall bring this profit."

Then the dear nurse Eurycleia answered her: "I mock thee not, dear child, but in very truth Odysseus is here, and has come home, even as I tell thee. He is that stranger to whom all men did dishonour in the halls. But Telemachus long ago knew that he was here, yet in his prudence he hid the purpose of his father, till he should take vengeance on the violence of overweening men."

So she spoke, and Penelope was glad, and she leapt from her bed and flung her arms about the old woman and let the tears fall from her eyelids; and she spoke, and addressed her with winged words:

"Come now, dear nurse, I pray thee tell me truly, if verily he has come home, as thou sayest, how he put forth his hands upon the shameless wooers, all alone as he was, while they remained always in a body in the house."

Then the dear nurse Eurycleia answered her: "I saw not, I asked not; only I heard the groaning of men that were being slain. As for us women, we sat terror-stricken in the innermost part of our well-built chambers, and the close-fitting doors shut us in, until the hour when thy son Telemachus called me from the hall, for his father had sent him forth to call me. Then I found Odysseus standing among the bodies of the slain, and they, stretched all around him on the hard floor, lay one upon the other; the sight would have warmed thy heart with cheer. And now the bodies are all gathered together at the gates of the court, but he is purging the fair house with sulphur, and has kindled a great fire, and sent me forth to call thee. Nay, come with me, that the hearts of you two may enter into joy, for you have suffered many woes. But now at length has this thy long desire been fulfilled: he has come himself, alive to his own hearth, and he has found both thee and his son in the halls; while as for those, even the wooers, who wrought him evil, on them has he taken vengeance one and all in his house."

Then wise Penelope answered her: "Dear nurse, boast not yet loudly over them with laughter. Thou knowest how welcome the sight of him in the halls would be to all, but above all to me and to his son, born of us two. But this is no true tale, as thou tellest it; nay, some one of the immortals has slain the lordly wooers in wrath at their grievous insolence and their evil deeds. For they honoured no one among men upon the earth, were he evil or good, whosoever came among them; therefore it is through their own wanton folly that they have suffered evil. But Odysseus far away has lost his return to the land of Achaea, and is lost himself."

Then the dear nurse Eurycleia answered her: "My child, what a word has escaped the barrier of thy teeth, in that thou saidst that thy husband, who even now is here, at his own hearth, would never more return! Thy heart is ever unbelieving. Nay come, I will tell thee a manifest sign besides, even the scar of the wound which long ago the boar dealt him with his white tusk. This I marked while I washed his feet, and was fain to tell it to thee as well, but he laid his hand upon my mouth, and in the great wisdom of his heart would not suffer me to speak. So come with me; but I will set my very life at stake that, if I deceive thee, thou shouldst slay me by a most pitiful death.

Then wise Penelope answered her: "Dear nurse, it is hard for thee to comprehend the counsels of the gods that are forever, how wise soever thou art. Nevertheless let us go to my son, that I may see the wooers dead and him that slew them."

So saying, she went down from the upper chamber, and much her heart pondered whether she should stand aloof and question her dear husband, or whether she should go up to him, and clasp and kiss his head and hands. But when she had come in and had passed over the stone threshold, she sat down opposite Odysseus in the light of the fire beside the further wall; but he was sitting by a tall pillar, looking down, and waiting to see whether his noble wife would say aught to him, when her eyes beheld him. Howbeit she sat long in silence, and amazement came upon her soul; and now with her eyes she would look full upon his face, and now again she would fail to know him, for that he had upon him mean raiment. But Telemachus rebuked her, and spoke, and addressed her:

"My mother, cruel mother, that hast an unyielding heart, why dost thou thus hold aloof from my father, and dost not sit by his side and ask and question him? No other woman would harden her heart as thou dost, and stand aloof from her husband, who after many grievous toils had come back to her in the twentieth year to his native land: but thy heart is ever harder than stone."

Then wise Penelope answered him: "My child, the heart in my breast is lost in wonder, and I have no power to speak at all, nor to ask a question, nor to look him in the face. But if in very truth he is

Odysseus, and has come home, we two shall surely know one another more certainly; for we have signs which we two alone know, signs hidden from others."

So she spoke, and the much-enduring, goodly Odysseus smiled, and straightway spoke to Telemachus winged words:

"Telemachus, suffer now thy mother to test me in the halls; presently shall she win more certain knowledge. But now because I am foul, and am clad about my body in mean clothing, she scorns me, and will not yet admit that I am he. But for us, let us take thought how all may be the very best. For whoso has slain but one man in a land, even though it be a man that leaves not many behind to avenge him, he goes into exile, and leaves his kindred and his native land; but we have slain those who were the very stay of the city, far the noblest of the youths of Ithaca. Of this I bid thee take thought."

Then wise Telemachus answered him: "Do thou thyself look to this, dear father; for thy counsel, they say, is the best among men, nor could any other of mortal men vie with thee. As for us, we will follow with thee eagerly, nor methinks shall we be wanting in valour, so far as we have strength."

Then Odysseus of many wiles answered him and said: "Then will I tell thee what seems to me to be the best way. First bathe yourselves, and put on your tunics, and bid the handmaids in the halls to take their raiment. But let the divine minstrel with his clear-toned lyre in hand be our leader in the gladsome dance, that any man who hears the sound from without, whether a passer-by or one of those who dwell around, may say that it is a wedding feast; and so the rumour of the slaying of the wooers shall not be spread abroad throughout the city before we go forth to our well-wooded farm. There shall we afterwards devise whatever advantage the Olympian may vouchsafe us."

So he spoke, and they all readily hearkened and obeyed. First they bathed and put on their tunics, and the women arrayed themselves, and the divine minstrel took the hollow lyre and aroused in them the desire of sweet song and goodly dance. So the great hall resounded all about with the tread of dancing men and of fair-girdled women; and thus would one speak who heard the noise from without the house:

"Aye, verily some one has wedded the queen wooed of many. Cruel she was, nor had she the heart to keep the great house of her wedded husband to the end, even till he should come."

So they would say, but they knew not how these things were. Meanwhile the housewife Eurynome bathed the great-hearted Odysseus in his house, and anointed him with oil, and cast about him a fair cloak and a tunic; and over his head Athene shed abundant beauty, making him taller to look upon and mightier, and from his head she made locks to flow in curls like the hyacinth flower. And as when a man overlays silver with gold, a cunning workman whom Hephaestus and Pallas

Athene have taught all manner of craft, and full of grace is the work he produces, even so the goddess shed grace on his head and shoulders, and forth from the bath he came, in form like unto the immortals. Then he sat down again on the chair from which he had risen, opposite his wife; and he spoke to her and said:

"Strange lady! to thee beyond all women have the dwellers on Olympus given a heart that cannot be softened. No other woman would harden her heart as thou dost, and stand aloof from her husband who after many grievous toils had come to her in the twentieth year to his native land. Nay come, nurse, strew me a couch, that all alone I may lay me down, for verily the heart in her breast is of iron."

Then wise Penelope answered him: "Strange sir, I am neither in any wise proud, nor do I scorn thee, nor yet am I too greatly amazed, but right well do I know what manner of man thou wast, when thou wentest forth from Ithaca on thy long-oared ship. Yet come, Eurycleia, strew for him the stout bedstead outside the well-built bridal chamber which he made himself. Thither do ye bring for him the stout bedstead, and cast upon it bedding, fleeces and cloaks and bright coverlets."

So she spoke, and made trial of her husband. But Odysseus, in a burst of anger, spoke to his true-hearted wife, and said: "Woman, truly this is a bitter word that thou hast spoken. Who has set my bed elsewhere? Hard would it be for one, though never so skilled, unless a god himself should come and easily by his will set it in another place. But of men there is no mortal that lives, be he never so young and strong, who could easily pry it from its place, for a great token is wrought in the fashioned bed, and it was I that built it and none other. A bush of long-leafed olive was growing within the court, strong and vigorous, and in girth it was like a pillar. Round about this I built my chamber, till I had finished it, with close-set stones, and I roofed it over well, and added to it jointed doors, close-fitting. Thereafter I cut away the leafy branches of the long-leafed olive, and, trimming the trunk from the root, I smoothed it around with the adze well and cunningly, and made it straight to the line, thus fashioning the bed-post; and I bored it all with the augur. Beginning with this I hewed out my bed, till I had finished it, inlaying it with gold and silver and ivory, and I stretched on it a thong of ox-hide, bright with purple. Thus do I declare to thee this token; but I know not, woman, whether my bedstead is still fast in its place, or whether by now some man has cut from beneath the olive stump, and set the bedstead elsewhere."

So he spoke, and her knees were loosened where she sat, and her heart melted, as she knew the sure tokens which Odysseus told her. Then with a burst of tears she ran straight toward him, and flung her arms about the neck of Odysseus, and kissed his head, and spoke, saying:

"Be not vexed with me, Odysseus, for in all else thou wast ever the wisest of men. It is the gods that gave us sorrow, the gods who be-

grudged that we two should remain with each other and enjoy our youth, and come to the threshold of old age. But be not now wroth with me for this, nor full of indignation, because at the first, when I saw thee, I did not thus give thee welcome. For always the heart in my breast was full of dread, lest some man should come and beguile me with his words; for there are many that plan devices of evil. Nay, even Argive Helen, daughter of Zeus, would not have lain in love with a man of another folk, had she known that the warlike sons of the Achaeans were to bring her home again to her dear native land. Yet verily in her case a god prompted her to work a shameful deed; nor until then did she lay up in her mind the thought of that folly, the grievous folly from which at the first sorrow came upon us too. But now, since thou hast told the clear tokens of our bed, which no mortal beside has ever seen save thee and me alone and one single handmaid, the daughter of Actor, whom my father gave me or ever I came hither, even her who kept the doors of our strong bridal chamber, lo, thou dost convince my heart, unbending as it is."

So she spoke, and in his heart aroused yet more the desire for lamentation; and he wept, holding in his arms his dear and true-hearted wife. And welcome as is the sight of land to men that swim, whose well-built ship Poseidon has smitten on the sea as it was driven on by the wind and the swollen wave, and but few have made their escape from the gray sea to the shore by swimming, and thickly are their bodies crusted with brine, and gladly have they set foot on the land and escaped from their evil case; even so welcome to her was her husband, as she gazed upon him, and from his neck she could in no wise let her white arms go. And now would the rosy-fingered Dawn have arisen upon their weeping, had not the goddess, flashing-eyed Athene, taken other counsel. The long night she held back at the end of its course, and likewise stayed the golden-throned Dawn at the streams of Oceanus, and would not suffer her to yoke her swift-footed horses that bring light to men, Lampus and Phaethon, who are the colts that bear the Dawn.

Then to his wife said Odysseus of many wiles: "Wife, we have not yet come to the end of all our trials, but still hereafter there is to be measureless toil, long and hard, which I must fulfil to the end; for so did the spirit of Teiresias foretell to me on the day when I went down into the house of Hades to enquire concerning the return of my comrades and myself. But come, wife, let us to bed, that lulled now by sweet slumber we may take our joy of rest."

Then wise Penelope answered him: "Thy bed shall be ready for thee whensoever thy heart shall desire it, since the gods have indeed caused thee to come back to thy well-built house and thy native land. But since thou hast bethought thee of this, and a god has put it into thy heart, come, tell me of this trial, for in time to come, methinks, I shall learn of it, and to know it at once is no whit worse."

And Odysseus of many wiles answered her, and said: "Strange lady! why dost thou now so urgently bid me tell thee? Yet I will declare it, and will hide nothing. Verily thy heart shall have no joy of it, even as I myself have none; for Teiresias bade me go forth to full many cities of men, bearing a shapely oar in my hands, till I should come to men that know naught of the sea, and eat not of food mingled with salt; aye, and they know naught of ships with purple cheeks, or of shapely oars that serve as wings to ships. And he told me this sign, right manifest; nor will I hide it from thee. When another wayfarer, on meeting me, should say that I had a winnowing fan on my stout shoulder, then he bade me fix my oar in the earth, and make goodly offerings to lord Poseidon— a ram and a bull and a boar, that mates with sows—and depart for my home, and offer sacred hecatombs to the immortal gods, who hold broad heaven, to each one in due order. And death shall come to me myself far from the sea, a death so gentle, that shall lay me low, when I am overcome with sleek old age, and my people shall dwell in prosperity around me. All this, he said, should I see fulfilled."

Then wise Penelope answered him: "If verily the gods are to bring about for thee a happier old age, there is hope then that thou wilt find an escape from evil."

Thus they spoke to one another; and meanwhile Eurynome and the nurse made ready the bed of soft coverlets by the light of blazing torches. But when they had busily spread the stout-built bedstead, the old nurse went back to her chamber to lie down, and Eurynome, the maiden of the bed-chamber, led them on their way to the couch with a torch in her hands; and when she had led them to the bridal chamber, she went back. And they then gladly came to the place of the couch that was theirs of old. But Telemachus and the neatherd and the swine-herd stayed their feet from dancing, and stayed the women, and themselves lay down to sleep throughout the shadowy halls.

But when the two had had their fill of the joy of love, they took delight in tales, speaking each to the other. She, the fair lady, told of all that she had endured in the halls, looking upon the destructive throng of the wooers, who for her sake slew many beasts, cattle and goodly sheep; and great store of wine was drawn from the jars. But Zeus-born Odysseus recounted all the woes that he had brought on men, and all the toil that in his sorrow he had himself endured, and she was glad to listen, nor did sweet sleep fall upon her eyelids, till he had told all the tale.

He began by telling how at the first he overcame the Cicones, and then came to the rich land of the Lotus-eaters, and all that the Cyclops wrought, and how he made him pay the price for his mighty comrades, whom the Cyclops had eaten, and had shown no pity. Then how he came to Aeolus, who received him with a ready heart, and sent him on his way; but it was not yet his fate to come to his dear native land, nay,

the storm-wind caught him up again, and bore him over the teeming deep, groaning heavily. Next how he came to Telepylus of the Laestrygonians, who destroyed his ships and his well-greaved comrades one and all, and Odysseus alone escaped in his black ship. Then he told of all the wiles and craftiness of Circe, and how in his benched ship he had gone to the dank house of Hades to consult the spirit of Theban Teiresias, and had seen all his comrades and the mother who bore him and nursed him, when a child. And how he heard the voice of the Sirens, who sing unceasingly, and had come to the Wandering Rocks, and to dread Charybdis, and to Scylla, from whom never yet had men escaped unscathed. Then how his comrades slew the kine of Helios, and how Zeus, who thunders on high, smote his swift ship with a flaming thunderbolt, and his goodly comrades perished all together, while he alone escaped the evil fates. And how he came to the isle Ogygia and to the nymph Calypso, who kept him there in her hollow caves, yearning that he should be her husband, and tended him, and said that she would make him immortal and ageless all his days; yet she could never persuade the heart in his breast. Then how he came after many toils to the Phaeacians, who heartily showed him all honour, as if he were a god, and sent him in a ship to his dear native land, after giving him stores of bronze and gold and raiment. This was the end of the tale he told, when sweet sleep, that loosens the limbs of men, leapt upon him, loosening the cares of his heart.

Then again the goddess, flashing-eyed Athene, took other counsel. When she judged that the heart of Odysseus had had its fill of dalliance with his wife and of sleep, straightway she roused from Oceanus golden-throned Dawn to bring light to men; and Odysseus rose from his soft couch, and gave charge to his wife, saying:

"Wife, by now have we had our fill of many trials, thou and I, thou here, mourning over my troublous journey home, while as for me, Zeus and the other gods bound me fast in sorrows far from my native land, all eager as I was to return. But now that we have both come to the couch of our desire, do thou care for the wealth that I have within the halls; as for the flocks which the insolent wooers have wasted, I shall myself get me many as booty, and others will the Achaeans give, until they fill all my folds; but I verily will go to my well-wooded farm to see my noble father, who for my sake is sore distressed, and on thee, wife, do I lay this charge, wise though thou art. Straightway at the rising of the sun will report go abroad concerning the wooers whom I slew in the halls. Therefore go thou up to thy upper chamber with thy handmaids, and abide there. Look thou on no man, nor ask a question."

He spoke, and girt about his shoulders his beautiful armour, and roused Telemachus and the neatherd and the swineherd, and bade them all take weapons of war in their hands. They did not disobey, but clad themselves in bronze, and opened the doors, and went forth, and

Odysseus led the way. By now there was light over the earth, but Athene hid them in night, and swiftly led them forth from the city.

Odyssey, xxiii, 1-372
Translated by A. T. Murray

One of the supreme scenes of human life.

W. H. D. ROUSE
The Story of Odysseus (1937)

HOMER

DATES UNKNOWN

HOMERIC METAPHORS

Αὖτις ἔπειτα πέπονδε κυλίνδετο λᾶας ἀναιδής.

Again the ruthless stone rolled down to the plain.

Odyssey, xi, 598

Ἕπτατ᾽ ὀϊστός.

The arrow flew.

Iliad, xiii, 587

ἐπιπτέσθαι μενεαίνων.

[The arrow] eager to fly [towards the crowd.]

Iliad, iv, 126

Ἐν γαίῃ ἵσταντο, λιλαιόμενα χροὸς ἆσαι.

[The spears] were buried in the ground, longing to take their fill of flesh.

Iliad, xi, 574

Αἰχμὴ δὲ στέρνοιο διέσσυτο μαιμώωσα,

The spear-point sped eagerly through his breast.

Iliad, xv, 542

Κυρτὰ φαληριόωντα, πρὸ μέν τ᾽ ἄλλ᾽, αὐτὰρ ἐπ᾽ ἄλλα·

Arched, foam-crested, some in front, others behind.

Iliad, xiii, 799
Translated by J. H. Freese

45

HESIOD

FL . 7 7 6 B . C .

PANDORA

Κρύψαντες γὰρ ἔχουσι θεοὶ βίον ἀνθρώποισι·
ῥηδίως γάρ κεν καὶ ἐπ᾿ ἤματι ἐργάσσαιο,
ὥστε σε κεῖς ἐνιαυτὸν ἔχειν καὶ ἀεργὸν ἐόντα·
αἶψά κε πηδάλιον μὲν ὑπὲρ καπνοῦ καταθεῖο,
ἔργα βοῶν δ᾿ ἀπόλοιτο καὶ ἡμιόνων ταλαεργῶν.
ἀλλὰ Ζεὺς ἔκρυψε χολωσάμενος φρεσὶ ᾗσιν,
ὅττι μιν ἐξαπάτησε Προμηθεὺς ἀγκυλομήτης·
τοὔνεκ᾿ ἄρ᾿ ἀνθρώποισιν ἐμήσατο κήδεα λυγρά.
κρύψε δὲ πῦρ· τὸ μὲν αὖτις ἐὺς πάις Ἰαπετοῖο
ἔκλεψ᾿ ἀνθρώποισι Διὸς πάρα μητιόεντος
ἐν κοίλῳ νάρθηκι λαθὼν Δία τερπικέραυνον.
τὸν δὲ χολωσάμενος προσέφη νεφεληγερέτα Ζεύς·
Ἰαπετιονίδη, πάντων πέρι μήδεα εἰδώς,
χαίρεις πῦρ κλέψας καὶ ἐμὰς φρένας ἠπεροπεύσας
σοί τ᾿ αὐτῷ μέγα πῆμα καὶ ἀνδράσιν ἐσσομένοισι·
τοῖς δ᾿ ἐγὼ ἀντὶ πυρὸς δώσω κακόν, ᾧ κεν ἅπαντες
τέρπωνται κατὰ θυμὸν ἑὸν κακὸν ἀμφαγαπῶντες.
Ὣς ἔφατ᾿ · ἐκ δ᾿ ἐγέλασσε πατὴρ ἀνδρῶν τε θεῶν τε·
Ἥφαιστον δ᾿ ἐκέλευσε περικλυτὸν ὅττι τάχιστα
γαῖαν ὕδει φύρειν, ἐν δ᾿ ἀνθρώπου θέμεν αὐδὴν
καὶ σθένος, ἀθανάτῃς δὲ θεῇς εἰς ὦπα ἐίσκειν
παρθενικῆς καλὸν εἶδος ἐπήρατον· αὐτὰρ Ἀθήνην
ἔργα διδασκῆσαι, πολυδαίδαλον ἱστὸν ὑφαίνειν·
καὶ χάριν ἀμφιχέαι κεφαλῇ χρυσέην Ἀφροδίτην
καὶ πόθον ἀργαλέον καὶ γυιοκόρους μελεδῶνας·
ἐν δὲ θέμεν κύνεόν τε νόον καὶ ἐπίκλοπον ἦθος
Ἑρμείην ἤνωγε, διάκτορον Ἀργειφόντην.
Ὣς ἔφαθ᾿· οἱ δ᾿ ἐπίθοντο Διὶ Κρονίωνι ἄνακτι.
αὐτίκα δ᾿ ἐκ γαίης πλάσσεν κλυτὸς Ἀμφιγυήεις

° These Homeric metaphors are specified in *Rhetoric* 1411b.

παρθένῳ αἰδοίῃ ἴκελον Κρονίδεω διὰ βουλάς·
ζῶσε δέ καὶ κόσμησε θεὰ γλαυκῶπις Ἀθήνη·
ἀμφὶ δὲ οἱ Χάριτές τε θεαὶ καὶ πότνια Πειθὼ
ὅρμους χρυσείους ἔθεσαν χροΐ· ἀμφὶ δὲ τήν γε
Ὥραι καλλίκομοι στέφον ἄνθεσι εἰαρινοῖσι·
[πάντα δὲ οἱ χροῒ κόσμον ἐφήρμοσε Παλλὰς Ἀθήνη.]
ἐν δ' ἄρα οἱ στήθεσσι διάκτορος Ἀργεϊφόντης
ψεύδεά θ' αἱμυλίους τε λόγους καὶ ἐπίκλοπον ἦθος
[τεῦξε Διὸς βουλῇσι βαρυκτύπου· ἐν δ' ἄρα φωνὴν]
θῆκε θεῶν κῆρυξ, ὀνόμηνε δὲ τήνδε γυναῖκα
Πανδώρην, ὅτι πάντες Ὀλύμπια δώματ' ἔχοντες
δῶρον ἐδώρησαν, πῆμ' ἀνδράσιν ἀλφηστῇσιν.
 Αὐτὰρ ἐπεὶ δόλον αἰπὺν ἀμήχανον ἐξετέλεσσεν,
εἰς Ἐπιμηθέα πέμπε πατὴρ κλυτὸν Ἀργεϊφόντην
δῶρον ἄγοντα, θεῶν ταχὺν ἄγγελον· οὐδ' Ἐπιμηθεὺς
ἐφράσαθ', ὥς οἱ ἔειπε Προμηθεὺς μή ποτε δῶρον
δέξασθαι πὰρ Ζηνὸς Ὀλυμπίου, ἀλλ' ἀποπέμπειν
ἐξοπίσω, μή πού τι κακὸν θνητοῖσι γένηται.
αὐτὰρ ὁ δεξάμενος, ὅτε δὴ κακὸν εἶχ', ἐνόησε.
 Τὸ πρὶν μὲν ζώεσκον ἐπὶ χθονὶ φῦλ' ἀνθρώπων
νόσφιν ἄτερ τε κακῶν καὶ ἄτερ χαλεποῖο πόνοιο
νούσων τ' ἀργαλέων, αἵ τ' ἀνδράσι κῆρας ἔδωκαν.
[αἶψα γὰρ ἐν κακότητι βροτοὶ καταγηράσκουσιν.]
ἀλλὰ γυνὴ χείρεσσι πίθου μέγα πῶμ' ἀφελοῦσα
ἐσκέδασ'· ἀνθρώποισι δ' ἐμήσατο κήδεα λυγρά.
μούνη δ' αὐτόθι Ἐλπὶς ἐν ἀρρήκτοισι δόμοισιν
ἔνδον ἔμιμνε πίθου ὑπὸ χείλεσιν, οὐδὲ θύραζε
ἐξέπτη· πρόσθεν γὰρ ἐπέμβαλε πῶμα πίθοιο
[αἰγιόχου βουλῇσι Διὸς νεφεληγερέταο.]
ἄλλα δὲ μυρία λυγρὰ κατ' ἀνθρώπους ἀλάληται.
πλείη μὲν γὰρ γαῖα κακῶν, πλείη δὲ θάλασσα·
νοῦσοι δ' ἀνθρώποισιν ἐφ' ἡμέρῃ ἠδ' ἐπὶ νυκτὶ
αὐτόματοι φοιτῶσι κακὰ θνητοῖσι φέρουσαι
σιγῇ, ἐπεὶ φωνὴν ἐξείλετο μητίετα Ζεύς.
οὕτως οὔ τί πη ἔστι Διὸς νόον ἐξαλέασθαι.

For the gods keep hidden from men the means of life. Else you would easily do work enough in a day to supply you for a full year even without working; soon would you put away your rudder over the smoke, and the fields worked by ox and sturdy mule would run to waste. But Zeus in the anger of his heart hid it, because Prometheus the crafty deceived him; therefore he planned sorrow and mischief against men. He hid fire; but that the noble son of Iapetus stole again for men from Zeus the

counsellor in a hollow fennel-stalk, so that Zeus who delights in thunder did not see it. But afterwards Zeus who gathers the clouds said to him in anger:

"Son of Iapetus, surpassing all in cunning, you are glad that you have outwitted me and stolen fire—a great plague to you yourself and to men that shall be. But I will give men as the price for fire an evil thing in which they may all be glad of heart while they embrace their own destruction."

So said the father of men and gods, and laughed aloud. And he bade famous Hephaestus make haste and mix earth with water and to put in it the voice and strength of human kind, and fashion a sweet, lovely maiden-shape, like to the immortal goddesses in face; and Athene to teach her needlework and the weaving of the varied web; and golden Aphrodite to shed grace upon her head and cruel longing and cares that weary the limbs. And he charged Hermes the guide, the Slayer of Argus, to put in her a shameless mind and a deceitful nature.

So he ordered. And they obeyed the lord Zeus the son of Cronos. Forthwith the famous Lame God moulded clay in the likeness of a modest maid, as the son of Cronos purposed. And the goddess bright-eyed Athene girded and clothed her, and the divine Graces and queenly Persuasion put necklaces of gold upon her, and the rich-haired Hours crowned her head with spring flowers. And Pallas Athene bedecked her form with all manner of finery. Also the Guide, the Slayer of Argus, contrived within her lies and crafty words and a deceitful nature at the will of loud thundering Zeus, and the Herald of the gods put speech in her. And he called this woman Pandora, because all they who dwelt on Olympus gave each a gift, a plague to men who eat bread.

But when he had finished the sheer, hopeless snare, the Father sent glorious Argus-Slayer, the swift messenger of the gods, to take it to Epimetheus as a gift. And Epimetheus did not think on what Prometheus had said to him, bidding him never take a gift of Olympian Zeus, but to send it back for fear it might prove to be something harmful to men. But he took the gift, and afterwards, when the evil thing was already his, he understood.

For ere this the tribes of men lived on earth remote and free from ills and hard toil and heavy sicknesses which bring the Fates upon men; for in misery men grow old quickly. But the woman took off the great lid of the jar with her hands and scattered all these and her thought caused sorrow and mischief to men. Only Hope remained there in an unbreakable home within under the rim of the great jar, and did not fly out at the door; for ere that, the lid of the jar stopped her, by the will of Aegis-holding Zeus who gathers the clouds. But the rest, count-less plagues, wander amongst men; for earth is full of evils and the sea is full. Of themselves diseases come upon men continually by day and

48

by night, bringing mischief to mortals silently; for wise Zeus took away speech from them. So is there no way to escape the will of Zeus.

<div align="right">

Works and Days, 42-105
Translated by H. G. Evelyn-White

</div>

Had Hesiod always written thus, he would have been superior to Homer!

<div align="right">

F. M. AROUET DE VOLTAIRE
Dictionnaire Philosophique (1764)

</div>

ANONYMOUS

S I X T H O R S E V E N T H C E N T U R Y B . C .

NATURE

Ἐγώ εἰμι πᾶν τὸ γεγονὸς καὶ ὂν καὶ ἐσόμενον καὶ τὸν ἐμὸν πέπλον οὐδείς πω θνητὸς ἀπεκάλυψεν.

I am all that is and that was and that shall be, and no mortal hath lifted my veil.

<div align="right">

Inscription on an Egyptian Temple to Neith, at Saïs

</div>

More sublime words perhaps were never uttered, nor a thought ever expressed more magnificently.

<div align="right">

IMMANUEL KANT
Kritik der Urtheilskraft (1790)

</div>

SAPPHO

C . 6 0 0 B . C .

ODE TO APHRODITE

Ποικιλόθρον' ἀθάνατ' Ἀφρόδιτα,
παῖ Δίος δολόπλοκα, λίσσομαί σε·
μή μ' ἄσαισι μηδ' ὀνίαισι δάμνα,
πότνια, θῦμον,
ἀλλὰ τυίδ' ἔλθ', αἴ ποτα κἀτέροττα
τᾶς ἔμας αὔδως ἀΐοισα πήλυι

49

ἔκλυες, πάτρος δὲ δόμον λίποισα
χρύσιον ἦλθες
ἄρμ' ὑπασδεύξαισα, κάλω δέ σ' ἄγον
ὤκεε στροῦθω προτὶ γὰρ μέλαιναν
πύκνα δίννεντε πτέρ' ἀπ' ὀρράνω αἴθε-
ρος διὰ μέσσω,
αἶψα δ' ἐξίκοντο· σὺ δ', ὦ μάκαιρα
μειδιάσαισ' ἀθανάτω προσώπω
ἤρε' ὄττι δηὖτε πέπονθα, κὤττι
δηὖτε κάλημι,
κὤττ' ἔμοι μάλιστα θέλω γένεσθαι
μαινόλᾳ θύμω· 'τίνα δηὖτε πείθω
καὶ σ' ἄγην ἐς Fὰν φιλότατα; τις τ', ὦ
Ψάπφ', ἀδικήει;
καὶ γὰρ αἰ φεύγει, ταχέως διώξει,
αἰ δὲ δῶρα μὴ δέκετ', ἀλλὰ δώσει,
αἰ δὲ μὴ φίλει, ταχέως φιλήσει
κωὔκ ἐθέλοισα·'
ἔλθε μοι καὶ νῦν, χαλέπαν δὲ λῦσον
ἐκ μερίμναν, ὄσσα δέ μοι τέλεσσαι
θῦμος ἰμμέρρει, τέλεσον, σὺ δ' αὖτα
σύμμαχος ἔσσο.

Glittering-throned undying Aphrodite,
Wile-weaving daughter of high Zeus, I pray thee
Tame not my soul with heavy woe, dread mistress,
 Nay, nor with anguish,
But hither come, if ever erst of old time
Thou didst incline, and listenedst to my crying,
And from thy father's palace down descending
 Camest with golden
Chariot yoked: thee fair swift flying sparrows
Over dark earth with multitudinous fluttering,
Pinion on pinion through middle ether
 Down from heaven hurried.
Quickly they came like light, and thou, blest lady,
Smiling with clear undying eyes, didst ask me
What was the woe that troubled me, and wherefore
 I had cried to thee;
What thing I longed for to appease my frantic
Soul: and Whom now must I persuade, thou askedst,
Whom must entangle to thy love, and who now,
 Sappho, hath wronged thee.
Yea, for if now he shun, he soon shall chase thee;

50

Yea, if he take not gifts, he soon shall give them;
Yea, if he loved not soon shall he begin to
　　Love thee, unwilling.
Come to me now too, and from tyrannous sorrow
Free me, and all things that my soul desires to
Have done, do for me Queen, and let thyself too
　　Be my great ally.

Fragment i
Translated by John Addington Symonds

ODE TO ANACTORIA

Φαίνεταί μοι κῆνος ἴσος θέοισιν
ἔμμεν ὤνηρ ὄττις ἐνάντιός τοι
ἰζάνει καὶ πλάσιον ἆδυ φωνεί-
σας ὐπακούει

καὶ γελαίσας ἰμμέροεν, τό μ’ ἦ μὰν
κάρζαν ἐν στήθεσιν ἐπεπτόασεν·
ὡς γὰρ ἔς τ’ ἴδω, Βρόχε’, ὥς με φώνας
οὐδεν ἔτ’ ἴκει,

ἀλλὰ κὰμ μὲν γλῶσσα Fέαγε, λέπτον
δ’ αὔτικα χρῷ πῦρ ὐπαδεδρόμακεν,
ὀππάτεσσι δ’ οὐδεν ὄρημ’, ἐπιρρόμ-
βεισι δ’ ἄκουαι,

ἀ δέ μ’ ἴδρως κακχέεται, τρόμος δὲ
παῖσαν ἄγρη, χλωροτέρα δὲ ποίας
ἔμμι, τεθνάκην δ’ ὀλίγω ’πιδεύFην
φαίνομαι—ἀλλὰ

πάντ « α νῦν τ » ολμάτε’, ἐπεὶ ’ πένησα.

That man seems to me peer of gods, who sits in thy presence, and hears
close to him thy sweet speech and lovely laughter; that indeed makes
my heart flutter in my bosom. For when I see thee but a little, I have
no utterance left, my tongue is broken down, and straightway a subtle
fire has run under my skin, with my eyes I have no sight, my ears ring,
sweat bathes me, and a trembling seizes all my body; I am paler than
grass, and seem in my madness little better than one dead. But I must
dare all, since one so poor. . .

Fragment ii
Translated by Henry Thornton Wharton

*Let us see further whether we could find anything else that can make
style sublime. Since there are in all things certain elements, essentially*

inherent, it follows that we shall find one factor of sublimity in a con-
sistently happy choice of these constituent elements, and in the power
of combining them together as it were into an organic whole. What
attracts the reader is partly the selection of ideas, partly the soldering of
these selected. Sappho, for instance, never fails to take the emotions
incident to erotic mania from the symptoms which accompany it in real
life. And wherein does she show her excellence? In the skill with which
she selects and combines the most striking and intense of those symp-
toms [in the ODE TO ANACTORIA]. . . . *Is it not wonderful how she*
summons at the same time, soul, body, hearing, tongue, sight, colour, all
as though they had wandered off apart from herself? She feels con-
tradictory sensations, freezes and burns, thinks unreasonably—for one
that is at the point of death is clearly beside herself. She wants to display
not a single emotion, but a whole congress of emotions. Lovers all show
such symptoms as these, but what gives supreme merit to her art is, as
I said, the skill with which she chooses the most striking and combines
them into a single whole. It is, I fancy, much in the same way that the
poet in describing storms picks out the most alarming circumstances.

LONGINUS
On the Sublime, x
Translated by W. Hamilton Fyfe

CATULLUS' TRANSLATION
OF THE ODE TO ANACTORIA

Ille mi par esse deo videtur,
Ille, si fas est, superare divos,
qui sedens adversus identidem te
 spectat et audit
dulce ridentem, misero quod omnis
eripit sensus mihi; nam simul te,
Lesbia, aspexi, nihil est super mi
 [vocis in ore]
lingua sed torpet, tenuis sub artus
flamma demanat, sonitu suopte
tintinant aures, gemina teguntur
 lumina nocte.

Like to a god he seems to me,
Above the gods, if so may be,
Who sitting often close to thee
 May see and hear

52

Thy lovely laugh: ah, luckless man!
It stuns me, Lesbia, but to scan
Thy face: my lips no longer can
 Say aught, my dear;
My tongue is dumb, and through each limb
Steals subtle fire: a drumming hymn
Beats in my ears: mine eyes are dim
 With darkness sheer.

Translated by Sir William Marris

*To translate the two odes and the remaining fragments of Sappho is
the one impossible task; and as witness of this I will call up one of the
greatest among poets. Catullus 'translated'—or as his countrymen would
now say 'traduced'—the 'Ode to Anactoria'—a more beautiful transla-
tion there never was and will never be; but compared with the Greek,
it is colourless and bloodless, puffed out by additions and enfeebled by
alterations. . . . The 'Ode to Anactoria' (as it is named by tradition)
. . . has in the whole world of verse no companion and no rival but
the 'Ode to Aphrodite.'*

ALGERNON CHARLES SWINBURNE
Notes on Poems and Reviews (1866)

SAPPHO

C . 6 0 0 B . C .

ATTHIS

Ἠράμαν μὲν ἔγω σέθεν, Ἄτθι, πάλαι ποτά

I loved thee once, Atthis, long ago.

Fragment xlviii

There is no sadder poem.

MAURICE BARING
Have You Anything to Declare? (1936)

SAPPHO

C . 6 0 0 B . C .

FOREVER DEAD

Κατθάνοισα δὲ κείσεαι οὐδέ τινι μναμόσυνα σέθεν
ἔσσετ' οὐδέποτ' <εἰς> ὕστερον· οὐ γὰρ
 πεδέχεις Βρόδων
τῶν ἐκ Πιερίας, ἀλλ' ἀφάνης κἠν Ἀΐδα δόμοις
φοιτάσεις πεδ' ἀμαύρων νεκύων
 ἐππεποταμένα.

Death shall be death forever unto thee,
Lady, with no remembrance of thy name
Then or thereafter; for thou gatherest not
The roses of Pieria, loving gold
Above the Muses. Even in Hades' House
Wander thou shalt unmarked, flitting forlorn
Among the shadowy, averted dead.

Fragment lxxi
Translated by William Ellery Leonard

*To antiquity Sappho was "the poetess" as Homer was "the poet." She
still remains so. Many women have written poetry, and some have
written poetry of high merit and extreme beauty. But no other woman
can claim an assured place in the first rank of poets. Among the Greek
lyrists are the names of some half-dozen women who came in the cata-
logue of the lyric poets, howbeit they attained not unto the Nine:
Corinna of Tanagra, the rival of Pindar and one of his most acute critics;
Murtis of Anthedon and Telesilla of Argos; Erinna, that fascinating and
elusive figure who somewhere and at some time—as to her country and
her date all is uncertainty—died at nineteen, an inheritress of unful-
filled renown. Of these as of their successors in other ages and countries
no one has stood by the side of the great Lesbian—*

οὔδ' ἴαν δοκίμοιμι προσίδοισαν φάος ἀλίω
ἔσσεσθαι σοφίαν πάρθενον εἰς οὐδένα πω Χρόνον τοιαύταν.

*"Into all time I think no maiden that looks on the light of the sun shall
be such in wisdom."*

J. W. MACKAIL
Lectures on Greek Poetry (1910)

SAPPHO

C . 6 0 0 B . C .

THE MOON HAS SET

Δέδυκε μὲν ἀ σέλαννα
καὶ Πληΐαδες, μέσαι δὲ
νύκτες, παρὰ δ' ἔρχετ' ὤρα,
ἔγω δὲ μόνα κατεύδω.

The moon has set, and the Pleiads; it is the middle of the night and time passes, time passes, and I lie alone.

Fragment cxi

Not even the best of the Chinese could have said more in so small a compass. Night, and desire, the anguish of waiting and, with it, the duller, the deeper, the more hopelessly incurable pain of knowing that every light must set, that life and love are declining, declining, inexorably westering towards the darkness—all these things are implied, how completely! in Sappho's lines. The words continue to echo, as it were, and re-echo along yet further corridors of memory, with a sound that can never completely die away (such is the strange power of the poet's voice) till memory itself is dead.

ALDOUS HUXLEY
Texts and Pretexts (1933)

SIMONIDES

C . 5 5 6 — C . 4 6 8 B . C .

THE THREE HUNDRED

Ὦ ξεῖν', ἀγγέλλειν Λακεδαιμονίοις ὅτι τῇδε
κείμεθα, τοῖς κείνων ῥήμασι πειθόμενοι.

Tell them in Lakëdaimôn, passer-by,
That here obedient to their word we lie.

The Greek Anthology, vii, 249
Translation anonymous

The oldest and best Inscription is that on the Altar-tomb of the Three Hundred.

CHRISTOPHER NORTH (JOHN WILSON)
Blackwood's Magazine (1833)

DANAË

῞Οτε λάρνακι κεῖτ' ἐν δαιδαλέᾳ
ἄνεμός τέ μιν πνέων ἐφόρει
κινηθεῖσά τε λίμνα,
δεῖμα προσεῖρπε τότ' οὐκ ἀδιάντοισι παρειαῖς,
ἀμφί τε Περσεῖ βάλεν φίλαν χέρ' εἶπέ τ'· «ὦ τέκος,

οἷον ἔχω πόνον·
οὐ δ' ἀωτεῖς· γαλαθηνῷ τ'
ἤτορι κνώσσεις ἐν ἀτερπεῖ
δούρατι χαλκεογόμφῳ,
νυκτιλαμπεῖ κυανέῳ τε δνόφῳ ταθείς.
ἅλμαν δ' ὕπερθεν τεᾶν κομᾶν βαθεῖαν
παριόντος κύματος οὐκ
ἀλέγεις οὐδ' ἀνέμου φθόγγον πορφυρέᾳ κείμενος

ἐν χλανίδι πρόσωπον κλιθὲν προσώπῳ.
εἰ δέ τοι δεινὸν τό γε δεινὸν ἦν, καί κεν
ἐμῶν ῥημάτων λεπτὸν ὑπεῖχες οὖας.
κέλομ', εὗδε, βρέφος, εὑδέτω δὲ πόντος, εὑδέτω δ'
ἄμετρον κακόν· μεταιβολία δέ τις φανείη,
Ζεῦ πάτερ, ἐκ σέο.
ὅτι δὴ θαρσαλέον ἔπος
εὔχομαι καὶ νόσφι δίκας, σύγγνωθί μοι.»

When, in the carven chest,
The winds that blew and waves in wild unrest
Smote her with fear, she, not with cheeks unwet,
Her arms of love round Perseus set,
 And said: O child, what grief is mine!
But thou dost slumber, and thy baby breast
Is sunk in rest,
Here in the cheerless brass-bound bark,
Tossed amid starless night and pitchy dark.
 Nor dost thou heed the scudding brine
Of waves that wash above thy curls so deep,
Nor the shrill winds that sweep,—
Lapped in thy purple robe's embrace,
Fair little face!

But if this dread were dreadful too to thee,
Then wouldst thou lend thy listening ear to me;
Therefore I cry,—Sleep, babe, and sea be still,
And slumber our unmeasured ill!
 Oh, may some change of fate, sire Zeus, from thee
Descend, our woes to end!
But if this prayer, too overbold, offend
Thy justice, yet be merciful to me!

<div align="right">Translated by John Addington Symonds</div>

*In style Simonides is always pure and exquisitely polished. The ancients called him the sweet poet—Melicertes—*PAR EXCELLENCE. *His* σωφροσύνη, *or tempered self-restraint, gives a mellow tone not merely to his philosophy and moral precepts, but also to his art. . . . What he possesses of quite peculiar to his own genius is pathos—the pathos of romance. This appears most remarkably in the fragment of a threnos which describes Danaë afloat upon the waves at night. . . . One of the most perfect pieces of pathetic poetry in any literature.*

<div align="right">JOHN ADDINGTON SYMONDS
Studies of The Greek Poets (1873)</div>

AESCHYLUS

525 — 456 B. C.

WELCOME TO AGAMEMNON

Ἄνδρες πολῖται, πρέσβος Ἀργείων τόδε,
οὐκ αἰσχυνοῦμαι τοὺς φιλάνορας τρόπους
λέξαι πρὸς ὑμᾶς· ἐν χρόνῳ δ' ἀποφθίνει
τὸ τάρβος ἀνθρώποισιν. οὐκ ἄλλων πάρα
μαθοῦσ', ἐμαυτῆς δύσφορον λέξω βίον
τοσόνδ' ὅσονπερ οὗτος ἦν ὑπ' Ἰλίῳ.
τὸ μὲν γυναῖκα πρῶτον ἄρσενος δίχα
ἧσθαι δόμοις ἔρημον ἔκπαγλον κακόν,
[πολλὰς κλύουσαν κληδόνας παλιγκότους]·
καὶ τὸν μὲν ἥκειν, τόν δ' ἐπεισέρρειν, κακοῦ
κάκιον ἄλλο πῆμα λάσκοντας δόμοις.
καὶ τραυμάτων μὲν εἰ τόσων ἐτύγχανεν
ἀνὴρ ὅδ', ὡς πρὸς οἶκον ὠχετεύετο
φάτις, τέτρηται δικτύου πλέον λέγειν.
εἰ δ' ἦν τεθνηκώς, ὡς ἐπλήθυον λόγοι,

τρισώματός τἂν Γηρυὼν ὁ δεύτερος
[πολλὴν ἄνωθεν, τὴν κάτω γὰρ οὐ λέγω,]
χθονὸς τρίμοιρον χλαῖναν ἐξηύχει λαβεῖν,
ἅπαξ ἑκάστῳ κατθανὼν μορφώματι.
τοιῶνδ' ἕκατι κληδόνων παλιγκότων
πολλὰς ἄνωθεν ἀρτάνας ἐμῆς δέρης
ἔλυσαν ἄλλοι πρὸς βίαν λελημμένης.
ἐκ τῶνδέ τοι παῖς ἐνθάδ' οὐ παραστατεῖ,
ἐμῶν τε καὶ σῶν κύριος πιστωμάτων,
ὡς χρῆν, Ὀρέστης· μηδὲ θαυμάσῃς τόδε.
τρέφει γὰρ αὐτὸν εὐμενὴς δορύξενος
Στρόφιος ὁ Φωκεύς, ἀμφίλεκτα πήματα
ἐμοὶ προφωνῶν, τόν θ' ὑπ' Ἰλίῳ σέθεν
κίνδυνον, εἴ τε δημόθρους ἀναρχία
βουλὴν καταρρίψειεν, ὥστε σύγγονον
βροτοῖσι τὸν πεσόντα λακτίσαι πλέον.
τοιάδε μέντοι σκῆψις οὐ δόλον φέρει.
ἔμοιγε μὲν δὴ κλαυμάτων ἐπίσσυτοι
πηγαὶ κατεσβήκασιν, οὐδ' ἔνι σταγών·
ἐν ὀψικοίτοις δ' ὄμμασιν βλάβας ἔχω
τὰς ἀμφί σοι κλάουσα λαμπτηρουχίας
ἀτημελήτους αἰέν. ἐν δ' ὀνείρασιν
λεπταῖς ὑπαὶ κώνωπος ἐξηγειρόμην
ῥιπαῖσι θωΰσσοντος, ἀμφί σοι πάθη
ὁρῶσα πλείω τοῦ ξυνεύδοντος χρόνου.
νῦν ταῦτα πάντα τλᾶσ', ἀπενθήτῳ φρενὶ
λέγοιμ' ἂν ἄνδρα τόνδ' ἐγὼ σταθμῶν κύνα,
σωτῆρα ναὸς πρότονον, ὑψηλῆς στέγης
στῦλον ποδήρη, μονογενὲς τέκνον πατρὶ,
καὶ γῆν φανεῖσαν ναυτίλοις παρ' ἐλπίδα,
κάλλιστον ἧμαρ εἰσιδεῖν ἐκ χείματος,
ὁδοιπόρῳ διψῶντι πηγαῖον ῥέος·
τερπνὸν δὲ τἀναγκαῖον ἐκφυγεῖν ἅπαν.

CLYTAEMNESTRA

My reverend Elders, worthy citizens,
I shall not blush now to confess before you
My amorous fondness; fear and diffidence
Fade from us all in time. O 'tis not from
Instruction I can tell
The story of my own unhappy life
All the long while my lord lay under Ilium.
First for a woman 'tis a passing trial
To sit forlorn at home with no man present,

Always malignant rumours in her ears,
One bawler tumbling on another's heels
With cruel blows each heavier than the last:—
Wounds! if my lord had got as many wounds
As rumour channelling to us homeward gave him,
He had been more riddled than a net with holes.
Or had his deaths but tallied with all tales!
He might have been a second Geryon,
Three-bodied, with a triple coverture
Of earth above to boast him—never speak
Of that beneath—one for each several corpse.
 By reason of
These cross malignant rumours, other hands
Full many a time have set my desperate neck
Free from the hanging noose, recovering me
Against my dearest will.—Hence too it is
We see not present by our side this day
The child, Orestes, in whose person dwell
The pledges of our love; nor wonder at it;
He rests in keeping of our trusty cousin,
Strophius the Phocian, my forewarner oft
Of danger on two scores,—thy jeopardy
At Troy, and fear of popular tumult hatching
Plots in the lack of master, as 'tis common
When the man's down the more to trample on him:
Under which showing lies no trace of guile.
 For me, the gushing fountains of my tears
Are e'en dried up, there's not a drop now left;
And my late-rested eyes have suffered hurt
From weeping o'er the lanterns lit for thee
That still were unregarded. If I slept,
The puniest whining of a pulsing gnat
Would rouse me from beholding in my dreams
More accidents to thee than could befall
Within the time that was my bedfellow.
 Now, after all this borne, with heart unpined
I hail my lord, safe watchdog of the fold,
Main forestay of the ship, firm-footed pillar
Bearing the roof up, sole-born child vouchsafed
To father, to the wave-tossed seaman land,
Bright day that greets the eyesight after storm,
Well-water to the thirsty wayfarer!
Sweet is escape from every harsh constraint.

<div align="right">

Agamemnon, 855-902
Translated by Walter Headlam

</div>

If we forget the characters, and think only of the poetry, we shall admit that it has never been surpassed in energy and magnificence.

THOMAS BABINGTON MACAULAY
Critical and Historical Essays (1843)

AESCHYLUS

5 2 5 — 4 5 6 B . C .

THE DEATH OF AGAMEMNON

KA. ὀτοτοτοῖ πόποι δᾶ.
 'Απόλλων, 'Απόλλων.
XO. τί ταῦτ' ἀνωτότυξας ἀμφὶ Λοξίου;
 οὐ γὰρ τοιοῦτος ὥστε θρηνητοῦ τυχεῖν.
KA. ὀτοτοτοῖ πόποι δᾶ.
 'Απόλλων, 'Απόλλων.
XO. ἡ δ' αὖτε δυσφημοῦσα τὸν θεὸν καλεῖ
 οὐδὲν προσήκοντ' ἐν γόοις παραστατεῖν.
KA. 'Απόλλων, 'Απόλλων
 ἀγυιᾶτ', ἀπόλλων ἐμός·
 ἀπώλεσας γὰρ οὐ μόλις τὸ δεύτερον.
XO. χρήσειν ἔοικεν ἀμφὶ τῶν αὐτῆς κακῶν.
 μένει τὸ θεῖον δουλίᾳ περ ἐν φρενί.
KA. 'Απόλλων, 'Απόλλων
 ἀγυιᾶτ', ἀπόλλων ἐμός·
 ἆ ποῖ ποτ' ἤγαγές με; πρὸς ποίαν στέγην;
XO. πρὸς τὴν 'Ατρειδῶν· εἰ σὺ μὴ τόδ' ἐννοεῖς,
 ἐγὼ λέγω σοι· καὶ τάδ' οὐκ ἐρεῖς ψύθη.
KA. μισόθεον μὲν οὖν, πολλὰ συνίστορα
 αὐτόφονα κακὰ κρεατόμα,
 ἀνδροσφαγεῖον καὶ πεδορραντήριον.
XO. ἔοικεν εὖρις ἡ ξένη κυνὸς δίκην
 εἶναι, ματεύει δ' ὧν ἀνευρήσει φόνον.
KA. μαρτυρίοισι γὰρ τοῖσδ' ἐπιπείθομαι·
 κλαόμενα τάδε βρέφη σφαγὰς
 ὀπτάς τε σάρκας πρὸς πατρὸς βεβρωμένας.
XO. ἤμεν κλέος σοῦ μαντικὸν πεπυσμένοι·
 <τούτων> προφήτας δ' οὔτινας ματεύομεν.
KA. ἰὼ πόποι, τί ποτε μήδεται;
 τί τόδ' ἄχος νέον [μέγα]
 μέγ' ἐν δόμοισι τοῖσδε μήδεται κακὸν

60

ἄφερτον φίλοισιν, δυσίατον. ἀλκὰ δ'
ἑκὰς ἀποστατεῖ.
ΧΟ. τούτων ἄϊδρίς εἰμι τῶν μαντευμάτων.
ἐκεῖνα δ' ἔγνων· πᾶσα γὰρ πόλις βοᾷ.
ΚΑ. ἰὼ τάλαινα, τόδε γὰρ τελεῖς,
τὸν ὁμοδέμνιον [πόσιν]
λουτροῖσι φαιδρύνασα; πῶς φράσω τέλος;
τάχος γὰρ τόδ' ἔσται· προτείνει δὲ χεὶρ ἐκ
χερὸς ὀρέγματα.
ΧΟ. οὔπω ξυνῆκα· νῦν γὰρ ἐξ αἰνιγμάτων
ἐπαργέμοισι θεσφάτοις ἀμηχανῶ.
ΚΑ. ἐὴ, παπαῖ παπαῖ, τί τόδε φαίνεται;
ἦ δίκτυόν τί γ' ῞Αιδου;
μάλ' ἄρκυς ἁ ξύνευνος, ἁ ξυναιτία
φόνου. στάσις δ' ἀκόρετος γένει
κατολολυξάτω θύματος λευσίμου.
ΧΟ. ποίαν Ἐρινὺν τήνδε δώμασιν κέλει
ἐπορθιάζειν; οὔ με φαιδρύνει λόγος.
ἐπὶ δὲ καρδίαν κροκοβαφὴς δράμε
σταγών, ἅτε καὶ δορὶ πτωσίμοις
ξυνανύτει βίου
δύντος αὐγαῖς. ταχεῖα δ' ἄτα πέλει.
ΚΑ. ἀᾶ, ἰδοὺ ἰδού· ἄπεχε τᾶς βοὸς
τὸν ταῦρον· ἐν πέπλοισιν
μελαγκέρῳ λαβοῦσα μηχανήματι
τύπτει· πίτνει δ' <ἐν> ἐνύδρῳ κύτει.
δολοφόνου λέβητος τέχναν σοι λέγω.
ΧΟ. οὐ κομπάσαιμ' ἂν θεσφάτων γνώμων ἄκρος
εἶναι, κακῷ δέ τῳ προσεικάζω τάδε.
ἀπὸ δὲ θεσφάτων τίς ἀγαθὰ φάτις
βροτοῖς τέλλεται; κακῶν γὰρ διαὶ
πολυεπεῖς τέχναι θεσπιῳδὸν
φόβον φέρουσιν μαθεῖν.
ΚΑ. ἰέ ἰὼ ταλαίνας κακόποτμοι τύχαι·
τὸ γὰρ ἐμὸν θροῶ πάθος ἐπεγχέασα.
ποῖ δή με δεῦρο τὴν τάλαιναν ἤγαγες;
οὐδέν ποτ' εἰ μὴ ξυνθανουμένην. τί γάρ;
ΧΟ. φρενομανής τις εἶ θεοφόρητος, ἀμ-
φὶ δ' αὑτᾶς θροεῖς
νόμον ἄνομον, οἷά τις ξουθὰ
ἀκόρετος βοᾶς, φεῦ, ταλαίναις φρεσὶν
῎Ιτυν ῎Ιτυν στένουσ' ἀμφιθαλῆ κακοῖς
ἀηδὼν βίον.

KA. ἰὼ ἰὼ λιγείας μόρον ἀηδόνος·
περίβαλον γὰρ οἱ πτεροφόρον δέμας θεοὶ
γλυκύν τ’ ἄγ<ειν αἰ>ῶνα κλαυμάτων διαί·
ἐμοὶ δὲ μίμνει σχισμὸς ἀμφήκει δορί.

ΧΟ. πόθεν ἐπισσύτους θεοφόρους ἔχεις
ματαίους δύας,
τὰ δ’ ἐπίφοβα δυσφάτῳ κλαγγᾷ
μελοτυπεῖς ὁμοῦ τ’ ὀρθίοις ἐν νόμοις;
πόθεν ὅρους ἔχεις θεσπεσίας ὁδοῦ
κακορρήμονας;

KA. ἰὼ γάμοι γάμοι Πάριδος ὀλέθριοι φίλων.
ἰὼ Σκαμάνδρου πάτριον ποτόν·
τότε μὲν ἀμφὶ σὰς ἀϊόνας τάλαιν’
ἠνυτόμαν τροφαῖς·
νῦν δ’ ἀμφὶ Κωκυτόν τε κἀχερουσίους
ὄχθους ἔοικα θεσπιῳδήσειν τάχα.

ΧΟ. τί τόδε τορὸν ἄγαν ἔπος ἐφημίσω;
<καὶ> νεογνὸς ἂν βροτῶν μάθοι.
πέπληγμαι δ’, ἅπερ δήγματι φοινίῳ,
δυσαλγεῖ τύχᾳ
μινυρὰ θρεομένας, θαύματ’ ἐμοὶ κλύειν.

KA. ἰὼ πόνοι πόνοι πόλεος ὀλομένας τὸ πᾶν.
ἰὼ πρόπυργοι θυσίαι πατρὸς
πολυκανεῖς βοτῶν ποιονόμων· ἄκος δ’
οὐδὲν ἐπήρκεσεν
τὸ μὴ <οὐ> πόλιν μὲν ὥσπερ οὖν ἔχει παθεῖν·
ἐγὼ δὲ θερμόνους τάχ’ ἐμπέδῳ βαλῶ.

ΧΟ. ἑπόμενα προτέροις τάδ’ <ἐπ>εφημίσω.
καί τίς σε κακοφρονῶν τίθη-
σι δαίμων ὑπερβαρὴς ἐμπίτνων
μελίζειν πάθη
γοερὰ θανατοφόρα· τέρμα δ’ ἀμηχανῶ.

KA. καὶ μὴν ὁ χρησμὸς οὐκέτ’ ἐκ καλυμμάτων
ἔσται δεδορκὼς νεογάμου νύμφης δίκην·
λαμπρὸς δ’ ἔοικεν ἡλίου πρὸς ἀντολὰς
πνέων ἐσᾴξειν, ὥστε κύματος δίκην
κλύζειν πρὸς αὐγὰς πῆμα πήματος πολὺ
μεῖζον· φρενώσω δ’ οὐκέτ’ ἐξ αἰνιγμάτων.
καὶ μαρτυρεῖτε συνδρόμως ἴχνος κακῶν
ῥινηλατούσῃ τῶν πάλαι πεπραγμένων.
τὴν γὰρ στέγην τήνδ’ οὔποτ’ ἐκλείπει χορὸς
σύμφθογγος οὐκ εὔφωνος· οὐ γὰρ εὖ λέγει.
καὶ μὴν πεπωκώς γ’, ὡς θρασύνεσθαι πλέον,
βρότειον αἷμα κῶμος ἐν δόμοις μένει,

62

δύσπεμπτος ἔξω, συγγόνων Ἐρινύων.
ὑμνοῦσι δ' ὕμνον δώμασιν προσήμεναι
πρώταρχον ἄτην· ἐν μέρει δ' ἀπέπτυσαν
εὐνὰς ἀδελφοῦ τῷ πατοῦντι δυσμενεῖς.
ἥμαρτον, ἢ κυρῶ τι τοξότης τις ὥς;
ἢ ψευδόμαντίς εἰμι θυροκόπος φλέδων;
ἐκμαρτύρησον προυμόσας τὸ μ' εἰδέναι
λόγῳ παλαιὰς τῶνδ' ἁμαρτίας δόμων.

ΧΟ. καὶ πῶς ἂν ὅρκου πῆγμα γενναίως παγὲν
παιώνιον γένοιτο; θαυμάζω δέ σε
πόντου πέραν τραφεῖσαν ἀλλόθρουν, τὸ πᾶν
κυρεῖν λέγουσαν, ὥσπερ εἰ παρεστάτεις.

ΚΑ. μάντις μ' Ἀπόλλων τῷδ' ἐπέστησεν τέλει.

ΧΟ. ..

ΚΑ. προτοῦ μὲν αἰδὼς ἦν ἐμοὶ λέγειν τάδε.

ΧΟ. μῶν καὶ θεός περ ἱμέρῳ πεπληγμένος;

ΚΑ. ..

ΧΟ. ἁβρύνεται γὰρ πᾶς τις εὖ πράσσων πλέον.

ΚΑ. ἀλλ' ἦν παλαιστὴς κάρτ' ἐμοὶ πνέων χάριν.

ΧΟ. ἦ καὶ τέκνων εἰς ἔργον ἠλθέτην νόμῳ;

ΚΑ. ξυναινέσασα Λοξίαν ἐψευσάμην.

ΧΟ. ἤδη τέχναισιν ἐνθέοις ᾑρημένη;

ΚΑ. ἤδη πολίταις πάντ' ἐθέσπιζον πάθη.

ΧΟ. πῶς δῆτ' ἄνατος ἦσθα Λοξίου κότῳ;

ΚΑ. ἔπειθον οὐδέν' οὐδέν, ὡς τάδ' ἤμπλακον.

ΧΟ. ἡμῖν γε μὲν δὴ πιστὰ θεσπίζειν δοκεῖς.

ΚΑ. ἰοὺ ἰού.
ὑπ' αὖ με δεινοῖς ὀρθομαντείας πόνος
στροβεῖ ταράσσων φροιμίοις, ὦ ὦ κακά.
ὁρᾶτε τούσδε τοὺς δόμοις ἐφημένους
νέους, ὀνείρων προσφερεῖς μορφώμασιν;
παῖδες θανόντες ὡσπερεὶ πρὸς τῶν φίλων,
χεῖρας κρεῶν πλήθοντες, οἰκείας βορᾶς,
σὺν ἐντέροις τε σπλάγχν', ἐποίκτιστον γέμος,
πρέπουσ' ἔχοντες, ὧν πατὴρ ἐγεύσατο.
ἐκ τῶνδε ποινάς φημι βουλεύειν τινὰ
λέοντ' ἄναλκιν ἐν λέχει στρωφώμενον
οἰκουρὸν ἐκ μόθου μολόντι δεσπότῃ
ἐμῷ· φέρειν γὰρ χρὴ τὸ δούλιον ζυγόν.
νεῶν τ' ἔπαρχος Ἰλίου τ' ἀναστάτης
οὐκ οἶδεν οἷα γλῶσσα μισητῆς κυνὸς
λέξασα καὶ κτείνασα φαιδρόνους, δίκην
ἄτης λαθραίου, τεύξεται κακῇ τύχῃ.
τοιάδε τόλμα· θῆλυς ἄρσενος φονεὺς

ἔστιν, τί νιν καλοῦσα δυσφιλὲς δάκος
τύχοιμ' ἄν; ἀμφίσβαιναν, ἢ Σκύλλαν τινὰ
οἰκοῦσαν ἐν πέτραισι, ναυτίλων βλάβην,
θύουσαν Ἅιδου μητέρ' ἄσπονδόν τ' Ἄρη
φίλοις πνέουσαν; ὡς δ' ἐπωλολύξατο
ἡ παντότολμος, ὥσπερ ἐν μάχης τροπῇ.
δοκεῖ δὲ χαίρειν νοστίμῳ σωτηρίᾳ.
καὶ τῶνδ' ὅμοιον εἴ τι μὴ πείθω· τί γάρ;
τὸ μέλλον ἥξει, καὶ σύ μ' ἐν τάχει παρὼν
ἄγαν ἀληθόμαντιν οἰκτίρας ἐρεῖς.

ΧΟ. τὴν μὲν Θυέστου δαῖτα παιδείων κρεῶν
ξυνῆκα καὶ πέφρικα, καὶ θάμβος μ' ἔχει
κλύοντ' ἀληθῶς, οὐδὲν ἐξῃκασμένα·
τὰ δ' ἄλλ' ἀκούσας ἐκ δρόμου πεσὼν τρέχω.

ΚΑ. Ἀγαμέμνονός σέ φημ' ἐπόψεσθαι μόρον.

ΧΟ. εὔφημον, ὦ τάλαινα, κοίμησον στόμα.

ΚΑ. ἀλλ' οὔτι παιὼν τῷδ' ἐπιστατεῖ λόγῳ.

ΧΟ. οὔκ, εἴπερ ἔσται γ'· ἀλλὰ μὴ γένοιτό πως.

ΚΑ. σὺ μὲν κατεύχει, τοῖς δ' ἀποκτείνειν μέλει.

ΧΟ. τίνος πρὸς ἀνδρὸς τοῦτ' ἄγος πορσύνεται;

ΚΑ. ἦ κάρτα τἄρα παρεκόπης χρησμῶν ἐμῶν.

ΧΟ. τοῦ γὰρ τελοῦντος; οὐ ξυνῆκ' ἀμηχανῶν.

ΧΑ. καὶ μὴν ἄγαν γ' Ἕλλην' ἐπίσταμαι φάτιν.

ΧΟ. καὶ γὰρ τὰ πυθόκραντα· δυσμαθῆ δ' ὅμως

ΚΑ. παπαῖ <παπαῖ>.
οἷον τὸ <δ' ἕρπει> πῦρ· ἐπέρχεται δ' ἐμοί.
ὀτοτοῖ Λύκει' Ἄπολλον, οἳ ἐγὼ ἐγώ.
αὕτη δίπους λέαινα συγκοιμωμένη
λύκῳ, λέοντος εὐγενοῦς ἀπουσίᾳ,
κτενεῖ με τὴν τάλαιναν· ὡς δὲ φάρμακον
τεύχουσα κἀμοῦ μισθὸν ἐνθήσει ποτῷ,
κἀπεύχεται, θήγουσα φωτὶ φάσγανον,
ἐμῆς ἀγωγῆς ἀντιτείσεσθαι φόνον.
τί δῆτ' ἐμαυτῆς καταγέλωτ' ἔχω τάδε,
καὶ σκῆπτρα καὶ μαντεῖα περὶ δέρῃ στέφη;
σφὲ μὲν πρὸ μοίρας τῆς ἐμῆς διαφθερῶ.
ἴτ' ἐς φθόρον πεσόντ', ἐγὼ δ' ἅμ' ἕψομαι.
ἄλλην τιν' ἄτης ἀντ' ἐμοῦ πλουτίζετε.
ἰδοὺ δ' Ἀπόλλων αὐτὸς ἐκδύων ἐμὲ
χρηστηρίαν ἐσθῆτ', ἐποπτεύσας ἐμὲ
κἀν τοῖσδε κόσμοις καταγελωμένην μέγα
φίλων ὑπ' ἐχθρῶν, οὐ διχορρόπως μάτην.
καλουμένη δὲ φοιτὰς, ὡς ἀγύρτρια
πτωχός τε μαινὰς λιμοθνὴς, ἠνεσχόμην.

64

καὶ νῦν ὁ μάντις μάντιν ἐκπράξας ἐμὲ
ἀπήγαγ' ἐς τοιάσδε θανασίμους τύχας.
βωμοῦ πατρῴου δ' ἀντ' ἐπίξηνον μένει,
θερμῷ κοπείσης φοίνιον προσφάγματι.
οὐ μὴν ἄτιμοί γ' ἐκ θεῶν τεθνήξομεν.
ἥξει γὰρ ἡμῶν ἄλλος αὖ τιμάορος,
μητροκτόνον φίτυμα, ποινάτωρ πατρός·
φυγὰς δ' ἀλήτης τῆσδε γῆς ἀπόξενος
κάτεισιν, ἄτας τάσδε θριγκώσων φίλοις·
ἄραρε γὰρ <τις> ὅρκος ἐκ θεῶν μέγας,
πράξειν νιν ὑπτίασμα κειμένου πατρός.
τί δῆτ' ἐγὼ κάτοικτος ὧδ' ἀναστένω;
ἐπεὶ τὸ πρῶτον εἶδον Ἰλίου πόλιν
πράξασαν ὡς ἔπραξεν, οἳ δ' εἷλον πόλιν
οὕτως ἀπαλλάσσουσιν ἐν θεῶν κρίσει,
αἰνοῦσ' ἃ πράξω τλήσομαι τὸ κατθανεῖν.
Ἅιδου πύλας δὴ τάσδ' ἐγὼ προσεννέπω·
ἐπεύχομαι δὲ καιρίας πληγῆς τυχεῖν,
ὡς ἀσφάδαστος, αἱμάτων εὐθνησίμων
ἀπορρυέντων, ὄμμα συμβάλω τόδε.

ΧΟ. ὦ πολλὰ μὲν τάλαινα, πολλὰ δ' αὖ σοφὴ
γύναι, μακρὰν ἔτεινας. εἰ δ' ἐτητύμως
μόρον τὸν αὑτῆς οἶσθα, πῶς θεηλάτου
βοὸς δίκην πρὸς βωμὸν εὐτόλμως πατεῖς;
ΚΑ. οὐκ ἔστ' ἄλυξις, οὔ, ξένοι χρόνῳ πλέον.
ΧΟ. ὁ δ' ὕστατός γε τοῦ χρόνου πρεσβεύεται.
ΚΑ. ἥκει τόδ' ἦμαρ· σμικρὰ κερδανῶ φυγῇ.
ΧΟ. ἀλλ' ἴσθι τλήμων οὖσ' ἀπ' εὐτόλμου φρενός.
ΚΑ. ἀλλ' εὐκλεῶς τοι κατθανεῖν χάρις βροτῷ.
ΧΟ. οὐδεὶς ἀκούει ταῦτα τῶν εὐδαιμόνων.
ΚΑ. ἰὼ πάτερ σοῦ σῶν τε γενναίων τέκνων.
ΧΟ. τί δ' ἐστὶ χρῆμα; τίς σ' ἀποστρέφει φόβος;
ΚΑ. φεῦ φεῦ.
ΧΟ. τί τοῦτ' ἔφευξας; εἴ τι μὴ φρενῶν στύγος.
ΚΑ. φόνον δόμοι πνέουσιν αἱμοσταγῆ.
ΧΟ. καὶ πῶς; τόδ' ὄζει θυμάτων ἐφεστίων.
ΚΑ. ὅμοιος ἀτμὸς ὥσπερ ἐκ τάφου πρέπει.
ΧΟ. οὐ Σύριον ἀγλάϊσμα δώμασιν λέγεις.
ΚΑ. ἰὼ ξένοι.
οὔτοι δυσοίζω θάμνον ὡς ὄρνις φόβῳ,
ἀλλ' ὡς θανούσῃ μαρτυρῆτέ μοι τότε,
ὅταν γυνὴ γυναικὸς ἀντ' ἐμοῦ θάνῃ,
ἀνήρ τε δυσδάμαρτος ἀντ' ἀνδρὸς πέσῃ.
ἐπιξενοῦμαι ταῦτα δ' ὡς θανουμένη.

65

XO. ὦ τλῆμον, οἰκτίρω σε θεσφάτου μόρου.

ΚΑ. ἅπαξ ἔτ' εἰπεῖν ῥῆσιν, οὐ θρῆνον θέλω
ἐμὸν τὸν αὐτῆς· ἡλίου δ' ἐπεύχομαι
πρὸς ὕστατον φῶς, τοῖς ἐμοῖς τιμαόροις
ἐχθροῖς φονεῦσι τοῖς ἐμοῖς τίνειν ὁμοῦ,
δούλης θανούσης, εὐμαροῦς χειρώματος.
ἀλλ' εἶμι κἄν θανοῦσι κωκύσουσ' ἐμὴν
Ἀγαμέμνονός τε μοῖραν· ἀρκείτω βίος.

XO. ἰὼ βρότεια πράγματ'· εὐτυχοῦντα μὲν
σκιᾷ τις ἂν πρέψειεν· εἰ δὲ δυστυχοῖ,
βολαῖς ὑγρώσσων σπόγγος ὤλεσεν γραφήν·
καὶ ταῦτ' ἐκείνων μᾶλλον οἰκτίρω πολύ.
τὸ μὲν εὖ πράσϲειν ἀκόρεστον ἔφυ
πᾶσι βροτοῖσιν· δακτυλοδείκτων δ'
οὔτις ἀπειπὼν εἴργει μελάθρων,
 μηκέτ' ἐσέλθῃς, τάδε φωνῶν.
καὶ τῷδε πόλιν μὲν ἑλεῖν ἔδοσαν
μάκαρες Πριάμου·
θεοτίμητος δ' οἴκαδ' ἱκάνει·
νῦν δ' εἰ προτέρων αἷμ' ἀποτείσας
καὶ τοῖσι θανοῦσι θανὼν ἄλλων
 ποινὰς θανάτων ἐπικραίνει,
τίς <ποτ'> ἂν εὔξαιτο βροτῶν ἀσινεῖ
δαίμονι φῦναι τάδ' ἀκούων;

ΑΓ. ὤμοι, πέπληγμαι καιρίαν <πλευρῶν> ἔσω.

XO. σῖγα· τίς πληγὴν ἀϋτεῖ καιρίως οὐτασμένος;

ΑΓ. ὤμοι μάλ' αὖθις, δευτέραν πεπληγμένος.

XO. τοὔργον εἰργάσθαι, δοκεῖ μοι βασιλέως οἰμώ-
 γμασιν·

CASSANDRA
Oh! Alas, Earth! Apollo, Apollo!

CHORUS
What is this cry in the name of Loxias?
He is not one to greet with lamentation.

CASSANDRA
Oh! Alas, Earth! Apollo, Apollo!

CHORUS
Again she calls with blasphemous utterance
The God who stands aloof from mourning cries.

CASSANDRA
Apollo, Apollo, the Wayfarer! Destroyed by thee!
Once more hast thou destroyed me wantonly!

66

CHORUS

Her own sad fate, it seems, she will prophesy.
She is now a slave, and yet God's gift abides.

CASSANDRA

Apollo, Apollo, the Wayfarer! Destroyed by thee!
Ah, whither hast thou led me? What house is this?

CHORUS

The House of the Atreidae. Nay, if that
Thou knowest not, then hear the truth from me.

CASSANDRA

Palace abhorred of God, conscious of hidden crime,
Sanguinary, sullied with slaughtered kin,
A charnel-house that streams with children's blood!

CHORUS

Keen as a hound upon the scent she seems,
This stranger, tracking down a murderous trail.

CASSANDRA

I can declare a testimony plain to read.
Listen to them as they lament the foul
Repast of roasted flesh for father's mouth!

CHORUS

We know of thy prophetic fame already,
And have no need of an interpreter.

CASSANDRA

Out, out, alas! What is it plotted now?
Horror unspeakable
Is plotted in this house, insufferable,
A hard cross for kinsfolk,
Without cure. The hoped-for succour is far away.

CHORUS

This prophecy escapes me. Yet the first
I recognised—the country cries of it.

CASSANDRA

Alas, O wicked! Is thy purpose *that*?
He who hath shared thy bed,
To bathe his limbs, to smile—how speak the end?
The end comes, and quickly:
A hand reaching out, followed by a hand again!

CHORUS

Still at a loss am I; riddles before,
Now sightless oracles obscure my way.

CASSANDRA

Ah, ah! O horrible!
What is appearing now? Some net of mesh infernal.
Mate of his bed and board, she is a snare

67

Of slaughter! Oh, murderous ministers,
Cry alleluia, cry,
Fat with blood, dance and sing!
CHORUS
What is this Fury thou hast called to cry
In exultation? It brings no cheer to me.
Oh, to the heart it falls, saffron of hue, the drop
Of blood which doth sink with life's setting sun,
Smitten with edge of steel.
Nearer, yet nearer draws the swift judgment-stroke.
CASSANDRA
Ah, ah! Beware, beware!
Let not the cow come near! See how the bull is captured!
She wraps him in the robe, the hornèd trap,
Then strikes. He falls into the bath, the foul
Treacherous bowl of blood. Such her skilled artistry.
CHORUS
No gift I boast in reading prophecy,
But this must signify calamity.
When did a prophet's voice issue in happiness?
Amidst mortal stress his word-woven art,
Ever divining ill,
Teacheth mankind before the hour chants of fear.
CASSANDRA
Alas, alas, unhappy, pitiful destiny!
Now I lament my own passion to fill the bowl.
Oh whither hast thou led me? O my grief,
Whither, unless that I with him must die?
CHORUS
Spirit of frenzy borne on by the breath of God,
Thy own mournful dirge
Singest thou, like the red-brown bird
Who never-weary pours out her full heart in song;
Itys, Itys! she cries, sorrow hath filled her days,
The sad nightingale.
CASSANDRA
Alas, alas, the sweet music of the nightingale!
Body of wings the Gods fashioned to cover her,
And gave her, free of weeping, happy days.
For me there waits the stroke of two-edged steel.
CHORUS
Whence is this passionate madness inspired of God
That still streameth on?
Tales of fear told in uncouth cries,
Set to a strain of high-pitched and harsh harmonies?

68

Whither the path of wild prophecy evil-tongued?
O where must it end?

CASSANDRA

O fatal bridal-day, Paris the curse of all his kin!
O swift Scamander, streaming past my home,
Once on the banks of those waters I dwelt, and they
Nourished me as a child.
But now, it seems, my cries shall soon resound
Beside Cocytus and sad Acheron.

CHORUS

What is it now? A cry simple for all to read.
Even a child may understand.
With sharp anguish cleft, as though red with blood
My heart breaks, as these pitiful plaintive cries
Shatter the listening soul.

CASSANDRA

Alas the pain, the pain, agony of a plundered town!
Alas, the King's rich offerings at the gates,
Lavished from flocks and herds, little availed to bring
Help to the city, so
That she might not have been what she is now.
And I distraught shall dash into the snare.

CHORUS

Like to the rest is this pitiful utterance.
What evil spirit hath possessed
Thy soul, cruelly bending those fevered lips
To give voice to such dolorous tunes of death?
Who shall divine the end?

CASSANDRA

Listen! No more my prophecy shall glance
As through a veil, like a new-wedded maid.
Nay, bright and fresh, I tell thee, it shall flow
Against the sunrise, and like a wave engulf
The daybreak in disaster greater far
Than this. No riddles now; I shall instruct,
And you shall bear me witness step by step,
As I track down the scent of crimes of old.
On yonder housetop ever abides a choir
Of minstrels unmelodious, singing of ill;
And deeply-drunk, to fortify their spirit,
In human blood, those revellers yet abide,
Whom none can banish, Furies congenital,
And settled on the roof they chant the tune
Of old primordial Ruin, each in turn
Spewing with horror at a brother's outraged bed.

69

Say, have I missed, or marked my quarry down?
Am I a false prophet babbling at the gates?
Bear me on oath your witness that I know
The story of this household's ancient crimes.

CHORUS

What could an oath, however truly sworn,
Avail to heal? Indeed I marvel at you,
Born far beyond the sea, speaking of this,
An alien country, as though you had been present.

CASSANDRA

The seer Apollo bestowed that gift upon me.

CHORUS

Was he smitten with the shaft of love, a God?

CASSANDRA

Time was, shame would not let me speak of this.

CHORUS

Prosperity makes man fastidious.

CASSANDRA

Oh, but he wrestled strenuously for my love.

CHORUS

Did he bring you to the act of getting child?

CASSANDRA

First I consented, then I cheated him.

CHORUS

Already captive to his craft divine?

CASSANDRA

Already I foretold my people's fate.

CHORUS

How did you find refuge from his displeasure?

CASSANDRA

The price I paid was that none gave me heed.

CHORUS

Your prophecies have earned belief from us.

CASSANDRA

Oh misery!
Again the travail of true prophecy
With prelude wild makes tumult in my soul!
Do you not see them, seated on the roof,
Those children, like the ghastly shapes of dreams,
Murdered, it seems, by their own kith and kin,
Meat in their hands from some familiar meal,
The inward parts and bowels, of which their father
Ate—what a pitiable load is theirs!
That is the sin for which is planned revenge
By the faint-hearted lion, stretched in the bed,

70

Who keeps house for my master—being his slave,
I must needs name him so—now home again.
Little he knows what that foul bitch, with ears
Laid back and lolling tongue, will bring to pass
With vicious snap of treacherous destruction.
So dead to shame! woman to murder man!
What beast abominable is her name?
Double-faced amphisbene, or skulking Scylla
Among the cliffs, waylaying mariners,
A hellish dam raging against her own,
In strife that gives no quarter! How loud she sang
Her alleluias over the routed foe,
While feigning gladness at his safe return!
Believe me not, what matter? 'Tis all one.
The future comes, and when your eyes have seen,
You shall cry out in pity, 'She spoke true.'

CHORUS

Thyestes' banquet of the flesh of babes
I understood, and shuddered, terrified
To hear that tale told with unerring truth;
But for the rest I wander far astray.

CASSANDRA

I say you shall see Agamemnon's death.

CHORUS

Unhappy girl, hush those ill-omened lips!

CASSANDRA

No healing god is here—there is no cure.

CHORUS

None, if it be so; and yet may it not be!

CASSANDRA

While you are praying, others prepare to kill.

CHORUS

What man would plot so foul a villainy?

CASSANDRA

Ah, you have missed my meaning utterly.

CHORUS

But who shall do it? That escapes me still.

CASSANDRA

And yet I know too well the speech of Greece.

CHORUS

So does the Delphian, yet are his sayings dark.

CASSANDRA

Ah, how it burns, the fire! It sweeps upon me!
Oh, oh! Apollo! Oh alas, my sorrow!
That lioness two-footed, lying with

71

The wolf in absence of the noble lion,
Shall kill me, O unhappy, and as though
Mixing a potion pours in the cup of wrath
My wages too, and while she sets an edge
Upon the steel for him, she vows to make
Murder the price of my conveyance hither.

 Why do I wear these tawdry mockeries,
This staff, this mantic wreath about my neck?
If I must die, then you shall perish first.
Down to perdition! Now you have your pay.
Bestow your fatal riches on another!
Behold Apollo stripping me himself
Of my prophetic raiment, regarding me,
Clad in his robes, a public laughing-stock
Of friend and enemy, one who has endured
The name of witch, waif, beggar, castaway.
So now the seer who made these eyes to see
Has led his servant to this mortal end.
No altar of my fathers waits for me,
But a block that drips blood at a dead man's grave.

 And yet we die not unavenged of heaven.
Another shall come to avenge us both,
Who for his father's sake shall kill his mother,
A wandering outcast, an exile far away,
He shall come back and set for his kin a crown
On this long tale of ruin. The Gods above
Have sworn a solemn covenant that his
Dead father's outstretched corpse shall call him home.

 Why do I weep for this so piteously?
Have I not seen the fall of Ilium?
And those who laid that city waste are thus
Discharged at last by heaven's arbitrament.
This door I name the gate of Hades: now
I will go and knock, I will endure to die.
My only prayer is that the blow be mortal,
To close these eyes in sleep without a struggle,
While my life's blood ebbs peacefully away.

CHORUS

O woman in whose wisdom is much grief,
Long have you spoken; and yet, if you know
The end, why like the consecrated ox
Walk with such patient step into the slaughter?

CASSANDRA

Should the end linger, that is no escape.

72

CHORUS

And yet the latest moment is the best.

CASSANDRA

What should I gain by flight? My hour has come.

CHORUS

You have the endurance of a valiant heart.

CASSANDRA

Such words are common for those whom life has crossed.

CHORUS

Yet there is comfort in honourable death.

CASSANDRA

O father, father, and thy noble sons!

(CASSANDRA *approaches the door, then recoils*)

CHORUS

What is it? What terror has turned you back?

CASSANDRA

Faugh!

CHORUS

What means that cry? Some sickening at the heart?

CASSANDRA

The palace reeks with fumes of dripping blood.

CHORUS

No, 'tis the smell of fireside sacrifice.

CASSANDRA

A vapour such as issues from a tomb.

CHORUS

No scent of Araby have you marked in it.

CASSANDRA

Nay, I will go to weep inside the house
Agamemnon's fate and mine. Enough of life!
O hear me, friends!
I am not scared like a bird once limed that takes
Fright at a bush. Witness, when I am dead,
The day when woman for this woman dies
And man mismarried for a man lies low.
I beg this of you at the point of death.

CHORUS

Poor soul, foredoomed to death, I pity you.

CASSANDRA

Yet one word more I have to speak, my own
Dirge for myself. I pray the Sun in heaven,
On whom I look my last, that he may grant
To him who shall come to avenge my master
From those who hate me payment of the price
For this dead slave-girl slain with so light a stroke.

Alas, mortality! when fortunate,
A painted image; in adversity,
The sponge's moist touch wipes it all away.

CHORUS

And this to me is far more pitiable.

(CASSANDRA *goes into the palace*)
Good fortune among mankind is a thing
Insatiable. Mansions of kings are marked
By the fingers of all, none warns her away,
None cries, O enter not hither!
Unto him the Immortals accorded the fall
Of the city of Troy,
And with honours divine he returns to his home.
But now, if the debt of the blood of the past
Is on him, if his death must crown it and pay
To the dead their price for the slaughtered of old,
Then who, when he hears these things, is assured
Of a life unwounded of sorrow?

AGAMEMNON

Oh me, I am struck down!

CHORUS

Hark, did you not hear that cry? The stroke of death!

AGAMEMNON

Oh me, again!

CHORUS

Ah, his voice it is, our King! The deed is done.

Agamemnon, 1072-1346
Translated by George Thomson

It offers a spectacle of tragic grandeur not to be surpassed, hardly to be equalled, by anything which even Shakespeare produced. What some modern critics might regard as defects—the lengthy choric passages, abstract in their thought, though splendid in their imagery— the concentration of the poet's powers on one terrific climax, for every word that Agamemnon, Clytemnestra, and Cassandra utter leads up to the death-cry of the king—contribute to the excellence of a drama of this style. If we lack the variety and subtlety that charm us in a work like HAMLET; *if, after reading the play over and over again, and testing it in many crucibles of critical analysis, we do not, as in the case of Shakespeare's tragedies, discover new and delicate beauties in the minor parts, but learn each time, and by each process, to admire the vigor of the poet's main conception, the godlike energy with which he has developed it; that may be taken as the strongest proof of its perfection as a monument of classic art. . . .*

Of all the terrors in this tragedy none is so awful in itself, or so artistically heightened, as Cassandra's prophecy. . . . The Chorus can only wonder that she, a foreign princess, should know the secrets of the fated race; but she tells them the story of Apollo's love, and how she deceived him, and what he wrought to punish her. Then, even as she speaks, the pang of inspiration thrills her. Perhaps the speech that follows, through its ghastly blending of visions evoked from the past with insight piercing into the immediate future, affects the imagination more intensely than any other piece of tragic declamation. . . .

Then, when our nerves have been strained to the cracking-point of expectation by Cassandra's prophecy and by the silence that succeeds it, from within the house is heard the deep-chested cry of Agamemnon: "O me, I am stricken with a stroke of death!" This shriek is the most terrible incident in all tragedy, owing to its absolute and awful timeliness, its adequacy to the situation. The whole dramatic apparatus of the play has been, as it were, constructed with a view to it; yet, though we expect it, our heart stops when at last it comes. The stillness, apparently of home repose, but really of death, which broods upon the house during those last moments, while every second brings the hero nearer to his fate, has in it a concentrated awfulness that surpasses even the knocking at the gate in MACBETH. *Then comes the cry of Agamemnon, and the whole structure of terror descends upon us. It is as though an avalanche had been gathering above our heads and gradually loosening —loosening with fearfully accelerated ratio of movement as the minutes fly—until a single word will be enough to make it crumble. That word, uttered from behind the stately palace-walls, startling the guilty and oppressive silence, intimating that the workers have done working, that the victim has been taken in their toils, is nothing less than the shriek of the smitten king. It sounds once for the death-blow given; and once again it sounds to mark a second stroke. Then shriek and silence are alike forgotten in the downfall of the mass of dread.*

J O H N A D D I N G T O N S Y M O N D S
Studies of The Greek Poets (1873)

A E S C H Y L U S

5 2 5 — 4 5 6 B . C .

THE SACRIFICE OF IPHIGENIA

Λιτὰς δὲ καὶ κληδόνας πατρῴους
παρ' οὐδὲν αἰῶνα παρθένειον
ἔθεντο φιλόμαχοι βραβῆς.

75

φράσεν δ' ἀόζοις πατὴρ μετ' εὐχὰν
δίκαν χιμαίρας ὕπερθε βωμοῦ
πέπλοισι περιπετῆ παντὶ θυμῷ
προνωπῆ λαβεῖν ἀέρ-
δην, στόματός τε καλλιπρῴ-
ρου φυλακᾷ κατασχεῖν
φθόγγον ἀραῖον οἴκοις,

βίᾳ χαλινῶν τ' ἀναύδῳ μένει.
κρόκου βαφὰς δ' ἐς πέδον χέουσα
ἔβαλλ' ἕκαστον θυτήρων ἀπ' ὄμματος βέλει
φιλοίκτῳ, πρέπουσά θ' ὡς ἐν γραφαῖς, προσεν-
νέπειν
θέλουσ', ἐπεὶ πολλάκις
πατρὸς κατ' ἀνδρῶνας εὐτραπέζους
ἔμελψεν· ἁγνᾷ δ' ἀταύρωτος αὐδᾷ πατρὸς
φίλου τριτόσπονδον εὔ-
ποτμον παιᾶνα φίλως ἐτίμα.

τὰ δ' ἔνθεν οὔτ' εἶδον οὔτ' ἐννέπω·

She cried aloud 'Father!', yet they heard not;
A maiden scarce flowered, yet they cared not,
The lords who gave the word for war.
Her father prayed, then he bade his servants
To seize her, where wrapt in robe and drooping
She lay, and lift her up, like a young kid,
With bold heart above the altar,
And her lovely lips to bridle
That they might not cry out, cursing the House of Atreus,
With gags, her mouth sealed in mute violence.
And then she let fall her cloak of saffron,
And glanced at each face around her
With eyes that dumbly craved compassion;
And like a picture she would but could not speak;
For oft aforetime at home
Her father's guests, after they had feasted,
Their cups replenished, had sat while with sweet voice she sang
The hymn of thanksgiving, pure and spotless,
Standing beside her father.
The end I saw not. It shall not be told.

Agamemnon, 228-48
Translated by George Thomson

76

MENELAUS ABANDONED

Οἶος καὶ Πάρις ἐλθὼν
ἐ; δόμον τὸν Ἀτρειδᾶν
ᾔσχυνε ξενίαν τράπε-
ζαν κλοπαῖσι γυναικός.

λιποῦσα δ' ἀστοῖσιν ἀσπίστορας
κλόνους λογχίμους τε καὶ ναυβάτας ὁπλισμούς,
ἄγουσά τ' ἀντίφερνον Ἰλίῳ φθορὰν,
βέβακεν ῥίμφα διὰ πυλᾶν ἄτλα-
τα τλᾶσα· πολλὰ δ' ἔστενον
τάδ' ἐννέποντες δόμων προφῆται·
"ἰὼ ἰὼ δῶμα δῶμα καὶ πρόμοι,
ἰὼ λέχος καὶ στίβοι φιλάνορες.
πάρεστι σιγᾶς ἄτιμος ἀλοίδορος
ἄδιστος ἀφεμένων ἰδεῖν.
πόθῳ δ' ὑπερποντίας φάσμα δό-
ξει δόμων ἀνάσσειν.
εὐμόρφων δὲ κολοσσῶν
ἔχθεται χάρις ἀνδρί·
ὀμμάτων δ' ἐν ἀχηνίαις
ἔρρει πᾶσ' Ἀφροδίτα.

ὀνειρόφαντοι δὲ πενθήμονες
πάρεισι δόξαι φέρουσαι χάριν ματαίαν.
μάταν γάρ, εὖτ' ἂν ἐσθλά τις δοκῶν ὁρᾷ,
παραλλάξασα διὰ χερῶν βέβα-
κεν ὄψις οὐ μεθύστερον,
πτεροῖς ὀπαδοῦσ' ὕπνου κελεύθοις.

And such did Paris come
 Unto Atrides' home,
And thence, with sin and shame his welcome to repay,
 Ravished the wife away—
And she, unto her country and her kin
Leaving the clash of shields and spears and arming ships,
And bearing unto Troy destruction for a dower,
 And overbold in sin,
Went fleetly thro' the gates, at midnight hour.
 Oft from the prophets' lips
Moaned out the warning and the wail—Ah woe!
Woe for the home, the home! and for the chieftains, woe!
 Woe for the bride-bed, warm

Yet from the lovely limbs, the impress of the form
 Of her who loved her lord, awhile ago!
 And woe! for him who stands
Shamed, silent, unreproachful, stretching hands
 That find her not, and sees, yet will not see,
 That she is far away!
And his sad fancy, yearning o'er the sea,
 Shall summon and recall
Her wraith, once more to queen it in his hall.
 And sad with many memories,
The fair cold beauty of each sculptured face—
 And all to hatefulness is turned their grace,
Seen blankly by forlorn and hungering eyes!
 And when the night is deep,
Come visions, sweet and sad, and bearing pain
 Of hopings vain—
Void, void and vain, for scarce the sleeping sight
 Has seen its old delight,
When thro' the grasps of love that bid it stay
 It vanishes away
On silent wings that roam adown the ways of sleep.

 Agamemnon, 399-426
 Translated by E. D. A. Morshead

The choric interludes of the AGAMEMNON, *though burdened with the mystery of sin and fate, and tuned to music stern and lofty, abound in strains of pathetic and of tender poetry, deep-reaching to the very fount of tears, unmatched by aught else in the Greek language. . . .*

The depth of his human pathos no mere plummet-line of scholarship or criticism can fathom. Before the vision of Iphigeneia at the altar we must needs be silent. . . . We do not need the sententious moral of Lucretius uttered four centuries later, TANTUM RELLIGIO POTUIT SUADERE MALORUM, *to point the pathos which Æschylus, with a profounder instinct, draws by one touch from the contrast between then and now. In the same strain is the description of Menelaus abandoned in his home by Helen. . . .*

To read the Greek aright in this wonderful lyric, so concentrated in its imagery, and so direct in its conveyance of the very soul of passion, is no light task; but far more difficult it is to render it into another language. Yet, even thus, we feel that this poem of defrauded desire and everlasting farewell, of vain outgoings of the spirit after vanished joy, is written not merely for Menelaus and the Greeks, but for all who stretch forth empty hands to clasp the dreams of dear ones, and then turn

away, face-downward on the pillow, from the dawn, to weep or strain
hot eyes that shed no tears.

JOHN ADDINGTON SYMONDS
Studies of The Greek Poets (1873)

AESCHYLUS

5 2 5 — 4 5 6 B . C .

THE CRIME OF ORESTES

ΟΡ ἀλλ', ὡς ἂν εἰδῆτ' — οὐ γὰρ οἶδ' ὅπη τελεῖ,
ὥσπερ ξὺν ἵπποις ἡνιοστροφῶν δρόμου
ἐξωτέρω· φέρουσι γὰρ νικώμενον
φρένες δύσαρκτοι πρὸς δὲ καρδίᾳ φόβος
ᾄδειν ἕτοιμος, ἢ δ' ὑπορχεῖσθαι κρότῳ —
ἕως δ' ἔτ' ἔμφρων εἰμί, κηρύσσω φίλους,
κτανεῖν τέ φημι μητέρ' οὐκ ἄνευ δίκης,
πατροκτόνον μίασμα καὶ θεῶν στύγος,
καὶ φίλτρα τόλμης τῆσδε πλειστηρίζομαι
τὸν πυθόμαντιν Λοξίαν, χρήσαντ' ἐμοὶ
πράξαντι μὲν ταῦτ' ἐκτὸς αἰτίας κακῆς
εἶναι, παρέντα δ' — οὐκ ἐρῶ τὴν ζημίαν·
τόξῳ γὰρ οὔτις πημάτων ἐφίξεται.
καὶ νῦν ὁρᾶτέ μ', ὡς παρεσκευασμένος
ξὺν τῷδε θαλλῷ καὶ στέφει προσίξομαι
μεσόμφαλόν θ' ἵδρυμα, Λοξίου πέδον,
πυρός τε φέγγος ἄφθιτον κεκλημένον,
φεύγων τόδ' αἷμα κοινόν· οὐδ' ἐφ' ἑστίαν
ἄλλην τραπέσθαι Λοξίας ἐφίετο.
τὰ δ' ἐν χρόνῳ μοι πάντας Ἀργείους λέγω
καὶ μαρτυρεῖν μὲν ὡς ἐπορσύνθη κακά.
ἐγὼ δ' ἀλήτης τῆσδε γῆς ἀπόξενος,
ζῶν καὶ τεθνηκὼς τάσδε κληδόνας λιπών.
ΧΟ. ἀλλ', εὖ γε πράξας, μήτ' ἐπιζευχθῆς στόμα
φήμη πονηρᾷ, μήτ' ἐπιγλωσσῶ κακά·
ἠλευθέρωσας πᾶσαν Ἀργείων πόλιν,
δυοῖν δρακόντοιν εὐπετῶς τεμὼν κάρα.
ΟΡ. ἀᾶ·
ποῖαι γυναῖκες αἵδε, Γοργόνων δίκην
φαιοχίτωνες καὶ πεπλεκτανημέναι
πυκνοῖς δράκουσιν· οὐκέτ' ἂν μείναιμ' ἐγώ.

ΧΟ. τίνες σὲ δόξαι, φίλτατ' ἀνθρώπων πατρί,
στροβοῦσιν; ἴσχε, μὴ φοβοῦ, νικῶν πολύ.

ΟΡ. οὐκ εἰσὶ δόξαι τῶνδε πημάτων ἐμοί·
σαφῶς γὰρ αἵδε μητρὸς ἔγκοτοι κύνες.

ΧΟ. ποταίνιον γὰρ αἷμά σοι χεροῖν ἔτι·
ἐκ τῶνδέ τοι ταραγμὸς ἐς φρένας πίτνει.

ΟΡ. ἄναξ Ἄπολλον, αἵδε πληθύουσι δή,
κἀξ ὀμμάτων στάζουσιν αἷμα δυσφιλές.

ΧΟ. εἴσω καθαρμός· Λοξίου δὲ προσθιγών,
ἐλεύθερόν σε τῶνδε πημάτων κτίσει.

ΟΡ. ὑμεῖς μὲν οὐχ ὁρᾶτε τάσδ', ἐγὼ δ' ὁρῶ·
ἐλαύνομαι δὲ κοὐκέτ' ἂν μείναιμ' ἐγώ.

ΧΟ. ἀλλ' εὐτυχοίης, καί σ' ἐποπτεύων πρόφρων
θεὸς φυλάσσοι καιρίοισι συμφοραῖς.
ὅδε τοι μελάθροις τοῖς βασιλείοις
τρίτος αὖ χειμὼν
 πνεύσας γονίας ἐτελέσθη.
παιδοβόροι μὲν πρῶτον ὑπῆρξαν
μόχθοι τάλανές [τε Θυέστου]·
δεύτερον ἀνδρὸς βασίλεια πάθη,
λουτροδάϊκτος δ' ὤλετ' Ἀχαιῶν
πολέμαρχος ἀνήρ·
νῦν δ' αὖ τρίτος ἦλθέ ποθεν σωτήρ,
ἢ μόρον εἴπω;
ποῖ δῆτα κρανεῖ, ποῖ καταλήξει
μετακοιμισθὲν μένος ἄτης;

ORESTES

So then, to tell you plainly,—I know not what
My end will be—my wits are out of hand,
Like horses that with victory in sight
Stampede out of the course, and in my heart,
As fear strikes up her tune, the dance begins,—
But, while I have my senses, I declare
To all my friends that I have killed my mother
In a just cause, my father's murderess,
A thing unclean, an execrable pest;
And to that desperate act my heart was lured
By homage to Apollo, who proclaimed
That, if I did this thing, I should be clear
Of guilt; if not,—I will not name the price,
Horrors beyond the furthest shaft of wit.
And now behold me as I turn my steps,
With boughs of supplication garlanded,

80

Unto the midmost shrine of Loxias
And glorious light of his undying fire,
An exile stained with kindred blood; for he
Commanded me to seek no hearth but his.
And all my countrymen I call to give
In time to come their witness, how these things
Were brought to pass—meanwhile, a wanderer,
An outcast from my country, I commend
Into their charge, in life and death, my name.

CHORUS

Thou hast done well, bend not thy lips to such
Ill-omened sayings and wild talk of woe.
Thou art deliverer of the land of Argos,
With one light stroke lopping two dragons' heads.

ORESTES

Ah!
What are those women? See them, Gorgon-like,
All clad in sable and entwined with coils
Of writhing snakes! Oh away, away!

CHORUS

What are these fancies, father's dearest son,
That fright thee? Stay and fear not. Thou hast won.

ORESTES

To me they are no fancies—only too clear—
Can you not see them?—hounds of a mother's curse!

CHORUS

Fresh is the bloodshed yet upon thy hands:
That is what brings confusion on thy wits.

ORESTES

O Lord Apollo, see how thick they come,
And from their eyes are dripping gouts of blood!

CHORUS

Thou shalt be purified! Apollo's touch
From these disasters shall deliver thee!

ORESTES

You cannot see them—look, how clear they are!
They come to hunt me down! Away, away!

(*Exit* ORESTES)

CHORUS

Fortune attend thee, may God graciously
Watch over thee and guide thee to the end!
On the house of the king with a turbulent blast
Has the third storm broke
And expended hath swept to its ending.
First came the unmerciful slaughter of babes

81

And the feast on their flesh;
Next followed the fall of a king, in the bath
Struck down, the Achaean commander who led
All Greece into war;
And the third now present is saviour—or else
Is destruction his name?
O when shall the end come, where shall the rage
Of calamity sink into slumber?

<div align="right">

Choephoroe, 1021-76
Translated by George Thomson

</div>

There is nothing in all poetry so awful, so nearly unendurable by the reader who is compelled by a natural instinct of imagination to realize and believe it, as the close of the CHOEPHORŒ, *except only the close of* KING LEAR.*

<div align="right">

ALGERNON CHARLES SWINBURNE
Three Plays of Shakespeare (1909)

</div>

AESCHYLUS

5 2 5 — 4 5 6 B . C .

THE CHORUS OF THE FURIES

Ἄγε δὴ καὶ χορὸν ἄψωμεν, ἐπεὶ
μοῦσαν στυγερὰν
ἀποφαίνεσθαι δεδόκηκεν,
λέξαι τε λάχη τὰ κατ᾽ ἀνθρώπους
ὡς ἐπινωμᾷ στάσις ἁμά.
εὐθυδίκαιοι δ᾽ εὐχόμεθ᾽ εἶναι·
τοὺς μὲν καθαρὰς
<καθαρῶς> χεῖρας προνέμοντας
οὔτις ἐφέρπει μῆνις ἀφ᾽ ἡμῶν,
ἀσινὴς δ᾽ αἰῶνα διοιχνεῖ·
ὅστις δ᾽ ἀλιτὼν ὥσπερ ὅδ᾽ ἀνὴρ
χεῖρας φονίας ἐπικρύπτει,
μάρτυρες ὀρθαὶ τοῖσι θανοῦσιν
παραγιγνόμεναι πράκτορες αἵματος
αὐτῷ τελέως ἐφάνημεν.
μᾶτερ ἅ μ᾽ ἔτικτες, ὦ μᾶτερ

* For an excerpt from the closing scene of *King Lear* see page 650.

Νύξ, ἀμαυροῖσι καὶ δεδορκόσιν ποινάν,
κλῦθ᾽· ὁ Λατοῦς γὰρ ἶνίς μ᾽ ἄτιμον τίθησιν
τόνδ᾽ ἀφαιρούμενος
πτῶκα, ματρῷον ἅγνισμα κύριον φόνου.
ἐπὶ δὲ τῷ τεθυμένῳ
τόδε μέλος παρακοπά, παραφορὰ φρενοπλανής,
ὕμνος ἐξ Ἐρινύων,
δέσμιος φρενῶν, ἀφόρμικτος, αὐονὰ βροτοῖς.

τοῦτο γὰρ λάχος διανταία
Μοῖρ᾽ ἐπέκλωσεν ἐμπέδως ἔχειν, θνατῶν
τοί νιν αὐτουργίαις ξυμπατῶσιν μάταιοι,
τοῖς ὁμαρτεῖν, ὄφρ᾽ ἂν
γᾶν ὑπέλθῃ· θανὼν δ᾽ οὐκ ἄγαν ἐλεύθερος.
ἐπὶ δὲ τῷ τεθυμένῳ
τόδε μέλος περικοπά, παραφορὰ φρενοπλανής,
ὕμνος ἐξ Ἐρινύων,
δέσμιος φρενῶν, ἀφόρμικτος, αὐονὰ βροτοῖς.

γιγνομέναισι λάχη τάδ᾽ ἐφ᾽ ἁμὶν ἐκράνθη,
ἀθανάτων δ᾽ ἀπέχειν γέρας, οὐδέ τις ἐστὶν
συνδαίτωρ μετάκοινος,
παλλεύκων δὲ πέπλων ἄμοιρος, ἄκληρος ἐτύχθην.
δωμάτων γὰρ εἱλόμαν
ἀνατροπάς, ὅταν Ἄρης
τιθασὸς ὢν φίλον ἕλῃ.
ἐπὶ τόν, ὦ, διόμεναι
κρατερὸν ὄνθ᾽ ὅμως μαυ-
ροῦμεν ὑφ᾽ αἵματος νέου.

σπευδόμεν αἵδ᾽ ἀφελεῖν τινὰ τάσδε μερίμνας,
θεῶν δ᾽ ἀτέλειαν ἐμαῖσι δίκαις ἐπικραίνειν,
μηδ᾽ εἰς ἄγκρισιν ἐλθεῖν —
Ζεὺς γὰρ αἱματοσταγὲς ἀξιόμισον ἔθνος τόδε λέσχας
ἇς ἀπηξιώσατο —
<ἀνατροπὰς, ὅταν Ἄρης
τιθασὸς ὢν φίλον ἕλῃ.
ἐπὶ τόν, ὦ διόμεναι
κρατερὸν ὄνθ᾽ ὅμως μαυ-
ροῦμεν ὑφ᾽ αἵματος νέου.>

δόξαι τ᾽ ἀνδρῶν καὶ μάλ᾽ ὑπ᾽ αἰθέρι σεμναὶ
τακόμεναι κατὰ γᾶν μινύθουσιν ἄτιμοι
ἁμετέραις ἐφόδοις μελανείμοσιν, ὀρχη-

83

σμοῖς τ' ἐπιφθόνοις ποδός.
μάλα γὰρ οὖν ἁλομένα
ἀνέκαθεν βαρυπεσῆ
καταφέρω ποδὸς ἀκμάν,
σφαλερὰ <καὶ> τανυδρόμοις
κῶλα, δύσφορον ἄταν.

πίπτων δ' οὐκ οἶδεν τόδ' ὑπ' ἄφρονι λύμᾳ·
τοῖον ἐπὶ κνέφας ἀνδρὶ μύσος πεπόταται,
καὶ δνοφερὰν τιν' ἀχλὺν κατὰ δώματος αὐδᾶ-
ται πολύστονος φάτις.
<μάλα γὰρ οὖν ἁλομένα
ἀνέκαθεν βαρυπεσῆ
καταφέρω ποδὸς ἀκμάν,
σφαλερὰ καὶ τανυδρόμοις
κῶλα, δύσφορον ἄταν.>

μένει γὰρ εὐμηχάνῳ τε καὶ τελείῳ, κακῶν
τε μνήμονες, σεμναὶ
καὶ δυσπαρήγοροι βροτοῖς,
ἄτιμα τίομεν ἀτίεται
λάχη θεῶν διχοστατοῦντ' ἀναλίῳ λάμπᾳ,
δυσποδοπαίπαλα δερκομένοισιν
καὶ δυσομμάτοις ὅμως.

τίς οὖν τάδ' οὐχ ἅζεταί τε καὶ δέδοικεν βροτῶν,
ἐμοῦ κλύων θεσμὸν
τὸν μοιρόκραντον, ἐκ θεῶν
δοθέντα τέλεον; ἔπι δέ μοι
<μένει> γέρας παλαιόν, οὐδ' ἀτιμίας κύρω,
καίπερ ὑπὸ χθόνα τάξιν ἔχουσα
καὶ δυσάλιον κνέφας.

Weave the weird dance,—behold the hour
 To utter forth the chant of hell,
 Our sway among mankind to tell,
The guidance of our power.
Of Justice are we ministers,
 And whosoe'er of men may stand
 Lifting a pure unsullied hand,
That man no doom of ours incurs,
 And walks thro' all his mortal path
 Untouched by woe, unharmed by wrath.

But if, as yonder man, he hath
Blood on the hands he strives to hide,
We stand avengers at his side,
Decreeing, *Thou hast wronged the dead:*
We are doom's witnesses to thee.
The price of blood, his hands have shed,
We wring from him; in life, in death,
Hard at his side are we!

Night, Mother Night, who brought me forth, a torment
To living men and dead,
Hear me, O hear! by Leto's stripling son
I am dishonourèd:
He hath ta'en from me him who cowers in refuge,
To me made consecrate,—
A rightful victim, him who slew his mother.
Given o'er to me and fate.

Hear the hymn of hell,
O'er the victim sounding,—
Chant of frenzy, chant of ill,
Sense and will confounding!
Round the soul entwining
Without lute or lyre—
Soul in madness pining,
Wasting as with fire!

Fate, all-pervading Fate, this service spun, commanding
That I should bide therein:
Whosoe'er of mortals, made perverse and lawless,
Is stained with blood of kin,
By his side are we, and hunt him ever onward,
Till to the Silent Land,
The realm of death, he cometh; neither yonder
In freedom shall he stand.

Hear the hymn of hell,
O'er the victim sounding,—
Chant of frenzy, chant of ill,
Sense and will confounding!
Round the soul entwining
Without lute or lyre—
Soul in madness pining,
Wasting as with fire!

When from womb of Night we sprang, on us this labour
 Was laid and shall abide.
Gods immortal are ye, yet beware ye touch not
 That which is our pride!
None may come beside us gathered round the blood feast—
 For us no garments white
Gleam on a festal day; for us a darker fate is,
 Another darker rite.
That is mine hour when falls an ancient line—
 When in the household's heart
The God of blood doth slay by kindred hands,—
 Then do we bear our part:
On him who slays we sweep with chasing cry:
 Though he be triply strong,
We wear and waste him; blood atones for blood,
 New pain for ancient wrong.

I hold this task—'tis mine, and not another's.
 The very gods on high,
Though they can silence and annul the prayers
 Of those who on us cry,
They may not strive with us who stand apart,
 A race by Zeus abhorred,
Blood-boltered, held unworthy of the council
 And converse of Heaven's lord.
Therefore the more I leap upon my prey;
 Upon their head I bound;
My foot is hard; as one that trips a runner
 I cast them to the ground;
Yea, to the depth of doom intolerable;
 And they who erst were great,
And upon earth held high their pride and glory,
 Are brought to low estate.
In underworld they waste and are diminished,
 The while around them fleet
Dark wavings of my robes, and, subtly woven,
 The paces of my feet.

Who falls infatuate, he sees not neither knows he
 That we are at his side;
So closely round about him, darkly flitting,
 The cloud of guilt doth glide.
Heavily 'tis uttered, how around his hearthstone
 The mirk of hell doth rise.

Stern and fixed the law is; we have hands t' achieve it,
 Cunning to devise.
Queens are we and mindful of our solemn vengeance.
 Not by tear or prayer
Shall a man avert it. In unhonoured darkness,
 Far from gods, we fare,
Lit unto our task with torch of sunless regions,
 And o'er a deadly way—
Deadly to the living as to those who see not
 Life and light of day—
Hunt we and press onward. Who of mortals hearing
 Doth not quake for awe,
Hearing all that Fate thro' hand of God hath given us
 For ordinance and law?
Yea, this right to us, in dark abysm and backward
 Of ages it befel:
None shall wrong mine office, tho' in nether regions
 And sunless dark I dwell.

<div align="right">

Eumenides, 307-96
Translated by E. D. A. Morshead

</div>

The height of sublimity.

<div align="right">

R. C. JEBB
The Growth and Influence of Classical Greek Poetry (1893)

</div>

<div align="center">

AESCHYLUS

5 2 5 — 4 5 6 B . C .

THE WORLD'S HARMONIOUS PLAN

</div>

Εἰθείη Διὸς εὖ παναλη-
θῶς. Διὸς ἵμερος οὐκ
εὐθήρατος ἐτύχθη.
παντᾶ τοι φλεγέθει
κἀν σκότῳ μελαίνᾳ
ξὺν τύχᾳ μερόπεσσι λαοῖς.

πίπτει δ' ἀσφαλὲς οὐδ' ἐπὶ νώ-
τῳ, Διὸς εἰ κορυφᾷ
κρανθῇ πρᾶγμα τέλειον.
δαυλοὶ γὰρ πραπίδων
δάσκιοί τε τείνου-
σιν πόροι κατιδεῖν ἄφραστοι.

<div align="center">

87

</div>

ἰάπτει δ' ἐλπίδων ἀφ' ὑψιπύρ-
γων πανώλεις βροτούς,
βίαν δ' οὔτιν' ἐξοπλίζει·
πᾶν ἄπονον δαιμόνιον·
θᾶσσον ἄνω φρόνημά πως
αὐτόθεν ἐξέπραξεν ἔμ-
πας ἑδράνων ἀφ' ἁγνῶν.

ἰδέσθω δ' εἰς ὕβριν βρότειον, οἷ-
α νεάζει πυθμὴν
δι' ἁμὸν γάμον τεθαλὼς
δυσπαραβούλοισι φρεσίν,
καὶ διάνοιαν μαινόλιν
κέντρον ἔχων ἄφυκτον, Ἄ-
τας δ' ἀπάταν μεταγνούς.

FIRST VOICE
O might we know beyond all doubt
What Zeus would—
SECOND VOICE
 Nay, past searching out!
God's will before our human sight
Shines against blackest foil of night
Only with dull and smouldering light.
FIRST VOICE
But all effects his will intends
Fall to safe undefeated ends.
SECOND VOICE
Tangled in gloomy thickets blind
And close beyond discerning wind
The dark ways of his secret mind.
THE WHOLE CHORUS
From towering Hope's ambitious height
 Down to Perdition's blackest pit
 He hurls the aspiring thoughts of Man,
 Yet stirs not, yet exerts no force:
Calm in his will's enabled might
 His throned imaginations sit,
 And see the World's harmonious Plan
 Move onward in its ordered course.
So let his eyes behold and see
 On earth now what intemperate sin,
 What violent heats of froward youth
 The old evil stock buds forth again!

Thus amorous and athirst for me,
With heart's own folly spurred within
To madness,—and the mocked heart's ruth
Repentant in its ruinous train!

The Suppliant Maidens, 85–110
Translated by Walter Headlam

The sublimity of this grand passage has been felt even through the imperfections of the text.

WALTER HEADLAM
A Book of Greek Verse (1907)

AESCHYLUS

5 2 5 — 4 5 6 B . C .

THE GHOST OF DARIUS

ΕΙΔΩΛΟΝ ΔΑΡΕΙΟΥ

Ὦ πιστὰ πιστῶν ἥλικές θ' ἥβης ἐμῆς
Πέρσαι γεραιοί, τίνα πόλις πονεῖ πόνον;
στένει, κέκοπται, καὶ χαράσσεται πέδον,
λεύσσων δ' ἄκοιτιν τὴν ἐμὴν τάφου πέλας
ταρβῶ, χοὰς δὲ πρευμενὴς ἐδεξάμην.
ὑμεῖς δὲ θρηνεῖτ' ἐγγὺς ἑστῶτες τάφου
καὶ ψυχαγωγοῖς ὀρθιάζοντες γόοις
οἰκτρῶς καλεῖσθέ μ'· ἐστὶ δ' οὐκ εὐέξοδον,
ἄλλως τε πάντως χοὶ κατὰ χθονὸς θεοὶ
λαβεῖν ἀμείνους εἰσὶν ἢ μεθιέναι.
ὅμως δ' ἐκείνοις ἐνδυναστεύσας ἐγὼ
ἥκω. τάχυνε δ', ὡς ἄμεμπτος ὦ χρόνου·
τί ἐστὶ Πέρσαις νεοχμὸν ἐμβριθὲς κακόν;

ΧΟ. σέβομαι μὲν προσιδέσθαι,
σέβομαι δ' ἀντία λέξαι
σέθεν ἀρχαίῳ περὶ τάρβει.

ΔΑ. ἀλλ' ἐπεὶ κάτωθεν ἦλθον σοῖς γόοις πεπεισμένος,
μή τι μακιστῆρα μῦθον, ἀλλὰ σύντομον λέγων
εἰπὲ καὶ πέραινε πάντα, τὴν ἐμὴν αἰδῶ μεθείς.

ΧΟ. δίεμαι μὲν χαρίσασθαι,
δίεμαι δ' ἀντία φάσθαι,
λέξας δύσλεκτα φίλοισιν.

89

ΔΑ. ἀλλ' ἐπεὶ δέος παλαιὸν σοὶ φρενῶν ἀνθίσταται,
τῶν ἐμῶν λέκτρων γεραιὰ ξύννομ', εὐγενὲς γύναι,
κλαυμάτων λήξασα τῶνδε καὶ γόων σαφές τί μοι
λέξον. ἀνθρώπεια δή τοι πήματ' ἂν τύχοι βροτοῖς.
πολλὰ μὲν γὰρ ἐκ θαλάσσης, πολλὰ δ' ἐκ χέρσου κακὰ
γίγνεται θνητοῖς, ὁ μάσσων βίοτος ἢν ταθῇ πρόσω.

ΑΤ. ὦ βροτῶν πάντων ὑπερσχὼν ὄλβον εὐτυχεῖ πότμῳ,
ὡς, ἕως τ' ἔλευσσες αὐγὰς ἡλίου, ζηλωτὸς ὢν
βίοτον εὐαίωνα Πέρσαις ὡς θεὸς διήγαγες,
νῦν τέ σε ζηλῶ θανόντα, πρὶν κακῶν ἰδεῖν βάθος·
πάντα γάρ, Δαρεῖ', ἀκούσει μῦθον ἐν βραχεῖ λόγῳ·
διαπεπόρθηται τὰ Περσῶν πράγμαθ', ὡς εἰπεῖν ἔπος.

ΔΑ. τίνι τρόπῳ; λοιμοῦ τις ἦλθε σκηπτός, ἢ στάσις πόλει;
ΑΤ. οὐδαμῶς· ἀλλ' ἀμφ' Ἀθήνας πᾶς κατέφθαρται στρατός.
ΔΑ. τίς δ' ἐμῶν ἐκεῖσε παίδων ἐστρατηλάτει; φράσον·
ΑΤ. θούριος Ξέρξης, κενώσας πᾶσαν ἠπείρου πλάκα.
ΔΑ. πεζὸς ἢ ναύτης δὲ πεῖραν τήνδ' ἐμώρανεν τάλας;
ΑΤ. ἀμφότερα· διπλοῦν μέτωπον ἦν δυοῖν στρατευμάτοιν.
ΔΑ. πῶς δὲ καὶ στρατὸς τοσόσδε πεζὸς ἤνυσεν περᾶν;
ΑΤ. μηχαναῖς ἔζευξεν Ἕλλης πορθμόν, ὥστ' ἔχεν πόρον.
ΔΑ. καὶ τόδ' ἐξέπραξεν, ὥστε Βόσπορον κλῇσαι μέγαν;
ΑΤ. ὧδ' ἔχει· γνώμης δέ πού τις δαιμόνων ξυνήψατο.
ΔΑ. φεῦ, μέγας τις ἦλθε δαίμων, ὥστε μὴ φρονεῖν καλῶς.
ΑΤ. ὡς ἰδεῖν τέλος πάρεστιν οἷον ἤνυσεν κακόν.
ΔΑ. καὶ τί δὴ πράξασιν αὐτοῖς ὧδ' ἐπιστενάζετε;
ΑΤ. ναυτικὸς στρατὸς κακωθεὶς πεζὸν ὤλεσε στρατόν.
ΔΑ. ὧδε παμπήδην δὲ λαὸς πᾶς κατέφθαρται δορί;
ΑΤ. πρὸς τάδ' ὡς Σούσων μὲν ἄστυ πᾶν κενανδρίαν στένει,
ΔΑ. ὦ πόποι κεδνῆς ἀρωγῆς κἀπικουρίας στρατοῦ.
ΑΤ. Βακτρίων δ' ἔρρει πανώλης δῆμος, οὐδέ τις περῶν
ΔΑ. ὦ μέλεος, οἵαν ἄρ' ἥβην ξυμμάχων ἀπώλεσεν.
ΑΤ. μονάδα δὲ Ξέρξην ἔρημόν φασιν οὐ πολλῶν μέτα
ΔΑ. πῶς τε δὴ καὶ ποῖ τελευτᾶν; ἔστι τις σωτηρία;
ΑΤ. ἄσμενον μολεῖν γέφυραν γαῖν δυοῖν ζευκτηρίαν.
ΔΑ. καὶ πρὸς ἤπειρον σεσῶσθαι τήνδε, τοῦτ' ἐτήτυμον;
ΑΤ. ναί· λόγος κρατεῖ σαφηνὴς τοῦτο κοὐκ ἔνι στάσις.
ΔΑ. φεῦ, ταχεῖά γ' ἦλθε χρησμῶν πρᾶξις, ἐς δὲ παῖδ' ἐμὸν
Ζεὺς ἀπέσκηψεν τελευτὴν θεσφάτων· ἐγὼ δέ που
διὰ μακροῦ χρόνου τάδ' ηὔχουν ἐκτελευτήσειν θεούς·
ἀλλ' ὅταν σπεύδῃ τις αὐτός, χὠ θεὸς συνάπτεται.
νῦν κακῶν ἔοικε πηγὴ πᾶσιν εὑρῆσθαι φίλοις.
παῖς δ' ἐμὸς τάδ' οὐ κατειδὼς ἤνυσεν νέῳ θράσει·
ὅστις Ἑλλήσποντον ἱρὸν δοῦλον ὣς δεσμώμασιν

ἤλπισε σχήσειν ῥέοντα, Βόσπορον ῥόον θεοῦ·
καὶ πόρον μετερρύθμιζε, καὶ πέδαις σφυρηλάτοις
περιβαλὼν πολλὴν κέλευθον ἤνυσεν πολλῷ στρατῷ,
θεῶν δὲ θνητὸς ὢν ἁπάντων ᾤετ᾽, οὐκ εὐβουλίᾳ,
καὶ Ποσειδῶνος κρατήσειν, πῶς τάδ᾽ οὐ νόσος φρενῶν
εἶχε παῖδ᾽ ἐμόν; δέδοικα μὴ πολὺς πλούτου πόνος
οὑμὸς ἀνθρώποις γένηται τοῦ φθάσαντος ἁρπαγή.
ΑΤ. ταῦτά τοι κακοῖς ὁμιλῶν ἀνδράσιν διδάσκεται
θούριος Ξέρξης· λέγουσι δ᾽ ὡς σὺ μὲν μέγαν τέκνοις
πλοῦτον ἐκτήσω ξὺν αἰχμῇ, τὸν δ᾽ ἀνανδρίας ὕπο
ἔνδον αἰχμάζειν, πατρῷον δ᾽ ὄλβον οὐδὲν αὐξάνειν.
τοιάδ᾽ ἐξ ἀνδρῶν ὀνείδη πολλάκις κλύων κακῶν
τήνδ᾽ ἐβούλευσεν κέλευθον καὶ στράτευμ᾽ ἐφ᾽ Ἑλλάδα.
ΔΑ. τοιγάρ σφιν ἔργον ἐστὶν ἐξειργασμένον
μέγιστον, ἀείμνηστον, οἷον οὐδέπω
τόδ᾽ ἄστυ Σούσων ἐξεκείνωσεν πεσόν,
ἐξ οὗτε τιμὴν Ζεὺς ἄναξ τήνδ᾽ ὤπασεν,
ἕν᾽ ἄνδρ᾽ ἁπάσης Ἀσίδος μηλοτρόφου
ταγεῖν, ἔχοντα σκῆπτρον εὐθυντήριον.
Μῆδος γὰρ ἦν ὁ πρῶτος ἡγεμὼν στρατοῦ·
ἄλλος δ᾽ ἐκείνου παῖς τόδ᾽ ἔργον ἤνυσεν·
φρένες γὰρ αὐτοῦ θυμὸν ᾠακοστρόφουν.
τρίτος δ᾽ ἀπ᾽ αὐτοῦ Κῦρος, εὐδαίμων ἀνήρ,
ἄρξας ἔθηκε πᾶσιν εἰρήνην φίλοις·
Λυδῶν δὲ λαὸν καὶ Φρυγῶν ἐκτήσατο,
Ἰωνίαν τε πᾶσαν ἤλασεν βίᾳ·
θεὸς γὰρ οὐκ ἤχθηρεν, ὡς εὔφρων ἔφυ.
Κύρου δὲ παῖς τέταρτος ἴθυνε στρατόν.
πέμπτος δὲ Μάρδις ἦρξεν, αἰσχύνη πάτρᾳ
θρόνοισί τ᾽ ἀρχαίοισι· τὸν δὲ σὺν δόλῳ
Ἀρταφρένης ἔκτεινεν ἐσθλὸς ἐν δόμοις,
ξὺν ἀνδράσιν φίλοισιν, οἷς τόδ᾽ ἦν χρέος.
[ἕκτος δὲ Μάραφις, ἕβδομος δ᾽ Ἀρταφρένης.]
κἀγὼ πάλου τ᾽ ἔκυρσα τοῦπερ ἤθελον,
κἀπεστράτευσα πολλὰ σὺν πολλῷ στρατῷ·
ἀλλ᾽ οὐ κακὸν τοσόνδε προσέβαλον πόλει.
Ξέρξης δ᾽ ἐμὸς παῖς ὢν νέος φρονεῖ νέα,
κοὐ μνημονεύει τὰς ἐμὰς ἐπιστολάς·
εὖ γὰρ σαφῶς τόδ᾽ ἴστ᾽, ἐμοὶ ξυνήλικες,
ἅπαντες ἡμεῖς, οἳ κράτη τάδ᾽ ἔσχομεν,
οὐκ ἂν φανεῖμεν πήματ᾽ ἔρξαντες τόσα.
ΧΟ. τί οὖν, ἄναξ Δαρεῖε, ποῖ καταστρέφεις
λόγων τελευτήν; πῶς ἂν ἐκ τούτων ἔτι
πράσσοιμεν ὡς ἄριστα Περσικὸς λεώς;

ΔΑ. εἰ μὴ στρατεύοισθ' ἐς τὸν Ἑλλήνων τόπον,
 μηδ' εἰ στράτευμα πλεῖον ᾖ τὸ Μηδικόν.
 αὐτὴ γὰρ ἡ γῆ ξύμμαχος κείνοις πέλει.
ΧΟ πῶς τοῦτ' ἔλεξας, τίνι τρόπῳ δὲ συμμαχεῖ;
ΔΑ. κτείνουσα λιμῷ τοὺς ὑπερπόλλους ἄγαν.
ΧΟ. ἀλλ' εὐσταλῆ τοι λεκτὸν ἀροῦμεν στόλον.
ΔΑ. ἀλλ' οὐδ' ὁ μείνας νῦν ἐν Ἑλλάδος τόποις
 στρατὸς κυρήσει νοστίμου σωτηρίας.
ΧΟ. πῶς εἶπας; οὐ γὰρ πᾶν στράτευμα βαρβάρων
 περᾷ τὸν Ἕλλης πορθμὸν Εὐρώπης ἄπο;
ΔΑ. παῦροί γε πολλῶν, εἴ τι πιστεῦσαι θεῶν
 χρὴ θεσφάτοισιν, ἐς τὰ νῦν πεπραγμένα
 βλέψαντα· συμβαίνει γὰρ οὐ τὰ μέν, τὰ δ' οὔ.
 κεῖπερ τάδ' ἐστί, πλῆθος ἔκκριτον στρατοῦ
 λείπει κεναῖσιν ἐλπίσιν πεπεισμένος.
 μίμνουσι δ' ἔνθα πεδίον Ἀσωπὸς ῥοαῖς
 ἄρδει, φίλον πίασμα Βοιωτῶν χθονί·
 οὗ σφιν κακῶν ὕψιστ' ἐπαμμένει παθεῖν,
 ὕβρεως ἄποινα κἀθέων φρονημάτων·
 οἳ γῆν μολόντες Ἑλλάδ' οὐ θεῶν βρέτη
 ᾐδοῦντο συλᾶν οὐδὲ πιμπράναι νεώς·
 βωμοὶ δ' ἄϊστοι, δαιμόνων θ' ἱδρύματα
 πρόρριζα φύρδην ἐξανέστραπται βάθρων.
 τοιγὰρ κακῶς δράσαντες οὐκ ἐλάσσονα
 πάσχουσι, τὰ δὲ μέλλουσι, κοὐδέπω κακῶν
 κρηπὶς ὕπεστιν, ἀλλ' ἔτ' ἐκπιδύεται.
 τόσος γὰρ ἔσται πέλανος αἱματοσφαγὴς
 πρὸς γῇ Πλαταιῶν Δωρίδος λόγχης ὕπο·
 νεκρῶν δὲ θῖνες καὶ τριτοσπόρῳ γονῇ
 ἄφωνα σημανοῦσιν ὄμμασιν βροτῶν
 ὡς οὐχ ὑπέρφευ θνητὸν ὄντα χρὴ φρονεῖν.
 ὕβρις γὰρ ἐξανθοῦσ' ἐκάρπωσε στάχυν
 ἄτης, ὅθεν πάγκλαυτον ἐξαμᾷ θέρος.
 τοιαῦθ' ὁρῶντες τῶνδε τἀπιτίμια
 μέμνησθ' Ἀθηνῶν Ἑλλάδος τε, μηδέ τις
 ὑπερφρονήσας τὸν παρόντα δαίμονα
 ἄλλων ἐρασθεὶς ὄλβον ἐκχέῃ μέγαν.
 Ζεύς τις κολαστὴς τῶν ὑπερκόπων ἄγαν
 φρονημάτων ἔπεστιν, εὔθυνος βαρύς.
 πρὸς ταῦτ' ἐκεῖνον σωφρονεῖν κεχρημένον
 πινύσκετ' εὐλόγοισι νουθετήμασιν,
 λῆξαι θεοβλαβοῦνθ' ὑπερκόμπῳ θράσει.
 σὺ δ', ὦ γεραιὰ μῆτερ ἡ Ξέρξου φίλη,
 ἐλθοῦσ' ἐς οἴκους κόσμον ὅστις εὐπρεπὴς

λαβοῦσ' ὑπαντίαζε παιδί. παντὶ γὰρ
κακῶν ὑπ' ἄλγους λακίδες ἀμφὶ σώματι
στημορραγοῦσι ποικίλων ἐσθημάτων.
ἀλλ' αὐτὸν εὐφρόνως σὺ πράϋνον λόγοις·
μόνης γὰρ, οἶδα, σοῦ κλύων ἀνέξεται.
ἐγὼ δ' ἄπειμι γῆς ὑπὸ ζόφον κάτω.
ὑμεῖς δέ, πρέσβεις, χαίρετ', ἐν κακοῖς ὅμως
ψυχὴν διδόντες ἡδονῇ καθ' ἡμέραν,
ὡς τοῖς θανοῦσι πλοῦτος οὐδὲν ὠφελεῖ.

The ghost of Darius rises from his tomb

DARIUS

O Trusty of the Trusty, compeers of my youth, ye aged Persians, with what travail travaileth the State? The earth groans and is furrowed by the stamp of men. As I behold my consort hard by my tomb I feel alarm, and I accept her libations in kindly mood; while ye, standing near my tomb, make lament, and with shrilling cries that summon the spirits of the dead, invoke me piteously. Not easy is the path from out the tomb; for this cause above all—that the gods beneath the earth are readier to seize than to release. Nevertheless, for that I have obtained dominion among them, I am come. But speed ye, that I may be void of blame as to the time of my sojourn. What is this unexpected ill that weighs the Persians down?

CHORUS

I shrink in awe from gazing upon thee, I shrink in awe from speaking in thy presence by reason of mine old-time dread of thee.

DARIUS

Nay, but since, in compliance with thy moanings, I am come from the world below, lay aside thine awe of me, make thy tale not long, but brief, speak out and deliver thy whole story to its end.

CHORUS

I fear to do thy pleasure, I fear to speak in thy presence and deliver unto those I love news hard to utter.

DARIUS

Nay, since the old-accustomed dread in thy mind restrains thee, do thou, high-born dame, venerable partner of my bed, cease thy tears and laments, and tell me a plain tale. Afflictions appointed unto human life must, we know, befall mankind. For many calamities from out the sea, many from out the land, arise to mortal men if their span of life be extended far.

ATOSSA

O thou who in prosperity didst surpass all mortal men by thy happy destiny, since, so long as thou didst gaze upon the beams of the sun, thou didst pass a life of felicity, envied of all, in Persian eyes a god, so now too I count thee happy in dying ere thou hast beheld the depth

93

of our calamities. The whole tale, O Darius, thou shalt hear in brief space of time. The power of Persia is ruined well-nigh utterly.

DARIUS

In what wise? Came there some stroke of pestilence or strife of faction upon the State?

ATOSSA

Neither; but near Athens our whole host has been brought to ruin.

DARIUS

Tell me, what son of mine led thither our embattled host?

ATOSSA

Impetuous Xerxes, unpeopling the whole surface of the continent.

DARIUS

Was it by land or sea that he made this mad emprise, the reckless man?

ATOSSA

By both. There was a twofold front of double armament.

DARIUS

But how was it that so vast a land force won a passage to the farther shore?

ATOSSA

By artful contrivances he yoked the firth of Helle so as to gain a passage.

DARIUS

What! Did he succeed in closing the mighty Bosporus?

ATOSSA

Even so. Some one of the powers divine, methinks, assisted him in his intent.

DARIUS

Alas! 'Twas some mighty power that came upon him so that he lost his sober judgment.

ATOSSA

Aye, since by the issue 'tis plain how great the ruin he has wrought.

DARIUS

And how then did they fare that ye thus make lament over them?

ATOSSA

Disaster to the naval force brought ruin to the force on land.

DARIUS

And has the whole army thus utterly perished by the spear?

ATOSSA

Aye, so that for this reason the whole city of Susa groans at its desolation.

DARIUS

Alas for the loss of our warriors' goodly force and defence!

ATOSSA

And the host of the Bactrians is lost, wholly destroyed—not even an old man is left.

94

DARIUS

Unhappy man, since he has brought to ruin such goodly youth of our allies.

ATOSSA

But Xerxes, alone and forlorn, with scanty train, they say—

DARIUS

Met his end, how, pray, and where? Of his safety is there any hope?

ATOSSA

Reached to his joy the bridge yoking the two continents.

DARIUS

And reached our continent in safety? Is this certain?

ATOSSA

Aye; a well proved report establishes this at least. Doubt there is none.

DARIUS

Alas! Swift indeed has come the fulfilment of the oracles, and 'tis my son upon whom Zeus hath caused their issue to descend. Yet I have been resting confident that, only after long lapse of time, the gods would in some way bring them to accomplishment; nevertheless, when man hasteneth to his own undoing, God too taketh part with him. A fountain of misfortune has now, methinks, been discovered for all I love. A son of mine it was who, in his ignorance, brought these things to pass through youthful recklessness; for he conceived the hope that he could by shackles, as if it were a slave, restrain the current of the sacred Hellespont, the Bosporus, a stream divine; set himself to fashion a roadway of a new order, and, by casting upon it hammer-wrought fetters, made a spacious causeway for his mighty host. Mortal though he was, he thought in his folly that he would gain the mastery over all the gods, aye even over Poseidon. Must this not have been a distemper of the soul that possessed my son? I fear me lest the plenteous treasure amassed by my toil may become the prey of the spoiler.

ATOSSA

This lesson impetuous Xerxes learned by converse with the vile. For they kept ever telling him that, whereas thou by thy spear didst win plenteous treasure for thy children, he, on his part, through lack of manly spirit, played the warrior at home and made no enlargement of his father's wealth. Hearing such taunts many a time and oft from evil counsellors he planned this expedition and armament against Hellas.

DARIUS

Therefore a calamity most evil and past all forgetting has been wrought by him to its accomplishment; a calamity such as never yet befell this city of Susa to its desolation since our Lord Zeus first ordained this high estate that one ruler should bear sway over all Asia with its flocks and wield the sceptre of its government. For

95

Medus was first to be the leader of its host; and another, his son, completed his work since his soul obeyed the direction of wise thoughts. Third, after him, Cyrus, blest in his fortune, came to the throne and stablished peace for all his people. The Lydians and Phrygians he won to his rule, and the whole of Ionia he subdued by force; for the gods hated him not, since he was right-minded. Fourth in succession, the son of Cyrus ruled the host. Fifth in the list, Mardus came to power, a disgrace to his native land and to the ancient throne; but he was slain in his palace by the guile of gallant Arta-phrenes, with the help of friends whose part this was. (Sixth came Maraphis, and seventh Artaphrenes.) And I in turn attained the lot I craved, and many a campaign I made with a goodly host: but dis-aster so dire as this I brought not upon the State. But Xerxes my son, youth that he is, has the mind of youth and remembers not my injunctions. Be very sure of this, ye compeers of my age: all of us who have held this sovereign power cannot be shown to have wrought ruin so great as this.

CHORUS

What then, O King Darius? What is the goal toward which thou dost direct the issue of thy speech? How, after this reverse, may we, the people of Persia, prosper best in time to come?

DARIUS

If ye take not the field against the Hellenes' land, even if the forces of the Medes outnumber theirs. The land itself is their ally.

CHORUS

How meanest thou this? In what way "their ally"?

DARIUS

It wastes with famine an over-numerous foe.

CHORUS

But we shall dispatch a force of picked and easily managed troops.

DARIUS

But not even the host that now remains in Hellas shall win return to safety.

CHORUS

How sayest thou? Shall not the whole army of the barbarians cross from Europe over Helle's firth?

DARIUS

Few indeed out of many, if, having beheld what has now been brought to pass, it is right to put any faith in the oracles of Heaven; for they have fulfilment—not some only, while others fail. And if this be truth, it is through persuasion of vain hopes that he is leaving behind a body of picked troops. They are now tarrying where the plain is watered by the stream of Asopus that gives kindly enrich-ment to Boeotia's fields. Here it awaits them to suffer their crowning disaster in requital for their presumptuous pride and impious

thoughts. For, on reaching the land of Hellas, restrained by no religious awe, they ravaged the images of the gods and gave their temples to the flames. Altars have been destroyed, statues of the gods have been overthrown from their bases in utter ruin and confusion. Wherefore having evil wrought, evil they suffer in no less measure; and other evils are still in store: not yet quenched is the spring of their woes, but it still wells forth. For so great shall be the mass of clotted gore spilled by the Dorian lance upon Plataean soil that heaps of dead shall make known, even to the third generation, a voiceless record for the eyes of men that mortal man needs must not vaunt him overmuch. For presumptuous pride, when it has burgeoned, bears as its fruit a crop of calamity, whence it reaps a plenteous harvest of tears.

Mark that such are the penalties for deeds like these and hold Athens and Hellas in your memory. Let no one of you, through disdain of present fortune and lust for more, squander his abundant wealth. Zeus, of a truth, is a chastiser of overweening pride and corrects with heavy hand. Therefore, now that my son has been warned to prudence by the voice of God, do ye instruct him by admonitions of reason to cease from drawing on himself the punishment of Heaven by his vaunting rashness. And do thou, beloved and venerable mother of Xerxes, withdraw to the palace and fetch thence vesture such as is seemly for him, and prepare to meet thy son. For through grief at his misfortunes, the embroidered apparel that covered his person has been utterly rent into tattered shreds. Do thou soothe him with words of kindness; for it is to thy voice alone, I know, that he will endure to listen. As for me, I depart to the darkness beneath the earth. Fare ye well, ye Elders, and albeit amid troubles give joyance to your souls while to-day is yours; since to the dead wealth profiteth no jot.

(*The ghost of Darius descends*)

The Persians, 681–842
Translated by Herbert Weir Smyth

The raising of the Great King from the lower world has been called the greatest ghost scene in all literature.

HERBERT WEIR SMYTH
Aeschylean Tragedy (1924)

AESCHYLUS

5 2 5 — 4 5 6 B . C .

ATHENA'S FAITH

Κἀγὼ πέποιθα Ζηνί, καὶ τί δεῖ λέγειν;
καὶ κλῇδας οἶδα δώματος μόνη θεῶν,
ἐν ᾧ κεραυνός ἐστιν ἐσφραγισμένος·

I too, yes I, trust Zeus. Need I say more?
I only of the high Gods know the keys
Of chambers where the sealed-up thunder lies.

<div align="right">

Eumenides, 826–28
Translated by E. H. Plumptre

</div>

*I doubt if any one of the poets has uttered a sentence full of warning
at once so impressive and so wise.*

<div align="right">

JOHN KEBLE
Lectures on Poetry (1832–41)
Translated by Edward K. Francis

</div>

PINDAR

5 2 2 ? — 4 4 3 B . C .

FOR HIERON OF SYRACUSE
WINNER IN THE HORSE RACE, 476 B.C.

στρ. α´
Ἄριστον μὲν ὕδωρ, ὁ δὲ χρυσὸς αἰθόμενον πῦρ
ἅτε διαπρέπει νυκτὶ μεγάνορος ἔξοχα πλούτου·
εἰ δ' ἄεθλα γαρύεν
ἔλδεαι, φίλον ἦτορ,
μηκέθ' ἁλίου σκόπει
ἄλλο θαλπνότερον ἐν ἁμέρᾳ φαεννὸν ἄστρον ἐρήμας δι' αἰθέρος,
μηδ' Ὀλυμπίας ἀγῶνα φέρτερον οὐδάσομεν·
ὅθεν ὁ πολύφατος ὕμνος ἀμφιβάλλεται
σοφῶν μητίεσσι, κελαδεῖν
Κρόνου παῖδ' ἐς ἀφνεὰν ἱκομένους
μάκαιραν Ἱέρωνος ἑστίαν,

98

ἀντ. α´
θεμιστεῖον ὃς ἀμφέπει σκᾶπτον ἐν πολυμάλῳ
Σικελίᾳ, δρέπων μὲν κορυφὰς ἀρετᾶν ἄπο πασᾶν,
ἀγλαΐζεται δὲ καὶ
μουσικᾶς ἐν ἀώτῳ,
οἷα παίζομεν φίλαν
ἄνδρες ἀμφὶ θαμὰ τράπεζαν. ἀλλὰ Δωρίαν ἀπὸ φόρμιγγα πασσάλου
λάμβαν᾽, εἴ τί τοι Πίσας τε καὶ Φερενίκου χάρις
νόον ὑπὸ γλυκυτάταις ἔθηκε φροντίσιν,
ὅτε παρ᾽ Ἀλφεῷ σύτο, δέμας
ἀκέντητον ἐν δρόμοισι παρέχων,
κράτει δὲ προσέμιξε δεπόταν,
ἐπ. α´
Συρακόσιον ἱπποχάρμαν βασιλῆα. λάμπει δέ οἱ κλέος
ἐν εὐάνορι Λυδοῦ Πέλοπος ἀποικίᾳ·
τοῦ μεγασθενὴς ἐράσσατο γαιάοχος
Ποσειδᾶν, ἐπεί νιν καθαροῦ λέβητος ἔξελε Κλωθὼ
ἐλέφαντι φαίδιμον ὦμον κεκαδμένον.
ἦ θαυματὰ πολλά, καί πού τι καὶ βροτῶν φάτις ὑπὲρ τὸν ἀληθῆ
 λόγον
δεδαιδαλμένοι ψεύδεσι ποικίλοις ἐξαπατῶντι μῦθοι.
στρ. β´
Χάρις δ᾽, ἅπερ ἅπαντα τεύχει τὰ μείλιχα θνατοῖς,
ἐπιφέροισα τιμὰν καὶ ἄπιστον ἐμήσατο πιστὸν
ἔμμεναι τὸ πολλάκις·
ἁμέραι δ᾽ ἐπίλοιποι
μάρτυρες σοφώτατοι.
ἔστι δ᾽ ἀνδρὶ φάμεν ἐοικὸς ἀμφὶ δαιμόνων καλά· μείων γὰρ αἰτία.
υἱὲ Ταντάλου, σὲ δ᾽, ἀντία προτέρων, φθέγξομαι,
ὁπότ᾽ ἐκάλεσε πατὴρ τὸν εὐνομώτατον
ἐς ἔρανον φίλαν τε Σίπυλον,
ἀμοιβαῖα θεοῖσι δεῖπνα παρέχων,
τότ᾽ Ἀγλαοτρίαιναν ἁρπάσαι
ἀντ. β´
δαμέντα φρένας ἱμέρῳ χρυσέαισί τ᾽ ἀν᾽ ἵπποις
ὕπατον εὐρυτίμου ποτὶ δῶμα Διὸς μεταβᾶσαι,
ἔνθα δευτέρῳ χρόνῳ
ἦλθε καὶ Γανυμήδης
Ζηνὶ τωῦτ᾽ ἐπὶ χρέος.
ὡς δ᾽ ἄφαντος ἔπελες, οὐδὲ ματρὶ πολλὰ μαιόμενοι φῶτες ἄγαγον,
ἔννεπε κρυφᾶ τις αὐτίκα φθονερῶν γειτόνων,
ὕδατος ὅτι σε πυρὶ ζέοισαν εἰς ἀκμὰν
μαχαίρᾳ τάμον κάτα μέλη,

99

τραπέζαισί τ', ἀμφὶ δεύτατα, κρεῶν
σέθεν διεδάσαντο καὶ φάγον.
ἐπ. β'
ἐμοὶ δ' ἄπορα γαστρίμαργον μακάρων τιν' εἰπεῖν. ἀμφίσταμαι.
ἀκέρδεια λέλογχεν θαμινὰ κακαγόρος.
εἰ δὲ δή τιν' ἄνδρα θνατὸν Ὀλύμπου σκοποὶ
ἐτίμασαν, ἦν Τάνταλος οὗτος· ἀλλὰ γὰρ καταπέψαι
μέγαν ὄλβον οὐκ ἐδυνάσθη, κόρῳ δ' ἕλεν
ἄταν ὑπέροπλον, ἄν οἱ πατὴρ ὑπερκρέμασε καρτερὸν αὐτῷ λίθον,
τὸν αἰεὶ μενοινῶν κεφαλᾶς βαλεῖν εὐφροσύνας ἀλᾶται.
στρ. γ'
ἔχει δ' ἀπάλαμον βίον τοῦτον ἐμπεδόμοχθον,
μετὰ τριῶν τέταρτον πόνον, ἀθανάτων ὅτι κλέψαις
ἁλίκεσσι συμπόταις
νέκταρ ἀμβροσίαν τε
δῶκεν, οἷσιν ἄφθιτον
θῆκαν. εἰ δὲ θεὸν ἀνήρ τις ἔλπεταί τι λαθέμεν ἔρδων, ἁμαρτάνει.
τοὔνεκα προῆκαν υἱὸν ἀθάνατοί οἱ πάλιν
μετὰ τὸ ταχύποτμον αὖτις ἀνέρων ἔθνος.
πρὸς εὐάνθεμον δ' ὅτε φυὰν
λάχναι νιν μέλαν γένειον ἔρεφον.
ἑτοῖμον ἀνεφρόντισεν γάμον
ἀντ. γ'
Πισάτα παρὰ πατρὸς εὔδοξον Ἱπποδάμειαν
σχεθέμεν. ἐγγὺς ἐλθὼν πολιᾶς οἷος ἐν ὄρφνᾳ
ἄπυεν βαρύκτυπον
Εὐτρίαιναν· ὁ δ' αὐτῷ
πὰρ ποδὶ σχεδὸν φάνη.
τῷ μὲν εἶπε· «Φίλια δῶρα Κυπρίας ἄγ' εἴ τι, Ποσείδαον, ἐς χάριν
τέλλεται, πέδασον ἔγχος Οἰνομάου χάλκεον,
ἐμὲ δ' ἐπὶ ταχυτάτων πόρευσον ἁρμάτων
ἐς Ἆλιν, κράτει δὲ πέλασον.
ἐπεὶ τρεῖς τε καὶ δέκ' ἄνδρας ὀλέσαις
ἐρῶντας ἀναβάλλεται γάμον
ἐπ. γ'
θυγατρός. ὁ μέγας δὲ κίνδυνος ἄναλκιν οὐ φῶτα λαμβάνει.
θανεῖν δ' οἷσιν ἀνάγκα, τί κέ τις ἀνώνυμον
γῆρας ἐν σκότῳ καθήμενος ἕψοι μάταν,
ἁπάντων καλῶν ἄμμορος; ἀλλ' ἐμοὶ μὲν οὗτος ἄεθλος
ὑποκείσεται· τὺ δὲ πρᾶξιν φίλαν δίδοι.»
ὣς ἔννεπεν· οὐδ' ἀκράντοις ἐφάψατ' ὦν ἔπεσι. τὸν μὲν ἀγάλλων
 θεὸς
ἔδωκεν δίφρον τε χρύσεον πτεροῖσίν τ' ἀκάμαντας ἵππους.

στρ. δ'
ἕλεν δ' Οἰνομάου βίαν παρθένον τε σύνευνον·
τέκε τε λαγέτας ἓξ ἀρεταῖσι μεμαότας υἱούς.
νῦν δ' ἐν αἱμακουρίαις
ἀγλααῖσι μέμικται,
'Αλφεοῦ πόρῳ κλιθείς,
τύμβον ἀμφίπολον ἔχων πολυξενωτάτῳ παρὰ βωμῷ. τὸ δὲ κλέος
τηλόθεν δέδορκε τᾶν 'Ολυμπιάδων ἐν δρόμοις
Πέλοπος, ἵνα ταχυτὰς ποδῶν ἐρίζεται
ἀκμαί τ' ἰσχύος θρασύπονοι·
ὁ νικῶν δὲ λοιπὸν ἀμφὶ βίοτον
ἔχει μελιτόεσσαν εὐδίαν

ἀντ. δ'
ἀέθλων γ' ἕνεκεν, τὸ δ' αἰεὶ παράμερον ἐσλὸν
ὕπατον ἔρχεται παντὶ βροτῶν. ἐμὲ δὲ στεφανῶσαι
κεῖνον ἱππίῳ νόμῳ
Αἰοληΐδι μολπᾷ
χρή· πέποιθα δὲ ξένον
μή τιν', ἀμφότερα καλῶν τε ἴδριν ἁμᾷ καὶ δύναμιν κυριώτερον,
τῶν γε νῦν κλυταῖσι δαιδαλωσέμεν ὕμνων πτυχαῖς.
θεὸς ἐπίτροπος ἐὼν τεαῖσι μήδεται
ἔχων τοῦτο κάδος, 'Ιέρων,
μερίμναισιν· εἰ δὲ μὴ ταχὺ λίποι,
ἔτι γλυκυτέραν κεν ἔλπομαι

ἐπ. δ'
σὺν ἅρματι θοῷ κλεΐξειν, ἐπίκουρον εὑρὼν ὁδὸν λόγων
παρ' εὐδείελον ἐλθὼν Κρόνιον. ἐμοὶ μὲν ὦν
Μοῖσα καρτερώτατον βέλος ἀλκᾷ τρέφει·
ἐπ' ἄλλοισι δ' ἄλλοι μεγάλοι. τὸ δ' ἔσχατον κορυφοῦται
βασιλεῦσι. μηκέτι πάπταινε πόρσιον.
εἴη σέ τε τοῦτον ὑψοῦ χρόνου πατεῖν, ἐμέ τε τοσσάδε νικαφόροις
ὁμιλεῖν, πρόφαντον σοφίᾳ καθ' Ἕλλανας ἐόντα παντᾷ.

Even as water is most excellent, while gold, like fire flaming at night, gleameth more brightly than all other lordly wealth; even so, fond heart, if thou art fain to tell of prizes won in the games, look not by day for any star in the lonely sky, that shineth with warmth more genial than the sun, nor let us think to praise a place of festival more glorious than Olympia.

Thence cometh the famous song of praise that enfoldeth the thoughts of poets wise, so that they loudly sing the son of Cronus, when they arrive at the rich and happy hearth of Hieron; Hieron, who wieldeth the sceptre of law in fruitful Sicily, culling the prime of all virtues, while

he rejoiceth in the full bloom of song, even in such merry strains as we men full often raise around the friendly board.

Now, take the Dorian lyre down from its resting-place, if in sooth the grateful thought of Pisa and of Pherenîcus laid upon thy heart the spell of sweetest musings, what time, beside the Alpheüs, that steed rushed by, lending those limbs that in the race needed not the lash, and thus brought power unto his master, the lord of Syracuse, that war-like horseman for whom glory shineth in the new home of heroes erst founded by the Lydian Pelops; Pelops, of whom Poseidon, the mighty shaker of the earth, was once enamoured, when Clôthô lifted him out of the purifying waters of the caldron with his shoulder gleaming with ivory. Wonders are rife indeed; and, as for the tale that is told among mortals, transgressing the language of truth, it may haply be that stories deftly decked with glittering lies lead them astray. But the Grace of song, that maketh for man all things that soothe him, by adding her spell, full often causeth even what is past belief to be indeed believed; but the days that are still to come are the wisest witnesses.

In truth it is seemly for man to say of the gods nothing ignoble; for so he giveth less cause for blame. Son of Tantalus! I will tell of thee a tale far other than that of earlier bards:—what time thy father, in return for the banquets he had enjoyed, bade the gods come to his own dear Sipylus, and share his duly-ordered festal board, then it was that the god of the gleaming trident, with his heart enthralled with love, seized thee and carried thee away on his golden chariot to the highest home of Zeus, who is honoured far and wide,—that home to which, in after-time, Ganymede was also brought for the self-same service; and when thou wast seen no more, and, in spite of many a quest, men brought thee not to thy mother, anon some envious neighbours secretly devised the story that with a knife they clave thy limbs asunder, and plunged them into water which fire had caused to boil, and at the tables, during the latest course, divided the morsels of thy flesh and feasted.

Far be it from me to call any one of the blessed gods a cannibal! I stand aloof. Full oft hath little gain fallen to the lot of evil-speakers. But, if indeed there was any mortal man who was honoured by the guardian-gods of Olympus, that man was Tantalus; but, alas! he could not brook his great prosperity, and, owing to his surfeit of good things, he gat himself an overpowering curse, which the Father hung over him in the semblance of a monstrous stone, which he is ever eager to thrust away from his head, thus wandering from the ways of joy. And thereby hath he a helpless life of never-ending labour, with three besides and his own toil the fourth, because he stole from the gods the nectar and ambrosia, with which they had made him immortal, and gave them to the partners of his feast. But, if any man hopeth, in aught he doeth, to escape the eye of God, he is grievously wrong. Therefore it was that the

immortals once more thrust forth the son of Tantalus amid the short-lived race of men. But when, about the time of youthful bloom, the down began to mantle his cheek with dusky hue, he turned his thoughts to a marriage that was a prize open to all, even to the winning of the glorious Hippodameia from the hand of her father, the lord of Pisa.

He drew near unto the foaming sea, and, alone in the darkness, called aloud on the loudly roaring god of the fair trident; who appeared to him, even close beside him, at his very feet; and to the god he said:—

"If the kindly gifts of Cypris count in any wise in one's favour, then stay thou, Poseidon, the brazen spear of Oenomaüs, and speed me in the swiftest of all chariots to Elis, and cause me to draw nigh unto power. Thirteen suitors hath he slain, thus deferring his daughter's marriage. But high emprise brooketh no coward wight. Yet, as all men must needs die, why should one, sitting idly in the darkness, nurse without aim an inglorious eld, reft of all share of blessings? As for me, on this contest shall I take my stand; and do thou grant a welcome consummation."

Even thus he spake, nor did he light upon language that came to naught. The god honoured him with the gift of a golden chariot and of steeds unwearied of wing; and he overcame the might of Oenomaüs, and won the maiden as his bride, and she bare him six sons, who were eager in deeds of valour. And now hath he a share in the splendid funeral-sacrifices, while he resteth beside the ford of the Alpheüs, having his oft-frequented tomb hard by the altar that is thronged by many a visitant; and the fame of the Olympic festivals shineth from afar amid the race-courses of Pelops, where strife is waged in swiftness of foot and in doughty deeds of strength; but he that overcometh hath, on either hand, for the rest of his life, the sweetest calm, so far as crowns in the games can give it. Yet for every one of all mortal men the brightest boon is the blessing that ever cometh day by day.

I must crown the victor with the horseman's song, even with the Aeolian strains, and I am persuaded that there is no host of the present time, whom I shall glorify with sounding bouts of song, as one who is at once more familiar with things noble, or is more sovereign in power. A god who hath this care, Hieron, watcheth and broodeth over thy desires; but, if he doth not desert thee too soon, I trust I shall celebrate a still sweeter victory, even with the swift chariot, having found a path that prompteth praises, when I have reached the sunny hill of Cronus.

Howsoever, for myself, the Muse is keeping a shaft most mighty in strength. Some men are great in one thing; others in another: but the crowning summit is for kings. Refrain from peering too far! Heaven grant that thou mayest plant thy feet on high, so long as thou livest, and that I may consort with victors for all my days, and be foremost in the lore of song among Hellenes in every land.

Olympian Odes, i.
Translated by Sir John Sandys

This ode is the most sublime of all lyrical poems: even less open to doubt is its supremacy as a masterpiece of poetical architecture, whereby thoughts, emotions, and interests that might seem utterly distinct are wrought into wondrous unity.

<div align="right">

GILBERT NORWOOD
Pindar (1945)

</div>

PINDAR

5 2 2 ? — 4 4 3 B . C .

PATHLESS BRIARS

<div align="right">

’Αλλ’ ἐν

</div>

κέκρυπτο γὰρ σχοίνῳ βατίᾳ τ’ ἐν ἀπειράτῳ,
ἴων ξανθαῖσι καὶ παμπορφύροις ἀκτῖσι βεβρεγμένος
ἁβρὸν
σῶμα· τὸ καὶ κατεφάμιξεν καλεῖσθαί νιν χρόνῳ
σύμπαντι μάτηρ
τοῦτ’ ὄνυμ’ ἀθάνατον.

For he five days
’Mong shrubs and pathless briars and rushes green
Had lain, the dewy violet’s mingled rays
Sprinkling with purple and gold his tender frame:
Whence fond Evadnè’s joy proclaimed his deathless name.

<div align="right">

Olympian Odes, vi, 89–93
Translated by Abraham Moore

</div>

*I know nothing more lovely than this, except perhaps Spenser’s soothing elegy over his lost friend Sidney.**

<div align="right">

JOHN KEBLE
Lectures on Poetry (1832–41)
Translated by Edward K. Francis

</div>

* For Spenser’s poem see page 564.

PINDAR

5 2 2 ? — 4 4 3 B . C .

JASON'S FATHER SEES HIS RETURNING SON

Ἐκ δ' ἄρ' αὐτοῦ πομφόλυξαν δάκρυα γηραλέων γλεφάρων,
ἂν περὶ ψυχὰν ἐπεὶ γάθησεν ἐξαίρετον
γόνον ἰδὼν κάλλιστον ἀνδρῶν.

And tears burst forth from those aged eyelids; for, with all his heart,
he rejoiced when he saw his son, the choicest and the fairest of men.

Pythian Odes, iv, 121-23
Translated by Sir John Sandys

*He was created to show what might be done in art and not done a
second time. One might perhaps without being over-fanciful draw an
analogy between him and the only other great figure in the history of
Thebes. Her two imperishable names are those of Pindar and Epami-
nondas. The two men came at times when the art of lyric poetry and
the art of warfare had been developed and reduced to system; they
revolutionised the practice of their arts by daring genius, that upset all
established ideas. Take one of Pindar's great crashing phrases—one like
the incomparable [passage quoted above]. I must reluctantly make an
exception here to my rule of translating any Greek that I quote; for the
essence of a phrase like this is just that it is untranslatable: the volume
and splendour of sound in it* ARE *the poetry. Its impact is as irresistible
as that of the wedged column of fifty shields in depth that rammed the
flower of the Spartan army to wreck at Leuctra. But Leuctra set no
fashion of tactics, and Pindar set no fashion of poetry; both remain
dazzling and lonely achievements. A generation after Epaminondas, the
art of war was put on a different footing by Alexander. Within Pindar's
own lifetime, the central life of poetry passed away from the lyric.*

J. W. MACKAIL
Lectures on Greek Poetry (1910)

105

PINDAR

5 2 2 ? — 4 4 3 B . C .

THE PRIZE

Οὗτω δ' ἐδίδου Λίβυς ἁρμόζων κόρα
νυμφίον ἄνδρα· ποτὶ γραμμᾷ μὲν αὐτὰν στᾶσε
κοσμήσαις τέλος ἔμμεν ἄκρον,
εἶπε δ' ἐν μέσσοις ἀπάγεσθαι, ὃς ἂν πρῶτος θορὼν
ἀμφί οἱ ψαύσειε πέπλοις.
ἔνθ' 'Αλεξίδαμος, ἐπεὶ φύγε λαιψηρὸν δρόμον,
παρθένον κεδνὰν χερὶ χειρὸς ἑλὼν
ἆγεν ἱππευτᾶν Νομάδων δι' ὅμιλον. πολλὰ μὲν
κεῖνοι δίκον
φύλλ' ἔπι καὶ στεφάνους,
πολλὰ δὲ πρόσθεν πτερὰ δέξατο νικᾶν.

Such offer did the Libyan also make in wedding his daughter to a husband. He placed her at the goal, when he had arrayed her as the crowning prize, and in their midst he proclaimed that whoever was the first to leap forward and touch her robes in the race, should lead her to his home. There it was that Alexidâmus, when he had outstripped the rest, took the noble maiden's hand in his own, and led her through the host of Nomad horsemen. Many leaves did they fling upon him, and many a wreath, and many plumes of victory had he received before.

<div style="text-align: right">

Pythian Odes, ix, 117–125
Translated by Sir John Sandys

</div>

I am inclined to think that nowhere in ancient poetry will you find such graceful playing with the theme, or anything that so closely approaches the style of those ballads which were such favourites with our own ancestors.

<div style="text-align: right">

JOHN KEBLE
Lectures on Poetry (1832–41)
Translated by Edward K. Francis

</div>

FOR ASOPICHUS OF ORCHOMENUS
WINNER IN THE BOYS' SHORT FOOT-RACE 488 (?) B.C.

στρ. α΄
Καφισίων ὑδάτων
λαχοῖσαι, αἴτε ναίετε καλλίπωλον ἕδραν,
ὦ λιπαρᾶς ἀοίδιμοι βασίλειαι
Χάριτες Ὀρχομενοῦ, παλαιγόνων Μινυᾶν ἐπίσκοποι,
κλῦτ᾽, ἐπεὶ εὔχομαι. σὺν γὰρ ὕμμιν τά τερπνὰ καὶ
τὰ γλυκέ᾽ ἄνεται πάντα βροτοῖς,
εἰ σοφός, εἰ καλός, εἴ τις ἀγλαὸς ἀνήρ.
οὐδὲ γὰρ θεοὶ σεμνᾶν Χαρίτων ἄτερ
κοιρανέοισιν χοροὺς οὔτε δαῖτας· ἀλλὰ πάντων ταμίαι
ἔργων ἐν οὐρανῷ, χρυσότοξον θέμεναι παρὰ
Πύθιον Ἀπόλλωνα θρόνους,
ἀέναον σέβοντι πατρὸς Ὀλυμπίοιο τιμάν.
στρ. β΄
<ὦ> πότνι᾽ Ἀγλαΐα
φιλησίμολπέ τ᾽ Εὐφροσύνα, θεῶν κρατίστου
παῖδες, ἐπακοοῖτε νῦν, Θαλία τε
ἐρασίμολπε, ἰδοῖσα τόνδε κῶμον ἐπ᾽ εὐμενεῖ τύχᾳ
κοῦφα βιβῶντα· Λυδῷ γὰρ Ἀσώπιχον τρόπῳ
ἔν τε μελέταις ἀείδων ἔμολον,
οὕνεκ᾽ Ὀλυμπιόνικος ἁ Μινυεία
σεῦ ἕκατι. μελανοτειχέα νῦν δόμον
Φερσεφόνας ἔλθ᾽, Ἀχοῖ, πατρὶ κλυτὰν φέροισ᾽ ἀγγελίαν,
Κλεόδαμον ὄφρ᾽ ἰδοῖσ᾽, υἱὸν εἴπῃς ὅτι οἱ νέαν
κόλποις παρ᾽ εὐδόξοις Πίσας
ἐστεφάνωσε κυδίμων ἀέθλων πτεροῖσι χαίταν.

Ye that have your portion beside the waters of Cephīsus! Ye that dwell in a home of fair horses! Ye Graces of fertile Orchomenus, ye queens of song that keep watch over the ancient Minyae, listen to my prayer! For, by your aid, all things pleasant and sweet are accomplished for mortals, if any man be skilled in song, or be fair to look upon, or hath won renown. Yea, not even the gods order the dance or the banquet, without the aid of the holy Graces. Nay, rather, they are the ministrants of all things in heaven, where their thrones are set beside the Lord of the golden bow, the Pythian Apollo, and where they adore the ever-flowing honour of the Olympian Father.

107

O queen Aglaïa, and Euphrosynê, that lovest the dance and song, ye daughters of the mightiest of the gods! may ye listen now; and thou Thalîa, that art enamoured of the song and dance, when thou hast looked upon this triumphant chorus, as it lightly steppeth along in honour of the victor's good fortune. For I have come to sing the praise of Asôpichus with Lydian tune and with meditated lays, because, thanks to thee, the house of the Minyae is victorious in Olympia.

Now! hie thee, Echo, to the dark-walled home of Persephonê, and bear the glorious tidings to the father, so that, when thou hast seen Cleodâmus, thou mayest tell him that, beside the famous vale of Pisa, his son hath crowned his youthful locks with garlands won from the ennobling games.

<div align="right">

Olympian Odes, xiv
Translated by Sir John Sandys

</div>

What an astonishing achievement it is, the Grand Style at its highest height! . . . Here is certainly the great subject made great by the greatness of the poet's mind. His ostensible subject is indeed the victory of Asopicus in a race at Olympia; and that is all the average man would have seen in it. But what does Pindar see? First he escapes from the individual point of view to the national or civic; the boy belongs to Orchomenus, and his success is the success of his city. But that city is under the special protection of the Graces who had a shrine there; and the thought of that carries us away up to the Graces, to all they are and mean in human life, and, more than that, in the life of the gods too. And so we have travelled from the individual to the state, from the human to the divine, from earth to heaven; and a poem that might have been a mere outburst of athleticism has become a song of thanksgiving and an act of prayer. By the last line of the first stanza we have reached the eternity of heaven. But the song is in the Lydian mode, says the poet, and, if Boeckh be right, that implies that it has in it the supplicant's cry. And so another eternity comes into the poet's mind; the eternity of the dead. And the last word is of yet another immortal thing, the undying love of father and son. All that greatness has been put into the story of a boy's running.

<div align="right">

JOHN BAILEY
The Continuity of Letters (1923)

</div>

JOCASTA'S DEATH

ΕΞΑΓΓΕΛΟΣ.

Ὦ γῆς μέγιστα τῆσδ᾽ ἀεὶ τιμώμενοι,
οἷ᾽ ἔργ᾽ ἀκούσεσθ᾽, οἷα δ᾽ εἰσόψεσθ᾽, ὅσον δ᾽
ἀρεῖσθε πένθος, εἴπερ ἐγγενῶς ἔτι
τῶν Λαβδακείων ἐντρέπεσθε δωμάτων.
οἶμαι γὰρ οὔτ᾽ ἂν Ἴστρον οὔτε Φᾶσιν ἂν
νίψαι καθαρμῷ τήνδε τὴν στέγην, ὅσα
κεύθει, τὰ δ᾽ αὐτίκ᾽ εἰς τὸ φῶς φανεῖ κακὰ
ἑκόντα κοὐκ ἄκοντα. τῶν δὲ πημονῶν
μάλιστα λυποῦσ᾽ αἳ φανῶσ᾽ αὐθαίρετοι.
ΧΟ. λείπει μὲν οὐδ᾽ ἃ πρόσθεν εἴδομεν τὸ μὴ οὐ
βαρύστον᾽ εἶναι· πρὸς δ᾽ ἐκείνοισιν τί φής;
ΕΞ. ὁ μὲν τάχιστος τῶν λόγων εἰπεῖν τε καὶ
μαθεῖν, τέθνηκε θεῖον Ἰοκάστης κάρα.
ΧΟ. ὦ δυστάλαινα, πρὸς τίνος ποτ᾽ αἰτίας;
ΕΞ. αὐτὴ πρὸς αὑτῆς. τῶν δὲ πραχθέντων τὰ μὲν
ἄλγιστ᾽ ἄπεστιν· ἡ γὰρ ὄψις οὐ πάρα.
ὅμως δ᾽, ὅσον γε κἀν ἐμοὶ μνήμης ἔνι,
πεύσει τὰ κείνης ἀθλίας παθήματα.
ὅπως γὰρ ὀργῇ χρωμένη παρῆλθ᾽ ἔσω
θυρῶνος, ἵετ᾽ εὐθὺ πρὸς τὰ νυμφικὰ
λέχη, κόμην σπῶσ᾽ ἀμφιδεξίοις ἀκμαῖς.
πύλας δ᾽, ὅπως εἰσῆλθ᾽, ἐπιρράξασ᾽ ἔσω
καλεῖ τὸν ἤδη Λάιον πάλαι νεκρόν,
μνήμην παλαιῶν σπερμάτων ἔχουσ᾽, ὑφ᾽ ὧν
θάνοι μὲν αὐτός, τὴν δὲ τίκτουσαν λίποι
τοῖς οἷσιν αὐτοῦ δύστεκνον παιδουργίαν.
γοᾶτο δ᾽ εὐνάς, ἔνθα δύστηνος διπλοῦς
ἐξ ἀνδρὸς ἄνδρα καὶ τέκν᾽ ἐκ τέκνων τέκοι.
χὤπως μὲν ἐκ τῶνδ᾽ οὐκέτ᾽ οἶδ᾽ ἀπόλλυται·
βοῶν γὰρ εἰσέπαισεν Οἰδίπους, ὑφ᾽ οὗ
οὐκ ἦν τὸ κείνης ἐκθεάσασθαι κακόν,
ἀλλ᾽ εἰς ἐκεῖνον περιπολοῦντ᾽ ἐλεύσσομεν.
φοιτᾷ γὰρ ἡμᾶς ἔγχος ἐξαιτῶν πορεῖν,
γυναῖκά τ᾽ οὐ γυναῖκα, μητρῷαν δ᾽ ὅπου
κίχοι διπλῆν ἄρουραν οὗ τε καὶ τέκνων.
λυσσῶντι δ᾽ αὐτῷ δαιμόνων δείκνυσί τις·
οὐδεὶς γὰρ ἀνδρῶν, οἳ παρῆμεν ἐγγύθεν.

δεινὸν δ' αὔσας ὡς ὑφηγητοῦ τινος
πύλαις διπλαῖς ἐνήλατ', ἐκ δὲ πυθμένων
ἔκλινε κοῖλα κλῇθρα κἀμπίπτει στέγῃ.
οὗ δὴ κρεμαστὴν τὴν γυναῖκ' ἐσείδομεν,
πλεκταῖς ἐώραις ἐμπεπλεγμένην. ὃ δὲ
ὅπως ὁρᾷ νιν, δεινὰ βρυχηθεὶς τάλας
χαλᾷ κρεμαστὴν ἀρτάνην. ἐπεὶ δὲ γῇ
ἔκειτο τλήμων, δεινὰ δ' ἦν τἀνθένδ' ὁρᾶν.
ἀποσπάσας γὰρ εἱμάτων χρυσηλάτους
περόνας ἀπ' αὐτῆς, αἷσιν ἐξεστέλλετο,
ἄρας ἔπαισεν ἄρθρα τῶν αὑτοῦ κύκλων,
αὐδῶν τοιαῦθ', ὁθούνεκ' οὐκ ὄψοιντό νιν
οὔθ' οἷ' ἔπασχεν οὔθ' ὁποῖ' ἔδρα κακά,
ἀλλ' ἐν σκότῳ τὸ λοιπὸν οὓς μὲν οὐκ ἔδει
ὀψοίαθ', οὓς δ' ἔχρῃζεν οὐ γνωσοίατο.
τοιαῦτ' ἐφυμνῶν πολλάκις τε κοὐχ ἅπαξ
ἤρασσ' ἐπαίρων βλέφαρα. φοίνιαι δ' ὁμοῦ
γλῆναι γένει' ἔτεγγον, οὐδ' ἀνίεσαν
φόνου μυδώσας σταγόνας, ἀλλ' ὁμοῦ μέλας
ὄμβρος χάλαζά θ' αἱματοῦσσ' ἐτέγγετο.
[τάδ' ἐκ δυοῖν ἔρρωγεν, οὐ μόνου κακά,
ἀλλ' ἀνδρὶ καὶ γυναικὶ συμμιγῆ κακά.]
ὁ πρὶν παλαιὸς δ' ὄλβος ἦν πάροιθε μὲν
ὄλβος δικαίως· νῦν δὲ τῇδε θἠμέρᾳ
στεναγμός, ἄτη, θάνατος, αἰσχύνη, κακῶν
ὅσ' ἐστὶ πάντων ὀνόματ', οὐδέν ἐστ' ἀπόν.

MESSENGER

Great Lords, that keep the dignities of Thebes,
What doings must ye hear, what sights must see,
And oh! what grief must bear, if ye are true
To Cadmus and the breed of Labdacus!
Can Ister or can Phâsis wash this house—
I trow not—, with their waters, from the guilt
It hides. . . . Yet soon shall publish to the light
Fresh, not unpurposed evil. 'Tis the woe
That we ourselves have compassed hurts the most.

CHORUS

That which we knew already, was enough
For lamentation. What have you besides?

MESSENGER

This is the briefest tale for me to tell,
For you to hear:—your queen Jocasta's dead.

110

Alas! Poor lady! Dead! What was the cause?
She died by her own hand. Of what befell
The worst is not for you, who saw it not.
Yet shall you hear, so much as memory
Remains in me, the sad Queen's tragedy.

When in her passionate agony she passed
Beyond these portals, straight to her bridal-room
She ran, and ever tore her hair the while;
Clashed fast the doors behind her; and within,
Cried to her husband Lâius in the grave,
With mention of that seed whereby he sowed
Death for himself, and left to her a son
To get on her fresh children, shamefully.
So wept she for her bridal's double woe,
Husband of husband got, and child of child.
And after that—I know not how—she died.

We could not mark her sorrows to the end,
For with a shout, Œdipus broke on us,
And all had eyes for him. Hither he rushed
And thither. For a sword he begged, and cried:
'Where is that wife that mothered in one womb
Her husband and his children! Show her me!
No wife of mine!' As thus he raged, some god—
'Twas none of us—guided him where she lay.
And he, as guided, with a terrible shout,
Leapt at her double door; free of the bolts
Burst back the yielding bar,—and was within.
And there we saw Jocasta. By a noose
Of swaying cords, caught and entwined, she hung.

He too has seen her—with a moaning cry
Looses the hanging trap, and on the ground
Has laid her. Then—Oh sight most terrible!—
He snatched the golden brooches from the Queen,
With which her robe was fastened, lifted them,
And struck. Deep to the very founts of sight
He smote, and vowed those eyes no more should see
The wrongs he suffered, and the wrong he did.
'Henceforth,' he cried, 'be dark!—since ye have seen
Whom ye should ne'er have seen, and never knew
Them that I longed to find.' So chanted he,
And raised the pins again, and yet again,
And every time struck home. Blood from the eyes
Sprinkled his beard, and still fresh clammy drops

111

Welled in a shower unceasing, nay, a storm
With blood for rain, and hail of clotting gore.
 So from these twain hath evil broken; so
Are wife and husband mingled in one woe.
Justly their ancient happiness was known
For happiness indeed; and lo! to-day—
Tears and Disasters, Death and Shame, and all
The ills the world hath names for—all are here.

<div align="right">

Œdipus Tyrannus, 1223–85
Translated by J. T. Sheppard

</div>

The Minds of the Spectators are in a perpetual Suspense; all the words of TIRESIAS, JOCASTA, *and the* CORINTHIAN, *as they give Light to the Discovery, cause Terrours and Surprizes; and clear it by little and little.* OEDIPUS *finding it to be himself that was Author of the* ASSASSINAT, *by Evidence of the* TESTIMONIES, *at the same time understood that* LAIUS, *whom he had slain, was his Father; and that* JOCASTA, *whom he had Married, is his Mother, which he knew not till then; because he had from his Infancy, been brought up in the Court of the King of* CORINTH. *This Discovery is like a Thunderclap that oblig'd him to abandon himself to all the Despair that his Conscience inspir'd; he Tears out both his Eyes, to punish himself the more Cruelly with his own Hands. But this* CRIMINAL *whom all the World abhors before he is known, by a return of Pity and Tenderness, becomes an Object of Compassion to all the Assembly; now he is bemoan'd, who a moment before pass'd for execrable; and they melt at the Misfortunes of the Person they had in Horrour; and excuse the most Abominable of all Crimes, because the Author is an* INNOCENT UNFORTUNATE, *and fell into this Crime, that was foretold him, notwithstanding all the Precautions he had taken to avoid it; and what is most strange, is, that all the steps he made to carry him from the Murder, brought him to commit it. Finally, this Flux and Reflux of Indignation, and of Pity, this Revolution of Horror and of Tenderness, has such a wonderful Effect on the Minds of the Audience; all in this Piece moves with an* AIR *so Delicate and Passionate, all is Unravell'd with so much Art, the Suspensions manag'd with so much Probability; there is made such an universal Emotion of the Soul, by the Surprises, Astonishments, Admirations; the sole Incident that is form'd in all the piece, is so natural, and all tends so in a direct Line to the* DISCOVERY *and* CATASTROPHE; *that it may not only be said, That never* SUBJECT *has been better devised than this, but that never can be invented a better for* TRAGEDY.

<div align="right">

RENÉ RAPIN
Reflexions sur la Poétique d'Aristote (1674)
Translation anonymous

</div>

THE POWER OF LOVE

Ἔρως ἀνίκατε μάχαν,
Ἔρως, ὃς ἐν πλεύμοσι πίπτεις,
ὃς ἐν μαλακαῖς παρειαῖς
νεάνιδος ἐννυχεύεις,
φοιτᾷς δ' ὑπερπόντιος ἔν τ' ἀγρονόμοις αὐλαῖς·
καί σ' οὔτ' ἀθανάτων φύξιμος οὐδεὶς
οὔθ' ἀμερίων σέ γ' ἀνθρώπων· ὁ δ' ἔχων μέμηνεν.
σὺ καὶ δικαίων ἀδίκους
φρένας παρασπᾷς ἐπὶ λώβᾳ,
σὺ καὶ τόδε νεῖκος ἀνδρῶν
ξύναιμον ἔχεις ταράξας·
νικᾷ δ' ἐναργὴς βλεφάρων ἵμερος εὐλέκτρου
νύμφας, τῶν μεγάλων ἐκτὸς ὁμιλῶν
θεσμῶν· ἄμαχος γὰρ ἐμπαίζει θεὸς Ἀφροδίτα.

When Love disputes
 He carries his battles!
Love he loots
 The rich of their chattels!
By delicate cheeks
 On maiden's pillow
 Watches he all the night-time long;
His prey he seeks
 Over the billow,
 Pastoral haunts he preys among.
Gods are deathless, and they
 Cannot elude his whim;
And oh! amid us whose life's a day
 Mad is the heart that broodeth him!

And Love can splay
 Uprightest of virtue;
Lead astray,
 Better to hurt you!
'Tis he did the wrong,
 'Tis he beguilèd
 Father and son to feud so dire.

113

Desire's too strong!
—Out of the eyelid
Peeped of a lovely bride, Desire!
He with Law has a court,
Sovran in might with her.
Divine Aphroditê wreaks her sport;
Who will be bold to fight with her?

Antigone, 781–800
Translated by J. S. Phillimore

THE GLORIES OF ATHENS

XO. εὐίππου, ξένε, τᾶσδε χώρας
ἵκου τὰ κράτιστα γᾶς ἔπαυλα,
τὸν ἀργῆτα Κολωνόν, ἔνθ᾽
ἁ λίγεια μινύρεται
θαμίζουσα μάλιστ᾽ ἀηδὼν
χλωραῖς ὑπὸ βάσσαις,
τὸν οἰνῶπα νέμουσα κισσὸν
καὶ τὰν ἄβατον θεοῦ
φυλλάδα μυριόκαρπον ἀνήλιον
ἀνήνεμόν τε πάντων
χειμώνων· ἵν᾽ ὁ βακχιώτας
ἀεὶ Διόνυσος ἐμβατεύει
θεαῖς ἀμφιπολῶν τιθήναις.
θάλλει δ᾽ οὐρανίας ὑπ᾽ ἄχνας
ὁ καλλίβοτρυς κατ᾽ ἦμαρ ἀεὶ
νάρκισσος, μεγάλαιν θεαῖν
ἀρχαῖον στεφάνωμ᾽, ὅ τε
χρυσαυγὴς κρόκος· οὐδ᾽ ἄυπνοι
κρῆναι μινύθουσιν
Κηφισοῦ νομάδες ῥεέθρων,
ἀλλ᾽ αἰὲν ἐπ᾽ ἤματι
ὠκυτόκος πεδίων ἐπινίσσεται
ἀκηράτῳ σὺν ὄμβρῳ
στερνούχου χθονός· οὐδὲ Μουσᾶν
χοροί νιν ἀπεστύγησαν οὐδ᾽ ἁ
χρυσάνιος Ἀφροδίτα.
ἔστιν δ᾽ οἷον ἐγὼ γᾶς Ἀσίας οὐκ ἐπακούω
οὐδ᾽ ἐν τᾷ μεγάλᾳ Δωρίδι νάσῳ Πέλοπος πώποτε βλαστὸν
φύτευμ᾽ ἀγήρατον αὐτόποιον,
ἐγχέων φόβημα δαΐων,
ὃ τᾷδε θάλλει μέγιστα χώρᾳ,
γλαυκᾶς παιδοτρόφου φύλλον ἐλαίας·

114

τὸ μέν τις οὔθ' ἁβὸς οὔτε γήρᾳ
σημαίνων ἁλιώσει χερὶ πέρσας· ὁ γὰρ αἰὲν ὁρῶν κύκλος
λεύσσει νιν μορίου Διὸς
χἀ γλαυκῶπις ᾿Αθάνα.
ἄλλον δ᾽ αἶνον ἔχω ματροπόλει τᾷδε κράτιστον,
δῶρον τοῦ μεγάλου δαίμονος, εἰπεῖν, χθονὸς αὔχημα μέγιστον,
εὔιππον, εὔπωλον, εὐθάλασσον.
ὦ παῖ Κρόνου, σὺ γάρ νιν εἰς
τόδ᾽ εἶσας αὔχημ᾽, ἄναξ Ποσειδάν,
ἵπποισιν τὸν ἀκεστῆρα χαλινὸν
πρώταισι ταῖσδε κτίσας ἀγυιαῖς.
ἁ δ᾽ εὐήρετμος ἔκπαγλ᾽ ἁλία χερσὶ παραπτομένα πλάτα
θρῴσκει, τῶν ἑκατομπόδων
Νηρῄδων ἀκόλουθος.

Stranger, in this land of goodly steeds thou hast come to earth's fairest home, even to our white Colonus; where the nightingale, a constant guest, trills her clear note in the covert of green glades, dwelling amid the wine-dark ivy and the god's inviolate bowers, rich in berries and fruit, unvisited by sun, unvexed by wind of any storm; where the reveller Dionysus ever walks the ground, companion of the nymphs that nursed him.

And, fed of heavenly dew, the narcissus blooms morn by morn with fair clusters, crown of the Great Goddesses from of yore; and the crocus blooms with golden beam. Nor fail the sleepless founts whence the waters of Cephisus wander, but each day with stainless tide he moveth over the plains of the land's swelling bosom, for the giving of quick increase; nor hath the Muses' quire abhorred this place, nor Aphrodite of the golden rein.

And a thing there is such as I know not by fame on Asian ground, or as ever born in the great Dorian isle of Pelops,—a growth unconquered, self-renewing, a terror to the spears of the foemen, a growth which mightily flourishes in this land,—the grey-leafed olive, nurturer of children. Youth shall not mar it by the ravage of his hand, nor any who dwells with old age; for the sleepless eye of the Morian Zeus beholds it, and the grey-eyed Athena.

And another praise have I to tell for this the city our mother, the gift of a great god, a glory of the land most high; the might of horses, the might of young horses, the might of the sea.

For thou, son of Cronus, our lord Poseidon, hast throned her in this pride, since in these roads first thou didst show forth the curb that cures the rage of steeds. And the shapely oar, apt to men's hands, hath a wondrous speed on the brine, following the hundred-footed Nereids.

Oedipus at Colonus, 668–719
Translated by R. C. Jebb

Odes such as those on the power of love in the ANTIGONE and on the glories of Athens in the OEDIPUS COLONEUS mark Sophocles a supreme master of lyrical expression.

E. S. FORSTER
An Anthology of Greek Verse (1935)

SOPHOCLES

4 9 6 ? — 4 0 6 B . C .

ELECTRA

AI. ὦ Ζεῦ, δέδορκα φάσμ' ἄνευ θεοῦ μὲν οὐ
πεπτωκός· εἰ δ' ἔπεστι νέμεσις, οὐ λέγω.
χαλᾶτε πᾶν κάλυμμ' ἀπ' ὀφθαλμῶν, ὅπως
τὸ συγγενές τοι κἀπ' ἐμοῦ θρήνων τύχῃ.

OP. αὐτὸς σὺ βάσταζ'· οὐκ ἐμὸν τόδ', ἀλλὰ σόν,
τὸ ταῦθ' ὁρᾶν τε καὶ προσηγορεῖν φίλως.

AI. ἀλλ' εὖ παραινεῖς κἀπιπείσομαι· σὺ δέ,
εἴ που κατ' οἶκόν μοι Κλυταιμνήστρα, κάλει.

OP. αὕτη πέλας σοῦ· μηκέτ' ἄλλοσε σκόπει.

AI. οἴμοι, τί λεύσσω; OP. τίνα φοβεῖ; τίν' ἀγνοεῖς;

AI. τίνων ποτ' ἀνδρῶν ἐν μέσοις ἀρκυστάτοις
πέπτωχ' ὁ τλήμων; OP. οὐ γὰρ αἰσθάνει πάλαι
ζῶντας θανοῦσιν οὕνεκ' ἀνταυδᾷς ἴσα;

AI. οἴμοι, ξυνῆκα τοὔπος· οὐ γὰρ ἔσθ' ὅπως
ὅδ' οὐκ Ὀρέστης ἔσθ' ὁ προσφωνῶν ἐμέ.

OP. καὶ μάντις ὢν ἄριστος ἐσφάλλου πάλαι.

AI. ὄλωλα δὴ δείλαιος. ἀλλά μοι πάρες
κἂν σμικρὸν εἰπεῖν. ΗΛ. μὴ πέρα λέγειν ἔα
πρὸς θεῶν, ἀδελφέ, μηδὲ μηκύνειν λόγους.
[τί γὰρ βροτῶν ἂν σὺν κακοῖς μεμιγμένων
θνῄσκειν ὁ μέλλων τοῦ χρόνου κέρδος φέροι;]
ἀλλ' ὡς τάχιστα κτεῖνε καὶ κτανὼν πρόθες
ταφεῦσιν, ὧν τόνδ' εἰκός ἐστι τυγχάνειν,
ἄποπτον ἡμῶν· ὡς ἐμοὶ τόδ' ἂν κακῶν
μόνον γένοιτο τῶν πάλαι λυτήριον.

OP. χωροῖς ἂν εἴσω σὺν τάχει· λόγων γὰρ οὐ
νῦν ἐστιν ἀγών, ἀλλὰ σῆς ψυχῆς πέρι.

AI. τί δ' ἐς δόμους ἄγεις με; πῶς, τόδ' εἰ καλὸν
τοὔργον, σκότου δεῖ κοὐ πρόχειρος εἶ κτανεῖν;

116

OP. μὴ τάσσε· χώρει δ' ἔνθαπερ κατέκτανες
πατέρα τὸν ἀμόν, ὡς ἂν ἐν ταὐτῷ θάνῃς.
AI. ἦ πᾶσ' ἀνάγκη τήνδε τὴν στέγην ἰδεῖν
τά τ' ὄντα καὶ μέλλοντα Πελοπιδῶν κακά;
OP. τὰ γοῦν σ'· ἐγώ σοι μάντις εἰμὶ τῶνδ' ἄκρος.
AI. ἀλλ' οὐ πατρῴαν τὴν τέχνην ἐκόμπασας.
OP. πόλλ' ἀντιφωνεῖς, ἡ δ' ὁδὸς βραδύνεται.
ἀλλ' ἔρφ'. ΑΙ. ὑφηγοῦ. OP. σοὶ βαδιστέον πάρος.
ἦ μὴ φύγω σε; OP. μὴ μὲν οὖν καθ' ἡδονὴν
θάνῃς· φυλάξαι δεῖ με τοῦτό σοι πικρόν.
[χρῆν δ' εὐθὺς εἶναι τήνδε τοῖς πᾶσιν δίκην,
ὅστις πέρα πράσσειν τι τῶν νόμων θέλει,
κτείνειν· τὸ γὰρ πανοῦργον οὐκ ἂν ἦν πολύ.]
XO. ὦ σπέρμ' Ἀτρέως, ὡς πολλὰ παθὸν
δι' ἐλευθερίας μόλις ἐξῆλθες
τῇ νῦν ὁρμῇ τελεωθέν.

Aegisthus is seen approaching, exultant at the report he has heard of Orestes' death. Electra confirms it, and bids him enter the palace and see with his own eyes the corpse. At his bidding the palace doors are thrown open and on a bier is seen a veiled corpse. Aegisthus lifts the face cloth and beholds the corpse of Clytemnestra with Orestes standing hard by. He knows that his fate is sealed, and is driven at the sword's point by Orestes to be slain in the hall where Agamemnon was slain. The Chorus of free Mycenean women hail the death of the usurper which ends the curse on the house of Atreus.

(The scene opens showing a shrouded corpse with Orestes and Pylades beside it.)

AEGISTHUS

O Zeus, I look upon this form laid low
By jealousy of Heaven, but if my words
Seem to thee overbold, be they unsaid.
Take from the face the face-cloth; I, as kin,
I too would pay my tribute of lament.

ORESTES

Lift it thyself; 'tis not for me but thee
To see and kindly greet what lieth here.

AEGISTHUS

Well said, so will I. (*To* ELECTRA.) If she be within
Go call me Clytemnestra, I would see her—

117

ORESTES

She is beside thee; look not otherwhere.

(AEGISTHUS *lifts the face-cloth.*)

AEGISTHUS

O horror!

ORESTES

Why dost start? is the face strange?

AEGISTHUS

Who spread the net wherein, O woe is me,
I lie enmeshed?

ORESTES

Hast thou not learnt ere this
The dead of whom thou spakest are alive?

AEGISTHUS

Alas! I read thy riddle; 'tis none else
Than thou, Orestes, whom I now address.

ORESTES

A seer so wise, and yet befooled so long!

AEGISTHUS

O I am spoiled, undone! yet suffer me,
One little word.

ELECTRA

Brother, in heaven's name
Let him not speak a word or plead his cause.
When a poor wretch is in the toils of fate
What can a brief reprieve avail him? No,
Slay him outright and having slain him give
His corse to such grave-makers as is meet,
Far from our sight; for me no otherwise
Can he wipe out the memory of past wrongs.

ORESTES (*To* AEGISTHUS)

Quick, get thee in; the issue lies not now
In words; the case is tried and thou must die.

AEGISTHUS

Why hale me indoors? if my doom be just,
What need of darkness? Why not slay me here?

ORESTES

'Tis not for thee to order; go within;
Where thou didst slay my father thou must die.

AEGISTHUS

Ah! is there need this palace should behold
All woes of Pelops' line, now and to come?

ORESTES

Thine own they shall; thus much I can predict.

118

AEGISTHUS

Thy skill as seer derives not from thy sire.

ORESTES

Thou bandiest words; our going is delayed.
Go.

AEGISTHUS

Lead the way.

ORESTES

No, thou must go the first.

AEGISTHUS

Lest I escape?

ORESTES

Nay, not to let thee choose
The manner of thy death; thou must be spared
No bitterness of death, and well it were
If on transgressors swift this sentence fall,
Slay him; so wickedness should less abound.

CHORUS

House of Atreus! thou hast passed
Through the fire and won at last
Freedom, perfected to-day
By this glorious essay.

Electra, 1466–1510
Translated by F. Storr

The swift and terrible end, a scene which even Sophocles never sur-
passed, perhaps the most shattering COUP DE THÉÂTRE *ever invented.*

H. D. F. KITTO
Greek Tragedy (1939)

SOPHOCLES

496? — 406 B.C.

BITTERNESS

'Επίσταμαι γὰρ ἀρτίως μαθὼν ὅτι
ὅ τ' ἐχθρὸς ἡμῖν ἐς τοσόνδ' ἐχθαρτέος,
ὡς καὶ φιλήσων αὖθις, ἔς τε τὸν φίλον
τοσαῦθ' ὑπουργῶν ὠφελεῖν βουλήσομαι,
ὡς αἰὲν οὐ μενοῦντα·

119

For I have learnt, though late,
This rule, to hate an enemy as one
Who may become a friend, and serve a friend
As knowing that his friendship may not last.

<div align="right">

Ajax, 678–82
Translated by F. Storr

</div>

In the mouth of Ajax the lines just quoted have the tang of Sophoklean bitterness than which there is little more bitter in all literature.

<div align="right">

BASIL L. GILDERSLEEVE
Selections from Brief Mention (1930)

</div>

SOPHOCLES

496? — 406 B.C.

THE TRIUMPH OF TIME

ῶ φίλτατ' Αἰγέως παῖ, μόνοις οὐ γίγνεται
θεοῖσι γῆρας οὐδὲ κατθανεῖν ποτε,
τὰ δ' ἄλλα συγχεῖ πάνθ' ὁ παγκρατὴς χρόνος.
φθίνει μὲν ἰσχὺς γῆς, φθίνει δὲ σώματος,
θνήσκει δὲ πίστις, βλαστάνει δ' ἀπιστία,
καὶ πνεῦμα ταὐτὸν οὔποτ' οὔτ' ἐν ἀνδράσιν
φίλοις βέβηκεν οὔτε πρὸς πόλιν πόλει.
[τοῖς μὲν γὰρ ἤδη, τοῖς δ' ἐν ὑστέρῳ χρόνῳ
τὰ τερπνὰ πικρὰ γίγνεται καὖθις φίλα.]
καὶ ταῖσι Θήβαις εἰ τανῦν εὐημερεῖ
καλῶς τὰ πρὸς σέ, μυρίας ὁ μυρίος
χρόνος τεκνοῦται νύκτας ἡμέρας τ' ἰών,
ἐν αἷς τὰ νῦν ξύμφωνα δεξιώματα
δόρει διασκεδῶσιν ἐκ σμικροῦ λόγου·

Dear son of Aegeus, to the gods alone
Is given immunity from eld and death;
But nothing else escapes all-ruinous time.
Earth's might decays, the might of men decays,
Honour grows cold, dishonour flourishes,
There is no constancy 'twixt friend and friend,
Or city and city; be it soon or late,
Sweet turns to bitter, hate once more to love.

<div align="center">

120

</div>

If now 'tis sunshine betwixt Thebes and thee
And not a cloud, Time in his endless course
Gives birth to endless days and nights, wherein
The merest nothing shall suffice to cut
With serried spears your bonds of amity.

<div align="right">

Oedipus at Colonus, 607–20
Translated by F. Storr

</div>

This speech of Oedipus is one of those passages in Sophocles which can be best commented on by saying that they are characteristically and essentially Shakespearian. There is no third writer, I think, who has ever written in just this manner. One can hardly speak of their style; they are beyond style. Language in them has become transfigured. One hardly notices the words; they have become translucent; it seems as if the poet who could do these things with these words could do anything with any words. Such power over language, or such insight into language, only comes once in the history of any single race. Many of the single lines and phrases in Sophocles have this intense and poignant quality. They do not come much in set speeches; they are not led up to; no special stress is laid on them. They just happen; and each time what happens is a miracle. In the

<div align="center">

πάτερ, πιθοῦ μοι, κεἰ νέα παραινέσω

</div>

of Antigone; or in the

<div align="center">

ὡς ὧδε τοῦδ' ἔχοντος αἰάζειν πάρα

</div>

of Tecmessa; or in the words of Hyllus,

<div align="center">

μεταίτιος σοί τ' αὖθις ὡς ἔχεις ἔχειν,

</div>

the language is so simple, so apparently unconscious and artless, that its overwhelming effect makes one gasp: it is like hearing human language uttered, and raised to a new and incredible power, by the lips of some one more than human. It is the speech of one who may speak softly, and need not raise his voice to make it heard clear through any storm of sound. It is so in Shakespeare likewise; in the strangely thrilling phrases of simple words in simple order, but reaching without effort the highest heights of poetry.

<div align="right">

J. W. MACKAIL
Lectures on Greek Poetry (1910)

</div>

AJAX'S DEATH

ΑΙ. ὁ μὲν σφαγεὺς ἕστηκεν ᾗ τομώτατος
γένοιτ' ἄν, εἴ τῳ καὶ λογίζεσθαι σχολή·
δῶρον μὲν ἀνδρὸς Ἕκτορος ξένων ἐμοὶ
μάλιστα μισηθέντος ἐχθίστου θ' ὁρᾶν·
πέπηγε δ' ἐν γῇ πολεμίᾳ τῇ Τρῳάδι,
σιδηροβρῶτι θηγάνῃ νεηκονής·
ἔπηξα δ' αὐτὸν εὖ περιστείλας ἐγώ,
εὐνούστατον τῷδ' ἀνδρὶ διὰ τάχους θανεῖν.
οὕτω μὲν εὐσκευοῦμεν· ἐκ δὲ τῶνδέ μοι
σὺ πρῶτος, ὦ Ζεῦ, καὶ γὰρ εἰκός, ἄρκεσον.
αἰτήσομαι δέ σ' οὐ μακρὸν γέρας λαχεῖν.
πέμψον τιν' ἡμῖν ἄγγελον, κακὴν φάτιν
Τεύκρῳ φέροντα, πρῶτος ὥς με βαστάσῃ
πεπτῶτα τῷδε περὶ νεορράντῳ ξίφει,
καὶ μὴ πρὸς ἐχθρῶν του κατοπτευθεὶς πάρος
ῥιφθῶ κυσὶν πρόβλητος οἰωνοῖς θ' ἕλωρ.
τοσαῦτά σ', ὦ Ζεῦ, προστρέπω, καλῶ δ' ἅμα
πομπαῖον Ἑρμῆν χθόνιον εὖ με κοιμίσαι,
ξὺν ἀσφαδάστῳ καὶ ταχεῖ πηδήματι
πλευρὰν διαρρήξαντα τῷδε φασγάνῳ.
καλῶ δ' [ἀρωγοὺς τὰς ἀεί τε παρθένους
ἀεί θ'] ὁρώσας πάντα τἀν βροτοῖς πάθη,
σεμνὰς Ἐρινῦς τανύποδας, μαθεῖν ἐμὲ
πρὸς τῶν Ἀτρειδῶν ὡς διόλλυμαι τάλας.
[καί σφας κακοὺς κάκιστα καὶ πανωλέθρους
ξυναρπάσειαν, ὥσπερ εἰσορῶσ' ἐμὲ
αὐτοσφαγῆ πίπτοντα, τὼς αὐτοσφαγεῖς
πρὸς τῶν φιλίστων ἐκγόνων ὀλοίατο.]
ἴτ', ὦ ταχεῖαι ποίνιμοί τ' Ἐρινύες,
σεύεσθε, μὴ φείδεσθε πανδήμου στρατοῦ.
σὺ δ', ὦ τὸν αἰπὺν οὐρανὸν διφρηλατῶν
ἥλιε, πατρῴαν τὴν ἐμὴν ὅταν χθόνα
ἴδῃς, ἐπισχὼν χρυσόνωτον ἡνίαν
ἄγγειλον ἄτας τὰς ἐμὰς μόρον τ' ἐμὸν
γέροντι πατρὶ τῇ τε δυστήνῳ τροφῷ.
ἦ που τάλαινα, τήνδ' ὅταν κλύῃ φάτιν,
ἥσει μέγαν κωκυτὸν ἐν πάσῃ πόλει.
ἀλλ' οὐδὲν ἔργον ταῦτα θρηνεῖσθαι μάτην,

ἀλλ' ἀρκτέον τὸ πρᾶγμα σὺν τάχει τινί.
ὦ Θάνατε Θάνατε, νῦν μ' ἐπίσκεψαι μολών·
καίτοι σὲ μὲν κἀκεῖ προσαυδήσω ξυνών.
σὲ δ', ὦ φαεννῆς ἡμέρας τὸ νῦν σέλας,
καὶ τὸν διφρευτὴν ἥλιον προσεννέπω,
πανύστατον δὴ κοὔποτ' αὖθις ὕστερον.
ὦ φέγγος, ὦ γῆς ἱερὸν οἰκείας πέδον
Σαλαμῖνος, ὦ πατρῷον ἑστίας βάθρον
κλειναί τ' Ἀθῆναι καὶ τὸ σύντροφον γένος
κρῆναί τε ποταμοί θ' οἴδε, καὶ τὰ Τρωικὰ
πεδία προσαυδῶ, χαίρετ', ὦ τροφῆς ἐμοί·
τοῦθ' ὑμὶν Αἴας τοὔπος ὕστατον θροεῖ,
τὰ δ' ἄλλ' ἐν Ἅιδου τοῖς κάτω μυθήσομαι.

(AJAX *alone on the sea-shore, planting his sword in the ground.*)

AJAX

The slayer standeth where his stroke is sure—
If I have time to muse thus curiously—
The gift of Hector erst my foeman-friend,
The man most hateful to my soul and sight,
Now fixed in foeman's land, the land of Troy;
Fresh edged upon the iron-fretting stone,
Here have I planted it and set it fast,
A friend to help me to a speedy death.
My part is done; for what remains, O Zeus,
First I invoke thine aid; and claim my due;
'Tis no excessive boon I shall demand.
I pray thee send some messenger to bear
To Teucer the sad tale, that he may come
To lift me where I lie a bleeding corpse,
Fallen on this gory sword, lest I be first
Discovered by some enemy and cast forth,
A prey to dogs and birds. Thus much, O Zeus,
I crave of thee; and Hermes I invoke,
Born guide of spirits to the nether world,
To lay me soft to rest at one swift gasp,
Without a struggle, when into my side
I plunge this sword. Ye too I call to aid,
Maidens immortal, with immortal eyes
Beholding all the many woes of man,
Swift-footed hounds of vengeance, mark ye well
How by the Atridae I am all undone.
Swoop on them, Furies, blight and blast them both
In utter ruin, as they see me now!
On, ye Avengers, glut your maw, spare not,

Let ruin seize the whole Achaean host!
And thou whose chariot climbs the steep of heaven,
When in thy course thou see'st my father-land,
Draw in thy gold-bedizened rein and tell
My aged sire and mother of their son,
His sorrows and his end. Poor mother! when
She hears the tale, her piercing wail will ring
Through all the city. But how profitless
These idle lamentations and delay!
With such despatch as may be let's to work.
O Death, Death, Death, draw nigh and look on me—
Yet there below I shall have time enow
To converse face to face with Death. But thee,
O bright effulgence of this radiant day,
On thee, the Sun-god charioteer, I call
For the last time and never more again.
O light! O sacred soil of mine own land,
My Salamis! my home, my ancestral hearth!
O far-famed Athens, race akin to mine,
Ye Trojan springs and streams, ye plains of Troy,
Farewell, ye nurses of my fame, farewell!
This is the last word Ajax speaks to you.
Henceforth he talks in Hades with the dead.
(He falls upon his sword.)

Ajax, 815–65
Translated by F. Storr

There is no finer psychological picture than the awakening of Ajax from his rage, his deep despair, his firm resolve to endure life no longer, his harsh treatment of Tecmessa, and yet his deep love for her and his child. Even his suicide is most exceptionally put upon the stage, for the purpose, I think, of the most splendid monologue which Greek tragedy affords us.

JOHN P. MAHAFFY
A History of Classical Greek Literature (1880)

HERODOTUS

4 8 4 ? — 4 2 5 B . C .

THE BATTLE OF MARATHON

Ἐνταῦτα ὡς ἀπείθησαν οἱ Ἀθηναῖοι, δρόμῳ ἵεντο ἐς τοὺς βαρ-
βάρους. ἦσαν δὲ στάδιοι οὐκ ἐλάσσονες τὸ μεταίχμιον αὐτῶν ἢ ὀκτώ.
οἱ δὲ Πέρσαι ὁρέοντες δρόμῳ ἐπιόντας παρεσκευάζοντο ὡς δεξό-
μενοι, μανίην τε τοῖσι Ἀθηναίοισι ἐπέφερον καὶ πάγχυ ὀλεθρίην,
ὁρέοντες αὐτοὺς ὀλίγους, καὶ τούτους δρόμῳ ἐπειγομένους οὔτε ἵπ-
που ὑπαρχούσης σφι οὔτε τοξευμάτων. ταῦτα μέν νυν οἱ βάρβαροι
κατείκαζον, Ἀθηναῖοι δὲ ἐπείτε ἀθρόοι προσέμιξαν τοῖσι βαρβάροι-
σι, ἐμάχοντο ἀξίως λόγου. πρῶτοι μὲν γὰρ Ἑλλήνων πάντων τῶν
ἡμεῖς ἴδμεν δρόμῳ ἐς πολεμίους ἐχρήσαντο, πρῶτοι δὲ ἀνέσχοντο
ἐσθῆτά τε Μηδικὴν ὁρέοντες καὶ τοὺς ἄνδρας ταύτην ἐσθημένους·
τέως δὲ ἦν τοῖσι Ἕλλησι καὶ τὸ οὔνομα τὸ Μήδων φόβος ἀκοῦσαι.
μαχομένων δὲ ἐν τῷ Μαραθῶνι χρόνος ἐγίνετο πολλός. καὶ τὸ μὲν
μέσον τοῦ στρατοπέδου ἐνίκεον οἱ βάρβαροι, τῇ Πέρσαι τε αὐτοὶ
καὶ Σάκαι ἐτετάχατο· κατὰ τοῦτο μὲν δὴ ἐνίκεον οἱ βάρβαροι, καὶ
ῥήξαντες ἐδίωκον ἐς τὴν μεσόγαιαν, τὸ δὲ κέρας ἑκάτερον ἐνίκεον
Ἀθηναῖοί τε καὶ Πλαταιέες. νικέοντες δὲ τὸ μὲν τετραμμένον τῶν
βαρβάρων φεύγειν ἔων, τοῖσι δὲ τὸ μέσον ῥήξασι αὐτῶν συναγα-
γόντες τὰ κέρεα ἀμφότερα ἐμάχοντο καὶ ἐνίκεον Ἀθηναῖοι. φεύ-
γουσι δὲ τοῖσι Πέρσῃσι εἵποντο κόπτοντες, ἐς ὃ ἐπὶ τὴν θάλασσαν
ἀπικόμενοι πῦρ τε αἴτεον καὶ ἐπελαμβάνοντο τῶν νεῶν.

Then the Athenians were let go, and charged the barbarians at a run.
Between the two armies was a mile or rather more. The Persians, seeing
them coming on at a run, prepared to receive them, imputing to the
Athenians nothing short of disastrous insanity when they saw them few,
and even so coming on at a run, with no force of cavalry or archers. So
the barbarians thought. But the Athenians, when they engaged the
barbarians in close order, fought worthily of account. The first of all
Greeks within our knowledge they charged an enemy at a run; the first
they stood the sight of the Median uniform and the men who wore it;
until then the very name of the Medians was a terror to Greeks to hear.
The fighting at Marathon lasted a long time. In the centre of the line
the barbarians had the advantage, where the Persians themselves and
the Sacians were posted; there the barbarians had the advantage,
broke the line, and began to pursue inland. But on each wing the Athen-
ians and Plateans won. As they won, they left the routed forces of the
barbarians to flee, and bringing both wings together, engaged those who

125

had broken their centre; and the Athenians won, and pursued the fleeing
Persians, cutting them down, until they reached the sea.

<div align="right">

Book vi, 112–13
Translated by J. W. Mackail

</div>

*That is all. In this or in any English it is bald. That is just my point. In
the Greek, the simplicity is charged with emotion that makes every
word tell; and it cannot be read, for the first or for the hundredth time,
without a thrill of exaltation and awe.*

<div align="right">

J. W. MACKAIL
Studies in Humanism (1938)

</div>

HERODOTUS

4 8 4 ? — 4 2 5 B. C.

XERXES' LAMENT

'Ως δὲ ὤρα πάντα μὲν τὸν 'Ελλήσποντον ὑπὸ τῶν νεῶν ἀποκε-
κρυμμένον, πάσας δὲ τὰς ἀκτὰς καὶ τὰ 'Αβυδηνῶν πεδία ἐπίπλεα
ἀνθρώπων, ἐνθαῦτα Ξέρξης ἑωυτὸν ἐμακάρισε, μετὰ δὲ τοῦτο ἐδά-
κρυσε. μαθὼν δέ μιν 'Αρτάβανος ὁ πάτρως, ὃς τὸ πρῶτον γνώμην
ἀπεδέξατο ἐλευθέρως οὐ συμβουλεύων Ξέρξῃ στρατεύεσθαι ἐπὶ τὴν
'Ελλάδα, οὗτος ὡνὴρ φρασθεὶς Ξέρξην δακρύσαντα εἴρετο τάδε·
Ὦ βασιλεῦ, ὡς πολλὸν ἀλλήλων κεχωρισμένα ἐργάσαο νῦν τε καὶ
ὀλίγῳ πρότερον· μακαρίσας γὰρ σεωυτὸν δακρύεις. ὁ δὲ εἶπε· 'Εσ-
ῆλθε γάρ με λογισάμενος κατοικτεῖραι, ὡς βραχὺς εἴη ὁ πᾶς ἀνθρω-
πήϊος βίος, εἰ τούτων γε ἐόντων τοσούτων οὐδεὶς ἐς ἑκατοστὸν ἔτος
περιέσται. ὁ δὲ ἀμείβετο λέγων· Ἕτερα τούτου παρὰ τὴν ζόην
πεπόνθαμεν οἰκτρότερα. ἐν γὰρ οὕτω βραχέϊ βίῳ οὐδεὶς οὕτω ἄν-
θρωπος ἐὼν εὐδαίμων πέφυκε, οὔτε τούτων οὔτε τῶν ἄλλων, τῷ οὐ
παραστήσεται πολλάκις καὶ οὐκὶ ἅπαξ τεθνάναι βούλεσθαι μᾶλλον
ἢ ζώειν. αἵ τε γὰρ συμφοραὶ προσπίπτουσαι καὶ αἱ νοῦσοι συντα-
ράσσουσαι καὶ βραχὺν ἐόντα μακρὸν δοκέειν εἶναι ποιεῦσι τὸν βίον.
οὕτω ὁ μὲν θάνατος μοχθηρῆς ἐούσης τῆς ζόης καταφυγὴ αἱρετω-
τάτη τῷ ἀνθρώπῳ γέγονε, ὁ δὲ θεὸς γλυκὺν γεύσας τὸν αἰῶνα φθο-
νερὸς ἐν αὐτῷ εὑρίσκεται ἐών.

When he saw the whole Hellespont hidden by his ships, and all the
shores and plains of Abydos thronged with men, Xerxes first declared
himself happy, and presently he fell a-weeping.

Perceiving that, his uncle Artabanus, who in the beginning had spoken his mind freely and counselled Xerxes not to march against Hellas—Artabanus, I say, marking how Xerxes wept, questioned him and said, "What a distance is there, O king, between your acts of this present and a little while ago! Then you declared your happiness, and now you weep." "Ay verily," said Xerxes; "for I was moved to compassion, when I considered the shortness of all human life, seeing that of all this multitude of men not one will be alive a hundred years hence." "In our life," Artabanus answered, "we have deeper sorrows to bear than that. For short as our lives are, there is no man here or elsewhere so fortunate, that he shall not be constrained, ay many a time and not once only, to wish himself dead rather than alive. Misfortunes so fall upon us and sicknesses so trouble us, that they make life to seem long for all its shortness. Thus is life so sorry a thing that death has come to be a man's most desirable refuge therefrom; the god is seen to be envious therein, after he has given us but a taste of the sweetness of living."

<div align="right">

Book vii, 45–46

Translated by A. D. Godley

</div>

Herodotus has no pretensions to be a philosopher. He is a 'Maker of Logoï', a professional Teller of Tales, an artist in the spoken word. He is much more than that, of course; but he is that. He is a popularizer, in the noble ancient way. He is content to express popular morality, the hard experience of the long generations, in language which the simple man will understand. Not an easy thing to do, certainly; but a thing which, when it is done as well as Herodotus does it, rings in the mind for ever.

<div align="right">

J. A. K. THOMSON
The Greek Tradition (1915)

</div>

EURIPIDES

480 — 406 B.C.

ANDROMACHE LEARNS OF HER SON'S FATE

TA. Φρυγῶν ἀρίστου πρίν ποθ' Ἕκτορος δάμαρ,
 μή με στυγήσῃς· οὐχ ἑκὼν γὰρ ἀγγελῶ.
 Δαναῶν τε κοινὰ Πελοπιδῶν τ' ἀγγέλματα.
AN. τί δ' ἔστιν; ὥς μοι φροιμίων ἄρχει κακῶν.

<div align="center">

127

</div>

ΤΑ. ἔδοξε τόνδε παῖδα, πῶς εἴπω λόγον;
ΑΝ. μῶν οὐ τὸν αὐτὸν δεσπότην ἡμῖν ἔχειν;
ΤΑ. οὐδεὶς Ἀχαιῶν τοῦδε δεσπόσει ποτέ.
ΑΝ. ἀλλ' ἐνθάδ' αὐτὸν λείψανον Φρυγῶν λιπεῖν;
ΤΑ. οὐκ οἶδ' ὅπως σοι ῥαδίως εἴπω κακά.
ΑΝ. ἐπήνησ' αἰδῶ, πλὴν ἐὰν λέγῃς καλά.
ΤΑ. κτενοῦσι σὸν παῖδ', ὡς πύθῃ κακὸν μέγα.
ΑΝ. οἴμοι, γάμων τόδ' ὡς κλύω μεῖζον κακόν.
ΤΑ. νικᾷ δ' Ὀδυσσεὺς ἐν Πανέλλησιν λέγων.
ΑΝ. αἰαῖ μάλ', οὐ γὰρ μέτρια πάσχομεν κακά.
ΤΑ. λέξας ἀρίστου παῖδα μὴ τρέφειν πατρός·
ΑΝ. τοιαῦτα νικήσειε τῶν αὑτοῦ πέρι.
ΤΑ. ῥῖψαι δὲ πύργων δεῖν σφε Τρωικῶν ἄπο.
 ἀλλ' ὡς γενέσθω, καὶ σοφώτερα φανεῖ,
 μήτ' ἀντέχου τοῦδ', εὐγενῶς δ' ἄλγει κακοῖς,
 μήτε σθένουσα μηδὲν ἰσχύειν δόκει.
 ἔχεις γὰρ ἀλκὴν οὐδαμῇ· σκοπεῖν δὲ χρή·
 πόλις τ' ὄλωλε καὶ πόσις, κρατεῖ δὲ σύ,
 ἡμεῖς τε πρὸς γυναῖκα μάρνασθαι μίαν
 οἷοί τε· τούτων οὕνεκ' οὐ μάχης ἐρᾶν,
 οὐδ' αἰσχρὸν οὐδὲν οὐδ' ἐπίφθονόν σε δρᾶν,
 οὔτ' αὖ σ' Ἀχαιοῖς βούλομαι ῥίπτειν ἀράς.
 εἰ γάρ τι λέξεις ᾧ χολώσεται στρατός,
 οὔτ' ἂν ταφείη παῖς ὅδ' οὔτ' οἴκτου τύχοι.
 σιγῶσα δ' εὖ τε τὰς τύχας κεκτημένη
 τὸν τοῦδε νεκρὸν οὐκ ἄθαπτον ἂν λίποις,
 αὐτή τ' Ἀχαιῶν πρευμενεστέρων τύχοις.
ΑΝ. ὦ φίλτατ', ὦ περισσὰ τιμηθεὶς τέκνον,
 θανεῖ πρὸς ἐχθρῶν, μητέρ' ἀθλίαν λιπών.
 ἡ τοῦ πατρὸς δέ σ' εὐγένει' ἀπώλεσεν,
 ἣ τοῖσιν ἄλλοις γίγνεται σωτηρία,
 τὸ δ' ἐσθλὸν οὐκ ἐς καιρὸν ἦλθε σοὶ πατρός.
 ὦ λέκτρα τἀμὰ δυστυχῆ τε καὶ γάμοι,
 οἷς ἦλθον ἐς μέλαθρον Ἕκτορός ποτε,
 [οὐχ ὡς σφαγεῖον Δαναΐδαις τέξουσ' ἐμόν
 ἀλλ' ὡς τύραννον Ἀσιάδος πολυσπόρου.]
 ὦ παῖ, δακρύεις; αἰσθάνει κακῶν σέθεν;
 τί μου δέδραξαι χερσὶ κἀντέχει πέπλων,
 νεοσσὸς ὡσεὶ πτέρυγας ἐσπίτνων ἐμάς;
 οὐκ εἶσιν Ἕκτωρ κλεινὸν ἁρπάσας δόρυ,
 γῆς ἐξανελθών, σοὶ φέρων σωτηρίαν,
 οὐ ξυγγένεια πατρός, οὐκ ἰσχὺς Φρυγῶν·
 λυγρὸν δὲ πήδημ' ἐς τράχηλον ὑψόθεν
 πεσὼν ἀνοίκτως πνεῦμ' ἀπορρήξεις σέθεν.

128

ὦ νέον ὑπαγκάλισμα μητρὶ φίλτατον,
ὦ χρωτὸς ἡδὺ πνεῦμα· διὰ κενῆς ἄρα
ἐν σπαργάνοις σε μαστὸς ἐξέθρεψ' ὅδε,
μάτην δ' ἐμόχθουν καὶ κατεξάνθην πόνοις.
νῦν, οὔποτ' αὖθις, μητέρ' ἀσπάζου σέθεν,
πρόσπιτνε τὴν τεκοῦσαν, ἀμφὶ δ' ὠλένας
ἕλισσ' ἐμοῖς νώτοισι καὶ στόμ' ἅρμοσον.
ὦ βάρβαρ' ἐξευρόντες Ἕλληνες κακά,
τί τόνδε παῖδα κτείνετ' οὐδὲν αἴτιον;
ὦ Τυνδάρειον ἔρνος, οὔποτ' εἶ Διός.
πολλῶν δὲ πατέρων φημί σ' ἐκπεφυκέναι,
Ἀλάστορος μὲν πρῶτον, εἶτα δὲ Φθόνου,
Φόνου τε Θανάτου θ', ὅσα τε γῆ τρέφει κακά.
οὐ γάρ ποτ' αὐχῶ Ζῆνά γ' ἐκφῦσαί σ' ἐγώ,
πολλοῖσι κῆρα βαρβάροις Ἕλλησί τε.
ὄλοιο· καλλίστων γὰρ ὀμμάτων ἄπο
αἰσχρῶς τὰ κλεινὰ πεδί' ἀπώλεσας Φρυγῶν.
δαίνυσθε τοῦδε σάρκας. ἔκ τε γὰρ θεῶν
ἀλλ' ἄγετε, φέρετε, ῥίπτετ', εἰ ῥίπτειν δοκεῖ·
διολλύμεσθα, παιδί τ' οὐ δυναίμεθ' ἂν
θάνατον ἀρῆξαι. κρύπτετ' ἄθλιον δέμας
καὶ ῥίπτετ' ἐς ναῦν. ἐπὶ καλὸν γὰρ ἔρχομαι
ὑμέναιον, ἀπολέσασα τοὐμαυτῆς τέκνον.

(*Enter* TALTHYBIUS.)

TALTHYBIUS
O wife of Hector, Phrygia's mightiest once,
Abhor not me: sore loth shall I announce
The Danaans' hest, the word of Pelops' sons.

ANDROMACHE
What now?—with what ill preface dost begin!

TALTHYBIUS
This child, have they decreed—how can I say it?

ANDROMACHE
Not—that he shall not have one lord with me?

TALTHYBIUS
None of Achaeans e'er shall be his lord.

ANDROMACHE
How?—here, a Phrygian remnant, shall he bide?

TALTHYBIUS
I know not gently how to break sad tidings.

ANDROMACHE
Thanks for thy shrinking, save thou bring glad tidings.

129

TALTHYBIUS

Thy son must die—since thou must hear the horror.

ANDROMACHE

Ah me!—a worse ill this than thraldom's couch!

TALTHYBIUS

Odysseus' speech to assembled Greeks prevailed—

ANDROMACHE

O God! O God! what measureless ill is mine!

TALTHYBIUS

Warning them not to rear a hero's son.

ANDROMACHE

May like rede dooming sons of his prevail!

TALTHYBIUS

He must be hurled from battlements of Troy.
Nay, let this be, so wiser shalt thou show,
Nor cling to him, but queenlike bear thy pain,
Nor, being strengthless, dream that thou art strong.
For nowhere hast thou help: needs must thou mark—
City and lord are gone; thou art held in thrall;
How can one woman fight against our host?
Wherefore I would not see thee set on strife,
Nor doing aught should breed thee shame or spite,
Nor on the Achaeans hurling malisons.
For, if to wrath thy words shall rouse the host,
This child shall find no burial, no, nor ruth.
Nay, hold thy peace, and meekly bow to fate;
So not unburied shalt thou leave his corse,
And kindlier the Achaeans shalt thou find.

ANDROMACHE

O darling child, O prized above all price,
Thou must leave thy poor mother, die by foes!
Thy father's heroism ruineth thee,
Which unto others was deliverance.
Ill-timed thy father's prowess was for thee!
O bridal mine and union evil-starred,
Whereby I came, time was, to Hector's hall,
Not as to bear a babe for Greeks to slay,
Nay, but a king for Asia's fruitful land!
Child, dost thou weep?—dost comprehend thy doom?
Why with thine hands clutch, clinging to my robe,
Like fledgling fleeing to nestle 'neath my wings?
No Hector, glorious spear in grip, shall rise
From earth, and bringing thee deliverance come,
No kinsman of thy sire, no might of Phrygians;

130

But, falling from on high with horrible plunge,
Unpitied shalt thou dash away thy breath.

O tender nursling, sweet to mother, sweet!
O balmy breath!—in vain and all in vain
This breast in swaddling-bands hath nurtured thee.
Vainly I travailed and was spent with toils!
Now, and no more for ever, kiss thy mother,
Fling thee on her that bare thee, twine thine arms
About my waist, and lay thy lips to mine.

O Greeks who have found out cruelties un-Greek,
Why slay this child who is guiltless wholly of wrong?
O Tyndareus' child, no child of Zeus art thou!
Nay, but of many sires I name thee born:
Child of the Haunting Curse, of Envy child,
Of Murder, Death, of all earth-nurtured plagues!
Thee never Zeus begat, I dare avouch,
A curse to many a Greek, barbarians many!
Now ruin seize thee, who by thy bright eyes
Foully hast wasted Phrygia's glorious plains!
Take him—bear hence, and hurl, if hurl ye will;—
Then on his flesh feast! For we perish now
By the Gods' doom, and cannot shield one child
From death. O hide this wretched body of mine,
Yea, cast into a ship. To a bridal fair
Have I attained—I, who have lost my son!

<div align="right">

The Daughters of Troy, 704–74
Translated by A. S. Way

</div>

*This scene . . . seems to me perhaps the most absolutely heart-rending
in all the tragic literature of the world. After rising from it one under-
stands Aristotle's judgment of Euripides as "the most tragic of the poets."*

<div align="right">

GILBERT MURRAY
Euripides and His Age (1913)

</div>

PERICLES' FUNERAL ORATION

Ἐν δὲ τῷ αὐτῷ χειμῶνι Ἀθηναῖοι τῷ πατρίῳ νόμῳ χρώμενοι δημοσίᾳ ταφὰς ἐποιήσαντο τῶν ἐν τῷδε τῷ πολέμῳ πρῶτον ἀποθανόντων, τρόπῳ τοιῷδε. τὰ μὲν ὀστᾶ προτίθενται τῶν ἀπογενομένων πρότριτα σκηνὴν ποιήσαντες, καὶ ἐπιφέρει τῷ αὑτοῦ ἕκαστος ἤν τι βούληται· ἐπειδὰν δὲ ἡ ἐκφορὰ ᾖ, λάρνακας κυπαρισσίνας ἄγουσιν ἅμαξαι, φυλῆς ἑκάστης μίαν· ἔνεστι δὲ τὰ ὀστᾶ ἧς ἕκαστος ἦν φυλῆς. μία δὲ κλίνη κενὴ φέρεται ἐστρωμένη τῶν ἀφανῶν, οἳ ἂν μὴ εὑρεθῶσιν ἐς ἀναίρεσιν. ξυνεκφέρει δὲ ὁ βουλόμενος καὶ ἀστῶν καὶ ξένων, καὶ γυναῖκες πάρεισιν αἱ προσήκουσαι ἐπὶ τὸν τάφον ὀλοφυρόμεναι. τιθέασιν οὖν ἐς τὸ δημόσιον σῆμα, ὅ ἐστιν ἐπὶ τοῦ καλλίστου προαστίου τῆς πόλεως, καὶ ἀεὶ ἐν αὐτῷ θάπτουσι τοὺς ἐκ τῶν πολέμων (πλήν γε τοὺς ἐν Μαραθῶνι· ἐκείνων δὲ διαπρεπῆ τὴν ἀρετὴν κρίναντες αὐτοῦ καὶ τὸν τάφον ἐποίησαν). ἐπειδὰν δὲ κρύψωσι γῇ, ἀνὴρ ᾑρημένος ὑπὸ τῆς πόλεως ὃς ἂν γνώμῃ τε δοκῇ μὴ ἀξύνετος εἶναι καὶ ἀξιώματι προήκῃ, λέγει ἐπ' αὐτοῖς ἔπαινον τὸν πρέποντα. μετὰ δὲ τοῦτο ἀπέρχονται. ὧδε μὲν θάπτουσι· καὶ διὰ παντὸς τοῦ πολέμου, ὁπότε ξυμβαίη αὐτοῖς, ἐχρῶντο τῷ νόμῳ. ἐπὶ δ' οὖν τοῖς πρώτοις τοῖσδε Περικλῆς ὁ Ξανθίππου ᾑρέθη λέγειν, καὶ ἐπειδὴ καιρὸς ἐλάμβανε, προελθὼν ἀπὸ τοῦ σήματος ἐπὶ βῆμα ὑψηλὸν πεποιημένον, ὅπως ἀκούοιτο ὡς ἐπὶ πλεῖστον τοῦ ὁμίλου, ἔλεγε τοιάδε.

' Οἱ μὲν πολλοὶ τῶν ἐνθάδε εἰρηκότων ἐπαινοῦσι τὸν προσθέντα τῷ νόμῳ τὸν λόγον τόνδε, ὡς καλὸν ὂν ἐπὶ τοῖς ἐκ τῶν πολέμων θαπτομένοις ἀγορεύεσθαι αὐτόν. ἐμοὶ δ' ἀρκοῦν ἂν ἐδόκει εἶναι ἀνδρῶν ἀγαθῶν ἔργῳ γενομένων ἔργῳ καὶ δηλοῦσθαι τὰς τιμάς, οἷα καὶ νῦν περὶ τὸν τάφον τόνδε δημοσίᾳ παρασκευασθέντα ὁρᾶτε, καὶ μὴ ἐν ἑνὶ ἀνδρὶ πολλῶν ἀρετὰς κινδυνεύεσθαι εὖ τε καὶ χεῖρον εἰπόντι πιστευθῆναι. χαλεπὸν γὰρ τὸ μετρίως εἰπεῖν ἐν ᾧ μόλις καὶ ἡ δόκησις τῆς ἀληθείας βεβαιοῦται. ὅ τε γὰρ ξυνειδὼς καὶ εὔνους ἀκροατὴς τάχ' ἄν τι ἐνδεεστέρως πρὸς ἃ βούλεταί τε καὶ ἐπίσταται νομίσειε δηλοῦσθαι, ὅ τε ἄπειρος ἔστιν ἃ καὶ πλεονάζεσθαι, διὰ φθόνον, εἴ τε ὑπὲρ τὴν ἑαυτοῦ φύσιν ἀκούοι. μέχρι γὰρ τοῦδε ἀνεκτοὶ οἱ ἔπαινοί εἰσι περὶ ἑτέρων λεγόμενοι, ἐς ὅσον ἂν καὶ αὐτὸς ἕκαστος οἴηται ἱκανὸς εἶναι δρᾶσαί τι ὧν ἤκουσε· τῷ δ' ὑπερβάλλοντι φθονοῦντες ἤδη καὶ ἀπιστοῦσιν. ἐπειδὴ δὲ τοῖς πάλαι οὕτως ἐδοκιμάσθη ταῦτα καλῶς ἔχειν, χρὴ καὶ ἐμὲ ἑπόμενον τῷ νόμῳ πειρᾶσθαι ὑμῶν τῆς ἑκάστου βουλήσεώς τε καὶ δόξης τυχεῖν ὡς ἐπὶ πλεῖστον.

' Ἄρξομαι δὲ ἀπὸ τῶν προγόνων πρῶτον· δίκαιον γὰρ αὐτοῖς,

καὶ πρέπον δὲ ἅμα ἐν τῷ τοιῷδε τὴν τιμὴν ταύτην τῆς μνήμης δί-
δοσθαι. τὴν γὰρ χώραν οἱ αὐτοὶ ἀεὶ οἰκοῦντες διαδοχῇ τῶν ἐπιγι-
γνομένων μέχρι τοῦδε ἐλευθέραν δι' ἀρετὴν παρέδοσαν. καὶ ἐκεῖ-
νοί τε ἄξιοι ἐπαίνου καὶ ἔτι μᾶλλον οἱ πατέρες ἡμῶν· κτησάμενοι
γὰρ πρὸς οἷς ἐδέξαντο ὅσην ἔχομεν ἀρχὴν οὐκ ἀπόνως ἡμῖν τοῖς
νῦν προσκατέλιπον. τὰ δὲ πλείω αὐτῆς αὐτοὶ ἡμεῖς οἵδε οἱ νῦν ἔτι
ὄντες μάλιστα ἐν τῇ καθεστηκυίᾳ ἡλικίᾳ ἐπηυξήσαμεν, καὶ τὴν πόλιν
τοῖς πᾶσι παρεσκευάσαμεν καὶ ἐς πόλεμον καὶ ἐς εἰρήνην αὐταρκε-
στάτην.

' Ὦν ἐγὼ τὰ μὲν κατὰ πολέμους ἔργα, οἷς ἕκαστα ἐκτήθη, ἢ εἴ
τι αὐτοὶ ἢ οἱ πατέρες ἡμῶν βάρβαρον ἢ Ἕλληνα πόλεμον ἐπιόντα
προθύμως ἠμυνάμεθα, μακρηγορεῖν ἐν εἰδόσιν οὐ βουλόμενος, ἐάσω·
ἀπὸ δὲ οἵας τε ἐπιτηδεύσεως ἤλθομεν ἐπ' αὐτὰ καὶ μεθ' οἵας πολι-
τείας καὶ τρόπων ἐξ οἵων μεγάλα ἐγένετο, ταῦτα δηλώσας πρῶτον
εἶμι καὶ ἐπὶ τὸν τῶνδε ἔπαινον, νομίζων ἐπί τε τῷ παρόντι οὐκ ἂν
ἀπρεπῆ λεχθῆναι αὐτὰ καὶ τὸν πάντα ὅμιλον καὶ ἀστῶν καὶ ξένων
ξύμφορον εἶναι ἐπακοῦσαι αὐτῶν.

' Χρώμεθα γὰρ πολιτείᾳ οὐ ζηλούσῃ τοὺς τῶν πέλας νόμους πα-
ράδειγμα δὲ μᾶλλον αὐτοὶ ὄντες τισὶν ἢ μιμούμενοι ἑτέρους. καὶ
ὄνομα μὲν διὰ τὸ μὴ ἐς ὀλίγους ἀλλ' ἐς πλείονας ἥκειν δημοκρατία κέ-
κληται, μέτεστι δὲ κατὰ μὲν τοὺς νόμους πρὸς τὰ ἴδια διάφορα πᾶσι
τὸ ἴσον, κατὰ δὲ τὴν ἀξίωσιν, ὡς ἕκαστος ἔν τῳ εὐδοκιμεῖ, οὐκ ἀπὸ
μέρους τὸ πλέον ἐς τὰ κοινὰ ἢ ἀπ' ἀρετῆς προτιμᾶται, οὐδ' αὖ κατὰ
πενίαν, ἔχων γέ τι ἀγαθὸν δρᾶσαι τὴν πόλιν, ἀξιώματος ἀφανείᾳ κε-
κώλυται. ἐλευθέρως δὲ τά τε πρὸς τὸ κοινὸν πολιτεύομεν καὶ ἐς τὴν
πρὸς ἀλλήλους τῶν καθ' ἡμέραν ἐπιτηδευμάτων ὑποψίαν, οὐ δι' ὀρ-
γῆς τὸν πέλας, εἰ καθ' ἡδονήν τι δρᾷ, ἔχοντες, οὐδὲ ἀζημίους μέν,
λυπηρὰς δὲ τῇ ὄψει ἀχθηδόνας προστιθέμενοι. ἀνεπαχθῶς δὲ τὰ
ἴδια προσομιλοῦντες τὰ δημόσια διὰ δέος μάλιστα οὐ παρανομοῦμεν,
τῶν τε ἀεὶ ἐν ἀρχῇ ὄντων ἀκροάσει καὶ τῶν νόμων, καὶ μάλιστα αὐ-
τῶν ὅσοι τε ἐπ' ὠφελίᾳ τῶν ἀδικουμένων κεῖνται καὶ ὅσοι ἄγραφοι
ὄντες αἰσχύνην ὁμολογουμένην φέρουσι. καὶ μὴν καὶ τῶν πόνων
πλείστας ἀναπαύλας τῇ γνώμῃ ἐπορισάμεθα, ἀγῶσι μέν γε καὶ θυ-
σίας διετησίοις νομίζοντες, ἰδίαις δὲ κατασκευαῖς εὐπρεπέσιν, ὧν
καθ' ἡμέραν ἡ τέρψις τὸ λυπηρὸν ἐκπλήσσει. ἐπεσέρχεται δὲ
διὰ μέγεθος τῆς πόλεως ἐκ πάσης γῆς τὰ πάντα, καὶ ξυμβαίνει ἡμῖν
μηδὲν οἰκειοτέρᾳ τῇ ἀπολαύσει τὰ αὐτοῦ ἀγαθὰ γιγνόμενα καρποῦ-
σθαι ἢ καὶ τὰ τῶν ἄλλων ἀνθρώπων.

' Διαφέρομεν δὲ κἀν ταῖς τῶν πολεμικῶν μελέταις τῶν ἐναντίων
τοῖσδε. τήν τε γὰρ πόλιν κοινὴν παρέχομεν, καὶ οὐκ ἔστιν ὅτε ξε-
νηλασίαις ἀπείργομέν τινα ἢ μαθήματος ἢ θεάματος, ὃ μὴ κρυφθὲν
ἄν τις τῶν πολεμίων ἰδὼν ὠφεληθείη, πιστεύοντες οὐ ταῖς παρα-
σκευαῖς τὸ πλέον καὶ ἀπάταις ἢ τῷ ἀφ' ἡμῶν αὐτῶν ἐς τὰ ἔργα
εὐψύχῳ. καὶ ἐν ταῖς παιδείαις οἱ μὲν ἐπιπόνῳ ἀσκήσει εὐθὺς

νέοι ὄντες τὸ ἀνδρεῖον μετέρχονται, ἡμεῖς δὲ ἀνειμένως διαιτώμενοι οὐδὲν ἧσσον ἐπὶ τοὺς κινδύνους ἰσοπαλεῖς χωροῦμεν. τεκμήριον δέ· οὔτε γὰρ Λακεδαιμόνιοι καθ' ἑαυτούς, μεθ' ἁπάντων δ' ἐς τὴν γῆν ἡμῶν στρατεύουσι, τήν τε τῶν πέλας αὐτοὶ ἐπελθόντες οὐ χαλεπῶς ἐν τῇ ἀλλοτρίᾳ τοὺς περὶ τῶν οἰκείων ἀμυνομένους μαχόμενοι τὰ πλείω κρατοῦμεν, ἀθρόᾳ τε τῇ δυνάμει ἡμῶν οὐδείς πω πολέμιος ἐνέτυχε διὰ τὴν τοῦ ναυτικοῦ τε ἅμα ἐπιμέλειαν καὶ τὴν ἐν τῇ γῇ ἐπὶ πολλὰ ἡμῶν αὐτῶν ἐπίπεμψιν· ἢν δέ που μορίῳ τινὶ προσμείξωσι, κρατήσαντές τέ τινας ἡμῶν πάντας αὐχοῦσιν ἀπεῶσθαι καὶ νικηθέντες ὑφ' ἁπάντων ἡσσῆσθαι. καίτοι εἰ ῥᾳθυμίᾳ μᾶλλον ἢ πόνων μελέτῃ καὶ μὴ μετὰ νόμων τὸ πλέον ἢ τρόπων ἀνδρείας ἐθέλομεν κινδυνεύειν, περιγίγνεται ἡμῖν τοῖς τε μέλλουσιν ἀλγεινοῖς μὴ προκάμνειν, καὶ ἐς αὐτὰ ἐλθοῦσι μὴ ἀτολμοτέρους τῶν ἀεὶ μοχθούντων φαίνεσθαι, καὶ ἔν τε τούτοις τὴν πόλιν ἀξίαν εἶναι θαυμάζεσθαι καὶ ἔτι ἐν ἄλλοις. φιλοκαλοῦμέν τε γὰρ μετ' εὐτελείας καὶ φιλοσοφοῦμεν ἄνευ μαλακίας· πλούτῳ τε ἔργου μᾶλλον καιρῷ ἢ λόγου κόμπῳ χρώμεθα, καὶ τὸ πένεσθαι οὐχ ὁμολογεῖν τινι αἰσχρόν, ἀλλὰ μὴ διαφεύγειν ἔργῳ αἴσχιον. ἔνι τε τοῖς αὐτοῖς οἰκείων ἅμα καὶ πολιτικῶν ἐπιμέλεια, καὶ ἑτέροις ἕτερα πρὸς ἔργα τετραμμένοις τὰ πολιτικὰ μὴ ἐνδεῶς γνῶναι· μόνοι γὰρ τόν τε μηδὲν τῶνδε μετέχοντα οὐκ ἀπράγμονα ἀλλ' ἀχρεῖον νομίζομεν, καὶ αὐτοὶ ἤτοι κρίνομέν γε ἢ ἐνθυμούμεθα ὀρθῶς τὰ πράγματα, οὐ τοὺς λόγους τοῖς ἔργοις βλάβην ἡγούμενοι, ἀλλὰ μὴ προδιδαχθῆναι μᾶλλον λόγῳ πρότερον ἢ ἐπὶ ἃ δεῖ ἔργῳ ἐλθεῖν. διαφερόντως γὰρ δὴ καὶ τόδε ἔχομεν, ὥστε τολμᾶν τε οἱ αὐτοὶ μάλιστα καὶ περὶ ὧν ἐπιχειρήσομεν ἐκλογίζεσθαι· ὃ τοῖς ἄλλοις ἀμαθία μὲν θράσος, λογισμὸς δὲ ὄκνον φέρει. κράτιστοι δ' ἂν ψυχὴν δικαίως κριθεῖεν οἱ τά τε δεινὰ καὶ ἡδέα σαφέστατα γιγνώσκοντες καὶ διὰ ταῦτα μὴ ἀποτρεπόμενοι ἐκ τῶν κινδύνων. καὶ τὰ ἐς ἀρετὴν ἐνηντιώμεθα τοῖς πολλοῖς· οὐ γὰρ πάσχοντες εὖ, ἀλλὰ δρῶντες κτώμεθα τοὺς φίλους. βεβαιότερος δὲ ὁ δράσας τὴν χάριν ὡς ὀφειλομένην δι' εὐνοίας ᾧ δέδωκε σῴζειν· ὁ δ' ἀντοφείλων ἀμβλύτερος, εἰδὼς οὐκ ἐς χάριν, ἀλλ' ἐς ὀφείλημα τὴν ἀρετὴν ἀποδώσων. καὶ μόνοι οὐ τοῦ ξυμφέροντος μᾶλλον λογισμῷ ἢ τῆς ἐλευθερίας τῷ πιστῷ ἀδεῶς τινα ὠφελοῦμεν. ξυνελών τε λέγω τήν τε πᾶσαν πόλιν τῆς Ἑλλάδος παίδευσιν εἶναι, καὶ καθ' ἕκαστον δοκεῖν ἄν μοι τὸν αὐτὸν ἄνδρα παρ' ἡμῶν ἐπὶ πλεῖστ' ἂν εἴδη καὶ μετὰ χαρίτων μάλιστ' ἂν εὐτραπέλως τὸ σῶμα αὔταρκες παρέχεσθαι.

'Καὶ ὡς οὐ λόγων ἐν τῷ παρόντι κόμπος τάδε μᾶλλον ἢ ἔργων ἐστὶν ἀλήθεια, αὐτὴ ἡ δύναμις τῆς πόλεως, ἣν ἀπὸ τῶνδε τῶν τρόπων ἐκτησάμεθα, σημαίνει. μόνη γὰρ τῶν νῦν ἀκοῆς κρείσσων ἐς πεῖραν ἔρχεται, καὶ μόνη οὔτε τῷ πολεμίῳ ἐπελθόντι ἀγανάκτησιν ἔχει ὑφ' οἵων κακοπαθεῖ, οὔτε τῷ ὑπηκόῳ κατάμεμψιν ὡς οὐχ ὑπ'

ἀξίων ἄρχεται. μετὰ μεγάλων δὲ σημείων καὶ οὐ δή τοι ἀμάρ-
τυρόν γε τὴν δύναμιν παρασχόμενοι τοῖς τε νῦν καὶ τοῖς ἔπειτα
θαυμασθησόμεθα, οὐδὲν προσδεόμενοι οὔτε Ὁμήρου ἐπαινέτου οὔτε
ὅστις ἔπεσι μὲν τὸ αὐτίκα τέρψει, τῶν δ' ἔργων τὴν ὑπόνοιαν ἡ
ἀλήθεια βλάψει, ἀλλὰ πᾶσαν μὲν θάλασσαν καὶ γῆν ἐσβατὸν τῇ
ἡμετέρᾳ τόλμῃ καταναγκάσαντες γενέσθαι, πανταχοῦ δὲ μνημεῖα
κακῶν τε κἀγαθῶν ἀίδια ξυγκατοικίσαντες.
 Ἁ Περὶ τοιαύτης οὖν πόλεως οἵδε τε γενναίως δικαιοῦντες μὴ
ἀφαιρεθῆναι αὐτὴν μαχόμενοι ἐτελεύτησαν, καὶ τῶν λειπομένων
πάντα τινὰ εἰκὸς ἐθέλειν ὑπὲρ αὐτῆς κάμνειν. διὸ δὴ καὶ ἐμή-
κυνα τὰ περὶ τῆς πόλεως, διδασκαλίαν τε ποιούμενος μὴ περὶ ἴσου
ἡμῖν εἶναι τὸν ἀγῶνα καὶ οἷς τῶνδε μηδὲν ὑπάρχει ὁμοίως, καὶ
τὴν εὐλογίαν ἅμα ἐφ' οἷς νῦν λέγω φανερὰν σημείοις καθιστάς, καὶ
εἴρηται αὐτῆς τὰ μέγιστα· ἃ γὰρ τὴν πόλιν ὕμνησα, αἱ τῶνδε καὶ
τῶν τοιῶνδε ἀρεταὶ ἐκόσμησαν, καὶ οὐκ ἂν πολλοῖς τῶν Ἑλλήνων
ἰσόρροπος ὥσπερ τῶνδε τῶν ἔργων ὁ λόγος φανείη. δοκεῖ δέ μοι δη-
λοῦν ἀνδρὸς ἀρετὴν πρώτη τε μηνύουσα καὶ τελευταία βεβαιοῦσα ἡ νῦν
τῶνδε καταστροφή. καὶ γὰρ τοῖς τἆλλα χείροσι δίκαιον τὴν ἐς τοὺς πο-
λέμους ὑπὲρ τῆς πατρίδος ἀνδραγαθίαν προτίθεσθαι· ἀγαθῷ γὰρ κα-
κὸν ἀφανίσαντες κοινῶς μᾶλλον ὠφέλησαν ἢ ἐκ τῶν ἰδίων ἔβλαψαν.
τῶνδε δὲ οὔτε πλούτου τις τὴν ἔτι ἀπόλαυσιν προτιμήσας ἐμαλακίσθη
οὔτε πενίας ἐλπίδι, ὡς κἂν ἔτι διαφυγὼν αὐτὴν πλουτήσειεν, ἀναβολὴν
τοῦ δεινοῦ ἐποιήσατο· τὴν δὲ τῶν ἐναντίον τιμωρίαν ποθεινοτέραν αὐ-
τῶν λαβόντες, καὶ κινδύνων ἅμα τόνδε κάλλιστον νομίσαντες ἐβου-
λήθησαν μετ' αὐτοῦ τοὺς μὲν τιμωρεῖσθαι, τῶν δὲ ἐφίεσθαι, ἐλπίδι
μὲν τὸ ἀφανὲς τοῦ κατορθώσειν ἐπιτρέψαντες, ἔργῳ δὲ περὶ τοῦ
ἤδη ὁρωμένου σφίσιν αὐτοῖς ἀξιοῦντες πεποιθέναι· καὶ ἐν αὐτῷ τῷ
ἀμύνεσθαι καὶ παθεῖν μᾶλλον ἡρημένοι ἢ ἐνδόντες σῴζεσθαι, τὸ μὲν
αἰσχρὸν τοῦ λόγου ἔφυγον, τὸ δ' ἔργον τῷ σώματι ὑπέμειναν καὶ
δ' ἐλαχίστου καιροῦ τύχης ἅμα ἀκμῇ τῆς δόξης μᾶλλον ἢ τοῦ δέους
ἀπηλλάγησαν.
 Ἁ Καὶ οἵδε μὲν προσηκόντως τῇ πόλει τοιοίδε ἐγένοντο· τοὺς δὲ
λοιποὺς χρὴ ἀσφαλεστέραν μὲν εὔχεσθαι, ἀτολμοτέραν δὲ μηδὲν
ἀξιοῦν τὴν ἐς τοὺς πολεμίους διάνοιαν ἔχειν, σκοποῦντας μὴ λόγῳ
μόνῳ τὴν ὠφελίαν, ἣν ἄν τις πρὸς οὐδὲν χεῖρον αὐτοὺς εἰδότας
μηκύνοι, λέγων ὅσα ἐν τῷ τοὺς πολεμίους ἀμύνεσθαι ἀγαθὰ ἔνεστιν,
ἀλλὰ μᾶλλον τὴν τῆς πόλεως δύναμιν καθ' ἡμέραν ἔργῳ θεωμένους
καὶ ἐραστὰς γιγνομένους αὐτῆς, καὶ ὅταν ὑμῖν μεγάλη δόξῃ εἶναι,
ἐνθυμουμένους, ὅτι τολμῶντες καὶ γιγνώσκοντες τὰ δέοντα καὶ ἐν
τοῖς ἔργοις αἰσχυνόμενοι ἄνδρες αὐτὰ ἐκτήσαντο, καὶ ὁπότε καὶ πεί-
ρᾳ του σφαλεῖεν, οὐκ οὖν καὶ τὴν πόλιν γε τῆς σφετέρας ἀρετῆς ἀξι-
οῦντες στερίσκειν, κάλλιστον δὲ ἔρανον αὐτῇ προϊέμενοι. κοινῇ γὰρ
τὰ σώματα διδόντες ἰδίᾳ τὸν ἀγήρων ἔπαινον ἐλάμβανον καὶ τὸν
τάφον ἐπισημότατον, οὐκ ἐν ᾧ κεῖνται μᾶλλον, ἀλλ' ἐν ᾧ ἡ δόξα

αὐτῶν παρὰ τῷ ἐντυχόντι ἀεὶ καὶ λόγου καὶ ἔργου καιρῷ ἀείμνηστος καταλείπεται. ἀνδρῶν γὰρ ἐπιφανῶν πᾶσα γῆ τάφος, καὶ οὐ στηλῶν μόνον ἐν τῇ οἰκείᾳ σημαίνει ἐπιγραφή, ἀλλὰ καὶ ἐν τῇ μὴ προσηκούσῃ ἄγραφος μνήμη παρ᾽ ἑκάστῳ τῆς γνώμης μᾶλλον ἢ τοῦ ἔργου ἐνδιαιτᾶται. οὓς νῦν ἡμεῖς ζηλώσαντες καὶ τὸ εὔδαιμον τὸ ἐλεύθερον, τὸ δὲ ἐλεύθερον τὸ εὔψυχον κρίναντες, μὴ περιορᾶσθε τοὺς πολεμικοὺς κινδύνους. οὐ γὰρ οἱ κακοπραγοῦντες δικαιότερον ἀφειδοῖεν ἂν τοῦ βίου, οἷς ἐλπὶς οὐκ ἔστ᾽ ἀγαθοῦ, ἀλλ᾽ οἷς ἡ ἐναντία μεταβολὴ ἐν τῷ ζῆν ἔτι κινδυνεύεται καὶ ἐν οἷς μάλιστα μεγάλα τὰ διαφέροντα, ἤν τι πταίσωσιν. ἀλγεινοτέρα γὰρ ἀνδρί γε φρόνημα ἔχοντι ἡ μετὰ τοῦ μαλακισθῆναι κάκωσις ἢ ὁ μετὰ ῥώμης καὶ κοινῆς ἐλπίδος ἅμα γιγνόμενος ἀναίσθητος θάνατος.

᾽Διόπερ καὶ τοὺς τῶνδε νῦν τοκέας, ὅσοι πάρεστε, οὐκ ὀλοφύρομαι μᾶλλον ἢ παραμυθήσομαι. ἐν πολυτρόποις γὰρ ξυμφοραῖς ἐπίστανται τραφέντες, τὸ δ᾽ εὐτυχές, οἳ ἂν τῆς εὐπρεπεστάτης λάχωσιν, ὥσπερ οἵδε μὲν νῦν τελευτῆς, ὑμεῖς δὲ λύπης, καὶ οἷς ἐνευδαιμονῆσαί τε ὁ βίος ὁμοίως καὶ ἐντελευτῆσαι ξυνεμετρήθη. χαλεπὸν μὲν οὖν οἶδα πείθειν ὄν, ὧν καὶ πολλάκις ἕξετε ὑπομνήματα ἐν ἄλλων εὐτυχίαις, αἷς ποτὲ καὶ αὐτοὶ ἠγάλλεσθε· καὶ λύπη οὐχ ὧν ἄν τις μὴ πειρασάμενος ἀγαθῶν στερίσκεται, ἀλλ᾽ οὗ ἂν ἐθὰς γενόμενος ἀφαιρεθῇ. καρτερεῖν δὲ χρὴ καὶ ἄλλων παίδων ἐλπίδι, οἷς ἔτι ἡλικία τέκνωσιν ποιεῖσθαι· ἰδίᾳ τε γὰρ τῶν οὐκ ὄντων λήθη οἱ ἐπιγιγνόμενοί τισιν ἔσονται, καὶ τῇ πόλει διχόθεν, ἔκ τε τοῦ μὴ ἐρημοῦσθαι καὶ ἀσφαλείᾳ, ξυνοίσει· οὐ γὰρ οἷόν τε ἴσον τι ἢ δίκαιον βουλεύεσθαι οἳ ἂν μὴ καὶ παῖδας ἐκ τοῦ ὁμοίου παραβαλλόμενοι κινδυνεύωσιν. ὅσοι δ᾽ αὖ παρηβήκατε, τόν τε πλείονα κέρδος ὃν εὐτυχεῖτε βίον ἡγεῖσθε καὶ τόνδε βραχὺν ἔσεσθαι, καὶ τῇ τῶνδε εὐκλείᾳ κουφίζεσθε. τὸ γὰρ φιλότιμον ἀγήρων μόνον, καὶ οὐκ ἐν τῷ ἀχρείῳ τῆς ἡλικίας τὸ κερδαίνειν, ὥσπερ τινές φασι, μᾶλλον τέρπει, ἀλλὰ τὸ τιμᾶσθαι.

᾽Παισὶ δ᾽ αὖ ὅσοι τῶνδε πάρεστε ἢ ἀδελφοῖς ὁρῶ μέγαν τὸν ἀγῶνα· τὸν γὰρ οὐκ ὄντα ἅπας εἴωθεν ἐπαινεῖν, καὶ μόλις ἂν καθ᾽ ὑπερβολὴν ἀρετῆς οὐχ ὁμοῖοι, ἀλλ᾽ ὀλίγῳ χείρους κριθεῖτε. φθόνος γὰρ τοῖς ζῶσι πρὸς τὸ ἀντίπαλον, τὸ δὲ μὴ ἐμποδὼν ἀνανταγωνίστῳ εὐνοίᾳ τετίμηται.

᾽Εἰ δέ με δεῖ καὶ γυναικείας τι ἀρετῆς, ὅσαι νῦν ἐν χηρείᾳ ἔσονται, μνησθῆναι, βραχείᾳ παραινέσει ἅπαν σημανῶ. τῆς τε γὰρ ὑπαρχούσης φύσεως μὴ χείροσι γενέσθαι ὑμῖν μεγάλη ἡ δόξα καὶ ἧς ἂν ἐπ᾽ ἐλάχιστον ἀρετῆς πέρι ἢ ψόγου ἐν τοῖς ἄρσεσι κλέος ᾖ.

᾽Εἴρηται καὶ ἐμοὶ λόγῳ κατὰ τὸν νόμον ὅσα εἶχον πρόσφορα, καὶ ἔργῳ οἱ θαπτόμενοι τὰ μὲν ἤδη κεκόσμηνται, τὰ δὲ αὐτῶν τοὺς παῖδας τὸ ἀπὸ τοῦδε δημοσίᾳ ἡ πόλις μέχρι ἥβης θρέψει, ὠφέλιμον στέφανον τοῖσδέ τε καὶ τοῖς λειπομένοις τῶν τοιῶνδε ἀγώνων προ-

136

τιθεῖσα· ἆθλα γὰρ οἷς κεῖται ἀρετῆς μέγιστα, τοῖς δὲ καὶ ἄνδρες ἄριστοι πολιτεύουσι. νῦν δὲ ἀπολοφυράμενοι ὃν προσήκει ἑκάστῳ ἄπιτε.'

In the same winter, following the law of their fathers, the Athenians held the first public funeral of those who had fallen in the war. The ceremony is as follows. The bones of the dead are exposed on a covered platform for three days, during which any one may place his personal offerings at their side. On the third day they are laid in ten coffins of cypress wood, one for each tribe, every man's bones in the coffin of his tribe; these are put on carriages and driven to the grave. One empty bed covered with a winding sheet is also borne for the missing whose bodies were not recovered for burning. All who so desire, whether citizens or strangers, may join in the procession, and the women folk of the dead are at the graveside bewailing them. The interment takes place in the State burial ground, which is situated in the most beautiful suburb of the city. All Athenians who have died in war lie buried there, except those who fell at Marathon; their valour was adjudged so conspicuous that the funeral was held on the field of battle. When the coffins have been laid in the earth some speaker elected by the city for his wisdom and public estimation delivers an appropriate eulogy; after this the gathering disperses. This is the customary ceremonial, and it was adhered to throughout the war whenever occasion arose. It was at the funeral of this first group of fallen that Pericles the son of Xanthippus was elected to speak. When the moment came, he stepped forward from the graveside on to a high platform made for the occasion, so that his voice might carry as far as possible over the crowd, and spoke as follows:—

Most of those who have stood in this place before me have commended the institution of this closing address. It is good, they have felt, that solemn words should be spoken over our fallen soldiers. I do not share this feeling. Acts deserve acts, not words, in their honour, and to me a burial at the State's charges, such as you see before you, would have appeared sufficient. Our sense of the deserts of a number of our fellow-citizens should not depend upon the felicity of one man's speech. Moreover, it is very hard for a speaker to be appropriate when many of his hearers will scarce believe that he is truthful. For those who have known and loved the dead may think his words scant justice to the memories they would hear honoured: while those who do not know will occasionally, from jealousy, suspect me of overstatement when they hear of any feat beyond their own powers. For it is only human for men not to bear praise of others beyond the point at which they still feel that they can rival their exploits. Transgress that boundary and they are jealous and distrustful. But since the wisdom of our ancestors en-

137

acted this law I too must submit and try to suit as best I can the wishes and feelings of every member of this gathering.

My first words shall be for our ancestors; for it is both just to them and seemly that on an occasion such as this our tribute of memory should be paid them. For, dwelling always in this country, generation after generation in unchanging and unbroken succession, they have handed it down to us free by their exertions. So they are worthy of our praises; and still more so are our fathers. For they enlarged the ancestral patrimony by the Empire which we hold to-day and delivered it, not without labour, into the hands of our own generation; while it is we ourselves, those of us who are now in middle life, who consolidated our power throughout the greater part of the Empire and secured the city's complete independence both in war and peace. Of the battles which we and our fathers fought, whether in the winning of our power abroad or in bravely withstanding the warfare of barbarian or Greek at home, I do not wish to say more: they are too familiar to you all. I wish rather to set forth the spirit in which we faced them, and the constitution and manners with which we rose to greatness, and to pass from them to the dead; for I think it not unfitting that these things should be called to mind at to-day's solemnity, and expedient too that the whole gathering of citizens and strangers should listen to them.

For our government is not copied from those of our neighbours: we are an example to them rather than they to us. Our constitution is named a democracy, because it is in the hands not of the few but of the many. But our laws secure equal justice for all in their private disputes, and our public opinion welcomes and honours talent in every branch of achievement, not for any sectional reason but on grounds of excellence alone. And as we give free play to all in our public life, so we carry the same spirit into our daily relations with one another. We have no black looks or angry words for our neighbour if he enjoys himself in his own way, and we abstain from the little acts of churlishness which, though they leave no mark, yet cause annoyance to whoso notes them. Open and friendly in our private intercourse, in our public acts we keep strictly within the control of law. We acknowledge the restraint of reverence; we are obedient to whomsoever is set in authority, and to the laws, more especially to those which offer protection to the oppressed and those unwritten ordinances whose transgression brings admitted shame. Yet ours is no work-a-day city only. No other provides so many recreations for the spirit—contests and sacrifices all the year round, and beauty in our public buildings to cheer the heart and delight the eye day by day. Moreover, the city is so large and powerful that all the wealth of all the world flows in to her, so that our own Attic products seem no more homelike to us than the fruits of the labours of other nations.

Our military training too is different from our opponents'. The gates

of our city are flung open to the world. We practise no periodical deportations, nor do we prevent our visitors from observing or discovering what an enemy might usefully apply to his own purposes. For our trust is not in the devices of material equipment, but in our own good spirits for battle.

So too with education. They toil from early boyhood in a laborious pursuit after courage, while we, free to live and wander as we please, march out none the less to face the self-same dangers. Here is the proof of my words. When the Spartans advance into our country, they do not come alone but with all their allies; but when we invade our neighbours we have little difficulty as a rule, even on foreign soil, in defeating men who are fighting for their own homes. Moreover, no enemy has ever met us in full strength, for we have our navy to attend to, and our soldiers are sent on service to many scattered possessions; but if they chance to encounter some portion of our forces and defeat a few of us, they boast that they have driven back our whole army, or, if they are defeated, that the victors were in full strength. Indeed, if we choose to face danger with an easy mind rather than after a rigorous training, and to trust rather in native manliness than in state-made courage, the advantage lies with us; for we are spared all the weariness of practising for future hardships, and when we find ourselves amongst them we are as brave as our plodding rivals. Here as elsewhere, then, the city sets an example which is deserving of admiration. We are lovers of beauty without extravagance, and lovers of wisdom without unmanliness. Wealth to us is not mere material for vainglory but an opportunity for achievement; and poverty we think it no disgrace to acknowledge but a real degradation to make no effort to overcome. Our citizens attend both to public and private duties, and do not allow absorption in their own various affairs to interfere with their knowledge of the city's. We differ from other states in regarding the man who holds aloof from public life not as 'quiet' but as useless; we decide or debate, carefully and in person, all matters of policy, holding, not that words and deeds go ill together, but that acts are foredoomed to failure when undertaken undiscussed. For we are noted for being at once most adventurous in action and most reflective beforehand. Other men are bold in ignorance, while reflection will stop their onset. But the bravest are surely those who have the clearest vision of what is before them, glory and danger alike, and yet notwithstanding go out to meet it. In doing good, too, we are the exact opposite of the rest of mankind. We secure our friends not by accepting favours but by doing them. And so we are naturally more firm in our attachments: for we are anxious, as creditors, to cement by kind offices our relation towards our friends. If they do not respond with the same warmness it is because they feel that their services will not be given spontaneously but only as the repayment of a debt. We are alone among mankind in doing men benefits, not on calculations of

self-interest, but in the fearless confidence of freedom. In a word I claim that our city as a whole is an education to Greece, and that her members yield to none, man by man, for independence of spirit, many-sidedness of attainment, and complete self-reliance in limbs and brain.

That this is no vainglorious phrase but actual fact the supremacy which our manners have won us itself bears testimony. No other city of the present day goes out to her ordeal greater than ever men dreamed; no other is so powerful that the invader feels no bitterness when he suffers at her hands, and her subjects no shame at the indignity of their dependence. Great indeed are the symbols and witnesses of our supremacy, at which posterity, as all mankind to-day, will be astonished. We need no Homer or other man of words to praise us; for such give pleasure for a moment, but the truth will put to shame their imaginings of our deeds. For our pioneers have forced a way into every sea and every land, establishing among all mankind, in punishment or benefi-cence, eternal memorials of their settlement.

Such then is the city for whom, lest they should lose her, the men whom we celebrate died a soldier's death: and it is but natural that all of us, who survive them, should wish to spend ourselves in her service. That, indeed, is why I have spent many words upon the city. I wished to show that we have more at stake than men who have no such inheritance, and to support my praise of the dead by making clear to you what they have done. For if I have chanted the glories of the city it was these men and their like who set hand to array her. With them, as with few among Greeks, words cannot magnify the deeds that they have done. Such an end as we have here seems indeed to show us what a good life is, from its first signs of power to its final consummation. For even where life's previous record showed faults and failures it is just to weigh the last brave hour of devotion against them all. There they wiped out evil with good and did the city more service as soldiers than they did her harm in private life. There no hearts grew faint because they loved riches more than honour; none shirked the issue in the poor man's dreams of wealth. All these they put aside to strike a blow for the city. Counting the quest to avenge her honour as the most glorious of all ventures, and leaving Hope, the uncertain goddess, to send them what she would, they faced the foe as they drew near him in the strength of their own manhood; and when the shock of battle came, they chose rather to suffer the uttermost than to win life by weakness. So their memory has escaped the reproaches of men's lips, but they bore instead on their bodies the marks of men's hands, and in a moment of time, at the climax of their lives, were rapt away from a world filled, for their dying eyes, not with terror but with glory.

Such were the men who lie here and such the city that inspired them. We survivors may pray to be spared their bitter hour, but must disdain to meet the foe with a spirit less triumphant. Let us draw strength, not

merely from twice-told arguments—how fair and noble a thing it is to show courage in battle—but from the busy spectacle of our great city's life as we have it before us day by day, falling in love with her as we see her, and remembering that all this greatness she owes to men with the fighter's daring, the wise man's understanding of his duty, and the good man's self-discipline in its performance—to men who, if they failed in any ordeal, disdained to deprive the city of their services, but sacrificed their lives as the best offerings on her behalf. So they gave their bodies to the commonwealth and received, each for his own memory, praise that will never die, and with it the grandest of all sepulchres, not that in which their mortal bones are laid, but a home in the minds of men, where their glory remains fresh to stir to speech or action as the occasion comes by. For the whole earth is the sepulchre of famous men; and their story is not graven only on stone over their native earth, but lives on far away, without visible symbol, woven into the stuff of other men's lives. For you now it remains to rival what they have done and, knowing the secret of happiness to be freedom and the secret of freedom a brave heart, not idly to stand aside from the enemy's onset. For it is not the poor and luckless, as having no hope of prosperity, who have most cause to reckon death as little loss, but those for whom fortune may yet keep reversal in store and who would feel the change most if trouble befell them. Moreover, weakly to decline the trial is more painful to a man of spirit than death coming sudden and unperceived in the hour of strength and enthusiasm.

Therefore I do not mourn with the parents of the dead who are here with us. I will rather comfort them. For they know that they have been born into a world of manifold chances and that he is to be accounted happy to whom the best lot falls—the best sorrow, such as is yours to-day, or the best death, such as fell to these, for whom life and happiness were cut to the self-same measure. I know it is not easy to give you comfort. I know how often in the joy of others you will have reminders of what was once your own, and how men feel sorrow, not for the loss of what they have never tasted, but when something that has grown dear to them has been snatched away. But you must keep a brave heart in the hope of other children, those who are still of age to bear them. For the newcomers will help you to forget the gap in your own circle, and will help the city to fill up the ranks of its workers and its soldiers. For no man is fitted to give fair and honest advice in council if he has not, like his fellows, a family at stake in the hour of the city's danger. To you who are past the age of vigour I would say: count the long years of happiness so much gain to set off against the brief space that yet remains, and let your burden be lightened by the glory of the dead. For the love of honour alone is not staled by age, and it is by honour, not, as some say, by gold, that the helpless end of life is cheered.

I turn to those amongst you who are children or brothers of the fallen,

for whom I foresee a mighty contest with the memory of the dead. Their praise is in all men's mouths, and hardly, even for supremest heroism, will you be adjudged to have achieved, not the same but a little less than they. For the living have the jealousy of rivals to contend with, but the dead are honoured with unchallenged admiration.

If I must also speak a word to those who are now in widowhood on the powers and duties of women, I will cast all my advice into one brief sentence. Great will be your glory if you do not lower the nature that is within you—hers greatest of all whose praise or blame is least bruited on the lips of men.

I have spoken such words as I had to say according as the law prescribes, and the graveside offerings to the dead have been duly made. Henceforward the city will take charge of their children till manhood: such is the crown and benefit she holds out to the dead and to their kin for the trials they have undergone for her. For where the prize is highest, there, too, are the best citizens to contend for it.

And now, when you have finished your lamentation, let each of you depart.

Book ii, 34–46
Translated by Alfred E. Zimmern

The speech is written, if ever writing was, 'not in ink but in blood.' For with Thucydides, more perhaps than with any other great writer, there is not a word but TELLS. *'You must read and mark him line by line till you can read between the lines as clearly as in them. There are few thinkers with so many ideas brooding in the background.' All great art is like a ghost seeking to express more than it can utter and beckoning to regions beyond. This is as true in history, which deals with nations, as in poetry or any more personal art. That is why the Funeral Speech, written of a small provincial city in the untried youth of the world, will always find an echo whenever men and nations are living true to themselves.*

ALFRED E. ZIMMERN
The Greek Commonwealth (1911)

THUCYDIDES

471 ? — 400 ? B . C .

THE QUARRIES OF SYRACUSE

'Ανθρώπεια δράσαντες ἀνεκτὰ ἔπαθον.

Having done what men could, they suffered what men must.

Book vii, 77

Thucydides gives in a single sentence the fate of those brilliant youths who, pledging the sea in wine from golden goblets, sailed away to conquer Sicily and slowly died in the quarries of Syracuse. . . . One sentence only for their glory and their anguish.

EDITH HAMILTON
The Greek Way (1930)

ARISTOPHANES

448 ? — 380 ? B . C .

THE ROGUE

ΑΙΑ. ξυνδεῖτε ταχέως τουτονὶ τὸν κυνοκλόπον,
 ἵνα δῷ δίκην· ἀνύετον. ΔΙ. ἥκει τῳ κακόν.
ΞΑ. οὐκ ἐς κόρακας; οὐ μὴ πρόσιτον.
ΑΙΑ. εἶεν, μαχεῖ;
 ὁ Διτύλας χὠ Σκεβλύας χὠ Παρδόκας
 χωρεῖτε δευρὶ καὶ μάχεσθε τουτῳί.
ΔΙ. εἶτ' οὐχὶ δεινὰ ταῦτα, τύπτειν τουτονὶ
 κλέπτοντα πρὸς τἀλλότρια; ΑΙΑ. μάλλ' ὑπερφυᾶ.
ΔΙ. σχέτλια μὲν οὖν καὶ δεινά.
ΞΑ. καὶ μὴν νὴ Δία,
 εἰ πώποτ' ἦλθον δεῦρ', ἐθέλω τεθνηκέναι,
 ἢ 'κλεψα τῶν σῶν ἄξιόν τι καὶ τριχός.
 καί σοι ποιήσω πρᾶγμα γενναῖον πάνυ·
 βασάνιζε γὰρ τὸν παῖδα τουτονὶ λαβών,
 κἂν ποτέ μ' ἕλῃς ἀδικοῦντ', ἀπόκτεινόν μ' ἄγων.
ΑΙΑ. καὶ πῶς βασανίσω;
ΞΑ. πάντα τρόπον, ἐν κλίμακι
 δήσας, κρεμάσας, ὑστριχίδι μαστιγῶν, δέρων,

143

στρεβλῶν, ἔτι δ' ἐς τὰς ῥῖνας ὄξος ἐγχέων,
πλίνθους ἐπιθείς, πάντα τἆλλα, πλὴν πράσῳ
μὴ τύπτε τοῦτον μηδὲ γητείῳ νέῳ.

ΑΙΑ. δίκαιος ὁ λόγος· κἄν τι πηρώσω γέ σου
τὸν παῖδα τύπτων, τἀργύριόν σοι κείσεται.

ΞΑ. μὴ δῆτ' ἔμοιγ'. οὕτω δὲ βασάνιζ' ἀπαγαγών.

ΑΙΑ. αὐτοῦ μὲν οὖν, ἵνα σοί κατ' ὀφθαλμοὺς λέγῃ.
κατάθου σὺ τὰ σκεύη ταχέως, χὤπως ἐρεῖς
ἐνταῦθα μηδὲν ψεῦδος.

ΔΙ. ἀγορεύω τινὶ
ἐμὲ μὴ βασανίζειν ἀθάνατον ὄντ'. εἰ δὴ μή,
αὐτὸς σεαυτὸν αἰτιῶ. ΑΙΑ. λέγεις δὲ τί;

ΔΙ. ἀθάνατος εἶναί φημι Διόνυσος Διός,
τοῦτον δὲ δοῦλον. ΑΙΑ. ταῦτ' ἀκούεις;

ΞΑ. φήμ' ἐγώ.
καὶ πολύ γε μᾶλλόν ἐστι μαστιγωτέος·
εἴπερ θεὸς γάρ ἐστιν, οὐκ αἰσθήσεται.

ΔΙ. τί δῆτ', ἐπειδὴ καὶ σὺ φὴς εἶναι θεός,
οὐ καὶ σὺ τύπτει τὰς ἴσας πληγὰς ἐμοί;

ΞΑ. δίκαιος ὁ λόγος· χὠπότερον ἂν νῷν ἴδῃς
κλαύσαντα πρότερον ἢ προτιμήσαντά τι
τυπτόμενον, εἶναι τοῦτον ἡγοῦ μὴ θεόν.

ΑΙΑ. οὐκ ἔσθ' ὅπως οὐκ εἶ σὺ γεννάδας ἀνήρ·
χωρεῖς γὰρ εἰς τὸ δίκαιον. ἀποδύεσθε δή.

ΞΑ. πῶς οὖν βασανιεῖς νὼ δικαίως;

ΑΙΑ. ῥᾳδίως·
πληγὴν παρὰ πληγὴν ἑκάτερον.

ΞΑ. καλῶς λέγεις.

ΑΙΑ. ἰδού. ΞΑ. σκόπει νυν ἤν μ' ὑποκινήσαντ' ἴδῃς.

ΑΙΑ. ἤδη 'πάταξά σ'.

ΞΑ. οὐ μὰ Δί', οὐκ ἐμοὶ δοκεῖς.

ΑΙΑ. ἀλλ' εἶμ' ἐπὶ τονδὶ καὶ πατάξω. ΔΙ. πηνίκα;

ΑΙΑ. καὶ δὴ 'πάταξα. ΔΙ. Κᾆτα πῶς οὐκ ἔπταρον;

ΑΙΑ. οὐκ οἶδα· τουδὶ δ' αὖθις ἀποπειράσομαι.

ΞΑ. οὔκουν ἀνύσεις; ἰατταταῖ.

ΑΙΑ. τί τάτταταῖ;
μῶν ὠδυνήθης;

ΞΑ. οὐ μὰ Δί', ἀλλ' ἐφρόντισα
ὁπόθ' Ἡράκλεια τἀν Διομείοις γίγνεται.

ΑΙΑ. ἄνθρωπος ἱερός. δεῦρο πάλιν βαδιστέον.

ΔΙ. ἰοὺ ἰού. ΑΙΑ. τί ἔστιν; ΔΙ. ἱππέας ὁρῶ.

ΑΙΑ. τί δῆτα κλάεις; ΔΙ. κρομμύων ὀσφραίνομαι.

ΑΙΑ. ἐπεὶ προτιμᾷς γ' οὐδέν. ΔΙ. οὐδέν μοι μέλει.

ΑΙΑ. βαδιστέον τἄρ' ἐστὶν ἐπὶ τονδὶ πάλιν.

144

ΞΑ. οἴμοι. ΑΙΑ. τί ἔστι; ΞΑ. τὴν ἄκανθαν ἔξελε.
ΑΙΑ. τί τὸ πρᾶγμα τουτί; δεῦρο πάλιν βαδιστέον.
ΔΙ. Ἄπολλον, ὅς που Δῆλον ἢ Πύθων' ἔχεις.
ΞΑ. ἤλγησεν· οὐκ ἤκουσας;
ΔΙ. οὐκ ἔγωγ', ἐπεὶ
ἴαμβον Ἱππώνακτος ἀνεμιμνησκόμην.
ΞΑ. οὐδὲν ποιεῖς γάρ, ἀλλὰ τὰς λαγόνας σπόδει.
ΑΙΑ. μὰ τὸν Δί', ἀλλ' ἤδη πάρεχε τὴν γαστέρα.
ΔΙ. Πόσειδον. ΞΑ. ἤλγησέν τις.
ΔΙ. ὃς Αἰγαίου πρῶνας ἢ γλαυκᾶς μέδεις
ἁλὸς ἐν βένθεσιν.
ΑΙΑ. οὔ τοι μὰ τὴν Δήμητρα δύναμαί πω μαθεῖν
ὁπότερος ὑμῶν ἐστι θεός. ἀλλ' εἴσιτον·
ὁ δεσπότης γὰρ αὐτὸς ὑμᾶς γνώσεται
χἠ Φερσέφατθ', ἅτ' ὄντε κἀκείνω θεώ.
ΔΙ. ὀρθῶς λέγεις· ἐβουλόμην δ' ἂν τοῦτό σε
πρότερον ποιῆσαι, πρὶν ἐμὲ τὰς πληγὰς λαβεῖν.

Enter AIAKUS, *followed by demons dressed as policemen.*

AIAKUS

Quick, bind this dog-thief! Haul the rogue away
For punishment!

BACCHUS

 Who's in a tight place, eh?

XANTHIAS

Go to the devil! Don't you dare draw near!

AIAKUS

What?—show fight? Ditylus, Strebylus, Pardokas, here!
At him—fight!—give the rogue a proper drubbing!

 XANTHIAS *lays about him with his club: they sheer off.*

BACCHUS

(*Raising hands in horror*). Oh shocking! shocking!—here's a fellow
 clubbing
The very folks he's robbed!

AIAKUS

 It's worse—it's awful!

BACCHUS

Quite so, sir—truly appalling—most unlawful!

 They begin cautiously to close in again.

XANTHIAS

Look here—by Jove, I'm willing to be put
To death, if here I've ever once set foot,

145

Or stolen from you the value of a hair!
I'll do the gentlemanly thing—see there!
My slave—seize and to the torture lead the boy;
And if you prove me guilty, I'll die with joy!

AIAKUS

Well, and what tortures am I free to employ?

XANTHIAS

All sorts—first tie him up to the triangle,
Then, as he hangs there, whip him, flay and mangle:
Rack him—that's slow and humorous: or suppose
You squirt some boiling vinegar up his nose?
Or lay upon his belly bricks red-hot?
Try all the tortures—only not, oh not
Use a soft whip of leek or young shallot.

AIAKUS

H'm, a fair offer! Of course, in case I maim
Your slave, I will discharge your damages-claim.

XANTHIAS

Never mind that! Quick, lead the fellow away,
And get on with the torture.

AIAKUS

 No, we'll stay
Here, and make him speak out before your eyes.
(*To* BACCHUS) Now, you, put down that bundle sharp! No lies
Here, mind you!

BACCHUS

 (*Shrieks*). You can't do it!—I warn you
I'm a cit—no, an immortal!—if you do,
Blame yourself for the consequences!

AIAKUS

 Eh?

What's that?

BACCHUS

 I'm an immortal God, I say,
Zeus' son Dionysus! He—he's just my slave,
This rogue!

AIAKUS

 D'ye hear that?

XANTHIAS

 O, I hear the knave!
All the more should you whack him; 'twill reveal it:
If he's a true God, he will never feel it.

BACCHUS

But if you too are a God, you can't deny
You should receive as many licks as I.

146

XANTHIAS

That's fair, of course. Whichever of us, when hit,
You see shed tears, or mind the blows one bit,
You'll know he's not a God, but just a fraud.

AIAKUS

You're a true gentleman—if not a God—
To meet us on fair terms like that! Coats off!

XANTHIAS

How will you test us fairly?

AIAKUS

 Easy enough:
I'll give you whack and whack about.

XANTHIAS

 All right.

The two are hoisted, each on a demon's back.

AIAKUS

(*Strikes* XANTHIAS). There!

XANTHIAS

 Watch now if you see me flinch one mite!

AIAKUS

Why, I *have* hit you!

XANTHIAS

 Hit?—not you, by Jove!

AIAKUS

No sign of it! I'll try the other cove. (*Strikes* BACCHUS.)

BACCHUS

Well, what are you waiting for?

AIAKUS

 I *have* hit!

BACCHUS

 No!
Why didn't I even sneeze, then, at the blow?

AIAKUS

I don't know. Well, I'll try this chap once more.

XANTHIAS

Look sharp, then! (AIAKUS *strikes*). Oh!—ah!—oh!

AIAKUS

 Why do you roar?
Weren't you in pain?

XANTHIAS

 Not I! I thought, 'O dear,
Herakles'—that's my—Feast must be quite near!'

AIAKUS

The holy man! Well, here again I'll try. (*Strikes* BACCHUS.)

BACCHUS

Oh!—oh!

AIAKUS

What's up?

BACCHUS

La!—I see cavalry!

AIAKUS

But why those tears?

BACCHUS

I smell sliced onions—faugh!

AIAKUS

But didn't you mind the whack?

BACCHUS

That?—never a straw!

AIAKUS

Must try again to make this fellow feel. (*Strikes* XANTHIAS.)

XANTHIAS

O dear!

AIAKUS

What?

XANTHIAS

Take this thorn out of my heel!

AIAKUS

What can this mean? Here goes at t'other again! (*Strikes* BACCHUS.)

BACCHUS

(*Yells*). O Phoebus!—'dweller in Pytho or Delos' fane!'

XANTHIAS

That stung! you heard!

BACCHUS

Tut! I recalled, you dunce,
A noble line Hipponax rolled out once.

XANTHIAS

You're bungling—his back's hardened to the whip.
Try the soft flesh in front above the hip.

AIAKUS

By Jove, yes! (*To demon.*) Turn his belly towards me now. (*Strikes.*)

BACCHUS

Oh Lord!—

XANTHIAS

That hurt!—no doubt about that row!

BACCHUS

'Of seas, thou monarch of the Aegean steep,
Lord of abysses of the hoary deep!'

148

Good heavens! I can't make out, I do declare,
Which of you is the God! . . . Well, pass in there. (*Points to door.*)
Master himself—he and Persephone
Are also Gods—will solve this mystery.

BACCHUS

That's sense! I only wish you'd done it, man,
Before the experiments on my back began!

The Frogs, 605-73
Translated by Arthur S. Way

Nothing in the world surpasses in stormy fun the scene in THE FROGS, *when Bacchus and Xanthias receive their thrashings from the hands of businesslike Œacus.*

GEORGE MEREDITH
An Essay on Comedy (1897)

ISOCRATES

4 3 6 — 3 3 8 B . C .

ON THE PUBLIC SAFETY

Πολλοὺς ὑμῶν οἶμαι θαυμάζειν ἥντινά ποτε γνώμην ἔχων περὶ σωτηρίας τὴν πρόσοδον ἐποιησάμην, ὥσπερ τῆς πόλεως ἐν κινδύνοις οὔσης ἢ σφαλερῶς αὐτῇ τῶν πραγμάτων καθεστηκότων, ἀλλ' οὐ πλείους μὲν τριήρεις ἢ διακοσίας κεκτημένης, εἰρήνην δὲ καὶ τὰ περὶ τὴν χώραν ἀγούσης, καὶ τῶν κατὰ θάλατταν ἀρχούσης, ἔτι δὲ συμμάχους ἐχούσης πολλοὺς μὲν τοὺς ἑτοίμως ἡμῖν, ἤν τι δέῃ, βοηθήσοντας, πολὺ δὲ πλείους τοὺς τὰς συντάξεις ὑποτελοῦντας καὶ τὸ προσταττόμενον ποιοῦντας· ὧν ὑπαρχόντων ἡμᾶς μὲν ἄν τις φήσειεν εἰκὸς εἶναι θαρρεῖν ὡς πόρρω τῶν κινδύνων ὄντας, τοῖς δ' ἐχθροῖς τοῖς ἡμετέροις προσήκειν δεδιέναι καὶ βουλεύεσθαι περὶ τῆς αὑτῶν σωτηρίας.

Ὑμεῖς μὲν οὖν οἶδ' ὅτι τούτῳ χρώμενοι τῷ λογισμῷ καὶ τῆς ἐμῆς προσόδου καταφρονεῖτε, καὶ πᾶσαν ἐλπίζετε τὴν Ἑλλάδα ταύτῃ τῇ δυνάμει κατασχήσειν· ἐγὼ δὲ δι' αὐτὰ ταῦτα τυγχάνω δεδιώς. ὁρῶ γὰρ τῶν πόλεων τὰς ἄριστα πράττειν οἰομένας κάκιστα βουλευομένας καὶ τὰς μάλιστα θαρρούσας εἰς πλείστους κινδύνους καθισταμένας. αἴτιον δὲ τούτων ἐστίν, ὅτι τῶν ἀγαθῶν καὶ τῶν κακῶν οὐδὲν αὐτὸ καθ' αὑτὸ παραγίγνεται τοῖς ἀνθρώποις, ἀλλὰ συντέτακται καὶ συνακολουθεῖ τοῖς μὲν πλούτοις καὶ ταῖς δυναστείαις ἄνοια

149

καὶ μετὰ ταύτης ἀκολασία, ταῖς δ' ἐνδείαις καὶ ταῖς ταπεινότηοι σω-
φροσύνη καὶ πολλὴ μετριότης, ὥστε χαλεπὸν εἶναι διαγνῶναι ποτέ-
ραν ἄν τις δέξαιτο τῶν μερίδων τούτων τοῖς παισὶ τοῖς αὑτοῦ κα-
ταλιπεῖν. ἴδοιμεν γὰρ ἂν ἐκ μὲν τῆς φαυλοτέρας εἶναι δοκούσης
ἐπὶ τὸ βέλτιον ὡς ἐπὶ τὸ πολὺ τὰς πράξεις ἐπιδιδούσας, ἐκ δὲ τῆς
κρείττονος φαινομένης ἐπὶ τὸ χεῖρον εἰθισμένας μεταπίπτειν.

Many of you are wondering, I suppose, what in the world my purpose
is in coming forward to address you on *the public safety*, as if Athens
were in danger or her affairs on an uncertain footing, when in fact she
possesses more than two hundred ships-of-war, enjoys peace throughout
her territory, maintains her empire on the sea, and has, furthermore,
many allies who, in case of any need, will readily come to her aid,
and many more allies who are paying their contributions and obeying
her commands. With these resources, one might argue that we have
every reason to feel secure, as being far removed from danger, while
our enemies may well be anxious and take thought for their own safety.

Now you, I know, following this reasoning, disdain my coming for-
ward, and are confident that with this power you will hold all Hellas
under your control. But as for myself, it is because of these very things
that I am anxious; for I observe that those cities which think they are
in the best circumstances are wont to adopt the worst policies, and that
those which feel the most secure are most often involved in danger. The
cause of this is that nothing of either good or of evil visits mankind
unmixed, but that riches and power are attended and followed by folly,
and folly in turn by licence; whereas poverty and lowliness are attended
by sobriety and great moderation; so that it is hard to decide which
of these lots one should prefer to bequeath to one's own children. For
we shall find that from a lot which seems to be inferior men's fortunes
generally advance to a better condition, whereas from one which ap-
pears to be superior they are wont to change to a worse.

<div align="right">

Areopagiticus, 1–5
Translated by George Norlin

</div>

*The smooth (or florid) mode of composition . . . has the following
features. It does not intend that each word should be seen on every
side, nor that all its parts should stand on broad, firm bases, nor that
the time-intervals between them should be long; nor in general is this
slow and deliberate movement congenial to it. It demands free move-
ment in its diction; it requires words to come sweeping along one on
top of another, each supported by that which follows, like the onflow
of a never-resting stream. It tries to combine and interweave its com-
ponent parts, and thus give, as far as possible, the effect of one continu-*

ous utterance. This result is produced by so nicely adjusting the junctures
that they admit no appreciable time-interval between the words. From
this point of view the style resembles finely woven stuffs, or pictures
in which the lights melt insensibly into the shadows. It requires that
all its words shall be melodious, smooth, soft as a maiden's face; and it
shrinks from harsh, clashing syllables, and carefully avoids everything
rash and hazardous. . . . Of all prose-writers he [Isocrates] is, I think,
the most finished master of this style of composition. . . .

The instinctive perception of the ear testifies that these words are
run and blended together; that they do not individually stand on a broad
foundation which gives an all-round view of each; and that they are not
separated by long time-intervals and planted far apart from one an-
other, but are plainly in a state of motion, being borne onwards in an
unbroken stream, while the links which bind the passage together are
gentle and soft and flowing. And it is easy to see that the sole cause lies
in the character of this style as I have previously described it. For no
dissonance of vowels will be found, at any rate in the harmonious
clauses which I have quoted, nor any, I think, in the entire speech,
unless some instance has escaped my notice. There are also few dis-
sonances of semi-vowels and mutes, and those not very glaring or
continuous. The euphonious flow of the passage is due to these circum-
stances, combined with the balance of the clauses and the cycle of the
periods which has about it something rounded and well-defined and
perfectly regulated in respect of symmetrical adjustment. Above all
there are the rhetorical figures, full of youthful exuberance: ANTITHESIS,
PARALLELISM IN SOUND, PARALLELISM IN STRUCTURE, and others like
these, by which the language of panegyric is brought to its highest
perfection.

<div align="right">

DIONYSIUS OF HALICARNASSUS
De Compositione Verborum, xxiii
Translated by W. Rhys Roberts

</div>

PLATO

4 2 7 ? — 3 4 7 B . C .

SOCRATES TO HIS JUDGES

'Αλλὰ γὰρ ἤδη ὥρα ἀπιέναι, ἐμοὶ μὲν ἀποθανουμένῳ, ὑμῖν δὲ βιωσο-
μένοις· ὁπότεροι δὲ ἡμῶν ἔρχονται ἐπὶ ἄμεινον πρᾶγμα, ἄδηλον
παντὶ πλὴν ἢ τῷ θεῷ,

151

But now the time has come to go away. I go to die, and you to live; but which of us goes to the better lot, is known to none but God.

Apology, 42A
Translated by H. N. Fowler

Perhaps the most beautiful prose sentence ever written.

GEORGE SAINTSBURY
A History of Engish Prose Rhythm (1922)

PLATO

4 2 7 ? — 3 4 7 B . C .

SOCRATES CONSULTS DIOTIMA ON LOVE

Τί οὖν ἄν, ἔφην, εἴη ὁ Ἔρως; θνητός;
Ἥκιστά γε.
Ἀλλὰ τί μήν;
Ὥσπερ τὰ πρότερα ἔφην, μεταξὺ θνητοῦ καὶ ἀθανάτου.
Τί οὖν, ὦ Διοτίμα;
Δαίμων μέγας, ὦ Σώκρατες· καὶ γὰρ πᾶν τὸ δαιμόνιον μεταξύ ἐστι θεοῦ τε καὶ θνητοῦ.
Τίνα, ἦν δ᾽ ἐγώ, δύναμιν ἔχον;
Ἑρμηνεῦον καὶ διαπορθμεῦον θεοῖς τὰ παρ᾽ ἀνθρώπων καὶ ἀνθρώ-ποις τὰ παρὰ θεῶν, τῶν μὲν τὰς δεήσεις καὶ θυσίας, τῶν δὲ τὰς ἐπιτάξεις τε καὶ ἀμοιβὰς [τῶν θυσιῶν], ἐν μέσῳ δὲ ὂν ἀμφοτέρων συμπληροῖ, ὥστε τὸ πᾶν αὐτὸ αὑτῷ συνδεδέσθαι. διὰ τούτου καὶ ἡ μαντικὴ πᾶσα χωρεῖ καὶ ἡ τῶν ἱερέων τέχνη τῶν τε περὶ τὰς θυσίας καὶ τὰς τελετὰς καὶ τὰς ἐπῳδὰς καὶ τὴν μαντείαν πᾶσαν καὶ γοη-τείαν. θεὸς δὲ ἀνθρώπῳ οὐ μίγνυται, ἀλλὰ διὰ τούτου πᾶσά ἐστιν ἡ ὁμιλία καὶ ἡ διάλεκτος θεοῖς πρὸς ἀνθρώπους <καὶ πρὸς θεοὺς ἀνθρώποις>, καὶ ἐγρηγορόσι καὶ καθεύδουσι· καὶ ὁ μὲν περὶ τὰ τοιαῦτα σοφὸς δαιμόνιος ἀνήρ, ὁ δὲ ἄλλο τι σοφὸς ὢν ἢ περὶ τέχνας ἢ χειρουργίας τινὰς βάναυσος. οὗτοι δὴ οἱ δαίμονες πολλοὶ καὶ παν-τοδαποί εἰσιν, εἷς δὲ τούτων ἐστὶ καὶ ὁ Ἔρως.
Πατρὸς δέ, ἦν δ᾽ ἐγώ, τίνος ἐστὶ καὶ μητρός;
Μακρότερον μέν, ἔφη, διηγήσασθαι· ὅμως δέ σοι ἐρῶ. ὅτε γὰρ ἐγένετο ἡ Ἀφροδίτη, εἱστιῶντο οἱ θεοί, οἵ τε ἄλλοι καὶ ὁ τῆς Μή-τιδος υἱὸς Πόρος. ἐπειδὴ δὲ ἐδείπνησαν, προσαιτήσουσα οἷον δὴ εὐωχίας οὔσης ἀφίκετο ἡ Πενία, καὶ ἦν περὶ τὰς θύρας. ὁ οὖν Πόρος μεθυσθεὶς τοῦ νέκταρος, οἶνος γὰρ οὔπω ἦν, εἰς τὸν τοῦ

Διὸς κῆπον εἰσελθὼν βεβαρημένος ηὗδεν. ἡ οὖν Πενία ἐπιβουλεύουσα διὰ τὴν αὑτῆς ἀπορίαν παιδίον ποιήσασθαι ἐκ τοῦ Πόρου, κατακλίνεταί τε παρ' αὐτῷ καὶ ἐκύησε τὸν Ἔρωτα. διὸ δὴ καὶ τῆς Ἀφροδίτης ἀκόλουθος καὶ θεράπων γέγονεν ὁ Ἔρως, γεννηθεὶς ἐν τοῖς ἐκείνης γενεθλίοις, καὶ ἅμα φύσει ἐραστὴς ὢν περὶ τὸ καλὸν καὶ τῆς Ἀφροδίτης καλῆς οὔσης. ἅτε οὖν Πόρου καὶ Πενίας υἱὸς ὢν ὁ Ἔρως ἐν τοιαύτῃ τύχῃ καθέστηκε. πρῶτον μὲν πένης ἀεί ἐστι, καὶ πολλοῦ δεῖ ἁπαλός τε καὶ καλός, οἷον οἱ πολλοὶ οἴονται, ἀλλὰ σκληρὸς καὶ αὐχμηρὸς καὶ ἀνυπόδητος καὶ ἄοικος, χαμαιπετὴς ἀεὶ ὢν καὶ ἄστρωτος, ἐπὶ θύραις καὶ ἐν ὁδοῖς ὑπαίθριος κοιμώμενος, τὴν τῆς μητρὸς φύσιν ἔχων, ἀεὶ ἐνδείᾳ σύνοικος. κατὰ δὲ αὖ τὸν πατέρα ἐπίβουλός ἐστι τοῖς καλοῖς καὶ τοῖς ἀγαθοῖς, ἀνδρεῖος ὢν καὶ ἴτης καὶ σύντονος, θηρευτὴς δεινός, ἀεί τινας πλέκων μηχανάς, καὶ φρονήσεως ἐπιθυμητὴς καὶ πόριμος, φιλοσοφῶν διὰ παντὸς τοῦ βίου, δεινὸς γόης καὶ φαρμακεὺς καὶ σοφιστής· καὶ οὔτε ὡς ἀθάνατος πέφυκεν οὔτε ὡς θνητός, ἀλλὰ τοτὲ μὲν τῆς αὐτῆς ἡμέρας θάλλει τε καὶ ζῇ, ὅταν εὐπορήσῃ, τοτὲ δὲ ἀποθνῄσκει, πάλιν δὲ ἀναβιώσκεται διὰ τὴν τοῦ πατρὸς φύσιν, τὸ δὲ ποριζόμενον ἀεὶ ὑπεκρεῖ· ὥστε οὔτε ἀπορεῖ Ἔρως ποτὲ οὔτε πλουτεῖ, σοφίας τε αὖ καὶ ἀμαθίας ἐν μέσῳ ἐστίν. ἔχει γὰρ ὧδε. θεῶν οὐδεὶς φιλοσοφεῖ οὐδ' ἐπιθυμεῖ σοφὸς γενέσθαι· ἔστι γάρ· οὐδ' εἴ τις ἄλλος σοφός, οὐ φιλοσοφεῖ. οὐδ' αὖ οἱ ἀμαθεῖς φιλοσοφοῦσιν οὐδ' ἐπιθυμοῦσι σοφοὶ γενέσθαι· αὐτὸ γὰρ τοῦτό ἐστι χαλεπὸν ἀμαθία, τὸ μὴ ὄντα καλὸν κἀγαθὸν μηδὲ φρόνιμον δοκεῖν αὐτῷ εἶναι ἱκανόν· οὔκουν ἐπιθυμεῖ ὁ μὴ οἰόμενος ἐνδεὴς εἶναι οὗ ἂν μὴ οἴηται ἐπιδεῖσθαι.

Τίνες οὖν, ἔφην ἐγώ, ὦ Διοτίμα, οἱ φιλοσοφοῦντες, εἰ μήτε οἱ σοφοὶ μήτε οἱ ἀμαθεῖς;

Δῆλον, ἔφη, τοῦτό γε ἤδη καὶ παιδί, ὅτι οἱ μεταξὺ τούτων ἀμφοτέρων, ὧν αὖ καὶ ὁ Ἔρως. ἔστι γὰρ δὴ τῶν καλλίστων ἡ σοφία, Ἔρως δ' ἐστὶν ἔρως περὶ τὸ καλόν, ὥστε ἀναγκαῖον Ἔρωτα φιλόσοφον εἶναι, φιλόσοφον δὲ ὄντα μεταξὺ εἶναι σοφοῦ καὶ ἀμαθοῦς. αἰτία δ' αὐτῷ καὶ τούτων ἡ γένεσις· πατρὸς μὲν γὰρ σοφοῦ ἐστι καὶ εὐπόρου, μητρὸς δὲ οὐ σοφῆς καὶ ἀπόρου. ἡ μὲν οὖν φύσις τοῦ δαίμονος, ὦ φίλε Σώκρατες, αὕτη· ὃν δὲ σὺ ᾠήθης Ἔρωτα εἶναι, θαυμαστὸν οὐδὲν ἔπαθες. ᾠήθης δέ, ὡς ἐμοὶ δοκεῖ τεκμαιρομένῃ ἐξ ὧν σὺ λέγεις, τὸ ἐρώμενον Ἔρωτα εἶναι, οὐ τὸ ἐρῶν. διὰ ταῦτά σοι, οἶμαι, πάγκαλος ἐφαίνετο ὁ Ἔρως. καὶ γὰρ ἔστι τὸ ἐραστὸν τὸ τῷ ὄντι καλὸν καὶ ἁβρὸν καὶ τέλεον καὶ μακαριστόν· τὸ δέ γε ἐρῶν ἄλλην ἰδέαν τοιαύτην ἔχον, οἵαν ἐγὼ διῆλθον.

Καὶ ἐγὼ εἶπον, Εἶεν δή, ὦ ξένη· καλῶς γὰρ λέγεις· τοιοῦτος ὢν ὁ Ἔρως τίνα χρείαν ἔχει τοῖς ἀνθρώποις;

Τοῦτο δὴ μετὰ ταῦτ', ἔφη, ὦ Σώκρατες, πειράσομαί σε διδάξαι. ἔστι μὲν γὰρ δὴ τοιοῦτος καὶ οὕτω γεγονὼς ὁ Ἔρως, ἔστι δὲ τῶν καλῶν, ὡς σὺ φής. εἰ δέ τις ἡμᾶς ἔροιτο· τί τῶν καλῶν ἐστιν ὁ

153

Ἔρως, ὦ Σώκρατές τε καὶ Διοτίμα; ὧδε δὲ σαφέστερον ἐρῶ· ὁ ἐρῶν τῶν καλῶν τί ἐρᾷ;

Καὶ ἐγὼ εἶπον ὅτι Γενέσθαι αὑτῷ.

Ἀλλ' ἔτι ποθεῖ, ἔφη, ἡ ἀπόκρισις ἐρώτησιν τοιάνδε· τί ἔσται ἐκείνῳ ᾧ ἂν γένηται τὰ καλά;

Οὐ πάνυ ἔφην ἔτι ἔχειν ἐγὼ πρὸς ταύτην τὴν ἐρώτησιν προχείρως ἀποκρίνασθαι.

Ἀλλ', ἔφη, ὥσπερ ἂν εἴ τις μεταβαλὼν ἀντὶ τοῦ καλοῦ τῷ ἀγαθῷ χρώμενος πυνθάνοιτο· φέρε, ὦ Σώκρατες, ἐρῶ· ὁ ἐρῶν τῶν ἀγαθῶν τί ἐρᾷ;

Γενέσθαι, ἦν δ' ἐγώ, αὑτῷ.

Καὶ τί ἔσται ἐκείνῳ ᾧ ἂν γένηται τἀγαθά;

Τοῦτ' εὐπορώτερον, ἦν δ' ἐγώ, ἔχω ἀποκρίνασθαι, ὅτι εὐδαίμων ἔσται.

Κτήσει γάρ, ἔφη, ἀγαθῶν οἱ εὐδαίμονες εὐδαίμονες, καὶ οὐκέτι προσδεῖ ἐρέσθαι, ἵνα τί δὲ βούλεται εὐδαίμων εἶναι ὁ βουλόμενος, ἀλλὰ τέλος δοκεῖ ἔχειν ἡ ἀπόκρισις.

Ἀληθῆ λέγεις, εἶπον ἐγώ.

Ταύτην δὲ τὴν βούλησιν καὶ τὸν ἔρωτα τοῦτον πότερα κοινὸν οἴει εἶναι πάντων ἀνθρώπων, καὶ πάντας τἀγαθὰ βούλεσθαι αὑτοῖς εἶναι ἀεί, ἢ πῶς λέγεις;

Οὕτως, ἦν δ' ἐγώ· κοινὸν εἶναι πάντων.

Τί δὴ οὖν, ἔφη, ὦ Σώκρατες, οὐ πάντας ἐρᾶν φαμέν, εἴπερ γε πάντες τῶν αὐτῶν ἐρῶσι καὶ ἀεί, ἀλλὰ τινάς φαμεν ἐρᾶν, τοὺς δ' οὔ;

Θαυμάζω, ἦν δ' ἐγώ, καὶ αὐτός.

Ἀλλὰ μὴ θαύμαζ', ἔφη· ἀφελόντες γὰρ τοῦ ἔρωτός τι εἶδος ὀνομάζομεν, τὸ τοῦ ὅλου ἐπιτιθέντες ὄνομα, ἔρωτα, τὰ δὲ ἄλλα ἄλλοις καταχρώμεθα ὀνόμασιν.

Ὥσπερ τί; ἦν δ' ἐγώ.

Ὥσπερ τόδε. οἶσθ' ὅτι ποίησίς ἐστί τι πολύ· ἡ γάρ τοι ἐκ τοῦ μὴ ὄντος εἰς τὸ ὂν ἰόντι ὁτῳοῦν αἰτία πᾶσά ἐστι ποίησις, ὥστε καὶ αἱ ὑπὸ πάσαις ταῖς τέχναις ἐργασίαι ποιήσεις εἰσὶ καὶ οἱ τούτων δημιουργοὶ πάντες ποιηταί.

Ἀληθῆ λέγεις.

Ἀλλ' ὅμως, ἦ δ' ἥ, οἶσθ' ὅτι οὐ καλοῦνται ποιηταὶ ἀλλ' ἄλλα ἔχουσιν ὀνόματα, ἀπὸ δὲ πάσης τῆς ποιήσεως ἓν μόριον ἀφορισθὲν τὸ περὶ τὴν μουσικὴν καὶ τὰ μέτρα τῷ τοῦ ὅλου ὀνόματι προσαγορεύεται. ποίησις γὰρ τοῦτο μόνον καλεῖται, καὶ οἱ ἔχοντες τοῦτο τὸ μόριον τῆς ποιήσεως ποιηταί.

Ἀληθῆ λέγεις, ἔφην.

Οὕτω τοίνυν καὶ περὶ τὸν ἔρωτα· τὸ μὲν κεφάλαιόν ἐστι πᾶσα ἡ τῶν ἀγαθῶν ἐπιθυμία καὶ τοῦ εὐδαιμονεῖν, "ὁ μέγιστός τε καὶ δολερὸς ἔρως παντί"· ἀλλ' οἱ μὲν ἄλλῃ τρεπόμενοι πολλαχῇ ἐπ' αὐτόν, ἢ κατὰ χρηματισμὸν ἢ κατὰ φιλογυμναστίαν ἢ κατὰ φιλοσοφίαν,

οὔτ' ἐρᾶν καλοῦνται οὔτ' ἐρασταί, οἱ δὲ κατὰ ἕν τι εἶδος ἰόντες τε καὶ ἐσπουδακότες τὸ τοῦ ὅλου ὄνομα ἴσχουσιν [ἔρωτά τε] καὶ ἐρᾶν καὶ ἐρασταί.

Κινδυνεύεις ἀληθῆ, ἔφην ἐγώ, λέγειν.

Καὶ λέγεται μέν γέ τις, ἔφη, λόγος, ὡς οἳ ἂν τὸ ἥμισυ ἑαυτῶν ζητῶσιν, οὗτοι ἐρῶσιν· ὁ δ' ἐμὸς λόγος οὔθ' ἡμίσεός φησιν εἶναι τὸν ἔρωτα οὔθ' ὅλου, ἐὰν μὴ τυγχάνῃ γέ που, ὦ ἑταῖρε, ἀγαθὸν ὄν· ἐπεὶ αὑτῶν γε καὶ πόδας καὶ χεῖρας ἐθέλουσιν ἀποτέμνεσθαι οἱ ἄνθρωποι, ἐὰν αὑτοῖς δοκῇ τὰ ἑαυτῶν πονηρὰ εἶναι. οὐ γὰρ τὸ ἑαυτῶν, οἶμαι, ἕκαστοι ἀσπάζονται, εἰ μὴ εἴ τις τὸ μὲν ἀγαθὸν οἰκεῖον καλεῖ καὶ ἑαυτοῦ, τὸ δὲ κακὸν ἀλλότριον· ὡς οὐδέν γε ἄλλο ἐστὶν οὗ ἐρῶσιν ἄνθρωποι ἢ τοῦ ἀγαθοῦ· ἢ σοὶ δοκοῦσιν;

Μὰ Δί' οὐκ ἔμοιγε, ἦν δ' ἐγώ.

Ἆρ' οὖν, ἦ δ' ἥ, οὕτως ἁπλοῦν ἐστι λέγειν, ὅτι οἱ ἄνθρωποι τοῦ ἀγαθοῦ ἐρῶσιν;

Ναί, ἔφην.

Τί δέ; οὐ προσθετέον, ἔφη, ὅτι καὶ εἶναι τὸ ἀγαθὸν αὑτοῖς ἐρῶσιν;

Προσθετέον.

Ἆρ' οὖν, ἔφη, καὶ οὐ μόνον εἶναι, ἀλλὰ καὶ ἀεὶ εἶναι;

Καὶ τοῦτο προσθετέον.

Ἔστιν ἄρα συλλήβδην, ἔφη, ὁ ἔρως τοῦ τὸ ἀγαθὸν αὑτῷ εἶναι ἀεί.

Ἀληθέστατα, ἔφην ἐγώ, λέγεις.

Ὅτε δὴ τούτου ὁ ἔρως ἐστὶν ἀεί, ἦ δ' ἥ, τῶν τίνα τρόπον διωκόντων αὐτὸ καὶ ἐν τίνι πράξει ἡ σπουδὴ καὶ ἡ σύντασις ἔρως ἂν καλοῖτο; τί τοῦτο τυγχάνειν ὂν τὸ ἔργον; ἔχεις εἰπεῖν;

Οὐ μεντἂν σέ, ἔφην ἐγώ, ὦ Διοτίμα, ἐθαύμαζον ἐπὶ σοφίᾳ καὶ ἐφοίτων παρὰ σὲ αὐτὰ ταῦτα μαθησόμενος.

Ἀλλ' ἐγώ σοι, ἔφη, ἐρῶ. ἔστι γὰρ τοῦτο τόκος ἐν καλῷ καὶ κατὰ τὸ σῶμα καὶ κατὰ τὴν ψυχήν.

Μαντείας, ἦν δ' ἐγώ, δεῖται ὅ τί ποτε λέγεις, καὶ οὐ μανθάνω.

Ἀλλ' ἐγώ, ἦ δ' ἥ, σαφέστερον ἐρῶ. κυοῦσι γάρ, ἔφη, ὦ Σώκρατες, πάντες ἄνθρωποι καὶ κατὰ τὸ σῶμα καὶ κατὰ τὴν ψυχήν, καὶ ἐπειδὰν ἔν τινι ἡλικίᾳ γένωνται, τίκτειν ἐπιθυμεῖ ἡμῶν ἡ φύσις. τίκτειν δὲ ἐν μὲν αἰσχρῷ οὐ δύναται, ἐν δὲ τῷ καλῷ. ἡ γὰρ ἀνδρὸς καὶ γυναικὸς συνουσία τόκος ἐστίν. ἔστι δὲ τοῦτο θεῖον τὸ πρᾶγμα, καὶ τοῦτο ἐν θνητῷ ὄντι τῷ ζῴῳ ἀθάνατον ἔνεστιν, ἡ κύησις καὶ ἡ γέννησις. τὰ δ' ἐν τῷ ἀναρμόστῳ ἀδύνατον γενέσθαι. ἀνάρμοστον δ' ἐστὶ τὸ αἰσχρὸν παντὶ τῷ θείῳ, τὸ δὲ καλὸν ἁρμόττον. Μοῖρα οὖν καὶ Εἰλείθυια ἡ Καλλονή ἐστι τῇ γενέσει. διὰ ταῦτα ὅταν μὲν καλῷ προσπελάζῃ τὸ κυοῦν, ἵλεών τε γίγνεται καὶ εὐφραινόμενον διαχεῖται καὶ τίκτει τε καὶ γεννᾷ· ὅταν δὲ αἰσχρῷ, σκυθρωπόν τε καὶ λυπούμενον συσπειρᾶται καὶ ἀποτρέπεται καὶ ἀνείλλεται καὶ οὐ γεννᾷ, ἀλλὰ ἴσχον τὸ κύημα χαλεπῶς φέρει. ὅθεν δὴ τῷ κυοῦντί τε καὶ ἤδη σπαργῶντι πολλὴ ἡ πτοίησις γέγονε περὶ τὸ καλὸν διὰ τὸ με-

155

γάλης ὠδῖνος ἀπολύειν τὸν ἔχοντα. ἔστι γάρ, ὦ Σώκρατες, ἔφη, οὐ τοῦ καλοῦ ὁ ἔρως, ὡς σὺ οἴει.

Ἀλλὰ τί μήν;

Τῆς γεννήσεως καὶ τοῦ τόκου ἐν τῷ καλῷ.

Εἶεν, ἦν δ' ἐγώ.

Πάνυ μὲν οὖν, ἔφη. τί δὴ οὖν τῆς γεννήσεως; ὅτι ἀειγενές ἐστι καὶ ἀθάνατον ὡς θνητῷ ἡ γέννησις. ἀθανασίας δὲ ἀναγκαῖον ἐπιθυμεῖν μετὰ ἀγαθοῦ ἐκ τῶν ὡμολογημένων, εἴπερ τοῦ ἀγαθὸν ἑαυτῷ εἶναι ἀεὶ ἔρως ἐστίν. ἀναγκαῖον δὴ ἐκ τούτου τοῦ λόγου καὶ τῆς ἀθανασίας τὸν ἔρωτα εἶναι.

Ταῦτά τε οὖν πάντα ἐδίδασκέ με, ὁπότε περὶ τῶν ἐρωτικῶν λόγους ποιοῖτο, καί ποτε ἤρετο Τί οἴει, ὦ Σώκρατες, αἴτιον εἶναι τούτου τοῦ ἔρωτος καὶ τῆς ἐπιθυμίας; ἢ οὐκ αἰσθάνῃ ὡς δεινῶς διατίθεται πάντα τὰ θηρία, ἐπειδὰν γεννᾶν ἐπιθυμήσῃ, καὶ τὰ πεζὰ καὶ τὰ πτηνά, νοσοῦντά τε πάντα καὶ ἐρωτικῶς διατιθέμενα, πρῶτον μὲν περὶ τὸ συμμιγῆναι ἀλλήλοις, ἔπειτα περὶ τὴν τροφὴν τοῦ γενομένου, καὶ ἕτοιμά ἐστιν ὑπὲρ τούτων καὶ διαμάχεσθαι τὰ ἀσθενέστατα τοῖς ἰσχυροτάτοις καὶ ὑπεραποθνήσκειν, καὶ αὐτὰ τῷ λιμῷ παρατεινόμενα ὥστ' ἐκεῖνα ἐκτρέφειν, καὶ ἄλλο πᾶν ποιοῦντα; τοὺς μὲν γὰρ ἀνθρώπους, ἔφη, οἴοιτ' ἄν τις ἐκ λογισμοῦ ταῦτα ποιεῖν· τὰ δὲ θηρία τίς αἰτία οὕτως ἐρωτικῶς διατίθεσθαι; ἔχεις λέγειν;

Καὶ ἐγὼ αὖ ἔλεγον ὅτι οὐκ εἰδείην· ἡ δ' εἶπε, Διανοῇ οὖν δεινός ποτε γενήσεσθαι τὰ ἐρωτικὰ ἐὰν ταῦτα μὴ ἐννοῇς;

Ἀλλὰ διὰ ταῦτά τοι, ὦ Διοτίμα, ὅπερ νῦν δὴ εἶπον, παρὰ σὲ ἥκω, γνοὺς ὅτι διδασκάλων δέομαι. ἀλλά μοι λέγε καὶ τούτων τὴν αἰτίαν καὶ τῶν ἄλλων τῶν περὶ τὰ ἐρωτικά.

Εἰ τοίνυν, ἔφη, πιστεύεις ἐκείνου εἶναι φύσει τὸν ἔρωτα, οὗ πολλάκις ὡμολογήκαμεν, μὴ θαύμαζε. ἐνταῦθα γὰρ τὸν αὐτὸν ἐκείνῳ λόγον ἡ θνητὴ φύσις ζητεῖ κατὰ τὸ δυνατὸν ἀεὶ τὸ εἶναι ἀθάνατος. δύναται δὲ ταύτῃ μόνον, τῇ γενέσει, ὅτι ἀεὶ καταλείπει ἕτερον νέον ἀντὶ τοῦ παλαιοῦ, ἐπεὶ καὶ ἐν ᾧ ἓν ἕκαστον τῶν ζῴων ζῆν καλεῖται καὶ εἶναι τὸ αὐτό, οἷον ἐκ παιδαρίου ὁ αὐτὸς λέγεται ἕως ἂν πρεσβύτης γένηται· οὗτος μέντοι οὐδέποτε τὰ αὐτὰ ἔχων ἐν αὑτῷ ὅμως ὁ αὐτὸς καλεῖται, ἀλλὰ νέος ἀεὶ γιγνόμενος, τὰ δὲ ἀπολλύς, καὶ κατὰ τὰς τρίχας καὶ σάρκα καὶ ὀστᾶ καὶ αἷμα καὶ σύμπαν τὸ σῶμα. καὶ μὴ ὅτι κατὰ τὸ σῶμα, ἀλλὰ καὶ κατὰ τὴν ψυχὴν οἱ τρόποι, τὰ ἤθη, δόξαι, ἐπιθυμίαι, ἡδοναί, λῦπαι, φόβοι, τούτων ἕκαστα οὐδέποτε τὰ αὐτὰ πάρεστιν ἑκάστῳ, ἀλλὰ τὰ μὲν γίγνεται, τὰ δὲ ἀπόλλυται. πολὺ δὲ τούτων ἀτοπώτερον ἔτι, ὅτι καὶ αἱ ἐπιστῆμαι μὴ ὅτι αἱ μὲν γίγνονται, αἱ δὲ ἀπόλλυνται ἡμῖν, καὶ οὐδέποτε οἱ αὐτοί ἐσμεν οὐδὲ κατὰ τὰς ἐπιστήμας, ἀλλὰ καὶ μία ἑκάστη τῶν ἐπιστημῶν ταὐτὸν πάσχει. ὃ γὰρ καλεῖται μελετᾶν, ὡς ἐξιούσης ἐστὶ τῆς ἐπιστήμης· λήθη γὰρ ἐπιστήμης ἔξοδος, μελέτη δὲ πάλιν καινὴν ἐμποιοῦσα ἀντὶ τῆς ἀπιούσης [μνήμην] σῴζει τὴν ἐπιστήμην, ὥστε

τὴν αὐτὴν δοκεῖν εἶναι. τούτῳ γὰρ τῷ τρόπῳ πᾶν τὸ θνητὸν σῴζεται, οὐ τῷ παντάπασι τὸ αὐτὸ ἀεὶ εἶναι ὥσπερ τὸ θεῖον, ἀλλὰ τῷ τὸ ἀπιὸν καὶ παλαιούμενον ἕτερον νέον ἐγκαταλείπειν οἷον αὐτὸ ἦν. ταύτῃ τῇ μηχανῇ, ὦ Σώκρατες, ἔφη, θνητὸν ἀθανασίας μετέχει, καὶ σῶμα καὶ τἆλλα πάντα· ἀδύνατον δὲ ἄλλῃ. μὴ οὖν θαύμαζε εἰ τὸ αὐτοῦ ἀποβλάστημα φύσει πᾶν τιμᾷ· ἀθανασίας γὰρ χάριν παντὶ αὕτη ἡ σπουδὴ καὶ ὁ ἔρως ἕπεται.

Καὶ ἐγὼ ἀκούσας τὸν λόγον ἐθαύμασά τε καὶ εἶπον Εἶεν, ἦν δ' ἐγώ, ὦ σοφωτάτη Διοτίμα, ταῦτα ὡς ἀληθῶς οὕτως ἔχει;

Καὶ ἥ, ὥσπερ οἱ τέλεοι σοφισταί, Εὖ ἴσθι, ἔφη, ὦ Σώκρατες· ἐπεί γε καὶ τῶν ἀνθρώπων εἰ ἐθέλεις εἰς τὴν φιλοτιμίαν βλέψαι, θαυμάζοις ἂν τῆς ἀλογίας [πέρι] ἃ ἐγὼ εἴρηκα εἰ μὴ ἐννοεῖς, ἐνθυμηθεὶς ὡς δεινῶς διάκεινται ἔρωτι τοῦ ὀνομαστοὶ γενέσθαι ''καὶ κλέος εἰς τὸν ἀεὶ χρόνον ἀθάνατον καταθέσθαι,'' καὶ ὑπὲρ τούτου κινδύνους τε κινδυνεύειν ἕτοιμοί εἰσι πάντας ἔτι μᾶλλον ἢ ὑπὲρ τῶν παίδων, καὶ χρήματ' ἀναλίσκειν καὶ πόνους πονεῖν οὑστινασοῦν καὶ ὑπεραποθνήσκειν. ἐπεὶ οἴει σύ, ἔφη, Ἄλκηστιν ὑπὲρ Ἀδμήτου ἀποθανεῖν ἄν, ἢ Ἀχιλλέα Πατρόκλῳ ἐπαποθανεῖν, ἢ προαποθανεῖν τὸν ὑμέτερον Κόδρον ὑπὲρ τῆς βασιλείας τῶν παίδων, μὴ οἰομένους ''ἀθάνατον μνήμην ἀρετῆς πέρι'' ἑαυτῶν ἔσεσθαι, ἣν νῦν ἡμεῖς ἔχομεν; πολλοῦ γε δεῖ, ἔφη, ἀλλ', οἶμαι, ὑπὲρ ἀρετῆς ἀθανάτου καὶ τοιαύτης δόξης εὐκλεοῦς πάντες πάντα ποιοῦσιν, ὅσῳ ἂν ἀμείνους ὦσι, τοσούτῳ μᾶλλον· τοῦ γὰρ ἀθανάτου ἐρῶσιν. οἱ μὲν οὖν ἐγκύμονες, ἔφη, κατὰ σώματα ὄντες πρὸς τὰς γυναῖκας μᾶλλον τρέπονται καὶ ταύτῃ ἐρωτικοί εἰσι, διὰ παιδογονίας ἀθανασίαν καὶ μνήμην καὶ εὐδαιμονίαν, ὡς οἴονται, αὑτοῖς ''εἰς τὸν ἔπειτα χρόνον πάντα ποριζόμενοι·'' οἱ δὲ κατὰ τὴν ψυχήν—εἰσὶ γὰρ οὖν, ἔφη, οἳ ἐν ταῖς ψυχαῖς κυοῦσιν ἔτι μᾶλλον ἢ ἐν τοῖς σώμασιν, ἃ ψυχῇ προσήκει καὶ κυῆσαι καὶ τεκεῖν· τί οὖν προσήκει; φρόνησίν τε καὶ τὴν ἄλλην ἀρετήν· ὧν δή εἰσι καὶ οἱ ποιηταὶ πάντες γεννήτορες καὶ τῶν δημιουργῶν ὅσοι λέγονται εὑρετικοὶ εἶναι· πολὺ δὲ μεγίστη, ἔφη, καὶ καλλίστη τῆς φρονήσεως ἡ περὶ τὰς τῶν πόλεών τε καὶ οἰκήσεων διακοσμήσεις, ᾗ δὴ ὄνομά ἐστι σωφροσύνη τε καὶ δικαιοσύνη· τούτων αὖ ὅταν τις ἐκ νέου ἐγκύμων ᾖ τὴν ψυχὴν θεῖος ὤν, καὶ ἡκούσης τῆς ἡλικίας τίκτειν τε καὶ γεννᾶν ἤδη ἐπιθυμῇ, ζητεῖ δή, οἶμαι, καὶ οὗτος περιιὼν τὸ καλὸν ἐν ᾧ ἂν γεννήσειεν· ἐν τῷ γὰρ αἰσχρῷ οὐδέποτε γεννήσει. τά τε οὖν σώματα τὰ καλὰ μᾶλλον ἢ τὰ αἰσχρὰ ἀσπάζεται ἅτε κυῶν, καὶ ἐὰν ἐντύχῃ ψυχῇ καλῇ καὶ γενναίᾳ καὶ εὐφυεῖ, πάνυ δὴ ἀσπάζεται τὸ συναμφότερον, καὶ πρὸς τοῦτον τὸν ἄνθρωπον εὐθὺς εὐπορεῖ λόγων περὶ ἀρετῆς καὶ περὶ οἷον χρὴ εἶναι τὸν ἄνδρα τὸν ἀγαθὸν καὶ ἃ ἐπιτηδεύειν, καὶ ἐπιχειρεῖ παιδεύειν. ἁπτόμενος γάρ, οἶμαι, τοῦ καλοῦ καὶ ὁμιλῶν αὐτῷ, ἃ πάλαι ἐκύει τίκτει καὶ γεννᾷ, καὶ παρὼν καὶ ἀπὼν μεμνημένος, καὶ τὸ γεννηθὲν συνεκτρέφει κοινῇ μετ' ἐκείνου, ὥστε πολὺ μείζω

157

κοινωνίαν τῆς τῶν παίδων πρὸς ἀλλήλους οἱ τοιοῦτοι ἴσχουσι καὶ φιλίαν βεβαιοτέραν, ἅτε καλλιόνων καὶ ἀθανατωτέρων παίδων κεκοινωνηκότες. καὶ πᾶς ἂν δέξαιτο ἑαυτῷ τοιούτους παῖδας μᾶλλον γεγονέναι ἢ τοὺς ἀνθρωπίνους, καὶ εἰς Ὅμηρον ἀποβλέψας καὶ Ἡσίοδον καὶ τοὺς ἄλλους ποιητὰς τοὺς ἀγαθοὺς ζηλῶν οἷα ἔκγονα ἑαυτῶν καταλείπουσιν, ἃ ἐκείνοις ἀθάνατον κλέος καὶ μνήμην παρέχεται αὐτὰ τοιαῦτα ὄντα· εἰ δὲ βούλει, ἔφη, οἵους Λυκοῦργος παῖδας κατελίπετο ἐν Λακεδαίμονι σωτῆρας τῆς Λακεδαίμονος καὶ ὡς ἔπος εἰπεῖν τῆς Ἑλλάδος. τίμιος δὲ παρ᾽ ὑμῖν καὶ Σόλων διὰ τὴν τῶν νόμων γέννησιν, καὶ ἄλλοι ἄλλοθι πολλαχοῦ ἄνδρες, καὶ ἐν Ἕλλησι καὶ ἐν βαρβάροις, πολλὰ καὶ καλὰ ἀποφηνάμενοι ἔργα, γεννήσαντες παντοίαν ἀρετήν· ὧν καὶ ἱερὰ πολλὰ ἤδη γέγονε διὰ τοὺς τοιούτους παῖδας, διὰ δὲ τοὺς ἀνθρωπίνους οὐδενός πω.

Ταῦτα μὲν οὖν τὰ ἐρωτικὰ ἴσως, ὦ Σώκρατες, κἂν σὺ μυηθείης· τὰ δὲ τέλεα καὶ ἐποπτικά, ὧν ἕνεκα καὶ ταῦτα ἔστιν, ἐάν τις ὀρθῶς μετίῃ, οὐκ οἶδ᾽ εἰ οἷός τ᾽ ἂν εἴης. ἐρῶ μὲν οὖν, ἔφη, ἐγὼ καὶ προθυμίας οὐδὲν ἀπολείψω· πειρῶ δὲ <καὶ σὺ> ἕπεσθαι, ἂν οἷός τε ᾖς. δεῖ γάρ, ἔφη, τὸν ὀρθῶς ἰόντα ἐπὶ τοῦτο τὸ πρᾶγμα ἄρχεσθαι μὲν νέον ὄντα ἰέναι ἐπὶ τὰ καλὰ σώματα, καὶ πρῶτον μέν, ἐὰν ὀρθῶς ἡγῆται ὁ ἡγούμενος, ἑνὸς αὐτὸν σώματος ἐρᾶν καὶ ἐνταῦθα γεννᾶν λόγους καλούς, ἔπειτα δὲ αὐτὸν κατανοῆσαι, ὅτι τὸ κάλλος τὸ ἐπὶ ὁτῳοῦν σώματι τῷ ἐπὶ ἑτέρῳ σώματι ἀδελφόν ἐστι, καὶ εἰ δεῖ διώκειν τὸ ἐπ᾽ εἴδει καλόν, πολλὴ ἄνοια μὴ οὐχ ἕν τε καὶ ταὐτὸν ἡγεῖσθαι τὸ ἐπὶ πᾶσι τοῖς σώμασι κάλλος· τοῦτο δ᾽ ἐννοήσαντα καταστῆναι πάντων τῶν καλῶν σωμάτων ἐραστήν, ἑνὸς δὲ τὸ σφόδρα τοῦτο χαλάσαι καταφρονήσαντα καὶ σμικρὸν ἡγησάμενον· μετὰ δὲ ταῦτα τὸ ἐν ταῖς ψυχαῖς κάλλος τιμιώτερον ἡγήσασθαι τοῦ ἐν τῷ σώματι, ὥστε καὶ ἐὰν ἐπιεικὴς ὢν τὴν ψυχήν τις κἂν σμικρὸν ἄνθος ἔχῃ, ἐξαρκεῖν αὐτῷ καὶ ἐρᾶν καὶ κήδεσθαι καὶ τίκτειν λόγους τοιούτους καὶ ζητεῖν οἵτινες ποιήσουσι βελτίους τοὺς νέους, ἵνα ἀναγκασθῇ αὖ θεάσασθαι τὸ ἐν τοῖς ἐπιτηδεύμασι καὶ τοῖς νόμοις καλὸν καὶ τοῦτ᾽ ἰδεῖν ὅτι πᾶν αὐτὸ αὑτῷ συγγενές ἐστιν, ἵνα τὸ περὶ τὸ σῶμα καλὸν σμικρόν τι ἡγήσηται εἶναι· μετὰ δὲ τὰ ἐπιτηδεύματα ἐπὶ τὰς ἐπιστήμας ἀγαγεῖν, ἵνα ἴδῃ αὖ ἐπιστημῶν κάλλος, καὶ βλέπων πρὸς πολὺ ἤδη τὸ καλὸν μηκέτι τῷ παρ᾽ ἑνί, ὥσπερ οἰκέτης, ἀγαπῶν παιδαρίου κάλλος ἢ ἀνθρώπου τινὸς ἢ ἐπιτηδεύματος ἑνός, δουλεύων φαῦλος ᾖ καὶ σμικρολόγος, ἀλλ᾽ ἐπὶ τὸ πολὺ πέλαγος τετραμμένος τοῦ καλοῦ καὶ θεωρῶν πολλοὺς καὶ καλοὺς λόγους καὶ μεγαλοπρεπεῖς τίκτῃ καὶ διανοήματα ἐν φιλοσοφίᾳ ἀφθόνῳ, ἕως ἂν ἐνταῦθα ῥωσθεὶς καὶ αὐξηθεὶς κατίδῃ τινὰ ἐπιστήμην μίαν τοιαύτην, ἥ ἐστι καλοῦ τοιοῦδε. πειρῶ δέ μοι, ἔφη, τὸν νοῦν προσέχειν ὡς οἷόν τε μάλιστα.

Ὃς γὰρ ἂν μέχρι ἐνταῦθα πρὸς τὰ ἐρωτικὰ παιδαγωγηθῇ, θεώ-

μενος ἐφεξῆς τε καὶ ὀρθῶς τὰ καλά, πρὸς τέλος ἤδη ἰὼν τῶν ἐρω-
τικῶν ἐξαίφνης κατόψεταί τι θαυμαστὸν τὴν φύσιν καλόν, τοῦτο
ἐκεῖνο, ὦ Σώκρατες, οὗ δὴ ἕνεκεν καὶ οἱ ἔμπροσθεν πάντες πόνοι
ἦσαν, πρῶτον μὲν ἀεὶ ὂν καὶ οὔτε γιγνόμενον οὔτε ἀπολλύμενον,
οὔτε αὐξανόμενον οὔτε φθῖνον, ἔπειτα οὐ τῇ μὲν καλόν, τῇ δ᾽ αἰσ-
χρόν, οὐδὲ τοτὲ μέν, τοτὲ δ᾽ οὔ, οὐδὲ πρὸς μὲν τὸ καλόν, πρὸς δὲ τὸ
αἰσχρόν, οὐδ᾽ ἔνθα μὲν καλόν, ἔνθα δὲ αἰσχρόν, ὡς τισὶ μὲν ὂν κα-
λόν, τισὶ δὲ αἰσχρόν· οὐδ᾽ αὖ φαντασθήσεται αὐτῷ τὸ καλὸν οἷον
πρόσωπόν τι οὐδὲ χεῖρες οὐδὲ ἄλλο οὐδὲν ὧν σῶμα μετέχει, οὐδέ τις
λόγος οὐδέ τις ἐπιστήμη, οὐδέ που ὂν ἐν ἑτέρῳ τινί, οἷον ἐν ζῴῳ
ἢ ἐν γῇ ἢ ἐν οὐρανῷ ἢ ἔν τῳ ἄλλῳ, ἀλλὰ αὐτὸ καθ᾽ αὑτὸ μεθ᾽ αὑτοῦ
μονοειδὲς ἀεὶ ὄν, τὰ δὲ ἄλλα πάντα καλὰ ἐκείνου μετέχοντα τρόπον
τινὰ τοιοῦτον, οἷον γιγνομένων τε τῶν ἄλλων καὶ ἀπολλυμένων μη-
δὲν ἐκεῖνο μήτε τι πλέον μήτε ἔλαττον γίγνεσθαι μηδὲ πάσχειν μη-
δέν. ὅταν δή τις ἀπὸ τῶνδε διὰ τὸ ὀρθῶς παιδεραστεῖν ἐπανιὼν
ἐκεῖνο τὸ καλὸν ἄρχηται καθορᾶν, σχεδὸν ἄν τι ἅπτοιτο τοῦ τέλους.
τοῦτο γὰρ δή ἐστι τὸ ὀρθῶς ἐπὶ τὰ ἐρωτικὰ ἰέναι ἢ ὑπ᾽ ἄλλου ἄγε-
σθαι, ἀρχόμενον ἀπὸ τῶνδε τῶν καλῶν ἐκείνου ἕνεκα τοῦ καλοῦ ἀεὶ
ἐπανιέναι, ὥσπερ ἐπαναβαθμοῖς χρώμενον, ἀπὸ ἑνὸς ἐπὶ δύο καὶ
ἀπὸ δυοῖν ἐπὶ πάντα τὰ καλὰ σώματα, καὶ ἀπὸ τῶν καλῶν σωμάτων
ἐπὶ τὰ καλὰ ἐπιτηδεύματα, καὶ ἀπὸ τῶν ἐπιτηδευμάτων ἐπὶ τὰ κα-
λὰ μαθήματα, καὶ ἀπὸ τῶν μαθημάτων ἐπ᾽ ἐκεῖνο τὸ μάθημα τελευ-
τῆσαι, ὅ ἐστιν οὐκ ἄλλου ἢ αὐτοῦ ἐκείνου τοῦ καλοῦ μάθημα, ἵνα
γνῷ αὐτὸ τελευτῶν ὅ ἔστι καλόν. ἐνταῦθα τοῦ βίου, ὦ φίλε Σώ-
κρατες, ἔφη ἡ Μαντινικὴ ξένη, εἴπερ που ἄλλοθι, βιωτὸν ἀνθρώπῳ,
θεωμένῳ αὐτὸ τὸ καλόν. ὃ ἐάν ποτε ἴδῃς, οὐ κατὰ χρυσίον τε καὶ
ἐσθῆτα καὶ τοὺς καλοὺς παῖδάς τε καὶ νεανίσκους δόξει σοι εἶναι,
οὓς νῦν ὁρῶν ἐκπέπληξαι καὶ ἕτοιμος εἶ καὶ σὺ καὶ ἄλλοι πολλοί,
ὁρῶντες τὰ παιδικὰ καὶ συνόντες ἀεὶ αὐτοῖς, εἴ πως οἷόν τ᾽ ἦν, μή-
τε ἐσθίειν μήτε πίνειν, ἀλλὰ θεᾶσθαι μόνον καὶ συνεῖναι. τί δῆτα,
ἔφη, οἰόμεθα, εἴ τῳ γένοιτο αὐτὸ τὸ καλὸν ἰδεῖν εἰλικρινές, καθα-
ρόν, ἄμικτον, ἀλλὰ μὴ ἀνάπλεων σαρκῶν τε ἀνθρωπίνων καὶ χρω-
μάτων καὶ ἄλλης πολλῆς φλυαρίας θνητῆς, ἀλλ᾽ αὐτὸ τὸ θεῖον καλὸν
δύναιτο μονοειδὲς κατιδεῖν; ἆρ᾽ οἴει, ἔφη, φαῦλον βίον γίγνεσθαι
ἐκεῖσε βλέποντος ἀνθρώπου καὶ ἐκεῖνο ᾧ δεῖ θεωμένου καὶ συνόν-
τος αὐτῷ; ἢ οὐκ ἐνθυμῇ, ἔφη, ὅτι ἐνταῦθα αὐτῷ μοναχοῦ γενήσε-
ται, ὁρῶντι ᾧ ὁρατὸν τὸ καλόν, τίκτειν οὐκ εἴδωλα ἀρετῆς, ἅτε οὐκ
εἰδώλου ἐφαπτομένῳ, ἀλλ᾽ ἀληθῆ, ἅτε τοῦ ἀληθοῦς ἐφαπτομένῳ· τε-
κόντι δὲ ἀρετὴν ἀληθῆ καὶ θρεψαμένῳ ὑπάρχει θεοφιλεῖ γενέσθαι,
καὶ εἴπερ τῳ ἄλλῳ ἀνθρώπων ἀθανάτῳ καὶ ἐκείνῳ;
Ταῦτα δή, ὦ Φαῖδρέ τε καὶ οἱ ἄλλοι, ἔφη μὲν Διοτίμα, πέπεισμαι
δ᾽ ἐγώ· πεπεισμένος δὲ πειρῶμαι καὶ τοὺς ἄλλους πείθειν, ὅτι τού-
του τοῦ κτήματος τῇ ἀνθρωπείᾳ φύσει συνεργὸν ἀμείνω Ἔρωτος
οὐκ ἄν τις ῥᾳδίως λάβοι.

159

" 'What, then,' I said, 'is Love a mortal?'—'By no means.'—'But what, then?'—'Like those things which I have before instanced, he is neither mortal nor immortal, but something intermediate.'—'What is that, O Diotima?'—'A great Dæmon, Socrates; and every thing dæmoniacal holds an intermediate place between what is divine and what is mortal.'

" 'What is his power and nature?' I inquired.—'He interprets and makes a communication between divine and human things, conveying the prayers and sacrifices of men to the Gods, and communicating the commands and directions concerning the mode of worship most pleasing to them, from Gods to men. He fills up that intermediate space between these two classes of beings, so as to bind together, by his own power, the whole universe of things. Through him subsist all divination, and the science of sacred things as it relates to sacrifices, and expiations, and disenchantments, and prophecy, and magic. The divine nature cannot immediately communicate with what is human, but all that intercourse and converse which is conceded by the Gods to men, both whilst they sleep and when they wake, subsists through the intervention of Love; and he who is wise in the science of this intercourse is supremely happy, and participates in the dæmoniacal nature; whilst he who is wise in any other science or art, remains a mere ordinary slave. These dæmons are, indeed, many and various, and one of them is Love.

" 'Who are the parents of Love?' I inquired.—'The history of what you ask,' replied Diotima, 'is somewhat long; nevertheless I will explain it to you. On the birth of Venus the Gods celebrated a great feast, and among them came Plenty, the son of Metis. After supper, Poverty, observing the profusion, came to beg, and stood beside the door. Plenty being drunk with nectar, for wine was not yet invented, went out into Jupiter's garden, and fell into a deep sleep. Poverty wishing to have a child by Plenty, on account of her low estate, lay down by him, and from his embraces conceived Love. Love is, therefore, the follower and servant of Venus, because he was conceived at her birth, and because by nature he is a lover of all that is beautiful, and Venus was beautiful. And since Love is the child of Poverty and Plenty, his nature and fortune participate in that of his parents. He is for ever poor, and so far from being delicate and beautiful, as mankind imagine, he is squalid and withered; he flies low along the ground, and is homeless and unsandalled; he sleeps without covering before the doors, and in the unsheltered streets; possessing thus far his mother's nature, that he is ever the companion of Want. But, inasmuch as he participates in that of his father, he is for ever scheming to obtain things which are good and beautiful; he is fearless, vehement, and strong; a dreadful hunter, for ever weaving some new contrivance; exceedingly cautious and prudent, and full of resources; he is also, during his whole existence, a philosopher, a powerful enchanter, a wizard, and a subtle sophist. And,

160

as his nature is neither mortal nor immortal, on the same day when he is fortunate and successful, he will at one time flourish, and then die away, and then, according to his father's nature, again revive. All that he acquires perpetually flows away from him, so that Love is never either rich or poor, and holding for ever an intermediate state between ignorance and wisdom. The case stands thus:—no God philosophizes or desires to become wise, for he is wise; nor, if there exist any other being who is wise, does he philosophize. Nor do the ignorant philosophize, for they desire not to become wise; for this is the evil of ignorance, that he who has neither intelligence, nor virtue, nor delicacy of sentiment, imagines that he possesses all those things sufficiently. He seeks not, therefore, that possession, of whose want he is not aware.'—'Who, then, O Diotima,' I enquired, 'are philosophers, if they are neither the ignorant nor the wise?'—It is evident, even to a child, that they are those intermediate persons, among whom is Love. For Wisdom is one of the most beautiful of all things; Love is that which thirsts for the beautiful, so that Love is of necessity a philosopher, philosophy being an intermediate state between ignorance and wisdom. His parentage accounts for his condition, being the child of a wise and well-provided father, and of a mother both ignorant and poor.

" 'Such is the dæmoniacal nature, my dear Socrates; nor do I wonder at your error concerning Love, for you thought, as I conjecture from what you say, that Love was not the lover but the beloved, and thence, well concluded that he must be supremely beautiful; for that which is the object of Love must indeed be fair, and delicate, and perfect, and most happy; but Love inherits, as I have declared, a totally opposite nature.'—'Your words have persuasion in them, O stranger,' I said; 'be it as you say. But this Love, what advantages does he afford to men?'— I will proceed to explain it to you, Socrates. Love being such and so produced as I have described, is, indeed, as you say, the love of things which are beautiful. But if any one should ask us, saying: O Socrates and Diotima, why is Love the love of beautiful things? Or, in plainer words, what does the lover of that which is beautiful, love in the object of his love, and seek from it?'—'He seeks,' I said, interrupting her, 'the property and possession of it.'—'But that,' she replied, 'might still be met with another question, What has he, who possesses that which is beautiful?'—'Indeed, I cannot immediately reply.'—'But if, changing the beautiful for good, any one should enquire,—I ask, O Socrates, what is that which he who loves that which is good, loves in the object of his love?'—'To be in his possession,' I replied.—'And what has he, who has the possession of good?'—'This question is of easier solution: he is happy.' —'Those who are happy, then, are happy through the possession; and it is useless to enquire what he desires, who desires to be happy; the question seems to have a complete reply. But do you think that this wish and this love are common to all men, and that all desire, that that

which is good should be for ever present to them?'—'Certainly, common to all.'—'Why do we not say then, Socrates, that every one loves? if, indeed, all love perpetually the same thing? But we say that some love, and some do not.'—'Indeed I wonder why it is so.'—'Wonder not,' said Diotima, 'for we select a particular species of love, and apply to it distinctively the appellation of that which is universal.'——

" 'Give me an example of such a select application,'—'Poetry; which is a general name signifying every cause whereby anything proceeds from that which is not, into that which is; so that the exercise of every inventive art is poetry, and all such artists poets. Yet they are not called poets, but distinguished by other names; and one portion or species of poetry, that which has relation to music and rhythm, is divided from all others, and known by the name belonging to all. For this is alone properly called poetry, and those who exercise the art of this species of poetry, poets. So, with respect to Love. Love is indeed universally all that earnest desire for the possession of happiness and that which is good; the greatest and the subtlest love, and which inhabits the heart of every living being; but those who seek this object through the acquirement of wealth, or the exercise of the gymnastic arts, or philosophy, are not said to love, nor are called lovers; one species alone is called love, and those alone are said to be lovers, and to love, who seek the attainment of the universal desire through one species of love, which is peculiarly distinguished by the name belonging to the whole. It is asserted by some, that they love, who are seeking the lost half of their divided being. But I assert, that Love is neither the love of the half nor of the whole, unless, my friend, it meets with that which is good; since men willingly cut off their own hands and feet, if they think that they are the cause of evil to them. Nor do they cherish and embrace that which may belong to themselves, merely because it is their own; unless, indeed, any one should choose to say, that that which is good is attached to his own nature and is his own, whilst that which is evil is foreign and accidental; but love nothing but that which is good. Does it not appear so to you?'—'Assuredly.'—'Can we then simply affirm that men love that which is good?'—'Without doubt.'—'What, then, must we not add, that, in addition to loving that which is good, they love that it should be present to themselves?'—'Indeed that must be added.'—'And not merely that it should be present, but that it should ever be present?'—'This also must be added.'

" 'Love, then, is collectively the desire in men that good should be for ever present to them.'—'Most true.'—'Since this is the general definition of Love, can you explain in what mode of attaining its object, and in what species of actions, does Love peculiarly consist?'—'If I knew what you ask, O Diotima, I should not have so much wondered at your wisdom, nor have sought you out for the purpose of deriving improvement from your instructions.'—'I will tell you,' she replied: 'Love is the

desire of generation in the beautiful, both with relation to the body and the soul.'—'I must be a diviner to comprehend what you say, for, being such as I am, I confess that I do not understand it.'—'But I will explain it more clearly. The bodies and the souls of all human beings are alike pregnant with their future progeny, and when we arrive at a certain age, our nature impels us to bring forth and propagate. This nature is unable to produce in that which is deformed, but it can produce in that which is beautiful. The intercourse of the male and female in generation, a divine work, through pregnancy and production, is, as it were, something immortal in mortality. These things cannot take place in that which is incongruous; for that which is deformed is incongruous, but that which is beautiful is congruous with what is immortal and divine. Beauty is, therefore, the fate, and the Juno Lucina to generation. Wherefore, whenever that which is pregnant with the generative principle, approaches that which is beautiful, it becomes transported with delight, and is poured forth in overflowing pleasure, and propagates. But when it approaches that which is deformed, it is contracted by sadness, and being repelled and checked, it does not produce, but retains unwillingly that with which it is pregnant. Wherefore, to one pregnant, and, as it were, already bursting with the load of his desire, the impulse towards that which is beautiful is intense, on account of the great pain of retaining that which he has conceived. Love, then, O Socrates, is not as you imagine the love of the beautiful.'—'What, then?'—'Of generation and production in the beautiful.'—'Why then of generation?'—'Generation is something eternal and immortal in mortality. It necessarily, from what has been confessed, follows, that we must desire immortality together with what is good, since Love is the desire that good be for ever present to us. Of necessity Love must also be the desire of immortality.'

"Diotima taught me all this doctrine in the discourse we had together concerning Love; and in addition, she enquired, 'What do you think, Socrates, is the cause of this love and desire? Do you not perceive how all animals, both those of the earth and of the air, are affected when they desire the propagation of their species, affected even to weakness and disease by the impulse of their love; first, longing to be mixed with each other, and then seeking nourishment for their offspring, so that the feeblest are ready to contend with the strongest in obedience to this law, and to die for the sake of their young, or to waste away with hunger, and do or suffer anything so that they may not want nourishment. It might be said that human beings do these things through reason, but can you explain why other animals are thus affected through love?'—I confessed that I did not know.—'Do you imagine yourself,' said she, 'to be skilful in the science of Love, if you are ignorant of these things?'—'As I said before, O Diotima, I come to you, well knowing how much I am in need of a teacher. But explain to me, I entreat you, the cause of these things, and of the other

163

things relating to Love.'—'If,' said Diotima, 'you believe that Love is of the same nature as we have mutually agreed upon, wonder not that such are its effects. For the mortal nature seeks, so far as it is able, to become deathless and eternal. But it can only accomplish this desire by generation, which for ever leaves another new in place of the old. For, although each human being be severally said to live, and be the same from youth to old age, yet, that which is called the same, never contains within itself the same things, but always is becoming new by the loss and change of that which it possessed before; both the hair, and the flesh, and the bones, and the entire body.

" 'And not only does this change take place in the body, but also with respect to the soul. Manners, morals, opinions, desires, pleasures, sorrows, fears; none of these ever remain unchanged in the same persons; but some die away, and others are produced. And, what is yet more strange is, that not only does some knowledge spring up, and another decay, and that we are never the same with respect to our knowledge, but that each several object of our thoughts suffers the same revolution. That which is called meditation, or the exercise of memory, is the science of the escape or knowledge of memory; for, forgetfulness is the going out of knowledge; and meditation, calling up a new memory in the place of that which has departed, preserves knowledge; so that, though for ever displaced and restored, it seems to be the same. In this manner every thing mortal is preserved: not that it is constant and eternal, like that which is divine; but that in the place of what has grown old and is departed, it leaves another new like that which it was itself. By this contrivance, O Socrates, does what is mortal, the body and all other things, partake of immortality; that which is immortal, is immortal in another manner. Wonder not, then, if every thing by nature cherishes that which was produced from itself, for this earnest Love is a tendency towards eternity.'

"Having heard this discourse, I was astonished, and asked, 'Can these things be true, O wisest Diotima?' And she, like an accomplished sophist, said, 'Know well, O Socrates, that if you only regard that love of glory which inspires men, you will wonder at your own unskilfulness in not having discovered all that I now declare. Observe with how vehement a desire they are affected to become illustrious and to prolong their glory into immortal time, to attain which object, far more ardently than for the sake of their children, all men are ready to engage in many dangers, and expend their fortunes, and submit to any labours and incur any death. Do you believe that Alcestis would have died in the place of Admetus, or Achilles for the revenge of Patroclus, or Codrus for the kingdom of his posterity, if they had not believed that the immortal memory of their actions, which we now cherish, would have remained after their death? Far otherwise; all such deeds are done for the sake of ever-living virtue, and this immortal glory which they have

obtained; and inasmuch as any one is of an excellent nature, so much the more is he impelled to attain this reward. For they love what is immortal.

" 'Those whose bodies alone are pregnant with this principle of immortality are attracted by women, seeking through the production of children what they imagine to be happiness and immortality and an enduring remembrance; but they whose souls are far more pregnant than their bodies, conceive and produce that which is more suitable to the soul. What is suitable to the soul? Intelligence, and every other power and excellence of the mind; of which all poets, and all other artists who are creative and inventive, are the authors. The greatest and most admirable wisdom is that which regulates the government of families and states, and which is called moderation and justice. Whosoever, therefore, from his youth feels his soul pregnant with the conception of these excellences, is divine; and when due time arrives, desires to bring forth; and wandering about, he seeks the beautiful in which he may propagate what he has conceived; for there is no generation in that which is deformed; he embraces those bodies which are beautiful rather than those which are deformed, in obedience to the principle which is within him, which is ever seeking to perpetuate itself. And if he meets, in conjunction with loveliness of form, a beautiful, generous, and gentle soul, he embraces both at once, and immediately undertakes to educate this object of his love, and is inspired with an overflowing persuasion to declare what is virtue, and what he ought to be who would attain to its possession, and what are the duties which it exacts. For, by the intercourse with, and as it were, the very touch of that which is beautiful, he brings forth and produces what he had formerly conceived; and nourishes and educates that which is thus produced together with the object of his love, whose image, whether absent or present, is never divided from his mind. So that those who are thus united are linked by a nobler community and a firmer love, as being the common parents of a lovelier and more enduring progeny than the parents of other children. And every one who considers what posterity Homer and Hesiod, and the other great poets, have left behind them, the sources of their own immortal memory and renown, or what children of his soul Lycurgus has appointed to be the guardians, not only of Lacedæmon, but of all Greece; or what an illustrious progeny of laws Solon has produced, and how many admirable achievements, both among the Greeks and Barbarians, men have left as the pledges of that love which subsisted between them and the beautiful, would choose rather to be the parent of such children than those in a human shape. For divine honours have often been rendered to them on account of such children, but on account of those in human shape, never.

" 'Your own meditation, O Socrates, might perhaps have initiated you in all these things which I have already taught you on the subject of

165

Love. But those perfect and sublime ends, to which these are only the means, I know not that you would have been competent to discover. I will declare them, therefore, and will render them as intelligible as possible: do you meanwhile strain all your attention to trace the obscure depth of the subject. He who aspires to love rightly, ought from his earliest youth to seek an intercourse with beautiful forms, and first to make a single form the object of his love, and therein to generate intellectual excellences. He ought, then, to consider that beauty in whatever form it resides is the brother of that beauty which subsists in another form; and if he ought to pursue that which is beautiful in form, it would be absurd to imagine that beauty is not one and the same thing in all forms, and would therefore remit much of his ardent preference towards one, through his perception of the multitude of claims upon his love. In addition, he would consider the beauty which is in souls more excellent than that which is in form. So that one endowed with an admirable soul, even though the flower of his form were withered, would suffice him as the object of his love and care, and the companion with whom he might seek and produce such conclusions as tend to the improvement of youth; so that it might be led to observe the beauty and the conformity which there is in the observation of its duties and the laws, and to esteem little the mere beauty of the outward form. The lover would then conduct his pupil to science, so that he might look upon the loveliness of wisdom; and that contemplating thus the universal beauty, no longer like some servant in love with his fellow would he unworthily and meanly enslave himself to the attractions of one form, nor one subject of discipline or science, but would turn towards the wide ocean of intellectual beauty, and from the sight of the lovely and majestic forms which it contains, would abundantly bring forth his conceptions in philosophy; until, strengthened and confirmed, he should at length steadily contemplate one science, which is the science of this universal beauty.

" 'Attempt, I entreat you, to mark what I say with as keen an observation as you can. He who has been disciplined to this point in Love, by contemplating beautiful objects gradually, and in their order, now arriving at the end of all that concerns Love, on a sudden beholds a beauty wonderful in its nature. This is it, O Socrates, for the sake of which all the former labours were endured. It is eternal, unproduced, indestructible; neither subject to increase nor decay: not, like other things, partly beautiful and partly deformed; not at one time beautiful and at another time not; not beautiful in relation to one thing and deformed in relation to another; not here beautiful and there deformed; not beautiful in the estimation of one person and deformed in that of another; nor can this supreme beauty be figured to the imagination like a beautiful face, or beautiful hands, or any portion of the body, nor like any discourse, nor any science. Nor does it subsist in any other

that lives or is, either in earth, or in heaven, or in any other place; but it is eternally uniform and consistent, and monoeidic with itself. All other things are beautiful through a participation of it, with this condition, that although they are subject to production and decay, it never becomes more or less, or endures any change. When any one, ascending from a correct system of Love, begins to contemplate this supreme beauty, he already touches the consummation of his labour. For such as discipline themselves upon this system, or are conducted by another beginning to ascend through these transitory objects which are beautiful, towards that which is beauty itself, proceeding as on steps from the love of one form to that of two, and from that of two, to that of all forms which are beautiful; and from beautiful forms to beautiful habits and institutions, and from institutions to beautiful doctrines; until, from the meditation of many doctrines, they arrive at that which is nothing else than the doctrine of the supreme beauty itself, in the knowledge and contemplation of which at length they repose.

"'Such a life as this, my dear Socrates,' exclaimed the stranger Prophetess, 'spent in the contemplation of the beautiful, is the life for men to live; which if you chance ever to experience, you will esteem far beyond gold and rich garments, and even those lovely persons whom you and many others now gaze on with astonishment, and are prepared neither to eat nor drink so that you may behold and live for ever with these objects of your love! What then shall we imagine to be the aspect of the supreme beauty itself, simple, pure, uncontaminated with the intermixture of human flesh and colours, and all other idle and unreal shapes attendant on mortality; the divine, the original, the supreme, the self-consistent, the monoeidic beautiful itself? What must be the life of him who dwells with and gazes on that which it becomes us all to seek? Think you not that to him alone is accorded the prerogative of bringing forth, not images and shadows of virtue, for he is in contact not with a shadow but with reality; with virtue itself, in the production and nourishment of which he becomes dear to the Gods, and if such a privilege is conceded to any human being, himself immortal.'

"Such, O Phædrus, and my other friends, was what Diotima said. And being persuaded by her words, I have since occupied myself in attempting to persuade others, that it is not easy to find a better assistant than Love in seeking to communicate immortality to our human natures."

Symposium, 202 B–212 C
Translated by Percy Bysshe Shelley

If the claim were advanced that the symposium *was absolutely the highest work of prose fiction ever composed, most perfect in power, beauty, imaginative truth, it would be hard to deny it; nor is it easy to controvert the metaphysician who holds it to be the deepest word*

yet spoken upon the nature of Love. . . . He is the greatest master of
Greek prose style, perhaps of prose style altogether, that ever lived.

<div align="right">
GILBERT MURRAY

A History of Ancient Greek Literature (1897)
</div>

PLATO

4 2 7 ? — 3 4 7 B . C .

FROM ASPASIA'S FUNERAL ORATION

Ἔργῳ μὲν ἡμῖν οἵδε ἔχουσι τὰ προσήκοντα σφίσιν αὐτοῖς, ὧν τυχόντες πορεύονται τὴν εἱμαρμένην πορείαν.

In very truth these men are receiving at our hands their fitting tribute: and when they have gained this guerdon, they journey on, along the path of destiny.

<div align="right">
Menexenus, 236 D

<i>Translated by W. Rhys Roberts</i>
</div>

What can be the device that produces its perfect dignity and beauty,
if it is not the beautiful and striking rhythms that compose it? The
passage is one of the best known and most often quoted.

<div align="right">
DIONYSIUS OF HALICARNASSUS

De Compositione Verborum, xviii

<i>Translated by W. Rhys Roberts</i>
</div>

PLATO

4 2 7 ? — 3 4 7 B . C .

SOCRATES' DREAM

SOCRATES

I must die on the day after the ship comes in, must I not?

CRITO

So those say who have charge of these matters.

SOCRATES

Well, I think it will not come in to-day, but to-morrow. And my

reason for this is a dream which I had a little while ago in the course
of this night. And perhaps you let me sleep just at the right time.

CRITO

What was the dream?

SOCRATES

I dreamed that a beautiful, fair woman, clothed in white raiment,
came to me and called me and said, "Socrates,
on the third day thou wouldst come to fertile Phthia." *

Crito, 44
Translated by H. N. Fowler

The most beautiful symbolic quotation in European literature.

PAUL SHOREY
What Plato Said (1933)

PLATO

4 2 7 ? — 3 4 7 B . C .

THE DEATH OF SOCRATES

Ἐκκαλυψάμενος, ἐνεκεκάλυπτο γάρ, εἶπεν, ὃ δὴ τελευταῖον ἐφθέγ-
ξατο. Ὦ Κρίτων, ἔφη, τῷ Ἀσκληπιῷ ὀφείλομεν ἀλεκτρυόνα· ἀλλ'
ἀπόδοτε καὶ μὴ ἀμελήσητε. Ἀλλὰ ταῦτα, ἔφη, ἔσται, ὁ Κρίτων·
ἀλλ' ὅρα, εἴ τι ἄλλο λέγεις. ταῦτα ἐρομένου αὐτοῦ οὐδὲν ἔτι ἀπε-
κρίνατο, ἀλλ' ὀλίγον χρόνον διαλιπὼν ἐκινήθη τε καὶ ὁ ἄνθρωπος
ἐξεκάλυψεν αὐτόν, καὶ ὃς τὰ ὄμματα ἔστησεν· ἰδὼν δὲ ὁ Κρίτων
ξυνέλαβε τὸ στόμα τε καὶ τοὺς ὀφθαλμούς. ἥδε ἡ τελευτή, ὦ Ἐχέ-
κρατες, τοῦ ἑταίρου ἡμῖν ἐγένετο, ἀνδρός, ὡς ἡμεῖς φαῖμεν ἄν, τῶν
τότε ὧν ἐπειράθημεν ἀρίστου καὶ ἄλλως φρονιμωτάτου καὶ δικαι-
οτάτου.

He uncovered his face, for he had covered himself up, and said:
Crito, I owe a cock to Asclepius; will you remember to pay the debt?
The debt shall be paid, said Crito; is there anything else? There was no
answer to this question; but in a minute or two a movement was heard,
and the attendants uncovered him; his eyes were set, and Crito closed
his eyes and mouth.

* Homer, *Iliad*, ix, 363.

Such was the end, Echecrates, of our friend; of whom I may truly say, that of all the men of his time whom I have known, he was the wisest and justest and best.

<div align="right">Phaedo, 118 A-B</div>
<div align="right">*Translated by Benjamin Jowett and Sir R. W. Livingston*</div>

Consummate art and incomparable beauty of language.

<div align="right">J. W. MACKAIL</div>
<div align="right">Studies in Humanism (1938)</div>

PLATO

<div align="center">4 2 7 ? — 3 4 7 B . C .</div>

ASTER

'Αστὴρ πρὶν μὲν ἔλαμπες ἐνὶ ζωοῖσιν Ἑῷος,
 νῦν δὲ θανὼν λάμπεις Ἕσπερος ἐν φθιμένοις.

Thou wert the morning-star among the living,
 Ere thy fair light had fled;
But now thou art as Hesperus, giving
 New splendour to the dead.

<div align="right">The Greek Anthology, vii, 670</div>
<div align="right">*Translated by Percy Bysshe Shelley*</div>

The most perfect of Greek epigrams.

<div align="right">PAUL ELMER MORE</div>
<div align="right">Shelburne Essays, Fifth Series (1908)</div>

ARISTOTLE

<div align="center">3 8 4 — 3 2 2 B . C .</div>

KNOWLEDGE

Πάντες οἱ ἄνθρωποι τοῦ εἰδέναι ὀρέγονται φύσει. σημεῖον δ' ἡ τῶν αἰσθήσεων ἀγάπησις· καὶ γὰρ χωρὶς τῆς χρείας ἀγαπῶνται δι' αὐτά, καὶ μάλιστα τῶν ἄλλων ἡ διὰ τῶν ὀμμάτων. οὐ γὰρ μόνον

ἵνα πράττωμεν ἀλλὰ καὶ μηθὲν μέλλοντες πράττειν τὸ ὁρᾶν αἱρούμεθα ἀντὶ πάντων ὡς εἰπεῖν τῶν ἄλλων. αἴτιον δ' ὅτι μάλιστα ποιεῖ γνωρίζειν τι ἡμᾶς αὕτη τῶν αἰσθήσεων, καὶ πολλὰς δηλοῖ διαφοράς. Φύσει μὲν οὖν αἴσθησιν ἔχοντα γίγνεται τὰ ζῷα, ἐκ δὲ ταύτης τοῖς μὲν αὐτῶν οὐκ ἐγγίγνεται μνήμη τοῖς δ' ἐγγίγνεται. καὶ διὰ τοῦτο ταῦτα φρονιμώτερα καὶ μαθητικώτερα τῶν μὴ δυναμένων μνημονεύειν ἐστί, φρόνιμα μὲν ἄνευ τοῦ μανθάνειν ὅσα μὴ δύναται τῶν ψόφων ἀκούειν, οἷον μέλιττα, καὶ εἴ τι τοιοῦτον ἄλλο γένος ζῴων ἔστι· μανθάνει δ' ὅσα πρὸς τῇ μνήμῃ καὶ ταύτην ἔχει τὴν αἴσθησιν. Τὰ μὲν οὖν ἄλλα ταῖς φαντασίαις ζῇ καὶ ταῖς μνήμαις, ἐμπειρίας δὲ μετέχειν μικρόν· τὸ δὲ τῶν ἀνθρώπων γένος καὶ τέχνῃ καὶ λογισμοῖς. γίγνεται δ' ἐκ τῆς μνήμης ἐμπειρία τοῖς ἀνθρώποις· αἱ γὰρ πολλαὶ μνῆμαι τοῦ αὐτοῦ πράγματος μιᾶς ἐμπειρίας δύναμιν ἀποτελοῦσιν. καὶ δοκεῖ σχεδὸν ἐπιστήμῃ καὶ τέχνῃ ὅμοιον εἶναι ἡ ἐμπειρία, ἀποβαίνει δὲ ἐπιστήμη καὶ τέχνη διὰ τῆς ἐμπειρίας τοῖς ἀνθρώποις· ἡ μὲν γὰρ ἐμπειρία τέχνην ἐποίησεν, ὡς φησὶ Πῶλος, ὀρθῶς λέγων, ἡ δ' ἀπειρία τύχην. γίγνεται δὲ τέχνη ὅταν ἐκ πολλῶν τῆς ἐμπειρίας ἐννοημάτων μία καθόλου γένηται περὶ τῶν ὁμοίων ὑπόληψις. τὸ μὲν γὰρ ἔχειν ὑπόληψιν ὅτι Καλλίᾳ κάμνοντι τηνδὶ τὴν νόσον τοδὶ συνήνεγκε καὶ Σωκράτη καὶ καθ' ἕκαστον οὕτω πολλοῖς, ἐμπειρίας ἐστίν· τὸ δ' ὅτι πᾶσι τοῖς τοιοῖσδε κατ' εἶδος ἓν ἀφορισθεῖσι, κάμνουσι τηνδὶ τὴν νόσον, συνήνεγκεν, οἷον τοῖς φλεγματώδεσιν ἢ χολώδεσι [ἢ] πυρέττουσι καύσῳ, τέχνης. Πρὸς μὲν οὖν τὸ πράττειν ἐμπειρία τέχνης οὐδὲν δοκεῖ διαφέρειν, ἀλλὰ καὶ μᾶλλον ἐπιτυγχάνοντας ὁρῶμεν τοὺς ἐμπείρους τῶν ἄνευ τῆς ἐμπειρίας λόγον ἐχόντων. αἴτιον δ' ὅτι ἡ μὲν ἐμπειρία τῶν καθ' ἕκαστόν ἐστι γνῶσις, ἡ δὲ τέχνη τῶν καθόλου, αἱ δὲ πράξεις καὶ αἱ γενέσεις πᾶσαι περὶ τὸ καθ' ἕκαστόν εἰσιν· οὐ γὰρ ἄνθρωπον ὑγιάζει ὁ ἰατρεύων, πλὴν ἀλλ' ἢ κατὰ συμβεβηκός, ἀλλὰ Καλλίαν ἢ Σωκράτην ἢ τῶν ἄλλων τινὰ τῶν οὕτω λεγομένων ᾧ συμβέβηκε καὶ ἀνθρώπῳ εἶναι. ἐὰν οὖν ἄνευ τῆς ἐμπειρίας ἔχῃ τις τὸν λόγον, καὶ τὸ καθόλου μὲν γνωρίζῃ τὸ δ' ἐν τούτῳ καθ' ἕκαστον ἀγνοῇ, πολλάκις διαμαρτυρήσεται τῆς θεραπείας· θεραπευτὸν γὰρ τὸ καθ' ἕκαστον μᾶλλον. ἀλλ' ὅμως τό γε εἰδέναι καὶ τὸ ἐπαΐειν τῇ τέχνῃ τῆς ἐμπειρίας ὑπάρχειν οἰόμεθα μᾶλλον, καὶ σοφωτέρους τοὺς τεχνίτας τῶν ἐμπείρων ὑπολαμβάνομεν, ὡς κατὰ τὸ εἰδέναι μᾶλλον ἀκολουθοῦσαν τὴν σοφίαν πᾶσι. τοῦτο δ', ὅτι οἱ μὲν τὴν αἰτίαν ἴσασιν, οἱ δ' οὔ. οἱ μὲν γὰρ ἔμπειροι τὸ ὅτι μὲν ἴσασι, διότι δ' οὐκ ἴσασιν· οἱ δὲ τὸ διότι καὶ τὴν αἰτίαν γνωρίζουσιν. διὸ καὶ τοὺς ἀρχιτέκτονας περὶ ἕκαστον τιμιωτέρους καὶ μᾶλλον εἰδέναι νομίζομεν τῶν χειροτεχνῶν καὶ σοφωτέρους, ὅτι τὰς αἰτίας τῶν ποιουμένων ἴσασιν (τοὺς δ' ὥσπερ καὶ τῶν ἀψύχων ἔνια, ποιεῖν μέν, οὐκ εἰδότα δὲ ποιεῖν ἃ ποιεῖ, οἷον καίει τὸ πῦρ· τὰ μὲν οὖν ἄψυχα φύσει τινὶ ποιεῖν τούτων ἕκαστον, τοὺς δὲ χειροτέχνας δι' ἔθος)· ὡς

οὐ κατὰ τὸ πρακτικοὺς εἶναι σοφωτέρους ὄντας, ἀλλὰ κατὰ τὸ λόγον ἔχειν αὐτοὺς καὶ τὰς αἰτίας γνωρίζειν.

Ὅλως τε σημεῖον τοῦ εἰδότος καὶ μὴ εἰδότος τὸ δύνασθαι διδάσκειν ἐστίν, καὶ διὰ τοῦτο τὴν τέχνην τῆς ἐμπειρίας ἡγούμεθα μᾶλλον ἐπιστήμην εἶναι· δύνανται γάρ, οἱ δὲ οὐ δύνανται διδάσκειν. ἔτι δὲ τῶν αἰσθήσεων οὐδεμίαν ἡγούμεθα εἶναι σοφίαν· καίτοι κυριώταταί γ' εἰσὶν αὗται τῶν καθ' ἕκαστα γνώσεις· ἀλλ' οὐ λέγουσι τὸ διὰ τί περὶ οὐδενός, οἷον διὰ τί θερμὸν τὸ πῦρ, ἀλλὰ μόνον ὅτι θερμόν.

Τὸ μὲν οὖν πρῶτον εἰκὸς τὸν ὁποιανοῦν εὑρόντα τέχνην παρὰ τὰς κοινὰς αἰσθήσεις θαυμάζεσθαι ὑπὸ τῶν ἀνθρώπων, μὴ μόνον διὰ τὸ χρήσιμον εἶναί τι τῶν εὑρεθέντων, ἀλλ' ὡς σοφὸν καὶ διαφέροντα τῶν ἄλλων· πλειόνων δ' εὑρισκομένων τεχνῶν, καὶ τῶν μὲν πρὸς τἀναγκαῖα, τῶν δὲ πρὸς διαγωγὴν οὐσῶν, ἀεὶ σοφωτέρους τοὺς τοιούτους ἐκείνων ὑπολαμβάνεσθαι, διὰ τὸ μὴ πρὸς χρῆσιν εἶναι τὰς ἐπιστήμας αὐτῶν. ὅθεν ἤδη πάντων τῶν τοιούτων κατεσκευασμένων αἱ μὴ πρὸς ἡδονὴν μηδὲ πρὸς τἀναγκαῖα τῶν ἐπιστημῶν εὑρέθησαν, καὶ πρῶτον ἐν τούτοις τοῖς τόποις οὗπερ ἐσχόλασαν. διὸ περὶ Αἴγυπτον αἱ μαθηματικαὶ πρῶτον τέχναι συνέστησαν, ἐκεῖ γὰρ ἀφείθη σχολάζειν τὸ τῶν ἱερέων ἔθνος. Εἴρηται μὲν οὖν ἐν τοῖς ἠθικοῖς τίς διαφορὰ τέχνης καὶ ἐπιστήμης καὶ τῶν ἄλλων τῶν ὁμογενῶν· οὗ δ' ἕνεκα νῦν ποιούμεθα τὸν λόγον τοῦτ' ἐστίν, ὅτι τὴν ὀνομαζομένην σοφίαν περὶ τὰ πρῶτα αἴτια καὶ τὰς ἀρχὰς ὑπολαμβάνουσι πάντες· ὥστε καθάπερ εἴρηται πρότερον, ὁ μὲν ἔμπειρος τῶν ὁποιανοῦν ἐχόντων αἴσθησιν εἶναι δοκεῖ σοφώτερος, ὁ δὲ τεχνίτης τῶν ἐμπείρων, χειροτέχνου δὲ ἀρχιτέκτων, αἱ δὲ θεωρητικαὶ τῶν ποιητικῶν μᾶλλον. ὅτι μὲν οὖν ἡ σοφία περί τινας ἀρχὰς καὶ αἰτίας ἐστὶν ἐπιστήμη, δῆλον.

Ἐπεὶ δὲ ταύτην τὴν ἐπιστήμην ζητοῦμεν, τοῦτ' ἂν εἴη σκεπτέον, ἡ περὶ ποίας αἰτίας καὶ περὶ ποίας ἀρχὰς ἐπιστήμη σοφία ἐστίν. εἰ δὴ λάβοι τις τὰς ὑπολήψεις ἃς ἔχομεν περὶ τοῦ σοφοῦ, τάχ' ἂν ἐκ τούτου φανερὸν γένοιτο μᾶλλον. ὑπολαμβάνομεν δὴ πρῶτον μὲν ἐπίστασθαι πάντα τὸν σοφὸν ὡς ἐνδέχεται, μὴ καθ' ἕκαστον ἔχοντα ἐπιστήμην αὐτῶν· εἶτα τὸν τὰ χαλεπὰ γνῶναι δυνάμενον καὶ μὴ ῥᾴδια ἀνθρώπων γιγνώσκειν, τοῦτον σοφόν (τὸ γὰρ αἰσθάνεσθαι πάντων κοινόν, διὸ ῥᾴδιον καὶ οὐδὲν σοφόν)· ἔτι τὸν ἀκριβέστερον καὶ τὸν διδασκαλικώτερον τῶν αἰτίων σοφώτερον εἶναι περὶ πᾶσαν ἐπιστήμην· καὶ τῶν ἐπιστημῶν δὲ τὴν αὑτῆς ἕνεκεν καὶ τοῦ εἰδέναι χάριν αἱρετὴν οὖσαν μᾶλλον εἶναι σοφίαν ἢ τὴν τῶν ἀποβαινόντων ἕνεκεν, καὶ τὴν ἀρχικωτέραν ὑπηρετούσης μᾶλλον σοφίαν· οὐ γὰρ δεῖν ἐπιτάττεσθαι τὸν σοφὸν ἀλλ' ἐπιτάττειν, καὶ οὐ τοῦτον ἑτέρῳ πείθεσθαι, ἀλλὰ τούτῳ τὸν ἧττον σοφόν. Τὰς μὲν οὖν ὑπολήψεις τοιαύτας καὶ τοσαύτας ἔχομεν περὶ τῆς σοφίας καὶ τῶν σοφῶν· τούτων δὲ τὸ μὲν πάντα ἐπίστασθαι τῷ μάλιστα ἔχοντι τὴν καθόλου

ἐπιστήμην ἀναγκαῖον ὑπάρχειν· οὗτος γὰρ οἶδέ πως πάντα τὰ ὑποκείμενα. σχεδὸν δὲ καὶ χαλεπώτατα ταῦτα γνωρίζειν τοῖς ἀνθρώποις, τὰ μάλιστα καθόλου· πορρωτάτω γὰρ τῶν αἰσθήσεών ἐστιν. ἀκριβέσταται δὲ τῶν ἐπιστημῶν αἳ μάλιστα τῶν πρώτων εἰσίν· αἱ γὰρ ἐξ ἐλαττόνων ἀκριβέστεραι τῶν ἐκ προσθέσεως λεγομένων, οἷον ἀριθμητικὴ γεωμετρίας. ἀλλὰ μὴν καὶ διδασκαλική γε ἡ τῶν αἰτιῶν θεωρητικὴ μᾶλλον· οὗτοι γὰρ διδάσκουσιν οἱ τὰς αἰτίας λέγοντες περὶ ἑκάστου. τὸ δ᾽ εἰδέναι καὶ τὸ ἐπίστασθαι αὐτῶν ἕνεκα μάλισθ᾽ ὑπάρχει τῇ τοῦ μάλιστα ἐπιστητοῦ ἐπιστήμῃ. ὁ γὰρ τὸ ἐπίστασθαι δι᾽ αὐτὸ αἱρούμενος τὴν μάλιστα ἐπιστήμην μάλιστα αἱρήσεται, τοιαύτη δ᾽ ἐστὶν ἡ τοῦ μάλιστα ἐπιστητοῦ, μάλιστα δὲ ἐπιστητὰ τὰ πρῶτα καὶ τὰ αἴτια· διὰ γὰρ ταῦτα καὶ ἐκ τούτων τἆλλα γνωρίζεται, ἀλλ᾽ οὐ ταῦτα τῶν ὑποκειμένων. ἀρχικωτάτη δὲ τῶν ἐπιστημῶν, καὶ μᾶλλον ἀρχικὴ τῆς ὑπηρετούσης, ἡ γνωρίζουσα τίνος ἕνεκεν πρακτέον ἕκαστον· τοῦτο δ᾽ ἐστὶν τἀγαθὸν ἑκάστου, ὅλως δὲ τὸ ἄριστον ἐν τῇ φύσει πάσῃ.

Ἐξ ἁπάντων οὖν τῶν εἰρημένων ἐπὶ τὴν αὐτὴν ἐπιστήμην πίπτει τὸ ζητούμενον ὄνομα· δεῖ γὰρ ταύτην τῶν πρώτων ἀρχῶν καὶ αἰτιῶν εἶναι θεωρητικήν· καὶ γὰρ τἀγαθὸν καὶ τὸ οὗ ἕνεκα ἓν τῶν αἰτίων ἐστίν. Ὅτι δ᾽ οὐ ποιητική, δῆλον καὶ ἐκ τῶν πρώτων φιλοσοφησάντων. διὰ γὰρ τὸ θαυμάζειν οἱ ἄνθρωποι καὶ νῦν καὶ τὸ πρῶτον ἤρξαντο φιλοσοφεῖν, ἐξ ἀρχῆς μὲν τὰ πρόχειρα τῶν ἀπόρων θαυμάσαντες, εἶτα κατὰ μικρὸν οὕτω προϊόντες, καὶ περὶ τῶν μειζόνων διαπορήσαντες, οἷον περί τε τῶν τῆς σελήνης παθημάτων, καὶ τῶν περὶ τὸν ἥλιον καὶ ἄστρα, καὶ περὶ τῆς τοῦ παντὸς γενέσεως. ὁ δ᾽ ἀπορῶν καὶ θαυμάζων οἴεται ἀγνοεῖν (διὸ καὶ ὁ φιλόμυθος φιλόσοφός πώς ἐστιν· ὁ γὰρ μῦθος σύγκειται ἐκ θαυμασίων)· ὥστ᾽ εἴπερ διὰ τὸ φεύγειν τὴν ἄγνοιαν ἐφιλοσόφησαν, φανερὸν ὅτι διὰ τὸ εἰδέναι τὸ ἐπίστασθαι ἐδίωκον, καὶ οὐ χρήσεώς τινος ἕνεκεν. μαρτυρεῖ δὲ αὐτὸ τὸ συμβεβηκός· σχεδὸν γὰρ πάντων ὑπαρχόντων τῶν ἀναγκαίων καὶ πρὸς ῥᾳστώνην καὶ διαγωγὴν ἡ τοιαύτη φρόνησις ἤρξατο ζητεῖσθαι. δῆλον οὖν ὡς δι᾽ οὐδεμίαν αὐτὴν ζητοῦμεν χρείαν ἑτέραν, ἀλλ᾽ ὥσπερ ἄνθρωπος, φαμέν, ἐλεύθερος ὁ αὑτοῦ ἕνεκα καὶ μὴ ἄλλου ὤν, οὕτω καὶ αὐτὴν ὡς μόνην ἐλευθέραν οὖσαν τῶν ἐπιστημῶν· μόνη γὰρ αὕτη αὑτῆς ἕνεκέν ἐστιν.

Διὸ καὶ δικαίως ἂν οὐκ ἀνθρωπίνη νομίζοιτο αὐτῆς ἡ κτῆσις· πολλαχῇ γὰρ ἡ φύσις δούλη τῶν ἀνθρώπων ἐστίν, ὥστε κατὰ Σιμωνίδην θεὸς ἂν μόνος τοῦτ᾽ ἔχοι γέρας, ἄνδρα δ᾽ οὐκ ἄξιον μὴ οὐ ζητεῖν τὴν καθ᾽ αὑτὸν ἐπιστήμην. εἰ δὴ λέγουσί τι οἱ ποιηταὶ καὶ πέφυκε φθονεῖν τὸ θεῖον, ἐπὶ τούτου συμβῆναι μάλιστα εἰκὸς καὶ δυστυχεῖς εἶναι πάντας τοὺς περιττούς. ἀλλ᾽ οὔτε τὸ θεῖον φθονερὸν ἐνδέχεται εἶναι, ἀλλὰ κατὰ τὴν παροιμίαν πολλὰ ψεύδονται ἀοιδοί, οὔτε τῆς τοιαύτης ἄλλην χρὴ νομίζειν τιμιωτέραν· ἡ γὰρ θειοτάτη καὶ τιμιωτάτη. τοιαύτη δὲ διχῶς ἂν εἴη μόνον· ἥν τε γὰρ μάλι-

στα ὁ θεὸς ἔχοι, θεία τῶν ἐπιστημῶν ἐστί, κἂν εἴ τις τῶν θεῶν εἴη. μόνη δ' αὕτη τούτων ἀμφοτέρων τετύχηκεν· ὅ τε γὰρ θεὸς δοκεῖ τῶν αἰτίων πᾶσιν εἶναι καὶ ἀρχή τις, καὶ τὴν τοιαύτην ἢ μόνος ἢ μάλιστ' ἂν ἔχοι ὁ θεός. ἀναγκαιότεραι μὲν οὖν πᾶσαι ταύτης, ἀμείνων δὲ οὐδεμία. Δεῖ μέντοι πως καταστῆναι τὴν κτῆσιν αὐτῆς εἰς τοὐναντίον ἡμῖν τῶν ἐξ ἀρχῆς ζητήσεων. ἄρχονται μὲν γάρ, ὥσπερ εἴπομεν ἀπὸ τοῦ θαυμάζειν πάντες εἰ οὕτως ἔχει, καθάπερ <περὶ> τῶν θαυμάτων ταὐτόματα ἢ περὶ τὰς τοῦ ἡλίου τροπὰς ἢ τὴν τῆς διαμέτρου ἀσυμμετρίαν· θαυμαστὸν γὰρ εἶναι δοκεῖ πᾶσι τοῖς μήπω τεθεωρηκόσι τὴν αἰτίαν, εἴ τι τῷ ἐλαχίστῳ μὴ μετρεῖται. δεῖ δὲ εἰς τοὐναντίον, καὶ τὸ ἄμεινον κατὰ τὴν παροιμίαν, ἀποτελευτῆσαι, καθάπερ καὶ ἐν τούτοις ὅταν μάθωσιν· οὐθὲν γὰρ ἂν οὕτως θαυμάσειεν ἀνὴρ γεωμετρικὸς ὡς εἰ γένοιτο ἡ διάμετρος μετρητή. Τίς μὲν οὖν ἡ φύσις τῆς ἐπιστήμης τῆς ζητουμένης εἴρηται, καὶ τίς ὁ σκοπὸς οὗ δεῖ τυγχάνειν τὴν ζήτησιν καὶ τὴν ὅλην μέθοδον.

All men naturally desire knowledge. An indication of this is our esteem for the senses; for apart from their use we esteem them for their own sake, and most of all the sense of sight. Not only with a view to action, but even when no action is contemplated, we prefer sight, generally speaking, to all the other senses. The reason of this is that of all the senses sight best helps us to know things, and reveals many distinctions.

Now animals are by nature born with the power of sensation, and from this some acquire the faculty of memory, whereas others do not. Accordingly the former are more intelligent and capable of learning than those which cannot remember. Such as cannot hear sounds (as the bee, and any other similar type of creature) are intelligent, but cannot learn; those only are capable of learning which possess this sense in addition to the faculty of memory.

Thus the other animals live by impressions and memories, and have but a small share of experience; but the human race lives also by art and reasoning. It is from memory that men acquire experience, because the numerous memories of the same thing eventually produce the effect of a single experience. Experience seems very similar to science and art, but actually it is through experience that men acquire science and art; for as Polus rightly says, "experience produces art, but inexperience chance." Art is produced when from many notions of experience a single universal judgement is formed with regard to like objects. To have a judgement that when Callias was suffering from this or that disease this or that benefited him, and similarly with Socrates and various other individuals, is a matter of experience; but to judge that it benefits all persons of a certain type, considered as a class, who suffer from this or that disease (e.g. the phlegmatic or bilious when suffering from burning fever) is a matter of art.

It would seem that for practical purposes experience is in no way inferior to art; indeed we see men of experience succeeding more than those who have theory without experience. The reason of this is that experience is knowledge of particulars, but art of universals; and actions and the effects produced are all concerned with the particular. For it is not man that the physician cures, except incidentally, but Callias or Socrates or some other person similarly named, who is incidentally a man as well. So if a man has theory without experience, and knows the universal, but does not know the particular contained in it, he will often fail in his treatment; for it is the particular that must be treated. Nevertheless we consider that knowledge and proficiency belong to art rather than to experience, and we assume that artists are wiser than men of mere experience (which implies that in all cases wisdom depends rather upon knowledge); and this is because the former know the cause, whereas the latter do not. For the experienced know the fact, but not the wherefore; but the artists know the wherefore and the cause. For the same reason we consider that the master crafts-men in every profession are more estimable and know more and are wiser than the artisans, because they know the reasons of the things which are done; but we think that the artisans, like certain inanimate objects, do things, but without knowing what they are doing (as, for instance, fire burns); only whereas inanimate objects perform all their actions in virtue of a certain natural quality, artisans perform theirs through habit. Thus the master craftsmen are superior in wisdom, not because they can do things, but because they possess a theory and know the causes.

In general the sign of knowledge or ignorance is the ability to teach, and for this reason we hold that art rather than experience is scientific knowledge; for the artists can teach, but the others cannot. Further, we do not consider any of the senses to be Wisdom. They are indeed our chief sources of knowledge about particulars, but they do not tell us the reason for anything, as for example why fire is hot, but only that it *is* hot.

It is therefore probable that at first the inventor of any art which went further than the ordinary sensations was admired by his fellow-men, not merely because some of his inventions were useful, but as being a wise and superior person. And as more and more arts were discovered, some relating to the necessities and some to the pastimes of life, the inventors of the latter were always considered wiser than those of the former, because their branches of knowledge did not aim at utility. Hence when all the discoveries of this kind were fully developed, the sciences which relate neither to pleasure nor yet to the necessities of life were invented, and first in those places where men had leisure. Thus the mathematical sciences originated in the neighbour-hood of Egypt, because there the priestly class was allowed leisure.

175

The difference between art and science and the other kindred mental activities has been stated in the *Ethics;* the reason for our present discussion is that it is generally assumed that what is called Wisdom is concerned with the primary causes and principles, so that, as has been already stated, the man of experience is held to be wiser than the mere possessors of any power of sensation, the artist than the man of experience, the master craftsman than the artisan; and the speculative sciences to be more learned than the productive. Thus it is clear that Wisdom is knowledge of certain principles and causes.

Since we are investigating this kind of knowledge, we must consider what these causes and principles are whose knowledge is Wisdom. Perhaps it will be clearer if we take the opinions which we hold about the wise man. We consider first, then, that the wise man knows all things, so far as it is possible, without having knowledge of every one of them individually; next, that the wise man is he who can comprehend difficult things, such as are not easy for human comprehension (for sense-perception, being common to all, is easy, and has nothing to do with Wisdom); and further that in every branch of knowledge a man is wiser in proportion as he is more accurately informed and better able to expound the causes. Again among the sciences we consider that that science which is desirable in itself and for the sake of knowledge is more nearly Wisdom than that which is desirable for its results, and that the superior is more nearly Wisdom than the subsidiary; for the wise man should give orders, not receive them; nor should he obey others, but the less wise should obey him.

Such in kind and in number are the opinions which we hold with regard to Wisdom and the wise. Of the qualities there described the knowledge of everything must necessarily belong to him who in the highest degree possesses knowledge of the universal, because he knows in a sense all the particulars which it comprises. These things, viz. the most universal, are perhaps the hardest for man to grasp, because they are furthest removed from the senses. Again, the most exact of the sciences are those which are most concerned with the first principles; for those which are based on fewer principles are more exact than those which include additional principles; *e.g.*, arithmetic is more exact than geometry. Moreover, the science which investigates causes is more instructive than one which does not, for it is those who tell us the causes of any particular thing who instruct us. Moreover, knowledge and understanding which are desirable for their own sake are most attainable in the knowledge of that which is most knowable. For the man who desires knowledge for its own sake will most desire the most perfect knowledge, and this is the knowledge of the most knowable, and the things which are most knowable are first principles and causes; for it is through these and from these that other things come to be known, and not these through the particulars which fall under them.

And that science is supreme, and superior to the subsidiary, which knows for what end each action is to be done; *i.e.* the Good in each particular case, and in general the highest Good in the whole of nature.

Thus as a result of all the above considerations the term which we are investigating falls under the same science, which must speculate about first principles and causes; for the Good, *i.e.* the *end,* is one of the causes.

That it is not a productive science is clear from a consideration of the first philosophers. It is through wonder that men now begin and originally began to philosophize; wondering in the first place at obvious perplexities, and then by gradual progression raising questions about the greater matters too, *e.g.* about the changes of the moon and of the sun, about the stars and about the origin of the universe. Now he who wonders and is perplexed feels that he is ignorant (thus the myth-lover is in a sense a philosopher, since myths are composed of wonders); therefore if it was to escape ignorance that men studied philosophy, it is obvious that they pursued science for the sake of knowledge, and not for any practical utility. The actual course of events bears witness to this; for speculation of this kind began with a view to recreation and pastime, at a time when practically all the necessities of life were already supplied. Clearly then it is for no extrinsic advantage that we seek this knowledge; for just as we call a man independent who exists for himself and not for another, so we call this the only independent science, since it alone exists itself.

For this reason its acquisition might justly be supposed to be beyond human power, since in many respects human nature is servile; in which case, as Simonides says, "God alone can have this privilege," and man should only seek the knowledge which is within his reach. Indeed if the poets are right and the Deity is by nature jealous, it is probable that in this case He would be particularly jealous, and all those who excel in knowledge unfortunate. But it is impossible for the Deity to be jealous (indeed, as the proverb says, "poets tell many a lie"), nor must we suppose that any other form of knowledge is more precious than this; for what is most divine is most precious. Now there are two ways only in which it can be divine. A science is divine if it is peculiarly the possession of God, or if it is concerned with divine matters. And this science alone fulfils both these conditions; for (a) all believe that God is one of the causes and a kind of principle, and (b) God is the sole or chief possessor of this sort of knowledge. Accordingly, although all other sciences are more necessary than this, none is more excellent.

The acquisition of this knowledge, however, must in a sense result in something which is the reverse of the outlook with which we first approached the inquiry. All begin, as we have said, by wondering that things should be as they are, *e.g.* with regard to marionettes, or the solstices, or the incommensurability of the diagonal of a square; because

it seems wonderful to everyone who has not yet perceived the cause that a thing should not be measurable by the smallest unit. But we must end with the contrary and (according to the proverb) the better view, as men do even in these cases when they understand them; for a geometrician would wonder at nothing so much as if the diagonal were to become measurable.

Thus we have stated what is the nature of the science which we are seeking, and what is the object which our search and our whole investigation must attain.

Metaphysics, 980a–983a
Translated by Hugh Tredennick

Knowledge has never been understood and recommended more purely, more earnestly, or more sublimely.

WERNER JAEGER
Aristotle (1934)
Translated by Richard Robinson

ARISTOTLE

3 8 4 — 3 2 2 B . C .

THE LIFE OF REASON

Εἰ δ' ἐστὶν ἡ εὐδαιμονία κατ' ἀρετὴν ἐνέργεια, εὔλογον κατὰ τὴν κρατίστην· αὕτη δ' ἂν εἴη τοῦ ἀρίστου. εἴτε δὴ νοῦς τοῦτο εἴτε ἄλλο τι, ὃ δὴ κατὰ φύσιν δοκεῖ ἄρχειν καὶ ἡγεῖσθαι καὶ ἔννοιαν ἔχειν περὶ καλῶν καὶ θείων, εἴτε θεῖον ὂν καὶ αὐτὸ εἴτε τῶν ἐν ἡμῖν τὸ θειότατον, ἡ τούτου ἐνέργεια κατὰ τὴν οἰκείαν ἀρετὴν εἴη ἂν ἡ τελεία εὐδαιμονία· ὅτι δ' ἐστὶ θεωρητική, εἴρηται. ὁμολογούμενον δὲ τοῦτ' ἂν δόξειεν εἶναι καὶ τοῖς πρότερον καὶ τῷ ἀληθεῖ. κρατίστη τε γὰρ αὕτη ἐστὶν ἡ ἐνέργεια (καὶ γὰρ ὁ νοῦς τῶν ἐν ἡμῖν, καὶ τῶν γνωστῶν, περὶ ἃ ὁ νοῦς)· ἔτι δὲ συνεχεστάτη, θεωρεῖν [τε] γὰρ δυνάμεθα συνεχῶς μᾶλλον ἢ πράττειν ὁτιοῦν, οἰόμεθά τε δεῖν ἡδονὴν παραμεμῖχθαι τῇ εὐδαιμονίᾳ, ἡδίστη δὲ τῶν κατ' ἀρετὴν ἐνεργειῶν ἡ κατὰ τὴν σοφίαν ὁμολογουμένως ἐστίν· δοκεῖ γοῦν ἡ φιλοσοφία θαυμαστὰς ἡδονὰς ἔχειν καθαρειότητι καὶ τῷ βεβαίῳ, εὔλογον δὲ τοῖς εἰδόσι τῶν ζητούντων ἡδίω τὴν διαγωγὴν εἶναι. ἥ τε λεγομένη αὐτάρκεια περὶ τὴν θεωρητικὴν μάλιστ' ἂν εἴη· τῶν μὲν γὰρ πρὸς τὸ ζῆν ἀναγκαίων καὶ σοφὸς καὶ δίκαιος καὶ οἱ λοιποὶ δέονται, τοῖς δὲ τοιούτοις ἱκανῶς κεχορηγημένων ὁ μὲν δίκαιος δεῖται πρὸς οὓς δικαιοπραγήσει καὶ μεθ' ὧν, ὁμοίως δὲ καὶ ὁ σώφρων

καὶ ὁ ἀνδρεῖος καὶ τῶν ἄλλων ἕκαστος, ὁ δὲ σοφὸς καὶ καθ' αὑτὸν ὢν δύναται θεωρεῖν, καὶ ὅσῳ ἂν σοφώτερος ᾖ μᾶλλον· βέλτιον δ' ἴσως συνεργοὺς ἔχων, ἀλλ' ὅμως αὐταρκέστατος. δόξαι τ' ἂν αὐτὴ μόνη δι' αὑτὴν ἀγαπᾶσθαι· οὐδὲν γὰρ ἀπ' αὐτῆς γίνεται παρὰ τὸ θεωρῆσαι, ἀπὸ δὲ τῶν πρακτικῶν ἢ πλεῖον ἢ ἔλαττον περιποιού- μεθα παρὰ τὴν πρᾶξιν. δοκεῖ τε ἡ εὐδαιμονία ἐν τῇ σχολῇ εἶναι· ἀσχολούμεθα γὰρ ἵνα σχολάζωμεν, καὶ πολεμοῦμεν ἵν' εἰρήνην ἄγω- μεν. τῶν μὲν οὖν πρακτικῶν ἀρετῶν ἐν τοῖς πολιτικοῖς ἢ ἐν τοῖς πολεμικοῖς ἡ ἐνέργεια· αἱ δὲ περὶ ταῦτα πράξεις δοκοῦσιν ἄσχολοι εἶναι, αἱ μὲν πολεμικαὶ καὶ παντελῶς (οὐδεὶς γὰρ αἱρεῖται τὸ πο- λεμεῖν τοῦ πολεμεῖν ἕνεκα, οὐδὲ παρασκευάζει πόλεμον· δόξαι γὰρ ἂν παντελῶς μιαιφόνος τις εἶναι, εἰ τοὺς φίλους πολεμίους ποιοῖτο, ἵνα μάχαι καὶ φόνοι γίγνοιντο)· ἔστι δὲ καὶ ἡ τοῦ πολιτικοῦ ἄσχο- λος, καὶ παρ' αὐτὸ τὸ πολιτεύεσθαι περιποιουμένη δυναστείας καὶ τιμὰς ἢ τήν γε εὐδαιμονίαν αὑτῷ καὶ τοῖς πολίταις, ἑτέραν οὖσαν τῆς πολιτικῆς, ἣν καὶ ζητοῦμεν δῆλον ὡς ἑτέραν οὖσαν. εἰ δὴ τῶν μὲν κατὰ τὰς ἀρετὰς πράξεων αἱ πολιτικαὶ καὶ πολεμικαὶ κάλλει καὶ μεγέθει προέχουσιν, αὗται δ' ἄσχολοι καὶ τέλους τινὸς ἐφίεν- ται καὶ οὐ δι' αὑτὰς αἱρεταί εἰσιν, ἡ δὲ τοῦ νοῦ ἐνέργεια σπουδῇ τε διαφέρειν δοκεῖ θεωρητικὴ οὖσα καὶ παρ' αὑτὴν οὐδενὸς ἐφίε- σθαι τέλους, ἔχειν τε ἡδονὴν οἰκείαν (αὕτη δὲ συναύξει τὴν ἐνέρ- γειαν), καὶ τὸ αὔταρκες δὴ καὶ σχολαστικὸν καὶ ἄτρυτον ὡς ἀν- θρώπῳ καὶ ὅσα ἄλλα τῷ μακαρίῳ ἀπονέμεται, τὰ κατὰ ταύτην τὴν ἐνέργειαν φαίνεται ὄντα· ἡ τελεία δὴ εὐδαιμονία αὕτη ἂν εἴη ἀν- θρώπου, λαβοῦσα μῆκος βίου τέλειον· οὐδὲν γὰρ ἀτελές ἐστι τῶν τῆς εὐδαιμονίας. ὁ δὲ τοιοῦτος ἂν εἴη βίος κρείττων ἢ κατ' ἄνθρω- πον· οὐ γὰρ ᾗ ἄνθρωπός ἐστιν οὕτω βιώσεται, ἀλλ' ᾗ θεῖόν τι ἐν αὐ- τῷ ὑπάρχει· ὅσον δὲ διαφέρει τοῦτο τοῦ συνθέτου, τοσοῦτον καὶ ἡ ἐνέργεια τῆς κατὰ τὴν ἄλλην ἀρετήν. εἰ δὴ θεῖον ὁ νοῦς πρὸς τὸν ἄνθρωπον, καὶ ὁ κατὰ τοῦτον βίος θεῖος πρὸς τὸν ἀνθρώπινον βίον. οὐ χρὴ δὲ κατὰ τοὺς παραινοῦντας ἀνθρώπινα φρονεῖν ἄν- θρωπον ὄντα οὐδὲ θνητὰ τὸν θνητόν, ἀλλ' ἐφ' ὅσον ἐνδέχεται ἀθα- νατίζειν καὶ πάντα ποιεῖν πρὸς τὸ ζῆν κατὰ τὸ κράτιστον τῶν ἐν αὐτῷ· εἰ γὰρ καὶ τῷ ὄγκῳ μικρόν ἐστι, δυνάμει καὶ τιμιότητι πολὺ μᾶλλον πάντων ὑπερέχει.

If happiness is activity in accordance with virtue, it is reasonable that it should be in accordance with the highest virtue; and this will be that of the best thing in us. Whether it be reason or something else that is this element which is thought to be our natural ruler and guide and to take thought of things noble and divine, whether it be itself also divine or only the most divine element in us, the activity of this in accordance with its proper virtue will be perfect happiness. That this activity is contemplative we have already said.

179

Now this would seem to be in agreement both with what we said before and with the truth. For, firstly, this activity is the best (since not only is reason the best thing in us, but the objects of reason are the best of knowable objects); and, secondly, it is the most continuous, since we can contemplate truth more continuously than we can *do* anything. And we think happiness has pleasure mingled with it, but the activity of philosophic wisdom is admittedly the pleasantest of virtuous activities; at all events the pursuit of it is thought to offer pleasures marvellous for their purity and their enduringness, and it is to be expected that those who know will pass their time more pleasantly than those who inquire. And the self-sufficiency that is spoken of must belong most to the contemplative activity. For while a philosopher, as well as a just man or one possessing any other virtue, needs the necessaries of life, when they are sufficiently equipped with things of that sort the just man needs people towards whom and with whom he shall act justly, and the temperate man, the brave man, and each of the others is in the same case, but the philosopher, even when by himself, can contemplate truth, and the better the wiser he is; he can perhaps do so better if he has fellow-workers, but still he is the most self-sufficient. And this activity alone would seem to be loved for its own sake; for nothing arises from it apart from the contemplating, while from practical activities we gain more or less apart from the action. And happiness is thought to depend on leisure; for we are busy that we may have leisure, and make war that we may live in peace. Now the activity of the practical virtues is exhibited in political or military affairs, but the actions concerned with these seem to be unleisurely. Warlike actions are completely so (for no one chooses to be at war, or provokes war, for the sake of being at war; any one would seem absolutely murderous if he were to make enemies of his friends in order to bring about battle and slaughter); but the action of the statesman is also unleisurely, and— apart from the political action itself—aims at despotic power and honours, or at all events happiness, for him and his fellow citizens—a happiness different from political action, and evidently sought as being different. So if among virtuous actions political and military actions are distinguished by nobility and greatness, and these are unleisurely and aim at an end and are not desirable for their own sake, but the activity of reason, which is contemplative, seems both to be superior in serious worth and to aim at no end beyond itself, and to have its pleasure proper to itself (and this augments the activity), and the self-sufficiency, leisureliness, unweariedness (so far as this is possible for man), and all the other attributes ascribed to the supremely happy man are evidently those connected with this activity, it follows that this will be the complete happiness of man, if it be allowed a complete term of life (for none of the attributes of happiness is *in*complete).

But such a life would be too high for man; for it is not in so far as he

is man that he will live so, but in so far as something divine is present in him; and by so much as this is superior to our composite nature is its activity superior to that which is the exercise of the other kind of virtue. If reason is divine, then, in comparison with man, the life according to it is divine in comparison with human life. But we must not follow those who advise us, being men, to think of human things, and, being mortal, of mortal things, but must, so far as we can, make ourselves immortal, and strain every nerve to live in accordance with the best thing in us; for even if it be small in bulk, much more does it in power and worth surpass everything.

<div align="right">

Ethica Nicomachea, 1177a
Translated by W. D. Ross

</div>

Never in any human soul did the theorising passion burn with so clear and bright and pure a flame. Under its inspiration his style more than once breaks into a strain of sublime, though simple and rugged eloquence.

<div align="right">

A L F R E D W I L L I A M B E N N
The Greek Philosophers (1882)

</div>

D E M O S T H E N E S

3 8 5 ? — 3 2 2 B . C .

DEMOSTHENES DEFENDS HIMSELF

Ἀλλὰ τί ταῦτ' ἐπιτιμῶ, πολλῷ σχετλιώτερα ἄλλα κατηγορηκότος αὐτοῦ καὶ κατεψευσμένου; ὃς γὰρ ἐμοῦ φιλιππισμὸν, ὦ γῆ καὶ θεοί, κατηγορεῖ, τί οὗτος οὐκ ἂν εἴποι; καίτοι νὴ τὸν Ἡρακλέα καὶ πάντας θεούς, εἴ γ' ἐπ' ἀληθείας δέοι σκοπεῖσθαι, εἰ τὸ καταψεύδεσθαι καὶ δι' ἔχθραν τι λέγειν ἀνελόντας ἐκ μέσου, τίνες ὡς ἀληθῶς εἰσὶν οἷς ἂν εἰκότως καὶ δικαίως τὴν τῶν γεγενημένων αἰτίαν ἐπὶ τὴν κεφαλὴν ἀναθεῖεν ἅπαντες, τοὺς ὁμοίους τούτῳ παρ' ἑκάστῃ τῶν πόλεων εὕρητ' ἄν, οὐ τοὺς ἐμοί· οἵ, ὅτ' ἦν ἀσθενῆ τὰ Φιλίππου πράγματα καὶ κομιδῇ μικρά, πολλάκις προλεγόντων ἡμῶν καὶ παρακαλούντων καὶ διδασκόντων τὰ βέλτιστα, τῆς ἰδίας ἔνεκ' αἰσχροκερδείας τὰ κοινῇ συμφέροντα προΐεντο, τοὺς ὑπάρχοντας ἕκαστοι πολίτας ἐξαπατῶντες καὶ διαφθείροντες, ἕως δούλους ἐποίησαν, Θετταλοὺς Δάοχος, Κινέας, Θρασυδαῖος, Ἀρκάδας Κερκιδᾶς, Ἱερώνυμος, Εὐκαμπίδας, Ἀργείους Μύρτις, Τελέδαμος, Μνασέας, Ἠλείους Εὐξίθεος, Κλεότιμος, Ἀρίσταιχμος, Μεσσηνίους οἱ Φιλιάδου τοῦ θεοῖς ἐχθροῦ παῖδες Νέων, καὶ Θρασύλοχος, Σικυωνίους Ἀρίστρατος, Ἐ-

πιχάρης, Κορινθίους Δείναρχος, Δημάρετος, Μεγαρέας Πτοιόδωρος, Ἕλιξος, Περίλαος, Θηβαίους Τιμόλαος, Θεογείτων, Ἀνεμοίτας, Εὐβοέας Ἵππαρχος, Κλείταρχος, Σωσίστρατος. ἐπιλείψει με λέγοντα ἡ ἡμέρα τὰ τῶν προδοτῶν ὀνόματα. οὗτοι πάντες εἰσὶν, ἄνδρες Ἀθηναῖοι, τῶν αὐτῶν βουλευμάτων ἐν ταῖς αὐτῶν πατρίσιν ὧνπερ οὗτοι παρ' ὑμῖν, ἄνθρωποι μιαροὶ καὶ κόλακες καὶ ἀλάστορες, ἠκρωτηριασμένοι τὰς ἑαυτῶν ἕκαστοι πατρίδας, τὴν ἐλευθερίαν προπεπωκότες πρότερον μὲν Φιλίππῳ, νῦν δὲ Ἀλεξάνδρῳ, τῇ γαστρὶ μετροῦντες καὶ τοῖς αἰσχίστοις τὴν εὐδαιμονίαν, τὴν δ' ἐλευθερίαν καὶ τὸ μηδένα ἔχειν δεσπότην αὐτῶν, ἃ τοῖς προτέροις Ἕλλησιν ὅροι τῶν ἀγαθῶν ἦσαν καὶ κανόνες, ἀνατετροφότες.

Ταύτης τοίνυν τῆς οὕτως αἰσχρᾶς καὶ περιβοήτου συστάσεως καὶ κακίας, μᾶλλον δ', ὦ ἄνδρες Ἀθηναῖοι, προδοσίας, εἰ δεῖ μὴ ληρεῖν, τῆς τῶν Ἑλλήνων ἐλευθερίας, ἥ τε πόλις παρὰ πᾶσιν ἀνθρώποις ἀναίτιος γέγονεν ἐκ τῶν ἐμῶν πολιτευμάτων καὶ ἐγὼ παρ' ὑμῖν. εἶτα μ' ἐρωτᾷς ἀντὶ ποίας ἀρετῆς ἀξιῶ τιμᾶσθαι; ἐγὼ δή σοι λέγω ὅτι τῶν πολιτευομένων παρὰ τοῖς Ἕλλησι διαφθαρέντων ἁπάντων, ἀρξαμένων ἀπὸ σοῦ, πρότερον μὲν ὑπὸ Φιλίππου, νῦν δ' ὑπ' Ἀλεξάνδρου, ἐμὲ οὔτε καιρὸς οὔτε φιλανθρωπία λόγων οὔτ' ἐπαγγελιῶν μέγεθος οὔτ' ἐλπὶς οὔτε φόβος οὔτ' ἄλλο οὐδὲν ἐπῆρεν οὐδὲ προηγάγετο ὧν ἔκρινα δικαίων καὶ συμφερόντων τῇ πατρίδι οὐδὲν προδοῦναι, οὐδ', ὅσα συμβεβούλευκα πώποτε τουτοισί, ὁμοίως ὑμῖν ὥσπερ τρυτάνη ῥέπων ἐπὶ τὸ λῆμμα συμβεβούλευκα, ἀλλ' ἀπ' ὀρθῆς καὶ δικαίας καὶ ἀδιαφθόρου τῆς ψυχῆς, καὶ μεγίστων δὴ πραγμάτων τῶν κατ' ἐμαυτὸν ἀνθρώπων προστὰς πάντα ταῦτα ὑγιῶς καὶ δικαίως πεπολίτευμαι. διὰ ταῦτ' ἀξιῶ τιμᾶσθαι. τὸν δὲ τειχισμὸν τοῦτον, ὃν σύ μου διέσυρες, καὶ τὴν ταφρείαν ἄξια μὲν χάριτος καὶ ἐπαίνου κρίνω, πῶς γὰρ οὔ; πόρρω μέντοι που τῶν ἐμαυτῷ πεπολιτευμένων τίθεμαι. οὐ λίθοις ἐτείχισα τὴν πόλιν οὐδὲ πλίνθοις ἐγώ, οὐδ' ἐπὶ τούτοις μέγιστον τῶν ἐμαυτοῦ φρονῶ· ἀλλ' ἐὰν τὸν ἐμὸν τειχισμὸν βούλῃ δικαίως σκοπεῖν, εὑρήσεις ὅπλα καὶ πόλεις καὶ τόπους καὶ λιμένας καὶ ναῦς καὶ ἵππους καὶ πολλοὺς τοὺς ὑπὲρ τούτων ἀμυνουμένους. ταῦτα προὐβαλόμην ἐγὼ πρὸ τῆς Ἀττικῆς, ὅσον ἦν ἀνθρωπίνῳ λογισμῷ δυνατόν, καὶ τούτοις ἐτείχισα τὴν χώραν, οὐχὶ τὸν κύκλον τοῦ Πειραιῶς οὐδὲ τοῦ ἄστεως. οὐδέ γ' ἡττήθην ἐγὼ τοῖς λογισμοῖς Φιλίππου, πολλοῦ γε καὶ δεῖ, οὐδὲ ταῖς παρασκευαῖς, ἀλλ' οἱ τῶν συμμάχων στρατηγοὶ καὶ αἱ δυνάμεις τῇ τύχῃ. τίνες αἱ τούτων ἀποδείξεις; ἐναργεῖς καὶ φανεραί. σκοπεῖτε δέ.

Τί χρῆν τὸν εὔνουν πολίτην ποιεῖν, τί τὸν μετὰ πάσης προνοίας καὶ προθυμίας καὶ δικαιοσύνης ὑπὲρ τῆς πατρίδος πολιτευόμενον; οὐκ ἐκ μὲν θαλάττης τὴν Εὔβοιαν προβαλέσθαι πρὸ τῆς Ἀττικῆς, ἐκ δὲ τῆς μεσογείου τὴν Βοιωτίαν, ἐκ δὲ τῶν πρὸς Πελοπόννησον τόπων τοὺς ὁμόρους ταύτῃ, οὐ τὴν σιτοπομπίαν, ὅπως παρὰ πᾶσαν

φιλίαν ἄχρι τοῦ Πειραιῶς κομισθήσεται, προϊδέσθαι; καὶ τὰ μὲν σῶσαι τῶν ὑπαρχόντων ἐκπέμποντα βοηθείας καὶ λέγοντα καὶ γράφοντα τοιαῦτα, τὴν Προκόννησον, τὴν Χερρόνησον, τὴν Τένεδον, τὰ δ' ὅπως οἰκεῖα καὶ σύμμαχ' ὑπάρξει πρᾶξαι, τὸ Βυζάντιον, τὴν Ἄβυδον, τὴν Εὔβοιαν; καὶ τῶν μὲν τοῖς ἐχθροῖς ὑπαρχουσῶν δυνάμεων τὰς μεγίστας ἀφελεῖν, ὧν δ' ἐνέλειπε τῇ πόλει, ταῦτα προσθεῖναι; ταῦτα τοίνυν ἅπαντα πέπρακται τοῖς ἐμοῖς ψηφίσμασι καὶ τοῖς ἐμοῖς πολιτεύμασιν, ἃ καὶ βεβουλευμένα, ὦ ἄνδρες 'Αθηναῖοι, ἐὰν ἄνευ φθόνου τις βούληται σκοπεῖν, ὀρθῶς εὑρήσει καὶ πεπραγμένα πάσῃ δικαιοσύνῃ, καὶ τὸν ἑκάστου καιρὸν οὐ παρεθέντα οὐδ' ἀγνοηθέντα οὐδὲ προεθέντα ὑπ' ἐμοῦ, καὶ ὅσα εἰς ἑνὸς ἀνδρὸς δύναμιν καὶ λογισμὸν ἧκεν, οὐδὲν ἐλλειφθέν. εἰ δὲ ἢ δαίμονός τινος ἢ τύχης ἰσχὺς ἢ στρατηγῶν φαυλότης ἢ τῶν προδιδόντων τὰς πόλεις ὑμῶν κακία ἢ πάντα ταῦτα ἅμα ἐλυμαίνετο τοῖς ὅλοις, ἕως ἀνέτρεψαν, τί Δημοσθένης ἀδικεῖ; εἰ δ' οἷος ἐγὼ παρ' ὑμῖν κατὰ τὴν ἐμαυτοῦ τάξιν, εἷς ἐν ἑκάστῃ τῶν Ἑλληνίδων πόλεων ἀνὴρ ἐγένετο, μᾶλλον δ' εἰ ἕνα ἄνδρα μόνον Θετταλία καὶ ἕνα ἄνδρα 'Αρκαδία ταὐτὰ φρονοῦντα ἔσχεν ἐμοί, οὐδεὶς οὔτε τῶν ἔξω Πυλῶν Ἑλλήνων οὔτε τῶν εἴσω τοῖς παροῦσι κακοῖς ἐκέχρητ' ἄν, ἀλλὰ πάντες ἂν ὄντες ἐλεύθεροι καὶ αὐτόνομοι μετὰ πάσης ἀδείας ἀσφαλῶς ἐν εὐδαιμονίᾳ τὰς ἑαυτῶν ᾤκουν πατρίδας, τῶν τοσούτων καὶ τοιούτων ἀγαθῶν ὑμῖν καὶ τοῖς ἄλλοις 'Αθηναίοις ἔχοντες χάριν δι' ἐμέ. ἵνα δ' εἰδῆτε ὅτι πολλῷ τοῖς λόγοις ἐλάττοσι χρῶμαι τῶν ἔργων, εὐλαβούμενος τὸν φθόνον, λέγε μοι ταυτὶ καὶ ἀνάγνωθι λαβὼν τὸν ἀριθμὸν τῶν βοηθειῶν κατὰ τὰ ἐμὰ ψηφίσματα.

But why reproach him for that imputation, when he has uttered calumnies of far greater audacity? A man who accuses me of Philippism—Heaven and Earth, of what lie is he not capable? I solemnly aver that, if we are to cast aside lying imputations and spiteful mendacity, and inquire in all sincerity who really are the men to whom the reproach of all that has befallen might by general consent be fairly and honestly brought home, you will find that they are men in the several cities who resemble Aeschines, and do not resemble me. At a time when Philip's resources were feeble and very small indeed, when we were constantly warning, exhorting, admonishing them for the best, these men flung away their national prosperity for private and selfish gain; they cajoled and corrupted all the citizens within their grasp, until they had reduced them to slavery. So the Thessalians were treated by Daochus, Cineas, Thrasydaus, the Arcadians by Cercidas, Hieronymus, Eucampidas, the Argives by Myrtis, Teledamus, Mnaseas, the Eleians by Euxitheus, Cleotimus, Aristaechmus, the Messenians by the sons of that god-forsaken Philiades, Neon and Thrasylochus, the Sicyonians by Aristratus and Epichares, the Corinthians by Deinarchus and Demaretus, the Megar-

ians by Ptoeodorus, Helixus, Perilaus, the Thebans by Timolaus, Theo-
geiton, Anemoetas, the Euboeans by Hipparchus, Cleitarchus, and
Sosistratus. I could continue this catalogue of traitors till the sun sets.
Every one of them, men of Athens, is a man of the same way of think-
ing in the politics of his own country as Aeschines and his friends are
in ours. They too are profligates, sycophants, fiends incarnate; they have
mutilated their own countries; they have pledged away their liberty in
their cups, first to Philip, and now to Alexander. They measure their
happiness by their belly and their baser parts; they have overthrown for
ever that freedom and independence which to the Greeks of an earlier
age were the very standard and canon of prosperity.

Of this disgraceful and notorious conspiracy, of this wickedness, or
rather, men of Athens, if I am to speak without trifling, this betrayal
of the liberties of Greece, you—thanks to my policy—are guiltless in the
eyes of the world, as I am guiltless in your eyes. And then, Aeschines,
you ask for what merit I claim distinction! I tell you that, when all the
politicians in Greece, starting with you, had been corrupted, first by
Philip, and now by Alexander, neither opportunity, nor civil speeches,
nor large promises, nor hope, nor fear, nor any other inducement, could
provoke or suborn me to betray the just claims and the true interests
of my country, as I conceived them; and that, whatever counsels I
have offered to my fellow-citizens here, I have not offered, like you, as
if I were a false balance with a bias in favour of the vendor. With a soul
upright, honest and incorruptible, appointed to the control of more
momentous transactions than any statesman of my time, I have admin-
istered them throughout in all purity and righteousness. On those
grounds I claim this distinction. As for my fortifications, which you
treated so satirically, and my entrenchments, I do, and I must, judge
these things worthy of gratitude and thanks; but I give them a place
far removed from my political achievements. I did not fortify Athens
with masonry and brickwork: they are not the works on which I chiefly
pride myself. Regard my fortifications as you ought, and you will find
armies and cities and outposts, seaports and ships and horses, and a
multitude ready to fight for their defence. These were the bastions I
planted for the protection of Attica so far as it was possible to human
forethought; and therewith I fortified, not the ring-fence of our port
and our citadel, but the whole country. Nor was I beaten by Philip in
forethought or in armaments; that is far from the truth. The generals
and the forces of the allies were beaten by his good fortune. Have I any
proofs of my claim? Yes, proofs definite and manifest. I ask you all to
consider them.

What course of action was proper for a patriotic citizen who was
trying to serve his country with all possible prudence and energy and
loyalty? Surely it was to protect Attica on the sea-board by Euboea, on
the inland frontier by Boeotia, and on the side towards Peloponnesus

by our neighbours in that direction; to make provision for the passage of our corn-supply along friendly coasts all the way to Peiraeus; to preserve places already at our disposal, such as Proconnesus, Chersonesus, Tenedos, by sending succour to them and by suitable speeches and resolutions; to secure the friendship and alliance of such places as Byzantium, Abydos, and Euboea; to destroy the most important of the existing resources of the enemy, and to make good the deficiencies of our own city. All these purposes were accomplished by my decrees and my administrative acts. Whoever will study them, men of Athens, without jealousy, will find that they were rightly planned and honestly executed; that the proper opportunity for each several measure was never neglected, or ignored, or thrown away by me: and that nothing within the compass of one man's ability or forethought was left undone. If the superior power of some deity or of fortune, or the incompetence of commanders, or the wickedness of traitors, or all these causes combined, vitiated and at last shattered the whole enterprise,—is Demosthenes guilty? If in each of the cities of Greece there had been some one man such as I was in my appointed station in your midst, nay, if Thessaly had possessed one man and Arcadia one man holding the same sentiments that I held, no Hellenic people beyond or on this side of Thermopylae would have been exposed to their present distresses: they would still be dwelling prosperously in their own countries, in freedom and independence, securely and without fear, grateful to you and to all the Athenians for the great and manifold blessings they owed to me. To prove that, as a precaution against envy, I am using words that do less than justice to my deeds, please take these papers, and read the list of expeditions sent in pursuance of my decrees.

<div align="right">

De Corona (330 B.C.), 294–305
Translated by C. A. and J. H. Vince

</div>

Certainly this speech so approximates the ideal form fixed in our minds that greater eloquence need not be required.

<div align="right">

MARCUS TULLIUS CICERO
Orator (46 B.C.), xxxviii

</div>

DEMOSTHENES

385 ? — 322 B . C .

ON THE CROWN

Ἐπειδὴ δὲ πολὺς τοῖς συμβεβηκόσιν ἔγκειται, βούλομαί τι καὶ παράδοξον εἰπεῖν. καί μου πρὸς Διὸς καὶ θεῶν μηδεὶς τὴν ὑπερβολὴν θαυμάσῃ, ἀλλὰ μετ' εὐνοίας ὃ λέγω θεωρησάτω. εἰ γὰρ ἦν ἅπασι πρόδηλα τὰ μέλλοντα γενήσεσθαι, καὶ προῄδεσαν πάντες, καὶ σὺ προὔλεγες, Αἰσχίνη, καὶ διεμαρτύρου βοῶν καὶ κεκραγώς, ὃς οὐδ' ἐφθέγξω, οὐδ' οὕτως ἀποστατέον τῇ πόλει τούτων ἦν, εἴπερ δόξης ἢ προγόνων ἢ τοῦ μέλλοντος αἰῶνος εἶχε λόγον. νῦν μέν γε ἀποτυχεῖν δοκεῖ τῶν πραγμάτων, ὃ πᾶσι κοινόν ἐστιν ἀνθρώποις, ὅταν τῷ θεῷ ταῦτα δοκῇ· τότε δ' ἀξιοῦσα προεστάναι τῶν ἄλλων, εἶτ' ἀποστᾶσα τούτου, Φιλίππῳ προδεδωκέναι πάντας ἂν ἔσχεν αἰτίαν. εἰ γὰρ ταῦτα προεῖτο ἀκονιτί, περὶ ὧν οὐδένα κίνδυνον ὄντιν' οὐχ ὑπέμειναν οἱ πρόγονοι, τίς οὐχὶ κατέπτυσεν ἂν σοῦ; μὴ γὰρ τῆς πόλεώς γε, μηδ' ἐμοῦ. τίσι δ' ὀφθαλμοῖς πρὸς Διὸς ἑωρῶμεν ἂν τοὺς εἰς τὴν πόλιν ἀνθρώπους ἀφικνουμένους, εἰ τὰ μὲν πράγματ' εἰς ὅπερ νυνὶ περιέστη, ἡγεμὼν δὲ καὶ κύριος ᾑρέθη Φίλιππος ἁπάντων, τὸν δ' ὑπὲρ τοῦ μὴ γενέσθαι ταῦτ' ἀγῶνα ἕτεροι χωρὶς ἡμῶν ἦσαν πεποιημένοι, καὶ ταῦτα μηδεπώποτε τῆς πόλεως ἐν τοῖς ἔμπροσθε χρόνοις ἀσφάλειαν ἄδοξον μᾶλλον ἢ τὸν ὑπὲρ τῶν καλῶν κίνδυνον ᾑρημένης. τίς γὰρ οὐκ οἶδε Ἑλλήνων, τίς δε βαρβάρων, ὅτι καὶ παρὰ Θηβαίων καὶ παρὰ τῶν ἔτι τούτων πρότερον ἰσχυρῶν γενομένων Λακεδαιμονίων καὶ παρὰ τοῦ Περσῶν βασιλέως μετὰ πολλῆς χάριτος τοῦτ' ἂν ἀσμένως ἐδόθη τῇ πόλει, ὅ τι βούλεται λαβούσῃ καὶ τὰ ἑαυτῆς ἐχούσῃ τὸ κελευόμενον ποιεῖν καὶ ἐᾶν ἕτερον τῶν Ἑλλήνων προεστάναι. ἀλλ' οὐκ ἦν ταῦθ', ὡς ἔοικε, τοῖς τότ' Ἀθηναίοις πάτρια οὐδ' ἀνεκτὰ οὐδ' ἔμφυτα, οὐδ' ἐδυνήθη πώποτε τὴν πόλιν οὐδεὶς ἐκ παντὸς τοῦ χρόνου πεῖσαι τοῖς ἰσχύουσι μέν, μὴ δίκαια δὲ πράττουσα προσθεμένην ἀσφαλῶς δουλεύειν, ἀλλ' ἀγωνιζομένη περὶ πρωτείων καὶ τιμῆς καὶ δόξης κινδυνεύουσα πάντα τὸν αἰῶνα διατετέλεκε. καὶ ταῦθ' οὕτω σεμνὰ καὶ προσήκοντα τοῖς ὑμετέροις ἤθεσιν ὑμεῖς ὑπολαμβάνετ' εἶναι ὥστε καὶ τῶν προγόνων τοὺς ταῦτα πράξαντας μάλιστ' ἐπαινεῖτε, εἰκότως. τίς γὰρ οὐκ ἂν ἀγάσαιτο τῶν ἀνδρῶν ἐκείνων τῆς ἀρετῆς, οἳ καὶ τὴν χώραν καὶ τὴν πόλιν ἐκλιπεῖν ὑπέμειναν εἰς τὰς τριήρεις ἐμβάντες ὑπὲρ τοῦ μὴ τὸ κελευόμενον ποιῆσαι, τὸν μὲν ταῦτα συμβουλεύσαντα Θεμιστοκλέα στρατηγὸν ἑλόμενοι, τὸν δ' ὑπακούειν ἀποφηνάμενον τοῖς ἐπιταττομένοις Κυρσίλον καταλιθώσαντες, οὐ μόνον αὐτόν, ἀλλὰ καὶ αἱ γυναῖκες αἱ ὑμέτεραι τὴν γυναῖκ' αὐτοῦ. οὐ γὰρ ἐζήτουν οἱ τότ' Ἀθηναῖοι οὔτε ῥήτορα οὔτε στρατηγὸν δι'

186

ὅτου δουλεύσουσιν εὐτυχῶς, ἀλλ' οὐδὲ ζῆν ἠξίουν, εἰ μὴ μετ' ἐλευθερίας ἐξέσται τοῦτο ποιεῖν. ἡγεῖτο γὰρ αὐτῶν ἕκαστος οὐχὶ τῷ πατρὶ καὶ τῇ μητρὶ μόνον γεγενῆσθαι, ἀλλὰ καὶ τῇ πατρίδι. διαφέρει δὲ τί; ὅτι ὁ μὲν τοῖς γονεῦσι μόνον γεγενῆσθαι νομίζων τὸν τῆς εἱμαρμένης καὶ τὸν αὐτόματον θάνατον περιμένει, ὁ δὲ καὶ τῇ πατρίδι ὑπὲρ τοῦ μὴ ταύτην ἐπιδεῖν δουλεύουσαν ἀποθνήσκειν, ἐθελήσει, καὶ φοβερωτέρας ἡγήσεται τὰς ὕβρεις καὶ τὰς ἀτιμίας, ἃς ἐν δουλευούσῃ τῇ πόλει φέρειν ἀνάγκη, τοῦ θανάτου.

Εἰ μὲν τοίνυν τοῦτ' ἐπεχείρουν λέγειν, ὡς ἐγὼ προήγαγον ὑμᾶς ἄξια τῶν προγόνων φρονεῖν, οὐκ ἔσθ' ὅστις οὐκ ἂν εἰκότως ἐπιτιμήσειέ μοι. νῦν δ' ἐγὼ μὲν ὑμετέρας τὰς τοιαύτας προαιρέσεις ἀποφαίνω, καὶ δείκνυμι ὅτι καὶ πρὸ ἐμοῦ τοῦτ' εἶχε τὸ φρόνημα ἡ πόλις, τῆς μέντοι διακονίας τῆς ἐφ' ἑκάστοις τῶν πεπραγμένων καὶ ἐμαυτῷ μετεῖναί φημι, οὗτος δὲ τῶν ὅλων κατηγορῶν, καὶ κελεύων ὑμᾶς ἐμοὶ πικρῶς ἔχειν ὡς φόβων καὶ κινδύνων αἰτίῳ τῇ πόλει, τῆς μὲν εἰς τὸ παρὸν τιμῆς ἐμὲ ἀποστερῆσαι γλίχεται, τὰ δ' εἰς ἅπαντα τὸν λοιπὸν χρόνον ἐγκώμια ὑμῶν ἀφαιρεῖται. εἰ γὰρ ὡς οὐ τὰ βέλτιστα ἐμοῦ πολιτευσαμένου τουδὶ καταψηφιεῖσθε, ἡμαρτηκέναι δόξετε, οὐ τῇ τῆς τύχης ἀγνωμοσύνῃ τὰ συμβάντα παθεῖν, ἀλλ' οὐκ ἔστιν, οὐκ ἔστιν ὅπως ἡμάρτετε, ἄνδρες Ἀθηναῖοι, τὸν ὑπὲρ τῆς ἁπάντων ἐλευθερίας καὶ σωτηρίας κίνδυνον ἀράμενοι, μὰ τοὺς Μαραθῶνι προκινδυνεύσαντας τῶν προγόνων καὶ τοὺς ἐν Πλαταιαῖς παραταξαμένους καὶ τοὺς ἐν Σαλαμῖνι ναυμαχήσαντας καὶ τοὺς ἐπ' Ἀρτεμισίῳ καὶ πολλοὺς ἑτέρους τοὺς ἐν τοῖς δημοσίοις μνήμασι κειμένους ἀγαθοὺς ἄνδρας, οὓς ἅπαντας ὁμοίως ἡ πόλις τῆς αὐτῆς ἀξιώσασα τιμῆς ἔθαψεν, Αἰσχίνη, οὐχὶ τοὺς κατορθώσαντας αὐτῶν οὐδὲ τοὺς κρατήσαντας μόνους. δικαίως. ὃ μὲν γὰρ ἦν ἀνδρῶν ἀγαθῶν ἔργον, ἅπασι πέπρακται· τῇ τύχῃ δ', ἣν ὁ δαίμων ἔνειμεν ἑκάστοις, ταύτῃ κέχρηνται.

As he lays so much stress on results, let me venture on a paradox. If it seems extravagant, I beg that you will not be surprised, but that you will still give friendly consideration to what I am saying. Suppose that the future had been revealed to all of us, that every one had known what would happen, and that you, Aeschines, had predicted and protested, and shouted and stormed—though in fact you never opened your mouth—even then the city could not have departed from that policy, if she had any regard for honour, or for our ancestors, or for the days that are to come. All that can be said now is, that we have failed: and that is the common lot of humanity, if God so wills. But then, if Athens, after claiming the primacy of the nations, had run away from her claims, she would have been held guilty of betraying Greece to Philip. If, without striking a blow, she had abandoned the cause for which our forefathers flinched from no peril, is there a man who would not have

187

spat in your face? In your face, Aeschines: not at Athens, not at me! How could we have returned the gaze of visitors to our city, if the result had been what it is—Philip the chosen lord paramount of all Greece— and if other nations had fought gallantly to avert that calamity without our aid, although never before in the whole course of history had our city preferred inglorious security to the perils of a noble cause? There is no man living, whether Greek or barbarian, who does not know that the Thebans, or the Lacedaemonians, who held supremacy before them, or the king of Persia himself, would cheerfully and gratefully have given Athens liberty to keep what she had and to take what she chose, if only she would do their behest and surrender the primacy of Greece. But to the Athenians of old, I suppose, such temporizing was forbidden by their heredity, by their pride, by their very nature. Since the world began, no man has ever prevailed upon Athens to attach herself in the security of servitude to the oppressors of mankind however formidable: in every generation she has striven without a pause in the perilous contention for primacy, and honour, and renown. Such constancy you deem so exemplary, and so congenial to your character, that you still sing the praises of those of your forefathers by whom it was most signally displayed. And you are right. Who would not exult in the valour of those famous men who, rather than yield to a conqueror's behests, left city and country and made the war-galleys their home; who chose Themistocles, the man who gave them that counsel, as their commander, and stoned Cyrsilus to death for advising obedient submission? Aye, and his wife also was stoned by your wives. The Athenians of that day did not search for a statesman or a commander who should help them to a servile security: they did not ask to live, unless they could live as free men. Every man of them thought of himself as one born, not to his father and his mother alone, but to his country. What is the difference? The man who deems himself born only to his parents will wait for his natural and destined end; the son of his country is willing to die rather than see her enslaved, and will look upon those outrages and indignities, which a commonwealth in subjection is compelled to endure, as more dreadful than death itself.

If I had attempted to claim that you were first inspired with the spirit of your forefathers by me, every one would justly rebuke me. But I do not: I am asserting these principles as your principles; I am showing you that such was the pride of Athens long before my time,—though for myself I do claim some credit for the administration of particular measures. Aeschines, on the other hand, arraigns the whole policy, stirs up your resentment against me as the author of your terrors and your dangers, and, in his eagerness to strip me of the distinction of a moment, would rob you of the enduring praises of posterity. For if you condemn Ctesiphon on the ground of my political delinquency, you yourselves will be adjudged as wrongdoers, not as men who owed the

calamities they have suffered to the unkindness of fortune. But no; you cannot, men of Athens, you cannot have done wrongly when you accepted the risks of war for the redemption and the liberties of mankind; I swear it by our forefathers who bore the brunt of warfare at Marathon, who stood in array of battle at Plataea, who fought in the sea-fights of Salamis and Artemisium, and by all the brave men who repose in our public sepulchres, buried there by a country that accounted them all to be alike worthy of the same honour—all, I say, Aeschines, not the successful and the victorious alone. So justice bids: for by all the duty of brave men was accomplished: their fortune was such as Heaven severally allotted to them.

<div align="right">

De Corona (330 B.C.), 199–208
Translated by C. A. and J. H. Vince

</div>

The Greatest Oration of the Greatest of Orators.

<div align="right">

HENRY, LORD BROUGHAM
Oration on the Crown (1840)

</div>

PLAUTUS

2 5 4 ? — 1 8 4 B . C .

VERTUE

Virtus praemium est optimum;
virtus omnibus rebus anteit profecto:
libertas salus vita res et parentes, patria et prognati
tutantur, servantur:
virtus omnia in sese habet, omnia adsunt
bona quem penest virtus.

Verily Vertue dothe all thinges excelle.
For if libertie, helthe, lyvyng and substance,
Our countray, our parentes and children do well
It hapneth by vertue; she doth all aduance.
Vertue hath all thinge under gouernaunce,
And in whom of vertue is founden great plentie,
Any thinge that is good may neuer be deintie.

<div align="right">

Amphitryon, 648–52
Translated by Sir Thomas Elyot

</div>

What may be better saide?

<div align="right">

SIR THOMAS ELYOT
The Boke Named The Gouernour (1531)

</div>

THE SORCERESS

Πᾷ μοι ταὶ δάφναι; φέρε, Θέστυλι· πᾷ δὲ τὰ φίλτρα;
στέψον τὰν κελέβαν φοινικέῳ οἰὸς ἀώτῳ,
ὡς τὸν ἐμὸν βαρυνεῦντα φίλον καταθύσομαι ἄνδρα,
ὅς μοι δωδεκαταῖος ἀφ' ὧ τάλας οὐδὲ ποθίκει,
οὐδ' ἔγνω πότερον τεθνάκαμες ἢ ζοοὶ εἰμές
οὐδὲ θύρας ἄραξεν ἀνάρσιος ἦ ῥά οἱ ἀλλᾷ
ᾤχετ' ἔχων ὅ τ' Ἔρως ταχινὰς φρένας ἅ τ' Ἀφροδίτα;
βασεῦμαι ποτὶ τὰν Τιμαγήτοιο παλαίστραν
αὔριον, ὥς νιν ἴδω καὶ μέμψομαι οἷά με ποιεῖ.
νῦν δέ νιν ἐκ θυέων καταθύσομαι. ἀλλά, Σελάνα,
φαῖνε καλόν· τὶν γὰρ ποτσείσομαι ἄσυχα, δαῖμον,
τᾷ χθονίᾳ θ' Ἑκάτα, τὰν καὶ σκύλακες τρομέοντι
ἐρχομέναν νεκύων ἀνά τ' ἠρία καὶ μέλαν αἷμα.
χαῖρ' Ἑκάτα δασπλῆτι, καὶ ἐς τέλος ἄμμιν ὀπάδει
φάρμακα ταῦτ' ἔρδοισα χερείονα μήτε τι Κίρκης
μήτε τι Μηδείας μήτε ξανθᾶς Περιμήδας.
[ἴυγξ, ἕλκε τὺ τῆνον ἐμὸν ποτὶ δῶμα τὸν ἄνδρα.]
ἄλφιτά τοι πρᾶτον πυρὶ τάκεται· ἀλλ' ἐπίπασσε,
Θέστυλι. δειλαία, πᾷ τὰς φρένας ἐκπεπότασαι;
ἦ ῥά γέ τοι, μυσαρά, καὶ τὶν ἐπίχαρμα τέτυγμαι;
πάσσ' ἅμα καὶ λέγε ταῦτα· 'τὰ Δέλφιδος ὄστια πάσσω.'
ἴυγξ, ἕλκε τὺ τῆνον ἐμὸν ποτὶ δῶμα τὸν ἄνδρα.

Δέλφις ἔμ' ἀνίασεν· ἐγὼ δ' ἐπὶ Δέλφιδι δάφναν
αἴθω· χὡς αὕτα λακεῖ μέγα καππυρίσασα,
κἠξαπίνας ἄφθη, κοὐδὲ σποδὸν εἴδομες αὐτᾶς,
οὕτω τοι καὶ Δέλφις ἐνὶ φλογὶ σάρκ' ἀμαθύνοι.
ἴυγξ, ἕλκε τὺ τῆνον ἐμὸν ποτὶ δῶμα τὸν ἄνδρα.

ὡς τοῦτον τὸν κηρὸν ἐγὼ σὺν δαίμονι τάκω,
ὣς τάκοιθ' ὑπ' ἔρωτος ὁ Μύνδιος αὐτίκα Δέλφις.
χὡς δινεῖθ' ὅδε ῥόμβος ὁ χάλκεος ἐξ Ἀφροδίτας,
ὣς τῆνος δινοῖτο ποθ' ἁμετέραισι θύραισιν.
ἴυγξ, ἕλκε τὺ τῆνον ἐμὸν ποτὶ δῶμα τὸν ἄνδρα.

νῦν θυσῶ τὰ πίτυρα. τὺ δ', Ἄρτεμι, καὶ τὸν ἐν Ἅιδα
κινήσαις κ' ἀδάμαντα καὶ εἴ τί περ ἀσφαλὲς ἄλλο. —
Θέστυλι, ταὶ κύνες ἄμμιν ἀνὰ πτόλιν ὠρύονται.
ἁ θεὸς ἐν τριόδοισι· τὸ χαλκέον ὡς τάχος ἄχει.
ἴυγξ, ἕλκε τὺ τῆνον ἐμὸν ποτὶ δῶμα τὸν ἄνδρα.

ἠνίδε, σιγῇ μὲν πόντος, σιγῶντι δ' ἀῆται·

ἁ δ' ἐμὰ οὐ σιγῇ στέρνων ἔντοσθεν ἀνία,
ἀλλ' ἐπὶ τήνῳ πᾶσα καταίθομαι, ὅς με τάλαιναν
ἀντὶ γυναικὸς ἔθηκε κακὰν καὶ ἀπάρθενον ἦμεν.
ἴυγξ, ἕλκε τὺ τῆνον ἐμὸν ποτὶ δῶμα τὸν ἄνδρα.

ἐς τρὶς ἀποσπένδω καὶ τρὶς τάδε, πότνια, φωνῶ·
εἴτε γυνὰ τήνῳ παρακέκλιται εἴτε καὶ ἀνήρ,
τόσσον ἔχοι λάθας, ὅσσον ποκὰ Θησέα φαντί
ἐν Δίᾳ λασθῆμεν ἐϋπλοκάμω 'Αριάδνας.
ἴυγξ, ἕλκε τὺ τῆνον ἐμὸν ποτὶ δῶμα τὸν ἄνδρα.

ἱππομανὲς φυτόν ἐστι παρ' 'Αρκάσι· τῷ δ' ἔπι πᾶσαι
καὶ πῶλοι μαίνονται ἀν' ὤρεα καὶ θοαὶ ἵπποι.
ὣς καὶ Δέλφιν ἴδοιμι, καὶ ἐς τόδε δῶμα περάσαι
μαινομένῳ ἴκελος λιπαρᾶς ἔκτοσθε παλαίστρας.
ἴυγξ, ἕλκε τὺ τῆνον ἐμὸν ποτὶ δῶμα τὸν ἄνδρα.

τοῦτ' ἀπὸ τᾶς χλαίνας τὸ κράσπεδον ὤλεσε Δέλφις,
ὠγὼ νῦν τίλλοισα κατ' ἀγρίῳ ἐν πυρὶ βάλλω.
αἰαῖ Ἔρως ἀνιηρέ, τί μευ μέλαν ἐκ χροὸς αἷμα
ἐμφὺς ὡς λιμνᾶτις ἅπαν ἐκ βδέλλα πέπωκας;
ἴυγξ, ἕλκε τὺ τῆνον ἐμὸν ποτὶ δῶμα τὸν ἄνδρα.

σαύραν τοι τρίψασα κακὸν ποτὸν αὔριον οἰσῶ.
Θέστυλι, νῦν δὲ λαβοῖσα τὺ τὰ θρόνα ταῦθ' ὑπόμαξον
τᾶς τήνω φλιᾶς καθ' ὑπέρτερον, ἇς ἔτι καὶ νῦν
[ἐκ θυμῶ δέδεμαι, ὁ δέ μευ λόγον οὐδένα ποιεῖ]
καὶ λέγ' ἐπιφθύζοισα· 'τὰ Δέλφιδος ὄστια πάσσω.'
ἴυγξ, ἕλκε τὺ τῆνον ποτὶ δῶμα τὸν ἄνδρα.

νῦν δὲ μούνη ἐοῖσα πόθεν τὸν ἔρωτα δακρύσω;
ἐκ τίνος ἄρξωμαι; τίς μοι κακὸν ἄγαγε τοῦτο;
ἦνθ' ἁ τὠὐβούλοιο κανηφόρος ἄμμιν 'Αναξώ
ἄλσος ἐς 'Αρτέμιδος, τᾷ δὴ τόκα πολλὰ μὲν ἄλλα
θηρία πομπεύεσκε περισταδόν, ἐν δὲ λέαινα.
φράζεό μευ τὸν ἔρωθ' ὅθεν ἵκετο, πότνα Σελάνα.

καί μ' ἁ Θευμαρίδα Θρᾶσσα τροφὸς ἁ μακαρῖτις,
ἀγχίθυρος ναίοισα, κατεύξατο καὶ λιτάνευσε
τὰν πομπὰν θάσασθαι· ἐγὼ δέ οἱ ἁ μεγάλοιτος
ὡμάρτευν βύσσοιο καλὸν σύροισα χιτῶνα,
κἀμφιστειλαμένα τὰν ξυστίδα τὰν Κλεαρίστας.
φράζεό μευ τὸν ἔρωθ' ὅθεν ἵκετο, πότνα Σελάνα.

ἤδη δ' εὖσα μέσαν κατ' ἀμαξιτόν, ἇ τὰ Λύκωνος,
εἶδον Δέλφιν ὁμοῦ τε καὶ Εὐδάμιππον ἰόντας.
τοῖς δ' ἦν ξανθοτέρα μὲν ἑλιχρύσοιο γενειάς,
στήθεα δὲ στίλβοντα πολὺ πλέον ἢ τύ, Σελάνα,
ὡς ἀπὸ γυμνασίοιο καλὸν πόνον ἄρτι λιπόντων.
φράζεό μευ τὸν ἔρωθ' ὅθεν ἵκετο, πότνα Σελάνα.

χὠς ἴδον, ὡς ἐμάνην, ὥς μοι περὶ θυμὸς ἰάφθη

δειλαίας· τὸ δὲ κάλλος ἐτάκετο, κοὔτε τι πομπᾶς
τήνας ἐφρασάμαν, οὔθ' ὡς πάλιν οἴκαδ' ἀπῆνθον
ἔγνων· ἀλλά μέ τις καπυρὰ νόσος ἐξαλάπαξεν,
κεῖμαν δ' ἐν κλιντῆρι δέκ' ἄματα καὶ δέκα νύκτας.
φράζεό μευ τὸν ἔρωθ' ὅθεν ἵκετο, πότνα Σελάνα.

καί μευ χρὼς μὲν ὁμοῖος ἐγίνετο πολλάκι θάψῳ,
ἔρρευν δ' ἐκ κεφαλᾶς πᾶσαι τρίχες, αὐτὰ δὲ λοιπά
ὄστι' ἔτ' ἦς καὶ δέρμα. καὶ ἐς τίνος οὐκ ἐπέρασα
ἢ ποίας ἔλιπον γραίας δόμον, ἅτις ἐπᾷδεν;
ἀλλ' ἦς οὐδὲν ἐλαφρόν· ὁ δὲ χρόνος ἄνυτο φεύγων.
φράζεό μευ τὸν ἔρωθ' ὅθεν ἵκετο, πότνα Σελάνα.

χοὔτω τᾷ δούλᾳ τὸν ἀληθέα μῦθον ἔλεξα·
'·εἰ δ' ἄγε Θέστυλί μοι χαλεπᾶς νόσω εὑρέ τι μῆχος.
πᾶσαν ἔχει με τάλαιναν ὁ Μύνδιος· ἀλλὰ μολοῖσα
τήρησον ποτὶ τὰν Τιμαγήτοιο παλαίστραν·
τηνεῖ γὰρ φοιτῇ, τηνεῖ δέ οἱ ἁδὺ καθῆσθαι.
φράζεό μευ τὸν ἔρωθ' ὅθεν ἵκετο, πότνα Σελάνα.

κἠπεί κά νιν ἐόντα μάθῃς μόνον, ἅσυχα νεῦσον,
κεῖφ' ὅτι Σιμαίθα τυ καλεῖ, καὶ ὑφάγεο τᾷδε.'
ὣς ἐφάμαν· ἁ δ' ἦνθε καὶ ἄγαγε τὸν λιπαρόχρων
εἰς ἐμὰ δώματα Δέλφιν· ἐγὼ δέ νιν ὡς ἐνόησα
ἄρτι θύρας ὑπὲρ οὐδὸν ἀμειβόμενον ποδὶ κούφῳ —
φράζεό μευ τὸν ἔρωθ' ὅθεν ἵκετο, πότνα Σελάνα —

πᾶσα μὲν ἐψύχθην χιόνος πλέον, ἐν δὲ μετώπῳ
ἱδρώς μευ κοχύδεσκεν ἴσον νοτίαισιν ἐέρσαις,
οὐδέ τι φωνᾶσαι δυνάμαν, οὐδ' ὅσσον ἐν ὕπνῳ
κνυζεῦνται φωνεῦντα φίλαν ποτὶ ματέρα τέκνα·
ἀλλ' ἐπάγην δαγῦδι καλὸν χρόα πάντοθεν ἴσα.
φράζεό μευ τὸν ἔρωθ' ὅθεν ἵκετο, πότνα Σελάνα.

καί μ' ἐσιδὼν ὥστοργος, ἐπὶ χθονὸς ὄμματα πήξας
ἕζετ' ἐπὶ κλιντῆρι καὶ ἑζόμενος φάτο μῦθον·
' ἦ ῥά με, Σιμαίθα, τόσον ἔφθασας, ὅσσον ἐγώ θην
πρᾶν ποκα τὸν χαρίεντα τρέχων ἔφθασσα Φιλῖνον,
ἐς τὸ τεὸν καλέσασα τόδε στέγος ἤ με παρεῖμεν.
φράζεό μευ τὸν ἔρωθ' ὅθεν ἵκετο, πότνα Σελάνα.

' ἦνθον γὰρ κἠγών, ναὶ τὸν γλυκὺν ἦνθον Ἔρωτα,
ἢ τρίτος ἠὲ τέταρτος ἐὼν φίλος αὐτίκα νυκτός,
μᾶλα μὲν ἐν κόλποισι Διωνύσοιο φυλάσσων,
κρατὶ δ' ἔχων λεύκαν, Ἡρακλέος ἱερὸν ἔρνος,
πάντοθε πορφυρέαισι περὶ ζώστραισιν ἑλικτάν.
φράζεό μευ τὸν ἔρωθ' ὅθεν ἵκετο, πότνα Σελάνα.

' καί μ' εἰ μέν κ' ἐδέχεσθε, τὰ δὲ ἦς φίλα· καὶ γὰρ ἐλαφρός
καὶ καλὸς πάντεσσι μετ' ἠϊθέοισι καλεῦμαι·
εὗδον δ' εἴ κε μόνον τὸ καλὸν στόμα τεῦς ἐφίλησα·

εἰ δ' ἀλλᾷ μ' ὠθεῖτε καὶ ἁ θύρα εἴχετο μοχλῷ,
πάντως καὶ πελέκεις καὶ λαμπάδες ἦνθον ἐφ' ὑμέας.
φράζεό μευ τὸν ἔρωθ' ὅθεν ἵκετο, πότνα Σελάνα.

' νῦν δὲ χάριν μὲν ἔφαν τᾷ Κύπριδι πρᾶτον ὀφείλειν,
καὶ μετὰ τὰν Κύπριν τύ με δευτέρα ἐκ πυρὸς εἵλευ,
ὦ γύναι, ἐσκαλέσασα τεὸν ποτὶ τοῦτο μέλαθρον
αὔτως ἡμίφλεκτον. Ἔρως δ' ἄρα καὶ Λιπαραίου
πολλάκις Ἡφαίστοιο σέλας φλογερώτερον αἴθει.
φράζεό μευ τὸν ἔρωθ' ὅθεν ἵκετο, πότνα Σελάνα.
' σὺν δὲ κακαῖς μανίαις καὶ παρθένον ἐκ θαλάμοιο
καὶ νύμφαν ἐφόβησ' ἔτι δέμνια θερμὰ λιποῖσαν
ἀνέρος. ' ὣς ὃ μὲν εἶπεν· ἐγὼ δὲ ἁ ταχυπειθής
χειρὸς ἐφαψαμένα μαλακῶν ἔκλιν' ἐπὶ λέκτρων.
καὶ ταχὺ χρὼς ἐπὶ χρωτὶ πεπαίνετο, καὶ τὰ πρόσωπα
θερμότερ' ἦς ἢ πρόσθε, καὶ ἐψιθυρίσδομες ἁδύ.

χὤς κά τοι μὴ μακρὰ φίλα θρυλέοιμι Σελάνα,
ἐπράχθη τὰ μέγιστα, καὶ ἐς πόθον ἤνθομες ἄμφω.
κοὔτε τι τῆνος ἐμὶν ἐπεμέμψατο μέσφα τό γ' ἐχθές,
οὔτ' ἐγὼ αὖ τήνῳ. ἀλλ' ἦνθέ μοι ἅ τε Φιλίστας
μάτηρ τᾶς ἁμᾶς αὐλητρίδος ἅ τε Μελιξοῦς
σάμερον, ἁνίκα πέρ τε ποτ' οὐρανὸν ἔτραχον ἵπποι
Ἀῶ τὰν ῥοδόπαχυν ἀπ' Ὠκεανοῖο φέροισαι·
κεῖπέ μοι ἄλλα τε πολλὰ καὶ ὡς ἄρα Δέλφις ἔραται.
κεῖτε νιν αὖτε γυναικὸς ἔχει πόθος εἴτε καὶ ἀνδρός,
οὐκ ἔφατ' ἀτρεκὲς ἴδμεν, ἀτὰρ τόσον· ' αἰὲν Ἔρωτος
ἀκράτω ἐπεχεῖτο καὶ ἐς τέλος ᾤχετο φεύγων,
καὶ φάτο οἱ στεφάνοισι τὰ δώματα τῆνα πυκάσδειν.'
ταῦτά μοι ἁ ξείνα μυθήσατο· ἔστι δ' ἀληθής·
ἦ γάρ μοι καὶ τρὶς καὶ τετράκις ἄλλοκ' ἐφοίτη,
καὶ παρ' ἐμὶν ἐτίθει τὰν Δωρίδα πολλάκις ὄλπαν·
νῦν δέ τε δωδεκαταῖος ἀφ' ὧτέ νιν οὐδὲ ποτεῖδον.
ἦ ῥ' οὐκ ἄλλο τι τερπνὸν ἔχει, ἁμῶν δὲ λέλασται;
νῦν μὲν τοῖς φίλτροις καταθύσομαι· αἰ δ' ἔτι κἠμέ
λυπῇ, τὰν Ἀίδαο πύλαν, ναὶ Μοίρας, ἀραξεῖ.
τοῖά οἱ ἐν κίστᾳ κακὰ φάρμακα φαμὶ φυλάσσειν,
Ἀσσυρίῳ, δέσποινα, παρὰ ξένοιο μαθοῖσα.

ἀλλὰ τὺ μὲν χαίροισα ποτ' Ὠκεανὸν τρέπε πώλους,
πότνι'· ἐγὼ δ' οἰσῶ τὸν ἐμὸν πόνον ὥσπερ ὑπέσταν.
χαῖρε, Σελαναία λιπαρόχροε, χαίρετε δ' ἄλλοι
ἀστέρες, εὐκήλοιο κατ' ἄντυγα Νυκτὸς ὀπαδοί.

Where are the bay-leaves, Thestylis, and the charms?
Fetch all; with fiery wool the caldron crown;
Let glamour win me back my false lord's heart!

Twelve days the wretch hath not come nigh to me,
Nor made enquiry if I die or live,
Nor clamoured (oh unkindness!) at my door.
Sure his swift fancy wanders otherwhere,
The slave of Aphroditè and of Love.
I'll off to Timagetus' wrestling-school
At dawn, that I may see him and denounce
His doings; but I'll charm him now with charms.
So shine out fair, O moon! To thee I sing
My soft low song: to thee and Hecatè
The dweller in the shades, at whose approach
E'en the dogs quake, as on she moves through blood
And darkness and the barrows of the slain.
All hail, dread Hecatè: companion me
Unto the end, and work me witcheries
Potent as Circè or Medea wrought,
Or Perimedè of the golden hair!
 Turn, magic wheel, draw homeward him I love.
First we ignite the grain. Nay, pile it on:
Where are thy wits flown, timorous Thestylis?
Shall I be flouted, I, by such as thou?
Pile, and still say, 'This pile is of his bones.'
 Turn, magic wheel, draw homeward him I love.
Delphis racks me: I burn him in these bays.
As, flame-enkindled, they lift up their voice,
Blaze once, and not a trace is left behind:
So waste his flesh to powder in yon fire!
 Turn, magic wheel, draw homeward him I love.
E'en as I melt, not uninspired, the wax,
May Mindian Delphis melt this hour with love:
And, swiftly as this brazen wheel whirls round,
May Aphroditè whirl him to my door.
 Turn, magic wheel, draw homeward him I love.
Next burn the husks. Hell's adamantine floor
And aught that else stands firm can Artemis move.
Thestylis, the hounds bay up and down the town:
The goddess stands i' the crossroads: sound the gongs.
 Turn, magic wheel, draw homeward him I love.
Hushed are the voices of the winds and seas;
But O not hushed the voice of my despair.
He burns my being up, who left me here
No wife, no maiden, in my misery.
 Turn, magic wheel, draw homeward him I love.
Thrice I pour out; speak thrice, sweet mistress, thus:
"What face soe'er hangs o'er him be forgot

Clean as, in Dia, Theseus (legends say)
Forgat his Ariadne's locks of love."
 Turn, magic wheel, draw homeward him I love.
The coltsfoot grows in Arcady, the weed
That drives the mountain-colts and swift mares wild.
Like them may Delphis rave: so, maniac-wise,
Race from his burnished brethren home to me.
 Turn, magic wheel, draw homeward him I love.
He lost this tassel from his robe; which I
Shred thus, and cast it on the raging flames.
Ah baleful Love! why, like the marsh-born leech,
Cling to my flesh, and drain my dark veins dry?
 Turn, magic wheel, draw homeward him I love.
From a crushed eft to-morrow he shall drink
Death! But now, Thestylis, take these herbs and smear
That threshold o'er, whereto at heart I cling
Still, still—albeit he thinks scorn of me—
And spit, and say, ' 'Tis Delphis' bones I smear.'
 Turn, magic wheel, draw homeward him I love.
Now, all alone, I'll weep a love whence sprung
When born? Who wrought my sorrow? Anaxo came,
Her basket in her hand, to Artemis' grove.
Bound for the festival, troops of forest beasts
Stood round, and in the midst a lioness.
 Bethink thee, mistress Moon, whence came my love.
Theucharidas' slave, my Thracian nurse now dead
Then my near neighbour, prayed me and implored
To see the pageant: I, the poor doomed thing,
Went with her, trailing a fine silken train,
And gathering round me Clearista's robe.
 Bethink thee, mistress Moon, whence came my love.
Now, the mid-highway reached by Lycon's farm,
Delphis and Eudamippus passed me by.
With beards as lustrous as the woodbine's gold
And breasts more sheeny than thyself, O Moon,
Fresh from the wrestler's glorious toil they came.
 Bethink thee, mistress Moon, whence came my love.
I saw, I raved, smit (weakling) to my heart.
My beauty withered, and I cared no more
For all that pomp; and how I gained my home
I know not: some strange fever wasted me.
Ten nights and days I lay upon my bed.
 Bethink thee, mistress Moon, whence came my love.
And wan became my flesh, as't had been dyed,

And all my hair streamed off, and there was left
But bones and skin. Whose threshold crossed I not,
Or missed what grandam's hut who dealt in charms?
For no light thing was this, and time sped on.
 Bethink thee, mistress Moon, whence came my love.
At last I spake the truth to that my maid:
"Seek, an thou canst, some cure for my sore pain.
Alas, I am all the Mindian's! But begone,
And watch by Timagetus' wrestling-school:
There doth he haunt, there soothly take his rest.
 Bethink thee, mistress Moon, whence came my love.
"Find him alone: nod softly: say, 'she waits';
And bring him." So I spake: she went her way,
And brought the lustrous-limbed one to my roof.
And I, the instant I beheld him step
Lightfooted o'er the threshold of my door,
 (*Bethink thee, mistress Moon, whence came my love.*)
Became all cold like snow, and from my brow
Brake the damp dewdrops: utterance I had none,
Not e'en such utterance as a babe may make
That babbles to its mother in its dreams;
But all my fair frame stiffened into wax.
 Bethink thee, mistress Moon, whence came my love.
He bent his pitiless eyes on me; looked down,
And sate him on my couch, and sitting, said:
"Thou hast gained on me, Simætha, (e'en as I
Gained once on young Philinus in the race,)
Bidding me hither ere I came unasked.
 Bethink thee, mistress Moon, whence came my love.
"For I had come, by Eros I had come,
This night, with comrades twain or may-be more,
The fruitage of the Wine-god in my robe,
And, wound about my brow with ribands red,
The silver leaves so dear to Heracles.
 Bethink thee, mistress Moon, whence came my love.
"Had ye said 'Enter,' well: for, 'mid my peers
High is my name for goodliness and speed:
I had kissed that sweet mouth once and gone my way
But had the door been barred, and I thrust out,
With brand and axe would we have stormed ye then.
 Bethink thee, mistress Moon, whence came my love.
"Now be my thanks recorded, first to Love,
Next to thee, maiden, who didst pluck me out,
A half-burned helpless creature, from the flames,

And badst me hither. It is Love that lights
A fire more fierce than his of Lipara,
 (*Bethink thee, mistress Moon, whence came my love.*)
"Scares, mischief-mad, the maiden from her bower,
The bride from her warm couch." He spake: and I,
A willing listener, sat, my hand in his,
Among the cushions, and his cheek touched mine,
Each hotter than its wont, and we discoursed
In soft low language. Need I prate to thee,
Sweet Moon, of all we said and all we did?
Till yesterday he found no fault with me,
Nor I with him. But lo, to-day there came
Philista's mother—hers who flutes to me—
With her Melampo's; just when up the sky
Gallop the mares that chariot rose-limbed Dawn:
And divers tales she brought me, with the rest
How Delphis loved, she knew not rightly whom:
But this she knew; that of the rich wine aye
He poured 'to Love;' and at the last had fled,
To line, she deemed, the fair one's halls with flowers.
Such was my visitor's tale, and it was true:
For thrice, nay four times, daily he would stroll
Hither, leave here full oft his Dorian flask:
Now—'tis a fortnight since I saw his face.
Doth he then treasure something sweet elsewhere?
Am I forgot? I'll charm him now with charms.
But let him try me more, and by the Fates
He'll soon be knocking at the gates of hell.
Spells of such power are in this chest of mine,
Learned, lady, from mine host in Palestine.

 Lady, farewell: turn ocean-ward thy steeds:
As I have purposed, so shall I fulfil.
Farewell, thou bright-faced Moon! Ye stars, farewell,
That wait upon the car of noiseless Night.

<div align="right">

Idylls, ii
Translated by C. S. Calverley

</div>

One of the finest poems ever written—a VIGNETTE *of the most exquisite finish.*

<div align="right">

R. Y. TYRRELL
Introduction, The Idylls of Theocritus (1908)

</div>

THEOCRITUS

THIRD CENTURY B. C.

SUMMER JOYS

'Ασεῖ δ' ὥς ποκ' ἔδεκτο τὸν αἰπόλον εὐρέα λάρναξ
ζωὸν ἐόντα κακαῖσιν ἀτασθαλίαισιν ἄνακτος,
ὥς τέ νιν αἱ σιμαὶ λειμωνόθε φέρβον ἰοῖσαι
κέδρον ἐς ἀδεῖαν μαλακοῖς ἄνθεσσι μέλισσαι,
οὕνεκά οἱ γλυκὺ Μοῖσα κατὰ στόματος χέε νέκταρ.
ὦ μακαριστὲ Κομᾶτα, τύ θην τάδε τερπνὰ πεπόνθης,
καὶ τὺ κατεκλάσθης ἐς λάρνακα, καὶ τὺ μελισσᾶν
κηρία φερβόμενος ἔτος ὥριον ἐξεπόνασας.
αἴθ' ἐπ' ἐμεῦ ζωοῖς ἐναρίθμιος ὤφελες εἶμεν,
ὥς τοι ἐγὼν ἐνόμευον ἀν' ὥρεα τὰς καλὰς αἶγας
φωνᾶς εἰσαΐων, τὺ δ' ὑπὸ δρυσὶν ἢ ὑπὸ πεύκαις
ἁδὺ μελισδόμενος κατακέκλισο, θεῖε Κομᾶτα.

And I'll have him sing how once a king, of wilful malice bent,
In the great coffer all alive the goatherd-poet pent,
And the snub bees came from the meadow to the coffer of sweet cedar-
 tree,
And fed him there o' the flowerets fair, because his lip was free
O' the Muses' wine; Comátas! 'twas joy, all joy to thee;
Though thou wast hid 'neath cedarn lid, the bees thy meat did bring,
Till thou didst thole, right happy soul, thy twelve months' prisoning.
And O of the quick thou wert this day! How gladly then with mine
I had kept thy pretty goats i' the hills, the while 'neath oak or pine
Thou'dst lain along and sung me a song,
 Comátas the divine!

<div style="text-align:right">

Idylls, vii, 78–89
Translated by J. M. Edmonds

</div>

*I doubt if any poet has ever more happily given us a picture of a mind
accustomed to delight in these summer joys of rural folk.*

<div style="text-align:right">

JOHN KEBLE
Lectures on Poetry (1832–41)
Translated by Edward K. Francis

</div>

HYLAS

Τρὶς μὲν Ὕλαν ἄυσεν
τρὶς δ᾽ ἄρ᾽ ὁ παῖς ὑπάκουσεν, ἀραιὰ δ᾽ ἵκετο φωνά
ἐξ ὕδατος, παρεὼν δὲ μάλα σχεδὸν εἴδετο πόρρω.

Thrice he called on Hylas, . . . and thrice too the boy heard, and faint came the voice from the water, and near as he was, he seemed afar off.

Idylls, xiii, 58–60

I should be content to die if I had written anything equal to this.
ALFRED LORD TENNYSON
Alfred Lord Tennyson: A Memoir by Hallam Tennyson (1897)

THE LION'S DEATH

Ψυχὴν δὲ πελώριος ἔλλαχεν Ἅιδης.

And gaping Hell received his mighty Soul.

Idylls, xxv, 271

The greatness of this is almost inexpressible.
RENÉ RAPIN
De Carmine Pastorali (1659)

CALLIMACHUS

THIRD CENTURY B. C.

HERACLITUS

Εἶπέ τις, Ἡράκλειτε, τεὸν μόρον, ἐς δέ με δάκρυ
ἤγαγεν, ἐμνήσθην δ' ὁσσάκις ἀμφότεροι
ἤλιον ἐν λέσχῃ κατεδύσαμεν· ἀλλὰ σὺ μέν που,
ξεῖν' Ἁλικαρνησεῦ, τετράπαλαι σποδιή·
αἱ δὲ τεαὶ ζώουσιν ἀηδόνες, ἧσιν ὁ πάντων
ἁρπακτὴς Ἀΐδης οὐκ ἐπὶ χεῖρα βαλεῖ.

They told me, Heraclitus, they told me you were dead;
They brought me bitter news to hear and bitter tears to shed.
I wept, as I remember'd, how often you and I
Had tired the sun with talking and sent him down the sky.

And now that thou art lying, my dear old Carian guest,
A handful of grey ashes, long, long ago at rest,
Still are thy pleasant voices, thy nightingales, awake,
For Death, he taketh all away, but them he cannot take.

<div align="right">

The Greek Anthology, vii, 80
Translated by William Cory

</div>

A grace of movement and a tenderness of pathos that are unsurpassed.
JOHN ADDINGTON SYMONDS
Studies of the Greek Poets (1873)

BION

THIRD OR SECOND CENTURY B. C.

LAMENT FOR ADONIS

Αἰάζω τὸν Ἄδωνιν· 'ἀπώλετο καλὸς Ἄδωνις·'
' ὤλετο καλὸς Ἄδωνις ' ἐπαιάζουσιν Ἔρωτες.
μηκέτι πορφυρέοις ἐνὶ φάρεσι Κύπρι κάθευδε·
ἔγρεο δειλαία, κυανόστολα καὶ πλατάγησον
στήθεα καὶ λέγε πᾶσιν ' ἀπώλετο καλὸς Ἄδωνις. '
αἰάζω τὸν Ἄδωνιν· ἐπαιάζουσιν Ἔρωτες.
κεῖται καλὸς Ἄδωνις ἐν ὤρεσι μηρὸν ὀδόντι,

200

λευκῷ λευκὸν ὀδόντι τυπείς, καὶ Κύπριν ἀνιῇ
λεπτὸν ἀποψύχων· τὸ δέ οἱ μέλαν εἴβεται αἷμα
χιονέας κατὰ σαρκός, ὑπ' ὀφρύσι δ' ὄμματα ναρκῇ,
καὶ τὸ ῥόδον φεύγει τῶ χείλεος· ἀμφὶ δὲ τήνῳ
θνάσκει καὶ τὸ φίλημα, τὸ μήποτε Κύπρις ἀνοίσει.
Κύπριδι μὲν τὸ φίλημα καὶ οὐ ζώοντος ἀρέσκει,
ἀλλ' οὐκ οἶδεν Ἄδωνις, ὅ νιν θνάσκοντ' ἐφίλησεν.
αἰάζω τὸν Ἄδωνιν· ἐπαιάζουσιν Ἔρωτες.

ἄγριον ἄγριον ἕλκος ἔχει κατὰ μηρὸν Ἄδωνις·
μεῖζον δ' ἁ Κυθέρεια φέρει ποτικάρδιον ἕλκος.
τῆνον μὲν περὶ παῖδα φίλοι κύνες ὠδύραντο
καὶ Νύμφαι κλαίουσιν ὀρειάδες· ἁ δ' Ἀφροδίτα
λυσαμένα πλοκαμῖδας ἀνὰ δρυμὼς ἀλάληται
πενθαλέα νήπλεκτος ἀσάνδαλος· αἱ δὲ βάτοι νιν
ἐρχομέναν κείροντι καὶ ἱερὸν αἷμα δρέπονται·
ὀξὺ δὲ κωκύουσα δι' ἄγκεα μακρὰ φορεῖται
Ἀσσύριον βοόωσα πόσιν καὶ παῖδα καλεῦσα.
ἀμφὶ δέ νιν μέλαν αἷμα παρ' ὀμφαλὸν ᾀωρεῖτο,
στήθεα δ' ἐκ μηρῶν φοινίσσετο, τοὶ δ' ὑπὸ μαζοὶ
χιόνεοι τὸ πάροιθεν Ἀδώνιδι πορφύροντο.
' αἰαῖ τὰν Κυθέρειαν ' ἐπαιάζουσιν Ἔρωτες.

ὤλεσε τὸν καλὸν ἄνδρα, συνώλεσεν ἱερὸν εἶδος.
Κύπριδι μὲν καλὸν εἶδος, ὅτε ζώεσκεν Ἄδωνις·
κάτθανε δ' ἁ μορφὰ σὺν Ἀδώνιδι. ' τὰν Κύπριν αἰαῖ '
ὤρεα πάντα λέγοντι, καὶ αἱ δρύες 'αἲ τὸν Ἄδωνιν.'
καὶ ποταμοὶ κλαίοντι τὰ πένθεα τᾶς Ἀφροδίτας,
καὶ παγαὶ τὸν Ἄδωνιν ἐν ὤρεσι δακρύοντι,
ἄνθεα δ' ἐξ ὀδύνας ἐρυθαίνεται· ἁ δὲ Κυθήρα
πάντας ἀνὰ κναμώς, ἀνὰ πᾶν νάπος οἰκτρὸν ἀείδει
' αἰαῖ τὰν Κυθέρειαν, ἀπώλετο καλὸς Ἄδωνις. '
Ἀχὼ δ' ἀντεβόασεν ' ἀπώλετο καλὸς Ἄδωνις. '
Κύπριδος αἰνὸν ἔρωτα τίς οὐκ ἔκλαυσεν ἂν αἰαῖ;

ὡς ἴδεν, ὡς ἐνόησεν Ἀδώνιδος ἄσχετον ἕλκος,
ὡς ἴδε φοίνιον αἷμα μαραινομένῳ περὶ μηρῷ,
πάχεας ἀμπετάσασα κινύρετο· ' μεῖνον Ἄδωνι,
δύσποτμε μεῖνον Ἄδωνι, πανύστατον ὥς σε κιχείω,
ὥς σε περιπτύξω καὶ χείλεα χείλεσι μίξω.
ἔγρεο τυτθὸν Ἄδωνι, τὸ δ' αὖ πύματόν με φίλησον,
τοσσοῦτόν με φίλησον, ὅσον ζώῃ τὸ φίλημα,
ἄχρις ἀποψύχῃς ἐς ἐμὸν στόμα κεὶς ἐμὸν ἧπαρ
πνεῦμα τεὸν ῥεύσῃ, τὸ δέ σου γλυκὺ φίλτρον ἀμέλξω,
ἐκ δὲ πίω τὸν ἔρωτα, φίλημα δὲ τοῦτο φυλάξω
ὡς αὐτὸν τὸν Ἄδωνιν, ἐπεὶ σύ με δύσμορε φεύγεις,
φεύγεις μακρὸν Ἄδωνι, καὶ ἔρχεαι εἰς Ἀχέροντα

πὰρ στυγνὸν βασιλῆα καὶ ἄγριον, ἁ δὲ τάλαινα
ζώω καὶ θεὸς ἐμμὶ καὶ οὐ δύναμαί σε διώκειν.
λάμβανε Περσεφόνα τὸν ἐμὸν πόσιν· ἐσσὶ γὰρ αὐτὰ
πολλὸν ἐμεῦ κρέσσων, τὸ δὲ πᾶν καλὸν ἐς σὲ καταρρεῖ·
ἐμμὶ δ' ἐγὼ πανάποτμος, ἔχω δ' ἀκόρεστον ἀνίαν,
καὶ κλαίω τὸν Ἄδωνιν, ὅ μοι θάνε, καί σε φοβεῦμαι.
θνάσκεις ὦ τριπόθητε, πόθος δέ μοι ὡς ὄναρ ἔπτα,
χήρα δ' ἁ Κυθέρεια, κενοὶ δ' ἀνὰ δώματ' Ἔρωτες.
σοὶ δ' ἅμα κεστὸς ὄλωλε. τί γὰρ τολμηρὲ κυνάγεις;
καλὸς ἐὼν τοσσοῦτον ἐμήναο θηρὶ παλαίειν;'
ὧδ' ὀλοφύρατο Κύπρις· ἐπαιάζουσιν Ἔρωτες
' αἰαῖ τὰν Κυθέρειαν, ἀπώλετο καλὸς Ἄδωνις. '
 δάκρυον ἁ Παφία τόσσον χέει, ὅσσον Ἄδωνις
αἷμα χέει· τὰ δὲ πάντα ποτὶ χθονὶ γίνεται ἄνθη.
αἷμα ῥόδον τίκτει, τὰ δὲ δάκρυα τὰν ἀνεμώναν.
αἰάζω τὸν Ἄδωνιν, ἀπώλετο καλὸς Ἄδωνις.
 μηκέτ' ἐνὶ δρυμοῖσι τὸν ἀνέρα μύρεο Κύπρι.
οὐκ ἀγαθὰ στιβάς ἐστιν Ἀδώνιδι φυλλὰς ἐρήμα·
λέκτρον ἔχοι Κυθέρεια τὸ σὸν καὶ νεκρὸς Ἄδωνις.
καὶ νέκυς ὢν καλός ἐστι, καλὸς νέκυς, οἷα καθεύδων.
κάτθεό νιν μαλακοῖς ἐνὶ φάρεσιν οἷς ἐνίαυεν,
ᾧ μετὰ τεῦς ἀνὰ νύκτα τὸν ἱερὸν ὕπνον ἐμόχθει
παγχρυσέῳ κλιντῆρι· ποθεῖ καὶ στυμνὸν Ἄδωνιν.
βάλλε δέ νιν στεφάνοισι καὶ ἄνθεσι· πάντα σὺν αὐτῷ,
ὡς τῆνος τέθνακε καὶ ἄνθεα πάντα θανόντων.
ῥαῖνε δέ νιν Συρίοισιν ἀλείφασι, ῥαῖνε μύροισιν·
ὀλλύσθω μύρα πάντα· τὸ σὸν μύρον ὤλετ' Ἄδωνις.
 κέκλιται ἁβρὸς Ἄδωνις ἐν εἵμασι πορφυρέοισιν·
ἀμφὶ δέ νιν κλαίοντες ἀναστενάχουσιν Ἔρωτες
κειράμενοι χαίτας ἐπ' Ἀδώνιδι· χὠ μὲν ὀϊστώς,
ὃς δ' ἐπὶ τόξον ἔβαλλεν, ὃ δὲ πτερόν, ὃς δὲ φαρέτραν·
χὠ μὲν ἔλυσε πέδιλον Ἀδώνιδος, οἱ δὲ λέβητι
χρυσείῳ φορέουσιν ὕδωρ, ὃ δὲ μηρία λούει,
ὃς δ' ὄπιθεν πτερύγεσσιν ἀναψύχει τὸν Ἄδωνιν.
' αἰαῖ τὰν Κυθέρειαν ' ἐπαιάζουσιν Ἔρωτες.
 ἔσβεσε λαμπάδα πᾶσαν ἐπὶ φλιαῖς Ὑμέναιος
καὶ στέφος ἐξεπέτασσε γαμήλιον· οὐκέτι δ' Ὑμήν,
Ὑμὴν οὐκέτ' ἀείδει ἑὸν μέλος, ἀλλ' ἐπαείδει
' αἰαῖ ' καὶ ' τὸν Ἄδωνιν ' ἔτι πλέον ἢ Ὑμέναιον.
αἱ Χάριτες κλαίοντι τὸν υἱέα τῶ Κινύραο,
' ὤλετο καλὸς Ἄδωνις ' ἐν ἀλλάλαισι λέγοισαι.
' αἰαῖ ' δ' ὀξὺ λέγοντι πολὺ πλέον ἢ Παιῶνα.
χαὶ Μοῖραι τὸν Ἄδωνιν ἀνακλείουσιν ' Ἄδωνιν, '
καί νιν ἐπαείδουσιν· ὃ δέ σφισιν οὐχ ὑπακούει·

οὐ μὰν οὐκ ἐθέλει, Κώρα δέ νιν οὐκ ἀπολύει.
λῆγε γόων Κυθέρεια τὸ σάμερον, ἴσχεο κομμῶν·
δεῖ σε πάλιν κλαῦσαι, πάλιν εἰς ἔτος ἄλλο δακρῦσαι.

Wail, wail, Ah for Adonis! He is lost to us, lovely Adonis!
Lost is lovely Adonis! The Loves respond with lamenting.

Nay, no longer in robes of purple recline, Aphrodite:
Wake from thy sleep, sad queen, black-stoled, rain blows on thy
 bosom;
Cry to the listening world, *He is lost to us, lovely Adonis!*
 Wail, wail, Ah for Adonis! The Loves respond with lamenting.

Lovely Adonis is lying, sore hurt in his thigh, on the mountains,
Hurt in his thigh with the tusk, while grief consumes Aphrodite:
Slowly he drops toward death, and the black blood drips from his
 fair flesh,
Down from his snow-white skin; his eyes wax dull 'neath the eyelids,
Yea and the rose hath failed his lips, and around them the kisses
Die and wither, the kisses that Kupris will not relinquish:
Still, though he lives no longer, a kiss consoles Aphrodite;
But he knows not, Adonis, she kissed him while he was dying.
 Wail, wail, Ah for Adonis! The Loves respond with lamenting.

Cruel, cruel the wound in the thigh that preys on Adonis:
But in her heart Cytherea hath yet worse wounds to afflict her.
Round him his dear hounds bay, they howl in their grief to the heavens;
Nymphs of the woodlands wail: but she, the Queen Aphrodite,
Loosing her locks to the air, roams far and wide through the forest,
Drowned in grief, disheveled, unsandaled, and as she flies onward,
Briars stab at her feet and cull the blood of the goddess.
She with shrill lamentation thro' glen and thro' glade is carried,
Calling her Syrian lord, demanding him back, and demanding.
But where he lies, dark blood wells up and encircles the navel;
Blood from the gushing thighs empurples the breast; and the snow-white
Flank that was once so fair, is now dyed red for Adonis.
 Wail, wail, Ah, Cytherea! The Loves respond with lamenting.

She then hath lost her lord, and with him hath lost her celestial
Beauty; for fair was he, and fair, while he lived, Aphrodite:
Now in his death her beauty hath died. *Ah, Ah, Cytherea!*
All the mountains lament, and the oaks moan, *Ah for Adonis*
Streams as they murmur and flow complain of thy griefs, Aphrodite:
Yea and the springs on the hills, in the woods, weep tears for Adonis:
Flowers of the field for woe flush crimson red; and Cythêra,
Through the dells and the glens, shrills loud the dirge of her anguish:

Woe, woe, Ah, Cytherea! He is lost to us, lovely Adonis!
Echo repeats the groan: *Lost, lost, is lovely Adonis!*
Kupris, who but bewailed thy pangs of a love overwhelming?

She, when she saw, when she knew the unstanchable wound of Adonis,
When she beheld the red blood on his pale thigh's withering blossom,
Spreading her arms full wide, she moaned out: "Stay, my Adonis!
Stay, ill-fated Adonis! that I once more may approach thee!
Clasp thee close to my breast, and these lips mingle with thy lips!
Rouse for a moment, Adonis, and kiss me again for the last time;
Kiss me as long as the kiss can live on the lips of a lover;
Till from thy inmost soul to my mouth and down to my marrow
Thy life-breath shall run, and I quaff the wine of thy philter,
Draining the draught of thy love: that kiss will I treasure, Adonis,
E'en as it were thyself; since thou, ill-starred, art departing.
Fleeing me far, O Adonis, to Acheron faring, the sad realm
Ruled by a stern savage king: while I, the unhappy, the luckless,
I live; goddess am I, and I may not follow or find thee.
Persephone, take thou my lord, my lover; I know thee
Stronger far than myself: all fair things drift to thy dwelling.
I meanwhile am accursed, possessed with insatiable sorrow,
Weeping my dead, my Adonis who died, and am shaken and shattered.
Diest thou then, my desired? and desire like a dream hath escaped me.
Widowed is now Cytherea; the Loves in her halls are abandoned;
Perished with thee is my girdle. Ah, why wouldst thou hunt, over-
 bold one?
Being so beautiful, why wast thou mad to fight with a wild beast?"
Thus then Kupris mourned; and the Loves respond with lamenting:
Wail, wail, Ah for Adonis! He is lost to us, lovely Adonis!
Tears the Paphian shed, drop by drop for the drops of Adonis'
Blood; and on earth each drop, as it fell, grew into a blossom:
Roses sprang from the blood, and the tears gave birth to the wind-flower.
 Wail, wail, Ah, Cytherea! He is lost to us, lovely Adonis!

 Wail, wail, Ah for Adonis! He is lost to us, lovely Adonis!
Now in the oak-woods cease to lament for thy lord, Aphrodite.
No proper couch is this which the wild leaves strew for Adonis.
Let him thy own bed share, Cytherea, the corpse of Adonis;
E'en as a corpse he is fair, fair corpse as fallen aslumber.
Now lay him soft to sleep, sleep well in the wool of the bedclothes,
Where with thee through the night in holy dreams he commingled,
Stretched on a couch all gold, that yearns for him stark though he
 now be.
Shower on him garlands, flowers: all fair things died in his dying;
Yea, as he faded away, so shrivel and wither the blossoms.
Syrian spikenard scatter, anoint him with myrrh and with unguents:

Perish perfumes all, since he, thy perfume, is perished.
Wail, wail, Ah for Adonis! The Loves respond with lamenting.

Lapped in his purple robes is the delicate form of Adonis.
Round him weeping Loves complain and moan in their anguish,
Clipping their locks for Adonis: and one of them treads on his arrows,
One of them breaks his bow, and one sets heel on the quiver;
One hath loosed for Adonis the lachet of sandals, and some bring
Water to pour in an urn; one laves the wound in his white thigh;
One from behind with his wings keeps fanning dainty Adonis.
Wail, wail, Ah for Adonis! The Loves respond with lamenting.

Wail, wail, Ah, Cytherea! The Loves respond with lamenting.
Every torch at the doors hath been quenched by thy hand, Hymenæus;
Every bridal wreath hath been torn to shreds; and no longer,
Hymen, Hymen, no more is the song, but a new song of sorrow,
Woe, woe! and Ah for Adonis! resounds in lieu of the bridesong.
This the Graces are shrilling, the son of Cinyras hymning,
Lost is lovely Adonis! in loud antiphonal accents.
Woe, woe! sharply repeat, far more than the praises of Païôn,
Woe! and Ah for Adonis! The Muses who wail for Adonis,
Chaunt their charms to Adonis.—But he lists not their singing;
Not that he wills not to hear, but the Maiden doth not release him.
Cease from moans, Cytherea, to-day refrain from the death-songs:
Thou must lament him again, and again shed tears in a new year.

Translated by John Addington Symonds

MOSCHUS

SECOND CENTURY B.C.

LAMENT FOR BION

Αἴλινά μοι στοναχεῖται νάπαι καὶ Δώριον ὕδωρ,
καὶ ποταμοὶ κλαίοιτε τὸν ἱμερόεντα Βίωνα.
νῦν φυτά μοι μύρεσθε, καὶ ἄλσεα νῦν γοάοισθε,
ἄνθεα νῦν στυμνοῖσιν ἀποπνείοιτε κορύμβοις,
νῦν ῥόδα φοινίσσεσθε τὰ πένθιμα, νῦν ἀνεμῶναι,
νῦν ὑάκινθε λάλει τὰ σὰ γράμματα καὶ πλέον αἰαῖ
βάμβανε τοῖς πετάλοισι· καλὸς τέθνακε μελικτάς.
 ἄρχετε Σικελικαὶ τῶ πένθεος ἄρχετε Μοῖσαι.
ἀδόνες αἱ πυκινοῖσιν ὀδυρόμεναι ποτὶ φύλλοις,
νάμασι τοῖς Σικελοῖς ἀγγείλατε τᾶς Ἀρεθοίσας,
ὅττι Βίων τέθνακεν ὁ βουκόλος, ὅττι σὺν αὐτῷ
καὶ τὸ μέλος τέθνακε καὶ ὤλετο Δωρὶς ἀοιδά.
 ἄρχετε Σικελικαὶ τῶ πένθεος ἄρχετε Μοῖσαι.

205

Στρυμόνιοι μύρεσθε παρ' ὕδασιν αἴλινα κύκνοι,
καὶ γοεροῖς στομάτεσσι μελίσδετε πένθιμον ῷδάν,
οἵαν ὑμετέροις ποτὶ χείλεσι γῆρας ἀείδει,
εἴπατε δ' αὖ κούραις Οἰαγρίσιν, εἴπατε πάσαις
Βιστονίαις Νύμφαισιν ' ἀπώλετο Δώριος Ὀρφεύς. '
 ἄρχετε Σικελικαὶ τῶ πένθεος ἄρχετε Μοῖσαι.
κεῖνος ὁ ταῖς ἀγέλαισιν ἐράσμιος οὐκέτι μέλπει,
οὐκέτ' ἐρημαίαισιν ὑπὸ δρυσὶν ἥμενος ᾄδει,
ἀλλὰ παρὰ Πλουτῆϊ μέλος Ληθαῖον ἀείδει.
ὥρεα δ' ἐστὶν ἄφωνα, καὶ αἱ βόες αἱ ποτὶ ταύροις
πλαζόμεναι γοάοντι καὶ οὐκ ἐθέλοντι νέμεσθαι.
 ἄρχετε Σικελικαὶ τῶ πένθεος ἄρχετε Μοῖσαι.
σεῖο Βίων ἔκλαυσε ταχὺν μόρον αὐτὸς Ἀπόλλων,
καὶ Σάτυροι μύροντο καὶ μελάγχλαινοί τε Πρίηποι·
καὶ Πᾶνες στοναχεῦντο τὸ σὸν μέλος, αἵ τε καθ' ὕλαν
Κρανίδες ὠδύραντο, καὶ ὕδατα δάκρυα γέντο.
Ἀχὼ δ' ἐν πέτραισιν ὀδύρεται, ὅττι σιωπῇ
κοὐκέτι μιμεῖται τὰ σὰ χείλεα, σῷ δ' ἐπ' ὀλέθρῳ
δένδρεα καρπὸν ἔριψε, τὰ δ' ἄνθεα πάντ' ἐμαράνθη.
μάλων οὐκ ἔρρευσε καλὸν γλάγος, οὐ μέλι σίμβλων,
κάτθανε δ' ἐν κηρῷ λυπεύμενον· οὐκέτι γὰρ δεῖ
τῶ μέλιτος τῶ σῶ τεθνακότος αὐτὸ τρυγᾶσθαι.
 ἄρχετε Σικελικαὶ τῶ πένθεος ἄρχετε Μοῖσαι.
οὐ τόσον εἰναλίαισι παρ' ᾄόσι μύρατο Σειρήν,
οὐδὲ τόσον ποκ' ἄεισεν ἐνὶ σκοπέλοισιν Ἀηδών,
οὐδὲ τόσον θρήνησεν ἀν' ὤρεα μακρὰ Χελιδών,
Ἀλκυόνος δ' οὐ τόσσον ἐπ' ἄλγεσιν ἴαχε Κῆϋξ,
οὐδὲ τόσον γλαυκοῖς ἐνὶ κύμασι κηρύλος ᾆδεν,
οὐ τόσον ἀῴοισιν ἐν ἄγκεσι παῖδα τὸν Ἀοῦς
ἱπτάμενος περὶ σᾶμα κινύρατο Μέμνονος ὄρνις,
ὅσσον ἀποφθιμένοιο κατωδύραντο Βίωνος.
 ἄρχετε Σικελικαὶ τῶ πένθεος ἄρχετε Μοῖσαι.
ἀδονίδες πᾶσαί τε χελιδόνες, ἅς ποκ' ἔτερπεν,
ἅς λαλέειν ἐδίδασκε, καθεζόμεναι ποτὶ πρέμνοις
ἀντίον ἀλλάλαισιν ἐκώκυον· αἱ δ' ὑπεφώνευν
' ὄρνιθες λυπεῖσθ' αἱ πενθάδες· ἀλλὰ καὶ ἡμεῖς. '
 ἄρχετε Σικελικαὶ τῶ πένθεος ἄρχετε Μοῖσαι.
τίς ποτὶ σᾷ σύριγγι μελίξεται ὦ τριπόθητε;
τίς δ' ἐπὶ σοῖς καλάμοις θήσει στόμα; τίς θρασὺς οὕτως;
εἰσέτι γὰρ πνείει τὰ σὰ χείλεα καὶ τὸ σὸν ἆσθμα,
ἀρχὰ δ' ἐν δονάκεσσι τεᾶς ἔτι βόσκετ' ἀοιδᾶς.
Πανὶ φέρω τὸ μέλισμα; τάχ' ἂν καὶ κεῖνος ἐρεῖσαι
τὸ στόμα δειμαίνοι, μὴ δεύτερα σεῖο φέρηται.
 ἄρχετε Σικελικαὶ τῶ πένθεος ἄρχετε Μοῖσαι.

206

κλαίει καὶ Γαλάτεια τὸ σὸν μέλος, ἅν πόκ' ἔτερπες
ἑζομέναν μετὰ σεῖο παρ' ἀϊόνεσσι θαλάσσας.
οὐ γὰρ ἴσον Κύκλωπι μελίσδεο· τὸν μὲν ἔφευγεν
ἁ καλὰ Γαλάτεια, σὲ δ' ἅδιον ἔβλεπεν ἅλμας.
καὶ νῦν λασαμένα τῶ κύματος ἐν ψαμάθοισιν
ἕζετ' ἐρημαίαισι, βόας δ' ἔτι σεῖο νομεύει.
 ἄρχετε Σικελικαὶ τῶ πένθεος ἄρχετε Μοῖσαι.
πάντα τοι ὦ βούτα συγκάτθανε δῶρα τὰ Μοισᾶν,
παρθενικᾶν ἐρόεντα φιλήματα, χείλεα παίδων,
καὶ στυμνοὶ περὶ σῶμα τεὸν κλαίουσιν Ἔρωτες.
χὰ Κύπρις ποθέει σε πολὺ πλέον ἢ τὸ φίλημα,
τὸ πρώαν τὸν Ἄδωνιν ἀποθνάσκοντα φίλησεν.
 τοῦτό τοι ὦ ποταμῶν λιγυρώτατε δεύτερον ἄλγος,
τοῦτο, Μέλη, νέον ἄλγος. ἀπώλετο πρᾶν τοι Ὅμηρος,
τῆνο τὸ Καλλιόπας γλυκερὸν στόμα, καί σε λέγοντι
μύρασθαι καλὸν υἷα πολυκλαύτοισι ῥεέθροις,
πᾶσαν δὲ πλῆσαι φωνᾶς ἅλα· νῦν πάλιν ἄλλον
υἷέα δακρύεις, καινῷ δ' ἐπὶ πένθεϊ τάκῃ.
ἀμφότεροι παγαῖς πεφιλημένοι, ὃς μὲν ἔπινε
Παγασίδος κράνας, ὃ δ' ἔχεν πόμα τᾶς Ἀρεθοίσας.
χὼ μὲν Τυνδαρέοιο καλὰν ἄεισε θύγατρα
καὶ Θέτιδος μέγαν υἷα καὶ Ἀτρείδαν Μενέλαον·
τῆνος δ' οὐ πολέμους, οὐ δάκρυα, Πᾶνα δ' ἔμελπε,
καὶ βούτας ἐλίγαινε καὶ ἀείδων ἐνόμευε,
καὶ σύριγγας ἔτευχε καὶ ἁδέα πόρτιν ἄμελγε,
καὶ παίδων ἐδίδασκε φιλήματα, καὶ τὸν Ἔρωτα
ἔτρεφεν ἐν κόλποισι καὶ ἤρεθε τὰν Ἀφροδίταν.
 ἄρχετε Σικελικαὶ τῶ πένθεος ἄρχετε Μοῖσαι.
πᾶσα Βίων θρηνεῖ σε κλυτὰ πόλις, ἄστεα πάντα.
Ἄσκρα μὲν γοάει σε πολὺ πλέον Ἡσιόδοιο·
Πίνδαρον οὐ ποθέοντι τόσον Βοιωτίδες ὗλαι·
οὐ τόσον Ἀλκαίῳ περιμύρατο Λέσβος ἐραννά·
οὐδὲ τόσον ὃν ἀοιδὸν ὀδύρατο Τήϊον ἄστυ·
σὲ πλέον Ἀρχιλόχοιο ποθεῖ Πάρος· ἀντὶ δὲ Σαπφῶς
εἰσέτι σεῦ τὸ μέλισμα κινύρεται ἁ Μιτυλάνα.
εἰ δὲ Συρακοσίοισι Θεόκριτος· αὐτὰρ ἐγώ τοι
Αὐσονικᾶς ὀδύνας μέλπω μέλος, οὐ ξένος ᾠδᾶς
βουκολικᾶς, ἀλλ' ἅντε διδάξαο σεῖο μαθητὰς
κλαρονόμος Μοίσας τᾶς Δωρίδος, ᾇ με γεραίρων
ἄλλοις μὲν τεὸν ὄλβον, ἐμοὶ δ' ἀπέλειπες ἀοιδάν.
 ἄρχετε Σικελικαὶ τῶ πένθεος ἄρχετε Μοῖσαι.
αἰαῖ ταὶ μαλάχαι μέν, ἐπὰν κατὰ κᾶπον ὄλωνται,
ἠδὲ τὰ χλωρὰ σέλινα τό τ' εὐθαλὲς οὖλον ἄνηθον,
ὕστερον αὖ ζώοντι καὶ εἰς ἔτος ἄλλο φύοντι·

ἄμμες δ' οἱ μεγάλοι καὶ καρτεροί, οἱ σοφοὶ ἄνδρες,
ὁππότε πρᾶτα θάνωμες, ἀνάκοοι ἐν χθονὶ κοίλᾳ
εὕδομες εὖ μάλα μακρὸν ἀτέρμονα νήγρετον ὕπνον.
καὶ σὺ μὲν ὢν σιγᾷ πεπυκασμένος ἔσσεαι ἐν γᾷ,
ταῖς Νύμφαισι δ' ἔδοξεν ἀεὶ τὸν βάτραχον ᾄδειν.
ταῖς δ' ἐγὼ οὐ φθονέοιμι· τὸ γὰρ μέλος οὐ καλὸν ᾄδει.
ἄρχετε Σικελικαὶ τῶ πένθεος ἄρχετε Μοῖσαι.
φάρμακον ἦλθε, Βίων, ποτὶ σὸν στόμα, φάρμακον ἦδες—
τοιούτοις χείλεσσι ποτέδραμε κοὐκ ἐγλυκάνθη;
τίς δὲ βροτὸς τοσσοῦτον ἀνάμερος ὡς κεράσαι τοι
ἢ δοῦναι καλέοντι τὸ φάρμακον;—ἔκψυγεν ᾠδά.
ἄρχετε Σικελικαὶ τῶ πένθεος ἄρχετε Μοῖσαι.
ἀλλὰ Δίκα κίχε πάντας. ἐγὼ δ' ἐπὶ πένθεϊ τῷδε
δακρυχέων τεὸν οἶτον ὀδύρομαι. εἰ δυνάμαν δέ,
ὡς Ὀρφεὺς καταβὰς ποτὶ Τάρταρον, ὥς ποκ' Ὀδυσσεύς,
ὡς πάρος Ἀλκείδας, κἠγὼ τάχ' ἂν ἐς δόμον ἦνθον
Πλουτέος, ὥς κέ σ' ἴδοιμι, καὶ εἰ Πλουτῆι μελίσδῃ,
ὡς ἂν ἀκουσαίμαν, τί μελίσδεαι. ἀλλ' ἄγε Κώρᾳ
Σικελικόν τι λίγαινε καὶ ἁδύ τι βουκολιάζευ.
καὶ κείνα Σικελά, καὶ ἐν Αἰτναίαισιν ἔπαιζεν
ᾄδοι, καὶ μέλος οἶδε τὸ Δώριον· οὐκ ἀγέραστος
ἐσσεῖθ' ἁ μολπά. χὼς Ὀρφεῖ πρόσθεν ἔδωκεν
ἁδέα φορμίζοντι παλίσσυτον Εὐρυδίκειαν,
καὶ σὲ Βίων πέμψει τοῖς ὤρεσιν. εἰ δέ τι κἠγὼν
συρίσδων δυνάμαν, παρὰ Πλουτέϊ κ' αὐτὸς ἄειδον.

Wail, let me hear you wail, ye woodland glades, and thou Dorian water; and weep ye rivers, for Bion, the well beloved! Now all ye green things mourn, and now ye groves lament him, ye flowers now in sad clusters breathe yourselves away. Now redden ye roses in your sorrow, and now wax red ye wind-flowers, now thou hyacinth, whisper the letters on thee graven, and add a deeper *ai ai* to thy petals; he is dead, the beautiful singer.

Begin, ye Sicilian Muses, begin the dirge.

Ye nightingales that lament among the thick leaves of the trees, tell ye to the Sicilian waters of Arethusa the tidings that Bion the herdsman is dead, and that with Bion song too has died, and perished hath the Dorian minstrelsy.

Begin, ye Sicilian Muses, begin the dirge.

Ye Strymonian swans, sadly wail ye by the waters, and chant with melancholy notes the dolorous song, even such a song as in his time with

voice like yours he was wont to sing. And tell again to the Œagrian maidens, tell to all the Nymphs Bistonian, how that he hath perished, the Dorian Orpheus.

Begin, ye Sicilian Muses, begin the dirge.

No more to his herds he sings, that beloved herdsman, no more 'neath the lonely oaks he sits and sings, nay, but by Pluteus's side he chants a refrain of oblivion. The mountains too are voiceless: and the heifers that wander by the bulls lament and refuse their pasture.

Begin, ye Sicilian Muses, begin the dirge.

Thy sudden doom, O Bion, Apollo himself lamented, and the Satyrs mourned thee, and the Priapi in sable raiment, and the Panes sorrow for thy song, and the fountain fairies in the wood made moan, and their tears turned to rivers of waters. And Echo in the rocks laments that thou art silent, and no more she mimics thy voice. And in sorrow for thy fall the trees cast down their fruit, and all the flowers have faded. From the ewes hath flowed no fair milk, nor honey from the hives, nay, it hath perished for mere sorrow in the wax, for now hath thy honey perished, and no more it behoves men to gather the honey of the bees.

Begin, ye Sicilian Muses, begin the dirge.

Not so much did the dolphin mourn beside the sea-banks, nor ever sang so sweet the nightingale on the cliffs, nor so much lamented the swallow on the long ranges of the hills, nor shrilled so loud the halcyon o'er his sorrows;

(Begin, ye Sicilian Muses, begin the dirge.)

Nor so much, by the grey sea-waves, did ever the sea-bird sing, nor so much in the dells of dawn did the bird of Memnon bewail the son of the Morning, fluttering around his tomb, as they lamented for Bion dead.

Nightingales, and all the swallows that once he was wont to delight, that he would teach to speak, they sat over against each other on the boughs and kept moaning, and the birds sang in answer, 'Wail, ye wretched ones, even ye!'

Begin, ye Sicilian Muses, begin the dirge.

Who, ah who will ever make music on thy pipe, O thrice desired Bion, and who will put his mouth to the reeds of thine instrument? who is so bold?

For still thy lips and still thy breath survive, and Echo, among the reeds, doth still feed upon thy songs. To Pan shall I bear the pipe? Nay, perchance even he would fear to set his mouth to it, lest, after thee, he should win but the second prize.

Begin, ye Sicilian Muses, begin the dirge.

Yea, and Galatea laments thy song, she whom once thou wouldst delight, as with thee she sat by the sea-banks. For not like the Cyclops didst thou sing—him fair Galatea ever fled, but on thee she still looked more kindly than on the salt water. And now hath she forgotten the wave, and sits on the lonely sands, but still she keeps thy kine.

Begin, ye Sicilian Muses, begin the dirge.

All the gifts of the Muses, herdsman, have died with thee, the delightful kisses of maidens, the lips of boys; and woful round thy tomb the loves are weeping. But Cypris loves thee far more than the kiss wherewith she kissed the dying Adonis.

Begin, ye Sicilian Muses, begin the dirge.

This, O most musical of rivers, is thy second sorrow, this, Meles, thy new woe. Of old didst thou lose Homer, that sweet mouth of Calliope, and men say thou didst bewail thy goodly son with streams of many tears, and didst fill all the salt sea with the voice of thy lamentation— now again another son thou weepest, and in a new sorrow art thou wasting away.

Begin, ye Sicilian Muses, begin the dirge.

Both were beloved of the fountains, and one ever drank of the Pegasean fount, but the other would drain a draught of Arethusa. And the one sang the fair daughter of Tyndarus, and the mighty son of Thetis, and Menelaus Atreus's son, but that other,—not of wars, not of tears, but of Pan, would he sing, and of herdsmen would he chant, and so singing, he tended the herds. And pipes he would fashion, and would milk the sweet heifer, and taught lads how to kiss, and Love he cherished in his bosom and woke the passion of Aphrodite.

Begin, ye Sicilian Muses, begin the dirge.

Every famous city laments thee, Bion, and all the towns. Ascra laments thee far more than her Hesiod, and Pindar is less regretted by the forests of Boeotia. Nor so much did pleasant Lesbos mourn for Alcaeus, nor did the Teian town so greatly bewail her poet, while for thee more

than for Archilochus doth Paros yearn, and not for Sappho, but still for thee doth Mytilene wail her musical lament; and in Syracuse Theocritus; but I sing thee the dirge of an Ausonian sorrow, I that am no stranger to the pastoral song, but heir of the Doric Muse which thou didst teach thy pupils. This was thy gift to me; to others didst thou leave thy wealth, to me thy minstrelsy.

Begin, ye Sicilian Muses, begin the dirge.

Ah me, when the mallows wither in the garden, and the green parsley, and the curled tendrils of the anise, on a later day they live again, and spring in another year; but we men, we, the great and mighty, or wise, when once we have died, in hollow earth we sleep, gone down into silence; a right long, and endless, and unawakening sleep. And thou too, in the earth wilt be lapped in silence, but the nymphs have thought good that the frog should eternally sing. Nay, him I would not envy, for 'tis no sweet song he singeth.

Begin, ye Sicilian Muses, begin the dirge.

Poison came, Bion, to thy mouth, thou didst know poison. To such lips as thine did it come, and was not sweetened? What mortal was so cruel that could mix poison for thee, or who could give thee the venom that heard thy voice? surely he had no music in his soul.

Begin, ye Sicilian Muses, begin the dirge.

But justice hath overtaken them all. Still for this sorrow I weep, and bewail thy ruin. But ah, if I might have gone down like Orpheus to Tartarus, or as once Odysseus, or Alcides of yore, I too would speedily have come to the house of Pluteus, that thee perchance I might behold, and if thou singest to Pluteus, that I might hear what is thy song. Nay, sing to the Maiden some strain of Sicily, sing some sweet pastoral lay.
And she too is Sicilian, and on the shores by Aetna she was wont to play, and she knew the Dorian strain. Not unrewarded will the singing be; and as once to Orpheus's sweet minstrelsy she gave Eurydice to return with him, even so will she send thee too, Bion, to the hills. But if I, even I, and my piping had aught availed, before Pluteus I too would have sung.

Translated by Andrew Lang

The most pathetic products of Greek idyllic poetry.

JOHN ADDINGTON SYMONDS
Shelley (1879)

LIGHT

Καὶ εἶπεν ὁ Θεός, γενηθήτω φῶς· καὶ ἐγένετο φῶς.

And God said, Let there be light: and there was light.

Genesis, 1:3

The lawgiver of the Jews, no common man, when he had duly conceived the power of the Deity, showed it forth as duly. At the very beginning of his Laws, 'God said,' he writes—What? 'Let there be light, and there was light, let there be earth, and there was earth.'

LONGINUS
On the Sublime, ix
Translated by A. O. Prickard

Longinus, Prince of Criticks, in the Excellent Book he writ touching the Sublime, gives a very great Commendation of Moses; for he says, That he had a due Notion of the Power of God, and express'd it accordingly by writing in the Beginning of his Laws, That GOD SAID, LET THERE BE LIGHT MADE, AND IT WAS MADE; LET THE EARTH BE MADE, AND IT WAS MADE. *However, what* LONGINUS *here alledges from* MOSES, *as a Sublime and figurative Expression, seems to me to be perfectly Simple.* MOSES, *it is true, relates a thing that is in it self great, but expresses it in a Manner, which is by no means so.*

PIERRE DANIEL HUET
Dissertation contre M. Boileau (1683)
Translated by Edward Combe

What then shall we say of one of the most learned men of his age, who though he had the advantage of the Gospel light, yet did not find out the beauty of this passage . . . but has presumed to advance, in a book he wrote in demonstration of the Christian religion, that Longinus was mistaken in thinking these words sublime?

NICOLAS BOILEAU-DESPRÉAUX
Préface au Traité du Sublime (1683)
Translation anonymous

Every one is acquainted with a dispute about that passage between two French critics, the one positively affirming it to be sublime, the other as

positively denying. What I have remarked shows that both of them have reached the truth, but neither of them the whole truth: the primary effect of the passage is undoubtedly an emotion of grandeur; which so far justifies Boileau: but then every one must be sensible, that the emotion is merely a flash which, vanishing instantaneously, gives way to humility and veneration. That indirect effect of sublimity justifies Huet, who, being a man of true piety, and probably not much carried by imagination, felt the humbling passion more sensibly than his antagonist did. And, laying aside difference of character, Huet's opinion may, I think, be defended as the more solid; because in such images, the depressing emotions are the more sensibly felt, and have the longer endurance.

<div align="right">

HENRY HOME OF KAMES
Elements of Criticism (1762)

</div>

THE GREEK ANTHOLOGY

VARIOUS DATES

EPITAPH ON TWO AGED PRIESTESSES

Αἰνόμενοι δύο γρῆες ὁμήλικες ἦμεν, ᾿Αναξὼ
 καὶ Κληνώ, δίδυμοι παῖδες ᾿Επικράτεος·
Κληνὼ μὲν Χαρίτων ἱερή, Δήμητρι δ᾿ ᾿Αναξὼ
 ἐν ζωῇ προπολεῦσ᾿· ἐννέα δ᾿ ἠελίων
ὀγδωκονταέτεις ἔτι λειπόμεθ᾿ ἐς τόδ᾿ ἱκέσθαι
 τῆς μοίρης. ἐτέων δ᾿ οὐ φθόνος ἰσοσίη.
καὶ πόσιας καὶ τέκνα φιλήσαμεν. αἱ δὲ παλαιαὶ
 πρῶθ᾿ ἡμεῖς ᾿Αΐδην πρηῢν ἀνυσσάμεθα.

Two aged matrons, daughters of one sire,
 Lie in one tomb, twin-buried and twin-born;
Clino, the priestess of the Graces' quire,
 Araxo, unto Ceres' service sworn.
Nine suns were wanting to our eightieth year;
 We died together—who could covet more?
We held our husbands and our children dear;
 Nor death unkind, to which we sped before.

<div align="right">

DIOTIMUS OF MILETUS
Translated by Charles Merivale

</div>

213

EPITAPH ON A FLUTE-PLAYER

Ἐλπίδες ἀνθρώπων, ἐλαφραὶ θεαί—οὐ γὰρ ἂν ὧδε
 Λέσβον' ὁ λυσιμελὴς ἀμφεκάλυψ' Ἀΐδης,
ὅς ποτε καὶ βασιλῆϊ συνέδραμε,—ναὶ μετ' Ἐρώτων
 χαίρετε κουφόταται δαίμονες ἀθανάτων.
αὐλοὶ δ' ἄφθεγκτοι καὶ ἀπευθέες, οἷς ἐνέπνευσε,
 κεῖσθ', ἐπεὶ οὐ θιάσους . . . οἶδ' Ἀχέρων.

Man's hopes are spirits with fast-fleeting wings.
 See where in death our hopeful Lesbus lies!
Lesbus is dead, the favourite of kings!
 Hail, light-winged hopes, ye swiftest deities!
On his cold tomb we carve a voiceless flute;
 For Pluto heeds not, and the grave is mute.

DIOTIMUS OF ATHENS
Translated by Charles Merivale

THY DISTAFF PLY

Ἀντιγένης ὁ Γελῷος ἔπος ποτὲ τοῦτο θυγατρὶ
 εἶπεν, ὅτ' ἦν ἤδη νεύμενος εἰς Ἀΐδην·
'·Παρθένε καλλιπάρῃε, κόρη δ' ἐμή, ἴσχε συνεργὸν
 ἠλακάτην, ἀρκεῦν κτῆμα πένητι βίῳ·
ἢν δ' ἴκῃ εἰς ὑμέναιον, Ἀχαιΐδος ἤθεα μητρὸς
 χρηστὰ φύλασσε, πόσει προῖκα βεβαιοτάτην.'

To his loved daughter, on his dying bed,
 Antigenes these fond words uttered:
"Bright maid, my own dear girl, thy distaff ply—
 Support and solace of thy poverty.
But shouldst thou wed, thy mother's life explore,
 And emulate—'twill form thy husband's surest dower."

ANTIPATER OF THESSALONICA
Translated by Francis Wrangham

MANY A TEAR

Εἰ καὶ ἐπὶ ξείνης σε, Λεόντιε, γαῖα καλύπτει,
 εἰ καὶ ἐρικλαύτων τῆλ' ἔθανες γονέων,
πολλά σοι ἐκ βλεφάρων ἐχύθη περιτύμβια φωτῶν
 δάκρυα, δυστλήτῳ πένθεϊ δαπτομένων·
πᾶσι γὰρ ἦσθα λίην πεφιλημένος, οἷά τε πάντων
 ξυνὸς ἐὼν κοῦρος, ξυνὸς ἐὼν ἔταρος.
αἰαῖ, λευγαλέη καὶ ἀμείλιχος ἔπλετο Μοῖρα,
 μηδὲ τεῆς ἥβης, δύσμορε, φεισαμένη.

Oh! many a tear from hearts by anguish torn,
 Around thy tomb our streaming eyelids pour'd;
A common son, a common friend, we mourn
 In thee too much beloved, so much deplored.
Harsh, heartless Fate no pity had nor ruth,
 Alas! alas!—nor spared thy tender youth.

<div align="right">

PAULUS SILENTIARIUS
Translated by William Hay

</div>

THINE EARLY DEATH

Νήπιον υἱὸν ἔλειπες. ἐν ἡλικίῃ δὲ καὶ αὐτός,
 Εὐρύμεδον, τύμβου τοῦδε θανὼν ἔτυχες.
σοὶ μὲν ἕδρη θείοισι παρ' ἀνδράσι· τὸν δὲ πολῖται
 τιμησεῦντι, πατρὸς μνώμενοι ὡς ἀγαθοῦ.

Thine early death, ah! brave Eurymedon,
 Hath made an orphan of thine infant son;
For thee, this tomb thy grateful country rears;
 For him, she bids thee calm a parent's fears:—
Secure thy rest among the Heroes take—
 He shall be honour'd for his father's sake.

<div align="right">

THEOCRITUS
Translated by D. M. P.

</div>

PEACE TO THE TOMB

Γνώσομαι εἴ τι νέμεις ἀγαθοῖς πλέον, ἢ καὶ ὁ δειλὸς
 ἐκ σέθεν ὡσαύτως ἴσον, ὁδοιπόρ', ἔχει.
'Χαιρέτω οὗτος ὁ τύμβος,' ἐρεῖς, 'ἐπεὶ Εὐρυμέδοντος
 κεῖται τῆς ἱερῆς κοῦφος ὑπὲρ κεφαλῆς.'

Give proof, oh! stranger, as thou passest by,
 Dost thou regard the good man's memory—
Or holds the base for thee an equal claim?
 Speak then these words, or silence be thy shame:—
"Peace to the tomb, that lightly lies upon
 The sacred dust of loved Eurymedon."

<div align="right">

THEOCRITUS OR LEONIDAS OF TARENTUM
Translated by D. M. P.

</div>

Six Epitaphs . . . as beautiful as any words ever engraven on stone.

<div align="right">

CHRISTOPHER NORTH (JOHN WILSON)
Blackwood's Magazine (1833)

</div>

MARCUS TULLIUS CICERO

106 — 43 B. C.

RESCUE US

Eripite nos ex miseriis, eripite nos ex faucibus eorum, quorum crudelitas nostro sanguine non potest expleri.

Rescue us from our misery; rescue us from the jaws of those whose ferocity can never be satiated with our blood.

De Oratore (55 B.C.), i, 52

In arranging the members of a period, no writer equals Cicero.

HENRY HOME OF KAMES
Elements of Criticism (1762)

MARCUS TULLIUS CICERO

106 — 43 B. C.

EULOGY OF LITERATURE

Haec studia adolescentiam acuunt, senectutem oblectant, secundas res ornant, adversis perfugium ac solacium praebent, delectant domi, non impediunt foris, pernoctant nobiscum, peregrinantur, rusticantur.

But this gives stimulus to our youth and diversion to our old age; this adds a charm to success, and offers a haven of consolation to failure. In the home it delights, in the world it hampers not. Through the night-watches, on all our journeying, and in our hours of country ease, it is our unfailing companion.

Pro Archia Poeta (62 B.C.), vii, 16
Translated by N. H. Watts

Perhaps the finest panegyric of literature that the ancient world offers us: a panegyric which has been quoted and admired by a long series of writers from Quintilian, through Petrarch, until to-day, when it has lost none of its lustre; and which perhaps inspired a great Elizabethan scholar and gentleman to write of poetry that it "holdeth children from play and old men from the chimney-corner; and, pretending no more, doth intend the winning of the mind from wickedness to virtue."

N. H. WATTS
Introduction, Pro Archia Poeta (1923)

LUCRETIUS

9 6 ? — 5 5 B . C .

THE GUILEFUL OCEAN

Sed quasi naufragiis magnis multisque coortis
disiectare solet magnum mare transtra guberna
antemnas proram malos tonsasque natantis,
per terrarum omnis oras fluitantia aplustra
ut videantur et indicium mortalibus edant,
infidi maris insidias virisque dolumque
ut vitare velint, neve ullo tempore credant,
subdola cum ridet placidi pellacia ponti.

As when great shipwrecks mark the tempest's might,
And planks and helms are tossing on the tide
With spars and prows and masts and drifting oars,
And many a hull goes floating by far shores,
A visible sign to mortals who would brave
The guileful ocean's treacherous strength and spite,
Bidding beware, nor evermore confide
In the false whisper of the windless wave.

De Rerum Natura, ii, 552–59
Translated by H. S. Salt

A passage ending up with one of the most beautiful lines in literature.
MAURICE BARING
Have You Anything to Declare? (1936)

LUCRETIUS

9 6 ? — 5 5 B . C .

WHEN WE ARE NO MORE

Velut ante acto nihil tempore sensimus aegri,
ad confligendum uenientibus undique Poenis,
omnia cum belli trepido concussa tumultu
horrida contremuere sub altis aetheris oris,
in dubioque fuere utrorum ad regna cadendum
omnibus humanis esset terraque marique,

sic, ubi non erimus, cum corporis atque animai
discidium fuerit, quibus e sumus uniter apti,
scilicet haud nobis quicquam, qui non erimus tum,
accidere omnino poterit sensumque mouere—
non si terra mari miscebitur et mare caelo!

 Just as in the ages gone before
We felt no touch of ill, when all sides round
To battle came the Carthaginian host,
And the times, shaken by tumultuous war,
Under the aery coasts of arching heaven
Shuddered and trembled, and all humankind
Doubted to which the empery should fall
By land and sea, thus when we are no more,
When comes that sundering of our body and soul
Through which we're fashioned to a single state,
Verily naught to us, us then no more,
Can come to pass, naught move our senses then—
No, not if earth confounded were with sea,
And sea with heaven.

<div align="right">

De Rerum Natura, iii, 832–42
Translated by William Ellery Leonard

</div>

Of all the long array of poets, from Homer to Propertius and from Villon to Baudelaire, who have written their greatest verse upon the theme of death, Lucretius is the most vivid, the most moving, and the most persuasive.

<div align="right">

STANLEY BARNEY SMITH
T. Lucreti Cari, De Rerum Natura (1942)

</div>

LUCRETIUS

96 ? — 55 B . C .

UNPATHED HAUNTS

Avia Pieridum peragro loca nullius ante
trita solo. iuvat integros accedere fontis
atque haurire, iuvatque novos decerpere flores
insignemque meo capiti petere inde coronam
unde prius nulli velarint tempora musae.

I wander afield, thriving in sturdy thought,
Through unpathed haunts of the Pierides,
Trodden by step of none before. I joy
To come on undefilèd fountains there,
To drain them deep; I joy to pluck new flowers,
To seek for this my head a signal crown
From regions where the Muses never yet
Have garlanded the temples of a man.

<div align="right">

De Rerum Natura, iv, 1–5
Translated by William Ellery Leonard

</div>

Has any one ever, I would ask, delineated more faithfully and sweetly the feelings of those who roam in the summer woods, joying in each intricate pathway, and exulting in the notion that they may finally issue upon some hidden retreat as yet untrodden by man?

<div align="right">

JOHN KEBLE
Lectures on Poetry (1832–41)
Translated by Edward K. Francis

</div>

LUCRETIUS

96? — 55 B.C.

ALL IS VANITY

Nequiquam, quoniam medio de fonte leporum
surgit amari aliquit quod in ipsis floribus angat.

But all is vanity, since from the very fountain of enchantment rises a drop of bitterness to torment even in the flowers.

<div align="right">

De Rerum Natura, iv, 1133–4
Translated by W. H. D. Rouse

</div>

Lines unsurpassed in any literature.

<div align="right">

E. V. RIEU
A Book of Latin Poetry (1925)

</div>

LUCRETIUS

9 6 ? — 5 5 B . C .

THE EARTH

Inque dies quanto circum magis aetheris aestus
et radii solis cogebant undique terram
verberibus crebris extrema ad limina in artum,
in medio ut propulsa suo condensa coiret,
tam magis expressus salsus de corpore sudor
augebat mare manando camposque natantis,
et tanto magis illa foras elapsa volabant
corpora multa vaporis et aeris altaque caeli
densebant procul a terris fulgentia templa.

And day by day, the more the tide of ether and the sun's rays compressed
the earth into compactness with frequent blows from all sides upon
its outermost confines, so that thus beaten it was packed together and
came together upon its own centre, so much the more did the salt sweat
squeezed out of its body oozing increase the sea and the swimming
plains, and so much the more slipped out and flew away those many
bodies of heat and air, and on high far from the earth packed the shin-
ing regions of the sky.

De Rerum Natura, v, 483–91
Translated by W. H. D. Rouse

Science was never so effectively written, before or since Lucretius's day.
HERBERT READ
Reason and Romanticism (1926)

CATULLUS

8 4 ? — 5 4 B . C .

LESBIA

Vivamus, mea Lesbia, atque amemus,
rumoresque senum severiorum
omnes unius aestimemus assis.

soles occidere et redire possunt:
nobis cum semel occidit brevis lux,
nox est perpetua una dormienda.
da mi basia mille, deinde centum,
dein mille altera, dein secunda centum,
deinde usque altera mille, deinde centum.
dein, cum milia multa fecerimus,
conturbabimus illa, ne sciamus,
aut nequis malus invidere possit,
cum tantum sciat esse basiorum.

Come and let us live my Deare,
Let us love and never feare,
What the sowrest Fathers say:
Brightest *Sol* that dyes to day
Lives againe as blith to morrow,
But if we darke sons of sorrow
Set; ô then, how long a Night
Shuts the Eyes of our short light!
Then let amorous kisses dwell
On our lips, begin and tell
A Thousand, and a Hundred, score
An Hundred, and a Thousand more,
Till another Thousand smother
That, and that wipe of another.
Thus at last when we have numbred
Many a Thousand, many a Hundred;
Wee'l confound the reckoning quite,
And lose our selves in wild delight:
While our joyes so multiply,
As shall mocke the envious eye.

Carmen v
Translated by Richard Crashaw

'Let us live, my Lesbia, and let us love,' he begins; and by this simple exhortation he means life and love are one, love is the only life, life without love is death. The idea may be narrow and perverted; but enough people have felt it to make it important. And who has both felt and expressed it like Catullus?

E. M. W. TILLYARD
Poetry Direct and Oblique (1945)

HYMN TO DIANA

Dianae sumus in fide
puellae et pueri integri:
Dianam pueri integri
 puellaeque canamus.
o Latonia, maximi
magna progenies Iovis,
quam mater prope Deliam
 deposivit olivam,
montium domina ut fores
silvarumque virentium
saltuumque reconditorum
 amniumque sonantum.
tu Lucina dolentibus
Iuno dicta puerperis,
tu potens Trivia et notho's
 dicta lumine Luna.
tu cursu, dea, menstruo
metiens iter annuum
rustica agricolae bonis
 tecta frugibus exples.
sis quocumque tibi placet
sancta nomine, Romulique,
antique ut solita's, bona
 sospites ope gentem.

We, lads and lasses pure,
 Abide in Dian safe;
Come, lads and lasses pure,
 To Dian sing a stave.

O child of Leto, rare
 Offspring of highest Jove,
Whom erst thy mother bare
 By Delos' olive-grove,

To be the queen of hills,
 Queen of the forest green,
And of the sounding rills,
 And glens that lie between,

Lucina, through the pain,
 And Juno when 'tis done,
And Trivia, and again
 The Moon who robs the Sun,

Goddess, whose monthly course
 The yearly circle plots,
And fills with goodly stores
 The farmers' rustic cots,

Hallowed by any name
 Thou wilt, be good to us;
Thy grace of old we claim,
 We, race of Romulus.

<div align="right">

Carmen xxxiv
Translated by Sir William Marris
</div>

The loveliest hymn that pagan Rome has bequeathed to us.

<div align="right">

E. V. RIEU
A Book of Latin Poetry (1925)
</div>

CATULLUS

8 4 ? — 5 4 B . C .

ACME AND SEPTIMIUS

Acmen Septimius suos amores
tenens in gremio "mea" inquit "Acme,
ni te perdite amo atque amare porro
omnes sum assidue paratus annos
quantum qui pote plurimum perire,
solus in Libya Indiaque tosta
caesio veniam obvius leoni."
hoc ut dixit, Amor, sinistra, ut ante
dextra, sternuit approbationem.
at Acme leviter caput reflectens
et dulcis pueri ebrios ocellos
illo purpureo ore saviata
"sic" inquit "mea vita Septimille,
huic uni domino usque serviamus,
ut multo mihi maior acriorque
ignis mollibus ardet in medullis."

hoc ut dixit, Amor, sinistram ut ante,
dextram sternuit approbationem.
nunc ab auspicio bono profecti
mutuis animis amant amantur.
unam Septimius misellus Acmen
mavolt quam Syrias Britanniasque:
uno in Septimio fidelis Acme
facit delicias libidinesque.
quis ullos homines beatiores
vidit, quis Venerem auspicatiorem?

Whilst on *Septimius* panting Brest,
(Meaning nothing less then Rest)
Acme lean'd her loving head,
Thus the pleas'd *Septimius* said.

My dearest *Acme,* if I be
Once alive, and love not thee
With a Passion far above
All that e're was called Love,
In a *Lybian* desert may
I become some Lions prey,
Let him, *Acme,* let him tear
My Brest, when *Acme* is not there.

The God of Love who stood to hear him,
(The God of Love was always near him)
Pleas'd and tickl'd with the sound,
Sneez'd aloud, and all around
The little Loves that waited by,
Bow'd and blest the Augurie.

Acme enflam'd with what he said,
Rear'd her gently-bending head,
And her purple mouth with joy
Stretching to the delicious Boy
Twice (and twice could scarce suffice)
She kist his drunken, rowling eyes.

My little Life, my All (said she)
So may we ever servants be
To this best God, and ne'r retain
Our hated Liberty again,
So may thy passion last for me,
As I a passion have for thee,
Greater and fiercer much then can
Be conceiv'd by Thee a Man.

Into my Marrow is it gone,
Fixt and setled in the Bone,
It reigns not only in my Heart,
But runs, like Life, through ev'ry part.

She spoke; the God of Love aloud,
Sneez'd again, and all the crowd
Of little Loves that waited by,
Bow'd and blest the Augurie.

This good Omen thus from Heaven
Like a happy signal given,
Their Loves and Lives (all four) embrace,
And hand in hand run all the race.
To poor *Septimius* (who did now
Nothing else but *Acme* grow)
Acme's bosome was alone,
The whole worlds Imperial Throne,
And to faithful *Acmes* mind
Septimius was all Human kind.

If the Gods would please to be
But advis'd for once by me,
I'de advise 'em when they spie,
Any illustrious Piety,
To reward Her, if it be she;
To reward Him, if it be He;
With such a Husband, such a Wife,
With *Acme's* and *Septimius'* Life.

<div align="right">

Carmen xlv
Translated by Abraham Cowley

</div>

The most delicious love poem ever written.

<div align="right">

JOHN CHURTON COLLINS
Ephemera Critica (1901)

</div>

CATULLUS

84 ? — 54 B. C.

ATTIS

Super alta vectus Attis celeri rate maria
Phrygium ut nemus citato cupide pede tetigit
adiitque opaca silvis redimita loca deae,

stimulatus ibi furenti rabie, vagus animi,
devolvit ili acuto sibi pondera silice.
itaque ut relicta sensit sibi membra sine viro,
etiam recente terrae sola sanguine maculans
niveis citata cepit manibus leve typanum,
typanum, tubam Cybelles, tua, Mater, initia,
quatiensque terga tauri teneris cava digitis
canere haec suis adortast tremebunda comitibus.
"agite ite ad alta, Gallae, Cybeles nemora simul,
simul ite, Dindymenae dominae vaga pecora,
aliena quae petentes velut exules loca celeri
sectam meam executae duce me mihi comites
rapidum salum tulistis truculentaque pelage
et corpus evirastis Veneris nimio odio,
hilarate erae citatis erroribus animum.
mora tarda mente cedat; simul ite, sequimini
Phrygiam ad domum Cybelles, Phrygia ad nemora deae,
ubi cymbalum sonat vox, ubi tympana reboant,
tibicen ubi canit Phryx curvo grave calamo,
ubi capita Maenades vi iaciunt ederigerae,
ubi sacra sancta acutis ululatibus agitant,
ubi suevit illa divae volitare vaga cohors:
quo nos decet citatis celerare tripudiis."
 Simul haec comitibus Attis cecinit notha mulier,
thiasus repente linguis trepidantibus ululat,
leve tympanum remugit, cava cymbala recrepant,
viridem citus adit Idam properante pede chorus.
furibunda simul anhelans vaga vadit, animam agens,
comitata tympano Attis per opaca nemora dux,
veluti iuvenca vitans onus indomita iugi:
rapidae ducem sequuntur Gallae properipedem.
itaque ut domum Cybelles tetigere lassulae,
nimio e labore somnum capiunt sine Cerere.
piger his labante langore oculos sopor operit:
abit in quiete molli rabidus furor animi.
sed ubi oris aurei Sol radiantibus oculis
lustravit aethera album, sola dura, mare ferum,
pepulitque noctis umbras vegetis sonipedibus,
ibi Somnus excitum Attin fugiens citus abiit:
trepidante eum recepit dea Pasithea sinu.
ita de quiete molli rapida sine rabie
simul ipse pectore Attis sua facta recoluit,
liquidaque mente vidit sine quis ubique foret,
animo aestuante rusum reditum ad vada tetulit.

ibi maria vasta visens lacrimantibus oculis,
patriam allocuta maestast ita voce miseriter.
 "Patria o mei creatrix, patria o mea genetrix,
ego quam miser relinquens, dominos ut erifugae
famuli solent, ad Idae tetuli nemora pedem,
ut apud nivem et ferarum gelida stabula forem
et earum omnia adirem furibunda latibula,
ubinam aut quibus locis te positam, patria, reor?
cupit ipsa pupula ad te sibi derigere aciem,
rabie fera carens dum breve tempus animus est.
egone a mea remota haec ferar in nemora domo?
patria, bonis, amicis, genitoribus abero?
abero foro, palaestra, stadio et guminasiis?
miser a miser, querendumst etiam atque etiam, anime.
quod enim genus figuraest, ego non quod habuerim?
ego mulier, ego adolescens, ego ephebus, ego puer,
ego guminasi fui flos, ego eram decus olei:
mihi ianuae frequentes, mihi limina tepida,
mihi floridis corollis redimita domus erat,
linquendum ubi esset orto mihi sole cubiculum.
ego nunc deum ministra et Cybeles famula ferar?
ego Maenas, ego mei pars, ego vir sterilis ero?
ego viridis algida Idae nive amicta loca colam?
ego vitam agam sub altis Phrygiae columinibus
ubi cerva silvicultrix, ubi aper nemorivagus?
iam iam dolet quod egi, iam iamque paenitet."
 Roseis ut hic labellis sonitus citus abiit,
geminas deorum ad aures nova nuntia referens,
ibi iuncta iuga resolvens Cybele leonibus
laevumque pecoris hostem stimulans ita loquitur.
"agedum" inquit "age ferox i, fac ut hunc furor agitet,
fac uti furoris ictu reditum in nemora ferat,
mea libere nimis qui fugere imperia cupit.
age caede terga cauda, tua verbera patere,
fac cuncta mugienti fremitu loca retonent,
rutilam ferox torosa cervice quate iubam."
ait haec minax Cybelle religatque iuga manu.
ferus ipse sese adhortans rapidum incitat animo.
vadit, fremit, refringit virgulta pede vago.
at ubi umida albicantis loca litoris adiit,
tenerumque vidit Attin prope marmora pelagi,
facit impetum: ille demens fugit in nemora fera:
ibi semper omne vitae spatium famula fuit.
 Dea magna, dea Cybelle, dea domina Dindymi,

227

procul a mea tuus sit furor omnis, era, domo:
alios age incitatos, alios age rabidos.

Attis propelled by his swift ship through deep waves, set his quick feet
upon the Phrygian shore;
entered the heavy sunless forest where his mind grew dark as shadows
over him
and there, his blood gone mad, seized a sharp stone, divorced his vital
members from his body,
then rising (the ground wet with blood) he was transformed, a woman
with her delicate white hands
sounding the tympanum, the tympanum singing praise through sacred
trumpets raised to goddess Cybele,
mysterious mother of a sexless race.
Then in his sweet falsetto Attis sang: Now follow me, O priests of
Cybele, come follow, we are creatures
of this goddess, wind, dance, unwind the dance again, O exiles from a
far land, come with me
across the rapid salt sea wave. Your bodies shall be clean; no more
shall Venus
stain you with foul disease and move your limbs with power of love.
Now under my leadership (this mad delight) land in her rich dominions,
sing you her praise
make her heart leap with the same joy that rises in your blood at this
sweet liberty.
No longer wait for her, but come, follow my way that winds upward
to her temple,
making glad noises with the pipe that plays a song to welcome her,
clash cymbals, dance and shake the earth with thunder, your quick
feet sounding her glory, and like the girls
who follow Bacchus, toss your heads, shout songs in measure to the
Phrygian pipes, come join her merry
company where drunken cries rise in a chorus. The sacred symbol of
her worship trembles in air
that moves with noise poured from your lips here in this place where
the great goddess wanders.

Now Attis (not quite woman) called her followers, leading then toward
green blooming Ida where
his followers crowded, tongues trembling with shrill noises, hollow
cymbals crashed and the tympanum rang again, again
the race sped forward. Then wavering exhausted, the ghost of their
very lives issuing
from lips, circling in delirium they followed Attis through the green
shadows, she who sprang

228

like a raging heifer freed from harness, till they sank, defeated (weariness in their eyes, and starved for lack of food) at the high temple of Cybele, their goddess,

then madness declined into a heavy wave of sleep, minds sunk in darkness.

But when the sun transformed the skies into a radiant heaven, his mighty rolling brilliant eye

disclosing hills, the savage sea all in clear outlines, and there was liquid peace within his mind, the horses

of dawn rose galloping, trampling night underfoot, and Attis, leaving sweet Pasithea wife of sleep, awoke,

looked back and saw what he had done, how his mad brain deceived him saw how he lost

his manhood—all this in passionless clarity seized his mind, and with his eyes turned homeward

across the sea, she wept, poor creature, neither man nor woman.

Land of my birth, creating me, my fatherland I left you (O miserably, a fugitive)

I have gone into this wilderness of snow to live with beasts that circle Ida's mountain,

my brain in darkness—and where are you, land of my fathers, for you have vanished and my eyes return

where you once rose before me. In this short hour while my brain still welcomes sunlight,

I praise you—now shall I be driven back into this wilderness where everyone,

my friends, my parents, and all I love shall fade. I shall not walk again through the city streets, nor join the crowd,

(O glorious young men) who fill the stadium and who excell in many pleasures.

Look at my misery and hear me cry my curse against this miserable fate,

I am a woman, hear my voice and look at me who once walked bravely hero of games, a boy who stood

rich flower of youth equal to all who challenged him. All these were mine: friends crowding at my door,

wreaths of sweet flowers in my room when morning sun called me away, and a welcome threshold that I left

behind me. Witness me, a girl, a slave of Cybele, dressed like a girlish follower of Bacchus,

half my soul destroyed, and sterile I must live on this cold mountain

and like all others in snow-bound Ida's province, follow the deer and wild boar—a man undone,

longing for home again. And as these words flowed from her glowing lips a prayer rose to the gods,

Cybele released her lions, driving one nearest to her side into the
forest saying:

Go follow him, he who is mad Attis, mangle his brain within your claws,
 go follow
him who longs to leave my empire; give your rage to him, transmute
 your madness to his person,
lash tail and throw your rolling head, mane erect in fury, follow him.
At this the creature sprang through the deep wilderness, and on a
 glittering sunstruck beach found Attis
drove him back to Ida where now wandering forever Attis delirious,
 sings praise, a servant to the goddess Cybele.

Great goddess, spare me, never haunt my home—take others for your
 slaves, those creatures
that you have driven mad and those who in their madness wake again
 your passionate cruelty.

<div align="right">

Carmen lxiii
Translated by Horace Gregory

</div>

As the author of the ATTIS *Catullus stands alone among poets. There
was, so far as we know, nothing like it before, and there has been nothing
like it since. If it be a study from the Greek, as it is generally supposed
to be, it is very difficult to conjecture at what period its original could
have been produced. There is nothing at all resembling it which has
come down from the lyric period; its theme is not one which would
have been likely to attract the Attic poets. If its model was the work
of some Alexandrian, we can only say that such a poem must have been
an even greater anomaly in that literature than Smart's* SONG TO DAVID *
is to our own literature, in the eighteenth century. It may, of course,
be urged that it is equally anomalous in Latin poetry, and that, if
resolved into its elements, it has much more affinity with what may
be traced to Greek than to Roman sources. In its compound epithets,
and more particularly in the singular use of "foro," so plainly sub-
stituted for the Greek* ἀγορά *and its associations, it certainly reads
like a translation from the Greek; and yet, in the total impression made
by it, the poem has not the air of a translation, but of an original, and
of an original struck out, in inspiration, at white heat.*

<div align="right">

JOHN CHURTON COLLINS
Ephemera Critica (1901)

</div>

* For this poem see page 932.

CATULLUS

84 ? — 54 B. C.

BREATH OF DAY

Hic, qualis flatu placidum mare matutino
horrificans Zephyrus proclivis incitat undas
Aurora exoriente vagi sub limina Solis,
quae tarde primum clementi flamine pulsae
procedunt, leviterque sonant plangore cachinni,
post vento crescente magis magis increbescunt
purpureaque procul nantes ab luce refulgent.

Yea, as the west wind with its breath of day
Roughs the still seas and stirs the sloping floors,
As Dawn goes up to wandering Phoebus' doors,
And first the waves, as the soft wind comes after,
Move slow, and lightly sound with plash of laughter;
Then the breeze freshens and more close they grow
And far afloat reflect the crimson glow.

Carmen lxiv, 269–75
Translated by Sir William Marris

*A more beautiful description, a sentence on the whole more harmonious,
or one in which every verse is better adapted to its peculiar office, is
neither to be found nor conceived.*

WALTER SAVAGE LANDOR
The Poems of Catullus (1842)

CATULLUS

84 ? — 54 B. C.

GRANT ME PEACE

Siqua recordanti benefacta priora voluptas
 est homini, cum se cogitat esse pium,
nec sanctam violasse fidem, nec foedere in ullo
 divum ad fallendos numine abusum homines,
multa parata manent in longa aetate, Catulle,
 ex hoc ingrato gaudia amore tibi.

231

nam quaecumque homines bene cuiquam aut dicere possunt
 aut facere, haec a te dictaque factaque sunt;
omnia quae ingratae perierunt credita menti.
 quare iam te cur amplius excrucies?
quin tu animum offirmas atque istinc teque reducis
 et dis invitis desinis esse miser?
difficilest longum subito deponere amorem.
 difficilest, verum hoc qualubet efficias.
una salus haec est, hoc est tibi pervincendum:
 hoc facias, sive id non pote sive pote.
o di, si vestrumst misereri, aut si quibus umquam
 extremam iam ipsa in morte tulistis opem,
me miserum aspicite et, si vitam puriter egi,
 eripite hanc pestem perniciemque mihi.
heu, mihi surrepens imos ut torpor in artus
 expulit ex omni pectore laetitias!
non iam illud quaero, contra me ut diligat illa,
 aut, quod non potis est, esse pudica velit:
ipse valere opto et taetrum hunc deponere morbum.
 o di, reddite mi hoc pro pietate mea.

> Is there a pious pleasure that proceeds
> From contemplation of our virtuous deeds?
> That all mean sordid actions we despise,
> And scorn to gain a throne by cheats and lies?
> Thyrsis, thou hast sure blessings laid in store,
> From thy just dealing in this curst amour:
> What honour can in words or deeds be shewn,
> Which to the fair thou hast not said and done?
> On her false heart they all are thrown away;
> She only swears, more eas'ly to betray.
> Ye Powers! that know the many vows she broke,
> Free my just soul from this unequal yoke!
> My love boils up, and, like a raging flood,
> Runs through my veins, and taints my vital blood.
> I do not vainly beg she may grow chaste,
> Or with an equal passion burn at last:
> The one she cannot practise, though she would:
> And I contemn the other, though she should:
> Nor ask I vengeance on the perjur'd jilt;
> 'Tis punishment enough to have her guilt.
> I beg but balsam for my bleeding breast,
> Cure for my wounds, and from my labours rest.

Carmen lxxvi
Translated by William Walsh

There is no more passionate poem in the world. . . . It is in the Latin as close in utterance as the tightest of Shakespeare's sonnets, and gives one the impression of a man almost inarticulate, so much has he to say. It expresses a crucifixion of the spirit and of the heart as excruciating as what is sometimes expressed in the lyrics of Heine.

MAURICE BARING
Have You Anything to Declare? (1936)

CATULLUS

84 ? — 54 B . C .

LOVE'S MADNESS

Nulla potest mulier tantum se dicere amatam
 vere, quantum a me Lesbia amata mea's.
nulla fides ullo fuit umquam foedere tanta,
 quanta in amore tuo ex parte reperta meast.

None could ever say that she,
Lesbia! was so loved by me.
Never all the world around
Faith so true as mine was found:
If no longer it endures
(Would it did!) the fault is yours.
I can never think again
Well of you: I try in vain:
But—be false—do what you will—
Lesbia! I must love you still.

Carmen lxxxvii
Translated by Walter Savage Landor

These four lines with their balanced mathematical structure provide a perfect specimen of that ancient verse-form known technically as the epigram.

E. A. HAVELOCK
The Lyric Genius of Catullus (1939)

233

CATULLUS

8 4 ? — 5 4 B . C .

ELEGY ON QUINTILIA

Si quicquam mutis gratum acceptumve sepulcris
 accidere a nostro, Calve, dolore potest,
quo desiderio veteres renovamus amores
 atque olim amissas flemus amicitias,
certe non tanto mors immatura dolorist
 Quintiliae, quantum gaudet amore tuo.

If the silent grave can receive any pleasure, or sweetness at all from
our grief, Calvus, the grief and regret with which we make our old loves
live again, and weep for long-lost friendships, surely Quintilia feels less
sorrow for her too early death, than pleasure from your love.

<div align="right">

Carmen xcvi
Translated by F. W. Cornish

</div>

Chiselled perfection.

<div align="right">

JAMES A. S. MCPEEK
Catullus in Strange and Distant Britain (1939)

</div>

CATULLUS

8 4 ? — 5 4 B . C .

HAIL AND FAREWELL

Multas per gentes et multa per aequora vectus
 advenio has miseras, frater, ad inferias,
ut te postremo donarem munere mortis
 et mutam nequiquam alloquerer cinerem,
quandoquidem fortuna mihi tete abstulit ipsum,
 heu miser indigne frater adempte mihi.
nunc tamen interea haec, prisco quae more parentum
 tradita sunt tristi munere ad inferias,
accipe fraterno multum manantia fletu,
 atque in perpetuum, frater, ave atque vale.

By ways remote and distant waters sped,
Brother, to thy sad grave-side am I come,
That I may give the last gifts to the dead,
And vainly parley with thine ashes dumb:
Since she who now bestows and now denies
Hath ta'en thee, hapless brother, from mine eyes.
But lo! these gifts, the heirlooms of past years,
Are made sad things to grace thy coffin shell,
Take them, all drenchèd with a brother's tears,
And, brother, for all time, hail and farewell!

<div align="right">

Carmen ci

Translated by Aubrey Beardsley

</div>

Could pathos go further?

<div align="right">

JOHN CHURTON COLLINS
Ephemera Critica (1901)

</div>

VIRGIL

70 — 19 B. C.

SUNT LACRIMAE RERUM

Lucus in urbe fuit media, laetissimus umbrae,
quo primum iactati undis et turbine Poeni
effodere loco signum, quod regia Iuno
monstrarat, caput acris equi; sic nam fore bello
egregiam et facilem victu per saecula gentem.
hic templum Iunoni ingens Sidonia Dido
condebat, donis opulentum et numine divae,
aerea cui gradibus surgebant limina nexaeque
aere trabes, foribus cardo stridebat aënis.
hoc primum in luco nova res oblata timorem
leniit, hic primum Aeneas sperare salutem
ausus et adflictis melius confidere rebus.
namque sub ingenti lustrat dum singula templo,
reginam opperiens, dum, quae fortuna sit urbi,
artificumque manus inter se operumque laborem
miratur, videt Iliacas ex ordine pugnas
bellaque iam fama totum volgata per orbem,
Atridas Priamumque et saevum ambobus Achillem.

constitit et lacrimans, "quis iam locus," inquit, "Achate,
quae regio in terris nostri non plena laboris?
en Priamus! sunt hic etiam sua praemia laudi,
sunt lacrimae rerum et mentem mortalia tangunt.
solve metus; feret haec aliquam tibi fama salutem."
 Sic ait, atque animum pictura pascit inani
multa gemens, largoque umectat flumine voltum.
namque videbat, uti bellantes Pergama circum
hac fugerent Grai, premeret Troiana iuventus,
hac Phryges, instaret curru cristatus Achilles.
nec procul hinc Rhesi niveis tentoria velis
adgnoscit lacrimans, primo quae prodita somno
Tydides multa vastabat caede cruentus,
ardentisque avertit equos in castra, prius quam
pabula gustassent Troiae Xanthumque bibissent.
parte alia fugiens amissis Troilus armis,
infelix puer atque impar congressus Achilli,
fertur equis curruque haeret resupinus inani,
lora tenens tamen; huic cervixque comaeque trahuntur
per terram et versa pulvis inscribitur hasta.
interea ad templum non aequae Palladis ibant
crinibus Iliades passis peplumque ferebant,
suppliciter tristes et tunsae pectora palmis;
diva solo fixos oculos aversa tenebat.
ter circum Iliacos raptaverat Hectora muros
exanimumque auro corpus vendebat Achilles.
tum vero ingentem gemitum dat pectore ab imo,
ut spolia, ut currus, utque ipsum corpus amici
tendentemque manus Priamum conspexit inermis.
se quoque principibus permixtum adgnovit Achivis,
Eoasque acies et nigri Memnonis arma.
ducit Amazonidum lunatis agmina peltis
Penthesilea furens mediisque in milibus ardet,
aurea subnectens exsertae cingula mammae,
bellatrix, audetque viris concurrere virgo.

 Within the city's midst a grove there stood
Bounteous of shade, where first the Punic host,
'Scaped from the brunt of whirlwind and of wave,
Dug forth, as queenly Juno had foreshown,
The symbol of a fiery horse's head:
For so, said she, their race should ever prove
Peerless in war and with abundance blest.
Sidonian Dido here a mighty fane
To Juno's praise was rearing, rich with gifts

And with the indwelling goddess: see! of brass
High on ascending steps the threshold lay,
And clenched with brass the lintels, of brass too
The doors on creaking hinges. In this grove
A strange sight met him, that first soothed his fear;
Here first Aeneas dared for safety hope,
And in his broken fortunes firmlier trust.
For 'neath the mighty fane while he surveys
Point after point, still waiting for the queen,
And marvels to behold what fortune crowns
The city, and her craftsmen's emulous hands
And toil of labour, there set forth he sees
The battlefields of Ilium, and the war
By fame now bruited over the whole world,
Priam and Atreus' sons, and, bane of both,
Achilles. With arrested steps he cries
Weeping, 'What place, Achates, or what clime
But with the story of our grief o'erflows?
See Priam! even here, too, honour hath its meed,
And there are tears for what befalls, and hearts
Touched by the chances of mortality.
Fear naught, and thou shalt find this fame will bring
Some safety with it.' He spake, and feasts his soul
Upon the empty picture, sighing sore,
His face all bathed with grief's abundant flow.
For, as they fought round Pergamus, behold!
Here fled the Greeks, Troy's bravest at their heels,
The Phrygians here, Achilles in his car
With crested helm pursuing. Nor far aloof
With tears he knew the snowy-canvassed tents
Of Rhesus, which, in the first sleep betrayed,
Red Tydeus' son was deluging with blood,
Who campward now drives off the fiery steeds,
Or e'er on Trojan pastures they have browsed,
Or drunk of Xanthus. Elsewhere was portrayed,
His arms in flight flung from him, Troilus:
Poor boy! for with Achilles overmatched,
Dragged by his steeds to the void car he clings,
Thrown backward, and yet grasping still the reins:
Neck, see! and hair are trailed along the ground,
And his reversed spear scribbles in the dust.
Meanwhile the Trojan women to the shrine
Of unregardful Pallas passed along
Bearing the peplus, all their tresses loosed,
As suppliant mourners with hand-bruisèd breasts;

On earth the goddess with averted gaze
Her eyes was fixing. There Achilles too
Had thrice dragged Hector round the walls of Troy,
And now was bartering his dead corse for gold.
Then from the bottom of his heart he heaved
A mighty groan, when he beheld the spoils,
The chariot, nay, the body of his friend,
And Priam outstretching his defenceless hands.
Himself too there among the Achaean chiefs
He recognized, and dusky Memnon's arms
And eastern warriors. With their moonèd shields
Penthesilea like a fury leads
The Amazonian ranks, and blazes forth
Amid her thousands, one protruding breast
Looped with a golden girdle—warrior-queen,
Who dares the shock of battle, maid with men.

<div align="right">

Aeneid, i, 441–93
Translated by James Rhoades

</div>

The highest point which any such description can reach, and the artistic skill here exhibited cannot be matched in Greek poetry.

<div align="right">

HENRY W. PRESCOTT
The Development of Virgil's Art (1927)

</div>

VIRGIL

7 0 — 1 9 B . C .

MISFORTUNE

Non ignara mali miseris succurrere disco.

Not unacquainted with misfortune do I learn to aid the unhappy.

<div align="right">

Aeneid, i, 630

</div>

I know no line so beautiful, so profound, so touching, so true.

<div align="right">

JEAN-JACQUES ROUSSEAU
Émile, ou de l'Éducation (1762)

</div>

VIRGIL

70 — 19 B. C.

SAD DIDO

Quis tibi tum, Dido, cernenti talia sensus,
quosve dabas gemitus, cum litora fervere late
prospiceres arce ex summa, totumque videres
misceri ante oculos tantis clamoribus aequor!

What wear thy thoughts sadd Dido on that day,
how deepe thy sighes; when from thy Towers above
thou seest the Phrigeans, in such order move,
and hearst the tumults of the clamorus sea.

<div align="right">

Aeneid, iv, 408–11
Translated by Sidney Godolphin

</div>

Nothing can be more moving.

<div align="right">

RENÉ LE BOSSU
Traité du poëme épique (1675)

</div>

VIRGIL

70 — 19 B. C.

DIDO'S LAMENT ON
THE DEPARTURE OF AENEAS

1. Hoc solum nomen quoniam de coniuge restat.

Since [guest] alone survives the name of husband.

<div align="right">

Aeneid, iv, 324

</div>

ANCHISES, SEEING THE SHADE OF
MARCELLUS IN HADES, LAMENTS
THAT HE WILL DIE EARLY

2. Tu Marcellus eris! Manibus date lilia plenis,
 purpureos spargam flores animamque nepotis
 his saltem accumulem donis et fungar inani
 munere.

239

Thou shalt be Marcellus! Give me handfuls of lilies; let me scatter purple flowers; let me heap at least these offerings over my descendant's shade and perform an unavailing service.

<div align="right">Aeneid, vi, 883–85</div>

AENEAS FACES HIS WIFE'S GHOST

3. Infelix simulacrum atque ipsius umbra Creusae.

The unhappy phantom and shadow of Creüsa herself.

<div align="right">Aeneid, ii, 772</div>

AENEAS ENTERS
THE HOUSE OF EVANDER

4. Aude, hospes, contemnere opes et te quoque dignum
finge deo, rebusque veni non asper egenis.

Dare, my guest, to despise wealth; make yourself also worthy of divinity, and come not scornful of our poverty.

<div align="right">Aeneid, viii, 364–65</div>

DIDO CURSES THE DEPARTED AENEAS

5. Exoriare, aliquis nostris ex ossibus ultor.

Arise, some avenger, from my ashes!

<div align="right">Aeneid, iv, 625</div>

THE VOICE OF POLYDORUS
WARNS AENEAS

6. Heu! Fuge crudelis terras, fuge litus avarum.

Alas! Flee from this cruel land, flee from this greedy shore!

<div align="right">Aeneid, iii, 44</div>

ANCHISES' LAMENT

7. Manibus date lilia plenis.

Give me handfuls of lilies.

<div align="right">Aeneid, vi, 883</div>

On this line (1), the poet's own voice faltered as he read. At this (2) Augustus and Octavia melted into passionate weeping. Here is the verse (3) which Augustine quotes as typical in its majestic rhythm of all the

pathos and the glory of pagan art, from which the Christian was bound to flee. This is the couplet (4) which Fénelon could never read without admiring tears. This line Filippo Strozzi scrawled on his prison-wall, when he slew himself to avoid worse ill (5). These are the words (6) which, like a trumpet-call, roused Savonarola to seek the things that are above. And this line (7) Dante heard on the lips of the Church Triumphant, at the opening of the Paradise of God.

<div align="right">

F. W. H. MYERS
Essays Classical (1897)

</div>

VIRGIL

70 — 19 B. C.

THE SOUND OF VERSES

Sternitur exanimisque tremens procumbit humi bos.

Outstretched and lifeless, the bull falls quivering on the ground.

<div align="right">

Aeneid, v, 481

</div>

Quas animosi Euri adsidue franguntque feruntque.

Which angry eastern gales ever toss and tear.

<div align="right">

Georgics, ii, 441
Translated by H. R. Fairclough

</div>

A supreme poetic art.

<div align="right">

THEODORE WATTS-DUNTON
Poetry and the Renascence of Wonder (1914)

</div>

VIRGIL

70 — 19 B. C.

WITH WOUND STILL FRESH

Hic, quos durus amor crudeli tabe peredit,
secreti celant calles et myrtea circum
silva tegit. . . .
. . . . Phoenissa recens a volnere Dido

241

errabat silva in magna. quam Troius heros
ut primum iuxta stetit adgnovitque per umbras
obscuram, qualem primo qui surgere mense
aut videt aut vidisse putat per nubila lunam. . . .

Here those whom stern Love has consumed with cruel wasting are
hidden in walks withdrawn, embowered in a myrtle grove. . . .
With wound still fresh, Phoenician Dido was wandering in the great
forest, and soon as the Trojan hero stood nigh and knew her, a dim
form amid the shadows—even as, in the early month, one sees or fancies
he has seen the moon rise amid the clouds. . . .

<div align="right">

Aeneid, vi, 442–54
Translated by H. R. Fairclough

</div>

*Happy are those who tremble at the miracles of this poetry. There are
in the world a thousand such lines, perhaps. If they should perish, the
world would be less beautiful.*

<div align="right">

ANATOLE FRANCE
Le Génie latin (1913)

</div>

VIRGIL

70 — 19 B. C.

ON SOME VERSES OF VIRGIL

Dixerat et niveis hinc atque hinc diva lacertis
cunctantem amplexu molli fovet. ille repente
accepit solitam flammam, notusque medullas
intravit calor et labefacta per ossa cucurrit,
non secus atque olim, tonitru cum rupta corusco
ignea rima micans percurrit lumine nimbos.
 ea verba locutus
optatos dedit amplexus placidumque petivit
coniugis infusus gremio per membra soporem.

The goddess ceased, and with the soft embrace
Of snowy arms about his body wound
Fondled him, as he faltered. Quick he caught
The wonted fire; the old heat pierced his heart,
Ran through his melting frame: as oftentimes
A fiery rift, burst by the thunder-clap,

Runs quivering down the cloud, with flash of light. . . .
So saying, he gave
The embrace she longed for, on her bosom sank,
And wooed calm slumber to o'er-glide his limbs.

Aeneid, viii, 387–406
Translated by James Rhoades

Venus is not so faire, nor so alluring, all naked, and quick panting, as she is here in Virgill.

MICHEL DE MONTAIGNE
Essais (1595), iii, 5
Translated by John Florio

VIRGIL

70 — 19 B. C.

THE STATELIEST MEASURE

Fluctus uti medio coepit cum albescere ponto,
longius ex altoque sinum trahit, utque volutus
ad terras immane sonat per saxa, neque ipso
monte minor procumbit; at ima exaestuat unda
verticibus nigramque alte subiectat harenam.

As, when a wave begins to whiten in mid-sea, from the farther deep it arches its curve, and, rolling shoreward, roars thundering along the reefs, and, huge as a very mountain, falls prone, while from below the water boils up in eddies, and tosses black sand aloft.

Georgics, iii, 237–41

Romanos, rerum dominos, gentemque togatam.

Romans, lords of the world, and the nation of the gown.

Aeneid, i, 282

Demens, qui nimbos et non imitabile fulmen
aere et cornipedum pulsu simularet equorum.

Madman! to mimic the storm-clouds and inimitable thunder with brass and the tramp of horn-footed horses!

Aeneid, vi, 590–91
Translated by H. R Fairclough

VIRGIL

7 0 — 1 9 B . C .

JUPITER SENDS A FURY
TO BAFFLE TURNUS IN BATTLE

Postquam acies videt Iliacas atque agmina Turni,
alitis in parvae subitam collecta figuram,
quae quondam in bustis aut culminibus desertis
nocte sedens serum canit importuna per umbras;
hanc versa in faciem Turni se pestis ob ora
fertque refertque sonans clipeumque everberat alis.
illi membra novus solvit formidine torpor.

Soon as she sees the Ilian ranks and Turnus' troops, suddenly shrinking to the shape of that small bird which oft, perched at night on tombs or deserted roofs, chants her late, ill-omened lay amid the shadows, so changed in form before the face of Turnus the fiend flits screaming to and fro, and wildly beats his buckler with her wings. A strange numbness unknits his limbs with dread.

Aeneid, xii, 861–67
Translated by H. R. Fairclough

The last hundred lines of THE AENEID *have a quality of terror that goes quite beyond the context. Here Virgil has emerged from the welter of general warfare and is confronted with the culminating fight, the death of Turnus at the hands of Aeneas. He chooses the supernatural mechanism of Jupiter's sending a Fury to baffle Turnus in the fight, and from the moment he describes this bird of hell till the end of the poem he is at the height of his powers. After the Fury has reached the earth, she takes the form of a little bird that men hear crying on tombs or lonely roof-tops, and flies backwards and forwards shrieking in front of Turnus's face. . . .*

This idea of compressing the great Fury into the little bird crying round the tombs is one of the most terrifying in literature; it cuts through all the comforting assurances of civilised life. And when Turnus, face to face with Aeneas, answers his threats with

> non me tua fervida terrent
> dicta, ferox: di me terrent et Iuppiter hostis

he is not Turnus speaking of the Latin pantheon, but man confronted with the terrors of a hostile and inexplicable universe.

<div align="right">

E. M. W. TILLYARD
Poetry Direct and Oblique (1945)

</div>

VIRGIL

7 0 — 1 9 B . C .

AMARILLIS

Formosam resonare doces Amaryllida silvas.

And the wood rings with Amarillis' name.

<div align="right">

Eclogues, i, 5
Translated by Samuel Johnson

</div>

All the modern languages cannot furnish so melodious a line.

<div align="right">

SAMUEL JOHNSON
in Boswell's Life of Johnson (1791)

</div>

VIRGIL

7 0 — 1 9 B . C .

FATAL BLINDNESS

Saepibus in nostris parvam te roscida mala
(dux ego vester eram) vidi cum matre legentem.
alter ab undecimo tum me iam acceperat annus,
iam fragilis poteram ab terra contingere ramos.
ut vidi, ut perii! ut me malus abstulit error!

Within our orchard's walls I saw thee—for I was there to point the way—
a little maid gathering dewy apples with my mother! Eleven years I
had numbered, and the twelfth already claimed me; from the ground
already I could reach the frail boughs. Ah, how I saw! How I fell! How
that fatal blindness swept me away!

<div align="right">

Eclogues, viii, 37–41
Translated by John Jackson

</div>

*I think that the finest lines in the Latin language are those five which
begin,*

 "Saepibus in nostris parvam te roscida mala—"

*I cannot tell you how they struck me. I was amused to find that Vol-
taire pronounces that passage to be the finest in Virgil.*

<div align="right">

THOMAS BABINGTON MACAULAY
Letter to Thomas Ellis (July 1, 1834)

</div>

VIRGIL

7 0 — 1 9 B . C .

THE SNAKE

Est etiam ille malus Calabris in saltibus anguis,
squamea convolvens sublato pectore terga
atque notis longam maculosus grandibus alvum,
qui, dum amnes ulli rumpuntur fontibus et dum
vere madent udo terrae ac pluvialibus Austris,
stagna colit, ripisque habitans hic piscibus atram
improbus ingluviem ranisque loquacibus explet;
postquam exusta palus, terraeque ardore dehiscunt,
exsilit in siccum, et flammantia lumina torquens
saevit agris asperque siti atque exterritus aestu.

In fair Calabria's woods a snake is bred,
With curling crest, and with advancing head:
Waving he rolls, and makes a winding track;
His belly spotted, burnish'd is his back.
While springs are broken, while the southern air
And dropping heav'ns the moisten'd earth repair,
He lives on standing lakes and trembling bogs,
And fills his maw with fish, or with loquacious frogs:

But when, in muddy pools, the water sinks,
And the chapt earth is furrow'd o'er with chinks,
He leaves the fens, and leaps upon the ground,
And, hissing, rolls his glaring eyes around.
With thirst inflam'd, impatient of the heats,
He rages in the fields, and wide destruction threats.

<div align="right">

Georgics, iii, 425–34
Translated by John Dryden

</div>

A picture which I should place at the head of all such descriptions.

<div align="right">

JOHN KEBLE
Lectures on Poetry (1832–41)
Translated by Edward K. Francis

</div>

HORACE

6 5 — 8 B . C .

WINTER GAMES

Nunc et latentis proditor intimo
gratus puellae risus ab angulo.

And now the merry laugh from some secret corner betrays the hiding girl.

<div align="right">

Odes, i, 9

</div>

*Horace is one of those poets, very few in number, who have been read and re-read with delight by cultivated men of alien languages and civilizations for two thousand years, and that not because he has anything very important to say, but simply for the beauty of his form. Beauty of form has made him immortal, and fully half of that beauty lies in the order of his words. This fact can be fully appreciated only after considerable familiarity with Horace. . . . If he had said, "*AB INTIMO ANGULO RISUS PRODITOR PUELLAE LATENTIS," *there would be nothing in it. But we have together, "*LATENTIS PRODITOR"*—"betrayer of one hiding"; *"*PRODITOR INTIMO"*—"betrayer in the deep"; *"*GRATUS PUELLAE"*—"delightful, of a girl"; *"*PUELLAE RISUS"*—"girl's laugh"; *"*RISUS AB ANGULO" *—"laugh from a corner." And I am not sure there is not something in *"*INTIMO GRATUS"*—"delightful in the deep." The total result is magical.*

<div align="right">

GILBERT MURRAY
The Classical Tradition in Poetry (1927)

</div>

HORACE

6 5 — 8 B . C .

EPIGRAM

Eheu fugaces, Postume, Postume,
labuntur anni.

What Horace says is—
Eheu fugaces
Anni labuntur, Postume, Postume!

Years glide away and are lost to me, lost to me!

Odes, ii, 14

Translated by R. H. Barham

The most poignantly melancholy of all lines.

MAURICE BARING

Have You Anything to Declare? (1936)

HORACE

6 5 — 8 B . C .

CELEBRATION FOR NEPTUNE

Festo quid potius die
 Neptuni faciam? prome reconditum,
Lyde, strenua Caecubum
 munitaeque adhibe vim sapientiae.

inclinare meridiem
 sentis ac, veluti stet volucris dies,
parcis deripere horreo
 cessantem Bibuli consulis amphoram.

nos cantabimus invicem
 Neptunum et virides Nereidum comas;
tu curva recines lyra
 Latonam et celeris spicula Cynthiae;

summo carmine, quae Cnidon
 fulgentesque tenet Cycladas et Paphum
iunctis visit oloribus;
 dicetur merita Nox quoque nenia.

248

This that is Neptune's own. Quick! Lyde mine,
How now to make of this a festal day?
The cellar keys, the hoarded Caecuban!
We'll wage a war on wisdom in good wine!

The noonday sun is sinking to the west;
Make haste, make haste! Think you day will not pass?
You shrink to tap the bins of Bibulus?
Come now! Fetch forth the lingering wine jars, lass!

Now music! Well, then, I will take first turn.
Of Neptune and his Nereids I will sing,
Combing their green locks underneath the sea.
Then, Lyde, you your curved lyre must string.

Touch it to music in Latona's praise,
And sing of Cynthia's arrows far and fleet,
But save your sweetest singing for the last—
For Venus' praise the best alone is meet,

The queen of Cnidus and the Shining Isle,
Who visits Paphos with her yoked swans white
Deserves a hymn. Night, too, her meed of praise.
In tuneful song let lyre and lips unite!

Odes, iii, 28

Translated by Roselle M. Montgomery

Perfect, too, is his art. The design is of the favourite type—two equal units (in this case the first two stanzas), completed by a longer third (the remaining two); and this form is repeated within the final unit—but not mechanically; for the third COLON *breaks off, and with a quiet coda* —MERITA NOX QUOQUE NENIA—*the music dies away; the sparkling brightness of the islands of Greece gives way to the dusk, and the lovers are left together. The sounds are beautiful too, with the responsive alliterations, each pair divided by a word, which tune the verse like rhyme—* SENTIS—STET, UELUTI—UOLUCRIS, CESSANTEM—CONSULIS, NEPTUNUM— NEREIDUM, CELERIS—CYNTHIAE, CARMINE—CNIDO, NOX—NENIA. *As Giorgione throws over a simple landscape with figures a strange, indefinable beauty, so Horace has made of a simple occasion a poem which has the subtle significance of a consummate work of art.*

L. P. WILKINSON
Horace and His Lyric Poetry (1945)

THIS IS THY GIFT, O MUSE

Quem tu, Melpomene, semel
 nascentem placido lumine videris,
illum non labor Isthmius
 clarabit pugilem, non equus impiger

curru ducet Achaico
 victorem, neque res bellica Deliis
ornatum foliis ducem,
 quod regum tumidas contuderit minas,

ostendet Capitolio;
 sed quae Tibur aquae fertile praefluunt
et spissae nemorum comae
 fingent Aeolio carmine nobilem.

Romae principis urbium
 dignatur suboles inter amabiles
vatum ponere me choros,
 et iam dente minus mordeor invido.

o testudinis aureae
 dulcem quae strepitum, Pieri, temperas,
o mutis quoque piscibus
 donatura cycni, si libeat, sonum,

totum muneris hoc tui est,
 quod monstror digito praetereuntium
Romanae fidicen lyrae:
 quod spiro et placeo, si placeo, tuum est.

He, on whose natal hour you glance
 A single smile with partial eyes,
Melpomene, shall not advance
 A champion for the Olympic prize,
Nor, drawn by steeds of managed pride,
In Grecian car victorious ride.

Nor honor'd with the Delphic leaf,
 A wreath for high achievements wove,
Shall he be shown triumphant chief,
 Where stands the Capitol of Jove,

As justly raised to such renown
For bringing boastful tyrants down.

But pleasing streams that flow before
 Fair Tibur's flow'ry-fertile land,
And bow'ring trees upon the shore
 Which in such seemly order stand,
Shall form on that Aeolic plan
The bard, and magnify the man.

The world's metropolis has deigned
 To place me with her darling care;
Rome has my dignity maintained
 Amongst her bards my bays to wear;
And hence it is against my verse
The tooth of envy's not so fierce.

O mistress of the golden shell!
 Whose silence you command, or break;
Thou that canst make the mute excel,
 And ev'n the sea-born reptiles speak;
And, like the swan, if you apply
Your touch, in charming accents die.

This is thy gift, and only thine,
 That, as I pass along, I hear—
"There goes the bard, whose sweet design
 Made lyrics for the Roman ear."
If life or joy I hold or give,
By thee I please, by thee I live.

<div align="right">Odes, iv, 3

Translated by Christopher Smart</div>

RECONCILIATION OF LOVERS

"Donec gratus eram tibi
 nec quisquam potior bracchia candidae
cervici iuvenis dabat,
 Persarum vigui rege beatior."

"donec non alia magis
 arsisti neque erat Lydia post Chloen,
multi Lydia nominis
 Romana vigui clarior Ilia."

"me nunc Thressa Chloe regit,
 dulcis docta modos et citharae sciens,

pro qua non metuam mori,
 si parcent animae fata superstiti."

"me torret face mutua
 Thurini Calais filius Ornyti,
pro quo bis patiar mori,
 si parcent puero fata superstiti."

"quid si prisca redit Venus
 diductosque iugo cogit aëneo?
si flava excutitur Chloe
 reiectaeque patet ianua Lydiae?"

"quamquam sidere pulchrior
 ille est, tu levior cortice et improbo
iracundior Hadria,
 tecum vivere amem, tecum obeam libens!"

HORACE

 Whilst, *Lydia,* I was lov'd of thee,
And ('bout thy Ivory neck,) no youth did fling,
 His armes more acceptable free,
I thought me richer then the Persian King.

LYDIA

 Whilst *Horace* lov'd no Mistres more,
Nor after *Chloë* did his *Lydia* sound;
 In name, I went all names before,
The Roman *Ilia* was not more renown'd.

HORACE

 'Tis true, I'am *Thracian Chloes,* I,
Who sings so sweet, and with such cunning plaies,
 As, for her, I'l'd not feare to die,
So Fate would give her life, and longer daies.

LYDIA

 And, I am mutually on fire
With gentle *Calais, Thurine Orniths* Sonne;
 For whom I doubly would expire,
So Fates would let the Boy a long thred run.

HORACE

 But, say old Love returne should make,
And us dis-joyn'd force to her brazen yoke,
 That I bright *Chloë* off should shake;
And to left-*Lydia,* now the gate stood ope

Though he be fairer then a Starre;
Thou lighter then the barke of any tree,
And then rough *Adria,* angrier, farre;
Yet would I wish to love, live, die with thee.

Odes, iii, 9
Translated by Ben Jonson

I would rather have composed odes like these than be king of all Aragon.
JULIUS CÆSAR SCALIGER
Poetics (1561), vi

HORACE

6 5 — 8 B . C .

SPRING'S RETURN

Diffugere nives, redeunt iam gramina campis
 arboribusque comae;
mutat terra vices, et decrescentia ripas
 flumina praetereunt;

Gratia cum Nymphis geminisque sororibus audet
 ducere nuda choros.
immortalia ne speres, monet annus et almum
 quae rapit hora diem.

frigora mitescunt zephyris, ver proterit aestas
 interitura, simul
pomifer autumnus fruges effuderit, et mox
 bruma recurrit iners.

damna tamen celeres reparant caelestia lunae;
 nos ubi decidimus,
quo pius Aeneas, quo Tullus dives et Ancus,
 pulvis et umbra sumus.

quis scit an adiciant hodiernae crastina summae
 tempora di superi?
cuncta manus avidas fugient heredis, amico
 quae dederis animo.

cum semel occideris et de te splendida Minos
 fecerit arbitria,
non, Torquate, genus, non te facundia, non te
 restituet pietas;

infernis neque enim tenebris Diana pudicum
 liberat Hippolytum,
nec Lethaea valet Theseus abrumpere caro
 vincula Pirithoo.

The snow dissolv'd no more is seen,
The fields, and woods, behold, are green,
The changing year renews the plain,
The rivers know their banks again,
The spritely Nymph and naked Grace
The mazy dance together trace.
The changing year's successive plan
Proclaims mortality to Man.
Rough Winter's blasts to Spring give way,
Spring yield[s] to Summer['s] sovereign ray,
Then Summer sinks in Autumn's reign,
And Winter chils the World again.
Her losses soon the Moon supplies,
But wretched Man, when once he lies
Where Priam and his sons are laid,
Is naught but Ashes and a Shade.
Who knows if Jove who counts our Score
Will toss us in a morning more?
What with your friend you nobly share
At least you rescue from your heir.
Not you, Torquatus, boast of Rome,
When Minos once has fix'd your doom,
Or Eloquence, or splendid birth,
Or Virtue shall replace on earth.
Hippolytus unjustly slain
Diana calls to life in vain,
Nor can the might of Theseus rend
The chains of hell that hold his friend.

<div align="right">

Odes, iv, 7
Translated by Samuel Johnson

</div>

It is, as Housman once said, the most perfect poem in the Latin language.
<div align="right">

L. P. WILKINSON
Horace and His Lyric Poetry (1945)

</div>

THE SHADE OF CORNELIA
CONSOLES HER HUSBAND

Desine, Paulle, meum lacrimis urgere sepulcrum:
 panditur ad nullas ianua nigra preces;
cum semel infernas intrarunt funera leges,
 non exorato stant adamante viae.
te licet orantem fuscae deus audiat aulae:
 nempe tuas lacrimas litora surda bibent.
vota movent superos: ubi portitor aera recepit,
 obserat umbrosos lurida porta locos. . . .

 et sum, quod digitis quinque legatur, onus.
damnatae noctes et vos vada lenta paludes,
 et quaecumque meos implicat unda pedes,
immatura licet, tamen huc non noxia veni. . . .

 in lapide hoc uni nupta fuisse legar.
testor maiorum cineres tibi, Roma, verendos,
 sub quorum titulis, Africa, tunsa iaces. . . .

 neque ulla
 labe mea nostros erubuisse focos.
non fuit exuviis tantis Cornelia damnum. . . .

mi natura dedit leges a sanguine ductas,
 ne possem melior iudicis esse metu.
quaelibet austeras de me ferat urna tabellas:
 turpior assessu non erit ulla meo,
vel tu, quae tardam movisti fune Cybellen,
 Claudia, turritae rara ministra deae,
vel cui, iuratos cum Vesta reposceret ignes,
 exhibuit vivos carbasus alba focos. . . .

nunc tibi commendo communia pignora natos:
 haec cura et cineri spirat inusta meo.
fungere maternis vicibus, pater.

Cease, Paullus, to burden my grave with tears: no prayers may open
the gate of darkness; when once the dead have passed beneath the
rule of Hell the ways are barred with inexorable adamant. Though

thine entreaty reac e ears of the god that reigns in the house of
gloom, the shores of Styx shall drink thy tears unmoved. Heaven only
is won by supplication: when the ferryman has received his toll, the
pale portal closes on the world of shadows. . . .

I am now but one little handful of dust. Dark night of doom, and
ye, O shallow, stagnant meres, and every stream that winds about my
feet, guiltless, though untimely, am I come hither. . . .

Behold the legend on this stone: "To one and one alone was she
espoused." I call to witness the ashes of my sires, revered, O Rome, by
thee; beneath their glory's record thou, Africa, liest beaten to the dust.
. . . My hearth ne'er blushed for sin of mine. Cornelia ne'er dimmed
the lustre of such spoils of war. . . .

The laws I followed sprang from pride of blood: 'twas nature gave
me them, that no fear of judgment might lead me toward virtue. I care
not who the judges be that pass stern sentence on me; no woman shall
be shamed by sitting at my side, not thou, Claudia, the peerless servant
of the tower-crowned goddess, that didst lay hold of the cable and
move Cybelle's lagging image, nor thou whose white linen robe showed
that the hearth still lived, when Vesta demanded the fire thou hadst
sworn to keep. . . .

And now to thee, Paullus, I commend our children, the common
pledges of our love: this care yet lives deep-burned even into mine
ashes. Father, 'tis thine to fill the mother's room.

Elegies, iv, 11
Translated by H. E. Butler

This is indeed the masterpiece of the Latin elegy.

ALBERT GRENIER
Le Génie romain (1925)

ANTIPATER OF SIDON

FIRST CENTURY B. C.

THE RUINS OF CORINTH

Ποῦ τὸ περίβλεπτον κάλλος σέο, Δωρὶ Κόρινθε·
 ποῦ στεθάναι πύργων, ποῦ τὰ πάλαι κτέανα,
ποῦ νηοὶ μακάρων, ποῦ δώματα, ποῦ δὲ δάμαρτες
 Σισύθιαι, λαῶν θ' αἱ ποτὲ μυριάδες;

οὐδὲ γὰρ οὐδ᾽ ἴχνος, πολυκάμμορε, σεῖο λέλειπται,
πάντα δὲ συμμάρψας ἐξέφαγεν πόλεμος.
μοῦναι ἀπόρθητοι Νηρηΐδες, Ὠκεανοῖο
κοῦραι, σῶν ἀχέων μίμνομεν ἀλκυόνες.

Where, Corinth, are thy glories now,
Thy ancient wealth, thy castled brow,
Thy solemn fanes, thy halls of state,
Thy high-born dames, thy crowded gate?
There's not a ruin left to tell
Where Corinth stood, how Corinth fell.
The Nereids of thy double sea
Alone remain to wail for thee.

The Greek Anthology, ix, 151
Translated by Goldwin Smith

*The splendid threnody by Antipater of Sidon upon the ruins of
Corinth, which was imitated by Agathias in his lines on Troy, may be
cited as perfect in this style of composition.*

JOHN ADDINGTON SYMONDS
Studies of The Greek Poets (1873)

SENECA

4 B . C . ? — 6 5 A . D .

JASON'S FAREWELL TO MEDEA

Per alta vade spatia sublimi aethere;
testare nullos esse, qua veheris, deos.

Go on through the lofty spaces of high heaven and bear witness, where
thou ridest, that there are no gods.

Medea, 1026–27
Translated by Frank Justus Miller

Seneca obtains, time after time, magnificent effects. In the verbal COUP
DE THÉÂTRE *no one has ever excelled him. The final cry of Jason to*

PETRONIUS ARBITER

? — 66 A . D . ?

KEEPING ENDLESS HOLIDAY

Foeda est in coitu et brevis voluptas,
et taedet Veneris statim peractae.
Non ergo ut pecudes libidinosae
caeci protinus irruamus illuc;
(nam languescit amor peritque flamma);
sed sic sic sine fine feriati
et tecum iaceamus osculantes.
Hic nullus labor est ruborque nullus:
hoc iuvit, iuvat et diu iuvabit;
hoc non deficit, incipitque semper.

Doing, a filthy pleasure is, and short;
And done, we straight repent us of the sport:
Let us not then rush blindly on unto it,
Like lustfull beasts, that onely know to doe it:
For lust will languish, and that heat decay,
But thus, thus, keeping endlesse Holy-day,
Let us together closely lie, and kisse,
There is no labour, nor no shame in this;
This hath pleas'd, doth please, & long will please; never
Can this decay, but is beginning ever.

<div align="right">*Translated by Ben Jonson*</div>

SED SIC SIC SINE FINE FERIATI—*the line is one of the loveliest in all Latin poetry and contains, what is more, the most succinct and accurate account with which I am acquainted of a certain almost supernatural state of bodily and mental beatitude—the* FELIX TRANSITUS AMORIS AD SOPOREM.

<div align="right">ALDOUS HUXLEY

Texts and Pretexts (1933)</div>

MARTIAL

C . 40 — C . 104 A . D .

MARRIAGE OF CLAUDIA

Claudia, Rufe, meo nubit Peregrina Pudenti:
 macte esto taedis, O Hymenaee, tuis.
tam bene rara suo miscentur cinnama nardo,
 Massica Theseis tam bene vina favis;
nec melius teneris iunguntur vitibus ulmi,
 nec plus lotos aquas, litora myrtus amat.
candida perpetuo reside, Concordia, lecto,
 tamque pari semper sit Venus aequa iugo:
diligat illa senem quondam, sed et ipsa marito
 tum quoque, cum fuerit, non videatur anus.

Pudens to-day his Claudia doth claim
 In love united,
A blessing, Hymen, on the twofold flame
 Thy torch hath lighted.
These are as honey poured in rarest wine;
 Could aught be meeter?
Not cinnamon with spikenard could combine
 In fragrance sweeter.
Beside this tender vine her elm doth tower
 His might to give her.
She is the myrtle sweet, the lotus flower,
 And he her river.
Fair Concord ever o'er their lives preside
 Unviolated;
Dear Venus bless the bridegroom and the bride
 So fitly mated;
And may the coming years so far and dim
 No change discover,
But she be loving still and fair to him,
 Her grey-haired lover.

Epigrams, iv, 13
Translated by John Arthur Pott

A perfect little epithalamium in ten lines.

E. V. RIEU
A Book of Latin Poetry (1925)

TACITUS

5 5 ? — A F T E R 1 1 7 A . D .

STYLE

Omnia sine dubio, optime parentum, adsidente amantissima uxore superfuere honori tuo: paucioribus tamen lacrimis comploratus es, et novissima in luce desideravere aliquid oculi tui.

All tributes, I doubt not, best of fathers, were rendered, were lavished, in your honour by the fond wife at your bedside; yet fewer by so much were the tears that fell for you, and something at least there was which your eyes missed when last they sought the light.

Ubi solitudinem faciunt, pacem appellant.

They make a desolation and they call it peace.

Tu vero felix, Agricola, non vitae tantum claritate, sed etiam opportunitate mortis.

Happy your fate, Agricola! happy not only in the lustre of your life, but in a timely death.

> Agricola, xlv, xxx
> *Translated by Maurice Hutton*

The AGRICOLA *has the stateliness, the ordered movement, of a funeral oration; the peroration, as it might not unfairly be called, of the two concluding chapters, reaches the highest level of the grave Roman eloquence, and its language vibrates with a depth of feeling to which Lucretius and Virgil alone in their greatest passages offer a parallel in Latin. The sentence, with its subtle Virgilian echoes, in which he laments his own and his wife's absence from Agricola's death-bed . . . shows a new and strange power in Latin. It is still the ancient language, but it anticipates in its cadences the language of the Vulgate and of the statelier mediaeval prose.*

Together with this remarkable power over new prose rhythms, Tacitus shows in the AGRICOLA *the complete mastery of mordant and unforgettable phrase which makes his mature writing so unique. Into three or four ordinary words he can put more concentrated meaning than any other author. The likeness and contrast between these brief phrases of his and the "half-lines" of Virgil might repay a long study. They are alike in their simple language, which somehow or other is charged with the whole personality of the author; but the personality itself is in the sharpest antithesis. The Virgilian phrases, with their grave pity, are steeped in a golden softness that is just touched with a far-off trouble,*

a pathetic waver in the voice as if tears were not far below it. Those of Tacitus are charged with indignation instead of pity; "like a jewel hung in ghastly night," to use Shakespeare's memorable simile, or like the red and angry autumnal star in the ILIAD, *they quiver and burn.*

J. W. MACKAIL
Latin Literature (1908)

TACITUS

55 ? — AFTER 117 A . D .

PASSION OR PLUNDER

Crebra hinc proelia, et saepius in modum latrocinii per saltus per paludes, ut cuique sors aut virtus, temere proviso, ob iram ob praedam, iussu et aliquando ignaris ducibus.

Frequent engagements followed, generally of the irregular type, in woods and fens; decided by individual luck or bravery; accidental or prearranged; with passion or plunder for the motives; by orders, or sometimes without the knowledge of the leaders.

Annals, xii, 39
Translated by John Jackson

A concise comprehensive style is a great ornament in narration; and a superfluity of unnecessary words, no less than of circumstances, a great nuisance. A judicious selection of the striking circumstances clothed in a nervous style is delightful. In this style, Tacitus excels all writers.

HENRY HOME OF KAMES
Elements of Criticism (1762)

THEON

SECOND OR THIRD CENTURY A . D .

A SCHOOLBOY'S LETTER

Θέων Θέωνι τῷ πατρὶ χαίρειν.
καλῶς ἐποίησες οὐκ ἀπένηχές με μετὲ σοῦ εἰς πόλιν. ἢ οὐ θέλις ἀπενέκκειν μετὲ σοῦ εἰς Ἀλεξανδρίαν οὐ μὴ γράψω σε ἐπιστολὴν οὔτε λαλῶ σε οὔτε υἰγένω σε, εἶτα ἂν δὲ ἔλθῃς εἰς Ἀλεξανδρίαν οὐ

μὴ λάβω χεῖραν παρὰ (σ)οῦ οὔτε πάλι χαίρω σε λυπόν. ἂμ μὴ
θέλης ἀπενέκαι μ(ε) ταῦτα γε(ί)νετε. καὶ ἡ μήτηρ μου εἶπε 'Αρχε-
λάῳ ὅτι ἀναστατοῖ μὲ ἄρρον αὐτόν. καλῶς δὲ ἐποίησες δῶρά μοι
ἔπεμψε(ς) μεγάλα ἀράκια πεπλανηκανημωσεκε(.) τῇ ἡμέρᾳ ιβ ὅτι
ἔπλευσες. λύρον πέμψον εἴ(ς) με παρακαλῶ σε. ἂμ μὴ πέμψῃς
οὐ μὴ φάγω, οὐ μὴ πείνω· ταῦτα.

ἐρῶσθέ σε εὔχ(ομαι).

Theon to Theon his father, greeting. That was a fine trick, not taking
me to the city with you! If you don't take me to Alexandria with you, I
won't write to you! I won't speak to you! I won't wish you good-morning!
If you do go to Alexandria, I won't hold your hand or have anything
more to say to you. That's what will happen if you don't take me!
Mother said to Archelaus, "Take him out of my way, he upsets me."
That was a fine thing you did, to send me that fine present of beans!
They kept me in the dark at home on the 12th, when you sailed. Please
send for me. If you don't I won't eat or drink. Goodbye.

Oxyrhynchus Papyri, cxix
Translated by F. A. Wright

Room must be found for the schoolboy's letter to his father.

F. A. WRIGHT
A History of Later Greek Literature (1932)

LUCIAN

C . 1 2 0 — C . 1 8 0 A . D .

THE DEPENDENT GREEK PHILOSOPHER
IN THE ROMAN HOUSEHOLD

If a wrecker or a pirate had taken you at sea and were offering you
for sale, would you not pity yourself for being ill-fated beyond your
deserts? . . . Then just for a few obols, at that age when, even if you
were a slave by birth, it would be high time for you to look forward at
last to liberty, have you gone and sold *yourself,* virtue and wisdom
included? . . . Are you not ashamed to undergo comparison with
flatterers and loafers and buffoons; to be the only person in all that
Roman throng who wears the incongruous cloak of a scholar and talks
Latin with a villainous accent; to take part, moreover, in uproarious
dinners, packed with human flotsam that is mostly vile? At these dinners
you are vulgar in your compliments, and you drink more than is dis-
creet. Then in the morning, roused by a bell, you shake off the sweetest

262

of your sleep and run about town with the pack, up hill and down dale, with yesterday's mud still on your legs. Were you so in want of lupines and herbs of the field, did even the springs of cold water fail you so completely, as to bring you to this pass out of desperation? No, clearly it was because you did not want water and lupines, but cates and meat and wine with a bouquet that you were caught, hooked like a pike in the very part that hankered for all this—in the gullet. . . .

To be sure, the purpose for which he engaged you, saying that he wanted knowledge, matters little to him; for, as the proverb says, "What has a jackass to do with a lyre?" Ah, yes, can't you see? they are mightily consumed with longing for the wisdom of Homer or the eloquence of Demosthenes or the sublimity of Plato, when, if their gold and their silver and their worries about them should be taken out of their souls, all that remains is pride and softness and self-indulgence and sensuality and insolence and ill-breeding! . . .

After all, one could perhaps put up with the conduct of the men. But the women—! That is another thing that the women are keen about —to have men of education living in their households on a salary and following their litters. They count it as one among their other embellishments if it is said that they are cultured and have an interest in philosophy and write songs not much inferior to Sappho's. To that end, forsooth, they too trail hired rhetoricians and grammarians and philosophers about, and listen to their lectures—when? it is ludicrous!—either while their toilet is being made and their hair dressed, or at dinner; at other times they are too busy! And often while the philosopher is delivering a discourse the maid comes up and hands her a note from her lover, so that the lecture on chastity is kept waiting until she has written a reply to the lover and hurries back to hear it. . . .

I make no bones of telling you a story that I was told by our friend Thesmopolis, the Stoic, of something that happened to him which was very comical, and it is not beyond the bounds of possibility that the same thing may happen to someone else. He was in the household of a rich and self-indulgent woman who belonged to a distinguished family in the city. . . .

The woman sent for him and said: "Thesmopolis, I am asking a great favour of you; please do it for me without making any objections or waiting to be asked repeatedly." He promised, as was natural, that he would do anything, and she went on: "I ask this of you because I see that you are kind and thoughtful and sympathetic—take my dog Myrrhina (you know her) into your carriage and look after her for me, taking care that she does not want for anything. The poor thing is unwell and is almost ready to have puppies, and these abominable, disobedient servants do not pay much attention even to me on journeys, let alone to her. So do not think that you will be rendering me a trivial service if you take good care of my precious, sweet doggie." Thes-

263

mopolis promised, for she plied him with many entreaties and almost wept. The situation was as funny as could be: a little dog peeping out of his cloak just below his beard, wetting him often, even if Thesmopolis did not add that detail, barking in a squeaky voice (that is the way with Maltese dogs, you know), and licking the philosopher's beard, especially if any suggestion of yesterday's gravy was in it! . . .

You are greatly envied, however, and perhaps some slanderous story or other gradually gets afoot by stealth and comes to a man who by now is glad to receive charges against you, for he sees that you are used up by your unbroken exertions and pay lame and exhausted court to him, and that the gout is growing upon you. To sum it up, after garnering all that was most profitable in you, after consuming the most fruitful years of your life and the greatest vigour of your body, after reducing you to a thing of rags and tatters, he is looking about for a rubbish-heap on which to cast you aside unceremoniously, and for another man to engage who can stand the work. Under the charge that you once made overtures to a page of his, or that, in spite of your age, you are trying to seduce an innocent girl, his wife's maid, or something else of that sort, you leave at night, hiding your face, bundled out neck and crop, destitute of everything and at the end of your tether, taking with you, in addition to the burden of your years, that excellent companion, gout. What you formerly knew you have forgotten in all these years, and you have made your belly bigger than a sack, an insatiable, inexorable curse. Your gullet, too, demands what it is used to, and dislikes to unlearn its lessons.

Nobody else would take you in, now that you have passed your prime and are like an old horse whose hide, even, is not as servicable as it was. Besides, the scandal of your dismissal, exaggerated by conjecture, makes people think you an adulterer or poisoner or something of the kind. Your accuser is trustworthy even when he holds his tongue, while you are a Greek, and easy-going in your ways and prone to all sorts of wrong-doing. That is what they think of us all, very naturally. For I believe I have detected the reason for that opinion which they have of us.

On Salaried Posts in Great Houses, xxiv-xl
Translated by A. M. Harmon

Lucian's description of the various functions which the Greek scholar fulfilled in a great Roman household is written in vitriol. This dialogue, 'The Dependent Scholar,' should be read by every one as the world's masterpiece of satire.

JOHN JAY CHAPMAN
Lucian, Plato and Greek Morals (1931)

LONGINUS

C . 2 1 3 — : 7 3 A . D .

THE RIGHT WORD

Ἐπειδὴ μέντοι ἡ τοῦ λόγου νόησις ἥ τε φράσις τὰ πλείω δι' ἑκατέρου διέπτυκται, ἴθι δή, ἂν τοῦ φραστικοῦ μέρους ἦ τινα λοιπα ἔτι, προσεπιθεασώμεθα. ὅτι μὲν τοίνυν ἡ τῶν κυρίων καὶ μεγαλοπρεπῶν ὀνομάτων ἐκλογὴ θαυμαστῶς ἄγει καὶ κατακηλεῖ τοὺς ἀκούοντας καὶ ὡς πᾶσι τοῖς ῥήτορσι καὶ συγγραφεῦσι κατ' ἄκρον ἐπιτήδευμα, μέγεθος ἅμα κάλλος εὐπίνειαν βάρος ἰσχὺν κράτος ἔτι δὲ γάνωσίν τινα τοῖς λόγοις ὥσπερ ἀγάλμασι καλλίστοις δι' αὐτῆς ἐπανθεῖν παρασκευάζουσα καὶ οἰονεὶ ψυχήν τινα τοῖς πράγμασι φωνητικὴν ἐντιθεῖσα, μὴ καὶ περιττὸν ἦ πρὸς εἰδότας διεξιέναι. φῶς γὰρ τῷ ὄντι ἴδιον τοῦ νοῦ τὰ καλὰ ὀνόματα. ὁ μέντοι γε ὄγκος αὐτῶν οὐ πάντη χρειώδης, ἐπεὶ τοῖς μικροῖς πραγματίοις περιτιθέναι μεγάλα καὶ σεμνὰ ὀνόματα ταὐτὸν ἂν φαίνοιτο, ὡς εἴ τις τραγικὸν προσωπεῖον μέγα παιδὶ περιθείη νηπίῳ. πλὴν ἐν μὲν ποιήσει καὶ ἱ . . .

θρεπτικώτατον καὶ γόνιμον, τὸ δ' Ἀνακρέοντος ' οὐκέτι Θρηικίης ἐπιστρέφομαι.' ταύτῃ καὶ τὸ τοῦ Θεοπόμπου καί <τοι ἦτ> τον ἐπαινετὸν διὰ τὸ ἀνάλογον ἔμοι γε σημαντικώτατα ἔχειν δοκεῖ· ὅπερ ὁ Κεκίλιος οὐκ οἶδ' ὅπως καταμέμφεται. ' δεινὸς ὤν,' φησίν, ' ὁ Φίλιππος ἀναγκοφαγῆσαι πράγματα.' ἔστιν ἄρ' ὁ ἰδιωτισμὸς ἐνίοτε τοῦ κόσμου παρὰ πολὺ ἐμφανιστικώτερον· ἐπιγινώσκεται γὰρ αὐτόθεν ἐκ τοῦ κοινοῦ βίου, τὸ δὲ σύνηθες ἤδη πιστότερον. οὐκοῦν ἐπὶ τοῦ τὰ αἰσχρὰ καὶ ῥυπαρὰ τλημόνως καὶ μεθ' ἡδονῆς ἕνεκα πλεονεξίας καρτεροῦντος τὸ ἀναγκοφαγεῖν τὰ πράγματα ἐναργέστατα παρείληπται. ὧδέ πως ἔχει καὶ τὰ Ἡροδότεια· ' ὁ Κλεομένης,' φησί, ' μανεὶς τὰς ἑαυτοῦ σάρκας ξιφιδίῳ κατέτεμεν εἰς λεπτά, ἕως ὅλον καταχορδεύων ἑαυτὸν διέφθειρεν,' καί ' ὁ Πύθης ἕως τοῦδε ἐπὶ τῆς νεὼς ἐμάχετο, ἕως ἅπας κατεκρεουργήθη.' ταῦτα γὰρ ἐγγὺς παραξύει τὸν ἰδιώτην, ἀλλ' οὐκ ἰδιωτεύει τῷ σημαντικῶς.

Now, since thought and diction often explain each other, we must further consider whether there are any elements of style still left untouched. It is probably superfluous to explain at length to those who know, how the choice of the right word and the fine word has a marvellously moving and seductive effect upon an audience and how all orators and historians make this their supreme object. For this of itself gives to the style at once grandeur, beauty, a classical flavour, weight, force, strength, and a sort of glittering charm, like the bloom on the surface of the most beautiful bronzes, and endues the facts as it were with a living voice. Truly, beautiful words are the very light of thought. However, their majesty is not for common use, since to attach great and

stately words to trivial things would be like fastening a great tragic mask on a simple child. However in poetry and h(istory). . . .

. . . is most illuminating and typical; so, too, with Anacreon's "No more care I for the Thracian colt." In the same way the phrase used by Theopompus, though less admirable, seems to me highly expressive in virtue of the analogy implied, though Cecilius for some reason finds fault with it. "Philip," he says, "had a wonderful faculty of stomaching things." Thus the vulgar phrase sometimes proves far more enlightening than elegant language. Being taken from our common life it is immediately recognized, and what is familiar is halfway to conviction. Applied to one whose greedy ambition makes him glad to endure with patience what is shameful and sordid, "stomaching things" forms a very vivid phrase. It is much the same with Herodotus's phrases: "In his madness," he says, "Cleomenes cut his own flesh into strips with a dagger, until he made mincemeat of himself and perished," and "Pythes went on fighting in the ship until he was all cut into collops." These come perilously near to vulgarity, but are not vulgar because they are so expressive.

On the Sublime, xxx, xxxi
Translated by W. Hamilton Fyfe

Here Longinus has begun to speak of diction generally; here he has made that admirable descant on "beautiful words" which, though almost all the book deserves to be written in letters of gold, would tempt one to indulge here in precious stones, so as to mimic, in jacinth and sapphire and chrysoprase, the effect which it celebrates.

GEORGE SAINTSBURY
A History of Criticism (1900)

ANONYMOUS

THIRD OR FOURTH CENTURY A.D.?

THE VIGIL OF VENUS

Cras amet qui nunquam amavit quique amavit cras amet.

Tomorrow let loveless, let lover tomorrow make love.

Pervigilium Veneris
Translated by Allen Tate

Divinely inspired.

E. E. SIKES
Roman Poetry (1923)

DAPHNIS

Ὁρᾷς ὡς ὑακίνθῳ μὲν τὴν κόμην ὁμοίαν ἔχει, λάμπουσι δὲ ὑπὸ ταῖς ὀφρύσιν οἱ ὀφθαλμοὶ καθάπερ ἐν χρυσῇ σφενδόνῃ ψηφίς; καὶ τὸ μὲν πρόσωπον ἐρυθήματος μεστόν, τὸ δὲ στόμα λευκῶν ὀδόντων ὥσπερ ἐλέφαντος; . . . βουκόλος ἦν Ἀγχίσης καὶ ἔσχεν αὐτὸν Ἀφροδίτη· αἶγας ἔνεμε Βράγχος καὶ Ἀπόλλων αὐτὸν ἐφίλησε· ποιμὴν ἦν Γανυμήδης καὶ αὐτὸν ὁ τῶν ὅλων βασιλεὺς ἥρπασε. μὴ καταφρονῶμεν παιδὸς ᾧ καὶ αἶγας, ὡς ἐρώσας, πειθομένας εἴδομεν, ἀλλ᾽ εἰ καὶ ἔτι μένειν ἐπὶ γῆς ἐπιτρέπουσι τοιοῦτον κάλλος χάριν ἔχωμεν τοῖς Διὸς ἀετοῖς.

Dost see how like the hyacinth is his hair, and how beneath his eyebrows his eyes flash forth like a jewel in a setting of gold! His face is all one rosy flush, his teeth are white like ivory. . . . Anchises was a neatherd, and yet Aphrodite took him for her own. Branchus tended goats, and yet Apollo kissed him. Ganymede was a shepherd, and the lord of all things ravished him away. Let us not despise the lad; we see the goats obedient like lovers to him. Nay, rather, let us be grateful to the eagles of Zeus that they allow such beauty to remain on earth.

Daphnis and Chloe, iv, 17
Translated by F. A. Wright

The style of Longus is perfect, for it is exactly suited to his subject. Apparently simple and artless, it really follows the most elaborate laws of prose rhythm: the passages that seem the most natural are the result of endless polishing and pains; but the art is so successfully hidden that it needs a trained ear to detect the subtle harmonies of a prose which is as musical as the lightest lyric. It is impossible to reproduce these melodies in English, for they depend on transpositions which are foreign to our usage; but even in our rough tongue they sometimes may be faintly heard.

F. A. WRIGHT
A History of Later Greek Literature (1932)

TO AUSONIUS

Ego te per omne quod datum mortalibus
 et distinatum saeculum est,
claudente donec continebor corpore,
 discernar orbe quolibet,

Nec ore longe, nec remotum lumine,
 tenebo fibris insitum,
videbo corde, mente complectar pia,
 ubique praesentem mihi.

Et cum solutus corporali carcere,
 terraque provolavero,
quo me locarit axe communis Pater
 illic quoque animo te geram.

Neque finis idem qui meo me corpore
 et amore laxabit tuo.
mens quippe, lapsis quae superstes artubus
 de stirpe durat coeliti.

Sensus necesse est simul et affectus suos
 teneat aeque ut vitam suam,
et ut mori sic oblivisci non capit,
 perenne vivax et memor.

I, through all chances that are given to mortals
And through all fates that be,
So long as this close prison shall contain me,
Yea, though a world shall sunder me and thee,

Thee shall I hold, in every fibre woven,
Not with dumb lips nor with averted face
Shall I behold thee, in my mind embrace thee,
Instant and present, thou, in every place.

Yea, when the prison of this flesh is broken,
And from the earth I shall have gone my way,
Wheresoe'er in the wide universe I stay me,
There shall I bear thee, as I do to-day.

Think not the end, that from my body frees me,
Breaks and unshackles from my love to thee.
Triumphs the soul above its house in ruin,
Deathless, begot of immortality.

Still must she keep her senses and affections,
Hold them as dear as life itself to be,
Could she choose death, then might she choose forgetting.
Living, remembering, to eternity.

<div align="right">

Carmina, xi
Translated by Helen Waddell

</div>

One of the loveliest lyric measures of the ancient world.

<div align="right">

HELEN WADDELL
The Wandering Scholars (1934)

</div>

SAINT AUGUSTINE

354 — 430 A . D .

WE SHALL ALL RISE AGAIN

Cumque ad eum finem sermo perduceretur, ut carnalium sensuum delectatio quantalibet, in quantalibet luce corporea, prae illius vitae iucunditate non conparatione, sed ne conmemoratione quidem digna videretur, erigentes nos ardentiore affectu in id ipsum, perambulavimus gradatim cuncta corporalia, et ipsum caelum, unde sol et luna et stellae lucent super terram. et adhuc ascendebamus, interius cogitando et loquendo et mirando opera tua, et venimus in mentes nostras et transcendimus eas, ut attingeremus regionem ubertatis indeficientis, unde pascis Israel in aeternum veritate pabulo, et ibi vita sapientia est, per quam fiunt omnia ista, etquae fuerunt et quae futura sunt. et ipsa non fit, sed sic est, ut fuit, et sic erit semper: quin potius fuisse et futurum esse non est in ea, sed esse solum, quoniam aeterna est: nam fuisse et futurum esse non est aeternum. et dum loquimur et inhiamus illi, attingimus eam modice toto ictu cordis; et suspiravimus, et reliquimus ibi religatas primitias spiritus, et remeavimus ad strepitum oris nostri, ubi verbum et incipitur et finitur. et quid simile verbo tuo, domino nostro, in se permanenti sine vetustate atque innovanti omnia?

Dicebamus ergo: "si cui sileat tumultus carnis, sileant phantasiae terrae et aquarum et aeris, sileant et poli et ipsa sibi anima sileat, et transeat se non se cogitando, sileant somnia et imaginariae revelationes,

omnis lingua et omne signum et quidquid transeundo fit si cui sileat omnino—quoniam si quis audiat, dicunt haec omnia: Non ipsa nos fecimus, sed fecit nos qui manet in aeternum:—his dictis si iam taceant, quoniam erexerunt aurem in eum, qui fecit ea, et loquatur ipse solus non per ea, sed per se ipsum, ut audiamus verbum eius, non per linguam carnis neque per vocem angeli nec per sonitum nubis nec per aenigma similitudinis, sed ipsum, quem in his amamus, ipsum sine his audiamus, sicut nunc extendimus nos et rapida cogitatione attingimus aeternam sapientiam super omnia manentem, si continuetur hoc et subtrahantur aliae visiones longe inparis generis, et haec una rapiat et absorbeat et recondat in interiora gaudia spectatorem suum, ut talis sit sempiterna vita, quale fuit hoc momentum intellegentiae, cui suspiravimus, nonne hoc est: Intra in gaudium domini tui? et istud quando? an cum omnes resurgimus, sed non omnes inmutabimur?"

And when our discourse was brought to that point, that the very highest delight of the earthly senses, in the very purest material light, was, in respect of the sweetness of that life, not only not worthy of comparison, but not even of mention; we raising up ourselves with a more glowing affection towards the "Self-same," did by degrees pass through all things bodily, even the very heaven, whence sun and moon, and stars shine upon the earth; yea, we were soaring higher yet, by inward musing, and discourse, and admiring of Thy works; and we came to our own minds, and went beyond them, that we might arrive at that region of never-failing plenty, where *Thou feedest Israel* for ever with the food of truth, and where life is the *Wisdom by whom all* these *things are made*, and what have been, and what shall be, and she is not made, but is, as she hath been, and so shall she be ever; yea rather, to "have been," and "hereafter to be," are not in her, but only "to be," seeing she is eternal. For to "have been," and to "be hereafter," are not eternal. And while we were discoursing and panting after her, we slightly touched on her with the whole effort of our heart; and we sighed, and there we leave bound *the first fruits of the Spirit;* and returned to vocal expressions of our mouth, where the word spoken has beginning and end. And what is like unto Thy Word, our Lord, who *endureth in Himself* without becoming old, and *maketh all things new?*

We were saying then: If to any the tumult of the flesh were hushed, hushed the images of earth, and waters, and air, hushed also the poles of heaven, yea the very soul be hushed to herself, and by not thinking on self surmount self, hushed all dreams and imaginary revelations, every tongue and every sign, and whatsoever exists only in transition, since if any could hear, all these say, *We made not ourselves, but He made us that abideth for ever*—If then having uttered this, they too should be hushed, having roused only our ears to Him who made them, and He alone speak, not by them, but by Himself, that we may hear

His Word, not through any tongue of flesh, nor Angel's voice, nor sound of thunder, nor in the dark riddle of a similitude, but, might hear Whom in these things we love, might hear His Very Self without these, (as we two now strained ourselves, and in swift thought touched on that Eternal Wisdom, which abideth over all;)—could this be continued on, and other visions of kind far unlike be withdrawn, and this one ravish, and absorb, and wrap up its beholder amid these inward joys, so that life might be for ever like that one moment of understanding which now we sighed after; were not this, *Enter into thy Master's joy?* And when shall that be? When *we shall all rise again,* though we *shall not all be changed?*

<div align="right">

Confessions (c. 399), ix, 10
Translated by E. B. Pusey

</div>

It was the peak of Augustine's experience. It is perhaps the most intense experience ever commemorated by a human being.

<div align="right">

REBECCA WEST
St. Augustine (1933)

</div>

SAINT AUGUSTINE

354 — 430 A. D.

FAITH

Nihil aliud habeo quam voluntatem; nihil aliud scio nisi fluxa et caduca spernenda esse, certa et aeterna requirenda.

Nothing have I but will; I know nothing but this, that things fleeting and transitory should be spurned, that things certain and eternal should be sought.

<div align="right">

Soliloquia (386?)

</div>

Than this, I venture to assert, no better definition of elementary, universal faith has ever been enounced.

<div align="right">

PAUL ELMER MORE
Shelburne Essays, Sixth Series (1909)

</div>

VENANTIUS FORTUNATUS

C . 5 3 0 — 6 1 0 ? A . D .

HYMN TO THE HOLY CROSS

Vexilla regis prodeunt,
fulget crucis mysterium,
quo carne carnis conditor
suspensus est patibulo.

Confixa clavis viscera,
tendens manus, vestigia,
redemptionis gratia
hic immolata est hostia.

Quo vulneratus insuper
mucrone diro lanceae,
ut nos lavaret crimine,
manavit unda et sanguine.

Impleta sunt quae concinit
David fideli carmine,
dicendo nationibus:
'regnavit a ligno Deus.'

Arbor decora et fulgida,
ornata regis purpura,
electa digno stipite
tam sancta membra tangere.

Beata cuius brachiis
pretium pependit saeculi,
statera facta est corporis,
praedam tulitque tartari.

Fundis aroma cortice,
vincis sapore nectare,
iucunda fructu fertili
plaudis triumpho nobili.

Salve ara, salve victima,
de passionis gloria
qua vita mortem pertulit
et morte vitam reddidit.

272

The royal banners forward go;
The cross shines forth in mystic glow,
Where he in flesh, our flesh who made,
Upon the tree of pain is laid.

Behold! the nails, with anguish fierce,
His outstretched hands and vitals pierce!
Here, our redemption to obtain,
The mighty sacrifice is slain!

Where deep for us the spear was dyed,
Life's torrent rushing from his side,
To wash us in that precious flood
Where mingled water flowed and blood.

Fulfilled is all that David told
In true prophetic song of old;
Amidst the nations, God (saith he)
Hath reigned and triumphed from the Tree.

O Tree of beauty! Tree of light!
O Tree with royal purple dight!
Elect on whose triumphal breast
Those holy limbs should find their rest!

On whose dear arms, so widely flung,
The weight of this world's ransom hung:
The price of human kind to pay,
And spoil the spoiler of his prey.

With fragrance dropping from each bough,
Sweeter than sweetest nectar thou,
Decked with the fruit of peace and praise,
And glorious with triumphal lays,

Hail, Altar! Hail, O Victim, thee
Decks now thy passion's victory;
Where life for sinners death endured,
And life by death for man procured.
 Translated by J. M. Neale (Chambers version)

*There is no hymn that can be put beside that mournful and majestic
processional song.*

JAMES JOYCE
A Portrait of the Artist as a Young Man (1916)

CAEDMON?

F L . 6 7 0 A . D .

CHRIST AND SATAN

Eala drihtenes þrym! Eala duguða helm!
Eala meotodes miht! Eala middaneard!
Eala dæg leohta! Eala dream godes!
Eala engla þreat! Eala upheofen!
Eala þæt ic eam ealles leas ecan dreames,
þæt ic mid handum ne mæg heofon geræcan,
ne mid eagum ne mot up locian,
ne huru mid earum ne sceal æfre geheran
þære byrhtestan beman stefne!

O thou glory of the Lord! Guardian of Heaven's hosts,
O thou might of the Creator! O thou mid-circle!
O thou bright day of splendour! O thou jubilee of God!
O ye hosts of angels! O thou highest heaven!
O that I am shut from the everlasting jubilee,
That I cannot reach my hands again to Heaven,
. . . Nor hear with my ears ever again
The clear-ringing harmony of the heavenly trumpets.

<div align="right">Satan, 164–72</div>

Deeper and more piercing lyric notes have never been struck.

<div align="right">JOHN CHURTON COLLINS
Ephemera Critica (1901)</div>

ANONYMOUS

TENTH CENTURY

THE BATTLE OF MALDON

brocen þurde.
Het þa hyssa hƿæne hors forlætan,
feor afysan 7 forð ȝanȝan,
hicȝan to handum 7 to hiȝe ȝodum.
Þa þæt Offan mæȝ ærest onfunde,

274

þæt se eorl nolde yrhðo ȝeþolian,
he let him þa of handon leofne fleoȝan
hafoc þið þæs holtes 7 to þære hilde stop.
Be þam man mihte oncnaþan þæt se cniht noldε
þacian æt þam þiȝȝe, þa he to þæpnum fenȝ.
Eac him þolde Eadric his ealdre ȝelæstan,
frean to ȝefeohte; onȝan þa forð beran
ȝar to ȝuþe. He hæfde ȝod ȝeþanc
þa hþile þe he mid handum healdan mihte
bord 7 brad sþurd: beot he ȝelæste

þa he ætforan his frean feohtan sceolde.
 Ða þær Byrhtnoð onȝan beornas trymian
rad 7 rædde, rincum tæhte
hu hi sceoldon standan 7 þone stede healdan,
7 bæd þæt hyra randas rihte heoldon
fæste mid folman 7 ne forhtedon na.
Þa he hæfde þæt folc fæȝere ȝetrymmed,
he lihte þa mid leodon þær him leofost þæs,
þær he his heorðþerod holdost þiste.
 Þa stod on stæðe, stiðlice clypode
þicinȝa ar, þordum mælde,
se on beot abead brimliþendra
ærænde to þam eorle þær he on ofre stod:
'Me sendon to þe sæmen snelle,
heton ðe secȝan þæt þu most sendan raðe
beaȝas þið ȝebeorȝe, 7 eoþ betere is
þæt ȝe þisne ȝarræs mid ȝafole forȝyldon
þonne þe sþa hearde hilde dælon.
Ne þurfe þe us spillan, ȝif ȝe spedaþ to þam;
þe þillað þið þam ȝolde ȝrið fæstnian.
Ȝyf þu þæt ȝerædest þe her ricost eart,
þæt þu þine leoda dysan þille,
syllan sæmannum on hyra sylfra dom
feoh þið freode 7 niman frið æt us,
þe þillaþ mid þam sceattum us to scype ȝanȝan,
on flot feran 7 eoþ friþes healdan.'
 Byrhtnoð maþelode, bord hafenode,
þand þacne æsc, þordum mælde,
yrre 7 anræd aȝeaf him andsþare:
'Ȝehyrst þu, sælida, hþæt þis folc seȝeð?
Hi þillað eoþ to ȝafole ȝaras syllan,
ættrynne ord 7 ealde sþurd,

þa hereȝeatu þe eoþ æt hilde ne deah.
Brimmanna boda, abeod eft onȝean,

275

seȝe þinum leodum miccle laþre spell,
þæt her stynt unforcuð eorl mid his þerode
þe þile ȝealȝean eþel þysne,
Æþelredes eard, ealdres mines
folc 7 foldan. Feallan sceolon
hæþene æt hilde. To heanlic me þinceð
þæt ȝe mid urum sceattum to scype ȝanȝon
unbefohtene, nu ȝe þus feor hider
on urne eard in becomon.
Ne sceole ȝe sþa softe sinc ȝeȝanȝan:
us sceal ord 7 ecȝ ær ȝeseman,
ȝrim ȝuðpleȝa, ær þe ȝofol syllon.'
 Het þa bord beran, beornas ȝanȝan
þæt hi on þam eásteðe ealle stodon.
Ne mihte þær for þætere þerod to þam oðrum:
þær com floþende flod æfter ebban;
lucon laȝustreamas. To lanȝ hit him þuhte
hþænne hi toȝædere ȝaras beron.
 Hi þær Pantan stream mid prasse bestodon,
Eastseaxena ord 7 se æschere;
ne mihte hyra æniȝ oþrum derian,
buton hþa þuhr flanes flyht fyl ȝename.
 Se flod ut ȝeþat. Þa flotan stodon ȝearoþe,
þicinȝa fela þiȝes ȝeorne.
Het þa hæleða hleo healdan þa bricȝe
þiȝan þiȝheardne—se þæs haten Þulfstan—
cafne mid his cynne: þæt þæs Ceolan sunu,
þe ðone forman man mid his francan ofsceat
þe þær baldlicost on þa bricȝe stop.
Þær stodon mid Þulfstane þiȝan unforhte,
Ælfere 7 Maccus, modiȝe tþeȝen,
þa noldon æt þam forda fleam ȝeþyrcan,
ac hi fæstlice þið ða fynd þeredon
þa hþile þe hi þæpna þealdan moston.
Þa hi þæt onȝeaton 7 ȝeorne ȝesaþon,
þæt hi þær bricȝþeardas bitere fundon,
onȝunnon lyteȝian þa laðe ȝystas,

bædon þæt hi upȝanȝ aȝan moston,
ofer þone ford faran, feþan lædan.
 Ða se eorl onȝan for his ofermode
alyfan landes to fela laþere ðeode;
onȝan ceallian þa ofer cald þæter
Byrhtelmes bearn—beornas ȝehlyston:
'Nu eoþ is ȝerymed: ȝað ricene to us

ȝuman to ȝuþe. Ȝod ana þat
hƿa þære þælstoƿe þealdan mote.'
 Ƿodon þa þælþulfas, for þætere ne murnon,
þicinȝa þerod; þest ofer Pantan
ofer scir þæter scyldas þeȝon,
lidmen to lande linde bæron.
Þær onȝean ȝramum ȝearoþe stodon
Byrhtnoð mid beornum. He mid bordum het
þyrcan þone þihaȝan 7 þæt þerod healdan
fæste þið feondum. Þa þæs feohte neh,
tir æt ȝetohte. Þæs seo tid cumen
þæt þær fæȝe men feallan sceoldon.
Þær þearð hream ahafen. Hremmas þundon,
earn æses ȝeorn. Þæs on eorþan cyrm.
 Hi leton þa of folman feolhearde speru,
ȝrimme ȝeȝrundene ȝaras fleoȝan.
Boȝan þæron bysiȝe, bord ord onfenȝ.
Biter þæs se beaduræs. Beornas feollon
on ȝehþæðere hand, hyssas laȝon.
 Ƿund þearð Ƿulfmær, þælræste ȝeceas

Byrhtnoðes mæȝ: he mid billum þærð,
his sƿustersunu, sƿiðe forheaþen.
Þær þearð þicinȝum þiþerlean aȝyfen:
ȝehyrde ic þæt Eadþeard anne sloȝe
sƿiðe mid his sƿurde, sƿenȝes ne þyrnde,
þæt him æt fotum feoll fæȝe cempa;
þæs him his ðeoden þanc ȝesæde
þam burþene, þa he byre hæfde.
 Sƿa stemnetton stiðhicȝende
hysas æt hilde, hoȝodon ȝeorne
hƿa þær mid orde ærost mihte
on fæȝean men feorh ȝeþinnan,
þiȝan mid þæpnum. Ƿæl feol on eorðan.
Stodon stædefæste, stihte hi Byrhtnoð,
bæd þæt hyssa ȝehþylc hoȝode to þiȝe,
þe on Denon þolde dom ȝefeohtan.
 Ƿod þa þiȝes heard, þæþen up áhof,
bord to ȝebeorȝe, 7 þið þæs beornes stop.
Eode sƿa anræd eorl to þam ceorle:
æȝþer hyra oðrum yfeles hoȝode.
Sende ða se særinc suþerne ȝar
þæt ȝeþundod þearð þiȝena hlaford.
He sceaf þa mid ðam scylde þæt se sceaft tobærst,
7 þæt spere sprenȝde þæt hit spranȝ onȝean.

Ȝeȝremod þearð se ȝuðrinc: he mid ȝare stanȝ
þlancne þicinȝ þe him þa þunde forȝeaf.
Frod þæs se fyrdrinc; he let his francan þadan
þuhr ðæs hysses hals, hand þisode
þæt he on þam færsceaðan feorh ȝeræhte.
 Ða he oþerne ofstlice sceat
þæt seo byrne tobærst: he þæs on breostum þund
þuhr ða hrinȝlocan; him æt heortan stod
ætterne ord. Se eorl þæs þe bliþra:
hloh þa modi man, sæde Metode þanc
ðæs dæȝþeorces þe him Drihten forȝeaf.
 Forlet þa drenȝa sum daroð of handa
fleoȝan of folman, þæt se to forð ȝeþat
þurh ðone æþelan Æþelredes þeȝen.
Him be healfe stod hyse únþeaxen,
cniht on ȝecampe, se full caflice
bræd of þam beorne blodiȝne ȝar,
Ƿulfstanes bearn, Ƿulfmær se ȝeonȝa;
forlet forheardne faran eft onȝean.
Ord in ȝeþod, þæt se on eorþan læȝ
þe his þeoden ær þearle ȝeræhte.
Eode þa ȝesyrþed secȝ to þam eorle;
he þolde þæs beornes beaȝas gefecȝan,
reaf 7 hrinȝas 7 ȝerenod sþurd.
 Þa Byrhtnoð bræd bill of sceðe
brad 7 bruneccȝ, 7 on þa byrnan sloh.
To raþe hine ȝelette lidmanna sum,
þa he þæs eorles earm amyrde.
Feoll þa to foldan fealohilte sþurd:
ne mihte he ȝehealdan heardne mece,
þæpnes þealdan. Þa ȝyt þæt þord ȝecþæð
har hilderinc, hyssas bylde,
bæd ȝanȝan forð ȝode ȝeferan.
Ne mihte þa on fotum lenȝ fæste ȝestandan;
he to heofenum þlat:
'Ic ȝeþancie þe, ðeoda Ƿaldend,
ealra þæra þynna þe ic on þorulde ȝebad.
Nu ic ah, milde Metod, mæste þearfe
þæt þu minum ȝaste ȝodes ȝeunne,
þæt min saþul to ðe siðian mote
on þin ȝeþeald, Þeoden enȝla,
mid friþe ferian. Ic eom frymdi to þe
þæt hi helsceaðan hynan ne moton.'
 Ða hine heoþon hæðene scealcas,
7 beȝan þa beornas þe him biȝ stodon,

Ælfnoð 7 Þulmær beȝen laȝon,
ða onemn hyra frean feorh ȝesealdon.
 Hi buȝon þa fram beaduþe þe þær beon noldon:
bær þurdon Oddan bearn ærest on fleame,
ðodric fram ȝuþe, 7 þone ȝodan forlet
þe him mæniȝne oft mear ȝesealde.
He ȝehleop þone eoh þe ahte his hlaford,
on þam ȝerædum þe hit riht ne þæs,
7 his broðru mid him beȝen ærndon,
ðodþine 7 ðodþiȝ ȝuþe ne ȝymdon,
ac þendon fram þam þiȝe 7 þone þudu sohton,
fluȝon on þæt fæsten 7 hyra feore burȝon,
7 manna ma þonne hit æniȝ mæð þære,
ȝyf hi þa ȝeearnunȝa ealle ȝemundon
þe he him to duȝuþe ȝedon hæfde.
Sþa him Offa on dæȝ ær asæde
on þam meþelstede, þa he ȝemot hæfde,
þæt þær modelice maneȝa spræcon
þe eft æt þearfe þolian noldon.
 Þa þearð afeallen þæs folces ealdor,
Æþelredes eorl. Ealle ȝesaþon
heorðȝeneatas þæt hyra heorra læȝ.
Þa ðær þendon forð þlance þeȝenas,
unearȝe men efston ȝeorne:
hi þoldon þa ealle oðer tþeȝa,
lif forlætan oððe leofne ȝeþrecan.
 Sþa hi bylde forð bearn Ælfrices,
þiȝa þintrum ȝeonȝ þordum mælde,
Ælfþine þa cþæð, he on ellen spræc:
'ȝemunaþ þara mæla þe þe oft æt meodo spræcon,
þonne þe on bence beot ahofon,
hæleð on healle ymbe heard ȝeþinn:
nu mæȝ cunnian hþa cene sy.
Ic þylle mine æþelo eallum ȝecyþan,
þæt ic þæs on Myrcon miccles cynnes;
þæs min ealda fæder Ealhelm haten,
þis ealdorman þoruldȝesæliȝ.
Ne sceolon me on þære þeode þeȝenas ætþitan
þæt ic of ðisse fyrde feran þille,
eard ȝesecan, nu min ealdor liȝeð
forheaþen æt hilde. Me is þæt hearma mæst:
he þæs æȝðer min mæȝ 7 min hlaford.'
Þa he forð eode, fæhðe ȝemunde,
þæt he mid orde anne ȝeræhte
flotan on þam folce, þæt se on foldan læȝ

forþeȝen mid his þæpne. Onȝan þa þinas **manian,**
frynd 7 ȝeferan, þæt hi forð eodon.
Offa ȝemælde, æscholt asceoc:
'Hƿæt, þu, Ælfƿine, hafast ealle ȝemanode
þeȝenas to þearfe. Nu ure þeoden lið
eorl on eorðan, us is eallum þearf
þæt ure æȝhƿylc oþerne bylde
þiȝan to þiȝe, þa hƿile þe he þæpen mæȝe
habban 7 healdan, heardne mece,
ȝar 7 ȝod sƿurd. Us ȝodric hæfð,
earh Oddan bearn, ealle besþicene.
Ƿende þæs formoni man, þa he on meare rad,
on þlancan þam þicȝe, þæt þære hit ure hlaford.
For þan þearð her on felda folc totþæmed,
scyldburh tobrocen. Abreoðe his anȝin,
þæt he her sþa maniȝne man aflymde.'
Leofsunu ȝemælde 7 his linde ahof,
bord to ȝebeorȝe; he þam beorne oncþæð:
'Ic þæt ȝehate, þæt ic heonon nelle
fleon fotes trym, ac þille furðor ȝan,
þrecan on ȝeþinne minne þinedrihten.
Ne þurfon me embe Sturmere stedefæste hælæð
þordum ætþitan, nu min þine ȝecranc,
þæt ic hlafordleas ham siðie,
þende fram þiȝe; ac me sceal þæpen niman,
ord 7 iren.' He ful yrre þod,
feaht fæstlice, fleam he forhoȝode.
Dunnere þa cþæð, daroð, acþehte,
unorne ceorl ofer eall clypode,
bæd þæt beorna ȝehþylc Byrhtnoð þręce:
'Ne mæȝ na þandian se þe þrecan þenceð
frean on folce, ne for feore murnan.'
Þa hi forð eodon, feores hi ne rohton.
Onȝunnon þa hiredmen heardlice feohtan,
ȝrame ȝarberend, 7 ȝod bædon
þæt hi moston ȝeþrecan hyra þinedrihten
7 on hyra feondum fyl ȝeþyrcan.
Him se ȝysel onȝan ȝeornlice fylstan;
he þæs on Norðhymbron heardes cynnes,
Ecȝlafes bearn; him þæs Æscferð nama.
He ne þandode na æt þam þiȝpleȝan,
ac he fysde forð flan ȝenehe;
hƿilon he on bord sceat, hƿilon beorne tæsde,
æfre embe stunde he sealde sume wunde,

þa hƿile ðe he þæpna þealdan moste.
 Þa ʒyt on orde stod Eadþeard se lanʒa
ʒearo 7 ʒeornful; ʒylpþordum spræc
þæt he nolde fleoʒan fotmæl landes,
ofer bæc buʒan, þa his betera leʒ.
He bræc þone bordþeall 7 þið þa beornas feaht,
oð þæt he his sincʒyfan on þam sæmannum
þurðlice þrec, ær he on þæle leʒe.
 Sþa dyde Æþeric, æþele ʒefera,
fus 7 forðʒeorn feaht eornoste,
Sibyrhtes broðor 7 sþiðe mæniʒ oþer,
clufon cellod bord, cene hi þeredon.
Bærst bordes læriʒ, 7 seo byrne sanʒ
ʒryreleoða sum. Þa æt ʒuðe sloh
Offa þone sælidan þæt he on eorðan feoll,
7 ðær ʒaddes mæʒ ʒrund ʒesohte:
hraðe þearð æt hilde Offa forheaþen.
He hæfde ðeah ʒeforþod þæt he his frean ʒehet,
sþa he beotode ær þið his beahʒifan,
þæt hi sceoldon beʒen on burh ridan
hale to hame oððe on here crincʒan,
on þælstoþe þundum sþeltan.
He læʒ ðeʒenlice ðeodne ʒehende.
Ða þearð borda ʒebræc. Brimmen þodon
ʒuðe ʒeʒremode. ʒar oft þuhrþod
fæʒes feorhhus. Forð ða eode Þistan,
Þurstanes suna þið þas secʒas feaht.
He þæs on ʒeþranʒ hyra þreora bana,
ær him Þiʒelmes bearn on þam þæle læʒe.
Þær þæs stið ʒemot. Stodon fæste
þiʒan on ʒeþinne. Þiʒend cruncon
þundum þeriʒe. Þæl feol on eorþan.
 Osþold 7 Eadþold ealle hþile,
beʒen þa ʒebroþru beornas trymedon,
hyra þinemaʒas þordon bædon
þæt hi þær æt ðearfe þolian sceoldon,
unþaclice þæpna neotan.
 Byrhtþold maþelode, bord hafenode—
se þæs eald ʒeneat—æsc acþehte;
he ful baldlice beornas lærde:
'Hiʒe sceal þe heardra, heorte þe cenre,
mod sceal þe mare, þe ure mæʒen lytlað.
Her lið ure ealdor eall forheaþen,
ʒód on ʒreote. A mæʒ ʒnornian
se ðe nu fram þis þiʒpleʒan þendan þenceð.

Ic eom frod feores. Fram ic ne þille,
ac ic me be healfe minum hlaforde,
be sþa leofan men licȝan þence.'
Sþa hi Æþelȝares bearn ealle bylde
ȝodric to ȝuþe. Oft he ȝar forlet,
þælspere þindan on þa þicinȝas;
sþa he on þam folce fyrmest eode,
heoþ 7 hynde, oð þæt he on hilde ȝecranc.
Næs þæt na se ȝodric þe ða ȝuðe forbeah.

. . . It was broken. Then he commanded each of the warriors to leave his horse, to drive it away and to go forth, to think of his hands and of good courage. Then the kinsman of Offa first found out that the earl was not minded to suffer cowardice. Then he let the loved hawk fly from his hands to the wood, and went forward to the battle. Thereby one might know that the youth would not weaken in the fight when he grasped the weapons. Eadric also wished to attend his leader, his prince, to battle. Then he began to bear his spear to the fight. He had a good heart while with his hands he could hold shield and broad sword. He achieved his boast, that he should fight before his prince.

Then Byrhtnoth began there to exhort his warriors. He rode and instructed; he directed the warriors how they should stand and keep their station, and bade them hold their shields upright firmly with their hands and be not afraid. When he had fairly exhorted those people, then he alighted with his men where he best wished, where he knew his most trusty household-troops were. Then the messenger of the Vikings stood on the shore, called out fiercely, spoke with words; he boastfully announced to the earl where he stood on the bank the message of the seafarers:

"Bold seamen have sent me to thee, bade me say to thee that thou mayest quickly send rings as a defence; and it is better for you that ye should avert with tribute this rush of spears than that we, so hardy, should deal out battle. We need not destroy each other, if ye will consent to that. We will establish a truce with that gold. If thou who art mightiest here wilt agree to disband thy men, wilt give to the seamen at their own judgment money for peace and accept a truce from us, we are willing to embark with that tribute, to go to sea, and keep peace with you."

Byrhtnoth spoke; he grasped the shield; he brandished the slender spear of ash. He uttered words; angry and resolute, he gave him answer: "Dost thou hear, seafarer, what this people say? They will give you darts for tribute, poisonous spears and ancient swords, gear which will profit you naught in the fight. Messenger of the seamen, take word back again, say to thy people far more hateful tidings, that here stands a noble earl with his troop who will defend this land, the home of

Æthelred, my prince, the people and the ground. The heathen shall fall in the battle. It seems to me too shameful that ye should embark with our tribute with impunity, now that ye have come thus far hither to our land. Nor shall ye win treasure so lightly; point and edge shall reconcile us first, grim battle-play, ere we yield tribute."

Then he commanded shields to be borne, the warriors to go, so that they all stood on the river bank. One troop could not come at the other there by reason of the water; there the flood came flowing after the ebb-tide; the streams ran together; they were impatient to clash their spears. There they stood in array beside the stream of Panta, the battle-line of the East Saxons and the ship-army. Nor could one of them injure the other, unless anyone received death from the arrow's flight. The tide went out; the pirates stood ready, many Vikings eager for battle. Then the protector of heroes commanded a warrior, stern in fight, to hold the bridge; he was called Wulfstan, bold among his race—he was the son of Ceola—who with his spear struck the first man who there most boldly stepped upon the bridge. There stood with Wulfstan warriors unafraid, Ælfere and Maccus, two brave men. They would not take to flight at the ford, but they firmly kept guard against the foe as long as they could wield weapons. When they beheld that and clearly saw that they found the guardians of the bridge fierce there, the hostile strangers began then to practise deceit. They asked to be allowed to approach, to go over the ford, to lead their soldiers. Then the earl began in his pride to yield the hateful people too much land. Then the son of Byrhtelm began to call over the cold water; the warriors listened:

"Now is space granted to you; come hither to us quickly, warriors to the battle. God alone can tell who will hold the place of battle."

Then the slaughterous wolves, the horde of Vikings, passed west over Panta. They cared not for the water; they bore shields over the gleaming water; the seamen carried targes to land. There Byrhtnoth stood ready with his warriors to oppose the enemy; he commanded the war-hedge to be made with shields and that troop to hold out stoutly against the foes. Then was the fight near, glory in battle; the time had come when doomed men must needs fall there. Then clamour arose; ravens wheeled, the eagle greedy for carrion; there was shouting on earth. Then they let the spears, hard as a file, go from their hands; let the darts, ground sharp, fly; bows were busy; shield received point; bitter was the rush of battle. Warriors fell on either hand; young men lay low. Wulfmær was wounded; he, the kinsman of Byrhtnoth, his sister's son, chose a bed of slaughter; he was sorely stricken with swords. There requital was given to the Vikings. I heard that Eadweard slew one with his sword stoutly; he withheld not the stroke, so that the fated warrior fell at his feet. For that his prince gave thanks to him, to the chamberlain, when he had opportunity. Thus the brave warriors stood firm in battle; eagerly they considered who there could first mortally wound a

fated man with spear, a warrior with weapons; the slain fell to the earth. They stood steadfast; Byrhtnoth incited them; he bade each warrior give thought to war who would win glory against the Danes. Then he who was hardy in battle advanced; he raised up the weapon, the shield for a defence, and stepped towards the man. Thus the earl went resolute to the churl; each of them planned evil to the other. Then the seafarer sent a spear from the south, so that the lord of warriors was wounded. He thrust then with the shield, so that the shaft burst; and that spear broke, and sprang back again. The warrior was enraged; with a spear he pierced the proud Viking who gave him the wound. The warrior was skilful; he let his lance go through the man's neck. His hand guided it, so that he reached the life of his sudden enemy. Then hastily he darted another, so that the corslet burst; he was wounded in the breast through the coat of ring-mail; the poisonous spear stood at his heart. The earl was the gladder; then the brave man laughed, gave thanks to God for that day's work which the Lord had granted him. Then one of the warriors let fly a javelin from his hand, from his fist, so that it went forth through the noble thane of Æthelred. By his side stood a youthful warrior, a stripling in the fight; full boldly he, Wulfstan's son, the young Wulfmær, plucked the bloody spear from the warrior. He let the exceeding hard spear go forth again; the point went in, so that he who erstwhile had sorely smitten his prince lay on the ground. Then a warrior went armed to the earl; he was minded to seize the bracelets of the man, the armour and rings and ornamented sword. Then Byrhtnoth drew the sword from the sheath, broad and gleaming-edged, and struck at the corslet. One of the seafarers hindered him too quickly and destroyed the earl's arm. Then the sword with golden hilt fell to the ground, nor could he hold the hard brand, wield the weapon.

Then the old warrior yet spoke these words, encouraged the fighters, bade the valiant comrades go forth; nor could he then longer stand firm on his feet; he looked to heaven: "I thank Thee, O Lord of the peoples, for all those joys which I have known in the world. Now, gracious Lord, I have most need that Thou shouldst grant good to my spirit, that my soul may journey to Thee, may pass in peace into thy keeping, Prince of angels. I entreat Thee that devils may not do it despite." Then the heathen men hewed him, and both the men who stood by him, Ælfnoth and Wulfmær, were laid low; then they gave up their lives by the side of their prince.

Then they who were not minded to be there retired from the battle. There the sons of Odda were the first in flight; Godric fled from the battle and left the valiant one who had often given him many a steed; he leaped on the horse which his lord had owned, on the trappings, as was not right, and both his brothers, Godrinc and Godwig, galloped with him; they cared not for war, but they turned from the fight and sought the wood; they fled to that fastness and saved their lives, and more men

than was at all fitting, if they had all remembered the rewards which he had given them for their benefit. Thus erstwhile Offa once said to him in the meeting-place, when he held assembly, that many spoke bravely there who would not endure in stress.

Then the people's prince had fallen, Æthelred's earl; all the hearth-companions saw that their lord was laid low. Then proud thanes, brave men, went forth there, eagerly hastened. Then they all wished for one of two things—to depart from life or to avenge the loved one. Thus the son of Ælfric urged them on, a warrior young in years. He uttered words; Ælfwine spoke then; boldly he said: "Remember the times when often we spoke at the mead-drinking, when on the bench we uttered boasting, heroes in hall, about hard strife. Now he who is brave may put it to the test. I will make known my lineage to all, that I was of a mighty race among the Mercians. My old father was called Ealhelm, a wise alderman, prosperous in the world. Thanes shall not reproach me among the people, that I wish to leave this army, to seek my home, now my prince lies low, hewn down in battle. That is the greatest of griefs to me; he was both my kinsman and my lord." Then he went forth; he forgot not the feud; he smote one pirate in the host with spear, so that he lay on the earth, slain by his weapon. Then he began to admonish his friends, companions and comrades, that they should go forth.

Offa spoke; he shook his spear-shaft: "Lo! thou, Ælfwine, hast admonished all the thanes as is needed. Now that our prince lies low, the earl on the earth, it is the task of all of us, that each should exhort the other warrior to fight whilst he can grasp and hold a weapon, a hard brand, a spear, and good sword. Godric, the cowardly son of Odda, has betrayed us all. Very many men believed when he rode on a horse, on the proud steed, that it was our lord. Wherefore here on the field the army was divided, the shield-array broken. May his enterprise fail for putting so many men to flight here."

Leofsunu spoke and raised his shield, his targe in defence; he spoke to the man: "I promise that I will not flee hence a footstep, but will go forward, avenge in fight my friendly lord. The steadfast heroes about Sturmere shall have no cause to taunt me with words, now that my friend has fallen, that I journey home lacking a lord, turn from the fight; but the weapon, spear and brand, shall take me." He went very wrathful, fought staunchly; he scorned flight.

Dunnere spoke then, shook his spear, a humble churl; he cried out over all, bade each man avenge Byrhtnoth: "He in the host who thinks to avenge the prince cannot waver nor mourn for life."

Then they went forth; they recked not of life. Then the retainers began to fight stoutly, fierce bearers of spears, and prayed God that they might avenge their friendly lord and work slaughter on their foes. The hostage began to help them eagerly; he was of a stout race among

the Northumbrians, the son of Ecglaf; his name was Æscferth. He wavered not at the war-play, but often he urged forth the dart; at times he shot on to the shield; at times he wounded a man. Ever and again he dealt out wounds whilst he could wield weapons.

Then Eadweard the tall still stood in the line of battle, ready and eager. With words of boasting he said that he would not flee a foot's length of land or move back, now that his leader lay low. He broke the wall of shields and fought with the men until he worthily avenged on the seamen his giver of treasure ere he lay among the slain. Likewise did Ætheric, the brother of Sibyrht, a noble companion, eager and impetuous; he fought earnestly, and many others also split the hollow shields; the bold men made defence. The border of the shield broke and the corslet sang a terrible song. Then in the fight Offa smote the seaman, so that he fell to the earth, and there the kinsman of Gadd sought the ground. Quickly was Offa hewn down in the battle; yet he had accomplished what he promised his prince, as erstwhile he boasted with his giver of rings, that they should both ride to the stronghold, unscathed to their home, or fall amid the host, perish of wounds on the field of battle. Near the prince he lay low, as befits a thane.

Then there was breaking of shields; the seamen advanced, enraged by war. Often the spear pierced the body of a fated man. Then Wistan went forth, the son of Thurstan; he fought with the men; he slew three of them in the press ere Wigelin's son was laid low among the slain. There was a stern meeting; the warriors stood firm in the struggle; fighters fell, wearied with wounds; the slaughtered dropped to the earth. Oswold and Ealdwold, both the brothers, exhorted the men all the while; they bade their kinsmen with words to bear up there in the stress, use their weapons resolutely. Byrhtwold spoke; he grasped his shield; he was an old companion; he shook his ash-spear; full boldly he exhorted the warriors: "Thought shall be the harder, heart the keener, courage the greater, as our might lessens. Here lies our leader all hewn down, the valiant man in the dust; may he lament for ever who thinks now to turn from this war-play. I am old in age; I will not hence, but I purpose to lie by the side of my lord, by the man so dearly loved." Godric, the son of Æthelgar, likewise exhorted them all to fight. Often he let fly the spear, the deadly dart, against the Vikings, as he went foremost in the host. He hewed and struck down until he fell in the battle; that was not the Godric who fled from the fight.

Translated by R. K. Gordon

The heroic faith was that all was well with the man whose spirit remained unyielding, however painfully the body might be sacrificed. This principle has never been more directly and clearly expressed than by Byrhtwold, the eald ʒeneat, *who taught courage in the words:*

Hiȝe sceal þe heardra, heorte þe cenre,
mod sceal þe mare, þe ure mæȝen lytlað. . . .

MALDON *must also be conceded the proud position of being the great-*
est battle-poem in the English language—or perhaps the only battle-
poem in our language that can justly be called great; and it has achieved
greatness through being primarily not a poem of battle, but a poem of
heroism.

E. V. GORDON
The Battle of Maldon (1937)

HILDEBERT OF LAVARDIN

1 0 5 5 — 1 1 3 3

ROMAN ELEGY

Par tibi, Roma, nihil, cum sis prope tota ruina;
 Quam magni fueris integra fracta doces.
Longa tuos fastusaetas destruxit, et arces
 Caesaris et superum templa palude jacent.
Ille labor, labor ille ruit quem dirus Araxes
 Et stantem tremuit et cecidisse dolet;
Quem gladii regum, quem provida cura senatus,
 Quem superi rerum constituere caput;
Quem magis optavit cum crimine solus habere
 Caesar, quam socius et pius esse socer,
Qui, crescens studiis tribus, hostes, crimen, amicos
 Vi domuit, secuit legibus, emit ope;
In quem, dum fieret, vigilavit cura priorum:
 Juvit opus pietas hospitis, unda, locus.
Materiem, fabros, expensas axis uterque
 Misit, se muris obtulitipse locus.
Expendere duces thesauros, fata favorem,
 Artifices studium, totus et orbis opes.
Urbs cecidit de qua si quicquam dicere dignum
 Moliar, hoc potero dicere: Roma fuit.
Non tamen annorum series, non flamma, nec ensis
 Ad plenum potuit hoc abolere decus.
Cura hominum potuit tantam componere Romam
 Quantam non potuit solvere cura deum.
Confer opes marmorque novum superumque favorem,
 Artificum vigilent in nova facta manus,

287

Non tamen aut fieri par stanti machina muro,
 Aut restaurari sola ruina potest.
Tantum restat adhuc, tantum ruit, ut neque pars stans
 Aequari possit, diruta nec refici.
Hic superum formas superi mirantur et ipsi,
 Et cupiunt fictis vultibus esse pares.
Non potuit natura deos hoc ore creare
 Quo miranda deum signa creavit homo.
Vultus adest his numinibus, potiusque coluntur
 Artificum studio quam deitate sua.
Urbs felix, si vel dominis urbs illa careret,
 Vel dominis esset turpe carere fide.

Nothing can match you, Rome, though you are almost wholly in ruins; even in destruction you still reveal your former greatness. Long ages have destroyed your proud monuments, and the citadels of Caesar and the temples of the gods lie in a marsh. Those achievements, those structures have gone to ruin that dire Araxes trembled at while they stood, and grieves at their having fallen, the city that the swords of kings, the farsighted care of the senate, and the gods established as the crown of the world. Caesar, advancing his fortunes by three devices, his enemies, crime and friends, rather than share as a partner and as a pious father-in-law, tamed you by violence, divided you by laws and purchased you with wealth. Over this city, while it was built, ancestors watched with care; the work was aided by the piety of the hospitable Romulus, the river and the location. Each region sent material, workmen, contributions; the place lent itself to the contruction of walls. The leaders spent treasures, the fates gave their favor, artists their skill and the whole world its wealth. The city has fallen; and its worthiest eulogy is: Rome was. Not the succession of the years, not fire, not sword could fully destroy this glory. Human endeavor built such a great Rome that supernatural forces could not shatter it. Bring together wealth, and new marble, and the favor of the gods, let the hands of artists labor carefully over new works, but it is not possible to construct any walls equal to those now standing, or even to restore a single ruin. So much now remains, so much has been destroyed, that the existing part could not be equalled, nor the ruined part restored. The gods themselves marvel at their own statues, and long to resemble the created images of themselves. Nature could not produce deities with faces like the man-created, admirable images of the gods. In these statues gods have become visible, and they are worshipped because of the skill of the artists more than because of their own godhead. A happy city this, if it had no rulers, or if those rulers were ashamed of their faithlessness.

HILDEBERT OF LAVARDIN

1 0 5 5 — 1 1 3 3

FROM PRAYER TO THE HOLY TRINITY

Me receptet Sion illa,
Sion David urbs tranquilla,
Cuius faber auctor lucis,
Cuius portae lignum crucis,
Cuius claves lingua Petri
Cuius cives semper laeti,
Cuius muri lapis vivus,
Cuius custos rex festivus:
In hac urbe lux solennis,
Ver aeternum, pax perennis:
In hac odor implens caelos,
In hac semper festum melos;
Non est ibi corruptela,
Non defectus, non querela;
Non minuti, non deformes,
Omnes Christo sunt conformes.

In Syon lodge me (Lord) for pitty
Syon *Dauids* kingly Cittie.

Built by him that's only good,
Whose gates are of the crosses wood.

Whose keies are Christs vndoubted word,
Whose dwellers feare none but the Lord.

Whose wals are stone, strong, quicke and bright,
Whose keeper is the Lord of light.

Here the light doth neuer cease
Endlesse spring and endlesse peace

Here is musicke, heauen filling,
Swetnesse euermore distilling.

289

Here is neither spot nor taint,
No defect, nor no complaint.

No man crooked, great nor small,
But to Christ conformed all.

Translated by William Crashaw

If Hildebert had written nothing but this one poem [ROMAN ELEGY]
*his fame would still be secure, for it is so perfect in execution and so
thoroughly classical in manner that before its authorship was established
it found its way into anthologies of ancient Latin verse. But the* ROMAN
ELEGY *is* *perhaps even surpassed by the accentual hymn which
was so beautifully translated by Crashaw.*

F. A. WRIGHT AND T. A. SINCLAIR
A History of Later Latin Literature (1931)

———————

ANONYMOUS

ELEVENTH CENTURY

A MAIDEN'S COMPLAINT IN
SPRING-TIME

Levis exsurgit zephyrus
et sol procedit tepidus;
jam terra sinus aperit,
dulcore suo diffluit.

Ver purpuratum exiit,
ornatus suos induit;
aspergit terram floribus,
ligna silvarum frondibus.

Struunt lustra quadrupedes,
et dulces nidos volucres;
inter ligna florentia
sua decantant gaudia.

Quod oculis dum video
et auribus dum audio,
hëu, pro tantis gaudiis,
tantis inflor suspiriis.

Cum mihi sola sedeo
et haec revolvens palleo,
si forte caput sublevo,
nec audio nec video.

Tu saltim, veris gratia,
exaudi et considera
frondes, flores et gramina;
nam mea languet anima.

Softly the west wind blows;
Gaily the warm sun goes;
The earth her bosom sheweth,
And with all sweetness floweth.

Goes forth the scarlet spring,
Clad with all blossoming,
Sprinkles the fields with flowers,
Leaves on the forest.

Dens for four-footed things,
Sweet nests for all with wings.
On every blossomed bough
Joy ringeth now.

I see it with my eyes,
I hear it with my ears,
But in my heart are sighs,
And I am full of tears.

Alone with thought I sit,
And blench, remembering it;
Sometimes I lift my head,
I neither hear nor see.

Do thou, O Spring most fair,
Squander thy care
On flower and leaf and grain.
—Leave me alone with pain!

<div align="right">

Ms. of St. Augustine at Canterbury
Translated by Helen Waddell

</div>

The first perfect example of medieval verse.

<div align="right">

F. A. WRIGHT AND T. A. SINCLAIR
A History of Later Latin Literature (1931)

</div>

THE DEATH OF ROLAND

Ço sent Rollanz que la mort le tresprent
Devers la teste sur le quer li descent.
Desuz un pin i est alez curanz
Sur l' erbe verte si est culchiez adenz
Desuz lui met s'espee e l'olifant
Turnat sa teste vers la paiene gent.
Pur ço l'ad fait que il voelt veirement
Que Carles diet et trestute sa gent
Li gentils quens quil fut morz cunqueranz. . . .

Ço sent Rollanz de sun tens ni ad plus
Devers Espaigne gist en un pui agut
A l'une main si ad sun piz batut.
"Deus meie culpe vers les tues vertuz
De mes pecchiez des granz e des menuz
Que jo ai fait des l'ure que nez fui
Tresqu'a cest jur que ci sui consouz."
Sun destre guant en ad vers deu tendut
Angle del ciel i descendent a lui. Aoi.

Li quens Rollanz se jut desuz un pin
Envers Espaigne en ad turnet sun vis
De plusurs choses a remembrer li prist
De tantes terres cume li bers cunquist
De dulce France des humes de sun lign
De Carlemagne sun seignur kil nurrit
Ne poet muer men plurt e ne suspirt
Mais lui meisme ne voelt metre en ubli
Claimet sa culpe si priet deu mercit.
"Veire paterne ki unkes ne mentis
Seint Lazarun de mort resurrexis
E Daniel des liuns guaresis
Guaris de mei l'anme de tuz perils
Pur les pecchiez que en ma vie fis."

Sun destre guant a deu en puroffrit
E de sa main seinz Gabriel lad pris
Desur sun braz teneit le chief enclin
Juintes ses mains est alez a sa fin.

Deus li tramist sun angle cherubin
E Seint Michiel de la mer del peril
Ensemble od els Seinz Gabriels i vint
L' anme del cunte portent en pareis.

Then Roland feels that death is taking him;
Down from the head upon the heart it falls.
Beneath a pine he hastens running;
On the green grass he throws himself down;
Beneath him puts his sword and oliphant,
Turns his face toward the pagan army.
For this he does it, that he wishes greatly
That Charles should say and all his men,
The gentle Count has died a conqueror. . . .

Then Roland feels that his last hour has come
Facing toward Spain he lies on a steep hill,
While with one hand he beats upon his breast:
"Mea culpa, God! through force of thy miracles
Pardon my sins, the great as well as small,
That I have done from the hour I was born
Down to this day that I have now attained."
His right glove toward God he lifted up.
Angels from heaven descend on him. Aoi.

Count Roland throws himself beneath a pine
And toward Spain has turned his face away.
Of many things he called the memory back,
Of many lands that he, the brave, had conquered,
Of gentle France, the men of his lineage,
Of Charlemagne his lord, who nurtured him;
He cannot help but weep and sigh for these,
But for himself will not forget to care;
He cries his Culpe, he prays to God for grace.
"O God the Father who has never lied,
Who raised up Saint Lazarus from death,
And Daniel from the lions saved,
Save my soul from all the perils
For the sins that in my life I did!"

His right-hand glove to God he proffered;
Saint Gabriel from his hand took it;
Upon his arm he held his head inclined,
Folding his hands he passed to his end.

293

God sent to him his angel cherubim
And Saint Michael of the Sea in Peril,
Together with them came Saint Gabriel.
The soul of the Count they bear to Paradise.

<div align="right">La Chanson de Roland, 2355–95

Translated by Henry Adams</div>

Our age has lost much of its ear for poetry, as it has its eye for colour and line, and its taste for war and worship, wine and women. Not one man in a hundred thousand could now feel what the eleventh century felt in these verses of the "Chanson," and there is no reason for trying to do so, but there is a certain use in trying for once to understand not so much the feeling as the meaning. The naïveté of the poetry is that of the society. God the Father was the feudal seigneur, who raised Lazarus —his baron or vassal—from the grave, and freed Daniel, as an evidence of his power and loyalty; a seigneur who never lied, or was false to his word. God the Father, as feudal seigneur, absorbs the Trinity, and, what is more significant, absorbs or excludes also the Virgin, who is not mentioned in the prayer. To this seigneur, Roland in dying, proffered (puroffrit) his right-hand gauntlet. Death was an act of homage. God sent down his Archangel Gabriel as his representative to accept the homage and receive the glove. To Duke William and his barons nothing could seem more natural and correct. God was not farther away than Charlemagne.

Correct as the law may have been, the religion even at that time must have seemed to the monks to need professional advice. Roland's life was not exemplary. The "Chanson" had taken pains to show that the disaster at Roncesvalles was due to Roland's headstrong folly and temper. In dying, Roland had not once thought of these faults, or repented of his worldly ambitions, or mentioned the name of Alda, his betrothed. He had clung to the memory of his wars and conquests, his lineage, his earthly seigneur Charlemagne, and of "douce France." He had forgotten to give so much as an allusion to Christ. The poet regarded all these matters as the affair of the Church; all the warrior cared for was courage, loyalty, and prowess.

The interest of these details lies not in the scholarship or the historical truth or even the local colour, so much as in the art. The naïveté of the thought is repeated by the simplicity of the verse. Word and thought are equally monosyllabic. Nothing ever matched it.

<div align="right">HENRY ADAMS

Mont-Saint-Michel and Chartres (1913)</div>

HÉLOÏSE

1 1 0 1 ? — 1 1 6 4 ?

FAREWELL, MY ALL

To her master, nay father, to her husband, nay brother; his handmaid, nay daughter, his spouse, nay sister: to ABELARD, HELOISE.

Your letter written to a friend for his comfort, beloved, was lately brought to me by chance. Seeing at once from the title that it was yours, I began the more ardently to read it in that the writer was so dear to me, that I might at least be refreshed by his words as by a picture of him whose presence I have lost. Almost every line of that letter, I remember, was filled with gall and wormwood, to wit those that related the miserable story of our conversion, and thy unceasing crosses, my all. Thou didst indeed fulfil in that letter what at the beginning of it thou hadst promised thy friend, namely that in comparison with thy troubles he should deem his own to be nothing or but a small matter. After setting forth thy former persecution by thy masters, then the outrage of supreme treachery upon thy body, thou hast turned thy pen to the execrable jealousy and inordinate assaults of thy fellow-pupils also, namely *Alberic* of Rheims and *Lotulph* the Lombard; and what by their instigation was done to that famous work of thy theology, and what to thyself, as it were condemned to prison, thou hast not omitted.

From these thou comest to the machinations of thine Abbot and false brethren, and the grave detraction of thee by those two pseudo-apostles, stirred up against thee by the aforesaid rivals, and to the scandal raised by many of the name of Paraclete given to the oratory in departure from custom: and then, coming to those intolerable and still continuing persecutions of thy life, thou hast carried to the end the miserable story of that cruellest of extortioners and those wickedest of monks, whom thou callest thy sons. Which things I deem that no one can read or hear with dry eyes, for they renewed in fuller measure my griefs, so diligently did they express each several part, and increased them the more, in that thou relatedst that thy perils are still growing, so that we are all alike driven to despair of thy life, and every day our trembling hearts and throbbing bosoms await the latest rumour of thy death.

And so in His Name Who still protects thee in a certain measure for Himself, in the Name of Christ, as His handmaids and thine, we beseech thee to deign to inform us by frequent letters of those shipwrecks in which thou still art tossed, that thou mayest have us at least, who alone have remained to thee, as partners in thy grief or joy. For they are wont to bring some comfort to a grieving man who grieve with him, and any burden that is laid on several is borne more easily, or trans-

ferred. And if this tempest should have been stilled for a space, then all the more hasten thou to write, the more pleasant thy letter will be. But whatsoever it be of which thou mayest write to us, thou wilt confer no small remedy on us; if only in this that thou wilt shew thyself to be keeping us in mind.

For how pleasant are the letters of absent friends *Seneca* himself by his own example teaches us, writing thus in a certain passage to his friend *Lucilius:* "Because thou writest to me often, I thank thee. For in the one way possible thou shewest thyself to me. Never do I receive a letter from thee, but immediately we are together." If the portraits of our absent friends are pleasant to us, which renew our memory of them and relieve our regret for their absence by a false and empty consolation, how much more pleasant are letters which bring us the written characters of the absent friend. But thanks be to God, that in this way at least no jealousy prevents thee from restoring to us thy presence, no difficulty impedes thee, no neglect (I beseech thee) need delay thee.

Thou hast written to thy friend the comfort of a long letter, considering his difficulties, no doubt, but treating of thine own. Which diligently recording, whereas thou didst intend them for his comfort, thou hast added greatly to our desolation, and while thou wert anxious to heal his wounds hast inflicted fresh wounds of grief on us and made our former wounds to ache again. Heal, I beseech thee, the wounds that thou thyself hast given, who art so busily engaged in healing the wounds given by others. Thou hast indeed humoured thy friend and comrade, and paid the debt as well of friendship as of comradeship; but by a greater debt thou hast bound thyself to us, whom it behoves thee to call not friends but dearest friends, not comrades but daughters, or by a sweeter and a holier name, if any can be conceived.

As to the greatness of the debt which binds thee to us neither argument nor evidence is lacking, that any doubt be removed; and if all men be silent the fact itself cries aloud. For of this place thou, after God, art the sole founder, the sole architect of this oratory, the sole builder of this congregation. Nothing didst thou build here on the foundations of others. All that is here is thy creation. This wilderness, ranged only by wild beasts or by robbers, had known no habitation of men, had contained no dwelling. In the very lairs of the beasts, in the very lurking places of the robbers, where the name of God is not heard, thou didst erect a divine tabernacle, and didst dedicate the Holy Ghost's own temple. Nothing didst thou borrow from the wealth of kings or princes, when thou couldst have obtained so much and from so many, that whatsoever was wrought here might be ascribed to thee alone. Clerks or scholars flocking in haste to thy teaching ministered to thee all things needful, and they who lived upon ecclesiastical benefices, who knew not how to make but only how to receive oblations, and had hands

for receiving, not for giving, became lavish and importunate here in the offering of oblations.

Thine, therefore, truly thine is this new plantation in the divine plan, for the plants of which, still most tender, frequent irrigation is necessary that they may grow. Frail enough, from the weakness of the feminine nature, is this plantation; it is infirm, even were it not new. Wherefore it demands more diligent cultivation and more frequent, after the words of the Apostle: "I have planted, *Apollos* watered; but God gave the increase." The Apostle had planted, by the doctrines of his preaching, and had established in the Faith the Corinthians, to whom he wrote. Thereafter *Apollos,* the Apostle's own disciple, had watered them with sacred exhortations, and so by divine grace the increment of virtues was bestowed on them. Thou art tending the vineyard of another's vine which thou didst not plant, which is turned to thine own bitterness, with admonitions often wasted and holy sermons preached in vain. Think of what thou owest to thine own, who thus spendest thy care on another's. Thou teachest and reprovest rebels, nor gainest than aught. In vain before the swine dost thou scatter the pearls of divine eloquence. Who givest so much thought to the obstinate, consider what thou owest to the obedient. Who bestowest so much on thine enemies, meditate what thou owest to thy daughters. And, to say nothing of the rest, think by what a debt thou art bound to me, that what thou owest to the community of devoted women thou mayest pay more devotedly to her who is thine alone.

How many grave treatises in the teaching, or in the exhortation, or for the comfort of holy women the holy Fathers composed, and with what diligence they composed them, thine excellence knows better than our humility. Wherefore to no little amazement thine oblivion moves the tender beginnings of our conversion, that neither by reverence for God, nor by love of us, nor by the examples of the holy Fathers hast thou been admonished to attempt to comfort me, as I waver and am already crushed by prolonged grief. either by speech in thy presence or by a letter in thine absence. And yet thou knowest thyself to be bound to me by a debt so much greater in that thou art tied to me more closely by the pact of the nuptial sacrament; and that thou art the more beholden to me in that I ever, as is known to all, embraced thee with an unbounded love. Thou knowest, dearest, all men know what I have lost in thee, and in how wretched a case that supreme and notorious betrayal took me myself also from me with thee, and that my grief is immeasurably greater from the manner in which I lost thee than from the loss of thee.

And the greater the cause of grief, the greater the remedies of comfort to be applied. Not, however, by another, but by thee thyself, that thou who art alone in the cause of my grief may be alone in the grace of

my comfort. For it is thou alone that canst make me sad, canst make me joyful or canst comfort me. And it is thou alone that owest me this great debt, and for this reason above all that I have at once performed all things that you didst order, till that when I could not offend thee in any-thing I had the strength to lose myself at thy behest. And what is more, and strange it is to relate, to such madness did my love turn that what alone it sought it cast from itself without hope of recovery when, straight-way obeying thy command, I changed both my habit and my heart, that I might shew thee to be the one possessor both of my body and of my mind. Nothing have I ever (God wot) required of thee save thyself, desiring thee purely, not what was thine. Not for the pledge of matri-mony, nor for any dowry did I look, nor my own passions or wishes but thine (as thou thyself knowest) was I zealous to gratify.

And if the name of wife appears more sacred and more valid, sweeter to me is ever the word friend, or, if thou be not ashamed, concubine or whore. To wit that the more I humbled myself before thee the fuller grace I might obtain from thee, and so also damage less the fame of thine excellence. And thou thyself wert not wholly unmindful of that kind-ness in the letter of which I have spoken, written to thy friend for his comfort. Wherein thou hast not disdained to set forth sundry reasons by which I tried to dissuade thee from our marriage, from an ill-starred bed; but wert silent as to many, in which I preferred love to wedlock, freedom to a bond. I call God to witness, if *Augustus*, ruling over the whole world, were to deem me worthy of the honour of marriage, and to confirm the whole world to me, to be ruled by me for ever, dearer to me and of greater dignity would it seem to be called thy strumpet than his empress.

For it is not by being richer or more powerful that a man becomes better; one is a matter of fortune, the other a virtue. Nor should she deem herself other than venal who weds a rich man rather than a poor, and desires more things in her husband than himself. Assuredly, whom-soever this concupiscence leads into marriage deserves payment rather than affection; for it is evident that she goes after his wealth and not the man, and is willing to prostitute herself, if she can, to a richer. As the argument advanced (in *Aeschines*) by the wise *Aspasia to Xenophon* and his wife plainly convinces us. When the wise woman aforesaid had propounded this argument for their reconciliation, she concluded as follows: "For when ye have understood this, that there is not a better man nor a happier woman on the face of the earth; then ye will ever and above all things seek that which ye think the best; thou to be the husband of so excellent a wife, and she to be married to so excellent a husband." A blessed sentiment, assuredly, and more than philosophic, expressing wisdom itself rather than philosophy. A holy error and a blessed fallacy among the married, that a perfect love should preserve

their bond of matrimony unbroken, not so much by the continence of their bodies as by the purity of their hearts. But what error shews to the rest of women the truth has made manifest to me. Since what they thought of their husbands, that I, that the entire world not so much believed as knew of thee. So that the more genuine my love was for thee, the further it was removed from error.

For who among kings or philosophers could equal thee in fame? What kingdom or city or village did not burn to see thee? Who, I ask, did not hasten to gaze upon thee when thou appearedst in public, nor on thy departure with straining neck and fixed eye follow thee? What wife, what maiden did not yearn for thee in thine absence, nor burn in thy presence? What queen or powerful lady did not envy me my joys and my bed? There were two things, I confess, in thee especially, wherewith thou couldst at once captivate the heart of any woman; namely the arts of making songs and of singing them. Which we know that other philosophers have seldom followed. Wherewith as with a game, refreshing the labour of philosophic exercise, thou hast left many songs composed in amatory measure or rhythm, which for the suavity both of words and of tune being oft repeated, have kept thy name without ceasing on the lips of all; since even illiterates the sweetness of thy melodies did not allow to forget thee. It was on this account chiefly that women sighed for love of thee. And as the greater part of thy songs descanted of our love, they spread my fame in a short time through many lands, and inflamed the jealousy of many women against me. For what excellence of mind or body did not adorn thy youth? What woman who envied me then does not my calamity now compel to pity one deprived of such delights? What man or woman, albeit an enemy at first, is not now softened by the compassion due to me?

And, though exceeding guilty, I am, as thou knowest, exceeding innocent. For it is not the deed but the intention that makes the crime. It is not what is done but the spirit in which it is done that equity considers. And in what state of mind I have ever been towards thee, only thou, who hast knowledge of it, canst judge. To thy consideration I commit all, I yield in all things to thy testimony. Tell me one thing only, if thou canst, why, after our conversion, which thou alone didst decree, I am fallen into such neglect and oblivion with thee that I am neither refreshed by thy speech and presence nor comforted by a letter in thine absence. Tell me, one thing only, if thou canst, or let me tell thee what I feel, nay what all suspect. Concupiscence joined thee to me rather than affection, the ardour of desire rather than love. When therefore what thou desiredst ceased, all that thou hadst exhibited at the same time failed. This, most beloved, is not mine only but the conjecture of all, not peculiar but common, not private but public. Would that it seemed thus to me only, and thy love found others to excuse it, by whom

my grief might be a little quieted. Would that I could invent reasons by which in excusing thee I might cover in some measure my own vileness.

Give thy attention, I beseech thee, to what I demand; and thou wilt see this to be a small matter and most easy for thee. While I am cheated of thy presence, at least by written words, whereof thou hast an abundance, present to me the sweetness of thine image. In vain may I expect thee to be liberal in things if I must endure thee niggardly in words. Until now I believed that I deserved more from thee when I had done all things for thee, persevering still in obedience to thee. Who indeed as a girl was allured to the asperity of monastic conversation not by religious devotion but by thy command alone. Wherein if I deserve nought from thee, thou mayest judge my labour to have been vain. No reward for this may I expect from God, for the love of Whom it is well known that I did not anything. When thou hastenedst to God, I followed thee in the habit, nay preceded thee. For as though mindful of the wife of *Lot*, who looked back from behind him, thou deliveredst me first to the sacred garments and monastic profession before thou gavest thyself to God. And for that in this one thing thou shouldst have had little trust in me I vehemently grieved and was ashamed. For I (God wot) would without hesitation precede or follow thee to the Vulcanian fires according to thy word. For not with me was my heart, but with thee. But now, more than ever, if it be not with thee, it is nowhere. For without thee it cannot anywhere exist. But so act that it may be well with thee, I beseech thee. And well with thee will it be if it find thee propitious, if thou give love for love, little for much, words for deeds. Would that thy love, beloved, had less trust in me, that it might be more anxious! But the more confident I have made thee in the past, the more neglectful now I find thee. Remember, I beseech thee, what I have done, and pay heed to what thou owest me. While with thee I enjoyed carnal pleasures, many were uncertain whether I did so from love or from desire. But now the end shews in what spirit I began. I have forbidden myself all pleasures that I might obey thy will. I have reserved nothing for myself, save this, to be now entirely thine. Consider therefore how great is thine injustice, if to me who deserve more thou payest less, nay nothing at all, especially when it is a small thing that is demanded of thee, and right easy for thee to perform.

And so in His Name to whom thou hast offered thyself, before God I beseech thee that in whatsoever way thou canst thou restore to me thy presence, to wit by writing me some word of comfort. To this end alone that, thus refreshed, I may give myself with more alacrity to the service of God. When in time past thou soughtest me out for temporal pleasures, thou visitedst me with endless letters, and by frequent songs didst set thy *Heloise* on the lips of all men. With me every public place, each house resounded. How more rightly shouldst thou excite me now towards God,

whom thou excitedst then to desire. Consider, I beseech thee, what thou owest me, pay heed to what I demand; and my long letter with a brief ending I conclude. Farewell, my all.

Translated by C. K. Scott Moncrieff

Is there another such love-letter?

HENRY OSBORN TAYLOR
The Mediaeval Mind (1911)

THE ARCHPOET

? — C. 1165

DRINKING SONG

Meum est propositum in taberna mori,
Ut sint vina proxima morientis ori.
Tunc cantabunt letius angelorum chori:
'Sit deus propitius huic potatori'.

Poculis accenditur animi lucerna,
Cor inbutum nectare volat ad superna.
Mihi sapit dulcius vinum de taberna,
Quam quod aqua miscuit presulis pincerna.

Unicuique proprium dat natura munus.
Ego nunquam potui scribere ieiunus,
Me ieiunum vincere posset puer unus.
Sitim et ieiunium odi tanquam funus.

Unicuique proprium dat natura donum.
Ego versus faciens bibo vinum bonum,
Et quod habent purius dolia cauponum,
Tale vinum generat copiam sermonum.

Tales versus facio, quale vinum bibo,
Nihil possum facere nisi sumpto cibo;
Nihil valent penitus, quae ieiunus scribo,
Nasonem post calices carmine preibo.

Mihi nunquam spiritus poetriae datur,
Nisi prius fuerit venter bene satur;
Dum in arce cerebri Bachus dominatur,
In me Phebus irruit et miranda fatur.

301

In the public-house to die
 Is my resolution;
Let wine to my lips be nigh
 At life's dissolution:
That will make the angels cry,
 With glad elocution,
"Grant this toper, God on high,
 Grace and absolution!"

With the cup the soul lights up,
 Inspirations flicker;
Nectar lifts the soul on high
 With its heavenly ichor:
To my lips a sounder taste
 Hath the tavern's liquor
Than the wine a village clerk
 Waters for the vicar.

Nature gives to every man
 Some gift serviceable;
Write I never could nor can
 Hungry at the table;
Fasting, any stripling to
 Vanquish me is able;
Hunger, thirst, I liken to
 Death that ends the fable.

Nature gives to every man
 Gifts as she is willing;
I compose my verses when
 Good wine I am swilling,
Wine the best for jolly guest
 Jolly hosts are filling;
From such wine rare fancies fine
 Flow like dews distilling.

Such my verse is wont to be
 As the wine I swallow;
No ripe thoughts enliven me
 While my stomach's hollow;
Hungry wits on hungry lips
 Like a shadow follow,
But when once I'm in my cups,
 I can beat Apollo.

Never to my spirit yet
 Flew poetic vision
Until first my belly had
 Plentiful provision;
Let but Bacchus in the brain
 Take a strong position,
Then comes Phoebus flowing in
 With a fine precision.

Translated by John Addington Symonds

The finest drinking-song in the world.

DAVID C. DOUGLAS
The Development of Medieval Europe
in European Civilization (1935)

ADAM OF ST. VICTOR

1 1 3 0 — 1 1 8 0

SALVE, MATER

Salve, mater pietatis,
Et totius Trinitatis
 Nobile triclinium;
Verbi tamen incarnati
Speciale majestati
 Praeparans hospitium!

Hail to thee, oh mother of religion, noble triclinium of all Trinity, who prepares a special dwelling-place for the glory of the incarnate word!

Beneath the Abbey Church of Saint-Victor there was a crypt conse-crated to the Mother of God. Here a certain monk was wont to retire and compose hymns in her honour. One day his lips uttered the lines. . . . Whereupon a flood of light filled the crypt, and the Virgin, appearing to him, inclined her head.

The monk's name was Adam, and he is deemed the best of Latin hymn-writers.

HENRY OSBORN TAYLOR
The Mediaeval Mind (1911)

GLORIOUS KING

Reis glorios, verais lums e clartatz,
Deus poderos, senher, si a vos platz,
al meu companh siatz fizels aiuda,
qu'eu non lo vi, pois la noitz fon venguda;
 et ades sera l'alba.

Bel companho, si dormetz o veillatz?
non dormatz plus, suau vos ressidatz,
qu'en orien vei l'estela creguda
qu'amena.l iorn, qu'eu l'ai ben coneguda;
 et ades sera l'alba.

Bel companho, en chantan vos apel:
non dormatz plus, qu'en aug chantar l'auzel,
que vai queren lo iorn per lo boscatge;
et ai paor que.l gilos vos assatge;
 et ades sera l'alba.

Bel companho, issetz al fenestrel
et regardatz las ensenhas del cel;
conoisseretz si.us soi fizels messatge.
Si non o faitz, vostres n'er lo dampnatge;
 et ades sera l'alba.

Bel companho, pos me parti de vos,
eu no.m dormi ni.m moc de genelhos,
anz preguei Dieu, lo filh Santa Maria,
que.us mi rendes per leial companhia;
 et ades sera l'alba.

Bel companho, la foras als peiros
mi preiavatz qu'eu no fos dormilhos,
enans veilles tota noit tro al dia;
ara no.us platz mos chans ni ma paria;
 et ades sera l'alba.

Bel dos companh, tan soi en ric soiorn
qu'eu no volgra mais fos alba ni iorn,
car la gensor que anc nasques de maire,
tenc e abras, per qu'eu non prezi gaire
 lo fol gelos ni l'alba.

Glorious King, veritable light, true splendor, Powerful God, Lord, may it please you to be of faithful assistance to my companion; I have not seen him since the night came, and soon dawn will break.

My lovely companion, are you asleep or are you awake? Do not sleep any longer, softly awake: in the east I perceive the star is rising which brings in day, well do I recognize it: and soon dawn will break.

My lovely companion, I call on you with my song: sleep no longer, I hear the bird singing, while it seeks for the day through the forest: and I fear that the jealous one may catch you. And soon dawn will break.

My lovely companion, come to the window and gaze at the pennons in the sky! You will know whether I am giving you a truthful message; if you do not, you will be the loser; and soon dawn will break.

My lovely companion, since I departed from you, I have not slept nor stirred from my kneeling position, but I prayed to God, Holy Mary's son, to bring you back to me for faithful company; and soon dawn will break.

My lovely companion, out there, on the front stairs, you requested me that I should not desire sleep, but stay awake all the night until day; now neither my singing nor my company please you: and soon dawn will break.

Beautiful sweet companion, I am in such a rich dwelling-place, that I wish neither dawn nor day to come: since the most beautiful creature that ever was born of a mother I hold and embrace, so that I do not give a snap of my fingers for the foolish jealous one and the dawn.

Translated by Elio Gianturco

One of the great masterpieces of Provençal verse.

WARNER FORREST PATTERSON
Three Centuries of French Poetic Theory (1935)

RICHARD CŒUR DE LION

1 1 5 7 — 1 1 9 9

PRISON SONG

Ja nus hons pris ne dirat sa raison
 Adroitement s'ansi com dolans non;
 Mais par confort puet il faire chanson.
Moult ai d'amins, mais povre sont li don;
Honte en avront se por ma rëançon
 Suix ces deus yvers pris.

Ceu sevent bien mi home et mi baron,
　Englois, Normant, Poitevin et Gascon,
　　Ke je n'avoie si povre compaingnon
Cui je laissasse por avoir an prixon.
Je nel di pas por nulle retraison,
　Mais ancor suix je pris.

Or sai ge bien de voir certainement
　Ke mors ne pris n'ait amin ne parent,
　　Cant on me lait por or ne por argent.
Moult m'est de moi, mais plus m'est de ma gent
C'apres ma mort avront reprochier grant
　Se longement suix pris.

N'est pas mervelle se j'ai lo cuer dolent
　Cant li miens sires tient ma terre en torment.
　　S'or li menbroit de nostre sairement
Ke nos fëismes andui communament,
Bien sai de voir ke ceans longement
　Ne seroie pas pris.

Ce sevent bien Angevin et Torain,
　Cil bacheler ki or sont fort et sain,
　　C'ancombreis suix long d'aus en autrui main.
Forment m'amoient, mais or ne m'aimment grain.
De belles armes sont ores veut cil plain,
　Por tant ke je suix pris.

Mes compaingnons cui j'amoie et cui j'aim,
　Ces dou Caheu et ces dou Percherain,
　　Me di, chanson, kil ne sont pas certain,
C'onques vers aus n'en oi cuer faus ne vain.
S'il me guerroient, il font moult que vilain
　Tant com je serai pris.

Comtesse suer, vostre pris soverain
Vos saut et gart cil a cui je me claim
　Et par cui je suix pris.
Je n'ou di pas de celi de Chartain
　La meire Lowëis.

No prisoner can tell his honest thought
　Unless he speaks as one who suffers wrong;
　　But for his comfort he may make a song.
My friends are many, but their gifts are naught.
Shame will be theirs, if, for my ransom, here
　I lie another year.

They know this well, my barons and my men,
 Normandy, England, Gascony, Poitou,
 That I had never follower so low
Whom I would leave in prison to my gain.
I say it not for a reproach to them,
 But prisoner I am!

The ancient proverb now I know for sure:
 Death and a prison know nor kin nor tie,
 Since for mere lack of gold they let me lie.
Much for myself I grieve; for them still more.
After my death they will have grievous wrong
 If I am prisoner long.

What marvel that my heart is sad and sore
 When my lord torments my helpless lands!
 Well do I know that, if he held his hands,
Remembering the common oath we swore,
I should not here imprisoned with my song,
 Remain a prisoner long.

They know this well who now are rich and strong
 Young gentlemen of Anjou and Touraine,
 That far from them, on hostile bonds I strain.
They loved me much, but have not loved me long.
Their plains will see no more fair lists arrayed,
 While I lie here betrayed.

Companions whom I loved, and still do love,
 Geoffroi du Perche and Ansel de Caïeux,
 Tell them, my song, that they are friends untrue.
Never to them did I false-hearted prove;
But they do villainy if they war on me,
 While I lie here, unfree.

Countess sister! your sovereign fame
May he preserve whose help I claim,
 Victim for whom am I!
I say not this of Chartres' dame,
 Mother of Louis!

Translated by Henry Adams

One of the chief monuments of English literature.

HENRY ADAMS
Mont-Saint-Michel and Chartres (1913)

GEOFFROI DE VILLEHARDOUIN

C . 1 1 6 0 — C . 1 2 1 3

TO DARE DEFY THE EMPEROR

Ensique descendirent à la porte et entrerent el palais, et troverent l'empereor Alexi et l'empereor Sursac son père seanz en deus chaieres lez-à-lez. Et delez aus seoit l'empereris qui ere fame al pere et marastre al fil, et ere suer al roi de Hungrie, bele dame et bone. Et furent à grant plenté de haltes genz, et mult sembla bien corz à riche prince.

Par le conseil as autres messages mostra la parole Coenes de Betune, qui mult ere sages et bien enparlez: "Sire, nos somes à toi venu de par les barons de l'ost et de par le duc de Venise. Et saches tu que il te reprovent le grant servise que il t'ont fait, con la gens sevent et cum il est apparisant. Vos lor avez juré, vos et vostre peres, la convenance à tenir que vos lor avez convent; et vos chartes en ont. Vos ne lor avez mie si bien tenue com vos deussiez.

"Semont vos en ont maintes foiz, et nos vos en semonons, voiant toz voz barons, de par als, que vos lor taignoiz la convenance qui est entre vos et als. Se vos le faites, mult lor ert bel; et se vos nel faites, sachiez que dès hore en avant il ne vos tienent ne por seignor ne por ami; ainz porchaceront que il auront le leur en totes les manieres que il porront. Et bien vos mandent-il que il ne feroient ne vos ne altrui mal, tant que il l'aussent desfié; que il ne firent onques traïson, ne en lor terre n'est-il mie acostumé que il le facent. Vos avez bien oï que nos vos avons dit, et vos vos conseilleroiz si con vos plaira."

Mult tindrent li Gré à grant mervoille et à grant oltrage ceste desfiance; et distrent que onques mais nus n'avoit esté si ardiz qui ossast l'empereor de Constantinople desfier en sa chambre meismes.

They dismounted at the gate and entered the palace, and found the Emperor Alexius and the Emperor Isaac seated on two thrones, side by side. And near them was seated the empress, who was the wife of the father, and stepmother of the son, and sister to the King of Hungary— a lady both fair and good. And there were with them a great company of people of note and rank, so that well did the court seem the court of a rich and mighty prince.

By desire of the other envoys Conon of Béthune, who was very wise and eloquent of speech, acted as spokesman: "Sire, we have come to thee on the part of the barons of the host and of the Doge of Venice. They would put thee in mind of the great service they have done to thee —a service known to the people and manifest to all men. Thou hast sworn, thou and thy father, to fulfil the promised covenants, and they have your charters in hand. But you have not fulfilled those covenants

well, as you should have done. Many times have they called upon you to do so, and now again we call upon you, in the presence of all your barons, to fulfil the covenants that are between you and them. Should you do so, it shall be well. If not, be it known to you that from this day forth they will not hold you as lord or friend, but will endeavour to obtain their due by all the means in their power. And of this they now give you warning, seeing that they would not injure you, nor any one, without first defiance given; for never have they acted treacherously, nor in their land is it customary to do so. You have heard what we have said. It is for you to take counsel thereon according to your pleasure."

Much were the Greeks amazed and greatly outraged by this open defiance; and they said that never had any one been so hardy as to dare defy the Emperor of Constantinople in his own hall.

<div align="right">

Conquête de Constantinople (c. 1207)

Translated by Sir Frank Marzials

</div>

It is no exaggeration to say that it will subsist as long as the French language.

<div align="right">

GUSTAVE MASSON

Early Chroniclers of Europe: France (1879)

</div>

WALTHER VON DER VOGELWEIDE

C . 1 1 7 0 — C . 1 2 3 0

UNDER DER LINDEN

'Under der linden
an der heide,
dâ unser zweier bette was,
Dâ mugent ir vinden
schône beide
gebrochen bluomen unde gras.
Vor dem walde in einem tal,
tandaradei,
 schône sanc diu nahtegal

Ich kam gegangen
zuo der ouwe:
dô was mîn friedel komen ê.
Dâ wart ich enpfangen
hêre frouwe,

daz ich bin sælic iemer mê.
Kuster mich? wol tûsentstunt:
tandaradei,
 seht wie rôt mir ist der munt.

 Dô het er gemachet
alsô rîche
von bluomen eine bettestat.
Des wirt noch gelachet
inneclîche,
kumt iemen an daz selbe pfat.
Bî den rôsen er wol mac,
tandaradei,
 merken wâ mirz houbet lac.

 Daz er bî mir læge,
wessez iemen
(nu enwelle got!), sô schamt ich mich.
Wes er mit mir pflæge,
niemer niemen
bevinde daz, wan er unt ich,
Und ein kleinez vogellîn:
tandaradei,
 daz mac wol getriuwe sîn.’

TANDARADEI

Under the lindens on the heather,
There was our double resting-place,
Side by side and close together
Garnered blossoms, crushed, and grass
Nigh a shaw in such a vale:
Tandaradei,
Sweetly sang the nightingale.

I came a-walking through the grasses;
Lo! my dear was come before.
Ah! what befell then—listen, listen, lasses—
Makes me glad for evermore.
Kisses?—thousands in good sooth:
Tandaradei,
See how red they've left my mouth.

310

There had he made ready—featly, fairly—
All of flow'ring herbs a yielding bed,
And that place in secret still smiles rarely.
If by chance your foot that path should tread,
You might see the roses pressed,
Tandaradei,
Where e'enow my head did rest.

How he lay beside me, did a soul discover
(Now may God forfend such shame from me):
Not a soul shall know it save my lover;
Not a soul could see save I and he,
And a certain small brown bird:
Tandaradei,
Trust him not to breathe a word.

Translated by Ford Madox Ford

*Perhaps never has there been given a more perfect picture both of
girlish bashfulness and the daring of first love.*

KUNO FRANCKE
A History of German Literature (1901)

THOMAS OF CELANO?

1 2 0 0 ? — 1 2 5 5 ?

DIES IRAE

Dies irae, dies illa
solvet saeclum in favilla,
teste David cum Sibylla.

Quantus tremor est futurus,
quando judex est venturus
cuncta stricte discussurus.

Tuba mirum spargens sonum
per sepulcra regionum
coget omnes ante thronum.

Mors stupebit et natura,
cum resurget creatura
judicanti responsura.

Liber scriptus proferetur,
in quo totum continetur
unde mundus judicetur.

Judex ergo cum censebit.
quidquid latet, apparebit;
nil inultum remanebit.

Quid sum miser tunc dicturus,
quem patronum rogaturus,
dum vix justus sit securus?

Rex tremendae majestatis,
qui salvandos salvas gratis,
salva me, fons pietatis.

Recordare, Jesu pie,
quod sum causa tuae viae,
ne me perdas illa die.

Quaerens me sedisti lassus,
redemisti crucem passus;
tantus labor non sit cassus.

Juste judex ultionis,
donum fac remissionis
ante diem rationis.

Ingemisco tanquam reus,
culpa rubet vultus meus;
supplicanti parce, Deus.

Qui Mariam absolvisti
et latronem exaudisti,
mihi quoque spem dedisti;

Preces meae non sunt dignae,
sed tu, bonus, fac benigne,
ne perenni cremer igne.

Inter oves locum praesta
et ab haedis me sequestra
statuens in parte dextra;

Confutatis maledictis,
flammis acribus addictis,
voca me cum benedictis.

Oro supplex et acclinis,
cor contritum quasi cinis,
gere curam mei finis.

312

Lacrimosa dies illa,
qua resurget ex favilla
judicandus homo reus—
huïc ergo parce, Deus,

Pie Jesu domine,
dona eis requiem.

Day of wrath, the years are keeping,
When the world shall rise from sleeping,
With a clamour of great weeping!

Earth shall fear and tremble greatly
To behold the advent stately
Of the Judge that judgeth straitly.

And the trumpet's fierce impatience
Scatter strange reverberations
Thro' the graves of buried nations.

Death and Nature will stand stricken
When the hollow bones shall quicken
And the air with weeping thicken.

When the Creature, sorrow-smitten,
Rises where the Judge is sitting
And beholds the doom-book written.

For, that so his wrath be slakèd,
All things sleeping shall be wakèd,
All things hidden shall be naked.

When the just are troubled for thee,
Who shall plead for me before thee,
Who shall stand up to implore thee?

Lest my great sin overthrow me,
Let thy mercy, quickened thro' me,
As a fountain overflow me!

For my sake thy soul was movèd;
For my sake thy name reprovèd,
Lose me not whom thou hast lovèd!

Yea, when shame and pain were sorest,
For my love the cross thou borest,
For my love the thorn-plait worest.

By that pain that overbore thee,
By those tears thou weepest for me,
Leave me strength to stand before thee.

For the heart within me yearneth,
And for sin my whole face burneth;
Spare me when thy day returneth.

By the Magdalen forgiven,
By the thief made pure for heaven,
Even to me thy hope was given.

Tho' great shame be heavy on me,
Grant thou, Lord, whose mercy won me,
That hell take not hold upon me.

Thou whom I have lovèd solely,
Thou whom I have lovèd wholly,
Leave me place among the holy!

When thy sharp wrath burns like fire,
With the chosen of thy desire,
Call me to the crownèd choir!

Prayer, like flame with ashes blending,
From my crushed heart burns ascending;
Have thou care for my last ending.

Translated by Algernon Charles Swinburne

The grandest of medieval Latin poems.

STEPHEN GASELEE
The Oxford Book of Medieval Latin Verse (1928)

THIBAUT OF CHAMPAGNE

1 2 0 1 — 1 2 5 3

OH, GENTLE BEAUTY

Nus hom ne puet ami reconforter
Se cele non ou il a son cuer mis.
Pour ce m'estuet sovent plaindre et plourer
Que nus confors ne me vient, ce m'est vis,
De la ou j'ai tote ma remembrance.

314

Pour bien amer ai sovent esmaiance
 A dire voir.
Dame, merci! donez moi esperance
 De joie avoir.

Je ne puis pas sovent a li parler
Ne remirer les biaus iex de son vis.
Ce pois moi que je n'i puis aler
Car ades est mes cuers ententis.
Ho! bele riens, douce sans conoissance,
Car me mettez en millor attendance
 De bon espoir!
Dame, merci! donez moi esperance
 De joie avoir.

Aucuns si sont qui me vuelent blamer
Quant je ne di a qui je suis amis;
Mais ja, dame, ne saura mon penser
Nus qui soit nes fors vous cui je le dis
Couardement a pavours a doutance
Dont puestes vous lors bien a ma semblance
 Mon cuer savoir.
Dame, merci! donez moi esperance
 De joie avoir.

There is no comfort to be found for pain
Save only where the heart has made its home.
Therefore I can but murmur and complain
Because no comfort to my pain has come
From where I garnered all my happiness.
From true love have I only earned distress
 The truth to say.
Grace, lady! give me comfort to possess
 A hope, one day.

Seldom the music of her voice I hear
Or wonder at the beauty of her eyes.
It grieves me that I may not follow there
Where at her feet my heart attentive lies.
Oh, gentle Beauty without consciousness,
Let me once feel a moment's hopefulness,
 If but one ray!
Grace, lady! give me comfort to possess
 A hope, one day.

Certain there are who blame upon me throw
Because I will not tell whose love I seek;
But truly, lady, none my thought shall know,
None that is born, save you to whom I speak
In cowardice and awe and doubtfulness,
That you may happily with fearlessness
 My heart essay.
Grace, lady! give me comfort to possess
 A hope, one day.

Translated by Henry Adams

Thibaut is said to have painted his verses on the walls of his château. If he did, he painted there, in the opinion of M. Gaston Paris, better poetry than any that was written on paper or parchment, for Thibaut was a great prince and great poet who did in both characters whatever he pleased. In modern equivalents, one would give much to see the château again with the poetry on its walls. Provins has lost the verses, but Troyes still keeps some churches and glass of Thibaut's time which hold their own with the best. Even of Thibaut himself, something survives, and though it were only the memories of his seneschal, the famous Sire de Joinville, history and France would be poor without him. With Joinville in hand, you may still pass an hour in the company of these astonishing thirteenth-century men and women:— crusaders who fight, hunt, make love, build churches, put up glass windows to the Virgin, buy missals, talk scholastic philosophy, compose poetry; Blanche, Thibaut, Perron, Joinville, Saint Louis, Saint Thomas, Saint Dominic, Saint Francis—you may know them as intimately as you can ever know a world that is lost; and in the case of Thibaut you may know more, for he is still alive in his poems; he even vibrates with life. . . .

Does Thibaut's verse sound simple? It is the simplicity of the thirteenth-century glass—so refined and complicated that sensible people are mostly satisfied to feel, and not to understand. Any blunderer in verse, who will merely look at the rhymes of these three stanzas, will see that simplicity is about as much concerned there as it is with the windows of Chartres; the verses are as perfect as the colours, and the versification as elaborate.

HENRY ADAMS
Mont-Saint-Michel and Chartres (1913)

316

SAINT THOMAS AQUINAS

1 2 2 5 ? — 1 2 7 4

HYMN FOR CORPUS CHRISTI DAY

Pange, lingua, gloriosi
corporis mysterium
sanguinisque pretiosi
quem in mundi pretium
fructus ventris generosi
rex effudit gentium.

Nobis datus, nobis natus
ex intacta virgine
et in mundo conversatus
sparso verbi semine
sui moras incolatus
miro clausit ordine.

In supremae nocte cenae
recumbens cum fratribus,
observata lege plene
cibis in legalibus
cibum turbae duodenae
se dat suis manibus.

Verbum-caro panem verum
verbo carnem efficit,
fitque sanguis Christi merum
et, si sensus deficit,
ad firmandum cor sincerum
sola fides sufficit.

Tantum ergo sacramentum
veneremur cernui,
et antiquum documentum
novo cedat ritui;
praestet fides supplementum
sensuum defectui.

Genitori genitoque
laus et jubilatio,
salus, honor, virtus quoque
sit et benedictio,
procedenti ab utroque
compar sit laudatio.

Of the glorious Body telling,
O my tongue, its mysteries sing,
And the Blood, all price excelling,
Which the world's eternal King,
In a noble womb once dwelling,
Shed for this world's ransoming.

Given for us, for us descending,
Of a Virgin to proceed,
Man with man in converse blending,
Scattered he the Gospel seed,
Till his sojourn drew to ending,
Which he closed in wondrous deed.

At the last great Supper lying
Circled by his brethren's band,
Meekly with the law complying,
First he finished its command,
Then, immortal Food supplying,
Gave himself with his own hand.

Word made Flesh, by word he maketh
Very bread his Flesh to be;
Man in wine Christ's Blood partaketh:
And if senses fail to see,
Faith alone the true heart waketh
To behold the mystery.

Therefore we, before him bending,
This great Sacrament revere;
Types and shadows have their ending,
For the newer rite is here;
Faith, our outward sense befriending,
Makes the inward vision clear.

Glory let us give, and blessing
To the Father, and the Son;
Honour, might, and praise addressing,
While eternal ages run;
Ever too his love confessing,
Who, from both, with both is one.

Translated by J. M. Neale, E. Caswall and others

The greatest poet in the Latin language of the whole Middle Ages.
ÉTIENNE GILSON
Le Thomisme (1927)

THE FALL OF THE NIBELUNGS

Alsô der küene Dancwart under die türe getrat,
daʒ Ezeln gesinde er hôher wîchen bat.
mit bluote berunnen was alleʒ sîn gewant:
ein vil starkeʒ wâfen daʒ truoger blôʒ an sîner hant.

Eʒ was reht in der wîle, dô er kom für die tür,
daʒ man Ortlieben truoc wider unde für
von tische ze tischen den fürsten wol geborn:
von disen starken mæren wart daʒ kindelîn verlorn.

Vil lûte rief dô Dancwart eime degene
'ir sitzet al ze lange, bruoder Hagene.
iu unt got von himele klage ich unser nôt:
ritter unde knehte sint in der herberge tôt.'

Er rief im engegene 'wer hât daʒ getân?'
'daʒ hât der herre Blœdel unde sîne man:
ouch hât ers niht genoʒʒen, daʒ wil ich iu sagen;
ich hân im sîn houbet mit mînen handen abe geslagen.

'Daʒ ist ein schade kleine,' —sprach aber Hagene—
'swâ man solhiu mære saget von degene:
ob er von recken handen verliuset sînen lîp,
in suln deste ringer klagen wætlîchiu wîp.

Nu saget mir, lieber bruoder, wie sît ir sô rôt ?
ich wæn ir von wunden lîdet grôʒe nôt.
ist er inder inme lande, derʒ iu hât getân?
in erner der übel tiufel, eʒ muoʒ im an sîn leben gân.'

'Ir seht mich wol gesunden, mîn wât ist bluotes naʒ:
von ander manne wunden ist mir geschehn daʒ,
der ich alsô manegen hiute hân erslagen,
ob ich des swern solde, ine kündeʒ nimmer gesagen.'

Er sprach 'bruoder Dancwart, sô hüetet uns der tür,
unt enlât der Hiunen einen komen niht der für:
ich wil reden mit den recken, des uns nu dwinget nôt:
unser ingesinde lît unverdienet hie tôt.'

'Sol ich sîn kamerære,' —sprach dô der küene man—
'alsô rîchen künegen ich wol gedienen kan:

319

sô hüet ich der stiegen nâch den êren mîn.
den Kriemhilde degenen kunde leider niht gesîn.

'Mich nimt des michel wunder,' —sprach dô Hagene—
'waȥ die recken rûnen in disem gademe:
si wæn des lîhte enbæren, der an der tür dort stât
unt ouch diu hovemære gesaget den Burgonden hât.

Ich hân gehôrt vil lange von Kriemhilde sagen,
daȥ si ir herzen leide wolde niht vertragen:
nu trinken wir die minne unt gelten süneges wîn,
der junge vogt der Hiunen der muoȥ hie der êrste sîn.'

Dô sluoc daȥ kint Ortlieben Hagen der helt guot,
daȥ im an dem swerte zer hende vlôȥ daȥ bluot
unt daȥ des kindes houbet spranc Kriemhilt in ir schôȥ
dô huop sich under degenen ein mort vil grimmec unde grôȥ

Ouch sluoger dem magezogen einen swinden slac
mit beiden sînen handen, der Ortliebes pflac,
daȥ im daȥ houbet schiere vor tischen nider lac:
eȥ was ein jæmerlîcher lôn, den er dem magezogen wac.

Er sach vor Ezeln tische einen spilman:
Hagen in sîme zorne gâhen dar began.
er sluog im ûf der videlen ab die einen hant:
'daȥ habe der boteschefte in der Burgonden lant.'

'Owê mir'—sprach Werbel, der Ezeln spilman—
'her Hagene von Tronege, waȥ hêt ich iu getân?
ich kom ûf grôȥe triuwe in iwer herren lant.
wie klenke ich nu die dœne, sît ih nu vlorn hân die hant?'

Hagenen ahte ringe, gevidelter nimmer mêr.
dô frumt er in dem hûse diu wercgrimmen sêr
an den Ezelen recken, der er sô manegen sluoc:
er brâht ir in dem gademe zuo dem tôde genuoc.

Volkêr sîn geselle von dem tische spranc:
sîn videlboge im lûte an sîner hende erklanc.
dô videlte ungefüege der künege spilman.
hey, waȥ er im ze vînden der küenen Hiunen gewan!

Dô sprungen von den tischen die drîe künege hêr:
si woldenȥ gerne scheiden ê des schaden würde mêr.
sine kundenȥ mit ir sinnen dô niht understân,
dô Volkêr unde Hagene sô sêre wüeten began.

Dô sach der vogt von Rîne ungescheiden den strît:
dô sluoc der fürste selbe vil manege wunden wît

durch die liehten ringe den vîanden sîn.
er was ein helt zen handen, daz wart dâ grœzlîchen schîn.

Dô kom ouch zuo dem strîte der starke Gêrnôt:
jâ frumt er den Hiunen vil manegen helt tôt
mit dem scharpfen swerte, daz im gap Rüedegêr.
den Ezeln mâgen frumter diu grœzlîchen sêr.

Der junge sun froun Uoten zuo dem strîte spranc:
sîn wâfen herrenlîche durch die helme erklanc
den Ezeln recken ûzer Hiunen lant.
dâ tet vil michel wunder mit strît diu Gîselheres hant.

Swie frum si alle wæren, die künege unt ouch ir man,
doch sah man Gîselhere ze vordereste stân
bî den vîanden: er was ein helt guot;
er schuof dâ mit den wunden vil manegen nider in daz bluot.

Ouch werten sich vil sêre die Ezeln man:
dô sah man die geste houwende gân
mit den liehten swerten durch des küneges sal.
dô hôrt man allenthalben von strîte grœzlîchen schal.

Dô wolden die dar ûzen mit friunden sîn dar in:
si nâmen an der stiegen vil kleinen gewin:
dô wolden si dar inne vil gerne für die tür;
done lie der portenære ir deheinen dar für.

Dô huop sich in der porte vil grôzer der gedranc,
unt ouch von den swerten ûf helme lûter klanc:
des kom der küene Dancwart in vil starke nôt.
daz bedâhte Hagene, als im sîn triuwe gebôt.

Vil lûte rief dô Hagene Volkêren an:
'seht ir dort, geselle, mînen bruoder stân
vor hiunischen recken under starken slegen?
friunt, nert mir den bruoder ê wir vliesen den degn.'

'Daz tuon ich sicherlîchen,' sprach der spilman.
er begunde videlende durch den palas gân.
ein scharpfez swert im dicke an sîner hende erklanc:
die recken von dem Rîne sagten im des grôzen danc.

Volkêr der vil küene zuo Dancwarte sprach
'ir habt erliten hiute grôzen ungemach:
mich bat iwer bruoder durch helfe zuo ziu gân.
welt ir nu sîn dar ûze, sô wil ich inrethalben stân.'

Dancwart der vil snelle stuont ûzerhalb der tür:
dô wert er in die stiegen, swaz ir kom der für.

321

des hôrt man wâfen hellen an der helede hant.
sam tet ouch inrethalben Volkêr von Buregonden lant.

Der küene videlære rief zuo dem degene
'daz hûs ist wol beslozzen, friunt Hagene.
ez ist alsô verschranket diu Ezeln tür
von zweier recken handen: dâ gênt wol tûsent rigel für

Dô der starke Hagene die tür sô sach behuot,
den schilt warf dô zerucke der küene degen guot:
dô êrst begunder rechen sîner friunde leit.
sîns zornes muose engelten vil manec ritter gemeit.

Dô der voget von Berne daz wunder reht ersach,
daz Hagene der starke sô manegen helm brach,
der künec der Amelunge spranc ûf einen banc:
er sprach 'hie schenket Hagene daz aller wirsiste tranc.

Der wirt hêt grôze sorge, sîn wîp diu hêt alsam
—waz man im lieber friunde vor sînen ougen nam!—
wand er von sînen vînden vil kûme dâ genas:
er saz vil angestlîche. waz half in daz er künec was?

Kriemhilt diu frouwe rief Dietrîchen an:
'nu hilf mir von dem sedele, ritter, von in dan,
durch aller fürsten tugende, ûz Amelunge lant:
unt erreichet mich dort Hagene, ich hân den tôt an der hant

'Wie sol ich iu gehelfen?' —sprach dô Dietrîch—
'vil edeliu küneginne, nu sorge ich umbe mich:
ez sint sô sêre erzürnet die Gunthers man,
daz ich an disen zîten gevriden niemen enkan.'

'Neinâ, herre Dietrîch, vil edel ritter guot,
lâzâ hiute schînen den tugentlîchen muot,
daz du mir helfest hinnen: oder ich belîbe tôt.
nu hilf mir unt dem künege ûz dirre angestlîcher nôt.'

'Daz wil ich versuochen, ob ich iu helfen kan;
wande ich in langen zîten niht gesehn hân
sô pitterlîch erzürnet manegen ritter guot.
jâ sihe ich durch die helme von swerten vliezen daz bluot

Mit kraft begunde ruofen der degn ûz erkorn,
daz im sîn stimme erlûte alsam ein wisents horn,
unt daz der palas wîte von sîner kraft erdôz:
diu sterke Dietrîches waz vil unmæzlîche grôz.

Dô gehôrte Gunther ruofen disen man.
in dem starken sturme losen er began:

er sprach 'Dietrîches stimme ist in mîn ôre komen;
ich wæn im unser degene haben etewen hie benomen.

Ich sihe in ûf dem tische, er winket mit der hant.
ir friunt unde mâge von Burgonden lant,
gehabt ûf des strîtes, lât hœren unde sehn,
waz hie Dietrîche von uns ze schaden sî geschehn.'

Dô der künec Gunther bat unt ouch gebôt,
si habten ûf mit swerten in des sturmes nôt:
daz was gewalt vil grôzer, daz dô niemen streit.
dô reiten mit einander die küenen recken gemeit.

Er sprach 'vil edel Dietrîch, waz ist iu hie getân
von den mînen mâgen? willen ich des hân,
suone unde buoze bin ich iu bereit:
swaz iu iemen tæte, daz wær mir inneclîchen leit.'

Dô sprach der herre Dietrîch 'mir ist noch niht getân,
des ich schaden deheinen von iu müge hân:
wan lât mih von dem strîte mit dem gesinde mîn,
daz wil ich umbe iuch degene immer dienende sîn.'

'Wie vlêget ir sô sêre?' —sprach dô Wolfhart—
'jane hât der videlære die tür nie sô verspart,
wir entsliezen si sô wîte, daz wir dar für gân.'
'nu swîget,'—sprach her Dietrîch— 'ir habt den tiufel getân

Dô sprach der künec Gunther 'erlouben ich iu wil,
füeret ûz dem hûse lützel oder vil,
âne mîne vînde: die suln hie bestân.
si habent mir zen Hiunen harte leides vil getân.'

Der herre von Berne under einen arm beslôz
die edeln küneginne: der angest diu was grôz.
dô fuort er anderthalben Ezeln mit im dan.
ouch giengen mit im dannen sehs hundert sîner küener man

Dô sprach der marcgrâve, der edel Rüedegêr,
'sol aber ûzem hûse iemen komen mêr,
die iu doch dienen gerne, daz lâzet uns vernemen,
sô sol ouch fride der stæte guoten friunden immer zemen.

Des antwurte Gîselher sîme sweher zehant
'vride unde suone sî iu von uns bekant:
sît ir sît triwen stæte, beide ir unt iwer man
sult gemeinlîche mit iwern friunden hinnen gân.'

Dô der marcgrâve gerûmte den sal
fünf hundert unde mêre im volgten zetal

die stiegen von dem hûse: daʒ wâren sîne man;
von den der künec Gunther vil grôʒen schaden sît gewan

Dô sach ein Hiunen recke Ezelen gân
bî dem Bernære: genoʒʒen wolders hân.
dem gap der videlære einen swæren slac,
daʒ im vor Ezeln füeʒen daʒ houbet schiere gelac.

Dô der wirt des landes kom von dem hûse dan,
dô kêrte er sich hin widere unt sach Volkêren an:
'owê mir dirre geste! daʒ ist ein grimmiu nôt,
daʒ alle mîne friunde suln vor in ligen tôt.'

'Ach wê der hôchgezîte:' —sprach der künec hêr—
'dâ vihtet einer inne, der heiʒet Volkêr,
alsam ein eber wilde, unt ist ein spilman:
ich dankes mîme heile, daʒ ich dem vâlande entran.

Sîne leyche lûtent übele, sîne züge die sint rôt:
jâ vellent sîne dœne vil manegen helt tôt.
ine weiʒ niht waʒ uns wîʒe der selbe spilman,
wan ich gast neheinen nie sô leiden gewan.'

Zir herbergen giengen die recken alsô hêr,
der herre von Berne unt ouch Rüedegêr:
sine wolden mit dem strîte niht ze schaffen hân
unt gebuten ouch ir degenen, daʒ sis mit fride solden lân

Unt hêten si getrouwet alsolher swære,
daʒ in diu von in beiden sô künftec wære,
sine wæren von dem hûse niht sô sanfte komen:
si hêten eine stroufe an den vil küenen ê genomen.

Sie hêten die si wolden lâʒen ûʒ dem sal.
dô huop sich inrethalben ein grœʒlîcher schal:
die geste sêre râchen daʒ in ê geschach.
Volkêr der vil küene, hey, waʒ er liehter helme brach!

Sich kêrte gein dem schalle Gunther, der künec hêr:
'hœrt ir die dœne, Hagene, die dort Volkêr
mit den Hiunen videlet, swer gegen der tür gât?
eʒ ist ein rôter anstrich, den er zem videlbogen hât.'

'Mich riwet âne mâʒe,' —sprach dô Hagene—
'daʒ ich vor Volkêre ie gesaʒ dem degene:
ich was ie sîn geselle unt ouch er der mîn,
unt kom wir immer widere, daʒ suln wir noch mit triwen sîn

Nu schowe, künec Gunther, Volkêr ist dir holt:
er dienet willeclîche dîn silber unt dîn golt.

sîn videlboge im snîdet durch den herten stâl:
er brichet ûf den helmen diu liehte schînenden mâl.

Man gesach nie videlære sô hêrlîchen stân,
alsô der degen Volkêr hiute hât getân:
die sînen leyche hellent durch helm unt durch den rant:
jâ sol er rîten guotiu ros unt tragen hêrlîch gewant.'

Swaz der Hiunen mâge in dem hûse was gewesen,
der enwas nu deheiner dar inne genesen:
des was der schal geswiftet, daz niemen mit in streit.
diu swert von handen legeten die küenen degene gemeit

Die herren nâch ir müede gesâzen dô zetal:
Volkêr unde Hagene die giengen für den sal:
sich leinten ûf die schilde die übermüeten man:
dâ wart rede genuoge von in beiden getân.

Dô sprach von Burgonden Gîselher der degen
'jane mügt ir, lieben friunde, niht ruowe noch gepflegen
ir sult die tôten liute ûz dem hûse tragen.
wir werden noch bestanden; ich wilz iu wærlîche sagen.

'Sô wol mich solhes herren:' —sprach dô Hagene—
'der rât enzæme niemen wan eime degene,
den uns mîn junger herre hiute hât getân:
des mugt ir Burgonden alle vrœlîche stân.'

Dô volgeten si dem kinde unt truogen für die tür
wol zwei tûsent tôten wurfen si der für:
vor des sales stiegen vielen si zetal.
dô huop sich von ir mâgen ein vil klagelîcher schal.

Ez was ir etelîcher sô mæzlîche wunt,
der sîn mit helfe pflæge, er würde noch gesunt,
der von dem hôhen valle muose ligen tôt.
die klagten dô ir friunde; des twanc si jâmerhaftiu nôt.

Dô sprach der videlære, ein recke vil gemeit,
'nu kiuse ich des die wârheit, als man mir hât geseit:
die Hiunen sint vil bœse, si klagent sam diu wîp:
nu solden si beruochen der vil sêre wunder lîp.'

Dô wânde ein marcgrâve er reit ez durch guot:
er sach einen sînen mâc gevallen in daz bluot,
er beslôz in mit den armen unt wolde in tragen dan:
den schôz ob im ze tôde der vil küene spilman.

Dô d'andern daz gesâhen, diu fluht huop sich von dan:
si begunden alle fluochen dem selben spilman.

noh huober under füeʒen einen gêr vil hart,
der von eime Hiunen in daʒ hûs geschoʒʒen wart.

Den schôʒ er dô hin widere durch die burc dan
mit sîner kraft sô verre: den Ezelen man
gab er herberge ûf hôher von dem sal.
daʒ sîn vil starkeʒ ellen die liute vorhten über al.

Dô stuonden vor dem hûse Ezel unt sîne man:
Volkêr unde Hagene reden dô began
mit der Hiunen künege ir willen unde muot.
des kômen sît in sorgen die helede küen unde guot.

'Eʒ zæme'—sô sprach Hagene— 'vil wol, volkes trôst,
daʒ die herren væhten zaller vorderôst,
alsô der künec Gunther unt Gêrnôt hie tuot:
die howent durch die helme, nâch swerten vliuʒet daʒ bluot.

Ezele was sô küene, er vaʒʒete sînen schilt.
'nu vart gewerlîche,' —sprach mîn frou Kriemhilt—
unt bietet ir den recken daʒ golt über rant:
wan erreichet iuch dort Hagene, ir habt den tôt an der hant.'

Done wolde der künec hêre des strîtes erwinden niht,
daʒ von sô rîchen fürsten selten nu geschiht:
man muos in bî dem veʒʒel wider ziehen dan.
Hagene der grimme sîn aber spotten began.

'Eʒ was ein nâhiu sippe,' —sprach dô Hagene—
'die Sîvrit unde Ezele hêten zesamene:
er minnete Kriemhilt, ê si ie gesæhe dich.
künec vil bœse, warumbe rætest an mich?'

Dise rede hôrte wol des küneges wîp:
des wart vil unmuotes der Kriemhilde lîp,
daʒ er si torste schelten vor Ezelen man.
dar umbe si aber râten an die geste began.

Si sprach 'der mir von Tronege Hagenen slüege
unde mir sîn houbet ze gibe trüege,
dem fult ich rôtes goldes den Ezeln rant.
ouch gæb ich im ze miete vil guote bürge unde lant.'

'Nune weiʒ ich wes si bîtent,' —sprach der spilman—
'ine gesach nie helde mêre sô zagelîche stân
dâ man hôrte bieten sô rehte rîchen solt:
si möhten gerne dienen die bürge unt ouch daʒ rôte golt.

Ezele der vil rîche hête jâmer unde nôt:
er klagte pitterlîche mâge unde manne tôt.

326

dâ stuont von manegen landen vil recken gemeit;
die weinten mit dem künege sîniu kreftigen leit.

Des begunde spotten der küene Volkêr:
'ich sihe hie sêre weinen vil manegen recken hêr:
si gestênt ir herren übele in sîner starken nôt.
jâ ezzent si mit schanden nu vil lange hie sîn brôt.'

Dô gedâhten in die besten 'er hât uns wâr geseit.'
doch enwas ez dâ niemen sô herzenlîche leit
als ouch Iringe, dem helede ûz Tenelant:
daz man in kurzen zîten mit der wârheit wol bevant.

Dô rief von Tenemarke der marcgrâve Irinc
'ich hân ûf êre lâzen nu lange mîniu dinc,
unt hân in volkes stürmen des besten vil getân.
nu brinc mir mîn gewæfen: jâ wil ich Hagenen bestân.'

'Daz wil ich widerrâten,' —sprach dô Hagene—
'sô gewinnent iwer mâge mêr ze klagene.
gespringent iwer zwêne oder drî zuo mir her in,
ist daz si mîn erbîtent, si scheident schedelîche hin.'

'Darumbe ihz niht enlâze:' —sprach aber Irinc—
'ich hân ouch ê versuochet sam sorclîchiu dinc.
jâ wil ich mit dem swerte aleine dich bestân,
ob du mit strîte hêtest mêr danne iemen getân.'

Dô wart gewâfent Irinc nâch ritterlîcher sit,
alsam wart von Düregen der lantgrâve Irnfrit
unt Hâwart der starke, wol mit tûsent man:
swes Irinc begunde, si woldens alle im gestân.

Dô sach der videlære eine grôze schar,
die mit Iringe gewâfent kômen dar:
si truogen ûf gebunden vil manegen helm guot.
des wart der küene Volkêr ein teil vil zornec gemuot.

Er sprach 'seht ir, Hagene, dort Iringen gân,
der iuch hie mit dem swerte lobt eine bestân?
wie zimt helede lügene? ich wil unprîsen daz:
ez gênt mit im gewâfent wol tûsent recken oder baz.'

'Nu heizet mich niht liegen:' —sprach Hâwartes man—
'ich wil ez leisten gerne, swaz ich gelobet hân:
durch deheine vorhte wil ihs abe gân,
swie vreislîch nu sî Hagene, ich wil in eine bestân.'

Ze füezen bôt sich Irinc mâgen unde man,
daz s'in eine liezen den recken bestân.

daz tâten si ungerne: wan in was wol bekant
der übermüete Hagene ûzer Burgonden lant.

Doch bat er si sô lange, daz ez sît geschach:
dô daz ingesinde den willen sîn ersach,
daz er warp nâch êren, dô liezen si in gân.
dô wart ein grimmez strîten von in beiden dâ getân.

Irinc der vil starke hôhe erburt den gêr:
den schilt er für sich zuchte, der tiure degen hêr.
dô lief er ûz zuo Hagene vaste für den sal:
dô huop sich von den degenen ein vil grœzlîcher schal.

Dô schuzzen si die gêre mit kreften von der hant
durch die vil vesten schilde ûf liehtez ir gewant,
daz die gêrstangen vil hôhe dræten dan:
dô griffen zuo den swerten die vil grimme küenen man.

Des starken Hagenen ellen was unmâzen grôz:
ouch sluoc ûf in Irinc, daz al diu burc erdôz;
palas unde türne erhullen nâch ir slegen.
done kunde niht verenden des sînen willen der degen.

Irinc lie dô Hagenen unverwundet stân.
zuo dem videlære gâhen er begau:
er wânde in solde twingen mit den grimmen slegen.
sich kunde wol beschirmen der vil zierlîche degen.

Dô sluoc der videlære, daz über schildes rant
dræte daz gespenge von Volkêres hant.
den liez er dô belîben: er was ein übel man.
er lief den künec Gunther dâ von Buregonden an.

Dô was ir ietwedere ze strîte starc genuoc.
swaz Gunther unde Irinc ûf ein ander sluoc,
daz enbrâhte niht von wunden daz vliezende bluot:
daz behuote ir gewæfen; daz was veste unde guot.

Gunthern er lie belîben, Gêrnôten lief er an:
daz fiur ûzen ringen er howen im began.
dô hête von Burgonden der starke Gêrnôt
den küenen Iringen vil nâch gesendet in den tôt.

Dô spranger von dem fürsten: snel er was genuoc
der Burgonden viere der helt vil schiere sluoc
des edeln ingesindes von Wormez über Rîn:
done kunde Gîselhere zorner nimmer gesîn.

'Gotweiz, her Irinc,' —sprach Gîselher daz kint—
'ir müezet mir die gelten, die veige vor iu sint

328

gelegen hie ze stunden.’ dô lief er in an:
er sluoc den von Tenemarke, daz er strûchen begam.

Er schôz vor sînen füezen nider in daz bluot,
daz si alle wolden wænen, daz der helt guot
ze strîte nimmer mêre geslüege keinen slac:
Irinc noch âne wunden hie vor Gîselhere lac.

Von des helmes dôze unt von des swertes klanc
wâren sîne witze worden alsô kranc,
daz sich der degen Irinc des lebenes niht versan:
daz hêt mit sîner sterke der küene Gîselher getân.

Dô im begunde wîchen von houbte der dôz
—von helm unt ouch von swerte der was gewesen grôz—,
er dâhte ‘ih bin noch lebende, mîn lîp ist ninder wunt:
nu ist mir aller êrste daz ellen Gîselhers kunt.’

Dô hôrter beidenhalben die vîande stân.
hêten siz gewisset, im wære mêr getân:
ouch hêt er Gîselhere dâ bî im vernomen.
er dâhte wie er solde mit dem lîbe dannen komen.

Wie rehte tobelîche er ûzem bluote spranc!
der sîner snelheite er mohte sagen danc.
dô lief er ûzem hûse da er aber Hagenen vant,
unt sluog im slege swinde mit sîner ellenthafter hant.

Dô gedâht ouch Hagene ‘du solt der mîne wesen;
dich enner der übel tiufel, du enkanst nu niht genesen.
doch wundet Irinc Hagenen durch sînen helmhuot:
daz tet der helt mit Wasechen, daz was ein wâfen alsô guot.

Dô der grimme Hagene der wunden enpfant,
do erwagt im ungefuoge daz swert an sîner hant.
aldâ muose im entwîchen der Hâwartes man:
ze tal von dem hûse Hagene volgen im begam.

Irinc über houbet den schilt vil balde swanc:
unt wær diu selbe stiege drîer stiegen lanc,
dône liez in Hagene slahen deheinen slac.
hey, waz rôter vanken ob sîme helme gelac!

Dô sâhen sîne friunde Iringen noch gesunt.
dô wurden disiu mære Kriemhilde kunt,
waz er dem von Tronege mit strîte hête getân:
des im diu küneginne hôhe danken begam.

‘Nu lône dir got, Irinc, vil mærer helt guot:
du hâst mir wol getrœstet daz herze unt ouch den muot.

nu sihe ich Hagene rôteʒ von bluote sîn gewant.'
dô nam si im selbe den schilt vor liebe von der hant.

'Ir mugt im mâʒe danken:' —sprach dô Hagene—
'jâ ist noch harte kleine dâ von ze sagene.
unt wolt erʒ noch versuochen, sô wær er küen ein man.
diu wunde frumt iuch kleine, die ich von im gewunnen hân.

Daʒ ir von mîner wunden die ringe sehet rôt,
daʒ hât mich erreizet ûf maneges mannes tôt:
ich bin alrêrste erzürnet ûf in unt manegen man.
mir hât der degen Irinc schaden kleinen noch getân.'

Dô stuont gegen dem winde Irinc von Tenelant.
er kuolte sich in ringen: den helm er abe gebant.
dô sprâchen al die liute, sîn ellen wære guot:
des hêt der marcgrâve von schulden hôhen muot.

Irinc der vil küene sînen friunden sagte daʒ
'nu wâfent mich vil balde: ich wilʒ versuochen baʒ,
ob ich noch müge betwingen den übermüeten man.'
sîn schilt der was verhouwen: einen bezʒern er gewan.

Vil schiere wart der recke aber gewâfent baʒ,
unt einen gêr vil starken den nam er ûf den haʒ,
daʒ er dâ mite Hagenen wolde noch bestân.
eʒ wær im frum unt êre, ob erʒ hête nu verlân.

Sîn mohte niht erbîten Hagene der degen:
dô lief er im engegene mit stichen unt mit slegen
der stiege unze an ein ende: sîn zürnen daʒ was grôʒ.
Irinc sîner sterke harte wênec dô genôʒ.

Si sluogen durch die schilde, deiʒ lougen began
von viurrôten winden: der Hâwartes man
wart von Hagenen swerte vil krefteclîchen wunt
durch schilt unt durch die brünne; des er wart nimmer mêr gesunt.

Dô der degen Irinc der wunden enpfant,
den schilt er baʒ bedachte über diu helmbant.
des schaden in dûht der volle, den er dâ gewan:
sît tet im noch mêre der vil übermüete man.

Hagen vor sînen füeʒen einen gêr er ligen vant:
dô schôʒ er Iringen, den helt von Tenelant,
daʒ im von dem houbte der gêr ragete dan.
im hêt der übermüete den grimmen ende getân.

Irinc muose wîchen zuo den von Tenelant.
ê daʒ man dô dem degene den helm ab gebant,

den gêr man brach von houbet: dô nâhet im der tôt.
daʒ weinten sîne mâge: des gie in wærlîche nôt.

Kriemhilt diu frouwe klagen ouch began
den küenen Iringen, den schadehaften man:
si weinte sîne wunden, wande eʒ was ir leit.
dô sprach vor sînen mâgen der snelle recke gemeit:

'Lât iwer klage belîben, vil hèrlîcheʒ wîp:
waʒ hilfet iwer weinen? jâ muoʒ ich mînen lîp
verliesen von den wunden, die ich enpfangen hân:
der tôt wil mich niht dienen iu unt Ezeln lân.'

Er sprach zuo den von Düregen unt den von Tenelant
'die gâbe sol enpfâhen iwer deheines hant
von der küneginne, ir liehteʒ golt sô rôt:
unt bestêt ir Hagenen, ir müeʒet lîden den tôt.'

Sîn varwe was erblichen, des tôdes zeichen truoc
Irinc der küene: daʒ was in leit genuoc.
genesen niht enkunde der Hâwartes man.
dô muos eʒ an ein strîten von den sînen friunden gân.

Irnfrit unde Hâwart die sprungen für daʒ gadem
wol mit tûsent heleden. vil ungefüegen kradem
hôrt man allenthalben vil krefteclîchen grôʒ:
hey, waʒ man starker gêre ûf die Burgonde schôʒ!

Irnvrit der herre lief an den spilman;
des er schaden grôʒen von sîner hant gewan:
der küene videlære den lantgrâven sluoc
durch einen helm vesten. jâ was er grimme genuoc.

Dô sluoc der lantgrâve den küenen spilman,
daʒ im muosen bresten ringes gespan,
unt daʒ sich beschutte diu prünne fiurrôt:
dô viel der lantgrâve vor dem videlære tôt.

Hâwart unde Hagene ze samne wâren komen:
er mohte wunder kiesen, ders hête war genomen.
diu swert genôte vielen den recken an der hant:
Hâwart muose ersterben von dem ûʒ Burgonde lant.

Dô die Tenen unt die Düregen ir herren sâhen tôt,
dô huop sich vor dem hûse ein vil grimmiu nôt,
ê si die tür gewunnen mit ellenthafter hant.
des wart dâ verhouwen vil manec helm unde rant.

'Wîchet,'—sprach dô Volkêr— 'lât si her in gân.
eʒ ist sus unverendet, des si dâ habent wân.

si müeȝen drinne ersterben in vil kurzer zît:
si arnent mit dem tôde daȝ in diu küneginne gît.'

Dô die übermüeten kômen in den sal,
manegem wart daȝ houbet geneiget sô zetal,
daȝ er muose ersterben von ir grimmen slegen.
wol streit der küene Gêrnôt: sam tet ouch Gîselher der degen.

Tûsent unde viere, die kômen dar in:
die erzeigten drinne schiere ir degenlîchen sin.
si wurden von den gesten al zehant erslagen:
man mohte michel wunder von den Burgonden sagen.

Dar nâch wart ein stille, daȝ der schal verdôȝ.
daȝ bluot dô allenthalben durch diu löcher vlôȝ
unt dâ zen rigelsteinen von den küenen man:
daȝ hêten die von Rîne mit grôȝem ellen getân.

Dô sâȝen aber ruowen die kômen in daȝ lant:
ir schilde unde wâfen si leiten von der hant.
dô stuont noch vor dem hûse der küene spilman,
ob iemen zuo zin wolde mit strîte zuo dem sale gân.

Der künec klagte sêre, sam tet ouch sîn wîp:
mägde unde frouwen die quelten ouch den lîp.
ich wæne des, daȝ hête der tôt ûf si gesworn:
des wart noch vil der degene von den gesten verlorn.

Then bold Dankwart strode in through the door, and bade Etzel's fol-
lowers void the way; all his harness was covered with blood. It was at
the time they were carrying Ortlieb to and fro from table to table among
the princes, and through the terrible news the child perished.

Dankwart cried aloud to one of the knights, "Thou sittest here too
long, brother Hagen. To thee, and God in Heaven, I bewail our wrong.
Knights and squires lie dead in our hall."

Hagen called back to him, "Who hath done it?"

"Sir Blœdel and his men. He paid for it bitterly, I can tell thee. I smote
off his head with my hands."

"He hath paid too little," said Hagen, "since it can be said of him that
he hath died by the hand of a hero. His womenfolk have the less cause
to weep. Now tell me, dear brother; wherefore art thou so red? I ween
thy wounds are deep. If he be anywhere near that hath done it, and the
devil help him not, he is a dead man."

"Unwounded I stand. My harness is wet with the blood of other men,
whereof I have to-day slain so many, that I cannot swear to the number."

Hagen said, "Brother Dankwart, keep the door, and let not a single

Hun out; I will speak with the knights as our wrong constraineth me. Guiltless, our followers lie dead."

"To such great kings will I gladly be chamberlain," said the bold man; "I will guard the stairs faithfully."

Kriemhild's men were sore dismayed.

"I marvel much," said Hagen, "what the Hunnish knights whisper in each other's ears. I ween they could well spare him that standeth at the door, and hath brought this court news to the Burgundians. I have long heard Kriemhild say that she could not bear her heart's dole. Now drink we to Love, and taste the king's wine. The young prince of the Huns shall be the first."

With that, Hagen slew the child Ortlieb, that the blood gushed down on his hand from his sword, and the head flew up into the queen's lap. Then a slaughter grim and great arose among the knights. He slew the child's guardian with a sword stroke from both his hands, that the head fell down before the table. It was sorry pay he gave the tutor. He saw a minstrel sitting at Etzel's table, and sprang at him in wrath, and lopped off his right hand on his viol: "Take that for the message thou broughtest to the Burgundians."

"Woe is me for my hand!" cried Werbel. "Sir Hagen of Trony, what have I done to thee? I rode with true heart to thy master's land. How shall I make my music now?"

Little recked Hagen if he never fiddled more. He quenched on Etzel's knights, in the house there, his grim lust for blood, and smote to death not a few.

Swift Folker sprang from the table; his fiddle-bow rang loud. Harsh were the tunes of Gunther's minstrel. Ha! many a foe he made among the Huns!

The three kings, too, rose hastily. They would have parted them or more harm was done. But they could not, for Folker and Hagen were beside themselves with rage.

When the King of Rhineland could not stint the strife, he, also, smote many a deep wound through the shining harness of his foemen. Well he showed his hardihood.

Then stark Gernot came into the battle, and slew many Huns with the sharp sword that Rudeger had given him. He brought many of Etzel's knights to their graves therewith.

Uta's youngest son sprang into the fray, and pierced the helmets of Etzel's knights valiantly with his weapon. Bold Giselher's hand did wonderly.

But howso valiant all the others were, the kings and their men, Folker stood up bolder than any against the foes; he was a hero; he wounded many, that they fell down in their blood.

Etzel's liegemen warded them well, but the guests hewed their way with their bright swords up and down the hall. From all sides came the

333

sound of wailing. They that were without would gladly have won in to their friends, but could not; and they that were within would have won out, but Dankwart let none of them up the stair or down. Then a great crowd gathered before the door, and the swords clanged loud upon the helmets, so that Dankwart came in much scathe. Hagen feared for him, as was meet, and he cried aloud to Folker, "Comrade, seest thou my brother beset by the stark blows of the Huns? Save him, friend, or we lose the warrior."

"That will I, without fail," said the minstrel; and he began to fiddle his way through the hall; it was a hard sword that rang in his hand. Great thank he won from the knights of the Rhine.

He said to Dankwart, "Thou hast toiled hard to-day. Thy brother bade me come to thy help. Do thou go without, and I will stand within."

Dankwart went outside the door and guarded the stair. Loud din made the weapons of the heroes. Inside, Folker the Burgundian did the like. The bold fiddler cried above the crowd, "The house is well warded, friend Hagen; Etzel's door is barred by the hands of two knights that have made it fast with a thousand bolts."

When Hagen saw the door secured, the famous knight and good threw back his shield, and began to avenge the death of his friends in earnest. Many a valiant knight suffered for his wrath.

When the Prince of Bern saw the wonders that Hagen wrought, and the helmets that he brake, he sprang on to a bench, and cried, "Hagen poureth out the bitterest wine of all."

The host and his wife fell in great fear. Many a dear friend was slain before their eyes. Etzel himself scarce escaped from his foemen. He sat there affrighted. What did it profit him that he was a king?

Proud Kriemhild cried to Dietrich, "Help me, noble knight, by the princely charity of an Amelung king, to come hence alive. If Hagen reach me, death standeth by my side."

"How can I help thee, noble queen? I cannot help myself. Gunther's men are so grimly wroth that I can win grace for none."

"Nay now, good Sir Dietrich, show thy mercy, and help me hence or I die. Save me and the king from this great peril."

"I will try. Albeit, for long, I have not seen good knights in such a fury. The blood gusheth from the helmets at their sword-strokes."

The chosen knight shouted with a loud voice that rang out like the blast of a buffalo horn, so that all the castle echoed with its strength, for stark and of mickle might was Dietrich.

King Gunther heard his cry above the din of strife, and hearkened. He said, "The voice of Dietrich hath reached me. I ween our knights have slain some of his men. I see him on the table, beckoning with his hand. Friends and kinsmen of Burgundy, hold, that we may learn what we have done to Dietrich's hurt."

When King Gunther had begged and prayed them, they lowered their

swords. Thereby Gunther showed his might, that they smote no blow. Then he asked the Prince of Bern what he wanted. He said, "Most noble Dietrich, what hurt have my friends done thee? I will make it good. Sore grieved were I, had any done thee scathe."

But Sir Dietrich answered, "Naught hath been done against me. With thy safe-conduct let me quit this hall, and the bitter strife, with my men. For this I will ever serve thee."

"Why ask this grace?" said Wolfhart. "The fiddler hath not barred the door so fast that we cannot set it wide, and go forth."

"Hold thy peace," cried Dietrich. "Thou hast played the devil."

Then Gunther answered, "I give thee leave. Lead forth few or many, so they be not my foemen. These shall tarry within, for great wrong have I suffered from the Huns."

When the knight of Bern heard that, he put one arm round the queen, for she was greatly affrighted, and with the other he led out Etzel. Six hundred good knights followed Dietrich.

Then said noble Rudeger, the Margrave, "If any more of them that love and would serve thee may win from this hall, let us hear it; that peace may endure, as is seemly, betwixt faithful friends."

Straightway Giselher answered his father-in-law. "Peace and love be betwixt us. Thou and thy liegemen have been ever true to us, wherefore depart with thy friends, fearing nothing."

When Sir Rudeger left the hall, five hundred or more went out with him. The Burgundian knights did honourably therein, but King Gunther suffered scathe for it after.

One of the Huns would have saved himself when he saw King Etzel go out with Dietrich, but the fiddler smote him such a blow that his head fell down at Etzel's feet.

When the king of the land was gone out from the house, he turned and looked at Folker. "Woe is me for such guests! It is a hard and bitter thing that all my knights fall dead before them! Alack! this high-tide!" wailed the great king. "There is one within that hight Folker. He is liker a wild boar than a fiddler. I thank Heaven that I escaped the devil. His tunes are harsh; his bow is red. His notes smite many a hero dead. I know not what this minstrel hath against us. Never was guest so unwelcome."

The knight of Bern, and Sir Rudeger, went each to his lodging. They desired not to meddle with the strife, and they bade their men avoid the fray.

Had the guests known what hurt the twain would do them after, they had not won so lightly from the hall, but had gotten a stroke from the bold ones in passing.

All that they would let go were gone. Then arose a mighty din. The guests avenged them bitterly. Ha! many a helmet did Folker break!

King Gunther turned his ear to the noise. "Dost thou hear the tunes,

Hagen, that Folker playeth yonder on the Huns, when any would win through the door? The hue of his bow is red."

"It repenteth me sore," spake Hagen, "to be parted from the knight. I was his comrade, and he mine. If we win home again, we shall ever be true friends. See now, great king, how he serveth thee. He earneth thy silver and thy gold. His fiddle-bow cleaveth the hard steel, and scattereth on the ground the bright jewels on the helmets. Never have I seen a minstrel make such stand. His measures ring through helmet and shield. Good horse shall he ride, and wear costly apparel."

Of the Huns that had been in the hall, not one was left alive. The tumult fell, for there was none to fight, and the bold warriors laid down their swords.

The knights sat down through weariness. Folker and Hagen went out before the hall. There the overweening men leaned on their shields and spake together.

Then said Giselher of Burgundy, "Rest not yet, dear friends. Ye must carry the dead out of the house. We shall be set upon again; trow my word. These cannot lie longer among our feet. Or the Huns overcome us, we will hew many wounds; to the which I am nothing loth."

"Well for me that I have such a lord," answered Hagen. "This counsel suiteth well such a knight as our young master hath approved him this day. Ye Burgundians have cause to rejoice."

They did as he commanded, and bare the seven thousand dead bodies to the door, and threw them out. They fell down at the foot of the stair. Then arose a great wail from their kinsmen. Some of them were so little wounded that, with softer nursing, they had come to. Now, from the fall, these died also. Their friends wept and made bitter dole.

Then said bold Folker the fiddler, "Now I perceive they spake the truth that told me the Huns were cowards. They weep like women, when they might tend these wounded bodies."

A Margrave that was there deemed he meant this truly. He saw one of his kinsmen lying in his blood, and put his arms round him to bear him away. Him the minstrel shot dead.

When the others saw this, they fled, and began to curse Folker. With that, he lifted a sharp spear and hard from the ground, that a Hun had shot at him, and hurled it strongly across the courtyard, over the heads of the folk. Etzel's men took their stand further off, for they all feared his might.

Then came Etzel with his men before the hall. Folker and Hagen began to speak out their mind to the King of the Huns. They suffered for it or all was done.

"It is well for a people when its kings fight in the forefront of the strife as doeth each of my masters. They hew the helmets, and the blood spurteth out."

Etzel was brave, and he grasped his shield. "Have a care," cried

Kriemhild, "and offer thy knights gold heaped upon the shield. If Hagen reach thee, thou hast death at thy hand."

But the king was so bold he would not stop; the which is rare enow among great princes to-day. They had to pull him back by his shield-thong: whereat grim Hagen began to mock anew. "Siegfried's darling and Etzel's are near of kin. Siegfried had Kriemhild to wife or ever she saw thee. Coward king, thou, of all men, shouldst bear me no grudge."

When Kriemhild heard him, she was bitterly wroth that he durst mock her before Etzel's warriors, and she strove to work them woe. She said, "To him that will slay Hagen of Trony and bring me his head, I will fill Etzel's shield with red gold. Thereto, he shall have, for his meed, goodly castles and land."

"I know not why ye hang back," said the minstrel. "I never yet saw heroes stand dismayed that had the offer of such pay. Etzel hath small cause to love you. I see many cowards standing here that eat the king's bread, and fail him now in his sore need, and yet call themselves bold knights. Shame upon them!"

Great Etzel was grieved enow. He wept sore for his dead men and kinsmen. Valiant warriors of many lands stood round him, and be-wailed his great loss with him.

Then bold Folker mocked them again. "I see many high-born knights weeping here, that help their king little in his need. Long have they eaten his bread with shame."

The best among them thought, "He sayeth sooth."

But none mourned so inly as Iring, the hero of Denmark; the which was proven or long by his deeds.

Then cried Iring, the Margrave of Denmark, "I have long followed honour, and done not amiss in battle. Bring me my harness, and I will go up against Hagen."

"Thou hadst better not," answered Hagen, "or thy kinsmen will have more to weep for. Though ye sprang up two or three together, ye would fall down the stair the worse for it."

"I care not," said Iring. "I have oft tried as hard a thing. With my single sword I would defy thee, if thou hadst done twice as much in the strife."

Sir Iring armed him straightway. Irnfried of Thuringia, likewise, a bold youth, and Hawart the stark, with a thousand men that were fain to stand by Iring.

When the fiddler saw so great an armed host with him, wearing bright helmets on their heads, he was wroth. "Behold how Iring cometh hither, that vowed to encounter thee alone. It beseemeth not a knight to lie. I blame him much. A thousand armed knights or more come with him."

"Call me no liar," said Hawart's liegeman. "I will gladly abide by my word, nor fail therein through fear. How grim soever Hagen may be, I will meet him alone."

Iring fell at the feet of his kinsmen and vassals, that they might let him defy the knight in single combat. They were loth, for they knew proud Hagen of Burgundy well. But he prayed them so long that they consented. When his followers saw that he wooed honour, they let him go. Then began a deadly strife betwixt them.

Iring of Denmark, the chosen knight, raised his spear; then he covered his body with his shield, and sprang at Hagen. The heroes made a loud din. They hurled their spears so mightily from their hands, that they pierced through the strong bucklers to the bright harness, and the shafts flew high in the air. Then the grimly bold men grasped their swords.

Hagen was strong beyond measure, yet Iring smote him, that all the house rang. Palace and tower echoed their blows. But neither had the advantage.

Iring left Hagen unwounded, and sprang at the fiddler. He thought to vanquish him by his mighty blows. But the gleeman stood well on his guard, and smote his foeman, that the steel plate of his buckler flew off. He was a terrible man.

Then Iring ran at Gunther, the King of Burgundy.

Fell enow were the twain. But though each smote fiercely at the other, they drew no blood. Their good harness shielded them.

He left Gunther, and ran at Gernot, and began to strike sparks from his mailcoat, but King Gernot of Burgundy well-nigh slew him. Then he sprang from the princes, for he was right nimble, and soon had slain four Burgundians from Worms beyond the Rhine. Giselher was greatly wroth thereat. "Now by God, Sir Iring," he cried, "thou shalt pay for them that lie dead!" and he fell on him. He smote the Dane, that began to stagger, and dropped down among the blood, so that all deemed the doughty warrior would never strike another blow. Yet Iring lay unwounded withal before Giselher. From the noise of his helmet and the clang of the sword his wits left him, and he lay in a swoon. That had Giselher done with his strong arm.

When the noise of the blow had cleared from his brain, he thought, "I live still, and am unwounded. Now I know the strength of Giselher." He heard his foemen on both sides. Had they been ware how it stood with him, worse had befallen him. He heard Giselher also, and he pondered by what device he might escape them. He sprang up furiously from among the blood. Well his swiftness served him. He fled from the house, past Hagen, and gave him a stout stroke as he ran.

"Ha!" thought Hagen, "Thou shalt die for this. The Devil help thee, or thou art a dead man." But Iring wounded Hagen through the helmet. He did it with Vasky, a goodly weapon.

When Hagen felt the wound, he swung his sword fiercely, that Hawart's man must needs fly. Hagen followed him down the stair. But Iring held his shield above his head. Had the stair been thrice as long,

Hagen had not left him time for a single thrust. Ha! what red sparks flew from his helmet! Yet, safe withal, Iring reached his friends.

When Kriemhild heard what he had done to Hagen of Trony in the strife, she thanked him. "God quit thee, Iring, thou hero undismayed! thou hast comforted me, heart and soul, for I see Hagen's harness red with blood." The glad queen took the shield from his hand herself.

"Stint thy thanks," said Hagen. "There is scant cause for them. If he tried it again, he were in sooth a bold man. The wound I got from him will serve thee little. The blood thou seest on my harness but urgeth me to slay the more. Only now, for the first time, I am wroth indeed. Sir Iring hath done me little hurt."

Iring of Denmark stood against the wind, and cooled him in his harness, with his helmet unlaced; and all the folk praised his hardihood, that the Margrave's heart was uplifted. He said, "Friends, arm me anew. I will essay it again. Haply I may vanquish this overweening man." His shield was hewn in pieces; they brought him a better straight.

The warrior was soon armed, and stronger than afore. Wrothfully he seized a stark spear, wherewith he defied Hagen yet again. He had won more profit and honour had he let it be.

Hagen waited not for his coming. Hurling darts, and with drawn sword, he sprang down the stairs in a fury. Iring's strength availed him little. They smote at each other's shields, that glowed with a fire-red wind. Through his helmet and his buckler, Hawart's man was wounded to the death by Hagen's sword. He was never whole again.

When Sir Iring felt the wound, he raised his shield higher to guard his head, for he perceived that he was sore hurt. But Gunther's man did worse to him yet. He found a spear lying at his feet, and hurled it at Iring, the knight of Denmark, that it stuck out on the other side of his head. The overweening knight made a grim end of his foeman.

Iring fell back among his friends. Or they did off his helmet, they drew the spear out. Then death stood at hand. Loud mourned his friends; their sorrow was bitter.

The queen came, and began to weep for stark Iring. She wept for his wounds, and was right doleful. But the undismayed hero spake before his kinsmen, "Weep not, noble lady. What avail thy tears? I must die from these wounds that I have gotten. Death will not leave me longer to thee and Etzel."

Then he said to them of Thuringia and Denmark, "See that none of you take the gifts of the queen—her bright gold so red. If ye fight with Hagen ye must die."

His cheek was pale; he bare death's mark. They grieved enow; for Hawart's man would nevermore be whole. Then they of Denmark must needs to the fray.

Irnfried and Hawart sprang forward with a thousand knights. The din was loud over all. Ha! what sharp spears were hurled at the Bur-

gundians! Bold Irnfried ran at the gleeman, and came in scathe by his hand. The fiddler smote the Landgrave through his strong helmet, for he was grim enow. Then Irnfried gave Folker a blow, that the links of his hauberk brake asunder, and his harness grew red like fire. Yet, for all, the Landgrave fell dead before the fiddler.

Hawart and Hagen closed in strife. Had any seen it, they had beheld wonders. They smote mightily with their swords. Hawart died by the knight of Burgundy.

When the Thuringians and Danes saw their masters slain, they rushed yet fiercer against the house, and grisly was the strife or they won to the door. Many a helmet and buckler were hewn in pieces.

"Give way," cried Folker, "and let them in. They shall not have their will, but, in lieu thereof, shall perish. They will earn the queen's gift with their death."

The proud warriors thronged into the hall, but many an one bowed his head, slain by swift blows. Well fought bold Gernot; the like did Giselher.

A thousand and four came in. Keen and bright flashed the sword; but all the knights died. Great wonders might be told of the Burgundians.

When the tumult fell, there was silence. Over all, the blood of the dead men trickled through the crannies into the gutters below. They of the Rhine had done this by their prowess.

Then the Burgundians sat and rested, and laid down their weapons and their shields. The bold gleeman went out before the house, and waited, lest any more should come to fight.

The king and his wife wailed loud. Maids and wives beat their breasts. I ween that Death had sworn an oath against them, for many a knight was yet to die by the hands of the strangers.

<div style="text-align: right">

Das Nibelungenlied
Translated by Margaret Armour

</div>

An epic Homeric in primitive directness of narrative, but brooded over by the fierce spirit of the murky North. Homeric are the repetitions of set epithet; Homeric is the simple pathos; more than Homeric the joy of battle; Homeric the overlaying of an earlier story with the manners of a later budding civilization. But there is no Homeric imagery; the narrative is utterly direct. . . . Very quiet and plain are the poet's grieving pictures, a lesson to the modern novelist, with his luxury of woe. They make no figure as elegant extracts; but in its place every simple line tells. Kriemhild is borne from her slaughtered lover's coffin in a swoon, 'as her fair body would have perished for sorrow.' No more; and one asks no more. But it is in battle that this truly great Unknown finds himself, and sayeth 'Ha! Ha!' among the trumpets.

Unique in all literature is the culmination of this epic of Death. . . .

In the midst of a magnificently imagined CRESCENDO of horror and heroism, death closes in, adamantine, on the destined Burgundian band. I am almost tempted to say that it is the grandest situation in all epic.

FRANCIS THOMPSON
The 'Nibelungen Lied' (1913)

ANONYMOUS

THIRTEENTH CENTURY

DUM DIANE VITREA

Dum Diane vitrea
sero lampas oritur,
et a fratris rosea
luce dum succenditur,
dulcis aura zephyri
spirans omnes etheri
nubes tollit;
sic emollit
vi chordarum pectora,
et inmutat
cor quod nutat
ad amoris pignora.
letum iubar hesperi
gratiorem
dat humorem
roris soporiferi
mortalium generi.

O quam felix est
antidotum soporis,
quod curarum tempestates
sedat et doloris!
dum surrepit clausis
oculorum poris,
gaudio equiparat
dulcedini amoris.

Morpheus in mentem
trahit impellentem
ventum lenem
segetes maturas,

341

murmura rivorum
per arenas puras,
circulares ambitus
molendinorum,
qui furantur somno
lumen oculorum.

Post blanda Veneris commercia,
lassatur cerebri substantia.
hinc caligantes mira novitate,
oculi nantes in palpebrarum rate!
hei quam felix transitus amoris ad soporem,
sed suavior regressus soporis ad amorem!

Fronde sub arboris amena,
dum querens canit philomena,
suave est quiescere,
suavius ludere
in gramine
cum virgine
speciosa.
si variarum
odor herbarum
spiraverit,
si dederit
thorum rosa,
dulciter soporis alimonia
post Veneris defessa commercia
captatur
dum lassis instillatur. . . .

When Diana lighteth
Late her crystal lamp,
Her pale glory kindleth
From her brother's fire,
Little straying west winds
Wander over heaven,
Moonlight falleth,
And recalleth
With a sound of lute-strings shaken,
Hearts that have denied his reign
To love again.
Hesperus, the evening star,
To all things that mortal are,
Grants the dew of sleep.

Thrice happy Sleep!
The antidote to care,
Thou dost allay the storm
Of grief and sore despair;
Through the fast-closed gates
Thou stealest light;
Thy coming gracious is
As Love's delight.

Sleep through the wearied brain
Breathes a soft wind
From fields of ripening grain,
The sound
Of running water over clearest sand,
A millwheel turning, turning slowly round,
These steal the light
From eyes weary of sight.

Love's sweet exchange and barter, then the brain
Sinks to repose;
Swimming in strangeness of a new delight
The eyelids close;
Oh sweet the passing o'er from love to sleep.
But sweeter the awakening to love.

Under the kind branching trees
Where Philomel complains and sings
Most sweet to lie at ease,
Sweeter to take delight
Of beauty and the night
On the fresh springing grass,
With smell of mint and thyme,
And for Love's bed, the rose.
Sleep's dew doth ever bless,
But most distilled on lovers' weariness.

Translated by Helen Waddell

DUM DIANAE VITREA *is the height of secular Latin poetry, even as the* DIES IRAE *of sacred: the twin peaks of the mediaeval Parnassus.*

HELEN WADDELL
The Wandering Scholars (1927)

LANCELOT AND GUENEVER

Et sen vint a la fenestre. Et la royne ne dort pas qui latent ains vient la. Et li vns lance a lautre [son bras si sentresentent] la ou il pooient auenir. Dame fet lancelot se iou pooie laiens entrer vous plairoit il Entrer fet elle biaus douls amis. comment porroit ce auenir. Dame fet il sil vous plaisoit il auendroit legierement. Certes fait elle iou le voldroie volentiers sour toute riens. Enon dieu fait il dont sera il bien. Car ia fers ne mi tenra. Ore atendes fait elle tant que iou soie couchie. . . . Et il sache lez fers hors des pertruis si soef que noise ni fait ne nul nen brise. . . .

Grant fu la ioie quil sentrefirent la nuit Car longement sen estoient soffert li vns de lautre. Et quant li iors aprocha si se departirent.

And he came to the window: and the Queen, who waited for him, slept not, but came thither. And the one threw to the other their arms, and they felt each other as much as they could reach. "Lady," said Lancelot, "if I could enter yonder, would it please you?" "Enter," said she, "fair sweet friend. How could this happen?" "Lady," said he, "if it please you, it could happen lightly." "Certainly," said she, "I should wish it willingly above everything." "Then, in God's name," said he, "that shall well happen. For the iron will never hold." "Wait, then," said she, "till I have gone to bed." . . . Then he drew the irons from their sockets so softly that no noise was made and no bar broke. . . . Great was the joy that they made each other that night, for long had each suffered for the other. And when the day came, they parted.

<div align="right">Le Livre de Lancelot del Lac</div>

Beat that who can!

<div align="right">

G E O R G E S A I N T S B U R Y
A History of the French Novel (1917)

</div>

ANONYMOUS

THIRTEENTH CENTURY

SIGURTH AND I

Munu við ofstríð
allz til lengi
konur ok karlar
kvikvir fœðaz;
vit skulum okrum
aldri slíta
Siguðr saman.

Ever with grief and all too long
Are men and women born in the world;
But yet we shall live our lives together,
Sigurth and I.

<div align="right">

Edda Sæmundar
Translated by Henry Adams Bellows

</div>

There was no rhythm ever conceived that encompasses such immensities of space and remoteness as this old Northern verse.

<div align="right">

OSWALD SPENGLER
Der Untergang des Abendlandes (1918)

</div>

ANONYMOUS

THIRTEENTH CENTURY

THRYMSKVITHA

Reiðr var þá Vingþórr,
er hann vaknaði
ok síns hamars
um saknaði;
skegg nam at hrísta,
skǫr nam at dýja,
réð Jarðar burr
um at þreifaz.

345

Ok hann þat orða
allz fyrst um kvað:
„heyrðu nú, Loki!
hvat ek nú m æli,
er engi veit
jarðar hvergi
né uphimins:
óss er stolinn hamri.”

Gengu þeir fagra
Freyju túna,
ok hann þat orða
allz fyrst um kvað:
„muntu mér, Freyja!
fjaðrhams ljá,
ef ek minn hamar
mættak hitta?”

 Freyja kvað:
„Þó munda ek gefa þér,
þótt ór gulli væri,
ok þó selja,
at væri ór silfri.”

Fló þá Loki
—fjaðrhamr dunði—
unz fyr útan kom
ása garða
ok fyr innan kom
jǫtna heima.

Þrymr sat á haugi,
þursa dróttinn,
greyjum sínum
gullbǫnd snøri
ok mǫrum sínum
mǫn jafnaði.

 Þrymr kvað:
„Hvat er með ósum?
hvat er með ǫlfum?
hví ertu einn kominn
í Jǫtunheima?”

 Loki kvað:
„Ilt er með ósum,
ilt er með ǫlfum;

hefir þú Hlórriða
hamar um folginn?"

Þrymr kvað:
„Ek hefi Hlórriða
hamar um folginn
átta rǫstum
fyr jǫrð neðan;
hann engi maðr
aptr um heimtir,
nema fœri mér
Freyju at kvæn."

Fló þá Loki
—fjaðrhamr dunði—
unz fyr útan kom
jǫtna heima
ok fyr innan kom
ása garða;
mœtti hann Þór
miðra garða,
ok hann þat orða
allz fyrst um kvað:

„Hefir þú erendi
sem erfiði?
segðu á lopti
lǫng tíðindi;
opt sitjanda
sǫgur um fallaz
ok liggjandi
lygi um bellir."

Loki kvað:
„Hefi ek erfiði
ok ørindi;
Þrymr hefir þinn hamar,
þursa dróttinn;
hann engi maðr
aptr um heimtir,
nema honum fœri
Freyju at kvǫn."

Ganga þeir fagra
Freyju at hitta,
ok hann þat orða

allz fyrst um kvað:
„bittu þik, Freyja!
brúðar líni,
vit skulum aka tvau
í Jǫtunheima.”

Reið varð þá Freyja
ok fnasaði,
—allr ása salr
undir bifðiz;
stǫkk þat it mikla
men Brísinga—:
„mik veiztu verða
vergjarnasta,
ef ek ek með þér
í Jǫtunheima.”

Senn vóru æsir
allir á þingi
ok ásynjur
allar á máli,
ok um þat réðu
ríkir tívar,
hvé þeir Hlórriða
hamar um sœtti.

Þá kvað þat Heimdallr,
hvítastr ása
—vissi hann vel fram
sem vanir aðrir—:
„bindu vér Þór þá
brúðar líni;
hafi hann it mikla
men Brísinga.

Lǫtum und hǫnum
hrynja lukla
ok kvennváðir
um kné falla,
en á brjósti
breiða steina,
ok hagliga
um hǫfuð typpum.”

Þá kvað þat Þórr
þrúðugr óss:

348

„mik munu æsir
argan kalla,
ef ek bindaz læt
brúðar líni.”
Þá kvað þat Loki,
Laufeyjar sonr:
„þegi þú, Þórr!
þeira orða;
þegar munu jǫtnar
Ásgarð búa,
nema þú þinn hamar
þér um heimtir.”

Bundu þeir Þór þá
brúðar líni
ok enu mikla
meni Brísinga,
létu und hǫnum
hrynja lukla,
ok kvennváðir
um kné falla,
en á brjósti
breiða steina,
ok hagliga
um hǫfuð typðu.

Þá kvað þat Loki,
Laufeyjar sonr:
„mun ek ok með þér
ambótt vera;
vit skulum aka tvau
í Jǫtunheima.”

Senn vóru hafrar
heim um reknir,
skyndir at skǫklum,
skyldu vel renna;
bjǫrg brotnuðu,
brann jǫrð loga,
ók Óðins sonr
í Jǫtunheima.

Þá kvað þat Þrymr,
þursa dróttinn:
„standið up, jǫtnar!
ok stráið bekki;

nú fœriþ mér
Freyju at kván,
Njarðar dóttur
ór Nóatúnum.

Ganga hér at garði
gullhyrnðar kýr,
øxn alsvartir
jǫtni at gamni;
fjǫlð á ek meiðma,
fjǫlð á ek menja,
einnar mér Freyju
ávant þykkir."

Var þar at kveldi
um komit snimma
ok fyr jǫtna
ǫl fram borit;
einn át oxa,
átta laxa,
krásir allar,
þær er konur skyldu,
drakk Sifjar verr
sǫld þrjú mjaðar.

Þá kvað þat Þrymr,
þursa dróttinn:
„hvar sáttu brúðir
bíta hvassara?
sáka ek brúðir
bíta breiðara,
né inn meira mjǫð
mey um drekka."

Sat in alsnotra
ambǫtt fyrir,
er orð um fann
við jǫtuns máli:
„át vætr Freyja
átta nóttum,
svá var hon óðfús
í Jǫtunheima.

Laut und línu,
lysti at kyssa,
en hann útan stǫkk

endlangan sal:
„hví eru ǫndótt
augu Freyju?
þykki mér ór augum
eldr um brenna."

Sat in alsnotra
ambótt fyrir,
er orð um fann
við jǫtuns máli:
„svaf vætr Freyja
átta nóttum,
svá var hon óðfús
í Jǫtunheima."

Inn kom in arma
jǫtna systir,
hin er brúðfjár
biðja þorði:
„láttu þér af hǫndum
hringa rauða,
ef þú øðlaz vill
ástir mínar,
ástir mínar,
alla hylli."

Þá kvað þat Þrymr,
þursa dróttinn:
„berið inn hamar,
brúði at vígja,
leggið Mjǫllni
í meyjar kné,
vígið okr saman
Várar hendi."

Hló Hlórriða
hugr í brjósti,
er harðhugaðr
hamar um þekði.
Þrym drap hann fyrstan,
þursa dróttin,
ok ætt jǫtuns
alla lamði.

Drap hann ina ǫldnu
jǫtna systur,

hin er brúðfjár
of beðit hafði;
hon skell um hlaut
fyr skillinga
en hǫgg hamars
fyr hringa fjǫlð.
Svá kom Óðíns sonr
endr at hamri.

Wild was Vingthor when he awoke,
And when his mighty hammer he missed;
He shook his beard, his hair was bristling,
As the son of Jorth about him sought.

Hear now the speech that first he spake:
"Harken, Loki, and heed my words,
Nowhere on earth is it known to man,
Nor in heaven above: our hammer is stolen."

To the dwelling fair of Freyja went they,
Hear now the speech that first he spake:
"Wilt thou, Freyja, thy feather-dress lend me,
That so my hammer I may seek?"

Freyja spake:

"Thine should it be though of silver bright,
And I would give it though 'twere of gold."
Then Loki flew, and the feather-dress whirred,
Till he left behind him the home of the gods,
And reached at last the realm of the giants.

Thrym sat on a mound, the giants' master,
Leashes of gold he laid for his dogs,
And stroked and smoothed the manes of his steeds.

Thrym spake:

"How fare the gods, how fare the elves?
Why comst thou alone to the giants' land?"

Loki spake:

"Ill fare the gods, ill fare the elves!
Hast thou hidden Hlorrithi's hammer?"

Thrym spake:

"I have hidden Hlorrithi's hammer,
Eight miles down deep in the earth;
And back again shall no man bring it
If Freyja I win not to be my wife."

Then Loki flew, and the feather-dress whirred,
Till he left behind him the home of the giants,
And reached at last the realm of the gods.
There in the courtyard Thor he met:
Hear now the speech that first he spake:

"Hast thou found tidings as well as trouble?
Thy news in the air shalt thou utter now;
Oft doth the sitter his story forget,
And lies he speaks who lays himself down."

Loki spake:

"Trouble I have, and tidings as well:
Thrym, king of the giants, keeps thy hammer,
And back again shall no man bring it
If Freyja he wins not to be his wife."

Freyja the fair then went they to find;
Hear now the speech that first he spake:
"Bind on, Freyja, the bridal veil,
For we two must haste to the giants' home."

Wrathful was Freyja, and fiercely she snorted,
And the dwelling great of the gods was shaken,
And burst was the mighty Brisings' necklace:
"Most lustful indeed should I look to all
If I journeyed with thee to the giants' home."

Then were the gods together met,
And the goddesses came and council held,
And the far-famed ones a plan would find,
How they might Hlorrithi's hammer win.

Then Heimdall spake, whitest of the gods,
Like the Wanes he knew the future well:
"Bind we on Thor the bridal veil,
Let him bear the mighty Brisings' necklace;

353

"Keys around him let there rattle,
And down to his knees hang woman's dress;
With gems full broad upon his breast,
And a pretty cap to crown his head."

Then Thor the mighty his answer made:
"Me would the gods unmanly call
If I let bind the bridal veil."

Then Loki spake, the son of Laufey:
"Be silent, Thor, and speak not thus;
Else will the giants in Asgarth dwell
If thy hammer is brought not home to thee."

Then bound they on Thor the bridal veil,
And next the mighty Brisings' necklace.

Keys around him let they rattle,
And down to his knees hung woman's dress;
With gems full broad upon his breast,
And a pretty cap to crown his head.

Then Loki spake, the son of Laufey:
"As thy maid-servant thither I go with thee;
We two shall haste to the giants' home."

Then home the goats to the hall were driven,
They wrenched at the halters, swift were they to run;
The mountains burst, earth burned with fire,
And Othin's son sought Jotunheim.

Then loud spake Thrym, the giants' leader:
"Bestir ye, giants, put straw on the benches;
Now Freyja they bring to be my bride,
The daughter of Njorth out of Noatun.

"Gold-horned cattle go to my stables,
Jet-black oxen, the giant's joy;
Many my gems, and many my jewels,
Freyja alone did I lack, methinks."

Early it was to evening come,
And forth was borne the beer for the giants;
Thor alone ate an ox, and eight salmon,
All the dainties as well that were set for the women;
And drank Sif's mate three tuns of mead.

Then loud spake Thrym, the giants' leader:
"Who ever saw bride more keenly bite?
I ne'er saw bride with a broader bite,
Nor a maiden who drank more mead than this!"

Hard by there sat the serving-maid wise,
So well she answered the giant's words:
"From food has Freyja eight nights fasted,
So hot was her longing for Jotunheim."

Thrym looked 'neath the veil, for he longed to kiss,
But back he leaped the length of the hall:
"Why are so fearful the eyes of Freyja?
Fire, methinks, from her eyes burns forth."

Hard by there sat the serving-maid wise,
So well she answered the giant's words:
"No sleep has Freyja for eight nights found,
So hot was her longing for Jotunheim."

Soon came the giant's luckless sister,
Who feared not to ask the bridal fee:
"From thy hands the rings of red gold take,
If thou wouldst win my willing love,
(My willing love and welcome glad.)"

Then loud spake Thrym, the giants' leader:
"Bring in the hammer to hallow the bride;
On the maiden's knees let Mjollnir lie,
That us both the hand of Vor may bless."

The heart in the breast of Hlorrithi laughed
When the hard-souled one his hammer beheld;
First Thrym, the king of the giants, he killed,
Then all the folk of the giants he felled.

The giant's sister old he slew,
She who had begged the bridal fee;
A stroke she got in the shilling's stead,
And for many rings the might of the hammer.

And so his hammer got Othin's son.

<div align="right">

Edda Sæmundar
Translated by Henry Adams Bellows

</div>

Artistically the THRYMSKVITHA *is one of the best, as it is, next to the* VOLUSPO, *the most famous, of the entire collection. It has, indeed, been called "the finest ballad in the world," and not without some reason. Its swift, vigorous action, the sharpness of its characterization and the humor of the central situation combine to make it one of the most vivid short narrative poems ever composed.*

<div align="right">

HENRY ADAMS BELLOWS
The Poetic Edda (1923)

</div>

ANONYMOUS

LATE THIRTEENTH CENTURY

IN HELL WITH MY SWEETEST LADY

En paradis qu'ai jë a faire? Je n'i quier entrer, mais que j'aie Nicolete, ma tresdouće amie que j'aim tant. C'en paradis ne vont fors tex gens, con je vous dirai. Il i vont ćil viel prestre et ćil viel clop et ćil manke, qui totejor et tote nuit cropent devant ćes autex et en ćes viés creutes, et ćil a ćes viés capes esreses et a ćes viés tatereles vestues, qui sont nu et descauć et estrumelé, qui moeurent de faim et de soi et de froit et de mesaises. Ićil vont en paradis; aveuc ćiax n'ai jou que faire. Mais en infer voil jou aler; car en infer vont li bel clerc, et li bel cevalier qui sont mort as tornois et as rices gueres, et li boin sergant et li franc home. Aveuc ćiax voil jou aler. Et s'i vont les beles dames cortoises, que eles ont deus amis ou trois avoc leur barons, et s'i va li ors et li argens et li vairs et li gris, et si i vont harpeor et jogleor et li roi del siecle. Avoc ćiax voil jou aler, mais que j'aie Nicolete, ma tresdouće amie, aveuc mi.

In Paradise what have I to win? Therein I seek not to enter, but only to have Nicolete, my sweet lady that I love so well. For into Paradise go none but such folk as I shall tell thee now: Thither go these same old priests, and halt old men and maimed, who all day and night cower continually before the altars, and in the crypts; and such folk as wear old amices and old clouted frocks, and naked folk and shoeless, and covered with sores, perishing of hunger and thirst, and of cold, and of little ease. These be they that go into Paradise, with them have I naught to make. But into Hell would I fain go; for into Hell fare the goodly clerks, and goodly knights that fall in tourneys and great wars, and stout men at arms, and all men noble. With these would I liefly go. And thither pass the sweet ladies and courteous that have two lovers, or three, and their lords also thereto. Thither goes the gold, and the silver, and cloth of vair, and cloth of gris, and harpers, and makers, and the prince

of this world. With these I would gladly go, let me but have with me, Nicolete, my sweetest lady.

Aucassin et Nicolette
Translated by Andrew Lang

Perhaps no truer picture of that chimera, the medieval mind, could be offered.

ALBERT GUÉRARD
Art for Art's Sake (1936)

DANTE ALIGHIERI

1 2 6 5 — 1 3 2 1

CANZONE

Donne ch' avete intelletto d' amore,
 i' vo' con voi de la mia donna dire,
 non perch' io creda sua laude finire,
 ma ragionar per isfogar la mente.
Io dico che pensando il suo valore,
Amor sì dolce mi si fa sentire,
 che s' io allora non perdessi ardire,
 farei parlando innamorar la gente.
E io non vo' parlar sì altamente,
 ch' io divenisse per temenza vile;
 ma tratterò del suo stato gentile
a respetto di lei leggeramente,
 donne e donzelle amorose, con vui,
 chè non è cosa da parlarne altrui.

Angelo clama in divino intelletto
 e dice: "Sire, nel mondo si vede
 maraviglia ne l' atto che procede
 d' un' anima che 'nfin qua su risplende".
Lo cielo, che non have altro difetto
che d' aver lei, al suo segnor la chiede,
 e ciascun santo ne grida merzede.
Sola Pietà nostra parte difende,
 che parla Dio, che di madonna intende:
 "Diletti miei, or sofferite in pace
 che vostra spene sia quanto me piace
là 'v' è alcun che perder lei s' attende,

e che dirà ne lo inferno: O mal nati,
io vidi la speranza de' beati".

Madonna è disiata in sommo cielo:
or voi di sua virtù farvi savere.
Dico, qual vuol gentil donna parere
vada con lei, che quando va per via,
gitta nei cor villani Amore un gelo,
per che onne lor pensero agghiaccia e pere;
e qual soffrisse di starla a vedere
diverria nobil cosa, o si morria.
E quando trova alcun che degno sia
di veder lei, quei prova sua vertute,
chè li avvien, ciò che li dona, in salute,
e sì l' umilia, ch' ogni offesa oblia.
Ancor l' ha Dio per maggior grazia dato
che non pò mal finir chi l' ha parlato.

Dice di lei Amor: "Cosa mortale
come esser pò sì adorna e sì pura?"
Poi la reguarda, e fra se stesso giura
che Dio ne 'ntenda di far cosa nova.
Color di perle ha quasi, in forma quale
convene a donna aver, non for misura:
ella è quanto de ben pò far natura;
per essemplo di lei bieltà si prova.
De li occhi suoi, come ch' ella li mova,
escono spirti d' amore inflammati,
che feron li occhi a qual che allor la guati,
e passan sì che 'l cor ciascun retrova:
voi le vedete Amor pinto nel viso,
la 've non pote alcun mirarla fiso.

Canzone, io so che tu girai parlando
a donne assai, quand' io t' avrò avanzata.
Or t' ammonisco, perch' io t' ho allevata
per figliuola d'Amor giovane e piana,
che là 've giugni tu dichi pregando:
"Insegnatemi gir, ch' io son mandata
a quella di cui laude so' adornata".
E se non vuoli andar sì come vana,
non restare ove sia gente villana:
ingegnati, se puoi, d' esser palese
solo con donne o con omo cortese,
che ti merranno là per via tostana.
Tu troverai Amor con esso lei;
raccomandami a lui come tu dei.

Ladies that have intelligence in love,
　　Of mine own lady I would speak with you;
　　Not that I hope to count her praises through,
　　　But telling what I may, to ease my mind.
And I declare that when I speak thereof,
Love sheds such perfect sweetness over me
That if my courage failed not, certainly
　　　To him my listeners must be all resign'd.
　　Wherefore I will not speak in such large kind
That mine own speech should foil me, which were base;
But only will discourse of her high grace
　　　In these poor words, the best that I can find,
With you alone, dear dames and damozels:
'Twere ill to speak thereof with any else.

An Angel, of his blessed knowledge, saith
　　To God: 'Lord, in the world that Thou hast made,
　　A miracle in action is display'd,
　　　By reason of a soul whose splendours fare
Even hither: and since Heaven requireth
　　Nought saving her, for her it prayeth Thee,
　　Thy Saints crying aloud continually.'
　　　Yet Pity still defends our earthly share
　　　In that sweet soul; God answering thus the prayer:
'My well-belovèd, suffer that in peace
Your hope remain, while so My pleasure is,
　　　There where one dwells who dreads the loss of her:
And who in Hell unto the doomed shall say,
"I have looked on that for which God's chosen pray."'

My lady is desired in the high Heaven:
　　Wherefore, it now behoveth me to tell,
　　Saying: Let any maid that would be well
　　　Esteemed keep with her: for as she goes by,
Into foul hearts a deathly chill is driven
By Love, that makes ill thought to perish there:
While any who endures to gaze on her
　　　Must either be ennobled, or else die.
　　When one deserving to be raised so high
Is found, 'tis then her power attains its proof,
Making his heart strong for his soul's behoof
　　　With the full strength of meek humility.
Also this virtue owns she, by God's will:
Who speaks with her can never come to ill.

Love saith concerning her: 'How chanceth it
 That flesh, which is of dust, should be thus pure?'
 Then, gazing always, he makes oath: 'Forsure,
 This is a creature of God till now unknown.'
She hath that paleness of the pearl that's fit
In a fair woman, so much and not more;
She is as high as Nature's skill can soar;
 Beauty is tried by her comparison.
 Whatever her sweet eyes are turned upon,
Spirits of love do issue thence in flame,
Which through their eyes who then may look on them
 Pierce to the heart's deep chamber every one.
And in her smile Love's image you may see;
Whence none can gaze upon her steadfastly.

Dear Song, I know thou wilt hold gentle speech
 With many ladies, when I send thee forth:
 Wherefore (being mindful that thou hadst thy birth
 From Love, and art a modest, simple child,)
Whomso thou meetest, say thou this to each:
'Give me good speed! To her I wend along
In whose much strength my weakness is made strong.'
 And if, i' the end, thou wouldst not be beguiled
 Of all thy labour, seek not the defiled
And common sort; but rather choose to be
 Where man and woman dwell in courtesy.
 So to the road thou shalt be reconciled,
 And find the lady, and with the lady, Love.
 Commend thou me to each, as doth behove.

<div align="right">

Vita Nuova (c. 1292)
Translated by Dante Gabriel Rossetti

</div>

The supreme canzone.

<div align="right">

DANTE ALIGHIERI
De Vulgari Eloquentia (1304?)

</div>

DANTE ENTERS THE GATE OF HELL

"Per me si va nella città dolente;
 per me si va nell' eterno dolore;
 per me si va tra la perduta gente.

Giustizia mosse il mio alto Fattore;
 fecemi la divina Potestate,
 la somma Sapienza e il primo Amore.

Dinanzi a me non fur cose create,
 se non eterne, ed io eterno duro:
 lasciate ogni speranza, voi ch' entrate."

Queste parole di colore oscuro
 vid' io scritte al sommo d' una porta;
 per ch' io: "Maestro, il senso lor m' è duro."

Ed egli a me, come persona accorta:
 "Qui si convien lasciare ogni sospetto;
 ogni viltà convien che qui sia morta.

Noi siam venuti al luogo ov' io t' ho detto
 che tu vedrai le genti dolorose,
 ch' hanno perduto il ben dello intelletto."

E poichè la sua mano alla mia pose,
 con lieto volto, ond' io mi confortai,
 mi mise dentro alle segrete cose.

Quivi sospiri, pianti, e alti guai
 risonavan per l' aer senza stelle,
 per ch' io al cominciar ne lagrimai.

Diverse lingue, orribili favelle,
 parole di dolore, accenti d' ira,
 voci alte e fioche, e suon di man con elle,

facevano un tumulto, il qual s' aggira
 sempre in quell' aria senza tempo tinta,
 come la rena quando a turbo spira.

Ed io, ch' avea d' orror la testa cinta,
 dissi: "Maestro, che è quel ch' i' odo?
 e che gente è, che par nel duol sì vinta?"

Ed egli a me: "Questo misero modo
 tengon l' anime triste di coloro,
 che visser senza infamia e senza lodo.

mischiate sono a quel cattivo coro
 degli angeli che non furon ribelli,
 nè fur fedeli a Dio, ma per sè foro.

Cacciarli i ciel per non esser men belli,
 nè lo profondo inferno gli riceve,
 chè alcuna gloria i rei avrebber d' elli."

Ed io: "Maestro, che è tanto greve
 a lor, che lamentar gli fa sì forte?"
 Rispose: "Dicerolti molto breve.

Questi non hanno speranza di morte,
 e la lor cieca vita è tanto bassa,
 che invidiosi son d' ogni altra sorte.

Fama di loro il mondo esser non lassa,
 misericordia e giustizia gli sdegna:
 non ragioniam di lor, ma guarda e passa."

Ed io, che riguardai, vidi una insegna,
 che girando correva tanto ratta,
 che d' ogni posa mi pareva indegna;

e dietro le venia sì lunga tratta
 di gente, ch' io non avrei mai creduto,
 che morte tanta n' avesse disfatta.

Poscia ch' io v' ebbi alcum riconosciuto,
 vidi e conobbi l' ombra di colui
 che fece per viltate il gran rifiuto.

Incontanente intesi, e certo fui,
 che quest' era la setta dei cattivi,
 a Dio spiacenti ed a' nemici sui.

Questi sciaurati, che mai non fur vivi,
 erano ignudi e stimolati molto
 da mosconi e da vespe ch' eran ivi.

Elle rigavan lor di sangue il volto,
 che mischiato di lagrime a' lor piedi
 da fastidiosi vermi era ricolto.

E poi che a riguardare oltre mi diedi,
 vidi gente alla riva d' un gran fiume;
 perch' io dissi: "Maestro, or mi concedi,

ch' io sappia quali sono, e qual costume
 le fa parer di trapassar sì pronte,
 com' io discerno per lo fioco lume."

Ed egli a me: "Le cose ti fien conte,
 quando noi fermerem li nostri passi
 sulla trista riviera d' Acheronte."

Allor con gli occhi vergognosi e bassi,
 temendo no 'l mio dir gli fusse grave,
 infino al fiume dal parlar mi trassi.

Ed ecco verso noi venir per nave
 un vecchio bianco per antico pelo,
 gridando: "Guai a voi, anime prave!

non isperate mai veder lo cielo:
 i' vegno per menarvi all' altra riva,
 nelle tenebre eterne, in caldo e in gelo.

E tu che sei costì, anima viva,
 partiti da cotesti, che son morti."
 Ma poi ch' ei vide, ch' io non mi partiva,

disse: "Per altra via, per altri porti
 verrai a piaggia, non qui, per passare:
 più lieve legno convien che ti porti."

E il duca a lui: "Caron, non ti crucciare:
 vuolsi così colà, dove si puote
 ciò che si vuole; e più non dimandare."

Quinci fur quete le lanose gote
 al nocchier della livida palude,
 che intorno agli occhi avea di fiamme rote.

Ma quell' anime ch' eran lasse e nude,
 cangiâr colore e dibattero i denti,
 ratto che inteser le parole crude.

Bestemmiavano Iddio e lor parenti,
 l' umana specie, il luogo, il tempo, e il seme
 di lor semenza e di lor nascimenti.

Poi si ritrasser tutte quante insieme,
 forte piangendo, alla riva malvagia,
 che attende ciascun uom, che Dio non teme.

Caron dimonio, con occhi di bragia
 loro accennando, tutte le raccoglie;
 batte col remo qualunque s' adagia.

Come d' autunno si levan le foglie
 l' una appresso dell' altra, infin che il ramo
 vede alla terra tutte le sue spoglie:

similemente il mal seme d' Adamo
 gittansi di quel lito ad una ad una,
 per cenni, come augel per suo richiamo.

Così sen vanno su per l' onda bruna,
 ed avanti che sian di là discese,
 anche di qua nova schiera s' aduna.

"Figliuol mio," disse il maestro cortese,
 "quelli, che muoion nell' ira di Dio,
 tutti convegnon qui d' ogni paese;

e pronti sono a trapassar lo rio,
 chè la divina giustizia gli sprona
 sì che la tema si volge in disio.

Quinci non passa mai anima buona:
 e però, se Caron di te si lagna,
 ben puoi saper omai, che il suo dir suona."

Finito questo, la buia campagna
 tremò sì forte, che dello spavento
 la mente di sudore ancor mi bagna.

La terra lagrimosa diede vento,
 che balenò una luce vermiglia,
 la qual mi vinse ciascun sentimento;

e caddi, come l' uom, cui sonno piglia.

"Through me is the way into the doleful city; through me the way into the eternal pain; through me the way among the people lost.

Justice moved my High Maker; Divine Power made me, Wisdom Supreme, and Primal Love.

Before me were no things created, but eternal; and eternal I endure: leave all hope, ye that enter."

These words, of colour obscure, saw I written above a gate; whereat I: "Master, their meaning to me is hard."

And he to me, as one experienced: "Here must all distrust be left; all cowardice must here be dead.

We are come to the place where I told thee thou shouldst see the wretched people, who have lost the good of the intellect."

And placing his hand on mine, with a cheerful countenance that comforted me, he led me into the secret things.

Here sighs, plaints, and deep wailings resounded through the starless air: it made me weep at first.

Strange tongues, horrible outcries, words of pain, tones of anger, voices deep and hoarse, and sounds of hands amongst them,

made a tumult, which turns itself unceasing in that air for ever dyed, as sand when it eddies in a whirlwind.

And I, my head begirt with horror, said: "Master, what is this that I hear? and who are these that seem so overcome with pain?"

And he to me: "This miserable mode the dreary souls of those sustain, who lived without blame, and without praise.

They are mixed with that caitiff choir of the angels, who were not rebellious, nor were faithful to God; but were for themselves.

Heaven chased them forth to keep its beauty from impair; and the deep Hell receives them not, for the wicked would have some glory over them."

And I: "Master, what is so grievous to them, that makes them lament thus bitterly?" He answered: "I will tell it to thee very briefly.

These have no hope of death; and their blind life is so mean, that they are envious of every other lot.

Report of them the world permits not to exist; Mercy and Justice disdains them: let us not speak of them; but look, and pass."

And I, who looked, saw an ensign, which whirling ran so quickly that it seemed to scorn all pause;

and behind it came so long a train of people, that I should never have believed death had undone so many.

After I had recognised some amongst them, I saw and knew the shadow of him who from cowardice made the great refusal.

Forthwith I understood and felt assured, that this was the crew of caitiffs, hateful to God and to his enemies.

These unfortunate, who never were alive, were naked, and sorely goaded by hornets and by wasps that were there.

These made their faces stream with blood, which mixed with tears was gathered at their feet by loathsome worms.

And then, as I looked onwards, I saw people on the Shore of a great
River: whereat I said: "Master, now grant

that I may know who these are; and what usage makes them seem so
ready to pass over, as I discern by the faint light."

And he to me: "The things shall be known to thee, when we stay our
steps upon the joyless strand of Acheron."

Then, with eyes ashamed and downcast, fearing my words might have
offended him, I kept myself from speaking till we reached the stream.

And lo! an old man, white with ancient hair, comes towards us in a
bark, shouting: "Woe to you, depraved spirits!

hope not ever to see Heaven: I come to lead you to the other shore;
into the eternal darkness; into fire and into ice.

And thou who art there, alive, depart thee from these who are dead."
But when he saw that I departed not,

he said: "By other ways, by other ferries, not here, shalt thou pass
over: a lighter boat must carry thee."

And my guide to him: "Charon, vex not thyself: thus it is willed there,
where what is willed can be done; and ask no more."

Then the woolly cheeks were quiet of the steersman on the livid marsh,
who round his eyes had wheels of flame.

But those spirits, who were foreworn and naked, changed colour and
chattered with their teeth, soon as they heard the bitter words.

They blasphemed God and their parents; the human kind; the place,
the time, and origin of their seed, and of their birth.

Then all of them together, sorely weeping, drew to the accursed shore,
which awaits every man that fears not God.

Charon the demon, with eyes of glowing coal, beckoning them, collects
them all; smites with his oar whoever lingers.

As the leaves of autumn fall off one after the other, till the branch sees
all its spoils upon the ground:

so one by one the evil seed of Adam cast themselves from that shore at
signals, as the bird at its call.

Thus they depart on the brown water; and ere they have landed on the
other shore, again a fresh crowd collects on this.

"My son," said the courteous Master, "those who die under God's
wrath, all assemble here from every country;

and they are prompt to pass the river, for Divine Justice spurs them so, that fear is changed into desire.

By this way no good spirit ever passes; and hence, if Charon complains of thee, thou easily now mayest know the import of his words."

When he had ended, the dusky champaign trembled so violently, that the remembrance of my terror bathes me still with sweat.

The tearful ground gave out wind, which flashed forth a crimson light that conquered all my senses; and I fell, like one who is seized with sleep.

<div align="right">

Inferno (c. 1319), iii, 1–136
Translated by J. A. Carlyle

</div>

Consider the wonderful profoundness of the whole third canto of the Inferno; and especially of the inscription over Hell gate:

Per me si va, etc.—

which can only be explained by a meditation on the true nature of religion; that is,—reason PLUS *the understanding. I say profoundness rather than sublimity; for Dante does not so much elevate your thoughts as send them down deeper. In this canto all the images are distinct, and even vividly distinct; but there is a total impression of infinity; the wholeness is not in vision or conception, but in an inner feeling of totality, and absolute being.*

<div align="right">

SAMUEL TAYLOR COLERIDGE
Lecture on Dante (1818)

</div>

DANTE ALIGHIERI

1 2 6 5 — 1 3 2 1

SALADIN

E solo in parte vidi il Saladino.

And alone, apart, I saw the Saladin.

<div align="right">

Inferno (c. 1319), iv, 129

</div>

The poet says that and leaves it so; he does not do any more to inform our minds or to arouse our imaginations. I know no passage which illustrates more forcibly the method of the Grand Style in its greatest moments, and I know none more fit to be the last word of an attempt to

study it. For it is, after all, the thing itself which explains itself; no labour of defining words can give the secret of that which unites the cloudy majesty of Milton with the open sunlight of Homer, the magic strokes of Shakespeare with the consummate art of Pindar, the severe simplicity of Dante, clear-cut as a precious stone, unyielding and immutable, with that so different simplicity, clear too, but with the clearness of a stream in the sunshine, a thing infinitely mobile and winning and gracious, the liquid and human simplicity of Catullus.

<div align="right">

JOHN BAILEY
The Continuity of Letters (1923)

</div>

DANTE ALIGHIERI

1 2 6 5 — 1 3 2 1

PAOLO AND FRANCESCA

"Siede la terra, dove nata fui,
 su la marina dove il Po discende
 per aver pace co' seguaci sui.

Amor, che al cor gentil ratto s' apprende,
 prese costui della bella persona
 che mi fu tolta, e il modo ancor m' offende.

Amor, che a nullo amato amar perdona,
 mi prese del costui piacer sì forte,
 che, come vedi, ancor non m' abbandona.

Amor condusse noi ad una morte;
 Caina attende chi vita ci spense."
 Queste parole da lor ci fur porte.

Da che io intesi quelle anime offense,
 chinai il viso, e tanto il tenni basso,
 finchè il poeta mi disse: "Che pense?"

Quando risposi, cominciai: "O lasso,
 quanti dolci pensier, quanto disio
 menò costoro al doloroso passo!"

Poi mi rivolsi a loro, e parlai io,
 e cominciai: "Francesca, i tuoi martiri
 a lagrimar mi fanno tristo e pio.

<div align="center">368</div>

Ma dimmi: al tempo de' dolci sospiri,
a che e come concedette amore,
che conosceste i dubbiosi desiri?"

Ed ella a me: "Nessun maggior dolore,
che ricordarsi del tempo felice
nella miseria; e ciò sa il tuo dottore.

Ma se a conoscer la prima radice
del nostro amor tu hai cotanto affetto,
farò come colui che piange e dice.

Noi leggevamo un giorno per diletto
di Lancillotto, come amor lo strinse;
soli eravamo e senza alcun sospetto.

Per più fiate gli occhi ci sospinse
quella lettura, e scolorocci il viso;
ma solo un punto fu quel che ci vinse.

Quando leggemmo il disiato riso
esser baciato da cotanto amante,
questi, che mai da me non fia diviso,

la bocca mi baciò tutto tremante:
Galeotto fu il libro, e chi lo scrisse;
quel giorno più non vi leggemmo avante."

Mentre che l' uno spirto questo disse,
l' altro piangeva sì, che di pietade
io venni men così com' io morisse;

e caddi, come corpo morto cade.

"The land where I was born sits by the seas,
 Upon that shore to which the Po descends,
 With all his followers, in search of peace.
Love, which the gentle heart soon apprehends,
 Seized him for the fair person which was ta'en
 From me, and me even yet the mode offends.
Love, who to none beloved to love again
 Remits, seized me with wish to please, so strong,
 That, as thou seest, yet, yet it doth remain.
Love to one death conducted us along,
 But Caina waits for him our life who ended:"
 These were the accents utter'd by her tongue.—

Since I first listen'd to these souls offended,
 I bow'd my visage, and so kept it till—
 "What think'st thou," said the bard; when I unbended,
And recommenced: "Alas! unto such ill
 How many sweet thoughts, what strong ecstasies,
 Led these their evil fortune to fulfil!"
And then I turn'd unto their side my eyes,
 And said, "Francesca, thy sad destinies
 Have made me sorrow till the tears arise.
But tell me, in the season of sweet sighs,
 By what and how thy love to passion rose,
 So as his dim desires to recognise?"
Then she to me: "The greatest of all woes
 Is to remind us of our happy days
 In misery, and that thy teacher knows.
But if to learn our passion's first root preys
 Upon thy spirit with such sympathy,
 I will do even as he who weeps and says.
We read one day for pastime, seated nigh,
 Of Lancilot, how love enchain'd him too.
 We were alone, quite unsuspiciously.
But oft our eyes met, and our cheeks in hue
 All o'er discolour'd by that reading were;
 But one point only wholly us o'erthrew;
When we read the long-sigh'd-for smile of her,
 To be thus kiss'd by such devoted lover,
 He who from me can be divided ne'er
Kiss'd my mouth, trembling in the act all over:
 Accursed was the book and he who wrote!
 That day no further leaf we did uncover."
While thus one spirit told us of their lot,
 The other wept, so that with pity's thralls
 I swoon'd, as if by death I had been smote
And fell down even as a dead body falls.

 Inferno (c. 1319), v, 97–142
 Translated by George Gordon, Lord Byron

Ugolino and Paolo and Francesca in Dante equal anything anywhere.
 ALFRED LORD TENNYSON
 Alfred Lord Tennyson: A Memoir by Hallam Tennyson (1897)

THE PROUD SOUL OF FARINATA IN HADES

Ed ei s' ergea col petto e colla fronte,
come avesse lo inferno in gran dispitto.

He rose upright with breast and countenance, as if he entertained
great scorn of Hell.

Inferno (c. 1319), x, 35–36
Translated by J. A. Carlyle

A perfect phrase.

T. S. ELIOT
Dante (1929)

DANTE ALIGHIERI

1 2 6 5 — 1 3 2 1

UGOLINO

Ed io sentii chiavar l' uscio di sotto
all' orribile torre: ond' io guardai
nel viso a' miei figliuoi senza far motto.

Io non piangeva, sì dentro impietrai;
piangevan elli; ed Anselmuccio mio
disse: 'Tu guardi sì, padre, che hai?'

Però non lagrimai, nè rispos' io
tutto quel giorno, nè la notte appresso,
infin che l' altro sol nel mondo uscio.

Come un poco di raggio si fu messo
nel doloroso carcere, ed io scorsi
per quattro visi il mio aspetto stesso,

ambo le mani per dolor mi morsi.
Ed ei, pensando ch' io 'l fessi per voglia
di manicar, di subito levorsi,

371

e disser: 'Padre, assai ci fia men doglia,
 se tu mangi di noi: tu ne vestisti
 queste misere carni, e tu le spoglia.'

Queta' mi allor per non farli più tristi;
 lo dì e l' altro stemmo tutti muti.
 Ahi dura terra, perchè non t' apristi?

Poscia che fummo al quarto dì venuti,
 Gaddo mi si gittò disteso a' piedi,
 dicendo: 'Padre mio, chè non m' aiuti?'

Quivi morì; e come tu mi vedi,
 vid' io cascar li tre ad uno ad uno
 tra il quinto dì e il sesto: ond' io mi diedi

già cieco a brancolar sopra ciascuno,
 e due dì li chiamai poi che fur morti;
 poscia, più che il dolor, potè il digiuno.

And down in the horrible tower I heard the door
 Locked up. Without a word I looked anew
 Into my sons' faces, all the four.
I wept not, so to stone within I grew.
 They wept; and one, my little Anselm, cried:
 'You look so, Father, what has come on you?'
But I shed not a tear, neither replied
 All that day nor the next night, until dawn
 Of a new day over the world rose wide.
A cranny of light crept in upon the stone
 Of that dungeon of woe; and I saw there
 On those four faces the aspect of my own.
I bit upon both hands in my despair.
 And they supposing it was in the access
 Of hunger, rose up with a sudden prayer,
And said: 'O Father, it will hurt much less
 If you of us eat: take what once you gave
 to clothe us, this flesh of our wretchedness.'
Thereon I calmed myself, their grief to save.
 That day and the one after we were dumb.
 Hard earth, couldst thou not open for our grave?
But when to the fourth morning we were come,
 Gaddo at my feet stretched himself with a cry:
 'Father, why won't you help me?' and lay numb

And there died. Ev'n as thou seest me, saw I,
　　One after the other, the three fall. They drew,
　　Between the fifth and sixth day, their last sigh.
I, blind now, groping arms about them threw,
　　And still called on them that were two days dead.
　　Then fasting did what anguish could not do.

<div align="right">Inferno (c. 1319), xxxiii, 46–75
Translated by Laurence Binyon</div>

The thirty lines from ED IO SENTJ, *are unequalled by any other continuous thirty in the whole dominions of poetry.*

<div align="right">WALTER SAVAGE LANDOR
The Pentameron (1836)</div>

DANTE ALIGHIERI

1 2 6 5 — 1 3 2 1

MARVEL YE NOT

"O ben finiti, o già spiriti eletti,"
　　Virgilio incominciò, "per quella pace
　　ch' io credo che per voi tutti si aspetti,

ditene dove la montagna giace,
　　sì che possibil sia l' andare in suso:
　　chè perder tempo a chi più sa più spiace."

Come le pecorelle escon del chiuso
　　ad una, a due, a tre, e l' altre stanno
　　timidette atterrando l' occhio e il muso;

e ciò che fa la prima, e l' altre fanno,
　　addossandosi a lei s' ella s' arresta,
　　semplici e quete, e lo 'mperchè non sanno:

sì vid' io movere a venir la testa
　　di quella mandria fortunata allotta,
　　pudica in faccia, e nell' andare onesta.

Come color dinanzi vider rotta
　　la luce in terra dal mio destro canto,
　　sì che l' ombra era da me alla grotta,

<div align="center">373</div>

restaro, e trasser sè indietro alquanto,
e tutti gli altri che venieno appresso,
non sapendo il perchè, fenno altrettanto.

"Senza vostra domanda io vi confesso,
che questo è corpo uman che voi vedete,
per che il lume del sole in terra è fesso.

Non vi maravigliate; ma credete
che, non senza virtù che dal ciel vegna,
cerchi di soperchiar questa parete."

"O ye whose end was happy, O spirits already chosen," Virgil began,
"by that same peace which I believe by you all is awaited,

tell us where the mountain slopes, so that it may be possible to go
upward; for time lost irks him most who knoweth most."

As sheep come forth from the pen, in ones, in twos, in threes, and the
others stand all timid, casting eye and nose to earth,

and what the first one doeth, the others do also, huddling up to her
if she stand still, silly and quiet, and know not why,

so saw I then the head of that happy flock move to come on, modest
in countenance, in movement dignified.

When those in front saw the light broken on the ground on my right
side, so that the shadow was from me to the rock,

they halted, and drew them back somewhat; and all the others that
came after, knowing not why, did the like.

"Without your question I confess to you, that this is a human body ye
see, by which the sun's light on the ground is cleft.

Marvel ye not, but believe that not without virtue which cometh from
heaven, he seeks to surmount this wall."

Purgatorio (c. 1319), iii, 73–99
Translated by Thomas Okey

*I think it the most perfect passage of the kind in the world, the most
imaginative, the most picturesque, and the most sweetly expressed.*
THOMAS BABINGTON MACAULAY
Critical and Historical Essays (1843)

BUONCONTE RELATES HIS FATE

Poi disse un altro: "Deh, se quel disio
 si compia che ti tragge all' alto monte,
 con buona pietate aiuta il mio.

Io fui di Montefeltro, io son Buonconte;
 Giovanna o altri non ha di me cura:
 per ch' io vo tra costor con bassa fronte."

Ed io a lui: "Qual forza o qual ventura
 ti traviò sì fuor di Campaldino
 che non si seppe mai tua sepoltura?"

"Oh," rispos' egli, "a piè del Casentino
 traversa un' acqua che ha nome l' Archiano,
 che sopra l' Ermo nasce in Apennino.

Dove il vocabol suo diventa vano
 arriva' io forato nella gola,
 fuggendo a piede e sanguinando il piano.

Quivi perdei la vista, e la parola
 nel nome di Maria finii; e quivi
 caddi, e rimase la mia carne sola.

Io dirò il vero, e tu il ridi' tra i vivi;
 l' angel di Dio mi prese, e quel d' inferno
 gridava: 'O tu del ciel, perchè mi privi?

Tu te ne porti di costui l' eterno
 per una lagrimetta che il mi toglie;
 ma io farò dell' altro altro governo.'

Ben sai come nell' aere si raccoglie
 quell' umido vapor, che in acqua riede
 tosto che sale dove il freddo il coglie.

Giunse quel mal voler, che pur mal chiede,
 con l' intelletto, e mosse il fummo e il vento
 per la virtù, che sua natura diede.

Indi la valle, come il dì fu spento,
da Pratomagno al gran giogo coperse
di nebbia, e il ciel di sopra fece intento

sì che il pregno aere in acqua si converse:
la pioggia cadde, ed ai fossati venne
di lei ciò che la terra non sofferse;

e come a' rivi grandi si convenne,
ver lo fiume real tanto veloce
si ruinò, che nulla la ritenne.

Lo corpo mio gelato in su la foce
trovò l' Archian rubesto; e quel sospinse
nell' Arno, e sciolse al mio petto la croce,

ch' io fei di me quando il dolor mi vinse;
voltommi per le ripe e per lo fondo,
poi di sua preda mi coperse e cinse."

Then said another, "Ah! so may that desire be fulfilled which draws thee to the high mountain, with good piety help thou mine. I was of Montefeltro, and am Buonconte. Joan or any other has no care for me, wherefore I go among these with downcast front." And I to him, "What violence, or what chance so carried thee astray from Campaldino, that thy burial place was never known?" "Oh!" replied he, "at foot of the Casentino crosses a stream, named the Archiano, which rises in the Apennine above the Hermitage. Where its proper name becomes vain I arrived, pierced in the throat, flying on foot, and bloodying the plain. Here I lost my sight, and I ended my speech with the name of Mary, and here I fell, and my flesh remained alone. I will tell the truth, and do thou repeat it among the living. The Angel of God took me, and he of Hell cried out, "O thou from Heaven, why dost thou rob me? Thou bearest away for thyself the eternal part of him for one little tear which takes him from me; but of the rest I will make other disposal." Thou knowest well how in the air is condensed that moist vapor which turns to water soon as it rises where the cold seizes it. He joined that evil will, which seeketh only evil, with intelligence, and moved the mist and the wind by the power that his own nature gave. Then when the day was spent he covered the valley with cloud, from Pratomagno to the great chain, and made the frost above so intense that the pregnant air was turned to water. The rain fell, and to the gullies came of it what the earth did not endure, and as it gathered in great streams it rushed so swiftly towards the royal river that nothing held it back. The robust Archiano found my frozen body near its outlet, and pushed it into the

Arno, and loosed on my breast the cross which I made of myself when the pain overcame me. It rolled me along its banks, and along its bottom, then with its spoil it covered and girt me."

<div align="right">

Purgatorio (c. 1319), v, 85–129
Translated by Charles Eliot Norton

</div>

There is, I feel assured, nothing else like it in all the range of poetry; a faint and harsh echo of it, only, exists in one Scottish ballad, "The Twa Corbies."

<div align="right">

JOHN RUSKIN
Modern Painters (1856)

</div>

DANTE ALIGHIERI

1 2 6 5 — 1 3 2 1

DANTE SEES BEATRICE IN GLORY

Quando il settentrion del primo cielo,
 che nè occaso mai seppe nè òrto,
 nè d' altra nebbia che di colpa velo,

e che faceva lì ciascuno accorto
 di suo dover, come il più basso face
 qual timon gira per venire a porto,

fermo s' affisse, la gente verace,
 venuta prima tra il grifone ed esso,
 al carro volse sè, come a sua pace;

ed un di loro, quasi da ciel messo,
 "*Veni, sponsa, de Libano*" cantando
 gridò tre volte, e tutti gli altri appresso.

Quali i beati al novissimo bando
 surgeran presti ognun di sua caverna,
 la rivestita voce alleluiando,

cotali, in su la divina basterna,
 si levar cento *ad vocem tanti senis*,
 ministri e messaggier di vita eterna.

<div align="center">

377

</div>

Tutti dicean: *"Benedictus qui venis"*;
 e, fior gittando di sopra e dintorno,
 "Manibus o date lilia plenis."

Io vidi già nel cominciar del giorno
 la parte oriental tutta rosata
 e l' altro ciel di bel sereno adorno,

e la faccia del sol nascere ombrata,
 sì che per temperanza di vapori,
 l' occhio la sostenea lunga fiata:

così dentro una nuvola di fiori,
 che dalle mani angeliche saliva
 e ricadeva in giù dentro e di fuori,

sopra candido vel, cinta d' oliva,
 donna m' apparve, sotto verde manto,
 vestita di color di fiamma viva.

E lo spirito mio, che già cotanto
 tempo era stato che alla sua presenza
 non era di stupor, tremando, affranto,

senza degli occhi aver più conoscenza,
 per occulta virtù che da lei mosse,
 d' antico amor sentì la gran potenza.

Tosto che nella vista mi percosse
 l' alta virtù, che già m' avea trafitto
 prima ch' io fuor di puerizia fosse,

volsimi alla sinistra col rispitto
 col quale il fantolin corre alla mamma,
 quando ha paura o quando egli è afflitto,

per dicere a Virgilio: "Men che dramma
 di sangue m' è rimaso, che non tremi;
 conosco i segni dell' antica fiamma."

Ma Virgilio n' avea lasciati scemi
 di sè, Virgilio dolcissimo patre,
 Virgilio a cui per mia salute die' mi:

nè quantunque perdè l' antica matre
 valse alle guance nette di rugiada,
 che lagrimando non tornassero atre,

"Dante, perchè Virgilio se ne vada,
non pianger anco, non pianger ancora:
chè pianger ti convien per altra spada."

Quasi ammiraglio, che in poppa ed in prora
viene a veder la gente che ministra
per gli altri legni, ed a ben far la incuora,

in su la sponda del carro sinistra,
quando mi volsi al suon del nome mio,
che di necessità qui si registra,

vidi la donna, che pria m' appario
velata sotto l' angelica festa,
drizzar gli occhi ver me di qua dal rio.

Tutto che il vel che le scendea di testa,
cerchiato delle fronde di Minerva,
non la lasciasse parer manifesta,

regalmente nell' atto ancor proterva
continuò, come colui che dice
e il più caldo parlar di retro serva:

"Guardami ben: ben son, ben son Beatrice.
Come degnasti d' accedere al monte?
non sapei tu che qui è l' uom felice?"

Gli occhi mi cadder giù nel chiaro fonte;
ma, veggendomi in esso, i trassi all' erba,
tanta vergogna mi gravò la fronte.

Così la madre al figlio par superba,
com' ella parve a me: perchè d' amaro
sente 'l sapor della pietade acerba.

Ella si tacque, e gli angeli cantaro
di subito: *"In te, Domine, speravi"*;
ma oltre *"pedes meos"* non passaro.

Sì come neve tra le vive travi
per lo dosso d' Italia si congela,
soffiata e stretta dagli venti schiavi,

poi liquefatta in sè stessa trapela,
pur che la terra, che perde ombra, spiri,
sì che par foco fonder la candela:

così fui senza lagrime e sospiri
 anzi il cantar di quei che notan sempre
 retro alle note degli eterni giri.

Ma poi che intesi nelle dolci tempre
 lor compatire a me, più che se detto
 avesser: "Donna, perchè sì lo stempre?"

Io gel che m' era intorno al cor ristretto,
 spirito ed acqua fèssi, e con angoscia
 per la bocca e per gli occhi uscì del petto.

Ella, pur ferma in su la detta coscia
 del carro stando, alle sustanzie pie
 volse le sue parole così poscia:

"Voi vigilate nell' eterno dìe,
 sì che notte nè sonno a voi non fura
 passo che faccia il secol per sue vie:

onde la mia risposta è con più cura,
 che m' intenda colui che di là piagne,
 per che sia colpa e duol d' una misura.

Non pur per opra delle rote magne,
 che drizzan ciascun seme ad alcun fine,
 secondo che le stelle son compagne;

ma per larghezza di grazie divine,
 che sì alti vapori hanno a lor piova
 che nostre viste là non van vicine,

questi fu tal nella sua vita nuova
 virtualmente, ch' ogni abito destro
 fatto averebbe in lui mirabil prova.

Ma tanto più maligno e più silvestro
 si fa il terren col mal seme e non côlto,
 quant' egli ha più del buon vigor terrestro.

Alcun tempo il sostenni col mio volto;
 mostrando gli occhi giovinetti a lui,
 meco il menava in dritta parte vôlto.

Sì tosto come in su la soglia fui
 di mia seconda etade, e mutai vita,
 questi si tolse a me, e diessi altrui.

Quando di carne a spirto era salita,
 e bellezza e virtù cresciuta m' era,
 fu' io a lui men cara e men gradita;

e volse i passi suoi per via non vera,
 imagini di ben seguendo false,
 che nulla promission rendono intera.

Nè impetrare spirazion mi valse,
 con le quali ed in sogno ed altrimenti
 lo rivocai; sì poco a lui ne calse.

Tanto giù cadde, che tutti argomenti
 alla salute sua eran già corti,
 fuor che mostrargli le perdute genti.

Per questo visitai l' uscio dei morti,
 ed a colui che l' ha quassù condotto
 li preghi miei, piangendo, furon porti.

Alto fato di Dio sarebbe rotto,
 se Lete si passasse, e tal vivanda
 fosse gustata senza alcuno scotto

di pentimento che lagrime spanda."

When the wain of the first heaven which setting nor rising never knew,
nor veil of other mist than of sin,

and which made there each one aware of his duty, even as the lower
wain guides him who turns the helm to come into port,

had stopped still, the people of truth, who had first come between the
grifon and it, turned them to the car as to their peace;

and one of them, as if sent from heaven, "*Veni sponsa de Libano*" did
shout thrice in song, and all the others after him.

As the saints at the last trump shall rise ready each one from his tomb,
with re-clad voice singing Halleluiah,

such on the divine chariot rose up a hundred *ad vocem tanti senis,*
ministers and messengers of life eternal.

All were saying: "*Benedictus qui venis*"; and, strewing flowers above
and around, "*Manibus o date lilia plenis.*"

Ere now have I seen, at dawn of day, the eastern part all rosy red, and the rest of heaven adorned with fair clear sky,

and the face of the sun rise shadowed, so that by the tempering of the mists the eye long time endured him:

so within a cloud of flowers, which rose from the angelic hands and fell down again within and without,

olive-crowned over a white veil, a lady appeared to me, clad, under a green mantle, with hue of living flame.

And my spirit, that now so long a time had passed, since, trembling in her presence, it had been broken down with awe,

without having further knowledge by mine eyes through hidden virtue which went out from her, felt the mighty power of ancient love.

Soon as on my sight the lofty virtue smote, which already had pierced me ere I was out of my boyhood,

I turned me to the left with the trust with which the little child runs to his mother when he is frightened or when he is afflicted,

to say to Virgil: "Less than a drop of blood is left in me that trembleth not; I recognise the tokens of the ancient flame."

But Virgil had left us bereft of himself, Virgil sweetest Father, Virgil to whom for my weal I gave me up;

nor did all that our ancient mother lost, avail to keep my dew-washed cheeks from turning dark again with tears.

"Dante, for that Virgil goeth away, weep not yet, weep not yet, for thou must weep for other sword."

Even as an admiral, who at stern and at bow, comes to see the folk that man the other ships, and heartens them to brave deeds,

so on the left side of the car, when I turned me at sound of my name, which of necessity here is recorded,

I saw the lady, who first appeared to me veiled beneath the angelic festival, directing her eyes to me on this side the stream.

Albeit the veil which fell from her head, crowned with Minerva's leaves, did not let her appear manifest,

queenlike in bearing yet stern, she continued, like one who speaks and holds back the hottest words till the last:

"Look at me well; verily am I, verily am I Beatrice. How didst thou deign to draw nigh the mount? knewest thou not that here man is happy?"

Mine eyes drooped down to the clear fount; but beholding me therein, I drew them back to the grass, so great a shame weighed down my brow.

So doth the mother seem stern to her child, as she seemed to me; for the savour of harsh pity tasteth of bitterness.

She was silent, and straightway the angels sang: *"In te, Domine, speravi";* but beyond *"pedes meos"* they passed not.

As the snow amid the living rafters along Italia's back is frozen under blast and stress of Slavonian winds,

then melted trickles down through itself, if but the land that loseth shade do breathe, so that it seems fire melting the candle,

so without tears or sighs was I before the song of those who ever accord their notes after the melodies of the eternal spheres.

But when I heard in their sweet harmonies their compassion on me, more than if they had said "Lady, why dost thou so shame him?"

the ice which had closed about my heart became breath and water, and with anguish through mouth and eyes issued from my breast.

She, standing yet fixed on the said side of the car, then turned her words to the pitying angels thus:

"Ye watch in the everlasting day, so that nor night nor sleep stealeth from you one step which the world may take along its ways;

wherefore my answer is with greater care, that he who yonder doth weep may understand me, so that sin and sorrow be of one measure.

Not only by operation of the mighty spheres that direct each seed to some end, according as the stars are its companions,

but by the bounty of graces divine, which have for their rain vapours so high that our eyes reach not nigh them,

this man was such in his new life potentially, that every good talent would have made wondrous increase in him.

But so much the more rank and wild the ground becomes with evil seed and untilled, the more it hath of good strength of soil.

Some time I sustained him with my countenance; showing my youthful eyes to him I led him with me turned to the right goal.

So soon as I was on the threshold of my second age, and I changed life, he forsook me, and gave him to others.

When I was risen from flesh to spirit, and beauty and virtue were increased within me, I was less precious and less pleasing to him;

and he did turn his steps by a way not true, pursuing false visions of good, that pay back no promise entire.

Nor did it avail me to gain inspirations, with which in dream and otherwise, I called him back; so little recked he of them.

So low sank he, that all means for his salvation were already unavailing, save showing him the lost people.

For this I visited the portal of the dead, and to him who has guided him up hither, weeping my prayers were borne.

God's high decree would be broken, if Lethe were passed, and such viands were tasted, without some scot of penitence that may shed tears."

<div align="right">

Purgatorio (c. 1319), xxx, 1–145
Translated by Thomas Okey

</div>

Unequalled in beauty.

<div align="right">

R. W. CHURCH
Dante (1850)

</div>

<div align="center">

D A N T E A L I G H I E R I

1 2 6 5 — 1 3 2 1

LOVE

</div>

"Vergine madre, figlia del tuo figlio,
 umile ed alta più che creatura,
 termine fisso d' eterno consiglio,

tu se' colei, che l' umana natura
 nobilitasti sì che il suo Fattore
 non disdegnò di farsi sua fattura.

Nel ventre tuo si raccese l' amore,
 per lo cui caldo nell' eterna pace
 così è germinato questo fiore.

<div align="center">

384

</div>

Qui sei a noi meridiana face
 di caritate, e giuso, intra i mortali,
 sei di speranza fontana vivace.

Donna, sei tanto grande e tanto vali,
 che qual vuol grazia ed a te non ricorre,
 sua disianza vuol volar senz' ali.

La tua benignità non pur soccorre
 a chi domanda, ma molte fiate
 liberamente al domandar precorre.

In te misericordia, in te pietate,
 in te magnificenza, in te s' aduna
 quantunque in creatura è di bontate.

Or questi, che dall' infima lacuna
 dell' universo infin qui ha vedute
 le vite spiritali ad una ad una,

supplica a te, per grazia, di virtute
 tanto che possa con gli occhi levarsi
 più alto verso l' ultima salute;

ed io, che mai per mio veder non arsi
 più ch' io fo per lo suo, tutti i miei preghi
 ti porgo, e prego che non sieno scarsi,

perchè tu ogni nube gli disleghi
 di sua mortalità coi preghi tuoi,
 sì che il sommo piacer gli si dispieghi.

Ancor ti prego, Regina che puoi
 ciò che tu vuoli, che conservi sani,
 dopo tanto veder, gli affetti suoi.

Vinca tua guardia i movimenti umani;
 vedi Beatrice con quanti beati
 per li miei preghi ti chiudon le mani."

Gli occhi da Dio diletti e venerati,
 fissi nell' orator, ne dimostraro
 quanto i devoti preghi le son grati.

Indi all' eterno lume si drizzaro,
 nel qual non si de' creder che s' invii
 per creatura l' occhio tanto chiaro.

Ed io ch' al fine di tutti i disii
 m' appropinquava, sì com' io dovea,
 l' ardor del desiderio in me finii.

Bernardo m' accennava, e sorridea,
 perch' io guardassi suso: ma io era
 già per me stesso tal qual ei volea;

chè la mia vista, venendo sincera,
 e più e più entrava per lo raggio
 dell' alta luce, che da sè è vera.

Da quinci innanzi il mio veder fu maggio
 che il parlar nostro ch' a tal vista cede,
 e cede la memoria a tanto oltraggio.

Qual è colui che somniando vede,
 chè dopo il sogno la passione impressa
 rimane, e l' altro alla mente non riede;

cotal son io, chè quasi tutta cessa
 mia visione, ed ancor mi distilla
 nel cor lo dolce che nacque da essa.

Così la neve al sol si disigilla,
 così al vento nelle foglie lievi
 si perdea la sentenza di Sibilla.

O somma luce, che tanto ti levi
 dai concetti mortali, alla mia mente
 ripresta un poco di quel che parevi,

e fa la lingua mia tanto possente,
 ch' una favilla sol della tua gloria
 possa lasciare alla futura gente;

chè, per tornare alquanto a mia memoria,
 e per sonare un poco in questi versi,
 più si conceperà di tua vittoria.

Io credo, per l' acume ch' io soffersi
 del vivo raggio, ch' io sarei smarrito,
 se gli occhi miei da lui fossero aversi.

E mi ricorda ch' io fui più ardito
 per questo a sostener tanto ch' io giunsi
 l' aspetto mio col valor infinito.

O abbondante grazia, ond' io presunsi
 ficcar lo viso per la luce eterna
 tanto che la veduta vi consunsi!

Nel suo profondo vidi che s' interna,
 legato con amore in un volume,
 ciò che per l' universo si squaderna;

sustanzia ed accidenti, e lor costume,
 quasi conflati insieme per tal modo,
 che ciò ch' io dico è un semplice lume.

La forma universal di questo nodo
 credo ch' io vidi, perchè più di largo,
 dicendo questo, mi sento ch' io godo.

Un punto solo m' è maggior letargo,
 che venticinque secoli alla impresa,
 che fe' Nettuno ammirar l' ombra d' Argo.

Così la mente mia, tutta sospesa,
 mirava fissa, immobile ed attenta,
 e sempre del mirar faceasi accesa.

A quella luce cotal si diventa,
 che volgersi da lei per altro aspetto
 è impossibil che mai si consenta.

Però che il ben, ch' è del volere obbietto,
 tutto s' accoglie in lei, e fuor di quella
 è difettivo ciò che lì è perfetto.

Omai sarà più corta mia favella,
 pure a quel ch' io ricordo, che di un fante
 che bagni ancor la lingua alla mammella.

Non perchè più ch' un semplice sembiante
 fosse nel vivo lume ch' io mirava,
 che tal è sempre qual era davante;

ma per la vista che s' avvalorava
 in me, guardando, una sola parvenza,
 mutandom' io, a me si travagliava.

Nella profonda e chiara sussistenza
 dell' alto lume parvemi tre giri
 di tre colori e d' una continenza;

e l' un dall' altro, come Iri da Iri,
 parea riflesso, e il terzo parea foco
 che quinci e quindi egualmente si spiri.

O quanto è corto il dire, e come fioco
 al mio concetto! e questo, a quel ch' io vidi,
 è tanto che non basta a dicer poco.

O luce eterna, che sola in te sidi,
 sola t' intendi, e, da te intelletta
 ed intendente te, ami ed arridi!

Quella circulazion, che sì concetta
 pareva in te come lume riflesso,
 dagli occhi miei alquanto circonspetta,

dentro da sè del suo colore stesso
 mi parve pinta della nostra effige,
 per che il mio viso in lei tutto era messo.

Qual è 'l geometra che tutto s' affige
 per misurar lo cerchio, e non ritrova,
 pensando, quel principio ond' egli indige;

tale era io a quella vista nuova:
 veder voleva, come si convenne
 l' imago al cerchio, e come vi s' indova;

ma non eran da ciò le proprie penne;
 se non che la mia mente fu percossa
 da un fulgore, in che sua voglia venne.

All' alta fantasia qui mancò possa;
 ma già volgeva il mio disiro e il *velle*,
 sì come rota ch' egualmente è mossa,

l' amor che move il sole e l' altre stelle.

"Virgin mother, daughter of thy son, lowly and uplifted more than any creature, fixed goal of the eternal counsel,

thou art she who didst human nature so ennoble that its own Maker scorned not to become its making.

In thy womb was lit again the love under whose warmth in the eternal peace this flower hath thus unfolded.

Here art thou unto us the meridian torch of love, and there below with mortals art a living spring of hope.

Lady, thou art so great and hast such worth, that if there be who would have grace yet betaketh not himself to thee, his longing seeketh to fly without wings.

Thy kindliness not only succoureth whoso requesteth, but doth often-times freely forerun request.

In thee is tenderness, in thee is pity, in thee munificence, in thee united whatever in created being is of excellence.

Now he who from the deepest pool of the universe even to here hath seen the spirit-lives, one by one,

imploreth thee, of grace, for so much power as to be able to uplift his eyes more high towards final bliss;

and I, who never burned for my own vision more than I do for his, proffer thee all my prayers, and pray they be not scant,

that thou do scatter for him every cloud of his mortality with prayers of thine, so that the joy supreme may be unfolded to him.

And further do I pray thee, Queen who canst do all that thou wilt, that thou keep sound for him, after so great a vision, his affections.

Let thy protection vanquish human ferments; see Beatrice, with how many Saints, for my prayers folding hands."

Those eyes, of God beloved and venerated, fixed upon him who prayed, showed us how greatly devout prayers please her.

Then to the eternal light they bent themselves, wherein we may not ween that any creature's eye findeth its way so clear.

And I, who to the goal of all my longings was drawing nigh, even as was meet, the ardour of the yearning quenched within me.

Bernard gave me the sign and smiled to me that I should look on high, but I already of myself was such as he would have me;

because my sight, becoming purged, now more and more was entering through the ray of the deep light which in itself is true.

Thenceforward was my vision mightier than our discourse, which faileth at such sight, and faileth memory at so great outrage.

As is he who dreaming seeth, and when the dream is gone the impression stamped remaineth, and naught else cometh to the mind again;

even such am I; for almost wholly faileth me my vision, yet doth the sweetness that was born of it still drop within my heart.

So doth the snow unstamp it to the sun, so to the wind on the light leaves was lost the Sibyl's wisdom.

O light supreme, who so far dost uplift thee o'er mortal thoughts, re-lend unto my mind a little of what then thou didst seem,

and give my tongue such power that it may leave only a single sparkle of thy glory unto the folk to come;

for by returning to my memory somewhat, and by a little sounding in these verses, more of thy victory will be conceived.

I hold that by the keenness of the living ray which I endured I had been lost, had mine eyes turned aside from it.

And so I was the bolder, as I mind me, so long to sustain it as to unite my glance with the Worth infinite.

Oh grace abounding, wherein I presumed to fix my look on the eternal light so long that I wearied my sight thereon!

Within its depths I saw ingathered, bound by love in one volume, the scattered leaves of all the universe;

substance and accidents and their relations, as though together fused, after such fashion that what I tell of is one simple flame.

The universal form of this complex I think that I beheld, because more largely, as I say this, I feel that I rejoice.

A single moment maketh a deeper lethargy for me than twenty and five centuries have wrought on the emprise that erst threw Neptune in amaze at Argo's shadow.

Thus all suspended did my mind gaze fixed, immovable, intent, ever enkindled by its gazing.

Such at that light doth man become that to turn thence to any other sight could not by possibility be ever yielded.

For the good, which is the object of the will, is therein wholly gathered, and outside it that same thing is defective which therein is perfect.

Now shall my speech fall farther short even of what I can remember, than an infant's who still bathes his tongue at the breast.

Not that more than a single semblance was in the living light whereon I looked, which ever is such as it was before;

but by the sight that gathered strength in me one sole appearance, even as I changed, worked on my gaze.

In the profound and shining being of the deep light appeared to me three circles, of three colours and one magnitude;

one by the second as Iris by Iris seemed reflected, and the third seemed a fire breathed equally from one and from the other.

Oh but how scant the utterance, and how faint, to my conception! and it, to what I saw, is such that it sufficeth not to call it little.

O Light eternal who only in thyself abidest, only thyself dost understand, and self-understood, self-understanding, turnest love on and smilest at thyself!

That circling which appeared in thee to be conceived as a reflected light, by mine eyes scanned some little,

in itself, of its own colour, seemed to be painted with our effigy, and thereat my sight was all committed to it.

As the geometer who all sets himself to measure the circle and who findeth not, think as he may, the principle he lacketh;

such was I at this new seen spectacle; I would perceive how the image consorteth with the circle, and how it settleth there;

but not for this were my proper wings, save that my mind was smitten by a flash wherein its will came to it.

To the high fantasy here power failed; but already my desire and will were rolled—even as a wheel that moveth equally—by the Love that moves the sun and the other stars.

<div style="text-align:right">

Paradiso (c. 1319), xxxiii, 1–145
Translated by Philip Henry Wicksteed

</div>

The highest point that poetry has ever reached or ever can reach.

<div style="text-align:right">

T. S. ELIOT
Dante (1929)

</div>

HEINRICH SUSO

1 3 0 0 ? — 1 3 6 6

SURSUM CORDA

Ich nahm vor meine inneren Augen mich selber, nach allem, das ich bin, mit Leib, Seele und allen meinen Kräften, und stellte um mich alle Kreatur, die Gott je schuf im Himmelreich, im Erdreich und in allen Elementen, ein jegliches sonderlich mit Namen, es wären Vögel der Luft, Thiere des Waldes, Fische des Wassers, Laub und Gras des Erdreichs und das unzählige Gries in dem Meer, und dazu all das kleine Gestäube, das in der Sonne Glanz scheinet, und alle die Wassertröpflein, die von Thau, von Schnee, oder Regen je fielen oder immer fallen, und wünschte, dass deren ein jegliches hätte ein süssaufdringendes Saitenspiel, wohlgeraiset [wohlbereitet] aus meines Herzens innerstem Safte, und also aufklingend ein neues hochgemuthes Lob brächte dem geminnten zarten Gott von Ende zu Ende. Und dann in einer begierlichen Weise zerdehnten und zerbreiteten sich die minnereichen Arme der Seele gen der unsäglichen Zahl aller Kreaturen, und war meine Meinung, sie alle fruchtbar darin zu machen, recht so wie ein freier wohlgemuther Vorsänger die singenden Gesellen reitzet, fröhlich zu singen und ihre Herzen zu Gott aufzubieten: SURSUM CORDA!

I place before my inward eyes myself with all that I am—my body, soul, and all my powers—and I gather round me all the creatures which God ever created in heaven, on earth, and in all the elements, each one severally with its name, whether birds of the air, beasts of the forest, fishes of the water, leaves and grass of the earth, or the innumerable sand of the sea, and to these I add all the little specks of dust which glance in the sunbeams, with all the little drops of water which ever fell or are falling from dew, snow, or rain, and I wish that each of these had a sweetly-sounding stringed instrument, fashioned from my heart's inmost blood, striking on which they might each send up to our dear and gentle God a new and lofty strain of praise for ever and ever. And then the loving arms of my soul stretch out and extend themselves towards the innumerable multitude of all creatures, and my intention is, just as a free and blithesome leader of a choir stirs up the singers of his company, even so to turn them all to good account by inciting them to sing joyously, and to offer up their hearts to God. "*Sursum corda.*"

Das Leben Heinrich Suso's (1333–41)
Translated by Thomas Francis Knox

I know of no passage of Christian mysticism more beautiful than that.
FORD MADOX FORD
The March of Literature (1938)

FRANCESCO PETRARCA

1 3 0 4 — 1 3 7 4

DISTANCE AND SOLITUDE

Di pensier in pensier, di monte in monte
 Mi guida Amor; ch' ogni segnato calle
 Provo contrario a la tranquilla vita.
 Se 'n solitaria piaggia, rivo o fonte,
 Se 'n fra duo poggi siede ombrosa valle,
 Ivi s' acqueta l' alma sbigottita;
 E, com' Amor la 'nvita,
 Or ride or piange, or teme or s' assicura;
 E 'l volto, che lei segue ov' ella il mena,
 Si turba e rasserena,
 Et in un esser picciol tempo dura;
 Onde a la vista uom di tal vita esperto
 Diria: 'Questi arde, e di suo stato è incerto.'

392

Per alti monti e per selve aspre trovo
Qualche riposo; ogni abitato loco
È nemico mortal degli occhi miei.
A ciascun passo nasce un pensier novo
De la mia donna, che sovente in gioco
Gira 'l tormento ch' io porto per lei.
Et a pena vorrei
Cangiar questo mio viver dolce amaro,
Ch' i' dico: 'Forse ancor ti serva Amore
Ad un tempo migliore;
Forse a te stesso vile, altrui se' caro'.
Et in questa trapasso sospirando:
'Or potrebbe esser vero? or come? or quando?'

Ove porge ombra un pino alto od un colle,
Talor m' arresto, e pur nel primo sasso
Disegno co' la mente il suo bel viso.
Poi ch' a me torno, trovo il petto molle
De la pietate; et allor dico: 'ahi lasso,
Dove se' giunto, et onde se' diviso!'
Ma, mentre tener fiso
Posso al primo pensier la mente vaga
E mirar lei et obblïar me stesso,
Sento Amor sì da presso
Che del suo proprio error l' alma s' appaga.
In tante parti e sì bella la veggio,
Che, se l' error durasse, altro non cheggio.

I' l' ho più volte (or chi fia che me 'l creda?)
Nell' acqua chiara e sopra l' erba verde
Veduta viva, e nel troncon d' un faggio,
E in bianca nube, sì fatta che Leda
Avria ben detto che sua figlia perde,
Come stella che 'l sol copre co 'l raggio;
E quanto in più selvaggio
Loco mi trovo e 'n più deserto lido,
Tanto più bella il mio pensier l' adombra.
Poi, quando il vero sgombra
Quel dolce error, pur lì medesmo assido
Me freddo, pietra morta in pietra viva,
In guisa d' uom che pensi e pianga e scriva.

Ove d' altra montagna ombra non tocchi,
Verso 'l maggiore e 'l più spedito giogo
Tirar mi suol un desiderio intenso:
Indi i miei danni a misurar con gli occhi

Comincio, e 'n tanto lagrimando sfogo
Di dolorosa nebbia il cor condenso,
Allor ch' i' miro e penso
Quant' aria dal bel viso mi diparte,
Che sempre m' è sì presso e sì lontano:
Poscia fra me pian piano:
'Che fai tu, lasso? forse in quella parte
Or di tua lontananza si sospira':
Et in questo pensier l' alma respira.

Canzone, oltra quell' alpe,
 Là dove il ciel è più sereno e lieto,
 Mi rivedrai sovr' un ruscel corrente,
 Ove l' aura si sente
 D' un fresco et odorifero laureto:
 Ivi è il mio cor, e quella che 'l m' invola,
 Qui veder pôi l' imagine mia sola.

From hill to hill I roam, from thought to thought,
With Love my guide; the beaten path I fly,
For there in vain the tranquil life is sought:
If 'mid the waste well forth a lonely rill,
Or deep embosom'd a low valley lie,
In its calm shade my trembling heart is still;
And there, if Love so will,
I smile, or weep, or fondly hope, or fear,
While on my varying brow, that speaks the soul,
The wild emotions roll,
Now dark, now bright, as shifting skies appear;
That whosoe'er has proved the lover's state
Would say, He feels the flame, nor knows his future fate.

On mountains high, in forests drear and wide,
I find repose, and from the throng'd resort
Of man turn fearfully my eyes aside;
At each lone step thoughts ever new arise
Of her I love, who oft with cruel sport
Will mock the pangs I bear, the tears, the sighs;
Yet e'en these ills I prize,
Though bitter, sweet, nor would they were removed:
For my heart whispers me, Love yet has power
To grant a happier hour:
Perchance, though self-despised, thou yet art loved:
E'en then my breast a passing sigh will heave,
Ah! when, or how, may I a hope so wild believe?

Where shadows of high rocking pines dark wave
I stay my footsteps, and on some rude stone
With thought intense her beauteous face engrave;
Roused from the trance, my bosom bathed I find
With tears, and cry, Ah! whither thus alone
Hast thou far wander'd, and whom left behind?
But as with fixèd mind
On this fair image I impassion'd rest,
And, viewing her, forget awhile my ills,
Love my rapt fancy fills;
In its own error sweet the soul is blest,
While all around so bright the visions glide;
Oh! might the cheat endure, I ask not aught beside.

Her form portray'd within the lucid stream
Will oft appear, or on the verdant lawn,
Or glossy beech, or fleecy cloud, will gleam
So lovely fair, that Leda's self might say,
Her Helen sinks eclipsed, as at the dawn
A star when cover'd by the solar ray:
And, as o'er wilds I stray
Where the eye nought but savage nature meets,
There Fancy most her brightest tints employs;
But when rude truth destroys
The loved illusion of those dreamèd sweets,
I sit me down on the cold rugged stone,
Less cold, less dead than I, and think, and weep alone.

Where the huge mountain rears his brow sublime,
On which no neighbouring height its shadow flings,
Led by desire intense the steep I climb;
And tracing in the boundless space each woe,
Whose sad remembrance my torn bosom wrings,
Tears, that bespeak the heart o'erfraught, will flow:
While, viewing all below,
From me, I cry, what worlds of air divide
The beauteous form, still absent and still near!
Then, chiding soft the tear,
I whisper low, haply she too has sigh'd
That thou art far away: a thought so sweet
Awhile my labouring soul will of its burthen cheat.

Go thou, my song, beyond that Alpine bound,
Where the pure smiling heavens are most serene,
There by a murmuring stream may I be found,
Whose gentle airs around

Waft grateful odours from the laurel green;
Nought but my empty form roams here unblest,
There dwells my heart with her who steals it from my breast.

<div align="right">

Canzone, xvii

Translated by Lady Barbarina Dacre

</div>

HERE RULES LOVE

Chiare, fresche e dolci acque,
 Ove le belle membra
 Pose colei che sola a me par donna;
 Gentil ramo, ove piacque
 (Con sospir mi rimembra)
 A lei di fare al bel fianco colonna;
 Erba e fior, che la gonna
 Leggiadra ricoverse
 Con l' angelico seno;
 Aer sacro sereno,
 Ov' Amor co' begli occhi il cor m' aperse;
 Date udienza insieme
 Alle dolenti mie parole estreme.

S' egli è pur mio destino,
 E 'l Cielo in ciò s' adopra,
 Ch' Amor quest' occhi lagrimando chiuda;
 Qualche grazia il meschino
 Corpo fra voi ricopra,
 E torni l' alma al proprio albergo ignuda.
 La morte fia men cruda,
 Se questa speme porto
 A quel dubbioso passo:
 Chè lo spirito lasso
 Non poria mai 'n più riposato porto,
 Nè in più tranquilla fossa
 Fuggir la carne travagliata e l' ossa.

Tempo verrà ancor forse,
 Che all' usato soggiorno
 Torni la fera bella e mansueta;
 E là ov' ella mi scorse
 Nel benedetto giorno,
 Volga la vista desïosa e lieta,
 Cercandomi: ed, oh pieta!
 Già terra infra le pietre
 Vedendo, Amor l' inspiri

In guisa che sospiri
Sì dolcemente che mercè m' impetre,
E faccia forza al Cielo,
Asciugandosi gli occhi col bel velo.

Da' bei rami scendea,
 Dolce nella memoria,
Una pioggia di fior sovra 'l suo grembo;
Ed ella si sedea
 Umile in tanta gloria,
Coverta già dell' amoroso nembo.
Qual fior cadea sul lembo,
Qual su le treccie bionde,
Ch' oro forbito e perle
Eran quel dì a vederle;
Qual si posava in terra, e qual su l' onde;
Qual con un vago errore
Girando parea dir: 'Qui regna Amore.'

Quante volte diss' io
 Allor pien di spavento:
'Costei per fermo nacque in Paradiso!'
Così carco d' oblio
 Il divin portamento,
E 'l volto e le parole e 'l dolce riso
M' aveano, e sì diviso
Dall' immagine vera,
Ch' io dicea sospirando:
'Qui come venn' io, o quando?'
Credendo esser in ciel, non là dov' era.
Da indi in qua mi piace
Quest' erba sì, ch' altrove non ho pace.

Se tu avessi ornamenti quant' hai voglia,
 Potresti arditamente
 Uscir del bosco, e gire infra la gente.

Clear, cool, and lovely brook
Where the fair body lies
Of one who seems the only woman here;
Sweet branch that once she took
(I think of it with sighs)
As a column to lean on, sitting near;
Grass and flower that her dear
Gown surrounded and starred,

397

With her angelic breast;
Limpid air, holy rest,
Where Love with her fair eyes opened my heart;
O hear you, all at once,
The mournful parting words that I pronounce.

If it must be my fate
(Such task heaven assays)
That Love close up my eyes with their last tear,
Let my poor body's weight
Be covered by your grace,
And let my soul come home naked and bare.
Death would be less to fear
If I could bring this hope
Unto that dubious goal;
For the exhausted soul
Could never in a more secluded scope
Or in a quieter zone
Retire and flee from aching flesh and bone.

Perhaps the time will come
That to the well-known way
The lovely and tame animal regress;
Then where I once stood numb,
Upon a blessed day
She will seek me with hope and happiness,
And, ah! all in distress
Before my earth and stone,
Perhaps Love will inspire
Her, and she will suspire
So sweetly that some mercy will be shown.
And she will force the skies
Wiping with her fair veil her weeping eyes.

From all the branches fair
(Sweet in my memory)
A rain of flowers on her lap fell down;
And she was sitting there,
Humble in such glory,
Already covered with a loving crown;
One flower fell on her gown,
One on her golden locks,
Which were like pearl and gold
On that day to behold;
Some lay upon the earth and waves and rocks,

Some strayed around, above,
In a sweet error, saying:—Here rules Love.

How often did I say,
At such time, full of dread:
—She certainly was born in paradise!—
Such forgetful delay
On her figure was spread,
And her words and her laughter and her eyes
So veiled like a disguise
Whatever came to pass,
That I said sighing then:
—How did I come here, when?—
Thinking that it was heaven where I was.
And since that time I care
So for this grass, I find no peace elsewhere.

Had you as many gifts as you have wishes,
You could with a brave mind
Part from this wood and go among mankind.

<div align="right">

Canzone, xiv
Translated by Anna Maria Armi

</div>

The two most profound canzoni of the Middle Ages.

<div align="right">

FRANCESCO DE SANCTIS
Storia della letteratura italiana (1870)

</div>

FRANCESCO PETRARCA

1 3 0 4 — 1 3 7 4

TO THE VIRGIN

Vergine bella, che di sol vestita,
 Coronata di stelle, al sommo Sole
 Piacesti sì, che 'n te sua luce ascose;
 Amor mi spinge a dir di te parole,
 Ma non so 'ncominciar senza tu' aita
 E di Colui ch' amando in te si pose.
 Invoco lei che ben sempre rispose
 Chi la chiamò con fede.

<div align="center">

399

</div>

Vergine, s' a mercede
Miseria estrema de l' umane cose
Già mai ti volse, al mio prego t' inchina;
Soccorri a la mia guerra,
Bench' i' sia terra, e tu del ciel regina.

Vergine saggia, e del bel numero una
De le beate vergini prudenti,
Anzi la prima e con più chiara lampa;
O saldo scudo de l' afflitte genti
Contr' a' colpi di Morte e di Fortuna,
Sotto 'l qual si trïonfa, non pur scampa;
O refrigerio al cieco ardor ch' avvampa
Qui fra i mortali sciocchi;
Vergine, que' belli occhi,
Che vider tristi la spietata stampa
Ne' dolci membri del tuo caro Figlio,
Volgi al mio dubbio stato,
Chè sconsigliato a te vèn per consiglio.

Vergine pura, d' ogni parte intera,
Del tuo parto gentil figliuola e madre,
Ch' allumi questa vita e l' altra adorni;
Per te il tuo Figlio e quel del sommo Padre,
O fenestra del ciel lucente, altera,
Venne a salvarne in su li estremi giorni;
E fra tutt' i terreni altri soggiorni
Sola tu fosti eletta,
Vergine benedetta,
Che 'l pianto d' Eva in allegrezza torni.
Fammi, chè puoi, de la sua grazia degno,
Senza fine, o beata
Già coronata nel superno regno.

Vergine santa, d' ogni grazia piena,
Che per vera et altissima umiltate
Salisti al ciel, onde miei preghi ascolti;
Tu partoristi il fonte di pietate,
E di giustizia il sol, che rasserena
Il secol pien d' errori oscuri e folti:
Tre dolci e cari nomi ha' in te raccolti,
Madre, figliuola e sposa;
Vergine glorïosa,
Donna del Re che nostri lacci ha sciolti
E fatto 'l mondo libero e felice:
Nelle cui sante piaghe
Prego ch' appaghe il cor, vera beatrice.

Vergine sola al mondo, senza esempio,
 Che 'l ciel di tue bellezze innamorasti,
 Cui nè prima fu simil, nè seconda;
 Santi pensieri, atti pietosi e casti
 Al vero Dio sacrato e vivo tempio
 Fecero in tua verginità feconda.
 Per te può la mia vita esser gioconda,
 S' a' tuoi preghi, o Maria,
 Vergine dolce e pia,
 Ove 'l fallo abbondò la grazia abbonda.
 Con le ginocchia de la mente inchine
 Prego che sia mia scorta,
 E la mia torta via drizzi a buon fine.

Vergine chiara e stabile in eterno,
 Di questo tempestoso mare stella,
 D' ogni fedel nocchier fidata guida;
 Pon' mente in che terribile procella
 I' mi ritrovo, sol, senza governo,
 Et ho già da vicin l' ultime strida.
 Ma pur in te l' anima mia si fida;
 Peccatrice, i' no 'l nego,
 Vergine; ma ti prego
 Che 'l tuo nemico del mio mal non rida.
 Ricorditi che fece il peccar nostro
 Prender Dio, per scamparne,
 Umana carne al tuo virginal chiostro.

Vergine, quante lagrime ho già sparte,
 Quante lusinghe e quanti preghi indarno,
 Pur per mia pena e per mio grave danno!
 Da poi ch' i' nacqui in su la riva d' Arno,
 Cercando or questa et or quell' altra parte,
 Non è stata mia vita altro ch' affanno.
 Mortal bellezza, atti e parole m' hanno
 Tutta ingombrata l' alma.
 Vergine sacra et alma,
 Non tardar, ch' i' son forse a l' ultimo anno.
 I dì miei, più correnti che saetta,
 Fra miserie e peccati
 Sonsen andati, e sol Morte n' aspetta.

Vergine, tale è terra e posto ha in doglia
 Lo mio cor, che vivendo in pianto il tenne,
 E di mille miei mali un non sapea;
 E, per saperlo, pur quel che n' avvenne

Fôra avvenuto; ch' ogni altra sua voglia
Era a me morte et a lei fama rea.
Or tu, Donna del ciel, tu nostra dea
(Se dir lice e convènsi),
Vergine d' alti sensi,
Tu vedi il tutto; e quel che non potea
Far altri è nulla a la tua gran vertute,
Por fine al mio dolore;
Che a te onore et a me fia salute.

Vergine, in cui ho tutta mia speranza
Che possi e vogli al gran bisogno aitarme,
Non mi lasciare in su l' estremo passo:
Non guardar me, ma chi degnò crearme;
No 'l mio valor, ma l' alta sua sembianza
Ch' è in me, ti mova a curar d' uom sì basso.
Medusa e l' error mio m' han fatto un sasso
D' umor vano stillante:
Vergine, tu di sante
Lagrime e pie adempi 'l mio cor lasso;
Ch' almen l' ultimo pianto sia devoto,
Senza terrestre limo,
Come fu 'l primo non d' insania vòto.

Vergine umana e nemica d' orgoglio,
Del comune principio amor t' induca;
Miserere d' un cor contrito, umile:
Chè se poca mortal terra caduca
Amar con sì mirabil fede soglio,
Che devrò far di te, cosa gentile?
Se dal mio stato assai misero e vile
Per le tue man resurgo,
Vergine, i' sacro e purgo
Al tuo nome e pensieri e 'ngegno e stile,
La lingua e 'l cor, le lagrime e i sospiri.
Scorgimi al miglior guado,
E prendi in grado i cangiati desiri.

Il dì s' appressa, e non pòte esser lunge,
Sì corre il tempo e vola,
Vergine unica e sola;
E 'l cor or conscïenzia or morte punge.
Raccomandami al tuo Figliuol, verace
Omo e verace Dio,
Ch' accolga 'l mio spirto ultimo in pace.

Virgin most lovely, who clothed with the sun,
Crowned with the stars, the great heavenly Light
Pleased so that he concealed in you his ray,
Love presses me to speak of your true height;
But to begin I need the vision
And help of you and of him who did stay
In you for love; you answer those who pray
And who call you with faith.
Virgin, if our lost breath
Inspired your mercy, and the sad decay
Of mortal things, hear my worshipping cry,
Bring comfort to my war,
Though I be straw, and you queen of the sky.

Virgin most wise, who the glad group enhance
Of the blessed and prudent virgins all,
Being the first, and with a clearer lamp;
O mighty shield of any suffering soul
Against the blows of death and treacherous chance,
That makes us triumph over evil's clamp;
O coolness in the bright furnace and swamp
That foolish mortals know;
Virgin, those eyes that glow,
Which saw with anguish the pitiless stamp
In the dear limbs of your beloved Son,
Turn to my dubious state
That, torn by fate, recites this orison.

Virgin all pure, in every part entire,
Of your lovable Child daughter and mother,
Who light this life, the other beautify,
For you, your Son and of the supreme Father,
O window of the sky, shining empire,
Came to save us in our last moment's cry;
And among all the dwellings that stood by
You were chosen alone,
Virgin who always shone
And did Eve's tears into mirth modify.
Make me, you have the power, deserve his grace,
O endlessly serene,
Who long have been enthroned in heaven's space.

Virgin most holy, full of every grace,
Who by a true and high humility
Rose to the sky from where you hear my prayer,
You gave birth to the spring of charity,

The sun of justice that brightens this place
And time, filled with thick error and despair:
Three dear and lovely names in you appear,
Mother, daughter, and bride;
O Virgin glorified,
Lady of the King who did our fetters tear
And did our world create free and serene,
In whose most sacred wound
I beg, make sound my heart, o blissful queen.

Virgin alone on earth, without compare,
Who with your beauties made the sky love you,
Of whom no like or second we shall see,
Holy thoughts, actions chaste, pious and true,
Raised to our God the temple and repair
Of your beneficent virginity.
Through you my life can reach felicity,
If, Mary, at your prayer,
Virgin sweet and fair,
Where once damage was spread, forgiveness be.
In my mind I bow down, my knees I bend,
And pray, be you my guide,
My wayward stride direct to rightful end.

Virgin all clear and eternally stable,
Of this tempestuous sea ever-fixed star,
Of every trustful pilot trusted guide,
Consider in what frightening stormy war
I find myself without a rule or label,
And I already touch the final tide.
And yet in you my soul is fortified,
Sinful, I do confess,
Virgin, but deign to bless
Me, that your foe may not my pain deride;
Remember how it was our sin that made
God take a human shape
And find escape for us in your bower's shade.

Virgin, how many tears I had to pour,
How many flatteries, prayers void and blank,
To my own punishment and grave mischief!
Ever since I was born on Arno's bank,
Seeking now this and now the other shore,
My life has never been other than grief.
Mortal grace, gestures, words, have been the chief

404

Interest of my soul.
Virgin sacred and whole,
Do not delay, perhaps my time is brief.
My days running more quick than lightning-chains,
Between sin and decay,
Have gone away and only death remains.

Virgin, someone is earth and has condemned
To pain my heart, who living made it weep;
And of my thousand ills not one she knew;
Had she known them, the harvest I did reap
Would not have changed; if other wish had stemmed
From her, I should be dead and she untrue.
Lady of heaven, goddess of the few,
If to say this is fit,
Virgin of holy wit,
You see all, and what others could not do
Is a small thing to your great majesty,
My suffering to end;
For this will lend you honour, bliss to me.

Virgin in whom I lay every hope
That you may, that you will help my great need,
Desert me not in the ultimate place,
Look not at me, but gaze on Him who did
Create my life; not my worth, but His scope,
Which is in me, may redeem my disgrace.
Medusa and my error made my face
A stone dripping in vain:
Virgin, now fill with sane
And holy tears my weary heart and base;
So that at least my last weeping be pure,
Without terrestrial mud,
As the first flood was mad and insecure.

Virgin quite human and averse to pride,
Let love of common origin move you;
Have mercy on a heart contrite and shy:
For if a little piece of earthly glue
I can love with a faith that is so wide,
What shall I do with you, thing of the sky?
If from the state so low in which I lie
By your hands I escape,
Virgin, to your pure shape

405

I will devote my mind and style and sigh,
My tongue, my heart, my tears and all my skill.
Lead me to my reprieve,
And do believe in my converted will.

The day is coming and soon it will start,
Time does so quickly run,
Virgin unique and one,
And now conscience, now death pierces my heart.
Recommend me to your Son, to the real
Man and the real God,
That Heaven's nod be my ghost's peaceful seal.

<div align="right">

Canzone, ccclxvi
Translated by Anna Maria Armi

</div>

It is, perhaps, the finest hymn in the world.

<div align="right">

THOMAS BABINGTON MACAULAY
Critical and Historical Essays (1843)

</div>

<div align="center">

ANONYMOUS

C . 1 3 0 5

ALYSOUN

</div>

Bytuene Mersh and Averil,
　　When spray biginneth to springe,
The lutel foul hath hire wyl
　　On hyre lud to synge.
　　Ich libbe in love-longinge
　　For semlokest of alle thinge;
　　He may me blisse bringe,
　　　　Icham in hire baundoun.

An hendy hap ichabbe yhent,
Ichot from hevene it is me sent,
From alle wymmen mi love is lent,
　　And lyht on Alysoun.

On heu hire her is fayr ynoh,
　　Hire browe broune, hire eye blake;
With lossum chere he on me loh;
　　With middel smal and wel ymake;

<div align="center">

406

</div>

Bote he me wolle to hire take,
For te buen hire owen make,
Longe to lyven ichulle forsake,
 And feye fallen adoun.

Nihtes when y wende and wake,
 Forthi myn wonges waxeth won;
Levedi, al for thine sake
 Longinge is ylent me on.
 In world nis non so wyter mon
 That al hire bounte telle con;
 Hire swyre is whittore than the swon,
 And feyrest may in toune.

Icham for wowyng al forwake,
 Wery so water in wore.
Lest eny reve me my make,
 Ychabbe y-yerned yore.
 Betere is tholien whyle sore
 Then mournen evermore.
 Geynest under gore,
 Herkne to my roun.

An hendy hap ichabbe yhent,
Ichot from hevene it is me sent,
From alle wymmen mi love is lent,
 And lyht on Alysoun.

There is no simple English lyric of its sort lovelier.

 T. EARLE WELBY
 A Popular History of English Poetry (1933)

JOHN GOWER

1 3 2 5 ? — 1 4 0 8

MEDEA GOES TO GATHER HERBS
FOR HER INCANTATIONS

Thus it befell upon a nyht,
Whan ther was noght bot sterreliht,
Sche was vanyssht riht as hir liste,
That no wyht bot hirself it wiste,

And that was ate mydnyht tyde.
The world was stille on every side;
With open hed and fot al bare,
Hir her tosprad sche gan to fare,
Upon hir clothes gert sche was,
Al specheles and on the gras
Sche glod forth as an Addre doth.

<div align="right">Confessio Amantis (1390), v</div>

If Chaucer's contemporary had written often thus, his name would
have been as famous.

<div align="right">

JAMES HENRY LEIGH HUNT
Imagination and Fancy (1845)

</div>

JEAN FROISSART

1 3 3 8 — 1 4 1 0 ?

THE SIX BURGESSES OF CALAIS

Cil VI bourgois se misent tantost en genouls pardevant le roy, et
disent ensi en joindant leurs mains: "Gentils sires et gentils rois, vés
nous chi VI qui avons esté d'ancisserie bourgois de Calais et grans
marceans. Si vous aportons les clés de le ville de Calais et du chastiel
aussi, et les vous rendons à vostre plaisir, et nous mettons en tel point
que vous nous veés, en vostre pure volenté, pour sauver le demorant
dou peuple de Calais qui a souffert moult de grieftés: si voelliés avoir
de nous pité et merci, par vostre très-haute noblèce." Certes, il n'i eut
adont en le place signeur, chevalier, ne vaillant homme, qui se peuist
abstenir de plorer de droite pité, ne qui peuist de grant pièce parler,
et vraiement ce n'estoit pas merveille, car c'est grant pité de veoir
hommes décheoir et estre en tel estat et dangier. Li rois regarda sus
yaus très-ireusement; car il avoit le coer si dur et si espris de grans
courous que il ne peut parler, et quant il parla, il commanda que on leur
copast les tiestes tantost. Tout li baron et li chevalier qui là estoient,
en plorant, prioient, si acertes que faire pooient, au roy qu'il en vosist
avoir pité et merci; mais il n'i voloit entendre. Adont parla li gentils
chevaliers messires Gautiers de Mauni et dist: "Ha! gentils sires, voellés
rafrener vostre corage. Vous avés le nom et le renommée de souverainne
gentillèce et noblèce: or ne voelliés dont faire cose par quoi elle soit
noient amerrie, ne que on puist parler sur vous en nulle manière vil-
lainne. Se vous n'avés pité de ces gens, toutes aultres gens diront que ce

sera grant cruaultés se vous estes si dur que vous faites morir ces honnestes bourgois qui de lor propre volenté se sont mis en vostre merci pour les aultres sauver." A ce point se grigna li rois et dist: "Messire Gautier, souffrés-vous. Il ne sera aultrement, mès on face venir le cope-teste. Chil de Calais ont fait morir tant de mes hommes que il convient chiaus morir ossi." Adont fist la noble royne d'Engleterre grant humilité, qui estoit durement enchainte, et ploroit si tenrement de pité, que on ne le pooit soustenir. Elle se jetta en genouls pardevant le roy son signeur et dist ensi: "Ha! gentils sires, puis que je apassai le mer en grant péril, sicom vous savés, je ne vous ay riens rouvet, ne don demandet. Or vous pri-jou humlement et requier en propre don, que pour le Fil sainte Marie et pour l'amour de mi, vous voelliés avoir de ces VI hommes merci." Li rois attendi un petit de parler, et regarda la bonne dame sa femme qui moult estoit enchainte et ploroit devant lui en genouls moult tenrement: se li amolia li coers, car envis l'euist couroucie ens ou point là où elle estoit: si dist: "Ha! dame, je amaisse trop mieuls que vous fuissiés d'autre part que ci. Vous me pryés si acertes que je ne le vous ose escondire, et comment que je le face envis, tenés, je les vous donne: si en faites vostre plaisir." La bonne dame dist: "Monsigneur, très-grans mercis." Lors se leva la royne, et fist lever les VI bourgois et leur fist oster les chevestres d'entours les cols, et les amena avoecques lui en sa cambre, et les fist revestir et donner à disner tout aise; et puis donna à chascun VI nobles et les fist conduire hors de l'ost à sauveté.

Whan sir Gaultier presented these burgesses to the kyng they kneled downe and helde up their handes and sayd: gentyll kyng beholde here we six who were burgesses of Calays & great marchantes, we have brought to you the kayes of the towne and of the castell, and we submyt oure selfe clerely into your wyll and pleasure, to save the resydue of the people of Calais, who have suffred great payne. Sir we beseche your grace to have mercy and pytie on us through your high nobles: than all the erles & barownes, and other that were there wept for pytie. The kyng loked felly on theym, for greatly he hated the people of Calys: for the gret damages and dyspleasures they had done hym on the see before. Than he commaunded their heedes to be stryken of, than every man requyred the kyng for mercy, but he wolde here no man in that behalfe: than sir Gaultier of Manny said: a noble kyng for goddessake refrayne your courage, ye have the name of soverayn nobles therfore nowe do nat a thyng that shulde blemysshe your renome, nor to gyve cause to some to speke of you villany, every man woll say it is a great cruelty to put to dethe suche honest persons, who by their owne wylles putte themselfe into your grace to save their company. Than the kyng wryed away fro hym and commaunded to sende for the hangman, and

sayd they of Calys hath caused many of my men to be slayne, wherfore these shall dye in likewyse. Than the quene beynge great with chylde, kneled downe & sore wepyng sayd: a gentyll sir syth I passed the see in great parell I have desyred nothyng of you, therfore nowe I humbly requyre you in the honour of the son of the virgin Mary and for the love of me, that ye woll take mercy of these sixe burgesses. The kyng behelde the quene & stode styll in a study a space and than sayd, a dame I wold ye had ben as nowe in some other place, ye make suche request to me that I can nat deny you: wherfore I gyve them to you to do your pleasure with theym, than the quene caused them to be brought into her chambre, and made the halters to be taken fro their neckes and caused them to be newe clothed, and gave them dyner at their leser. And than she gave ech of them sixe nobles, and made them to be brought out of thoost in savegard, & set at their lyberte.

Translated by Sir John Bourchier, Lord Berners

A great "prose-poet." He is almost without rival in word-painting.

F. J. SNELL
The Fourteenth Century (1899)

GEOFFREY CHAUCER

1 3 4 0 ? — 1 4 0 0

CAPTIVITY

Your yën two wol sle me sodenly,
I may the beaute of hem not sustene,
So woundeth hit through-out my herte kene.

And but your word wol helen hastily
My hertes wounde, whyl that hit is grene,
　Your yën two wol sle me sodenly;
　I may the beaute of hem not sustene.

Upon my trouthe I sey yow feithfully,
That ye ben of my lyf and deth the quene;
For with my deth the trouthe shal be sene.
　Your yën two wol sle me sodenly,
　I may the beaute of hem not sustene,
　So woundeth hit through-out my herte kene.

Merciles Beaute (1380–96?)

410

Much of the variation in sound of this wonderful poetry is due (as I have said already) to the fact that some lines are divided sharply in two by a deep pause, whilst at other times there is no pause at all, or else several small pauses. An example is that miracle, the first rondel of 'Merciles Beaute'—to me the only perfect rondel in the English language. . . . The English rondel is usually a giggling, trivial horror; but this poem has a most clear, noble, and grave beauty.

<div style="text-align: right">

EDITH SITWELL
A Poet's Notebook (1943)

</div>

GEOFFREY CHAUCER

1 3 4 0 ? — 1 4 0 0

PROLOGUE TO THE CANTERBURY TALES

WHÁN that Aprílle with his shoures soote
The droghte of March hath perced to the roote,
And bathed every veyne in swich licóur
Of which vertú engendred is the flour;
Whan Zephirus eek with his swete breeth
Inspired hath in every holt and heeth
The tendre croppes, and the yonge sonne
Hath in the Ram his halfe cours y-ronne,
And smale foweles maken melodye,
That slepen al the nyght with open eye,—
So priketh hem Natúre in hir coráges,—
Thanne longen folk to goon on pilgrimages,
And palmeres for to seken straunge strondes,
To ferne halwes, kowthe in sondry londes;
And specially, from every shires ende
Of Engelond, to Caunturbury they wende,
The hooly blisful martir for to seke,
That hem hath holpen whan that they were seeke.

Bifil that in that seson on a day,
In Southwerk at the Tabard as I lay,
Redy to wenden on my pilgrymage
To Caunterbury with ful devout corage,
At nyght were come into that hostelrye
Wel nyne-and-twenty in a compaignye,
Of sondry folk, by áventure y-falle

<div style="text-align: center">

411

</div>

In felaweshipe, and pilgrimes were they alle,
That toward Caunterbury wolden ryde.
The chambres and the stables weren wyde,
And wel we weren esèd attè beste.
And shortly, whan the sonnè was to reste,
So hadde I spoken with hem everychon,
That I was of hir felaweshipe anon,
And madè forward erly for to ryse,
To take oure wey, ther as I yow devyse.
 But nathèlees, whil I have tyme and space,
Er that I ferther in this talè pace,
Me thynketh it accordaunt to resoun
To tellè yow al the condicioun
Of ech of hem, so as it semèd me,
And whiche they weren and of what degree,
And eek in what array that they were inne;
And at a Knyght than wol I first bigynne.

 A KNYGHT ther was and that a worthy man,
That fro the tymè that he first bigan
To riden out, he lovèd chivalrie,
Trouthe and honóur, fredom and curteisie.
Ful worthy was he in his lordès werre,
And therto hadde he riden, no man ferre,
As wel in cristendom as in hethènesse,
And ever honoured for his worthynesse.
At Alisaundre he was whan it was wonne;
Ful oftè tyme he hadde the bord bigonne
Aboven allè nacïons in Pruce.
In Lettow hadde he reysèd and in Ruce,—
No cristen man so ofte of his degree.
In Gernade at the seege eek hadde he be
Of Algezir, and riden in Belmarye.
At Lyeys was he, and at Satalye,
Whan they were wonne; and in the Gretè See
At many a noble armee hadde he be.
 At mortal batailles hadde he been fiftene,
And foughten for oure feith at Tramyssene
In lystès thriès, and ay slayn his foo.
This ilkè worthy knyght hadde been also
Somtymè with the lord of Palatye
Agayn another hethen in Turkye;
And evermoore he hadde a sovereyn prys.
And though that he were worthy, he was wys,
And of his port as meeke as is a mayde.

He never yet no vileynye ne sayde,
In al his lyf, unto no maner wight.
He was a verray parfit, gentil knyght.
 But for to tellen yow of his array,
His hors weren goode, but he ne was nat gay;
Of fustian he werèd a gypon
Ál bismótered with his habergeon,
For he was late y-come from his viage,
And wentè for to doon his pilgrymage.
 With hym ther was his sone, a yong SQUIÉR,
A lovyere and a lusty bacheler,
With lokkès crulle as they were leyd in presse.
Of twenty yeer of age he was, I gesse.
Of his statúre he was of evene lengthe,
And wonderly delyvere and greet of strengthe;
And he hadde been somtyme in chyvachie,
In Flaundrès, in Artoys and Pycardie,
And born hym weel, as of so litel space,
In hope to stonden in his lady grace.
Embrouded was he, as it were a meede
Al ful of fresshè flourès whyte and reede;
Syngynge he was, or floytynge, al the day;
He was as fressh as is the monthe of May.
Short was his gowne, with slevès longe and wyde;
Wel koude he sitte on hors and fairè ryde;
He koudè songès make and well endite,
Juste and eek daunce and weel purtreye and write.
So hoote he lovède that by nyghtertale
He sleep namoore than dooth a nyghtyngale.
Curteis he was, lowely and servysáble,
And carf biforn his fader at the table.

 A YEMAN hadde he and servántz namo
At that tyme, for hym listè ridè soo;
And he was clad in cote and hood of grene.
A sheef of pocok arwès, bright and kene,
Under his belt he bar ful thriftily—
Wel koude he dresse his takel yemanly;
His arwès droupèd noght with fetherès lowe—
And in his hand he baar a myghty bowe.
A not-heed hadde he, with a broun viságe.
Of woodècraft wel koude he al the uságe.
Upon his arm he baar a gay bracér,
And by his syde a swerd and a bokeler,
And on that oother syde a gay daggere,

413

Harneisėd wel and sharpe as point of spere;
A Cristophere on his brest of silver sheene;
An horn he bar, the bawdryk was of grene.
A forster was he, soothly as I gesse.
 Ther was also a Nonne, a PRIORESSE,
That of hir smylyng was ful symple and coy;
Hire gretteste ooth was but by seintė Loy,
And she was clepėd madame Eglentyne.
Ful weel she soong the servicė dyvyne,
Entunėd in hir nose ful semėly,
And Frenssh she spak ful faire and fetisly
After the scole of Stratford-attė-Bowe,
For Frenssh of Parys was to hire unknowe.
At metė wel y-taught was she with-alle,
She leet no morsel from hir lippės falle,
Ne wette hir fyngrės in hir saucė depe.
Wel koude she carie a morsel and wel kepe,
Thát no drope ne fille upon hire breste;
In curteisie was set ful muchel hir leste.
Hire over-lippė wypėd she so clene,
That in hir coppe ther was no ferthyng sene
Of grecė, whan she dronken hadde hir draughte.
Ful semėly after hir mete she raughte,
And sikerly she was of greet desport,
And ful plesáunt and amyable of port,
And peynėd hire to countrefetė cheere
Of Court, and been estatlich of manere,
And to ben holden digne of reverence.
But for to speken of hire conscïence,
She was so charitable and so pitous
She wolde wepe, if that she saugh a mous
Kaught in a trappe, if it were deed or bledde.
Of smalė houndės hadde she that she fedde
With rosted flessh, or milk and wastel breed;
But soorė wepte she if oon of hem were deed,
Or if men smoot it with a yerdė smerte;
And al was conscïence and tendrė herte.
 Ful semyly hir wympul pynchėd was;
Hire nose tretys, hir eyen greye as glas,
Hir mouth ful smal and ther-to softe and reed,
But sikerly she hadde a fair forheed;
It was almoost a spannė brood I trowe,
For, hardily, she was nat undergrowe.
Ful fetys was hir cloke, as I was war;
Of smal coral aboute hire arm she bar

414

A peire of bedes, gauded al with grene,
And ther-on heng a brooch of gold ful sheene,
On which ther was first write a crownėd **A**,
And after *Amor vincit omnia.*
 Another NONNĖ with hire haddė she
That was hire Chapėleyne, and PREESTĖS thre.

 A MONK ther was, a fair for the maistrie,
An outridere, that lovėde venerie;
A manly man, to been an abbot able.
Ful many a deyntee hors haddė he in stable,
And whan he rood men myghte his brydel heere
Gýnglen in a whistlynge wynd als cleere,
And eek as loude, as dooth the chapel belle,
Ther as this lord was kepere of the celle.
The reule of seint Maure or of seint Beneit,
By-cause that it was old and som-del streit,—
This ilkė Monk leet oldė thyngės pace,
And heeld after the newė world the space.
He yaf nat of that text a pullėd hen
That seith that hunters beth nat hooly men,
Ne that a Monk whan he is recchėlees
Is likned til a fissh that is waterlees;
This is to seyn, a Monk out of his cloystre.
But thilkė text heeld he nat worth an oystre;
And I seyde his opinioun was good.
What sholde he studie and make hymselven wood,
Upon a book in cloystre alwey to poure,
Or swynken with his handės and labóure,
As Austyn bit? how shal the world be served?
Lat Austyn have his swynk to him reserved.
Therfore he was a prikasour aright;
Grehoundes he hadde, as swift as fowel in flight:
Of prikyng and of huntyng for the hare
Was al his lust, for no cost wolde he spare.
I seigh his sleves y-purfiled at the hond
With grys, and that the fyneste of a lond;
And for to festne his hood under his chyn
He hadde of gold y-wroght a ful curious pyn,
A love knotte in the gretter ende ther was.
His heed was balled that shoon as any glas,
And eek his face as he hadde been enoynt.
He was a lord ful fat and in good poynt;
Hise eyėn stepe and rollynge in his heed,
That stemėd as a forneys of a leed;

His bootės souple, his hors in greet estaat.
Now certeinly he was a fair prelaat.
He was nat pale, as a forpynėd goost:
A fat swan loved he best of any roost;
His palfrey was as broun as is a berye.

A FRERE ther was, a wantowne and a merye,
A lymytour, a ful solempnė man,
In allė the ordrės foure is noon that kan
So muchel of daliaunce and fair langage;
He haddė maad ful many a marïage
Of yongė wommen at his owene cost:
Unto his ordre he was a noble post,
Ful wel biloved and famulier was he
With frankeleyns over al in his contree;
And eek with worthy wommen of the toun,
For he hadde power of confessïoun,
As seydė hym-self, moorė than a curát,
For of his ordre he was licenciat.
Ful swetely herdė he confessïoun,
And plesaunt was his absolucioun.
He was an esy man to yeve penaunce
Ther as he wiste to have a good pitaunce;
For unto a poure ordre for to yive
Is signė that a man is wel y-shryve;
For, if he yaf, he dorstė make avaunt
He wistė that a man was répentaunt:
For many a man so harde is of his herte
He may nat wepe al thogh hym soorė smerte,
Therfore in stede of wepynge and preyėres
Men moote yeve silver to the pourė freres.
His typet was ay farsed full of knyves
And pynnės, for to yeven yongė wyves;
And certeinly he hadde a murye note;
Wel koude he synge and pleyen on a rote:
Of yeddynges he baar outrėly the pris;
His nekkė whit was as the flour-de-lys,
Ther-to he strong was as a champioun.
He knew the tavernes well in all the toun
And everich hostiler and tappestere
Bet than a lazar or a beggestere;
For unto swich a worthy man as he
Acordėd nat, as by his facultee,
To have with sikė lazars aqueyntaunce;
It is nat honeste, it may nat avaunce

Fór to deelen with no swiche poraille;
But al with riche and selleres of vitaille.
And over al, ther as profit sholde arise,
Curteis he was and lowely of servyse,
Ther nas no man nowher so vertuous.
He was the bestè beggere in his hous,
For thogh a wydwe haddè noght a sho,
So plesaunt was his *In principio,*
Yet wolde he have a ferthyng er he wente:
His purchas was wel bettre than his rente.
And rage he koudè, as it were right a whelpe.
In lovè-dayes ther koude he muchel helpe,
For there he was nat lyk a cloysterer
With a thredbare cope, as is a poure scolér,
But he was lyk a maister, or a pope;
Of double worstede was his semycope,
That rounded as a belle out of the presse.
Somwhat he lipsèd for his wantonnesse,
To make his Englissh sweet upon his tonge,
And in his harpyng, whan that he hadde songe,
His eyèn twynkled in his heed aryght
As doon the sterrès in the frosty nyght.
This worthy lymytour was cleped Huberd.

A MARCHANT was ther with a forkèd berd,
In mottèleye, and hye on horse he sat;
Upon his heed a Flaundryssh bevere hat;
His bootès claspèd faire and fetisly;
His resons he spak ful solempnèly,
Sownynge alway thencrees of his wynnyng.
He wolde the see were kept for any thing
Bitwixè Middelburgh and Orèwelle.
Wel koude he in eschaungè sheeldès selle.
This worthy man ful wel his wit bisette,
Ther wistè no wight that he was in dette,
So estatly was he of his governaunce
With his bargaynes and with his chevyssaunce.
For sothe he was a worthy man with-alle
But, sooth to seyn, I noot how men hym calle.

A CLERK ther was of Oxenford also
That unto logyk haddè longe y-go.
As leenè was his hors as is a rake,
And he nas nat right fat, I undertake,
But lookèd holwe, and ther-to sobrely;

417

Ful thredbare was his overeste courtepy;
For he hadde geten hym yet no benefice,
Ne was so worldly for to have office;
For hym was levere have at his beddes heed
Twénty bookés clad in blak or reed
Of Aristotle and his philosophie,
Than robés riche, or fithele, or gay sautrie:
But al be that he was a philosophre,
Yet haddé he but litel gold in cofre;
But al that he myghte of his freendes hente
On bookés and his lernynge he it spente,
And bisily gan for the soulés preye
Of hem that yaf hym wher-with to scoleye.
Of studie took he moost cure and moost heede,
Noght o word spak he mooré than was neede,
And that was seyd in forme and reverence,
And short and quyk and ful of hy senténce.
Sownynge in moral vertu was his speche
And gladly wolde he lerne and gladly teche.

 A SERGEANT OF THE LAWÉ, war and wys,
That often haddé been at the Parvys,
Ther was also, ful riche of excellence.
Discreet he was, and of greet reverence:
He seméd swich, hise wordés weren so wise.
Justice he was ful often in Assise,
By patente and by pleyn commissioun:
For his science and for his heigh renoun.
Of fees and robés hadde he many oon;
So greet a purchasour was nowher noon.
Al was fee symple to hym in effect,
His purchasyng myghté nat been infect.
Nowher so bisy a man as he ther nas,
And yet he seméd bisier than he was.
In termés hadde he caas and doomés alle
That from the tyme of kyng William were falle;
Ther-to he coude endite and make a thyng,
Ther koudé no wight pynchen at his writyng;
And every statut coude he pleyn by rote.
He rood but hoomly in a medlee cote,
Girt with a ceint of silk, with barrés smale;
Of his array telle I no lenger tale.

 A FRANKÉLEYN was in his compaignye.
Whit was his berd as is a dayésye,

Of his complexioun he was sangwyn.
Wel loved he by the morwe a sope in wyn;
To lyven in delit was ever his wone,
For he was Epicurus owenė sone,
That heeld opinioun that pleyn delit
Was verraily felicitee parfit.
An housholdere, and that a greet, was he:
Seint Julian was he in his contree;
His breed, his ale, was alweys after oon;
A better envynėd man was nowher noon.
Withoutė bakė mete was never his hous,
Of fissh and flessh, and that so plenteuous
It snewėd in his hous of mete and drynke.
Of allė deyntees that men koudė thynke
After the sondry sesons of the yeer,
So chaungėd he his mete and his soper.
Ful many a fat partrich hadde he in muwe
And many a breem and many a luce in stuwe.
Wo was his cook but if his saucė were
Poynaunt and sharpe and redy al his geere.
His table dormant in his halle alway,
Stood redy covered al the longė day.
At sessiouns ther was he lord and sire;
Ful oftė tymė he was knyght of the shire.
An anlaas, and a gipser al of silk,
Heeng at his girdel, whit as mornė milk;
A shirreve hadde he been, and a countour.
Was nowher such a worthy vavasour.

An HABERDASSHERE, and a CARPENTER,
A WEBBE, a DYERE, and a TAPYCER,—
And they were clothed alle in o lyveree
Of a solémpne and greet fraternitee;
Ful fressh and newe hir geere apikėd was;
Hir knyvės werė chapėd noght with bras,
But al with silver, wroght ful clene and weel,
Hire girdles and hir pouches everydeel.
Wel semėd ech of hem a fair burgeys
To sitten in a yeldehalle, on a deys.
Éverich for the wisdom that he kan
Was shaply for to been an alderman.
For catel haddė they ynogh and rente,
And eek hir wyvės wolde it wel assente
And ellės certeyn werė they to blame.
It is ful fair to been y-cleped *Madame,*

419

And goon to vigiliės al bifore,
And have a mantel roialliche y-bore.

 A Cook they haddė with hem for the nones,
To boille the chiknės with the marybones,
And poudrė-marchant tart and galyngale;
Wel koude he knowe a draughte of Londoun ale;
He koudė rooste and sethe and boille and frye,
Máken mortreux and wel bake a pye.
But greet harm was it, as it thoughtė me,
That on his shyne a normal haddė he.
For blankmanger, that made he with the beste.

 A Shipman was ther, wonynge fer by weste;
For aught I woot he was of Dertėmouthe.
He rood upon a rouncy as he kouthe,
In a gowne of faldyng to the knee.
A daggere hangynge on a laas hadde he
Aboute his nekke under his arm adoun.
The hootė somer hadde maad his hewe al broun;
And certeinly he was a good felawe.
Ful many a draughte of wyn hadde he y-drawe
Fro Burdeuxward whil that the Chapman sleepe.
Of nycė conscïence took he no keepe.
If that he faught, and hadde the hyer hond;
By water he sente hem hoom to every lond.
But of his craft to rekene wel his tydes,
His stremės and his daungers hym bisides,
His herberwe and his moone, his lode-menage,
Ther nas noon swich from Hullė to Cartage.
Hardy he was, and wys to undertake:
With many a tempest hadde his berd been shake;
He knew wel alle the havenes, as they were,
From Gootlond to the Cape of Fynystere,
And every cryke in Britaigne and in Spayne.
His barge y-clepėd was the Maudėlayne.

 With us ther was a Doctour of Phisik;
In all this world ne was ther noon hym lik,
To speke of phisik and of surgerye;
For he was grounded in astronomye.
He kepte his pacïent a ful greet deel
In hourės, by his magyk natureel.
Wel koude he fortunen the ascendent
Of his ymáges for his pacïent.

He knew the cause of everich maladye,
Were it of hoot, or cold, or moyste, or drye,
And where they engendred and of what humour;
He was a verray parfit praktisour.
The cause y-knowe and of his harm the roote,
Anon he yaf the siké man his boote.
Ful redy hadde he his apothecaries
To sende him droggès and his letuaries,
For ech of hem made oother for to wynne,
Hir frendshipe nas nat newè to bigynne.
Wel knew he the oldè Esculapius
And Deÿscorides, and eek Rufus
Olde Ypocras, Haly and Galyen,
Serapion, Razis and Avycen,
Averrois, Damascien and Constantyn,
Bernard and Gatèsden and Gilbertyn.
Of his dietè mesurable was he,
For it was of no superfluitee,
But of greet norissyng and digestíble.
His studie was but litel on the Bible.
In sangwyn and in pers he clad was al,
Lynèd with taffata and with sendal.
And yet he was but esy of dispence,
He keptè that he wan in pestilence.
For gold in phisik is a cordial,
Therefore he lovède gold in special.

A Good wif was ther of bisidè Bathe,
But she was som-del deef, and that was scathe.
Of clooth-makyng she haddè swich an haunt
She passèd hem of Yprès and of Gaunt.
In al the parisshe wif ne was ther noon
That to the offrynge bifore hire sholdè goon;
And if ther dide, certeyn so wrooth was she,
That she was out of allè charitee.
Hir coverchiefs ful fynè weren of ground,—
I dorstè swere they weyèden ten pound,—
That on a Sonday weren upon hir heed.
Hir hosen weren of fyn scarlet reed,
Ful streite y-teyd, and shoes ful moyste and newe;
Boold was hir face, and fair, and reed of hewe.
She was a worthy womman al hir lyve,
Housbondes at chirchè dore she haddè fyve,
Withouten oother compaignye in youthe,—
But ther-of nedeth nat to speke as nowthe,—

And thriës hadde she been at Jerusálem;
She haddë passëd many a straungë strem;
At Rome she haddë been, and at Boloigne,
In Galice at Seint Jame, and at Coloigne,
She koudë muchel of wandrynge by the weye.
Gat-tothëd was she, soothly for to seye.
Upon an amblere esily she sat,
Y-wymplëd wel, and on hir heed an hat
As brood as is a bokeler or a targe;
A foot mantel aboute hir hipës large,
And on hire feet a paire of sporës sharpe.
In felaweshipe wel koude she laughe and carpe;
Of remedies of love she knew per chaunce,
For she koude of that art the oldë daunce.

 A good man was ther of religioun,
And was a POURE PERSOUN OF A TOUN;
But riche he was of hooly thoght and werk;
He was also a lernëd man, a clerk,
That Cristës Gospel trewély wolde preche:
His parisshens devoutly wolde he teche.
Benygne he was, and wonder diligent,
And in adversitee ful pacient;
And swich he was y-prevëd oftë sithes.
Ful looth were hym to cursen for his tithes,
But rather wolde he yeven, out of doute,
Unto his pourë parisshens aboute,
Of his offrýng and eek of his substaunce:
He koude in litel thyng have suffisaunce.
Wyd was his parisshe, and houses fer asonder,
But he ne leftë nat for reyn ne thonder,
In siknesse nor in meschief to visíte
The ferreste in his parisshe, muche and lite,
Upon his feet, and in his hand a staf.
This noble ensample to his sheepe he yaf
That firste he wroghte and afterward he taughte.
Out of the gospel he tho wordës caughte,
And this figure he added eek therto,
That if gold rustë what shal iren doo?
For if a preest be foul, on whom we truste,
No wonder is a lewëd man to ruste;
And shame it is, if a prest takë keepe,
A shiten shepherde and a clenë sheepe.
Wel oghte a preest ensample for to yive
By his clennesse how that his sheepe sholde lyve.

He settė nat his benefice to hyre
And leet his sheepe encombred in the myre,
And ran to Londoun, unto Seïnt Poules,
To seken hym a chaunterie for soules;
Or with a bretherhed to been withholde,
But dwelte at hoom and keptė wel his folde,
So that the wolf ne made it nat myscarie,—
He was a shepherde, and noght a mercenarie:
And though he hooly were and vertuous,
He was to synful man nat despitous,
Ne of his spechė daungerous ne digne,
But in his techyng déscreet and benygne
To drawen folk to hevene by fairnesse,
By good ensample, this was his bisynesse:
But it were any persone obstinat,
What so he were, of heigh or lough estat,
Hym wolde he snybben sharply for the nonys.
A bettrė preest I trowe that nowher noon ys;
He waited after no pompe and reverence,
Ne maked him a spicėd conscience,
But Cristės loore, and his Apostles twelve,
He taughte, but first he folwed it hym selve.

With hym ther was a PLOWMAN, was his brother,
That haddė y-lad of dong ful many a fother,—
A trewė swynkere and a good was he,
Lyvynge in pees and parfit charitee.
God loved he best, with al his hoolė herte,
At allė tymės, thogh him gamed or smerte,
And thanne his neighėbore right as hymselve.
He woldė thresshe, and therto dyke and delve,
For Cristės sake, for every pourė wight,
Withouten hire, if it lay in his myght.
His tithės paydė he ful faire and wel,
Bothe of his proprė swynk and his catel.
In a tabard he rood upon a mere.

Ther was also a REVE and a MILLERE,
A SOMNOUR and a PARDONER also,
A MAUNCIPLE and myself,—ther were namo.
 The MILLERE was a stout carl for the nones,
Ful byg he was of brawn and eek of bones;
That provėd wel, for over-al, ther he cam,
At wrastlynge he wolde have awey the ram.

He was short-sholdred, brood, a thikkė knarre,
Ther nas no dore that he nolde heve of harre,
Or breke it at a rennyng with his heed.
His berd, as any sowe or fox, was reed,
And therto brood, as though it were a spade.
Upon the cope right of his nose he hade
A werte, and thereon stood a toft of herys,
Reed as the brustles of a sowes erys;
His nosėthirlės blakė were and wyde;
A swerd and a bokeler bar he by his syde;
His mouth as wyde was as a greet forneys,
He was a janglere and a goliardeys,
And that was moost of synne and harlotriës.
Wel koude he stelen corn and tollen thriës,
And yet he hadde a thombe of gold, pardee.
A whit cote and a blew hood werėd he.
A baggėpipe wel koude he blowe and sowne,
And therwithal he broghte us out of towne.

A gentil MAUNCIPLE was ther of a temple,
Of which achátours myghtė take exemple
For to be wise in byynge of vitaille;
For, wheither that he payde or took by taille,
Algate he wayted so in his achaat
That he was ay biforn and in good staat.
Now is nat that of God a ful fair grace
That swich a lewėd mannės wit shal pace
The wisdom of an heepe of lerned men?
Of maistrės hadde he mo than thriës ten,
That weren of lawe expert and curious,
Of whiche ther weren a duszeyne in that hous
Worthy to been stywardes of rente and lond
Of any lord that is in Engėlond,
To maken hym lyvė by his proprė good
In honour dettėlees, but he were wood,
Or lyve as scarsly as hym list desire;
And able for to helpen al a shire
In any caas that myghtė falle or happe;
And yet this Manciple sette hir aller cappe.

The REVĖ was a sclendrė colerik man,
His berd was shave as ny as ever he kan;
His heer was by his erys round y-shorn,
His tope was dokėd lyk a preest biforn,

424

Ful longe were his legges and ful lene,
Y-lyk a staf, ther was no calf y-sene.
Wel koude he kepe a gerner and a bynne,
Ther was noon auditour koude on him wynne.
Wel wiste he, by the droghte and by the reyn,
The yeldynge of his seed and of his greyn.
His lordes sheepe, his neet, his dayerye,
His swyn, his hors, his stoor, and his pultrye,
Was hoolly in this reves governyng,
And by his covenant yaf the rekenyng
Syn that his lord was twenty yeer of age;
Ther koude no man brynge hym in arrerage.
There nas baillif, ne hierde, nor oother hyne,
That he ne knew his sleighte and his covyne;
They were adrad of hym as of the deeth.
His wonyng was ful faire upon an heeth,
With grene trees y-shadwed was his place.
He koude bettre than his lord purchace.
Ful riche he was a-stored pryvely,
His lord wel koude he plesen subtilly
To yeve and lene hym of his owene good
And have a thank, and yet a gowne and hood.
In youthe he lerned hadde a good myster,
He was a wel good wrighte, a carpenter.
This Reve sat upon a ful good stot,
That was al pomely grey, and highte Scot;
A long surcote of pers upon he hade,
And by his syde he baar a rusty blade.
Of Northfolk was this Reve of which I telle,
Biside a toun men clepen Baldeswelle.
Tukked he was as is a frere, aboute,
And ever he rood the hyndreste of oure route.

A Somonour was ther with us in that place,
That hadde a fyr-reed cherubynnes face,
For sawcefleem he was, with eyen narwe.
As hoot he was, and lecherous, as a sparwe,
With scaled browes blake and piled berd,—
Of his visage children were aferd.
Ther nas quyk-silver, lytarge, ne brymstoon,
Boras, ceruce, ne oille of Tartre noon,
Ne oynement that wolde clense and byte,
That hym myghte helpen of the whelkes white,
Nor of the knobbes sittynge on his chekes.
Wel loved he garleek, oynons, and eek lekes,

425

And for to drynken strong wyn, reed as blood;
Thanne wolde he speke, and crie as he were wood,
And whan that he wel dronken hadde the wyn,
Than wolde he speke no word but Latyn.
A fewe termes hadde he, two or thre,
That he had lernėd out of som decree,—
No wonder is, he herde it al the day,
And eek ye knowen wel how that a jay
Kan clepen *Watte* as wel as kan the pope.
But whoso koude in oother thyng hym grope,
Thanne hadde he spent al his philosophie;
Ay *Questio quid juris* wolde he crie.
He was a gentil harlot and a kynde;
A bettre felawe sholdė men noght fynde.
He woldė suffre, for a quart of wyn,
A good felawe to have his concubyn
A twelf monthe, and excuse hym attė fulle;
And privėly a fynch eek koude he pulle;
And if he foond owher a good felawe,
He woldė techen him to have noon awe,
In swich caas, of the Ercėdekenes curs,
But-if a mannės soule were in his purs;
For in his purs, he sholde y-punysshed be:
'Purs is the Ercėdekenes helle,' seyde he.
But wel I woot he lyėd right in dede,
Of cursyng oghte ech gilty man him drede,
For curs wol slee,—right as assoillyng savith;
And also war him of a *Significavit.*
In daunger hadde he at his owėne gise
The yongė girlės of the diocise,
And knew hir conseil, and was al hir reed.
A gerland hadde he set upon his heed,
As greet as it were for an alė-stake;
A bokeleer hadde he maad him of a cake.

 With hym ther rood a gentil PARDONER
Of Rouncivale, his freend and his compeer,
That streight was comen fro the court of Romė.
Ful loude he soong *Com hider, lovė, to me!*
This Somonour bar to hym a stif burdoun,
Was never trompe of half so greet a soun.
This Pardoner hadde heer as yelow as wex
But smothe it heeng as dooth a strike of flex;
By ounces henge his lokkės that he hadde,
And therwith he his shuldres overspradde.

But thynne it lay by colpons oon and oon;
But hood, for jolitee, ne wered he noon,
For it was trussėd up in his walėt.
Hym thoughte he rood al of the newė jet;
Dischevelee, save his cappe, he rood al bare.
Swiche glarynge eyen hadde he as an hare,
A vernycle hadde he sowed upon his cappe;
His walet lay biforn hym in his lappe
Bret-ful of pardon, comen from Rome al hoot.
A voys he hadde as smal as hath a goot;
No berd hadde he, ne never sholdė have,
As smothe it was as it were latė shave;
I trowe he were a geldyng or a mare.
But of his craft, fro Berwyk unto Ware
Ne was ther swich another pardoner,
For in his male he hadde a pilwė-beer,
Which that, he seydė, was oure lady veyl;
He seyde he hadde a gobet of the seyl
That Seintė Peter hadde, whan that he wente
Upon the see, til Jhesu Crist hym hente.
He hadde a croys of latoun, ful of stones,
And in a glass he haddė piggės bones.
But with thise relikės, whan that he fond
A pourė person dwellynge upon lond,
Upon a day he gat hym moore moneye
Than that the person gat in monthės tweye;
And thus with feynėd flaterye and japes
He made the person and the peple his apes.
But, trewėly to tellen attė laste,
He was in chirche a noble ecclesiaste;
Wel koude he rede a lessoun or a storie,
But alderbest he song an Offertorie;
For wel he wistė, whan that song was songe,
He mostė preche, and wel affile his tonge
To wynnė silver, as he ful wel koude;
Therefore he song the murierly and loude.
 Now have I toold you shortly, in a clause,
The staat, tharray, the nombre, and eek the cause
Why that assembled was this compaignye
In Southwerk, at this gentil hostelrye,
That highte the Tabard, fastė by the Belle.
But now is tymė to yow for to telle
How that we baren us that ilkė nyght,
Whan we were in that hostelrie alyght;

And after wol I telle of our viage
And al the remenaunt of oure pilgrimage.
　　But first, I pray yow of youre curteisye,
That ye narette it nat my vileynye,
Thogh that I pleynly speke in this mateere
To tellė yow hir wordės and hir cheere,
Ne thogh I speke hir wordės proprely;
For this ye knowen al-so wel as I,
Whoso shal telle a tale after a man,
He moote reherce, as ny as ever he kan,
Everich a word, if it be in his charge,
Al speke he never so rudėliche or large;
Or ellis he moot telle his tale untrewe,
Or feynė thyng, or fyndė wordės newe.
He may nat spare, althogh he were his brother;
He moot as wel seye o word as another.
Crist spak hymself ful brode in hooly writ,
And wel ye woot no vilenye is it.
Eek Plato seith, whoso that kan hym rede,
'The wordės moote be cosyn to the dede.'
　　Also I prey yow to foryeve it me
Al have I nat set folk in hir degree
Heere in this tale, as that they sholdė stonde;
My wit is short, ye may wel understonde.
　　Greet chierė made oure hoost us everichon,
And to the soper sette he us anon,
And servėd us with vitaille at the beste:
Strong was the wyn and wel to drynke us leste.
　　A semely man OURE HOOSTĖ was with-alle
For to han been a marchal in an halle.
A largė man he was, with eyen stepe,
A fairer burgeys is ther noon in Chepe;
Boold of his speche, and wys and well y-taught
And of manhod hym lakkedė right naught.
Eek therto he was right a myrie man,
And after soper pleyen he bigan,
And spak of myrthe amongės othere thynges,
Whan that we haddė maad our rekenynges;
And seydė thus: 'Now, lordynges, trewėly,
Ye been to me right welcome, hertėly;
For by my trouthe, if that I shal nat lye,
I ne saugh this yeer so myrie a compaignye
At onės in this herberwe as is now;
Fayn wolde I doon yow myrthė, wiste I how.

428

And of a myrthe I am right now bythoght,
To doon yow ese, and it shal costė noght.
 'Ye goon to Canterbury—God yow speede,
The blisful martir quitė yow youre meede!
And, wel I woot, as ye goon by the weye,
Ye shapen yow to talen and to pleye;
For trewėly confort ne myrthe is noon
To ridė by the weye doumb as a stoon;
And therfore wol I maken yow disport,
As I seyde erst, and doon yow som confort.
And if you liketh alle, by oon assent,
Now for to stonden at my juggėment,
And for to werken as I shal yow seye,
To-morwė, whan ye riden by the weye,
Now, by my fader soulė, that is deed,
But ye be myrie, smyteth of myn heed!
Hoold up youre hond, withouten moorė speche.'
 Oure conseil was nat longė for to seche;
Us thoughte it was noght worth to make it wys,
And graunted hym withouten moore avys,
And bad him seye his verdit, as hym leste.
 'Lordynges,' quod he, 'now herkneth for the beste;
But taak it nought, I prey yow, in desdeyn;
This is the poynt, to speken short and pleyn,
That ech of you, to shortė with your weye,
In this viage shal tellė talės tweye,—
To Caunterburyward, I mean it so,
And homward he shal tellen othere two,—
Of aventúres that whilom han bifalle.
And which of yow that bereth hym beste of alle,
That is to seyn, that telleth in this caas
Talės of best senténce and moost solaas,
Shal have a soper at oure aller cost,
Heere in this placė, sittynge by this post,
Whan that we come agayn fro Caunterbury.
And, for to makė yow the moorė mury,
I wol myselven gladly with yow ryde
Right at myn owene cost, and be youre gyde;
And whoso wole my juggėment withseye
Shal paye al that we spenden by the weye.
And if ye vouchė-sauf that it be so
Tel me anon, withouten wordės mo,
And I wol erly shapė me therfore.'
 This thyng was graunted, and oure othės swore

With ful glad herte, and preyden hym also
That he would vouche-sauf for to do so,
And that he wolde been oure governour,
And of our tales juge and réportour,
And sette a soper at a certeyn pris,
And we wol reuled been at his devys
In heigh and lough; and thus, by oon assent,
We been acorded to his juggément.
And therupon the wyn was fet anon;
We dronken, and to reste wente echon,
Withouten any lenger taryynge.
 Amorwe, whan that day gan for to sprynge,
Up roos oure Hoost and was oure aller cok,
And gadrede us togidre alle in a flok,
And forth we riden, a litel moore than paas,
Unto the wateryng of Seint Thomas;
And there oure Hoost bigan his hors areste
And seyde, 'Lordynges, herkneth, if yow leste:
Ye woot youre foreward and I it yow recorde.
If even-song and morwe-song accorde,
Lat se now who shal telle the firste tale.
As ever mote I drynke wyn or ale,
Whoso be rebel to my juggément
Shal paye for all that by the wey is spent!
Now draweth cut, er that we ferrer twynne.
He which that hath the shorteste shal bigynne.
Sire Knyght,' quod he, 'my mayster and my lord,
Now draweth cut, for that is myn accord.
Cometh neer,' quod he, 'my lady Prioresse,
And ye sire Clerk, lat be your shamefastnesse,
Ne studieth noght; ley hond to, every man.'

 Anon to drawen every wight bigan,
And, shortly for to tellen as it was,
Were it by áventúre, or sort, or cas,
The sothe is this, the cut fil to the knyght,
Of which ful blithe and glad was every wyght:
And telle he moste his tale, as was resoun,
By foreward and by composicioun,
As ye han herd; what nedeth wordes mo?
And whan this goode man saugh that it was so,
As he that wys was and obedient
To kepe his foreward by his free assent,
He seyde, 'Syn I shal bigynne the game,
What, welcome be the cut, a Goddes name!

Now lat us ryde, and herkneth what I seye.'
And with that word we ryden forth oure weye;
And he bigan with right a myrie cheere
His tale anon, and seyde in this manére.

<div style="text-align:right">The Canterbury Tales (c. 1387)</div>

The Prologue to the "Canterbury Tales," in which we make the acquaint-
ance of the pilgrims, is the ripest, most genial, and humorous—altogether
the most masterly thing which Chaucer has left us. In its own way, and
within its own limits, it is the most wonderful thing in the language.
The people we read about are as real as the people we brush clothes
with in the street,—nay, much MORE *real, for we not only see their faces,*
and the fashion and texture of their garments, we know also what they
think, how they express themselves, and with what eyes they look out
on the world. Chaucer's art in this prologue is simple perfection.

<div style="text-align:right">ALEXANDER SMITH
Dreamthorp (1864)</div>

GEOFFREY CHAUCER

1 3 4 0 ? — 1 4 0 0

FROM THE KNIGHT'S TALE

Whan that Arcite to Thebés comen was,
Ful ofte a day he swelte and seyde, 'Allas!'
For seen his lady shal he never mo.
And, shortly to concluden al his wo,
So muché sorwe hadde never creäture
That is, or shal, whil that the world may dure.
His slepe, his mete, his drynke, is hym biraft,
That lene he wexe and drye as is a shaft;
His eyen holwe, and grisly to biholde,
His hewé falow, and pale as asshen colde,
And solitarie he was and ever allone,
And waillynge al the nyght, makynge his mone:
And if he herdé song or instrument
Thanne wolde he wepe, he myghté nat be stent.
So feble eek were his spiritz and so lowe,
And chaungéd so that no man koudé knowe
His speché nor his voys, though men it herde.

<div style="text-align:right">The Canterbury Tales (c. 1387)</div>

GEOFFREY CHAUCER

1 3 4 0 ? — 1 4 0 0

THE WIFE OF BATH

In tholdė dayės of the Kyng Arthour,
Of which that Britons speken greet honour,
All was this land fulfild of faïrye.
The elf queene with hir joly compaignye
Dauncėd ful ofte in many a grenė mede.
This was the olde opinion as I rede,—
I speke of manye hundred yeres ago,—
But now kan no man se none elvės mo,
For now the gretė charitee and prayeres
Of lymytours, and othere hooly freres,
That serchen every lond and every streem,
As thikke as motės in the sonnė beem,—
Blėssynge hallės, chambres, kichenes, boures,
Cítees, burghes, castels, hyė toures,
Thrópės, bernės, shipnes, daÿeryes,—
This maketh that ther been no faïryes;
For ther as wont to walken was an elf,
Ther walketh now the lymytour hymself,
In undermelės and in morwenynges,
And seyth his matyns and his hooly thynges
As he gooth in his lymytacioun.
Wommen may go now saufly up and doun;
In every bussh or under every tree,
Ther is noon oother incubus but he,
And he ne wol doon hem non dishonour.
 And so bifel it that this kynge, Arthour,
Hadde in his hous a lusty bacheler
That on a day cam ridynge fro ryver,
And happėd that, allone as she was born,
He saugh a maydė walkynge hym biforn,

Of whichė mayde, anon, maugree hir heed,
By verray force birafte hire maydenhed;
For which oppressioun was swich clamour,
And swich pursute unto the kyng Arthour,
That dampnėd was this knyght for to be deed
By cours of lawe, and sholde han lost his heed,—
Paráventure swich was the statut tho,—
But that the queene and othere ladyes mo,
So longė preyėden the kyng of grace,
Til he his lyf hym graunted in the place,
And yaf hym to the queene al at hir wille
To chesė wheither she wolde hym save or spille.

The queene thanketh the kyng with al hir myght,
And after this thus spak she to the knyght,
Whan that she saugh hir tyme upon a day:
'Thou standest yet,' quod she, 'in swich array,
That of thy lyf yet hastow no suretee.
I grante thee lyf, if thou kanst tellen me
What thyng is it that wommen moost desiren,—
Be war, and keepe thy nekkė-boon from iren,—
And if thou kanst nat tellen it anon,
Yet shal I yeve thee levė for to gon
A twelf-month and a day, to seche and leere
An answere suffisant in this mateere;
And suretee wol I han, er that thou pace,
Thy body for to yelden in this place.'

Wo was this knyght, and sorwefully he siketh;
But what? he may nat do al as hym liketh,
And at the laste he chees hym for to wende,
And come agayn right at the yerės ende,
With swich answere as God wolde hym purveye,
And taketh his leve, and wendeth forth his weye.

He seketh every hous and every place
Where as he hopeth for to fyndė grace
To lernė what thyng wommen loven moost;
But he ne koude arryven in no coost
Wher as he myghtė fynde in this mateere
Two creäturės áccordynge in feere.

Somme seydė wommen loven best richesse,
Somme seyde honóur, somme seydė jolynesse,
Somme riche array, somme seyden lust abedde,
And oftė tymė to be wydwe and wėdde.
Somme seydė that oure hertės been moost esed
Whan that we beeny-flatered and y-plesed.

He gooth ful ny the sothe, I wol nat lye,—
A man shal wynne us best with flaterye;
And with attendance and with bisynesse,
Been we y-lymèd, bothè moore and lesse.

And sommè seyen that we loven best
For to be free, and do right as us lest,
And that no man repreve us of oure vice,
But seye that we be wise and no-thyng nyce;
For trewèly ther is noon of us alle,
If any wight wol clawe us on the galle,
That we nyl kikè, for he seith us sooth.
Assay, and he shal fynde it that so dooth,
For, be we never so vicious with-inne,
We wol been holden wise and clene of synne.

And sommè seyn that greet delit han we
For to been holden stable and eke secree,
And in o purpos stedefastly to dwelle,
And nat biwreyè thyng that men us telle;
But that tale is nat worth a rakè-stele.
Pardee, we wommen konnè no thyng hele;
Witnesse on Myda,—wol ye heere the tale?

Ovyde, amongès othere thyngès smale,
Seyde Myda hadde under his longè heres,
Growynge upon his heed, two asses eres,
The whichè vice he hydde as he best myghte,
Ful subtilly, from every mannès sighte,
That save his wyf ther wiste of it namo.
He loved hire moost, and trusted hire also;
He preydè hire that to no creäture
She sholdè tellen of his disfigure.

She swoor him nay, for al this world to wynne,
She noldè do that vileynye or synne,
To make hir housbonde han so foul a name.
She nolde nat telle it for hir owene shame;
But nathèlees hir thoughtè that she dyde,
That she so longè sholde a conseil hyde;
Hir thoughte it swal so soore aboute hir herte,
That nedèly som word hire moste asterte;
And sith she dorstè telle it to no man,
Doun to a mareys fastè by she ran.
Til she came there her hertè was a-fyre,
And as a bitore bombleth in the myre
She leyde hir mouth unto the water doun:
'Biwreye me nat, thou water, with thy soun,'

434

Quod she, 'to thee I telle it and namo,—
Myn housbonde hath longe asses erys two.
Now is myn herte all hool, now is it oute,
I myghte no lenger kepe it, out of doute.'
Heere may ye se, thogh we a tyme abyde,
Yet, out it moot, we kan no conseil hyde.
The remenant of the tale if ye wol heere,
Redeth Ovyde, and ther ye may it leere.

This knyght, of which my tale is specially,
Whan that he saugh he myghte nat come therby,
That is to seye, what wommen love moost,
Withinne his brest ful sorweful was the goost.
But hoom he gooth, he myghte nat sojourne,
The day was come that homward moste he tourne,
And in his wey it happèd hym to ryde
In al this care, under a forest syde,
Wher as he saugh upon a dauncè go
Of ladyes foure and twenty, and yet mo;
Toward the whichè daunce he drow ful yerne,
In hopè that som wysdom sholde he lerne;
But certeinly, er he came fully there,
Vanysshèd was this daunce, he nystè where.
No creäturè saugh he that bar lyf,
Save on the grene he saugh sittynge a wyf;
A fouler wight ther may no man devyse.
Agayn the knyght this oldè wyf gan ryse,
And seyde, 'Sire knyght, heer-forth ne lith no wey;
Tel me what that ye seken, by youre fey!
Paráventure it may the bettre be;
Thise oldè folk kan muchel thyng,' quod she.

'My leevè mooder,' quod this knyght, 'certeyn
I nam but deed but if that I kan seyn
What thyng it is that wommen moost desire:
Koude ye me wisse I wolde wel quite youre hire.'

'Plight me thy trouthe, heere in myn hand,' quod she,
'The nextè thyng that I requerè thee
Thou shalt it do, if it lye in thy myght,
And I wol telle it yow, er it be nyght.'

'Have heer my trouthè,' quod the knyght, 'I graunte!'

Thannè quod she, 'I dar me wel avaunte
Thy lyf is sauf, for I wol stonde thereby;
Upon my lyf, the queene wol seye as I.
Lat se, which is the proudeste of hem alle
That wereth on a coverchief or a calle,

That dar seye "nay" of that I shal thee teche.
Lat us go forth withouten lenger speche.'
Tho rownèd she a pistel in his ere,
And bad hym to be glad and have no fere.

 Whan they be comen to the court, this knyght
Seyde he had holde his day as he hadde hight,
And redy was his answere, as he sayde.
Ful many a noble wyf, and many a mayde,
And many a wydwè, for that they had been wise,
The queene hirself sittynge as a justise,
Assembled been, his answere for to heere;
And afterward this knyght was bode appere.

 To every wight comanded was silence,
And that the knyght sholde telle in audience
What thyng that worldly wommen loven best.
This knyght ne stood nat stille as doth a best,
But to his questioun anon answerde,
With manly voys, that al the court it herde.

 'My ligè lady, generally,' quod he,
'Wommen desiren have sovereynetee,
As wel over hir housbond, as hir love,
And for to been in maistrie hym above.
This is youre mooste desir, thogh ye me kille.
Dooth as yow list, I am heer at youre wille.'

 In al the court ne was ther wyf, ne mayde,
Ne wydwè, that contraried that he sayde,
But seyden he was worthy han his lyf;
And with that word up stirte the oldè wyf,
Which that the knyght saugh sittynge on the grene;
'Mercy!' quod she, 'my sovereyn lady queene!
Er that youre court departè, do me right;
I taughtè this answere unto the knyght,
For which he plightè me his trouthè there,
The firstè thyng I woldè hym requere,
He wolde it do, if it lay in his myght.
Bifore the court thanne, preye I thee, sir knyght,'
Quod she, 'that thou me take unto thy wyf,
For wel thou woost that I have kept thy lyf.
If I sey fals, sey "nay," upon thy fey!'

 This knyght answerde, 'Allas, and weylawey!
I woot right wel that swich was my biheste.
For Goddès love, as chees a newe requeste!
Taak al my good, and lat my body go.'

 'Nay, thanne,' quod she, 'I shrewe us bothè two!

436

For thogh that I be foul, and oold, and poore,
I nolde, for al the metal, ne for oore
That under erthe is grave, or lith above,
But if thy wyf I were, and eek thy love!'
 'My "love"!' quod he, 'nay, my dampnacioun!
Allas! that any of my nacioun
Sholde ever so foulé disparáged be!'
But al for noght, the ende is this, that he
Constreynéd was, he nedés moste hire wedde,
And taketh his oldé wyf, and gooth to bedde.
 Now wolden som men seye, paráventure,
That for my necligence I do no cure
To tellen yow the joye and al tharray,
That at the feesté was that ilké day;
To which thyng shortly answeren I shal;
I seye, ther nas no joye ne feeste at al.
Ther nas but hevynesse, and muché sorwe,
For privély he wedded hire on a morwe,
And al day after hidde hym as an owle,
So wo was hym, his wyf lookéd so foule.
 Greet was the wo the knyght hadde in his thoght,
Whan he was with his wyf abedde y-broght.
He walweth, and he turneth to and fro;
His oldé wyf lay smylynge evermo,
And seyde, 'O deeré housbonde, *benedicitee!*
Fareth every knyght thus with his wyf, as ye?
Is this the law of kyng Arthúrés hous?
Is every knyght of his so dangerous?
I am youre owene love, and youré wyf;
I am she which that savéd hath youre lyf,
And certes, yet dide I yow never unright,
Why fare ye thus with me, this firsté nyght?
Ye faren lyk a man had lost his wit;
What is my gilt? For Goddés love tel it,
And it shal been amended, if I may.'
 'Amended!' quod this knyght, 'allas! nay, nay!
It wol nat been amended never mo,
Thou art so loothly, and so oold also,
And ther-to comen of so lough a kynde,
That litel wonder is thogh I walwe and wynde.
So, woldé God! myn herté woldé breste!'
 'Is this,' quod she, 'the cause of youre unreste?'
 'Ye, certeinly,' quod he, 'no wonder is.'
 'Now, sire,' quod she, 'I koude amende al this,

If that me liste, er it were dayès thre;
So wel ye myghtè bere yow unto me.
 'But for ye speken of swich gentillesse
As is descended out of old richesse,
That therfore sholden ye be gentil men,
Swich arrogance is nat worth an hen.
Looke, who that is moost vertuous alway,
Pryvee and apert, and moost entendeth ay
To do the gentil dedès that he kan,
Taak hym for the grettest gentil man.
Crist wole we clayme of hym oure gentillesse,
Nat of oure eldrès for hire old richesse;
For, thogh they yeve us al hir heritage,—
For which we clayme to been of heigh parage,—
Yet may they nat biquethè for no thyng,
To noon of us, hir vertuous lyvyng,
That made hem gentil men y-called be,
And bad us folwen hem in swich degree.
 'Wel kan the wisè poete of Florence,
That hightè Dant, speken in this sentence,—
Lo, in swich maner rym is Dantes tale,—
 'Ful selde up riseth by his branches smale
Prowesse of man, for God of his goodnesse
Wole that of hym we clayme oure gentillesse;
For of oure eldrès may we no-thyng clayme,
But temporel thyng that man may hurte and mayme.'
 'Eek every wight woot this as wel as I,
If gentillesse were planted natureelly,
Unto a certeyn lynage doun the lyne,
Pryvee nor apert, thanne wolde they never fyne
To doon of gentillesse the faire office;
They myghtè do no vileynye or vice.
 'Taak fyr and ber it in the darkeste hous,
Bitwix this and the mount of Kaukasous,
And lat mèn shette the dorès and go thenne,
Yet wole the fyr as fairè lye and brenne
As twenty thousand men myghte it biholde;
His office natureel ay wol it holde,
Up peril of my lyf, til that it dye.
 'Heere may ye se wel how that genterye
Is nat annexèd to possessioun,
Sith folk ne doon hir operacioun
Alwey, as dooth the fyr, lo, in his kynde;
For, God it woot, men may wel often fynde

A lordès sone do shame and vileynye;
And he that wole han pris of his gentrye,
For he was boren of a gentil hous,
And hadde his eldrès noble and vertuous,
And nyl hymselven do no gentil dedis,
Ne folwen his gentil auncestrè that deed is,
He nys nat gentil, be he duc or erl;
For vileyns synful dedès make a cherl;
For gentillessè nys but renomee
Of thyne auncéstrès, for hire heigh bountee,
Which is a strangè thyng to thy persone.
Thy gentillessè cometh fro God allone;
Thanne comth oure verray gentillesse of grace,
It was no thyng biquethe us with oure place.

 'Thenketh how noble, as seith Valerius,
Was thilkè Tullius Hostillius,
That out of poverte roos to heigh noblesse.
Redeth Senek, and redeth eek Boece,
Ther shul ye seen expressè, that no drede is,
That he is gentil that dooth gentil dedis;
And herfore, leeve housbonde, I thus conclude;
Al were it that myne auncestres weren rude,
Yet may the hyè God, and so hope I,
Grantè me grace to lyven vertuously;
Thanne am I gentil, whan that I bigynne
To lyven vertuously and weyvè synne.

 'And ther as ye of poverte me repreeve
The hyè God, on whom that we bileeve,
In wilful poverte chees to lyve his lyf,
And certès, every man, mayden, or wyf,
May understonde that Jhesus, hevene kyng,
Ne wolde nat chese a vicious lyvyng.
Glad poverte is an honeste thyng, certeyn;
This wole Senec and othere clerkès seyn;
Whoso that halt hym payd of his poverte,
I holde hym riche, al hadde he nat a sherte;
He that coveiteth is a povere wight,
For he wolde han that is nat in his myght;
But he that noght hath, ne coveiteth have,
Is riche, although ye holde hym but a knave.

 'Verray poverte, it syngeth proprèly;
Juvenal seith of poverte, myrily,
"The pourè man, whan he goth by the weye,
Bifore the thevès he may synge and pleye."

439

Poverte is hateful good, and as I gesse
A ful greet bryngere-out of bisynesse,
A greet amendere eek of sapience,
To hym that taketh it in pacience.
Poverte is this, although it seme alenge,
Possessioun that no wight wol chalenge.
Poverte ful ofté, whan a man is lowe,
Maketh his God, and eek hymself, to knowe.
Poverte a spectacle is, as thynketh me,
Thurgh which he may his verray freendés see;
And therfore, sire, syn that I noght yow greve,
Of my poverte namoore ye me repreve.

 'Now, sire, of eldé ye reprevé me;
And certés, sire, thogh noon auctoritee
Were in no book, ye gentils of honóur
Seyn that men sholde an oold wight doon favóur,
And clepe hym fader, for youre gentillesse,
And auctours shal I fynden, as I gesse.

 'Now, ther ye seye that I am foul and old,
Than drede you noght to been a cokéwold;
For filthe and eeldé, al so moot I thee!
Been greté wardeyns upon chastitee:
But nathélees, syn I knowe youre delit,
I shal fulfille youre worldly appetit.

 'Chese now,' quod she, 'oon of thise thyngés tweye:
To han me foul and old til that I deye,
And be to yow a trewé, humble wyf,
And never yow displese in al my lyf;
Or ellés ye wol han me yong and fair,
And take youre áventure of the repair
That shal be to youre hous by cause of me,
Or in som oother placé may wel be;
Now chese yourselven, wheither that yow liketh.'

 This knyght avyseth hym and soré siketh;
But atté laste he seyde in this manere:
'My lady and my love, and wyf so deere,
I put me in youre wisé governance;
Cheseth youre self which may be moost plesance,
And moost honóur to yow and me also;
I do no fors the wheither of the two,
For as yow liketh it suffiseth me.'

 'Thanne have I gete of yow maistrie,' quod she,
'Syn I may chese, and governe as me lest?'

 'Ye, certés, wyf,' quod he, 'I holde it best.'

'Kys me,' quod she, 'we be no lenger wrothe,
For, by my trouthe, I wol be to yow bothe,—
This is to seyn, ye, bothe fair and good.
I prey to God that I moote sterven wood,
But I to yow be al so good and trewe,
As ever was wyf syn that the world was newe;
And but I be to-morn as fair to seene
As any lady, emperice, or queene,
That is bitwixe the est and eek the west;
Dooth with my lyf and deth right as yow lest.
Cast up the curtyn,—looke, how that it is.
 And whan the knyght saugh verraily al this,
That she so fair was, and so yong ther-to,
For joye he hente hire in his armes two,
His herte bathed in a bath of blisse;
A thousand tyme arewe he gan hire kisse,
And she obeyed hym in every thyng
That myghte doon hym plesance or likyng.
 And thus they lyve unto hir lyves ende
In parfit joye; and Jhesu Crist us sende
Housbondes meeke, yonge, fressh a-bedde,
And grace toverbyde hem that we wedde,
And eek, I praye Jhesu to shorte hir lyves
That nat wol be governed by hir wyves;
And olde and angry nygardes of dispence,
God sende hem soone verray pestilence!

<div align="right">The Canterbury Tales (c. 1387)</div>

Perhaps, unequalled as a comic story.

<div align="right">WILLIAM HAZLITT
Lectures on the English Poets (1818)</div>

GEOFFREY CHAUCER

1 3 4 0 ? — 1 4 0 0

THE PARDONER'S TALE

In Flaundres whilom was a compaignye
Of yonge folk, that haunteden folye,
As riot, hasard, stywes and tavernes,
Where-as with harpes, lutes and gyternes,

They daunce and pleyen at dees, bothe day and nyght,
And eten also, and drynken over hir myght,
Thurgh which they doon the devel sacrifise
Withinne that develes temple, in cursėd wise,
By superfluytee abhomynable.
Hir othės been so grete and so dampnable
That it is grisly for to heere hem swere;
Oure blissėd Lordės body they to-tere;
Hem thoughte that Jewės rente hym noght ynough,
And ech of hem at otheres synnė lough;
And right anon thanne comen tombesteres
Fetys and smale, and yongė frutesteres,
Syngeres with harpės, baudės, wafereres,
Whiche been the verray develes officeres,
To kyndle and blowe the fyr of lecherye,
That is annexėd unto glotonye.
The Hooly Writ take I to my witnessc
That luxurie is in wyn and dronkėnesse.

'Lo, how that dronken Looth, unkyndėly,
Lay by his doghtrės two unwityngly;
So dronke he was he nystė what he wroghte.

Herodės, (who so wel the stories soghte,)
Whan he of wyn was repleet at his feeste,
Right at his owenė table, he yaf his heeste
To sleen the Baptist John, ful giltėlees.

Seneca seith a good word, doutėlees;
He seith he kan no differencė fynde
Bitwix a man that is out of his mynde
Ánd a man which that is dronkėlewe,
But that woodnessė, fallen in a shrewe,
Persėvereth lenger than dooth dronkenesse.
O glotonyė, ful of cursednesse;
O causė first of oure confusioun;
O original of oure dampnacioun;
Til Crist hadde boght us with his blood agayn!

Ló, how deerė, shortly for to sayn,
Aboght was thilkė cursėd vileynye;
Corrupt was al this world for glotonye.
Adam oure fader, and his wyf also,
Fro Paradys, to labour and to wo
Were dryven for that vice, it is no drede,—
For whil that Adam fasted, as I rede,
He was in Paradys, and whan that he
Eet of the fruyt deffended, on the tree,

Anon he was out cast to wo and peyne.
O glotonye, on thee wel oghte us pleyne!
　　O, wiste a man how manye maladyes
Folwen of excesse and of glotonyes,
He woldė been the moorė mesurable
Of his dietė, sittynge at his table!
Allas! the shortė throte, the tendrė mouth,
Maketh that est and west, and north and south,
In erthe, in eir, in water, man to-swynke
To gete a glotoun deyntee mete and drynke!
Of this matiere, O Paul, wel kanstow trete!
'Mete unto wombe, and wombe eek unto mete,
Shal God destroyen bothe,' as Paulus seith.
Allas! a foul thyng is it, by my feith,
To seye this word, and fouler is the dede
Whan man so drynketh of the white and rede,
That of his throte he maketh his pryvee,
Thurgh thilkė cursėd superfluitee.
　　The Apostel wepyng seith ful pitously,
'Ther walken manye of whiche yow toold have I,
I seye it now wepyng with pitous voys,
That they been enemys of Cristės croys,
Of whiche the ende is deeth, wombe is hir god.'
O wombe! O bely! O stynkyng is thi cod!
Fulfilled of donge and of corrupcioun!
At either ende of thee foul is the soun;
How greet labóur and cost is thee to fynde!
Thise cookės, how they stampe, and streyne, and gryndė,
And turnen substaunce into accident,
To fulfillen al thy likerous talent!
Out of the hardė bonės knokkė they
The mary, for they castė noght awey
That may go thurgh the golet softe and swoote.
Of spicerie, of leef, and bark, and roote,
Shal been his sauce y-makėd by delit,
To make hym yet a newer appetit;
But certės he that haunteth swiche delices
Is deed, whil that he lyveth in tho vices.
　　A lecherous thyng is wyn, and dronkenesse
Is ful of stryvyng and of wrecchednesse.
O dronkė man! disfigured is thy face,
Sour is thy breeth, foul artow to embrace,
And thurgh thy dronkė nose semeth the soun,
As though thou seydest ay, 'Sampsoun! Sampsoun!'

And yet, God woot, Sampsoun drank never no **wyn**.
Thou fallest as it were a stykèd swyn,
Thy tonge is lost and al thyn honeste cure;
For dronkenesse is verray sepulture
Of mannès wit and his discrecioun;
In whom that drynke hath dominacioun,
He kan no conseil kepe, it is no drede.
Now kepe yow fro the white and fro the **rede**,
And namely fro the whitè wyn of Lepe,
That is to selle in Fysshstrete, or in Chepe.
This wyn of Spaignè crepeth subtilly
In othere wynès growynge fastè by,
Of which ther ryseth swich fumositee,
That whan a man hath dronken draughtès **thre**,
And weneth that he be at hoom in Chepe,
He is in Spaigne right at the toune of **Lepe**,—
Nat at the Rochele, ne at Burdeux-toun,—
And thannè wol he seye, 'Sampsoun, Sampsoun!'

But herkneth, lordyngs, o word, I yow preye,
That alle the sovereyn actès, dar I seye,
Of victories in the Oldè Testament,
Thurgh verray God that is omnipotent,
Were doon in abstinence and in preyere;
Looketh the Bible and ther ye may it leere.

Looke, Attilla, the gretè conquerour,
Deyde in his sleepe, with shame and dishonour,
Bledynge ay at his nose in dronkenesse.
A capitayn sholde lyve in sobrenesse;
And over al this avyseth yow right wel
What was comaunded unto Lamuel,—
Nat Samuel, but Lamuel seye I;
Redeth the Bible, and fynde it expresly
Of wyn-yevyng to hem that han justise.
Namoore of this, for it may wel suffise.

And now that I have spoken of glotonye,
Now wol I yow deffenden hasardrye.
Hasard is verray mooder of lesynges,
And of deceite, and cursèd forswerynges,
Blaspheme of Crist, manslaughtre, and wast also
Of catel, and of tyme, and forthermo
It is repreeve and contrarie of honour
For to ben holde a commune hasardour
And ever the hyer he is of estaat,
The moorè is he holden desolaat.

If that a prynċė useth hasardrye
In allė governaunce and policye,
He is, as by commune opinioun,
Y-holde the lasse in reputacioun.
 Stilbon, that was a wys embassadour,
Was sent to Corynthe in ful greet honour
Fro Lacidomye to maken hire alliaunce;
And whan he cam, hym happedė *par chaunce*
That alle the gretteste that were of that lond
Pléyynge attė hasard he hem fond;
For which, as soonė as it myghtė be,
He stal hym hoom agayn to his contree,
And seydė, 'Ther wol I nat lese my name,
Ne I wol nat take on me so greet defame,
Yow for to allie unto none hasardours;
Sendeth otherė wise embassadours,
For, by my trouthė, me were levere dye,
Than I yow sholde to hasardours allye;
For ye that been so glorious in honours,
Shul nat allyėn yow with hasardours,
As by my wyl, ne as by my tretee!'
This wisė philosophrė thus seyde hee.
 Looke eek that to the kyng Demetrius,
The kyng of Parthės, as the book seith us,
Sente him a pairė of dees of gold, in scorn,
For he haddė usėd hasard ther-biforn;
For which he heeld his glorie or his renoun
At no value or reputacioun.
Lordės may fynden oother maner pley
Honeste ynough to dryve the day awey.
 Now wol I speke of othės false and grete
A word or two, as oldė bookės trete.
Gret sweryng is a thyng abhomináble,
And fals sweryng is yet moore repreváble.
The heighė God forbad sweryng at al,—
Witnesse on Mathew, but in special
Of sweryng seith the hooly Jeremye,
'Thou shalt seye sooth thyne othės, and nat lye
And swere in doom, and eek in rightwisnesse';
But ydel sweryng is a cursednesse.
Bihoold and se, that in the firstė table
Of heighė Goddės heestės, honourable,
How that the seconde heeste of hym is this:
'Take nat my name in ydel, or amys';

445

Lo, rather he forbedeth swich sweryng
Than homycide, or many a cursèd thyng;
I seye that as by ordrè thus it stondeth.
This knowen, that his heestès understondeth,
How that the seconde heeste of God is that;
And forther over, I wol thee telle, al plat,
That vengeance shal nat parten from his hous
That of his othes is to outrageous,—
'By Goddès precious herte,' and 'By his nayles,'
And 'By the blood of Crist that is in Hayles,'
'Sevene is my chaunce, and thyn is cynk and treye,
By Goddès armès, if thou falsly pleye,
This daggere shal thurghout thyn hertè go!'
This fruyt cometh of the bicchèd bonès two,
Forsweryng, irè, falsnesse, homycide.
Now for the love of Crist that for us dyde,
Leveth youre othès, bothè grete and smale.
But, sires, now wol I tellè forth my tale.

 Thise riotourès thre, of whiche I telle,
Longe erst er primè rong of any belle,
Were set hem in a taverne for to drynke;
And as they sat they herde a bellè clynke
Biforn a cors. was caried to his grave.
That oon of hem gan callen to his knave:
'Go bet,' quod he, 'and axè redily
What cors is this that passeth heer forby,
And looke that thou reporte his namè weel.'
 'Sire,' quod this boy, 'it nedeth never a deel,
It was me toold er ye cam heere two houres;
He was, *pardee,* an old felawe of youres,
And sodeynly he was y-slayn to-nyght,
For-dronke, as he sat on his bench upright;
Ther cam a privee theef, men clepeth **Deeth,**
That in this contree al the peplè sleeth,
And with his spere he smoot his herte atwo,
And wente his wey withouten wordès mo.
He hath a thousand slayn this pestilence,
And, maister, er ye come in his presence,
Me thynketh that it werè necessarie
For to be war of swich an adversarie;
Beth redy for to meete hym evermoore;
Thus taughtè me my dame; I sey namoore.'
 'By Seinte Mariè!' seyde this taverner,
'The child seith sooth, for he hath slayn this yeer

446

Henne over a mile, withinne a greet village,
Bothe man and womman, child, and hyne, and page;
I trowe his habitacioun be there;
To been avysėd greet wysdom it were,
Er that he dide a man a dishonour.'
'Ye, Goddės armės!' quod this riotour,
'Is it swich peril with hym for to meete?
I shal hym seke by wey, and eek by strete;
I make avow to Goddės dignė bones!
Herkneth, felawės, we thre been al ones,
Lat ech of us holde up his hand til oother,
And ech of us bicomen otheres brother,
And we wol sleen this falsė traytour, Deeth;
He shal be slayn, he that so manye sleeth,
By Goddės dignitee, er it be nyght!'
Togidres han thise thre hir trouthės plight
To lyve and dyen ech of hem for oother,
As though he were his owene y-borė brother;
And up they stirte, al dronken, in this rage;
And forth they goon towardės that village
Of which the taverner hadde spoke biforn:
And many a grisly ooth thanne han they sworn;
And Cristės blessed body they to-rente,—
Deeth shal be deed, if that they may hym hente.
Whan they han goon nat fully half a mile.
Right as they wolde han troden over a stile,
An oold man and a pourė with hem mette;
This oldė man ful mekėly hem grette,
And seydė thus: 'Now, lordės, God yow see!'
The proudeste of thise riotourės three
Answerde agayn, 'What, carl with sory grace,
Why artow al for-wrappėd, save thy face?
Why lyvėstow so longe in so greet age?'
This oldė man gan looke in his visage,
And seydė thus: 'For I ne kan nat fynde
A man, though that I walkėd into Ynde,
Neither in citee, ne in no village,
That woldė chaunge his youthė for myn age;
And therfore moot I han myn agė stille,
As longė tyme as it is Goddės wille.
Ne Deeth, allas! ne wol nat han my lyf;
Thus walke I, lyk a restėlees kaityf,
And on the ground, which is my moodrės gate,
I knokkė with my staf, erly and late,

And seyė, 'Leevė mooder, leet me in!
Lo, how I vanysshe, flessh and blood and skyn;
Allas! whan shul my bonės been at reste?
Mooder, with yow wolde I chaungė my cheste
That in my chambrė longė tyme hath be,
Ye, for an heyrė-clowt to wrappė me!'
But yet to me she wol nat do that grace,
For which ful pale and welkėd is my face.

 'But, sires, to yow it is no curteisye
To speken to an old man vileynye,
But he trespasse in word, or elles in dede.
In Hooly Writ ye may your self wel rede,
Agayns an oold man, hoor upon his heed,
Ye sholde arise; wherfore I yeve yow reed,
Ne dooth unto an oold man noon harm now,
Namoorė than ye wolde men did to yow
In agė, if that ye so longe abyde.
And God be with yow, where ye go or ryde;
I moote go thider as I have to go.'

 'Nay oldė cherl, by God, thou shalt nat so!'
Seydė this oother hasardour anon;
'Thou partest nat so lightly, by Seint John!
Thou spak right now of thilkė traytour, Deeth,
That in this contree alle oure freendės sleeth;
Have heer my trouthe, as thou art his espye,
Telle where he is, or thou shalt it abye,
By God and by the hooly sacrement!
For soothly, thou art oon of his assent
To sleen us yongė folk, thou falsė theef!'

 'Now, sires,' quod he, 'if that ye be so leef
To fyndė Deeth, turne up this croked wey,
For in that grove I lafte hym, by my fey,
Under a tree, and there he wole abyde;
Noght for youre boost he wole him no thyng hyde.
Se ye that ook? Right there ye shal hym fynde.
God savė yow that boghte agayn mankynde,
And yow amende!' thus seyde this oldė man;
And evėrich of thise riotourės ran
Til he cam to that tree, and ther they founde,
Of floryns fyne, of gold y-coynėd rounde,
Wel ny a seven busshels, as hem thoughte.
No lenger thannė after Deeth they soughte,
But ech of hem so glad was of that sighte,
For that the floryns been so faire and brighte,

That doun they sette hem by this precious hoord.
The worste of hem he spak the firstè word.

 'Bretheren,' quod he, 'taak kepè what I seye;
My wit is greet, though that I bourde and pleye.
This tresor hath Fortúne unto us yeven
In myrthe and joliftee oure lyf to lyven,
And lightly as it comth so wol we spende.
Ey, Goddès precious dignitee! who wende
To-day, that we sholde han so fair a grace?
But myghte this gold be caried fro this place
Hoom to myn hous, or ellès unto youres,—
For wel ye woot that al this gold is oures,—
Thanne werè we in heigh felicitee.
But trewèly, by daye it may nat bee;
Men woldè seyn that we were thevès stronge,
And for oure owenè tresor doon us honge.
This tresor moste y-caried be by nyghte
As wisely and as slyly as it myghte.
Wherfore, I rede that cut among us alle
Be drawe, and lat se wher the cut wol falle;
And he that hath the cut with hertè blithe
Shal rennè to the towne, and that ful swithe,
And brynge us breed and wyn ful privèly,
And two of us shul kepen subtilly
This tresor wel; and if he wol nat tarie,
Whan it is nyght we wol this tresor carie,
By oon assent, where as us thynketh best.'
That oon of hem the cut broghte in his fest,
And bad hem drawe and looke where it wol falle;
And it fil on the yongeste of hem alle,
And forth toward the toun he wente anon;
And al so soonè as that he was gon,
That oon of hem spak thus unto that oother:
'Thow knowest wel thou art my swornè brother;
Thy profit wol I tellè thee anon;
Thou woost wel that oure felawe is agon,
And heere is gold, and that ful greet plentee,
That shal departèd been among us thre;
But nathèlees, if I kan shape it so
That it departed were among us two,
Hadde I nat doon a freendès torn to thee?'

 That oother answerde, 'I noot how that may be;
He woot how that the gold is with us tweye;
What shal we doon, what shal we to hym seye?'

'Shal it be conseil?' seyde the firstè shrewe,
'And I shal tellen thee in wordès fewe
What we shal doon, and bryngen it wel aboute.'
 'I grauntè,' quod that oother, 'out of doute,
That by my trouthe I shal thee nat biwreye.'
 'Now,' quod the firste, 'thou woost wel we be tweye,
And two of us shul strenger be than oon.
Looke whan that he is set, and right anoon
Arys, as though thou woldest with hym pleye,
And I shal ryve hym thurgh the sydès tweye,
Whil that thou strogelest with hym as in game,
And with thy daggere looke thou do the same;
And thanne shal al this gold departed be,
My deerè freend, bitwixen me and thee.
Thanne may we bothe oure lustès all fulfille.
And pleye at dees right at oure owene wille.'
And thus acorded been thise shrewès tweye,
To sleen the thridde, as ye han herd me seye.
 This yongeste, which that wente unto the toun,
Ful ofte in herte he rolleth up and doun
The beautee of thise floryns newe and brighte;
'O Lord,' quod he, 'if so were that I myghte
Have al this tresor to my self allone,
Ther is no man that lyveth under the trone
Of God, that sholdè lyve so murye as I!'
And attè laste the feend, oure enemy,
Putte in his thought that he sholde poyson beye,
With which he myghtè sleen his felawes tweye;
For-why the feend foond hym in swich lyvynge,
That he hadde levè hym to sorwè brynge,
For this was outrèly his fulle entente
To sleen hem bothe and never to repente.
And forth he gooth, no lenger wolde he tarie,
Into the toun, unto a pothecarie,
And preydè hym that he hym woldè selle
Som poysoun, that he myghte his rattès quelle;
And eek ther was a polcat in his hawe,
That, as he seyde, his capouns hadde y-slawe,
And fayn he woldè wreke hym, if he myghte,
On vermyn, that destroyèd hym by nyghte.
 The pothecarie answerde, 'And thou shalt have
A thyng that, al so God my soulè save!
In al this world ther nis no creäture,
That eten or dronken hath of this confiture,

450

Noght but the montance of a corn of whete,
That he ne shal his lif anon forlete;
Ye, sterve he shal, and that in lasse while
Than thou wolt goon a-paas nat but a mile;
This poysoun is so strong and violent.'
 This cursed man hath in his hond y-hent
This poysoun in a box, and sith he ran
Into the nexte strete unto a man,
And borwed hym large botelles thre,
And in the two his poyson poured he;
The thridde he kepte clene for his owene drynke;
For al the nyght he shoope hym for to swynke
In cariynge of the gold out of that place.
And whan this riotour with sory grace
Hadde filled with wyn his grete botels thre,
To his felawes agayn repaireth he.
 What nedeth it to sermone of it moore?
For right as they hadde cast his deeth bifoore,
Right so they han hym slayn, and that anon,
And whan that this was doon thus spak that oon:
'Now lat us sitte and drynke, and make us merie,
And afterward we wol his body berie';
And with that word it happed hym, *par cas*,
To take the botel ther the poysoun was,
And drank and yaf his felawe drynke also,
For which anon they storven bothe two.
 But certes, I suppose that Avycen
Wroot never in no Canon, ne in no fen,
Mo wonder signes of empoisonyng
Than hadde thise wreeches two, er hir endyng.
Thus ended been thise homycides two,
And eek the false empoysonere also.
 O cursed synne of alle cursednesse!
O traytorous homycide! O wikkednesse!
O glotonye, luxurie, and hasardrye!
Thou blasphemour of Crist with vileynye,
And othes grete, of usage and of pride!
Allas! mankynde, how may it bitide
That to thy Creätour which that thee wroghte,
And with his precious herte-blood thee boghte.
Thou art so fals and so unkynde, allas!
 Now, goode men, God foryeve yow youre trespas,
And ware yow fro the synne of avarice.
Myn hooly pardoun may yow alle warice,

451

So that ye offre nobles, or sterlynges,
Or ellès silver broches, spoonès, rynges.
Boweth youre heed under this hooly bulle!
Cometh up, ye wyvès, offreth of youre wolle!
Youre names I entre heer in my rolle anon;
Into the blisse of hevene shul ye gon;
I yow assoillè by myn heigh power,—
Yow that wol offre,—as clene and eek as cleer
As ye were born; and lo, sires, thus I preche,
And Jhesu Crist, that is oure soulès leche,
So grauntè yow his pardoun to receyve;
For that is best; I wol yow nat deceyve.

'But, sires, o word forgat I in my tale;
I have relikes and pardoun in my male
As faire as any man in Engelond,
Whiche were me yeven by the popès hond.
If any of yow wole of devocioun
Offren, and han myn absolucioun,
Com forth anon, and kneleth heere adoun,
And mekèly receyveth my pardoun;
Or ellès taketh pardoun as ye wende,
Al newe and fressh at every milès ende,—
So that ye offren, alwey newe and newe,
Nobles or pens, whiche that be goode and trewe.
It is an honour to everich that is heer
That ye mowe have a suffisant Pardoneer
Tassoillè yow in contree as ye ryde,
For áventúres whiche that may bityde.
Paráventure ther may fallen oon or two
Doun of his hors and breke his nekke atwo;
Looke which a seuretee is it to yow alle,
That I am in youre felaweshipe y-falle,
That may assoillè yow, bothe moore and lasse,
Whan that the soule shal fro the body passe.
I redè that oure Hoost heere shal bigynne,
For he is moost envoluped in synne!
Com forth, sire Hoost, and offrè first anon,
And thou shalt kisse my relikes everychon,—
Ye, for a grote! Unbokele anon thy purs.'
 'Nay, nay,' quod he, 'thanne have I Cristès curs!
Lat be,' quod he, 'it shal nat be, so theech!
Thou woldest make me kisse thyn oldè breech,
And swere it were a relyk of a seint,
Though it were with thy fundèment depeint;

452

But, by the croys which that Seint Eleyne fond,
I wolde I hadde thy coillons in myn hond
Instide of relikes, or of seintuarie.
Lat kutte hem of, I wol thee helpe hem carie,
They shul be shryned in an hogges toord.'
 This Pardoner answerdė nat a word;
So wrooth he was no word ne wolde he seye.
 'Now,' quod oure Hoost, 'I wol no lenger pleye
With thee, ne with noon oother angry man.'
But right anon the worthy Knyght bigan,—
Whan that he saugh that al the peple lough,—
 'Namoore of this, for it is right ynough!
Sire Pardoner, be glad and myrie of cheere;
And ye, sir Hoost, that been to me so deere,
I prey yow that ye kisse the Pardoner;
And Pardoner, I prey thee drawe thee neer,
And as we diden, lat us laughe and pleye.'
Anon they kiste and ryden forth hir weye.
 The Canterbury Tales (c. 1387)

Perhaps the best short narrative poem in the language.
 GEORGE LYMAN KITTREDGE
 Chaucer's Pardoner (The Atlantic Monthly, 1893)

GEOFFREY CHAUCER

1 3 4 0 ? — 1 4 0 0

THE COCK AND THE FOX

A poure wydwė, somdel stape in age,
Was whilom dwellyng in a narwe cotage
Beside a grevė, stondynge in a dale.
This wydwe, of which I tellė yow my tale,
Syn thilkė day that she was last a wyf,
In paciẽnce ladde a ful symple lyf,
For litel was hir catel and hir rente.
By housbondrie of swich as God hire sente
She foond hirself, and eek hire doghtren two.
Thre largė sowės hadde she, and namo;
Three keen and eek a sheep that hightė Malle.
Ful sooty was hir bour, and eek hire halle,

453

In which she eet ful many a sklendre meel;
Of poynaunt sauce hir neded never a deel.
No deyntee morsel passèd thurgh hir throte,
Hir diete was accordant to hir cote;
Repleccioun ne made hire never sik,
Attempree diete was al hir phisik,
And exercise, and hertès suffisaunce.
The goutè lette hire no-thyng for to daunce,
Napoplexïe shentè nat hir heed;
No wyn ne drank she, neither whit ne reed;
Hir bord was servèd moost with whit and blak,—
Milk and broun breed,—in which she foond no lak;
Seynd bacoun and somtyme an ey or tweye,
For she was, as it were, a maner deye.

A yeerd she hadde, enclosèd al aboute
With stikkès, and a dryè dych withoute,
In which she hadde a cok, heet Chauntècleer.
In al the land of crowyng nas his peer.
His voys was murier than the murie orgon
On messè dayes that in the chirchè gon:
Wel sikerer was his crowyng in his logge
Than is a clokke, or an abbey orlogge.
By nature knew he eche ascencioun
Of the equynoxial in thilkè toun;
For whan degreès fiftene weren ascended,
Thanne crew he that it myghte nat been amended.
His coomb was redder than the fyn coral,
And batailled as it were a castel wal;
His byle was blak, and as the jeet it shoon;
Lyk asure were his leggès and his toon;
His naylès whiter than the lylye flour,
And lyk the burnèd gold was his colour.

This gentil cok hadde in his governaunce
Sevene hennès for to doon al his plesaunce,
Whiche were his sustrès and his paramours,
And wonder lyk to hym, as of colours;
Of whiche the faireste hewèd on hir throte
Was clepèd faire damoysele Pertèlote.
Curteys she was, discreet and debonaire,
And compaignable, and bar hyrself so faire
Syn thilkè day that she was seven nyght oold,
That trewèly she hath the herte in hoold
Of Chauntècleer, loken in every lith;
He loved hire so that wel was hym therwith;

454

But swiche a joye was it to here hem synge,
Whan that the brightė sonne bigan to sprynge,
In sweete accord, 'My lief is faren in londe';
For thilkė tyme, as I have understonde,
Beestės and briddės koudė speke and synge.
 And so bifel, that in the dawėnynge,
As Chauntėcleer among his wyvės alle
Sat on his perchė, that was in the halle,
And next hym sat this fairė Pertelote,
This Chauntėcleer gan gronen in his throte,
As man that in his dreeme is drecchėd soore.
And whan that Pertelote thus herde hym roore,
She was agast, and seyde, 'O hertė deere!
What eyleth yow, to grone in this manére?
Ye been a verray sleper; fy, for shame!'
 And he answerde and seydė thus: 'Madame,
I pray yow that ye take it nat agrief;
By God, me mette I was in swich meschief
Right now, that yet myn herte is soore afright.
Now God,' quod he, 'my swevene recche aright,
And kepe my body out of foul prisoun!
Me mette how that I romėd up and doun
Withinne our yeerd, wheer as I saugh a beest
Was lyk an hound, and wolde han maad areest
Upon my body, and han had me deed.
His colour was bitwixė yelow and reed,
And tippėd was his tayl, and bothe his eeris,
With blak, unlyk the remenant of his heeris;
His snowtė smal, with glowynge eyen tweye.
Yet of his look for feere almoost I deye;
This causėd me my gronyng doutėlees.'
 'Avoy!' quod she, 'fy on yow, hertėlees!
Allas!' quod she, 'for by that God above!
Now han ye lost myn herte and al my love.
I kan nat love a coward, by my feith!
For certės, what so any womman seith,
We alle desiren, if it myghtė bee,
To han housbóndės hardy, wise, and free,
And secree, and no nygard, ne no fool,
Ne hym that is agast of every tool,
Ne noon avauntour, by that God above!
How dorste ye seyn, for shame, unto youre love
That any thyng myghte makė yow aferd?
Have ye no mannės herte, and han a berd?

'Allas! and konne ye been agast of swevenys?
No thyng, God woot, but vanitee in swevene is.
Swevenes engendren of repleccioun,
And ofte of fume, and of complecciouns,
Whan humours been to habundant in a wight.
 'Certès this dreem, which ye han met to-nyght,
Cometh of the greet superfluytee
Of yourè redè colera, *pardee*,
Which causeth folk to dreden in hir dremes
Of arwès, and of fyre with redè lemes,
Of redè beestès, that they wol hem byte,
Of contekes and of whelpès, grete and lyte;
Right as the humour of malencolie
Causeth ful many a man in sleepe to crie,
For feere of blakè beres, or bolès blake,
Or ellès blakè develes wole hem take.
Of othere humours koude I telle also
That werken many a man in sleepe ful wo;
But I wol passe as lightly as I kan.
Lo, Catoun, which that was so wys a man,
Seyde he nat thus, "Ne do no fors of dremes"?
 'Now, sire,' quod she, 'whan we flee fro the bemes,
For Goddès love, as taak som laxatyf.
Up peril of my soule, and of my lyf,
I conseille yow the beste, I wol nat lye,
That bothe of colere and of malencolye
Ye purgè yow, and, for ye shal nat tarie,
Though in this toun is noon apothecarie,
I shal myself to herbès techen yow
That shul been for youre hele, and for youre prow;
And in oure yeerd tho herbès shal I fynde,
The whiche han of hire propretee by kynde
To purgè yow, bynethe and eek above.
Forget nat this, for Goddès owenè love!
Ye been ful coleryk of complecccioun.
Warè the sonne in his ascencioun
Ne fynde yow nat repleet of humours hoote;
And if it do, I dar wel leye a grote
That ye shul have a fevere terciane,
Or an agu, that may be yourè bane.
A day or two ye shul have digestyves
Of wormès, er ye take youre laxatyves
Of lawriol, centaure and fumetere,
Or elles of ellèbor that groweth there,

456

Of katapuce or of gaitrys beryis,
Of herbe yve, growyng in oure yeerd, ther mery is;
Pekke hem up right as they growe and ete hem yn;
Be myrie, housbonde, for youre fader kyn!
Dredeth no dreem; I kan sey yow namoore.'
 'Madame,' quod he, '*graunt mercy* of youre loore,
But nathèlees, as touchyng daun Catoun,
That hath of wysdom swich a greet renoun,
Though that he bad no dremès for to drede,
By God, men may in oldè bookès rede
Of many a man, moore of auctorite
Than ever Caton was, so moot I thee!
That al the revers seyn of his sentence,
And han wel founden by experience
That dremès been significaciouns
As wel of joye as tribulaciouns,
That folk enduren in this lif present.
Ther nedeth make of this noon argument,
The verray preevè sheweth it in dede.
 'Oon of the gretteste auctours that men rede
Seith thus, that whilom two felawès wente
On pilgrimage, in a ful good entente,
And happèd so they coomen in a toun,
Wher as ther was swich congregacioun
Of peple, and eek so streit of herbergage,
That they ne founde as muche as o cotage
In which they bothè myghtè loggèd bee;
Wherfore they mosten of necessitee,
As for that nyght, departen compaignye;
And ech of hem gooth to his hostelrye,
And took his loggyng as it woldè falle.
That oon of hem was loggèd in a stalle,
Fer in a yeerd, with oxen of the plough;
That oother man was loggèd wel ynough,
As was his áventure, or his fortúne,
That us governeth alle as in commune.
 'And so bifel that longe er it were day,
This man mette in his bed, ther as he lay,
How that his felawe gan upon hym calle,
And seyde, "Allas! for in an oxes stalle
This nyght I shal be mordred ther I lye;
Now helpe me, deerè brother, or I dye;
In allè hastè com to me!" he seyde.
 'This man out of his sleepe for feere abrayde;

457

But whan that he was wakened of his sleepe,
He turnèd hym and took of this no keepe;
Hym thoughte his dreem nas but a vanitee.
Thus twiès in his slepyng dremed hee,
And attè thriddè tyme yet his felawe
Cam, as hym thoughte, and seide, "I am now slawe!
Bihoold my bloody woundès, depe and wyde;
Arys up erly in the morwè tyde,
And at the west gate of the toun," quod he,
"A cartè ful of donge ther shaltow se,
In which my body is hid ful privèly;
Do thilkè carte arresten boldèly;
My gold causèd my mordrè, sooth to sayn."
And tolde hym every point how he was slayn,
With a ful pitous facè, pale of hewe;
And trustè wel, his dreem he foond ful trewe;
For on the morwe, as soone as it was day,
To his felawès in he took the way,
And whan that he cam to this oxes stalle,
After his felawe he bigan to calle.

'The hostiler answerdè hym anon
And seydè, "Sire, your felawe is agon;
As soone as day he wente out of the toun."

'This man gan fallen in suspecioun,—
Remembrynge on his dremès, that he mette,—
And forth he gooth, no lenger wolde he lette,
Unto the west gate of the toun, and fond
A dong carte, as it were to dongè lond,
That was arrayèd in that samè wise
As ye han herd the dedè man devyse;
And with an hardy herte he gan to crye
Vengeance and justice of this felonye.
"My felawe mordred is this samè nyght,
And in this carte he lith gapyng upright.
I crye out on the ministres," quod he,
"That sholden kepe and reulen this citee;
Harrow! allas! heere lith my felawe slayn!"
What sholde I moore unto this talè sayn?
The peple out sterte and caste the cart to grounde,
And in the myddel of the dong they founde
The dedè man, that mordred was al newe.

'O blisful God, that art so just and trewe!
Lo, how that thou biwreyest mordre alway!
Mordrè wol out, that se we day by day;

Mordre is so wlatsom, and abhomynable
To God, that is so just and resonable,
That he ne wol nat suffre it heléd be,
Though it abyde a yeer, or two, or thre;
Mordré wol out, this my conclusioun.
And right anon, ministres of that toun
Han hent the carter, and so soore hym pyned,
And eek the hostiler so soore engyned,
That they biknewe hire wikkednesse anon,
And were an-hanged by the nekké bon.
 "Heere may men seen that dremés been to drede;
And certés, in the samé book I rede,
Right in the nexté chapitre after this,—
I gabbé nat, so have I joye or blis,—
Two men that wolde han passéd over see,
For certeyn cause, into a fer contree,
If that the wynd ne haddé been contrarie,
That made hem in a citee for to tarie
That stood ful myrie upon an haven syde;
But on a day, agayn the even-tyde,
The wynd gan chaunge, and blew right as hem leste.
Jolif and glad they wente unto hir reste,
And casten hem ful erly for to saille.
 'But to that o man fil a greet mervaille;
That oon of hem in slepyng as he lay,
Hym mette a wonder dreem, agayn the day:
Him thoughte a man stood by his beddés syde
And hym comanded that he sholde abyde,
And seyde hym thus: "If thou tomorwé wende,
Thou shalt be dreynt, my tale is at an ende."
 'He wook, and tolde his felawe what he mette,
And preydé hym his viage for to lette;
As for that day, he preydé hym to byde.
His felawe, that lay by his beddés syde,
Gan for to laughe, and scornéd him ful faste;
"No dreem," quod he, "may so myn herte agaste,
That I wol letté for to do my thynges;
I setté not a straw by thy dremynges,
For swevenes been but vanytees and japes;
Men dreme al day of owlés or of apes,
And eke of many a mazé therwithal;
Men dreme of thyng that never was ne shal;
But sith I see that thou wolt heere abyde,
And thus forslewthen wilfully thy tyde,

God woot it reweth me, and have good day!"
And thus he took his leve, and wente his way;
But er that he hadde half his cours y-seyled,
Noot I nat why, ne what myschaunce it eyled,
But casuelly the shippès botmè rente,
And shipe and man under the water wente
In sighte of othere shippès it bisyde,
That with hem seylèd at the samè tyde!
And therefore, fairè Pertèlote so deere,
By swiche ensamplès olde yet maistow leerc,
That no man sholdè been to recchelees
Of dremès, for I seye thee doutèlees,
That many a dreem ful soore is for to drede.

 'Lo, in the lyf of Seint Kenelm I rede,
That was Kenulphus sone, the noble kyng
Of Mercenrike, how Kenelm mette a thyng.
A lite er he was mordred, on a day
His mordre in his avysioun he say.
His norice hym expownèd every deel
His swevene, and bad hym for to kepe hym weel
For traisoun; but he nas but seven yeer oold,
And therfore litel talè hath he toold
Of any dreem, so hooly was his herte.
By God, I haddè levere than my sherte
That ye hadde rad his legende as have I.
Dame Pertèlote, I sey yow trewèly,
Macrobeus, that writ the avisioun
In Affrike of the worthy Cipioun,
Affermeth dremes, and seïth that they been
Warnynge of thyngès that men after seen;
And forther-moore, I pray yow looketh wel
In the Oldè Testament of Daniel,
If he heeld dremès any vanitee.

 'Reed eek of Joseph, and ther shul ye see
Wher dremès be somtyme,—I sey nat alle,—
Warnynge of thyngès that shul after falle.
Looke of Egipte the kyng, daun Pharao,
His baker and his butiller also,
Wher they ne feltè noon effect in dremes.
Whoso wol seken actes of sondry remes
May rede of dremès many a wonder thyng.

 'Lo, Cresus, which that was of Lydè kyng,
Mette he nat that he sat upon a tree,
Which signified he sholde an hanged bee?

'Lo heere Andromacha, Ectorës wyf,
That day that Ector sholdë lese his lyf,
She dremëd on the samë nyght biforn,
How that the lyf of Ector sholde be lorne,
If thilkë day he wente into bataille;
She warnëd hym, but it myghte nat availle;
He wentë forth to fightë nathëles,
And he was slayn anon of Achilles;
But thilkë tale is al to longe to telle,
And eek it is ny day, I may nat dwelle;
Shortly I seye, as for conclusioun,
That I shal han of this avisioun
Adversitee; and I seye forthermoor,
That I ne telle of laxatyves no stoor,
For they been venymës, I woot it weel;
I hem diffye, I love hem never a deel!
 'Now let us speke of myrthe, and stynte al this;
Madamë Pertëlote, so have I blis,
Of o thyng God hath sent me largë grace;
For whan I se the beautee of youre face,
Ye been so scarlet reed aboute youre eyen,
It maketh al my dredë for to dyen,
For, al-so siker as *In principio,*
Mulier est hominis confusio,—
Madame, the sentence of this Latyn is,
"Womman is mannës joye, and al his blis";
For whan I feele a-nyght your softë syde,
Al be it that I may nat on yow ryde,
For that oure perche is maad so narwe, allas!
I am so ful of joye and of solas,
That I diffyë bothë swevene and dreem':
And with that word he fly doun fro the beem,
For it was day, and eke his hennës alle;
And with a chuk he gan hem for to calle,
For he hadde founde a corn, lay in the yerd.
Rëal he was, he was namoore aferd,
He fethered Pertëlotë twenty tyme,
And trad as oftë, er that it was pryme.
He looketh as it were a grym leoun,
And on his toos he rometh up and doun;
Hym deignëd nat to sette his foot to grounde.
He chukketh whan he hath a corn y-founde,
And to hym rennen thanne his wyvës alle.
Thus roial, as a prince is in an halle,

461

Leve I this Chauntecleer in his pasture,
And after wol I telle his áventure.
　Whan that the monthe in which the world bigan,
That highte March, whan God first maked man,
Was compleet, and [y-] passed were also,
Syn March bigan, thritty dayes and two,
Bifel that Chauntecleer in al his pryde,
His sevene wyves walkynge by his syde,
Caste up his eyen to the brighte sonne
That in the signe of Taurus hadde y-ronne
Twenty degrees and oon, and som-what moore,
And knew by kynde, and by noon oother loore,
That it was pryme, and crew with blisful stevene.
'The sonne,' he seyde, 'is clomben up on hevene
Fourty degrees and oon, and moore y-wis.
Madame Pertelote, my worldes blis,
Herkneth thise blisful briddes how they synge,
And se the fresshe floures how they sprynge;
Ful is myn herte of revel and solas!'
But sodeynly hym fil a sorweful cas;
For ever the latter ende of joy is wo.
God woot that worldly joye is soone ago,
And if a rethor koude faire endite,
He in a cronycle saufly myghte it write,
As for a sovereyn notabilitee.
Now every wys man, lat him herkne me;
This storie is al so trewe, I undertake,
As is the book of Launcelot de Lake,
That wommen holde in ful greet reverence.
Now wol I torne agayn to my sentence.
　A colfox, ful of sly iniquitee,
That in the grove hadde wonned yeres three,
By heigh ymaginacioun forn-cast,
The same nyght thurgh-out the hegges brast
Into the yerd, ther Chauntecleer the faire
Was wont, and eek his wyves, to repaire;
And in a bed of wortes stille he lay,
Til it was passed undren of the day,
Waitynge his tyme on Chauntecleer to falle,
As gladly doon thise homycides alle
That in await liggen to mordre men.
　O false mordrour lurkynge in thy den!
O newe Scariot, newe Genyloun!
False dissymulour, O Greek Synoun,

462

That broghtest Troye al outrely to sorwe!
O Chauntecleer, acursed be that morwe,
That thou into that yerd flaugh fro the bemes!
Thou were ful wel y-warned by thy dremes
That thilke day was perilous to thee;
But what that God forwoot moot nedes bee,
After the opinioun of certein clerkis.
Witnesse on hym that any parfit clerk is,
That in scole is greet altercacioun
In this mateere, and greet disputisoun,
And hath been of an hundred thousand men;
But I ne kan nat bulte it to the bren,
As kan the hooly doctour Augustyn,
Or Boece, or the bisshope Bradwardyn,
Wheither that Goddes worthy forwityng
Streyneth me nedely to doon a thyng,—
Nedely clepe I symple necessitee,—
Or elles if free choys be graunted me
To do that same thyng, or do it noght,
Though God forwoot it er that it was wroght;
Or if his wityng streyneth never a deel,
But by necessitee condicioneel.
I wil nat han to do of swich mateere,
My tale is of a cok, as ye may heere,
That took his conseil of his wyf with sorwe,
To walken in the yerd upon that morwe
That he hadde met that dreem that I yow tolde.
Wommennes conseils been ful ofte colde;
Wommannes conseil broghte us first to wo
And made Adam fro Paradys to go,
Ther as he was ful myrie and wel at ese;
But for I noot to whom it myght displese,
If I conseil of wommen wolde blame,
Passe over, for I seyde it in my game.
Rede auctours where they trete of swich mateere,
And what they seyn of wommen ye may heere;
Thise been the cokkes wordes, and nat myne,
I kan noon harm of no womman divyne!
 Faire in the soond, to bathe hire myrily,
Lith Pertelote, and alle hire sustres by,
Agayn the sonne, and Chauntecleer so free
Soong murier than the mermayde in the see;
For *Phisiologus* seith sikerly,
How that they syngen wel and myrily.

And so bifel that as he cast his eye
Among the wortès, on a boterflye,
He was war of this fox that lay ful lowe.
No-thyng ne liste hym thannè for to crowe,
But cride anon, 'Cok, cok!' and up he sterte,
As man that was affrayèd in his herte,—
For natureelly a beest desireth flee
Fro his contrárie, if he may it see,
Though he never erst hadde seyn it with his eye.
This Chauntècleer, whan he gan hym espye,
He wolde han fled, but that the fox anon
Seyde, 'Gentil sire, allas! wher wol ye gon?
Be ye affrayed of me that am youre freend?
Now, certès, I were worsè than a feend,
If I to yow wolde harm or vileyne.
I am nat come your conseil for tespye,
But trewèly the cause of my comynge
Was oonly for to herkne how that ye synge;
For trewèly, ye have as myrie a stevene
As any aungel hath that is in hevene.
Therwith ye han in musyk moore feelynge
Than hadde Boece, or any that kan synge.
My lord youre fader,—God his soulè blesse!
And eek youre mooder, of hire gentillesse,
Han in myn hous y-been to my greet ese,
And certès, sire, ful fayn wolde I yow plese.
But for men speke of syngyng, I wol seye,—
So moote I broukè wel myne eyen tweye,—
Save yow, I herdè never man so synge
As dide youre fader in the morwenynge.
Certès, it was of herte, al that he song;
And for to make his voys the moorè strong,
He wolde so peyne hym that with bothe his eyen
He mostè wynke, so loude he woldè cryen;
And stonden on his tiptoon therwithal,
And strecchè forth his nekkè, long and smal;
And eek he was of swich discrecioun
That ther nas no man in no regioun
That hym in song or wisedom myghtè passe.
I have wel rad, in "Daun Burnel the Asse,"
Among his vers, how that ther was a cok,
For that a preestès sone yaf hym a knok
Upon his leg, whil he was yong and nyce,
He made hym for to lese his benefice;

464

But certeyn, ther nys no comparisoun
Bitwixe the wisedom and discrecioun
Of youre fader and of his subtiltee.
Now syngeth, sire, for seinte charitee;
Lat se, konne ye youre fader countrefete.'
 This Chauntecleer his wynges gan to bete,
As man that koude his traysoun nat espie,
So was he ravysshed with his flaterie.
 Allas, ye lordes, many a fals flatour
Is in youre courtes, and many a losengeour,
That plesen yow wel moore, by my feith,
Than he that soothfastnesse unto yow seith,—
Redeth Ecclesiaste of flaterye,—
Beth war, ye lordes, of hir trecherye.
 This Chauntecleer stood hye upon his toos
Strecchynge his nekke, and heeld his eyen cloos,
And gan to crowe loude for the nones,
And daun Russell, the fox, stirte up atones,
And by the gargat hente Chauntecleer,
And on his bak toward the wode hym beer;
For yet ne was ther no man that hym sewed.
 O destinee, that mayst nat been eschewed!
Alas, that Chauntecleer fleigh fro the bemes!
Allas, his wyf ne roghte nat of dremes!
And on a Friday fil al this meschaunce.
 O Venus, that art goddesse of plesaunce,
Syn that thy servant was this Chauntecleer,
And in thy servyce dide al his poweer,
Moore for delit than world to multiplye,
Why woltestow suffre hym on thy day to dye?
 O Gaufred, deere maister soverayn,
That, whan thy worthy kyng Richard was slayn
With shot, compleynedest his deeth so soore!
Why ne hadde I now thy sentence, and thy loore,
The Friday for to chide, as diden ye?—
For on a Friday, soothly, slayn was he.
Thanne wolde I shewe yow how that I koude pleyne
For Chauntecleres drede, and for his peyne.
 Certes, swich cry, ne lamentacioun,
Was never of ladyes maad whan Ylioun
Was wonne, and Pirrus with his streite swerd,
Whan he hadde hent kyng Priam by the berd,
And slayn hym,—as seith us *Eneydos,*—
As maden alle the hennes in the clos,

465

Whan they had seyn of Chauntécleer the sighte.
But sovereynly dame Pertéloté shrighte,
Ful louder than dide Hasdrubalés wyf,
Whan that hir housbonde haddé lost his lyf,
And that the Romayns haddé brend Cartage,—
She was so ful of torment and of rage,
That wilfully into the fyr she sterte,
And brende hirselven with a stedefast herte.

O woful hennés, right so criden ye,
As, whan that Nero brendé the citee
Of Romé, cryden senatourés wyves,
For that hir husbondes losten alle hir lyves
Withouten gilt,—this Nero hath hem slayn.
Now wol I torné to my tale agayn.

This sely wydwe, and eek hir doghtrés two,
Herden thise hennés crie and maken wo,
And out at dorés stirten they anon,
And syen the fox toward the grové gon,
And bar upon his bak the cok away,
And cryden, 'Out! harrow! and weyl-away!
Ha! ha! the fox!' and after hym they ran,
And eek with staves many another man;
Ran Colle, oure dogge, and Talbot, and Gerland
And Malkyn, with a dystaf in hir hand;
Ran cow and calf, and eek the verray hogges,
So were they fered for berkynge of the dogges,
And shoutyng of the men and wommen eek;
They ronné so hem thoughte hir herté breek.
They yolléden, as feendés doon in helle;
The dokés cryden, as men wolde hem quelle;
The gees, for feerë, flowen over the trees;
Out of the hyvé cam the swarm of bees;
So hydous was the noys, *a benedicitee!*
Certés, he Jakke Straw, and his meynee,
Ne made never shoutés half so shrille,
Whan that they wolden any Flemyng kille,
As thilké day was maad upon the fox.
Of bras they broghten bemés, and of box,
Of horn, of boon, in whiche they blewe and powped,
And therwithal they skrikéd and they howped,
It seméd as that hevene sholdé falle.

Now, goodé men, I pray yow herkneth alle;
Lo, how Fortuné turneth sodeynly
The hope and pryde eek of hir enemy!

466

This cok, that lay upon the foxes bak,
In al his drede unto the fox he spak,
And seyde, 'Sire, if that I were as ye,
Yet wolde I seyn, as wys God helpė me,
"Turneth agayn, ye proudė cherlės alle!
A verray pestilence upon yow falle;
Now am I come unto the wodės syde,
Maugree youre heed, the cok shal heere abyde;
I wol hym ete in feith, and that anon!"' '
 The fox answerde, 'In feith it shal be don';
And as he spak that word, al sodeynly
This cok brak from his mouth delyverly,
And heighe upon a tree he fleigh anon;
And whan the fox saugh that he was y-gon,—
 'Allas!' quod he, 'O Chauntėcleer, allas!
I have to yow,' quod he, 'y-doon trespas,
In as muche as I makėd yow aferd,
Whan I yow hente and broght out of the yerd;
But, sire, I dide it of no wikke entente.
Com doun, and I shal telle yow what I mente;
I shal seye sooth to yow, God help me so!'
 'Nay thanne,' quod he, 'I shrewe us bothė two,
And first I shrewe myself, bothe blood and bones,
If thou bigyle me any ofter than ones.
Thou shalt na moorė, thurgh thy flaterye,
Do me to synge, and wynkė with myn eye,
For he that wynketh, whan he sholdė see,
Al wilfully, God lat him never thee!'
 'Nay,' quod the fox, 'but God yeve hym meschaunce,
That is so undiscreet of governaunce
That jangleth whan he sholdė holde his pees.'
 Lo, swich it is for to be recchėlees
And necligent, and truste on flaterye.
But ye that holden this tale a folye,—
As of a fox, or of a cok and hen,—
Tȧketh the moralitė, good men;
For Seint Paul seith that al that writen is,
To oure doctrine it is y-write y-wis;
Taketh the fruyt and lat the chaf be stille.
Now, goodė God, if that it be thy wille,
As seith my lord, so make us alle goodė men,
And brynge us to his heighė blisse! *Amen.*

 The Canterbury Tales (c. 1387)

467

The story of the Cock and the Fox, in the Nun's Priest's Tale, is allowed by all judges to be the most admirable fable (in the narration) that ever was written.

CHARLES COWDEN CLARKE
The Riches of Chaucer (1896)

CHARLES DUC D'ORLÉANS

1391 — 1465

RONDEL

Le temps a laissié son manteau
De vent, de froidure et de pluye,
Et s'est vestu de broderye,
De soleil raiant, cler et beau.
Il n'y a beste ne oiseau
Qui en son jargon ne chante ou crye;
Le temps a laissié son manteau.

Rivière, fontaine et ruisseau
Portent en livrée jolye
Goultes d'argent d'orfaverie;
Chascun s'abille de nouveau,
Le temps a laissié son manteau.

SPRING

The year has changed his mantle cold
 Of wind, of rain, of bitter air;
And he goes clad in cloth of gold,
 Of laughing suns and season fair;
No bird or beast of wood or wold
 But doth with cry or song declare
The year lays down his mantle cold.
All founts, all rivers, seaward rolled,
 The pleasant summer livery wear,
 With silver studs on broidered vair;
The world puts off its raiment old,
The year lays down his mantle cold.

Translated by Andrew Lang

For the exquisite rondel form, we must look for nearly all the master-pieces in the work of Prince Charles d'Orléans.

THÉODORE DE BANVILLE
Petit Traité de poésie française (1871)

ANONYMOUS

FOURTEENTH CENTURY

LANGUAGE OF THE LAW

An heir in tail rebutted from his formedon by a lineal warranty with descended assets.

It is forgotten that during the later middle age English lawyers enjoyed the inestimable advantage of being able to make a technical language. And a highly technical language they made.... Precise ideas are here expressed in precise terms, every one of which is French: the geometer or the chemist could hardly wish for terms that are more exact or less liable to have their edges worn away by the vulgar.

F. W. MAITLAND
Year Books of Edward II (1903)

FRANÇOIS VILLON

1 4 J 1 – A F T. 1 4 6 3

BALLADE DES DAMES DU TEMPS JADIS

Dictes-moy où, n'en quel pays,
Est Flora, la belle Romaine;
Archipiada, ne Thaïs,
Qui fut sa cousine germaine;
Echo, parlant quand bruyt on maine
Dessus rivière ou sus estan,
Qui beauté eut trop plus qu'humaine?
Mais où sont les neiges d'antan!

469

Où est la très sage Heloïs,
Pour qui fut chastré et puis moyne
Pierre Esbaillart à Sainct-Denys?
Pour son amour eut cest essoyne
Semblablement, où est la royne
Qui commanda que Buridan
Fust jetté en ung sac en Seine?
Mais où sont les neiges d'antan!

La royne Blanche comme ung lys.
Qui chantoit à voix de sereine,
Berthe au grand pied, Bietris, Allys;
Harembourges, qui tient le Mayne,
Et Jehanne, la bonne Lorraine,
Qu'Anglois bruslèrent à Rouen;
Où sont-ils, Vierge souveraine? . .
Mais où sont les neiges d'antan!

Envoi

Prince, n'enquerez de sepmaine
Où elles sont, ne de cest an,
Que ce refrain ne vous remaine:
Mais où sont les neiges d'antan!

THE BALLAD OF DEAD LADIES

Tell me now in what hidden way is
 Lady Flora the lovely Roman?
Where's Hipparchia, and where is Thais,
 Neither of them the fairer woman?
 Where is Echo, beheld of no man,
Only heard on river and mere,—
 She whose beauty was more than human? . . .
But where are the snows of yester-year?

Where's Héloïse, the learned nun,
 For whose sake Abeillard, I ween,
Lost manhood and put priesthood on?
 (From Love he won such dule and teen!)
 And where, I pray you, is the Queen
Who willed that Buridan should steer
 Sewed in a sack's mouth down the Seine? . . .
But where are the snows of yester-year?

470

White Queen Blanche, like a queen of lilies,
 With a voice like any mermaiden,—
Bertha Broadfoot, Beatrice, Alice,
 And Ermengarde the lady of Maine,—
 And that good Joan whom Englishmen
At Rouen doomed and burned her there,—
 Mother of God, where are they then? . . .
But where are the snows of yester-year?

Nay, never ask this week, fair lord,
 Where they are gone, nor yet this year,
Save with this for an overword,—
 But where are the snows of yester-year?

<div align="right">

Le Grand Testament (1461)
Translated by Dante Gabriel Rossetti

</div>

One of the master-songs of the world, with its gentle rhymes in -is *and* -aine, *the exquisite ache of its music, caressing and soothing to dreams, and its lovely refrain. Its melancholy inquiry and evocation and its concern with Death are common to large masses of medieval poetry: but it is incomparable.*

<div align="right">

D. B. WYNDHAM LEWIS
François Villon (1928)

</div>

FRANÇOIS VILLON

1 4 3 1 — A F T. 1 4 6 3

BALLADE

Que Villon feit a la requeste de sa mère,
pour prier Nostre Dame

Dame du ciel, regente terrienne,
Emperière des infernaulx palux,
Recevez-moy, vostre humble chrestienne,
Que comprinse soye entre voz esleuz,
Ce non obstant qu'oncques rien ne valuz.
Les biens de vous, ma dame et ma maistresse,
Sont trop plus grans que ne suis pecheresse,
Sans lesquelz biens ame ne peult merir
N'avoir les cieulx, je n'en suis jengleresse.
En ceste foy je vueil vivre et mourir.

A vostre Filz dictes que je suis sienne;
Que de luy soyent mes pechez aboluz:
Pardonnés moi comme à l'Egyptienne,
Ou comme il feit au clerc Theophilus,
Lequel par vous fut quitte et absoluz,
Combien qu'il eust au diable faict promesse.
Preservez-moy, que point je ne face ce;
Vierge portant sans rompure encourir
Le sacrement qu'on celebre à la messe.
En ceste foy je vueil vivre et mourir.

Femme je suis povrette et ancienne,
Ne riens ne sçay; oncques lettre ne leuz,
Au monstier voy dont suis parroissienne
Paradis painct, où sont harpes et luz,
Et ung enfer où damnez sont boulluz:
L'ung me faict paour, l'autre joye et liesse.
La joye avoir fais-moy, haulte Deesse,
A qui pecheurs doivent tous recourir,
Comblez de foy, sans faincte ne paresse.
En ceste foy je vueil vivre et mourir.

Envoi

Vous portastes, Vierge, digne princesse,
JESUS regnant, qui n'a ne fin ne cesse.
Le Tout-Puissant, prenant nostre foiblesse,
Laissa les cieulx et nous vint secourir;
Offrist à mort sa très clère jeunese;
Nostre Seigneur tel est, tel le confesse,
En ceste foy je vueil vivre et mourir.

BALLAD

That Villon made at the Request of His Mother,
Wherewithal to do Her Homage to Our Lady

Lady of Heaven, Regent of the earth,
 Empress of all the infernal marshes fell,
Receive me, Thy poor Christian, 'spite my dearth,
 In the fair midst of Thine elect to dwell:
 Albeit my lack of grace I know full well;
For that Thy grace, my Lady and my Queen,
Aboundeth more than all my misdemean,
 Withouten which no soul of all that sigh

May merit Heaven. 'Tis sooth I say, for e'en
 In this belief I will to live and die.

Say to Thy Son I am His,—that by His birth
 And death my sins be all redeemable,—
As Mary of Egypt's dole He changed to mirth
 And eke Theophilus', to whom befell
 Quittance of Thee, albeit (So men tell)
To the foul fiend he had contracted been.
Assoilzie me, that I may have no teen,
 Maid, that without breach of virginity
Didst bear our Lord that in the Host is seen.
 In this belief I will to live and die.

A poor old wife I am, and little worth:
 Nothing I know, nor letter aye could spell:
Where in the church to worship I fare forth,
 I see Heaven limned, with harps and lutes, and Hell,
 Where damned folk seethe in fire unquenchable.
One doth me fear, the other joy serene:
Grant I may have the joy, O Virgin clean,
 To whom all sinners lift their hands on high,
Made whole in faith through Thee their go-between.
 In this belief I will to live and die.

Envoi

Thou didst conceive, Princess most bright of sheen,
Jesus the Lord, that hath nor end nor mean,
Almighty, that, departing Heaven's demesne
 To succour us, put on our frailty,
Offering to death His sweet of youth and green:
Such as He is, our Lord He is, I ween!
 In this belief I will to live and die.

<div align="right">Le Grand Testament (1461)

Translated by John Payne</div>

One of the masterpieces of the world.

<div align="right">HILAIRE BELLOC

Avril (1904)</div>

The verses of the third stanza are among the finest in the language.

<div align="right">FERDINAND BRUNETIÈRE

Nouvelles Questions de critique (1898)</div>

FRANÇOIS VILLON

1 4 3 1 — A F T. 1 4 6 3

CHRISTMAS TIME

En ce temps que j'ay dit devant,
Sur le Noël, morte saison,
Lorsque les loups vivent de vent,
Et qu'on se tient en sa maison,
Pour le frimas, près du tison.

In this year, as before I said,
 Hard by the dead of Christmas-time,
When upon wind the wolves are fed,
 And for the rigour of the rime
One hugs the hearth from none to prime.

<div align="right">

Le Petit Testament (1456)
Translated by John Payne

</div>

L'ÉPITAPHE EN FORME DE BALLADE

*Que feit Villon pour luy et ses compagnons,
s'attendant estre pendu avec eulx.*

Frères humains, qui après nous vivez,
N'ayez les cueurs contre nous endurciz,
Car, si pitié de nous pouvres avez,
Dieu en aura plustost de vous merciz.
Vous nous voyez cy attachez cinq, six:
Quant de la chair, que trop avons nourrie,
Elle est piéça devorée et pourrie,
Et nous, les os, devenons cendre et pouldre.
De nostre mal personne ne s'en rie,
Mais priez Dieu que tous nous vueille absouldre!

Se vous clamons, frères, pas n'en devez
Avoir desdaing, quoyque fusmes occis
Par justice. Toutesfois, vous sçavez
Que tous les hommes n'ont pas bon sens assis;
Intercedez doncques, de cueur rassis,
Envers le Filz de la Vierge Marie,
Que sa grace ne soit pour nous tarie,

Nous preservant de l'infernale fouldre.
Nous sommes mors, ame ne nous harie;
Mais priez Dieu que tous nous vueille absouldre!

La pluye nous a debuez et lavez,
Et le soleil dessechez et noirciz;
Pies, corbeaulx, nous ont les yeux cavez,
Et arrachez la barbe et les sourcilz.
Jamais, nul temps, nous se sommes rassis;
Puis çà, puis là, comme le vent varie,
A son plaisir sans cesser nous charie,
Plus becquetez d'oyseaulx que dez à couldre.
Ne soyez donc de nostre confrairie,
Mais priez Dieu que tous nous vueille absouldre!

Envoi

Prince JESUS, qui sur tous seigneurie,
Garde qu'Enfer n'ayt de nous la maistrie:
A luy n'ayons que faire ne que souldre.
Hommes, icy n'usez de mocquerie
Mais priez Dieu que tous nous vueille absouldre!

THE EPITAPH IN FORM OF A BALLAD

*Which Villon made for himself and his comrades
expecting to be hanged along with them.*

Men, brother men, that after us yet live,
 Let not your hearts too hard against us be;
For if some pity of us poor men ye give,
 The sooner God shall take of you pity.
 Here are we five or six strung up, you see,
And here the flesh that all too well we fed
Bit by bit eaten and rotten, rent and shred,
 And we the bones grow dust and ash withal;
Let no man laugh at us discomforted,
 But pray to God that he forgive us all.

If we call on you, brothers, to forgive,
 Ye should not hold our prayer in scorn, though we
Were slain by law; ye know that all alive
 Have not wit alway to walk righteously;
 Make therefore intercession heartily

With him that of a virgin's womb was bred,
That his grace be not as a dry well-head
 For us, nor let hell's thunder on us fall;
We are dead, let no man harry or vex us dead,
 But pray to God that he forgive us all.

The rain has washed and laundered us all five,
 And the sun dried and blackened; yea, perdie,
Ravens and pies with beaks that rend and rive
 Have dug our eyes out, and plucked off for fee
 Our beards and eyebrows; never are we free,
Not once, to rest; but here and there still sped,
Drive at its wild will by the wind's change led,
 More pecked of birds than fruits on garden-wall;
Men, for God's love, let no gibe here be said,
 But pray to God that he forgive us all.

Prince Jesus, that of all art lord and head,
Keep us, that hell be not our bitter bed;
 We have nought to do in such a master's hall.
Be not ye therefore of our fellowhead,
 But pray to God that he forgive us all.

Translated by Algernon Charles Swinburne

It is possible to say of Villon that he created French poetry, and that at the same time he lead it to one of its purest and most glorious summits.

THIERRY MAULNIER
Introduction à la poésie française (1939)

PHILIPPE DE COMINES

1 4 4 7 ? — 1 5 1 1 ?

THE DEATH OF ILLUSTRIOUS MEN

Or voyez-vous la mort de tant de grands hommes, en si peu de temps, qui tant ont travaillé pour s'accroistre, et pour avoir gloire, et tant en ont souffert de passion et de peines, et abrégé leur vie; et par adventure leurs ames en pourront souffrir. En ceci ne parle point dudit Turc; car je tiens ce poinct pour vuidé, et qu'il est logé avec ses prédécesseurs. De nostre roy j'ay espérance (comme j'ay dit) que nostre Seigneur ait eu miséricorde de luy et aussi aura-il des autres, s'il luy plaist. Mais à parler naturellement (comme homme qui n'a aucune littérature, mais quelque peu d'expérience et sens naturel) n'eust-il point mieux valu à

eux, et à tous autres princes, et hommes de moyen estat, qui ont vescu soubs ces grands, et vivront soubs ceux qui régnent, eslir le moyen chemin en ces choses. C'est à sçavoir moins se soucier, et moins se travailler, et entreprendre moins de choses, et plus craindre à offenser Dieu, et à persécuter le peuple, et leurs voisins, et par tant de voies cruelles que j'ay assez déclarées par cydevant, et prendre des aises et plaisirs honnestes? Leurs vies en seroient plus longues. Les maladies en viendroient plus tard, et leur mort en seroit plus regrettée, et de plus de gens, et moins désirée; et auroient moins à douter la mort. Pourroit-l'on voir de plus beaux exemples pour connoistre que c'est peu de choses que de l'homme, et que cette vie est misérable et briefve, et que ce n'est riens des grands; et qu'incontinent qu'ils sont morts, tout homme en a le corps en horreur et vitupère? et qu'il faut que l'ame sur l'heure se sépare d'eux et qu'elle aille recevoir son jugement? Et à la vérité, en l'instant que l'ame est séparée du corps, jà la sentence en est donnée de Dieu, selon les œuvres et mérites du corps, laquelle sentence s'appelle le jugement particulier.

Thus have you seen the death of many illustrious persons in a short time, who had borne so much sorrow, and endured so many fatigues, only to extend their dominions, and advance their fame and glory, as perhaps tended not only to the shortening of their lives, but to the endangering the welfare of their immortal souls. I am not speaking here of the Turk, for I question not but that he is gone to his predecessors, but of our king and the rest, on whom I hope God will have mercy. But to speak freely (as one that is no great scholar or genius, but has had some experience in the world), would it not have been better for them, and for all other great princes and subjects whatever, to choose a middle course in all their desires; that is, not to be so solicitous and careful about temporal things, and have such vast and unreasonable designs in view; but to be more cautious of offending God, oppressing their subjects, and invading their neighbours, by so many cruel and unchristian ways, as I have mentioned before, and rather employ their time in tranquillity and innocent diversions? Their lives would be longer, their infirmities the later in coming, their deaths less desirable to other people, and less terrible to themselves. Can we desire any clearer examples to prove how poor and inconsiderable a creature man is, how short and miserable his life, and how little difference there is betwixt princes and private persons, since as soon as they are dead, whether rich or poor, their bodies become abominable, all people fly and shun them, and their souls are no sooner separated but they prepare to receive their doom, which is given by God at that very instant of time, according to every man's works, and bodily deserts.

<div align="right">Mémoires (1488–1501) vi, 12

Translated by Andrew R. Scoble</div>

No historian voices more vividly than he the profound realization of the misery of the great, the kings, the powerful and the fortunate of the world.

C.-A. SAINTE-BEUVE
Causeries du lundi (1850)

SIR THOMAS MALORY

FL. 1470

HOW SIR LAUNCELOT DEPARTED TO SEEK THE QUEEN GUENEVER

Than came syr Bors de ganys and sayd my lord syr Launcelot what thynke ye for to doo now to ryde in this royame wyt you wel ye shal fynde fewe frendes be as be may sayd Syr Launcelot kepe you stylle here for I wyl forth on my Iourney and noo man nor chylde shall goo with me. So it was no bote to stryue but he departed and rode westerly & there he sought a vij or viij dayes & atte last he cam to a nonnerye & than was quene Gueneuer ware of sir Launcelot as he walked in the cloystre & whan she sawe hym there she swouned thryse that al the ladyes & Ientyl wymmen had werke ynough to holde the quene vp. So whan she myght speke she callyd ladyes & Ientyl wymmen to hir & sayd ye meruayl fayr ladyes why I make this fare. Truly she said it is for the syght of yonder knyght that yender standeth. Wherfore I praye you al calle hym to me whan syr Launcelot was brought to hyr. Than she sayd to al the ladyes thorowe this man & me hath al this warre be wrought & the deth of the moost noblest knyghtes of the world for thorugh our loue that we haue loued to gyder is my moost noble lord slayn. Therfor syr Launcelot wyt thou wel I am sette in suche a plyte to gete my soule hele & yet I truste thorugh goddes grace that after my deth to haue a syght of the blessyd face of cryst and at domes day to sytte on his ryght syde for as synful as euer I was are sayntes in heuen therfore syr Launcelot I requyre the & beseche the hertelye for al the loue that euer was be-twyxte vs that thou neuer see me more in the vysage & I comande the on goddes behalfe that thou forsake my companye & to thy kyngdom thou torne ageyn & kepe wel thy royame from warre & wrake for as wel as I haue loued the myn hert wyl not serue me to see the for thorugh the & me is the flour of kynges & knyghtes destroyed therfor sir Launcelot goo to thy royame & there take the a wyf & lyue with hir with Ioye & blysse & I praye the hertelye praye for me to our lord that I may amende my

myslyuyng. Now swete madam sayd syr Launcelot wold ye that I shold torne ageyn vnto my cuntreye & there to wedde a lady. Nay Madam wyt you wel that shal I neuer do for I shal neuer be soo fals to you of that I haue promysed but the same deystenye that ye haue taken you to I wyl take me vnto for to plese Ihesu & euer for you I cast me specially to praye. Ys thou wylt do so sayd the quene holde thy promyse but I may neuer byleue but that thou wylt torne to the world ageyn wel madam sayd he ye say as pleseth you yet wyst you me neuer fals of my promesse & god defende but I shold forsake the world as ye haue do for in the quest of the sank greal I had fosaken the vanytees of the world had not your lord ben. And ys I had done so at that tyme wyth my herte wylle and thought I had passed al the knyghtes that were in the sanke greal excepte syr Galahad my sone and therfore lady sythen ye haue taken you to perfeccion I must nedys take me to perfection of ryght for I take recorde of god in you I haue had myn erthly Ioye and ys I had founden you now so dysposed I had caste me to haue had you in to myn owne royame.

<div align="right">Le Morte Darthur (1485), xxi</div>

Malory's language and style exactly suit his subject. In no work is there a perfecter harmony—a more sympathetic marriage—of this kind. This chronicler of knighthood is himself a knight. His heart is devoted to the chivalry he portrays, and his tongue is the faithful spokesman of his heart.

<div align="right">JOHN W. HALES
in Craik's English Prose (1893)</div>

LODOVICO ARIOSTO

1 4 7 4 — 1 5 3 3

THE ROSE

Simile alla rosa
che nun chiuso horto in la natiua spina
mentre sola e sicura si riposa
ne gregge ne pastor se le auicina
l aura soaue, e l alba rugiadosa,
l acqua, la terra al suo fauor s inchina
gioueni uaghi e dōne inamorate
amano hauerne, e seni, e tempie ornate

<div align="center">479</div>

Ma non si tosto dal materno stelo
rimossa uiene, e dal suo ceppo uerde,
ch el fauor e de li huomini e del Cielo
e de l Elementi e di Natura perde.

Like the blooming rose
Which on its native stem unsully'd grows;
Where fencing walls the garden-space surround,
Nor swains, nor browzing cattle tread the ground:
The earth and streams their mutual tribute lend,
Soft breathe the gales, the pearly dews descend:
Fair youths and amorous maidens with delight
Enjoy the grateful scent, and bless the sight.
But if some hand the tender stalk invades,
Lost is its beauty and its colour fades:
No more the care of heaven, or garden's boast,
And all its praise with youths and maidens lost.

<div align="right">

Orlando Furioso (1516), i
Translated by John Hoole

</div>

*Never once does the poet let his own personality come into the story;
he is more a spectator than an actor—a spectator who is enjoying himself
looking on at his world, almost as though it were not his own creation,
the child of his own imagination. The result is the perfect objectivity and
lucidity that are known as "Homeric clearness." In this simplicity and
clearness of Ariosto Italian art touches perfection; simplicity and clearness
are the two qualities that make him the prince of Italian artists—of
artists, not of poets. Ariosto cares nothing at all for the things themselves,
which are detached from reality and a game of the imagination, but he
cares immensely for their form, and at this he toils with the greatest
seriousness. No smallest detail escapes his attention, or is left without
its finishing touches. And the interest being not in the thing but in its
form, we no longer have the sober and comprehensive manner of Dante:
instead of the Dantesque sketches we have finished pictures. The
DECAMERON gave us the period; the ORLANDO gives us the octave, with
a perfect framework, and composed like a picture, with its protagonist,
its accessories, and its background. Politian gave us a series, with the
links left to the imagination. Ariosto gives us a real period, so well distributed
and proportioned that it seems like a person. And the effect is
due not only to the material framework, so solid and well composed,
but also to that musical wave, to that flowing and facile surface which
makes us reach forward to the soul while we are following the events
and the motives and effects. In that century of great painters, when the
Italian artists aimed at depicting the image with the last possible touch*

*of perfection, Ariosto is the perfect painter. . . . This sublime sim-
plicity combined with complete clearness of vision, is what Galilei rightly
described as the "divineness" of Ariosto.*

Storia della letteratura italiana (1870)
Translated by Joan Redfern

LODOVICO ARIOSTO

1 4 7 4 — 1 5 3 3

HER MATCHLESS PERSON

Di persona era tanto ben formata
 quanto me pinger san pittori industri
 cō bionda chioma lunga, et annodata
 oro nō é che piú risplenda, et lustri
 spargeasi per la guancia delicata
 misto color di rose et di ligustri
 di terso Auorio, era la fronte lieta
 che finia il spatio suo, con giusta meta

Sotto duo negri, et sottilissimi archi
 son duo negri occhi, āzi duo chiari soli
 pietosi a riguardar a muouer parchi
 ītorno cui par ch Amor scherzi et uoli
 et ch indi tutta la pharetra scarchi
 et che uisibilmente i cori inuoli
 quindi il naso per mezo il uiso scende
 che non ritroua Inuidia oue l emende.

Her matchless person every charm combin'd,
Form'd in th' idea of a painter's mind.
Bound in a knot behind, her ringlets roll'd
Down her soft neck, and seem'd like waving gold.
Her cheeks with lilies mix the blushing rose;
Her forehead high like polish'd iv'ry shows.
Beneath two arching brows with splendor shone
Her sparkling eyes, each eye a radiant sun!
Here artful glances, winning looks appear,
And wanton Cupid lies in ambush here:

481

'Tis hence he bends his bow, he points his dart,
'Tis hence he steals th' unwary gazer's heart.
Her nose so truly shap'd, the faultless frame
Not envy can deface, nor art can blame.

<div align="right">

Orlando Furioso (1516), vii
Translated by John Hoole

</div>

*If painters wish to find easily a perfect example of the beautiful woman,
let them read those stanzas of Ariosto in which he describes marvel-
lously the beauties of the enchantress Alcina, and they will see likewise
to what extent excellent poets are themselves painters.*

<div align="right">

L O D O V I C O D O L C E
L'Aretino. Dialogo della pittura (1557)

</div>

MARTIN LUTHER

1 4 8 3 — 1 5 4 6

DOMESTICITY

Ach solt ich das kind wiegen, die windell wasschen, bette machen,
stanck riechen, die nacht wachen, seyns schreiens wartten, seyn grindt
und blattern heylen, darnach des weybs pflegen, sie erneeren, erbeytten,
hie sorgen, da sorgen, hie thun, da thun, das leyden und diss leyden?

Oh, should I nurse the child, wash the diapers, make the beds, smell
the stench, remain awake through the night, wait for it to cry, heal its
scurf and pimples, afterwards take care of the wife, feed her, work, care
for this, care for that, do this, do that, suffer this and suffer that?

<div align="right">

Predigt vom ehelichen Leben (1522)

</div>

*We are not surprised to find in Luther (notoriously a musical man) a rich
crop of every kind of vocalic and consonantal assonance. To turn from
pre-Lutheran German prose to Luther is, in this respect as well, to pass
from medieval night to Renaissance day, as even cursory comparison
of Luther with his forerunners will show. . . . We may cite a familiar
passage from* VOM EHELICHEN LEBEN *that is perhaps the supreme ex-
ample of this type of almost musical prose. . . . The perfection of this
piece of early German prose is such that one does not immediately
realize how it* MIGHT *have sounded. Something is undoubtedly due to*

the occasional omission of the definite article; compare for sound 'das kind wiegen, den stanck riechen, die windell wasschen, das bett machen, die nacht wachen' with Luther's arrangement. Or read the last dozen words with DISS *and* DAS *transposed. It is not, of course, suggested that Luther deliberately selected or shaped his phrases; the assumption is merely that here a naturally associative mind has dictated words and clauses linked to one another by their sound.*

<div align="right">WALTER ETTINGHAUSEN</div>

<div align="center">in German Studies Presented to H. G. Fiedler (1938)</div>

FRANÇOIS RABELAIS

1 4 9 0 ? — 1 5 5 3

THE MOST HORRIBLE SPECTACLE

Il chocqua doncques si roydement sus eulx, sans dyre guare, qu'il les renversoyt comme porcs, frapant à tors et à travers à vieille escrime.

Es uns escarbouilloyt la cervelle, ès aultres rompoyt bras et jambes, ès aultres deslochoyt les spondyles du coul, ès aultres demoulloyt les reins, avalloyt le nez, poschoyt les yeulx, fendoyt les mandibules, enfonçoyt les dens en la gueule, descroulloyt les omoplates, sphaceloyt les greves, desgondoit les ischies, debezilloit les faucilles.

Si quelq'un se vouloyt cascher entre les sepes plus espès, à icelluy freussoit toute l'areste du douz et l'esrenoit comme un chien.

Si aulcun saulver se vouloyt en fuyant, à icelluy faisoyt voler la teste en pieces par la commissure lambdoïde.

Sy quelq'un gravoyt en une arbre, pensant y estre en seureté, icelluy de son baston empaloyt par le fondement.

Si quelq'un de sa vieille congnoissance luy crioyt:

"Ha, Frere Jean, mon amy, Frere Jean, je me rend!

— Il t'est (disoyt il) bien force; mais ensemble tu rendras l'ame à tous les diables."

Et soubdain luy donnoit dronos. Et, si personne tant feust esprins de temerité qu'il luy voulust resister en face, là monstroyt il la force de ses muscles, car il leurs transperçoyt la poictrine par le mediastine et par le cueur. A d'aultres donnant suz la faulte des coustes, leur subvertissoyt l'estomach, et mouroient soubdainement. Es aultres tant fierement frappoyt par le nombril qu'il leurs faisoyt sortir les tripes. Es aultres parmy les couillons persoyt le boiau cullier. Croiez que c'estoyt le plus horrible spectacle qu'on veit oncques.

He hurried therefore upon them so rudely, without crying gare or beware, that he overthrew them like hogs, tumbled them over like swine, striking athwart and alongst, and by one means or other laid so about him, after the old fashion of fencing, that to some he beat out their braines, to others he crushed their armes, battered their legs, and bethwacked their sides till their ribs cracked with it; to others again he unjoynted the spondyles or knuckles of the neck, disfigured their chaps, gashed their faces, made their cheeks hang flapping on their chin, and so swinged and belammed them, that they fell down before him like hay before a Mower: to some others he spoiled the frame of their kidneys, marred their backs, broke their thigh-bones, pash't in their noses, poached out their eyes, cleft their mandibules, tore their jaws, dung in their teeth into their throat, shook asunder their omo-plates or shoulder-blades, sphacelated their shins, mortified their shanks, inflamed their ankles, heaved off of the hinges their ishies, their sciatica or hip-gout, dislocated the joints of their knees, squattered into pieces the boughts or pestles of their thighs, and so thumped, mawled and be-laboured them every where, that never was corne so thick and threefold thresht upon by Plowmens flailes, as were the pitifully disjoynted mem-bers of their mangled bodies, under the mercilesse baton of the crosse. If any offered to hide himself amongst the thickest of the Vines, he laid him squat as a flounder, bruised the ridge of his back, and dash't his reines like a dog. If any thought by flight to escape, he made his head to flie in pieces by the Lambdoidal commissure, which is a seame in the hinder part of the scull. If any one did scramble up into a tree, thinking there to be safe, he rent up his perinee, and impaled him in at the funda-ment. If any of his old acquaintance happened to cry out, Ha Fryar Jhon my friend, Fryar Jhon, quarter, quarter, I yield my self to you, to you I render my self: So thou shalt (said he,) and must whether thou wouldst or no, and withal render and yield up thy soul to all the devils in hell, then suddenly gave them dronos, that is, so many knocks, thumps, raps, dints, thwacks and bangs, as sufficed to warne Pluto of their coming, and dispatch them a going: if any was so rash and full of temerity as to resist him to his face, then was it he did shew the strength of his muscles, for without more ado he did transpierce him by running him in at the breast, through the mediastine and the heart. Others, again, he so quashed and bebumped, that with a sound bounce under the hollow of their short ribs, he overturned their stomachs so that they died immedi-ately: to some with a smart souse on the Epigaster, he would make their midrif swag, then redoubling the blow, gave them such a home-push on the navel, that he made their puddings to gush out. To others through their ballocks he pierced their bum-gut, and left not bowel, tripe nor intral in their body, that had not felt the impetuosity, fiercenesse and fury of his violence. Beleeve that it was the most horrible spectacle that ever one saw.

Les fouaces destroussées, comparurent davant Picrochole les duc de Menuail, comte Spadassin et capitaine Merdaille, et luy dirent:

"Cyre, aujourd'huy nous vous rendons le plus heureux, plus chevaleureux prince qui oncques feust depuis la mort de Alexandre Macedo.

— Couvrez, couvrez vous, dist Picrochole.

— Grand mercy (dirent ilz), Cyre, nous sommes à nostre debvoir. Le moyen est tel:

"Vous laisserez icy quelque capitaine en garnison avec petite bande de gens pour garder la place, laquelle nous semble assez forte, tant par nature que par les rampars faictz à vostre invention. Vostre armée partirez en deux, comme trop mieulx l'entendez. L'une partie ira ruer sur ce Grandgousier et ses gens. Par icelle sera de prime abordée facilement desconfit. Là recouvrerez argent à tas, car le vilain en a du content; vilain, disons nous, parce que un noble prince n'a jamais un sou. Thesaurizer est faict de vilain.— L'aultre partie, cependent, tirera vers Onys, Sanctonge, Angomoys et Gascoigne, ensemble Perigot, Medoc et Elanes. Sans resistence prendront villes, chasteaux et forteresses. A Bayonne, à Sainct Jean de Luc et Fontarabie saysirez toutes les naufs, et, coustoyant vers Galice et Portugal, pillerez tous les lieux maritimes jusques à Ulisbonne, où aurez renfort de tout equipage requis à un conquerent. Par le corbieu, Hespaigne se rendra, car ce ne sont que madourrez! Vous passerez par l'estroict de Sibyle, et là erigerez deux colomnes, plus magnificques que celles de Hercules, à perpetuelle memoire de vostre nom, et sera nommé cestuy destroict la mer Picrocholine. . . .

— Mais (dist il) que faict ce pendent la part de nostre armée qui desconfit ce villain humeux Grandgousier?

— Ilz ne chomment pas (dirent ilz); nous les rencontrerons tantost. Ilz vous ont pris Bretaigne, Normandie, Flandres, Haynault, Brabant, Artoys, Hollande, Selande. Ilz ont passé le Rhein par sus le ventre des Suices et Lansquenetz, et part d'entre eulx ont dompté Luxembourg, Lorraine, La Champaigne, Savoye jusques à Lyon, auquel lieu ont trouvé voz garnisons retournans des conquestes navales de la mer Mediterrannée, et se sont reassemblez en Boheme, après avoir mis à sac Soueve, Vuitemberg, Bavieres, Austriche, Moravie et Stirie; puis ont donné fierement ensemble sus Lubek, Norwerge, Swedenrich, Dace, Gotthie, Engroneland, les Estrelins, jusques à la mer Glaciale. Ce faict, conquesterent les isles Orchades et subjuguerent Escosse, Angleterre et Irlande. . . .

Là present estoit un vieux gentilhomme, esprouvé en divers hazars et vray routier de guerre, nommé Echephron, lequel, ouyant ces propous, dist:

"J'ay grand peur que toute ceste entreprinse sera semblable à la farce du pot au laict, duquel un cordouannier se faisoit riche par resverie; puis, le pot cassé, n'eut de quoy disner. Que pretendez vous par ces belles conquestes? Quelle sera la fin de tant de travaulx et traverses?

— Ce sera (dist Picrochole) que, nous retournez, repouserons à noz aises."

Dont dist Echephron:

"Et, si par cas jamais n'en retournez, car le voyage est long et pereil-leux, n'est ce mieulx que dès maintenant nous repousons, sans nous mettre en ces hazars?

— O (dist Spadassin) par Dieu, voicy un bon resveux! Mais allons nous cacher au coing de la cheminée, et là passons avec les dames nostre vie et nostre temps à enfiller des perles, ou à filler comme Sardanapalus. Qui ne se adventure, n'a cheval ny mule, ce dist Salomon.

— Qui trop (dist Echephron) se adventure perd cheval et mule, respondit Malcon.

— Baste! (dist Picrochole) passons oultre. Je ne crains que ces diables de legions de Grandgousier. Ce pendent que nous sommes en Meso-potamie, s'ilz nous donnoient sus la queue, quel remede?"

The carts being unloaded, and the money and cakes secured, there came before Picrochole the Duke of Smalltrash, the Earle Swash-buckler, and Captain Durtaille, who said unto him, Sir, this day we make you the happiest, the most warlike and chivalrous Prince that ever was since the death of Alexander of Macedonia. Be covered, be covered, (said Pichrochole.) Grammercie (said they) we do but our duty: The manner is thus, you shall leave some Captain here to have the charge of this Garrison, with a Party competent for keeping of the place, which besides its natural strength, is made stronger by the rampiers and fortresses of your devising. Your Army you are to divide into two parts, as you know very well how to do. One part thereof shall fall upon Grangousier and his forces, by it shall he be easily at the very first shock routed, and then shall you get money by heaps, for the Clown hath store of ready coine: Clown we call him, because a noble and generous Prince hath never a penny, and that to hoard up treasure is but a clownish trick. The other part of the Army in the mean time shall draw towards Onys, Xaintonge, Angoulesme and Gascony: then march to Perigourt, Medos, and Elanes, taking whereever you come without resistance, townes, castles, and forts: Afterwards to Bayonne, St. Jhon de Luz, to Fuentarabia, where you shall seize upon all the ships, and coasting along Galicia and Portugal, shall pillage all the maritime places, even unto Lisbone, where you shall be supplied with all necessaries befitting a Conquerour. By copsodie Spain will yield, for they are but a race of Loobies: then are

486

you to passe by the streights of Gibraltar, where you shall erect two pillars more stately than those of Hercules, to the perpetual memory of your name, and the narrow entrance there shall be called the Picrocholinal sea. . . .

But (said he) what doth that part of our Army in the mean time, which overthrows that unworthy Swill-pot Grangousier? They are not idle (said they) we shall meet with them by and by, they shall have won you Britany, Normandy, Flanders, Haynault, Brabant, Artois, Holland, Zealand; they have past the Rhine over the bellies of the Switsers and Lanskenets, and a Party of these hath subdued Luxemburg, Lorrain, Champaigne, and Savoy, even to Lions, in which place they have met with your forces, returning from the naval Conquests of the Mediterranean sea: and have rallied again in Bohemia, after they had plundered and sacked Suevia, Wittemberg, Bavaria, Austria, Moravia, and Styria. Then they set fiercely together upon Lubeck, Norway, Swedeland, Rie, Denmark, Gitland, Greenland, the Sterlins, even unto the frozen sea: this done, they conquered the iles of Orkney, and subdued Scotland, England, and Ireland. . . . There was there present at that time an old Gentleman well experienced in the warres, a sterne souldier, and who had been in many great hazards, named Echephron, who hearing this discourse, said, I do greatly doubt that all this enterprise will be like the tale or interlude of the pitcher full of milk, wherewith a Shoemaker made himself rich in conceit: but, when the pitcher was broken, he had not whereupon to dine: what do you pretend by these large Conquests? what shall be the end of so many labours and crosses? Thus it shall be (said Picrochole) that when we are returned, we shall sit down, rest and be merry. But (said Echephron,) if by chance you should never come back, for the voyage is long and dangerous, were it not better for us to take our rest now, then unnecessarily to expose our selves to so many dangers? O (said Swashbuckler,) by G——, here is a good dotard, come, let us go hide our selves in the corner of a chimney, and there spend the whole time of our life amongst ladies, in threading of pearles, or spinning like Sardanapalus: He that nothing ventures, hath neither horse nor mule, (sayes Solomon). He who adventureth too much (said Echephron) loseth both horse and mule, answered Malchon. Enough (said Picrochole,) go forward: I feare nothing, but that these devillish legions of Grangousier, whilest we are in Mesopotamia, will come on our backs, and charge up our reer.

La Vie treshorrificque du grand Gargantua (1552)
Translated by Sir Thomas Urquhart

I have re-read, after CLARISSA, *some chapters of Rabelais, such as the battle of Frère Jean des Entommeures, and the counselling of Picrochole (I know them, however, almost by heart). But I have read them*

487

again with very great pleasure, because they are the most vivid pictures in the world.

It is not that I put Rabelais beside Horace, but if Horace is the first among the writers of good epistles, Rabelais, when he is good, is the first among good buffoons. It is not necessary that there be two men of this profession in a nation, but it is necessary that there be one. I repent having formerly spoken too much ill of him.

<div align="right">

F. M. AROUET DE VOLTAIRE
Letter to Marquise du Deffand (April 12, 1760)

</div>

FRANÇOIS RABELAIS

1 4 9 0 ? — 1 5 5 3

FELICITY OF MARRIAGE

Et voyent les dolens peres & meres hors leurs maisons enleuer & tirer par vn incongneu, estrangier, barbare, mastin tout pourry, chancreux, cadauereux, paouure, malheureux, leurs tant belles, delicates, riches, & saines filles, les quelles tant cherement auoient nourriez en tout exercice vertueux, auoient disciplinées en toute honesteté: esperans en temps oportun les colloquer par mariage auecques les enfans de leurs voisins & antiques amis nourriz & instituez de mesme soing, pour paruenir à ceste felicité de mariage, que d'eulx ilz veissent naistre lignaige raportant & hæreditant non moins aux meurs de leurs peres & meres, que à leurs biens meubles & hæritaiges. Quel spectacle pensez vous que ce leurs soit? Ne croyez, que plus enorme feust la desolation du peuple Romain & ses confœderez entendens le deces de Germanicus Drusus. Ne croyez que plus pitoyable feust le desconfort des Lacedæmoniens, quand de leurs pays veirent par l'adultere Troian furtiuement enleuée Helene Grecque. . . . Et restent en leurs maisons priuez de leurs filles tant aimées, le pere mauldissant le iour & heure de ses nopces: la mere regrettant que n'estoit auortée en tel tant triste & malheureux enfantement: & en pleurs & lamentations finent leurs vie, laquelle estoit de raison finir en ioye & bon tractement de icelles.

May not these Fathers and Mothers (think you) be sorrowful and heavy-hearted, when they see an unknown Fellow, a Vagabond Stranger, a barbarous Lowt, a rude Curr, rotten, fleshless, putrified, scraggy, bily, botchy, poor, a forlorn Caitif and miserable Snake, by an open Rapt, snatch away before their own Eyes, their so fair, delicate, neat, well-

behavoured, richly provided for, and healthful Daughters, on whose Breeding and Education they had spared no Cost nor Charges, by bringing them up in an honest Discipline, to all the honourable and vertuous Employments becoming one of their Sex, descended of a noble Parentage, hoping by those commendable and industrious means in an opportune and convenient time to bestow them on the worthy sons of their well-deserving Neighbours and ancient Friends, who had nourished, entertained, taught, instructed and schooled their Children with the same Care and Sollicitude, to make them Matches fit to attain to the Felicity of a so happy Marriage; that from them might issue an Off-spring and Progeny no less Heirs to the laudable Endowments and exquisite Qualifications of their Parents whom they every way resemble, than to their Personal and Real Estates, Moveables and Inheritances? How doleful, trist and plangorous would such a Sight and Pageantry prove unto them? You shall not need to think that the Collachrymation of the Romans, and their Confederates, at the Decease of Germanicus Drusus, was comparable to this Lamentation of theirs? Neither would I have you to believe, that the Discomfort and Anxiety of the Lacedæmonians, when the Greek Helen, by the Perfidiousness of the Adulterous Trojan Paris was privily stollen away out of their Country, was greater or more pitiful than this ruthful and deplorable Collugency of theirs? . . . They wretchedly stay at their own miserable Homes, destitute of their well-beloved Daughters; the Fathers cursing the days and the hours wherein they were married; and the Mothers howling, and crying that it was not their fortune to have brought forth Abortive Issues, when they hapned to be delivered of such unfortunate Girls; and in this pitiful plight spend at best the remainder of their Time with Tears and Weeping for those their Children of and from whom they expected (and with good reason should have obtained and reaped) in these latter days of theirs, Joy and Comfort.

<div style="text-align: right">

Le Tiers Livre des faicts et dicts
Heroïques du bon Pantagruel (1552)
Translated by Sir Thomas Urquhart

</div>

Rabelais, before Montaigne, is the father of that clear, robust and supple French prose, that is to be spoken rather than written, that is meant to fall from the lips, and that has never been more beautiful.

<div style="text-align: right">

ÉMILE FAGUET
Seizième Siècle: Études littéraires (1894)

</div>

CLÉMENT MAROT

1495 ? — 1544

DE L'ABBÉ, & DE SON VALET

Monsieur l'Abbé et monsieur son valet
Sont faictz egaulx tous deux comme de cire:
L'un est grand fol, l'autre petit folet;
L'un veult railler, l'autre gaudir et rire;
L'un boit du bon, l'autre ne boit du pire;
Mais un debat au soir entre eulx s'esmeut,
Car maistre abbé toute la nuict ne veult
Estre sans vin, que sans secours ne meure,
Et son valet jamais dormir ne peult
Tandis qu'au pot une goute en demeure.

OF THE ABBOT AND HIS VALET

His grace the Abbot and his servynge ladde
 Are of one claye as honey is of wax;
One is a loon, the other one is madde;
 One loves a joke, the other his sides cracks;
 One drinks goode wine, the other never lacks.
Thus a debate one nighte between them rose:
Wineless his worship would no more repose
 Than he would die of all his friends bereft,
Wheras his valet's eyelids could not close
 Whyle in the bowle a single drop was left.

<div align="right">

Epigramme lxxxv (1536)
Translated by Wilfrid Thorley

</div>

The model of the two-edged epigram.

<div align="right">

ÉMILE FAGUET
Seizième siècle: Études littéraires (1894)

</div>

CLÉMENT MAROT

1 4 9 5 ? — 1 5 4 4

L'AMOUR AU BON VIEULX TEMPS

Au bon vieulx temps un train d'amour regnoit
Qui sans grand art et dons se demenoit,
Si qu'un bouquet donné d'amour profonde,
C'estoit donné toute la terre ronde,
Car seulement au cueur on se prenoit.
Et si par cas à jouyr on venoit,
Sçavez-vous bien comme on s'entretenoit?
Vingt ans, trente ans: cela duroit un monde
 Au bon vieulx temps.

Or est perdu ce qu'amour ordonnoit:
Rien que pleurs fainctz, rien que changes on n'oyt;
Qui vouldra donc qu'à aymer je me fonde,
Il fault premier que l'amour on refonde,
Et qu'on la meine ainsi qu'on la menoit
 Au bon vieulx temps.

OLD-TIME LOVE

In good old days such sort of love held sway
As artlessly and simply made its way,
And a few flowers, the gift of love sincere,
Than all the round earth's riches were more dear:

For to the heart alone did they address their lay.
And if they chanced to love each other, pray
Take heed how well they then knew how to stay
For ages faithful—twenty, thirty year—
 In good old days.

But now is lost Love's rule they used t' obey;
Only false tears and changes fill the day.
Who would have me a lover now appear
Must love make over in the olden way,
And let it rule as once it held its sway
 In good old days.

Translation Anonymous

491

ANONYMOUS

FIFTEENTH CENTURY ?

CHEVY CHASE

The First Fit.

The Persé owt of Northombarlande.
 An a vowe to God mayd he,
That he wolde hunte in the mountayns
 Off Chyviat within dayes thre,
In the mauger of doughtè Dogles,
 And all that ever with him be.

The fattiste hartes in all Cheviat
 He sayd he wold kill, and cary them away:
Be my feth, sayd the dougheti Doglas agayn,
 I wyll let that hontyng yf that I may.

Then the Persé owt of Banborowe cam,
 With him a myghtye meany;
With fifteen hondrith archares bold;
 The wear chosen out of shyars thre.

This begane on a monday at morn
 In Cheviat the hillys so he;
The chyld may rue that ys un-born,
 It was the mor pitté.

The dryvars thorowe the woodes went
 For to reas the dear;
Bomen bickarte uppone the bent
 With ther browd aras cleare.

Then the wyld thorowe the woodes went
 On every syde shear;
Grea-hondes thorowe the greves glent
 For to kyll thear dear.

492

The begane in Chyviat the hyls abone
 Yerly on a monnyn-day;
Be that it drewe to the oware off none
 A hondrith fat hartes ded ther lay.

The blewe a mort uppone the bent,
 The semblyd on sydis shear;
To the quyrry then the Persè went
 To se the bryttlynge off the deare.

He sayd, It was the Duglas promys
 This day to meet me hear;
But I wyste he wold faylle verament:
 A gret oth the Persè swear.

At the laste a squyar of Northombelonde
 Lokyde at his hand full ny,
He was war ath the doughetie Doglas comynge:
 With him a myghtè meany,

Both with spear, 'byll,' and brande:
 Yt was a myghti sight to se.
Hardyar men both off hart nar hande
 Wear not in Christiantè.

The wear twenty hondrith spear-men good
 Withouten any fayle;
The wear borne a-long be the watter a Twyde,
 Yth bowndes of Tividale.

Leave off the brytlyng of the dear, he sayde,
 And to your bowys look ye tayk good heed;
For never sithe ye wear on your mothars borne
 Had ye never so mickle need.

The dougheti Dogglas on a stede
 He rode all his men beforne;
His armor glytteryde as dyd a glede;
 A bolder barne was never born.

Tell me 'what' men ye ar, he says,
 Or whos men that ye be:
Who gave youe leave to hunte in this
 Chyviat chays in the spyt of me?

The first mane that ever him an answear mayd,
 Yt was the good lord Persè:

We wyll not tell the 'what' men we ar, he says,
 Nor whos men that we be;
But we wyll hount hear in this chays
 In the spyte of thyne, and of the.

The fattiste hartes in all Chyviat
 We have kyld, and cast to carry them a-way.
Be my troth, sayd the doughtè Dogglas agayn,
 Ther-for the ton of us shall de this day.

Then sayd the doughtè Doglas
 Unto the lord Persè:
To kyll all thes giltless men,
 A-las! it wear great pittè.

But, Persè, thowe art a lord of lande,
 I am a yerle callyd within my contre;
Let all our men uppone a parti stande;
 And do the battell off the and of me.

Nowe Cristes cors on his crowne, sayd the lord Persè.
 Who-soever ther-to says nay.
Be my troth, doughtè Doglas, he says,
 Thow shalt never se that day;

Nethar in Ynglonde, Skottlonde, nar France,
 Nor for no man of a woman born,
But and fortune be my chance,
 I dar met him on man for on.

Then bespayke a squyar off Northombarlonde,
 Ric. Wytharynton was his nam;
It shall never be told in Sothe-Ynglonde, he says,
 To kyng Herry the fourth for sham.

I wat youe byn great lordes twaw,
 I am a poor squyar of lande;
I wyll never se my captayne fyght on a fylde,
 And stande my-selffe, and looke on,
But whyll I may my weppone welde,
 I wyll not 'fayl' both harte and hande.

That day, that day, that dredfull day:
 The first Fit here I fynde.
And youe wyll here any mor athe hountyng a the Chyviat,
 Yet ys ther mor behynde.

The Yngglishe men hade ther bowys yebent,
 Ther hartes were good yenoughe;
The first of arros that the shote off,
 Seven skore spear-men the sloughe.

Yet bydys the yerle Doglas uppon the bent,
 A captayne good yenoughe,
And that was sene verament,
 For he wrought hom both woo and wouche.

The Dogglas pertyd his ost in thre,
 Lyk a cheffe cheften off pryde,
With suar speares off myghttè tre
 The cum in on every syde.

Thrughe our Ynglishe archery
 Gave many a wounde full wyde;
Many a doughete the garde to dy,
 Which ganyde them no pryde.

The Ynglishe men let thear bowys be,
 And pulde owt brandes that wer bright;
It was a hevy syght to se
 Bryght swordes on basnites lyght.

Thorowe ryche male, and myne-ye-ple
 Many sterne the stroke downe streght:
Many a freyke, that was full free,
 Ther undar foot dyd lyght.

At last the Duglas and the Persè met,
 Lyk to captayns of myght and mayne;
The swapte togethar tyll the both swat
 With swordes, that wear of fyn myllàn.

Thes worthè freckys for to fyght
 Ther-to the wear full fayne,
Tyll the bloode owte off thear basnetes sprente,
 As ever dyd heal or rayne.

Holde the, Persè, sayd the Doglas,
 And i' feth I shall the brynge
Wher thowe shalte have a yerls wagis
 Of Jamy our Scottish kynge.

Thoue shalte have thy ransom fre,
 I hight the hear this thinge,
For the manfullyste man yet art thowe,
 That ever I conqueryd in filde fightyng.

Nay 'then' sayd the lord Persè,
 I tolde it the beforne,
That I wolde never yeldyde be
 To no man of a woman born.

With that ther cam an arrowe hastely
 Forthe off a mightie wane,
Hit hathe strekene the yerle Duglas
 In at the brest bane.

Thoroue lyvar and longs bathe
 The sharp arrowe ys gane,
That never after in all his lyffe days,
 He spayke mo wordes but ane,
That was, Fyghte ye, my merry men, whyllys ye may,
 For my lyff days ben gan.

The Persè leanyde on his brande,
 And sawe the Duglas de;
He tooke the dede man be the hande,
 And sayd, Wo ys me for the!

To have savyde thy lyffe I wold have pertyd with
 My landes for years thre,
For a better man of hart, nare of hande
 Was not in all the north countrè.

Off all that se a Skottishe knyght,
 Was callyd Sir Hewe the Mongon-byrry,
He sawe the Duglas to the deth was dyght;
 He spendyd a spear a trusti tre:

He rod uppon a corsiare
 Throughe a hondrith archery;
He never styntyde, nar never blane,
 Tyll he came to the good lord Persè.

He set uppone the lord Persè
 A dynte, that was full soare;
With a suar spear of a myghtè tre
 Clean thorow the body he the Persè bore,

496

Athe tothar syde, that a man myght se,
 A large cloth yard and mare:
Towe bettar captayns wear nat in Christiantè,
 Then that day slain wear ther.

An archar off Northomberlonde
 Say slean was the lord Persè,
He bar a bende-bow in his hande,
 Was made off trusti tre:

An arow, that a cloth yarde was lang,
 To th' hard stele halyde he;
A dynt, that was both sad and soar,
 He sat on Sir Hewe the Mongon-byrry.

The dynt yt was both sad and sar,
 That he of Mongon-byrry sete;
The swane-fethars, that his arrowe bar,
 With his hart blood the wear wete.

Ther was never a freake wone foot wolde fle,
 But still in stour dyd stand,
Heawyng on yche othar, whyll the myght dre,
 With many a bal-ful brande.

This battell begane in Chyviat
 An owar befor the none,
And when even-song bell was rang
 The battell was nat half done.

The tooke 'on' on ethar hand
 Be the lyght off the mone;
Many hade no strenght for to stande,
 In Chyviat the hyllys aboun.

Of fifteen hondrith archars of Ynglonde
 Went away but fifti and thre;
Of twenty hondrith spear-men of Skotlonde,
 But even five and fifti:

But all wear slayne Cheviat within:
 The hade no strengthe to stand on hie;
The chylde may rue that ys un-borne,
 It was the mor pittè.

Thear was slayne with the lord Persè
 Sir John of Agerstone,
Sir Roger the hinde Hartly,
 Sir Wyllyam the bolde Hearone.

Sir Jorg the worthè Lovele
 A knyght of great renowen,
Sir Raff the ryche Rugbè
 With dyntes wear beaten dowene.

For Wetharryngton my harte was wo,
 That ever he slayne shulde be;
For when both his leggis wear hewyne in to,
 Yet he knyled and fought on hys kne.

Ther was slayne with the dougheti Douglas
 Sir Hewe the Mongon-byrry,
Sir Davye Lwdale, that worthè was,
 His sistars son was he:

Sir Charles a Murrè, in that place,
 That never a foot wolde fle;
Sir Hewe Maxwell, a lorde he was,
 With the Duglas dyd he dey.

So on the morrowe the mayde them byears
 Off byrch, and hasell so 'gray;'
Many wedous with wepyng tears,
 Cam to fach ther makys a-way.

Tivydale may carpe off care,
 Northombarlond may mayk grat mone,
For towe such captayns, as slayne wear thear,
 On the march perti shall never be none.

Word ys commen to Edden-burrowe,
 To Jamy the Skottishe kyng,
That dougheti Duglas, lyff-tenant of the Merches
 He lay slean Chyviot with-in.

His handdes dyd he weal and wryng,
 He sayd, Alas, and woe ys me!
Such another captayn Skotland within,
 He sayd, y-feth shuld never be.

Worde ys commyn to lovly Londone
 Till the fourth Harry our kyng,
That lord Persè, leyff-tennante of the Merchis,
 He lay slayne Chyviat within.

God have merci on his soll, sayd kyng Harry,
 Good lord, yf thy will it be!
I have a hondrith captayns in Yynglonde, he sayd,
 As good as ever was hee:
But Persè, and I brook my lyffe,
 Thy deth well quyte shall be.

As our noble kyng made his a-vowe,
 Lyke a noble prince of renowen,
For the deth of the lord Persè,
 He dyd the battel of Hombyll-down:

Wher syx and thritte Skottish knyghtes
 On a day wear beaten down:
Glendale glytteryde on ther armor bryght,
 Over castill, towar, and town.

This was the hontynge off the Cheviat;
 That tear begane this spurn:
Old men that knowen the grownde well yenoughe,
 Call it the Battell of Otterburn.

At Otterburn began this spurne
 Uppon a monnyn day:
Ther was the dougghté Doglas slean,
 The Persè never went away.

Ther was never a tym on the march partes
 Sen the Doglas and the Persè met,
But yt was marvele, and the redde blude ronne not,
 As the reane doys in the stret.

Jhesue Christ our balys bete,
 And to the blys us brynge!
Thus was the hountynge of the Chevyat:
 God send us all good ending!

*The old song of Chevy-Chase is the favourite ballad of the common
people of England, and Ben Jonson used to say he had rather have been
the author of it than of all his works. Sir Philip Sidney in his Discourse*

of Poetry speaks of it in the following words: 'I never heard the old song of Piercy and Douglas, that I found not my heart more moved than with a trumpet; and yet it is sung but by some blind crowder with no rougher voice than rude style; which being so evil apparelled in the dust and cobwebs of that uncivil age, what would it work trimmed in the gorgeous eloquence of Pindar?'

<div align="right">

JOSEPH ADDISON
The Spectator (May 21, 1711)

</div>

ANONYMOUS

FIFTEENTH CENTURY

LAWYER PATELIN

Patelin.

Or vien çà, et parles. Qu'es tu?
Ou demandeur ou defendeur?

Le Bergier.

J'ay afaire à un entendeur,
Entendez vous bien, mon doulx maistre,
A qui j'ay long temps mené paistre
Ses brebis, et les (y) gardoye.
Par mon serment, je regardoye
Qu'il me payoit petitement. . . .
Diray je tout?

Patelin.

Dea, seurement
A son conseil doit on tout dire.

Le Bergier.

Il est vray et vérité, sire,
Que je les y'ay assommées,
Tant que plusieurs se sont pasmées
Maintesfois et sont cheutes mortes
Tant feussent elles saines et fortes.
Et puis je luy fesoie entendre,
Affin qu'il ne m'en peust reprendre,

Qu'ilz mouroient de la clavelée.
Ha! fait il, ne soit plus meslée
Avec les aultres: jette la!
Volentiers, fais-je. Mais cela
Se faisoit par une autre voye,
Car, par saint Jehan, je les mengeoye,
Qui sçavoye bien la maladie!
Que voulez vous que je vous die?
J'ay cecy tant continué,
J'en ai assommé et tué
Tant qu'il s'en est bien apperceu;
Et quant il s'est trouvé deceu,
M'aist dieu! il m'a fait espier,
Car on les oyt bien hault crier,
Entendez vous, quant on le fait.
Or ay je esté prins sur le fait,
Je ne le puis jamais nier.
Si vous voudroy je bien prier
(Pour du mien j'ay assez finance)
Que nous deux luy baillons l'avance.
Je sçay bien qu'il a bonne cause:
Mais vous trouverez bien tel clause,
Se voulez, qu'il l'aura mauvaise.

Patelin.

Par ta foy, seras tu bien aise?
Que donras tu se je renverse
Le droit de ta partie adverse,
Et se l'en t'en envoye assoulz?

Le Bergier.

Je ne vous paieray point en solz,
Mais en bel or à la couronne.

Patelin.

Donc auras tu ta cause bonne. . . .
Se tu parles, on te prendra
Coup à coup aux positions;
Et en telz cas, confessions
Sont si tres prejudiciables
Et nuysent tant que ce sont diables!
Et pour ce vecy qu'il fauldra:
Ja tost quant on t'appellera

501

Pour comparoir en jugement,
Tu ne respondras nullement
Fors Bê, pour rien que l'en te die.

Patelin

Come here and speak. What are you? Plaintiff or defendant?

The Shepherd

I am talking to an expert; listen well! My gentle master, whose sheep I have pastured and kept for a long time—on my oath, I considered my pay too small—shall I tell everything?

Patelin

Surely, you must tell everything to your lawyer.

The Shepherd

It is true and the truth, sir, that I knocked them on the head, so that many a time several fainted and dropped dead, however healthy and strong they might have been. And then I made him believe (so he would not blame me) that they died of the sheep-pox. "Ha!" says he, "don't let it get mixed up with the others; throw it away!" "Gladly," says I. But I did it differently, for, by George, I ate them, knowing well of what they died. What shall I tell you? I continued at it until I slaughtered so many of them that my master noticed it; and when he found out he'd been fooled, so help me God, he got someone to spy on me. For, as you understand, they can be heard bleating very loudly when one does the job. Now, I was caught in the act, I cannot deny it. I would like to propose (as for me, I have enough money) that both of us should post a bond against loss of the case. I know well that he has a good case; but you'll devise such a trick, if you want, that the plaintiff will have a bad one.

Patelin

By God, won't you be glad if I should do that! What will you give me if I succeed in turning the tables on your adversary, and obtain you an acquittal?

The Shepherd

I will not pay you in coin, but in beautiful crowned gold.

Patelin

Then your case will be good! . . . If you speak, they'll catch you every time you make a statement, and in such cases, confessions are so tre-

502

mendously prejudicial, and harmful like the devil! Therefore, let me suggest what you should do: as soon as they call you to appear at trial, you will answer nothing except *ba-aa-h*, however much they might question you!

<div align="right">

L'Avocat Patelin (c. 1470)

</div>

A little prodigy of art.

<div align="right">

JEAN FRANÇOIS MARMONTEL
Éléments de littérature (1787)

</div>

ANONYMOUS

FIFTEENTH CENTURY

OF THE VIRGIN AND CHILD

'*Lullay, myn lykyng, my dere sone, myn swetyng,*
Lullay, my dere herte, myn owyn dere derlyng.'

I saw a fayr maydyn syttyn and synge;
Sche lullyd a lytyl chyld, a swete lordyng.

That eche Lord is that that made alle thinge;
Of alle lordis he is Lord, of alle kynges Kyng.

Ther was mekyl melody at that chyldes berthe;
Alle tho wern in heuene blys, thei made mekyl merth.

Aungele bryght, thei song that nyght and seydyn to that chyld,
'Blyssid be thou. and so be sche that is bothe mek and myld.'

Prey we now to that chyld, and to his moder dere,
Grawnt hem his blyssyng that now makyn chere.

The masterpiece of the lullaby carols.

<div align="right">

RICHARD L. GREENE
The Early English Carols (1935)

</div>

ON THE VIRGIN

I syng a of a mayden
 that is makeles,
Kyng of alle kynges
 to here sone che ches.
He cam also stylle
 ther his moder was,
As dew in Aprylle
 that fallyt on the gras.
He cam also stylle
 to his moderes bowr,
As dew in Aprille
 that fallyt on the flour.
He cam also stylle
 ther his moder lay,
As dew in Aprille
 that fallyt on the spray.
Moder and maydyn
 was never non but che;
Wel may swych a lady
 Godes moder be.

ADAM

Adam lay i-bowndyn,
 bowndyn in a bond,
Fowre thowsand wynter
 thowt he not to long;
And al was for an appil,
 an appil that he tok,
As clerkes fyndyn wretyn
 in here book.
Ne hadde the appil take ben,
 the appil taken ben,
Ne hadde never our lady
 a ben hevene quen.
Blyssid be the tyme
 that appil take was!
Therfore we mown syngyn
 Deo gracias.

504

The highest level of lyrical beauty of which medieval poetry was capable.

English Literature at the Close of the Middle Ages (1945)

ANONYMOUS

FIFTEENTH CENTURY?

QUIA AMORE LANGUEO

In the vaile of restles mynd
 I sowght in mownteyn & in mede,
trustyng a treulofe for to fynd:
 vpon an hyll than toke I hede;
 a voise I herd (and nere I yede)
 in gret dolour complaynyng tho,
 "see, derë soule, my sydës blede
 Quia amore langueo."

Vpon thys mownt I fand a tree;
 vndir thys tree a man sittyng;
from hede to fote wowndyd was he,
 hys hert blode I saw bledyng;
 A semely man to be a kyng,
 A graciose face to loke vnto.
 I askyd hym how he had paynyng,
 he said, "*Quia amore langueo.*"

I am treulove that fals was neuer:
 my sistur, mannys soule, I loued hyr thus;
By-cause I wold on no wyse disseuere,
 I left my kyngdome gloriouse;
 I purueyd hyr a place full preciouse;
 she flytt I folowyd I luffed her soo;
 that I suffred thes paynès piteuouse
 Quia amore langueo.

My faire love and my spousë bryght,
 I saued hyr fro betyng and she hath me bett;
I clothed hyr in grace and heuenly lyght,
 this blody surcote she hath on me sett;

for langyng love, I will not lett,
 swetë strokys be thes, loo;
I haf loued euer als I hett,
 Quia amore langueo.

I crownyd hyr with blysse and she me with thorne,
I led hyr to chambre and she me to dye;
I browght hyr to worship and she me to skorne,
 I dyd hyr reuerence and she me velanye.
to love that loueth is no maistrye,
 hyr hate made neuer my love hyr foo;
ask than no moo questions whye,
 but *Quia amore langueo.*

loke vnto myn handys, man!
thes gloues were geuen me whan I hyr sowght;
they be nat white but rede and wan,
 embrodred with blode my spouse them bowght;
they wyll not of I lefe them nowght,
 I wowe hyr with them where euer she goo;
thes handes full frendly for hyr fowght,
 Quia amore langueo.

Maruell not, man, thof I sitt styll,
 my love hath shod me wondyr strayte;
she boklyd my fete as was hyr wyll
 with sharp nailes well thow maist waite!
in my love was neuer dissaite,
 for all my membres I haf opynd hyr to;
my body I made hyr hertys baite,
 Quia amore langueo.

In my syde I haf made hyr nest,
 loke in me how wyde a wound is here!
this is hyr chambre here shall she rest,
 that she and I may slepe in fere.
here may she wasshe if any filth were;
 here is socour for all hyr woo;
cum if she will she shall haf chere,
 Quia amore langueo.

I will abide till she be redy,
 I will to hyr send or she sey nay;
If she be rechelesse I will be redy,
 If she be dawngerouse I will hyr pray.

If she do wepe than byd I nay;
 myn armes ben spred to clypp hyr to;
crye onys, "I cum!" now, soule, assaye!
 Qui amore langueo.

I sitt on an hille for to se farre,
I loke to the vayle my spouse I see;
now rynne she awayward, now cummyth she narre,
 yet fro myn eye syght she may nat be;
 sum waite ther pray to make hyr flee,
 I rynne tofore to chastise hyr foo;
recouer my soule agayne to me,
 Quia amore langueo.

My swete spouse will we goo play;
 apples ben rype in my gardine;
I shall clothe the in new array,
 thy mete shall be mylk honye & wyne;
 now, dere soule, latt us go dyne,
 thy sustenance is in my skrypp, loo!
tary not now fayre spousë myne,
 Quia amore langueo.

yf thow be fowle I shall make [thee] clene,
 if thow be seke, I shall the hele;
yf thow owght morne I shall be-mene,
 spouse, why will thow nowght with me dele?
 thow fowndyst neuer love so lele;
 what wilt thow, sowle that I shall do?
I may of vnkyndnes the appele,
 Quia amore langueo.

What shall I do now with my spouse?
 abyde I will hyre iantilnesse,
wold she loke onys owt of hyr howse
 of flesshely affeccions and vnclennesse;
 hyr bed is made hyr bolstar is in blysse,
 hyr chambre is chosen, suche ar no moo;
loke owt at the wyndows of kyndnesse,
 Quia amore langueo.

Long and love thow neuer so hygh,
 yit is my love more than thyn may be;
thow gladdyst thou wepist I sitt the bygh,
 yit mygth thow, spouse loke onys at me!

spouse, shuld I alway fedë the
 with childys mete? nay, love, nat so!
I pray the, love, with aduersite,
 Quia amore langueo.

My spouse is in chambre, hald your pease!
 make no noyse but lat hyr slepe;
my babe shall sofre noo disease,
 I may not here my dere childe wepe,
 for with my pappe I shall hyr kepe;
 no wondyr thowgh I tend hyr to,
thys hoole in my side had neuer ben so depe,
 but Quia amore langueo.

Wax not wery, myn owne dere wyfe,
 what mede is aye to lyffe in comfort?
for in tribulacion, I ryñ more ryfe
 ofter tymes than in disport;
 In welth, in woo, euer I support;
 than, derë soule, go neuer me fro!
thy mede is markyd, whan thow art mort,
 in blysse; Quia amore langueo.

The finest mystical poem written in English before the great age of English mystical poetry, the seventeenth century.

T. EARLE WELBY
A Popular History of English Poetry (1933)

MAURICE SCÈVE

C. 1 5 0 0 — 1 5 6 4

FROM LA DELIE

Au Caucasus de mon souffrir lyé
Dedans l'Enfer de ma peine eternelle,
Ce grand desir de mon bien oblyé,
Comme l'Aultour de ma mort immortelle,
Ronge l'esprit par une fureur telle,
Que consommé d'un si ardent poursuyvre,
Espoir le fait, non pour mon bien, revivre:

508

Mais pour au mal renaistre incessamment,
Affin qu'en moy ce mien malheureux vivre
Prometheus tourmente innocemment.

Bound to the Caucasus of my suffering, within the Hell of my eternal
punishment, the great desire of my forgotten happiness, vulture of my
everlasting death, gnaws my soul with such fury that, consumed by so
fiery a pursuit, hope makes my spirit live again, to my loss; I am reborn
constantly to suffering so that this unhappy life of mine tortures me like
an innocent Prometheus.

<div style="text-align:right">Délie, Objet de plus haute vertu (1544)</div>

Without doubt LA DÉLIE *is the most powerful and masterly of poetic
meditations.*

<div style="text-align:right">THIERRY MAULNIER
Introduction à la poésie française (1939)</div>

JOACHIM DU BELLAY

C . 1 5 2 2 — 1 5 6 0

THE POET

O combien je desire voir secher ces *Printemps,* chastier ces *Petites
jeunesses,* rabattre ces *Coups d'essay,* tarir ces *Fontaines,* bref, abolir
tous ces beaux titres assez suffisans pour degouster tout lecteur sçavant
d'en lire davantage. Je ne souhaite moins, que ces *Despourveus,* ces
humbles *Esperans,* ces *Bannis de lyesse,* ces *Esclaves,* ces *Traverseurs*
soient renvoyez à la table ronde, et ces belles petites devises aux gentils
hommes et damoiselles, d'où on les a empruntées. Que diray plus? Je
supplie à Phœbus Apollon, que la France, après avoir esté si longtemps
sterile, grosse de luy, enfante bientost un poëte, dont le luc bien resonant
fasse taire ces enrouées cornemuses, non autrement que les grenouilles,
quand on jette une pierre en leurs marais. Et si, nonobstant cela, cette
fievre chaude d'escrire les tourmentoit encores, je leur conseilleroy' ou
d'aller prendre medecine en Anticyre, ou, pour le mieux, se remettre à
l'etude, et sans honte, à l'exemple de Caton, qui en sa vieillesse apprit
les lettres grecques. Je pense bien qu'en parlant ainsi de nos rymeurs, je
sembleray à beaucoup trop mordant et satyrique: mais veritable à ceux
qui ont sçavoir et jugement et qui desirent la santé de nostre langue, où

cet ulcere et chair corrompue de mauvaises poësies est si inveterée, qu'elle ne se peut oster qu'avec le fer et le cautere. Pour conclure ce propos, sçache, lecteur, que celui sera veritablement le poëte que je cerche en nostre langue, qui me fera indigner, appaiser, ejouir, douloir, aimer, haïr, admirer, estonner: bref, qui tiendra la bride de mes affections, me tournant çà et là à son plaisir. Voyla la vraye pierre de touche où il faut que tu esprouves tous poëmes et en toutes langues.

Oh, how greatly do I desire to see dried up these springs, chastised these little youths, and destroyed these experimental verses, running dry these fountains, in short, abolished all these fine titles, sufficient to disgust any learned reader from reading further.

I hope no less that these *deprived ones*, these humble *hopefuls*, these *exiles from joy*, these *slaves*, and these *travellers* may be sent back to the round table, and these pretty little devices to the gentlemen and damosels from whom they were borrowed. What shall I say more? I beg Phoebus Apollo, that France, having been so long sterile, big with child through him may soon bring forth a poet, whose well resounding lute may silence these hoarse bagpipes, none otherwise than the frogs when a stone is thrown into their marsh. And if, notwithstanding this, the hot fever of writing torment them still, I would advise them either to go take medicine in Anticyra, or, better, to return to their studies: and without shame, after the example of Cato, who in his old age, learnt Greek letters.

I well believe that in thus speaking of our rhymesters I shall appear to many too biting and satirical, but veridical to those who have learning and judgment, and who desire the health of our language, wherein that ulcer and corrupt flesh of bad poetry is so inveterate, that it can be removed only with iron and cauterizing. To conclude this question, know, reader, that he will be veritably the poet whom I seek in our language, who will make me to be angry, to be appeased, to rejoice, to be grieved, to love, to hate, to admire, to wonder, in short, who will hold the reins of my emotions, turning me this way and that at his pleasure. That is the true touchstone whereby thou shouldst test all poems in every language.

La Deffense et illustration de la langue française (1549)
Translated by Gladys M. Turquet

One of the noblest descriptions of the true poet ever penned.
WARNER FORREST PATTERSON
Three Centuries of French Poetic Theory (1935)

EPISODE OF ADAMASTOR OFF THE CAPE OF GOOD HOPE

Porem já cinco soes erão passados,
Que d'ali nos partiramos, cortando
Os mares nunca de outrem navegados,
Prosperamente os ventos assoprando,
Quando hũa noite, estando descuidados
Na cortadora proa vigiando,
Hũa nuvem, que os ares escurece,
Sobre nossas cabeças aparece.

Tão temerosa vinha e carregada,
Que pôs nos corações hum grande medo;
Bramindo o negro mar de longe brada
Como se désse em vão nalgum rochedo.
"O' Potestade" disse "sublimada,
Que ameaço divino ou que segredo
Este clima e este mar nos apresenta,
Que mór cousa parece que tormenta!"

Não acabava, quando hũa figura
Se nos mostra no ar, robusta e valida,
De disforme e grandissima estatura,
O rosto carregado, a barba esqualida,
Os olhos encovados, e a postura
Medonha e má, e a côr terrena e pallida,
Cheios de terra e crespos os cabellos,
A boca negra, os dentes amarellos.

Tão grande era de membros, que bem posso
Certificar-te que este era o segundo
De Rhodes estranhissimo Colosso,
Que hum dos sete milagres foi do mundo.
Cum tom de voz nos falla horrendo e grosso,
Que pareceo sair do mar profundo:
Arrepião-se as carnes e o cabello
A mi e a todos só de ouvi-lo e ve-lo.

E disse: "O' gente ousada, mais que quantas
No mundo cometêrão grandes cousas,

511

Tu, que por guerras cruas, taes e tantas,
E por trabalhos vãos nunca repousas,
Pois os vedados terminos quebrantas
E navegar meus longos mares ousas,
Que eu tanto tempo ha já que guardo e tenho,
Nunca arados de estranho ou proprio lenho,

Pois vens ver os segredos escondidos
Da natureza e do humido elemento,
A nenhum grande humano concedidos
De nobre ou de immortal merecimento,
Ouve os damnos de mi, que apercebidos
Estão a teu sobejo atrevimento
Por todo o largo mar e pola terra
Que inda has-de sojugar com dura guerra.

Sabe que quantas naos esta viagem,
Que tu fazes, fizerem de atrevidas,
Inimiga terão esta paragem
Com ventos e tormentas desmedidas;
E na primeira armada que passagem
Fizer por estas ondas insoffridas,
Eu farei de improviso tal castigo,
Que seja mór o damno que o perigo.

Aqui espero tomar, se não me engano,
De quem me descobrio, summa vingança.
E não se acabará só nisto o damno
De vossa pertinace confiança;
Antes em vossas naos vereis cada anno,
Se he verdade o que meu juizo alcança,
Naufragios, perdições de toda sorte,
Que o menor mal de todos seja a morte.

E do primeiro illustre que a ventura
Com fama alta fizer tocar os ceos,
Serei eterna e nova sepultura
Por juizos incognitos de Deos.
Aqui porá da Turca armada dura
Os soberbos e prosperos tropheos;
Comigo de seus damnos o ameaça
A destruida Quiloa com Mombaça.

Outro tambem virá de honrada fama,
Liberal, cavalleiro e namorado,
E comsigo trará a fermosa dama

Que Amor por grão mercê lhe terá dado.
Triste ventura e negro fado os chama
Neste terreno meu, que duro e irado
Os deixará de hum crú naufragio vivos
Pera verem trabalhos excessivos.

Verão morrer com fome os filhos caros,
Em tanto amor gèrados e nacidos;
Verão os Cafres asperos e avaros
Tirar á linda dama seus vestidos;
Os crystallinos membros e perclaros
A' calma, ao frio, ao ar verão despidos,
Despois de ter pisada longamente
Cos delicados pés a areia ardente.

E verão mais os olhos que escaparem
De tanto mal, de tanta desventura,
Os dous amantes miseros ficarem
Na férvida e implacabil espessura;
Ali, despois que as pedras abrandarem
Com lagrimas de dor, de magoa pura,
Abraçados as almas soltarão
Da fermosa e miserrima prisão."

Mais hia por diante o monstro horrendo
Dizendo nossos fados, quando alçado
Lhe disse eu: "Quem és tu? que esse estupendo
Corpo certo me tem maravilhado."
A boca e os olhos negros retorcendo
E dando hum espantoso e grande brado,
Me respondeo com voz pesada e amara,
Como quem da pergunta lhe pesara:

"Eu sou aquelle occulto e grande cabo
A quem chamais vós outros Tormentorio,
Que nunca a Ptolomeu, Pomponio, Estrabo,
Plinio, e quantos passárão, fui notorio.
Aqui toda a Africana costa acabo
Neste meu nunca visto promontorio,
Que pera o pólo Antarctico se estende;
A quem vossa ousadia tanto offende.

Fui dos filhos asperrimos da Terra,
Qual Encelado, Egeo e o Centimano;
Chamei-me Adamastor, e fui na guerra
Contra o que vibra os raios de Vulcano;

Não que posesse serra sobre serra,
Mas conquistando as ondas do Oceano
Fui capitão do mar, por onde andava
A armada de Neptuno, que eu buscava.

Amores da alta esposa de Peleo
Me fizerão tomar tamanha empresa;
Todas as Deosas desprezei do ceo
Só por amar das agoas a Princesa.
Hum dia a vi, co as filhas de Nereo
Sair nua na praia, e logo presa
A vontade senti de tal maneira,
Que inda não sinto cousa que mais queira.

Como fosse impossibil alcançá-la
Pola grandeza feia de meu gesto,
Determinei por armas de tomá-la,
E a Doris este caso manifesto.
De medo a Deosa então por mi lhe falla;
Mas ella cum fermoso riso honesto
Respondeo: "Qual será o amor bastante
De Nympha que sustente o de hum Gigante?

Com tudo por livrarmos o Oceano
De tanta guerra, eu buscarei maneira
Com que, com minha honra, escuse o damno."
Tal resposta me torna a mensageira.
Eu que cair não pude neste engano
—Que he grande dos amantes a cegueira—
Enchêrão-me com grandes abondanças
O peito de desejos e esperanças.

Já nescio, já da guerra desistindo,
Hũa noite de Doris prometida
Me aparece de longe o gesto lindo
Da branca Thetis, unica, despida.
Como doudo corri, de longe abrindo
Os braços, pera aquella que era vida
D'este corpo, e começo os olhos bellos
A lhe beijar, as faces e os cabellos.

O' que não sei de nojo como o conte!
Que crendo ter nos braços quem amava,
Abraçado me achei cum duro monte
De aspero mato e de espessura brava.

Estando cum penedo fronte a fronte,
Que eu polo rosto angelico apertava,
Não fiquei homem, não, mas mudo e quedo,
E junto de hum penedo outro penedo.

O' Nympha, a mais fermosa do Oceano,
Já que minha presença não te agrada,
Que te custava ter-me neste engano,
Ou fosse monte, nuvem, sonho, ou nada?
D'aqui me parto, irado e quasi insano
Da magoa e da deshonra ali passada,
A buscar outro mundo onde não visse
Quem de meu pranto e de meu mal se risse.

Erão já neste tempo meus irmãos
Vencidos e em miseria estrema postos,
E por mais segurar-se os Deoses vãos,
Alguns a varios montes sottopostos.
E como contra o Ceo não valem mãos,
Eu que chorando andava meus desgostos,
Comecei a sentir do fado immigo
Por meus atrevimentos o castigo.

Converte-se-me a carne em terra dura,
Em penedos os ossos se fizerão,
Estes membros que vês e esta figura
Por estas longas agoas se estendêrão;
Em fim minha grandissima estatura
Neste remoto cabo convertêrão
Os Deoses, e por mais dobradas magoas
Me anda Thetis cercando d'estas agoas."

Assi contava, e cum medonho choro
Subito de ante os olhos se apartou;
Desfez-se a nuvem negra, e cum sonoro
Bramido muito longe o mar soou.
Eu levantando as mãos ao sancto coro
Dos Anjos, que tão longe nos guiou,
A Deos pedi que removesse os duros
Casos que Adamastor contou futuros.

The *Sun* five times the *Earth* had compassed
Since *We* (from thence departed) *Seas* did plough
Where never Canvas wing before was spred,

515

A prosp'rous Gale making the *top-yards* bow:
When on a *night* (without suspect, or dred,
Chatting together in the cutting *Prow*)
 Over our Heads appear'd a sable *Clowd,*
 Which in thick darkness did the *Welkin* shrowd.

So big it lookt, such stern *Grimaces* made,
As fill'd our Hearts with horror, and appall,
Black was the *Sea,* and at long distance brayd
As if it roar'd *through* Rocks, *down* Rocks did fall.
O *Pow'r* inhabiting the *Heav'ns,* I said!
What divine threat is? What *mystical*
 Imparting of thy will in so *new form,*
 For this is a Thing greater than a *Storm?*

I had not ended, when a *humane* Feature
Appear'd to us ith' *Ayre,* Robustious, ralli'd
Of *Heterogeneal* parts, of *boundless* Stature,
A *Clowd* in's *Face,* a *Beard* prolix and squallid:
Cave-Eyes, a *gesture* that betray'd ill *nature,*
And a worse mood, a clay *complexion* pallid:
 His crispt *Hayre* fill'd with *earth,* and hard as *Wyre,*
 A *mouth* cole-black, of *Teeth* two yellow Tyre.

Of such *portentous* Bulk was this COLOSSE,
That I may tell thee (and not tell amiss)
Of that of RHODES it might supply the loss
(One of the WORLD's *Seav'n Wonders*) out of this
A *Voyce* speaks to us: so profound, and grosse,
It seems ev'n torn out of the vast ABYSS.
 The *Hayre* with horror stands on end, of *mee*
 And all of us, at what we *hear,* and *see.*

And *this* it spake. O *you,* the boldest Folke
That ever in the world great things assayd;
Whom such dire *Wars,* and infinite, the *smoke*
And *Toyle* of GLORY have not weary made;
Since these *forbidden* bounds by *you* are broke,
And *my* large Seas *your* daring *keeles* invade,
 Which I so long injoy'd, and kept *alone,*
 Unplough'd by *forreign* Vessel, or our *owne.*

Since the hid secrets you are come to spye
Of NATURE and the *humid* Element;
Never reveal'd to any MORTAL's Eye
Noble, or *Heroes,* that before you went:

Hear from *my* mouth, for your presumption high
What *losses* are in store, what *Plagues* are meant,
 All the wide OCEAN over, and the LAND,
 Which with hard *War* shall *bow* to your command.

This know; As many *Ships* as shall persever
Boldly to make the Voyage *you* make now,
Shall find this POYNT their enemie for ever
With *winds* and *tempests* that no bound shall know:
And the first FLEET OF WAR that shall indeaver
Through these inextricable Waves to go,
 So fearful an *example* will I make,
 That men shall say I *did* more than I *spake.*

Here I expect (unless my hopes have ly'de)
On my *discov'rer* full Revenge to have;
Nor shall *He* (onely) *all* the Ills abide,
Your *pertinacious* confidences crave:
But to your Vessels *yearly* shall betide
(Unless, provoked, I in vain do rave)
 Shipwracks, and *losses* of each kinde and Race;
 Amongst which, *death* shall have the lowest place.

And of the first that comes this way (in whom
With heighth of *Fortune,* heighth of *Fame* shall meet)
I'll be a new, and everlasting Tomb,
Through GOD's unfathom'd judgement. At these Feet
He shall drop *all* his *Glories,* and inhume
The glitt'ring *Trophies* of a *Turkish* Fleet.
 With *me* conspire his Ruine, and his Fall,
 Destroyd QUILOA, and MOMBASSA's Wall.

Another shall come after, of good *fame,*
A *Knight,* a *Lover,* and a *lib'ral Hand;*
And with him bring a fair and gentle *dame,*
Knit *his* by LOVE, and HYMEN's sacred Band.
In an ill hour, and to your loss and shame,
Ye come within the *Purlews* of *my* land;
 Which (kindly cruel) from the *sea* shall free you,
 Drown'd in a *sea* of miseries to see you.

Sterv'd shall they see to death their *Children* deare;
Begot, and *rear'd,* in so great *love.* The black
Rude CAFRES (out of *Avarice*) shall teare
The *Cloathes* from the *Angellick Lady's* back.

Her dainty limbs of *Alablaster* cleare
To *Heate,* to *Cold,* to *Storm,* to *Eyes's* worse *Rack*
 Shall be laid *naked;* after she hath trod
 (Long time) with her soft Feet the burning Clod.

Besides all this; *Their Eyes* (whose happier lot
Will be to scape from so much miserie)
This *Yoake* of LOVERS, out into the hot
And unrelenting *Thickets* turn'd shall see.
Ev'n *there* (when *Teares* they shall have squeez'd and got
From *Rocks* and *Desarts,* vvhere no *waters* be)
 Embracing *(kind)* their *souls* they shall exhale
 Out of the faire, but miserable, *Iayle.*

The ugly *Monster* vvent to rake into
More, of our *Fate;* vvhen, starting on my feet,
I ask him, *Who art Thou?* (for to say true
Thy hideous Bulk amazes me to see't.)
HEE (vvreathing his black mouth) about him threvv
His savvcer-Eyes: And (as his soul vvould fleet)
 Fetching a dismal groan, *replide* (as *sory,*
 Or *vext,* or *Both,* at the *Intergatory.*)

I am that great and secret HEAD of LAND,
Which *you* the CAPE OF TEMPESTS well did call;
From STRABO, PTOLOMEE, POMPONIUS, And
Grave PLINY hid, and from the ANTIENTS all.
I the *but-end,* that knits wide AFFRICK's strand;
My *Promontory* is her *Moun'd* and *Wall,*
 To the ANTARTICK POLE: which (neverthelesse)
 You, only, have the boldness to transgresse.

Of the rough *sons* oth' EARTH, was *I:* and *Twin,*
Brother to *Him,* that had an hundred Hands,
I was call'd ADAMASTOR, and was in
The *Warr* 'gainst *Him,* That hurls hot VULCAN's Brands.
Yet Hills on Hills *I* heapt not: but (to win
That *Empire,* which the SECOND JOVE commands)
 Was GENERALL at *Sea;* on which did sayle
 The *Fleet* of NEPTUNE, which *I* was to quayle.

The *love* I bare to PELEUS's spouse divine
Imbarqu'd mee in so wild an *Enterprize.*
The fayrest GODDESSE that the *Heav'ns* inshrine
I, for the *Princesse* of the *Waves* despise.

Vpon a day when *out* the *Sun* did shine,
With Nereus's daughters (on the Beach) these eyes
 Beheld her *naked:* streight I felt a *dart*
 Which *Time,* nor *scorns,* can pull out of my *Heart.*

I knew't impossible to gain her *Love*
By reason of my great deformitie
What *force* can doe I purpose then to prove:
And, Doris call'd, let *Her* my purpose see.
The *Goddess* (out of feare) did Thetys move
On my behalfe: but with a chaste smile *shee*
 (As *vertuous* full, as she is *fayre*) replide,
 What Nymph can such a heavy love abide?

How ever *Wee* (to save the *sea* a part
In so dire *War*) will take it into thought
How with our *honour* we may cure his smart.
My *Messenger* to *mee* thus answer brought.
I, That suspect no *stratagem,* no *Art,*
(How easily are purblind *Lovers* caught)
 Feel my selfe wondrous light with this Return;
 And fann'd with *Hopes,* with fresh *desire* doe burn.

Thus fool'd, thus cheated from the warr begun,
On a time (Doris pointing where to meet)
I spy the glitt'ring forme, ith' *evening* dun,
Of snowy Thetys with the silver feet.
With open Armes (farr off) like mad I run
To clip therein my *Ioy,* my *Life,* my *Sweet:*
 And (*clipt*) begin those orient *Eyes* to kis,
 That Face, *that* Hayre, *that* Neck, *that* All that is.

O, how I choake in utt'ring my disgrace!
Thinking I *Her* embrac'd whom I did seek,
A *Mountain* hard I found I did embrace
O'regrown with Trees and Bushes nothing sleek.
Thus (grapling with a *Mountain* face to face,
Which I stood pressing for her *Angel's* cheek)
 I was no *Man:* No but a stupid *Block*
 And *grew* unto a *Rock* another *Rock.*

O *Nymph* (the fayrest of the Ocean's Brood)!
Since with my *Features* thou could'st not be caught,
What had it cost to spare me that *false* good,
Were it a *Hill,* a *Clowd,* a *Dreame,* or *Thought?*

519

Away fling I (with *Anger* almost *wood*,
Nor lesse with *shame* of the *Affront* distraught)
 To seek *another* World: That I might live,
 Where *none* might *laugh*, to see me *weep*, and *grieve*.

By this my *Brethren* on their Backs were cast,
Reduc'd unto the depth of misery:
And the *vain Gods* (all hopes to put them past)
On *Those*, That *Mountayns* pyl'd, pyl'd *Mountains* high.
Nor I, that mourn'd farr off my deep distast,
"(HEAU'N, HANDS in vain *resist*, in vain FEET *fly*.
 For my *design'd* Rebellion, and Rape,
 The vengeance of pursuing *Fate* could scape.

My *solid flesh* converteth to *tough Clay*:
My *Bones* to *Rocks* are metamorphosed:
These *leggs*, these *thighs* (behold how large are *they*!)
O're the long *sea* extended were and spred.
In fine into this CAPE out of the way
My monstrous *Trunk*, and high-erected *Head*,
 The GODS did turn: where (for my greater payn)
 THETYS doth *Tantalize* me with the MAYN.

Here ends. And (gushing out into a *Well*
Of *Tears*) forthwith he vanish from our sight.
The black *Clowd* melting, with a hideous yell
The OCEAN sounded a long way forthright.
I (in *their* presence, who by *miracle*
Had thus far brought us, ev'n the ANGELLS bright)
 Besought the LORD to shield his *Heritage*
 From *all* that ADAMASTOR did presage.

<div align="right">

Os Lusiadas (1571), v, 37–60
Translated by Richard Fanshaw

</div>

Our minds are entranced, infused with a feeling of admiration; we experience at the same time sublime emotions and a heightened interest in a picture that, without either physical or moral being, justifiably enjoys all the noblest, boldest and most sublime privileges that ever existed in the most fanciful universe of the most supreme poetry. Such is the sovereign marvel of the never sufficiently to be praised episode of Adamastor in the Lusiads, the first epopee that appeared in Europe written in octave rhyme.

<div align="right">

FRANCISCO DIAS GOMES
Analyse (1790)

</div>

ODE

Mignonne, allons voir si la rose
Qui ce matin avoit desclose
Sa robe de pourpre au Soleil,
A point perdu ceste vesprée
Les plis de sa robe pourprée
Et son teint au vostre pareil.

Las! voyez comme en peu d'espace,
Mignonne, elle a dessus la place
Las, las, ses beautez laissé cheoir!
O vrayment marastre Nature,
Puis qu'une telle fleur ne dure
Que du matin jusques au soir!

Donc, si vous me croyez mignonne,
Tandis que vostre âge fleuronne
En sa plus verte nouveauté,
Cueillez, cueillez vostre jeunesse:
Comme à ceste fleur la vieillesse
Fera ternir vostre beauté.

See, Mignonne, hath not the rose,
That this morning did unclose
 Her purple mantle to the light,
Lost, before the day be dead,
The glory of her raiment red,
 Her color, bright as yours is bright?

Ah, Mignonne, in how few hours
The petals of her purple flowers
 All have faded, fallen, died;
Sad Nature, mother ruinous,
That seest thy fair child perish thus
 'Twixt matin song and even-tide.

Hear me, darling, speaking sooth,
Gather the fleet flower of your youth,
 Take ye your pleasure at the best;

Be merry ere your beauty flit,
For length of days will tarnish it
Like roses that were loveliest.

Translated by Andrew Lang

It is the perfection of his tongue. Its rhythm reaches the exact limit of change which a simple metre will tolerate: where it saddens, a lengthy hesitation at the opening of the seventh line introduces a new cadence, a lengthy lingering upon the last syllables of the tenth, eleventh and twelfth closes a grave complaint. So, also by an effect of quantities, the last six lines rise out of melancholy into their proper character of appeal and vivacity: an exhortation.

Certainly those who are so unfamiliar with French poetry as not to know that its whole power depends upon an extreme subtlety of rhythm, may find here the principal example of the quality they have missed. Something much less weighty than the stress of English lines, a just perceptible difference between nearly equal syllables, marks the excellent from the intolerable in French prosody: and to feel this truth in the eighteen lines . . . it is necessary to read them virtually in the modern manner—for the "s" in "vesprée" or "vostre" were pedantries in the sixteenth century—but one must give the mute "e's" throughout as full a value as they have in singing. Indeed, reading this poem, one sees how it must have been composed to some good and simple air in the man's head.

If the limits of a page permitted it, I would also show how worthy the thing was of fame from its pure and careful choice of verb— "Tandis que vostre age FLEURONNE"*—but space prevents me, luckily, for all this is like splitting a diamond.*

HILAIRE BELLOC
Avril (1904)

PIERRE DE RONSARD

1 5 2 4 — 1 5 8 5

SONNET

Je fuy les pas frayez du meschant populaire,
Et les villes où sont les peuples amassez:
Les rochers, les forests desja sçavent assez
Quelle trampe a ma vie estrange et solitaire.
Si ne suis-je si seul, qu'Amour mon secretaire

N'accompagne mes pieds debiles et cassez:
Qu'il ne conte mes maux et presens et passez
A ceste voix sans corps, qui rien ne sçauroit taire.
 Souvent plein de discours, pour flatter mon esmoy,
Je m'arreste, et je dy: Se pourroit-il bien faire
Qu'elle pensast, parlast, ou se souvint de moy?
 Qu'à sa pitié mon mal commençast à desplaire?
Encor que je me trompe, abusé du contraire,
Pour me faire plaisir, Helene, je le croy.

I fly the crowded roads where thousands hurry,
 and fly the populous town for rock and wood,
those friends, who know how well their natures marry
 with my strange temper and my solitude.
Am I alone, when love, my secretary,
 follows my halting steps, as though he could
with his immortal voice bid Time to tarry
 while he repeats the pains I have withstood?
Often indeed, when most my sorrows fret me,
 I stop to wonder, "Does she speak, my pretty,
or think of him who loves her—or forget me
 because my agony outruns her pity?"
And thus, though knowing it is false, I feign
to dream of pleasure while I live in pain.

Translated by Humbert Wolfe

He has the right to wear the purple in the Olympia of the poets.

THÉODORE DE BANVILLE
Les Poëtes français (1861)

PIERRE DE RONSARD

1 5 2 4 — 1 5 8 5

MY GOLDEN HELEN

Ma douce Hélène, non, mais bien ma douce haleine,
 Qui froide rafraischis la chaleur de mon cœur,
Je prens de ta vertu cognoissance et vigueur,
 Et ton œil, comme il veut, à son plaisir me meine:
 Heureux celuy qui souffre une amoureuse peine

Pour un nom si fatal! heureuse la douleur,
Bienheureux le tourment qui vient pour la valeur
Des yeux, non, pas des yeux, mais de l'astre d'Hélène!
 Nom malheur des Troyens, sujet de mon soucy,
Ma sage Penelope et mon Hélène aussi,
Qui d'un soin amoureux tout le cœur m'envelope:
 Nom qui m'a jusqu'au Ciel de la terre enlevé,
Qui eust jamais pensé que j'eusse retrouvé
 En une mesme Hélène une autre Penelope?

L'autre jour que j'estois sur le haut d'un degré
 Passant tu m'advisas, et, me tournant la veue,
Tu m'esblouis les yeux, tant j'avois l'ame esmeue
De me voir en sursaut de tes yeux rencontré.
 Ton regard dans le cœur, dans le sang m'est rentré,
Comme un esclat de foudre alors qu'il fend la nue
J'eus de froid et de chaud la fievre continue
D'un si poignant regard mortellement outré.
 Et si ta belle main passant ne m'eust faict signe,
Main blanche qui se vante d'estre celle d'un cygne,
Je fusse mort, Hélène, aux rayons de tes yeux:
 Mais ton signe retint l'ame presque ravie,
Ton œil se contenta d'estre victorieux,
Ta main se réjouit de me donner la vie.

Ma Dame se levoit un beau matin d'esté,
 Quand le Soleil attache à ses chevaux la bride:
Amour estoit present avecq sa trousse vuide,
Venu pour la remplir des traicts de sa clarté.
 J'entre-vy dans son sein deux pommes de beauté,
Telles qu'on ne void point au verger Hesperide:
Telles ne porte point la deësse de Cnide,
Ny celle qui a Mars des siennes allaicté.
 Telle enflure d'yvoire en sa voute arrondie,
Tel relief de porphyre, ouvrage de Phidie,
Eut Andromede alors que Persée passa,
 Quand il la vid liée à des roches marines,
Et quand la peur de mort tout le corps luy glaça,
Transformant ses tetins en deux boules marbrines.

Je ne veux comparer tes beautez à la Lune:
 La Lune est inconstante, et ton vouloir n'est qu'un:
Encor moins au Soleil; le Soleil est commun,
Commune est sa lumiere, et tu n'est pas commune.
 Tu forces par vertu l'envie et la rancune,

Je ne suis, te louant, un flateur importun;
Tu sembles à toymesme, et n'as pourtraict aucun,
Tu es toute ton Dieu, ton astre et ta fortune.
 Ceux qui font de leur dame à toy comparaison
Sont ou presomptueux, ou perclus de raison;
D'esprit et de sçavoir de bien loin tu les passes.
 Ou bien quelque demon de ton corps s'est vestu,
Ou bien tu es pourtraict de la mesme Vertu,
Ou bien tu es Pallas, ou bien l'une des Graces.

Vous estes le bouquet de vostre bouquet mesme,
 Et la fleur de sa fleur, sa grace et sa verdeur:
De vostre douce haleine il a pris son odeur,
Il est, comme je suis, de vostre amour tout blesme.
 Madame, voyez donc, puis qu'un bouquet vous aime,
Indigne de juger que peut vostre valeur,
Combien doy-je sentir l'ame de douleur
Qui sers par jugement vostre excellence extresme.
 Mais ainsi qu'un bouquet se flestrit en un jour,
J'ay peur qu'un mesme jour flestrisse vostre amour:
 Toute amitié de femme est soudain effacée.
 Advienne le Destin comme il pourra venir,
Il ne peut de vos yeux m'oster le souvenir:
 Il faudroit m'arracher le cœur et la pensée.

A fin qu'à tout jamais de siecle en siecle vive
 La parfaicte amitié que Ronsard vous portoit,
 Comme vostre beauté la raison luy ostoit,
Comme vous enchaisniez sa liberté captive,
 A fin que d'âge en âge à nos nepveux arrive
Que toute dans mon sang vostre figure estoit,
Et que rien sinon vous mon cœur ne souhaittoit,
Je vous fais un present de ceste sempervive.
 Elle vit longuement en sa jeune verdeur;
 Long temps aprez la mort je vous feray revivre,
Tant peut le docte soin d'un gentil serviteur,
 Qui veut en vous servant toutes vertus ensuivre.
Vous vivrez, croyez-moy, comme Laure en grandeur,
Au moins tant que vivront les plumes et le livre.

My golden Helen, nay my gold inhaling
 that tempers my hot heart with its cool air,
 your eyes at will mislead me everywhere

slave to your virtue noted and prevailing.
Thrice happy he, whose stricken heart is ailing
 for Helen's fatal name, enchanted care,
 exquisite pain for eyelids that outwear
earthlight to shine in heaven a star unveiling.
Anguish of Troy, name! ensign of my grief,
 my wise Penelope, my Helen splendid
 whose lovely torment holds the heart of me,
name, that enskied a lover beyond belief,
 who could have guessed I'd find when all was ended
 in the same Helen a new Penelope.

Lately as dreaming on a stair I stood
 you passed me by, and, looking on my face,
 blinded my eyes with the immediate grace
of unanticipated neighbourhood.
As lightning splits the clouds, my heart and blood
 split with your beauty, and began to race,
 now ice, now fever, shattered in their place
by that unparalleled beatitude.
And, if your hand, in passing, had not beckoned—
 your whiter hand than is the swan's white daughter,
 Helen, your eyes had wounded me to death.
But your hand saved me in the mortal second,
 and your triumphant eyes the moment after
 revived their captive with an alms of breath.

When the sun yoked his horses of the air
 Helen one summer morning took the breeze,
while love, with empty quiver, did repair
 for arrows to his lucid armouries.
I saw the apples of her breast as fair
 as orchard fruit of the Hesperides,
outshining what the Cnidian laid bare,
 or hers who suckled Mars upon her knees.
The swelling ivories in their rounded arches
 were as such as Pheidias fashioned in relief
 for his Andromeda, when her young Greek
found her rock-fastened by the sea's cold marches,
 her breasts by mortal terror changed and grief
 into the marbled globe of Verd Antique.

Shall I your beauties with the moon compare?
 She's faithless, you a single purpose own.
Or to the general sun, who everywhere
 goes common with his light; You walk alone?

And you are such that envy must despair
 of finding in my praise aught to condone,
who have no likeness since there's naught as fair,
 yourself your god, your star, Fate's overtone.
Those mad or rash, who make some other woman
 your rival, hurt themselves when they would hurt you,
 so far your excellence their dearth outpaces.
Either your body shields some noble demon,
 or mortal you image immortal virtue,
 Or Pallas you or first among the Graces.

You are the scent wherewith your posy's scented,
 bloom of its bloom, the wherefore and the whence
of all its sweet, that with your love acquainted
 suffers, like me, passion's pale decadence.
And if these flowers are by love demented,
 adoring what so far exceeds their sense,
judge if I am divinely discontented
 who know by heart your perfect excellence!
But, as the flower's beauty is diurnal
 may not, as is the way with woman's kindness,
 a single day bring all your love to naught?
Fate, do your worst! My love will be eternal,
 unless you overwhelm my eyes with blindness,
 and pluck my heart out and uproot all thought.

Let all men know reborn from age to age
 the perfect love love-perfect Ronsard bore you,
so that within your beauty, as in a cage,
 his mind's sole liberty was to adore you.
And let these be our children's heritage—
 this evergreen that I have woven for you,
bright with your face, immortal in the page,
 long as the love for which I did implore you.
Nor ever will its verdant youth be withered,
 unless to death your lover must surrender
 his utmost skill through which you live again
with all your graces in their blossom gathered.
 No! but with Laura you shall share love's splendour
 as long as there is life in book and pen.

Translated by Humbert Wolfe

The perfection and quintessence of high love-poetry.

D. B. WYNDHAM LEWIS
Ronsard (1944)

MAGIC

Quand vous serez bien vieille, au soir, à la chandelle.

When you grow old, at evening, in the candle-light.

Is there any single line in all English poetry more subdued to magic?
. . . That single line has sounded in the ears of the poets down the
centuries. Supreme in itself, it has begotten children of the divine race.
And when W. B. Yeats wrote his version:

'When you are old and gray and full of sleep'

he was on behalf of English poetry paying the ultimate tribute to the
great Frenchman, whom he could imitate but could not equal.

HUMBERT WOLFE
Pierre de Ronsard: Sonnets pour Helene (1934)

PIERRE DE RONSARD

1 5 2 4 — 1 5 8 5

DE L'ELECTION DE SON SEPULCRE

Antres, & vous fontaines
De ces roches hautaines
Devallans contre bas
D'un glissant pas:

Et vous forests, & ondes
Par ces prez vagabondes,
Et vous rives, & bois
Oiez ma vois.

Quand le ciel, & mon heure
Jugeront que je meure,
Ravi du dous sejour
Du commun jour,

528

Je veil, j'enten, j'ordonne,
Qu'un sepulcre on me donne,
Non pres des Rois levé,
 Ne d'or gravé,

Mais en cette isle verte,
Où la course entrouverte
Du Loir, autour coulant,
 Est accolant'.

Là où Braie s'amie
D'une eau non endormie,
Murmure à l'environ
 De son giron.

Je deffen qu'on ne rompe
Le marbre pour la pompe
De vouloir mon tumbeau
 Bâtir plus beau,

Mais bien je veil qu'un arbre
M'ombrage en lieu d'un marbre:
Arbre qui soit couvert
 Tousjours de vert.

De moi puisse la terre
Engendrer un l'hierre,
M'embrassant en maint tour
 Tout alentour.

Et la vigne tortisse
Mon sepulcre embellisse,
Faisant de toutes pars
 Un ombre épars.

Là viendront chaque année
A ma feste ordonnée,
Les pastoureaus estans
 Prés habitans.

Puis aiant fait l'office
De leur beau sacrifice,
Parlans à l'isle ainsi
 Diront ceci.

Que tu es renommée
D'estre tumbeau nommée

D'un de qui l'univers
 Ouira les vers!

Et qui onc en sa vie
Ne fut brulé d'envie
Mendiant les honneurs
 Des grans seigneurs!

Ni ne r'apprist l'usage
De l'amoureus breuvage,
Ni l'art des anciens
 Magiciens!

Mais bien à nos campaignes,
Feist voir les seurs compaignes
Foulantes l'herbe aus sons
 De ses chansons.

Car il sçeut sur sa lire
Si bons acords élire,
Qu'il orna de ses chants
 Nous, & nos champs.

La douce manne tumbe
A jamais sur sa tumbe,
Et l'humeur que produit
 En Mai, la nuit.

Tout alentour l'emmure
L'herbe, & l'eau qui murmure,
L'un d'eus i verdoiant,
 L'autre ondoiant.

Et nous aians memoire
Du renom de sa gloire,
Lui ferons comme à Pan
 Honneur chaque an.

Ainsi dira la troupe,
Versant de mainte coupe
Le sang d'un agnelet
 Avec du laict

Desus moi, qui à l'heure
Serai par la demeure
Où les heureus espris
 Ont leurs pourpris.

La gresle, ne la nége,
N'ont tels lieus pour leur siege,
Ne la foudre onque là
 Ne devala.

Mais bien constante i dure
L'immortelle verdure,
Et constant en tout tens
 Le beau printens.

Et Zephire i alaine
Les mirtes, & la plaine
Qui porte les couleurs
 De mile fleurs.

Le soin qui solicite
Les Rois, ne les incite
Le monde ruiner
 Pour dominer.

Ains comme freres vivent,
Et morts encore suivent
Les métiers qu'ils avoient
 Quand ils vivoient.

Là, là, j'oirai d'Alcée
La lire courroucée,
Et Saphon qui sur tous
 Sonne plus dous.

Combien ceus qui entendent
Les odes qu'ils rependent,
Se doivent réjouir
 De les ouir!

Quand la peine receue
Du rocher, est deceue
Sous les acords divers
 De leurs beaus vers!

La seule lire douce
L'ennui des cueurs repousse,
Et va l'esprit flattant
 De l'écoutant.

OF THE CHOICE OF HIS BURIAL-PLACE

Caverns and you, cascades,
From yonder steep arcades
That downward, valeward, fleet,
 With gliding feet;

And forests you and hills,
Runnels and wandering rills,
That through these meadows stray,
 Hark what I say!

Whenever death to me
Heaven and my hour decree,
Bidding me take my flight
 From kindly light,

I do forbid them hew
Out marble, so to view
My tomb may statelier show
 And fairer. No;

No, I will have a tree,
For marble, shadow me,
A tree that shall be seen
 Still full of green.

Yea, let an ivy birth
Have from my mouldering earth
And clip me, as I lie,
 With many a ply;

And let the trellised vine
About my tomb entwine,
Shedding, on every side,
 Its shadow wide.

So, on my festal day,
Each year, the shepherds gay
Shall to this grave of mine
 Come with their kine;

And having offered there
Their due of praise and prayer,
To th' eyot on this wise
 Shall they devise;

"How art thou high-renowned,
Being his burial-ground,
Of whom the universe
 Chanteth the verse!

Who in his lifetime ne'er
Consumed was with the care
Of honours nor chagrin
 Worship to win,

Who ne'er professed t'impart
The necromantic art
Nor eke the philtres sold
 Of usance old;

But to our lands, in fine,
He showed the Sisters Nine,
Following his tuneful song,
 The meads along:

For from his lyre he drew
Such sweet accords and true,
Us and our fields elect
 With songs he decked.

Be heaven's manna shed
For ever on his head
And those sweet dews that still
 May-nights distil!

Green grasses wall him round
And waters' murmuring sound,
These ever fresh and sweet,
 Those live and fleet!

Whilst we, still holding dear
His glory, every year,
To him, as Pan unto,
 Will honour do."

Thus shall the pastoral band
Discourse, with lavish hand,
Lambs' blood and milk, withal,
 Outpouring all

Upon my grave, who, then,
Beyond the abodes of men,
Shall be where spirits blest
 Forever rest.

533

There neither hail nor snow
The happy regions know,
Nor ever on them broke
 The thunderstroke;

But still on fields and woods
Immortal verdure broods
And constant ever there
 Is Springtide fair.

The care, that harries kings,
These happy never stings,
For empire's sake, to work
 Their neighbours' irk.

They dwell in brotherhood
And that which they ensued,
Whilst life on earth they led,
 Still follow, dead.

Alcæus' angry lyre
Shall greet me in that choir
And Sappho's, that o'er all
 Doth sweetliest fall.

How those, whose ears partake
The music that they make,
Must joy with glad amaze
 To hear their lays!

Since Sisyphus his toil
Their sweetness doth assoil
and Tantalus forgets
 His torment's frets.

The dulcet Lyre's sole air
Doth purge the heart of care
And healeth of despite
 The heark'ner's spright.

<div align="right">

Odes, iv, 5
Translated by John Payne

</div>

*All merits are united in this delectable work. . . . Above all its execu-
tion is perfect.*

<div align="right">

C.-A. SAINTE-BEUVE
Tableau historique et critique de la poésie française (1842)

</div>

ÉTIENNE JODELLE

1532 — 1573

AUX CENDRES DE CLAUDE COLET

Si ma voix, qui me doit bien tost pousser au nombre
 Des Immortels, pouuoit aller iusqu'à ton ombre,
 COLET, à qui la mort
 Se monstra trop ialouse & dépite d'attendre
 Que tu eusses parfait ce qui te peut deffendre
 De son auare port:

Si tu pouuois encor sous la cadence saincte
 D'vn Lut, qui gemiroit & ta mort, & ma plainte,
 Tout ainsi te rauir,
 Que tu te rauissois dessous tant de merueilles,
 Lors que durant tes iours ie faisois tes oreilles
 Sous mes loix s'asseruir:

Tu ferois escouter à la trouppe sacree
 Des Manes bien heureux, qui seule se recree
 Entre les lauriers verds,
 Les mots que maintenant deuôt en mon office
 Ie rediray neuf fois, pour l'heureux sacrifice,
 Que te doiuent mes vers.

Mais pource que ma voix, aduersaire aux tenebres,
 Ne pourroit pas passer par les fleuues funebres,
 Qui de bras tortillez
 Vous serrent à l'entour, & dont, peut estre, l'onde
 Pourroit souiller mes vers, qui dedans nostre monde
 Ne seront point souillez:

Il me faut contenter, pour mon deuoir te rendre,
 De tesmoigner tout bas à ta muette cendre,
 Bien que ce soit en vain,
 Que ceste horrible Sœur qui a tranché ta vie,
 Ne trancha point alors l'amitié qui me lie,
 Où rien ne peut sa main.

Que les fardez amis, dont l'amitié chancelle
 Sous le vouloir du fort, euitent vn IODELLE,
 Obstiné pour vanger
 Toute amitié rompue, amoindrie, & volage,
 Autant qu'il est ami des bons amis, que l'age
 Ne peut iamais changer.

Sois moy donc vn tesmoin, ô toy Tumbe poudreuse,
 Sois moy donc vn tesmoin, ô toy Fosse cendreuse,
 Qui t'anoblis des os
 Desia pourris en toy, sois tesmoin que i'arrache
 Maugré l'iniuste mort ce beau nom, qui se cache
 Dedans ta poudre enclos.

Vous qui m'accompagnez, ô trois fois trois pucelles,
 Qu'on donne à ce beau nom des ailes immortelles,
 Pour voler de ce lieu,
 Iusqu'à l'autel que tient vostre mere Memoire,
 Qui regaignant sans fin sus la mort la victoire,
 D'vn homme fait vn Dieu.

Pour accomplir mon vœu, ie vois trois fois espandre
 Trois gouttes de ce laict dessus la seiche cendre,
 Et tout autant de vin,
 Tien, reçoy le cyprés, l'amaranthe, & la rose,
 O Cendre bien heureuse, & mollement repose
 Icy iusqu'à la fin.

TO THE ASHES OF CLAUDE COLET

If only my song, that soon must exalt me to the band of Immortals, could reach your shade, Colet, for which death showed itself too jealous and spiteful to wait till you had fulfilled the work that would have saved you from oblivion; if only you could again hear the holy cadence of a lute which would lament your death with my sorrow, and enchant you just as you were transported by spells of magic in the days when I enslaved your ears to my will; then you would impel the sacred band of the blessed Shades, who alone rejoice among the green laurels, to listen to the words that now I shall repeat nine times in devout fulfillment of the happy sacrifice that my verses owe you.

But because my song, enemy of darkness, can not cross the funereal rivers that enclose you with tortuous arms, and because those waves might defile my verses, which in our world shall never be defiled, I must be content, in fulfilling my duty to honor you, to testify vainly in a soft voice to your silent ashes. The awesome Fate which has cut short your life did not sever, and has no power over, the friendship that binds me. Let the false friends, whose friendship slackens under the will of the strong, avoid Jodelle, who, as a friend of true friends whom time can never change, is determined to revenge all broken, weakened, and fickle friendships.

Be to me then a witness, O dusty Tomb! Be to me a witness, O ashy Grave, ennobled by bones already mouldered in you! Be witness that, in spite of unjust death, I snatch from you Colet's beautiful name that is concealed and enclosed in your dust. You that accompany me, O three times three maidens, give to Colet's beautiful name immortal wings to fly from this place as far as the altar held by your mother, Memory, who, gaining forever victory over death, changes a man into a god.

To accomplish my vow, three times I shall scatter three drops of milk over the dry ashes, and as much wine. Therefore receive the cypress, the amaranth, and the rose, O blessed Shade, and gently rest here till the end.

An incontestable masterpiece of French poetry.

Introduction à la poésie française (1939)

JEAN-ANTOINE DE BAÏF

1 5 3 2 — 1 5 8 9

LOVES

O doux plaisir plein de doux pensement,
 Quand la douceur de la douce meslee,
 Etreint & ioint, l'ame en l'ame meslee,
 Le corps au corps d'vn mol embrassement,

O douce vie! ô doux trepassement!
 Mon ame alors de grand' ioye troublee,
 De moy dans toy cherche d'aller emblee,
 Puis haut, puis bas s'écoulant doucement.

Quand nous ardants, Meline, d'amour forte,
 Moy d'estre en toy, toy d'en toy tout me prendre,
 Par cela mien, qui dans toy entre plus,

Tu la reçois, me laissant masse morte:
 Puis vient ta bouche en ma bouche la rendre,
 Me ranimant tous mes membres perclus.

Oh, the sweet pleasure full of sweet thought, when the sweetness of the sweet love struggle, clasps and joins, soul in soul mingled, body to body with a soft embrace. Oh, sweet life! Oh, sweet death! My

537

soul then stirred with great joy, seeks at once to transfuse itself into you, now high, now low and sweetly flowing. When both of us, Meline, ardent with strong desire, I being part of you, and you fully receptive, I being wholly myself the more I become part of you; you receive my life, leaving me a dead mass, then your lips restore life into my lips, reviving all my lifeless limbs.

A sonnet of a unique voluptuous sweetness which is perhaps the masterpiece of French erotic poetry.

THIERRY MAULNIER
Introduction à la poésie française (1939)

JEAN PASSERAT

1 5 3 4 — 1 6 0 2

VILLANELLE

J'ai perdu ma tourterelle;
Est-ce point celle que j'oy?
Je veux aller après elle.

Tu regrettes ta femelle,
Hélas! aussi fais-je moy.
J'ai perdu ma tourterelle.

Si ton amour est fidelle,
Aussi est ferme ma foy;
Je veux aller après elle.

Ta plainte se renouvelle,
Toujours plaindre je me doy;
J'ai perdu ma tourterelle.

En ne voyant plus la belle,
Plus rien de beau je ne voy;
Je veux aller après elle.

Mort, que tant de fois j'appelle,
Prends ce qui se donne à toy!
J'ai perdu ma tourterelle;
Je veux aller après elle.

I have lost my turtle-doo.
Is't not she I hear hard by?
After her I'd fain ensue.

Thou thy mate regrettest too.
Wellaway! And so do I.
I have lost my turtle-doo.

If thy love, indeed, is true,
So my faith is firm and high;
After her I'd fain ensue.

Thy complaint is ever new;
I too still must weep and sigh;
I have lost my turtle-doo.

Since I bade my fair adieu,
Nought of pleasance I espy;
After her I'd fain ensue.

Death, to whom so oft I sue,
Take thine own and let me die.
I have lost my turtle-doo;
After her I'd fain ensue.

Translated by John Payne

*It has given its exact character to the subsequent history of the villanelle.
. . . This exquisite lyric has continued to be the type of its class.*

EDMUND GOSSE
in Encyclopædia Britannica (1911)

ST. JOHN OF THE CROSS

1 5 4 2 — 1 5 9 1

CANCIONES ENTRE EL ALMA
Y EL ESPOSO

ESPOSA

1.—¿A dónde te escondiste,
 Amado, y me dejaste con gemido?
 Como el ciervo huiste,
 Habiéndome herido;
 Salí tras tí clamando, y eras ido.

2.—Pastores, los que fuerdes
 Allá por las majadas al Otero,
 Si por ventura vierdes
 Aquel que yo más quiero,
 Decilde que adolezco, peno y muero.

3.—Buscando mis amores,
 Iré por esos montes y riberas,
 Ni cogeré las flores,
 Ni temeré las fieras,
 Y pasaré los fuertes y fronteras.

PREGUNTA A LAS CRIATURAS

4.—¡Oh, bosques y espesuras,
 Plantadas por la mano del Amado!
 ¡Oh, prado de verduras,
 De flores esmaltado,
 Decid si por vosotros ha pasado!

RESPUESTA DE LAS CRIATURAS

5.—Mil gracias derramando,
 Pasó por estos sotos con presura,
 Y yéndolos mirando,
 Con sola su figura
 Vestidos los dejó de hermosura.

ESPOSA

6.—¡Ay, quién podrá sanarme!
 Acaba de entregarte ya de vero,
 No quieras enviarme
 De hoy más ya mensajero,
 Que no saben decirme lo que quiero.

7.—Y todos cuantos vagan,
 De ti me van mil gracias refiriendo,
 Y todos más me llagan,
 Y déjame muriendo
 Un no sé qué que quedan balbuciendo.

8.—Mas, ¿cómo perseveras,
 Oh vida, no viviendo donde vives,
 Y haciendo porque mueras,
 Las flechas que recibes,
 De lo que del Amado en ti concibes?

9.—¿Por qué, pues has llagado
 Aqueste corazón, no le sanaste?
 Y pues me le has robado,
 ¿Por qué así le dejaste,
 Y no tomas el robo que robaste?

10.—Apaga mis enojos,
 Pues que ninguno basta a deshacellos,
 Y véante mis ojos,
 Pues eres lumbre dellos,
 Y sólo para ti quiero tenellos.

11.—¡Oh, cristalina fuente,
 Si en esos tus semblantes plateados,
 Formases de repente
 Los ojos deseados,
 Que tengo en mis entrañas dibujados!

12.—Apártalos, Amado,
 Que voy de vuelo.

EL ESPOSO

 Vuélvete, paloma,
 Que el ciervo vulnerado
 Por el otero asoma,
 Al aire de tu vuelo, y fresco toma.

LA ESPOSA

13.—Mi Amado las montañas,
 Los valles solitarios nemorosos,
 Las ínsulas extrañas,
 Los ríos sonorosos,
 El silbo de los aires amorosos.

14.—La noche sosegada
 En par de los levantes de la aurora,
 La música callada,
 La soledad sonora,
 La cena que recrea y enamora.

15.—Nuestro lecho florido
 De cuevas de leones enlazado,
 En púrpura tendido,
 De paz edificado,
 De mil escudos de oro coronado

16.—A zaga de tu huella
Las jóvenes discurren al camino
Al toque de centella,
Al adobado vino,
Emisiones de bálsamo divino.

17.—En la interior bodega
De mi Amado bebí, y cuando salía
Por toda aquesta vega,
Ya cosa no sabía,
Y el ganado perdí que antes seguía.

18.—Allí me dió su pecho,
Allí me enseñó ciencia muy sabrosa,
Y yo le di de hecho
A mí, sin dejar cosa,
Allí le prometí de ser su esposa.

19.—Mi alma se ha empleado,
Y todo mi caudal en su servicio;
Ya no guardo ganado,
Ni ya tengo otro oficio,
Que ya sólo en amar es mi ejercicio.

20.—Pues ya si en el ejido
De hoy más no fuere vista ni hallada,
Diréis que me he perdido;
Que andando enamorada,
Me hice perdidiza, y fuí ganada.

21.—De flores y esmeraldas,
En las frescas mañanas escogidas,
Haremos las guirnaldas
En tu amor florecidas,
Y en un cabello mío entretejidas.

22.—En sólo aquel cabello
Que en mi cuello volar consideraste,
Mirástele en mi cuello,
Y en él preso quedaste,
Y en uno de mis ojos te llagaste.

23.—Cuando tú me mirabas,
Tu gracia en mí tus ojos imprimían;
Por eso me adamabas,
Y en eso merecían
Los míos adorar lo que en ti vían.

24.—No quieras despreciarme,
 Que si color moreno en mí hallaste,
 Ya bien puedes mirarme,
 Despúes que me miraste,
 Que gracia y hermosura en mí dejaste.

25.—Cogednos las raposas,
 Que está ya florecida nuestra viña,
 En tanto que de rosas
 Hacemos una piña,
 Y no parezca nadie en la montiña.

26.—Detente, Cierzo muerto,
 Ven, Austro, que recuerdas los amores,
 Aspira por mi huerto,
 Y corran sus olores,
 Y pacerá el Amado entre las flores.

ESPOSO

27.—Entrado se ha la Esposa
 En el ameno huerto deseado,
 Y a su sabor reposa,
 El cuello reclinado
 Sobre los dulces brazos del Amado.

28.—Debajo del manzano,
 Allí conmigo fuiste desposada,
 Allí te dí la mano,
 Y fuiste reparada
 Donde tu madre fuera violada.

29.—A las aves ligeras,
 Leones, ciervos, gamos saltadores,
 Montes, valles, riberas,
 Aguas, aires, ardores
 Y miedos de las noches veladores.

30.—Por las amenas liras,
 Y canto de serenas os conjuro,
 Que cesen vuestras iras,
 Y no toquéis al muro,
 Porque la Esposa duerma más seguro.

ESPOSA

31.—Oh, ninfas de Judea,
En tanto que en las flores y rosales
El ámbar perfumea,
Morá en los arrabales,
Y no queráis tocar nuestros umbrales.

32.—Escóndete, Carillo,
Y mira con tu haz a las montañas,
Y no quieras decillo;
Mas mira las compañas
De la que va por ínsulas extrañas.

ESPOSO

33.—La blanca palomica
Al arca con el ramo se ha tornado,
Y ya la tortolica
Al socio deseado
En las riberas verdes ha hallado.

34.—En soledad vivía,
Y en soledad ha puesto ya su nido,
Y en soledad la guía
A solas su querido,
También en soledad de amor herido.

ESPOSA

35.—Gocémonos, Amado,
Y vámonos a ver en tu hermosura
Al monte o al collado,
Do mana el agua pura,
Entremos más adentro en la espesura.

36.—Y luego a las subidas
Cavernas de la piedra nos iremos,
Que están bien escondidas,
Y allí nos entraremos,
Y el mosto de granadas gustaremos.

37.—Allí me mostrarías
Aquello que mi alma pretendía,
Y luego me darías
Allí tú, vida mía,
Aquello que me diste el otro día.

38.—El aspirar del aire,
 El canto de la dulce filomena,
 El soto y su donaire,
 En la noche serena
 Con llama que consume y no da pena.

39.—Que nadie lo miraba,
 Aminadab tampoco parecía,
 Y el cerco sosegaba,
 Y la caballería
 A vista de las aguas descendía.

SONG OF THE SOUL
AND THE BRIDEGROOM

THE BRIDE

1. Where hast Thou hidden Thyself,
 And abandoned me in my groaning, O my Beloved?
 Thou hast fled like the hart,
 Having wounded me.
 I ran after Thee, crying; but Thou wert gone.

2. O shepherds, you who go
 Through the sheepcots up the hill,
 If you shall see Him
 Whom I love the most,
 Tell Him I languish, suffer, and die.

3. In search of my Love
 I will go over mountains and strands;
 I will gather no flowers,
 I will fear no wild beasts;
 And pass by the mighty and the frontiers.

QUESTION TO THE CREATURES

4. O groves and thickets
 Planted by the hand of the Beloved;
 O verdant meads
 Enamelled with flowers,
 Tell me, has He passed by you?

5. A thousand graces diffusing
 He passed through the groves in haste,
 And merely regarding them
 As He passed
 Clothed them with His beauty.

THE BRIDE

6. Oh! who can heal me?
 Give me at once Thyself,
 Send me no more
 A messenger
 Who cannot tell me what I wish.

7. All they who serve are telling me
 Of Thy unnumbered graces;
 And all wound me more and more,
 And something leaves me dying,
 I know not what, of which they are darkly speaking.

8. But how thou perseverest, O life,
 Not living where thou livest;
 The arrows bring death
 Which thou receivest
 From thy conceptions of the Beloved.

9. Why, after wounding
 This heart, hast Thou not healed it?
 And why, after stealing it,
 Has Thou thus abandoned it.
 And not carried away the stolen prey?

10. Quench Thou my troubles,
 For no one else can soothe them;
 And let mine eyes behold Thee,
 For thou art their light,
 And I will keep them for Thee alone.

11. O crystal well!
 Oh that on Thy silvered surface
 Thou wouldest mirror forth at once
 Those eyes desired
 Which are outlined in my heart!

12. Turn them away, O my Beloved!
 I am on the wing:

THE BRIDEGROOM

Return, My Dove!
The wounded hart
Looms on the hill
In the air of thy flight and is refreshed.

THE BRIDE

13. My Beloved is the mountains,
 The solitary wooded valleys,
 The strange islands,
 The roaring torrents,
 The whisper of the amorous gales;

14. The tranquil night
 At the approaches of the dawn,
 The silent music,
 The murmuring solitude,
 The supper which revives, and enkindles love.

15. Our bed is of flowers
 By dens of lions encompassed,
 Hung with purple,
 Made in peace,
 And crowned with a thousand shields of gold.

16. In Thy footsteps
 The young ones run Thy way;
 At the touch of the fire
 And by the spiced wine,
 The divine balsam flows.

17. In the inner cellar
 Of my Beloved have I drunk; and when I went forth
 Over all the plain
 I knew nothing,
 And lost the flock I followed before.

18. There He gave me His breasts,
 There He taught me the science full of sweetness.
 And there I gave to Him
 Myself without reserve;
 There I promised to be His bride.

547

19. My soul is occupied,
 And all my substance in His service;
 Now I guard no flock,
 Nor have I any other employment:
 My sole occupation is love.

20. If, then, on the common land
 I am no longer seen or found,
 You will say that I am lost;
 That, being enamoured,
 I lost myself; and yet was found.

21. Of emeralds, and of flowers
 In the early morning gathered,
 We will make the garlands,
 Flowering in Thy love,
 And bound together with one hair of my head.

22. By that one hair
 Thou hast observed fluttering on my neck,
 And on my neck regarded,
 Thou wert captivated;
 And wounded by one of my eyes.

23. When Thou didst regard me,
 Thine eyes imprinted in me Thy grace:
 For this didst Thou love me again,
 And thereby mine eyes did merit
 To adore what in Thee they saw

24. Despise me not,
 For if I was swarthy once
 Thou canst regard me now;
 Since Thou hast regarded me,
 Grace and beauty hast Thou given me.

25. Catch us the foxes,
 For our vineyard hath flourished;
 While of roses
 We make a nosegay,
 And let no one appear on the hill.

26. O killing north wind, cease!
 Come, south wind, that awakenest love!
 Blow through my garden,
 And let its odours flow,
 And the Beloved shall feed among the flowers.

THE BRIDEGROOM

27. The bride has entered
 The pleasant and desirable garden,
 And there reposes to her heart's content;
 Her neck reclining
 On the sweet arms of the Beloved.

28. Beneath the apple-tree
 There wert thou betrothed;
 There I gave thee My hand,
 And thou wert redeemed
 Where thy mother was corrupted.

29. Light-wingèd birds,
 Lions, fawns, bounding does,
 Mountains, valleys, strands,
 Waters, winds, heat,
 And the terrors that keep watch by night;

30. By the soft lyres
 And the siren strains, I adjure you,
 Let your fury cease,
 And touch not the wall,
 That the bride may sleep in greater security.

THE BRIDE

31. O nymphs of Judea!
 While amid the flowers and the rose-trees
 The amber sends forth its perfume,
 Tarry in the suburbs,
 And touch not our thresholds.

32. Hide thyself, O my Beloved!
 Turn Thy face to the mountains.
 Do not speak,
 But regard the companions
 Of her who is travelling amidst strange islands.

THE BRIDEGROOM

33. The little white dove
 Has returned to the ark with the bough;
 And now the turtle-dove
 Its desired mate
 On the green banks has found.

34. In solitude she lived,
 And in solitude built her nest;
 And in solitude, alone
 Hath the Beloved guided her,
 In solitude also wounded with love.

THE BRIDE

35. Let us rejoice, O my Beloved!
 Let us go forth to see ourselves in Thy beauty.
 To the mountain and the hill,
 Where the pure water flows:
 Let us enter into the heart of the thicket.

36. We shall go at once
 To the deep caverns of the rock
 Which are all secret,
 There we shall enter in
 And taste of the new wine of the pomegranate.

37. There thou wilt show me
 That which my soul desired;
 And there Thou wilt give at once,
 O Thou, my life!
 That which Thou gavest me the other day.

38. The breathing of the air,
 The song of the sweet nightingale,
 The grove and its beauty
 In the serene night,
 With the flame that consumes, and gives no pains.

39. None saw it;
 Neither did Aminadab appear.
 The siege was intermitted,
 And the cavalry dismounted
 At the sight of the waters.

Translated by David Lewis

We exclaim, as Dante exclaimed of Virgil: 'Onorate l'altissimo poeta.'
 E. ALLISON PEERS
 The Complete Works of Saint John of the Cross (1934)

ERMINIA WANDERS IN THE FIELDS
AND DREAMS OF LOVE

Fuggí tutta la notte, e tutto il giorno
Errò senza consiglio e senza guida,
Non udendo o vedendo altro d' intorno,
Che le lagrime sue, che le sue strida.
Ma ne l' ora che 'l sol dal carro adorno
Scioglie i corsieri, e in grembo al mar s' annida,
Giunse del bel Giordano a le chiare acque,
E scese in riva al fiume, e qui si giacque. . . .

La fanciulla regal di rozze spoglie
S' ammanta, e cinge al crin ruvido velo;
Ma nel moto de gli occhi e de le membra
Non già di boschi abitatrice sembra.

Non copre abito vil la nobil luce,
E quanto è in lei d' altero e di gentile;
E fuor la mäestà regia traluce
Per gli atti ancor de l' esercizio umíle.
Guida la greggia a i paschi e la riduce
Con la povera verga al chiuso ovile;
E da l' irsute mamme il latte preme,
E 'n giro accolto poi lo stringe insieme.

Sovente, allor che su gli estivi ardori
Giacean le pecorelle a l' ombra assise,
Ne la scorza de' faggi e de gli allori
Segnò l' amato nome in mille guise:
E de' suoi strani ed infelici amori
Gli aspri successi in mille piante incise;
E in rileggendo poi le proprie note
Rigò di belle lagrime le gote.

Indi dicea piangendo: In voi serbate
Questa dolente istoria, amiche piante;
Perché, se fia ch' a le vostr' ombre grate
Giammai soggiorni alcun fedele amante,
Senta svegliarsi al cor dolce pietate
De le sventure mie sí varie e tante;

551

E dica: Ah troppo ingiusta empia mercede
Diè fortuna ed amore a sí gran fede!

Forse avverrà, se 'l Ciel benigno ascolta
Affettüoso alcun prego mortale,
Che venga in queste selve anco tal volta
Quegli a cui di me forse or nulla cale;
E, rivolgendo gli occhi ove sepolta
Giacerà questa spoglia inferma e frale,
Tardo premio conceda a' miei martíri
Di poche lacrimette e di sospiri:

Onde, se in vita il cor misero fue,
Sia lo spirito in morte almen felice,
E 'l cener freddo de le fiamme sue
Goda quel ch' or godere a me non lice.

Through thicke and thin, all night, all day, she driued,
Withouten comfort, company or guide,
Her plaints and teares with euery thought reuiued,
She heard and saw her griefes, but nought beside:
But when the sun his burning chariot diued
In *Thetis* waue, and weary teame vntide,
 On Iordans sandy bankes her course she staid
 At last, there downe she light, and downe she laid. . . . ₒ

The Princesse dond a poore pastoraes geare,
A kerchiefe course vpon her head she tide;
 But yet her gestures and her lookes (I gesse)
 Were such, as ill beseem'd a shepherdesse.

Not those rude garments could obscure and hide,
The heau'nly beauty of her angels face,
Nor was her princely off-spring damnifide,
Or ought disparag'd by those labours base;
Her little flocks to pasture would she guide,
And milke her goats, and in their folds them place,
 Both cheese and butter could she make, and frame
 Her selfe to please the shepherd and his dame.

But oft, when vnderneath the greene-wood shade
Her flocks lay hid from *Phœbus* scorching raies,
Vnto her Knight she songs and sonnets made,
And them engrau'd in barke of beech and baies;

She told how *Cupid* did her first inuade,
How conquer'd her, and ends with *Tancreds* praise:
 And when her passions writ she ouer read,
 Againe she mourn'd, againe salt teares she shed.

You happy trees for euer keepe (quoth shee)
This wofull story in your tender rinde,
Another day vnder your shade may bee,
Will come to rest againe some louer kinde;
Who if these trophies of my griefes he see,
Shall feele deare pitie pearce his gentle minde;
 With that she sigh'd and said, too late I proue
 There is no troath in fortune, trust in loue.

Yet may it be (if gracious heau'ns attend
The earnest suit of a distressed wight)
At my entreat they will vouchsafe to send
To these huge desarts that vnthankfull Knight,
That when to earth the man his eyes shall bend,
And sees my graue, my tombe, and ashes light,
 My wofull death, his stubborne heart may **moue,**
 With teares and sorrowes to reward my loue.

So, though my life hath most vnhappy beene,
At least yet shall my spirit dead be blest,
My ashes cold shall buried on this greene,
Enioy that good this bodie nere possest.
<div align="right">

Gerusalemme Liberata (1581), vii
Translated by Edward Fairefax
</div>

*Erminia abandoned to love has exquisite moments of lyricism. . . . Her
soul has the melancholy and thoughtful imprint of Tasso: a sort of sweet-
ness and delicacy of fibre that keeps her far from despair, and attunes her
heart to the peace and solitude of the country, the picture of which is
one of the most finished in Italian poetry.*
<div align="right">

FRANCESCO DE SANCTIS
Storia della letteratura italiana (1870)
Translated by Joan Redfern
</div>

ŒDIPUS

Je me veux séparer moymesme de mon corps.
Je me fuiray moymesme aux plutoniques bords.
Je fuiray ces deux mains, ces deux mains parricides,
Ce cœur, cet estomac, ces entrailles humides,
Horribles de forfaits. J'esloigneray les cieux,
L'air, la mer et la terre, édifices des dieux.
Puis-je encore fouler les campagnes fécondes
Que Cérès embellist de chevelures blondes?
Puis-je respirer l'air, boire l'eau qui refuit,
Et me paistre du bien que la terre produit?
Puis-je encore, polu des baisers d'Iocaste,
De ma dextre toucher la tienne qui est chaste?
Puis-je entendre le son, qui le cœur me refend,
Des sacrez noms de père et de mère et d'enfant?
Las! dequoy m'a servy qu'en la nuict éternelle
J'aye fait amortir ma lumière jumelle,
Si tous mes autres sens également touchez
De mes crimes ne sont, comme mes yeux, bouchez?
Il faut que tout mon corps pourrisse sous la terre,
Et que mon âme triste aux noirs rivages erre,
Victime de Pluton. Que fay-je plus ici,
Qu'infecter de mon corps l'air et la terre aussi?
Je ne voyois encor la clairté vagabonde
Du jour, et je n'estois encores en ce monde,
Les doux flancs maternels me retenoyent contraint,
Qu'on me craignoit desjà, que j'estois desjà craint.

I wish to cast off my body. On the Plutonic shores I will flee from myself. I will flee from these hands, these two parricidal hands, this heart, this stomach, these blood-dripping entrails, horrible in crime. I will thrust away the heavens, the air, the sea and the land, abodes of the gods. Can I again tread upon the fruitful fields that Ceres embellishes with golden grain? Can I breathe the air, drink the elusive water, and feed on the bounty of the land? Can I again, polluted with the kisses of Jocasta, with my right hand touch your chaste one. Can I hear the heart-rending sound of the sacred names of father, mother and child? Alas! what profits it me that in the eternal night I have quenched the twin lights of my eyes, if all my other senses, equally touched by my crimes, are not closed like my eyes? All my body must rot under the earth, and

my sad soul must wander along the black shores, a victim of **Pluto**.
Nothing is left for me here now but to pollute with my body both the
air and the earth. When I had not yet seen the wandering light of day,
before I had seen this world, the sweet maternal flanks held me en-
closed; even then they already feared me; I even then was feared.

<div align="right">

Antigone (1579)
Act i, Scene i

</div>

*He has no equal in our literature. His equivalent is found only in
Shakespeare and in the ancient writers. . . . He is the incomparable
poet of invocation, imprecation and malediction.*

<div align="right">

THIERRY MAULNIER
Introduction à la poésie française (1939)

</div>

MIGUEL DE CERVANTES

1 5 4 7 — 1 6 1 6

FIRST AND LAST

En un lugar de la Mancha, de cuyo nombre no quiero acordarme, no
há mucho tiempo que vivía un hidalgo de los de lanza en astillero, adarga
antigua, rocín flaco, y galgo corredor.

In a certain village in La Mancha, of which I cannot remember the
name, there lived not long ago one of those old-fashioned gentlemen,
who are never without a lance upon a rack, an old target, a lean horse,
and a greyhound.

<div align="center">

❋ ❋ ❋ ❋

</div>

Yo, señores, siento que me voy muriendo a toda priesa: déjense burlas
aparte, y tráiganme un confesor que me confiese, y un escribano que
haga mi testamento, que en tales trances como éste no se ha de burlar
el hombre con el alma.

I find it comes fast upon me; therefore pray, gentlemen, let us be
serious. I want a priest to receive my confession, and a scrivener to
draw up my will. There is no trifling at a time like this.

<div align="right">

Don Quixote (1605–15)
Translated by Peter Anthony Motteux

</div>

No book has such a good beginning as DON QUIXOTE*. . . . No book has
a finer end.*

<div align="right">

MAURICE BARING
Have You Anything to Declare? (1936)

</div>

Of all the books I have read, DON QUIXOTE *is the one I would desire most to have written.*

CHARLES DE SAINT-ÉVREMOND
De Quelques Livres espagnols, italiens et français (1705)

GILLES DURANT

1 5 5 0 ? — 1 6 0 5 ?

ODE

Charlotte, si ton ame
Se sent ore allumer
De cette douce flâme
Qui nous force d'aimer,
 Allons contens,
Allons sur la verdure,
Allons, tandis que dure
Notre jeune printemps.

Avant que la journée
De notre âge qui fuit,
Se trouve environnée
Des ombres de la nuit,
 Prenons loisir
De vivre notre vie;
Et, sans craindre l'envie,
Donnons-nous du plaisir.

Du soleil la lumiere
Vers le soir se déteint,
Puis à l'aube premiere
Elle reprend son teint;
 Mais notre jour,
Quand une fois il tombe,
Demeure sous la tombe,
Sans espoir de retour.

Et puis les ombres saintes,
Hotesses de là-bas,
Ne démennent qu'en feintes
Les amoureux ébats:

556

Entre elles, plus
Amour n'a de puissance,
Et plus n'ont connoissance
Des plaisirs de Vénus.

Mais, tristement couchées
Sous les myrthes pressés,
Elles pleurent fâchées
Leurs âges mal passés;
 Se lamentant
Que n'ayant plus de vie,
Encore cette envie
Les aille tourmentant.

En vain elles desirent
De quitter leur séjour;
En vain elles soupirent
De revoir notre jour:
 Jamais un mort,
Ayant passé le fleuve
Qui les ombres abreuve,
Ne revoit notre bord.

Aimons donc à notre aise,
Baisons-nous bien et beau,
Puisque plus on ne baise
Là-bas sous le tombeau.
 Sentons-nous pas
Comme jà la jeunesse,
Des plaisirs larronnesse,
Fuit de nous à grands pas?

Çà, finette affinée,
Çà, trompons le destin,
Qui clôt notre journée
Souvent dès le matin.

TO HIS MISTRESS

If, fairest, through thy heart
Anon thou feelest course
The fire of that sweet smart,
That makes us love perforce,

On the sward sooth
Come let us take our fill
Of ease, whilst dureth still
The Springtide of our youth.

Or e'er the dulcet day
Of this our age in flight
Be given for a prey
Unto the shades of night,
 Let's leisure take
Our life at ease to live
Nor heed to envy give,
But love and merry make.

The sun, indeed, is shorn
Of all his rays at e'en;
Yet, with the break of morn,
He hath again his sheen:
 But this our day,
When once 't hath lost its bloom,
Descendeth to the tomb
Nor thence returneth aye.

Yea, and the shadows blest,
That fill the realms below,
But counterfeit, at best,
Love's sports in empty show:
 Among these sprights,
He hath no puissance more;
The taste the dead ignore
Of Venus's delights.

Nay, lying sad and prone,
Among the myrtles pale,
Their sweet days they bemoan,
Forspent without avail,
 Lamenting shrill
That, though they're quit of life,
The wish thereof to strife
And sorrow stirs them still.

In vain and still in vain
To quit their stead they sigh;
In vain they yearn, again
To see the day on high:

The dead ne'ermore,
Once past the river's brink,
Whereof the shadows drink,
Set eyes upon Life's shore.

Then let us kiss and share
Our fill of love and mirth.
There is no kissing, fair,
Beneath the graveyard earth.
 Do we not feel
How Time, with hurrying feet,
That thief of pleasance sweet,
Our youth from us doth steal?

Come, then, coquettish maid,
Let's steal a march on Fate,
That doth our day o'ershade,
Oft ere the morn wax late.
 On the sward sooth
Come let us take our fill
Of ease, whilst dureth still
The Springtide of our youth.

Translated by John Payne

Neither Passerat, nor Ronsard nor any other poet of the century ex-
pressed better than he that sensation of sadness which is born even in
the midst of gaiety, and those thoughts of death eternally linked with
experiences of pleasure.

C.-A. SAINTE-BEUVE
La Poésie française (1843)

THÉODORE AGRIPPA D'AUBIGNÉ

1 5 5 2 — 1 6 3 0

CAIN

Ainsi Abel offroit en pure conscience
Sacrifices à Dieu, Caïn offroit aussi:
L'un offroit un cœur doux, l'autre un cœur endurci,
L'un fut au gré de Dieu, l'autre non agreable.
Caïn grinça les dents, palit, espouvantable,

Il massacra son frere, & de cet agneau doux
Il fit un sacrifice à son amer courroux.
Le sang fuit de son front, & honteux se retire
Sentant son frere sang que l'aveugle main tire;
Mais, quand le coup fut fait, sa premiere pasleur
Au prix de la seconde estoit vive couleur:
Ses cheveux vers le ciel herissés en furie,
Le grincement de dents en sa bouche flestrie,
L'œil sourcillant de peur descouvroit son ennuy.
Il avoit peur de tout, tout avoit peur de luy:
Car le ciel s'affeubloit du manteau d'une nue
Si tost que le transi au ciel tournoit la veuë;
S'il fuyoit au desert, les rochers & les bois
Effrayés abbayoyent au son de ses abois.
Sa mort ne peut avoir de mort pour recompense,
L'enfer n'eut point de morts à punir cette offense,
Mais autant que de jours il sentit de trespas:
Vif il ne vescut point, mort il ne mourut pas.
Il fuit d'effroi transi, troublé, tremblant et blesme,
Il fuit de tout le monde, il s'enfuit de soy-mesme.
Les lieux plus asseurés luy estoyent des hazards,
Les fueilles, les rameaux & les fleurs des poignards,
Les plumes de son lict des esguilles piquantes,
Ses habits plus aisez des tenailles serrantes,
Son eau jus de ciguë, & son pain des poisons;
Ses mains le menaçoyent de fines trahisons:
Tout image de mort, & le pis de sa rage
C'est qu'il cerche la mort & n'en voit que l'image.
De quelqu'autre Caïn il craignoit la fureur,
Il fut sans compagnon & non pas sans frayeur,
Il possedoit le monde et non une asseurance,
Il estoit seul par tout, hors mis sa conscience:
Et fut marqué au front afin qu'en s'enfuyant
Aucun n'osast tuer ses maux en le tuant.

Just as Abel offered sacrifices to God, with a pure conscience, Cain offered them as well. The one offered a gentle, the other a hardened heart; the one was acceptable to God, but not the other. Cain gnashed his teeth, grew pale, full of dread; he slaughtered his brother, and of that gentle lamb he made a sacrifice to his bitter wrath. The blood leaves his face, shamefully withdraws as it feels the brotherly blood drawn by the murderous blind hand; but, when the deed was done, its first pallor was vivid in comparison with the one which followed it. His hair bristled in fury towards heaven; the gnashing of teeth in his withered mouth, his eyes frowning with fear, disclosed his distress. He dreaded everything,

and everything dreaded him; whenever the trembling Cain turned his eyes towards the sky, it appeared wrapped in a cloak of clouds. When he ran towards the desert, the crags and woods shouted back with fright at the sound of his cries. His deadly crime cannot be atoned for by death. Hell contained no deaths adequate to punish his crime. But he suffered as many deaths as the days of his life; alive he did not live, dead he died not. He flees distressed with fright, troubled, trembling and pale; he flees from everyone, he flees from himself. The most secure places were menacing for him; the leaves, the branches and the flowers were daggers, the feathers of his bed were as pricking needles, his most comfortable clothing was like a tightening vice, his water the juice of hemlock, his bread poison. His hands threaten him with subtle treason; everything to him was an image of death; and his greatest grief was that he sought for death and found only its image. He feared the fury of some other Cain, he walked alone but not without fright, he possessed the world but no self-trust. He was alone everywhere except within his conscience, and was branded on his forehead, so that, while fleeing, none dared kill his agony by killing him.

<div align="right">Les Tragiques (c. 1577)</div>

Since the beginnings of French literature there has never been a page with such sustained and truly eloquent power.

<div align="right">

ÉMILE FAGUET

Histoire de la poésie française (1923)

</div>

THÉODORE AGRIPPA D'AUBIGNÉ

1 5 5 2 — 1 6 3 0

PSEAUME HUICTANTE HUICT

Sauveur Eternel, nuict & jour devant toi
Mes soupirs s'en vont relevés de leur foi.
Sus, soupirs, montez de ce creux & bas lieu
 Jusques à mon Dieu!

Au milieu des vifs demi-mort je transis:
Au milieu des morts demi-vif je languis.
C'est mourir sans mort, & ne rien avancer,
 Qu'ainsi balancer.

Dans le ventre obscur du mal-heur reserré,
Ainsi qu'au tombeau je me sens atterré,

Sans amis, sans jour qui me luise & sans voir
 L'aube de l'espoir.

Qui se souviendra de loüer ta grandeur
Dans le profond creux d'oubliance & d'horreur?
Pourroit aux Enfers tenebreux ta bonté
 Rendre sa clarté.

Quand le jour s'enfuit, le serain brunissant,
Quand la nuict s'en va, le matin renaissant,
Au silence obscur, à l'esclair des hauts jours
 J'invoque toujours.

Mais voulant chanter je ne rends que sanglots,
En joignant les mains je ne joins que des os:
Il ne sort nul feu, nulle humeur de mes yeux
 Pour lever aux Cieux.

Veux-tu donc, ô Dieu, que mon ombre sans corps
Serve pour chanter ton ire entre les morts,
Et que ton grand Nom venerable & tant beau
 Sorte du tombeau?

Ou que les vieux tests à la fosse rangés
Soyent rejoincts des nerfs que la mort a rongés,
Pour crier tes coups, & glacer de leurs cris
 Nos foibles esprits?

N'est-ce plus au Ciel que triomphent tes faits?
N'as tu plus d'autels que sepulchres infects?
Donc ne faut-il plus d'holocaustes chauffer
 Temple que l'Enfer?

Mes amis s'en vont devenus mes bourreaux,
Tel flattoit mes biens qui se rit de mes maux,
Mon lict est un cep, ce qui fut ma maison
 M'est une prison.

Si jadis forclos de ton œil, le berceau
Dur me fut, moins dur ne sera le tombeau.
Or coulez, mes jours orageux, & mes nuicts
 Fertiles d'ennuis.

Pour jamais as-tu ravi d'entre mes bras
Ma moitié, mon tout, & ma compaigne? helas!
Las! ce dur penser de regrets va tranchant
 Mon cœur & mon chant.

PSALM EIGHTY-EIGHT

Savior Eternal, night and day before Thee my sighs ascend, uplifted by their faith. Courage, sighs, rise from this empty, wretched place unto my God! Half dead, in the midst of the living, I am numbed; half alive, in the midst of the dead, I languish. To waver thus is to die without death, and to move not. Hemmed about by the gloomy maw of misfortune, I feel as if I were buried in a tomb, without friends, without day to light me, and unable to see the dawn of hope. Who will remember to praise Thy grandeur in the profound depths of forgetfulness and misery? Only Thy goodness could restore light to darkest Hell. When the day departs at darkling evening, when the night passes with the coming of morning, in obscure silence, in the light of full day, I invoke Thee ever. Wishing to sing I do but sigh; in joining my hands, I join but bones; no fire, no moisture issues from my eyes when I raise them to Heaven. Oh, God, dost Thou desire that my bodiless shadow may sing Thy wrath only among the dead, and that Thy great, venerable, and so beautiful Name issue out of a tomb? Or that the ancient skulls ranged in the grave be rejoined to the nerves that death has gnawed away, to cry out at Thy blows, and to chill by their cries our weak spirits? Do Thy deeds no longer triumph in Heaven? Hast Thou no more altars but contaminated sepulchers? Is there no other temple but Hell to warm with holocausts? My friends depart, having become my executioners; he who formerly fawned on my riches laughs at my evils; my bed is a manacle; what formerly was my house is but a prison. Formerly, when I was shut out of Thy glance, the cradle was hard to me; my grave will be hard no less. Flow on my stormy days, my nights rife with grief! For ever hast Thou snatched from my arms my half, my all, my mate? Alas! Alas! my heart and song are torn with regrets at this cruel thought.

His great procession of stanzas maintains the highest flight without a fault.

THIERRY MAULNIER
Introduction à la poésie française (1939)

563

EDMUND SPENSER

1 5 5 2 ? — 1 5 9 9

ASTROPHEL

Shepheards that wont on pipes of oaten reed,
Oft times to plaine your loues concealed smart:
And with your piteous layes haue learnd to breed
Compassion in a countrey lasses hart.
Hearken ye gentle shepheards to my song,
And place my dolefull plaint your plaints emong.

To you alone I sing this mournfull verse,
The mournfulst verse that euer man heard tell:
To you whose softened hearts it may empierse,
With dolours dart for death of Astrophel.
To you I sing and to none other wight,
For well I wot my rymes bene rudely dight.

Yet as they been, if any nycer wit
Shall hap to heare, or couet them to read:
Thinke he, that such are for such ones most fit,
Made not to please the liuing but the dead.
And if in him found pity euer place,
Let him be moov'd to pity such a case.

A Gentle Shepheard borne in *Arcady,*
Of gentlest race that euer shepheard bore:
About the grassie bancks of *Hæmony,*
Did keepe his sheep, his litle stock and store.
Full carefully he kept them day and night,
In fairest fields, and *Astrophel* he hight.

Young *Astrophel* the pride of shepheards praise,
Young *Astrophel* the rusticke lasses loue:
Far passing all the pastors of his daies,
In all that seemly shepheard might behoue.
In one thing onely fayling of the best,
That he was not so happie as the rest.

For from the time that first the Nymph his mother
Him forth did bring, and taught her lambs to feed,
A sclender swaine excelling far each other,
In comely shape, like her that did him breed,
He grew vp fast in goodnesse and in grace,
And doubly faire wox both in mynd and face.

564

Which daily more and more he did augment,
With gentle vsage and demeanure myld:
That all mens hearts with secret rauishment
He stole away, and weetingly beguyld.
Ne spight it selfe that all good things doth spill,
Found ought in him, that she could say was ill.

His sports were faire, his ioyance innocent,
Sweet without sowre, and honny without gall:
And he himselfe seemd made for meriment,
Merily masking both in bowre and hall.
There was no pleasure nor delightfull play,
When *Astrophel* so euer was away.

For he could pipe and daunce, and caroll sweet,
Emongst the shepheards in their shearing feast:
As Somers larke that with her song doth greet
The dawning day forth comming from the East.
And layes of loue he also could compose.
Thrise happie she, whom he to praise did chose.

Full many Maydens often did him woo,
Them to vouchsafe emongst his rimes to name,
Or make for them as he was wont to doo,
For her that did his heart with loue inflame.
For which they promised to dight, for him,
Gay chapelets of flowers and gyrlonds trim.

And many a Nymph both of the wood and brooke,
Soone as his oaten pipe began to shrill:
Both christall wells and shadie groues forsooke,
To heare the charmes of his enchanting skill.
And brought him presents, flowers if it were prime,
Or mellow fruit if it were haruest time.

But he for none of them did care a whit,
Yet wood Gods for them often sighed sore:
Ne for their gifts vnworthie of his wit,
Yet not vnworthie of the countries store.
For one alone he cared, for one he sight,
His lifes desire, and his deare loues delight.

Stella the faire, the fairest star in skie,
As faire as *Venus* or the fairest faire:
A fairer star saw neuer liuing eie,
Shot her sharp pointed beames through purest aire.
Her he did loue, her he alone did honor,
His thoughts, his rimes, his songs were all vpon her.

To her he vowd the seruice of his daies,
On her he spent the riches of his wit:
For her he made hymnes of immortall praise,
Of onely her he sung, he thought, he writ.
Her, and but her, of loue he worthie deemed,
For all the rest but litle he esteemed.

Ne her with ydle words alone he wowed,
And verses vaine (yet verses are not vaine)
But with braue deeds to her sole seruice vowed,
And bold atchieuements her did entertaine.
For both in deeds and words he nourtred was,
Both wise and hardie (too hardie alas).

In wrestling nimble, and in renning swift,
In shooting steddie, and in swimming strong:
Well made to strike, to throw, to leape, to lift,
And all the sports that shepheards are emong.
In euery one he vanquisht euery one,
He vanquisht all, and vanquisht was of none.

Besides, in hunting, such felicitie,
Or rather infelicitie he found:
That euery field and forest far away,
He sought, where saluage beasts do most abound.
No beast so saluage but he could it kill,
No chace so hard, but he therein had skill.

Such skill matcht with such courage as he had,
Did prick him foorth with proud desire of praise:
To seek abroad, of daunger nought y'drad,
His mistresse name, and his owne fame to raise.
What needeth perill to be sought abroad,
Since round about vs, it doth make aboad?

It fortuned, as he that perilous game
In forreine soyle pursued far away:
Into a forest wide and waste he came
Where store he heard to be of saluage pray.
So wide a forest and so waste as this,
Nor famous *Ardeyn*, nor fowle *Arlo* is.

There his welwouen toyles and subtil traines
He laid, the brutish nation to enwrap:
So well he wrought with practise and with paines,
That he of them great troups did soone entrap.
Full happie man (misweening much) was hee,
So rich a spoile within his power to see.

Eftsoones all heedlesse of his dearest hale,
Full greedily into the heard he thrust:
To slaughter them, and worke their finall bale,
Least that his toyle should of their troups be brust.
Wide wounds emongst them many one he made,
Now with his sharp borespear, now with his blade.

His care was all how he them all might kill,
That none might scape (so partiall vnto none)
Ill mynd so much to mynd anothers ill,
As to become vnmyndfull of his owne.
But pardon that vnto the cruell skies,
That from himselfe to them withdrew his eies.

So as he rag'd emongst that beastly rout,
A cruell beast of most accursed brood
Vpon him turnd (despeyre makes cowards stout)
And with fell tooth accustomed to blood,
Launched his thigh with so mischieuous might,
That it both bone and muscles ryued quight.

So deadly was the dint and deep the wound,
And so huge streames of blood thereout did flow,
That he endured not the direfull stound,
But on the cold deare earth himselfe did throw.
The whiles the captiue heard his nets did rend,
And hauing none to let, to wood did wend.

Ah where were ye this while his shepheard peares,
To whom aliue was nought so deare as hee:
And ye faire Mayds the matches of his yeares,
Which in his grace did boast you most to bee?
Ah where were ye, when he of you had need,
To stop his wound that wondrously did bleed?

Ah wretched boy the shape of dreryhead,
And sad ensample of mans suddein end:
Full litle faileth but thou shalt be dead,
Vnpitied, vnplaynd, of foe or frend.
Whilest none is nigh, thine eylids vp to close,
And kisse thy lips like faded leaues of rose.

A sort of shepheards sewing of the chace,
As they the forest raunged on a day:
By fate or fortune came vnto the place,
Where as the lucklesse boy yet bleeding lay.
Yet bleeding lay, and yet would still haue bled,
Had not good hap those shepheards thether led.

They stopt his wound (too late to stop it was)
And in their armes then softly did him reare:
Tho (as he wild) vnto his loued lasse,
His dearest loue him dolefully did beare.
The dolefulst beare that euer man did see,
Was *Astrophel,* but dearest vnto mee.

She when she saw her loue in such a plight,
With crudled blood and filthie gore deformed:
That wont to be with flowers and gyrlonds dight,
And her deare fauours dearly well adorned,
Her face, the fairest face, that eye mote see,
She likewise did deforme like him to bee.

Her yellow locks that shone so bright and long,
As Sunny beames in fairest somers day
She fiersly tore, and with outragious wrong
From her red cheeks the roses rent away.
And her faire brest the threasury of ioy,
She spoyld thereof, and filled with annoy.

His palled face impictured with death,
She bathed oft with teares and dried oft:
And with sweet kisses suckt the wasting breath,
Out of his lips like lillies pale and soft.
And oft she cald to him, who answerd nought,
But onely by his lookes did tell his thought.

The rest of her impatient regret,
And piteous mone the which she for him made,
No toong can tell, nor any forth can set,
But he whose heart like sorrow did inuade.
At last when paine his vitall powres had spent,
His wasted life her weary lodge forwent.

Which when she saw, she staied not a whit,
But after him did make vntimely haste:
Forth with her ghost out of her corps did flit,
And followed her make like Turtle chaste.
To proue that death their hearts cannot diuide,
Which liuing were in loue so firmly tide.

The Gods which all things see, this same beheld,
And pittying this paire of louers trew,
Transformed them there lying on the field,
Into one flowre that is both red and blew.
It first growes red, and then to blew doth fade,
Like *Astrophel,* which thereinto was made.

And in the midst thereof a star appeares,
As fairly formd as any star in skyes:
Resembling *Stella* in her freshest yeares,
Forth darting beames of beautie from her eyes,
And all the day it standeth full of deow,
Which is the teares, that from her eyes did flow.

That hearbe of some, Starlight is cald by name,
Of others *Penthia*, though not so well
But thou where euer thou doest finde the same,
From this day forth do call it *Astrophel*.
And when so euer thou it vp doest take,
Do pluck it softly for that shepheards sake.

Hereof when tydings far abroad did passe,
The shepheards all which loued him full deare,
And sure full deare of all he loued was,
Did thether flock to see what they did heare.
And when that pitteous spectacle they vewed.
The same with bitter teares they all bedewed.

And euery one did make exceeding mone,
With inward anguish and great griefe opprest:
And euery one did weep and waile, and mone,
And meanes deviz'd to shew his sorrow best.
That from that houre since first on grassie greene
Shepheards kept sheep, was not like mourning seen.

But first his sister that *Clorinda* hight,
The gentlest shepheardesse that liues this day:
And most resembling both in shape and spright
Her brother deare, began this dolefull lay.
Which least I marre the sweetnesse of the vearse,
In sort as she it sung, I will rehearse.

Ay me, to whom shall I my case complaine,
That may compassion my impatient griefe?
Or where shall I enfold my inward paine,
That my enriuen heart may find reliefe?
Shall I vnto the heauenly powres it show?
Or vnto earthly men that dwell below?

To heauens? ah they alas the authors were,
And workers of my vnremedied wo:
For they foresee what to vs happens here,
And they foresaw, yet suffred this be so.
 From them comes good, from them comes also il,
 That which they made, who can them warne to spill.

To men? ah they alas like wretched bee,
And subiect to the heauens ordinance:
Bound to abide what euer they decree,
Their best redresse, is their best sufferance.
 How then can they, like wretched, comfort mee,
 The which no lesse, need comforted to bee?

Then to my selfe will I my sorrow mourne,
Sith none aliue like sorrowfull remaines:
And to my selfe my plaints shall back retourne,
To pay their vsury with doubled paines.
 The woods, the hills, the riuers shall resound
 The mournfull accent of my sorrowes ground.

Woods, hills and riuers, now are desolate,
Sith he is gone the which them all did grace:
And all the fields do waile their widow state,
Sith death their fairest flowre did late deface.
 The fairest flowre in field that euer grew,
 Was *Astrophel;* that was, we all may rew,

What cruell hand of cursed foe vnknowne,
Hath cropt the stalke which bore so faire a flowre?
Vntimely cropt, before it well were growne,
And cleane defaced in vntimely howre.
 Great losse to all that euer him did see,
 Great losse to all, but greatest losse to mee.

Breake now your gyrlonds, O ye shepheards lasses,
Sith the faire flowre, which them adornd, is gon:
The flowre, which them adornd, is gone to ashes,
Neuer againe let lasse put gyrlond on.
 In stead of gyrlond, weare sad Cypres nowe,
 And bitter Elder, broken from the bowe.

Ne euer sing the loue-layes which he made,
Who euer made such layes of loue as hee?
Ne euer read the riddles, which he sayd
Vnto your selues, to make you mery glee.
 Your mery glee is now laid all abed,
 Your mery maker now alasse is dead.

Death the deuourer of all worlds delight,
Hath robbed you and reft fro me my ioy:
Both you and me, and all the world he quight
Hath robd of ioyance, and left sad annoy.
 Ioy of the world, and shepheards pride was hee,
 Shepheards hope neuer like againe to see.

Oh death that hast vs of such riches reft,
Tell vs at least, what hast thou with it done?
What is become of him whose flowre here left
Is but the shadow of his likenesse gone.
 Scarse like the shadow of that which he was,
 Nought like, but that he like a shade did pas.

But that immortall spirit, which was deckt
With all the dowries of celestiall grace:
By soueraine choyce from th'heuenly quires select,
And lineally deriv'd from Angels race,
 O what is now of it become, aread.
 Ay me, can so diuine a thing be dead?

Ah no: it is not dead, ne can it die,
But liues for aie, in blisfull Paradise:
Where like a new-borne babe it soft doth lie.
In bed of lillies wrapt in tender wise.
 And compast all about with roses sweet,
 And daintie violets from head to feet.

There thousand birds all of celestiall brood,
To him do sweetly caroll day and night:
And with straunge notes, of him well vnderstood,
Lull him a sleep in Angelick delight;
 Whilest in sweet dreame to him presented bee
 Immortall beauties, which no eye may see.

But he them sees and takes exceeding pleasure
Of their diuine aspects, appearing plaine,
And kindling loue in him aboue all measure,
Sweet loue still ioyous, neuer feeling paine.
 For what so goodly forme he there doth see,
 He may enioy from iealous rancor free.

There liueth he in euerlasting blis,
Sweet spirit neuer fearing more to die:
Ne dreading harme from any foes of his,
Ne fearing saluage beasts more crueltie.
 Whilest we here wretches waile his priuate lack,
 And with vaine vowes do often call him back.

But liue thou there still happie, happie spirit,
And giue vs leaue thee here thus to lament:
Not thee that doest thy heauens ioy inherit,
But our owne selues that here in dole are drent.
 Thus do we weep and waile, and wear our eies,
 Mourning in others, our owne miseries.

Which when she ended had, another swaine
Of gentle wit and daintie sweet deuice:
Whom *Astrophel* full deare did entertaine,
Whilest here he liv'd, and held in passing price,
Hight *Thestylis,* began his mournfull tourne,
And made the *Muses* in his song to mourne.

And after him full many other moe,
As euerie one in order lov'd him best,
Gan dight themselues t'expresse their inward woe,
With dolefull layes vnto the time addrest.
The which I here in order will rehearse,
As fittest flowres to deck his mournfull hearse.

<div align="right">(1586)</div>

One of the most finished and beautiful elegies in the English language.
<div align="right">PATRICK FRASER TYTLER
Life of Sir Walter Raleigh (1833)</div>

EDMUND SPENSER

1 5 5 2 ? — 1 5 9 9

VNWORTHY WRETCHEDNESSE

Nought is there vnder heau'ns wide hollownesse,
 That moues more deare compassion of mind,
 Then beautie brought t'vnworthy wretchednesse.
<div align="right">The Faerie Queene (1590–96), i</div>

The mournful sweetness of those lines is insurpassable; and they are quintessential Spenser. Yet it is unluckily characteristic of him, too, that he mars half the effect of this perfect passage by not stopping with its completion, but following it with a line which makes an anti-climax, and is too manifestly inserted for rhyme's sake:

Through envy's snares, or fortune's freaks unkind.

One might almost take that little passage as a text for one's whole disquisition on Spenser. For, after all, it is not in the richly luxuriant descriptive embroidery, or the pictures brushed in with words as with line and colour, which are traditionally quoted by this poet's critics,

<div align="center">572</div>

that the highest Spenser lies. The secret of him is shut in those three lines.

Wherein lies their power? The language is so utterly plain that an uninspired poet would have fallen upon baldness. Yet Spenser is a mine of diction (as was remarked to us by a poet who had worked in that mine). But here he had no need for his gorgeous opulence of diction: a few commonest words, and the spell was worked. It is all a matter of relation: the words take life from each other, and become an organism, as with Coleridge. And it is a matter of music; an integral element in the magic of the passage is its sound. In this necromancy, by which the most elementary words, entering into a secret relation of sense and sound, acquire occult property, Spenser is a master. And that which gives electric life to their relation is the Spenserian subtlety of emotion. Here it is specifically pathos, at another time it is joyous exultation, or again the pleasure of beauty. But behind and underneath all these emotional forms, the central and abiding quality, the essence of his emotion, is peace, and the radiance of peace. The final effect of all, in this and kindred passages, is lyrical.

FRANCIS THOMPSON
The Poets' Poet (1913)

EDMUND SPENSER

1 5 5 2 ? — 1 5 9 9

THE CAVE OF MAMMON

That houses forme within was rude and strong,
　　Like an huge caue, hewne out of rocky clift,
　　From whose rough vaut the ragged breaches hong,
　　Embost with massy gold of glorious gift,
　　And with rich metall loaded euery rift,
　　That heauy ruine they did seeme to threat;
　　And ouer them *Arachne* high did lift
　　Her cunning web, and spred her subtile net,
Enwrapped in fowle smoke and clouds more blacke then Iet.

Both roofe, and floore, and wals were all of gold,
　　But ouergrowne with dust and old decay,
　　And hid in darkenesse, that none could behold
　　The hew thereof: for vew of chearefull day
　　Did neuer in that house it selfe display,

573

But a faint shadow of vncertain light;
Such as a lamp, whose life does fade away:
Or as the Moone cloathed with clowdy night,
Does shew to him, that walkes in feare and sad affright.

<div align="center">

✿ ✿ ✿ ✿

</div>

And ouer them sad Horrour with grim hew,
 Did alwayes sore, beating his yron wings;
 And after him Owles and Night-rauens flew,
 The hatefull messengers of heauy things,
 Of death and dolour telling sad tidings;
 Whiles sad *Celeno,* sitting on a clift,
 A song of bale and bitter sorrow sings,
 That hart of flint a sunder could haue rift:
Which hauing ended, after him she flyeth swift.

<div align="right">

The Faerie Queene (1590–96), ii

</div>

*Unrivalled for the portentous massiness of the forms, the splendid
chiaro-scuro, and shadowy horror.*

<div align="right">

WILLIAM HAZLITT
Lectures on the English Poets (1818)

</div>

<div align="center">

EDMUND SPENSER

1 5 5 2 ? — 1 5 9 9

THE WANTON MAIDEN

</div>

Withall she laughed, and she blusht withall,
 That blushing to her laughter gaue more grace,
 And laughter to her blushing.

<div align="right">

The Faerie Queene (1590–96), ii

</div>

*Perhaps this is the loveliest thing of the kind, mixing the sensual with
the graceful, that ever was painted.*

<div align="right">

JAMES HENRY LEIGH HUNT
Imagination and Fancy (1844)

</div>

EDMUND SPENSER

1 5 5 2 ? — 1 5 9 9

EPITHALAMION

Ye learned sisters which haue oftentimes
Beene to me ayding, others to adorne:
Whom ye thought worthy of your gracefull rymes,
That euen the greatest did not greatly scorne
To heare theyr names sung in your simple layes,
But ioyed in theyr prayse.
And when ye list your owne mishaps to mourne,
Which death, or loue, or fortunes wreck did rayse,
Your string could soone to sadder tenor turne,
And teach the woods and waters to lament
Your dolefull dreriment.
Now lay those sorrowfull complaints aside,
And hauing all your heads with girland crownd,
Helpe me mine owne loues prayses to resound,
Ne let the same of any be enuide:
So Orpheus did for his owne bride,
So I vnto my selfe alone will sing,
The woods shall to me answer and my Eccho ring.

Early before the worlds light giuing lampe,
His golden beame vpon the hils doth spred,
Hauing disperst the nights vnchearefull dampe,
Doe ye awake, and with fresh lusty hed,
Go to the bowre of my beloued loue,
My truest turtle doue,
Bid her awake; for Hymen is awake,
And long since ready forth his maske to moue,
With his bright Tead that flames with many a flake,
And many a bachelor to waite on him,
In theyr fresh garments trim.
Bid her awake therefore and soone her dight,
For lo the wished day is come at last,
That shall for al the paynes and sorrowes past,
Pay to her vsury of long delight:
And whylest she doth her dight,
Doe ye to her of ioy and solace sing,
That all the woods may answer and your eccho ring.

Bring with you all the Nymphes that you can heare
Both of the riuers and the forrests greene:
And of the sea that neighbours to her neare,
Al with gay girlands goodly wel beseene.
And let them also with them bring in hand,
Another gay girland
For my fayre loue of lillyes and of roses,
Bound trueloue wize with a blew silke riband.
And let them make great store of bridale poses,
And let them eeke bring store of other flowers
To deck the bridale bowers.
And let the ground whereas her foot shall tread,
For feare the stones her tender foot should wrong
Be strewed with fragrant flowers all along,
And diapred lyke the discolored mead.
Which done, doe at her chamber dore awayt,
For she will waken strayt,
The whiles doe ye this song vnto her sing,
The woods shall to you answer and your Eccho ring.

Ye Nymphes of Mulla which with carefull heed,
The siluer scaly trouts doe tend full well,
And greedy pikes which vse therein to feed,
(Those trouts and pikes all others doo excell)
And ye likewise which keepe the rushy lake,
Where none doo fishes take,
Bynd vp the locks the which hang scatterd light,
And in his waters which your mirror make,
Behold your faces as the christall bright,
That when you come whereas my loue doth lie,
No blemish she may spie.
And eke ye lightfoot mayds which keepe the deere,
That on the hoary mountayne vse to towre,
And the wylde wolues which seeke them to deuoure,
With your steele darts doo chace from comming neer
Be also present heere,
To helpe to decke her and to help to sing,
That all the woods may answer and your eccho ring.

Wake, now my loue, awake; for it is time,
The Rosy Morne long since left Tithones bed,
All ready to her siluer coche to clyme,
And Phœbus gins to shew his glorious hed.
Hark how the cheerefull birds do chaunt theyr laies
And carroll of loues praise.

The merry Larke hir mattins sings aloft,
The thrush replyes, the Mauis descant playes,
The Ouzell shrills, the Ruddock warbles soft,
So goodly all agree with sweet consent,
To this dayes merriment.
Ah my deere loue why doe ye sleepe thus long,
When meeter were that ye should now awake,
T'awayt the comming of your ioyous make,
And hearken to the birds louelearned song,
The deawy leaues among.
For they of ioy and pleasance to you sing,
That all the woods them answer and theyr eccho ring.

My loue is now awake out of her dreame,
And her fayre eyes like stars that dimmed were
With darksome cloud, now shew theyr goodly beams
More bright then Hesperus his head doth rere.
Come now ye damzels, daughters of delight,
Helpe quickly her to dight,
But first come ye fayre houres which were begot
In Loues sweet paradice, of Day and Night,
Which doe the seasons of the yeare allot,
And al that euer in this world is fayre
Doe make and still repayre.
And ye three handmayds of the Cyprian Queene,
The which doe still adorne her beauties pride,
Helpe to addorne my beautifullest bride:
And as ye her array, still throw betweene
Some graces to be seene,
And as ye vse to Venus, to her sing,
The whiles the woods shal answer and your eccho ring.

Now is my loue all ready forth to come,
Let all the virgins therefore well awayt,
And ye fresh boyes that tend vpon her groome
Prepare your selues; for he is comming strayt.
Set all your things in seemely good aray
Fit for so ioyfull day,
The ioyfulst day that euer sunne did see.
Faire Sun, shew forth thy fauourable ray,
And let thy lifull heat not feruent be
For feare of burning her sunshyny face,
Her beauty to disgrace.
O fayrest Phœbus, father of the Muse,
If euer I did honour thee aright,
Or sing the thing, that mote thy mind delight,

577

Doe not thy seruants simple boone refuse,
But let this day let this one day be myne,
Let all the rest be thine.
Then I thy souerayne prayses loud wil sing,
That all the woods shal answer and theyr eccho ring.

Harke how the Minstrels gin to shrill aloud
Their merry Musick that resounds from far,
The pipe, the tabor, and the trembling Croud,
That well agree withouten breach or iar.
But most of all the Damzels doe delite,
When they their tymbrels smyte,
And thereunto doe daunce and carrol sweet,
That all the sences they doe rauish quite,
The whyles the boyes run vp and downe the street,
Crying aloud with strong confused noyce,
As if it were one voyce.
Hymen io Hymen, Hymen they do shout,
That euen to the heauens theyr shouting shrill
Doth reach, and all the firmament doth fill,
To which the people standing all about,
As in approuance doe thereto applaud
And loud aduaunce her laud,
And euermore they Hymen Hymen sing,
That al the woods them answer and theyr eccho ring.

Loe where she comes along with portly pace
Lyke Phœbe from her chamber of the East,
Arysing forth to run her mighty race,
Clad all in white, that seemes a virgin best.
So well it her beseemes that ye would weene
Some angell she had beene.
Her long loos yellow locks lyke golden wyre,
Sprinckled with perle, and perling flowres a tweene,
Doe lyke a golden mantle her attyre,
And being crowned with a girland greene,
Seeme lyke some mayden Queene.
Her modest eyes abashed to behold
So many gazers, as on her do stare,
Vpon the lowly ground affixed are.
Ne dare lift vp her countenance too bold,
But blush to heare her prayses sung so loud,
So farre from being proud.
Nathlesse doe ye still loud her prayses sing.
That all the woods may answer and your eccho ring.

Tell me ye merchants daughters did ye see
So fayre a creature in your towne before,
So sweet, so louely, and so mild as she,
Adornd with beautyes grace and vertues store,
Her goodly eyes lyke Saphyres shining bright,
Her forehead yuory white,
Her cheekes lyke apples which the sun hath rudded,
Her lips lyke cherryes charming men to byte,
Her brest like to a bowle of creame vncrudded,
Her paps lyke lyllies budded,
Her snowie necke lyke to a marble towre,
And all her body like a pallace fayre,
Ascending vppe with many a stately stayre,
To honors seat and chastities sweet bowre.
Why stand ye still ye virgins in amaze,
Vpon her so to gaze,
Whiles ye forget your former lay to sing,
To which the woods did answer and your eccho ring.

But if ye saw that which no eyes can see,
The inward beauty of her liuely spright,
Garnisht with heauenly guifts of high degree,
Much more then would ye wonder at that sight,
And stand astonisht lyke to those which red
Medusaes mazeful hed.
There dwels sweet loue and constant chastity,
Vnspotted fayth and comely womanhood,
Regard of honour and mild modesty,
There vertue raynes as Queene in royal throne,
And giueth lawes alone.
The which the base affections doe obay,
And yeeld theyr seruices vnto her will,
Ne thought of thing vncomely euer may
Thereto approch to tempt her mind to ill.
Had ye once seene these her celestial threasures,
And vnreuealed pleasures,
Then would ye wonder and her prayses sing,
That al the woods should answer and your echo ring.

Open the temple gates vnto my loue,
Open them wide that she may enter in,
And all the postes adorne as doth behoue,
And all the pillours deck with girlands trim,
For to recyue this Saynt with honour dew,
That commeth in to you.

With trembling steps and humble reuerence,
She commeth in, before th'almighties vew,
Of her ye virgins learne obedience,
When so ye come into those holy places,
To humble your proud faces:
Bring her vp to th'high altar, that she may
The sacred ceremonies there partake,
The which do endlesse matrimony make,
And let the roring Organs loudly play
The praises of the Lord in liuely notes,
The whiles with hollow throates
The Choristers the ioyous Antheme sing,
That al the woods may answere and their eccho ring.

Behold whiles she before the altar stands
Hearing the holy priest that to her speakes
And blesseth her with his two happy hands,
How the red roses flush vp in her cheekes,
And the pure snow with goodly vermill stayne,
Like crimsin dyde in grayne,
That euen th'Angels which continually,
About the sacred Altare doe remaine,
Forget their seruice and about her fly,
Ofte peeping in her face that seemes more fayre,
The more they on it stare.
But her sad eyes still fastened on the ground,
Are gouerned with goodly modesty,
That suffers not one looke to glaunce awry,
Which may let in a little thought vnsownd.
Why blush ye loue to giue to me your hand,
The pledge of all our band?
Sing ye sweet Angels, Alleluya sing,
That all the woods may answere and your eccho ring.

Now al is done; bring home the bride againe,
Bring home the triumph of our victory,
Bring home with you the glory of her gaine,
With ioyance bring her and with iollity.
Neuer had man more ioyfull day then this,
Whom heauen would heape with blis.
Make feast therefore now all this liue long day,
This day for euer to me holy is,
Poure out the wine without restraint or stay,
Poure not by cups, but by the belly full,
Poure out to all that wull,

580

And sprinkle all the postes and wals with wine,
That they may sweat, and drunken be withall.
Crowne ye God Bacchus with a coronall,
And Hymen also crowne with wreathes of vine,
And let the Graces daunce vnto the rest;
For they can doo it best:
The whiles the maydens doe theyr carroll sing,
To which the woods shal answer and theyr eccho ring.

Ring ye the bels, ye yong men of the towne,
And leaue your wonted labors fòr this day:
This day is holy; doe ye write it downe,
That ye for euer it remember may.
This day the sunne is in his chiefest hight,
With Barnaby the bright,
From whence declining daily by degrees,
He somewhat loseth of his heat and light,
When once the Crab behind his back he sees.
But for this time it ill ordained was,
To chose the longest day in all the yeare,
And shortest night, when longest fitter weare:
Yet neuer day so long, but late would passe.
Ring ye the bels, to make it weare away,
And bonefiers make all day,
And daunce about them, and about them sing:
That all the woods may answer, and your eccho ring.

Ah when will this long weary day haue end,
And lende me leaue to come vnto my loue?
How slowly do the houres theyr numbers spend?
How slowly does sad Time his feathers moue?
Hast thee O fayrest Planet to thy home
Within the Westerne fome:
Thy tyred steedes long since haue need of rest.
Long though it be, at last I see it gloome,
And the bright euening star with golden creast
Appeare out of the East.
Fayre childe of beauty, glorious lampe of loue
That all the host of heauen in rankes doost lead,
And guydest louers through the nightes dread,
How chearefully thou lookest from aboue,
And seemst to laugh atweene thy twinkling light
As ioying in the sight
Of these glad many which for ioy doe sing,
That all the woods them answer and their echo ring.

Now ceasse ye damsels your delights forepast;
Enough is it, that all the day was youres:
Now day is doen, and night is nighing fast:
Now bring the Bryde into the brydall boures.
Now night is come, now soone her disaray,
And in her bed her lay;
Lay her in lillies and in violets,
And silken courteins ouer her display,
And odourd sheetes, and Arras couerlets.
Behold how goodly my faire loue does ly
In proud humility;
Like vnto Maia, when as Ioue her tooke,
In Tempe, lying on the flowry gras,
Twixt sleepe and wake, after she weary was,
With bathing in the Acidalian brooke.
Now it is night, ye damsels may be gon,
And leaue my loue alone,
And leaue likewise your former lay to sing:
The woods no more shal answere, nor your echo ring.

Now welcome night, thou night so long expected,
That long daies labour doest at last defray,
And all my cares, which cruell loue collected,
Hast sumd in one, and cancelled for aye:
Spread thy broad wing ouer my loue and me,
That no man may vs see,
And in thy sable mantle vs enwrap,
From feare of perrill and foule horror free.
Let no false treason seeke vs to entrap,
Nor any dread disquiet once annoy
The safety of our ioy:
But let the night be calme and quietsome,
Without tempestuous storms or sad afray:
Lyke as when Ioue with fayre Alcmena lay,
When he begot the great Tirynthian groome:
Or lyke as when he with thy selfe did lie,
And begot Maiesty.
And let the mayds and yongmen cease to sing:
Ne let the woods them answer, nor theyr eccho ring.

Let no lamenting cryes, nor dolefull teares,
Be heard all night within nor yet without:
Ne let false whispers, breeding hidden feares,
Breake gentle sleepe with misconceiued dout.
Let no deluding dreames, nor dreadful sights
Make sudden sad affrights;

Ne let housefyres, nor lightnings helpelesse harmes,
Ne let the Pouke, nor other euill sprights,
Ne let mischiuous witches with theyr charmes,
Ne let hob Goblins, names whose sence we see not,
Fray vs with things that be not.
Let not the shriech Oule, nor the Storke be heard:
Nor the night Rauen that still deadly yels,
Nor damned ghosts cald vp with mighty spels,
Nor griesly vultures make vs once affeard:
Ne let th'unpleasant Quyre of Frogs still croking
Make vs to wish theyr choking.
Let none of these theyr drery accents sing;
Ne let the woods them answer, nor theyr eccho ring.

But let stil Silence trew night watches keepe,
That sacred peace may in assurance rayne,
And tymely sleep, when it is tyme to sleepe,
May poure his limbs forth on your pleasant playne,
The whiles an hundred little winged loues,
Like diuers fethered doues,
Shall fly and flutter round about your bed,
And in the secret darke, that none reproues,
Their prety stealthes shal worke, and snares shal spread
To filch away sweet snatches of delight,
Conceald through couert night.
Ye sonnes of Venus, play your sports at will,
For greedy pleasure, carelesse of your toyes,
Thinks more vpon her paradise of ioyes,
Then what ye do, albe it good or ill.
All night therefore attend your merry play,
For it will soone be day:
Now none doth hinder you, that say or sing,
Ne will the woods now answer, nor your Eccho ring.

Who is the same, which at my window peepes?
Or whose is that faire face, that shines so bright,
Is it not Cinthia, she that neuer sleepes,
But walkes about high heauen al the night?
O fayrest goddesse, do thou not enuy
My loue with me to spy:
For thou likewise didst loue, though now vnthought,
And for a fleece of woll, which priuily,
The Latmian shephard once vnto thee brought,
His pleasures with thee wrought.
Therefore to vs be fauorable now;

And sith of wemens labours thou hast charge,
And generation goodly dost enlarge,
Encline thy will t'effect our wishfull vow,
And the chast wombe informe with timely seed,
That may our comfort breed:
Till which we cease our hopefull hap to sing,
Ne let the woods vs answere, nor our Eccho ring.

And thou great Iuno, which with awful might
The lawes of wedlock still dost patronize,
And the religion of the faith first plight
With sacred rites hast taught to solemnize:
And eeke for comfort often called art
Of women in their smart,
Eternally bind thou this louely band,
And all thy blessings vnto vs impart.
And thou glad Genius, in whose gentle hand,
The bridale bowre and geniall bed remaine,
Without blemish or staine,
And the sweet pleasures of theyr loues delight
With secret ayde doest succour and supply,
Till they bring forth the fruitfull progeny,
Send vs the timely fruit of this same night.
And thou fayre Hebe, and thou Hymen free,
Grant that it may so be.
Til which we cease your further prayse to sing,
Ne any woods shal answer, nor your Eccho ring.

And ye high heauens, the temple of the gods,
In which a thousand torches flaming bright
Doe burne, that to vs wretched earthly clods,
In dreadful darknesse lend desired light;
And all ye powers which in the same remayne,
More then we men can fayne,
Poure out your blessing on vs plentiously,
And happy influence vpon vs raine,
That we may raise a large posterity,
Which from the earth, which they may long possesse,
With lasting happinesse,
Vp to your haughty pallaces may mount,
And for the guerdon of theyr glorious merit
May heauenly tabernacles there inherit,
Of blessed Saints for to increase the count.
So let vs rest, sweet loue, in hope of this,
And cease till then our tymely ioyes to sing,
The woods no more vs answer, nor our eccho ring.

Song made in lieu of many ornaments,
With which my loue should duly haue bene dect,
Which cutting off through hasty accidents,
Ye would not stay your dew time to expect,
But promist both to recompens,
Be vnto her a goodly ornament,
And for short time an endlesse moniment.

(1595)

The most pure and exalted love-poem that was ever written.

COVENTRY PATMORE
Religio Poetæ (1898)

SIR WALTER RALEIGH

1 5 5 2 ? — 1 6 1 8

DEATH

O eloquent, just, and mighty Death! whom none could advise, thou hast perswaded; what none have dared, thou hast done; and whom all the world hath flattered, thou only hast cast out of the world and despised: thou hast drawn together all the far stretched greatness, all the pride, cruelty, and ambition of man, and covered it all over with these two narrow words, *Hic jacet.*

A History of the World (1614)

I sometimes like to make clear to myself what are the great sentences in English that appeal to me most. As to Raleigh's invocation of Death, as the most magnificent, I seldom vary. It may not be a perfect sentence, one touch more to its grandiosity and it might topple over into absurdity. But the most magnificent it still remains.

HAVELOCK ELLIS
Impressions and Comments, Second Series (1921)

FRANÇOIS DE MALHERBE

1 5 5 5 — 1 6 2 8

IMITATION DU PSEAUME

N'esperons plus, mon ame, aux promesses du monde:
Sa lumiere est un verre, et sa faveur une onde,
Que tousjours quelque vent empesche de calmer;
Quittons ces vanitez, lassons-nous de les suivre:
 C'est Dieu qui nous faict vivre,
 C'est Dieu qu'il faut aimer.

En vain, pour satisfaire à nos lasches envies,
Nous passons pres des rois tout le temps de nos vies,
A souffrir des mespris et ployer les genoux;
Ce qu'ils peuvent n'est rien: ils sont comme nous sommes,
 Veritablement hommes,
 Et meurent comme nous.

Ont-ils rendu l'esprit, ce n'est plus que poussiere
Que cette majesté si pompeuse et si fiere
Dont l'esclat orgueilleux estonne l'univers;
Et dans ces grands tombeaux où leurs ames hautaines
 Font encore les vaines,
 Ils sont mangez des vers.

Là se perdent ces noms de maistres de la terre,
D'arbitres de la paix, de foudres de la guerre:
Comme ils n'ont plus de sceptre, ils n'ont plus de flatteurs,
Et tombent avecque eux d'une cheute commune
 Tous ceux que leur fortune
 Faisoit leurs serviteurs.

IMITATION OF A PSALM

Let us trust no longer, my soul, in the promises of the world; its light is like a glass, and its favor a wave, that some wind always prevents from subsiding. Let us leave these vanities, let us weary of following them; it is God who makes us live, it is God whom we must love. Vainly, to gratify our base desires, we pass all the days of our lives near kings, suffering their contempt, and bending our knee. What they can do is nothing; they are as we are, only men, and die like us. When they die their proud and pompous majesty, whose showy glitter impresses the world, is only dust. And in the great tombs, where their arrogant souls

still flaunt vanity, they are eaten by worms. The names of masters of the earth, arbiters of peace, thunderbolts of war, are lost there. As they no longer have the scepter, they no longer have the flatterers; and there fall with them, altogether, those whom fortune compelled to be their servants.

The four stanzas in which he has paraphrased a section of Psalm CXLV are perfect. . . . Stanzas of this type suffice to restore a language, and are worthy of a lyre.

C. - A. SAINTE-BEUVE
Causeries du lundi (1853)

FRANÇOIS DE MALHERBE

1 5 5 5 — 1 6 2 8

ON THE DEATH OF MLLE. DE CONTY

N'égalons point cette petite
Aux déesses que nous récite
L'histoire des siècles passés:
Tout cela n'est qu'une chimère;
Il faut dire, pour dire assez,
Elle est belle comme sa mère.

This little child do not compare
With goddesses however fair
Who lived, we're told, in days of yore;
These are but fancies woven in space.
Say this, and you need say no more:
She has her mother's lovely face.

Translated by J. G. Legge

His short poem on the death in infancy of Mlle de Conty. . . . shows how high within his range was Malherbe's poetic sense, and how the union of grace, finesse, and tact makes a French compliment the most exquisite in the world.

J. G. LEGGE
Chanticleer (1935)

GEORGE PEELE

1 5 5 8 ? — 1 5 9 7 ?

CUPID'S CURSE

INCIPIT OENONE
Faire and fayre and twise so faire,
 As fayre as any may be:

OENONE
The fayrest sheepeherd on our grene,
 A loue for anie Ladie.

PARIS
Faire and faire and twise so fayre,
 As fayre as anie may bee:
Thy loue is fayre for thee alone,
 And for no other Ladie.

OENONE
My loue is faire, my loue is gaie,
 As fresh as bine the flowers in May,
And of my loue my roundylaye,
My merrie merrie merrie roundelaie
Concludes with Cupids curse:
They that do chaunge olde loue for newe,
Pray Gods they chaunge for worse.

AMBO (*Simul.*)
They that do chaunge, &c.

OENONE
Faire and faire, &c,

PARIS
Faire and faire, &c. Thy loue is faire &c.

OENONE
My loue can pype, my loue can sing,
My loue can manie a pretie thing,
And of his louelie prayses ring
My merry merry roundelayes: Amen to Cupids curse:
They that do chaunge, &c.

PARIS
They that do chaunge, &c.

AMBO
Faire and fayre, &c.

The Araygnement of Paris (1584)
Act i, Scene v

588

Dear Sir,

I conjure you, in the name of all the sylvan deities, and of the Muses, whom you honour, and they reciprocally love and honour you,—rescue this old and passionate DITTY—*the very flower of an old* FORGOTTEN PASTORAL, *which had it been in all parts equal, the Faithful Shepherdess of Fletcher had been but a second name in this sort of writing— rescue it from the profane hands of every common composer; and in one of your tranquillest moods, when you have most leisure from those sad thoughts, which sometimes unworthily beset you; yet a mood, in itself not unallied to the better sort of melancholy; laying by for once the lofty organ, with which you shake the Temples; attune, as to the pipe of Paris himself, to some milder and more love-according instrument, this pretty courtship between Paris and his (then-not as yet-forsaken) Œnone. Oblige me, and all more knowing judges of music and of poesy by the adaptation of fit musical numbers, which it only wants to be the rarest love dialogue in our language.*

<div align="right">

Your implorer,
C. L.

</div>

<div align="center">

CHARLES LAMB
Specimens of English Dramatic Poets (1808)

</div>

<div align="center">

GEORGE CHAPMAN

1 5 5 9 ? — 1 6 3 4

FROM HOMER'S ILIADS

</div>

For *Hectors* glorie still he stood; and euer went about,
To make him cast the fleet such fire, as neuer should go out;
Heard *Thetis* foule petition; and wisht, in any wise,
The splendor of the burning ships, might satiate his eyes.
From him yet, the repulse was then, to be on *Troy* conferd,
The honor of it giuen the *Greeks;* which (thinking on) he stird
(With such addition of his spirit) the spirit *Hector* bore,
To burne the fleet; that of it selfe, was hote enough before.
But now he far'd like *Mars* himselfe, so brandishing his lance;
As through the deepe shades of a hill, a raging fire should glance;
Held vp to all eyes by a hill; about his lips, a fome
Stood; as when th' *Ocean* is enrag'd; his eyes were ouercome
With feruour, and resembl'd flames; set off, by his darke browes:
And from his temples, his bright helme, abhorred lightnings throwes.

<div align="center">

589

</div>

For *Ioue*, from foorth the sphere of starres, to his state, put his owne;
And all the blaze of both the hosts, confin'd, in him alone.
And all this was, since after this, he had not long to liue;
This lightning flew before his death: which *Pallas* was to giue,
(A small time thence, and now prepar'd) beneath the violence
Of great *Pelides*. In meane time, his present eminence,
Thought all things vnder it: and he, still where he saw the stands
Of greatest strength, and brauest arm'd, there he would proue his hands:
Or no where; offering to breake through. But that past all his powre,
Although his will, were past all theirs; they stood him like a towre
Conioynd so firme: that as a rocke, exceeding high and great;
And standing neare the hoarie sea, beares many a boisterous threate
Of high-voic't winds, and billowes huge, belcht on it by the stormes;
So stood the *Greeks* great *Hectors* charge, nor stird their battellous
formes.

Ἕκτορι γάρ οἱ θυμὸς ἐβούλετο κῦδος ὀρέξαι,
Πριαμίδῃ, ἵνα νηυσὶ κορωνίσι θεσπιδαὲς πῦρ
ἐμβάλῃ ἀκάματον, Θέτιδος δ' ἐξαίσιον ἀρὴν
πᾶσαν ἐπικρήνειε· τὸ γὰρ μένε μητίετα Ζεύς,
νηὸς καιομένης σέλας ὀφθαλμοῖσιν ἰδέσθαι.
ἐκ γὰρ δὴ τοῦ ἔμελλε παλίωξιν παρὰ νηῶν
θησέμεναι Τρώων, Δαναοῖσι δὲ κῦδος ὀρέξαι.
τὰ φρονέων, νήεσσιν ἔπι γλαφυρῇσιν ἔγειρεν
Ἕκτορα Πριαμίδην, μάλα περ μεμαῶτα καὶ αὐτόν.
μαίνετο δ', ὡς ὅτ' Ἄρης ἐγχέσπαλος, ἢ ὀλοὸν πῦρ
οὔρεσι μαίνηται, βαθέης ἐν τάρφεσιν ὕλης·
ἀφλοισμὸς δὲ περὶ στόμα γίγνετο, τὼ δέ οἱ ὄσσε
λαμπέσθην βλοσυρῇσιν ὑπ' ὀφρύσιν· ἀμφὶ δὲ πήληξ
σμερδαλέον κροτάφοισι τινάσσετο μαρναμένοιο.
[Ἕκτορος· αὐτὸς γάρ οἱ ἀπ' αἰθέρος ἦεν ἀμύντωρ
Ζεύς, ὅς μιν πλεόνεσσι μετ' ἀνδράσι μοῦνον ἐόντα
τίμα καὶ κύδαινε. μινυνθάδιος γὰρ ἔμελλεν
ἔσσεσθ'· ἤδη γάρ οἱ ἐπώρνυε μόρσιμον ἦμαρ
Παλλὰς Ἀθηναίη ὑπὸ Πηλείδαο βίηφιν.]
καί ῥ' ἔθελεν ῥῆξαι στίχας ἀνδρῶν, πειρητίζων,
ᾗ δὴ πλεῖστον ὅμιλον ὅρα καὶ τεύχε' ἄριστα·
ἀλλ' οὐδ' ὣς δύνατο ῥῆξαι, μάλα περ μενεαίνων.
ἴσχον γὰρ πυργηδὸν ἀρηρότες, ἠύτε πέτρη
ἠλίβατος, μεγάλη, πολιῆς ἁλὸς ἐγγὺς ἐοῦσα,
ἥτε μένει λιγέων ἀνέμων λαιψηρὰ κέλευθα,
κύματά τε τροφόεντα, τάτε προσερεύγεται αὐτήν·
ὣς Δαναοὶ Τρῶας μένον ἔμπεδον, οὐδ' ἐφέβοντο.

Iliad, xv, 596–622

590

He himself spoke of his Homeric translations (he rendered the whole works, doing also Hesiod, a satire of Juvenal, and some minor fragments, Pseudo-Virgilian, Petrarchian and others) as "the work that he was born to do." His version, with all its faults, outlived the popularity even of Pope, was for more than two centuries the resort of all who, unable to read Greek, wished to know what the Greek was, and, despite the finical scholarship of the present day, is likely to survive all the attempts made with us. I speak with all humility, but as having learnt Homer from Homer himself, and not from any translation, prose or verse. I am perfectly aware of Chapman's outrageous liberties, of his occasional unfaithfulness (for a libertine need not necessarily be unfaithful in translation), and of the condescension to his own fancies and the fancies of his age, which obscures not more perhaps than some condescensions which nearness and contemporary influences prevent some of us from seeing the character of the original. But at the same time, either I have no skill in criticism, and have been reading Greek for thirty years to none effect, or Chapman is far nearer Homer than any modern translator in any modern language.

<div align="right">

GEORGE SAINTSBURY
A History of Elizabethan Literature (1887)

</div>

GEORGE CHAPMAN

1 5 5 9 ? — 1 6 3 4

INVOCATION TO SPIRIT

 I long to know
How my deare mistresse fares; and be informd
What hand she now holds on the troubled bloud
Of her incensed Lord: me thought the Spirit,
(When he had vtterd his perplext presage)
Threw his chang'd countenance headlong into clowdes;
His forehead bent, as it would hide his face;
He knockt his chin against his darkned breast,
And struck a churlish silence through his powrs;
Terror of darknesse: O thou King of flames,
That with thy Musique-footed horse dost strike
The cleere light out of chrystall, on darke earth;
And hurlst instructiue fire about the world:
Wake, wake, the drowsie and enchanted night;
That sleepes with dead eies in this heauy riddle:

Or thou great Prince of shades where neuer sunne
Stickes his far-darted beames: whose eies are made,
To shine in darknesse: and see euer best
Where men are blindest: open now the heart
Of thy abashed oracle: that for feare,
Of some ill it includes, would faine lie hid,
And rise thou with it in thy greater light.

<div style="text-align: right;">Bussy D'Ambois (1613)</div>

*This calling upon Light and Darkness for information, but, above all,
the description of the spirit—"Threw his changed countenance headlong
into clouds"—is tremendous, to the curdling of the blood. I know nothing
in poetry like it.*

<div style="text-align: right;">CHARLES LAMB</div>
<div style="text-align: right;">Specimens of English Dramatic Poets (1808)</div>

LOPE DE VEGA

1 5 6 2 — 1 6 3 5

ESTRELLA LEARNS THAT HER LOVER
HAS KILLED HER BROTHER

(Sala en casa de Busto. Estrella y Teodora.)

ESTRELLA

No sé si me vestí bien,
como me vestí de prisa.
Dame, Teodora, ese espejo.

TEODORA

Verte, Señora, en tí misma
puedes, porque no hay cristal
que tantas verdades diga,
ni de hermosura tan grande
haga verdadera cifra.

ESTRELLA

Alterado tengo el rostro
y la color encendida.

TEODORA

Es, Señora, que la sangre
se ha asomado á las mejillas

entre temor y vergüenza,
sólo á celebrar tus dichas.

ESTRELLA

Ya me parece que llega,
el rostro bañado de risa,
mi esposo á darme la mano
entre mil tiernas caricias.
Ya me parece que dice,
mil ternezas y que oídas,
sale el alma por los ojos,
disimulando las niñas.
¡Ay venturoso día!
Esta ha sido, Teodora, estrella mía.

TEODORA

Parece que gente suena.
Cayó el espejo. De envidia, (*Álzale*)
el cristal, dentro la hoja,
de una luna hizo infinitas.

ESTRELLA

¿Quebróse?

TEODORA

 Señora, sí.

ESTRELLA

Bien hizo, porque imagina
que aguardo el cristal, Teodora,
en que mis ojos se miran.
Y pues tal espejo aguardo,
quiébrese el espejo, amiga;
que no quiero que con él,
este de espejo me sirva.

(*Clarindo, muy galán.—Dichas.*)

CLARINDO

Ya aquesto suena, Señora,
á gusto y volatería;
que las plumas del sombrero
los casamientos publican.
Á mi dueño dí el papel,
y dióme aquesta sortija
en albricias.

ESTRELLA

 Pues yo quiero
feriarte aquesas albricias.
Dámela, y toma por ella
este diamante.

593

CLARINDO

 Partida
está por medio la piedra:
será de melancolía;
que los jacintos padecen
de ese mal, aunque le quitan.
Partida por medio está.

ESTRELLA

 No importa que esté partida;
que es bien que las piedras sientan
mis contentos y alegrías.
¡Ay, venturoso día!
Esta, amigos, ha sido estrella mía!

TEODORA

 Gran tropel suena en los patios.

CLARINDO

 Y ya la escalera arriba
parece que sube gente.

ESTRELLA

 ¿Qué valor hay que resista
al placer?

*(Los dos Alcaldes mayores, con gente que
trae el cadáver de Busto.—Dichos.)*

ESTRELLA

 Pero. . . . ¿qué es esto?

DON PEDRO

 Los desastres y desdichas
se hicieron para los hombres;
que es mar de llanto esta vida.
El Señor Busto Tabera
es muerto.

ESTRELLA

 ¡Suerte enemiga!

DON PEDRO

 El consuelo que aquí os queda,
es que está el fiero homicida,
Sancho Ortiz de las Roelas,
preso, y dél se hará justicia
mañana sin falta . . .

ESTRELLA

 Dejadme, gente enemiga;
que en vuestras lenguas traéis
de los infiernos las iras.
¡Mi hermano es muerto, y le ha muerto

594

Sancho Ortiz! ¿Hay quien lo diga?
¿Hay quien lo escuche y no muera?
Píedra soy, pues estoy viva.
¡Ay riguroso día!
Esta, amigos, ha sido estrella mía.
Pero si hay piedad humana,
matadme.

DON PEDRO

El dolor la priva,
y con razón.

ESTRELLA

¡Desdichada
ha sido la estrella mía!
¡Mi hermano es muerto, y le ha muerto
Sancho Ortiz! ¡Él quien divida
tres almas de un corazón! . . .
Dejadme que estoy perdida.

DON PEDRO

Ella está desesperada.

FARFÁN

¡Infeliz beldad!

DON PEDRO

Seguidla.

CLARINDO

Señora . . .

ESTRELLA

Déjame, ingrato,
sangre de aquel fratricida.
Y pues acabo con todo,
quiero acabar con la vida.
¡Ay riguroso día!
Esta ha sido, Teodora, estrella mía.

A Room in Busto Tabera's House.
Enter Estrella and Theodora.

ESTRELLA

I know not, Theodora, if this robe
Becomes me, for I dressed in such glad haste.
Give me the glass.

THEODORA

Madam, you are yourself
Beauty's own mirror, nor can any glass
Declare such sweet perfection, nor resume
In its small sphere so many dazzling charms.

ESTRELLA

See how my looks are changed, my cheeks how flushed.

THEODORA

Why, 'tis the blood mounts to your cheeks, and there,
Mocking reserve and maiden modesty,
Betrays your happiness.

ESTRELLA

Methinks he comes,
My well-beloved, his eyes lit with love's joy,
To take my hand with many a soft caress.
And now methinks he whispers in my ear
A thousand tender messages of love,
And from the rapture of my swooning eyes
Calls forth my willing soul. Ah, happy day!
This, Theodora, is my kindly star.

THEODORA

Hark, hear you not the sound of merriment?
Alas! the mirror's fallen. The envious glass
Within its frame has formed of one smooth face
A thousand facets.

ESTRELLA

What? 'Tis broken then?

THEODORA

Ay, madam.

ESTRELLA

'Tis well done; poor glass, it knows
I have a mirror in whose loving eyes
My own shall see themselves reflected. So,
Let your glass break, since I await my own,
Which having, I shall need no other glass.

Enter Clarindo, dressed in his best.

CLARINDO

Madam, here is a wind that blows you fair—
And foul. These feathered furnishings proclaim
Your wedding day. I to my master gave
The letter you gave me, and he in turn
Gave me this ring for a reward.

ESTRELLA

Why then,
I will outbid him. Come, give me the ring,
And take this diamond in exchange.

CLARINDO

The stone
Is cleft in twain. A sign, they say, of sadness.

596

Your jacinth suffers from the self-same ill
It takes away. The stone is cleft in twain.

ESTRELLA

What matter? It is right that stones should feel
My joy, my sweet content. Ah, happy day!
Dear friends, this is my charitable star.

THEODORA

A noisy throng fills the courtyard below.

CLARINDO

And now it seems that footsteps mount the stair.

ESTRELLA

Who can resist such joy?

> *Enter the two Chief Magistrates,*
> *with others carrying the dead body.*

But . . . what is this?

PEDRO

Misfortunes and disasters were ordained
For mortal men. This life is but a sea
Of tears. Busto Tabera's slain.

ESTRELLA

O cruel,
Cruel fate!

PEDRO

Lady, this comfort still
Remains: the bloody murderer, Sancho Ortiz,
Is taken, and tomorrow without fail
Shall pay the penalty.

ESTRELLA

Ah God! Avaunt,
Ye fiends that bear Hell's fury in your tongues,
Away! My brother slain, and by the hand
Of Sancho Ortiz! How can I utter it,
How hear it and still live? I am a stone,
That still I am alive. Unhappy day!
This, friends, is my unfriendly star. But if
One spark of human pity linger yet,
Come, slay me now.

PEDRO

Alas, she's crazed with grief!

ESTRELLA

Unhappy destiny! My brother dead,
And by the hand of Sancho Ortiz! That he
Should sever three souls from one bleeding heart!
Leave me; I am undone.

PEDRO

She is distraught.

FARFÁN

Alas, unhappy woman!

PEDRO, TO CLARINDO

Go with her.

CLARINDO

Lady . . . ?

ESTRELLA

Begone, thou art contaminate
With that false fratricide. All, all is lost,
All but the hope of death. Unhappy day!
This, Theodora, is my cruel star.

> *Exeunt*

La Estrella de Sevilla
Translated by Henry Thomas

No finer example of a fearful peripeteia exists on any stage.

RUDOLPH SCHEVILL
The Dramatic Art of Lope de Vega (1918)

———————

SAMUEL DANIEL

1 5 6 2 — 1 6 1 9

ULYSSES AND THE SIREN

Come worthy Greeke, *Vlisses* come
Possesse these shores with me:
The windes and Seas are troublesome,
And heere we may be free.
 Here may we sit, and view their toile
That trauaile in the deepe,
And ioy the day in mirth the while,
And spend the night in sleepe.

Certaine Small Poems (1605)

A promising young poetaster could not do better than lay up that stanza
in his memory, not necessarily as a pattern to set before him, but as a
touchstone to keep at his side. Diction and movement alike, it is perfect.
It is made out of the most ordinary words, yet it is pure from the least

alloy of prose; and however much nearer heaven the art of poetry may have mounted, it has never flown on a surer or a lighter wing.

<div align="right">

A. E. HOUSMAN

The Name and Nature of Poetry (1933)

</div>

SAMUEL DANIEL

1 5 6 2 — 1 6 1 9

THE WRITER'S TRAGEDY

And therefore since I haue out-liu'd the date
Of former grace, acceptance and delight,
I would my lines late-borne beyond the fate
Of her spent line, had neuer come to light.
So had I not beene tax'd for wishing well,
Nor now mistaken by the censuring Stage,
Nor, in my fame and reputation fell,
Which I esteeme more then what all the age
Or th'earth can giue. But yeeres hath done this wrong,
To make me write too much, and liue too long.

<div align="right">

The Tragedie of Philotas (1605)

</div>

These words—perhaps the most pathetic ever uttered by an artist upon his work.

<div align="right">

SIR ARTHUR QUILLER-COUCH

Adventures in Criticism (1925)

</div>

CHRISTOPHER MARLOWE

1 5 6 4 — 1 5 9 3

HELEN OF TROY

FAUSTUS

Was this the face that lancht a thousand shippes?
And burnt the toplesse Towres of *Ilium*?
Sweete *Helen*, make me immortall with a kisse: (*Kisses her.*)
Her lips suckes forth my soule, see where it flies:

<div align="center">

599

</div>

Come *Helen,* come giue mee my soule againe.
Here wil I dwel, for heauen be in these lips,
And all is drosse that is not *Helena:* *Enter old man.*
I wil be *Paris,* and for loue of thee,
Insteede of *Troy* shal *Wertenberge* be sackt,
And I wil combate with weake *Menelaus,*
And weare thy colours on my plumed Crest:
Yea I wil wound *Achillis* in the heele,
And then returne to *Helen* for a kisse.
O thou art fairer then the euening aire,
Clad in the beauty of a thousand starres,
Brighter art thou then flaming *Iupiter,*
When he appeard to haplesse *Semele,*
More louely then the monarke of the skie
In wanton *Arethusaes* azurde armes,
And none but thou shalt be my paramour.

 The tragicall History of Doctor Faustus (1601)
 Scene xiv

O LENTE, LENTE, CURITE NOCTIS EQUI

FAUSTUS

Ah Faustus,
Now hast thou but one bare hower to liue,
And then thou must be damnd perpetually:
Stand stil you euer moouing spheres of heauen,
That time may cease, and midnight neuer come:
Faire Natures eie, rise, rise againe, and make
Perpetuall day, or let this houre be but
A yeere, a moneth, a weeke, a naturall day,
That Faustus may repent, and saue his soule,
O lente, lente curite noctis equi:
The starres mooue stil, time runs, the clocke wil strike,
The diuel wil come, and Faustus must be damnd.
O Ile leape vp to my God: who pulles me downe?
See see where Christs blood streames in the firmament.
One drop would saue my soule, halfe a drop, ah my Christ.
Ah rend not my heart for naming of my Christ,
Yet wil I call on him: oh spare me *Lucifer!*
Where is it now? tis gone: And see where God
Stretcheth out his arme, and bends his irefull browes:
Mountaines and hilles, come, come, and fall on me,
And hide me from the heauy wrath of God.
No, no.

Then wil I headlong runne into the earth:
Earth gape. O no, it wil not harbour me:
You starres that raignd at my natiuitie,
Whose influence hath alotted death and hel,
Now draw vp Faustus like a foggy mist,
Into the intrailes of yon labring cloude,
That when you vomite foorth into the ayre,
My limbes may issue from your smoaky mouthes,
So that my soule may but ascend to heauen:
Ah, halfe the houre is past: *The watch strikes.*
Twil all be past anone:
Oh God,
If thou wilt not haue mercy on my soule,
Yet for Christs sake, whose bloud hath ransomd me,
Impose some end to my incessant paine.
Let Faustus liue in hel a thousand yeeres,
A hundred thousand, and at last be sau'd.
O no end is limited to damned soules,
Why wert thou not a creature wanting soule?
Or, why is this immortall that thou hast?
Ah *Pythagoras metemsucosis,* were that true,
This soule should flie from me, and I be changde
Vnto some brutish beast: al beasts are happy,
For when they die,
Their soules are soone dissolud in elements,
But mine must liue still to be plagde in hel:
Curst be the parents that ingendred me:
No Faustus, curse thy selfe, curse *Lucifer,*
That hath depriude thee of the ioyes of heauen:
 The clocke striketh twelue.

O it strikes, it strikes: now body turne to ayre,
Or *Lucifer* wil beare thee quicke to hel:
 Thunder and lightning.

O soule, be changde into little water drops,
And fal into the *Ocean,* nere be found:
My God, my God, looke not so fierce on me:
 Enter diuels.

Adders, and Serpents, let me breathe a while:
Vgly hell gape not, come not *Lucifer,*
Ile burne my bookes, ah *Mephastophilis.*
 Exeunt with him.
 The tragicall History of Doctor Faustus (1601)
 Scene xvi

601

TAMBURLAINE

If all the pens that euer poets held,
Had fed the feeling of their maisters thoughts,
And euery sweetnes that inspir'd their harts,
Their minds, and muses on admyred theames:
If all the heauenly Quintessence they still
From their immortall flowers of Poesy,
Wherein as in a myrrour we perceiue
The highest reaches of a humaine wit.
If these had made one Poems period
And all combin'd in Beauties worthinesse,
Yet should ther houer in their restlesse heads,
One thought, one grace, one woonder at the least,
Which into words no vertue can digest:
But how vnseemly is it for my Sex
My discipline of armes and Chiualrie,
My nature and the terrour of my name,
To harbour thoughts effeminate and faint?
Saue onely that in Beauties iust applause,
With whose instinct the soule of man is toucht,
And euery warriour that is rapt with loue,
Of fame, of valour, and of victory
Must needs haue beauty beat on his conceites,
I thus conceiuing and subduing both
That which hath st(o)opt the tempest of the Gods,
Euen from the fiery spangled vaile of heauen,
To feele the louely warmth of shepheards flames,
And martch in cottages of strowed weeds,
Shal giue the world to note for all my byrth,
That Vertue solely is the sum of glorie,
And fashions men with true nobility.

Tamburlaine the Great (1590)
Part i, Act v, Scene ii

Shakespere himself has not surpassed, which is equivalent to saying that no other writer has equalled, the famous and wonderful passages in "Tamburlaine" and "Faustus," which are familiar to every student of English literature as examples of the NE PLUS ULTRA *of the poetic powers, not of the language but of language.*

GEORGE SAINTSBURY
A History of Elizabethan Literature (1887)

CHRISTOPHER MARLOWE

1 5 6 4 — 1 5 9 3

EDWARD'S DEATH

EDWARD

Whose there, what light is that, wherefore comes thou?

LIGHTBORNE

To comfort you, and bring you ioyfull newes.

EDWARD

Small comfort findes poore *Edward* in thy lookes,
Villaine, I know thou comst to murther me.

LIGHTBORNE

To murther you my most gratious lorde?
Farre is it from my hart to do you harme.
The Queene sent me, to see how you were vsed,
For she relents at this your miserie.
And what eyes can refraine from shedding teares,
To see a king in this most pittious state?

EDWARD

Weepst thou already? list a while to me,
And then thy heart, were it as *Gurneys* is,
Or as *Matreuis*, hewne from the *Caucasus*,
Yet will it melt, ere I haue done my tale.
This dungeon where they keepe me, is the sincke,
Wherein the filthe of all the castell falles.

LIGHTBORNE

O villaines!

EDWARD

And there in mire and puddle haue I stood,
This ten dayes space, and least that I should sleepe,
One plaies continually vpon a Drum,
They giue me bread and water being a king,
So that for want of sleepe and sustenance,
My mindes distempered, and my bodies numde,
And whether I haue limmes or no, I know not.
O would my bloud dropt out from euery vaine,
As doth this water from my tattered robes:
Tell *Isabell* the Queene, I lookt not thus,
When for her sake I ran at tilt in Fraunce,
And there vnhorste the duke of *Cleremont*.

LIGHTBORNE

O speake no more my lorde, this breakes my heart.
Lie on this bed, and rest your selfe a while.

603

EDWARD

These lookes of thine can harbor nought but death.
I see my tragedie written in thy browes,
Yet stay a while, forbeare thy bloudie hande,
And let me see the stroke before it comes,
That euen then when I shall lose my life,
My minde may be more stedfast on my God.

LIGHTBORNE

What meanes your highnesse to mistrust me thus?

EDWARD

What meanes thou to dissemble with me thus?

LIGHTBORNE

These handes were neuer stainde with innocent bloud,
Nor shall they now be tainted with a kings.

EDWARD

Forgiue my thought, for hauing such a thought
One iewell haue I left, receiue thou this.
Still feare I, and I know not whats the cause,
But euerie iointe shakes as I giue it thee:
O if thou harborst murther in thy hart,
Let this gift change thy minde, and saue thy soule,
Know that I am a king, oh at that name,
I feele a hell of greefe: where is my crowne?
Gone, gone, and doe I remaine aliue?

LIGHTBORNE

Your ouerwatchde my lord, lie downe and rest.

EDWARD

But that greefe keepes me waking, I shoulde sleepe,
For not these ten daies haue these eyes lids closd.
Now as I speake they fall, and yet with feare
Open againe. O wherefore sits thou heare?

LIGHTBORNE

If you mistrust me, ile be gon my lord.

EDWARD

No, no, for if thou meanst to murther me,
Thou wilt returne againe, and therefore stay.

LIGHTBORNE

He sleepes.

EDWARD

O let me not die yet, stay, O stay a while.

LIGHTBORNE

How now my Lorde.

EDWARD

Something still busseth in mine eares,
And tels me, if I sleepe I neuer wake,

604

This feare is that which makes me tremble thus,
And therefore tell me, wherefore art thou come?
LIGHTBORNE
To rid thee of thy life. *Matreuis* come.
EDWARD
I am too weake and feeble to resist,
Assist me sweete God, and receiue my souïe.

<div align="right">

The Tragedie of Edward the second (1594)

Act v, Scene v
</div>

The death-scene of Marlowe's king moves pity and terror beyond any scene ancient or modern with which I am acquainted.

<div align="right">

CHARLES LAMB

Specimens of English Dramatic Poets (1808)
</div>

WILLIAM SHAKESPEARE

1 5 6 4 — 1 6 1 6

THE GRAND STYLE

Our Reuels now are ended: These our actors,
(As I foretold you) were all Spirits, and
Are melted into Ayre, into thin Ayre,
And like the baselesse fabricke of this vision
The Clowd-capt Towres, the gorgeous Pallaces,
The solemne Temples, the great Globe it selfe,
Yea, all which it inherit, shall dissolue,
And like this insubstantiall Pageant faded
Leaue not a racke behinde: we are such stuffe
As dreames are made on; and our little life
Is rounded with a sleepe.

<div align="right">

The Tempest (1623)

Act iv, Scene i
</div>

My definition of the Grand Style is certainly wider than Mr. Arnold's, whose own seems to have been framed to insist upon that "high serious-ness" of his which is no doubt a grand thing. Mine would, I think, come nearer to the Longinian "Sublime"—the perfection of expression in every direction and kind, the commonly called great and the commonly called small, the tragic and the comic, the serious, the ironic, and even to some extent the trivial (not in the worst sense, of course). Whenever this perfection of expression acquires such force that it transmutes the

subject and transports the hearer or reader, then and there the Grand
Style exists, for so long, and in such a degree, as the transmutation
of the one and the transportation of the other lasts. It may persist, or
cease, or disappear and reappear, like a fixed or a revolving light, but
there it is IN ESSENTIA or IN POTENTIA. . . . It comes sometimes, as it
were, "promiscuously" in the vulgar sense of that term. It would, for
instance, be exceedingly difficult for the most expert, or the most futile,
ingenuity of the commentator to assign an exact reason for the occur-
rence, where it occurs, of what is perhaps the grandest example of the
Grand Style in all literature—the words of Prospero to Ferdinand, when
the revels are ended. An excuse is wanted to break off the pretty
"vanity of his art"; to get rid of the lovers; and to punish, in defeating
it, the intentionally murderous but practically idle plot of Caliban and
his mates. Anything would do; and the actual pretext is anything or
nothing. But Shakespeare chooses to accompany it with a "criticism of
life"—and of more than life—so all-embracing, couched in expression
of such magnificence, that one knows not where to look for its like as
form and matter combined. An ordinary man, if, PER IMPOSSIBLE, he
could have written it, would have put it at the end; an extraordinary
one might have substituted it for, or added it to, the more definite an-
nouncement of abdication and change which now comes later with "Ye
elves," etc. Shakespeare puts it here.

<div align="right">

GEORGE SAINTSBURY
Collected Essays (1923)

</div>

WILLIAM SHAKESPEARE

1 5 6 4 — 1 6 1 6

LET ME LIVE

ISABELLA
What saies my brother?

CLAUDIO
Death is a fearefull thing.

ISABELLA
And shamed life, a hatefull.

CLAUDIO
I, but to die, and go we know not where,
To lie in cold obstruction, and to rot,
This sensible warme motion, to become
A kneaded clod; And the delighted spirit
To bath in fierie floods, or to recide
In thrilling Region of thicke-ribbed Ice,

To be imprison'd in the viewlesse windes
And blowne with restlesse violence round about
The pendant world: or to be worse than worst
Of those, that lawlesse and incertaine thought,
Imagine howling, 'tis too horrible.
The weariest, and most loathed worldly life
That Age, Ache, penury, and imprisonment
Can lay on nature, is a Paradise
To what we feare of death.

ISABELLA

Alas, alas.

CLAUDIO

Sweet Sister, let me liue.
What sinne you do, to saue a brothers life,
Nature dispenses with the deede so farre,
That it becomes a vertue.

ISABELLA

Oh you beast,
Oh faithlesse Coward, oh dishonest wretch,
Wilt thou be made a man, out of my vice?
Is't not a kinde of Incest, to take life
From thine owne sisters shame? What should I thinke,
Heauen shield my Mother plaid my Father faire:
For such a warped slip of wildernesse
Nere issu'd from his blood. Take my defiance,
Die, perish: Might but my bending downe
Repreeue thee from thy fate, it should proceede.
Ile pray a thousand praiers for thy death,
No word to saue thee.

CLAUDIO

Nay heare me *Isabell*.

ISABELLA

Oh fie, fie, fie:
Thy sinn's not accidentall, but a Trade;
Mercy to thee would proue it selfe a Bawd,
'Tis best that thou diest quickly.

CLAUDIO

Oh heare me *Isabella*.

<div align="right">

Measure for Measure (1623)

Act iii, Scene i

</div>

The very perfection of poetic diction.

<div align="right">

HERBERT READ

Phases of English Poetry (1929)

</div>

WILLIAM SHAKESPEARE

1 5 6 4 — 1 6 1 6

IN SUCH A NIGHT

LORENZO

The moone shines bright. In such a night as this,
When the sweet winde did gently kisse the trees,
And they did make no noyse, in such a night
Troylus me thinkes mounted the Troian walls,
And sigh'd his soule toward the Grecian tents
Where *Cressed* lay that night.

JESSICA

In such a night
Did *Thisbie* fearefully ore-trip the dewe,
And saw the Lyons shadow ere himselfe,
And ranne dismayed away.

LORENZO

In such a night
Stood *Dido* with a Willow in her hand
Vpon the wilde sea bankes, and waft her Loue
To come againe to Carthage.

JESSICA

In such a night
Medea gathered the inchanted hearbs
That did renew old *Eson.*

LORENZO

In such a night
Did *Jessica* steale from the wealthy Jewe,
And with an Vnthrift Loue did runne from Venice,
As farre as Belmont.

JESSICA

In such a night
Did young *Lorenzo* sweare he lou'd her well,
Stealing her soule with many vowes of faith,
And nere a true one.

LORENZO

In such a night
Did pretty *Jessica* (like a little shrow)
Slander her Loue, and he forgaue it her.

JESSICA

I would out-night you did no body come:
But harke, I heare the footing of a man.

The Merchant of Venice (1623)
Act v, Scene i

608

The Elizabethan was an open-air theatre, and plays were presented in the afternoon by the light of the sun; it was therefore necessary for Shakespeare in writing the Merchant of Venice, Act V. i. to invoke before the eyes of his audience such a picture of the night as would be forever memorable in the literature of the world.

<div align="right">

GEORGE GORDON
Airy Nothings or What You Will (1917)

</div>

WILLIAM SHAKESPEARE

1 5 6 4 — 1 6 1 6

MOONLIGHT

How sweet the moone-light sleepes vpon this banke.

<div align="right">

The Merchant of Venice (1623)
Act v, Scene i

</div>

The happiest instance I remember of imaginative metaphor.

<div align="right">

JAMES HENRY LEIGH HUNT
Imagination and Fancy (1844)

</div>

WILLIAM SHAKESPEARE

1 5 6 4 — 1 6 1 6

THIS ENGLAND

This royall Throne of Kings, this sceptred Isle,
This earth of Maiesty, this seate of Mars,
This other Eden, demy paradise,
This Fortresse built by Nature for her selfe,
Against infection, and the hand of warre:
This happy breed of men, this little world,
This precious stone set in the siluer sea,
Which serues it in the office of a wall,
Or as a Moate defensiue to a house,
Against the enuy of lesse happier Lands,
This blessed plot, this earth, this Realme, this England.

<div align="right">

King Richard the Second (1597)
Act ii, Scene i

</div>

WILLIAM SHAKESPEARE

1 5 6 4 — 1 6 1 6

GENTLE RICHARD

As in a Theater, the eyes of men
After a well graced Actor leaues the Stage,
Are idely bent on him that enters next,
Thinking his prattle to be tedious:
Euen so, or with much more contempt, mens eyes
Did scowle on gentle *Richard:* no man cried, God saue him:
No ioyfull tongue gaue him his welcome home,
But dust was throwne vpon his Sacred head,
Which with such gentle sorrow he shooke off,
His face still combating with teares and smiles
(The badges of his greefe and patience)
That had not God for some strong purpose steel'd
The hearts of men, they must perforce haue melted,
And Barbarisme it selfe haue pittied him.

King Richard the Second (1597)
Act v, Scene ii

WILLIAM SHAKESPEARE

1 5 6 4 — 1 6 1 6

THE KING'S ARMY

All furnisht, all in Armes:
All plum'd like Estridges that with the wind
Baited like Eagles hauing lately bathd,
Glittering in golden coates like images,

610

As ful of spirit as the month of May,
And gorgeous as the sunne at Midsummer:
Wanton as youthful goates, wild as young buls,
I saw yong Harry with his Beuer on,
His cushes on his thighs, gallantly armde,
Rise from the ground like feathered Mercury,
And vaulted with such ease into his seat,
As if an Angel dropt down from the clouds,
To turne and wind a fiery Pegasus,
And witch the world with noble horsemanship.

<div align="right">

King Henry the Fourth, Part One (1598)

Act iv, Scene i
</div>

*There are also many descriptions in the poets and orators which owe
their sublimity to a richness and profusion of images in which the
mind is so dazzled as to make it impossible to attend to that exact co-
herence and agreement of the illusions which we should require on
every other occasion. I do not now remember a more striking example
of this than the description which is given of the King's army in the
play of* HENRY THE FOURTH.

<div align="right">

EDMUND BURKE

On the Sublime and Beautiful (1756)
</div>

WILLIAM SHAKESPEARE

1 5 6 4 — 1 6 1 6

THE TAVERN

A Room in the Boar's-head Tavern in EAST-CHEAP.

1 DRAWER

What the diuel hast thou brought there? Apple-Iohns? Thou know'st
Sir *Iohn* cannot endure an Apple-Iohn.

2 DRAWER

Mas thou say'st true: the Prince once set a Dish of Apple-Iohns be-
fore him, and told him there were fiue more Sir *Iohns*: and, putting
off his Hat, said, I will now take my leaue of these six drie, round,
old-wither'd Knights. It anger'd him to the heart: but hee hath
forgot that.

1 DRAWER

Why then couer, and set them downe: and see if thou canst finde out
Sneakes Noyse; Mistris *Teare-sheet* would faine heare some Musique.

<div align="center">

611
</div>

Dispatch! The roome where they supt is too hot, theile come in straight.

2 DRAWER

Sirrha, heere will be the Prince, and Master *Points,* anon: and they will put on two of our Ierkins, and Aprons, and Sir *Iohn* must not know of it: *Bardolph* hath brought word.

1 DRAWER

By the mas here will be old Vtis: it will be an excellent strategem.

2 DRAWER

Ile see if I can finde out *Sneake.*

Exit.

Enter Hostesse, and Dol.

HOSTESSE

Yfaith sweet-heart, me thinkes now you are in an excellent good temperalitie: your Pulsidge beates as extraordinarily, as heart would desire; and your Colour (I warrant you) is as red as any Rose, in good truth la! but yfaith you haue drunke too much Canaries, and that's a maruellous searching Wine; and it perfumes the blood, ere one can say what's this. How doe you now?

DOL

Better then I was: Hem.

HOSTESSE

Why thats well said: A good heart's worth Gold. Loe, here comes Sir *Iohn.*

Enter Falstaffe.

FALSTAFFE

When Arthur first in Court— *Sings.*
(Emptie the Iordan) *Exit 1 Drawer.*
And was a worthy King:
How now Mistris *Dol?*

HOSTESSE

Sick of a Calme: yea, good faith.

FALSTAFFE

So is all her Sect: and they be once in a Calme, they are sick.

DOL

A pox damne you, you muddie Rascall, is that all the comfort you giue me?

FALSTAFFE

You make fat Rascalls, Mistris *Dol.*

DOL

I make them? Gluttonie and Diseases make them, I make them not.

FALSTAFFE

If the Cooke help to make the Gluttonie, you helpe to make the

612

Diseases (*Dol*) we catch of you (*Dol*) we catch of you: Grant that. my poore Vertue, grant that.

DOL

Yea ioy, our Chaynes, and our Iewels.

FALSTAFFE

Your Brooches, Pearles, and Owches: For to serue brauely, is to come halting off: you know, to come off the Breach, with his Pike bent brauely, and to Surgerie brauely; to venture vpon the charg'd-Chambers brauely.

DOL

Hang your selfe, you muddie Cunger, hang your selfe.

HOSTESSE

By my troth this is the olde fashion: you two neuer meete, but you fall to some discord: you are both (in good truth) as Rheumatike as two drie Tostes, you cannot one beare with anothers Confirmities. What the good-yere? One must beare, and that must bee you: you are the weaker Vessell; as they say, the emptier Vessell.

DOL

Can a weake emptie Vessell beare such a huge full Hogs-head? There's a whole Marchants Venture of Burdeux-Stuffe in him: you haue not seene a Hulke better stufft in the Hold. Come, Ile be friends with thee *Iacke*: Thou art going to the Warres, and whether I shall euer see thee againe, or no, there is no body cares.

Enter Drawer.

DRAWER

Sir, Ancient *Pistoll* is below, and would speake with you.

DOL

Hang him, swaggering Rascall, let him not come hither: it is the foule-mouth'dst Rogue in England.

HOSTESSE

If hee swagger, let him not come here: no by my faith I must liue among my Neighbors, Ile no Swaggerers: I am in good name, and fame, with the very best: shut the doore, there comes no Swaggerers heere: I haue not liu'd all this while, to haue swaggering now: shut the doore, I pray you.

FALSTAFFE

Do'st thou heare, Hostesse?

HOSTESSE

'Pray you pacifie your selfe (Sir *Iohn*) there comes no Swaggerers heere.

FALSTAFFE

Do'st thou heare? it is mine Ancient.

HOSTESSE

Tilly-fally (Sir *Iohn*) nere tell me, your ancient Swaggerer comes not

in my doores. I was before Master *Tisick* the Debuty, tother day: and
as hee said to me, twas no longer agoe then Wednesday last: I' good
faith, Neighbour *Quickly* (sayes hee;) Master *Dumbe*, our Minister,
was by then: Neighbour *Quickly* (sayes hee) receiue those that are
Ciuill; for (saide hee) you are in an ill Name: now a saide so, I can
tell whereupon: for (sayes hee) you are an honest Woman, and well
thought on; therefore take heede what Guests you receiue: Receiue
(sayes hee) no swaggering Companions. There comes none heere.
You would blesse you to heare what hee said. No, Ile no Swaggerers.

FALSTAFFE

Hee's no Swaggerer (Hostesse:) a tame Cheater, yfaith: you may
stroake him as gently, as a Puppie Greyhound: heele not swagger
with a Barbarie Henne, if her feathers turne backe in any shew of
resistance. Call him vp (Drawer.) *Exit Drawer.*

HOSTESSE

Cheater, call you him? I will barre no honest man my house, nor no
Cheater: but I doe not loue swaggering. By my troth, I am the worse
when one sayes, swagger: Feele Masters, how I shake: looke you, I
warrant you.

DOL

So you doe, Hostesse.

HOSTESSE

Doe I? yea, in very truth doe I, and twere an Aspen Leafe: I cannot
abide Swaggerers.

Enter Pistol, and Bardolph and his Boy.

PISTOL

God saue you, Sir *Iohn*.

FALSTAFFE

Welcome Ancient *Pistol*. Here (*Pistol*) I charge you with a Cup of
Sacke: doe you discharge vpon mine Hostesse.

PISTOL

I will discharge vpon her (Sir *Iohn*) with two Bullets.

FALSTAFFE

She is Pistoll-proofe (Sir) you shall hardly offend her.

HOSTESSE

Come, Ile drinke no Proofes, nor no Bullets: Ile drinke no more then
will doe me good, for no mans pleasure, I.

PISTOL

Then to you (Mistris *Dorothie*) I will charge you.

DOL

Charge me? I scorne you (scuruie Companion) what? you poore, base,
rascally, cheating, lacke-Linnen-Mate: away you mouldie Rogue,
away; I am meat for your master.

614

PISTOL

I know you, Mistris *Dorothie.*

DOL

Away you Cut-purse Rascall, you filthy Bung, away: By this Wine, Ile thrust my Knife in your mouldie Chappes, and you play the sawcie Cuttle with me. Away you Bottle-Ale Rascall, you Basket-hilt stale Iugler, you. Since when, I pray you, Sir? Gods light, with two Points on your shoulder? much.

PISTOL

God let me not liue, but I will murther your Ruffe, for this.

FALSTAFFE

No more *Pistol,* I would not haue you go off here, discharge your selfe of our company, *Pistoll.*

HOSTESSE

No, good Captaine *Pistol:* not heere, sweete Captaine.

DOL

Captaine? thou abhominable damn'd Cheater, art thou not asham'd to be call'd Captaine? And Captaines were of my minde, they would trunchion you out, for taking their Names vpon you, before you haue earn'd them. You a Captaine? you slaue, for what? for tearing a poore Whores Ruffe in a Bawdy-house? Hee a Captaine? hang him Rogue, hee liues vpon mouldie stew'd-Pruines, and dry'de Cakes. A Captaine? Gods light these Villaines will make the word as odious as the word occupy, which was an excellent good worde before it was il sorted, therefore Captaines had neede looke too't.

BARDOLPH

'Pray thee goe downe, good Ancient.

FALSTAFFE

Hearke thee hither, Mistris *Dol.*

PISTOL

Not I: I tell thee what, Corporall *Bardolph,* I could teare her: Ile be reueng'd of her.

PAGE

'Pray thee goe downe.

PISTOL

Ile see her damn'd first: to *Pluto's* damn'd Lake, by this hand to the Infernall Deepe, with *Erebus* and Tortures vile also. Hold Hooke and Line, say I: Downe: downe Dogges, downe Faters: haue wee not *Hiren* here?

HOSTESSE

Good Captaine *Peesel* be quiet, tis very late yfaith: I beseeke you now, aggrauate your Choler.

PISTOL

These be good Humors indeede. Shall Pack-Horses,
And hollow-pamper'd Iades of Asia,

Which cannot goe but thirtie mile a day,
Compare with *Cæsars,* and with Caniballs,
And Troian Greekes? nay, rather damne them with
King *Cerberus,* and let the Welkin roare:
Shall wee fall foule for Toyes?

HOSTESSE

By my troth Captaine, these are very bitter words.

BARDOLPH

Be gone, good Ancient: this will grow to a Brawle anon.

PISTOL

Die men, like Dogges; giue Crownes like Pinnes: Haue we not
Hiren here?

HOSTESSE

O' my word (Captaine) there's none such here. What the good-yere,
doe you thinke I would denye her? for Gods sake be quiet.

PISTOL

Then feed, and be fat (My faire *Calipolis.*)
Come, giue's some Sack.
Si fortune me tormente, sperato me contento.
Feare wee broad-sides? No, let the Fiend giue fire:
Giue me some Sack: and Sweet-heart lye thou there.

 Layes down his sword.

Come wee to full Points here, and are *et cetera's* nothing?

FALSTAFFE

Pistol, I would be quiet.

PISTOL

Sweet Knight, I kisse thy Neaffe: what? wee haue seene the seuen
Starres.

DOL

For Gods sake thrust him downe stayres, I cannot endure such a
Fustian Rascall.

PISTOL

Thrust him downe stayres? know we not *Galloway* Nagges?

FALSTAFFE

Quoit him downe (*Bardolph*) like a shoue-groat shilling: nay, and a
doe nothing but speake nothing, a shall be nothing here.

BARDOLPH

Come, get you downe stayres.

PISTOL

What? shall wee haue Incision? shall wee embrew?

 Snatches up his sword.

Then Death rocke me asleepe, abridge my dolefull dayes:
Why then let grieuous, gastly, gaping Wounds,
Vntwin'd the Sisters three: Come *Atropos,* I say.

HOSTESSE

Here's goodly stuffe toward.

FALSTAFFE

Giue me my Rapier, Boy.

DOL

I pray thee *Iack*, I pray thee doe not draw.

FALSTAFFE

Get you downe stayres.

Drawing and driving Pistol out.

HOSTESSE

Here's a goodly tumult: Ile forsweare keeping house, afore Ile be in these tirrits, and frights. So: Murther I warrant now. Alas, alas, put vp your naked Weapons, put vp your naked Weapons.

Exeunt Pistol and Bardolph.

DOL

I pray thee *Iack* be quiet, the Rascall's gone: ah, you whorson little valiant Villaine, you.

HOSTESSE

Are you not hurt i'th'Groyne? me thought a made a shrewd Thrust at your Belly.

Enter Bardolph.

FALSTAFFE

Haue you turn'd him out o' doores?

BARDOLPH

Yea Sir: the Rascall's drunke: you haue hurt him (Sir) i'th shoulder.

FALSTAFFE

A Rascall to braue me.

DOL

Ah, you sweet little Rogue, you: alas, poore Ape, how thou sweat'st? Come, let me wipe thy Face: Come on, you whorson Chops: Ah Rogue, yfaith I loue thee: Thou art as valorous as *Hector* of Troy, worth fiue of *Agamemnon,* and tenne times better then the nine Worthies: ah Villaine.

FALSTAFFE

A rascally Slaue, I will tosse the Rogue in a Blanket.

DOL

Doe, and thou dar'st for thy heart: and thou doo'st, Ile canuas thee betweene a paire of Sheetes.

Enter Musique.

PAGE

The Musique is come, Sir.

FALSTAFFE

Let them play: play Sirs. Sit on my Knee, *Dol.* A Rascall, bragging Slaue: the Rogue fled from me like Quick-siluer.

617

DOL

Yfaith and thou followd'st him like a Church: thou whorson little tydie *Bartholmew* Bore-pigge, when wilt thou leaue fighting a dayes, and foyning a nights, and begin to patch vp thine old Body for Heauen?

Enter the Prince and Poines disguis'd.

FALSTAFFE

Peace (good *Dol*) doe not speake like a Deaths-head: doe not bid me remember mine end.

DOL

Sirrha, what humor's the Prince of?

FALSTAFFE

A good shallow young fellow: a would haue made a good Pantler, a would a chipp'd Bread well.

DOL

They say *Poines* has a good Wit.

FALSTAFFE

Hee a good Wit? hang him Baboone, his Wit's as thicke as Tewksburie Mustard: theres no more conceit in him, then is in a Mallet.

DOL

Why does the Prince loue him so then?

FALSTAFFE

Because their Legges are both of a bignesse: and a playes at Quoits well, and eates Conger and Fennell, and drinkes off Candles ends for Flap-dragons, and rides the wilde-Mare with the Boyes, and iumpes vpon Ioyn'd-stooles, and sweares with a good grace, and weares his Bootes very smooth, like vnto the Signe of the Legge; and breedes no bate with telling of discreete stories: and such other Gamboll Faculties a has, that shew a weake Minde, and an able Body, for the which the Prince admits him; for the Prince himselfe is such another: the weight of a hayre will turne the Scales betweene their *Haber-de-pois.*

PRINCE

Would not this Naue of a Wheele haue his Eares cut off?

POINES

Lets beat him before his Whore.

PRINCE

Looke, where the wither'd Elder hath not his Poll claw'd like a Parrot.

POINES

Is it not strange, that Desire should so many yeeres out-liue performance?

FALSTAFFE

Kisse me *Dol.*

618

PRINCE

Saturne and *Venus* this yeere in Coniunction? What sayes the Almanack to that?

POINES

And looke whether the fierie *Trigon*, his Man, be not lisping to his Masters old Tables, his Note-Booke, his Councell-keeper?

FALSTAFFE

Thou do'st giue me flatt'ring Busses.

DOL

By my troth, I kisse thee with a most constant heart.

FALSTAFFE

I am olde, I am olde.

DOL

I loue thee better, then I loue ere a scuruie young Boy of them all.

FALSTAFFE

What Stuffe wilt haue a Kirtle of? I shall receiue Money a Thursday: shalt haue a Cappe to morrow. A merrie Song, come: it growes late, weele to bed. Thou't forget me, when I am gone.

DOL

By my troth thou't set me a weeping, and thou say'st so: proue that euer I dresse my selfe handsome, till thy returne: well, hearken a'th end.

FALSTAFFE

Some Sack, *Francis.*

PRINCE, POINES

Anon, anon, Sir.

FALSTAFFE

Ha? a Bastard Sonne of the Kings? And art not thou *Poines* his Brother?

PRINCE

Why thou Globe of sinfull Continents, what a Life do'st thou lead?

FALSTAFFE

A better then thou: I am a Gentleman, thou art a Drawer.

PRINCE

Very true, Sir: and I come to draw you out by the Eares.

HOSTESSE

Oh, the Lord preserue thy good Grace: by my troth welcom to London. Now the Lord blesse that sweete Face of thine: O *Iesu,* are you come from Wales?

FALSTAFFE

Thou whorson mad Compound of Maiestie: by this light Flesh, and corrupt Blood, thou art welcome.

DOL

How? you fat Foole, I scorne you.

619

POINES

My Lord, hee will driue you out of your reuenge, and turne all to a merryment, if you take not the heat.

PRINCE

You whorson Candle-myne you, how vilely did you speake of me euen now, before this honest, vertuous, ciuill Gentlewoman?

HOSTESSE

Gods blessing of your good heart, and so shee is by my troth.

FALSTAFFE

Didst thou heare me?

PRINCE

Yea: and you knew me, as you did when you ranne away by *Gads-hill*: you knew I was at your back, and spoke it on purpose, to trie my patience.

FALSTAFFE

No, no, no: not so: I did not thinke, thou wast within hearing.

PRINCE

I shall driue you then to confesse the wilfull abuse, and then I know how to handle you.

FALSTAFFE

No abuse (*Hall*) a mine Honor, no abuse.

PRINCE

Not to disprayse me? and call me Pantler, and Bread-chipper, and I know not what?

FALSTAFFE

No abuse (*Hal.*)

POINES

No abuse?

FALSTAFFE

No abuse (*Ned*) i'th World: honest *Ned* none. I disprays'd him before the Wicked, that the Wicked might not fall in loue with him: In which doing, I haue done the part of a carefull Friend, and a true Subiect, and thy Father is to giue me thankes for it. No abuse (*Hal:*) none (*Ned*) none; no faith Boyes, none.

PRINCE

See now whether pure Feare, and entire Cowardise, doth not make thee wrong this vertuous Gentlewoman, to close with vs? Is shee of the Wicked? Is thine Hostesse heere, of the Wicked? Or is thy Boy of the Wicked? Or honest *Bardolph* (whose Zeale burnes in his Nose) of the Wicked?

POINES

Answere thou dead Elme, answere.

FALSTAFFE

The Fiend hath prickt downe *Bardolph* irrecouerable, and his Face

620

is *Lucifers* Priuy-Kitchin, where hee doth nothing but rost Mault-
Wormes: for the Boy, there is a good Angell about him, but the
Deuill outbids him too.

PRINCE

For the Women?

FALSTAFFE

For one of them, shees in Hell alreadie, and burnes poore Soules: for
the other, I owe her Money; and whether shee bee damn'd for that,
I know not.

HOSTESSE

No, I warrant you.

FALSTAFFE

No, I thinke thou art not: I thinke thou art quit for that. Marry, there
is another Indictment vpon thee, for suffering flesh to bee eaten in
thy house, contrary to the Law, for the which I thinke thou wilt
howle.

HOSTESSE

All Victuallers doe so: Whats a Ioynt of Mutton, or two, in a whole
Lent?

PRINCE

You, Gentlewoman.

DOL

What sayes your Grace?

FALSTAFFE

His Grace sayes that, which his flesh rebells against.

Peto knockes at doore.

HOSTESSE

Who knocks so lowd at doore? Looke to the doore there, *Francis.*

Enter Peto.

PRINCE

Peto, how now? what newes?

PETO

The King, your Father, is at Westminster,
And there are twentie weake and wearied Postes,
Come from the North: and as I came along,
I met, and ouer-tooke a dozen Captaines,
Bare-headed, sweating, knocking at the Tauernes,
And asking euery one for Sir *Iohn Falstaffe.*

PRINCE

By Heauen (*Poines*) I feele me much to blame,
So idly to prophane the precious time,
When Tempest of Commotion, like the South,
Borne with black Vapour, doth begin to melt,

621

And drop vpon our bare vnarmed heads.
Giue me my Sword, and Cloake: *Falstaffe*, good night.

Exeunt Prince, Poines, [Peto, and Bardolph.]

FALSTAFFE

Now comes in the sweetest Morsell of the night, and wee must hence, and leaue it vnpickt. More knocking at the doore?

Enter Bardolph.

How now? what's the matter?

BARDOLPH

You must away to Court, Sir, presently,
A dozen Captaines stay at doore for you.

FALSTAFFE [*to the Page*]

Pay the Musitians, Sirrha.
Farewell Hostesse, farewell *Dol*. You see (my good Wenches) how men of Merit are sought after: the vndeseruer may sleepe, when the man of Action is call'd on. Farewell good Wenches: if I be not sent away poste, I will see you againe, ere I goe.

DOL

I cannot speake: if my heart bee not readie to burst— Well (sweete *Iacke*) haue a care of thy selfe.

FALSTAFFE

Farewell, farewell. *Exit [with Bardolph].*

HOSTESSE

Well, fare thee well: I haue knowne thee these twentie nine yeeres, come Pescod-time: but an honester, and truer-hearted man— Well, fare thee well.

BARDOLPH [*within*]

Mistris *Teare-sheet.*

HOSTESSE

What's the matter?

BARDOLPH

Bid Mistris *Teare-sheet* come to my Master.

HOSTESSE

Oh runne *Dol*, runne: runne, good *Dol*, come. (*She comes blubbered.*) Yea! will you come *Doll*? *Exeunt.*

King Henry the Fourth, Part Two (1600)
Act ii, Scene iv

The finest tavern scene ever written.

JOHN MASEFIELD
Shakespeare (1911)

WILLIAM SHAKESPEARE

1 5 6 4 — 1 6 1 6

MORTALITY

SHALLOW

Come-on, come-on, come-on sir: giue mee your Hand, Sir; giue mee
your Hand, Sir: an early stirrer, by the Rood. And how doth my
good Cousin *Silence*?

SILENCE

Good-morrow, good Cousin *Shallow.*

SHALLOW

And how doth my Cousin, your Bed-fellow? and your fairest Daughter,
and mine, my God-daughter *Ellen*?

SILENCE

Alas, a blacke Woosel (Cousin *Shallow.*)

SHALLOW

By yea and no, Sir, I dare say my Cousin *William* is become a good
Scholler? hee is at Oxford still, is hee not?

SILENCE

Indeede Sir, to my cost.

SHALLOW

A must then to the Innes a Court shortly: I was once of *Clements*
Inne; where (I thinke) they will talke of mad *Shallow* yet.

SILENCE

You were call'd lustie *Shallow* then (Cousin.)

SHALLOW

By the masse I was call'd any thing: and I would haue done any
thing indeede too, and roundly too. There was I, and little *Iohn Doit*
of Staffordshire, and blacke *George Barnes,* and *Francis Pick-bone,*
and *Will Squele* a Cotsole-man, you had not foure such Swindge-
bucklers in all the Innes a Court againe: And I may say to you, wee
knew where the *Bona-Roba's* were, and had the best of them all at
commandement. Then was *Iacke Falstaffe* (now Sir *Iohn*) a Boy, and
Page to *Thomas Mowbray,* Duke of Norfolke.

SILENCE

This Sir *Iohn* (Cousin) that comes hither anon about Souldiers?

SHALLOW

The same Sir *Iohn,* the very same: I see him breake *Scoggan's* Head
at the Court-Gate, when a was a Crack, not thus high: and the very
same day did I fight with one *Sampson Stock-fish,* a Fruiterer, be-
hinde Greyes-Inne. *Iesu, Iesu,* the mad dayes that I haue spent! and
to see how many of my olde Acquaintance are dead?

SILENCE

Wee shall all follow (Cousin.)

SHALLOW

Certaine: 'tis certaine: very sure, very sure: Death (as the Psalmist saith) is certaine to all, all shall dye. How a good Yoke of Bullocks at Stamford Fayre?

SILENCE

By my troth, I was not there.

SHALLOW

Death is certaine. Is old *Double* of your Towne liuing yet?

SILENCE

Dead, Sir.

SHALLOW

Iesu, Iesu, dead! a drew a good Bow: and dead? a shot a fine shoote. *Iohn* a Gaunt loued him well, and betted much Money on his head. Dead? a would haue clapt ith Clowt at Twelue-score, and carryed you a fore-hand Shaft a foureteene, and foureteene and a halfe, that it would haue done a mans heart good to see. How a score of Ewes now?

SILENCE

Thereafter as they be: a score of good Ewes may be worth tenne pounds.

SHALLOW

And is olde *Double* dead?

<div align="right">

King Henry the Fourth, Part Two (1600)
Act iii, Scene ii

</div>

A finer sermon on mortality was never preached.

<div align="right">

WILLIAM HAZLITT
Lectures on the English Comic Writers (1819)

</div>

WILLIAM SHAKESPEARE

1 5 6 4 — 1 6 1 6

THE DEATH OF FALSTAFF

PISTOLL

Bardolph, be blythe: *Nim,* rowse thy vaunting Veines:
Boy, brissle thy Courage vp: for *Falstaffe* hee is dead,
And wee must erne therefore.

BARDOLPH

Would I were with him, wheresomere hee is, eyther in Heauen, or in Hell.

HOSTESSE

Nay sure, hee's not in Hell: hee's in *Arthurs* Bosome, if euer man went to *Arthurs* Bosome: a made a finer end, and went away an it had beene any Christome Child: a parted eu'n iust betweene Twelue and One, eu'n at the turning o'th'Tyde: for after I saw him fumble with the Sheets, and play with Flowers, and smile vpon his fingers ends, I knew there was but one way: for his Nose was as sharpe as a Pen, and a babled of greene fields. How now Sir *Iohn* (quoth I?) what man? be a good cheare: so a cryed out, God, God, God, three or foure times: now I, to comfort him, bid him a should not thinke of God; I hop'd there was no neede to trouble himselfe with any such thoughts yet: so a bad me lay more Clothes on his feet: I put my hand into the Bed, and felt them, and they were as cold as any stone: then I felt to his knees, and so vpward, and vpward, and all was as cold as any stone.

<div align="right">

King Henry the Fifth (1623)

Act ii, Scene iii

</div>

It is wonderful. There is nothing remotely like it in all the literature of the world. How should there be? It is Shakespeare's requiem over the darling of his imagination.

<div align="right">

JOHN MIDDLETON MURRY

Shakespeare (1936)

</div>

WILLIAM SHAKESPEARE

1 5 6 4 — 1 6 1 6

WINTER OF OUR DISCONTENT

Now is the Winter of our Discontent,
Made glorious Summer by this Son of Yorke:
And all the clouds that lowr'd vpon our house
In the deepe bosome of the Ocean buried.
Now are our browes bound with Victorious Wreathes,
Our bruised armes hung vp for Monuments;
Our sterne Alarums chang'd to merry Meetings;
Our dreadfull Marches, to delightfull Measures.
Grim-visag'd Warre, hath smooth'd his wrinkled Front:
And now, in stead of mounting Barbed Steeds,
To fright the Soules of fearfull Aduersaries,

He capers nimbly in a Lady's Chamber,
To the lasciuious pleasing of a Lute.
But I, that am not shap'd for sportiue trickes,
Nor made to court an amorous Looking-glasse:
I, that am Rudely stampt, and want loue's Maiesty,
To strut before a wanton ambling Nymph:
I, that am curtail'd of this faire Proportion,
Cheated of Feature by dissembling Nature,
Deform'd, vn-finish'd, sent before my time
Into this breathing World, scarse halfe made vp,
And that so lamely and vnfashionable,
That dogges barke at me, as I halt by them.
Why I (in this weake piping time of Peace)
Haue no delight to passe away the time,
Vnlesse to see my Shadow in the Sunne,
And descant on mine owne Deformity.

<div align="right">King Richard the Third (1623)
Act i, Scene i</div>

No poet in history opens a play with a more magnificent certainty.

<div align="right">JOHN MASEFIELD
William Shakespeare (1931)</div>

WILLIAM SHAKESPEARE

1 5 6 4 — 1 6 1 6

LOVE'S LIGHT WINGS

With Loue's light wings did I o'er-perch these Walls,
For stony limits cannot hold Loue out.

❋ ❋ ❋ ❋

It is my soule that calls vpon my name;
How siluer sweet sound Louers' tongues by night,
Like softest Musicke to attending eares!

<div align="right">Romeo and Juliet (1599)
Act ii, Scene ii</div>

The most exquisite words of love that ever were penned.

<div align="right">GEORG BRANDES
William Shakespeare (1898)</div>

WILLIAM SHAKESPEARE

1 5 6 4 — 1 6 1 6

THE VISION

Enter Katharine Dowager, sicke, lead betweene Griffith, her
Gentleman Vsher, and Patience her Woman.

GRIFFITH

How do's your Grace?

KATHARINE

 O *Griffith*, sicke to death:
My Legges like loaden Branches bow to'th'Earth,
Willing to leaue their burthen: Reach a Chaire,
So now (me thinkes) I feele a little ease.
Did'st thou not tell me *Griffith*, as thou lead'st mee,
That the great Childe of Honor, Cardinall *Wolsey*
Was dead?

GRIFFITH

 Yes Madam: but I thinke your Grace
Out of the paine you suffer'd, gaue no eare too't.

KATHARINE

Pre'thee good *Griffith*, tell me how he dy'de.
If well, he stept before me happily
For my example.

GRIFFITH

 Well, the voyce goes Madam,
For after the stout Earle Northumberland
Arrested him at Yorke, and brought him forward
As a man sorely tainted, to his Answer,
He fell sicke sodainly, and grew so ill
He could not sit his Mule.

KATHARINE

 Alas poore man.

GRIFFITH

At last, with easie Rodes, he came to Leicester,
Lodg'd in the Abbey; where the reuerend Abbot
With all his Couent, honourably receiu'd him;
To whom he gaue these words. O Father Abbot,
An old man, broken with the stormes of State,
Is come to lay his weary bones among ye:
Giue him a little earth for Charity.
So went to bed; where eagerly his sicknesse
Pursu'd him still, and three nights after this,
About the houre of eight, which he himselfe

Foretold should be his last, full of Repentance,
Continuall Meditations, Teares, and Sorrowes,
He gaue his Honors to the world agen,
His blessed part to Heauen, and slept in peace.

KATHARINE

So may he rest, his Faults lye gently on him:
Yet thus farre *Griffith*, giue me leaue to speake him,
And yet with Charity. He was a man
Of an vnbounded stomacke, euer ranking
Himselfe with Princes. One that by suggestion
Ty'de all the Kingdome. Symonie, was faire play,
His owne Opinion was his Law. I'th'presence
He would say vntruths, and be euer double
Both in his words, and meaning. He was neuer
(But where he meant to Ruine) pittifull.
His Promises, were as he then was, Mighty:
But his performance, as he is now, Nothing:
Of his owne body he was ill, and gaue
The Clergy ill example.

GRIFFITH

Noble Madam:
Mens euill manners liue in Brasse, their Vertues
We write in Water. May it please your Highnesse
To heare me speake his good now?

KATHARINE

Yes good *Griffith*,
I were malicious else.

GRIFFITH

This Cardinall,
Though from an humble Stocke, vndoubtedly
Was fashion'd to much Honor from his Cradle.
He was a Scholler, and a ripe, and good one:
Exceeding wise, faire spoken, and perswading:
Lofty, and sowre to them that lou'd him not:
But, to those men that sought him, sweet as Summer.
And though he were vnsatisfied in getting,
(Which was a sinne) yet in bestowing, Madam,
He was most Princely: Euer witnesse for him
Those twinnes of Learning, that he rais'd in you,
Ipswich and Oxford: one of which, fell with him,
Vnwilling to out-liue the good that did it.
The other (though vnfinish'd) yet so Famous,
So excellent in Art, and still so rising,
That Christendome shall euer speake his Vertue.

628

His Ouerthrow, heap'd Happinesse vpon him:
For then, and not till then, he felt himselfe,
And found the Blessednesse of being little.
And to adde greater Honors to his Age
Then man could giue him; he dy'de, fearing God.

KATHARINE

After my death, I wish no other Herald,
No other speaker of my liuing Actions,
To keepe mine Honor, from Corruption,
But such an honest Chronicler as *Griffith*.
Whom I most hated Liuing, thou hast made mee
With thy Religious Truth, and Modestie,
(Now in his Ashes) Honor: Peace be with him.
Patience, be neere me still, and set me lower.
I haue not long to trouble thee. Good *Griffith*,
Cause the Musitians play me that sad note
I nam'd my Knell; whil'st I sit meditating
On that Cœlestiall Harmony I go too.

> *Sad and solemne Musicke.*

GRIFFITH

She is asleep: Good wench, let's sit down quiet,
For feare we wake her. Softly, gentle *Patience*.

The Uision.

> *Enter solemnely tripping one after another, sixe Personages,
> clad in white Robes, wearing on their heades Garlands of
> Bayes, and golden Vizards on their faces, Branches of
> Bayes or Palme in their hands. They first Conge vnto her,
> then Dance: and at certaine Changes, the first two hold a
> spare Garland ouer her Head, at which the other foure
> make reuerend Curtsies. Then the two that held the Gar-
> land, deliuer the same to the other next two, who obserue the
> same order in their Changes, and holding the Garland ouer
> her head. Which done, they deliuer the same Garland to
> the last two: who likewise obserue the same Order. At which
> (as it were by inspiration) she makes (in her sleepe) signes
> of reioycing, and holdeth vp her hands to heauen. And so,
> in their Dancing vanish, carrying the Garland with them.
> The Musicke continues.*

KATHARINE

Spirits of peace, where are ye? Are ye all gone?
And leaue me heere in wretchednesse, behind ye?

GRIFFITH

Madam, we are heere.

KATHARINE

It is not you I call for,
Saw ye none enter since I slept?

GRIFFITH

None Madam.

KATHARINE

No? Saw you not euen now a blessed Troope
Inuite me to a Banquet, whose bright faces
Cast thousand beames vpon me, like the Sun?
They promis'd me eternall Happinesse,
And brought me Garlands (*Griffith*) which I feele
I am not worthy yet to weare: I shall assuredly.

GRIFFITH

I am most ioyfull Madam, such good dreames
Possesse your Fancy.

KATHARINE

Bid the Musicke leaue,
They are harsh and heauy to me.

Musicke ceases.

PATIENCE

Do you note
How much her Grace is alter'd on the sodaine?
How long her face is drawne? How pale she lookes,
And of an earthy cold? Marke her eyes?

GRIFFITH

She is going Wench. Pray, pray.

PATIENCE

Heauen comfort her.

Enter a Messenger.

MESSENGER

And't like your Grace—

KATHARINE

You are a sawcy Fellow,
Deserue we no more Reuerence?

GRIFFITH

You are too blame,
Knowing she will not loose her wonted Greatnesse
To vse so rude behauiour. Go too, kneele.

MESSENGER

I humbly do entreat your Highnesse pardon,
My hast made me vnmannerly. There is staying
A Gentleman sent from the King, to see you.

KATHARINE
 Admit him entrance *Griffith*. But this Fellow
 Let me ne're see againe.

Exit Messenger.

Enter Lord Capuchius.

 If my sight faile not,
 You should be Lord Ambassador from the Emperor,
 My Royall Nephew, and your name *Capuchius*.
CAPUCHIUS
 Madam the same. Your Seruant.
KATHARINE
 O my Lord,
 The Times and Titles now are alter'd strangely
 With me, since first you knew me. But I pray you,
 What is your pleasure with me?
CAPUCHIUS
 Noble Lady,
 First mine owne seruice to your Grace, the next
 The Kings request, that I would visit you,
 Who greeues much for your weaknesse, and by me
 Sends you his Princely Commendations,
 And heartily entreats you take good comfort.
KATHARINE
 O my good Lord, that comfort comes too late,
 'Tis like a Pardon after Execution;
 That gentle Physicke giuen in time, had cur'd me:
 But now I am past all Comforts heere, but Prayers.
 How does his Highnesse?
CAPUCHIUS
 Madam, in good health.
KATHARINE
 So may he euer do, and euer flourish,
 When I shall dwell with Wormes, and my poore name
 Banish'd the Kingdome. *Patience*, is that Letter
 I caus'd you write, yet sent away?
PATIENCE
 No Madam.
KATHARINE
 Sir, I most humbly pray you to deliuer
 This to my Lord the King.
CAPUCHIUS
 Most willing Madam.

631

KATHARINE

In which I haue commended to his goodnesse
The Modell of our chaste loues: his yong daughter,
The dewes of Heauen fall thicke in Blessings on her,
Beseeching him to giue her vertuous breeding.
She is yong, and of a Noble modest Nature,
I hope she will deserue well; and a little
To loue her for her Mothers sake, that lou'd him,
Heauen knowes how deerely. My next poore Petition,
Is, that his Noble Grace would haue some pittie
Vpon my wretched women, that so long
Haue follow'd both my Fortunes, faithfully,
Of which there is not one, I dare auow
(And now I should not lye) but will deserue
For Vertue, and true Beautie of the Soule,
For honestie, and decent Carriage
A right good Husband (let him be a Noble)
And sure those men are happy that shall haue'em.
The last is for my men, they are the poorest,
(But pouerty could neuer draw'em from me)
That they may haue their wages, duly paid'em,
And something ouer to remember me by.
If Heauen had pleas'd to haue giuen me longer life
And able meanes, we had not parted thus.
These are the whole Contents, and good my Lord,
By that you loue the deerest in this world,
As you wish Christian peace to soules departed,
Stand these poore peoples Friend, and vrge the King
To do me this last right.

CAPUCHIUS

 By Heauen I will,
Or let me loose the fashion of a man.

KATHARINE

I thanke you honest Lord. Remember me
In all humilitie vnto his Highnesse:
Say his long trouble now is passing
Out of this world. Tell him in death I blest him
(For so I will) mine eyes grow dimme. Farewell
My Lord. *Griffith* farewell. Nay *Patience*,
You must not leaue me yet. I must to bed,
Call in more women. When I am dead, good Wench,
Let me be vs'd with Honor; strew me ouer
With Maiden Flowers, that all the world may know
I was a chaste Wife, to my Graue: Embalme me,

Then lay me forth (Although vnqueen'd) yet like
A queene, and Daughter to a King enterre me.
I can no more. *Exeunt leading Katharine.*

<div align="right">

King Henry the Eighth (1623)
Act iv, Scene ii

</div>

This scene is, above any other part of SHAKESPEARE'S *tragedies, and perhaps above any scene of any other poet, tender and pathetick, without gods, or furies, or poisons, or precipices, without the help of romantick circumstances, without improbable sallies of poetical lamentation, and without any throes of tumultuous misery.*

<div align="right">

SAMUEL JOHNSON
The Plays of William Shakespeare (1765)

</div>

WILLIAM SHAKESPEARE

1 5 6 4 — 1 6 1 6

GOOD DEEDS PAST

Time hath (my Lord) a wallet at his backe,
Wherein he puts almes for obliuion:
A great siz'd monster of ingratitudes:
Those scraps are good deedes past, which are deuour'd
As fast as they are made, forgot as soone
As done: perseuerance, deere my Lord,
Keepes honour bright, to haue done, is to hang
Quite out of fashion, like a rustie mail,
In monumentall mockrie: take the instant way,
For honour trauels in a straight so narrow,
Where one but goes a breast, keepe then the path:
For emulation hath a thousand Sonnes,
That one by one pursue; if you giue way,
Or hedge aside from the direct forth right,
Like to an entred Tyde they all rush by,
And leaue you hindmost:
Or like a gallant Horse falne in first ranke,
Lye there for pauement to the abiect rear,
Ore-run and trampled on.

<div align="right">

Troilus and Cressida (1609)
Act iii, Scene iii

</div>

When Shakespeare's petulant Achilles asks, "What, are my deeds for-
got?"—his Ulysses has an answer for him which is one of the greatest
things in the world. Yet it could all be reduced to the merest common-
places of proverbial wisdom. But this worldly lore has come to new and
individual life in Shakespeare's mind; it is being experienced there like
a keenly appreciated event. It is something vividly happening, and all
the powers of imagination come trooping together to join in. Common
sense, without ceasing to be thought, turns also to a pomp of things seen
and felt; and the language of the poet gives us a rich and instantaneous
harmony of imaginative experience which is thought, sensation, and feel-
ing all at once.

<div align="right">

LASCELLES ABERCROMBIE
The Theory of Poetry (1926)

</div>

WILLIAM SHAKESPEARE

1 5 6 4 — 1 6 1 6

NIGHT

MACBETH

Is this a Dagger, which I see before me,
The Handle toward my Hand? Come, let me clutch thee:
I haue thee not, and yet I see thee still.
Art thou not fatall Vision, sensible
To feeling, as to sight? or art thou but
A Dagger of the Minde, a false Creation,
Proceeding from the heat-oppressed Braine?
I see thee yet, in forme as palpable,
As this which now I draw.
Thou marshall'st me the way that I was going,
And such an Instrument I was to vse.
Mine Eyes are made the fooles o'th'other Sences,
Or else worth all the rest: I see thee still;
And on thy Blade, and Dudgeon, Gouts of Blood,
Which was not so before. There's no such thing:
It is the bloody Businesse, which informes
Thus to mine Eyes. Now o're the one halfe World
Nature seemes dead, and wicked Dreames abuse
The Curtain'd sleepe: Witchcraft celebrates
Pale *Heccats* Offrings: and wither'd Murther,
Alarum'd by his Centinell, the Wolfe,

Whose howle's his Watch, thus with his stealthy pace,
With *Tarquins* rauishing strides, towards his designe
Moues like a Ghost. Thou sure and firme-set Earth
Heare not my steps, which way they walke, for feare
Thy very stones prate of my where-about,
And take the present horror from the time,
Which now sutes with it. Whiles I threat, he liues:
Words to the heat of deedes too cold breath giues.

<div align="right">

A Bell rings
</div>

I goe, and it is done: the Bell inuites me.
Heare it not, *Duncan,* for it is a Knell,
That summons thee to Heauen, or to Hell.

<div align="right">

Macbeth (1623)
Act ii, Scene i
</div>

——Now o'er one half the world
Nature seems dead,—

That is, over our hemisphere all action and motion seem to have ceased. This image, which is perhaps the most striking that poetry can produce, has been adopted by DRYDEN *in his* CONQUEST OF *Mexico.*

All things are hush'd as Nature's self lay dead,
The mountains seem to nod their drowsy head;
The little birds in dreams their songs repeat,
And sleeping flow'rs beneath the night dews sweat.
Even lust and envy sleep!

These lines, though so well known, I have transcribed, that the contrast between them and this passage of SHAKESPEARE *may be more accurately observed.*

Night is described by two great poets, but one describes a night of quiet, the other of perturbation. In the night of Dryden, all the disturbers of the world are laid asleep; in that of SHAKESPEARE, *nothing but sorcery, lust and murder, is awake. He that reads* DRYDEN, *finds himself lull'd with serenity, and disposed to solitude and contemplation. He that peruses* SHAKESPEARE, *looks round alarmed, and starts to find himself alone. One is the night of a lover, the other, of a murderer.*

<div align="right">

SAMUEL JOHNSON
The Plays of William Shakespeare (1765)
</div>

MULTITUDINOUS SEAS INCARNADINE

MACBETH
I haue done the deed: Didst thou not heare a noyse?

LADY MACBETH
I heard the Owle schreame, and the Crickets cry.
Did not you speake?

MACBETH
 When?

LADY MACBETH
 Now.

MACBETH
 As I descended?

LADY MACBETH
I.

MACBETH
Hearke,
Who lyes i'th'second Chamber?

LADY MACBETH
 Donalbaine.

MACBETH
This is a sorry sight. *Looks on his hand.*

LADY MACBETH
A foolish thought, to say a sorry sight.

MACBETH
There's one did laugh in's sleepe, and one cry'd Murther,
That they did wake each other: I stood, and heard them:
But they did say their Prayers, and addrest them
Againe to sleepe.

LADY MACBETH
 There are two lodg'd together.

MACBETH
One cry'd God blesse vs, and Amen the other,
As they had seene me with these Hangmans hands:
Listning their feare, I could not say Amen,
When they did say God blesse vs.

LADY MACBETH
 Consider it not so deepely.

MACBETH
But wherefore could not I pronounce Amen?

I had most need of Blessing, and Amen
Stuck in my throat.

LADY MACBETH

 These deeds must not be thought
After these wayes: so, it will make vs mad.

MACBETH

Me thought I heard a voyce cry, Sleep no more:
Macbeth does murther Sleepe, the innocent Sleepe,
Sleepe that knits vp the rauel'd Sleeue of Care,
The death of each dayes Life, sore Labors Bath,
Balme of hurt Mindes, great Natures second Course,
Chiefe nourisher in Life's Feast.

LADY MACBETH

 What doe you meane?

MACBETH

Still it cry'd, Sleepe no more to all the House:
Glamis hath murther'd Sleepe, and therefore *Cawdor*
Shall sleepe no more: *Macbeth* shall sleepe no more.

LADY MACBETH

Who was it, that thus cry'd? why worthy Thane,
You doe vnbend your Noble strength, to thinke
So braine-sickly of things: Goe get some Water,
And wash this filthie Witnesse from your Hand.
Why did you bring these Daggers from the place?
They must lye there: goe carry them, and smeare
The sleepie Groomes with blood.

MACBETH

 Ile goe no more:
I am afraid, to thinke what I haue done:
Looke on't againe, I dare not.

LADY MACBETH

 Infirme of purpose:
Giue me the Daggers: the sleeping, and the dead,
Are but as Pictures: 'tis the Eye of Child-hood,
That feares a painted Deuill. If he doe bleed,
Ile guild the Faces of the Groomes withall,
For it must seeme their Guilt. *Exit.*
 Knocke within.

MACBETH

 Whence is that knocking?
How is't with me, when euery noyse appalls me?
What Hands are here? hah: they pluck out mine Eyes.
Will all great *Neptunes* Ocean wash this blood
Cleane from my Hand? no: this my Hand will rather

The multitudinous Seas incarnardine,
Making the Greene one, Red.

Enter Lady Macbeth.

LADY MACBETH

My Hands are of your colour: but I shame
To weare a Heart so white.

Knocke.

I heare a knocking
At the South entry: retyre we to our Chamber:
A little Water cleares vs of this deed.
How easie is it then? your Constancie
Hath left you vnattended.

Knocke.

Hearke, more knocking.
Get on your Night-Gowne, lest occasion call vs,
And shew vs to be Watchers: be not lost
So poorely in your thoughts.

MACBETH

To know my deed,

Knocke.

'Twere best not know my selfe.
Wake *Duncan* with thy knocking: I would thou could'st.

Exeunt.

Macbeth (1623)
Act ii, Scene ii

*It was my custom to study my characters at night, when all the domestic
cares and business of the day were over. On the night preceding that in
which I was to appear in this part for the first time, I shut myself up, as
usual, when all the family were retired, and commenced my study of*
LADY MACBETH. *As the character is very short, I thought I should soon
accomplish it. Being then only twenty years of age, I believed, as many
others do believe, that little more was necessary than to get the words
into my head; for the necessity of discrimination, and the development
of character, at that time of my life, had scarcely entered into my imagin-
ation. But, to proceed. I went on with tolerable composure, in the silence
of the night, (a night I never can forget,) till I came to the assassination
scene, when the horrors of the scene rose to a degree that made it im-
possible for me to get farther. I snatched up my candle, and hurried out
of the room, in a paroxysm of terror. My dress was of silk, and the rustling
of it, as I ascended the stairs to go to bed, seemed to my panic-struck
fancy like the movement of a spectre pursuing me. At last I reached my
chamber, where I found my husband fast asleep. I clapt my candlestick*

down upon the table, without the power of putting the candle out; and I threw myself on my bed, without daring to stay even to take off my clothes.

Life of Mrs. Siddons, by Thomas Campbell (1834)

WILLIAM SHAKESPEARE

1 5 6 4 — 1 6 1 6

LIFE'S FITFUL FEVER

After Lifes fitfull Feuer, he sleepes well.

Macbeth (1623)
Act iii, Scene ii

THEOCRITUS

THIRD CENTURY B. C.

NOT FOR ME

μή μοι γᾶν Πέλοπος, μή μοι Κροίσεια τάλαντα

O, not for me the land of Pelops' pride;
The golden hoard of Croesus not for me.

Idylls, viii, 53
Translated by Henry Harmon Chamberlin

LUCRETIUS

9 6 ? — 5 5 B . C .

LORD OF LIGHTNING

Altitonans Volturnus et Auster fulmine pollens.

Volturnus thundering on high and Auster lord of lightning.

De Natura Rerum, v, 745
Translated by W. H. D. Rouse

639

I have heard good critics say that the most musical verse in English poetry is

 After life's fitful fever he sleeps well.

Evidently they are counting as elements in the music not merely the sounds but the associations of the various words, and probably also the contrast of rhythm between this line and the other blank verse lines round about it. In that sense one may value the music of Shakespeare's line more highly than that of

 Μή μοι γᾶν Πέλοπος, μή μοι χρυσειὰ τάλαντα,

or

 Altitonans Volturnus et Auster fulmine pollens.

I only suggest that the classical verses are, first, more sonorous, and, secondly, far nearer to dancing and music and more remote from the rhythm of common speech.

<div align="right">

GILBERT MURRAY

The Classical Tradition in Poetry (1927)

</div>

<div align="center">

WILLIAM SHAKESPEARE

1 5 6 4 — 1 6 1 6

FRAILTY, THY NAME IS WOMAN

</div>

HAMLET

Oh that this too too solid Flesh, would melt,
Thaw, and resolue it selfe into a Dew:
Or that the Euerlasting had not fixt
His Cannon 'gainst Selfe-slaughter. O God, O God!
How weary, stale, flat, and vnprofitable
Seeme to me all the vses of this world!
Fie on't! Ah fie, 'tis an vnweeded Garden
That growes to Seed: Things rank, and grosse in Nature
Possesse it meerely. That it should come to this:
But two months dead: Nay, not so much; not two,
So excellent a King, that was to this
Hiperion to a Satyre: so louing to my Mother,
That he might not beteeme the windes of heauen
Visit her face too roughly. Heauen and Earth!
Must I remember? why she would hang on him,

As if encrease of Appetite had growne
By what it fed on; and yet within a month,—
Let me not thinke on't: Frailty, thy name is woman.
A little Month, or ere those shooes were old,
With which she followed my poore Fathers body
Like *Niobe*, all teares, why she, euen she
(O God! a beast that wants discourse of Reason
Would haue mourn'd longer) married with my Vnkle,
My Fathers Brother: but no more like my Father,
Than I to *Hercules*. Within a Moneth?
Ere yet the salt of most vnrighteous Teares
Had left the flushing in her gauled eyes,
She married. O most wicked speed, to post
With such dexterity to Incestuous sheets:
It is not, nor it cannot come to good.
But breake my heart, for I must hold my tongue.

<div align="right">

Hamlet (1604)
Act i, Scene ii

</div>

WHAT I AM, I CANNOT AVOIDE

FORD

Hum: ha? Is this a vision? Is this a dreame? doe I sleepe? Master *Ford* awake, awake Master *Ford:* ther's a hole made in your best coate (Master *Ford:*) this 'tis to be married; this 'tis to haue Lynnen, and Buck-baskets: Well, I will proclaime my selfe what I am: I will now take the Leacher: hee is at my house: hee cannot scape me: 'tis impossible hee should: hee cannot creepe into a halfe-penny purse, nor into a Pepper-Boxe: But least the Diuell that guides him, should aide him, I will search impossible places: though what I am, I cannot auoide; yet to be what I would not, shall not make me tame: If I haue hornes, to make one mad, let the prouerbe goe with me, Ile be horne-mad.

<div align="right">

The Merry Wives of Windsor (1623)
Act iii, Scene v

</div>

Shakespeare's soliloquies may justly be established as a model; for it is not easy to conceive any model more perfect.

<div align="right">

HENRY HOME OF KAMES
Elements of Criticism (1762)

</div>

WILLIAM SHAKESPEARE

1 5 6 4 — 1 6 1 6

TO BE OR NOT TO BE

HAMLET

To be, or not to be, that is the Question:
Whether 'tis Nobler in the minde to suffer
The Slings and Arrowes of outragious Fortune,
Or to take Armes against a Sea of troubles,
And by opposing end them: to dye, to sleepe:
No more; and by a sleepe, to say we end
The Heart-ake, and the thousand Naturall shockes
That Flesh is heyre to. 'Tis a consummation
Deuoutly to be wish'd. To dye, to sleepe,
To sleepe, perchance to Dreame; I, there's the rub,
For in that sleepe of death, what dreames may come,
When we haue shuffled off this mortall coile,
Must giue vs pawse. There's the respect
That makes Calamity of so long life:
For who would beare the Whips and Scornes of time,
Th' Oppressor's wrong, the proude man's Contumely,
The pangs of despiz'd Loue, the Lawes delay,
The insolence of Office, and the Spurnes
That patient merit of the vnworthy takes,
When he himselfe might his *Quietus* make
With a bare Bodkin? Who would these Fardles beare
To grunt and sweat vnder a weary life,
But that the dread of something after death,
The vndiscouer'd Countrey, from whose Borne
No Traueller returnes, Puzels the will,
And makes vs rather beare those illes we haue,
Than flye to others that we know not of.
Thus Conscience does make Cowards of vs all,
And thus the Natiue hew of Resolution
Is sicklied o're, with the pale cast of Thought,
And enterprizes of great pith and moment,
With this regard their Currants turne awry,
And loose the name of Action.

<div align="right">

Hamlet (1604)
Act iii, Scene i

</div>

The supreme soliloquy.

<div align="right">

ALGERNON CHARLES SWINBURNE
A Study of Shakespeare (1880)

</div>

WILLIAM SHAKESPEARE

1 5 6 4 — 1 6 1 6

O FOOLE, I SHALL GO MAD

Enter Cornewall, Regan, Gloster, Seruants

LEAR

Good morrow to you both.

CORNEWALL

> Haile to your Grace.
>
> *Kent here set at liberty.*

REGAN

I am glad to see your Highnesse.

LEAR

Regan, I thinke you are. I know what reason
I haue to thinke so, if thou should'st not be glad,
I would diuorce me from thy Mothers Tombe,
Sepulchring an Adultresse. O are you free?

> *To Kent.*

Some other time for that. Beloued *Regan,*
Thy Sisters naught: oh *Regan,* she hath tied
Sharpe tooth'd vnkindnesse, like a vulture, heere,

> [*Lays his hand on his heart.*]

I can scarce speake to thee, thou'lt not beleeue
With how deprau'd a quality. Oh *Regan.*

REGAN

I pray you Sir, take patience, I haue hope
You lesse know how to value her desert,
Then she to scant her dutie.

LEAR

> Say? How is that?

REGAN

I cannot thinke my Sister in the least
Would faile her Obligation. If Sir perchance
She haue restrained the Riots of your Followres,
'Tis on such ground, and to such wholesome end,
As cleeres her from all blame.

LEAR

My curses on her.

REGAN

> O Sir, you are old,
Nature in you stands on the very Verge
Of her confine: you should be rul'd, and led
By some discretion, that discernes your state

Better then you your selfe: therefore I pray you,
That to our Sister, you do make returne,
Say you haue wrong'd her sir.

LEAR

 Aske her forgiuenesse?
Do you but marke how this becomes the house?
Deere daughter, I confesse that I am old;
Age is vnnecessary: on my knees I begge,
That you'l vouchsafe me Rayment, Bed and Food.

REGAN

Good Sir, no more: these are vnsightly trickes:
Returne you to my Sister.

LEAR

 Neuer *Regan:*
She hath abated me of halfe my Traine;
Look'd blacke vpon me, strooke me with her **Tongue**
Most Serpent-like, vpon the very Heart.
All the stor'd Vengeances of Heauen, fall
On her ingratefull top: strike her yong bones
You taking Ayres, with Lamenesse.

CORNEWALL

 Fye sir, **fie.**

LEAR

You nimble Lightnings, dart your blinding **flames**
Into her scornfull eyes: Infect her Beauty,
You Fen-suck'd Fogges, drawne by the powrfull **Sunne,**
To fall, and blast her pride.

REGAN

O the blest Gods! so will you wish on **me,**
When the rash moode is on.

LEAR

No *Regan,* thou shalt neuer haue my **curse:**
Thy tender-hefted Nature shall not giue
Thee o're to harshnesse: Her eyes are fierce, but **thine**
Do comfort, and not burne. 'Tis not in thee
To grudge my pleasures, to cut off my Traine,
To bandy hasty words, to scant my sizes,
And in conclusion, to oppose the bolt
Against my comming in. Thou better know'st
The Offices of Nature, bond of Childhood,
Effects of Curtesie, dues of Gratitude:
Thy halfe o' th' Kingdome hast thou not forgot,
Wherein I thee endow'd.

REGAN

 Good Sir, to th' purpose.

644

LEAR

Who put my man i'th'Stockes? *Tucket within.*

CORNEWALL

What Trumpet's that?

REGAN

I know't, my Sisters: this approues her Letter,
That she would soone be heere.

Enter Steward.

Is your Lady come?

LEAR

This is a Slaue, whose easie borrowed pride
Dwels in the fickle grace of her he followes.
Out Varlet, from my sight.

CORNEWALL

What meanes your Grace?

Enter Gonerill.

LEAR

Who stockt my Seruant? *Regan,* I haue good hope
Thou did'st not know on't. Who comes here?
O Heauens!
If you do loue old men, if your sweet sway
Allow Obedience; if your selues are old,
Make it your cause: Send downe, and take my part.

To Gonerill.

Art not asham'd to looke vpon this Beard?
O *Regan,* will you take her by the hand?

GONERILL

Why not by th' hand Sir? How haue I offended?
All's not offence that indiscretion findes,
And dotage termes so.

LEAR

O sides, you are too tough!
Will you yet hold? How came my man i'th' Stockes?

CORNEWALL

I set him there, Sir: but his owne Disorders
Deseru'd much lesse aduancement.

LEAR

You? Did you?

REGAN

I pray you Father being weake, seeme so.
If till the expiration of your Moneth
You will returne and soiourne with my Sister,
Dismissing halfe your traine, come then to me,

645

I am now from home, and out of that prouision
Which shall be needfull for your entertainment.

LEAR

Returne to her? and fifty men dismiss'd?
No, rather I abiure all roofes, and chuse
To wage against the enmity o' th' ayre,
To be a Comrade with the Wolfe, and Owle,
Necessities sharpe pinch. Returne with her?
Why the hot-bloodied *France*, that dowerlesse tooke
Our yongest borne, I could as well be brought
To knee his Throne, and Squire-like pension beg,
To keepe base life a foote; returne with her?
Perswade me rather to be slaue and sumpter
To this detested groome.

GONERILL

<div align="center">At your choice Sir.</div>

LEAR

I prythee Daughter do not make me mad,
I will not trouble thee my Child; farewell:
Wee'l no more meete, no more see one another.
But yet thou art my flesh, my blood, my Daughter,
Or rather a disease that's in my flesh,
Which I must needs call mine. Thou art a Byle,
A plague sore, an imbossed Carbuncle
In my corrupted blood. But Ile not chide thee,
Let shame come when it will, I do not call it,
I do not bid the Thunder-bearer shoote,
Nor tell tales of thee to high-iudging *Ioue*,
Mend when thou can'st, be better at thy leisure,
I can be patient, I can stay with *Regan*,
I and my hundred Knights.

REGAN

<div align="right">Not altogether so,</div>
I look'd not for you yet, nor am prouided
For your fit welcome, giue eare Sir to my Sister,
For those that mingle reason with your passion,
Must be content to thinke you old, and so—
But she knowes what she doe's.

LEAR

<div align="right">Is this well spoken?</div>

REGAN

I dare auouch it, Sir. What, fifty Followers?
Is it not well? What should you need of more?
Yea, or so many? Sith that both charge and danger,
Speake 'gainst so great a number? How in one house

<div align="center">646</div>

Should many people, vnder two commands
Hold amity? 'Tis hard, almost impossible.

GONERILL

Why might not you my Lord, receiue attendance
From those that she cals Seruants, or from mine?

REGAN

Why not my Lord? If then they chanc'd to slacke ye,
We could comptroll them; if you will come to me,
(For now I spie a danger) I entreate you
To bring but fiue and twentie, to no more
Will I giue place or notice.

LEAR

I gaue you all.

REGAN

 And in good time you gaue it.

LEAR

Made you my Guardians, my Depositaries,
But kept a reseruation to be followed
With such a number. What, must I come to you
With fiue and twenty? *Regan*, said you so?

REGAN

And speak't againe my Lord, no more with me.

LEAR

Those wicked Creatures yet do look wel fauor'd
When others are more wicked, not being the worst
Stands in some ranke of praise. [*To Gonerill.*] Ile go with thee,
Thy fifty yet doth double fiue and twenty,
And thou art twice her Loue.

GONERILL

 Heare me my Lord;
What need you fiue and twenty? Ten? or fiue?
To follow in a house, where twice so many
Haue a command to tend you?

REGAN

 What need one?

LEAR

O reason not the need: our basest Beggers
Are in the poorest thing superfluous,
Allow not Nature, more then Nature needs:
Mans life is cheape as Beastes. Thou art a Lady;
If onely to go warme were gorgeous,
Why Nature needs not what thou gorgeous wear'st,
Which scarcely keepes thee warme. But for true need—
You Heauens, giue me that patience, patience I need,
You see me heere (you Gods) a poore old man,

647

As full of griefe as age, wretched in both,
If it be you that stirres these Daughters hearts
Against their Father, foole me not so much,
To beare it tamely: touch me with Noble anger,
And let not womens weapons, water drops,
Staine my mans cheekes. No you vnnaturall Hags,
I will haue such reuenges on you both,
That all the world shall—I will do such things,
What they are yet, I know not, but they shalbe
The terrors of the earth! you thinke Ile weepe,
No, Ile not weepe, I haue full cause of weeping,

Storm and Tempest.

But this heart shal break into a hundred thousand flawes
Or ere Ile weepe; O Foole, I shall go mad.

Exeunt.

King Lear (1623)
Act ii, Scene iv

If there is anything in any author like this yearning of the heart, these throes of tenderness, this profound expression of all that can be thought and felt in the most heart-rending situations, we are glad of it; but it is in some author that we have not read.

WILLIAM HAZLITT
Characters of Shakespeare's Plays (1817)

WILLIAM SHAKESPEARE

1 5 6 4 — 1 6 1 6

LEAR AND CORDELIA

CORDELIA

How does my Royall Lord? How fares your Maiesty?

LEAR

You do me wrong to take me out o'th'graue,
Thou art a Soule in blisse, but I am bound
Vpon a wheele of fire, that mine owne teares
Do scal'd, like molten Lead.

648

CORDELIA

<p style="text-align:center">Sir, do you know me?</p>

LEAR

You are a spirit I know, when did you dye?

CORDELIA

Still, still, farre wide.

DOCTOR

He's scarse awake, let him alone a while.

LEAR

Where haue I bin? Where am I? Faire day light?
I am mightily abus'd; I should eu'n dye with pitty
To see another thus. I know not what to say:
I will not sweare these are my hands: let's see,
I feele this pin pricke, would I were assur'd
Of my condition.

CORDELIA

<p style="text-align:center">O looke vpon me Sir,</p>

And hold your hands in benediction o're me,
No Sir, you must not kneele.

LEAR

<p style="text-align:center">Pray do not mocke me:</p>

I am a very foolish fond old man,
Fourescore and vpward, not an houre more, nor lesse:
And to deale plainely,
I feare I am not in my perfect mind.
Me thinkes I should know you, and know this man;
Yet I am doubtfull: For I am mainely ignorant
What place this is: and all the skill I haue
Remembers not these garments: nor I know not
Where I did lodge last night. Do not laugh at me,
For (as I am a man) I thinke this Lady
To be my childe *Cordelia*.

CORDELIA

<p style="text-align:center">And so I am: I am.</p>

LEAR

Be your teares wet? Yes faith: I pray weepe not,
If you haue poyson for me, I will drinke it:
I know you do not loue me, for your Sisters
Haue (as I do remember) done me wrong.
You haue some cause, they haue not.

CORDELIA

<p style="text-align:center">No cause, no cause.</p>

<p style="text-align:right">King Lear (1623)
Act iv, Scene vii</p>

*One is loth to analyse its perfection; but we are talking of mere tech-
nique, of the means to the end, not trying to explain in what the great
poet is great—and possibly at his greatest when he can achieve such
pregnant simplicity. What are the means? The contrast with the Lear
that was; the homeliness of the speech, given its one enhancing touch of
richness in that 'wheel of fire'; the quiet cadence of the lines, kept from
monotony by a short line here and there; the descent from 'You are a
spirit, I know' through 'I should e'en die with pity to see another thus'
(this from Lear!) to the deliberately commonplace 'Would I were assured
of my condition!' Then, for an answer to the gracious beauty of '. . . hold
your hands in benediction o'er me', the sudden sight instead of the old
king falling humbly on his knees to her, and Cordelia's compassionate
horror at the sight; this picture informing her suspense and ours with the
silent question: Will he come to his right senses now? His passing from
darkness back to light is told in the opposition of two words: I think this
LADY to be my CHILD Cordelia. And at that she falls on her knees, too.
We may be as sure she is meant to as if Shakespeare had written the
direction; for this was the poignant moment in the old play, and no
false pride would stop him taking for his own such a thing of beauty—
the two there together, contending in humility as they had contended
in pride—when he found it. A daring and unmatchable picture, for it is
upon the extreme edge of beauty.*

HARLEY GRANVILLE-BARKER
Shakespeare's Dramatic Art (1934)

WILLIAM SHAKESPEARE

1 5 6 4 — 1 6 1 6

MY POORE FOOLE

LEAR

And my poore Foole is hang'd: no, no, no life?
Why should a Dog, a Horse, a Rat haue life,
And thou no breath at all? Thou'lt come no more,
Neuer, neuer, neuer, neuer, neuer.
Pray you vndo this Button. Thanke you Sir,
Do you see this? Looke on her! Looke, her lips!
Looke there, looke there.

King Lear (1623)
Act v, Scene iii

Lear's five-times repeated 'Never', in which the simplest and most un-answerable cry of anguish rises note by note till the heart breaks, is romantic in its naturalism; and to make a verse out of this one word required the boldness as well as the inspiration which came infallibly to Shakespeare at the greatest moments. But the familiarity, boldness and inspiration are surpassed (if that can be) by the next line, which shows the bodily oppression asking for bodily relief. The imagination that pro-duced Lear's curse or his defiance of the storm may be paralleled in its kind, but where else are we to seek the imagination that could venture to follow that cry of 'Never' with such a phrase as 'undo this button', and yet could leave us on the topmost peaks of poetry?

A. C. BRADLEY
Shakespearean Tragedy (1904)

WILLIAM SHAKESPEARE

1 5 6 4 — 1 6 1 6

JEALOUSY

Not Poppy, nor Mandragora,
Nor all the drowsie Syrrups of the world
Shall euer medicine thee to that sweete sleepe
Which thou owd'st yesterday.

Othello (1623)
Act iii, Scene iii

The effect is stupendous. The passage assaults and benumbs the faculties.

H. L. MENCKEN
Prejudices Third Series (1922)

WILLIAM SHAKESPEARE

1564 — 1616

OTHELLO'S DEATH

OTHELLO

Soft you; a word or two before you goe:
I haue done the State some seruice, and they know't:
No more of that. I pray you in your Letters,
When you shall these vnluckie deeds relate,
Speake of me, as I am. Nothing extenuate,
Nor set downe ought in malice. Then must you speake,
Of one that lou'd not wisely, but too well:
Of one, not easily Iealious, but being wrought,
Perplexed in the extreame: Of one, whose hand
(Like the base Indean) threw a Pearle away
Richer than all his Tribe: Of one, whose subdu'd Eyes,
Albeit vn-vsed to the melting moode,
Drops teares as fast as the Arabian Trees
Their medicinall gumme. Set you downe this:
And say besides, that in *Aleppo* once,
Where a malignant, and a Turbond-Turke
Beate a Venetian, and traduc'd the State,
I tooke by th'throat the circumcised Dogge,
And smoate him, thus.

Othello (1623)
Act v, Scene ii

There is a kind of criticism that would see in all these allusions, figures of speech, and wandering reflections, an unnatural rendering of suicide. The man, we might be told, should have muttered a few broken phrases, and killed himself without this pomp of declamation, like the jealous husbands in the daily papers. But the conventions of the tragic stage are more favourable to psychological truth than the conventions of real life. If we may trust the imagination (and in imagination lies, as we have seen, the test of propriety), this is what Othello would have felt. If he had not expressed it, his dumbness would have been due to external hindrances, not to the failure in his mind of just such complex and rhetorical thoughts as the poet has put into his mouth. The height of passion is naturally complex and rhetorical. Love makes us poets, and the approach of death should make us philosophers. When a man knows that his life is over, he can look back upon it from a universal standpoint. He has nothing more to live for, but if the energy of his mind remains unimpaired, he will still wish to live, and, being cut off from his personal

652

ambitions, he will impute to himself a kind of vicarious immortality by identifying himself with what is eternal. He speaks of himself as he is, or rather as he was. He sums himself up, and points to his achievement. This I have been, says he, this I have done.

This comprehensive and impartial view, this synthesis and objectification of experience, constitutes the liberation of the soul and the essence of sublimity.

GEORGE SANTAYANA
The Sense of Beauty (1896)

WILLIAM SHAKESPEARE

1 5 6 4 — 1 6 1 6

THE ETERNAL FEMININE

Enter Cleopatra, Charmian, Iras, and Alexas

CLEOPATRA

Giue me some Musicke: Musicke, moody foode
Of vs that trade in Loue.

OMNES

The Musicke, hoa.

Enter Mardian the Eunuch

CLEOPATRA

Let it alone, let's to Billiards: come *Charmian.*

CHARMIAN

My arme is sore, best play with *Mardian.*

CLEOPATRA

As well a woman with an Eunuch plaide,
As with a woman. Come you'le play with me Sir?

MARDIAN

As well as I can Madam.

CLEOPATRA

And when good will is shewed, though't come to short
The Actor may pleade pardon. Ile none now,
Giue me mine Angle, weele to'th'Riuer there
My Musicke playing farre off, I will betray
Tawny-finn'd fishes, my bended hooke shall pierce
Their slimy iawes: and as I draw them vp,
Ile thinke them euery one an *Anthony,*
And say, ah ha; y'are caught.

653

CHARMIAN

 'Twas merry when
You wager'd on your Angling, when your diuer
Did hang a salt fish on his hooke which he
With feruencie drew vp.

CLEOPATRA

 That time? Oh times:
I laught him out of patience: and that night
I laught him into patience, and next morne,
Ere the ninth houre, I drunke him to his bed:
Then put my Tires and Mantles on him, whilst
I wore his Sword Phillippan. Oh from Italie,

Enter a Messenger

Ramme thou thy fruitefull tidings in mine eares,
That long time haue bin barren.

MESSENGER

 Madam, Madam.

CLEOPATRA

Anthony's dead. If thou say so Villaine,
Thou kil'st thy Mistris: but well and free,
If thou so yield him, there is Gold, and heere
My blewest vaines to kisse: a hand that Kings
Haue lipt, and trembled kissing.

MESSENGER

First Madam, he is well.

CLEOPATRA

 Why there's more Gold.
But sirrah marke, we vse
To say, the dead are well: bring it to that,
The Gold I giue thee, will I melt and powr
Downe thy ill vttering throate.

MESSENGER

Good Madam heare me.

CLEOPATRA

 Well, go too I will:
But there's no goodnesse in thy face; if *Anthony*
Be free and healthfull; why so tart a fauour
To trumpet such good tidings? If not well,
Thou shouldst come like a Furie crown'd with Snakes,
Not like a formall man.

MESSENGER

 Wilt please you heare me?

CLEOPATRA

I haue a mind to strike thee ere thou speak'st:

654

Yet if thou say *Anthony* liues, 'tis well,
Or friends with *Cæsar*, or not Captiue to him,
Ile set thee in a shower of Gold, and haile
Rich Pearles vpon thee.

MESSENGER

 Madam, he's well.

CLEOPATRA

 Well said.

MESSENGER

And Friends with *Cæsar*.

CLEOPATRA

 Th'art an honest man.

MESSENGER

Cæsar, and he, are greater Friends than euer.

CLEOPATRA

Make thee a Fortune from me.

MESSENGER

 But yet Madam.

CLEOPATRA

I do not like but yet, it does alay
The good precedence, fie vpon but yet,
But yet is as a Iaylor to bring foorth
Some monstrous Malefactor. Prythee Friend,
Powre out the packe of matter to mine eare,
The good and bad together: he's friends with *Cæsar*,
In state of health thou saist, and thou saist, free.

MESSENGER

Free Madam, no: I made no such report,
He's bound vnto *Octauia*.

CLEOPATRA

 For what good turne?

MESSENGER

For the best turne i'th'bed.

CLEOPATRA

 I am pale *Charmian*.

MESSENGER

Madam, he's married to *Octauia*.

CLEOPATRA

The most infectious Pestilence vpon thee.

 Strikes him downe.

MESSENGER

Good Madam patience.

CLEOPATRA

 What say you? Hence

 Strikes htm.

Horrible Villaine, or Ile spurne thine eyes
Like balls before me: Ile vnhaire thy head,

She hales him vp and downe.

Thou shalt be whipt with Wyer, and stew'd in brine,
Smarting in lingring pickle.

MESSENGER

Gratious Madam,
I that do bring the newes, made not the match.

CLEOPATRA

Say 'tis not so, a Prouince I will giue thee,
And make thy Fortunes proud: the blow thou had'st
Shall make thy peace, for mouing me to rage,
And I will boot thee with what guift beside
Thy modestie can begge.

MESSENGER

He's married Madam.

CLEOPATRA

Rogue, thou hast liu'd too long.

Draw a knife.

MESSENGER

Nay then Ile runne:
What meane you Madam, I haue made no fault.

Exit.

CHARMIAN

Good Madam keepe your selfe within your selfe,
The man is innocent.

CLEOPATRA

Some Innocents scape not the thunderbolt:
Melt Egypt into Nyle: and kindly creatures
Turne all to Serpents. Call the slaue againe,
Though I am mad, I will not byte him: Call!

CHARMIAN

He is afeared to come.

CLEOPATRA

I will not hurt him. *Exit Charmian.*
These hands do lacke Nobility, that they strike
A meaner then my selfe: since I my selfe
Haue giuen my selfe the cause. Come hither Sir.

Enter Charmian and the Messenger againe.

Though it be honest, it is neuer good
To bring bad newes: giue to a gratious Message
An host of tongues, but let ill tydings tell
Themselues, when they be felt.

MESSENGER

I haue done my duty.

CLEOPATRA

Is he married?
I cannot hate thee worser then I do,
If thou againe say yes.

MESSENGER

He's married Madam.

CLEOPATRA

The Gods confound thee, dost thou hold there still?

MESSENGER

Should I lye Madame?

CLEOPATRA

Oh, I would thou didst:
So halfe my Egypt were submerg'd and made
A Cesterne for scal'd Snakes. Go get thee hence,
Had'st thou *Narcissus* in thy face, to me
Thou would'st appeere most vgly: He is married?

MESSENGER

I craue your Highnesse pardon.

CLEOPATRA

He is married?

MESSENGER

Take no offence, that I would not offend you,
To punnish me for what you make me do
Seemes much vnequall, he's married to *Octauia*.

CLEOPATRA

Oh that his fault should make a knaue of thee,
That art not what th'art sure of. Get thee hence,
The Marchandize which thou hast brought from Rome
Are all too deere for me: lye they vpon thy hand,
And be vndone by 'em.

Exit Messenger.

CHARMIAN

Good your Highnesse patience.

CLEOPATRA

In praysing *Anthony*, I haue disprais'd *Cæsar*.

CHARMIAN

Many times Madam.

CLEOPATRA

I am paid for't now:
Lead me from hence,
I faint, oh *Iras, Charmian:* 'tis no matter.
Go to the Fellow, good *Alexas* bid him
Report the feature of *Octauia:* her yeares,

657

Her inclination, let him not leaue out
The colour of her haire. Bring me word quickly,

Exit Alexas.

Let him for euer go: let him not! *Charmian!*
Though he be painted one way like a Gorgon,
The other wayes a Mars. [*To Mardian.*] Bid you *Alexas*
Bring me word, how tall she is: pitty me *Charmian*,
But do not speake to me. Lead me to my Chamber. *Exeunt.*

Antony and Cleopatra (1623)
Act ii, Scene v

*Perhaps the most wonderful revelation that literature gives us of the
essentially feminine; not necessarily of woman in the general, but of that
which radically, in looking at human nature, seems to differentiate the
woman from the man.*

ARTHUR SYMONS
Studies in the Elizabethan Drama (1919)

WILLIAM SHAKESPEARE

1 5 6 4 — 1 6 1 6

ANTONY'S FAREWELL TO CLEOPATRA

I am dying, Egypt, dying.

Antony and Cleopatra (1623)
Act iv, Scene xv

*Those ineffable penultimate words which attain the absolute per-
fection of pathos in verbal music.*

GEORGE SAINTSBURY
George Saintsbury: The Memorial Volume (1945)

WILLIAM SHAKESPEARE

1 5 6 4 — 1 6 1 6

EASTERNE STARRE

IRAS

Finish good Lady, the bright day is done,
And we are for the darke.

 ✽ ✽ ✽ ✽

CHARMIAN

Oh Easterne Starre.

CLEOPATRA

 Peace, peace:

Dost thou not see my Baby at my breast,
That suckes the Nurse asleepe.

Antony and Cleopatra (1623)
Act v, Scene ii

Among the most beautiful things ever written by man.

JOHN MASEFIELD
William Shakespeare (1911)

WILLIAM SHAKESPEARE

1 5 6 4 — 1 6 1 6

I AM FIRE, AND AYRE

CLEOPATRA

Giue me my Robe, put on my Crowne, I haue
Immortall longings in me. Now no more
The iuyce of Egypt's Grape shall moyst this lip.
Yare, yare, good *Iras;* quicke: Me thinkes I heare
Anthony call: I see him rowse himselfe
To praise by Noble Act. I heare him mock
The lucke of *Cæsar,* which the Gods giue men
To excuse their after wrath. Husband, I come:
Now to that name, my Courage proue my Title.
I am Fire, and Ayre; my other Elements

659

I giue to baser life. So, haue you done?
Come then, and take the last warmth of my Lippes.
Farewell kinde *Charmian, Iras,* long farewell
Haue I the Aspicke in my lippes? Dost fall?
If thou, and Nature can so gently part,
The stroke of death is as a Louer's pinch,
Which hurts, and is desir'd. Dost thou lye still?
If thus thou vanishest, thou tell'st the world,
It is not worth leaue-taking.

Antony and Cleopatra (1623)
Act v, Scene ii

*A passage surpassed in poetry, if at all, only by the final speech of Othello.**

A. C. BRADLEY
Oxford Lectures on Poetry (1923)

WILLIAM SHAKESPEARE

1 5 6 4 — 1 6 1 6

FUNERAL SONG

Feare no more the heate o'th'Sun,
Nor the furious Winters rages,
Thou thy worldly task hast don,
Home art gon, and tane thy wages.
 Golden Lads, and Girles all must,
 As Chimney-Sweepers come to dust.

Feare no more the frowne o'th'Great,
Thou art past the Tirants stroake,
Care no more to cloath and eate,
To thee the Reede is as the Oake:
 The Scepter, Learning, Physicke must,
 All follow this and come to dust.

Feare no more the Lightning flash.
Nor th'all-dreaded Thunderstone.
Feare not Slander, Censure rash.
Thou hast finish'd Ioy and mone.

* For Othello's speech, see page 652.

660

All Louers young, all Louers must,
Consigne to thee and come to dust.

No Exorcisor harme thee,
Nor no witch-craft charme thee.
Ghost vnlaid forbeare thee.
Nothing ill come neere thee.
 Quiet consumation haue,
 And renowned be thy graue.

Cymbeline (1623)
Act iv, Scene ii

O MISTRIS MINE

O Mistris mine where are you roming?
O stay and heare, your true loues coming,
That can sing both high and low.
Trip no further prettie sweeting:
Iourneys end in louers meeting,
Euery wise mans sonne doth know.

What is loue? tis not heereafter,
Present mirth, hath present laughter:
What's to come, is still vnsure.
In delay there lies no plentie,
Then come kisse me sweet and twentie:
Youth's a stuffe will not endure.

Twelfth Night (1623)
Act ii, Scene iii

The very summits of lyrical achievement.

A. E. HOUSMAN
The Name and Nature of Poetry (1933)

WILLIAM SHAKESPEARE

1 5 6 4 — 1 6 1 6

CRABBED AGE AND YOUTH

Crabbed age and youth cannot liue together,
Youth is full of pleasance, Age is full of care,
Youth like summer morne, Age like winter weather,
Youth like summer braue, Age like winter bare.

Youth is full of sport, Age's breath is short,
Youth is nimble, Age is lame
Youth is hot and bold, Age is weake and cold,
Youth is wild, and Age is tame.
 Age I doe abhor thee, Youth I doe adore thee,
 O my loue my loue is young:
 Age I doe defie thee. Oh sweet Shepheard hie thee:
 For me thinks thou staies too long.

<div align="right">The Passionate Pilgrim (1599), xii</div>

One of the loveliest lyrics in the language.

<div align="right">SIR ARTHUR QUILLER-COUCH
Adventures in Criticism (1925)</div>

WILLIAM SHAKESPEARE

1 5 6 4 — 1 6 1 6

DEUOURING TIME

Deuouring time blunt thou the Lyons pawes,
And make the earth deuoure her owne sweet brood,
Plucke the keene teeth from the fierce Tygers yawes,
And burne the long liu'd Phænix in her blood,
Make glad and sorry seasons as thou fleet'st,
And do what ere thou wilt swift-footed time,
To the wide world and all her fading sweets:
But I forbid thee one most hainous crime,
O carue not with thy howers my loues faire brow,
Nor draw noe lines there with thine antique pen,
Him in thy course vntainted doe allow,
For beauties patterne to succeding men.
 Yet doe thy worst ould Time dispight thy wrong,
 My loue shall in my verse euer liue young.

<div align="right">Sonnets (1609), xix</div>

*This is, in all probability, the greatest sonnet in the English language,
with its tremendous first lines. . . . The huge, fiery, and majestic double
vowels contained in 'deuouring' and 'Lyons' (those in 'Lyons' rear them-
selves up and then bring down their splendid and terrible weight)—
these make the line stretch onward and outward until it is overwhelmed,
as it were, by the dust of death, by darkness, with the muffling sounds,*

first of 'blunt', than of the far thicker, more muffling sound of 'pawes'.
This gigantic system of stretching double vowels, long single vowels muffled by the earth, continues through the first three lines:

> And make the earth deuoure her owne sweet brood;
> Plucke the keene teeth from the fierce Tygers yawes,
> And burne the long-liu'd Phœnix in her blood.

The thick p of 'pawes' muffles us with the dust, the dark hollow sound of 'yawes' covers us with the eternal night.
The music is made more vast still by the fact that, in the third line, two long stretching double vowels are placed close together ('keene teeth'), and that in the fourth there are two alliterative B's,—'burne' and 'blood', these giving an added majesty, a gigantic balance.

<div align="right">

EDITH SITWELL
A Poet's Notebook (1943)

</div>

WILLIAM SHAKESPEARE

1 5 6 4 — 1 6 1 6

HEAUENLY ALCUMY

Guilding pale streames with heauenly alcumy.

<div align="right">

Sonnets (1609), xxxiii

</div>

When to the Sessions of sweet silent thought.

<div align="right">

Sonnets (1609), xxx

</div>

The perfection of human utterance.

<div align="right">

SIDNEY LEE
Shakespeares Sonnets (1905)

</div>

BEING YOUR SLAUE

Being your slaue what should I doe but tend,
Vpon the houres, and times of your desire?
I haue no precious time at al to spend;
Nor seruices to doe til you require.
Nor dare I chide the world without end houre,
Whilst I (my soueraine) watch the clock for you,
Nor thinke the bitternesse of absence sowre,
When you haue bid your seruant once adieue.
Nor dare I question with my iealious thought,
Where you may be, or your affaires suppose,
But like a sad slaue stay and thinke of nought
Saue where you are, how happy you make those.
 So true a foole is loue, that in your Will,
 (Though you doe any thing) he thinkes no ill.

<div align="right">Sonnets (1609), lvii</div>

Technically perfect and altogether admirable.

<div align="right">

JOHN CROWE RANSOM
The World's Body (1938)

</div>

THE SPIGHT OF FORTUNE

Then hate me when thou wilt, if euer, now,
Now while the world is bent my deeds to crosse,
Ioyne with the spight of fortune, make me bow,
And doe not drop in for an after losse:
Ah doe not, when my heart hath scapte this sorrow,
Come in the rereward of a conquerd woe,
Giue not a windy night a rainie morrow,
To linger out a purposd ouer-throw.
If thou wilt leaue me, do not leaue me last,
When other pettie griefes haue done their spight,

But in the onset come, so shall I taste
At first the very worst of fortunes might.
 And other straines of woe, which now seeme woe,
 Compar'd with losse of thee, will not seeme so.

<div align="right">Sonnets (1609), xc</div>

*I doubt if in all recorded speech such faultless perfection may be found,
so sustained through fourteen consecutive lines.*

<div align="right">GEORGE WYNDHAM
The Poems of Shakespeare (1898)</div>

WILLIAM SHAKESPEARE

1 5 6 4 — 1 6 1 6

THE MARRIAGE OF TRUE MINDES

Let me not to the marriage of true mindes
Admit impediments, loue is not loue
Which alters when it alteration findes,
Or bends with the remouer to remoue.
O no, it is an euer fixed marke
That lookes on tempests and is neuer shaken;
It is the star to euery wandring barke,
Whose worths vnknowne, although his higth be taken.
Lou's not Times foole, though rosie lips and cheeks
Within his bending sickles compasse come,
Loue alters not with his breefe houres and weekes,
But beares it out euen to the edge of doome:
 If this be error and vpon me proued,
 I neuer writ, nor no man euer loued.

<div align="right">Sonnets (1609), cxvi</div>

*It consists of three separate quatrains, each concluded by a full stop,
and a summarizing couplet. The chief pause in sense is after the twelfth
line. Seventy-five per cent of the words are monosyllables; only three
contain more syllables than two; none belongs in any degree to the
vocabulary of 'poetic' diction. There is nothing recondite, exotic, or
'metaphysical' in the thought. There are three run-on lines, one pair of
double endings. There is nothing to remark about the riming except the
happy blending of open and closed vowels, and of liquids, nasals, and
stops; nothing to say about the harmony except to point out how the*

fluttering accents in the quatrains give place in the couplet to the em-
phatic march of ten almost unrelieved iambic feet. In short, the poet has
employed one hundred and ten of the simplest words in the language,
and the two simplest rime-schemes, to produce a poem which has about
it no strangeness whatever except the strangeness of perfection.

<div align="right">

TUCKER BROOKE
Shakespeare's Sonnets (1936)

</div>

WILLIAM SHAKESPEARE

1 5 6 4 — 1 6 1 6

PAST REASON HUNTED

Th' expence of Spirit in a waste of shame
Is lust in action, and till action, lust
Is periurd, murdrous, blouddy full of blame,
Sauage, extreame, rude, cruell, not to trust,
Inioyd no sooner but dispised straight,
Past reason hunted, and no sooner had
Past reason hated as a swollowed bayt,
On purpose layd to make the taker mad.
Made In pursut and in possession so,
Had, hauing, and in quest, to haue extreame,
A blisse in proofe and proud and very wo,
Before a ioy proposd behind a dreame,
 All this the world well knowes yet none knowes well,
 To shun the heauen that leads men to this hell.

<div align="right">

Sonnets (1609), cxxix

</div>

The greatest in the world.

<div align="right">

THEODORE WATTS-DUNTON
Quoted, William Sharp, The Songs, Poems, and
Sonnets of William Shakespeare (1880)

</div>

SONNET

La voix qui retentit de l'vn à l'autre Pole,
 La terreur & l'espoir des viuans & des morts,
 Qui du rien sçait tirer les esprits & les corps,
 Et qui fit l'Vniuers, d'vne seule parole.

La voix du Souuerain, qui les cedres desole,
 Cependant que l'espine estale ses tresors;
 Qui contre la cabane espargne ses efforts,
 Et reduit à neant l'orgueil du Capitole.

Ce tonnerre esclatant, cette diuine voix,
 A qui sçavent respondre & les monts, & les bois,
 Et qui fait qu'à leur fin toutes choses se rendent.

Que les Cieux les plus hauts, que les lieux les plus bas,
 Que ceux qui ne sont point, & que les morts entendent,
 Mon ame, elle t'appelle, & tu ne l'entens pas.

The Voice that resounds from pole to pole, the terror and hope of the living and dead, that Voice which can evoke spirits and bodies from nothingness, and that created the Universe, with a single word. The Voice of the Lord, that ravages the cedars, while the thorn flaunts its treasures; that spares the hut and reduces to nothingness the pride of the capital. The resounding thunder, the divine Voice, to which the mountains and the woods respond, and that directs all things to their end. The Voice that is heard by the highest heavens, and the lowest depths, by those that are not, and by those that are dead, beseeches Thee, my soul, and Thou hearest it not.

The best ode in your language is in the form of a sonnet by Gombaud.
WALTER SAVAGE LANDOR
Imaginary Conversations, Abbé Delille and Landor (1824-9)

JOHN DONNE

1 5 7 3 — 1 6 3 1

OF THE PROGRESSE OF THE SOULE

So long,
As till Gods great *Venite* change the song.
The Second Anniversary (1612)

The finest line in English sacred poetry . . . a DIES IRAE *and a* VENITE
itself combined in ten English syllables.

GEORGE SAINTSBURY
Introduction, Poems of Donne (1896)

JOHN DONNE

1 5 7 3 — 1 6 3 1

THE WILL

Before I sigh my last gaspe, let me breath,
Great love, some Legacies; Here I bequeath
Mine eyes to *Argus,* if mine eyes can see,
If they be blinde, then Love, I give them thee;
My tongue to Fame; to'Embassadours mine eares;
 To women or the sea, my teares.
Thou, Love, hast taught mee heretofore
By making mee serve her who'had twenty more,
That I should give to none, but such, as had too much before.

My constancie I to the planets give;
My truth to them, who at the Court doe live;
Mine ingenuity and opennesse,
To Jesuites; to Buffones my pensivenesse;
My silence to'any, who abroad hath beene;
 My mony to a Capuchin.
Thou Love taught'st me, by appointing mee
To love there, where no love receiv'd can be,
Onely to give to such as have an incapacitie.

My faith I give to Roman Catholiques;
All my good works unto the Schismaticks

668

Of Amsterdam: my best civility
And Courtship, to an Universitie;
My modesty I give to souldiers bare,
 My patience let gamesters share.
Thou Love taughtst mee, by making mee
Love her that holds my love disparity,
Onely to give to those that count my gifts indignity.

I give my reputation to those
Which were my friends; Mine industrie to foes;
To Schoolemen I bequeath my doubtfulnesse;
My sicknesse to Physitians, or excesse;
To Nature, all that I in Ryme have writ;
 And to my company my wit.
Thou Love, by making mee adore
Her, who begot this love in mee before,
Taughtst me to make, as though I gave, when I did but restore.

To him for whom the passing bell next tolls,
I give my physick bookes; my writen rowles
Of Morall counsels, I to Bedlam give;
My brazen medals, unto them which live
In want of bread; To them which passe among
 All forrainers, mine English tongue.
Thou, Love, by making mee love one
Who thinkes her friendship a fit portion
For yonger lovers, dost my gifts thus disproportion.

Therefore I'll give no more; But I'll undoe
The world by dying; because love dies too.
Then all your beauties will bee no more worth
Then gold in Mines, where none doth draw it forth;
And all your graces no more use shall have
 Then a Sun dyall in a grave.
Thou Love taughtst mee, by making mee
Love her, who doth neglect both mee and thee,
To'invent, and practise this one way, to'annihilate all three.

(1633)

THE WILL OF JOHN DONNE *is probably the wittiest and the bitterest lyric in our language.*

OSWALD CRAWFURD
Lyrical Verse (1896)

JOHN DONNE

1 5 7 3 — 1 6 3 1

GOD'S MERCIES

If some King of the earth have so large an extent of Dominion, in North, and South, as that he hath Winter and Summer together in his Dominions, so large an extent East and West, as that he hath day and night together in his Dominions, much more hath God mercy and judgement together: He brought light out of darknesse, not out of a lesser light; he can bring thy Summer out of Winter, though thou have no Spring; though in the wayes of fortune, or understanding, or conscience, thou have been benighted till now, wintred and frozen, clouded and eclypsed, damped and benummed, smothered and stupefied till now, now God comes to thee, not as in the dawning of the day, not as in the bud of the spring, but as the Sun at noon to illustrate all shadowes, as the sheaves in harvest, to fill all penuries, all occasions invite his mercies, and all times are his seasons.

<div align="right">LXXX Sermons (1640)</div>

And now for Donne; in a passage than which I hardly know anything more exquisitely rhythmed in the whole range of English from Ælfric to Pater. . . . Here there could be no change without disaster, except in the possible substitution of some other word for the thrice-repeated "dominion[s]," which to our ears (though apparently neither to French nor to English ones of the seventeenth century) make a disagreeable jingle without emphasis to excuse it. "Now," as repeated, is in a very different position, and makes one of the appeals of the piece. The Shakespearian magnificence of the diction, such as the throng of kindred but never tautological phrase in "wintered and frozen," etc., and the absolute perfection of rhythmical——never metrical——movement, could not be better wedded. It has, I have said, never been surpassed. I sometimes doubt whether it has ever been equalled.

<div align="right">

GEORGE SAINTSBURY
A History of English Prose Rhythm (1912)

</div>

JOHN DONNE

1 5 7 3 — 1 6 3 1

ETERNITY

A state but of one Day, because no Night shall over-take, or determine it, but such a Day, as is not of a thousand yeares, which is the longest measure in the Scriptures, but of a thousand millions of millions of generations: *Qui nec præceditur hesterno, nec excluditur crastino,* A day that hath no *pridie,* nor *postridie,* yesterday doth not usher it in, nor to morrow shall not drive it out. *Methusalem,* with all his hundreds of yeares, was but a Mushrome of a nights growth, to this day, And all the foure Monarchies, with all their thousands of yeares, And all the powerfull Kings, and all the beautifull Queenes of this world, were but as a bed of flowers, some gathered at six, some at seaven, some at eight, All in one Morning, in respect of this Day. In all the two thousand yeares of Nature, before the Law given by *Moses,* And the two thousand yeares of Law, before the Gospel given by Christ, And the two thousand of Grace, which are running now, (of which last houre we have heard three quarters strike, more than fifteen hundred of this last two thousand spent) In all this six thousand, and in all those, which God may be pleased to adde, *In domo patris,* In this House of his Fathers, there was never heard quarter clock to strike, never seen minute glasse to turne.

LXXX Sermons (1640)

A description of the unending day of eternity unsurpassed in our literature.

LOGAN PEARSALL SMITH
Donne's Sermons (1919)

BEN JONSON

1 5 7 3 ? — 1 6 3 7

HERE'S THE RICH PERU

MAMMON, SVRLY

MAMMON
Come on, sir. Now, you set your foot on shore
In *nouo orbe;* Here's the rich *Peru:*
And there within, sir, are the golden mines,

671

Great SALOMON's *Ophir!* He was sayling to't,
Three yeeres, but we haue reach'd it in ten months.
This is the day, wherein, to all my friends,
I will pronounce the happy word, *be rich.*
This day, you shall be *spectatissimi.*
You shall no more deale with the hollow die,
Or the fraile card. No more be at charge of keeping
The liuery-punke, for the yong heire, that must
Seale, at all houres, in his shirt. No more
If he denie, ha'him beaten to't, as he is
That brings him the commoditie. No more
Shall thirst of satten, or the couetous hunger
Of veluet entrailes, for a rude-spun cloke,
To be displaid at *Madame* AVGVSTA's, make
The sonnes of *sword,* and *hazzard* fall before
The golden calfe, and on their knees, whole nights,
Commit idolatrie with wine, and trumpets:
Or goe a feasting, after drum and ensigne.
No more of this. You shall start vp yong *Vice-royes,*
And haue your punques, and punquettees, my SVRLY.
And vnto thee, I speake it first, *be rich.*
Where is my SVBTLE, there? Within hough?

FACE

(*Within*) Sir. Hee'll come to you, by and by.

MAMMON

That's his fire-drake,
His lungs, his *Zephyrus,* he that puffes his coales,
Till he firke nature vp, in her owne center.
You are not faithfull, sir. This night, I'll change
All, that is mettall, in thy house, to gold.
And, early in the morning, will I send
To all the plumbers, and the pewterers,
And buy their tin, and lead vp: and to *Lothbury,*
For all the copper.

SVRLY

What, and turne that too?

MAMMON

Yes, and I'll purchase *Deuonshire,* and *Cornwaile,*
And make them perfect *Indies!* You admire now?

SVRLY

No, faith.

MAMMON

But when you see th' effects of the great med'cine!
Of which one part proiected on a hundred
Of *Mercurie,* or *Venus,* or the *Moone,*

672

Shall turne it to as many of the *Sunne;*
Nay, to a thousand, so *ad infinitum:*
You will beleeue me.

SVRLY

 Yes, when I see't, I will.
But, if my eyes doe cossen me so (and I
Giuing'hem no occasion) sure, I'll haue
A whore, shall pisse'hem out, next day.

MAMMON

 Ha! Why?
Doe you thinke, I fable with you? I assure you,
He that has once the *flower of the sunne,*
The perfect *ruby,* which we call *elixir,*
Not onely can doe that, but by it's vertue,
Can confer honour, loue, respect, long life,
Giue safety, valure: yea, and victorie,
To whom he will. In eight, and twentie dayes,
I'll make an old man, of fourescore, a childe.

SVRLY

No doubt, hee's that alreadie.

MAMMON

 Nay, I meane,
Restore his yeeres, renew him, like an eagle,
To the fifth age; make him get sonnes, and daughters,
Yong giants; as our *Philosophers* haue done
(The antient *Patriarkes* afore the floud)
But taking, once a weeke, on a kniues point,
The quantitie of a graine of mustard, of it:
Become stout MARSES, and beget yong CVPIDS.

SVRLY

The decay'd *Vestalls* of *Pickt-hatch* would thanke you,
That keepe the fire a-liue, there.

MAMMON

 'Tis the secret
Of nature, naturiz'd 'gainst all infections,
Cures all diseases, comming of all causes,
A month's griefe, in a day; a yeeres, in twelue:
And, of what age soeuer, in a month.
Past all the doses of your drugging Doctors.
I'll vndertake, withall, to fright the plague
Out o' the kingdome, in three months.

SVRLY

 And I'll
Be bound the players shall sing your praises, then,
Without their poets.

MAMMON

 Sir, I'll doo't. Meane time,
I'll giue away so much, vnto my man,
Shall serue th'whole citie, with preseruatiue,
Weekely, each house his dose, and at the rate—

SVRLY

As he that built the water-worke, do's with water?

MAMMON

You are incredulous.

SVRLY

 Faith, I haue a humor,
I would not willingly be gull'd. Your *stone*
Cannot transmute me.

MAMMON

 Pertinax, Svrly,
Will you beleeue antiquitie? recordes?
I'll shew you a booke, where Moses, and his sister,
And Salomon haue written, of the art;
I, and a treatise penn'd by Adam.

SVRLY

 How!

MAMMON

O' the *Philosophers stone,* and in high-*Dutch.*

SVRLY

Did Adam write, sir, in high-*Dutch?*

MAMMON

 He did:
Which proues it was the primitiue tongue.

SVRLY

 What paper?

MAMMON

On cedar board.

SVRLY

 O that, indeed (they say)
Will last 'gainst wormes.

MAMMON

 'Tis like your *Irish* wood,
'Gainst cob-webs. I haue a peece of Iasons fleece, too,
Which was no other, then a booke of *alchemie,*
Writ in large sheepe-skin, a good fat ram-vellam.
Such was Pythagora's thigh, Pandora's tub;
And, all that fable of Medeas charmes,
The manner of our worke: The Bulls, our fornace,
Still breathing fire; our *argent-viue,* the Dragon:
The Dragons teeth, *mercury* sublimate,

674

That keepes the whitenesse, hardnesse, and the biting;
And they are gather'd, into IASON's helme,
(Th'*alembeke*) and then sow'd in MARS his field,
And, thence, sublim'd so often, till they are fix'd.
Both this, th'*Hesperian* garden, CADMVS storie,
IOVE's shower, the boone of MIDAS, ARGVS eyes,
BOCCACE his *Demogorgon,* thousands more,
All abstract riddles of our *stone.* How now?

 (*Enter Face*)

Doe we succeed? Is our day come? and holds it?
FACE

The euening will set red, vpon you, sir;
You haue colour for it, crimson: the red *ferment*
Has done his office. Three houres hence, prepare you
To see proiection.
MAMMON

 PERTINAX, my SVRLY,
Againe, I say to thee, aloud: *be rich.*
This day, thou shalt haue ingots: and, to morrow,
Giue lords th'affront. Is it, my ZEPHYRVS, right?
Blushes the *bolts-head?*
FACE

 Like a wench with child, sir,
That were, but now, discouer'd to her master.
MAMMON

Excellent wittie *Lungs!* My onely care is,
Where to get stuffe, inough now, to proiect on,
This towne will not halfe serue me.
FACE

 No, sir? Buy
The couering of o'churches.
MAMMON

 That's true.
FACE

 Yes.
Let'hem stand bare, as doe their auditorie.
Or cap 'hem, new, with shingles.
MAMMON

 No, good thatch:
Thatch will lie light vpo'the rafters, *Lungs.*
Lungs, I will manumit thee, from the fornace;
I will restore thee thy complexion, *Puffe,*
Lost in the embers; and repaire this braine,
Hurt wi'the fume o'the mettalls.

FACE

I haue blowne, sir,
Hard, for your worship; throwne by many a coale,
When 'twas not beech; weigh'd those I put in, iust,
To keepe your heat, still euen; These bleard-eyes
Haue wak'd, to reade your seuerall colours, sir,
Of the *pale citron*, the *greene lyon*, the *crow*,
The *peacocks taile*, the *plumed swan*.

MAMMON

And lastly,
Thou hast descryed the *flower*, the *sanguis agni?*

FACE

Yes, sir.

MAMMON

Where's master?

FACE

At's praiers, sir, he,
Good man, hee's doing his deuotions,
For the successe.

MAMMON

Lungs, I will set a period,
To all thy labours: Thou shalt be the master
Of my *seraglia*.

FACE

Good, sir.

MAMMON

But doe you heare?
I'll geld you, *Lungs*.

FACE

Yes, sir.

MAMMON

For I doe meane
To haue a list of wiues, and concubines,
Equall with SALOMON; who had the *stone*
Alike, with me: and I will make me, a back
With the *elixir*, that shall be as tough
As HERCVLES, to encounter fiftie a night.
Th'art sure, thou saw'st it *bloud?*

FACE

Both *bloud, and spirit,* sir.

MAMMON

I will haue all my beds, blowne vp; not stuft:
Downe is too hard. And then, mine oual roome,
Fill'd with such pictures, as TIBERIVS tooke

From ELEPHANTIS: and dull ARETINE
But coldly imitated. Then, my glasses,
Cut in more subtill angles, to disperse,
And multiply the figures, as I walke
Naked betweene my *succubæ*. My mists
I'le haue of perfume, vapor'd 'bout the roome,
To loose our selues in; and my baths, like pits
To fall into: from whence, we will come forth,
And rowle vs drie in gossamour, and roses.
(Is it arriu'd at *ruby*?)—Where I spie
A wealthy citizen, or rich lawyer,
Haue a sublim'd pure wife, vnto that fellow
I'll send a thousand pound, to be my cuckold.

FACE

And I shall carry it?

MAMMON

 No. I'll ha'no bawds,
But fathers, and mothers. They will doe it best.
Best of all others. And, my flatterers
Shall be the pure, and grauest of Diuines,
That I can get for money. My mere fooles,
Eloquent burgesses, and then my poets
The fame that writ so subtly of the *fart*,
Whom I will entertaine, still, for that subiect.
The few, that would giue out themselues, to be
Court, and towne-stallions, and, each where, belye
Ladies, who are knowne most innocent, for them;
Those will I begge, to make me *eunuchs* of:
And they shall fan me with ten estrich tailes
A piece, made in a plume, to gather wind.
We will be braue, *Puffe*, now we ha'the *med'cine*.
My meat, shall all come in, in *Indian* shells,
Dishes of agate, set in gold, and studded,
With emeralds, saphyres, hiacynths, and rubies.
The tongues of carpes, dormise, and camels heeles,
Boil'd i'the spirit of SOL, and dissolu'd pearle,
(APICIVS diet, 'gainst the *epilepsie*)
And I will eate these broaths, with spoones of amber,
Headed with diamant, and carbuncle.
My foot-boy shall eate phesants, calured salmons,
Knots, godwits, lampreys: I my selfe will haue
The beards of barbels, seru'd, in stead of sallades;
Oild mushromes; and the swelling vnctuous paps
Of a fat pregnant sow, newly cut off
Drest with an exquisite, and poynant sauce;

677

For which, Ile say vnto my cooke, there's gold,
Goe forth, and be a knight.

FACE

 Sir, I'll goe looke
A little, how it heightens.

MAMMON

 Doe. My shirts
I'll haue of taffata-sarsnet, soft, and light
As cob-webs; and for all my other rayment
It shall be such, as might prouoke the *Persian;*
Were he to teach the world riot, a new.
My gloues of fishes, and birds-skins, perfum'd
With gummes of *paradise,* and easterne aire—

SVRLY

And do'you thinke to haue the *stone,* with this?

MAMMON

No, I doe thinke, t'haue all this, with the *stone.*

SVRLY

Why, I haue heard, he must be *homo frugi,*
A pious, holy, and religious man,
One free from mortall sinne, a very virgin.

MAMMON

That makes it, sir, he is so. But I buy it.
My venter brings it me. He, honest wretch,
A notable, superstitious, good soule,
Has worne his knees bare, and his slippers bald,
With prayer, and fasting for it: and, sir, let him
Do'it alone, for me, still. Here he comes,
Not a prophane word, afore him: 'Tis poyson.

 The Alchemist (1612)
 Act ii, Scenes i, ii

*The judgement is perfectly overwhelmed by the torrent of images,
words, and book-knowledge with which Mammon confounds and stuns
his incredulous hearer. They come pouring out like the successive strokes
of Nilus. They "doubly redouble strokes upon the foe." Description out-
strides proof. We are made to believe effects before we have testimony
for their causes; as a lively description of the joys of heaven sometimes
passes for an argument to prove the existence of such a place. If there
be no one image which rises to the height of the sublime, yet the con-
fluence and assemblage of them all produces an effect equal to the
grandest poetry. Xerxes' army that drank up whole rivers from their
numbers may stand for single Achilles. Epicure Mammon is the most
determined offspring of the author. It has the whole "matter and copy of
the father, eye, nose, lip, the trick of his frown." It is just such a swag-*

gerer as contemporaries have described old Ben to be. Meercraft, Boba-
dil, the Host of the New Inn, have all his "image and superscription;"
but Mammon is arrogant pretension personified. Sir Sampson Legend,
in Love for Love, is such another lying overbearing character, but he
does not come up to Epicure Mammon. What a "towering bravery"
there is in his sensuality! He affects no pleasure under a sultan. It is as if
"Egypt with Assyria strove in luxury."

CHARLES LAMB

Specimens of English Dramatic Poets (1808)

BEN JONSON

1 5 7 3 ? — 1 6 3 7

SONG. TO CELIA

Drinke to me, onely, with thine eyes,
 And I will pledge with mine;
Or leave a kisse but in the cup,
 And Ile not looke for wine.
The thirst, that from the soule doth rise,
 Doth aske a drinke divine:
But might I of JOVE's *Nectar* sup,
 I would not change for thine.
I sent thee, late, a rosie wreath,
 Not so much honoring thee,
As giving it a hope, that there
 It could not withered bee.
But thou thereon did'st onely breath,
 And sent'st it backe to mee:
Since when it growes, and smells, I sweare,
 Not of it selfe, but thee.

The Forrest (1616), ix

One of those perfect poems which somehow seem to have always
existed.

DOUGLAS BUSH

English Literature in the Earlier Seventeenth Century (1945)

BEN JONSON

1 5 7 3 ? — 1 6 3 7

INJURIES

Injuries doe not extinguish courtesies: they only suffer them not to appeare faire. For a man that doth me an injury after a courtesie, takes not away the courtesie, but defaces it: As he that writes other verses upon my verses, takes not away the first Letters, but hides them.

Timber: or, Discoveries; Made Vpon Men and Matter (1641)

No sentence more high-minded and generous than that was ever written.

ALGERNON CHARLES SWINBURNE
A Study of Ben Jonson (1889)

CYRIL TOURNEUR

1 5 7 5 ? — 1 6 2 6

CASTIZA REBUKES HER MOTHER

I haue endur'd you with an eare of fire,
Your Tongues haue struck hotte yrons on my face;
Mother, come from that poysonous woman there.

The Revengers Tragædie (1607)
Act ii, Scene i

In 'The Revenger's Tragedy' there is an imaginative stroke which the greatest of poets might envy, when Castiza cries out to her mother, who has been swayed by her brother's cynical pretence to the idea of traffic in her honour. . . . That appeal to the mother to stand forth from her false self is beyond praise.

T. EARLE WELBY
A Popular History of English Poetry (1933)

I WAS THE MAN

Enter VINDICE *and* HIPPOLITO, *bringing out their Mother one
by one shoulder, and the other by the other, with daggers
in their hands.*

VINDICE

O thou? for whom no name is bad ynough.

MOTHER

What meanes my sonnes? what will you murder me?

VINDICE

Wicked, vnnaturall Parent.

HIPPOLITO

Feend of women.

MOTHER

Oh! are sonnes turnd monsters? helpe.

VINDICE

In vaine.

MOTHER

Are you so barbarous to set Iron nipples
Vpon the brest that gaue you suck?

VINDICE

That brest,
Is turnd to Quarled poyson.

MOTHER

Cut not your daies for't, am not I your mother?

VINDICE

Thou dost vsurpe that title now by fraud
For in that shell of mother breeds a bawde.

MOTHER

A bawde? O name far loathsomer then hell.

HIPPOLITO

It should be so knewst thou thy Office well.

MOTHER

I hate it.

VINDICE

Ah ist possible, you [heavenly] powers on hie,
That women should dissemble when they die.

MOTHER

Dissemble.

VINDICE

Did not the Dukes sonne direct

681

A fellow, of the worlds condition, hither,
That did corrupt all that was good in thee:
Made the vnciuilly forget thy selfe,
And worke our sister to his lust?

MOTHER

Who I?
That had beene monstrous. I defie that man
For any such intent; none liues so pure,
But shall be soild with slander,—good sonne beleiue it not.

VINDICE

Oh I'me in doubt,
Whether I'me my selfe, or no.
Stay, let me looke agen vpon this face.
Who shall be sau'd when mothers haue no grace?

HIPPOLITO

Twould make one halfe dispaire.

VINDICE

I was the man,
Defie me, now? lets see, do't modestly.

MOTHER

O hell vnto my soule.

VINDICE

In that disguize, I sent from the Dukes sonne,
Tryed you, and found you base mettell,
As any villaine might haue donne.

MOTHER

O no, no tongue but yours could haue bewitcht me so.

VINDICE

O nimble in damnation, quick in tune,
There is no diuill could strike fire so soone:
I am confuted in a word.

MOTHER

Oh sonnes, forgiue me, to my selfe ile proue more true,
You that should honor me, I kneele to you.

VINDICE

A mother to giue ayme to her owne daughter.

HIPPOLITO

True brother, how far beyond nature 'tis,
Tho many Mothers do't.

VINDICE

Nay and you draw teares once, go you to bed,
Wet will make yron blush and change to red:
Brother it raines, twill spoile your dagger, house it.

HIPPOLITO

Tis done.

VINDICE

Yfaith tis a sweete shower, it dos much good.
The fruitfull grounds, and meadowes of her soule,
Has beene long dry: powre downe thou blessed dew;
Rise Mother, troth this shower has made you higher.

MOTHER

O you heauens! take this infectious spot out of my soule,
Ile rence it in seauen waters of mine eyes.
Make my teares salt ynough to tast of grace.
To weepe, is to our sexe naturally giuen:
But to weepe truely thats a gift from heauen.

VINDICE

Nay Ile kisse you now: kisse her brother.
Lets marry her to our soules, wherein's no lust,
And honorably loue her.

HIPPOLITO

Let it be.

VINDICE

For honest women are so sild and rare,
Tis good to cherish those poore few that are.
Oh you of easie waxe, do but imagine
Now the disease has left you, how leprously
That Office would haue cling'd vnto your forehead.
All mothers that had any gracefull hue,
Would haue worne maskes to hide their face at you:
It would haue growne to this, at your foule name
Greene-collour'd maides would haue turnd red with shame.

HIPPOLITO

And then our sister full of hire, and bassenesse.

VINDICE

There has beene boyling lead agen,
The dukes sonnes great Concubine:
A drab of State, a cloath a siluer slut,
To haue her traine borne vp, and her soule traile i'th durt; great.

HIPPOLITO

To be miserably great, rich to be eternally wretched.

VINDICE

O common madnesse:
Aske but the thriuingst harlot in cold bloud,
Sheed giue the world to make her honour good,
Perhaps youle say but onely to th' Dukes sonne,
In priuate; why, shee first begins with one,
Who afterward to thousand prooues a whore:
Breake Ice in one place, it will crack in more.

683

MOTHER

Most certainly applyed.

HIPPOLITO

Oh Brother, you forget our businesse.

VINDICE

And well remembred, ioye's a subtill elfe,
I thinke man's happiest, when he forgets himselfe:
Farewell once dryed, now holy-watred Meade,
Our hearts weare Feathers, that before wore Lead.

MOTHER

Ile giue you this, that one I neuer knew
Plead better, for, and gainst the Diuill, then you.

VINDICE

You make me proud ont.

HIPPOLITO

Commend vs in all vertue to our Sister.

VINDICE

I for the loue of heauen, to that true maide.

MOTHER

With my best words.

VINDICE

Why that was motherly sayd. *Exeunt.*

The Revengers Tragædie (1607)
Act iv, Scene iv

*The reality and life of this dialogue passes any scenical illusion I ever
felt. I never read it but my ears tingle, and I feel a hot blush spread my
cheeks, as if I were presently about to "proclaim" some such "malefac-
tions" of myself, as the brothers here rebuke in their unnatural parent;
in words more keen and dagger-like than those which Hamlet speaks
to his mother. Such power has the passion of shame truly personated,
not only to "strike guilty creatures unto the soul," but to "appal" even
those that are "free."*

CHARLES LAMB
Specimens of English Dramatic Poets (1808)

684

JOHN FLETCHER

1 5 7 9 — 1 6 2 5

SWEETEST MELANCHOLY

Hence all you vain Delights,
As short as are the nights,
 Wherein you spend your folly,
There's nought in this life sweet,
If man were wise to see't,
 But only melancholly,
 Oh sweetest melancholly.
Welcome folded Arms, and fixed Eyes,
A sigh that piercing mortifies,
A look that's fast'ned to the ground,
A tongue chain'd up without a sound.

Fountain heads, and pathless Groves,
Places which pale passion loves:
Moon-light walks, when all the Fowls
Are warmly hous'd, save Bats and Owls;
 A mid-night Bell, a parting groan,
 These are the sounds we feed upon;
Then stretch our bones in a still gloomy valley,
Nothing's so dainty sweet, as lovely melancholly.

The Nice Valour (1647)
Act iii, Scene i

The perfection of this kind of writing.

WILLIAM HAZLITT
Lectures on the Dramatic Literature of the Age of Elizabeth (1820)

JOHN WEBSTER

1 5 8 0 ? — 1 6 2 5 ?

DIRGE

CORNELIA

Call for the Robin-Red-brest and the wren,
Since ore shadie groves they hover,
And with leaves and flowres doe cover
The friendlesse bodies of unburied men.
Call unto his funerall Dole
The Ante, the field-mouse, and the mole
To reare him hillockes, that shall keepe him warme,
And (when gay tombes are rob'd) sustaine no harme,
But keepe the wolfe far thence, that's foe to men,
For with his nailes hee'l dig them up agen.

The White Divel (1612)
Act v, Scene iv

WILLIAM SHAKESPEARE

1 5 6 4 — 1 6 1 6

DITTY

Full fadom fiue thy Father lies,
Of his bones are Corrall made:
Those are pearles that were his eies,
Nothing of him that doth fade,
But doth suffer a Sea-change
Into something rich, and strange.
Sea Nymphs hourly ring his knell.

Burthen: ding dong

Harke now I heare them, ding-dong bell.

The Tempest (1623)
Act i, Scene ii

I never saw anything like this Dirge, except the Ditty which reminds
Ferdinand of his drowned father in the Tempest. As that is of the water,
watery; so this is of the earth, earthy. Both have that intenseness of
feeling, which seems to resolve itself into the elements which it con-
templates.

CHARLES LAMB
Specimens of English Dramatic Poets (1808)

JOHN FORD

1 5 8 6 — 1 6 3 9 ?

ROYALL LADY

An Altar couered with white.

Two lights of Virgin wax, during which musicke of Recorders,
enter foure bearing Ithocles on a hease, or in a chaire, in
a rich robe, and a Crowne on his head; place him on one side
of the Altar, after him enter Calantha in a white robe, and
crown'd Euphranea; Philema, Christalla in white, Nearchus,
Armostes, Crotolon, Prophilus, Amelus, Bassanes, Lemophil,
and Groneas. Calantha goes and kneeles before the Altar,
the rest stand off, the women kneeling behind; cease
Recorders during her deuotions. Sofe musicke. Calantha
and the rest rise doing obeysance to the Altar.

CALANTHA

Our Orisons are heard, the gods are mercifull:
Now tell me, you whose loyalties payes tribute
To vs your lawfull Soueraigne, how vnskilfull
Your duties or obedience is, to render
Subiection to the Scepter of a Virgin,
Who haue beene euer fortunate in Princes
Of masculine and stirring composition?
A woman has enough to gouerne wisely
Her owne demeanours, passions, and diuisions.
A Nation warlike and inur'd to practice
Of policy and labour, cannot brooke
A feminate authority: we therefore
Command your counsaile, how you may aduise vs
In choosing of a husband whose abilities
Can better guide this kingdome.

NEARCHUS

 Royall Lady,
Your law is in your will.

ARMOSTES

 We haue seene tokens
Of constancy too lately to mistrust it.

CROTOLON

Yet if your highnesse settle on a choice
By your owne iudgement both allow'd and lik'd of,
Sparta may grow in power, and proceed
To an increasing height.

CALANTHA

Hold you the same minde.

BASSANES

Alas great mistris, reason is so clouded
With the thicke darkenesse of my infinites woes
That I forecast, nor dangers, hopes, or safety:
Give me some corner of the world to weare out
The remnant of the minutes I must number,
Where I may heare no sounds, but sad complaints
Of Virgins who have lost contracted partners;
Of husbands howling that their wives were ravisht
By some untimely fate; of friends divided
By churlish opposition, or of fathers
Weeping upon their childrens slaughtered carcasses;
Or daughters groaning ore their fathers hearses,
And I can dwell there, and with these keepe consort
As musicall as theirs: what can you looke for
From an old foolish peevish doting man,
But crasinesse of age?

CALANTHA

Cozen of *Argos*.

NEARCHUS

Madam.

CALANTHA

Were I presently
To choose you for my Lord, Ile open freely
What articles I would propose to treat on
Before our marriage.

NEARCHUS

Name them vertuous Lady.

CALANTHA

I would presume you would retaine the royalty
Of *Sparta* in her owne bounds: then in *Argos*
Armostes might be Viceroy; in *Messene*
Might *Crotolon* beare sway, and *Bassanes*—

BASSANES

I, Queene? alas! what I?

CALANTHA

Be *Sparta's* Marshall:
The multitudes of high imployments could not
But set a peace to priuate griefes: these Gentlemen,
Groneas and *Lemophil,* with worthy pen ons
Should wait vpon your person in your Chamber:
I would bestow *Christalla* on *Amelus,*

688

Shee'll proue a constant wife, and *Philema*
Should into *Vesta's* Temple.

BASSANES

This is a Testament,
It sounds not like conditions on a marriage.

NEARCHUS

All this should be perform'd.

CALANTHA

Lastly, for *Prophilus,*
He should be (Cozen) solemnly inuested
In all those honors, titles, and preferments
Which his deare friend, and my neglected husband
Too short a time enioy'd.

PROPHILUS

I am vnworthy
To liue in your remembrance.

EUPHRANEA

Excellent Lady!

NEARCHUS

Madam, what meanes that word neglected husband?

CALANTHA

Forgiue me: now I turne to thee thou shadow
Of my contracted Lord: beare witnesse all,
I put my mother wedding Ring vpon
His finger, 'twas my fathers last bequest:
Thus I new marry him whose wife I am;
Death shall not separate vs: ô my Lords,
I but deceiu'd your eyes with Anticke gesture,
When one newes straight came hudling on another,
Of death, and death, and death, still I danc'd forward,
But it strooke home, and here, and in an instant,
Be such meere women, who with shreeks and out-cries
Can vow a present end to all their sorrowes,
Yet liue to vow new pleasures, and out-liue them:
They are the silent griefes which cut the hart-strings;
Let me dye smiling.

NEARCHUS

'Tis a truth too ominous.

CALANTHA

One kisse on these cold lips, my last; cracke, cracke.
Argos now's *Sparta's* King.

The Broken Heart (1633)
Act v, Scene ii

I do not know where to find in any play a catastrophe so grand, so solemn, and so surprising as this. This in indeed, according to Milton, to "describe high passions and high actions." The fortitude of the Spartan boy who let a beast gnaw out his bowels till he died without expressing a groan, is a faint bodily image of this dilaceration of the spirit and exenteration of the inmost mind, which Calantha with a holy violence against her nature keeps closely covered, till the last duties of a wife and a queen are fulfilled. Stories of martyrdom are but of chains and the stake; a little bodily suffering; these torments

> *On the purest spirits prey*
> *As on entrails, joints, and limbs,*
> *With answerable pains, but more intense.*

What a noble thing is the soul in its strengths and in its weaknesses! who would be less weak than Calantha? who can be so strong? the expression of this transcendent scene almost bears me in imagination to Calvary and the Cross; and I seem to perceive some analogy between the scenical sufferings which I am here contemplating, and the real agonies of that final completion to which I dare no more than hint a reference.

Ford was of the first order of poets. He sought for sublimity, not by parcels in metaphors or visible images, but directly where she has her full residence in the heart of man; in the actions and sufferings of the greatest minds. There is a grandeur of the soul above mountains, seas, and the elements.

CHARLES LAMB
Specimens of English Dramatic Poets (1808)

ROBERT HERRICK

1 5 9 1 — 1 6 7 4

CORINNA'S GOING A MAYING

Get up, get up for shame, the Blooming Morne
Upon her wings presents the god unshorne.
 See how *Aurora* throwes her faire
 Fresh-quilted colours through the aire:
 Get up, sweet-Slug-a-bed, and see
 The Dew-bespangling Herbe and Tree.

Each Flower has wept, and bow'd toward the East,
Above an houre since; yet you not drest,
 Nay! not so much as out of bed?
 When all the Birds have Mattens seyd,
 And sung their thankfull Hymnes: 'tis sin,
 Nay, profanation to keep in,
When as a thousand Virgins on this day,
Spring, sooner then the Lark, to fetch in May.

Rise; and put on your Foliage, and be seene
To come forth, like the Spring-time, fresh and greene;
 And sweet as *Flora*. Take no care
 For Jewels for your Gowne, or Haire:
 Feare not; the leaves will strew
 Gemms in abundance upon you:
Besides, the childhood of the Day has kept,
Against you come, some *Orient Pearls* unwept:
 Come, and receive them while the light
 Hangs on the Dew-locks of the night:
 And *Titan* on the Eastern hill
 Retires himselfe, or else stand still
Till you come forth. Wash, dresse, be briefe in praying:
Few Beads are best, when once we goe a Maying.

Come, my *Corinna*, come; and comming, marke
How each field turns a street; each street a Parke
 Made green, and trimm'd with trees: see how
 Devotion gives each House a Bough,
 Or Branch: Each Porch, each doore, ere this,
 An Arke a Tabernacle is
Made up of white-thorn neatly enterwove;
As if here were those cooler shades of love.
 Can such delights be in the street,
 And open fields, and we not see't?
 Come, we'll abroad; and let's obay
 The Proclamation made for May:
And sin no more, as we have done, by staying;
But my *Corinna*, come, let's goe a Maying.

There's not a budding Boy, or Girle, this day,
But is got up, and gone to bring in May.
 A deale of Youth, ere this, is come
 Back, and with *White-thorn* laden home.
 Some have dispatcht their Cakes and Creame,
 Before that we have left to dreame:

691

And some have wept, and woo'd, and plighted Troth,
And chose their Priest, ere we can cast off sloth:
 Many a green-gown has been given;
 Many a kisse, both odde and even:
 Many a glance too has been sent
 From out the eye, Loves Firmament:
Many a jest told of the Keyes betraying
This night, and Locks pickt, yet w'are not a Maying.

Come, let us goe, while we are in our prime;
And take the harmlesse follie of the time.
 We shall grow old apace, and die
 Before we know our liberty.
 Our life is short; and our dayes run
 As fast away as do's the Sunne:
And as a vapour, or a drop of raine
Once lost, can ne'r be found againe:
 So when or you or I are made
 A fable, song, or fleeting shade;
 All love, all liking, all delight
 Lies drown'd with us in endlesse night.
Then while time serves, and we are but decaying;
Come, my *Corinna*, come, let's goe a Maying.

<div align="right">Hesperides (1648)</div>

One of the most perfect studies of idealized village life in the language.
<div align="right">J. H. B. MASTERMAN
The Age of Milton (1897)</div>

THE BIBLE,
SIXTINE-CLEMENTINE EDITION

1 5 9 2

BEING

Ego sum qui sum.

I am that I am.

<div align="right">Exodus, iii, 14</div>

The author of Exodus often surpasses Homer in loftiness of expression; and, at the same time, he has hidden meanings that in the sublimity of their significance surpass all metaphysics, as in that phrase with which

God describes himself to Moses: SUM QUI SUM, *admired by Dionysius Longinus, prince of critics, as reaching complete grandeur of poetic style.*

<div align="right">

GIAMBATTISTA VICO
La Scienza Nuova Prima (1725)

</div>

VINCENT VOITURE

1 5 9 8 — 1 6 4 8

RONDEAU

Ma foi, c'est fait de moi; car Isabeau
M'a conjuré de lui faire un rondeau,
Cela me met en une peine extrême.
Quoi! treize vers, huit en eau, cinq en ème!
Je lui ferais aussitôt un bateau.

En voilà cinq pourtant en un monceau,
Faisons en huit, en invoquant Brodeau,
Et puis mettons par quelque stratagème:
 Ma foi, c'est fait!

Si je pouvais encor de mon cerveau
Tirer cinq vers, l'ouvrage serait beau.
Mais cependant je suis dedans l'onzième,
Et ci je crois que je fais le douzième,
En voilà treize ajustés au niveau:
 Ma foi, c'est fait!

By Jove, 'tis done with me, for Isabeau
Conjures me straight a Rondeau to bestow,
 Which puts me in perplexity extreme!
 Verses thirteen, in 'eau' eight, five in 'eme'—
As well attempt to build a boat I trow.

But here at least are five, I'd have you know,
To make them eight I here invoke Brédeau;
 Next will squeeze in by some ingenious scheme.
 By Jove, 'tis done!

<div align="center">

693

</div>

Now from my labouring brain if yet would flow
Five more, 'twould make indeed a goodly show;
 And now the twelfth is added to my team;
And here at last the thirteenth joins the row.
 By Jove, 'tis done.

<div align="right">Translated by H. Carrington</div>

Above all he is the king and the master of the rondeau. In this little poem which is so spirited, airy, fleet and sprightly in its pace, and at the same time so clean and incisive, none has surpassed or equaled Voiture. Here is his absolute triumph.

<div align="right">

THÉODORE DE BANVILLE
Les Poëtes français (1861)

</div>

PEDRO CALDERÓN DE LA BARCA

1 6 0 0 — 1 6 8 1

THE CROSS

Arbol, donde el cielo quiso
Dar el fruto verdadero
Contra el bocado primero,
Flor del nuevo paraiso,
Arco de luz, cuyo aviso
En piélago mas profundo
La paz publicó del mundo,
Planta hermosa, fértil vid,
Harpa del nuevo David,
Tabla del Moises segundo:
Pecador soy, tus favores
Pido por justicia yo:
Pues Dios en tí padeció
Solo por los pecadores.
A mí me debes tus loores;
Que por mí solo muriera
Dios, si mas mundo no hubiera.

Tree, which heaven has willed to dower
With that true fruit whence we live,
As that other, death did give;
Of new Eden loveliest flower;

Bow of light, that in worst hour
Of the worst flood signal true
O'er the world, of mercy threw;
Fair plant, yielding sweetest wine;
Of our David harp divine;
Of our Moses tables new;
Sinner am I, therefore I
Claim upon thy mercies make,
Since alone for sinners' sake
God on thee endured to die;
And for me would God have died
Had there been no world beside.

<div align="right">

La Devocion de la Cruz
Translated by Richard Chenevix Trench

</div>

Perfect finish and completeness in itself.

<div align="right">

RICHARD CHENEVIX TRENCH
Life's a Dream: The Great Theatre of the World (1856)

</div>

SIR THOMAS BROWNE

1 6 0 5 — 1 6 8 2

URNE-BURIALL

Now since these dead bones have already out-lasted the living ones of Methuselah, and in a yard under ground, and thin walls of clay, out-worn all the strong and specious buildings above it; and quietly rested under the drums and tramplings of three conquests; What Prince can promise such diuturnity unto his Reliques, or might not gladly say,

Sic ego componi versus in ossa velim.

Time which antiquates Antiquities, and hath an art to make dust of all things, hath yet spared these minor monuments. In vain we hope to be known by open and visible conservatories, when to be unknown was the means of their continuation, and obscurity their protection: If they dyed by violent hands, and were thrust into their Urnes, these bones become considerable, and some old Philosophers would honour them, whose soules they conceived most pure, which were thus snatched from their bodies; and to retain a stronger propension unto them: whereas they weariedly left a languishing corps, and with faint desires of re-

union. If they fell by long and aged decay, yet wrapt up in the bundle of time, they fall into indistinction, and make but one blot with infants. If we begin to die when we live, and long life be but a prolongation of death; our life is a sad composition; we live with death, and die not in a moment. How many pulses made up the life of Methuselah, were work for Archimedes: Common Counters sum up the life of Moses his name. Our dayes become considerable like petty sums by minute accumulations; where numerous fractions make up but small round numbers; and our dayes of a span long make not one little finger.

If the nearnesse of our last necessity, brought a nearer conformity unto it, there were a happinesse in hoary hairs, and no calamity in half senses. But the long habit of living indisposeth us for dying; When Avarice makes us the sport of death; When even David grew politickly cruel; and Solomon could hardly be said to be the wisest of men. But many are too early old, and before the date of age. Adversity stretcheth our dayes, misery makes Alcmena's nights, and time hath no wings unto it. But the most tedious being is that which can unwish it self, content to be nothing, or never to have been, which was beyond the *male*-content of Job, who cursed not the day of his life, but his nativity: Content to have so far been, as to have a title to future being; Although he had lived here but in an hidden state of life, and as it were an abortion.

What Song the Syrens sang, or what name Achilles assumed when he hid himself among women, though puzling questions are not beyond all conjecture. What time the persons of these Ossuaries entred the famous Nations of the dead, and slept with Princes and Counsellors, might admit a wide solution. But who were the proprietaries of these bones, or what bodies these ashes made up, were a question above Antiquarism; not to be resolved by man, nor easily perhaps by spirits, except we consult the Provincial Guardians, or tutelary observators. Had they made as good provision for their names, as they have done for their Reliques, they had not so grosly erred in the art of perpetuation. But to subsist in bones, and be but Pyramidally extant, is a fallacy in duration. Vain ashes, which in the oblivion of names, persons, times and sexes, have found unto themselves, a fruitlesse continuation, and onely arise unto late posterity, as Emblemes of mortal vanities; Antidotes against pride, vainglory, and madding vices. Pagan vainglories which thought the world might last for ever, had encouragement for ambition, and finding an *Atropos* unto the immortality of their names, were never dampt with the necessity of oblivion. Even old ambitions had the advantage of ours, in the attempts of their vainglories, who acting early, and before the probable Meridian of time, have by this time found great accomplishment of their designes, whereby the ancient Heroes have already outlasted their Monuments, and Mechanical preservations. But in this latter Scene of time we cannot expect such Mummies unto our memories, when

ambition may fear the Prophecy of Elias, and Charles the fift can never hope to live within two Methusela's of Hector.

And therefore restlesse inquietude for the diuturnity of our memories unto present considerations, seemes a vanity almost out of date, and superannuated peece of folly. We cannot hope to live so long in our names, as some have done in their persons, one face of Janus holds no proportion to the other. 'Tis too late to be ambitious. The great mutations of the world are acted, or time may be too short for our designes. To extend our memories by Monuments, whose death we dayly pray for, and whose duration we cannot hope, without injury to our expectations, in the advent of the last day, were a contradiction to our beliefs. We whose generations are ordained in this setting part of time, are providentially taken off from such imaginations. And being necessitated to eye the remaining particle of futurity, are naturally constituted unto thoughts of the next world, and cannot excusably decline the consideration of that duration, which maketh Pyramids pillars of snow, and all that's past a moment.

Circles and right lines limit and close all bodies, and the mortal right-lined-circle must conclude and shut up all. There is no antidote against the Opium of time, which temporally considereth all things; Our fathers finde their graves in our short memories, and sadly tell us how we may be buried in our Survivors. Grave-stones tell truth scarce fourty yeers: Generations passe while some trees stand, and old Families last not three Oakes. To be read by bare inscriptions like many in Gruter, to hope for Eternity by Ænigmatical Epithetes, or first letters of our names, to be studied by Antiquaries, who we were, and have new Names given us like many of the Mummies, are cold consolations unto the Students of perpetuity, even by everlasting Languages.

To be content that times to come should onely know there was such a man, not caring whether they knew more of him, was a frigid ambition in Cardan: disparaging his horoscopal inclination and judgement of himself, who cares to subsist like Hippocrates' Patients, or Achilles' horses in Homer, under naked nominations, without deserts and noble acts, which are the balsame of our memories, the Entelechia and soul of our subsistences. To be namelesse in worthy deeds exceeds an infamous history. The Canaanitish woman lives more happily without a name, then Herodias with one. And who had not rather have been the good theef, then Pilate?

But the iniquity of oblivion blindly scattereth her poppy, and deals with the memory of men without distinction to merit of perpetuity. Who can but pity the founder of the Pyramids? Herostratus lives that burnt the Temple of Diana, he is almost lost that built it. Time hath spared the Epitaph of Adrian's horse, confounded that of himself. In vain we compute our felicities by the advantage of our good names, since bad have equal durations; and Thersites is like to live as long as Agamemnon.

Who knows whether the best of men be known? or whether there be not more remarkable persons forgot, then any that stand remembred in the known account of time? Without the favour of the everlasting register the first man had been as unknown as the last, and Methuselah's long life had been his only Chronicle.

Oblivion is not to be hired: The greater part must be content to be as though they had not been, to be found in the register of God, not in the record of man. Twenty seven names make up the first story, and the recorded names ever since contain not one living Century. The number of the dead long exceedeth all that shall live. The night of time far surpasseth the day, and who knows when was the Æquinox? Every houre addes unto that current Arithmetique, which scarce stands one moment. And since death must be the Lucina of life, and even Pagans could doubt whether thus to live, were to die; Since our longest Sun sets at right descensions, and makes but winter arches, and therefore it cannot be long before we lie down in darknesse, and have our light in ashes; Since the brother of death daily haunts us with dying *memento's,* and time that grows old it self, bids us hope no long duration: Diuturnity is a dream and folly of expectation.

Darknesse and light divide the course of time, and oblivion shares with memory, a great part even of our living beings; we slightly remember our felicities, and the smartest stroaks of affliction leave but short smart upon us. Sense endureth no extremities, and sorrows destroy us or themselves. To weep into stones are fables. Afflictions induce calosities; miseries are slippery, or fall like snow upon us, which notwithstanding is no unhappy stupidity. To be ignorant of evils to come, and forgetful of evils past, is merciful provision in nature, whereby we digest the mixture of our few and evil dayes, and, our delivered senses not relapsing into cutting remembrances, our sorrows are not kept raw by the edge of repetitions. A great part of Antiquity contented their hopes of subsistency with a transmigration of their souls: a good way to continue their memories, while having the advantage of plural successions, they could not but act something remarkable in such variety of beings, and enjoyning the fame of their passed selves, make accumulation of glory unto their last durations. Others rather then be lost in the uncomfortable night of nothing, were content to recede into the common being, and made one particle of the publick soul of all things, which was no more then to return into their unknown and divine Original again. Ægyptian ingenuity was more unsatisfied, contriving their bodies in sweet consistences, to attend the return of their souls. But all was vanity, feeding the winde, and folly. The Ægyptian Mummies, which Cambyses or time hath spared, avarice now consumeth. Mummie is become Merchandise, Mizraim cures wounds, and Pharoah is sold for balsams.

In vain do individuals hope for immortality, or any patent from oblivion, in preservations below the Moon: Men have been deceived

698

even in their flatteries above the Sun, and studied conceits to perpetuate their names in heaven. The various Cosmography of that part hath already varied the names of contrived constellations; Nimrod is lost in Orion, and Osyris in the Dogge-star. While we look for incorruption in the heavens, we finde they are but like the Earth; Durable in their main bodies, alterable in their parts: whereof beside Comets and new Stars, perspectives begin to tell tales. And the spots that wander about the Sun, with Phaeton's favour, would make clear conviction.

There is nothing strictly immortal, but immortality; whatever hath no beginning may be confident of no end (all others have a dependent being, and within the reach of destruction); which is the peculiar of that necessary essence that cannot destroy it self; And the highest strain of omnipotency to be so powerfully constituted, as not to suffer even from the power of it self. But the sufficiency of Christian Immortality frustrates all earthly glory, and the quality of either state after death makes a folly of posthumous memory. God who can onely destroy our souls, and hath assured our resurrection, either of our bodies or names hath directly promised no duration. Wherein there is so much of chance that the boldest expectants have found unhappy frustration; and to hold long subsistence, seems but a scape in oblivion. But man is a noble Animal, splendid in ashes, and pompous in the grave, solemnizing Nativities and Deaths with equal lustre, nor omitting Ceremonies of bravery, in the infamy of his nature.

Life is a pure flame, and we live by an invisible Sun within us. A small fire sufficeth for life, great flames seemed too little after death, while men vainly affected precious pyres, and to burn like Sardanapalus; but the wisdom of funeral Laws found the folly of prodigal blazes, and reduced undoing fires unto the rule of sober obsequies, wherein few could be so mean as not to provide wood, pitch, a mourner, and an Urne.

Five Languages secured not the Epitaph of Gordianus. The man of God lives longer without a Tomb then any by one, invisibly interred by Angels, and adjudged to obscurity, though not without some marks directing humane discovery. Enoch and Elias without either tomb or burial, in an anomalous state of being, are the great examples of perpetuity, in their long and living memory, in strict account being still on this side death, and having a late part yet to act upon this stage of earth. If in the decretory term of the world we shall not all die but be changed, according to received translation; the last day will make but few graves; at least quick Resurrections will anticipate lasting Sepultures; Some graves will be opened before they be quite closed, and Lazarus be no wonder. When many that feared to die shall groan that they can die but once, the dismal state is the second and living death, when life puts despair on the damned; when men shall wish the coverings of Mountains, not of Monuments, and annihilation shall be courted.

While some have studied Monuments, others have studiously de-

clined them: and some have been so vainly boisterous, that they durst not acknowledge their Graves; wherein Alaricus seems most subtle, who had a River turned to hide his bones at the bottome. Even Sylla that thought himself safe in his Urne, could not prevent revenging tongues, and stones thrown at his Monument. Happy are they whom privacy makes innocent, who deal so with men in this world, that they are not afraid to meet them in the next, who when they die, make no commotion among the dead, and are not toucht with that poeticall taunt of Isaiah.

Pyramids, Arches, Obelisks, were but the irregularities of vain-glory, and wilde enormities of ancient magnanimity. But the most magnanimous resolution rests in the Christian Religion, which trampleth upon pride, and sets on the neck of ambition, humbly pursuing that infallible perpetuity, unto which all others must diminish their diameters and be poorly seen in Angles of contingency.

Pious spirits who passed their dayes in raptures of futurity, made little more of this world, then the world that was before it, while they lay obscure in the Chaos of preordination, and night of their fore-beings. And if any have been so happy as truely to understand Christian annihilation, extasis, exolution, liquefaction, transformation, the kisse of the Spouse, gustation of God, and ingression into the divine shadow, they have already had an handsome anticipation of heaven; the glory of the world is surely over, and the earth in ashes unto them.

To subsist in lasting Monuments, to live in their productions, to exist in their names, and prædicament of Chymera's, was large satisfaction unto old expectations and made one part of their Elyziums. But all this is nothing in the Metaphysicks of true belief. To live indeed is to be again our selves, which being not onely an hope but an evidence in noble beleevers, 'tis all one to lie in St. Innocent's Church-yard, as in the Sands of Ægypt: Ready to be anything, in the extasie of being ever, and as content with six foot as the Moles of Adrianus.

Hydriotaphia (1658)

One of the greatest poems in our language . . . the famous fifth chapter, which to have written, brief as it is, were sufficient for eternal fame.

CHARLES WHIBLEY
Essays in Biography (1913)

700

EDMUND WALLER

1 6 0 6 — 1 6 8 7

THREE WORDS

Goe lovely Rose.

Poems (1645)

Most of all I envy the octogenarian poet who joined three words—

'Go, lovely Rose'—

so happily together, that he left his name to float down through time on the wings of a phrase and a flower.

LOGAN PEARSALL SMITH
Afterthoughts (1931)

PIERRE CORNEILLE

1 6 0 6 — 1 6 8 4

STANCES À LA MARQUISE

Marquise, si mon visage
A quelques traits un peu vieux,
Souvenez-vous qu'à mon âge
Vous ne vaudrez guère mieux.

Le temps aux plus belles choses
Se plaît à faire un affront,
Et saura faner vos roses
Comme il a ridé mon front.

Le même cours des planètes
Règle nos jours et nos nuits,
On m'a vu ce que vous êtes;
Vous serez ce que je suis.

Cependant j'ai quelques charmes
Qui sont assez éclatants
Pour n'avoir pas trop d'alarmes
De ces ravages du temps.

701

Vous en avez qu'on adore,
Mais ceux que vous méprisez
Pourraient bien durer encore
Quand ceux-là seront usés.

Ils pourront sauver la gloire
Des yeux qui me semblent doux,
Et dans mille ans faire croire
Ce qu'il me plaira de vous.

Chez cette race nouvelle
Où j'aurai quelque crédit,
Vous ne passerez pour belle
Qu'autant que je l'aurai dit.

Pensez-y, belle Marquise:
Quoiqu'un grison fasse effroi,
Il vaut bien qu'on le courtise,
Quand il est fait comme moi.

STANZAS

Lady fair, if on the page
Of my face traits elderly
Show, remember, at my age,
Yours will little better be.

Time to all that is most fair
Loves to offer his affront;
He your roses will not spare,
As he furrowed hath my front.

The same course of star and star
Rules the days of you and me:
Folk have seen me what you are;
And what I am you will be.

None the less, I have some charm,
Enough puissant, anydele,
For me not o'er much alarm
At Time's ravages to feel.

Charms you have, that men adore;
But this other, that you scorn,
Well may last, when yours of yore
Have been long ago outworn.

I the glory of your eyes
Can preserve for ages new
And cause races yet to rise
What I choose believe of you.

'Midst the newborn nations, where
I shall in some credit be,
You will only pass for fair,
Inasmuch as pleases me.

So bethink you, fair Marquise:
Though a greybeard fright the eye,
He is worth the pains to please,
When he fashioned is as I.

Translated by John Payne

The masterpiece of its kind.

EUGÈNE NOEL
Les Poëtes français (1861)

THOMAS HEYWOOD

? — C. 1 6 5 0

THE ANGRY KYNGES

Goe hurtles soules, whom mischiefe hath opprest
Even in first porch of life but lately had,
And fathers fury goe unhappy kind
O litle children, by the way ful sad
 Of journey knowen.
 Goe see the angry kynges.

 ite ad Stygios, umbrae, portus
 ite, innocuae, quas in primo
 limine vitae scelus oppressit
 patriusque furor;
 ite, iratos visite reges.

Seneca
Hercules Furens, Act iv

The whole of the chorus at the end of Act IV of Heywood's HERCULES
FURENS *is very fine, but the last six lines seem to me of singular beauty;
and as the original, too, is a lovely passage, it is both fair and interesting
to quote original and translation. The persons addressed are the dead
children of Hercules, whom he has just slain in his madness. . . . Noth-
ing can be said of such a translation except that it is perfect. It is a last
echo of the earlier tongue, the language of Chaucer, with an overtone
of that Christian piety and pity which disappears with Elizabethan verse.*

<div align="right">

T. S. ELIOT
Seneca in Elizabethan Translation (1927)

</div>

JOHN MILTON

1 6 0 8 — 1 6 7 4

L'ALLEGRO

Hence loathed Melancholy
 Of *Cerberus,* and blackest midnight born,
In *Stygian* Cave forlorn.
 'Mongst horrid shapes, and shreiks, and sights unholy,
Find out some uncouth cell,
 Where brooding darkness spreads his jealous wings,
And the night-Raven sings;
 There under *Ebon* shades, and low-brow'd Rocks,
As ragged as thy Locks,
 In dark *Cimmerian* desert ever dwell.
But com thou Goddess fair and free,
In Heav'n ycleap'd *Euphrosyne,*
And by men, heart-easing Mirth,
Whom lovely *Venus* at a birth
With two sister Graces more
To Ivy-crowned *Bacchus* bore;
Or whether (as som Sager sing)
The frolick Wind that breathes the Spring,
Zephir with *Aurora* playing,
As he met her once a Maying,
There on Beds of Violets blew,
And fresh-blown Roses washt in dew,
Fill'd her with thee a daughter fair,
So bucksom, blith, and debonair.
Haste thee nymph, and bring with thee

Jest and youthful Jollity,
Quips and Cranks, and wanton Wiles,
Nods, and Becks, and Wreathed Smiles,
Such as hang on *Hebe's* cheek,
And love to live in dimple sleek;
Sport that wrincled Care derides,
And Laughter holding both his sides.
Com, and trip it as you go
On the light fantastick toe,
And in thy right hand lead with thee,
The Mountain Nymph, sweet Liberty;
And if I give thee honour due,
Mirth, admit me of thy crue
To live with her, and live with thee,
In unreproved pleasures free;
To hear the Lark begin his flight,
And singing startle the dull night,
From his watch-towre in the skies,
Till the dappled dawn doth rise;
Then to com in spight of sorrow,
And at my window bid good morrow,
Through the Sweet-Briar, or the Vine,
Or the twisted Eglantine,
While the Cock with lively din,
Scatters the rear of darkness thin,
And to the stack, or the Barn dore,
Stoutly struts his Dames before,
Oft list'ning how the Hounds and Horn
Chearly rouse the slumbring morn,
From the side of som Hoar Hill,
Through the high wood echoing shrill.
Som time walking not unseen
By Hedge-row Elms, on Hillocks green,
Right against the Eastern gate,
Where the great Sun begins his state,
Roab'd in flames, and Amber light,
The clouds in thousand Liveries dight,
While the Plowman neer at hand,
Whistles ore the Furrow'd Land,
And the Milkmaid singeth blithe,
And the Mower whets his sithe,
And every Shepherd tells his tale
Under the Hawthorn in the dale.
Streit mine eye hath caught new pleasures
Whilst the Lantskip round it measures,

Russet Lawns, and Fallows Gray,
Where the nibling flocks do stray,
Mountains on whose barren brest
The labouring clouds do often rest:
Meadows trim with Daisies pide,
Shallow Brooks, and Rivers wide.
Towers, and Battlements it sees
Boosom'd high in tufted Trees,
Wher perhaps som beauty lies,
The Cynosure of neighbouring eyes.
Hard by, a Cottage chimney smokes,
From betwixt two aged Okes,
Where *Corydon* and *Thyrsis* met,
Are at their savory dinner set
Of Hearbs, and other Country Messes,
Which the neat-handed *Phillis* dresses
And then in haste her Bowre she leaves,
With *Thestylis* to bind the Sheaves;
Or if the earlier season lead
To the tann'd Haycock in the Mead,
Some times with secure delight
The up-land Hamlets will invite,
When the merry Bells ring round,
And the jocond rebecks sound
To many a youth, and many a maid,
Dancing in the Chequer'd shade;
And young and old com forth to play
On a Sunshine Holyday,
Till the live-long day-light fail,
Then to the Spicy Nut-brown Ale,
With stories told of many a feat,
How *Faery Mab* the junkets eat,
She was pincht, and pull'd she sed,
And by the Friars Lanthorn led
Tells how the drudging *Goblin* swet,
To ern his Cream-bowle duly set,
When in one night, ere glimps of morn,
His shadowy Flale hath thresh'd the Corn,
That ten day-labourers could not end,
Then lies him down the Lubbar Fend.
And stretch'd out all the Chimney's length,
Basks at the fire his hairy strength;
And Crop-full out of dores he flings,
Ere the first Cock his Mattin rings,

Thus done the Tales, to bed they creep,
By whispering Winds soon lull'd asleep.
Towred Cities please us then,
And the busie humm of men,
Where throngs of Knights and Barons bold,
In weeds of Peace high triumphs hold,
With store of Ladies, whose bright eies
Rain influence, and judge the prise,
Of Wit, or Arms, while both contend
To win her Grace, whom all commend,
There let *Hymen* oft appear
In Saffron robe, with Taper clear,
And pomp, and feast, and revelry,
With mask, and antique Pageantry,
Such sights as youthful Poets dream
On Summer eeves by haunted stream.
Then to the well-trod stage anon,
If *Jonsons* learned Sock be on,
Or sweetest *Shakespear* fancies childe,
Warble his native Wood-notes wilde,
And ever against eating Cares,
Lap me in soft *Lydian* Aires,
Married to immortal verse
Such as the meeting soul may pierce
In notes, with many a winding bout
Of lincked sweetness long drawn out,
With wanton heed, and giddy cunning,
The melting voice through mazes running;
Untwisting all the chains that ty
The hidden soul of harmony.
That *Orpheus* self may heave his head
From golden slumber on a bed
Of heapt *Elysian* flowres, and hear
Such streins as would have won the ear
Of *Pluto*, to have quite set free
His half regain'd *Eurydice*.
These delights, if thou canst give,
Mirth with thee, I mean to live.

(1632)

*In none of the works of Milton is his peculiar manner more happily
displayed than in the Allegro and the Penseroso. It is impossible to con-
ceive that the mechanism of language can be brought to a more ex-
quisite degree of perfection. These poems differ from others, as attar
of roses differs from ordinary rose-water, the close-packed essence from*

the thin diluted mixture. They are indeed not so much poems, as col-
lections of hints, from each of which the reader is to make out a poem
for himself. Every epithet is a text for a stanza.

<div align="right">

THOMAS BABINGTON MACAULAY
Critical and Historical Essays (1843)
</div>

JOHN MILTON

1 6 0 8 — 1 6 7 4

IL PENSEROSO

Hence vain deluding joyes,
 The brood of folly without father bred,
How little you bested,
 Or fill the fixed mind with all your toyes;
Dwell in some idle brain,
 And fancies fond with gaudy shapes possess,
As thick and numberless
 As the gay motes that people the Sun Beams,
Or likest hovering dreams
 The fickle Pensioners of *Morpheus* train.
But hail thou Goddess, sage and holy,
Hail divinest Melancholy,
Whose Saintly visage is too bright
To hit the Sense of human sight;
And therefore to our weaker view,
Ore laid with black staid Wisdoms hue.
Black, but such as in esteem,
Prince *Memnons* sister might beseem,
Or that starr'd *Ethiope* Queen that strove
To set her beauties praise above
The Sea Nymphs, and their powers offended,
Yet thou art higher far descended,
Thee bright-hair'd *Vesta* long of yore,
To solitary *Saturn* bore;
His daughter she (in *Saturns* raign,
Such mixture was not held a stain)
Oft in glimmering Bowres, and glades
He met her, and in secret shades
Of woody *Ida's* inmost grove,
While yet there was no fear of *Jove.*

Com pensive Nun, devout and pure,
Sober, stedfast, and demure,
All in a robe of darkest grain,
Flowing with majestick train,
And sable stole of *Cipres* Lawn,
Over thy decent shoulders drawn.
Com, but keep thy wonted state,
With eev'n step, and musing gate,
And looks commercing with the skies,
Thy rapt soul sitting in thine eyes:
There held in holy passion still,
Forget thy self to Marble, till
With a sad Leaden downward cast,
Thou fix them on the earth as fast.
And joyn with thee calm Peace, and Quiet
Spare Fast, that oft with gods doth diet,
And hears the Muses in a ring,
Ay round about *Joves* Altar sing.
And adde to these retired leasure,
That in trim Gardens takes his pleasure;
But first, and chiefest, with thee bring,
Him that yon soars on golden wing,
Guiding the fiery-wheeled throne,
The Cherub Contemplation,
And the mute Silence hist along,
'Less *Philomel* will deign a Song,
In her sweetest, saddest plight,
Smoothing the rugged brow of night,
While *Cynthia* checks her Dragon yoke,
Gently o're th' accustom'd Oke;
Sweet Bird that shunn'st the noise of folly,
Most musical, most Melancholy!
Thee Chauntress oft the Woods among,
I woo to hear thy Even-Song;
And missing thee, I walk unseen
On the dry smooth-shaven Green,
To behold the wandring Moon,
Riding neer her highest noon,
Like one that had bin led astray
Through the Heav'ns wide pathles way;
And oft, as if her head she bow'd,
Stooping through a fleecy cloud.
Oft on a Plat of rising ground,
I hear the far-off *Curfeu* sound,

Over some wide-water'd shoar,
Swinging slow with sullen roar;
Or if the Ayr will not permit,
Som still removed place will fit,
Where glowing Embers through the room
Teach light to counterfeit a gloom,
Far from all resort of mirth,
Save the Cricket on the hearth,
Or the Belmans drowsie charm,
To bless the dores from nightly harm:
Or let my Lamp at midnight hour,
Be seen in some high lonely Towr,
Where I may oft out-watch the *Bear*,
With thrice great *Hermes*, or unsphear
The spirit of *Plato* to unfold
What Worlds, or what vast Regions hold
The immortal mind that hath forsook
Her mansion in this fleshly nook:
And of those *Dæmons* that are found
In fire, air, flood, or under ground,
Whose power hath a true consent
With Planet, or with Element.
Som time let Gorgeous Tragedy
In Scepter'd Pall com sweeping by,
Presenting *Thebs*, or *Pelops* line,
Or the tale of *Troy* divine.
Or what (though rare) of later age,
Ennobled hath the Buskind stage.
But, O sad Virgin, that thy power
Might raise *Musæus* from his bower,
Or bid the soul of *Orpheus* sing
Such notes as warbled to the string,
Drew Iron tears down *Pluto's* cheek,
And made Hell grant what Love did seek.
Or call up him that left half told
The story of *Cambuscan* bold,
Of *Camball*, and of *Algarsife*,
And who had *Canace* to wife,
That own'd the vertuous Ring and Glass,
And of the wondrous Hors of Brass,
On which the *Tartar* King did ride;
And if ought els, great *Bards* beside,
In sage and solemn tunes have sung,
Of Turneys and of Trophies hung;

710

Of Forests, and inchantments drear,
Where more is meant then meets the ear.
Thus night oft see me in thy pale career,
Till civil-suited Morn appeer,
Not trickt and frounc't as she was wont,
With the Attick Boy to hunt,
But Cherchef't in a comely Cloud,
While rocking Winds are Piping loud,
Or usher'd with a shower still,
When the gust hath blown his fill,
Ending on the russling Leaves,
With minute drops from off the Eaves.
And when the Sun begins to fling
His flaring beams, me Goddess bring
To arched walks of twilight groves,
And shadows brown that *Sylvan* loves
Of Pine, or monumental Oake,
Where the rude Ax with heaved stroke,
Was never heard the Nymphs to daunt,
Or fright them from their hallow'd haunt.
There in close covert by some Brook,
Where no prophaner eye may look,
Hide me from Day's garish eie,
While the Bee with Honied thie,
That at her flowry work doth sing,
And the Waters murmuring
With such consort as they keep,
Entice the dewy-feather'd Sleep;
And let som strange mysterious dream,
Wave at his Wings in Airy stream,
Of lively portrature display'd,
Softly on my eye-lids laid.
And as I wake, sweet musick breath
Above, about, or underneath,
Sent by som spirit to mortals good,
Or th' unseen Genius of the Wood.
But let my due feet never fail,
To walk the studious Cloysters pale.
And love the high embowed Roof,
With antick Pillars massy proof,
And storied Windows richly dight,
Casting a dimm religious light.
There let the pealing Organ blow,
To the full voic'd Quire below,

In Service high, and Anthems cleer,
As may with sweetness, through mine ear,
Dissolve me into extasies,
And bring all Heav'n before mine eyes.
And may at last my weary age
Find out the peacefull hermitage,
The Hairy Gown and Mossy Cell,
Where I may sit and rightly spell
Of every Star that Heav'n doth shew,
And every Herb that sips the dew;
Till old experience do attain
To something like Prophetic strain.
These pleasures *Melancholy* give,
And I with thee will choose to live.

<div align="right">(1632)</div>

*I have not the least doubt, that the finest poem in the English language,
I mean Milton's Il Penseroso, was composed in the long resounding isle
of a mouldering cloister or ivy'd abbey.*

<div align="right">EDMUND BURKE
Letter to Matthew Smith (1750)</div>

JOHN MILTON

1 6 0 8 — 1 6 7 4

LYCIDAS

*In this Monody the Author bewails a learned Friend, unfortunatly
drown'd in his passage from* CHESTER *on the* IRISH *Seas, 1637. And by
occasion foretels the ruine of our corrupted Clergy then in their height.*

Yet once more, O ye Laurels, and once more
Ye Myrtles brown, with Ivy never-sear,
I com to pluck your Berries harsh and crude,
And with forc'd fingers rude,
Shatter your leaves before the mellowing year.
Bitter constraint, and sad occasion dear,
Compels me to disturb your season due:
For *Lycidas* is dead, dead ere his prime
Young *Lycidas*, and hath not left his peer:
Who would not sing for *Lycidas*? he knew
Himself to sing, and build the lofty rhyme.

He must not flote upon his watry bear
Unwept, and welter to the parching wind,
Without the meed of som melodious tear.
 Begin then, Sisters of the sacred well,
That from beneath the seat of *Jove* doth spring,
Begin, and somwhat loudly sweep the string.
Hence with denial vain, and coy excuse,
So may som gentle Muse
With lucky words favour my destin'd Urn,
And as he passes turn,
And bid fair peace be to my sable shrowd.
For we were nurst upon the self-same hill,
Fed the same flocks; by fountain, shade, and rill.
 Together both, ere the high Lawns appear'd
Under the opening eye-lids of the morn,
We drove a field, and both together heard
What time the Gray-fly winds her sultry horn,
Batt'ning our flocks with the fresh dews of night,
Oft till the Star that rose, at Ev'ning, bright
Toward Heav'ns descent had slop'd his westering wheel.
Mean while the Rural ditties were not mute,
Temper'd to th'Oaten Flute,
Rough *Satyrs* danc'd, and *Fauns* with clov'n heel,
From the glad sound would not be absent long,
And old *Damætas* lov'd to hear our song.
 But O the heavy change, now thou art gon,
Now thou art gon, and never must return!
Thee Shepherd, thee the Woods, and desert Caves,
With wilde Thyme and the gadding Vine o'regrown,
And all their echoes mourn.
The Willows, and the Hazle Copses green,
Shall now no more be seen,
Fanning their joyous Leaves to thy soft layes.
As killing as the Canker to the Rose,
Or Taint-worm to the weanling Herds that graze,
Or Frost to Flowers, that their gay wardrop wear,
When first the White thorn blows;
Such, *Lycidas*, thy loss to Shepherds ear.
 Where were ye Nymphs when the remorseless deep
Clos'd o're the head of your lov'd *Lycidas*?
For neither were ye playing on the steep,
Where your old *Bards*, the famous *Druids* ly,
Nor yet on the shaggy top of *Mona* high,
Nor yet where *Deva* spreads her wisard stream:
Ay me, I fondly dream!

Had ye bin there—for what could that have don?
What could the Muse her self that *Orpheus* bore,
The Muse her self, for her inchanting son
Whom Universal nature did lament,
When by the rout that made the hideous roar,
His goary visage down the stream was sent,
Down the swift *Hebrus* to the *Lesbian* shore.

 Alas! what boots it with uncessant care
To tend the homely slighted Shepherds trade,
And strictly meditate the thankles Muse,
Were it not better don as others use,
To sport with *Amaryllis* in the shade,
Or with the tangles of *Neæra's* hair?
Fame is the spur that the clear spirit doth raise
(That last infirmity of Noble mind)
To scorn delights, and live laborious dayes;
But the fair Guerdon when we hope to find,
And think to burst out into sudden blaze,
Comes the blind *Fury* with th'abhorred shears,
And slits the thin-spun life. But not the praise,
Phœbus repli'd, and touch'd my trembling ears;
Fame is no plant that grows on mortal soil,
Nor in the glistering foil
Set off to th'world, nor in broad rumour lies,
But lives and spreds aloft by those pure eyes,
And perfet witnes of all judging *Jove;*
As he pronounces lastly on each deed,
Of so much fame in Heav'n expect thy meed.

 O fountain *Arethuse,* and thou honour'd floud,
Smooth-sliding *Mincius,* crown'd with vocall reeds,
That strain I heard was of a higher mood:
But now my Oate proceeds,
And listens to the Herald of the Sea
That came in *Neptune's* plea,
He ask'd the Waves, and ask'd the Fellon winds,
What hard mishap hath doom'd this gentle swain?
And question'd every gust of rugged wings
That blows from off each beaked Promontory,
They knew not of his story,
And sage *Hippotades* their answer brings,
That not a blast was from his dungeon stray'd,
The Ayr was calm, and on the level brine,
Sleek *Panope* with all her sisters play'd.
It was that fatall and perfidious Bark
Built in th'eclipse, and rigg'd with curses dark,

714

That sunk so low that sacred head of thine.
　　Next *Camus*, reverend Sire, went footing slow,
His Mantle hairy, and his Bonnet sedge,
Inwrought with figures dim, and on the edge
Like to that sanguine flower inscrib'd with woe.
Ah; Who hath reft (quoth he) my dearest pledge?
Last came, and last did go,
The Pilot of the *Galilean* lake,
Two massy Keyes he bore of metals twain,
(The Golden opes, the Iron shuts amain)
He shook his Miter'd locks, and stern bespake,
How well could I have spar'd for thee, young swain,
Anow of such as for their bellies sake,
Creep and intrude, and climb into the fold?
Of other care they little reck'ning make,
Then how to scramble at the shearers feast,
And shove away the worthy bidden guest.
Blind mouthes! that scarce themselves know how to hold
A Sheep-hook, or have learn'd ought els the least
That to the faithfull Herdmans art belongs!
What recks it them? What need they? They are sped;
And when they list, their lean and flashy songs
Grate on their scrannel Pipes of wretched straw,
The hungry Sheep look up, and are not fed,
But swoln with wind, and the rank mist they **draw**,
Rot inwardly, and foul contagion spread:
Besides what the grim Woolf with privy paw
Daily devours apace, and nothing sed,
But that two-handed engine at the door,
Stands ready to smite once, and smite no more.
　　Return *Alpheus*, the dread voice is past,
That shrunk thy streams; Return *Sicilian* Muse,
And call the Vales, and bid them hither cast
Their Bels, and Flourets of a thousand hues.
Ye valleys low where the milde whispers use,
Of shades and wanton winds, and gushing brooks,
On whose fresh lap the swart Star sparely looks,
Throw hither all your quaint enameld eyes,
That on the green terf suck the honied showres,
And purple all the ground with vernal flowres.
Bring the rathe Primrose that forsaken dies.
The tufted Crow-toe, and pale Gessamine,
The white Pink, and the Pansie freakt with jeat,
The glowing Violet.
The Musk-rose, and the well attir'd Woodbine,

715

With Cowslips wan that hang the pensive hed,
And every flower that sad embroidery wears:
Bid *Amaranthus* all his beauty shed,
And Daffadillies fill their cups with tears,
To strew the Laureat Herse where *Lycid* lies.
For so to interpose a little ease,
Let our frail thoughts dally with false surmise.
Ay me! Whilst thee the shores, and sounding Seas
Wash far away, where ere thy bones are hurld,
Whether beyond the stormy *Hebrides*,
Where thou perhaps under the whelming tide
Visit'st the bottom of the monstrous world;
Or whether thou to our moist vows deny'd,
Sleep'st by the fable of *Bellerus* old,
Where the great vision of the guarded Mount
Looks toward *Namancos* and *Bayona's* hold;
Look homeward Angel now, and melt with ruth.
And, O ye *Dolphins*, waft the haples youth.
 Weep no more, woful Shepherds weep no more,
For *Lycidas* your sorrow is not dead,
Sunk though he be beneath the watry floar,
So sinks the day-star in the Ocean bed,
And yet anon repairs his drooping head,
And tricks his beams, and with new spangled Ore,
Flames in the forehead of the morning sky:
So *Lycidas* sunk low, but mounted high,
Through the dear might of him that walk'd the waves
Where other groves, and other streams along,
With *Nectar* pure his oozy Lock's he laves,
And hears the unexpressive nuptiall Song,
In the blest Kingdoms meek of joy and love.
There entertain him all the Saints above,
In solemn troops, and sweet Societies
That sing, and singing in their glory move,
And wipe the tears for ever from his eyes.
Now *Lycidas* the Shepherds weep no more;
Hence forth thou art the Genius of the shore,
In thy large recompense, and shalt be good
To all that wander in that perilous flood.
 Thus sang the uncouth Swain to th'Okes and rills,
While the still morn went out with Sandals gray,
He touch'd the tender stops of various Quills,
With eager thought warbling his *Dorick* lay:
And now the Sun had stretch'd out all the hills,
And now was dropt into the Western bay;

At last he rose, and twitch'd his Mantle blew:
To morrow to fresh Woods, and Pastures new.

(1637)

One of the most staggering performances in any literature.

ALDOUS HUXLEY
Texts & Pretexts (1933)

JOHN MILTON

1 6 0 8 — 1 6 7 4

SATAN GREETS HELL

 Farewel happy Fields
Where Joy for ever dwells: Hail horrours, hail
Infernal world, and thou profoundest Hell
Receive thy new Possessor: One who brings
A mind not to be chang'd by Place or Time.
The mind is its own place, and in it self
Can make a Heav'n of Hell, a Hell of Heav'n.
What matter where, if I be still the same,
And what I should be, all but less then hee
Whom Thunder hath made greater? Here at least
We shall be free; th' Almighty hath not built
Here for his envy, will not drive us hence:
Here we may reign secure, and in my choyce
To reign is worth ambition though in Hell:
Better to reign in Hell, then serve in Heav'n.

Paradise Lost (1667), i

Nothing could be better than that, and nothing is.

MARK VAN DOREN
The Noble Voice (1946)

717

JOHN MILTON

1 6 0 8 — 1 6 7 4

SATAN

He above the rest
In shape and gesture proudly eminent
Stood like a Towr; his form had yet not lost
All her Original brightness, nor appear'd
Less then Arch Angel ruind, and th' excess
Of Glory obscur'd: As when the Sun new ris'n
Looks through the Horizontal misty Air
Shorn of his Beams, or from behind the Moon
In dim Eclips disastrous twilight sheds
On half the Nations, and with fear of change
Perplexes Monarchs.

Paradise Lost (1667), i

*We do not anywhere meet a more sublime description than this justly
celebrated one of Milton.*

EDMUND BURKE
On the Sublime and Beautiful (1756)

JOHN MILTON

1 6 0 8 — 1 6 7 4

DEATH

The other shape,
If shape it might be call'd that shape had none
Distinguishable in member, joynt, or limb,
Or substance might be call'd that shadow seem'd,
For each seem'd either; black it stood as Night,
Fierce as ten Furies, terrible as Hell,
And shook a dreadful Dart; what seem'd his head
The likeness of a Kingly Crown had on.

Paradise Lost (1667), ii

*No person seems better to have understood the secret of heightening,
or of setting terrible things, if I may use the expression, in their strongest
light, by the force of a judicious obscurity, than Milton. His description
of Death, in the second book, is admirably studied: it is astonishing with*

718

*what a gloomy pomp, with what a significant and expressive uncertainty
of strokes and coloring, he has finished the portrait of the king of terrors.
... In this description all is dark, uncertain, confused, terrible, and
sublime to the last degree.*

<div align="right">

EDMUND BURKE
On the Sublime and Beautiful (1756)

</div>

JOHN MILTON

1 6 0 8 — 1 6 7 4

HAIL HOLY LIGHT

Hail holy light, ofspring of Heav'n first-born,
Or of th' Eternal Coeternal beam
May I express thee unblam'd? since God is light,
And never but in unapproached light
Dwelt from Eternitie, dwelt then in thee,
Bright effluence of bright essence increate.
Or hear'st thou rather pure Ethereal stream,
Whose Fountain who shall tell? before the Sun,
Before the Heavens thou wert, and at the voice
Of God, as with a Mantle didst invest
The rising world of water dark and deep,
Won from the void and formless infinite.
Thee I re-visit now with bolder wing,
Escap't the *Stygian* Pool, though long detain'd
In that obscure sojourn, while in my flight
Through utter and through middle darkness borne
With other notes then to th' *Orphean* Lyre
I sung of *Chaos* and *Eternal Night*,
Taught by the heav'nly Muse to venture down
The dark descent, and up to reascend,
Though hard and rare: thee I revisit safe,
And feel thy sovran vital Lamp; but thou
Revisit'st not these eyes, that rowle in vain
To find thy piercing ray, and find no dawn;
So thick a drop serene hath quencht their Orbs,
Or dim suffusion veild. Yet not the more
Cease I to wander where the Muses haunt
Cleer Spring, or shadie Grove, or Sunnie Hill,
Smit with the love of sacred song; but chief
Thee *Sion* and the flowrie Brooks beneath

That wash thy hallowd feet, and warbling flow,
Nightly I visit: nor somtimes forget
Those other two equal'd with me in Fate,
So were I equal'd with them in renown,
Blind *Thamyris* and blind *Mæonides*,
And *Tiresias* and *Phineus* Prophets old.
Then feed on thoughts, that voluntarie move
Harmonious numbers; as the wakeful Bird
Sings darkling, and in shadiest Covert hid
Tunes her nocturnal Note. Thus with the Year
Seasons return, but not to me returns
Day, or the sweet approach of Ev'n or Morn,
Or sight of vernal bloom, or Summers Rose,
Or flocks, or herds, or human face divine;
But cloud in stead, and ever-during dark
Surrounds me, from the chearful wayes of men
Cut off, and for the Book of knowledg fair
Presented with a Universal blanc
Of Natures works to mee expung'd and ras'd,
And wisdome at one entrance quite shut out.
So much the rather thou Celestial light
Shine inward, and the mind through all her powers
Irradiate, there plant eyes, all mist from thence
Purge and disperse, that I may see and tell
Of things invisible to mortal sight.

<div align="right">Paradise Lost (1667), iii</div>

*Not all the poetry of all the world can produce more than a few passages
that equal this in moving power.*

<div align="right">

JOHN BAILEY
Milton (1915)

</div>

JOHN MILTON

1 6 0 8 — 1 6 7 4

ADAM AND EVE

Now Morn her rosie steps in th' Eastern Clime
Advancing, sow'd the Earth with Orient Pearle,
When *Adam* wak't, so customd, for his sleep
Was Aerie light from pure digestion bred,
And temperat vapors bland, which th' only sound
Of leaves and fuming rills, *Aurora's* fan,

<div align="center">720</div>

Lightly dispers'd, and the shrill Matin Song
Of Birds on every bough; so much the more
His wonder was to find unwak'nd *Eve*
With Tresses discompos'd, and glowing Cheek,
As through unquiet rest: he on his side
Leaning half-rais'd, with looks of cordial Love
Hung over her enamour'd, and beheld
Beautie, which whether waking or asleep,
Shot forth peculiar Graces; then with voice
Milde, as when *Zephyrus* on *Flora* breathes,
Her hand soft touching, whisperd thus. Awake
My fairest, my espous'd, my latest found,
Heav'ns last best gift, my ever new delight,
Awake, the morning shines, and the fresh field
Calls us, we lose the prime, to mark how spring
Our tended Plants, how blows the Citron Grove,
What drops the Myrrhe, and what the balmie Reed,
How Nature paints her colours, how the Bee
Sits on the Bloom extracting liquid sweet.

Paradise Lost (1667), v

The richest melody as well as the sublimest sentiments.

HENRY HOME OF KAMES
Elements of Criticism (1762)

JOHN MILTON

1 6 0 8 — 1 6 7 4

FAR OFF HIS COMING SHONE

Attended with ten thousand thousand Saints,
He onward came, farr off his coming shon.

Paradise Lost (1667), vi

What can be finer in any poet than that beautiful passage in Milton—
. . . Onward he moved
And thousands of his saints around.
This is grandeur, but it is grandeur without completeness: but he adds—
Far off their coming shone;
which is the highest sublime. There is TOTAL *completeness.*

S. T. COLERIDGE
Table Talk (1836)

721

JOHN MILTON

1 6 0 8 — 1 6 7 4

YONDER NETHER WORLD

This most afflicts me, that departing hence,
As from his face I shall be hid, depriv'd
His blessed count'nance; here I could frequent,
With worship, place by place where he voutsaf'd
Presence Divine, and to my Sons relate;
On this Mount he appeerd, under this Tree
Stood visible, among these Pines his voice
I heard, here with him at this Fountain talk'd:
So many grateful Altars I would reare
Of grassie Terfe, and pile up every Stone
Of lustre from the brook, in memorie,
Or monument to Ages, and thereon
Offer sweet smelling Gumms and Fruits and Flours:
In yonder nether World where shall I seek
His bright appearances, or footstep trace?
For though I fled him angrie, yet recall'd
To life prolongd and promisd Race, I now
Gladly behold though but his utmost skirts
Of glory, and farr off his steps adore.

Paradise Lost (1667), xi

Nothing can be conceived more sublime and poetical.

JOSEPH ADDISON
The Spectator (April 26, 1712)

JOHN MILTON

1 6 0 8 — 1 6 7 4

CALM AND SINLESS PEACE

And either Tropic now
'Gan thunder, and both ends of Heav'n, the Clouds
From many a horrid rift abortive pour'd
Fierce rain with lightning mixt, water with fire
In ruine reconcil'd: nor slept the winds

Within thir stony caves, but rush'd abroad
From the four hinges of the world, and fell
On the vext Wilderness, whose tallest Pines,
Though rooted deep as high, and sturdiest Oaks
Bow'd their Stiff necks, loaden with stormy blasts,
Or torn up sheer: ill wast thou shrouded then,
O patient Son of God, yet only stoodst
Unshaken; nor yet staid the terror there,
Infernal Ghosts, and Hellish Furies, round
Environ'd thee, some howl'd, some yell'd, some shriek'd,
Some bent at thee their fiery darts, while thou
Sat'st unappall'd in calm and sinless peace.

<div align="right">Paradise Regain'd (1671), iv</div>

No such poetry as this has been written since, and little at any time before.

<div align="right">

WALTER SAVAGE LANDOR
The Poems of Catullus (1842)

</div>

<div align="center">

JOHN MILTON

1 6 0 8 — 1 6 7 4

WITH THEM THAT REST

</div>

I feel my genial spirits droop,
My hopes all flat, nature within me seems
In all her functions weary of herself;
My race of glory run, and race of shame,
And I shall shortly be with them that rest.

<div align="right">Samson Agonistes (1671)</div>

The noblest lines in English poetry. . . . As for ourselves, we will go on wondering whether anything finer than those verses was ever written by Milton or any other mortal man.

<div align="right">

WILLIAM PATON KER
The Art of Poetry (1923)

</div>

THE ATHENIAN WALLS

To save th' *Athenian* Walls from ruine bare.

<div align="right">Sonnet (1645)</div>

Assonance of long vowels makes [it] perhaps the most beautiful line in the language.

<div align="right">

HERBERT J. C. GRIERSON and J. C. SMITH

A Critical History of English Poetry (1944)

</div>

ON HIS BLINDNESS

When I consider how my light is spent,
 E're half my days, in this dark world and wide,
 And that one Talent which is death to hide,
 Lodg'd with me useless, though my Soul more bent
To serve therewith my Maker, and present
 My true account, least he returning chide,
 Doth God exact day-labour, light deny'd,
 I fondly ask; But patience to prevent
That murmur, soon replies, God doth not need
 Either man's work or his own gifts, who best
 Bear his milde yoak, they serve him best, his State
Is Kingly. Thousands at his bidding speed
 And post o're Land and Ocean without rest:
 They also serve who only stand and waite.

<div align="right">(1673)</div>

Those few supreme words.

<div align="right">

ALGERNON CHARLES SWINBURNE

Essays and Studies (1875)

</div>

TWO SONNETS

Daughter to that good Earl, once President
 Of *Englands* Counsel, and her Treasury,
 Who liv'd in both, unstain'd with gold or fee,
 And left them both, more in himself content,
Till the sad breaking of that Parlament
 Broke him, as that dishonest victory
 At *Chæronéa,* fatal to liberty
 Kil'd with report that Old man eloquent,
Though later born, then to have known the dayes
 Wherin your Father flourisht, yet by you
 Madam, me thinks I see him living yet;
So well your words his noble vertues praise,
 That all both judge you to relate them true,
 And to possess them, Honour'd *Margaret.*

 (1645)

Lawrence of vertuous Father vertuous Son,
 Now that the Fields are dank, and ways are mire,
 Where shall we sometimes meet, and by the fire
 Help wast a sullen day; what may be won
From the hard Season gaining: time will run
 On smoother, till *Favonius* re-inspire
 The frozen earth; and cloth in fresh attire
 The Lillie and Rose, that neither sow'd nor spun.
What neat repast shall feast us, light and choice,
 Of Attick tast, with Wine, whence we may rise
 To hear the Lute well toucht, or artfull voice
Warble immortal Notes and *Tuskan* Ayre?
 He who of those delights can judge, And spare
 To interpose them oft, is not unwise.

 (1673)

In easy majesty and severe beauty, unequalled by any other compositions of the kind.

ALEXANDER DYCE
Specimens of English Sonnets (1833)

JOHN MILTON

1 6 0 8 — 1 6 7 4

THE FIFTH ODE OF *HORACE*. LIB. I

Quis multa gracilis te puer in Rosa, *Rendred almost word for word
without Rhyme according to the Latin Measure, as near as the
Language will permit.*

Horatius ex Pyrrhae illecebris tanquam e naufragio enataverat, cujus
amore irretitos affirmat esse miseros.

What slender Youth bedew'd with liquid odours
Courts thee on Roses in some pleasant Cave,
　　Pyrrha for whom bindst thou
　　In wreaths thy golden Hair,
Plain in thy neatness; O how oft shall he
On Faith and changed Gods complain: and Seas
　　Rough with black winds and storms
　　Unwonted shall admire:
Who now enjoyes thee credulous, all Gold,
Who alwayes vacant, always amiable
　　Hopes thee; of flattering gales
　　Unmindfull. Hapless they
To whom thou untry'd seem'st fair. Me in my vow'd
Picture the sacred wall declares t' have hung
　　My dank and dropping weeds
　　To the stern God of Sea.

Quis multa gracilis te puer in rosa
perfusus liquidis urget odoribus
　　grato, Pyrrha, sub antro?
　　cui flavam religas comam,

simplex munditiis? heu quotiens fidem
mutatosque deos flebit et aspera
　　nigris aequora ventis
　　emirabitur insolens,

qui nunc te fruitur credulus aurea,
qui semper vacuam, semper amabilem
　　sperat, nescius aurae
　　fallacis. miseri, quibus

intemptata nites. me tabula sacer
votiva paries indicat uvida
suspendisse potenti
vestimenta maris deo.

Horace
Odes, i, 5

One of the most exquisite lyrics in English.

CYRIL CONNOLLY
The Condemned Playground (1946)

JOHN MILTON

1 6 0 8 — 1 6 7 4

MACBETH

Imaginary Works (n. d.)

The most fascinating poem—certainly, if play it were, the most fascina-ting play—ever unwritten.

ARTHUR QUILLER-COUCH
Poetry (1914)

A BALLAD OF A WEDDING

I tell thee, DICK! where I have been,
Where I the rarest things have seen,
 O, things beyond compare!
Such sights again can not be found
In any place on English ground,
 Be it at wake or fair.

At Charing-Cross, hard by the way
Where we, thou know'st, do sell our hay,
 There is a House with stairs;
And there did I see coming down
Such volk as are not in our town,
 Vorty at least, in pairs.

Amongst the rest One pest'lent fine,
His beard no bigger though than thine,
 Walk'd on before the best:
Our Landlord looks like nothing to him;
The King, God bless him! 'twould undo him
 Should he go still so dress'd.

At course-a-park, without all doubt,
He should have first been taken out
 By all the maids i' the town,
Though lusty Roger there had been,
Or little George upon the Green,
 Or Vincent of the Crown.

But wot you what? the Youth was going
To make an end of all his wooing;
 The parson for him stay'd:
Yet by his leave, for all his haste,
He did not so much wish all past,
 Perchance, as did the Maid.

The Maid,—and thereby hangs a tale,
For such a Maid no Widson ale
 Could ever yet produce:
No grape that's kindly ripe could be
So round, so plump, so soft as she,
 Nor half so full of juice.

728

Her finger was so small the ring
Would not stay on which he did bring,
 It was too wide a peck;
And to say truth, for out it must,
It look'd like the great collar, just,
 About our young colt's neck.

Her feet beneath her petticoat
Like little mice stole in and out,
 As if they fear'd the light;
But, Dick! she dances such a way,
No sun upon an Easter day
 Is half so fine a sight.

He would have kiss'd her once or twice,
But she would not, she was so nice,
 She would not do 't in sight;
And then she look'd as who would say
I will do what I list to-day,
 And you shall do 't at night.

Her cheeks so rare a white was on,
No daisy makes comparison,—
 Who sees them is undone:
For streaks of red were mingled there
Such as are on a Katherine pear,
 The side that's next the sun.

Her lips were red, and one was thin,
Compared to that was next her chin,—
 Some bee had stung it newly:
But, Dick! her eyes so guard her face,
I durst no more upon them gaze
 Than on the sun in Jùly.

Her mouth so small, when she does speak,
Thou 'dst swear her teeth her words did break,
 That they might passage get;
But she so handled still the matter,
They came as good as ours, or better,
 And are not spent a whit.

If wishing should be any sin
The parson himself had guilty been,
 She look'd that day so purely;
And did the Youth so oft the feat
At night as some did in conceit,
 It would have spoil'd him surely.

Passion o' me! how I run on:
There's that that would be thought upon,
 I trow, besides the Bride:
The business of the kitchen's great,
For it is fit that men should eat;
 Nor was it there denied.

Just in the nick the cook knock'd thrice,
And all the waiters in a trice
 His summons did obey;
Each serving-man with dish in hand
March'd boldly up, like our train'd band,
 Presented, and away.

When all the meat was on the table
What man of knife, or teeth, was able
 To stay to be intreated?
And this the very reason was
Before the parson could say grace
 The company was seated.

Now hats fly off, and youths carouse;
Healths first go round, and then the house,—
 The Bride's came thick and thick;
And when 'twas named another's health,
Perhaps he made it her's by stealth:
 And who could help it? Dick!

O' the sudden up they rise and dance;
Then sit again, and sigh, and glance;
 Then dance again and kiss:
Thus several ways the time did pass,
Whilst every woman wish'd her place,
 And every man wish'd his.

By this time all were stolen aside
To counsel and undress the Bride,
 But that he must not know:
But it was thought he guess'd her mind,
And did not mean to stay behind
 Above an hour or so.

When in he came, Dick! there she lay
Like new-fall'n snow melting away,—
 'Twas time, I trow, to part:
Kisses were now the only stay,
Which soon she gave, as who would say
 God b' w' y'! with all my heart.

But just as heavens would have to cross it
In came the bridemaids with the posset;
 The Bridegroom eat in spite:
For had he left the women to 't,
It would have cost two hours to do 't,
 Which were too much that night.

At length the candle 's out, and now
All that they had not done they do:
 What that is who can tell?
But I believe it was no more
Than thou and I have done before
 With Bridget and with Nell.

Twenty-two incomparable verses.

<div align="right">

EDMUND GOSSE
in Ward's The English Poets (1880)

</div>

THE BIBLE, AUTHORIZED VERSION

1 6 1 1

VISIONS OF THE NIGHT

In thoughts from the visions of the night, when deepe sleepe falleth
on men:
 Feare came vpon me, and trembling, which made all my bones to
shake.
 Then a spirit passed before my face: the haire of my flesh stood vp.
 It stood still, but I could not discerne the forme thereof: an image
was before mine eyes, *there was* silence, and I heard a voyce, *saying,*
 Shall mortall man be more iust then God?

<div align="right">

Job, iv, 13–17

</div>

Amazingly sublime.

<div align="right">

EDMUND BURKE
On the Sublime and Beautiful (1756)

</div>

A PSALME OF ASAPH

The mightie God, *euen* the LORD hath spoken, and called the earth from the rising of the sunne, vnto the going downe thereof.

Out of Sion the perfection of beautie, God hath shined.

Our God shall come, and shall not keepe silence: a fire shall deuoure before him, and it shalbe very tempestuous round about him.

He shall call to the heauens from aboue, and to the earth, that hee may iudge his people.

Gather my Saints together vnto mee: those that haue made a couenant with me, by sacrifice.

And the heauens shall declare his righteousnes; for God *is* iudge himselfe. Selah.

Heare, O my people, and I will speake, O Israel, and I will testifie against thee; I *am* God, *euen* thy God.

I will not reproue thee for thy sacrifices, or thy burnt offerings, *to haue bene* continually before me.

I will take no bullocke out of thy house, *nor* hee goates out of thy folds.

For euery beast of the forrest *is* mine, *and* the cattell vpon a thousand hilles.

I know all the foules of the mountaines: and the wild beasts of the field *are* mine.

If I were hungry, I would not tell thee, for the world *is* mine, and the fulnesse thereof.

Will I eate the flesh of bulles, or drinke the blood of goats?

Offer vnto God thankesgiuing, and pay thy vowes vnto the most high.

And call vpon mee in the day of trouble; I will deliuer thee, and thou shalt glorifie me.

But vnto the wicked God saith, What hast thou to doe, to declare my Statutes, or that thou shouldest take my Couenant in thy mouth?

Seeing thou hatest instruction, and casteth my words behinde thee.

When thou sawest a thiefe, then thou consentedst with him, and hast bene partaker with adulterers.

Thou giuest thy mouth to euill, and thy tongue frameth deceit.

Thou sittest *and* speakest against thy brother; thou slanderest thine owne mothers sonne.

These things hast thou done, and I kept silence: thou thoughtest that I was altogether such a one as thy selfe: *but* I will reproue thee, and set *them* in order before thine eyes.

732

Now consider this, ye that forget God, lest I teare *you* in pieces, and *there be* none to deliuer.

Who so offereth praise, glorifieth me: and to him that ordereth *his* conuersation *aright,* will I shew the saluation of God.

<div align="right">Psalms, l</div>

Comfort ye, comfort ye my people, sayth your God.

Speake ye comfortably to Jerusalem, and cry vnto her, that her warrefare is accomplished, that her iniquitie is pardoned: for shee hath receiued of the LORDS hand double for all her sinnes.

The voyce of him that cryeth in the wildernesse, Prepare yee the way of the LORD, make straight in the desert a high way for our God.

Euery valley shalbe exalted, and euery mountaine and hill shalbe made low: and the crooked shall be made straight, and the rough places plaine.

And the glory of the LORD shall be reuealed, and all flesh shall see *it* together: for the mouth of the LORD hath spoken *it.*

The voyce sayd; Cry. And hee sayd; What shall I cry? All flesh *is* grasse, and all the goodlinesse thereof *is* as the flowre of the field.

The grass withereth, the flowre fadeth; because the spirit of the LORD bloweth vpon it: surely the people *is* grasse.

The grasse withereth, the flowre fadeth: but the word of our **God** shall stand for euer.

O Zion, that bringest good tydings, get thee vp into the high mountaine: O Jerusalem, that bringest good tidings, lift vp thy voyce with strength, lift it vp, be not afraid: say vnto the cities of Judah; Behold your God.

Behold, the Lord GOD will come with strong *hand,* and his arme shall rule for him: behold, his reward *is* with him, and his worke before him.

He shall feede his flocke like a shepheard: he shall gather the lambes with his arme, and carie *them* in his bosome, *and* shall gently lead those that are with yoong.

Who hath measured the waters in the hollow of his hand; and meted out heauen with the spanne, and comprehended the dust of the earth in a measure, and weighed the mountaines in scales, and the hilles in a balance?

Who hath directed the spirit of the LORD, or, being his counseller, hath taught him?

With whom tooke he counsell, and *who* instructed him, and taught him in the path of iudgement; and taught him knowledge, and shewed to him the way of vnderstanding?

Behold, the nations *are* as a drop of a bucket, and are counted as the small dust of the balance: behold, hee taketh vp the yles as a very litle thing.

And Lebanon *is* not sufficient to burne, nor the beasts thereof suffi-
cient for a burnt offring.

All nations before him *are* as nothing, and they are counted to him
lesse then nothing, and vanitie.

To whom then will ye liken God? or what likenesse will ye compare
vnto him?

The workeman melteth a grauen image, and the goldsmith spreadeth
it ouer with golde, and casteth siluer chaines.

He that *is* so impouerished that he hath no oblation, chooseth a tree
that will not rot; he seeketh vnto him a cunning workeman, to prepare
a grauen image *that* shall not be mooued.

Haue yee not knowen? haue yee not heard? hath it not beene tolde
you from the beginning? haue yee not vnderstood from the foundations
of the earth?

It is he that sitteth vpon the circle of the earth, and the inhabitants
thereof *are* as grashoppers; that stretcheth out the heauens as a curtaine,
and spreadeth them out as a tent to dwel in:

That bringeth the princes to nothing; hee maketh the Judges of the
earth as vanitie.

Yea they shal not be planted, yea they shall not be sowen, yea their
stocke shall not take roote in the earth: and he shall also blow vpon
them, & they shall wither, and the whirlewinde shall take them away
as stubble.

To whom then will ye liken me, or shal I be equall, saith the Holy One?

Lift vp your eyes on high, and behold who hath created these things,
that bringeth out their host by number: he calleth them all by names,
by the greatnesse of his might, for that hee *is* strong in power, not one
faileth.

Why sayest thou, O Jacob, and speakest O Israel, My way is hid from
the LORD, and my iudgement is passed ouer from my God?

Hast thou not knowen? hast thou not heard, *that* the euerlasting
God, the LORD, the Creatour of the ends of the earth, fainteth not,
neither is wearie? there is no searching of his vnderstanding.

He giueth power to the faint, and to them that haue no might, he
increaseth strength.

Euen the youths shall faint, and be weary, and the yong men shall
vtterly fall.

But they that waite vpon the LORD, shall renew *their* strength:
they shall mount vp with wings as Eagles, they shal runne and not be
weary, *and* they shall walke, and not faint.

<div align="right">Isaiah, xl</div>

*Never was any Greek or Latin ode able to attain the grandeur of the
Psalms. For example, that which commences thus "The mighty God,
even the Lord hath spoken, and called the earth" surpasses all human*

imagination. Neither Homer nor any other poet has equalled Isaiah in depicting the majesty of God.

FRANÇOIS DE SALIGNAC FÉNELON
Dialogues sur l'éloquence (1718)

THE BIBLE, AUTHORIZED VERSION

1 6 1 1

DAUID PRAISETH GOD FOR HIS MANIFOLD AND MARUEILOUS BLESSINGS

To the chiefe musicion, *a psalme* of Dauid, the seruant of the LORD, who spake vnto the LORD the words of this song, in the day *that* the LORD deliuered him from the hand of all his enemies, and from the hand of Saul: And he said,

I will loue thee, O LORD, my strength.

The LORD *is* my rocke, and my fortresse, and my deliuerer: my God, my strength in whome I will trust, my buckler, and the horne of my saluation, *and* my high tower.

I will call vpon the LORD, who is worthy to be praised: so shall I be saued from mine enemies.

The sorrowes of death compassed me, and the floods of vngodly men made me afraid.

The sorrowes of hell compassed me about: the snares of death preuented me.

In my distresse I called vpon the LORD, and cryed vnto my God: hee heard my voyce out of his temple, and my crie came before him, *euen* into his eares.

Then the earth shooke and trembled; the foundations also of the hilles mooued and were shaken, because hee was wroth.

There went vp a smoke out of his nostrils, and fire out of his mouth deuoured, coales were kindled by it.

He bowed the heauens also, and came downe: and darkenesse *was* vnder his feet.

And he rode vpon a Cherub, and did flie: yea he did flie vpon the wings of the wind.

He made darkenes his secret place: his pauilion round about him, *were* darke waters, *and* thicke cloudes of the skies.

At the brightnes *that was* before him his thicke clouds passed, haile *stones* and coales of fire.

735

The LORD also thundered in the heauens, and the highest gaue his voyce; haile stones and coales of fire.

Yea, he sent out his arrowes, and scattered them; and he shot out lightnings, and discomfited them.

Then the chanels of waters were seene, and the foundations of the world were discouered: at thy rebuke, O LORD, at the blast of the breath of thy nostrils.

He sent from aboue, he tooke me, he drew me out of many waters.

He deliuered me from my strong enemie, and from them which hated me: for they were too strong for me.

They preuented me in the day of my calamitie: but the LORD was my stay.

He brought me forth also into a large place: he deliuered me, because he delighted in me.

The LORD rewarded me according to my righteousnesse, according to the cleannesse of my hands hath hee recompensed me.

For I haue kept the wayes of the LORD, and haue not wickedly departed from my God.

For all his iudgements *were* before me, and I did not put away his statutes from me.

I was also vpright before him: and I kept my selfe from mine iniquity.

Therefore hath the LORD recompensed me according to my righteousnesse, according to the cleannesse of my hands in his eye-sight.

With the mercifull thou wilt shew thy selfe mercifull, with an vpright man thou wilt shew thy selfe vpright.

With the pure thou wilt shewe thy selfe pure, and with the froward thou wilt shew thy selfe froward.

For thou wilt saue the afflicted people: but wilt bring downe high lookes.

For thou wilt light my candle: the LORD my God will enlighten my darkenesse.

For by thee I haue run through a troupe; and by my God haue I leaped ouer a wall.

As for God, his way is perfect: the word of the LORD is tried: he is a buckler to all those that trust in him.

For who *is* God saue the LORD? or who *is* a rocke saue our God?

It is God that girdeth mee with strength, and maketh my way perfect.

Hee maketh my feete like hindes *feete*, and setteth me vpon my high places.

He teacheth my hands to warre, so that a bow of steele is broken by mine armes.

Thou hast also giuen me the shield of thy saluation: and thy right hand hath holden me vp, and thy gentlenesse hath made me great.

Thou hast enlarged my steppes vnder me; that my feete did not slippe.

I haue pursued mine enemies, and ouertaken them: neither did I turne againe till they were consumed.

I haue wounded them that they were not able to rise: they are fallen vnder my feete.

For thou hast girded mee with strength vnto the battell: thou hast subdued vnder me, those that rose vp against me.

Thou hast also giuen mee the neckes of mine enemies: that I might destroy them that hate me.

They cried, but there was none to saue *them: euen* vnto the LORD, but he answered them not.

Then did I beate them small as the dust before the winde: I did cast them out, as the dirt in the streetes.

Thou hast deliuered me from the striuings of the people, *and* thou hast made mee the head of the heathen: a people *whom* I haue not knowen, shall serue me.

As soone as they heare of mee, they shall obey me: the strangers shall submit themselues vnto me.

The strangers shall fade away, and be afraid out of their close places.

The LORD liueth, and blessed *be* my rocke: and let the God of my saluation be exalted.

It is God that auengeth mee, and subdueth the people vnder me.

He deliuereth me from mine enemies: yea thou liftest mee vp aboue those that rise vp against me; thou hast deliuered me from the violent man.

Therefore will I giue thankes vnto thee, (O LORD) among the heathen: and sing prayses vnto thy name.

Great deliuerance giueth he to his King: and sheweth mercy to his Annointed, to Dauid, and to his seede for euermore.

<div align="right">Psalms, xviii</div>

We must concede that this sublimity is as far above all other sublimity as the spirit of God is above the mind of man. We see here the conception of grandeur in its essence, the rest is only a shadow, as created intelligence is only a feeble emanation of creative intelligence, as fiction, when it is beautiful, is only the shadow of truth, and draws all its merit from a basic resemblance.

<div align="right">

JEAN FRANÇOIS DE LA HARPE
Le Psautier français (1797–8)

</div>

A VINE OUT OF EGYPT

Thou hast brought a vine out of Egypt: thou hast cast out the heathen, and planted it.

Thou preparedst *roome* before it: and didst cause it to take deepe root, and it filled the land.

The hilles were couered with the shadow of it, and the boughs thereof were like the goodly cedars.

She sent out her boughs vnto the Sea: and her branches vnto the riuer.

Why hast thou *then* broken downe her hedges: so that all they which passe by the way, doe plucke her?

The boare out of the wood doth waste it: and the wild beast of the field doth deuoure it.

Returne, we beseech thee, O God of hosts: looke downe from heauen, and behold, and visit this vine:

And the vineyard which thy right hand hath planted: and the branch *that* thou madest strong for thy selfe.

Psalms, lxxx, 8–15

A finer or more correct allegory is not to be found.

HENRY HOME OF KAMES
Elements of Criticism (1762)

LOVE

Set mee as a seale vpon thine heart, as a seale vpon thine arme: for loue *is* strong as death, iealousie *is* cruel as the graue: the coales thereof *are* coales of fire, *which hath* a most vehement flame.

Many waters cannot quench loue, neither can the floods drowne it: if a man would giue all the substance of his house for loue, it would vtterly be contemned.

Song of Solomon, viii, 6–7

Now the requirement of a perfect prose rhythm is that, while it admits of indication by quantity-marks, and even by divisions into feet, the simplicity and equivalence of feet within the clause answering to the line are absent, and the exact correspondence of clause for clause, that is to say, of line for line, is absent also, and still more necessarily absent. Let us take an example. I know no more perfect example of English prose rhythm than the famous verses of the last chapter of the Canticles in the Authorized Version: I am not certain that I know any so perfect. Here they are arranged for the purpose of exhibition in clause-lines, quantified and divided into feet.

Sēt mě | ăs ă seāl | ŭpŏn thīne heārt | ăs ă seāl | ŭpŏn thīne ārm |
Fŏr lōve | ĭs strōng | ăs deāth | jeālŏusў | ĭs crūĕl | ăs thĕ grāve |
Thĕ coāls thĕreŏf | āre coāls | ŏf fīrĕ | whīch hāth | ă mŏst vē | hĕmĕnt
 flāme |
Mănў wătĕrs | cānnŏt quēnch lōve | neīthĕr | căn thĕ floōds | drōwn ĭt |
If ă mān | shoŭld gīve | ăll thĕ sūb | stānce | ŏf hĭs hoūse | fŏr lōve | ĭt
 shŏuld ūt | tĕrlў bĕ cŏntēmned. |

I by no means give the quantification of this, or the distribution into lines and feet as final or impeccable, though I think it is, on the whole—as a good elocutionist would read the passage—accurate enough. But the disposition will, I think, be sufficient to convince anyone who has an ear and a slight acquaintance with RES METRICA, that here is a system of rhythm irreducible to poetic form. The movement of the whole is perfectly harmonious, exquisitely modulated, finally complete. But it is the harmony of perfectly modulated speech, not of song; harmony, in short, but not melody, divisible into clauses, but not into bars or staves, having parts which continue each other, but do not correspond to each other.

<div align="right">

GEORGE SAINTSBURY
Specimens of English Prose Style (1886)

</div>

THE BIBLE, AUTHORIZED VERSION

1 6 1 1

ZION REDEEMED

Arise, shine, for thy light is come, and the glory of the LORD is risen vpon thee.

For behold, the darknesse shall couer the earth, and grosse darknesse the people: but the LORD shall arise vpon thee, and his glory shall

be seene vpon thee. And the Gentiles shall come to thy light, and kings to the brightnesse of thy rising.

Lift vp thine eyes round about, and see: all they gather themselues together, they come to thee: thy sonnes shall come from farre, and thy daughters shalbe nourced at *thy* side.

Then thou shalt see, and flow together, and thine heart shall feare and be inlarged, because the abundance of the Sea shalbe conuerted vnto thee, the forces of the Gentiles shall come vnto thee.

The multitude of camels shall couer thee, the dromedaries of Midian and Ephah: all they from Sheba shall come: they shal bring gold and incense, and they shall shew forth the praises of the LORD.

All the flockes of Kedar shall be gathered together vnto thee, the rams of Nebaioth shall minister vnto thee: they shall come vp with acceptance on mine altar, and I wil glorifie the house of my glory.

Who *are* these that flie as a cloude, and as the doues to their windowes? Surely the yles shall wait for me, and the ships of Tarshish first, to bring thy sonnes from farre, their siluer and their gold with them, vnto the Name of the LORD thy God, and to the Holy One of Israel, because he hath glorified thee.

And the sonnes of strangers shall build vp thy walles, and their kings shal minister vnto thee: for in my wrath I smote thee, but in my fauour haue I had mercie on thee.

Therefore thy gates shal be open continually, they shall not bee shut day nor night, that *men* may bring vnto thee the forces of the Gentiles, and that their kings may be brought.

For the nation and kingdome that will not serue thee, shall perish, yea those nations shall be vtterly wasted.

The glory of Lebanon shal come vnto thee, the Firre tree, the Pine tree, and the Boxe together, to beautifie the place of my Sanctuarie, and I will make the place of my feete glorious.

The sonnes also of them that afflicted thee, shall come bending vnto thee: and all they that despised thee shal bow themselues downe at the soles of thy feet, and they shall call thee the citie of the LORD, the Zion of the Holy One of Israel.

Whereas thou hast bene forsaken and hated, so that no man went thorow *thee*, I will make thee an eternall excellencie, a ioy of many generations.

Thou shalt also sucke the milke of the Gentiles, and shalt sucke the brest of kings, and thou shalt know that I the LORD *am* thy Sauiour and thy Redeemer, the mightie One of Iacob.

For brasse I will bring gold, and for yron I will bring siluer, and for wood brasse, and for stones yron: I will also make thy officers peace, and thine exactours righteousnesse.

Violence shall no more be heard in thy land, wasting nor destruction

within thy borders, but thou shalt call thy walles saluation, and thy gates praise.

The Sunne shall be no more thy light by day, neither for brightnesse shall the moone giue light vnto thee: but the LORD shall be vnto thee an euerlasting light, & thy God thy glory.

Thy Sunne shall no more goe downe, neither shall thy moone withdraw it selfe: for the LORD shall bee thine euerlasting light, and the dayes of thy mourning shall be ended.

Thy people also *shall be* all righteous: they shal inherit the land for euer, the branch of my planting, the worke of my hands, that I may be glorified.

A litle one shall become a thousand, and a small one a strong nation: I the LORD will hasten it in his time.

<div align="right">Isaiah, lx</div>

One of the highest points of English prose is probably reached in the Authorised Version of the sixtieth chapter of ISAIAH. *So utterly magnificent is the rendering that even those dolefullest of creatures—the very Ziim and Ochim and Iim of the fauna of our literature—the Revisers of 1870–1885, hardly dared to touch it at all. To compare it with the same passage in other languages is a liberal education in despising and discarding the idle predominance of "the subject." The subject is the same in all, and the magnificence of the imagery can hardly be obscured by any. Of the Hebrew I cannot unfortunately speak, for at the time when I knew a very little Hebrew I knew nothing about literary criticism; and now, when I know perhaps a little about literary criticism, I have entirely lost my Hebrew. But I can read it with some critical competence in Greek and in Latin, in French and in German; and I can form some idea of what its rhetorical value is in Italian and in Spanish. That any one of the modern languages (even Luther's German) can vie with ours I can hardly imagine any one, who can appreciate both the sound and the meaning of English, maintaining for a moment. With the Septuagint and the Vulgate it is different, for the Greek of the one has not quite lost the glory of the most glorious of all languages, and has in places even acquired a certain additional uncanny witchery from its eastern associations; while as for the Vulgate Latin "there is no mistake about* THAT." *But we can meet and beat them both.*

<div align="right">GEORGE SAINTSBURY
A History of English Prose Rhythm (1912)</div>

UNTO THE DAY

Sufficient vnto the day is the euill thereof.

<div align="right">Matthew, vi, 34</div>

The most remarkable, the most self-sustained and powerful sentence.

<div align="right">BENJAMIN DISRAELI</div>

<div align="right">Quoted, Austin Dobson, A Bookman's Budget (1917)</div>

RICHARD CRASHAW

1 6 1 3 ? — 1 6 4 9

A HYMN TO THE NAME AND HONOR
OF THE ADMIRABLE SAINTE TERESA

Loue, thou art Absolute sole lord
Of LIFE & DEATH. To proue the word,
Wee'l now appeal to none of all
Those thy old Souldiers, Great & tall,
Ripe Men of Martyrdom, that could reach down
With strong armes, their triumphant crown;
Such as could with lusty breath
Speak lowd into the face of death
Their Great LORD's glorious name, to none
Of those whose spatious Bosomes spread a throne
For LOVE at larg to fill: spare blood & sweat;
And see him take a priuate seat,
Making his mansion in the mild
And milky soul of a soft child.
 Scarse has she learn't to lisp the name
Of Martyr; yet she thinks it shame
Life should so long play with that breath
Which spent can buy so braue a death.
She neuer vndertook to know
What death with loue should haue to doe;
Nor has she e're yet vnderstood
Why to show loue, she should shed blood

Yet though she cannot tell you why,
She can Love, & she can Dy.
 Scarse has she Blood enough to make
A guilty sword blush for her sake;
Yet has she'a Heart dares hope to proue
How much lesse strong is Death then Love.
 Be loue but there; let poor six yeares
Be pos'd with the maturest Feares
Man trembles at, you straight shall find
Love knowes no nonage, nor the Mind.
'Tis Love, not Yeares or Limbs that can
Make the Martyr, or the man.
 Love touch't her Heart, & lo it beates
High, & burnes with such braue heates;
Such thirsts to dy, as dares drink vp,
A thousand cold deaths in one cup.
Good reason. For she breathes All fire.
Her weake brest heaues with strong desire
Of what she may with fruitles wishes
Seek for amongst her Mother's kisses.
 Since 'tis not to be had at home
She'l trauail to a Martyrdom.
No home for hers confesses she
But where she may a Martyr be.
 Sh'el to the Moores; And trade with them,
For this vnualued Diadem.
She'l offer them her dearest Breath,
With Christ's Name in't, in change for death.
Sh'el bargain with them; & will giue
Them God; teach them how to liue
In him: or, if they this deny,
For him she'l teach them how to Dy.
So shall she leaue amongst them sown
Her Lord's Blood; or at lest her own.
 Farewel then, all the world! Adieu.
Teresa is no more for you.
Farewell, all pleasures, sports, & ioyes,
(Neuer till now esteemed toyes)
Farewell what ever deare may bee,
Mother's armes or Father's knee
Farewell house, & farewell home!
She's for the Moores, & Martyrdom.
 Sweet, not so fast! lo thy fair Spouse
Whom thou seekst with so swift vowes,
Calls thee back, & bidds thee come

743

T'embrace a milder Martyrdom.

 Blest powres forbid, Thy tender life
Should bleed vpon a barborous knife;
Or some base hand haue power to race
Thy Brest's chast cabinet, & vncase
A soul kept there so sweet, ô no;
Wise heaun will neuer haue it so
Thov art love's victime; & must dy
A death more mysticall & high.
Into loue's armes thou shalt let fall
A still-suruiuing funerall.
His is the Dart must make the Death
Whose stroke shall tast thy hallow'd breath;
A Dart thrice dip't in that rich flame
Which writes thy spouse's radiant Name
Vpon the roof of Heau'n; where ay
It shines, & with a soueraign ray
Beates bright vpon the burning faces
Of soules which in that name's sweet graces
Find euerlasting smiles. So rare,
So spirituall, pure, & fair
Must be th'immortall instrument
Vpon whose choice point shall be sent
A life so lou'd; And that there be
Fitt executioners for Thee,
The fair'st & first-born sons of fire
Blest Seraphim, shall leaue their quire
And turn loue's souldiers, vpon Thee
To exercise their archerie.

 O how oft shalt thou complain
Of a sweet & subtle Pain.
Of intolerable Ioyes;
Of a Death, in which who dyes
Loues his death, and dyes again.
And would for euer so be slain.
And liues, & dyes; and knowes not why
To liue, But that he thus may neuer leaue to Dy.

 How kindly will thy gentle Heart
Kisse the sweetly-killing Dart!
And close in his embraces keep
Those delicious Wounds, that weep
Balsom to heal themselues with. Thus
When These thy Deaths, so numerous,
Shall all at last dy into one,
And melt thy Soul's sweet mansion;

Like a soft lump of incense, hasted
By too hott a fire, & wasted
Into perfuming clouds, so fast
Shalt thou exhale to Heaun at last
In a resoluing Sigh, and then
O what? Ask not the Tongues of men.
Angells cannot tell, suffice,
Thy selfe shall feel thine own full ioyes
And hold them fast for euer. There
So soon as thou shalt first appear,
The Moon of maiden starrs, thy white
Mistresse, attended by such bright
Soules as thy shining self, shall come
And in her first rankes make thee room;
Where 'mongst her snowy family
Immortall wellcomes wait for thee.
 O what delight, when reueal'd Life shall stand
And teach thy lipps heau'n with his hand;
On which thou now maist to thy wishes
Heap vp thy consecrated kisses.
What ioyes shall seize thy soul, when she
Bending her blessed eyes on thee
(Those second Smiles of Heau'n) shall dart
Her mild rayes through thy melting heart!
 Angels, thy old freinds, there shall greet thee
Glad at their own home now to meet thee.
 All thy good Workes which went before
And waited for thee, at the door,
Shall own thee there; and all in one
Weaue a constellation
Of Crowns, with which the King thy spouse
Shall build vp thy triumphant browes.
 All thy old woes shall now smile on thee
And thy paines sitt bright vpon thee
All thy sorrows here shall shine,
All thy Svffrings be diuine.
Teares shall take comfort, & turn gemms
And Wrongs repent to Diademms.
Eu'n thy Deaths shall liue; & new
Dresse the soul that erst they slew.
Thy wounds shall blush to such bright scarres
As keep account of the Lamb's warres.
 Those rare Workes where thou shalt leaue writt,
Loue's noble history, with witt

745

Taught thee by none but him, while here
They feed our soules, shall cloth THINE there.
Each heaunly word by whose hid flame
Our hard Hearts shall strike fire, the same
Shall flourish on thy browes. & be
Both fire to vs & flame to thee;
Whose light shall liue bright in thy FACE
By glory, in our hearts by grace.
 Thou shalt look round about, & see
Thousands of crown'd Soules throng to be
Themselues thy crown. Sons of thy vowes
The virgin-births with which thy soueraign spouse
Made fruitfull thy fair soul, goe now
And with them all about thee bow
To Him, put on (hee'l say) put on
(My rosy loue) That thy rich zone
Sparkling with the sacred flames
Of thousand soules, whose happy names
Heau'n keeps vpon thy score. (Thy bright
Life brought them first to kisse the light
That kindled them to starrs.) and so
Thou with the LAMB, thy lord, shalt goe;
And whereso'ere he setts his white
Stepps, walk with HIM those wayes of light
Which who in death would liue to see,
Must learn in life to dy like thee.

<div align="right">Carmen Deo Nostro (1652)</div>

The most unerring explosion of passionate feeling to be found in Eng-
lish, perhaps in all poetry.

<div align="right">

GEORGE SAINTSBURY

A Short History of English Literature (1898)

</div>

RICHARD CRASHAW

1 6 1 3 ? — 1 6 4 9

THE FLAMING HEART

Liue in these conquering leaues; liue all the same;
And walk through all tongues one triumphant FLAME
Liue here, great HEART; & loue and dy & kill;
And bleed & wound; and yeild & conquer still.

Let this immortall life wherere it comes
Walk in a crowd of loues & MARTYRDOMES.
Let mystick DEATHS wait on't; & wise soules be
The loue-slain wittnesses of this life of thee.
O sweet incendiary! shew here thy art,
Vpon this carcasse of a hard, cold, hart,
Let all thy scatter'd shafts of light, that play
Among the leaues of thy larg Books of day,
Combin'd against this BREST at once break in
And take away from me my self & sin,
This gratious Robbery shall thy bounty be;
And my best fortunes such fair spoiles of me.
O thou vndanted daughter of desires!
By all thy dowr of LIGHTS & FIRES;
By all the eagle in thee, all the doue;
By all thy liues & deaths of loue;
By thy larg draughts of intellectuall day,
And by thy thirsts of loue more large then they;
By all thy brim-fill'd Bowles of feirce desire
By thy last Morning's draught of liquid fire;
By the full kingdome of that finall kisse
That seiz'd thy parting Soul, & seal'd thee his;
By all the heau'ns thou hast in him
(Fair sister of the SERAPHIM!
By all of HIM we haue in THEE;
Leaue nothing of my SELF in me.
Let me so read thy life, that I
Vnto all life of mine may dy.

<div style="text-align: right">Carmen Deo Nostro (1652)</div>

One of the most astonishing things in English or any other literature.
<div style="text-align: right">GEORGE SAINTSBURY
A History of Elizabethan Literature (1887)</div>

RICHARD CRASHAW

1613 ? — 1649

SANCTA MARIA DOLORVM, OR THE MOTHER OF SORROWS

A patheticall descant vpon the deuout
Plainsong of Stabat Mater Dolorosa.

I

In shade of death's sad TREE
 Stood Dolefull SHEE.
Ah SHE! now by none other
Name to be known, alas, but SORROW'S MOTHER.
 Before her eyes
Her's, & the whole world's ioyes,
Hanging all torn she sees; and in his woes
And Paines, her Pangs & throes.
Each wound of His, from euery Part,
All, more at home in her owne heart.

II

 What kind of marble **than**
 Is that cold man
 Who can look on & see,
Nor keep such noble sorrowes company?
 Sure eu'en from you
 (My Flints) some drops are due
To see so many vnkind swords contest
 So fast for one soft Brest.
While with a faithfull, mutuall, floud
Her eyes bleed TEARES, his wounds weep BLOOD.

III

 O costly intercourse
 Of deaths, & worse,
 Diuided loues. While son & mother
Discourse alternate wounds to one another;
 Quick Deaths that grow
 And gather, as they come & goe:

His Nailes write swords in her, which soon her heart
 Payes back, with more then their own smart
Her SWORDS, still growing with his pain,
Turn SPEARES, & straight come home again.

IV

 She sees her son, her GOD,
 Bow with a load
 Of borrowd sins; And swimme
In woes that were not made for Him.
 Ah hard command
 Of loue! Here must she stand
Charg'd to look on, & with a stedfast ey
 See her life dy:
Leauing her only so much Breath
As serues to keep aliue her death.

V

 O Mother turtle-doue!
 Soft sourse of loue
 That these dry lidds might borrow
Somthing from thy full Seas of sorrow!
 O in that brest
 Of thine (the noblest nest
Both of loue's fires & flouds) might I recline
 This hard, cold, Heart of mine!
The chill lump would relent, & proue
Soft subject for the seige of loue.

VI

 O teach those wounds to bleed
 In me; me, so to read
 This book of loues, thus writ
In lines of death, my life may coppy it
 With loyall cares.
 O let me, here, claim shares;
Yeild somthing in thy sad prærogatiue
 (Great Queen of greifes) & giue
Me too my teares; who, though all stone,
Think much that thou shouldst mourn alone.

VII

Yea let my life & me
Fix here with thee,
And at the Humble foot
Of this fair TREE take our eternall root.
That so we may
At least be in loues way;
And in these chast warres while the wing'd wounds flee
So fast 'twixt him & thee,
My brest may catch the kisse of some kind dart,
Though as at second hand, from either heart.

VIII

O you, your own best Darts
Dear, dolefull hearts!
Hail; & strike home & make me see
That wounded bosomes their own weapons be.
Come wounds! come darts!
Nail'd hands! & peirced hearts!
Come your whole selues, sorrow's great son & mother!
Nor grudge a yonger-Brother
Of greifes his portion, who (had all their due)
One single wound should not haue left for you.

IX

Shall I, sett there
So deep a share
(Dear wounds) & onely now
In sorrows draw no Diuidend with you?
O be more wise
If not more soft, mine eyes!
Flow, tardy founts! & into decent showres
Dissolue my Dayes & Howres.
And if thou yet (faint soul!) deferr
To bleed with him, fail not to weep with her.

X

Rich Queen, lend some releife;
At least an almes of greif
To'a heart who by sad right of sin
Could proue the whole summe (too sure) due to him.
By all those stings
Of loue, sweet bitter things,

Which these torn hands transcrib'd on thy true heart
O teach mine too the art
To study him so, till we mix
Wounds; and become one crucifix.

XI

O let me suck the wine
So long of this chast vine
Till drunk of the dear wounds, I be
A lost Thing to the world, as it to me.
O faithfull freind
Of me & of my end!
Fold vp my life in loue; and lay't beneath
My dear lord's vitall death.
Lo, heart, thy hope's whole Plea! Her pretious Breath
Powr'd out in prayrs for thee; thy lord's in death.

Carmen Deo Nostro (1652)

The eleven stanzas are an inspiration, I would almost say, incomparable in hymnology—a combination of woe and triumph, submission and sovereignty, pathos, spiritual sublimity, everything!

WILLIAM STEBBING
Five Centuries of English Verse (1910)

JEREMY TAYLOR

1613 — 1667

THE WIDOW OF EPHESUS

The *Ephesian Woman* that the souldier told of in *Petronius*, was the talk of all the town, and the rarest example of a dear affection to her husband; she descended with the corps into the vault, and there being attended with her maiden resolved to weep to death, or dye with famine, or a distempered sorrow: from which resolution nor his, nor her friends, nor the reverence of the principal citizens, who used the intreaties of their charity and their power, could perswade her. But a souldier that watched seven dead bodies hanging upon trees just over against this monument, crept in, and a while stared upon the silent and comely dis-orders of the sorrow: and having let the wonder a while breath out at each others eyes, at last he fetched his supper and a bottle of wine with

751

purpose to eat and drink, and still to feed himself with that sad prettinesse; His pity and first draught of wine made him bold and curious to try if the maid would drink, who having many hours since felt her resolution faint as her wearied body, took his kindnesse, and the light returned into her eyes and danced like boyes in a festival; and fearing lest the pertinaciousnesse of her Mistresse sorrows should cause her evil to revert, or her shame to approach, assayed whether she would endure to hear an argument to perswade her to drink and live. The violent passion had layed all her spirits in wildness and dissolution and the maid found them willing to be gathered into order, at the arrest of any new object; being weary of the first, of which like leeches they had sucked their fill, till they fell down and burst. The weeping woman took her cordial and was not angry with her maid, and heard the souldier talk, and he was so pleased with the change, that he who first lov'd the silence of the sorrow was more in love with the musick of her returning voice, especially which himself had strung and put in tune; and the man began to talk amorously, and the womans weak heart and head was soon possessed with a little wine, and grew gay, and talked, and fell in love, and that very night in the morning of her passion, in the grave of her husband, in the pompes of mourning, and in her funeral garments, married her new and stranger Guest. For so the wilde forragers of *Lybia* being spent with heat, and dissolved by the too fond kisses of the sun, do melt with their common fires, and die with faintnesse, and descend with motions slow and unable to the little brooks that descend from heaven in the wildernesse; and when they drink they return into the vigor of a new life, & contract strange marriages; & the Lioness is courted by a Panther, and she listens to his love, and conceives a monster that all men call unnatural, and the daughter of an equivocal passion and of a sudden refreshment: and so also it was in the Cave at *Ephesus:* for by this time the souldier began to think it was fit he should return to his watch, and observe the dead bodies he had in charge; but when he ascended from his mourning bridal chamber, he found that one of the bodies was stolne by the friends of the dead, and that he was fallen into an evil condition, because by the laws of *Ephesus* his body was to be fixed in the place of it. The poor man returns to his woman, cryes out bitterly, and in her presence resolves to dye to prevent his death, and *in secret to prevent his shame;* but now the womans *love was raging* like her former sadnesse, and grew witty, and she comforted her souldier, and perswaded him to live, lest by losing him who had brought her from death and a more grievous sorrow, she should return to her old solemnities of dying and lose her honour for a dream, or the reputation of her constancy without the change and satisfaction of an enjoyed love. The man would fain have lived if it had been possible, and she found out this way for him, that he should take the body of her first husband whose funeral she had so strangely mourned, and put it upon the gallows in the place of

the stolne thief; he did so and escaped the present danger to possesse a love which might change as violently as her grief had done: But so have I seen a croud of disordered people rush violently and in heaps till their utmost border was restrained by a wall, or had spent the fury of the first fluctuation and watry progress, and by & by it returned to the contrary with the same earnestness, only because it was violent & ungoverned; a raging passion is this croud, which when it is not under discipline and the conduct of reason, and the proportions of temperate humanity, runs passionatly the way it happens, and by and by as greedily to another side, being swayed by its own weight, and driven any whither by chance, in all its pursuits having no rule, but to do all it can, and spend it self in haste and expire with some shame and much undecency.

<div align="right">Holy Dying (1651)</div>

Or for another specimen (where so many beauties crowd, the judgment has yet vanity enough to think it can discern the handsomest, till a second judgment and a third AD INFINITUM *start up to disallow their elder brother's pretensions) turn to the Story of the Ephesian Matron in the second section of the 5th chapter of the same* HOLY DYING *(I still refer to the* DYING *part, because it contains better matter than the 'Holy Living,' which deals more in rules than illustrations—I mean in comparison with the other only, else it has more and more beautiful illustrations—than any prose book besides)—read it yourself and show it to Plumstead (with my* LOVE, *and bid him write to me), and ask him if* WILLY *[Shakespeare] himself has ever told a story with more circumstances of* FANCY *and* HUMOUR.

<div align="right">CHARLES LAMB
Letter to Robert Lloyd (April 6, 1801)</div>

FRANÇOIS DUC DE LA ROCHEFOUCAULD

1 6 1 3 — 1 6 8 0

MAXIMS

Nous avons tous assez de force pour supporter les maux d'autrui.

We all have sufficient fortitude to bear the misfortunes of others.

Le refus des louanges est un désir d'être loué deux fois.

Rejection of compliments means that we desire to be complimented further.

Quelque bien qu'on nous dise de nous, on ne nous apprend rien de nouveau.

We are never surprised when we hear how well people speak of us.

On croit quelquefois haïr la flatterie; mais on ne hait que la manière de flatter.

We sometimes think we dislike flattery, but we dislike only the way it is done.

Les passions les plus violentes nous laissent quelquefois du relâche; mais la vanité nous agite toujours.

The most violent passions give us some respite, but vanity moves us always.

The first French writer to understand completely the wonderful capacities for epigrammatic statement which his language possessed; and in the dexterous precision of pointed phrase no succeeding author has ever surpassed him.

<div align="right">

LYTTON STRACHEY
Landmarks in French Literature (1923)

</div>

CARDINAL DE RETZ

1 6 1 4 — 1 6 7 9

REVOLUTIONS

Les Suisses paraissaient, pour ainsi parler, si étouffés sous la pesanteur de leurs chaînes, qu'ils ne respiraient plus, quand la révolte de trois de leurs paysans forma les Ligues. Les Hollandais se croyaient subjugués par le duc d'Albe quand le prince d'Orange, par le sort réservé aux grands génies, qui voient devant tous les autres le point de la possibilité, conçut et enfanta leur liberté. Voilà des exemples; la raison y est. Ce qui cause l'assoupissement dans les États qui souffrent est la durée du mal, qui saisit l'imagination des hommes, et qui leur fait croire qu'il ne finira jamais. Aussitôt qu'ils trouvent jour à en sortir, ce qui ne manque jamais lorsqu'il est venu jusques à un certain point, ils sont si surpris, si aises et si emportés, qu'ils passent tout d'un coup à l'autre extrémité, et que bien loin de considérer les révolutions comme impossibles, ils les croient faciles; et cette disposition toute seule est quelque-

fois capable de les faire. Nous avons éprouvé et senti toutes ces vérités dans notre dernière révolution. Qui eût dit, trois mois devant la petite pointe des troubles, qu'il en eût pu naître dans un État où la maison royale était parfaitement unie, où la cour était esclave du Ministre, où les provinces et la capitale lui étaient soumises, où les armées étaient victorieuses, où les compagnies paraissaient de tout point impuissantes: qui l'eût dit eût passé pour insensé, je ne dis pas dans l'esprit du vulgaire, mais je dis entre les Estrées et les Senneterres.

The Swiss seemed as it were crushed under the weight of their chains, when three of their powerful cantons revolted and formed themselves into a league. The Dutch thought of nothing but an entire subjection to the tyrant Duke of Alva, when the Prince of Orange, by the peculiar destiny of great geniuses, who see further into the future than all the world besides, conceived a plan and restored their liberty. The reason of all this is plain: that which causes a supineness in suffering States is the duration of the evil, which inclines the sufferers to believe it will never have an end; as soon as they have hopes of getting out of it, which never fails when the evil has arrived at a certain pitch, they are so surprised, so glad, and so transported, that they run all of a sudden into the other extreme, and are so far from thinking revolutions impossible that they suppose them easy, and such a disposition alone is sometimes able to bring them about; witness the late revolution in France. Who could have imagined three months before the critical period of our disorders that such a revolution could have happened in a kingdom where all the branches of the Royal Family were strictly united, where the Court was a slave to the Prime Minister, where the capital city and all the provinces were in subjection to him, where the armies were victorious, and where the corporations and societies seemed to have no power?—whoever, I say, had said this would have been thought a madman, not only in the judgment of the vulgar, but in the opinion of a D'Estrées or a Senneterre.

Mémoires (1655–65?), ii
Translation anonymous

The vague humours of public discontent are very quick, in hours of crises, to be caught by emulation, letting the example of a neighbour decide them, and taking the particular form of malady that reigns and circulates. Retz understands and makes us understand all that admirably. Do not suppose that he understands seditions and riots only; he comprehends and divines revolutions. He describes as an observer gifted with an exquisite sensitiveness of tact, their period of oncoming, so brusque sometimes, so unforeseen, and yet so long in preparation. I know no finer page of history than that in which he paints the sudden passage from the discouragement and supineness of minds, making them

believe that present evils can never end, to the contrary extreme where, far from considering revolutions as impossible, they think them, in a moment, simple and easy.

C.-A. SAINTE-BEUVE
Causeries du lundi (1851)
Translated by K. P. Wormeley

RICHARD LOVELACE

1 6 1 8 — 1 6 5 8

SONG
TO LUCASTA, *GOING TO THE WARRES*

I.

Tell me not (Sweet) I am unkinde,
 That from the Nunnerie
Of thy chaste breast, and quiet minde,
 To Warre and Armes I flie.

II.

True; a new Mistresse now I chase,
 The first Foe in the Field;
And with a stronger Faith imbrace
 A Sword, a Horse, a Shield.

III.

Yet this Inconstancy is such,
 As you too shall adore;
I could not love thee (Deare) so much,
 Lov'd I not Honour more.

Lucasta (1649)

Contains no line or part of a line that could by any possibility be improved.

EDMUND GOSSE
in Ward's The English Poets (1880)

THE GARDEN

I

How vainly men themselves amaze
To win the Palm, the Oke, or Bayes;
And their uncessant Labours see
Crown'd from some single Herb or Tree.
Whose short and narrow verged Shade
Does prudently their Toyles upbraid;
While all Flow'rs and all Trees do close
To weave the Garlands of repose.

II

Fair quiet, have I found thee here,
And Innocence thy Sister dear!
Mistaken long, I sought you then
In busie Companies of Men.
Your sacred Plants, if here below,
Only among the Plants will grow.
Society is all but rude,
To this delicious Solitude.

III

No white nor red was ever seen
So am'rous as this lovely green.
Fond Lovers, cruel as their Flame,
Cut in these Trees their Mistress name.
Little, Alas, they know, or heed,
How far these Beauties Hers exceed!
Fair Trees! where s'eer your barkes I wound,
No Name shall but your own be found.

IV

When we have run our Passions heat,
Love hither makes this best retreat.
The *Gods,* that mortal Beauty chase,
Still in a Tree did end their race.

Apollo hunted *Daphne* so,
Only that She might Laurel grow.
And *Pan* did after *Syrinx* speed,
Not as a Nymph, but for a Reed.

V

What wond'rous Life in this I lead!
Ripe Apples drop about my head;
The Luscious Clusters of the Vine
Upon my Mouth do crush their Wine;
The Nectaren, and curious Peach,
Into my hands themselves do reach;
Stumbling on Melons, as I pass,
Insnar'd with Flow'rs, I fall on Grass.

VI

Mean while the Mind, from pleasure less,
Withdraws into its happiness:
The Mind, that Ocean where each kind
Does streight its own resemblance find;
Yet it creates, transcending these,
Far other Worlds, and other Seas;
Annihilating all that's made
To a green Thought in a green Shade.

VII

Here at the Fountains sliding foot,
Or at some Fruit-trees mossy root,
Casting the Bodies Vest aside,
My Soul into the boughs does glide:
There like a Bird it sits, and sings,
Then whets, and combs its silver Wings;
And, till prepar'd for longer flight,
Waves in its Plumes the various Light.

VIII

Such was that happy Garden-state,
While Man there walk'd without a Mate:
After a Place so pure, and sweet,
What other Help could yet be meet!

But 'twas beyond a Mortal's share
To wander solitary there:
Two Paradises 'twere in one
To live in Paradise alone.

IX

How well the skilful Gardner drew
Of flow'rs and herbes this Dial new;
Where from above the milder Sun
Does through a fragrant Zodiack run;
And, as it works, th' industrious Bee
Computes its time as well as we.
How could such sweet and wholsome Hours
Be reckon'd but with herbs and flow'rs!

<div align="right">Miscellaneous Poems (1681)</div>

One of the loveliest short poems in our language. Its green and leafy summer of rich sun and richer shade will live while our language still lives. This is the poem which contains the immortal

> *"Annihilating all that's made*
> *To a green thought in a green shade."*

The beauty of this poem is largely dependent upon association and imagery. But there are, also, technical points to be noted about the fifth verse, where the several P's in

> *"Ripe apples drop about my head"*

give a feeling of roundness, like that of the apples they are describing; and where the perfectly managed Sh-sounds in

> *"The luscious clusters of the vine*
> *Upon my mouth do crush their wine"*

give us the richness of the juice of these ripe grapes. In fact, the leafiness and the richness and the greenness of the world he is describing is conveyed in every syllable.

<div align="right">EDITH SITWELL
The Pleasures of Poetry, First Series (1930)</div>

759

ANDREW MARVELL

1 6 2 1 — 1 6 7 8

AN HORATIAN *ODE UPON* CROMWELL'S *RETURN FROM* IRELAND

The forward Youth that would appear
Must now forsake his *Muses* dear,
 Nor in the Shadows sing
 His Numbers languishing.
'Tis time to leave the Books in dust,
And oyl th' unused Armours rust:
 Removing from the Wall
 The Corslet of the Hall.
So restless *Cromwel* could not cease
In the inglorious Arts of Peace,
 But through adventrous War
 Urged his active Star.
And, like the three-fork'd Lightning, first
Breaking the Clouds where it was nurst,
 Did thorough his own Side
 His fiery way divide.
For 'tis all one to Courage high
The Emulous or Enemy;
 And with such to inclose
 Is more then to oppose.
Then burning through the Air he went,
And Pallaces and Temples rent:
 And *Cæsars* head at last
 Did through his Laurels blast.
'Tis Madness to resist or blame
The force of angry Heavens flame:
 And, if we would speak true,
 Much to the Man is due.
Who, from his private Gardens, where
He liv'd reserved and austere,
 As if his highest plot
 To plant the Bergamot,
Could by industrious Valour climbe
To ruine the great Work of Time,
 And cast the Kingdome old
 Into another Mold.
Though Justice against Fate complain,
And plead the antient Rights in vain:

760

But those do hold or break
As Men are strong or weak.
Nature that hateth emptiness,
Allows of penetration less:
 And therefore must make room
 Where greater Spirits come.
What Field of all the Civil Wars
Where his were not the deepest Scars?
 And *Hampton* shows what part
 He had of wiser Art.
Where, twining subtile fears with hope,
He wove a Net of such a scope,
 That *Charles* himself might chase
 To *Caresbrooks* narrow case.
That thence the *Royal Actor* born
The *Tragick Scaffold* might adorn:
 While round the armed Bands
 Did clap their bloody hands.
He nothing common did or mean
Upon that memorable Scene:
 But with his keener Eye
 The Axes edge did try:
Nor call'd the *Gods* with vulgar spight
To vindicate his helpless Right,
 But bow'd his comely Head,
 Down as upon a Bed.
This was that memorable Hour
Which first assur'd the forced Pow'r.
 So when they did design
 The *Capitols* first Line,
A bleeding Head where they begun,
Did fright the Architects to run;
 And yet in that the *State*
 Foresaw it's happy Fate.
And now the *Irish* are asham'd
To see themselves in one Year tam'd:
 So much one Man can do,
 That does both act and know.
They can affirm his Praises best,
And have, though overcome, confest
 How good he is, how just,
 And fit for highest Trust:
Nor yet grown stiffer with Command,
But still in the *Republick's* hand:

How fit he is to sway
That can so well obey.
He to the *Commons Feet* presents
A *Kingdome,* for his first years rents:
 And, what he may, forbears
 His Fame to make it theirs:
And has his Sword and Spoyls ungirt,
To lay them at the *Publick's* skirt.
 So when the Falcon high
 Falls heavy from the Sky,
She, having kill'd, no more does search,
But on the next green Bow to pearch;
 Where, when he first does lure,
 The Falckner has her sure.
What may not then our *Isle* presume
While Victory his Crest does plume!
 What may not others fear
 If thus he crown each Year!
A *Cæsar* he ere long to *Gaul,*
To *Italy* an *Hannibal,*
 And to all States not free
 Shall *Clymacterick* be.
The *Pict* no shelter now shall find
Within his party-colour'd Mind;
 But from this Valour sad
 Shrink underneath the Plad:
Happy if in the tufted brake
The *English Hunter* him mistake;
 Nor lay his Hounds in near
 The *Caledonian* Deer.
But thou the Wars and Fortunes Son
March indefatigably on;
 And for the last effect
 Still keep thy Sword erect:
Besides the force it has to fright
The Spirits of the shady Night,
 The same *Arts* that did *gain*
 A *Pow'r* must it *maintain.*

(1650)

The most truly classic [ode] in our language.

JAMES RUSSELL LOWELL
Among My Books (1870)

JEAN DE LA FONTAINE

1 6 2 1 -- 1 6 9 5

ADONIS AND THE WATER NYMPHS

Les nymphes, de qui l'œil voit les choses futures,
L'avoient fait égarer en des routes obscures.
Le son des cors se perd par un charme inconnu.

The nymphs, who hold the future in their gaze,
Led him to wander in uncertain ways.
The horns are muffled by an unknown spell.

<div align="right">

Adonis (1657?)
Translated by Malcolm Cowley

</div>

The loveliest verses in the world.

<div align="right">

PAUL VALÉRY
Variété (1924)

</div>

JEAN DE LA FONTAINE

1 6 2 1 — 1 6 9 5

LE LOUP ET LE CHIEN

Un loup n'avait que les os et la peau,
 Tant les chiens faisaient bonne garde:
Ce loup rencontre un dogue aussi puissant que beau,
Gras, poli, qui s'était fourvoyé par mégarde.
 L'attaquer, le mettre en quartiers,
 Sire loup l'eût fait volontiers:
 Mais il fallait livrer bataille;
 Et le mâtin était de taille
 A se défendre hardiment.
 Le loup donc l'aborde humblement,
 Entre en propos, et lui fait compliment
 Sur son embonpoint qu'il admire.
 Il ne tiendra qu'à vous, beau sire,
D'être aussi gras que moi, lui répartit le chien.
 Quittez les bois, vous ferez bien:
 Vos pareils y sont misérables,
 Cancres, hères, et pauvres diables

Dont la condition est de mourir de faim.
Car, quoi! rien d'assuré! point de franche lippée!
Tout à la pointe de l'épée!
Suivez-moi, vous aurez un bien meilleur destin.
Le loup reprit: que me faudra-t-il faire?
Presque rien, dit le chien: donner la chasse aux gens
Portant bâtons, et mendiants;
Flatter ceux du logis, à son maître complaire:
Moyennant quoi votre salaire
Sera force reliefs de toutes les façons,
Os de poulets, os de pigeons,
Sans parler de mainte caresse.
Le loup déja se forge une félicité
Qui le fait pleurer de tendresse.
Chemin faisant, il vit le cou du chien pelé:
Qu'est-cela? lui dit-il. Rien. Quoi! rien!
Peu de chose.
Mais encor? Le collier dont je suis attaché
De ce que vous voyez est peut-être la cause.
Attaché! dit le loup: vous ne courez donc pas
Où vous voulez? Pas toujours: mais qu'importe?
Il importe si bien, que de tous vos repas
Je ne veux en aucune sorte,
Et ne voudrais pas même à ce prix un trésor.
Cela dit, maître loup s'enfuit, et court encor.

THE WOLF AND THE DOG

A prowling wolf, whose shaggy skin
(So strict the watch of dogs had been)
Hid little but his bones,
Once met a mastiff dog astray.
A prouder, fatter, sleeker Tray,
No human mortal owns.
Sir Wolf in famish'd plight,
Would fain have made a ration
Upon his fat relation;
But then he first must fight;
And well the dog seem'd able
To save from wolfish table
His carcass snug and tight.
So, then, in civil conversation
The wolf express'd his admiration
Of Tray's fine case. Said Tray, politely,
Yourself, good sir, may be as sightly,

Quit but the woods, advised by me.
For all your fellows here, I see,
Are shabby wretches, lean and gaunt,
Belike to die of haggard want.
With such a pack, of course it follows,
One fights for every bit he swallows.
 Come, then, with me, and share
 On equal terms our princely fare.
 But what with you
 Has one to do?
Inquires the wolf. Light work indeed,
Replies the dog; you only need
 To bark a little now and then,
 To chase off duns and beggar men,
To fawn on friends that come or go forth,
Your master please, and so forth;
 For which you have to eat
 All sorts of well-cook'd meat—
Cold pullets, pigeons, savoury messes—
Besides unnumber'd fond caresses.
 The wolf, by force of appetite,
 Accepts the terms outright,
 Tears glistening in his eyes,
 But faring on, he spies
 A gall'd spot on the mastiff's neck.
What's that? he cries. O, nothing but a speck.
A speck? Ay, ay; 'tis not enough to pain me;
Perhaps the collar's mark by which they chain me.
 Chain! chain you! What! run you not, then,
 Just where you please, and when?
 Not always, sir; but what of that?
 Enough for me, to spoil your fat!
 It ought to be a precious price
 Which could to servile chains entice;
 For me, I'll shun them while I've wit.
 So ran Sir Wolf, and runneth yet.

<div align="right">

Fables, (1668), i, 5
Translated by E. Wright

</div>

La Fontaine offers the unheard of spectacle of a man of genius who was able to realize completely and with absolute perfection the work which he had dreamed.

<div align="right">

THÉODORE DE BANVILLE
Les Poëtes français (1861)

</div>

THE GLUTTON

Ne nous flattons donc point; voyons sans indulgence
 L'état de notre conscience.
Pour moi, satisfaisant mes appétits gloutons,
 J'ai dévoré force moutons.
 Que m'avoient-ils fait? Nulle offense;
Même il m'est arrivé quelquefois de manger
 Le berger.
Je me dévouerai donc, s'il le faut: mais je pense
Qu'il est bon que chacun s'accuse ainsi que moi:
Car on doit souhaiter, selon toute justice,
 Que le plus coupable périsse.

 Himself let no one spare nor flatter,
 But make clean conscience in the matter.
For me, my appetite has play'd the glutton
 Too much and often upon mutton.
 What harm had e'er my victims done?
 I answer, truly, None.
 Perhaps, sometimes, by hunger press'd,
 I've eat the shepherd with the rest.
 I yield myself, if need there be;
 And yet I think, in equity,
Each should confess his sins with me;
 For laws of right and justice cry,
 The guiltiest alone should die.

Fables (1668), vii, 1
Translated by E. Wright

The fables of La Fontaine are perfection itself, and the ultimate expression of genius. . . . REGARDEZ, MAIS N'Y TOUCHEZ PAS!

THÉODORE DE BANVILLE
Petit Traité de poésie française (1870)

HENRY VAUGHAN

1 6 2 2 — 1 6 9 5

FROM THE NIGHT

There is in God (some say)
A deep, but dazling darkness.

<div align="right">Silex Scintillans (1650)</div>

That is not only sublime—it is sublimity.

<div align="right">FRANCIS THOMPSON
Milton (1913)</div>

MOLIÈRE (JEAN BAPTISTE POQUELIN)

1 6 2 2 — 1 6 7 3

THE HYPOCRITE

*Madame Pernelle and Flipote, her servant, Elmire, Mariane,
Dorine, Damis, Cléante.*

MADAME PERNELLE

Come along, Flipote, come along; let me get away from them.

ELMIRE

You walk so fast that I can scarcely keep up with you.

MADAME PERNELLE

You need not come any further, child. I can dispense with such
ceremony.

ELMIRE

We only give what is due to you. But, mother, why are you in such
a hurry to leave us?

MADAME PERNELLE

Because I cannot bear to see such goings on and no one takes any
pains to meet my wishes. Yes, I leave your house not very well pleased:
you ignore all my advice, you do not show any respect for anything,
everyone says what he likes, and it is just like the Court of King
Pétaud.

DORINE

If . . .

MADAME PERNELLE

You are far too free with your tongue for your position, my lass, and too saucy. You offer your advice about everything.

DAMIS

But . . .

MADAME PERNELLE

You are a fool thrice over, my boy, though it is your own grandmother who says it. I have told your father a hundred times that you will become a ne'er-do-weel, and will cause him nothing but trouble.

MARIANE

I think . . .

MADAME PERNELLE

As for you, his sister, you put on such a demure air that it is difficult to catch you tripping. But, as the saying is, still waters are the most dangerous, and I hate your underhand ways.

ELMIRE

But, mother . . .

MADAME PERNELLE

Let me tell you, daughter, that your whole conduct is entirely wrong. You ought to set them a good example: their late mother did much better. You are extravagant: I am shocked to see you decked out like a princess. If a woman wishes to please her husband only, she has no need for so much finery, my child.

CLÉANTE

But, madam, after all . . .

MADAME PERNELLE

As for you, sir, who are her brother, I think very highly of you, and I both love and respect you, but, at the same time, if I were my son, her husband, I should request you not to enter our house. You are always laying down rules of conduct which respectable people should not follow. I speak rather frankly to you, but that is my nature: I do not mince matters when I have anything on my mind.

DAMIS

Your Mr. Tartuffe is, no doubt, an excellent person . . .

MADAME PERNELLE

He is a very worthy man, one who should be listened to; and it makes me very angry to hear him sneered at by a fool like you.

DAMIS

What! Am I to permit a censorious bigot to exercise a tyrannical influence in the family; and are we not to be allowed any pleasures unless this good gentleman condescends to give his consent?

DORINE

Were we to listen to him and to put faith in his maxims, we should look upon all our acts as criminal, for the zealous critic finds fault with everything.

MADAME PERNELLE

And whatever he finds fault with deserves censure. He wants to lead you to Heaven, and it is my son's duty to teach you to value him.

DAMIS

No; look here, grandmother, neither my father nor anyone else shall ever induce me to think well of him: I should be false to myself were I to speak otherwise. His ways irritate me constantly. I can see what the consequence will be: that underbred fellow and I will soon quarrel.

DORINE

Surely it is a scandalous thing to see a stranger exercise such authority in this house: to see a beggar, who, when he came, had not shoes on his feet, and whose whole clothing may have been worth twopence, so far forget himself as to interfere with everything, and play the master.

MADAME PERNELLE

Ah! mercy on me! it would be much better if everything were done in accordance with his good rules.

DORINE

He is a saint in your opinion, but, in mine, he is a hypocrite.

MADAME PERNELLE

What language!

DORINE

I should not like to trust myself either with him or with his man Laurent, without good security.

MADAME PERNELLE

I do not know what the servant may be at heart, but I will swear the master is a worthy man. You all hate and flout him because he tells you unpleasant truths. His anger is directed against sin, and his only desire is to further the cause of Heaven.

DORINE

Yes; but why, especially for some time past, can he not bear any one to come to the house? Why is a polite call so offensive to Heaven that he needs make noise enough about it to split our heads? Between ourselves I will tell you what I think. Upon my word, I believe that he is jealous of Madame.

MADAME PERNELLE

Hold your tongue, and take care what you say. He is not the only person who blames these visits. The whole neighbourhood is annoyed by the bustle of the people you receive, their carriages always waiting before the door, and the noisy crowd of servants. I am willing to believe that there is no actual harm done, but people will talk, and it is better not to give them cause.

CLÉANTE

Ah! madam, how can you stop people talking? It would be a sorry

thing if in this world we had to give up our best friends, because of idle chatter aimed at us. And even if we could bring ourselves to do so, do you think it would stop people's tongues? There is not any protection against slander. Do not let us pay any attention to foolish gossip, but endeavour to live honestly and leave the scandal-mongers to say what they will.

DORINE

Probably our neighbour Daphné, and her little husband, are at the bottom of all this slander. Those who are the most ridiculous in their own conduct are always the first to libel others. They are quick to get hold of the slightest rumour of a love-affair, to spread it abroad with high glee, giving the story just what twist they like. They paint the actions of others in their own colours, thinking thereby to justify their own conduct to the world; and in the vain hope of a resemblance they try to give their intrigues some show of innocence, or else to shift to other shoulders a part of that blame with which they themselves are overburdened.

MADAME PERNELLE

All these arguments have nothing to do with the matter. Everybody knows that Orante leads an exemplary life, and that all her thoughts are towards heaven. Well, I have been told that she strongly disapproves of the company who visit here.

DORINE

The example is admirable, and the lady is beyond reproach! It is true that she lives an austere life, but age is responsible for her fervent zeal, and people know that she is a prude because she cannot help it. She made the most of all her advantages while she had the power of attracting attention. But now that her eyes have lost their lustre she renounces the world which renounces her, and hides under the pompous cloak of prudence the decay of her worn-out charms. Such is the last shift of a modern coquette. Mortified to see their lovers fall away from them, their gloomy despair sees nothing for it, when thus forsaken, but the rôle of prudery; and in their strictness these good women censure everything and pardon nothing. They loudly condemn the actions of others, not from principles of charity, but out of envy, since they cannot bear to see another taste those pleasures for which age has taken away their appetite.

MADAME PERNELLE

These are idle tales told to please you. I have to be silent in your house, my child, for madam keeps the ball rolling all day long. Still, I mean to have my say in my turn. I tell you that my son never did a wiser act than when he received this good man into his family; Heaven mercifully sent him into your house to convert your erring thoughts. You ought to hear him for your soul's sake, since he censures nothing but that which deserves censure. All these visits, these balls,

these tales, are inventions of the evil one. Not one good word is heard
at them, nothing but idle gossip, songs and chatter. Often enough
the neighbour comes in for his share, and there is scandal right and
left. Indeed the heads of sensible people are quite turned by the dis-
traction of these gatherings. A thousand ill-natured stories are spread
abroad in no time; and, as a certain doctor very truly said the other
day, it is a perfect tower of Babylon, for every one babbles as long
as he likes. And to tell the story which brought this up . . . Here is
this gentleman giggling already! Go and find the fools who make you
laugh, and without . . . Good-bye, my child. I'll say no more. My
regard for your house has fallen by one-half, and it will be a very
long time before I set foot in it again. *(Slapping Flipote's face.)*
Come along, you, don't stand there dreaming and gaping. Good Lord!
I'll warm your ears for you, come on, hussy, come on.

<div align="right">

Tartuffe (1664), Act i, Scene i
Translated by A. R. Waller

</div>

I asked how a piece must be constructed so as to be fit for the theatre.
"It must be symbolical," replied Goethe; "that is to say, each incident
must be significant in itself, and lead to another still more important.
The TARTUFFE *of Molière is, in this respect, a great example. Only think*
what an introduction is the first scene! From the very beginning every-
thing is highly significant, and leads us to expect something still more
important. The beginning of Lessing's MINNA VON BARNHELM *is also*
admirable; but that of the TARTUFFE *comes only once into the world:*
it is the greatest and best thing that exists of the kind."

<div align="right">

JOHANN WOLFGANG VON GOETHE
J. P. ECKERMANN Gespräche mit Goethe (1837–48)
Translated by John Oxenford

</div>

BLAISE PASCAL

1 6 2 3 — 1 6 6 2

CHARITY IS SUPERNATURAL

La distance infinie des corps aux esprits figure la distance infiniment
plus infinie des esprits à la charité, car elle est surnaturelle.

Tout l'éclat des grandeurs n'a point de lustre pour les gens qui sont
dans les recherches de l'esprit.

La grandeur des gens d'esprit est invisible aux rois, aux riches, aux
capitaines, à tous ces grands de chair.

La grandeur de la sagesse, qui n'est nulle sinon de Dieu, est invisible aux charnels et aux gens d'esprit. Ce sont trois ordres différents de genre.

Les grands génies ont leur empire, leur éclat, leur grandeur, leur victoire, leur lustre et n'ont nul besoin des grandeurs charnelles, où elles n'ont pas de rapport. Ils sont vus non des yeux, mais des esprits, c'est assez.

Les saints ont leur empire, leur éclat, leur victoire, leur lustre, et n'ont nul besoin des grandeurs charnelles ou spirituelles, où elles n'ont nul rapport, car elles n'y ajoutent ni ôtent. Ils sont vus de Dieu et des anges, et non des corps ni des esprits curieux: Dieu leur suffit.

Archimède, sans éclat, serait en même vénération. Il n'a pas donné des batailles pour les yeux, mais il a fourni à tous les esprits ses inventions. Oh! qu'il a éclaté aux esprits!

Jésus-Christ, sans biens et sans aucune production au dehors de science, est dans son ordre de sainteté. Il n'a point donné d'invention, il n'a point régné; mais il a été humble, patient, saint, saint, saint à Dieu, terrible aux démons, sans aucun péché. Oh! qu'il est venu en grande pompe et en une prodigieuse magnificence, aux yeux du cœur et qui voient la sagesse!

Il eût été inutile à Archimède de faire le prince dans ses livres de géométrie, quoiqu'il le fût.

Il eût été inutile à Notre Seigneur Jésus-Christ, pour éclater dans son règne de sainteté, de venir en roi; mais il y est bien venu avec l'éclat de son ordre!

Il est bien ridicule de se scandaliser de la bassesse de Jésus-Christ, comme si cette bassesse était du même ordre, duquel est la grandeur qu'il venait faire paraître. Qu'on considère cette grandeur-là dans sa vie, dans sa passion, dans son obscurité, dans sa mort, dans l'élection des siens, dans leur abandon, dans sa secrète résurrection, et dans le reste: on la verra si grande qu'on n'aura pas sujet de se scandaliser d'une bassesse qui n'y est pas.

Mais il y en a qui ne peuvent admirer que les grandeurs charnelles, comme s'il n'y en avait pas de spirituelles; et d'autres qui n'admirent que les spirituelles, comme s'il n'y en avait pas d'infiniment plus hautes dans la sagesse.

Tous les corps, le firmament, les étoiles, la terre et ses royaumes, ne valent pas le moindre des esprits; car il connaît tout cela, et soi; et les corps, rien.

Tous les corps ensemble, et tous les esprits ensemble, et toutes leurs productions, ne valent pas le moindre mouvement de charité. Cela est d'un ordre infiniment plus élevé.

De tous les corps ensemble, on ne saurait en faire réussir une petite pensée: cela est impossible, et d'un autre ordre. De tous les corps et

esprits, on n'en saurait tirer un mouvement de vraie charité, cela est impossible, et d'un autre ordre, surnaturel.

The infinite distance between body and mind is a type of the infinitely more infinite distance between mind and charity, for charity is supernatural.

All the splendour of greatness lacks lustre for those who seek understanding.

The greatness of men of understanding is invisible to kings, the rich, leaders, to all who are great according to the flesh.

The greatness of wisdom which has no existence save in God, is invisible to the carnal-minded and the men of understanding. These are three orders, differing in kind.

Men of exalted genius have their empire, their splendour, their greatness, their victory, their lustre, and do not need material greatness, with which they have nothing to do. They are seen, not by the outward eye, but by the mind, and that is enough for them.

The saints have their empire, their splendour, their victory, their lustre, and need no worldly or intellectual greatness, with which they have nothing to do, for these add nothing to them, nor do they take anything away from them. They are seen by God and the angels, and not by the bodily eye, nor by the enquiring mind; God suffices them.

Archimedes, without splendour, would have had the same reverence. He fought no battles for the eyes to gaze upon, but he left his discoveries for all minds. And how splendid he was to the mind!

Jesus Christ, without wealth or any outward scientific equipment, is in His own order of holiness. He furnished no scientific discovery, and He never reigned; but He was humble, patient, holy, holy, holy, in God's sight, terrible to devils, and sinless. Oh, in what great pomp, and with what transcendent magnificence did He come, to the eyes of the heart that can discern wisdom!

There would have been no need for Archimedes, though of princely birth, to play the prince in his books on geometry.

There would have been no need for our Lord Jesus Christ, for the purpose of shining in His kingdom of holiness, to come as a king; but He did come in the glory proper to His order.

It is most unreasonable to be offended by the lowliness of Jesus Christ, as if this lowliness were in the same order as the greatness He came to set forth. Let us consider this greatness in His life, His Passion, His obscurity and His death; in the selection of His disciples, in their desertion of Him, in His secret resurrection, and the rest; and it will seem so vast that there will be no room for offence at a lowliness which is of another order.

But there are those who can only admire worldly greatness, as if there were no intellectual greatness; and others who only admire intel-

lectual greatness, as if there were not infinitely greater heights in wisdom.

All bodies, the firmament, the stars, the earth and its kingdoms, are not to be compared with the lowest mind, for mind knows all these, and itself; the bodies know nothing.

All bodies together, and all minds together, and all they can effect, are not to be compared with the least motion of charity, for that is of an order infinitely more exalted.

All bodies together cannot furnish one spark of thought; it is an impossibility, for thought is of another order. All bodies and minds cannot produce a single motion of true charity; it is an impossibility, for charity is of another, a supernatural order.

<div align="right">

Pensées (1670)
Translated by Lilian A. Clare

</div>

A page that illuminates all Pascal's work, and which has been called, not without reason, the most beautiful in the French language.

<div align="right">

JACQUES CHEVALIER
Pascal (1922)

</div>

BLAISE PASCAL

1 6 2 3 — 1 6 6 2

HEAR GOD

Quelle chimère est-ce donc que l'homme? quelle nouveauté, quel monstre, quel chaos, quel sujet de contradiction, quel prodige! Juge de toutes choses, imbécile ver de terre, dépositaire du vrai, cloaque d'incertitude et d'erreur, gloire et rebut de l'univers.

What a chimera then is man! What a novelty! What a monster, what a chaos, what a contradiction, what a prodigy! Judge of all things, imbecile worm of the earth; depositary of truth, a sink of uncertainty and error; the pride and refuse of the universe!

Nous sommes plaisans de nous reposer dans la société de nos semblables. Misérables comme nous, impuissans comme nous, ils ne nous aideront pas; on mourra seul.

We are fools to depend upon the society of our fellow-men. Wretched as we are, powerless as we are, they will not aid us; we shall die alone.

Le dernier acte est sanglant, quelque belle que soit la comédie en tout le reste. On jette enfin de la terre sur la tête, et en voilà pour jamais.

The last act is tragic, however happy all the rest of the play is; at the last a little earth is thrown upon our head, and that is the end for ever.

Connoissez donc, superbe, quel paradoxe vous êtes à vous-même. Humiliez-vous, raison impuissante; taisez-vous, nature imbécile: apprenez que l'homme passe infiniment l'homme, et entendez de votre maître votre condition véritable que vous ignorez. Écoutez Dieu.

Know then, proud man, what a paradox you are to yourself. Humble yourself, weak reason; be silent, foolish nature; learn that man infinitely transcends man, and learn from your Master your true condition, of which you are ignorant. Hear God.

<div align="right">

Pensées (1670)
Translated by William Finlayson Trotter

</div>

In the LETTRES PROVINCIALES *Pascal created French prose—the French prose that we know to-day, the French prose which ranks by virtue of its vigour, elegance, and precision as a unique thing in the literature of the world. . . .*

In sheer genius Pascal ranks among the very greatest writers who have lived upon this earth. And his genius was not simply artistic; it displayed itself no less in his character and in the quality of his thought. These are the sides of him which are revealed with extraordinary splendour in his PENSÉES—*a collection of notes intended to form the basis for an elaborate treatise in defence of Christianity which Pascal did not live to complete. The style of many of these passages surpasses in brilliance and force even that of the* LETTRES PROVINCIALES. *In addition, one hears the intimate voice of Pascal, speaking upon the profoundest problems of existence—the most momentous topics which can agitate the mind of men. Two great themes compose his argument: the miserable insignificance of all that is human—human reason, human knowledge, human ambition; and the transcendent glory of God. Never was the wretchedness of mankind painted with a more passionate power.*

<div align="right">

LYTTON STRACHEY
Landmarks in French Literature (1923)

</div>

THE CLIMAX OF IMPIETY

—O mon père! lui dis-je, il n'y a point de patience que vous ne mettiez à bout, et on ne peut ouïr sans horreur les choses que je viens d'entendre. —Ce n'est pas de moi-même, dit-il. —Je le sais bien, mon père, mais vous n'en avez point d'aversion; et, bien loin de détester les auteurs de ces maximes, vous avez de l'estime pour eux. Ne craignez-vous pas que votre consentement ne vous rende participant de leur crime? Et pouvez-vous ignorer que saint Paul juge "dignes de mort, non-seulement les auteurs des maux, mais aussi ceux qui y consentent?" Ne suffisoit-il pas d'avoir permis aux hommes tant de choses défendues par les palliations que vous y avez apportées? falloit-il encore leur donner l'occasion de commettre les crimes mêmes que vous n'avez pu excuser par la facilité et l'assurance de l'absolution que vous leur en offrez, en détruisant à ce dessein la puissance des prêtres, et les obligeant d'absoudre, plutôt en esclaves qu'en juges, les pécheurs les plus envieillis, sans changement de vie, sans aucun signe de regret, que des promesses cent fois violées; sans pénitence, *s'ils n'en veulent point accepter;* et sans quitter les occasions des vices, *s'ils en reçoivent de l'incommodité?*

"Mais on passe encore au delà, et la licence qu'on a prise d'ébranler les règles les plus saintes de la conduite chrétienne se porte jusqu'au renversement entier de la loi de Dieu. On viole *le grand commandement, qui comprend la loi et les prophètes;* on attaque la piété dans le cœur; on en ôte l'esprit qui donne la vie; on dit que l'amour de Dieu n'est pas nécessaire au salut; et on va même jusqu'à prétendre que *cette dispense d'aimer Dieu est l'avantage que Jésus-Christ a apporté au monde.* C'est le comble de l'impiété. Le prix du sang de Jésus-Christ sera de nous obtenir la dispense de l'aimer! Avant l'incarnation, on étoit obligé d'aimer Dieu; mais depuis que *Dieu a tant aimé le monde, qu'il lui a donné son Fils unique,* le monde, racheté par lui, sera déchargé de l'aimer! Etrange théologie de nos jours! On ose lever *l'anathème* que saint Paul prononce *contre ceux qui n'aiment pas le Seigneur Jésus!* On ruine ce que dit saint Jean, que *qui n'aime point demeure en la mort;* et ce que dit Jésus-Christ même, que *qui ne l'aime point ne garde point ses préceptes!* Ainsi on rend dignes de jouir de Dieu dans l'éternité ceux qui n'ont jamais aimé Dieu en toute leur vie! Voilà le mystère d'iniquité accompli. Ouvrez enfin les yeux, mon père; et si vous n'avez point été touché par les autres égaremens de vos casuistes, que ces derniers vous en retirent par leurs excès. Je le souhaite de tout mon cœur pour vous et pour tous vos pères; et je prie Dieu qu'il daigne leur faire connoître combien est fausse la lumière qui les a conduits jusqu'à de tels

précipices, et qu'il remplisse de son amour ceux qui en osent dispenser les hommes."

Après quelques discours de cette sorte, je quittai le père, et je ne vois guère d'apparence d'y retourner. Mais n'y ayez pas de regret; car s'il étoit nécessaire de vous entretenir encore de leurs maximes, j'ai assez lu leurs livres pour pouvoir vous en dire à peu près autant de leur morale, et peut-être plus de leur politique, qu'il n'eût fait lui-même. Je suis, etc.

"O father!" cried I; "no patience can stand this any longer. It is impossible to listen without horror to the sentiments I have just heard."

"They are not my sentiments," said the monk.

"I grant it, sir," said I; "but you feel no aversion to them; and, so far from detesting the authors of these maxims, you hold them in esteem. Are you not afraid that your consent may involve you in a participation of their guilt? and are you not aware that St. Paul judges worthy of death, not only the authors of evil things, but also 'those who have pleasure in them that do them?' Was it not enough to have permitted men to indulge in so many forbidden things, under the covert of your palliations? Was it necessary to go still further, and hold out a bribe to them to commit even those crimes which you found it impossible to excuse, by offering them an easy and certain absolution; and for this purpose nullifying the power of the priests, and obliging them, more as slaves than as judges, to absolve the most inveterate sinners—without any amendment of life—without any sign of contrition except promises a hundred times broken—without penance 'unless they choose to accept of it'—and without abandoning the occasions of their vices, 'if they should thereby be put to any inconvenience?'

"But your doctors have gone even beyond this; and the license which they have assumed to tamper with the most holy rules of Christian conduct amounts to a total subversion of the law of God. They violate 'the great commandment on which hang all the law and the prophets'; they strike at the very heart of piety; they rob it of the spirit that giveth life; they hold that to love God is not necessary to salvation; and go so far as to maintain that 'this dispensation from loving God is the privilege which Jesus Christ has introduced into the world!' This, sir, is the very climax of impiety. The price of the blood of Jesus Christ paid to obtain us a dispensation from loving him! Before the incarnation, it seems men were obliged to love God; but since 'God has so loved the world as to give his only-begotten Son,' the world, redeemed by him, is released from loving him! Strange divinity of our days—to dare to take off the 'anathema' which St. Paul denounces on those 'that love not the Lord Jesus!' To cancel the sentence of St. John: 'He that loveth not, abideth in death!' and that of Jesus Christ himself: 'He that loveth me not

keepeth not my precepts!' and thus to render those worthy of enjoying
God through eternity who never loved God all their life! Behold the
Mystery of Iniquity fulfilled! Open your eyes at length, my dear father,
and if the other aberrations of your casuists have made no impression
on you, let these last, by their very extravagance, compel you to abandon
them. This is what I desire from the bottom of my heart, for your own
sake and for the sake of your doctors; and my prayer to God is, that he
would vouchsafe to convince them how false the light must be that has
guided them to such precipices; and that he would fill their hearts with
that love of himself from which they have dared to give man a dis-
pensation!"

After some remarks of this nature, I took my leave of the monk, and
I see no great likelihood of my repeating my visits to him. This, how-
ever, need not occasion you any regret; for, should it be necessary to
continue these communications on their maxims, I have studied their
books sufficiently to tell you as much of their morality, and more, per-
haps, of their policy, than he could have done himself.—I am, &c.

<div align="right">

Lettres Provinciales (1656), x
Translated by Thomas M'Crie

</div>

*All the gifts of the writer are combined in Pascal to the point of per-
fection which no one excels. His style is, perhaps, of all the great styles
of the seventeenth and eighteenth centuries, the most lofty.*

<div align="right">

DÉSIRÉ NISARD
Histoire de la littérature française (1844)

</div>

MADAME DE SÉVIGNÉ

1 6 2 6 — 1 6 9 6

THE MARRIAGE OF MADEMOISELLE

Je m'en vais vous mander la chose la plus étonnante, la plus surpren-
ante, la plus merveilleuse, la plus miraculeuse, la plus triomphante, la
plus étourdissante, la plus inouïe, la plus singulière, la plus extraordi-
naire, la plus incroyable, la plus imprévue, la plus grande, la plus petite,
la plus rare, la plus commune, la plus éclatante, la plus secrète jusqu'à
aujourd'hui, la plus brillante, la plus digne d'envie; enfin une chose dont
on ne trouve qu'un exemple dans les siècles passés, encore cet exemple
n'est-il pas juste, une chose que nous ne saurions croire à Paris,
comment la pourrait-on croire à Lyon? une chose qui fait crier miséri-
corde à tout le monde; une chose qui comble de joie madame de Rohan

et madame d'Hauterive; une chose, enfin, qui se fera dimanche, où ceux qui la verront croiront avoir la *berlue;* une chose qui se fera dimanche, et qui ne sera peut-être pas faite lundi. Je ne puis me résoudre à la dire, devinez-la; je vous le donne en trois; *jetez-vous votre langue aux chiens?* Hé bien! il faut donc vous la dire: M. de Lauzun épouse dimanche au Louvre, devinez qui? Je vous le donne en quatre, je vous le donne en dix, je vous le donne en cent. Madame de Coulanges dit: Voilà qui est bien difficile à deviner: c'est madame de la Vallière. Point du tout, Madame; c'est donc mademoiselle de Retz? Point du tout; vous êtes bien provinciale. Ah, vraiment, nous sommes bien bêtes! dites-vous; c'est mademoiselle Colbert. Encore moins. C'est assurément mademoiselle de Créqui? Vous n'y êtes pas. Il faut donc à la fin vous le dire: il épouse, dimanche au Louvre, avec la permission du roi, mademoiselle, mademoiselle de mademoiselle: devinez le nom; il épouse Mademoiselle, ma foi! par ma foi! ma foi jurée! MADEMOISELLE, la grande Mademoiselle, Mademoiselle, fille de feu MONSIEUR, Mademoiselle, petite-fille de HENRI IV, mademoiselle d'Eu, mademoiselle de Dombes, mademoiselle de Montpensier, mademoiselle d'Orléans, Mademoiselle, cousine germaine du roi; Mademoiselle, destinée au trône; Mademoiselle, le seul parti de France qui fût digne de MONSIEUR. Voilà un beau sujet de discourir. Si vous criez, si vous êtes hors de vous-même, si vous dites que nous avons menti, que cela est faux, qu'on se moque de vous, que voilà une belle raillerie, que cela est bien fade à imaginer; si enfin vous nous dites des injures, nous trouverons que vous avez raison; nous en avons fait autant que vous. Adieu; les lettres qui seront portées par cet ordinaire vous feront voir si nous disons vrai ou non.

I am going to tell you a thing the most astonishing, the most surprising, the most marvellous, the most miraculous, the most magnificent, the most confounding, the most unheard of, the most singular, the most extraordinary, the most incredible, the most unforeseen, the greatest, the least, the rarest, the most common, the most public, the most private till to-day, the most brilliant, the most enviable; in short, a thing of which there is but one example in past ages, and that not an exact one neither; a thing that we cannot believe at Paris; how then will it gain credit at Lyons? a thing which makes everybody cry, "Lord, have mercy upon us!" a thing which causes the greatest joy to Madame de Rohan and Madame de Hauterive; a thing, in fine, which is to happen on Sunday next, when those who are present will doubt the evidence of their senses; a thing which, though it is to be done on Sunday, yet perhaps will not be finished on Monday. I cannot bring myself to tell it you: guess what it is. I give you three times to do it in. What, not a word to throw at a dog? Well then, I find I must tell you. Monsieur de Lauzun is to be married next Sunday at the Louvre, to ——, pray guess

to whom! I give you four times to do it in, I give you six, I give you a hundred. Says Madame de Coulanges, "It is really very hard to guess: perhaps it is Madame de la Vallière." Indeed, Madam, it is not. "It is Mademoiselle de Retz, then." No, nor she neither; you are extremely provincial. "Lord, bless me," say you, "what stupid wretches we are! it is Mademoiselle de Colbert all the while." Nay, now you are still farther from the mark. "Why then it must certainly be Mademoiselle de Crequi." You have it not yet. Well, I find I must tell you at last. He is to be married next Sunday, at the Louvre, with the King's leave, to Mademoiselle, Mademoiselle de—Mademoiselle—guess, pray guess her name: he is to be married to Mademoiselle, the great Mademoiselle; Mademoiselle, daughter to the late Monsieur; Mademoiselle, granddaughter of Henry the Fourth; Mademoiselle d'Eu, Mademoiselle de Dombes, Mademoiselle de Montpensier, Mademoiselle d'Orléans, Mademoiselle, the King's cousin-german, Mademoiselle, destined to the Throne, Mademoiselle, the only match in France that was worthy of Monsieur. What glorious matter for talk! If you should burst forth like a bedlamite, say we have told you a lie, that it is false, that we are making a jest of you, and that a pretty jest it is without wit or invention; in short, if you abuse us, we shall think you quite in the right; for we have done just the same things ourselves. Farewell, you will find by the letters you receive this post, whether we tell you truth or not.

Letter to M. de Coulanges (December 15, 1670)
Translation Anonymous

Perhaps the most famous and remarkable of all letter-writers in literature.

GEORGE SAINTSBURY
A Short History of French Literature (1882)

JACQUES BÉNIGNE BOSSUET

1 6 2 7 — 1 7 0 4

SAINT PAUL

Il ira, cet ignorant dans l'art de bien dire, avec cette locution rude, avec cette phrase qui sent l'étranger, il ira en cette Grèce polie, la mère des philosophes et des orateurs; et malgré la résistance du monde, il y établira plus d'Eglises, que Platon n'y a gagné de disciples par cette éloquence qu'on a crue divine. Il prêchera Jésus dans Athènes, et le plus savant de ses sénateurs passera de l'Aréopage en l'école de ce

barbare. Il poussera encore plus loin ses conquêtes; il abattra aux pieds du Sauveur la majesté des faisceaux romains en la personne d'un proconsul, et il fera trembler dans leurs tribunaux les juges devant lesquels on le cite. Rome même entendra sa voix; et un jour cette ville maîtresse se tiendra bien plus honorée d'une lettre du style de Paul, adressée à ses citoyens, que de tant de fameuses harangues qu'elle a entendues de son Cicéron.

Et d'où vient cela, chrétiens? C'est que Paul a des moyens pour persuader que la Grèce n'enseigne pas, et que Rome n'a pas appris. Une puissance surnaturelle, qui se plaît de relever ce que les superbes méprisent, s'est répandue et mêlée dans l'auguste simplicité de ses paroles. De là vient que nous admirons dans ses admirables Epîtres une certaine vertu plus qu'humaine, qui persuade contre les règles, ou plutôt qui ne persuade pas tant, qu'elle captive les entendements; qui ne flatte pas les oreilles, mais qui porte ses coups droit au cœur. De même qu'on voit un grand fleuve qui retient encore, coulant dans la plaine, cette force violente et impétueuse, qu'il avoit acquise aux montagnes d'où il tire son origine; ainsi cette vertu céleste, qui est contenue dans les Ecrits de saint Paul, même dans cette simplicité de style conserve toute la vigueur qu'elle apporte du ciel, d'où elle descend.

Yes, this man, so ignorant of the art of the polished speaker, will go, with his rugged speech and his foreign phrase and accent, into Greece, the mother of philosophers and orators, and in spite of the world's resistance, will establish there more churches than Plato gained disciples by that eloquence which was thought divine. St. Paul will preach Jesus Christ in Athens, and the most learned of her senators will pass from the Areopagus into the school of this barbarian. He will pursue his triumph; he will lay prostrate at the feet of Jesus the majesty of the Roman fasces, in the person of a proconsul, and he will cause the very judges, before whom he is arraigned, to quake on their tribunals. Rome herself shall hear his voice, and the day will come when this city, this mistress of the world, will esteem herself more honoured by a letter addressed by him to her citizens, than by all the harangues which she has heard from her Cicero.

And how, Christians, how happens all this? It is that Paul has means of persuasion which Greece does not teach and which Rome has not learned. A supernatural power, which exalts that which the haughty despise, mingles with the august simplicity of his language, and breathes in every word he utters. Hence it is that in his amazing Epistles we feel some subtle charm, a certain superhuman force, which does not flatter the taste and tickle the ear, but which grips and stirs the soul, leading captive the understanding and going straight to the heart. Just as a mighty river retains, when flowing through the plain, all that violent and

impetuous force which it had acquired in the mountains whence it derived its source, so does this Divine virtue that resides in St. Paul's Epistles preserve undiminished, even in the plainness of his style, all the vigour and power which it brings from the Heaven whence it has descended.

<div align="right">Panégyrique de l'Apôtre Saint Paul (1657)

Translated by D. O'Mahony</div>

The limit of beauty.

<div align="right">C.-A. SAINTE-BEUVE

Causeries du lundi (1854)</div>

JACQUES BÉNIGNE BOSSUET

1 6 2 7 — 1 7 0 4

MADAME IS DEAD

O nuit désastreuse! ô nuit effroyable! où retentit tout à coup, comme un éclat de tonnerre, cette étonnante nouvelle: MADAME se meurt! MADAME est morte!

O disastrous night! O dreadful night! that resounded suddenly like a clap of thunder with the shocking news: Madame is dying, Madame is dead!

<div align="right">Oraison Funèbre de Henriette-Anne d'Angleterre (1670)</div>

The splendid words flow out like a stream of lava, molten and glowing, and then fix themselves for ever in adamantine beauty.

<div align="right">LYTTON STRACHEY

Landmarks in French Literature (1923)</div>

JOHN BUNYAN

1 6 2 8 — 1 6 8 8

THE WILDERNESS OF THIS WORLD

As I walked through the wilderness of this world, I lighted on a certain place where was a Den, and I laid me down in that place to sleep: and, as I slept, I dreamed a dream. I dreamed, and behold, I saw a man

clothed with rags, standing in a certain place, with his face from his own house, a book in his hand, and a great burden upon his back.

<p style="text-align:center">❁ ❁ ❁ ❁</p>

Now I saw in my dream that these two men went in at the gate: and lo, as they entered, they were transfigured, and they had raiment put on that shone like gold. There was also that met them with harps and crowns, and gave them to them—the harps to praise withal, and the crowns in token of honour. Then I heard in my dream that all the bells in the city rang again for joy.

Now, just as the gates were opened to let in the men, I looked in after them, and, behold, the City shone like the sun; the streets also were paved with gold, and in them walked many men, with crowns on their heads, palms in their hands, and golden harps to sing praises withal.

There were also of them that had wings, and they answered one another without intermission, saying, *Holy, holy, holy, is the Lord.* And after that they shut up the gates; which, when I had seen, I wished myself among them.

<p style="text-align:right">The Pilgrim's Progress (1678)</p>

The first half-dozen lines of THE PILGRIM'S PROGRESS *give an example of a perfect beginning. . . . In these few words, as in a few strokes by some master of etching, the atmosphere is made, the movement is launched, the effect is got for the whole narrative. But even more remarkable is the skill with which he brings it to an end. . . . Notice the beautiful cadence of these last words. They give the quiet ending which was insisted upon by Greek art, and which is so conspicuous in Milton at the close both of the* PARADISE LOST *and of the* SAMSON.

<p style="text-align:right">J. W. M A C K A I L
Studies in Humanism (1938)</p>

SIR WILLIAM TEMPLE

<p style="text-align:center">1 6 2 8 — 1 6 9 9</p>

HUMAN LIFE

When all is done, Humane Life is at the greatest and the best, but like a froward Child, that must be Play'd with, and Humour'd a little, to keep it quiet, till it falls asleep, and then the Care is over.

<p style="text-align:right">Miscellanea (1690)</p>

<p style="text-align:center">783</p>

The most beautiful to me is Temple's sentence on Life. . . . There is a cadence there to thrill along the nerves as in no other sentence I can recall.

HAVELOCK ELLIS
Impressions and Comments, Second Series (1923)

JOHN DRYDEN

1 6 3 1 — 1 7 0 0

ABSALOM AND ACHITOPHEL

In pious times, e'r Priest-craft did begin,
Before *Polygamy* was made a Sin;
When Man on many multipli'd his kind,
E'r one to one was cursedly confin'd,
When Nature prompted and no Law deni'd
Promiscuous Use of Concubine and Bride;
Then *Israel's* Monarch, after Heavens own heart,
His vigorous warmth did, variously, impart
To Wives and Slaves: And, wide as his Command,
Scatter'd his Maker's Image through the Land.
Michal, of Royal Blood, the Crown did wear,
A soil ungrateful to the Tiller's care:
Not so the rest; for several Mothers bore
To God-like *David* several sons before.
But since like Slaves his Bed they did ascend,
No True Succession could their Seed attend.
Of all this Numerous Progeny was none
So Beautiful so Brave as *Absalon:*
Whether, inspird by some diviner Lust,
His father got him with a greater Gust,
Or that his Conscious Destiny made way
By manly Beauty to Imperial Sway.
Early in Foreign Fields he won Renown
With Kings and States allied to *Israel's* Crown:
In Peace the thoughts of War he coud remove
And seem'd as he were onely born for Love.
What e'r he did was done with so much ease,
In him alone, 'twas Natural to please;
His motions all accompanied with grace;
And *Paradise* was open'd in his face.

With secret joy, indulgent *David* view'd
His Youthful Image in his Son renew'd;
To all his wishes Nothing he deni'd
And made the Charming *Annabel* his Bride.
What faults he had (for who from faults is free?)
His father coud not or he woud not see.
Some warm excesses, which the Law forbore,
Were constru'd Youth that purg'd by boiling o'r:
And *Amnon's* Murther, by a specious Name,
Was call'd a Just Revenge for injur'd Fame.
Thus Prais'd and Lov'd, the Noble Youth remain'd,
While *David,* undisturb'd, in *Sion* reign'd.
But Life can never be sincerely blest:
Heav'n punishes the bad, and proves the best.
The *Jews,* a Headstrong, Moody, Murm'ring race
As ever tri'd th' extent and stretch of grace;
God's pamper'd People, whom, debauch'd with ease,
No King could govern nor no God could please;
(Gods they had tri'd of every shape and size
That God-smiths could produce or Priests devise:)
These *Adam*-wits, too fortunately free,
Began to dream they wanted liberty;
And when no rule, no president was found
Of men, by Laws less circumscrib'd and bound;
They led their wild desires to Woods and Caves;
And thought that all but Savages were Slaves.
They who, when *Saul* was dead, without a blow
Made foolish *Ishbosheth* the Crown forgo;
Who banisht *David* did from *Hebron* bring,
And, with a General shout, proclaim'd him King:
Those very *Jews* who at their very best
Their Humour more than Loyalty exprest,
Now wondred why so long they had obey'd
An Idol-Monarch which their hands had made;
Thought they might ruine him they could create
Or melt him to that Golden Calf, a State.
But these were random Bolts: No form'd Design
Nor Interest made the Factious Croud to join:
The sober part of *Israel,* free from stain,
Well knew the value of a peaceful reign;
And, looking backward with a wise afright,
Saw Seams of wounds, dishonest to the sight:
In contemplation of whose ugly Scars,
They curst the memory of Civil Wars.

The moderate sort of Men, thus qualifi'd,
Inclin'd the Ballance to the better side;
And *David's* mildness manag'd it so well,
The bad found no occasion to Rebel.
But, when to Sin our byast Nature leans,
The careful Devil is still at hand with means;
And providently Pimps for ill desires:
The Good Old Cause, reviv'd, a Plot requires,
Plots, true or false, are necessary things,
To raise up Common-wealths and ruin Kings.

 Th' inhabitants of old *Jerusalem,*
Were *Jebusites;* the Town so call'd from them;
And their's the Native right—
But when the chosen People grew more strong,
The rightful cause at length became the wrong;
And every loss the men of *Jebus* bore,
They still were thought God's enemies the more.
Thus, worn and weaken'd, well or ill content,
Submit they must to *David's* Government:
Impoverish't and depriv'd of all Command,
Their Taxes doubled as they lost their Land;
And, what was harder yet to flesh and blood,
Their Gods disgrac'd, and burnt like common Wood.
This set the Heathen Priesthood in a flame,
For Priests of all Religions are the same:
Of whatsoe'er descent their Godhead be,
Stock, Stone, or other homely Pedigree,
In his defence his Servants are as bold,
As if he had been born of beaten Gold.
The *Jewish Rabbins,* though their Enemies,
In this conclude them honest men and wise:
For 'twas their duty, all the Learned think,
T' espouse his Cause by whom they eat and drink.
From hence began that Plot, the Nations Curse,
Bad in itself, but represented worse,
Rais'd in extremes, and in extremes decri'd,
With Oaths affirm'd, with dying Vows deni'd,
Not weigh'd or winnow'd by the Multitude,
But swallow'd in the Mass, unchewed and crude.
Some Truth there was, but dashed and brew'd with Lies;
To please the Fools, and puzzle all the Wise.
Succeeding Times did equal Folly call
Believing nothing or believing all.

The *Egyptian* Rites the *Jebusites* embrac'd,
Where Gods were recommended by their taste.
Such sav'ry Deities must needs be good
As serv'd at once for Worship and for Food.
By force they could not Introduce these Gods,
For Ten to One in former days was odds.
So Fraud was us'd, (the Sacrificers Trade,)
Fools are more hard to Conquer than Persuade.
Their busie Teachers mingled with the *Jews*
And rak'd for Converts even the Court and Stews:
Which *Hebrew* Priests the more unkindly took,
Because the Fleece accompanies the Flock.
Some thought they God's Anointed meant to slay
By Guns, invented since full many a day:
Our Author swears it not; but who can know
How far the Devil and *Jebusites* may go?
This Plot, which fail'd for want of common Sense,
Had yet a deep and dangerous Consequence;
For as, when raging Fevers boil the Blood
The standing Lake soon floats into a Floud;
And ev'ry hostile Humour which before
Slept quiet in its Channels bubbles o're:
So, several Factions from this first Ferment
Work up to Foam, and threat the Government.
Some by their Friends, more by themselves thought wise,
Oppos'd the Pow'r to which they could not rise.
Some had in Courts been Great and, thrown from thence,
Like Fiends were hardened in Impenitence.
Some, by their Monarch's fatal mercy grown,
From Pardon'd Rebels, Kinsmen to the Throne
Were raised in Pow'r and Publick Office high;
Strong Bands, if Bands ungrateful men coud tie.
Of these the false *Achitophel* was first,
A Name to all succeeding Ages curst.
For close Designs and crooked Counsels fit,
Sagacious, Bold, and Turbulent of wit,
Restless, unfixt in Principles and Place,
In Pow'r unpleased, impatient of Disgrace;
A fiery Soul, which working out its way,
Fretted the Pigmy Body to decay:
And o'r informed the Tenement of Clay.
A daring Pilot in extremity;
Pleas'd with the Danger, when the Waves went high
He sought the Storms; but, for a Calm unfit,
Would Steer too nigh the Sands to boast his Wit.

Great Wits are sure to Madness near alli'd
And thin Partitions do their Bounds divide;
Else, why should he, with Wealth and Honour blest,
Refuse his Age the needful hours of Rest?
Punish a Body which he coud not please,
Bankrupt of Life, yet Prodigal of Ease?
And all to leave what with his Toil he won
To that unfeather'd two-legg'd thing, a Son:
Got, while his Soul did huddled Notions trie;
And born a shapeless Lump, like Anarchy.
In Friendship false, implacable in Hate,
Resolv'd to Ruine or to Rule the State;
To Compass this the Triple Bond he broke;
The Pillars of the Publick Safety shook,
And fitted *Israel* for a Foreign Yoke;
Then, seiz'd with Fear, yet still affecting Fame,
Usurp'd a Patriot's All-attoning Name.
So easie still it proves in Factious Times
With publick Zeal to cancel private Crimes:
How safe is Treason and how sacred ill,
Where none can sin against the Peoples Will,
Where Crouds can wink; and no offence be known,
Since in anothers guilt they find their own.
Yet, Fame deserv'd, no Enemy can grudge;
The Statesman we abhor, but praise the Judge.
In *Israels* courts ne'er sat an *Abbethdin*
With more discerning Eyes or Hands more clean,
Unbrib'd, unsought, the Wretched to redress;
Swift of Dispatch and easie of Access.
Oh, had he been content to serve the Crown
With Vertues onely proper to the Gown,
Or had the rankness of the Soil been freed
From Cockle that opprest the Noble Seed,
David for him his tuneful Harp had strung,
And Heav'n had wanted one Immortal Song.
But wild Ambition loves to slide, not stand,
And Fortunes Ice prefers to Vertues Land.
Achitophel, grown weary to possess
A lawful Fame, and lazie Happiness,
Disdain'd the Golden Fruit to gather free
And lent the Crowd his Arm to shake the Tree.
Now, manifest of Crimes, contriv'd long since,
He stood at bold Defiance with his Prince:
Held up the Buckler of the Peoples Cause
Against the Crown; and sculk'd behind the Laws.

The wish'd occasion of the Plot he takes;
Some Circumstances finds, but more he makes.
By buzzing Emissaries, fills the ears
Of listening Crouds, with Jealousies and Fears
Of Arbitrary Counsels brought to light,
And proves the King himself a *Jebusite.*
Weak Arguments! which yet he knew full well,
Were strong with People easie to Rebel.
For, govern'd by the *Moon,* the giddy *Jews*
Tread the same Track when she the Prime renews:
And once in twenty Years, their Scribes record,
By natural Instinct they change their Lord.
Achitophel still wants a Chief, and none
Was found so fit as Warlike *Absalon:*
Not, that he wish'd his Greatness to create,
(For Polititians neither love nor hate:)
But, for he knew his Title not allow'd,
Would keep him still depending on the Croud,
That Kingly pow'r, thus ebbing out, might be
Drawn to the Dregs of a Democracie.
Him he attempts with studied Arts to please
And sheds his Venome in such words as these.

 Auspicious Prince! at whose Nativity
Some Royal Planet rul'd the Southern Sky;
Thy longing Countries Darling and Desire,
Their cloudy Pillar, and their guardian Fire,
Their second *Moses,* whose extended Wand
Divides the Seas and shows the promis'd Land,
Whose dawning Day, in every distant Age,
Has exercised the Sacred Prophets rage,
The Peoples Pray'r, the glad Diviners Theam,
The Young mens Vision and the Old mens Dream!
Thee, *Saviour,* Thee the Nations Vows confess;
And, never satisfi'd with seeing, bless:
Swift, unbespoken Pomps, thy steps proclaim,
And stammering Babes are taught to lisp thy Name.
How long wilt thou the general Joy detain;
Starve, and defraud the People of thy Reign?
Content ingloriously to pass thy days,
Like one of Vertues Fools that Feeds on Praise;
Till thy fresh Glories, which now shine so bright,
Grow Stale and Tarnish with our dayly sight.
Believe me, Royal Youth, thy Fruit must be
Or gather'd Ripe, or rot upon the Tree.

Heav'n has to all allotted, soon or late,
Some lucky Revolution of their Fate:
Whose Motions, if we watch and guide with Skill,
(For humane Good depends on humane Will,)
Our Fortune rolls as from a smooth Descent
And, from the first impression, takes the Bent;
But, if unseiz'd, she glides away like wind;
And leaves repenting Folly far behind.
Now, now she meets you with a glorious prize
And spreads her Locks before her as she flies.
Had thus Old *David,* from whose Loins you spring,
Not dar'd, when Fortune call'd him, to be King,
At *Gath* an Exile he might still remain,
And Heavens Anointing Oil had been in vain.
Let his successful Youth your hopes engage,
But shun th' example of Declining Age.
Behold him setting in his Western Skies,
The Shadows lengthening as the Vapours rise.
He is not now, as when, on *Jordan's* Sand,
The Joyful People throng'd to see him Land,
Cov'ring the *Beach* and blackning all the *Strand:*
But like the Prince of Angels, from his height,
Comes tumbling downward with diminish'd light:
Betray'd by one poor Plot to publick Scorn,
(Our onely blessing since his curst Return,)
Those heaps of People which one Sheaf did bind,
Blown off and scatter'd by a puff of Wind.
What strength can he to your Designs oppose,
Naked of Friends, and round beset with Foes?
If *Pharaoh's* doubtful succour he should use,
A Foreign Aid would more incense the *Jews:*
Proud *Egypt* woud dissembled Friendship bring;
Foment the War, but not support the King:
Nor woud the Royal Party e'r unite
With *Pharaoh's* arms t' assist the *Jebusite;*
Or if they shoud, their Interest soon would break,
And, with such odious Aid, make *David* weak.
All sorts of men, by my successful Arts
Abhorring Kings, estrange their altered Hearts
From *David's* Rule: And 'tis the general Cry,
Religion, Common-wealth, and Liberty.
If you, as Champion of the Publique Good,
Add to their Arms a Chief of Royal Blood;
What may not *Israel* hope, and what Applause
Might such a General gain by such a Cause?

790

Not barren Praise alone, that Gaudy Flow'r,
Fair onely to the sight, but solid Pow'r:
And Nobler is a limited Command,
Giv'n by the Love of all your Native Land,
Than a Successive Title, Long, and Dark,
Drawn from the Mouldy Rolls of *Noah's* ark.

What cannot Praise effect in Mighty Minds,
When Flattery Sooths and when Ambition Blinds!
Desire of Pow'r, on Earth a Vitious Weed,
Yet, sprung from High is of Cœlestial Seed;
In God 'tis Glory: And when Men Aspire,
'Tis but a Spark too much of Heavenly Fire.
Th' Ambitious Youth, too Covetous of Fame,
Too Full of Angels Metal in his Frame,
Unwarily was led from Vertues ways,
Made Drunk with Honour, and debauch'd with Praise.
Half loath and half consenting to the Ill,
(For Loyal Blood within him strugled still,)
He thus repli'd—And what Pretence have I
To take up Arms for Publick Liberty?
My Father Governs with unquestion'd Right;
The Faiths Defender and Mankinds Delight,
Good, Gracious, Just, observant of the Laws;
And Heav'n by Wonders has espous'd his Cause.
Whom has he Wrong'd in all his Peaceful Reign?
Who sues for Justice to his Throne in Vain?
What Millions has he pardoned of his Foes
Whom Just Revenge did to his Wrath expose?
Mild, Easie, Humble, Studious of our Good,
Enclin'd to Mercy, and averse from Blood.
If Mildness Ill with Stubborn *Israel* Suit,
His Crime is God's beloved Attribute.
What could he gain, his People to Betray
Or change his Right, for Arbitrary Sway?
Let Haughty *Pharaoh* Curse with such a Reign
His Fruitful *Nile,* and Yoak a Servile Train.
If *David's* Rule *Jerusalem* Displease,
The *Dog-star* heats their Brains to this Disease.
Why then should I, Encouraging the Bad,
Turn Rebel and run Popularly Mad?
Were he a Tyrant who, by Lawless Might,
Opprest the *Jews* and rais'd the *Jebusite,*
Well might I Mourn; but Nature's holy Bands
Would Curb my Spirits, and Restrain my Hands;

791

The People might assert their Liberty;
But what was Right in them, were Crime in me.
His Favour leaves me nothing to require;
Prevents my Wishes and out-runs Desire
What more can I expect while *David* lives?
All but his Kingly Diadem he gives:
And that: But there he paus'd; then Sighing, said,
Is Justly destin'd for a Worthier head.
For when my Father from his Toyls shall Rest
And late Augment the Number of the Blest:
His Lawful Issue shall the Throne ascend,
Or the *Collat'ral* Line, where that shall end.
His Brother, though Opprest with Vulgar Spight,
Yet Dauntless and Secure of Native Right,
Of every Royal Vertue stands possest;
Still Dear to all the Bravest and the Best.
His Courage Foes, his Friends his Truth Proclaim;
His Loyalty the King, the World his Fame.
His Mercy ev'n th' Offending Croud will find,
For sure he comes of a Forgiving Kind.
Why shoud I then Repine at Heavens Decree
Which gives me no Pretence to Royalty?
Yet oh that Fate, Propitiously Inclin'd,
Had rais'd my Birth, or had debas'd my Mind;
To my large Soul, not all her Treasure lent,
And then betrai'd it to a mean Descent.
I find, I find my mounting Spirits Bold,
And *David's* part disdains my Mothers Mold.
Why am I scanted by a Niggard Birth?
My soul Disclaims the Kindred of her Earth:
And, made for Empire, Whispers me within;
Desire of Greatness is a God-like Sin.

 Him Staggering so when Hells dire Agent found,
While fainting Vertue scarce maintain'd her Ground,
He pours fresh Forces in, and thus Replies:
 Th' eternal God, Supreamly Good and Wise,
Imparts not these Prodigious Gifts in vain;
What Wonders are Reserv'd to bless your Reign?
Against your will your Arguments have shown,
Such Vertue's only giv'n to guide a Throne.
Not that your Father's Mildness I contemn,
But manly Force becomes the Diadem.
'Tis true he grants the People all they crave;
And more perhaps than Subject ought to have:

For Lavish Grants suppose a Monarch tame
And more his Goodness than his Wit proclaim.
But when should People strive their Bonds to break,
If not when Kings are Negligent or Weak?
Let him give on till he can give no more,
The thrifty Sanhedrin shall keep him poor:
And every Sheckle which he can receive
Shall cost a Limb of his Prerogative.
To ply him with new Plots shall be my care;
Or plunge him deep in some Expensive War;
Which, when his Treasure can no more supply,
He must, with the Remains of Kingship, buy.
His faithful Friends our Jealousies and Fears
Call *Jebusites;* and *Pharaoh's* Pensioners,
Whom, when our Fury from his Aid has torn,
He shall be naked left to publick Scorn.
The next Successor, whom I fear and hate,
My Arts have made obnoxious to the State;
Turn'd all his Vertues to his Overthrow,
And gain'd our Elders to pronounce a Foe.
His Right, for Sums of necessary Gold,
Shall first be Pawn'd, and afterwards be Sold;
Till time shall Ever-wanting *David* draw,
To pass your doubtful Title into Law.
If not; the People have a Right Supreme
To make their Kings; for Kings are made for them.
All Empire is no more than Pow'r in Trust,
Which, when resum'd, can be no longer Just.
Succession, for the general Good design'd,
In its own wrong a Nation cannot bind:
If altering that, the People can relieve,
Better one suffer, than a Nation grieve.
The *Jews* well know their pow'r: e'r *Saul* they chose
God was their King, and God they durst Depose.
Urge now your Piety, your Filial Name,
A Father's Right and Fear of future Fame;
The Publick Good, that Universal Call,
To which even Heav'n submitted, answers all.
Nor let his Love enchant your generous Mind;
'Tis Natures trick to propagate her Kind.
Our fond Begetters, who would never die,
Love but themselves in their Posterity.
Or let his kindness by th' Effects be tried
Or let him lay his vain Pretence aside.

God said he loved your Father; coud he bring
A better Proof than to anoint him King?
It surely shew'd, He lov'd the Shepherd well
Who gave so fair a Flock as *Israel*.
Would *David* have you thought his Darling Son?
What means he then, to Alienate the Crown?
The name of Godly he may blush to bear:
'Tis after Gods own heart to Cheat his Heir.
He to his Brother gives Supreme Command;
To you a Legacie of Barren Land:
Perhaps th' old Harp on which he thrums his Lays:
Or some dull *Hebrew* Ballad in your Praise.
Then the next Heir, a Prince, Severe and Wise,
Already looks on you with Jealous Eyes,
Sees through the thin Disguises of your Arts,
And marks your Progress in the Peoples Hearts.
Though now his mighty Soul its Grief contains;
He meditates Revenge who least Complains.
And like a Lion, Slumb'ring in the way,
Or Sleep dissembling, while he waits his Prey,
His fearless Foes within his Distance draws,
Constrains his Roaring, and Contracts his Paws:
Till at the last, his time for Fury found,
He shoots with sudden Vengeance from the Ground:
The Prostrate Vulgar, passes o'r and Spares;
But with a Lordly Rage, his Hunters tears;
Your Case no tame Expedients will afford;
Resolve on Death, or Conquest by the Sword,
Which for no less a Stake than Life, you Draw,
And Self-defence is Natures Eldest Law.
Leave the warm People no Considering time;
For then Rebellion may be thought a Crime.
Prevail your self of what Occasion gives,
But trie your Title while your Father lives;
And, that your Arms may have a fair Pretence,
Proclaim, you take them in the King's Defence;
Whose Sacred Life each minute woud Expose,
To Plots, from seeming Friends and secret Foes,
And who can sound the depth of *David's* Soul?
Perhaps his fear, his kindness may Controul.
He fears his Brother, though he loves his Son,
For plighted Vows too late to be undone.
If so, by Force he wishes to be gain'd,
Like Womens Leachery to seem Constrain'd:

Doubt not; but, when he most affects the Frown,
Commit a pleasing Rape upon the Crown.
Secure his Person to secure your Cause;
They who possess the Prince, possess the Laws.

 He said, And this Advice above the rest
With *Absalom's* Mild Nature suited best;
Unblamed of Life (Ambition set aside,)
Not stain'd with Cruelty, nor puft with pride.
How happy had he been, if Destiny
Had higher placed his Birth, or not so high!
His Kingly Vertues might have claim'd a Throne
And blest all other Countries but his own:
But charming Greatness, since so few refuse;
'Tis Juster to Lament him, than Accuse.
Strong were his hopes a Rival to remove,
With Blandishments to gain the publick Love,
To Head the Faction while their Zeal was hot,
And Popularly Prosecute the Plot.
To farther this, *Achitophel* Unites
The Malecontents of all the Israelites:
Whose differing Parties he could wisely Join
For several Ends, to serve the same Design.
The Best, and of the Princes some were such,
Who thought the pow'r of Monarchy too much:
Mistaken Men, and Patriots in their Hearts;
Not Wicked, but seduc'd by Impious Arts.
By these the Springs of Property were bent,
And wound so high, they Crack'd the Government.
The next for Interest sought t' embroil the State,
To sell their Duty at a dearer rate;
And make their *Jewish* Markets of the Throne;
Pretending Publick Good, to serve their own.
Others thought Kings an useless heavy Load,
Who Cost too much, and did too little Good.
These were for laying Honest *David* by
On Principles of pure good Husbandry.
With them join'd all th' Haranguers of the Throng
That thought to get Preferment by the Tongue.
Who follow next, a double danger bring,
Not onely hating *David,* but the King;
The *Solymæan* Rout; well Vers'd of old
In Godly Faction, and in Treason bold;
Cowring and Quaking at a Conqu'ror's Sword,
But Lofty to a Lawful Prince Restored;

Saw with Disdain an *Ethnick* Plot begun
And Scorned by *Jebusites* to be Out-done.
Hot *Levites* Headed these; who pul'd before
From th' *Ark*, which in the Judges days they bore,
Resum'd their Cant, and with a Zealous Crie
Pursu'd their old belov'd Theocracie.
Where Sanhedrin and Priest enslav'd the Nation
And justifi'd their Spoils by Inspiration:
For who so fit for Reign as *Aaron's* Race,
If once Dominion they could found in Grace?
These led the Pack; though not of surest scent,
Yet deepest mouth'd against the Government.
A numerous Host of dreaming Saints succeed;
Of the true old Enthusiastick Breed:
'Gainst Form and Order they their Pow'r imploy.
Nothing to Build, and all things to Destroy.
But far more numerous was the Herd of such,
Who think too little, and who talk too much.
These, out of meer instinct, they knew not why,
Adored their Fathers' God, and Property:
And, by the same blind Benefit of Fate,
The Devil and the *Jebusite* did hate:
Born to be sav'd, even in their own despight;
Because they could not help believing right.
Such were the Tools; but a whole Hydra more
Remains, of sprouting heads too long to score.
Some of their Chiefs were Princes of the Land;
In the first Rank of these did *Zimri* stand:
A man so various, that he seem'd to be
Not one, but all Mankind's Epitome.
Stiff in Opinions, always in the wrong;
Was Every thing by starts, and Nothing long:
But, in the course of one revolving Moon,
Was Chymist, Fidler, States-man, and Buffoon;
Then all for Women, Painting, Rhiming, Drinking,
Besides ten thousand Freaks that died in thinking.
Blest Madman, who coud every hour employ,
With something New to wish, or to enjoy!
Railing and praising were his usual Theams;
And both (to shew his Judgment) in Extreams:
So over Violent, or over Civil,
That every Man, with him, was God or Devil.
In squandring Wealth was his peculiar Art:
Nothing went unrewarded, but Desert.

Begger'd by fools, whom still he found too late:
He had his Jest, and they had his Estate.
He laugh'd himself from Court; then sought Relief
By forming Parties, but could ne'r be Chief:
For, spight of him, the weight of Business fell
On *Absalom* and wise *Achitophel:*
Thus wicked but in Will, of Means bereft,
He left not Faction, but of that was ieft.
 Titles and Names 'twere tedious to Reherse
Of Lords, below the Dignity of Verse.
Wits, Warriors, Commonwealths-men were the best:
Kind Husbands and meer Nobles all the rest.
And, therefore in the name of Dulness, be
The well-hung *Balaam* and cold *Caleb* free;
And Canting *Nadab* let Oblivion damn,
Who made new Porridge for the Paschal Lamb.
Let Friendships holy Band some Names assure,
Some their own Worth, and some let Scorn secure.
Nor shall the Rascal Rabble here have Place,
Whom Kings no Titles gave, and God no Grace:
Not Bull-fac'd *Jonas*, who coud Statutes draw
To mean Rebellion, and make Treason Law.
But he, though bad, is follow'd by a worse,
The Wretch, who Heav'ns Anointed dar'd to Curse.
Shimei, whose Youth did early Promise bring
Of Zeal to God, and Hatred to his King;
Did wisely from Expensive Sins refrain,
And never broke the Sabbath, but for Gain:
Nor ever was he known an Oath to vent,
Or curse, unless against the Government.
Thus, heaping Wealth, by the most ready way
Among the *Jews*, which was to Cheat and Pray;
The City, to reward his pious Hate
Against his Master, chose him Magistrate:
His Hand a Vare of Justice did uphold;
His Neck was loaded with a Chain of Gold.
During his Office, Treason was no Crime.
The Sons of *Belial* had a Glorious Time:
For *Shimei*, though not prodigal of pelf,
Yet lov'd his wicked Neighbour as himself:
When two or three were gather'd to declaim
Against the Monarch of *Jerusalem*,
Shimei was always in the midst of them.
And, if they Curst the King when he was by,
Would rather Curse, than break good Company.

If any durst his Factious Friends accuse,
He pact a jury of dissenting *Jews:*
Whose fellow-feeling, in the godly Cause
Would free the suff'ring Saint from Humane **Laws.**
For Laws are onely made to Punish those
Who serve the King, and to protect his Foes.
If any leisure time he had from Pow'r,
(Because 'tis Sin to misimploy an hour;)
His bus'ness was by Writing to persuade
That Kings were Useless, and a Clog to Trade:
And that his noble Stile he might refine,
No *Rechabite* more shund the fumes of Wine.
Chaste were his Cellars; and his Shrieval Board
The Grossness of a City Feast abhor'd:
His Cooks, with long disuse, their Trade forgot;
Cool was his Kitchin, though his Brains were hot.
Such frugal Vertue Malice may accuse;
But sure 'twas necessary to the *Jews:*
For Towns once burnt, such Magistrates require
As dare not tempt Gods Providence by Fire.
With Spiritual Food he fed his Servants well,
But free from Flesh that made the *Jews* rebel:
And *Moses's* Laws he held in more account,
For forty days of Fasting in the Mount.
To speak the rest, who better are forgot,
Would tire a well-breath'd Witness of the Plot:
Yet, *Corah,* thou shalt from Oblivion pass;
Erect thy self thou Monumental Brass:
High as the Serpent of thy Metal made,
While Nations stand secure beneath thy shade.
What though his Birth were base, yet Comets rise
From Earthy Vapours, e'r they shine in Skies.
Prodigious Actions may as well be done
By Weaver's issue as by Prince's son.
This Arch-Attestor for the Publick Good
By that one Deed enobles all his Bloud.
Who ever ask'd the Witnesses high race
Whose Oath with Martyrdom did *Stephen* grace?
Ours was a *Levite,* and as times went then,
His tribe were God-almighties Gentlemen.
Sunk were his Eyes, his Voice was harsh and loud,
Sure signs he neither Cholerick was, nor Proud:
His long Chin prov'd his Wit; his Saint-like Grace
A Church Vermilion, and a *Moses's* Face.

His Memory, miraculously great,
Coud Plots, exceeding mans belief, repeat;
Which, therefore cannot be accounted Lies,
For humane Wit coud never such devise.
Some future Truths are mingled in his Book;
But where the Witness fail'd, the Prophet spoke:
Some things like Visionary flights appear;
The Spirit caught him up, the Lord knows where:
And gave him his *Rabinical* degree,
Unknown to Foreign University.
His Judgment yet his Mem'ry did excel,
Which piec'd his wondrous Evidence so well:
And suited to the temper of the Times;
Then groaning under *Jebusitick* Crimes.
Let *Israels* foes suspect his Heav'nly call,
And rashly judge his Writ Apocryphal;
Our Laws for such affronts have Forfeits made:
He takes his Life, who takes away his Trade.
Were I myself in Witness *Corah's* place,
The Wretch who did me such a dire disgrace
Should whet my memory, though once forgot,
To make him an Appendix of my Plot.
His Zeal to Heav'n, made him his Prince despise,
And load his Person with indignities:
But Zeal peculiar priviledge affords,
Indulging latitude to deeds and words:
And *Corah* might for *Agag's* murther call,
In terms as course as *Samuel* us'd to *Saul*.
What others in his Evidence did join,
(The best that coud be had for love or coin,)
In *Corah's* own predicament will fall
For *Witness* is a Common Name to all.

 Surrounded thus with Friends of every sort,
Deluded *Absalom* forsakes the Court:
Impatient of high hopes, urg'd with renown,
And Fir'd with near possession of a Crown.
The admiring Croud are dazled with surprize
And on his goodly person feed their eyes:
His joy conceal'd, he sets himself to show;
On each side bowing popularly low:
His looks, his gestures, and his words he frames
And with familiar ease repeats their Names.
Thus, form'd by Nature, furnished out with Arts,
He glides unfelt into their secret hearts:

Then with a kind compassionating look,
And sighs, bespeaking pity e'r he spoke.
Few words he said, but easie those and fit,
More slow than Hybla drops, and far more sweet.
 I mourn, my Country-men, your lost Estate,
Though far unable to prevent your Fate:
Behold a Banish'd man, for your dear cause
Expos'd a prey to Arbitrary Laws!
Yet oh! that I alone coud be undone,
Cut off from Empire, and no more a Son!
Now all your Liberties a spoil are made;
Egypt and *Tyrus* intercept your Trade,
And *Jebusites* your Sacred Rites invade.
My Father, whom with reverence yet I name,
Charm'd into Ease, is careless of his Fame:
And, brib'd with petty sums of Foreign Gold,
Is grown in *Bathsheba's* Embraces old:
Exalts his Enemies, his Friends destroys,
And all his pow'r against himself imploys.
He gives, and let him give my right away;
But why should he his own and yours betray?
He onely, he can make the Nation bleed,
And he alone from my revenge is freed.
Take then my tears (with that he wiped his Eyes)
'Tis all the Aid my present pow'r supplies:
No Court-Informer can these Arms accuse;
These Arms may Sons against their Fathers use;
And, 'tis my wish, the next Successor's reign
May make no other *Israelite* complain.

 Youth, Beauty, Graceful Action seldom fail:
But Common Interest always will prevail:
And pity never Ceases to be shown
To him, who makes the Peoples wrongs his own.
The Croud, (that still believe their Kings oppress,)
With lifted hands their young *Messiah* bless:
Who now begins his Progress to ordain
With Chariots, Horsemen, and a num'rous train;
From East to West his Glories he displays:
And, like the Sun, the Promis'd Land surveys.
Fame runs before him as the Morning-Star,
And shouts of Joy salute him from afar:
Each house receives him as a Guardian God;
And Consecrates the Place of his abode:

But hospitable Treats did most commend
Wise *Issachar,* his wealthy Western Friend.
This moving Court that caught the Peoples Eyes,
And seem'd but Pomp, did other Ends disguise:
Achitophel had form'd it, with intent
To sound the depths, and fathom where it went,
The Peoples hearts distinguish Friends from Foes;
And trie their strength before they came to Blows.
Yet all was colour'd with a smooth pretence
Of specious love, and duty to their Prince.
Religion, and Redress of Grievances,
Two names, that always cheat and always please,
Are often urg'd; and good King *David's* life
Endanger'd by a Brother and a Wife.
Thus, in a Pageant Shew, a Plot is made;
And Peace it self is War in Masquerade.
Oh foolish *Israel!* never warn'd by Ill:
Still the same Bait, and circumvented still!
Did ever men forsake their present ease,
In midst of health imagine a Disease;
Take pains Contingent mischiefs to foresee,
Make Heirs for Monarchs, and for God decree?
What shall we think! Can People give away
Both for themselves and Sons their Native sway?
Then they are left Defenceless, to the Sword
Of each unbounded, Arbitrary Lord:
And Laws are vain, by which we Right enjoy,
If Kings unquestion'd can those Laws destroy.
Yet if the Croud be Judge of Fit and Just,
And Kings are onely Officers in Trust,
Then this resuming Cov'nant was declar'd
When Kings were made, or is for ever bar'd:
If those who gave the Scepter, coud not tie
By their own Deed their own Posterity,
How then coud *Adam* bind his future Race?
How coud his Forfeit on Mankind take place?
Or how coud heavenly Justice damn us all
Who ne'r consented to our Fathers Fall?
Then Kings are Slaves to those whom they command,
And Tenants to their Peoples pleasure stand.
Add that the Pow'r, for Property allow'd,
Is mischievously seated in the Croud;
For who can be secure of private Right,
If Sovereign Sway may be dissolv'd by Might?

Nor is the Peoples Judgment always true:
The Most may err as grosly as the Few.
And faultless Kings run down, by Common Cry,
For Vice, Oppression, and for Tyranny.
What Standard is there in a fickle rout,
Which, flowing to the Mark, runs faster out?
Nor onely crouds, but Sanhedrins may be
Infected with this publick Lunacy:
And Share the madness of Rebellious Times,
To Murther Monarchs for Imagin'd crimes.
If they may Give and Take when e'r they please,
Not Kings alone, (the Godheads Images,)
But Government it self at length must fall
To Natures state, where all have Right to all.
Yet, grant our Lords the People, Kings can make,
What prudent men a setled Throne woud shake?
For whatsoe'r their Sufferings were before,
That Change they Covet makes them suffer more.
All other Errors but disturb a State;
But Innovation is the Blow of Fate.
If ancient Fabricks nod, and threat to fall,
To Patch the Flaws, and Buttress up the Wall,
Thus far 'tis Duty; but here fix the Mark:
For all beyond it is to touch our Ark.
To change Foundations, cast the Frame anew,
Is work for Rebels who base Ends pursue:
At once Divine and Humane Laws controul,
And mend the Parts by ruine of the Whole.
The tamp'ring World is subject to this Curse,
To Physick their Disease into a Worse.

Now what Relief can Righteous *David* bring?
How Fatal 'tis to be too good a King!
Friends he has few, so high the madness grows;
Who dare be such, must be the People's Foes:
Yet some there were ev'n in the worst of days;
Some let me name, and Naming is to praise.

In this short File *Barzillai* first appears;
Barzillai crown'd with Honour and with Years:
Long since, the rising Rebels he withstood
In Regions Waste, beyond the *Jordans* Flood:
Unfortunately Brave to buoy the State;
But sinking underneath his Master's Fate:

In Exile with his God-like Prince he Mourn'd,
For him he Suffer'd, and with him Return'd.
The Court he practis'd, not the Courtier's Art:
Large was his Wealth, but larger was his Heart:
Which, well the Noblest Objects knew to chuse,
The Fighting Warriour, and Recording Muse.
His Bed coud once a Fruitful Issue boast:
Now more than half a Father's Name is lost.
His Eldest Hope, with every Grace adorn'd,
By me (so Heav'n will have it) always Mourn'd
And always honour'd, snatch'd in manhoods prime
B' unequal Fates and Providences crime:
Yet not before the Goal of Honour won,
All Parts fulfill'd of Subject and of Son;
Swift was the Race, but short the Time to run.
Oh Narrow Circle, but of Pow'r Divine,
Scanted in Space, but perfect in thy Line!
By Sea, by Land, the Matchless Worth was known;
Arms thy Delight, and War was all thy Own:
Thy force, Infus'd, the fainting *Tyrians* prop'd;
And haughty *Pharaoh* found his Fortune stop'd.
Oh Ancient Honour, Oh unconquered Hand,
Whom Foes unpunish'd never coud withstand!
But *Israel* was unworthy of thy Name:
Short is the date of all Immoderate Fame.
It looks as Heav'n our Ruine had design'd,
And durst not trust thy Fortune and thy Mind.
Now, free from Earth, thy disencumbred Soul
Mounts up, and leaves behind the Clouds and Starry Pole:
From thence thy kindred Legions maist thou bring,
To aid the Guardian Angel of thy King.
Here stop my Muse, here cease thy painful flight;
No pinions can pursue Immortal height:
Tell good *Barzillai* thou canst sing no more,
And tell thy Soul she should have fled before;
Or fled she with his life, and left this Verse
To hang on her departed Patron's Herse?
Now take thy steepy flight from Heav'n, and see
If thou canst find on Earth another *He;*
Another he would be too hard to find;
See then whom thou canst see not far behind.
Zadock the priest, whom, shunning Pow'r and Place,
His lowly mind advanc'd to *David's* Grace:
With him the *Sagan* of *Jerusalem,*
Of hospitable Soul and noble Stem;

Him of the Western dome, whose weighty sense
Flows in fit words and heavenly eloquence.
The Prophets Sons, by such Example led,
To Learning and to Loyalty were bred:
For *Colleges* on bounteous Kings depend,
And never Rebel was to Arts a Friend.
To these succeed the Pillars of the Laws,
Who best coud plead, and best can judge a Cause.
Next them a train of Loyal Peers ascend:
Sharp judging *Adriel*, the Muses Friend,
Himself a Muse:—In Sanhedrins debate
True to his Prince, but not a Slave of State.
Whom *David's* love with Honours did adorn,
That from his disobedient Son were torn.
Jotham of piercing Wit and pregnant Thought,
Endew'd by nature and by learning taught
To move Assemblies, who but onely tri'd
The worse a while, then chose the better side;
Nor chose alone, but turned the Balance too;
So much the weight of one brave man can do.
Hushai the friend of *David* in distress,
In publick storms of manly stedfastness;
By Foreign Treaties he inform'd his Youth;
And join'd Experience to his Native Truth.
His frugal care suppli'd the wanting Throne;
Frugal for that, but bounteous of his own:
'Tis easie Conduct when Exchequers flow;
But hard the task to manage well the low:
For Sovereign Power is too deprest or high,
When Kings are forced to sell, or Crouds to buy.
Indulge one labour more, my weary Muse,
For *Amiel;* who can *Amiel's* praise refuse?
Of ancient race by birth, but nobler yet
In his own worth, and without Title great:
The Sanhedrin long time as Chief he rul'd,
Their Reason guided, and their Passion cool'd:
So dextrous was he in the Crown's defence,
So form'd to speak a Loyal Nations Sense,
That, as their Band was *Israels* Tribes in small,
So fit was he to represent them all.
Now rasher Charioteers the Seat ascend,
Whose loose Carriers his steady Skill commend:
They, like th' unequal Ruler of the Day,
Misguide the Seasons, and mistake the Way;

While he withdrawn at their mad Labour smiles
And safe enjoys the Sabbath of his Toils.

These were the chief; a small but faithful Band
Of Worthies in the Breach who dar'd to stand
And tempt th' united Fury of the Land.
With grief they view'd such powerful Engines bent
To batter down the lawful Government.
A numerous Faction with pretended frights,
In Sanhedrins to plume the Regal Rights.
The true Successor from the Court removed:
The plot, by hireling Witnesses improv'd.
These Ills they saw, and, as their Duty bound,
They shew'd the King the danger of the Wound:
That no Concessions from the Throne woud please;
But Lenitives fomented the Disease;
That *Absalom,* ambitious of the Crown,
Was made the Lure to draw the People down:
That false *Achitophel's* pernitious Hate
Had turn'd the Plot to ruine Church and State;
The Council violent, the Rabble worse:
That *Shimei* taught *Jerusalem* to Curse.

With all these loads of Injuries opprest,
And long revolving in his careful Brest
Th' event of things; at last his patience tir'd,
Thus from his Royal Throne, by Heav'n inspir'd,
The God-like *David* spoke; with awful fear
His Train their Maker in their Master hear.

Thus long have I by Native Mercy sway'd,
My Wrongs dissembl'd, my Revenge delay'd;
So willing to forgive th' Offending Age;
So much the Father did the King asswage.
But now so far my Clemency they slight,
Th' Offenders question my Forgiving Right.
That one was made for many, they contend;
But 'tis to Rule, for that's a Monarch's End.
They call my tenderness of Blood, my Fear,
Though Manly tempers can the longest bear.
Yet since they will divert my Native course,
'Tis time to show I am not Good by Force.
Those heap'd Affronts that haughty Subjects bring,
Are burdens for a Camel, not a King:

Kings are the publick Pillars of the State,
Born to sustain and prop the Nations weight:
If my young *Sampson* will pretend a Call
To shake the Column, let him share the Fall:
But oh that yet he woud repent and live!
How easie 'tis for Parents to forgive!
With how few Tears a Pardon might be won
From Nature, pleading for a Darling Son!
Poor pitied youth, by my Paternal care,
Rais'd up to all the Height his Frame coud bear:
Had God ordain'd his Fate for Empire born,
He woud have giv'n his Soul another turn:
Gull'd with a Patriot's name, whose Modern sense
Is one that woud by Law supplant his Prince:
The Peoples Brave, the Politicians Tool;
Never was Patriot yet, but was a Fool.
Whence comes it that Religion and the Laws
Should more be *Absalom's* than *David's* Cause?
His old Instructor, e'r he lost his Place,
Was never thought indu'd with so much Grace.
Good heav'ns, how Faction can a Patriot Paint!
My Rebel ever proves my Peoples Saint:
Woud *They* impose an Heir upon the Throne?
Let Sanhedrins be taught to give their Own.
A king's at least a part of Government;
And mine as requisite as their Consent:
Without my leave a future King to choose,
Infers a Right the present to Depose:
True, they petition me t' approve their Choice:
But *Esau's* Hands suit ill with *Jacob's* Voice.
My Pious Subjects for my Safety pray,
Which to Secure, they take my Pow'r away.
From Plots and Treasons Heav'n preserve my Years,
But save me most from my Petitioners.
Unsatiate as the barren Womb or Grave;
God cannot Grant so much as they can Crave.
What then is left but with a Jealous Eye
To guard the Small remains of Royalty?
The Law shall still direct my peaceful Sway,
And the same Law teach Rebels to obey:
Votes shall no more Established Pow'r controul,
Such Votes as make a Part exceed the Whole:
No groundless Clamours shall my Friends remove
Nor Crouds have pow'r to Punish e'r they Prove;

For Gods and God-like kings their Care express,
Still to defend their Servants in distress.
Oh that my Pow'r to Saving were confin'd:
Why am I forc'd, like Heav'n, against my mind,
To make Examples of another Kind?
Must I at length the Sword of Justice draw?
Oh curst Effects of necessary Law!
How ill my Fear they by my Mercy scan,
Beware the Fury of a Patient Man.
Law they require, let Law then shew her Face;
They could not be content to look on Grace,
Her hinder parts, but with a daring Eye
To tempt the terror of her Front, and Die.
By their own Arts 'tis Righteously decreed,
Those dire Artificers of Death shall bleed.
Against themselves their Witnesses will Swear,
Till, Viper-like, their Mother Plot they tear,
And suck for Nutriment that bloudy gore
Which was their Principle of Life before.
Their *Belial* with their *Belzebub* will fight;
Thus on my Foes, my Foes shall do me Right.
Nor doubt th' event; for Factious crouds engage
In their first Onset, all their Brutal Rage;
Then let 'em take an unresisted Course;
Retire and Traverse, and Delude their Force:
But when they stand all Breathless, urge the fight,
And rise upon 'em with redoubled might:
For Lawful Pow'r is still Superiour found,
When long driv'n back, at length it stands the ground.

He said. Th' Almighty, nodding, gave consent;
And peals of Thunder shook the Firmament.
Henceforth a Series of new time began,
The mighty Years in long Procession ran:
Once more the God-like *David* was Restor'd,
And willing Nations knew their Lawful Lord.

(1681)

In 1822 Byron wrote THE VISION OF JUDGEMENT * *. . . . with*
ABSALOM AND ACHITOPHEL, *the greatest political satire in our language.*
HERBERT J. C. GRIERSON and J. C. SMITH
A Critical History of English Poetry (1944)

* For an extract from *The Vision of Judgment,* see page 1089.

807

RELIGIO LAICI

Dim, as the borrow'd beams of Moon and Stars
To *lonely, weary, wandring* Travellers
Is *Reason* to the *Soul:* And as on high
Those rowling Fires *discover* but the Sky
Not light us *here;* So *Reason's* glimmering Ray
Was lent, not to *assure* our *doubtfull* way,
But *guide* us upward to a *better Day.*
And as those nightly Tapers disappear
When Day's bright Lord ascends our Hemisphere;
So pale grows *Reason* at *Religions* sight;
So *dyes,* and so *dissolves* in *Supernatural Light.*
Some few, whose Lamp shone brighter, have been led
From Cause to Cause to *Natures* secret head;
And found that *one first principle* must be;
But *what,* or *who,* that UNIVERSAL HE;
Whether some *Soul* incompassing this Ball,
Unmade, unmov'd; yet *making, moving All;*
Or various *Atom's,* interfering Dance
Leapt into *Form* (the Noble work of *Chance,*)
Or this great *All* was from *Eternity;*
Not ev'n the *Stagirite* himself could see;
And *Epicurus Guess'd* as well as He.
As *blindly grop'd* they for a *future State,*
As *rashly Judg'd* of *Providence* and *Fate:*
But least of all could their Endeavours find
What most concern'd the good of Humane kind:
For *Happiness* was never to be found;
But vanish'd from 'em, like Enchanted ground.
One thought *Content* the Good to be enjoyed:
This, every little *Accident* destroyed:
The *wiser Madmen* did for *Vertue* toyl,
A Thorny, or at best a barren Soil:
In *Pleasure* some their glutton Souls would steep,
But found their Line too short, the Well too deep,
And leaky Vessels which no *Bliss* cou'd keep.
Thus, *anxious Thoughts* in *endless Circles* roul,
Without a *Centre* where to fix the *Soul:*
In this wilde Maze their vain Endeavours end:
How can the *less* the *Greater* comprehend?

Or *finite Reason* reach *Infinity?*
For what cou'd *Fathom* GOD were *more* than *He.*

 The *Deist* thinks he stands on firmer ground,
Cries εὕρεκα: the mighty Secret's found:
God is that *Spring* of *Good; Supreme* and *Best,*
We, made to *serve,* and in that Service *blest;*
If so, some *Rules* of Worship must be given,
Distributed alike to all by Heaven:
Else *God* were *partial,* and to *some* deny'd
The Means His Justice shou'd for *all* provide.
This *general Worship* is to PRAISE, and PRAY:
One part to *borrow* Blessings, one to *pay:*
And when frail Nature slides into *Offence,*
The *Sacrifice* for *Crimes* is *Penitence.*
Yet, since th' Effects of Providence, we find
Are variously dispensed to Humane kind;
That *Vice Triumphs* and *Vertue suffers* here,
(A Brand that Sovereign justice cannot bear;)
Our Reason prompts us to a *future* State,
The *last Appeal* from *Fortune,* and from *Fate,*
Where God's all-righteous ways will be declar'd,
The *Bad* meet *Punishment,* the *Good, Reward.*

 Thus Man by his own strength to Heaven wou'd soar:
And wou'd not be Obliged to God for more.
Vain, wretched Creature, how art thou misled
To think thy Wit these God-like notions bred!
These Truths are not the product of thy Mind,
But dropt from Heaven, and of a Nobler kind.
Reveal'd Religion first inform'd thy sight,
And *Reason* saw not till *Faith* sprung the Light.
Hence all thy *Natural Worship* takes the *Source:*
'Tis *Revelation* what thou thinkst *Discourse.*
Else how com'st *Thou* to see these truths so clear,
Which so obscure to *Heathens* did appear?
Not *Plato* these, nor *Aristotle* found.
Nor He whose wisedom *Oracles* renown'd.
Hast thou a Wit so deep, or so sublime,
Or canst thou lower dive, or higher climb?
Canst *Thou,* by *Reason,* more of *God-head* know
Than *Plutarch, Seneca,* or *Cicero?*
Those Gyant Wits, in happyer Ages born,
(When *Arms,* and *Arts* did *Greece* and *Rome* adorn,)

Knew no such *Systeme:* no such Piles cou'd raise
Of *Natural Worship,* built on *Pray'r* and *Praise,*
To One sole GOD:
Nor did Remorse, to Expiate Sin, prescribe:
But slew their fellow Creatures for a Bribe:
The guiltless *Victim* groan'd for their Offence;
And *Cruelty* and *Blood,* was *Penitence.*
If *Sheep* and *Oxen* cou'd Attone for Men
Ah! at how cheap a rate the *Rich* might Sin!
And great Oppressours might Heavens Wrath beguile
By offering his own Creatures for a Spoil!

 Dar'st thou, poor Worm, offend *Infinity?*
And must the Terms of Peace be given by *Thee?*
Then *Thou* art *Justice* in the *last Appeal;*
Thy easie God instructs Thee to *rebell:*
And, like a King remote, and weak, must take
What Satisfaction *Thou* art pleased to make.

 But if there be a *Pow'r* too *Just,* and *strong*
To wink at *Crimes* and bear unpunish'd *Wrong;*
Look humbly upward, see his Will disclose
The *Forfeit* first, and then the *Fine* impose
A *Mulct thy* poverty cou'd never pay
Had not *Eternal Wisedom* found the way
And with Cœlestial Wealth supply'd thy Store;
His Justice makes the *Fine, his Mercy* quits the *Score.*
See God descending in thy Humane Frame;
Th' *offended,* suffering in th' *Offenders* name:
All thy Misdeeds to Him imputed see,
And all his Righteousness devolv'd on thee.

 For granting we have Sin'd, and that th' offence
Of *Man,* is made against *Omnipotence,*
Some Price, that bears *proportion,* must be paid
And *Infinite* with *Infinite* be weigh'd.
See then the *Deist lost: Remorse* for *Vice*
Not paid, or *paid, inadequate* in price:
What farther means can *Reason* now direct,
Or what Relief from *humane Wit* expect?
That shews us *sick;* and sadly are we sure
Still to be Sick, till *Heav'n* reveal the *Cure:*
If then *Heaven's Will* must needs be understood,
(Which must, if we want *Cure,* and *Heaven* be *Good,*)

810

Let all Records of *Will reveal'd* be shown;
With *Scripture,* all in equal ballance thrown,
And *our one Sacred Book* will be *That one.*

 Proof needs not here; for whether we compare
That Impious, Idle, Superstitious Ware
Of *Rites, Lustrations, Offerings,* (which before,
In various Ages, various Countries bore,)
With *Christian Faith and Vertues,* we shall find
None answ'ring the great ends of humane kind,
But *This one rule of Life;* That shews us best
How *God* may be *appeas'd,* and *mortals blest.*
Whether from length of *Time* its worth we draw,
The *World* is scarce more *Ancient* than the *Law:*
Heav'ns early Care prescrib'd for every Age;
First, in the *Soul,* and after, in the *Page.*
Or, whether more abstractedly we look,
Or on the *Writers,* or the *written* Book,
Whence, but from *Heav'n* cou'd men, unskilled in Arts,
In several Ages born, in several parts,
Weave such *agreeing Truths?* or *how* or *why*
Shou'd *all* conspire to cheat us with a *Lye?*
Unask'd their *Pains, ungratefull* their *Advice,*
Starving their *Gain* and *Martyrdom* their *Price.*

 If on the Book itself we cast our view,
Concurrent Heathens prove the Story *True:*
The *Doctrine, Miracles;* which must convince,
For *Heav'n* in *Them* appeals to *humane Sense;*
And though they *prove* not, they *Confirm* the Cause,
When what is *Taught* agrees with *Natures Laws.*

 Then for the *Style, Majestick* and *Divine,*
It speaks no less than God in every Line;
Commanding words; whose *Force* is still the same
As the first *Fiat* that produc'd our Frame.
All Faiths *beside,* or did by *Arms* ascend;
Or *Sense* indulg'd has made *Mankind* their *Friend;*
This *onely* Dⱻctrine does our *Lusts* oppose:
Unfed by Natures Soil, in which it grows;
Cross to our *Interests,* curbing Sense and Sin;
Oppress'd without, and undermin'd within,
It thrives through pain; its own Tormentours tires;
And with a stubborn patience still aspires.

To what can *Reason* such Effects assign,
Transcending *Nature*, but to *Laws Divine?*
Which in that Sacred Volume are contain'd;
Sufficient, clear, and for that use ordained.

But stay: the *Deist* here will urge anew,
No *Supernatural Worship* can be *True:*
Because a *general Law* is that alone
Which must to *all* and every *where* be known:
A Style so large as not *this* Book can claim,
Nor aught that bears *reveal'd* Religions *Name.*
'Tis said the sound of a *Messiah's Birth*
Is gone through all the habitable Earth:
But still that Text must be confin'd alone
To what was *Then* inhabited, and known:
And what Provision could from *thence* accrue
To *Indian* Souls, and Worlds discovered *New?*
In other parts it helps, that Ages past,
The Scriptures there were *known,* and were *imbrac'd,*
Till Sin spread once again the Shades of Night:
What's that to these who never *saw* the Light?

Of all Objections this indeed is chief
To startle Reason, stagger frail Belief:
We grant, 'tis true, that Heav'n from humane Sense
Has hid the secret paths of *Providence;*
But *boundless Wisedom, boundless Mercy,* may
Find ev'n for those *be-wildred* Souls, a *way:*
If from his *Nature Foes* may Pity claim,
Much more may *Strangers* who ne'er heard his *Name.*
And though *no Name* be for *Salvation* known,
But that of His *Eternal Sons* alone;
Who knows how far transcending Goodness can
Extend the *Merits* of *that Son* to *Man?*
Who knows what *Reasons* may his *Mercy* lead;
Or *Ignorance invincible* may plead?
Not onely *Charity* bids hope the *best,*
But *more* the great Apostle has exprest:
That, if the Gentiles, (whom no Law inspir'd,)
By Nature did what was by *Law required,*
They, who the written Rule had never known,
Were to themselves both Rule and Law alone:
To Natures plain indictment they shall plead;
And, by their Conscience, be condemn'd or freed.

Most Righteous Doom! because a *Rule reveal'd*
Is *none* to *Those*, from whom it was *conceal'd*.
Then those who follow'd *Reasons* Dictates right;
Liv'd up, and lifted high their *Natural Light;*
With *Socrates* may see their Maker's Face,
While Thousand *Rubrick-Martyrs* want a place.

Nor does it baulk my Charity to find
Th' *Egyptian* Bishop of another mind:
For, though his *Creed Eternal Truth* contains,
'Tis hard for *Man* to doom to *endless pains*
All who believ'd not all, his Zeal requir'd;
Unless he first cou'd prove he was inspir'd.
Then let us either think he meant to say
This Faith, where *publish'd*, was the onely way;
Or else conclude that, *Arius* to confute,
The good old Man, too eager in dispute,
Flew high; and, as his *Christian* Fury rose,
Damn'd all for *Hereticks* who durst *oppose*.

Thus far my Charity this path has try'd,
(A much unskilfull, but well meaning guide:)
Yet what they are, even these crude thoughts were bred
By reading that, which better thou hast read,
Thy Matchless Author's work: which thou, my Friend,
By well translating better dost commend:
Those youthfull hours, which of thy Equals most
In *Toys* have *squander'd*, or in Vice have *lost*,
Those hours hast thou to Nobler use employ'd;
And the severe Delights of Truth enjoy'd.
Witness this weighty Book, in which appears
The crabbed Toil of many thoughtfull years,
Spent by thy Authour in the Sifting Care
Of *Rabbins'* old Sophisticated Ware
From Gold Divine, which he who well can sort
May afterwards make *Algebra* a Sport.
A Treasure which, if *Country-Curates* buy,
They *Junius*, and *Tremellius* may defy:
Save pains in various readings, and Translations,
And without *Hebrew* make most learn'd quotations.
A Work so full with various Learning fraught,
So nicely pondred, yet so strongly wrought,
As Natures height and Arts last hand requir'd:
As much as Man cou'd compass, uninspir'd.

Where we may see what *Errours* have been made
Both in the *Copiers* and *Translaters Trade:*
How *Jewish, Popish,* Interests have prevail'd,
And where *Infallibility* has *fail'd.*

 For some, who have his secret meaning ghes'd,
Have found our Authour not too *much* a *Priest;*
For *Fashion-sake* he seems to have recourse
To *Pope,* and *Councils,* and *Traditions* force:
But he that *old* Traditions cou'd subdue,
Cou'd not but find the weakness of the *New:*
If *Scripture,* though deriv'd from *heav'nly birth,*
Has been but carelessly preserved on *Earth;*
If *God's own People,* who of *God* before
Knew what we know, and had been promis'd more,
In fuller Terms of Heaven's assisting Care,
And who did neither *Time,* nor *Study* spare
To keep this Book *untainted, unperplext;*
Let in gross *Errours* to corrupt the *Text,*
Omitted *paragraphs,* embroyl'd the *Sense,*
With vain *Traditions* stopt the gaping Fence,
Which every common hand pull'd up with ease:
What Safety from such *brushwood-helps* as these?
If *written words* from time are not secur'd,
How can we think have *oral Sounds* endur'd?
Which *thus* transmitted, if *one* Mouth has fail'd,
Immortal Lyes on *Ages* are intail'd;
And that some such have been, is prov'd too plain;
If we consider *Interest, Church,* and *Gain.*

 Oh but, says one, *Tradition* set aside,
Where can we hope for an *unerring Guid?*
For since th' *original* Scripture has been lost,
All Copies *disagreeing, maim'd* the *most,*
Or *Christian Faith* can have no *certain* ground
Or *Truth* in *Church Tradition* must be found.

 Such an *Omniscient* Church we wish indeed;
'Twere worth *Both Testaments,* and cast in the *Creed:*
But if *this Mother* be a *Guid* so sure
As can all *doubts resolve,* all *truth secure,*
Then her *Infallibility,* as well
Where Copies are *corrupt,* or *lame,* can tell;
Restore *lost Canon* with as little pains,
As *truly explicate* what still *remains:*

Which yet no *Council* dare *pretend* to doe;
Unless like *Esdras,* they could *write* it new:
Strange Confidence, still to *interpret* true,
Yet not be sure that all they have explain'd,
Is in the blest *Original* contain'd.
More Safe, and much more modest 'tis to say
God wou'd not leave Mankind without a way:
And that the *Scriptures,* though not *every where*
Free from Corruption, or intire, or clear,
Are uncorrupt, sufficient, clear, intire,
In all things which our needfull *Faith* require.
If *others* in the *same Glass better* see,
'Tis for *Themselves* they look, but not for *me:*
For MY Salvation must its Doom receive
Not from what OTHERS, but what I believe.

 Must *all tradition* then be set aside?
This to affirm were Ignorance or Pride.
Are there not many points, some needfull sure
To saving Faith, that Scripture leaves obscure?
Which every Sect will wrest a several way
(For what *one* Sect interprets, *all* Sects *may:*)
We hold, and say we prove from Scripture plain,
That *Christ* is GOD; the bold *Socinian*
From the *same* Scripture urges he's but MAN.
Now what Appeal can end th' important Suit;
Both parts *talk* loudly, but the *Rule* is *mute.*

 Shall I speak plain, and in a Nation free
Assume an honest *Layman's Liberty?*
I think (according to my little Skill,)
To my own Mother-Church submitting still)
That many have been sav'd, and many may,
Who never heard this Question brought in play.
Th' *unletter'd* Christian, who believes in *gross,*
Plods on to *Heaven* and ne'er is at a loss:
For the *Streight-gate* would be made *streighter* yet,
Were *none* admitted there but men of *Wit.*
The few, by Nature form'd, with Learning fraught,
Born to instruct, as others to be taught,
Must Study well the Sacred Page; and see
Which Doctrine, this, or that, does best agree
With the whole *Tenour* of the Work Divine:
And plainlyest points to Heaven's reveal'd Design:

Which Exposition flows from *genuine Sense;*
And which is *forc'd* by *Wit* and *Eloquence.*
Not that Traditions parts are useless here:
When general, old, disinteress'd and clear:
That Ancient Fathers thus expound the Page
Gives *Truth* the reverend Majesty of *Age,*
Confirms its force by biding every *Test;*
For best *Authority's,* next *Rules,* are best.
And still the nearer to the Spring we go
More limpid, more unsoyl'd, the Waters flow.
Thus, *first Traditions* were a proof alone;
Cou'd we be *certain* such they *were,* so *known:*
But since some Flaws in long descent may be,
They make not *Truth* but *Probability.*
Even *Arius* and *Pelagius* durst provoke
To what the *Centuries preceding* spoke.
Such difference is there in an oft-told Tale:
But Truth by its own Sinews will prevail.
Tradition written therefore more commends
Authority, than what from *Voice* descends:
And this, as perfect as its kind can be,
Rouls down to us the Sacred History:
Which, from the *Universal Church* receiv'd,
Is *try'd,* and *after* for its *self* believed.

 The partial *Papists* wou'd infer from hence,
Their Church, in last resort, shou'd Judge the *Sense.*
But first they would assume, with wondrous Art,
Themselves to be the *whole,* who are but *part*
Of that vast Frame, the Church; yet grant they were
The handers down, can they from thence infer
A right t' interpret? or wou'd they alone
Who brought the Present claim it for their own?
The *Book's* a *Common Largess* to *Mankind;*
Not more for *them* than *every* Man design'd;
The *welcome News* is in the *Letter* found;
The *Carrier's* not Commission'd to *expound.*
It *speaks* it *Self,* and what it does contain,
In all things *needfull* to be *known,* is *plain.*

 In times o'ergrown with Rust and Ignorance,
A gainfull Trade their Clergy did advance:
When want of Learning kept the *Laymen* low,
And none but *Priests* were *Authoriz'd* to *know;*

When what small Knowledge was, in them did **dwell;**
And he a *God* who cou'd but *Reade* or *Spell;*
Then *Mother Church* did mightily prevail:
She parcel'd out the Bible by *retail:*
But still *expounded* what She *sold* or *gave;*
To keep it in *her Power* to *Damn* and *Save:*
Scripture was *scarce,* and as the Market went,
Poor *Laymen* took *Salvation* on *Content;*
As needy men take Money, good or bad:
God's Word they had not, but the *Priests* they had.
Yet, whate'er *false Conveyances* they made,
The *Lawyer* still was *certain* to be paid.
In those dark times they learn'd their knack so well,
That by long use they grew *Infallible:*
At last, a knowing Age began t' enquire
If *they* the *Book,* or *That* did *them* inspire:
And, making narrower search they found, thô' late,
That what they thought the *Priest's* was *Their Estate,*
Taught by the *Will produc'd,* (the written Word,)
How long they had been *cheated* on *Record.*
Then, every man who saw the title fair,
Claim'd a Child's part, and put in for a Share:
Consulted Soberly his private good;
And sav'd himself as cheap as e'er he cou'd.

 'Tis true, my Friend, (and far be Flattery hence)
This good had full as bad a Consequence:
The Book thus put in every vulgar hand,
Which each presum'd he best cou'd understand,
The *Common Rule* was made the *common Prey;*
And at the mercy of the *Rabble* lay.
The tender Page with horney Fists was gaul'd;
And he was gifted most that loudest baul'd;
The *Spirit* gave the *Doctoral Degree,*
And every member of a *Company*
Was of *his Trade* and of the *Bible free.*
Plain *Truths* enough for needfull *use* they found;
But men wou'd still be itching to *expound;*
Each was ambitious of th' obscurest place,
No measure ta'n from *Knowledge,* all from GRACE.
Study and *Pains* were now no more their Care;
Texts were explain'd by *Fasting* and by *Prayer:*
This was the Fruit the *private Spirit* brought;
Occasion'd by *great Zeal* and *little Thought.*

While Crouds unlearn'd, with rude Devotion warm,
About the Sacred Viands buz and swarm,
The *Fly-blown Text* creates a *crawling Brood;*
And turns to *Maggots* what was meant for *Food.*
A *Thousand daily Sects rise up, and dye;*
A *Thousand more the perish'd Race supply:*
So all we make of Heavens discover'd Will
Is, not to have it, or to use it ill.
The Danger's much the same; on several Shelves
If *others* wreck *us* or *we* wreck our *selves.*

 What then remains, but, waving each Extreme,
The Tides of Ignorance, and Pride to stem?
Neither so rich a Treasure to forgo;
Nor proudly seek beyond our pow'r to know:
Faith is not built on disquisitions vain;
The things we *must* believe, are *few* and *plain:*
But since men *will* believe more than they *need;*
And very man will make *himself* a Creed,
In doubtful questions 'tis the safest way
To learn what unsuspected Ancients say:
For 'tis not likely *we* should higher Soar
In search of Heav'n than *all the Church before:*
Nor can we be deceiv'd, unless we see
The *Scripture* and the *Fathers disagree.*
If after all, they stand suspected still,
(For no man's Faith depends upon his Will;)
'Tis some Relief, that points not clearly known,
Without much hazard may be let alone:
And after hearing what our Church can say,
If still our Reason runs another way,
That private Reason 'tis more Just to curb,
Than by Disputes the publick Peace disturb.
For points obscure are of small use to learn:
But *Common quiet* is *Mankind's concern.*

 Thus have I made my own Opinions clear:
Yet neither Praise expect, not Censure fear:
And this unpolish'd, rugged Verse I chose;
As fittest for Discourse, and nearest prose;
For while from *Sacred Truth* I do not swerve,
Tom Sternhold's or *Tom Sha—ll's Rhimes* will serve.

(1682)

818

The RELIGIO LAICI *is one of the most admirable poems in the language. The argumentative part is conducted with singular skill, upon those topics which occasioned the principal animosity between the religious sects; and the deductions are drawn in favour of the church of England with so much apparent impartiality, that those who could not assent, had at least no title to be angry. The opinions of the various classes of free-thinkers are combated by an appeal to those feelings of the human mind, which always acknowledge an offended Deity, and to the various modes in which all ages and nations have shewn their sense of the necessity of an atonement by sacrifice and penance. . . .*

The doctrine of the RELIGIO LAICI *is admirably adapted to the subject; though treating of the most abstruse doctrines of Christianity, it is as clear and perspicuous as the most humble prose, while it has all the elegance and effect which argument is capable of receiving from poetry. Johnson, usually sufficiently niggard of praise, has allowed, that this "is a composition of great excellence in its kind, in which the familiar is very properly diversified with the solemn, and the grave with the humorous; in which metre has neither weakened the force, nor clouded the perspicuity of argument; nor will it be easy to find another example, equally happy, of this middle kind of writing, which, though prosaic in some parts, rises to high poetry in others, and neither towers to the skies, nor creeps along the ground."*

<div align="right">

SIR WALTER SCOTT
The Works of John Dryden (1821)

</div>

JOHN DRYDEN

1 6 3 1 — 1 7 0 0

TO THE MEMORY OF MR. OLDHAM

Farewell, too little and too lately known,
Whom I began to think and call my own:
For sure our Souls were near alli'd, and thine
Cast in the same poetick mold with mine.
One common Note on either Lyre did strike,
And Knaves and Fools we both abhorr'd alike.
To the same Goal did both our Studies drive:
The last set out the soonest did arrive.
Thus *Nisus* fell upon the slippery place,
Whilst his young Friend perform'd and won the Race.

O early ripe! to thy abundant Store
What could advancing Age have added more?
It might (what Nature never gives the Young)
Have taught the Numbers of thy Native Tongue.
But Satire needs not those, and Wit will shine
Through the harsh Cadence of a rugged Line.
A noble Error, and but seldom made,
When Poets are by too much force betray'd.
Thy gen'rous Fruits, though gather'd ere their prime,
Still shew'd a Quickness; and maturing Time
But mellows what we write to the dull Sweets of Rhyme.
Once more, hail, and farewell! farewell, thou young,
But ah! too short, *Marcellus* of our Tongue!
Thy Brows with Ivy and with Laurels bound;
But Fate and gloomy Night encompass thee around.

(1684)

He was partial to literary history and literary parallels as subjects for
poems, and no one in English has done better criticism in metre.

MARK VAN DOREN
The Poetry of John Dryden (1920)

JOHN DRYDEN

1631 — 1700

TO THE PIOUS MEMORY OF THE ACCOMPLISHT YOUNG LADY MRS. ANNE KILLIGREW,

EXCELLENT IN THE TWO SISTER-ARTS OF POESIE AND PAINTING. *AN ODE.*

1

Thou youngest Virgin-Daughter of the Skies,
 Made in the last Promotion of the *Blest;*
Whose Palms, new pluckt from Paradise,
In spreading *Branches* more sublimely rise,
 Rich with Immortal Green above the rest:
Whether, adopted to some Neighbouring Star,
Thou rol'st above us in thy wand'ring Race,
 Or, in Procession fixt and regular,

Mov'd with the Heavens Majestick pace;
 Or, call'd to more Superiour *Bliss*,
Thou tread'st, with Seraphims, the vast *Abyss:*
Whatever happy region is thy place,
Cease thy Celestial Song a little space;
(Thou wilt have time enough for Hymns Divine,
Since Heav'ns Eternal Year is thine.)
Hear then a Mortal Muse thy praise rehearse
 In no ignoble Verse;
But such as thy own voice did practise here,
When thy first Fruits of Poesie were given,
To make thyself a welcome Inmate there;
 While yet a young Probationer,
 And Candidate of Heav'n.

2

 If by Traduction came thy Mind,
 Our Wonder is the less to find
A Soul so charming from a Stock so good;
Thy Father was transfus'd into thy *Blood:*
So wert thou born into the tuneful strain,
(An early, rich, and inexhausted Vein.)
 But if thy Præ-existing Soul
Was form'd, at first, with Myriads more,
 It did through all the Mighty Poets roul
Who *Greek* or *Latine* Laurels wore,
And was that *Sappho* last, which once it was before.
 If so, then cease thy flight, *O Heav'n-born Mind!*
Thou hast no *Dross* to purge from thy Rich Ore:
 Nor can thy Soul a fairer Mansion find
 Than was the *Beauteous* Frame she left behind:
Return, to fill or mend the Quire of thy Celestial kind.

3

 May we presume to say, that at thy *Birth,*
New joy was sprung in HEAV'N as well as here on *Earth?*
For sure the Milder Planets did combine
On thy *Auspicious* Horoscope to shine,
And ev'n the most Malicious were in Trine.
Thy *Brother-Angels* at thy *Birth*
 Strung each his Lyre, and tun'd it high,
 That all the People of the Skie

Might know a Poetess was born on Earth.
 And then if ever, Mortal Ears
 Had heard the Musick of the Spheres!
 And if no clust'ring Swarm of *Bees*
On thy sweet Mouth distill'd their golden Dew,
 'Twas that, such vulgar Miracles
 Heav'n had not Leasure to renew:
 For all the *Blest* Fraternity of Love
Solemniz'd there thy *Birth,* and kept thy Holyday above.

4

 O Gracious God! How far have we
 Prophan'd thy Heav'nly Gift of Poesy!
 Made prostitute and profligate the Muse,
 Debas'd to each obscene and impious use,
 Whose Harmony was first ordain'd *Above,*
 For Tongues of *Angels* and for *Hymns* of *Love!*
Oh wretched We! why were we hurry'd down
 This lubrique and adult'rate age,
 (Nay, added fat Pollutions of our own)
 T' increase the steaming Ordures of the Stage?
What can we say t' excuse our *Second Fall?*
Let this thy *Vestal,* Heav'n, atone for all:
Her *Arethusian* Stream remains unsoil'd,
Unmixt with Forreign Filth and undefil'd,
Her Wit was more than Man, her Innocence a **Child.**

5

Art she had none, yet wanted none,
 For Nature did that Want supply:
So rich in Treasures of her Own,
 She might our boasted Stores defy:
Such Noble Vigour did her Verse adorn,
That it seem'd borrow'd, where 'twas only born.
Her Morals too were in her *Bosom* bred
 By great Examples daily fed,
What in the best of *Books,* her Father's Life, she read.
 And to be read her self she need not fear;
 Each Test, and ev'ry Light, her Muse will bear,
 Though *Epictetus* with his Lamp were there.
 Ev'n Love (for Love sometimes her Muse exprest),
Was but a Lambent-flame which play'd about her *Breast:*

Light as the Vapours of a Morning Dream,
So cold herself, whilst she such Warmth exprest,
'Twas *Cupid* bathing in *Diana's* Stream.

6

Born to the Spacious Empire of the Nine,
One wou'd have thought, she should have been content
To manage well that Mighty Government;
But what can young ambitious Souls confine?
　To the next Realm she stretcht her Sway,
　For *Painture* near adjoyning lay,
A plenteous Province, and alluring Prey.
A *Chamber of Dependences* was fram'd,
(As Conquerors will never want Pretence,
　When arm'd, to justifie th' Offence),
And the whole Fief, in right of Poetry she claim'd.
　The Country open lay without Defence;
For Poets frequent In-rodes there had made,
　And perfectly cou'd represent
　The Shape, the Face, with ev'ry Lineament;
And all the large Demains which the Dumb-sister sway'd;
　All bow'd beneath her Government,
　Receiv'd in Triumph wheresoe're she went.
Her Pencil drew whate're her Soul design'd
And oft the *happy Draught* surpass'd the *Image* in her *Mind*.
　The *Sylvan* Scenes of Herds and Flocks
　And fruitful Plains and barren Rocks,
　Of shallow *Brooks* that flow'd so clear,
　The bottom did the top appear;
　Of deeper too and ampler Floods
　Which as in Mirrors, shew'd the Woods;
　Of lofty Trees, with Sacred Shades
　And Perspectives of pleasant Glades,
　Where Nymphs of brightest Form appear,
　And shaggy Satyrs standing near,
　Which them at once admire and fear.
　The Ruines too of some Majestick Piece,
　Boasting the Pow'r of ancient *Rome* or *Greece*,
　Whose Statues, Freezes, Columns, broken lie,
　And, tho' defac'd, the Wonder of the Eye;
　What *Nature, Art*, bold *Fiction*, e're durst frame,
　Her forming Hand gave Feature to the Name.
　So strange a Concourse ne're was seen before,
But when the peopl'd *Ark* the whole Creation bore.

The Scene then chang'd; with bold Erected Look
Our Martial King the sight with Reverence strook:
For, not content t' express his Outward Part,
Her hand call'd out the Image of his Heart,
His Warlike Mind, his Soul devoid of Fear,
His High-designing *Thoughts* were figurd' there,
As when, by Magick, Ghosts are made appear.
 Our Phenix queen was portrai'd too so bright,
Beauty alone cou'd *Beauty* take so right:
Her Dress, her Shape, her matchless Grace,
Were all observ'd, as well as heav'nly Face.
With such a Peerless Majesty she stands,
As in that Day she took the Crown from Sacred hands:
Before a Train of Heroins was seen,
In *Beauty* foremost, as in Rank, the Queen!
 Thus nothing to her Genius was deny'd,
But like a *Ball* of Fire, the farther thrown,
Still with a greater *Blaze* she shone,
 And her bright Soul broke out on ev'ry side.
What next she had design'd, Heaven only knows:
To such Immod'rate Growth her Conquest rose
That Fate alone its Progress cou'd oppose.

<p style="text-align:center">8</p>

Now all those Charms, that blooming Grace,
The well-proportion'd Shape and beauteous Face,
Shall never more be seen by Mortal Eyes;
In Earth the much-lamented Virgin lies!
 Not Wit nor Piety cou'd Fate prevent;
 Nor was the cruel *Destiny* content
 To finish all the Murder at a blow,
 To sweep at once her *Life* and *Beauty* too;
But, like a hardn'd Fellon, took a pride
 To work more Mischievously slow,
And plunder'd first, and then destroy'd.
O double Sacriledge on things Divine,
To rob the Relique, and deface the Shrine!
 But thus *Orinda* dy'd:
Heav'n, by the same Disease, did both translate,
As equal were their Souls, so equal was their fate.

Mean time, her *Warlike Brother* on the Seas
His waving Streamers to the Winds displays,
And vows for his Return, with vain Devotion, pays.
 Ah, Generous Youth! that Wish forbear,
 The Winds too soon will waft thee here!
 Slack all thy Sails, and fear to come,
Alas, thou know'st not, thou art wreck'd at home!
No more shalt thou behold thy Sister's Face,
Thou hast already had her last Embrace.
But look aloft, and if thou ken'st from far,
Among the *Pleiad's,* a New-kindl'd star,
If any sparkles, than the rest, more bright,
'Tis she that shines in that propitious Light.

<div align="center">10</div>

When in mid-Air the Golden Trump shall sound,
 To raise the Nations under ground;
 When in the Valley of *Jehosaphat*
The Judging God shall close the book of Fate;
 And there the last *Assizes* keep
 For those who Wake and those who Sleep;
 When ratling *Bones* together fly
 From the four Corners of the Skie,
When Sinews o're the Skeletons are spread,
Those cloath'd with Flesh, and Life inspires the **Dead**;
The Sacred Poets first shall hear the Sound,
And formost from the Tomb shall bound:
For they are cover'd with the lightest ground;
And streight, with in-born Vigour, on the Wing,
Like mounting Larks, to the New Morning sing.
There *Thou,* sweet Saint, before the Quire shalt go,
As Harbinger of Heav'n, the Way to show,
The Way which thou so well hast learn'd below.

<div align="right">(1693)</div>

Undoubtedly the noblest ode that our language has ever produced. **The**
first part flows with a torrent of enthusiasm. FERVET IMMENSUSQUE RUIT.
<div align="right">S A M U E L J O H N S O N
The Lives of the Poets (1779–81)</div>

JOHN DRYDEN

1 6 3 1 — 1 7 0 0

LINES PRINTED UNDER THE
ENGRAVED PORTRAIT OF MILTON

Three Poets, in three distant Ages born,
Greece, Italy, and *England* did adorn.
The first in Loftiness of Thought surpass'd,
The next in Majesty, in both the last:
The Force of Nature could no farther go;
To make a third she join'd the former two.

<div align="right">

In Tonson's Folio Edition
of the 'Paradise Lost' (1688)

</div>

It is a remarkable fact, that the very finest epigram in the English language happens also to be the worst. EPIGRAM *I call it in the austere Greek sense; which thus far resembled our modern idea of an epigram, that something pointed and allied to wit was demanded in the management of the leading thought at its close, but otherwise nothing tending towards the comic or the ludicrous. The epigram I speak of is the well-known one of Dryden dedicated to the glorification of Milton. It is irreproachable as regards its severe brevity. Not one word is there that could be spared; nor could the wit of man have cast the movement of the thought into a better mould. There are three couplets. In the first couplet we are reminded of the fact that this earth had, in three different stages of its development, given birth to a trinity of transcendent poets; meaning narrative poets, or, even more narrowly, epic poets. The duty thrown upon the second couplet is to characterize these three poets, and to value them against each other, but in such terms as that, whilst nothing less than the very highest praise should be assigned to the two elder poets in this trinity—the Greek and the Roman—nevertheless, by some dexterous artifice, a higher praise than the highest should suddenly unmask itself, and drop, as it were, like a diadem from the clouds upon the brows of their English competitor. In the kind of expectation raised, and in the extreme difficulty of adequately meeting this expectation, there was pretty much the same challenge offered to Dryden as was offered, somewhere about the same time, to a British ambassador when dining with his political antagonists. One of these—the ambassador of France—had proposed to drink his master, Louis XIV., under the character of the sun, who dispensed life and light to the whole political system. To this there was no objection; and immediately, by way of intercepting any further draughts upon the rest of the solar system, the Dutch ambassador rose, and proposed the health of their high mightinesses the Seven*

United States, as the moon and six planets, who gave light in the ab-
sence of the sun. The two foreign ambassadors, Monsieur and Mynheer,
secretly enjoyed the mortification of their English brother, who seemed
to be thus left in a state of bankruptcy, 'no funds' being available for
retaliation, or so they fancied. But suddenly our British representative
toasted HIS *master as Joshua, the son of Nun, that made the sun and*
moon stand still. All had seemed lost for England, when in an instant
of time both her antagonists were checkmated. Dryden assumed some-
thing of the same position. He gave away the supreme jewels in his
exchequer; apparently nothing remained behind; all was exhausted. To
Homer he gave A; to Virgil he gave B; and, behold! after these were
given away, there remained nothing at all that would not have been a
secondary praise. But, in a moment of time, by giving A AND *B to Milton,*
at one sling of his victorious arm he raised him above Homer by the
whole extent of B, and above Virgil by the whole extent of A. This
felicitous evasion of the embarrassment is accomplished in the second
couplet; and, finally, the third couplet winds up with graceful effect,
by making a RESUMÉ, *or recapitulation of the logic concerned in the*
distribution of prizes just announced. Nature, he says, had it not in her
power to provide a third prize separate from the first and second; her
resource was, to join the first and second in combination: 'To make a
third, she joined the former two.'

 Such is the abstract of this famous epigram; and, judged simply by
the outline and tendency of the thought, it merits all the vast popularity
which it has earned. But in the meantime, it is radically vicious as regards
the filling in of this outline; for the particular quality in which Homer
is accredited with the pre-eminence, viz., LOFTINESS OF THOUGHT, *hap-*
pens to be a mere variety of expression for that quality, viz. MAJESTY,
in which the pre-eminence is awarded to Virgil. Homer excels Virgil in
the very point in which lies Virgil's superiority to Homer; and that syn-
thesis, by means of which a great triumph is reserved to Milton, becomes
obviously impossible, when it is perceived that the supposed analytic
elements of this synthesis are blank reiterations of each other.

 Exceedingly striking it is, that a thought should have prospered for
one hundred and seventy years, which, on the slightest steadiness of
examination, turns out to be no thought at all, but mere blank vacuity.
There is, however, this justification of the case, that the mould, the set
of channels, into which the metal of the thought is meant to run, really
HAS *the felicity which it appears to have: the form is perfect; and it is*
merely in the MATTER, *in the accidental filling up of the mould, that a*
fault has been committed. Had the Virgilian point of excellence been
LOVELINESS *instead of* MAJESTY, *or any word whatever suggesting the*
common antithesis of sublimity and beauty; or had it been power on the
one side, matched against grace on the other, the true lurking tendency

of the thought would have been developed, and the sub-conscious purpose of the epigram would have fulfilled itself to the letter.

N.B.—It is not meant that LOFTINESS OF THOUGHT and MAJESTY are expressions so entirely interchangeable, as that no shades of difference could be suggested; it is enough that these 'shades' are not substantial enough, or broad enough, to support the weight of opposition which the epigram assigns to them. GRACE and ELEGANCE, for instance, are far from being in all relations synonymous; but they are so to the full extent of any purposes concerned in this epigram.

Nevertheless, it is probable enough that Dryden had moving in his thoughts a relation of the word MAJESTY, which, if developed, would have done justice to his meaning. It was, perhaps, the decorum and sustained dignity of the COMPOSITION—the workmanship apart from the native grandeur of the materials—the majestic style of the artistic treatment as distinguished from the original creative power—which Dryden, the translator of the Roman poet, familiar therefore with his weakness and with his strength, meant in this place to predicate as characteristically observable in Virgil.

<div style="text-align:right">

THOMAS DE QUINCEY
The Note Book of An English Opium-Eater (1855)

</div>

JOHN DRYDEN

1 6 3 1 — 1 7 0 0

ALEXANDER'S FEAST;
OR, THE POWER OF MUSIQUE.

AN ODE IN HONOUR OF ST. CECILIA'S DAY: 1697.

I

'Twas at the Royal Feast, for *Persia* won,
 By *Philip's* Warlike Son:
 Aloft in awful State
 The God-like Heroe sate
 On his Imperial Throne;
His valiant Peers were plac'd around;
Their Brows with Roses and with Myrtles bound.
 (So should Desert in Arms be Crown'd:)
 The lovely *Thais* by his side,
 Sate like a blooming *Eastern* Bride

828

In Flow'r of Youth and Beauty's Pride.
 Happy, happy, happy Pair!
 None but the Brave,
 None but the Brave,
 None but the Brave deserves the Fair.

CHORUS

 Happy, happy, happy Pair!
 None but the Brave,
 None but the Brave,
 None but the Brave deserves the Fair.

II

 Timotheus plac'd on high
 Amid the tuneful Quire,
 With the flying Fingers touch'd the Lyre:
 The trembling Notes ascend the Sky,
 And Heav'nly Joys inspire.
 The Song began from *Jove;*
 Who left his blissful Seats above,
 (Such is the Pow'r of mighty Love.)
 A Dragon's fiery Form bely'd the God:
 Sublime on Radiant Spires He rode,
 When He to fair *Olympia* press'd:
 And while He sought her snowy Breast:
 Then, round her slender Waist he curl'd,
And stamp'd an Image of himself, a Sov'raign of the World.
 The list'ning crowd admire the lofty Sound,
 A present Deity, they shout around:
 A present Deity, the vaulted Roofs rebound.
 With ravish'd Ears,
 The Monarch hears,
 Assumes the God,
 Affects to nod,
 And seems to shake the Spheres.

CHORUS

 With ravish'd Ears
 The Monarch hears,
 Assumes the God,
 Affects to nod,
 And seems to shake the Spheres.

III

The Praise of *Bacchus* then the sweet Musician sung,
 Of *Bacchus* ever Fair, and ever Young:
 The jolly God in Triumph comes;
 Sound the Trumpets; beat the Drums;
 Flush'd with a purple Grace
 He shows his honest Face:
Now give the Hautboys breath; He comes, He comes.
 Bacchus ever Fair and Young
 Drinking Joys did first ordain;
 Bacchus Blessings are a Treasure;
 Drinking is the Soldiers Pleasure;
 Rich the Treasure;
 Sweet the Pleasure;
 Sweet is Pleasure after Pain.

CHORUS

 Bacchus *Blessings are a Treasure,*
 Drinking is the Soldier's Pleasure;
 Rich the Treasure,
 Sweet the Pleasure,
 Sweet is Pleasure after Pain.

IV

 Sooth'd with the Sound the King grew vain;
 Fought all his Battails o'er again;
And thrice He routed all his Foes, and thrice he slew the slain.
 The Master saw the Madness rise,
 His glowing Cheeks, his ardent Eyes;
 And while He Heav'n and Earth defy'd,
 Chang'd his Hand, and check'd his Pride.
 He chose a Mournful Muse,
 Soft Pity to infuse;
 He sung *Darius* Great and Good,
 By too severe a Fate,
 Fallen, fallen, fallen, fallen,
 Fallen from his high Estate,
 And weltring in his Blood:
 Deserted at his utmost Need
 By those his former Bounty fed;
 On the bare Earth expos'd He lies,
 With not a Friend to close his Eyes.

With down-cast Looks the joyless Victor sate,
 Revolving in his alter'd Soul
 The various Turns of Chance below;
 And, now and then, a Sigh he stole,
 And Tears began to flow.

<p style="text-align:center">CHORUS</p>

Revolving in his alter'd Soul
 The various Turns of Chance below;
And, now and then, a Sigh he stole,
 And Tears began to flow.

<p style="text-align:center">V</p>

The Mighty Master smil'd to see
That Love was in the next Degree;
'Twas but a Kindred-Sound to move,
For Pity melts the Mind to Love.
 Softly sweet, in *Lydian* Measures,
 Soon he sooth'd his Soul to Pleasures.
War, he sung, is Toil and Trouble;
Honour but an empty Bubble.
 Never ending, still beginning,
Fighting still, and still destroying,
 If the World be worth thy Winning,
Think, O think, it worth Enjoying.
 Lovely *Thais* sits beside thee,
 Take the Good the Gods provide thee.
The Many rend the Skies, with loud applause;
So Love was Crown'd, but Musique won the Cause.
 The Prince, unable to conceal his Pain,
 Gaz'd on the Fair
 Who caus'd his Care,
And sigh'd and look'd, sigh'd and look'd,
Sigh'd and look'd, and sigh'd again:
At length, with Love and Wine at once oppress'd,
The vanquish'd Victor sunk upon her Breast.

<p style="text-align:center">CHORUS</p>

The Prince, unable to conceal his Pain,
 Gaz'd on the fair
 Who caus'd his Care,
And sigh'd and look'd, sigh'd and look'd,
Sigh'd and look'd, and sigh'd again;
At length, with Love and Wine at once oppress'd,
The vanquish'd Victor sunk upon her Breast.

VI

Now strike the Golden Lyre again;
A lowder yet, and yet a lowder Strain.
Break his Bands of Sleep asunder,
And rouze him, like a rattling Peal of Thunder.
Hark, hark, the horrid Sound
Has rais'd up his Head;
As awak'd from the Dead,
And amaz'd, he stares around.
Revenge, revenge, *Timotheus* cries
See the Furies arise!
See the Snakes that they rear,
How they hiss in their Hair,
And the Sparkles that flash from their Eyes!
Behold a ghastly Band,
Each a Torch in his Hand!
Those are *Grecian* Ghosts, that in Battail were slain,
And unbury'd remain
Inglorious on the Plain:
Give the Vengeance due
To the Valiant Crew.
Behold how they toss their Torches on high,
How they point to the *Persian* Abodes,
And glitt'ring Temples of their Hostile Gods.
The Princes applaud with a furious Joy;
And the King seized a Flambeau with Zeal to destroy;
Thais led the Way,
To light him to his Prey,
And, like another *Hellen*, fir'd another *Troy*.

CHORUS

And the King seiz'd a Flambeau with Zeal to destroy;
Thais *led the Way,*
To light him to his Prey,
And, like another Hellen, *fir'd another Troy.*

VII

Thus long ago,
'Ere heaving Bellows learn'd to blow,
While Organs yet were mute,
Timotheus, to his breathing Flute
And sounding Lyre,
Cou'd swell the Soul to rage, or kindle soft Desire.

At last Divine *Cecilia* came,
 Inventress of the Vocal Frame;
The Sweet Enthusiast, from her Sacred Store,
 Enlarg'd the former narrow Bounds,
 And added Length to solemn Sounds,
With Nature's Mother-Wit, and Arts unknown before.
 Let old *Timotheus* yield the Prize,
 Or both divide the Crown:
 He rais'd a Mortal to the Skies;
 She drew an Angel down.

GRAND CHORUS

At last Divine Cecilia came,
 Inventress of the Vocal Frame;
The sweet Enthusiast, from her Sacred Store,
 Enlarg'd the former narrow Bounds,
 And added Length to solemn Sounds,
With Nature's Mother-Wit, and Arts unknown before.
 Let old Timotheus yield the Prize,
 Or both divide the Crown:
 He rais'd a Mortal to the Skies;
 She drew an Angel down.

(1700)

*We have had in our language no other odes of the sublime kind, than
that of Dryden on St. Cecilia's day.*

THOMAS GRAY
The Progress of Poesy (1754)

JOHN DRYDEN

1 6 3 1 — 1 7 0 0

CYMON AND IPHIGENIA

The deep Recesses of the Grove he gain'd;
Where, in a Plain, defended by the Wood,
Crept through the matted Grass a Chrystal Flood,
By which an Alabaster Fountain stood:
And on the Margin of the Fount was laid
(Attended by her Slaves) a sleeping Maid

Like *Dian* and her Nymphs, when, tir'd with **Sport,**
To rest by cool *Eurotas* they resort:
The Dame herself the Goddess well express'd,
Not more distinguish'd by her Purple Vest,
Than by the charming Features of her Face,
And ev'n in Slumber a superiour Grace:
Her comely Limbs compos'd with decent Care,
Her Body shaded with a slight Cymarr;
Her Bosom to the view was only bare:
Where two beginning Paps were scarcely spy'd
For yet their Places were but signify'd:
The fanning Wind upon her Bosom blows,
To meet the fanning Wind the Bosom rose;
The fanning Wind, and purling Streams continue her repose.
 The Fool of Nature, stood with stupid Eyes
And gaping Mouth, that testify'd Surprize,
Fix'd on her Face, nor cou'd remove his Sight,
New as he was to Love, and Novice in Delight:
Long mute he stood, and leaning on his Staff,
His Wonder witness'd with an Ideot laugh;
Then would have spoke, but by his glimmering Sense
First found his want of Words, and fear'd Offence:
Doubted for what he was he should be known,
By his Clown-Accent and his Country-Tone.
 Through the rude Chaos thus the running Light
Shot the first Ray that pierc'd the Native Night:
Then Day and Darkness in the Mass were mix'd,
Till gather'd in a Globe, the Beams were fix'd:
Last shon the Sun who, radiant in his Sphere
Illumin'd Heav'n, and Earth, and rowl'd around the Year.
So Reason in this Brutal Soul began:
Love made him first suspect he was a Man;
Love made him doubt his broad barbarian Sound;
By Love his want of Words and Wit he found;
That sense of want prepar'd the future way
To Knowledge, and disclos'd the promise of a Day.
 What not his Father's Care, nor Tutor's Art
Cou'd plant with Pains in his unpolish'd Heart,
The best Instructor Love at once inspir'd,
As barren Grounds to Fruitfulness are fir'd;
Love taught him Shame, and Shame with Love at **Strife**
Soon taught the sweet Civilities of Life;
His gross material Soul at once could find
Somewhat in her excelling all her Kind:

Exciting a Desire till then unknown,
Somewhat unfound, or found in her alone.
This made the first Impression in his Mind,
Above, but just above, the Brutal Kind.
For Beasts can like, but not distinguish too,
Nor their own liking by reflection know;
Nor why they like or this, or t'other Face,
Or judge of this or that peculiar Grace;
But love in gross, and stupidly admire;
As Flies allur'd by Light, approach the Fire.
Thus our Man-Beast advancing by degrees
First likes the whole, then sep'rates what he sees;
On sev'ral Parts, a sev'ral Praise bestows,
The ruby Lips, the well-proportion'd Nose,
The snowy Skin, in Raven-glossy Hair,
The dimpled Cheek, the Forehead rising fair,
And ev'n in Sleep it self a smiling Air.
From thence his Eyes descending view'd the rest,
Her plump round Arms, white Hands, and heaving Breast.
Long on the last he dwelt, though ev'ry part
A pointed Arrow sped to pierce his Heart.
 Thus in a trice a Judge of Beauty grown,
(A Judge erected from a Country-Clown)
He long'd to see her Eyes in Slumber hid,
And wish'd his own cou'd pierce within the Lid:
He wou'd have wak'd her, but restrain'd his Thought,
And Love new-born the first good Manners taught.
An awful Fear his ardent Wish withstood,
Nor durst disturb the Goddess of the Wood;
For such she seem'd by her celestial Face,
Excelling all the rest of human Race:
And Things divine, by common Sense he knew,
Must be devoutly seen at distant view:
So checking his Desire, with trembling Heart
Gazing he stood, nor would, nor could depart;
Fix'd as a Pilgrim wilder'd in his way,
Who dares not stir by Night for fear to stray;
But stands with awful Eyes to watch the dawn of Day.

 Fables Antient and Modern (1700)

There is not in our language a strain of more beautiful and melodious poetry.

 SIR WALTER SCOTT
 The Works of John Dryden (1808)

JOHN DRYDEN

1 6 3 1 — 1 7 0 0

THE TWENTY-NINTH ODE OF THE THIRD BOOK OF HORACE

PARAPHRASED IN PINDARICK VERSE, AND INSCRIBED TO THE RIGHT HON. LAURENCE EARL OF ROCHESTER.

I

Descended of an ancient Line,
　　That long the *Tuscan* Scepter sway'd,
Make haste to meet the generous Wine,
　　Whose piercing is for thee delay'd:
The rosie wreath is ready made;
　　And artful hands prepare
The fragrant *Syrian* Oyl, that shall perfume thy hair.

II

When the Wine sparkles from a far,
　　And the well-natur'd Friend cries, come away;
Make haste, and leave thy business and thy care:
　　No mortal int'rest can be worth thy stay.

III

Leave for a while thy costly Country Seat;
　　And, to be Great indeed, forget
The nauseous pleasures of the Great:
　　Make haste and come:
Come, and forsake thy cloying store;
　　Thy Turret that surveys, from high,
The smoke, and wealth, and noise of *Rome;*
　　And all the busie pageantry
That wise men scorn, and fools adore:
Come, give thy Soul a loose, and taste the pleasures of the poor.

IV

Sometimes 'tis grateful to the Rich, to try
A short vicissitude, and fit of Poverty:
　　A savoury Dish, a homely Treat,
　　Where all is plain, where all is neat,

Without the stately spacious Room,
The *Persian* Carpet, or the *Tyrian* Loom,
Clear up the cloudy foreheads of the Great.

V

The Sun is in the Lion mounted high;
 The *Syrian* Star
 Barks from afar,
And with his sultry breath infects the Sky;
The ground below is parch'd, the heav'ns above us **fry**.
 The Shepheard drives his fainting Flock
 Beneath the covert of a Rock,
 And seeks refreshing Rivulets nigh
 The *Sylvans* to their shades retire,
Those very shades and streams new shades and streams require,
And want a cooling breeze of wind to fan the raging fire.

VI

Thou, what befits the new Lord May'r,
And what the City Faction dare,
And what the *Gallique* arms will do,
And what the Quiverbearing foe,
Art anxiously inquisitive to know:
But God has, wisely, hid from humane sight
 The dark decrees of future fate;
 And sown their seeds in depth of night;
He laughs at all the giddy turns of State;
When Mortals search too soon, and fear too late.

VII

Enjoy the present smiling hour;
 And put it out of Fortunes pow'r:
The tide of bus'ness, like the running stream,
 Is sometimes high, and sometimes low,
A quiet ebb, or a tempestuous flow,
 And alwayes in extream.
 Now with a noiseless gentle course
 It keeps within the middle Bed;
 Anon it lifts aloft the head,
And bears down all before it with impetuous force:
 And trunks of Trees come rowling down,
 Sheep and their Folds together drown:

Both House and Homested into Seas are borne;
And Rocks are from their old foundations torn,
And woods, made thin with winds, their scatter'd honours mourn.

VIII

Happy the Man, and happy he alone,
 He, who can call to day his own:
 He who, secure within, can say,
To morrow do thy worst, for I have liv'd to-day.
 Be fair, or foul, or rain, or shine,
 The joys I have possest, in spight of fate, are mine.
Not Heav'n it self upon the past has pow'r;
But what has been, has been, and I have had my hour.

IX

Fortune, that with malicious joy
 Does Man her slave oppress,
Proud of her Office to destroy,
 Is seldome pleas'd to bless:
Still various, and unconstant still,
But with an inclination to be ill.
 Promotes, degrades, delights in strife,
 And makes a Lottery of life.
I can enjoy her while she's kind;
But when she dances in the wind,
 And shakes the wings, and will not stay,
 I puff the Prostitute away:
The little or the much she gave, is quietly resign'd:
 Content with poverty, my Soul I arm;
 And Vertue, tho' in rags, will keep me warm.

X

 What is't to me,
Who never sail in her unfaithful Sea,
 If Storms arise, and Clouds grow black;
 If the Mast split, and threaten wreck?
Then let the greedy Merchant fear
 For his ill gotten gain;
And pray to Gods that will not hear,
While the debating winds and billows bear
 His Wealth into the Main
 For me, secure from Fortunes blows
 (Secure of what I cannot lose,)

In my small Pinnace I can sail,
Contemning all the blustring roar;
 And running with a merry gale,
With friendly Stars my safety seek
Within some little winding Creek;
 And see the storm a shore.

<div align="right">

Horace
Odes, iii, 29

</div>

One of the great poems in English.

<div align="right">

CYRIL CONNOLLY
The Condemned Playground (1946)

</div>

JOHN LOCKE

1632 — 1704

WIT AND JUDGMENT

And hence, perhaps, may be given some Reason of that common Observation, That Men who have a great deal of Wit, and prompt Memories, have not always the clearest Judgment, or deepest Reason. For *Wit* lying most in the assemblage of *Ideas,* and putting those together with quickness and variety, wherein can be found any resemblance or congruity, thereby to make up pleasant Pictures, and agreeable Visions in the Fancy: *Judgment,* on the contrary, lies quite on the other side, in separating carefully *Ideas* one from another, wherein can be found the least difference, thereby to avoid being misled by Similitude, and by affinity to take one thing for another. This is a way of proceeding quite contrary to Metaphor and Allusion, wherein, for the most part, lies that entertainment and pleasantry of Wit, which strikes so lively on the Fancy; and therefore so acceptable to all People.

<div align="center">

An Essay Concerning Humane Understanding (1690)

</div>

This is, I think, the best and most philosophical account that I have ever met with of wit.

<div align="right">

JOSEPH ADDISON
The Spectator (May 11, 1711)

</div>

ANTITHESIS

Et, pour le rendre libre, il le faut enchaîner.

To set him free, he must be enchained.

This verse alone was worth a pension from Louis. It is indeed the most violent antithesis that ever was constructed.

WALTER SAVAGE LANDOR
Imaginary Conversations, Abbé Delille and Landor (1824–9)

MALHERBE

Dans mes vers recousus mettre en pièces Malherbe.

In my patched-up verses to tear Malherbe to pieces.

Satires, ii (1664)

I would give the most beautiful of my verses to have written this one.

JEAN DE LA FONTAINE
Quoted, Désiré Nisard, Histoire de la littérature française (1844)

THE OPENING LINES OF *BAJAZET*

ACOMAT
Viens, suis-moi. La Sultane en ce lieu se doit rendre.
Je pourrai cependant te parler et t'entendre.
OSMIN
Et depuis quand, Seigneur, entre-t-on dans ces lieux

Dont l'accès était même interdit à nos yeux?
Jadis une mort prompte eût suivi cette audace.

ACOMAT

Quand tu seras instruit de tout ce qui se passe,
Mon entrée en ces lieux ne te surprendra plus.
Mais laissons, cher Osmin, les discours superflus.
Que ton retour tardait à mon impatience!
Et que d'un œil content je te vois dans Byzance!
Instruis-moi des secrets que peut t'avoir appris
Un voyage si long pour moi seul entrepris.
De ce qu'ont vu tes yeux parle en témoin sincère:
Songe que du récit, Osmin, que tu vas faire
Dépendent les destins de l'empire ottoman.
Qu'as-tu vu dans l'armée, et que fait le Sultan?

OSMIN

Babylone, Seigneur, à son prince fidèle,
Voyait sans s'étonner notre armée autour d'elle;
Les Persans rassemblés marchaient à son secours,
Et du camp d'Amurat s'approchaient tous les jours.
Lui-même, fatigué d'un long siège inutile,
Semblait vouloir laisser Babylone tranquille,
Et sans renouveler ses assauts impuissants,
Résolu de combattre, attendait les Persans.
Mais, comme vous savez, malgré ma diligence,
Un long chemin sépare et le camp et Byzance;
Mille obstacles divers m'ont même traversé,
Et je puis ignorer tout ce qui s'est passé.

ACOMAT

Que faisaient cependant nos braves janissaires?
Rendent-ils au Sultan des hommages sincères?
Dans le secret des cœurs, Osmin, n'as-tu rien lu?
Amurat jouit-il d'un pouvoir absolu?

OSMIN

Amurat est content, si nous le voulons croire,
Et semblait se promettre une heureuse victoire.
Mais en vain par ce calme il croit nous éblouir:
Il affecte un repos dont il ne peut jouir.
C'est en vain que forçant ses soupçons ordinaires,
Il se rend accessible à tous les janissaires:
Il se souvient toujours que son inimitié,
Voulut de ce grand corps retrancher la moitié,
Lorsque, pour affermir sa puissance nouvelle,
Il voulait, disait-il, sortir de leur tutelle.
Moi-même, j'ai souvent entendu leurs discours;
Comme il les craint sans cesse, ils le craignent toujours.

Ses caresses n'ont point effacé cette injure.
Votre absence est pour eux un sujet de murmure.
Ils regrettent le temps, à leur grand cœur si doux,
Lorsqu' assurés de vaincre ils combattaient sous vous.

ACOMAT

Quoi? tu crois, cher Osmin, que ma gloire passée
Flatte encor leur valeur et vit dans leur pensée?
Crois-tu qu'ils me suivraient encore avec plaisir,
Et qu'ils reconnaîtraient la voix de leur vizir?

ACOMAT

Here, *Osmyn*, we may reason unobserv'd.
The Sultaness, from yonder high-rais'd Terras,
Views the wide *Euxine*, and enjoys the Breeze.

OSMYN

Where am I, Vizier! Whither do you lead me?
'Tis Death to breathe within these Walls; this Place
Our earthly Gods hold Sacred: The *Seraglio*
Is fenc'd by *Mahomet's* severest Laws:
'Tis Sacrilege, 'tis Height of Prophanation,
For vulgar Feet to tread where the dread Race
Of *Ottoman* is form'd.—But tell me, General,
How durst those tongueless Slaves, who guard this Palace
In dreadful Silence, open to your Signal?
I dare no farther press.

ACOMAT

Yet check a while
Thy curious Fears: I am thy Guide. Say, *Osmyn*,
Why didst thou suffer *Acomat* thus long
To wait thy needful Presence in *Bysantium*?
What Seas, what Sands, what Dangers hast thou cross'd
To serve thy Friend? What Tidings of Importance?
What Secret dost thou bring? What of our Army?
What of our Sultan knowest thou? Open all.
Speak, *Osmyn*: Ease my impatient Heart: Thy *own*,
Thy Vizier's *Fate*, the *Fate* of a whole Empire
Lyes in thy Breast, and hangs upon thy Words.

OSMYN

Still *Babylon* stands faithful to her Prince:
Unshaken yet, she sees our turban'd Hosts
Surround her Walls. Mean Time, the *Persians* arm:
From every Side their num'rous Bands advancing,
Move to her Aid; and each succeeding Morn,
Gain on the Sight, and thicken to the View.

The *Sultan,* weary'd with a fruitless Siege,
No more renews his vain Assaults; resolv'd
To wait their Arms before those lofty Bulwarks;
In one decisive Hour to try his Fate,
And fix at once the Empire of the East.

ACOMAT

Go on, my Soldier: I am all Attention.

OSMYN

Since that, I little know. Long tedious Leagues
Divide this City from the Camp; each Day
New Obstacles have cross'd my speedy Course,
And intercepted all my Diligence.

ACOMAT

How do our Gallant Janizaries bear
Their great Imperial Master's jealous Eye?
Or is the Homage which they pay, Sincere?

OSMYN

Proud *Amurat* puts on a pleasing Look,
And seems secure of Conquest; but in vain
He smooths his troubl'd Brow; the thin Disguise
Serves but to render him yet more suspected,
In vain he courts his hardy Janizaries:
Their Hearts are inaccessible: They think,
And think with secret Malice, on the Attempt
The *Sultan* made to break their Gallant Troops.
They fear him, Sir; and whom they fear, they hate.
I know they murmur at their *Vizier's* Absence;
And oftentimes regret those Days of Glory,
When you conducted them to certain Conquest.

ACOMAT

Dost thou then think, dear *Osmyn,* those bless'd Days
Still swell their Hearts, and make them full of me?
Think'st thou they still will follow where I lead,
And recognize once more their *Vizier's* Voice?

Bajazet (1672)
Act i, Scene i
The Charles Johnson Version (1717)

*What would be, for example, the best model for the opening passage of
a tragedy? It would be that of* BAJAZET. . . . *This passage is conceded
to be a masterpiece of the human mind.*

F. M. AROUET DE VOLTAIRE
Lettre à l'Académie Française (1776)

JEAN RACINE

1 6 3 9 — 1 6 9 9

MONIME ANSWERS HER LOVER'S FATHER

Et, quand il n'en perdroit que l'amour de son père,
Il en mourra, Seigneur.

If he loses naught but his father's love he will die of it, my lord.
<div align="right">

Mithridate (1673)

Act iv, Scene iv
</div>

Sublime words, in that domain of delicate thoughts and verities of the heart, where Racine is without an equal as without a model.
<div align="right">

DÉSIRÉ NISARD

Histoire de la littérature française (1844)
</div>

JEAN RACINE

1 6 3 9 — 1 6 9 9

DEATH

Mais la mort fuit encor sa grande âme trompée.

But Death still shuns his great defrauded soul.
<div align="right">

Mithridate (1673)

Act v, Scene iv

Translated by Maurice Baring
</div>

One of the most poignant lines in poetry.
<div align="right">

MAURICE BARING

Have You Anything to Declare? (1936)
</div>

PHÆDRA

La fille de Minos et de Pasiphaé.

Daughter of Minos and Pasiphaë.

Phèdre (1677)
Act i, Scene i

The most beautiful line in all French literature, a phrase of eternal and sublime beauty.

GUSTAVE FLAUBERT
Quoted, J. G. Palache, Gautier and the Romantics (1926)

JEAN RACINE

1 6 3 9 — 1 6 9 9

PHÆDRA DECLARES HER LOVE FOR HER STEPSON

PHÈDRE, HIPPOLYTE, OENONE.

PHÈDRE, à OENONE
Le voici. Vers mon cœur tout mon sang se retire.
J'oublie, en le voyant, ce que je viens lui dire.
OENONE
Souvenez-vous d'un fils qui n'espère qu'en vous.
PHÈDRE
On dit qu'un prompt départ vous éloigne de nous,
Seigneur. A vos douleurs je viens joindre mes larmes.
Je vous viens pour un fils expliquer mes alarmes.
Mon fils n'a plus de père; et le jour n'est pas loin
Qui de ma mort encor doit le rendre témoin.
Déjà mille ennemis attaquent son enfance.
Vous seul pouvez contre eux embrasser sa défense.

845

Mais un secret remords agite mes esprits.
Je crains d'avoir fermé votre oreille à ses cris.
Je tremble que sur lui votre juste colère
Ne poursuive bientôt une odieuse mère.

HIPPOLYTE

Madame, je n'ai point des sentiments si bas.

PHÈDRE

Quand vous me haïriez, je ne m'en plaindrois pas,
Seigneur. Vous m'avez vue attachée à vous nuire;
Dans le fond de mon cœur vous ne pouviez pas lire.
A votre inimitié j'ai pris soin de m'offrir.
Aux bords que j'habitois je n'ai pu vous souffrir.
En public, en secret, contre vous déclarée,
J'ai voulu par des mers en être séparée;
J'ai même défendu, par une expresse loi,
Qu'on osât prononcer votre nom devant moi.
Si pourtant à l'offense on mesure la peine,
Si la haine peut seule attirer votre haine,
Jamais femme ne fut plus digne de pitié,
Et moins digne, Seigneur, de votre inimitié.

HIPPOLYTE

Des droits de ses enfants une mère jalouse
Pardonne rarement au fils d'une autre épouse.
Madame, je le sais. Les soupçons importuns
Sont d'un second hymen les fruits les plus communs.
Toute autre auroit pour moi pris les mêmes ombrages,
Et j'en aurois peut-être essuyé plus d'outrages.

PHÈDRE

Ah! Seigneur, que le ciel, j'ose ici l'attester,
De cette loi commune a voulu m'excepter!
Qu'un soin bien différent me trouble et me dévore!

HIPPOLYTE

Madame, il n'est pas temps de vous troubler encore.
Peut-être votre époux voit encore le jour;
Le ciel peut à nos pleurs accorder son retour.
Neptune le protége, et ce dieu tutélaire
Ne sera pas en vain imploré par mon père.

PHÈDRE

On ne voit point deux fois le rivage des morts,
Seigneur. Puisque Thésée a vu les sombres bords,
En vain vous espérez qu'un dieu vous le renvoie;
Et l'avare Achéron ne lâche point sa proie.
Que dis-je? Il n'est point mort, puisqu'il respire en vous.
Toujours devant mes yeux je crois voir mon époux.

Je le vois, je lui parle; et mon cœur. . . . Je m'égare,
Seigneur, ma folle ardeur malgré moi se déclare.

HIPPOLYTE

Je vois de votre amour l'effet prodigieux.
Tout mort qu'il est, Thésée est présent à vos yeux;
Toujours de son amour votre âme est embrasée.

PHÈDRE

Oui, Prince, je languis, je brûle pour Thésée.
Je l'aime, non point tel que l'ont vu les enfers,
Volage adorateur de mille objets divers,
Qui va du dieu des morts déshonorer la couche;
Mais fidèle, mais fier, et même un peu farouche,
Charmant, jeune, traînant tous les cœurs après soi,
Tel qu'on dépeint nos dieux, ou tel que je vous voi.
Il avoit votre port, vos yeux, votre langage,
Cette noble pudeur coloroit son visage
Lorsque de notre Crète il traversa les flots,
Digne sujet des vœux des filles de Minos.
Que faisiez-vous alors? Pourquoi, sans Hippolyte,
Des héros de la Grèce assembla-t-il l'élite?
Pourquoi, trop jeune encor, ne pûtes-vous alors
Entrer dans le vaisseau qui le mit sur nos bords?
Par vous auroit péri le monstre de la Crète,
Malgré tous les détours de sa vaste retraite.
Pour en développer l'embarras incertain,
Ma sœur du fil fatal eût armé votre main.
Mais non, dans ce dessein je l'aurois devancée
L'amour m'en eût d'abord inspiré la pensée.
C'est moi, Prince, c'est moi dont l'utile secours
Vous eût du Labyrinthe enseigné les détours.
Que de soins m'eût coûtés cette tête charmante!
Un fil n'eût point assez rassuré votre amante.
Compagne du péril qu'il vous falloit chercher,
Moi-même devant vous j'aurois voulu marcher;
Et Phèdre au Labyrinthe avec vous descendue
Se seroit avec vous retrouvée, ou perdue.

HIPPOLYTE

Dieux! qu'est-ce que j'entends? Madame, oubliez-vous
Que Thésée est mon père, et qu'il est votre époux?

PHÈDRE

Et sur quoi jugez-vous que j'en perds la mémoire,
Prince? Aurois-je perdu tout le soin de ma gloire?

HIPPOLYTE

Madame, pardonnez. J'avoue, en rougissant,
Que j'accusois à tort un discours innocent.

847

Ma honte ne peut plus soutenir votre vue;
Et je vais. . . .

PHÈDRE

Ah! cruel, tu m'as trop entendue.
Je t'en ai dit assez pour te tirer d'erreur.
Hé bien! connois donc Phèdre et toute sa fureur.
J'aime. Ne pense pas qu'au moment que je t'aime,
Innocente à mes yeux, je m'approuve moi-même;
Ni que du fol amour qui trouble ma raison
Ma lâche complaisance ait nourri le poison.
Objet infortuné des vengeances célestes,
Je m'abhorre encor plus que tu ne me détestes.
Les Dieux m'en sont témoins, ces Dieux qui dans mon flanc
Ont allumé le feu fatal à tout mon sang;
Ces Dieux qui se sont fait une gloire cruelle
De séduire le cœur d'une foible mortelle.
Toi-même en ton esprit rappelle le passé.
C'est peu de t'avoir fui, cruel, je t'ai chassé;
J'ai voulu te paroître odieuse, inhumaine;
Pour mieux te résister, j'ai recherché ta haine.
De quoi m'ont profité mes inutiles soins?
Tu me haïssois plus, je ne t'aimois pas moins.
Tes malheurs te prêtoient encor de nouveaux charmes.
J'ai langui, j'ai séché, dans les feux, dans les larmes.
Il suffit de tes yeux pour t'en persuader,
Si tes yeux un moment pouvoient me regarder.
Que dis-je? Cet aveu que je te viens de faire,
Cet aveu si honteux, le crois-tu volontaire?
Tremblante pour un fils que je n'osois trahir,
Je te venois prier de ne le point haïr.
Foibles projets d'un cœur trop plein de ce qu'il aime!
Hélas! je ne t'ai pu parler que de toi-même.
Venge-toi, punis-moi d'un odieux amour.
Digne fils du héros qui t'a donné le jour,
Délivre l'univers d'un monstre qui t'irrite.
La veuve de Thésée ose aimer Hippolyte!
Crois-moi, ce monstre affreux ne doit point t'échapper.
Voilà mon cœur. C'est là que ta main doit frapper.
Impatient déjà d'expier son offense,
Au-devant de ton bras je le sens qui s'avance.
Frappe. Ou si tu le crois indigne de tes coups,
Si ta haine m'envie un supplice si doux,
Ou si d'un sang trop vil ta main seroit trempée,

Au défaut de ton bras prête-moi ton épée.
Donne.

OENONE

 Que faites-vous, Madame? Justes Dieux!
Mais on vient. Évitez des témoins odieux;
Venez, rentrez, fuyez une honte certaine.

PHÆDRA (*to* ŒNONE).
 Look, I see him!
My blood forgets to flow,—tongue will not speak
What I have come to say!

ŒNONE
 Think of your son.
And think that all his hopes depend on you.

PHÆDRA
 They tell me that you leave us, hastily.
I come to add my own tears to your sorrow,
And I would plead my fears for my young son.
He has no father, now; 'twill not be long
Until the day that he will see my death,
And even now, his youth is much imperiled
By a thousand foes. You only can defend him.
And in my inmost heart, remorse is stirring,—
Yes, and fear, too, lest I have shut your ears
Against his cries; I fear that your just anger
May, before long, visit on him that hatred
His mother earned.

HIPPOLYTUS
 Madam, you need not fear.
Such malice is not mine.

PHÆDRA
 I should not blame you
If you should hate me; I have injured you.
So much you know;—you could not read my heart.
Yes, I have tried to be your enemy,
For the same land could never hold us both.
In private and abroad I have declared it;—
I was your enemy! I found no peace
Till seas had parted us; and I forbade
Even your name to be pronounced to me.
And yet, if punishment be meted out
Justly, by the offense;—if only hatred
Deserves a hate, then never was there woman
Deserved more pity, and less enmity.

HIPPOLYTUS

A mother who is jealous for her children
Will seldom love the children of a mother
Who came before her. Torments of suspicion
Will often follow on a second marriage.
Another would have felt that jealousy
No less than you; perhaps more violently.

PHÆDRA

Ah, prince, but Heaven made me quite exempt
From what is usual, and I can call
That Heaven as my witness! 'Tis not this—
No, quite another ill devours my heart!

HIPPOLYTUS

This is no time for self-reproaching, madam.
Perhaps your husband still beholds the light,
Perhaps he may be granted safe return
In answer to our prayers; his guarding god
Is Neptune, whom he never called in vain.

PHÆDRA

He who has seen the mansions of the dead
Returns not thence. Since Theseus has gone
Once to those gloomy shores, we need not hope,
For Heaven will not send him back again.
Prince, there is no release from Acheron;—
It is a greedy maw,—and yet I think
He lives and breathes in you,—and still I see him
Before me here; I seem to speak to him—
My heart—! Oh, I am mad! Do what I will,
I cannot hide my passion.

HIPPOLYTUS

Yes, I see
What strange things love will do, for Theseus, dead,
Seems present to your eyes, and in your soul
A constant flame is burning.

PHÆDRA

Ah, for Theseus
I languish and I long, but not, indeed,
As the Shades have seen him, as the fickle lover
Of a thousand forms, the one who fain would ravish
The bride of Pluto;—but one faithful, proud,
Even to slight disdain,—the charm of youth
That draws all hearts, even as the gods are painted,—
Or as yourself. He had your eyes, your manner,—
He spoke like you, and he could blush like you,
And when he came across the waves to Crete,

My childhood home, worthy to win the love
Of Minos' daughters,—what were you doing then?
Why did my father gather all these men,
The flower of Greece, and leave Hippolytus?
Oh, why were you too young to have embarked
On board the ship that brought your father there?
The monster would have perished at your hands,
Despite the windings of his vast retreat.
My sister would have armed you with the clue
To guide your steps, doubtful within the maze.—
But no—for Phædra would have come before her,
And love would first have given me the thought,
And I it would have been, whose timely aid
Had taught you all the labyrinthine ways!
The care that such a dear life would have cost me!
No thread could satisfy my lover's fears.
I would have wished to lead the way myself,
And share the peril you were sure to face.
Yes, Phædra would have walked the maze with you,—
With you come out in safety, or have perished!

HIPPOLYTUS

Gods! What is this I hear? Have you forgotten
That Theseus is my father and your husband?

PHÆDRA

Why should you fancy I have lost remembrance
And that I am regardless of my honor?

HIPPOLYTUS

Forgive me, madam! With a blush I own
That I mistook your words, quite innocent.
For very shame I cannot see you longer—
Now I will go—

PHÆDRA

Ah, prince, you understood me,—
Too well, indeed! For I had said enough.
You could not well mistake. But do not think
That in those moments when I love you most
I do not feel my guilt. No easy yielding
Has helped the poison that infects my mind.
The sorry object of divine revenge,
I am not half so hateful to your sight
As to myself. The gods will bear me witness,—
They who have lit this fire within my veins,
The gods who take their barbarous delight
In leading some poor mortal heart astray!
Nay, do you not remember, in the past,

851

How I was not content to fly?—I drove you
Out of the land, so that I might appear
Most odious—and to resist you better
I tried to make you hate me—and in vain!
You hated more, and I loved not the less,
While your misfortunes lent you newer charms.
I have been drowned in tears and scorched by fire!
Your own eyes might convince you of the truth
If you could look at me, but for a moment!
What do I say? You think this vile confession
That I have made, is what I meant to say?
I did not dare betray my son. For him
I feared,—and came to beg you not to hate him.
This was the purpose of a heart too full
Of love for you to speak of aught besides.
Take your revenge, and punish me my passion!
Prove yourself worthy of your valiant father,
And rid the world of an offensive monster!
Does Theseus' widow dare to love his son?
Monster indeed! Nay, let her not escape you!
Here is my heart! Here is the place to strike!
It is most eager to absolve itself!
It leaps impatiently to meet your blow!—
Strike deep! Or if, indeed, you find it shameful
To drench your hand in such polluted blood,—
If that be punishment too mild for you,—
Too easy for your hate,—if not your arm,
Then lend your sword to me.—Come! Give it now!—

ŒNONE

What would you do, my lady? Oh, just gods!
But someone comes;—go quickly. Run from shame.
You cannot fly, if they should find you thus.

<div align="right">

Phèdre (1677)

Act ii, Scene v

Translated by Robert Henderson

</div>

As for the tremendous "scene of the declaration" it is a crime of LÈSE-
LITTÉRATURE *to mutilate it in the slightest degree. It is fairly safe to
say that such a variety of emotion—fear, loss of conscious control, volup-
tuous abandonment, indignation, pride, shame, anger, remorse—has
not elsewhere been compressed within a little over one hundred lines.*

<div align="right">

A. F. B. CLARK

Jean Racine (1939)

</div>

PHÆDRA JEALOUS

PHÈDRE

 Ils s'aimeront toujours.
Au moment que je parle, ah! mortelle pensée!
Ils bravent la fureur d'une amante insensée.
Malgré ce même exil qui va les écarter,
Ils font mille serments de ne se point quitter.
 Non, je ne puis souffrir un bonheur qui m'outrage,
Œnone, prends pitié de ma jalouse rage:
Il faut perdre Aricie. Il faut de mon époux
Contre un sang odieux réveiller le courroux.
Qu'il ne se borne pas à des peines légères:
Le crime de la sœur passe celui des frères.
Dans mes jaloux transports je le veux implorer.
 Que fais-je? Où ma raison se va-t-elle égarer?
Moi jalouse! et Thésée est celui que j'implore!
Mon époux est vivant, et moi je brûle encore!
Pour qui? Quel est le cœur où prétendent mes vœux?
Chaque mot sur mon front fait dresser mes cheveux.
Mes crimes désormais ont comblé la mesure.
Je respire à la fois l'inceste et l'imposture.
Mes homicides mains, promptes à me venger,
Dans le sang innocent brûlent de se plonger.
Misérable! et je vis? et je soutiens la vue
De ce sacré soleil dont je suis descendue?
J'ai pour aïeul le père et le maître des Dieux:
Le ciel, tout l'univers est plein de mes aïeux.
Où me cacher? Fuyons dans la nuit infernale.
Mais que dis-je? mon père y tient l'urne fatale;
Le sort, dit-on, l'a mise en ses sévères mains:
Minos juge aux enfers tous les pâles humains.
Ah! combien frémira son ombre épouvantée,
Lorsqu'il verra sa fille à ses yeux présentée,
Contrainte d'avouer tant de forfaits divers,
Et des crimes peut-être inconnus aux enfers!
Que diras-tu, mon père, à ce spectacle horrible?
Je crois voir de ta main tomber l'urne terrible;
Je crois te voir, cherchant un supplice nouveau,
Toi-même de ton sang devenir le bourreau.

Pardonne. Un Dieu cruel a perdu ta famille;
Reconnais sa vengeance aux fureurs de ta fille.
Hélas! du crime affreux dont la honte me suit
Jamais mon triste cœur n'a recueilli le fruit.
Jusqu'au dernier soupir de malheurs poursuivie,
Je rends dans les tourments une pénible vie.

PHÆDRA
 Love will stay,
And it will stay forever. While I speak—
O dreadful thought—they laugh and scorn my madness
And my distracted heart. In spite of exile,
In spite of that which soon must come to part them,
They make a thousand oaths to bind their union.
Œnone, can I bear this happiness
Which so insults me? I would have your pity.
Yes, she must be destroyed. My husband's fury
Against her hated race shall be renewed.
The punishment must be a heavy one.
Her guilt outruns the guilt of all her brothers.
I'll plead with Theseus, in my jealousy,—
What do I say? Oh, have I lost my senses?
Is Phædra jealous? will she, then, go begging
For Theseus' help? He lives,—and yet I burn.
For whom? Whose heart is this I claim as mine?
My hair stands up with horror at my words,
And from this time, my guilt has passed all bounds!
Hypocrisy and incest breathe at once
Through all I do. My hands are ripe for murder,
To spill the guiltless blood of innocence.
Do I still live, a wretch, and dare to face
The holy Sun, from whom I have my being?
My father's father was the king of gods;
My race is spread through all the universe.—
Where can I hide? In the dark realms of Pluto?
But there my father holds the fatal urn.
His hands award the doom irrevocable.—
Minos is judge of all the ghosts in hell.
And how his awful shade will start and shudder
When he shall see his daughter brought before him,
And made confess such many-colored sins,
Such crimes, perhaps, as hell itself knows not!
O father, what will be thy words at seeing
So dire a sight? I see thee drop the urn,

Turning to seek some punishment unheard of,--
To be, thyself, mine executioner!
O spare me! For a cruel deity
Destroys thy race. O look upon my madness,
And in it see her wrath. This aching heart
Gathers no fruit of pleasure from its crime.
It is a shame which hounds me to the grave,
And ends a life of misery in torment.

<div align="right">

Phèdre (1677)
Act iv, Scene vi
Translated by Robert Henderson

</div>

The play contains one of the most finished and beautiful, and at the same time one of the most overwhelming studies of passion in the literature of the world. The tremendous rôle of Phèdre—which, as the final touchstone of great acting, holds the same place on the French stage as that of Hamlet on the English—dominates the piece, rising in intensity as act follows act, and "horror on horror's head accumulates." Here, too, Racine has poured out all the wealth of his poetic powers. He has performed the last miracle, and infused into the ordered ease of the Alexandrine a strange sense of brooding mystery and indefinable terror and the awful approaches of fate. The splendour of the verse reaches its height in the fourth act, when the ruined queen, at the culmination of her passion, her remorse, and her despair, sees in a vision Hell opening to receive her, and the appalling shade of her father Minos dispensing his unutterable doom. The creator of this magnificent passage, in which the imaginative grandeur of the loftiest poetry and the supreme force of dramatic emotion are mingled in a perfect whole, has a right to walk beside Sophocles in the high places of eternity.

<div align="right">

LYTTON STRACHEY
Landmarks in French Literature (1923)

</div>

JEAN DE LA BRUYÈRE

1 6 4 5 — 1 6 9 6

THE LOVER OF FLOWERS

Vous le voyez planté, et qui a pris racine au milieu de ses tulipes et devant la *Solitaire:* il ouvre de grands yeux, il frotte ses mains, il se baisse, il la voit de plus près, il ne l'a jamais vue si belle, il a le cœur épanoui de joie; il la quitte pour l'*Orientale;* de là il va à la *Veuve;* il

passe au *Drap d'or*, de celle-ci à *l'Agathe*, d'où il revient enfin à la *Solitaire*, où il se fixe, où il se lasse, où il s'assit, où il oublie de dîner: aussi est-elle nuancée, bordée, huilée, à pièces emportées; elle a un beau vase ou un beau calice: il la contemple, il l'admire. Dieu et la nature sont en tout cela ce qu'il n'admire point; il ne va pas plus loin que l'oignon de sa tulipe, qu'il ne livrerait pas pour mille écus, et qu'il donnera pour rien quand les tulipes seront négligées et que les œillets auront prévalu. Cet homme raisonnable, qui a une âme, qui a un culte et une religion, revient chez soi fatigué, affamé, mais fort content de sa journée: il a vu des tulipes.

You see him standing there, and would think he had taken root in the midst of his tulips before his "Solitaire;" he opens his eyes wide, rubs his hands, stoops down and looks closer at it; it never before seemed to him so handsome; he is in an ecstasy of joy, and leaves it to go to the "Orient," then to the "Veuve," from thence to the "Cloth of Gold," on to the "Agatha," and at last returns to the "Solitaire," where he remains, is tired out, sits down, and forgets his dinner; he looks at the tulip and admires its shade, shape, colour, sheen, and edges, its beautiful form and calix; but God and nature are not in his thoughts, for they do not go beyond the bulb of his tulip, which he would not sell for a thousand crowns, though he will give it to you for nothing when tulips are no longer in fashion, and carnations are all the rage. This rational being, who has a soul and professes some religion, comes home tired and half-starved, but very pleased with his day's work; he has seen some tulips.

<div align="right">

Les Caractères (1688)
Translated by Henri van Laun

</div>

The rhythm is absolutely perfect, and, with its suspensions, its elaborations, its gradual crescendos, its unerring conclusions, seems to carry the sheer beauty of expressiveness to the farthest conceivable point.

<div align="right">

LYTTON STRACHEY
Landmarks in French Literature (1923)

</div>

BOOK OF COMMON PRAYER

1 6 6 2

NO MAN MAY DELIVER

But no man may deliver his brother: nor make agreement unto God for him.

<div align="right">

Psalms, xlix, 7

</div>

That is to me poetry so moving that I can hardly keep my voice steady in reading it.

The Name and Nature of Poetry (1933)

MATTHEW PRIOR

1 6 6 4 — 1 7 2 1

EPIGRAM

To John I ow'd great Obligation;
 But John, unhappily, thought fit
To publish it to all the Nation:
 Sure John and I are more than Quit.

ANOTHER

Yes, every Poet is a Fool:
 By Demonstration Ned can show it:
Happy, cou'd Ned's inverted Rule
 Prove every Fool to be a Poet.

FOR MY OWN TOMB-STONE

To Me 'twas giv'n to die: to Thee 'tis giv'n
 To live: Alas! one Moment sets us ev'n.
Mark! how impartial is the Will of Heav'n?
 Poems on Several Occasions (1718)

As an epigrammatist he is unrivalled in English.

AUSTIN DOBSON
in Ward's The English Poets (1880)

857

TO CLOE JEALOUS, A BETTER ANSWER

I court others in Verse; but I love Thee in Prose:
And They have my Whimsies; but Thou hast my Heart.
<div align="right">Poems on Several Occasions (1718)</div>

*Prior is probably the greatest of all who dally with the light lyre which
thrills to the wings of fleeting Loves—the greatest English writer of*
VERS DE SOCIÉTÉ.

<div align="right">A N D R E W L A N G
Letters on Literature (1889)</div>

M A T T H E W P R I O R

1 6 6 4 — 1 7 2 1

AN ODE

I

The Merchant, to secure his Treasure,
Conveys it in a borrow'd Name:
Euphelia serves to grace my Measure;
But Cloe is my real Flame.

II

My softest Verse, my darling Lyre
Upon Euphelia's Toylet lay;
When Cloe noted her Desire,
That I should sing, that I should play.

III

My Lyre I tune, my Voice I raise;
But with my Numbers mix my Sighs:
And whilst I sing Euphelia's Praise,
I fix my Soul on Cloe's Eyes.

Fair Cloe blush'd: Euphelia frown'd:
I sung and gaz'd: I play'd and trembl'd:
And Venus to the Loves around
Remark'd, how ill We all dissembl'd.

Poems on Several Occasions (1718)

TO A CHILD OF QUALITY,

FIVE YEARS OLD, THE AUTHOR FORTY

I

Lords, knights, and squires, the num'rous band,
That wear the fair miss Mary's fetters,
Were summon'd by her high command,
To show their passions by their letters.

II

My pen amongst the rest I took,
Lest those bright eyes that cannot read
Shou'd dart their kindling fires, and look,
The power they have to be obey'd.

III

Nor quality, nor reputation,
Forbid me yet my flame to tell,
Dear five years old befriends my passion,
And I may write till she can spell.

IV

For while she makes her silk-worms beds,
With all the tender things I swear,
Whilst all the house my passion reads,
In papers round her baby's hair.

V

She may receive and own my flame,
For tho' the strictest prudes shou'd know it,
She'll pass for a most virtuous dame,
And I for an unhappy poet.

VI

Then too alas! when she shall tear
 The lines some younger rival sends,
She'll give me leave to write I fear,
 And we shall still continue friends.

VII

For as our diff'rent ages move,
 'Tis so ordain'd, wou'd fate but mend it,
That I shall be past making love
 When she begins to comprehend it.

(1704)

The perfection of VERS DE SOCIÉTÉ.

WALTER HEADLAM
A Book of Greek Verse (1907)

JONATHAN SWIFT

1 6 6 7 — 1 7 4 5

TO THEIR EXCELLENCIES THE LORDS JUSTICES OF IRELAND

THE HUMBLE PETITION OF FRANCES HARRIS,

Who must Starve, and Die a Maid if it miscarries.

Anno 1700

Humbly Sheweth.
That I went to warm my self in Lady *Betty's* Chamber, because I was cold,
And I had in a Purse, seven Pound, four Shillings and six Pence, besides Farthings, in Money, and Gold;
So because I had been buying things for my *Lady* last Night,
I was resolved to tell my Money, to see if it was right:
Now you must know, because my Trunk has a very bad Lock,
Therefore all the Money, I have, which, *God* knows, is a very small Stock,
I keep in my Pocket ty'd about my Middle, next my Smock.

860

So when I went to put up my Purse, as *God* would have it, my **Smock** was unript,
And, instead of putting it into my Pocket, down it slipt:
Then the Bell rung, and I went down to put my *Lady* to Bed,
And, *God* knows, I thought my Money was as safe as my Maidenhead.
So when I came up again, I found my Pocket feel very light,
But when I search'd, and miss'd my Purse, *Lord!* I thought I should have sunk outright:
Lord! Madam, says *Mary,* how d'ye do? Indeed, says I, never worse;
But pray, *Mary,* can you tell what I have done with my Purse!
Lord help me, said *Mary,* I never stirr'd out of this Place!
Nay, said I, I had it in Lady *Betty's* Chamber, that's a plain Case.
So *Mary* got me to bed, and cover'd me up warm;
However, she stole away my Garters, that I might do my self no Harm:
So I tumbl'd and toss'd all Night, as you may very well think,
But hardly ever set my Eyes together, or slept a Wink.
So I was a-dream'd, methought, that we went and search'd the Folks round,
And in a Corner of Mrs. *Dukes's* Box, ty'd in a Rag, the Money was found.
So next Morning we told *Whittle,* and he fell a Swearing;
Then my Dame *Wadgar* came, and she, you know, is thick of Hearing;
Dame, said I, as loud as I could bawl, Do you know what a Loss I have had?
Nay, said she, my Lord *Collway's* Folks are all very sad,
For my Lord *Dromedary* comes a *Tuesday* without fail;
Pugh! said I, but that's not the Business that I ail.
Says *Cary,* says he, I have been a Servant this Five and Twenty Years, come Spring,
And in all the Places I Liv'd, I never heard of such a Thing.
Yes, says the *Steward,* I remember when I was at my Lady *Shrewsbury's,*
Such a Thing as this happen'd, just about the time of *Goosberries.*
So I went to the Party suspected, and I found her full of Grief;
(Now you must know, of all Things in the World, I hate a Thief.)
However I was resolv'd to bring the Discourse slily about,
Mrs. *Dukes,* said I, here's an ugly Accident has happen'd out;
'Tis not that I value the Money three Skips of a Louse;
But the Thing I stand upon, is the Credit of the House;
'Tis true, seven Pounds, four Shillings and six Pence, makes a great Hole in my Wages,
Besides, as they say, Service is no Inheritance in these Ages.
Now, Mrs. *Dukes,* you know, and every Body understands,
That tho' 'tis hard to judge, yet Money can't go without Hands.
The *Devil* take me, said she, (blessing her self,) is ever I saw't!
So she roar'd like a *Bedlam,* as tho' I had call'd her all to naught;

So you know, what could I say to her any more,
I e'en left her, and came away as wise as I was before.
Well: But then they would have had me gone to the Cunning Man;
No, said I, 'tis the same Thing, the *Chaplain* will be here anon.
So the *Chaplain* came in; now the Servants say, he is my Sweet-heart,
Because he's always in my Chamber, and I always take his Part;
So, as the *Devil* would have it, before I was aware, out I blunder'd,
Parson, said I, can you cast a *Nativity*, when a Body's plunder'd?
(Now you must know, he hates to be call'd *Parson*, like the *Devil*.)
Truly, says he, Mrs. *Nab*, it might become you to be more civil:
If your Money be gone, as a Learned *Divine* says, d'ye see,
You are no *Text* for my Handling, so take that from me:
I was never taken for a *Conjurer* before, I'd have you to know.
Lord, said I, don't be angry, I'm sure I never thought you so;
You know, I honour the Cloth, I design to be a *Parson's* Wife,
I never took one in *Your Coat* for a *Conjurer* in all my Life.
With that, he twisted his Girdle at me like a Rope, as who should say,
Now you may go hang your self for me, and so went away.
Well; I thought I should have swoon'd; *Lord*, said I, what shall I do?
I have lost my *Money*, and shall lose my *True-Love* too.
Then my *Lord* call'd me; *Harry*, said my *Lord*, don't cry,
I'll give something towards thy Loss; and says my *Lady*, so will I.
Oh! but, said I, what if after all my Chaplain won't *come to*?
For that, he said, (an't please your *Excellencies*) I must petition You.
The Premises tenderly consider'd, I desire your *Excellencies* Protection,
And that I may have a Share in next *Sunday's* Collection:
And over and above, that I may have your *Excellencies* Letter,
With an Order for the *Chaplain* aforesaid: or instead of Him, a Better:
And then your poor *Petitioner*, both Night and Day,
Or the *Chaplain*, (for 'tis his *Trade*) as in Duty bound, shall ever *Pray*.

Perhaps this is the most humorous piece of verse in the English language.
FREDERICK LOCKER-LAMPSON
Lyra Elegantiarum (1867)

862

JONATHAN SWIFT

1 6 6 7 — 1 7 4 5

THE EPISTLE DEDICATORY,
TO HIS ROYAL HIGHNESS PRINCE POSTERITY

SIR,

I here present *Your Highness* with the Fruits of a very few leisure Hours, stollen from the short Intervals of a World of Business, and of an Employment quite alien from such Amusements as this: The poor Production of that Refuse of Time which has lain heavy upon my Hands, during a long Prorogation of Parliament, a great Dearth of Forein News, and a tedious Fit of rainy Weather: For which, and other Reasons, it cannot chuse extreamly to deserve such a Patronage as that of *Your Highness,* whose numberless Virtues in so few Years, make the World look upon You as the future Example to all Princes: For altho' *Your Highness* is hardly got clear of Infancy, yet has the universal learned World already resolv'd upon appealing to Your future Dictates with the lowest and most resigned Submission: Fate having decreed You sole Arbiter of the Productions of human Wit, in this polite and most accomplish'd Age. Methinks, the Number of Appellants were enough to shock and startle any Judge of a Genius less unlimited than Yours: But in order to prevent such glorious Tryals, the *Person* (it seems) to whose Care the Education of *Your Highness* is committed, has resolved (as I am told) to keep you in almost an universal Ignorance of our Studies, which it is Your inherent Birth-right to inspect.

IT is amazing to me, that this *Person* should have Assurance in the face of the Sun, to go about persuading *Your Highness,* that our Age is almost wholly illiterate, and has hardly produc'd one Writer upon any Subject. I know very well, that when *Your Highness* shall come to riper Years, and have gone through the Learning of Antiquity, you will be too curious to neglect inquiring into the Authors of the very age before You: And to think that this *Insolent,* in the Account he is preparing for Your View, designs to reduce them to a Number so insignificant as I am asham'd to mention; it moves my Zeal and my Spleen for the Honor and Interest of our vast flourishing Body, as well as of my self, for whom I know by long Experience, he has profess'd, and still continues a peculiar Malice.

'TIS not unlikely, that when *Your Highness* will one day peruse what I am now writing, You may be ready to expostulate with Your *Governour* upon the Credit of what I here affirm, and command Him to shew You some of our Productions. To which he will answer, (for I am well informed of his Designs) by asking *Your Highness,* where they are? and

what is become of them? and pretend it a Demonstration that there never were any, because they are not then to be found: Not to be found! Who has mislaid them? Are they sunk in the Abyss of Things? 'Tis certain, that in their own Nature they were *light* enough to swim upon the Surface for all Eternity. Therefore the Fault is in Him, who tied Weights so heavy to their Heels, as to depress them to the Center. Is their very Essence destroyed? Who has annihilated them? Were they drowned by *Purges* or martyred by *Pipes?* Who administred them to the Posteriors of ——? But that it may no longer be a Doubt with *Your Highness,* who is to be the Author of this universal Ruin; I beseech You to observe that large and terrible *Scythe* which your *Governour* affects to bear continually about him. Be pleased to remark the Length and Strength, the Sharpness and Hardness of his *Nails* and *Teeth:* Consider his baneful abominable *Breath,* Enemy to Life and Matter, infectious and corrupting: And then reflect whether it be possible for any mortal Ink and Paper of this Generation to make a suitable Resistance. Oh, that *Your Highness* would one day resolve to disarm this Usurping *Maitre du Palais,* of his furious Engins, and bring Your Empire *hors de Page.*

IT were endless to recount the several Methods of Tyranny and Destruction, which Your *Governour* is pleased to practise upon this Occasion. His inveterate Malice is such to the Writings of our Age, that of several Thousands produced yearly from this renowned City, before the next Revolution of the Sun, there is not one to be heard of: Unhappy Infants, many of them barbarously destroyed, before they have so much as learnt their *Mother-Tongue* to beg for Pity. Some he stifles in their Cradles, others he frights into Convulsions, whereof they suddenly die; Some he flays alive, others he tears Limb from Limb. Great Numbers are offered to *Moloch,* and the rest tainted by his Breath, die of a languishing Consumption.

BUT the Concern I have most at Heart, is for our Corporation of *Poets,* from whom I am preparing a Petition to *Your Highness,* to be subscribed with the Names of one hundred thirty six of the first Rate, but whose immortal Productions are never likely to reach your Eyes, tho' each of them is now an humble and an earnest Appellant for the Laurel, and has large comely Volumes ready to shew for a Support to his Pretensions. The *never-dying* Works of these illustrious Persons, Your *Governour,* Sir, has devoted to unavoidable Death, and *Your Highness* is to be made believe, that our Age has never arrived at the Honor to produce one single Poet.

WE confess *Immortality* to be a great and powerful Goddess, but in vain we offer up to her our Devotions and our Sacrifices, if *Your Highness's Governour,* who has usurped the *Priesthood,* must by an unparallel'd Ambition and Avarice, wholly intercept and devour them.

TO affirm that our Age is altogether Unlearned, and devoid of

864

Writers in any kind, seems to be an Assertion so bold and so false, that I have been sometime thinking, the contrary may almost be proved by uncontroulable Demonstration. 'Tis true indeed, that altho' their Numbers be vast, and their Productions numerous in proportion, yet are they hurryed so hastily off the Scene, that they escape our Memory, and delude our Sight. When I first thought of this Address, I had prepared a copious List of *Titles* to present *Your Highness* as an undisputed Argument for what I affirm. The Originals were posted fresh upon all Gates and Corners of Streets; but returning in a very few Hours to take a Review, they were all torn down, and fresh ones in their Places: I enquired after them among Readers and Booksellers, but I enquired in vain, the *Memorial of them was lost among Men, their Place was no more to be found:* and I was laughed to scorn, for a *Clown* and a *Pedant,* without all Taste and Refinement, little versed in the Course of *present* Affairs, and that knew nothing of what had pass'd in the best Companies of Court and Town. So that I can only avow in general to *Your Highness,* that we do abound in Learning and Wit; but to fix upon Particulars, is a Task too slippery for my slender Abilities. If I should venture in a windy Day, to affirm to *Your Highness,* that there is a large Cloud near the *Horizon* in the Form of a *Bear,* another in the *Zenith* with the Head of an *Ass,* a third to the Westward with Claws like a *Dragon;* and *Your Highness* should in a few Minutes think fit to examine the Truth, 'tis certain, they would all be changed in Figure and Position, new ones would arise, and all we could agree upon would be, that Clouds there were, but that I was grossly mistaken in the *Zoography* and *Topography* of them.

BUT Your *Governour,* perhaps, may still insist, and put the Question: What is then become of those immense Bales of Paper, which must needs have been employ'd in such Numbers of Books? Can these also be wholly annihilate, and so of a sudden as I pretend? What shall I say in return of so invidious an Objection? It ill befits the Distance between *Your Highness* and Me, to send You for ocular Conviction to a *Jakes,* or an *Oven;* to the Windows of a *Bawdy-house,* or to a sordid *Lanthorn.* Books, like Men their Authors, have no more than one Way of coming into the World, but there are ten Thousand to go out of it, and return no more.

I profess to *Your Highness,* in the Integrity of my Heart, that what I am going to say is literally true this Minute I am writing: What Revolutions may happen before it shall be ready for your Perusal, I can by no means warrant: However I beg You to accept it as a Specimen of our Learning, our Politeness and our Wit. I do therefore affirm upon the Word of a sincere Man, that there is now actually in being, a certain Poet called *John Dryden,* whose Translation of *Virgil* was lately printed in a large Folio, well bound, and if diligent search were made, for ought I know, is yet to be seen. There is another call'd *Nahum Tate,* who is

ready to make Oath that he has caused many Rheams of Verse to be published, whereof both himself and his Bookseller (if lawfully required) can still produce authentick Copies, and therefore wonders why the World is pleased to make such a Secret of it. There is a Third, known by the Name of *Tom Durfey*, a Poet of a vast Comprehension, an universal Genius, and most profound Learning. There are also one Mr. *Rymer*, and one Mr. *Dennis*, most profound Criticks. There is a Person styl'd Dr. *B--tl-y*, who has written near a thousand Pages of immense Erudition, *giving a full and true Account* of a certain *Squable* of wonderful Importance between himself and a Bookseller: He is a Writer of infinite Wit and Humour; no Man raillyes with a better Grace, and in more sprightly Turns. Farther, I avow to *Your Highness*, that with these Eyes I have beheld the Person of *William W--tt--n*, B.D. who has written a good sizeable volume against a *Friend of Your Governor*, (from whom, alas! he must therefore look for little Favour) in a most gentlemanly Style, adorned with utmost Politeness and Civility; replete with Discoveries equally valuable for their Novelty and Use: and embellish'd with *Traits* of Wit so poignant and so apposite, that he is a worthy Yokemate to his foremention'd *Friend*.

WHY should I go upon farther Particulars, which might fill a Volume with the just Elogies of my cotemporary Brethren? I shall bequeath this Piece of Justice to a larger Work: wherein I intend to write a Character of the present Set of *Wits* in our Nation: Their Persons I shall describe particularly, and at Length, their Genius and Understandings in *Mignature*.

IN the mean time, I do here make bold to present *Your Highness* with a faithful Abstract drawn from the Universal Body of all Arts and Sciences, intended wholly for your Service and Instruction: Nor do I doubt in the least, but *Your Highness* will peruse it as carefully, and make as considerable Improvements, as *other* young *Princes* have already done by the many Volumes of late Years written for a Help to their Studies.

THAT *Your Highness* may advance in Wisdom and Virtue, as well as Years, and at last out-shine all Your Royal Ancestors, shall be the daily Prayer of,

<div align="center">

SIR,

</div>

Decemb.
1697.

<div align="right">

Your Highness's
Most devoted, &c.

</div>

<div align="center">

A Tale of a Tub (1704)

</div>

Of all English prose Swift's has the most of flexibility, the most of nervous and of sinewy force; it is the most perfect as an instrument, and the most deadly in its unerring accuracy of aim. It often disdains grammatical correctness, and violates not infrequently the rules of con-

*struction and arrangement. But it is significant that Swift attained the
perfection of his art, not by deliberately setting aside the proprieties of
diction, but by setting before himself consistently the first and highest
ideal of simplicity, by disdaining eccentricity and paradox and the
caprice of fashion, and that although he wrote "his own English," as no
other did before or since, he was inspired from first to last by a deep
reverence for the language, and an ardent desire to maintain its dignity
and its purity unchanged and unimpaired.*

<div align="right">

HENRY CRAIK

English Prose (1906)

</div>

JONATHAN SWIFT

1 6 6 7 — 1 7 4 5

A MODEST PROPOSAL

*for preventing the Children of Poor People from being a Burthen to
to their Parents, or the Country, and for making them
Beneficial to the Publick.*

It is a melancholly Object to those, who walk through this great Town,
or travel in the Country, when they see the *Streets*, the *Roads*, and
Cabbin-Doors, crowded with *Beggars* of the female Sex, followed by
three, four, or six Children, *all in Rags*, and importuning every Pas-
senger for an Alms. . . .

I think it is agreed by all Parties, that this prodigious number of
Children. . . . is *in the present deplorable state of the Kingdom*, a very
great additional grievance; and therefore whoever could find out a fair,
cheap and easy method of making these Children sound and useful
Members of the common-wealth would deserve so well of the publick,
as to have his Statue set up for a preserver of the Nation. . . .

I shall now therefore humbly propose my own thoughts, which I hope
will not be lyable to the least Objection.

I have been assured by a very knowing *American* of my acquaintance
in *London*, that a young healthy Child well Nursed is at a year Old a
most delicious, nourishing, and wholesome Food, whether *Stewed,
Roasted, Baked, or Boyled*, and I make no doubt that it will equally
serve in a *Fricasie*, or a *Ragoust*.

I do therefore humbly offer it to *publick consideration*, that of the
hundred and twenty thousand Children, already computed, twenty
thousand may be reserved for Breed, whereof only one fourth part to
be Males. . . . That the remaining hundred thousand may at a year

Old be offered in Sale to the *persons of Quality*, and *Fortune*, through the Kingdom, always advising the Mother to let them Suck plentifully in the last Month, so as to render them Plump, and Fat for a good Table. A Child will make two Dishes at an Entertainment for Friends, and when the Family dines alone, the fore or hind Quarter will make a reasonable Dish, and seasoned with a little Pepper or Salt will be very good Boiled on the fourth Day, especially in Winter.

I have reckoned upon a Medium, that a Child just born will weigh 12 pounds, and in a solar Year if tollerably nursed encreaseth to 28 Pound. . . .

I have already computed the Charge of nursing a Beggars Child (in which list I reckon all *Cottagers, Labourers,* and four fifths of the *Farmers*) to be about two Shillings *per Annum*, Rags included, and I believe no Gentleman would repine to give Ten Shillings for the *Carcass of a good fat Child*, which, as I have said will make four Dishes of excellent Nutritive Meat. . . .

Those who are more thrifty (*as I must confess the Times require*) may flay the Carcass; the Skin of which, Artificially dressed, will make admirable *Gloves for Ladies*, and *Summer Boots for fine Gentlemen*.

As to our City of *Dublin*, Shambles may be appointed for this purpose, in the most convenient parts of it, and Butchers we may be assured will not be wanting, although I rather recommend buying the Children alive, and dressing them hot from the Knife, as we do *roasting Pigs.* . . .

Some Persons of a desponding Spirit are in great concern about that vast Number of poor People, who are aged, diseased, or maimed, and I have been desired to imploy my thoughts what Course may be taken, to ease the Nation of so grievous an Incumbrance. But I am not in the least pain about the matter, because it is very well known, that they are every Day *dying*, and *rotting*, by *cold*, and *famine*, and *filth*, and *vermin*, as fast as can be reasonably expected. And as to the younger Labourers they are now in almost as hopeful a Condition. They cannot get Work, and consequently pine away for want of Nourishment, to a degree, that if at any time they are accidentally hired to common Labour, they have not strength to perform it, and thus the Country and themselves are happily delivered from the Evils to come. . . .

I think the advantages by the Proposal which I have made are obvious and many as well as of the highest importance.

For first, as I have already observed, it would greatly lessen *the Number of Papists*, with whom we are Yearly over-run, being the principal Breeders of the Nation, as well as our most dangerous Enemies. . . .

Thirdly, Whereas the Maintenance of an hundred thousand Children, from two Years old, and upwards, cannot be computed at less than Ten Shillings a piece *per Annum*, the Nation's Stock will be thereby encreased fifty thousand pounds *per Annum*, besides the profit of a new Dish, introduced to the Tables of all *Gentlemen of Fortune* in the

Kingdom, who have any refinement in Taste, and the Money will circulate among our selves, the Goods being entirely of our own Growth and Manufacture. . . .

Sixthly, This would be a great Inducement to Marriage, which all wise Nations have either encouraged by Rewards, or enforced by Laws and Penalties. It would encrease the care and tenderness of Mothers towards their Children, when they were sure of a Settlement for Life, to the poor Babes, provided in some sort by the Publick to their Annual profit instead of Expence. . . .

Many other advantages might be enumerated: For Instance, the addition of some thousand Carcases in our exportation of Barreled Beef. The Propagation of *Swines Flesh,* and Improvement in the Art of making good *Bacon.* . . . But this, and many others I omit, being studious of Brevity. . . .

I Profess in the sincerity of my Heart that I have not the least personal Interest in endeavouring to promote this necessary Work having no other Motive than the *publick Good of my Country, by advancing our Trade, providing for Infants, relieving the Poor, and giving some Pleasure to the Rich.* I have no Children, by which I can propose to get a single Penny; the youngest being nine Years old, and my Wife past Childbearing.

(1729)

I give it almost entire; it merits it. I know nothing its equal in any literature.

HIPPOLYTE TAINE
Histoire de la littérature anglaise (1863)

JONATHAN SWIFT

1 6 6 7 — 1 7 4 5

INSCRIPTION ACCOMPANYING A LOCK OF STELLA'S HAIR

Only a woman's hair.

The riddle of the painful earth in one of its forms expressed more poignantly and finally than it has been expressed by any uninspired human being excepting Shakespeare.

GEORGE SAINTSBURY
The Peace of the Augustans (1916)

JEAN-BAPTISTE ROUSSEAU

1 6 6 9 — 1 7 4 1

EPIGRAM

Le traducteur qui rima l'Iliade,
De douze chants prétendit l'abréger:
Mais par son style, aussi triste que fade,
De douze en sus il a su l'allonger.
Or, le lecteur, qui se sent affliger,
Le donne au diable, et dit, perdant haleine:
Hé! finissez, rimeur à la douzaine!
Vos abrégés sont longs au dernier point.
Ami lecteur, vous voilà bien en peine;
Rendons-les courts en ne les lisant point.

The translator who rhymed the Iliad claimed to have shortened it twelve cantos; but through his tasteless and sorry style, he lengthened it twelve cantos more. Now, the aggrieved reader consigns it to hell, and says, out of breath: Hey! be done, you cheap rhymster! Your abbreviations are excessively lengthy. Dear Reader, you are in a sorry fix; let us save time by not reading them at all.

Rousseau without doubt has reached the supreme height in this minor genre in which perfection is rare, as it is everywhere.

PIERRE MALITOURNE
Les Poëtes français (1861)

WILLIAM CONGREVE

1 6 7 0 — 1 7 2 9

VALENTINE AND HIS FATHER DISCUSS PATERNAL RESPONSIBILITY

JEREMY
He is here, Sir.
VALENTINE
Your Blessing, Sir.

SIR SAMPSON

You've had it already, Sir, I think I sent it you to Day in a Bill of Four thousand Pound: A great deal of Mony, Brother *Foresight*.

FORESIGHT

Ay indeed, Sir *Sampson*, a great deal of Mony for a young Man, I wonder what he can do with it!

SIR SAMPSON

Body o'me, so do I.—Hark ye, *Valentine*, if there be too much, refund the Superfluity; Do'st hear Boy?

VALENTINE

Superfluity, Sir, it will scarce pay my Debts,—I hope you will have more Indulgence, than to oblige me to those hard Conditions, which my Necessity sign'd to.

SIR SAMPSON

Sir, how, I beseech you, what were you pleas'd to intimate, concerning Indulgence?

VALENTINE

Why, Sir, that you wou'd not go to the extremity of the Conditions, but release me at least from some Part.—

SIR SAMPSON

Oh Sir, I understand you—that's all, ha?

VALENTINE

Yes, Sir, all that I presume to ask.—But what you, out of Fatherly Fondness, will be pleas'd to add, shall be doubly welcome.

SIR SAMPSON

No doubt of it, sweet Sir, but your filial Piety, and my fatherly Fondness wou'd fit like two Tallies.—Here's a Rogue, Brother *Foresight*, makes a Bargain under Hand and Seal in the Morning, and would be releas'd from it in the Afternoon; here's a Rogue, Dog, here's Conscience and Honesty; this is your Wit now, this is the Morality of your Wits! You are a Wit, and have been a Beau, and may be a— Why Sirrah, is it not here under Hand and Seal—Can you deny it?

VALENTINE

Sir, I don't deny it.—

SIR SAMPSON

Sirrah, you'll be hang'd; I shall live to see you go up *Holborn-Hill* —Has he not a Rogue's Face?—Speak, Brother, you understand Physiognomy, a hanging Look to me—of all my Boys the most unlike me; he has a damn'd *Tyburn*-Face, without the Benefit o'the Clergy.

FORESIGHT

Hum—truly I don't care to discourage a young Man,—he has a violent Death in his Face; but I hope no Danger of Hanging.

VALENTINE

Sir, is this Usage for your Son?—for that old Weather-headed Fool, I know how to laugh at him; but you, Sir—

SIR SAMPSON

You, Sir; and you, Sir:—Why, who are you, Sir?

VALENTINE

Your Son, Sir.

SIR SAMPSON

That's more than I know, Sir, and I believe not.

VALENTINE

Faith, I hope not.

SIR SAMPSON

What, wou'd you have your Mother a Whore! Did you ever hear the like! Did you ever hear the like! Body o'me—

VALENTINE

I would have an Excuse for your Barbarity and unnatural Usage.

SIR SAMPSON

Excuse! Impudence! Why, Sirrah, mayn't I do what I please? Are not you my Slave? Did not I beget you? And might not I have chosen whether I would have begot you or no? 'Oons who are you? Whence came you? What brought you into the World? How came you here, Sir? Here, to stand here, upon those two Legs, and look erect with that audacious Face, hah? Answer me that? Did you come a Volunteer into the World? Or did I, with the lawful Authority of a Parent, press you to the Service?

VALENTINE

I know no more why I came, than you do why you call'd me. But here I am, and if you don't mean to provide for me, I desire you would leave me as you found me.

SIR SAMPSON

With all my Heart: Come, uncase, strip, and go naked out of the World, as you came into't.

VALENTINE

My Cloaths are soon put off:—But you must also divest me of Reason, Thought, Passions, Inclinations, Affections, Appetites, Senses, and the huge Train of Attendants that you begot along with me.

SIR SAMPSON

Body o'me, what a many-headed Monster have I propagated!

VALENTINE

I am of my self, a plain easie simple Creature; and to be kept at small Expence; but the Retinue that you gave me are craving and invincible; they are so many Devils that you have rais'd, and will have Employment.

SIR SAMPSON

'Oons, what had I to do to get Children,—can't a private Man be born without all these Followers?—Why nothing under an Emperor

872

should be born with Appetites,—Why at this rate a Fellow that has but a Groat in his Pocket, may have a Stomach capable of a Ten Shilling Ordinary.

JEREMY

Nay that's as clear as the Sun; I'll make Oath of it before any Justice in *Middlesex*.

SIR SAMPSON

Here's a Cormorant too,—'S'heart this Fellow was not born with you?—I did not beget him, did I?—

JEREMY

By the Provision that's made for me, you might have begot me too: —Nay, and to tell your Worship another Truth, I believe you did, for I find I was born with those same Whoreson Appetites too, that my Master speaks of.

SIR SAMPSON

Why look you there now,—I'll maintain it, that by the Rule of right Reason, this Fellow ought to have been born without a Palate. 'S'heart, what shou'd he do with a distinguishing Taste?—I warrant now he'd rather eat a Pheasant, than a Piece of poor *John;* and smell, now, why I warrant he can smell, and loves Perfumes above a Stink.—Why there's it; and Musick, don't you love Musick, Scoundrel?

JEREMY

Yes, I have a reasonable good Ear, Sir, as to Jiggs and Country Dances; and the like; I don't much matter your *Solo's* or *Sonata's,* they give me the Spleen.

SIR SAMPSON

The Spleen, ha, ha, ha, a Pox confound you—*Solo's* or *Sonata's?* 'Oons whose Son are you? How were you engendred, Muckworm?

JEREMY

I am by my Father, the Son of a Chairman; my Mother sold Oisters in Winter, and Cucumbers in Summer; and I came up Stairs into the World; for I was born in a Cellar.

FORESIGHT

By your Looks, you shou'd go up Stairs out of the World too, Friend.

SIR SAMPSON

And if this Rogue were Anatomiz'd now, and dissected, he has his Vessels of Digestion and Concoction, and so forth, large enough for the inside of a Cardinal, this Son of a Cucumber.—These things are unaccountable and unreasonable,—Body o'me, why was not I a Bear? that my Cubs might have liv'd upon sucking their Paws; Nature has been provident only to Bears and Spiders; the one has its Nutriment in his own Hands; and t'other spins his Habitation out of his own Entrails.

VALENTINE

Fortune was provident enough to supply all the Necessities of my Nature; if I had my right of Inheritance.

SIR SAMPSON

Again! 'Oons han't you four thousand Pound—if I had it again, I wou'd not give thee a Groat,—What, would'st thou have me turn Pelican, and feed thee out of my own Vitals?—'S'heart, live by your Wits,—You were always fond of the Wits,—Now let's see, if you have Wit enough to keep your self—Your Brother will be in Town to Night, or to Morrow Morning, and then look you perform Covenants, and so your Friend and Servant.—Come Brother *Foresight*.

<div align="right">Love for Love (1695)
Act ii, Scene vii</div>

One of the most admirable scenes in all comedy.

<div align="right">EDMUND GOSSE
Life of William Congreve (1924)</div>

WILLIAM CONGREVE

1 6 7 0 — 1 7 2 9

THE TEMPLE

ALMERIA

It was a fancy'd Noise, for all is hush'd.

LEONORA

It bore the Accent of a Human Voice.

ALMERIA

It was thy Fear, or else some transient Wind
Whistling thro' Hollows of this vaulted Isle.
We'll listen—

LEONORA

Hark!

ALMERIA

No, all is hush'd, and still as Death—'Tis dreadful!
How reverend is the Face of this tall Pile,
Whose ancient Pillars rear their Marble Heads,
To bear aloft its arch'd and pond'rous Roof,
By its own Weight made stedfast and immoveable,
Looking Tranquility. It striks an Awe
And Terror on my aking Sight; the Tombs

<div align="center">874</div>

And Monumental Caves of Death look cold,
And shoot a Chilness to my trembling Heart.
Give me thy Hand, and let me hear thy Voice;
Nay, quickly speak to me, and let me hear
Thy Voice—my own affrights me with its Echo's.

<div align="right">

The Mourning Bride (1697)

Act ii, Scene iii

</div>

If I were required to select from the whole mass of English poetry the most poetical paragraph, I know not what I could prefer to an exclamation in THE MOURNING BRIDE. *. . . . He who reads those lines enjoys for a moment the powers of a poet; he feels what he remembers to have felt before, but he feels it with great increase of sensibility; he recognizes a familiar image, but meets it again amplified and expanded, embellished with beauty, and enlarged with majesty.*

<div align="right">

SAMUEL JOHNSON

The Lives of the Poets (1779–81)

</div>

Johnson said, that the description of the temple, in the MOURNING BRIDE, *was the finest poetical passage he had ever read: he recollected none in Shakspeare equal to it. 'But, (said Garrick, all alarmed for the 'God of his idolatry,') we know not the extent and variety of his powers. We are to suppose there are such passages in his works. Shakspeare must not suffer from the badness of our memories.' Johnson, diverted by this enthusiastick jealousy, went on with greater ardour: 'No, Sir; Congreve has* NATURE;' *(smiling on the tragick eagerness of Garrick;) but composing himself, he added, 'Sir, this is not comparing Congreve on the whole, with Shakspeare on the whole; but only maintaining that Congreve has one finer passage than any that can be found in Shakspeare. Sir, a man may have no more than ten guineas in the world, but he may have those ten guineas in one piece; and so may have a finer piece than a man who has ten thousand pounds: but then he has only one ten-guinea piece. What I mean is, that you can shew me no passage where there is simply a description of material objects, without any intermixture of moral notions, which produces such an effect.'*

<div align="right">

JAMES BOSWELL

The Life of Samuel Johnson L.L.D. (1799)

</div>

WILLIAM CONGREVE

1670 — 1729

MRS. MILLAMANT IS SEEN
COMING THROUGH THE CROWD
IN ST. JAMES'S PARK

Here she comes I'faith full Sail, with her Fan spread and Streamers
out, and a Shoal of Fools for Tenders— Ha, no, I cry her Mercy.

The Way of the World (1700)
Act ii, Scene i

SHE DENIES THAT BEING LOVED
MAKES WOMEN BEAUTIFUL

Beauty the Lover's Gift— Lord, what is a Lover, that it can give?
Why one makes Lovers as fast as one pleases, and they live as long as
one pleases, and they die as soon as one pleases: And then if one
pleases one makes more.

The Way of the World (1700)
Act ii, Scene i

THE WAY OF THE WORLD *is throughout authentic Congreve, and is of
incomparable beauty in its kind. Here, whatever he may have learned
from his predecessors, he made something peculiarly his own, impos-
sible to imitate. For sinewy flexibility and point, combined with seduc-
tive gentleness; for the full gamut of vowel sounds and the varied
spacing of stresses, English literature had to wait for Landor until it
once more heard a voice that had something of the especial quality
of Congreve. . . .
The beauty of that [sentence that ushers in Mrs. Millamant for the
first time] needs no insistence; the delicate play of the vowels, the danc-
ing rhythm, with the sharp uptake at the end attended with the en-
tirely new sound of 'cry', sweep us away with their effect of spontaneity.
And see, too, a little later in the same scene, [when Mrs. Millamant
denies that being loved is what makes women beautiful] how skilfully he
can now play on one note, recurring to the same word. . . . 'How it
chimes, and cries tink in the close, divinely!' The reiteration never
gives the ear the smallest bother, because, said as they must be to gain
the full meaning, the phrases only gather their weight upon 'pleases'
in the last instance, the stresses otherwise playing all around it. At*

last the voice fatefully pounces upon the word, as a hawk, after several feints, lands upon a predestined prey.

Those extracts are from that miraculous second act, which shows a more consummate mastery than any other passage in the dramatic literature of the period.

<div align="right">

BONAMY DOBRÉE

Variety of Ways (1932)

</div>

JOSEPH ADDISON

1 6 7 2 — 1 7 1 9

A LADY'S LIBRARY

Some months ago, my friend Sir Roger, being in the country, enclosed a letter to me, directed to a certain lady whom I shall here call by the name of Leonora, and as it contained matters of consequence, desired me to deliver it to her with my own hand. Accordingly I waited upon her ladyship pretty early in the morning, and was desired by her woman to walk into her lady's library, till such time as she was in readiness to receive me. The very sound of a lady's library gave me a great curiosity to see in it; and as it was some time before the lady came to me, I had an opportunity of turning over a great many of her books, which were ranged together in a very beautiful order. At the end of the folios (which were finely bound and gilt) were great jars of China placed one above another in a very noble piece of architecture. The quartos were separated from the octavos by a pile of smaller vessels, which rose in a delightful pyramid. The octavos were bounded by tea-dishes of all shapes, colours, and sizes, which were so disposed on a wooden frame, that they looked like one continued pillar indented with the finest strokes of sculpture, and stained with the greatest variety of dyes. That part of the library which was designed for the reception of plays and pamphlets, and other loose papers, was enclosed in a kind of square, consisting of one of the prettiest grotesque works that ever I saw, and made up of scaramouches, lions, monkeys, mandarines, trees, shells, and a thousand other odd figures in China ware. In the midst of the room was a little Japan table, with a quire of gilt paper upon it, and on the paper a silver snuff-box made in the shape of a little book. I found there were several other counterfeit books upon the upper shelves, which were carved in wood, and served only to fill up the numbers, like fagots in the muster of a regiment. I was wonderfully pleased with such a mixt kind of furniture, as seemed very suitable to both the lady and the scholar, and did

not know at first whether I should fancy myself in a grotto, or in a library.

<div align="right">The Spectator (April 12, 1711)</div>

That is a little jewel of Addisonian prose. There is a slightly periodic character about the first sentence. Otherwise, the order of words in each sentence is simple and idiomatic. Nor is there apparently any attempt to give an emphatic close to each sentence. In the first, "with my own hand" ends the sentence well because it gives the reason of his visit. But "till such time as she was in readiness to receive me," "which were ranged together in a very beautiful order," "in a very noble piece of architecture," "which rose in a delightful pyramid," etc.—none of these SEEM *very weighty statements, but they are, in fact, fine strokes of Addisonian irony. The end of each sentence* IS *emphatic; and the emphasis thus thrown on trifling and apparently irrelevant details contributes delicately and penetratingly to what is intended to be the pervading innuendo of the whole paragraph and essay—that Leonora is more interested in the elegant accessories of her books than in their contents.*

<div align="right">HERBERT J. C. GRIERSON
Rhetoric and English Composition (1945)</div>

LOUIS DE SAINT-SIMON

1 6 7 5 — 1 7 5 5

THE DEATH OF MONSEIGNEUR

While Meudon was filled with horror, all was tranquil at Versailles, without the least suspicion. We had supped. The company some time after had retired, and I was talking with Madame de Saint-Simon, who had nearly finished undressing herself to go to bed, when a servant of Madame la Duchesse de Berry, who had formerly belonged to us, entered, all terrified. He said that there must be some bad news from Meudon, since Monseigneur le Duc de Bourgogne had just whispered in the ear of M. le Duc de Berry, whose eyes had at once become red, that he left the table, and that all the company shortly after him rose with precipitation. So sudden a change rendered my surprise extreme. I ran in hot haste to Madame la Duchesse de Berry's. Nobody was there. Everybody had gone to Madame la Duchesse de Bourgogne. I followed on with all speed.

I found all Versailles assembled on arriving, all the ladies hastily dressed—the majority having been on the point of going to bed—all

<div align="center">878</div>

the doors open, and all in trouble. I learnt that Monseigneur had received the extreme unction, that he was without consciousness and beyond hope, and that the King had sent word to Madame de Bourgogne that he was going to Marly, and that she was to meet him as he passed through the avenue between the two stables.

The spectacle before me attracted all the attention I could bestow. The two Princes and the two Princesses were in the little cabinet behind the bed. The bed toilette was as usual in the chamber of the Duchesse de Bourgogne, which was filled with all the Court in confusion. She came and went from the cabinet to the chamber, waiting for the moment when she was to meet the King; and her demeanour, always distinguished by the same graces, was one of trouble and compassion, which the trouble and compassion of others induced them to take for grief. Now and then, in passing, she said a few rare words. All present were in truth expressive personages. Whoever had eyes, without any knowledge of the Court, could see the interests of all interested painted on their faces, and the indifference of the indifferent; these tranquil, the former penetrated with grief, or gravely attentive to themselves to hide their emancipation and their joy.

For my part, my first care was to inform myself thoroughly of the state of affairs, fearing lest there might be too much alarm for too trifling a cause; then, recovering myself, I reflected upon the misery common to all men, and that I myself should find myself some day at the gates of death. Joy, nevertheless, found its way through the momentary reflections of religion and of humanity, by which I tried to master myself. My own private deliverance seemed so great and so unhoped for, that it appeared to me that the State must gain everything by such a loss. And with these thoughts I felt, in spite of myself, a lingering fear lest the sick man should recover, and was extremely ashamed of it.

Wrapped up thus in myself, I did not fail, nevertheless, to cast clandestine looks upon each face, to see what was passing there. I saw Madame la Duchesse d'Orléans arrive, but her countenance, majestic and constrained, said nothing. She went into the little cabinet, whence she presently issued with the Duc d'Orléans, whose activity and turbulent air marked his emotion at the spectacle more than any other sentiment. They went away, and I noticed this expressly, on account of what happened afterwards in my presence.

Soon afterwards I caught a distant glimpse of the Duc de Bourgogne, who seemed much moved and troubled; but the glance with which I probed him rapidly, revealed nothing tender, and told merely of a mind profoundly occupied with the bearings of what had taken place.

Valets and chamber-women were already indiscreetly crying out; and *their* grief showed well that they were about to lose something!

Towards half-past twelve we had news of the King, and immediately after Madame de Bourgogne came out of the little cabinet with the

879

Duke, who seemed more touched than when I first saw him. The Princess took her carf and her coifs from the toilette, standing with a deliberate air, her eyes scarcely wet—a fact betrayed by inquisitive glances cast rapidly to the right and left—and, followed only by her ladies, went to her coach by the great staircase.

I took the opportunity to go to the Duchesse d'Orléans, where I found many people. Their presence made me very impatient; the Duchess, who was equally impatient, took a light and went in. I whispered in the ear of the Duchesse de Villeroy, who thought as I thought of this event. She nudged me, and said in a very low voice that I must contain myself. I was smothered with silence, amidst the complaints and the narrative surprises of these ladies; but at last M. le Duc d'Orléans appeared at the door of his cabinet, and beckoned me to come to him.

I followed him into the cabinet, where we were alone. What was my surprise, remembering the terms on which he was with Monseigneur, to see the tears streaming from his eyes.

"Sir!" exclaimed I, rising. He understood me at once; and answered in a broken voice, really crying: "You are right to be surprised—I am surprised myself; but such a spectacle touches. He was a man with whom I passed much of my life, and who treated me well when he was uninfluenced. I feel very well that my grief won't last long; in a few days I shall discover motives of joy; at present, blood, relationship, humanity,—all work; and my entrails are moved." I praised his sentiments, but repeated my surprise. He rose, thrust his head into a corner, and with his nose there, wept bitterly and sobbed, which if I had not seen I could not have believed.

After a little silence, however, I exhorted him to calm himself. I represented to him that, everybody knowing on what terms he had been with Monseigneur, he would be laughed at, as playing a part, if his eyes showed that he had been weeping. He did what he could to remove the marks of his tears, and we then went back into the other room.

The interview of the Duchesse de Bourgogne with the King had not been long. She met him in the avenue between the two stables, got down, and went to the door of the carriage. Madame de Maintenon cried out, "Where are you going? We bear the plague about with us." I do not know what the King said or did. The Princess returned to her carriage, and came back to Versailles, bringing in reality the first news of the actual death of Monseigneur.

Acting upon the advice of M. de Beauvilliers, all the company had gone into the salon. The two Princes, Monseigneur de Bourgogne and M. de Berry, were there, seated on one sofa, their Princesses at their sides; all the rest of the company were scattered about in confusion, seated or standing, some of the ladies being on the floor, near the sofa. There could be no doubt of what had happened. It was plainly written on every face in the chamber and throughout the apartment. Monseig-

neur was no more: it was known: it was spoken of: constraint with re-spect to him no longer existed. Amidst the surprise, the confusion, and the movements that prevailed, the sentiments of all were painted to the life in looks and gestures.

In the outside rooms were heard the constrained groans and sighs of the valets—grieving for the master they had lost as well as for the master that had succeeded. Farther on began the crowd of courtiers of all kinds. The greater number—that is to say the fools—pumped up sighs as well as they could, and with wandering but dry eyes, sung the praises of Monseigneur—insisting especially on his goodness. They pitied the King for the loss of so good a son. The keener began already to be uneasy about the health of the King; and admired themselves for preserving so much judgment amidst so much trouble, which could be perceived by the frequency of their repetitions. Others, really afflicted—the dis-comfited cabal—wept bitterly, and kept themselves under with an effort as easy to notice as sobs. The most strong-minded or the wisest, with eyes fixed on the ground, in corners, meditated on the consequences of such an event—and especially on their own interests. Few words passed in conversation—here and there an exclamation wrung from grief was answered by some neighbouring grief—a word every quarter of an hour—sombre and haggard eyes—movements quite involuntary of the hands—immobility of all other parts of the body. Those who al-ready looked upon the event as favourable in vain exaggerated their gravity so as to make it resemble chagrin and severity; the veil over their faces was transparent and hid not a single feature. They remained as motionless as those who grieved most, fearing opinion, curiosity, their own satisfaction, their every movement; but their eyes made up for their immobility. Indeed they could not refrain from repeatedly changing their attitude like people ill at ease, sitting or standing, from avoiding each other too carefully, even from allowing their eyes to meet—nor repress a manifest air of liberty—nor conceal their increased liveliness—nor put out a sort of brilliancy which distinguished them in spite of themselves.

The two Princes, and the two Princesses who sat by their sides, were more exposed to view than any other. The Duc de Bourgogne wept with tenderness, sincerity, and gentleness, the tears of nature, of religion, and patience. M. le Duc de Berry also sincerely shed abundance of tears, but bloody tears, so to speak, so great appeared their bitterness; and he uttered not only sobs, but cries, nay, even yells. He was silent sometimes, but from suffocation, and then would burst out again with such a noise, such a trumpet sound of despair, that the majority present burst out also at these dolorous repetitions, either impelled by affliction or decorum. He became so bad, in fact, that his people were forced to undress him then and there, put him to bed, and call in the doctor. Madame la Duchesse de Berry was beside herself, and we shall soon

see why. The most bitter despair was painted with horror on her face. There was seen written, as it were, a sort of furious grief, based on interest, not affection; now and then came dry lulls deep and sullen, then a torrent of tears and involuntary gestures, yet restrained, which showed extreme bitterness of mind, fruit of the profound meditation that had preceded. Often aroused by the cries of her husband, prompt to assist him, to support him, to embrace him, to give her smelling-bottle, her care for him was evident; but soon came another profound reverie —then a gush of tears assisted to suppress her cries. As for Madame la Duchesse de Bourgogne she consoled her husband with less trouble than she had to appear herself in want of consolation. Without attempt-ing to play a part, it was evident that she did her best to acquit herself of a pressing duty of decorum. But she found extreme difficulty in keeping up appearances. When the Prince her brother-in-law howled, she blew her nose. She had brought some tears along with her and kept them up with care; and these combined with the art of the handkerchief, enabled her to redden her eyes, and make them swell, and smudge her face; but her glances often wandered on the sly to the countenances of all present.

Madame arrived, in full dress she knew not why, and howling she knew not why, inundated everybody with her tears in embracing them, making the château echo with renewed cries, and furnished the odd spectacle of a Princess putting on her robes of ceremony in the dead of night to come and cry among a crowd of women with but little on except their night-dresses,—almost as masqueraders.

In the gallery several ladies, Madame la Duchesse d'Orléans, Madame de Castries, and Madame de Saint-Simon among the rest, finding no one close by, drew near each other by the side of a tent-bedstead, and began to open their hearts to each other, which they did with the more free-dom, inasmuch as they had but one sentiment in common upon what had occurred. In this gallery, and in the salon, there were always during the night several beds, in which, for security's sake, certain Swiss guards and servants slept. These beds had been put in their usual place this evening before the bad news came from Meudon. In the midst of the conversation of the ladies, Madame de Castries touched the bed, felt something move, and was much terrified. A moment after they saw a sturdy arm, nearly naked, raise on a sudden the curtains, and thus show them a great brawny Swiss under the sheets, half awake, and wholly amazed. The fellow was a long time in making out his position, fixing his eyes upon every face one after the other; but at last, not judg-ing it advisable to get up in the midst of such a grand company, he reburied himself in his bed, and closed the curtains. Apparently the good man had gone to bed before anything had transpired, and had slept so soundly ever since that he had not been aroused until then. The sad-

dest sights have often the most ridiculous contrasts. This caused some of the ladies to laugh, and Madame d'Orléans fear lest the conversation should have been overheard. But after reflection, the sleep and the stupidity of the sleeper reassured her.

I had some doubts yet as to the event that had taken place; for I did not like to abandon myself to belief, until the word was pronounced by some one in whom I could have faith. By chance I met D'O, and I asked him. He answered me clearly that Monseigneur was no more. Thus answered, I tried not to be glad. I know not if I succeeded well, but at least it is certain, that neither joy nor sorrow blunted my curiosity, and that while taking due care to preserve all decorum, I did not consider myself in any way forced to play the doleful. I no longer feared any fresh attack from the citadel of Meudon, nor any cruel charges from its implacable garrison. I felt, therefore, under no constraint, and followed every face with my glances, and tried to scrutinise them unobserved. It must be admitted, that for him who is well acquainted with the privacies of a Court, the first sight of rare events of this nature, so interesting in so many different respects, is extremely satisfactory. Every countenance recalls the cares, the intrigues, the labours employed in the advancement of fortunes—in the overthrow of rivals: the relations, the coldness, the hatreds, the evil offices done, the baseness of all; hope, despair, rage, satisfaction, express themselves in the features. See how all eyes wander to and fro examining what passes around—how some are astonished to find others more mean, or less mean than was expected! Thus this spectacle produced a pleasure, which, hollow as it may be, is one of the greatest a Court can bestow.

The turmoil in this vast apartment lasted about an hour, at the end of which M. de Beauvilliers thought it was high time to deliver the Princes of their company. The rooms were cleared. M. le Duc de Berry went away to his rooms, partly supported by his wife. All through the night he asked, amid tears and cries, for news from Meudon; he would not understand the cause of the King's departure to Marly. When at length the mournful curtain was drawn from before his eyes, the state he fell into cannot be described. The night of Monseigneur and Madame de Bourgogne was more tranquil. Some one having said to the Princess, that having no real cause to be affected, it would be terrible to play a part, she replied, quite naturally, that without feigning, pity touched her and decorum controlled her; and indeed she kept herself within these bounds with truth and decency. Their chamber, in which they invited several ladies to pass the night in arm-chairs, became immediately a palace of Morpheus. All quietly fell asleep. The curtains were left open, so that the Prince and Princess could be seen sleeping profoundly. They woke up once or twice for a moment. In the morning the Duke and Duchess rose early, their tears quite dried up. They shed

no more for this cause, except on special and rare occasions. The ladies who had watched and slept in their chamber, told their friends how tranquil the night had been. But nobody was surprised, and as there was no longer a Monseigneur, nobody was scandalised. Madame de Saint-Simon and I remained up two hours before going to bed, and then went there without feeling any want of rest. In fact, I slept so little that at seven in the morning I was up; but it must be admitted that such restlessness is sweet, and such re-awakenings are savoury.

Mémoires (1829–30)
Translated by Bayle St. John

A scene that surpasses anything imaginable for sagacity of observation and genius of expression in human matters.

C.-A. SAINTE-BEUVE
Causeries du lundi (1851)

ALEXANDER POPE

1688 — 1744

THE HEIGHTS OF ARTS

Fir'd at first sight with what the Muse imparts,
In fearless youth we tempt the heights of Arts,
While from the bounded level of our mind,
Short views we take, nor see the lengths behind;
But more advanc'd, behold with strange surprize
New distant scenes of endless science rise!
So pleas'd at first the tow'ring Alps we try,
Mount o'er the vales, and seem to tread the sky,
Th' eternal snows appear already past,
And the first clouds and mountains seem the last:
But, those attain'd, we tremble to survey
The growing labours of the lengthen'd way,
Th' increasing prospect tires our wand'ring eyes,
Hills peep o'er hills, and Alps on Alps arise!

Essay on Criticism (1711)

I cannot forbear to observe, that the comparison of a student's progress in the sciences with the journey of a traveller in the Alps, is perhaps the best that English poetry can show. A simile, to be perfect, must both

884

illustrate and ennoble the subject; must show it to the understanding in a clearer view, and display it to the fancy with greater dignity; but either of these qualities may be sufficient to recommend it. In didactic poetry, of which the great purpose is instruction, a simile may be praised which illustrates, though it does not ennoble; in heroics, that may be admitted which ennobles, though it does not illustrate. That it may be complete, it is required to exhibit, independently of its references, a pleasing image; for a simile is said to be a short episode. To this antiquity was so attentive, that circumstances were sometimes added, which, having no parallels, served only to fill the imagination, and produced what Perrault ludicrously called "comparisons with a long tail." In their similes the greatest writers have sometimes failed; the ship-race, compared with the chariot-race, is neither illustrated or aggrandised; land and water make all the difference: when Apollo, running after Daphne, is likened to a greyhound chasing a hare, there is nothing gained; the ideas of pursuit and flight are too plain to be made plainer; and a god and the daughter of a god, are not represented much to their advantage by a hare and dog. The simile of the Alps has no useless parts, yet affords a striking picture by itself; it makes the foregoing position better understood, and enables it to take faster hold on the attention; it assists the apprehension, and elevates the fancy.

<div align="right">

SAMUEL JOHNSON
The Lives of the Poets (1779–81)

</div>

ALEXANDER POPE

1688 — 1744

THE SOUND AND THE SENSE

'Tis not enough no harshness gives offence,
The sound must seem an Echo to the sense:
Soft is the strain when Zephyr gently blows,
And the smooth stream in smoother numbers flows;
But when loud surges lash the sounding shoar,
The hoarse, rough verse should like the torrent roar:
When Ajax strives some rock's vast weight to throw,
The line too labours, and the words move slow;
Not so, when swift Camilla scours the plain,
Flies o'er th' unbending corn, and skims along the main.

<div align="right">

Essay on Criticism (1711)

</div>

ALEXANDER POPE

1 6 8 8 — 1 7 4 4

THE RAPE OF THE LOCK

Canto I

What dire offence from am'rous causes springs,
What mighty contests rise from trivial things,
I sing—This verse to *Caryll*, Muse! is due:
This, ev'n Belinda may vouchsafe to view:
Slight is the subject, but not so the praise,
If she inspire, and he approve my lays.
 Say what strange motive, Goddess! could compel
A well-bred Lord t' assault a gentle Belle?
O say what stranger cause, yet unexplor'd,
Could make a gentle Belle reject a Lord?
In tasks so bold, can little men engage,
And in soft bosoms dwells such mighty Rage?
 Sol thro' white curtains shot a tim'rous ray,
And oped those eyes that must eclipse the day:
Now lapdogs give themselves the rousing shake,
And sleepless lovers, just at twelve, awake:
Thrice rung the bell, the slipper knock'd the ground,
And the press'd watch return'd a silver sound.
Belinda still her downy pillow prest,
Her guardian Sylph prolong'd the balmy rest:
'Twas He had summon'd to her silent bed
The morning-dream that hover'd o'er her head;
A Youth more glitt'ring than a Birth-night Beau,
(That ev'n in slumber caus'd her cheek to glow)
Seem'd to her ear his winning lips to lay,
And thus in whispers said, or seem'd to say.
 Fairest of mortals, thou distinguish'd **care**
Of thousand bright Inhabitants of Air!
If e'er one vision touch'd thy infant thought,
Of all the Nurse and all the Priest have taught;

886

Of airy Elves by moonlight shadows seen,
The silver token, and the circled green,
Or virgins visited by Angel-pow'rs,
With golden crowns and wreaths of heav'nly flow'rs;
Hear and believe! thy own importance know,
Nor bound thy narrow views to things below.
Some secret truths, from learned pride conceal'd,
To Maids alone and Children are reveal'd:
What tho' no credit doubting Wits may give?
The Fair and Innocent shall still believe.
Know, then, unnumber'd Spirits round thee fly,
The light Militia of the lower sky:
These, tho' unseen, are ever on the wing,
Hang o'er the Box, and hover round the Ring.
Think what an equipage thou hast in Air,
And view with scorn two Pages and a Chair.
As now your own, our beings were of old,
And once inclos'd in Woman's beauteous mould;
Thence, by a soft transition, we repair
From earthly Vehicles to these of air.
Think not, when Woman's transient breath is fled,
That all her vanities at once are dead;
Succeeding vanities she still regards,
And tho' she plays no more, o'erlooks the cards.
Her joy in gilded Chariots, when alive,
And love of Ombre, after death survive.
For when the Fair in all their pride expire,
To their first Elements their Souls retire:
The Sprites of fiery Termagants in Flame
Mount up, and take a Salamander's name.
Soft yielding minds to Water glide away,
And sip, with Nymphs, their elemental Tea.
The graver Prude sinks downward to a Gnome,
In search of mischief still on Earth to roam.
The light Coquettes in Sylphs aloft repair,
And sport and flutter in the fields of Air.
 Know further yet; whoever fair and chaste
Rejects mankind, is by some Sylph embrac'd:
For Spirits, freed from mortal laws, with ease
Assume what sexes and what shapes they please.
What guards the purity of melting Maids,
In courtly balls, and midnight masquerades,
Safe from the treach'rous friend, the daring spark,
The glance by day, the whisper in the dark,
When kind occasion prompts their warm desires,

When music softens, and when dancing fires?
'Tis but their Sylph, the wise Celestials know,
Tho' Honour is the word with Men below.
 Some nymphs there are, too conscious of their face,
For life predestin'd to the Gnomes' embrace.
These swell their prospects and exalt their pride,
When offers are disdain'd, and love deny'd:
Then gay Ideas crowd the vacant brain,
While Peers, and Dukes, and all their sweeping train,
And Garters, Stars, and Coronets appear,
And in soft sounds, Your Grace salutes their ear.
'Tis these that early taint the female soul,
Instruct the eyes of young Coquettes to roll,
Teach infant-cheeks a bidden blush to know,
And little hearts to flutter at a Beau.
 Oft, when the world imagine women stray,
The Sylphs thro' mystic mazes guide their way,
Thro' all the giddy circle they pursue,
And old impertinence expel by new.
What tender maid but must a victim fall
To one man's treat, but for another's ball?
When Florio speaks what virgin could withstand,
If gentle Damon did not squeeze her hand?
With varying vanities, from ev'ry part,
They shift the moving Toyshop of their heart;
Where wigs with wigs, with sword-knots sword-knots strive,
Beaux banish beaux, and coaches coaches drive.
This erring mortals Levity may call;
Oh blind to truth! the Sylphs contrive it all.
 Of these am I, who thy protection claim,
A watchful sprite, and Ariel is my name.
Late, as I rang'd the crystal wilds of air,
In the clear Mirror of thy ruling Star
I saw, alas! some dread event impend,
Ere to the main this morning sun descend,
But heav'n reveals not what, or how, or where:
Warn'd by the Sylph, oh pious maid, beware!
This to disclose is all thy guardian can:
Beware of all, but most beware of Man!
 He said; when Shock, who thought she slept too long,
Leap'd up, and wak'd his mistress with his tongue.
'Twas then, Belinda, if report say true,
Thy eyes first open'd on a Billet-doux;
Wounds, Charms and Ardours were no sooner read,
But all the Vision vanish'd from thy head.

888

And now, unveil'd, the Toilet stands display'd,
Each silver Vase in mystic order laid.
First, rob'd in white, the Nymph intent adores,
With head uncover'd, the Cosmetic pow'rs.
A heav'nly image in the glass appears,
To that she bends, to that her eyes she rears;
Th' inferior Priestess, at her altar's side,
Trembling begins the sacred rites of Pride.
Unnumber'd treasures ope at once, and here
The various off'rings of the world appear;
From each she nicely culls with curious toil,
And decks the Goddess with the glitt'ring spoil.
This casket India's glowing gems unlocks,
And all Arabia breathes from yonder box.
The Tortoise here and Elephant unite,
Transform'd to combs, the speckled, and the white.
Here files of pins extend their shining rows,
Puffs, Powders, Patches, Bibles, Billet-doux.
Now awful Beauty puts on all its arms;
The fair each moment rises in her charms,
Repairs her smiles, awakens ev'ry grace,
And calls forth all the wonders of her face;
Sees by degrees a purer blush arise,
And keener lightnings quicken in her eyes.
The busy Sylphs surround their darling care,
These set the head, and those divide the hair,
Some fold the sleeve, whilst others plait the gown;
And Betty's prais'd for labours not her own.

Canto II

Not with more glories, in th' etherial plain,
The Sun first rises o'er the purpled main,
Than, issuing forth, the rival of his beams
Launch'd on the bosom of the silver Thames.
Fair Nymphs, and well-drest Youths around her shone,
But ev'ry eye was fix'd on her alone.
On her white breast a sparkling Cross she wore,
Which Jews might kiss, and Infidels adore.
Her lively looks a sprightly mind disclose,
Quick as her eyes, and as unfix'd as those:
Favours to none, to all she smiles extends;
Oft she rejects, but never once offends.
Bright as the sun, her eyes the gazers strike,
And, like the sun, they shine on all alike.

Yet graceful ease, and sweetness void of pride,
Might hide her faults, if Belles had faults to hide:
If to her share some female errors fall,
Look on her face, and you'll forget 'em all.

This Nymph, to the destruction of mankind,
Nourish'd two Locks, which graceful hung behind
In equal curls, and well conspir'd to deck
With shining ringlets the smooth iv'ry neck.
Love in these labyrinths his slaves detains,
And mighty hearts are held in slender chains.
With hairy springes we the birds betray,
Slight lines of hair surprise the finny prey,
Fair tresses man's imperial race ensnare
And beauty draws us with a single hair.

Th' advent'rous Baron the bright locks admir'd;
He saw, he wish'd, and to the prize aspir'd.
Resolv'd to win, he meditates the way,
By force to ravish, or by fraud betray;
For when success a Lover's toil attends,
Few ask, if fraud or force attain'd his ends.

For this, ere Phœbus rose, he had implor'd
Propitious heav'n, and ev'ry pow'r ador'd,
But chiefly Love—to Love an Altar built,
Of twelve vast French Romances, neatly gilt.
There lay three garters, half a pair of gloves;
And all the trophies of his former loves;
With tender Billet-doux he lights the pyre,
And breathes three am'rous sighs to raise the fire.
Then prostrate falls, and begs with ardent eyes
Soon to obtain, and long possess the prize:
The pow'rs gave ear, and granted half his pray'r,
The rest, the winds dispers'd in empty air.

But now secure the painted vessel glides,
The sun-beams trembling on the floating tides:
While melting music steals upon the sky,
And soften'd sounds along the waters die;
Smooth flow the waves, the Zephyrs gently play,
Belinda smil'd, and all the world was gay.
All but the Sylph—with careful thoughts opprest,
Th' impending woe sat heavy on his breast.
He summons strait his Denizens of air;
The lucid squadrons round the sails repair:
Soft o'er the shrouds aërial whispers breathe,
That seem'd but Zephyrs to the train beneath.

Some to the sun their insect-wings unfold,
Waft on the breeze, or sink in clouds of gold;
Transparent forms, too fine for mortal sight,
Their fluid bodies half dissolv'd in light,
Loose to the wind their airy garments flew,
Thin glitt'ring textures of the filmy dew,
Dipt in the richest tincture of the skies,
Where light disports in ever-mingling dyes,
While ev'ry beam new transient colours flings,
Colours that change whene'er they wave their wings.
Amid the circle, on the gilded mast,
 uperior by the head, was Ariel plac'd;
His purple pinions op'ning to the sun,
He rais'd his azure wands, and thus begun.

 Ye Sylphs and Sylphids, to your chief give ear.
Fays, Fairies, Genii, Elves, and Dæmons, hear!
Ye know the spheres and various tasks assign'd
By laws eternal to th' aërial kind.
Some in the fields of purest Æther play,
And bask and whiten in the blaze of day.
Some guide the course of wand'ring orbs on high,
Or roll the planets thro' the boundless sky.
Some less refin'd, beneath the moon's pale light
Pursue the stars that shoot athwart the night,
Or suck the mists in grosser air below,
Or dip their pinions in the painted bow,
Or brew fierce tempests on the wintry main,
Or o'er the glebe distil the kindly rain.
Others on earth o'er human race preside,
Watch all their ways, and all their actions guide:
Of these the chief the care of Nations own,
And guard with Arms divine the British Throne.

 Our humbler province is to tend the Fair,
Not a less pleasing, tho' less glorious care;
To save the powder from too rude a gale,
Nor let th' imprison'd essences exhale;
To draw fresh colours from the vernal flow'rs;
To steal from rainbows e'er they drop in show'rs
A brighter wash; to curl their waving hairs,
Assist their blushes, and inspire their airs;
Nay oft, in dreams, invention we bestow,
To change a Flounce, or add a Furbelow.

 This day, black Omens threat the brightest **Fair,**
That e'er deserv'd a watchful spirit's care;

Some dire disaster, or by force, or slight;
But what, or where, the fates have wrapt in night.
Whether the nymph shall break Diana's law,
Or some frail China jar receive a flaw;
Or stain her honour or her new brocade;
Forget her pray'rs, or miss a masquerade;
Or lose her heart, or necklace, at a ball;
Or whether Heav'n has doom'd that Shock must fall.
Haste, then, ye spirits! to your charge repair:
The flutt'ring fan be Zephyretta's care;
The drops to thee, Brillante, we consign;
And, Momentilla, let the watch be thine;
Do thou, Crispissa, tend her fav'rite Lock;
Ariel himself shall be the guard of Shock.

 To fifty chosen Sylphs, of special note,
We trust th' important charge, the Petticoat:
Oft have we known that seven-fold fence to fail,
Tho' stiff with hoops, and arm'd with ribs of whale;
Form a strong line about the silver bound,
And guard the wide circumference around.

 Whatever spirit, careless of his charge,
His post neglects, or leaves the fair at large,
Shall feel sharp vengeance soon o'ertake his sins,
Be stopp'd in vials, or transfix'd with pins;
Or plung'd in lakes of bitter washes lie,
Or wedg'd whole ages in a bodkin's eye:
Gums and Pomatums shall his flight restrain,
While clogg'd he beats his silken wings in vain;
Or Alum styptics with contracting pow'r
Shrink his thin essence like a rivel'd flow'r:
Or, as Ixion fix'd, the wretch shall feel
The giddy motion of the whirling Mill,
In fumes of burning Chocolate shall glow,
And tremble at the sea that froths below!

 He spoke; the spirits from the sails descend;
Some, orb in orb, around the nymph extend;
Some thrid the mazy ringlets of her hair;
Some hang upon the pendants of her ear:
With beating hearts the dire event they wait,
Anxious, and trembling for the birth of Fate.

Canto III

Close by those meads, for ever crown'd with flow'rs,
Where Thames with pride surveys his rising tow'rs,

There stands a structure of majestic frame,
Which from the neighb'ring Hampton takes its name.
Here Britain's statesmen oft the fall foredoom
Or foreign Tyrants and of Nymphs at home;
Here thou, great ANNA! whom three realms obey,
Dost sometimes counsel take—and sometimes Tea.

Hither the heroes and the nymphs resort,
To taste awhile the pleasures of a Court;
In various talk th' instructive hours they past,
Who gave the ball, or paid the visit last;
One speaks the glory of the British Queen,
And one describes a charming Indian screen;
A third interprets motions, looks, and eyes;
At ev'ry word a reputation dies.
Snuff, or the fan, supply each pause of chat,
With singing, laughing, ogling, *and all that*.

Mean while, declining from the noon of day,
The sun obliquely shoots his burning ray;
The hungry Judges soon the sentence sign,
And wretches hang that jury-men may dine;
The merchant from th' Exchange returns in peace,
And the long labours of the Toilet cease.
Belinda now, whom thirst of fame invites,
Burns to encounter two advent'rous Knights,
At Ombre singly to decide their doom;
And swells her breast with conquests yet to come.
Straight the three bands prepare in arms to join,
Each band the number of the sacred nine.
Soon as she spreads her hand, th' aërial guard
Descend, and sit on each important card:
First Ariel perch'd upon a Matadore,
Then each, according to the rank they bore;
For Sylphs, yet mindful of their ancient race,
Are, as when women, wondrous fond of place.

Behold four Kings in majesty revered,
With hoary whiskers and a forky beard;
And four fair Queens whose hands sustain a flow'r,
Th' expressive emblem of their softer pow'r;
Four Knaves in garbs succinct, a trusty band,
Caps on their heads, and halberts in their hand;
And particolour'd troops, a shining train,
Draw forth to combat on the velvet plain.

The skilful Nymph reviews her force with care:
Let Spades be trumps! she said, and trumps they were.

Now move to war her sable Matadores,
In show like leaders of the swarthy Moors.
Spadillio first, unconquerable Lord!
Led off two captive trumps, and swept the board.
As many more Manillio forc'd to yield,
And march'd a victor from the verdant field.
Him Basto follow'd, but his fate more hard
Gain'd but one trump and one Plebeian card.
With his broad sabre next, a chief in years,
The hoary Majesty of Spades appears,
Puts forth one manly leg, to sight reveal'd,
The rest, his many-colour'd robe conceal'd.
The rebel Knave, who dares his prince engage,
Proves the just victim of his royal rage.
Ev'n mighty Pam, that Kings and Queens o'erthrew
And mow'd down armies in the fights of Lu,
Sad chance of war! now destitute of aid,
Falls undistinguish'd by the victor spade!
 Thus far both armies to Belinda yield;
Now to the Baron fate inclines the field.
His warlike Amazon her host invades,
Th' imperial consort of the crown of Spades.
The Club's black Tyrant first her victim dy'd,
Spite of his haughty mien, and barb'rous pride:
What boots the regal circle on his head,
His giant limbs, in state unwieldy spread;
That long behind he trails his pompous robe,
And, of all monarch's, only grasps the globe?
 The Baron now his Diamonds pours apace;
Th' embroider'd King who shows but half his face,
And his refulgent Queen, with pow'rs combin'd
Of broken troops an easy conquest find.
Clubs, Diamonds, Hearts, in wild disorder seen,
With throngs promiscuous strow the level green.
Thus when dispers'd a routed army runs,
Of Asia's troops, and Afric's sable sons,
With like confusion different nations fly,
Of various habit, and of various dye,
The pierced battalions disunited fall,
In heaps on heaps; one fate o'erwhelms them all.
 The Knave of Diamonds tries his wily arts,
And wins (oh shameful chance!) the Queen of Hearts.
At this, the blood the virgin's cheek forsook,
A livid paleness spreads o'er all her look;

894

She sees, and trembles at th' approaching ill,
Just in the jaws of ruin, and Codille.
And now (as oft in some distemper'd State)
On one nice Trick depends the gen'ral fate.
An Ace of Hearts steps forth: The King unseen
Lurk'd in her hand, and mourn'd his captive Queen:
He springs to Vengeance with an eager pace,
And falls like thunder on the prostrate Ace.
The nymph exulting fills with shouts the sky;
The walls, the woods, and long canals reply.

 Oh thoughtless mortals! ever blind to fate,
Too soon dejected, and too soon elate.
Sudden, these honours shall be snatch'd away,
And curs'd for ever this victorious day.

 For lo! the board with cups and spoons is crown'd,
The berries crackle, and the mill turns round;
On shining altars of Japan they raise
The silver lamp; the fiery spirits blaze:
From silver spouts the grateful liquors glide,
While China's earth receives the smoking tide:
At once they gratify their scent and taste,
And frequent cups prolong the rich repast.
Straight hover round the Fair her airy band;
Some, as she sipp'd, the fuming liquor fann'd,
Some o'er her lap their careful plumes display'd,
Trembling, and conscious of the rich brocade.
Coffee, (which makes the politician wise,
And see thro' all things with his half-shut eyes)
Sent up in vapours to the Baron's brain
New Stratagems, the radiant Lock to gain.
Ah cease, rash youth! desist ere 'tis too late,
Fear the just Gods, and think of Scylla's Fate!
Chang'd to a bird, and sent to flit in air,
She dearly pays for Nisus' injur'd hair!

 But when to mischief mortals bend their will,
How soon they find fit instruments of ill!
Just then, Clarissa drew with tempting grace
A two-edg'd weapon from her shining case:
So Ladies in Romance assist their Knight,
Present the spear, and arm him for the fight.
He takes the gift with rev'rence, and extends
The little engine on his fingers' ends;
This just behind Belinda's neck he spread,
As o'er the fragrant steams she bends her head.

Swift to the Lock a thousand Sprites repair,
A thousand wings, by turns, blow back the hair;
And thrice they twitch'd the diamond in her ear;
Thrice she look'd back, and thrice the foe drew near.
Just in that instant, anxious Ariel sought
The close recesses of the Virgin's thought;
As on the nosegay in her breast reclin'd,
He watch'd th' Ideas rising in her mind,
Sudden he view'd, in spite of all her art,
An earthly Lover lurking at her heart.
Amaz'd, confus'd, he found his pow'r expir'd,
Resign'd to fate, and with a sigh retir'd.

The Peer now spreads the glitt'ring Forfex wide,
T' inclose the Lock; now joins it, to divide.
Ev'n then, before the fatal engine clos'd,
A wretched Sylph too fondly interpos'd;
Fate urg'd the shears, and cut the Sylph in twain,
(But airy substance soon unites again)
The meeting points the sacred hair dissever
From the fair head, for ever, and for ever!

Then flash'd the living lightning from her eyes,
And screams of horror rend th' affrighted skies.
Not louder shrieks to pitying heav'n are cast,
When husbands, or when lapdogs breathe their last;
Or when rich China vessels fall'n from high,
In glitt'ring dust and painted fragments lie!

Let wreaths of triumph now my temples twine,
(The victor cry'd) the glorious Prize is mine!
While fish in streams, or birds delight in air,
Or in a coach and six the British Fair,
As long as Atalantis shall be read,
Or the small pillow grace a Lady's bed,
While visits shall be paid on solemn days,
When num'rous wax-lights in bright order blaze,
While nymphs take treats, or assignations give,
So long my honour, name, and praise shall live!
What Time would spare, from Steel receives its date,
And monuments, like men, submit to fate!
Steel could the labour of the Gods destroy,
And strike to dust th' imperial tow'rs of Troy;
Steel could the works of mortal pride confound,
And hew triumphal arches to the ground.
What wonder then, fair nymph! thy hairs should feel,
The conqu'ring force of unresisted steel?

But anxious care the pensive nymph oppress'd,
And secret passions labour'd in her breast.
Not youthful kings in battle seiz'd alive,
Not scornful virgins who their charms survive,
Not ardent lovers robb'd of all their bliss,
Not ancient ladies when refus'd a kiss,
Not tyrants fierce that unrepenting die,
Not Cynthia when her manteau's pinn'd awry,
E'er felt such rage, resentment, and despair,
As thou, sad Virgin! for thy ravish'd Hair.

For, that sad moment, when the Sylphs withdrew
And Ariel weeping from Belinda flew,
Umbriel, a dusky, melancholy sprite,
As ever sully'd the fair face of light,
Down to the central earth, his proper scene,
Repair'd to search the gloomy Cave of Spleen.

Swift on his sooty pinions flits the Gnome,
And in a vapour reach'd the dismal dome.
No cheerful breeze this sullen region knows,
The dreaded East is all the wind that blows.
Here in a grotto, shelter'd close from air,
And screen'd in shades from day's detested glare,
She sighs for ever on her pensive bed,
Pain at her side, and Megrim at her head.

Two handmaids wait the throne: alike in place,
But diff'ring far in figure and in face.
Here stood Ill-nature like an ancient maid,
Her wrinkled form in black and white array'd;
With store of pray'rs, for mornings, nights, and noons,
Her hand is fill'd; her bosom with lampoons.

There Affectation, with a sickly mien,
Shows in her cheek the roses of eighteen,
Practis'd to lisp, and hang the head aside,
Faints into airs, and languishes with pride,
On the rich quilt sinks with becoming woe,
Wrapt in a gown, for sickness, and for show.
The fair ones feel such maladies as these,
When each new night-dress gives a new disease.

A constant Vapour o'er the palace flies;
Strange phantoms rising as the mists arise;
Dreadful, as hermit's dreams in haunted shades,
Or bright, as visions of expiring maids.

Now glaring fiends, and snakes on rolling spires,
Pale spectres, gaping tombs, and purple fires:
Now lakes of liquid gold, Elysian scenes,
And crystal domes, and angels in machines.
Unnumber'd throngs on every side are seen,
Of bodies chang'd to various forms by Spleen.
Here living Tea-pots stand, one arm held out,
One bent; the handle this, and that the spout:
A Pipkin there, like Homer's Tripod walks;
Here sighs a Jar, and there a Goose-pie talks;
Men prove with child, as pow'rful fancy works,
And maids turn'd bottles, call aloud for corks.
Safe past the Gnome thro' this fantastic band,
A branch of healing Spleenwort in his hand.
Then thus address'd the pow'r: "Hail, wayward Queen!
Who rule the sex to fifty from fifteen:
Parent of vapours and of female wit,
Who give th' hysteric, or poetic fit,
On various tempers act by various ways,
Make some take physic, other scribble plays;
Who cause the proud their visits to delay,
And send the godly in a pet to pray.
A nymph there is, that all thy pow'r disdains,
And thousands more in equal mirth maintains.
But oh! if e'er thy Gnome could spoil a grace,
Or raise a pimple on a beauteous face,
Like Citron-waters matrons' cheeks inflame,
Or change complexions at a losing game;
If e'er with airy horns I planted heads,
Or rumpled petticoats, or tumbled beds,
Or caus'd suspicion when no soul was rude,
Or discompos'd the head-dress of a Prude,
Or e'er to costive lap-dog gave disease,
Which not the tears of brightest eyes could ease:
Hear me, and touch Belinda with chagrin,
That single act gives half the world the spleen."
The Goddess with a discontented air
Seems to reject him, tho' she grants his pray'r.
A wond'rous Bag with both her hands she binds,
Like that where once Ulysses held the winds;
There she collects the force of female lungs,
Sighs, sobs, and passions, and the war of tongues.
A Vial next she fills with fainting fears,
Soft sorrows, melting griefs, and flowing tears.

The Gnome rejoicing bears her gifts away,
Spreads his black wings, and slowly mounts to day.
 Sunk in Thalestris' arms the nymph he found,
Her eyes dejected and her hair unbound.
Full o'er their heads the swelling bag he rent,
And all the Furies issu'd at the vent.
Belinda burns with more than mortal ire,
And fierce Thalestris fans the rising fire.
"O wretched maid!" she spread her hands, and cry'd,
(While Hampton's echoes, "Wretched maid!" reply'd)
"Was it for this you took such constant care
The bodkin, comb, and essence to prepare?
For this your locks in paper durance bound,
For this with tort'ring irons wreath'd around?
For this with fillets strain'd your tender head,
And bravely bore the double loads of lead?
Gods! shall the ravisher display your hair,
While the Fops envy, and the Ladies stare!
Honour forbid! at whose unrivall'd shrine
Ease, pleasure, virtue, all our sex resign.
Methinks already I your tears survey,
Already hear the horrid things they say,
Already see you a degraded toast,
And all your honour in a whisper lost!
How shall I, then, your hapless fame defend?
'Twill then be infamy to seem your friend!
And shall this prize, th' inestimable prize,
Expos'd thro' crystal to the gazing eyes,
And heighten'd by the diamond's circling rays,
On that rapacious hand for ever blaze?
Sooner shall grass in Hyde-park Circus grow,
And wits take lodgings in the sound of Bow;
Sooner let earth, air, sea, to Chaos fall,
Men, monkeys, lap-dogs, parrots, perish all!"
 She said; then raging to Sir Plume repairs,
And bids her Beau demand the precious hairs:
(Sir Plume of amber snuff-box justly vain,
And the nice conduct of a clouded cane)
With earnest eyes, and round unthinking face,
He first the snuff-box open'd, then the case,
And thus broke out—"My Lord, why, what the devil?
"Z—ds! damn the lock! 'fore Gad, you must be civil!
"Plague on't! 'tis past a jest—nay prithee, pox!
"Give her the hair"—he spoke, and rapp'd his box.

"It grieves me much" (reply'd the Peer again)
"Who speaks so well should ever speak in vain.
But by this Lock, this sacred Lock I swear,
(Which never more shall join its parted hair;
Which never more its honours shall renew,
Clipp'd from the lovely head where late it grew)
That while my nostrils draw the vital air,
This hand, which won it, shall for ever wear."
He spoke, and speaking, in proud triumph spread
The long-contended honours of her head.

But Umbriel, hateful Gnome! forbears not so;
He breaks the Vial whence the sorrows flow.
Then see! the nymph in beauteous grief appears,
Her eyes half-languishing, half-drown'd in tears;
On her heav'd bosom hung her drooping head,
Which, with a sigh, she rais'd; and thus she said.

"For ever curs'd be this detested day,
Which snatch'd my best, my fav'rite curl away!
Happy! ah ten times happy had I been,
If Hampton-Court these eyes had never seen!
Yet am not I the first mistaken maid,
By love of Courts to num'rous ills betray'd.
Oh had I rather un-admir'd remain'd
In some lone isle, or distant Northern land;
Where the gilt Chariot never marks the way,
Where none learn Ombre, none e'er taste Bohea!
There kept my charms conceal'd from mortal eye,
Like roses, that in deserts bloom and die.
What mov'd my mind with youthful Lords to roam?
Oh had I stay'd, and said my pray'rs at home!
'Twas this, the morning omens seem'd to tell,
Thrice from my trembling hand the patch-box fell;
The tott'ring China shook without a wind,
Nay, Poll sat mute, and Shock was most unkind!
A Sylph too warn'd me of the threats of fate,
In mystic visions, now believ'd too late!
See the poor remnants of these slighted hairs!
My hands shall rend what ev'n thy rapine spares:
These in two sable ringlets taught to break,
Once gave new beauties to the snowy neck;
The sister-lock now sits uncouth, alone,
And in its fellow's fate foresees its own;
Uncurl'd it hangs, the fatal shears demands,
And tempts once more, thy sacrilegious hands.

Oh hadst thou, cruel! been content to seize
Hairs less in sight, or any hairs but these!"

Canto V

She said: the pitying audience melt in tears,
But Fate and Jove had stopp'd the Baron's ears.
In vain Thalestris with reproach assails,
For who can move when fair Belinda fails?
Not half so fix'd the Trojan could remain,
While Anna begg'd and Dido rag'd in vain.
Then grave Clarissa graceful wav'd her fan;
Silence ensu'd, and thus the nymph began.
 "Say why are Beauties prais'd and honour'd most,
The wise man's passion, and the vain man's toast?
Why deck'd with all that land and sea afford,
Why Angels call'd, and Angel-like ador'd?
Why round our coaches croud the white-glov'd Beaux,
Why bows the side-box from its inmost rows;
How vain are all these glories, all our pains,
Unless good sense preserve what beauty gains:
That men may say, when we the front-box grace:
'Behold the first in virtue as in face!'
Oh! if to dance all night, and dress all day,
Charm'd the small-pox, or chas'd old-age away;
Who would not scorn what housewife's cares produce,
Or who would learn one earthly thing of use?
To patch, nay ogle, might become a Saint,
Nor could it sure be such a sin to paint.
But since, alas! frail beauty must decay,
Curl'd or uncurl'd, since Locks will turn to grey;
Since painted, or not painted, all shall fade,
And she who scorns a man, must die a maid;
What then remains but well our pow'r to use,
And keep good-humour still whate'er we lose?
And trust me, dear! good-humour can prevail,
When airs, and flights, and screams, and scolding fail.
Beauties in vain their pretty eyes may roll;
Charms strike the sight, but merit wins the soul."
 So spoke the Dame, but no applause ensu'd;
Belinda frown'd, Thalestris call'd her Prude.
"To arms, to arms!" the fierce Virago cries,
And swift as lightning to the combat flies.
All side in parties, and begin th' attack;
Fans clap, silks rustle, and tough whalebones crack;

901

Heroes' and Heroines' shouts confus'dly rise,
And bass, and treble voices strike the skies.
No common weapons in their hands are found,
Like Gods they fight, nor dread a mortal wound.

So when bold Homer makes the Gods engage,
And heav'nly breasts with human passions rage;
'Gainst Pallas, Mars; Latona, Hermes arms;
And all Olympus rings with loud alarms:
Jove's thunder roars, heav'n trembles all around,
Blue Neptune storms, the bellowing deeps resound:
Earth shakes her nodding tow'rs, the ground gives way,
And the pale ghosts start at the flash of day!

Triumphant Umbriel on a sconce's height
Clapp'd his glad wings, and sate to view the fight:
Propp'd on their bodkin spears, the Sprites survey
The growing combat, or assist the fray.

While thro' the press enrag'd Thalestris flies,
And scatters death around from both her eyes,
A Beau and Witling perish'd in the throng,
One died in metaphor, and one in song.
"O cruel nymph! a living death I bear,"
Cry'd Dapperwit, and sunk beside his chair.
A mournful glance Sir Fopling upwards cast,
"Those eyes are made so killing"—was his last.
Thus on Mæander's flow'ry margin lies
Th' expiring Swan, and as he sings he dies.

When bold Sir Plume had drawn Clarissa down,
Chloe stepp'd in, and kill'd him with a frown;
She smil'd to see the doughty hero slain,
But, at her smile, the Beau reviv'd again.

Now Jove suspends his golden scales in air,
Weighs the Men's wits against the Lady's hair;
The doubtful beam long nods from side to side;
At length the wits mount up, the hairs subside.

See, fierce Belinda on the Baron flies,
With more than usual lightning in her eyes:
Nor fear'd the Chief th' unequal fight to try,
Who sought no more than on his foe to die.
But this bold Lord with manly strength endu'd,
She with one finger and a thumb subdu'd:
Just where the breath of life his nostrils drew,
A charge of Snuff the wily virgin threw;
The Gnomes direct, to ev'ry atom just,
The pungent grains of titillating dust.

Sudden, with starting tears each eye o'erflows,
And the high dome re-echoes to his nose.
 Now meet thy fate, incens'd Belinda cry'd,
And drew a deadly bodkin from her side.
(The same, his ancient personage to deck,
Her great great grandsire wore about his neck,
In three seal-rings; which after, melted down,
Form'd a vast buckle for his widow's gown:
Her infant grandame's whistle next it grew,
The bells she jingled, and the whistle blew;
Then in a bodkin grac'd her mother's hairs,
Which long she wore, and now Belinda wears.)
 "Boast not my fall" (he cry'd) "insulting foe!
Thou by some other shalt be laid as low,
Nor think, to die dejects my lofty mind:
All that I dread is leaving you behind!
Rather than so, ah let me still survive,
And burn in Cupid's flames—but burn alive."
 "Restore the Lock!" she cries; and all around
"Restore the Lock!" the vaulted roofs rebound.
Not fierce Othello in so loud a strain
Roar'd for the handkerchief that caus'd his pain.
But see how oft ambitious aims are cross'd,
And chiefs contend 'till all the prize is lost!
The Lock, obtain'd with guilt, and kept with pain,
In ev'ry place is sought, but sought in vain:
With such a prize no mortal must be blest,
So heav'n decrees! with heav'n who can contest?
 Some thought it mounted to the Lunar sphere,
Since all things lost on earth are treasur'd there.
There Hero's wits are kept in pond'rous vases,
And beau's in snuff-boxes and tweezer-cases.
There broken vows and death-bed alms are found,
And lovers' hearts with ends of riband bound,
The courtier's promises, and sick man's pray'rs,
The smiles of harlots, and the tears of heirs,
Cages for gnats, and chains to yoke a flea,
Dry'd butterflies, and tomes of casuistry.
 But trust the Muse—she saw it upward rise,
Tho' mark'd by none but quick, poetic eyes:
(So Rome's great founder to the heav'ns withdrew,
To Proculus alone confess'd in view)
A sudden Star, it shot thro' liquid air,
And drew behind a radiant trail of hair.

903

Not Berenice's Locks first rose so bright,
The heav'ns bespangling with dishevell'd light.
The Sylphs behold it kindling as it flies,
And pleas'd pursue its progress thro' the skies.
　　This the Beau monde shall from the Mall survey,
And hail with music its propitious ray.
This the blest Lover shall for Venus take,
And send up vows from Rosamonda's lake.
This Partridge soon shall view in cloudless skies,
When next he looks thro' Galileo's eyes;
And hence th' egregious wizard shall foredoom
The fate of Louis, and the fall of Rome.
　　Then cease, bright Nymph! to mourn thy ravish'd hair,
Which adds new glory to the shining sphere!
Not all the tresses that fair head can boast,
Shall draw such envy as the Lock you lost.
For, after all the murders of your eye,
When, after millions slain, yourself shall die:
When those fair suns shall set, as set they must,
And all those tresses shall be laid in dust,
This Lock, the Muse shall consecrate to fame,
And 'midst the stars inscribe Belinda's name.

<div align="right">(1712)</div>

It is one of the few things wholly without a flaw.

<div align="right">

WILLIAM PATON KER
The Art of Poetry (1923)

</div>

<div align="center">

ALEXANDER POPE

1 6 8 8 — 1 7 4 4

LORD MAYOR'S SHOW

</div>

Now Night descending, the proud scene was o'er,
But liv'd, in Settle's numbers, one day more.°

<div align="right">The Dunciad (1728), i</div>

The finest piece of wit I know of.

<div align="right">

WILLIAM HAZLITT
Lectures on the English Comic Writers (1818)

</div>

° Settle was poet to the city of London and composed yearly panegyrics upon the Lord Mayors.

A GOLDEN RULE

Never elated while one man's oppress'd;
Never dejected while another's bless'd.
<div align="right">An Essay on Man (1734), iv</div>

The most complete, concise, and lofty expression of moral temper exist-ing in English words.

<div align="right">

JOHN RUSKIN
Lectures on Art (1887)

</div>

ALEXANDER POPE

1 6 8 8 — 1 7 4 4

COMPLIMENTS

Despise low joys, low gains;
Disdain whatever Cornbury disdains;
Be virtuous, and be happy for your pains.
<div align="right">The Sixth Epistle of the First Book of Horace (1738)</div>

Conspicuous scene! another yet is nigh
(More silent far), where Kings and Poets lie;
Where Murray (long enough his country's pride)
Shall be no more than Tully or than Hyde!
<div align="right">The Sixth Epistle of the First Book of Horace (1738)</div>

Why rail they then if but a wreath of mine,
O all-accomplish'd St. John! deck thy shrine?
<div align="right">Epilogue to the Satires (1738)</div>

A. But why then publish? P. Granville the polite,
And knowing Walsh, would tell me I could write;
Well-natured Garth inflamed with early praise,
And Congreve lov'd, and Swift endured my lays;
The courtly Talbot, Somers, Sheffield, read;
Ev'n mitred Rochester would nod the head,

<div align="center">905</div>

And St. John's self (great Dryden's friends before)
With open arms receiv'd one poet more.
Happy my studies, when by these approv'd!
Happier their author, when by these belov'd!
From these the world will judge of men and books,
Not from the Burnets, Oldmixons, and Cookes.

<div align="right">Epistle to Dr. Arbuthnot (1735)</div>

"Compliments! I did not know he ever made any."—"The finest," said Lamb, "that were ever paid by the wit of man. Each of them is worth an estate for life—nay, is an immortality."

<div align="right">CHARLES LAMB
Quoted, William Hazlitt, Of Persons One Would Wish
to Have Seen (1826)</div>

JACQUES RANCHIN

C . 1 6 9 0

THE KING OF TRIOLETS

Le premier jour du mois de mai
Fut le plus heureux de ma vie:
Le beau dessein que je formais,
Le premier jour du mois de mai!
Je vous vis et je vous aimais.
Si ce dessein vous plut, Sylvie,
Le premier jour du mois de mai
Fut le plus heureux de ma vie.

The first day in the month of May
Counts for the happiest in my life.
How fair a plan I formed that day,
The first day in the month of May!
I saw you and I loved straightway;
And if my plan pleased you, my wife,
The first day in the month of May
Counts for the happiest in my life.

<div align="right">*Translated by J. G. Legge*</div>

The King of Triolets.

<div align="right">GILLES MÉNAGE
Menagiana (1715)</div>

F. M. AROUET DE VOLTAIRE

1 6 9 4 — 1 7 7 8

NO TIME FOR JESTING

Ce n'est plus le temps de plaisanter; les bons mots ne conviennent point aux massacres. Quoi! des Busiris en robe font périr dans les plus horribles supplices des enfans de seize ans! et cela malgré l'avis de dix juges intègres et humains! et la nation le souffre! A peine en parle-t-on un moment, on court ensuite à l'Opéra-Comique; et la barbarie, devenue plus insolente par notre silence, égorgera demain qui elle voudra juridiquement; et vous surtout, qui aurez élevé la voix contre elle deux ou trois minutes. Ici Calas roué, là Sirven pendu, plus loin un bâillon dans la bouche d'un lieutenant-général; quinze jours après, cinq jeunes gens condamnés aux flammes pour des folies qui méritaient Saint-Lazare. Qu'importe l'avant-propos du roi de Prusse? Apporte-t-il le moindre remède à ces maux exécrables? est-ce là le pays de la philosophie et des agrémens? c'est celui de la Saint-Barthélemi. L'inquisition n'aurait pas osé faire ce que des juges jansénistes viennent d'exécuter. . . . Vous voulez prendre le parti de rire, mon cher Platon! il faudrait prendre celui de se venger, ou du moins quitter un pays où se commettent tous les jours tant d'horreurs. . . .

Non, encore une fois, je ne puis souffrir que vous finissiez votre lettre en disant: *Je rirai.* Ah! mon cher ami, est-ce là le temps de rire? riait-on en voyant chauffer le taureau de Phalaris?

This is no longer a time for jesting: witty things do not go well with massacres. What? These Busirises in wigs destroy in the midst of horrible tortures children of sixteen! And that in face of the verdict of ten upright and humane judges! And the victim suffers it! People talk about it for a moment, and the next they are hastening to the comic opera; and barbarity, become the more insolent for our silence, will to-morrow cut throats juridically at pleasure. Here Calas broken on the wheel, there Sirven condemned to be hung, further off a gag thrust into the mouth of a lieutenant-general, a fortnight after that five youths condemned to the flames for extravagances that deserved nothing worse than Saint Lazare. Is this the country of philosophy and pleasure? It is the country rather of the Saint Bartholomew massacre. Why, the Inquisition would not have ventured to do what these Jansenist judges have done. . . . What, you would be content to laugh? We ought rather to resolve to seek vengeance, or at any rate to leave a country where day after day such horrors are committed. . . . No, once more, I cannot bear that you should finish your letter by saying, I mean to laugh. Ah, my friend,

is it a time for laughing? Did men laugh when they saw Phalaris's bull being made red-hot?

Letters to D'Alembert (July 18–23, 1766)
Translated by John Morley

These atrocities kindled in Voltaire a blaze of anger and pity, that remains among the things of which humanity has most reason to be proud. Everybody who has read much of the French writing of the middle of the eighteenth century, is conscious from time to time of a sound of mocking and sardonic laughter in it. This laugh of the eighteenth century has been too often misunderstood as the expression of a cynical hardness of heart, proving the hollowness of the humanitarian pretensions in the midst of which it is heard. It was in truth something very different; it was the form in which men sought a little relief from the monotony of the abominations which oppressed them, and from whose taint they had such difficulty to escape. This refrain, that after all a man can do nothing better than laugh, apparently so shallow and inhuman, in reality so penetrated with melancholy, we may count most certainly on finding at the close of the narration of some more than usually iniquitous or imbecile exploit of those in authority. It was when the thought of the political and social and intellectual degradation of their country became too vivid to be endured, that men like Voltaire and D'Alembert would abruptly turn away from it, and in the bitterness of their impotence cry that there was nothing for it but to take the world and all that befalls therein in merriment. It was the grimacing of a man who jests when he is perishing of hunger, or is shrinking under knife or cautery.

JOHN MORLEY
Voltaire (1903)

F. M. AROUET DE VOLTAIRE

1 6 9 4 — 1 7 7 8

CANDIDE

"Je sçai aussi, dit Candide, qu'il faut cultiver nôtre jardin. — Vous avez raison, dit Pangloss; car quand l'homme fut mis dans le jardin d'Eden, il y fut mis, *ut operaretur eum*, pour qu'il travaillat; ce qui prouve que l'homme n'est pas né pour le repos. — Travaillons sans raisonner, dit Martin, c'est le seul moyen de rendre la vie suportable."

Toute la petite societé entra dans ce louable dessein; chacun se mit à exercer ses talents. La petite terre raporta beaucoup. Cunégonde était à la vérité bien laide; mais elle devint une excellente patissiére; Paquette broda; la Vieille eut soin du linge. Il n'y eut pas jusqu'à Frère Giroflée qui ne rendit service; il fut un très bon menuisier, & même devint honnête homme: & Pangloss disait quelquefois à Candide: "Tous les événements sont enchaînés dans le meilleur des Mondes possibles; car enfin, si vous n'aviez pas été chassé d'un beau Château à grands coups de pied dans le derrière, pour l'amour de Mademoiselle Cunégonde, si vous n'aviez pas été mis à l'Inquisition, si vous n'aviez pas couru l'Amérique à pied si vous n'aviez pas donné un bon coup d'épée au Baron, si vous n'aviez pas perdu tous vos moutons du bon pays d'Eldorado, vous ne mangeriez pas ici des cédras confits & des pistaches.— Cela est bien dit, répondit Candide, mais il faut cultiver nôtre jardin."

"Yes," said Candide, "and I know too that we must attend to our garden."

"You are right," said Pangloss; "for when man was put into the Garden of Eden, he was placed there 'ut operaretur eum,'—to dress it and to keep it, which proves that man is not born for idleness and repose."

"Let us work without arguing," said Martin; "that is the only way of rendering life tolerable."

All the little company entered into this praiseworthy resolution, and each began busily to exert his or her peculiar talents. The small orchard brought forth abundant crops. Cunegund, it could not be denied, was very ugly, but she became an excellent hand at making pastry; Paquette embroidered; the old woman took care of the linen. There was no one who did not make himself useful, not even friar Giroflée; he was a first-rate carpenter, and actually turned out an honest fellow.

Pangloss used sometimes to say to Candide: "All events are inextricably linked together in this best of all possible worlds; for, look you, if you had not been driven out of a magnificent castle by hearty kicks upon your hinder parts for presuming to make love to Miss Cunegund, if you had not been put into the Inquisition, if you had not roamed over America on foot, if you had never run your sword through the Baron, or lost all your sheep from the fine country of El Dorado, you would not be here now eating candied citrons and pistachio-nuts."

"Well said!" answered Candide; "but we must attend to our garden."

Candide, ou l'optimisme (1758)
Translated by R. Bruce Boswell

The book is a catalogue of all the woes, all the misfortunes, all the degradations, and all the horrors that can afflict humanity; and through-

out it Voltaire's grin is never for a moment relaxed. As catastrophe follows catastrophe, and disaster succeeds disaster, not only does he laugh himself consumedly, but he makes his reader laugh no less; and it is only when the book is finished that the true meaning of it is borne in upon the mind. Then it is that the scintillating pages begin to exercise their grim unforgettable effect; and the pettiness and misery of man seem to borrow a new intensity from the relentless laughter of Voltaire.

But perhaps the most wonderful thing about CANDIDE is that it contains, after all, something more than mere pessimism—it contains a positive doctrine as well. Voltaire's common sense withers the Ideal; but it remains common sense. "Il faut cultiver notre jardin" is his final word—one of the very few pieces of practical wisdom ever uttered by a philosopher.

Voltaire's style reaches the summit of its perfection in CANDIDE; but it is perfect in all that he wrote. His prose is the final embodiment of the most characteristic qualities of the French genius. If all that that great nation had ever done or thought were abolished from the world, except a single sentence of Voltaire's, the essence of their achievement would have survived.

LYTTON STRACHEY
Landmarks in French Literature (1923)

F. M. AROUET DE VOLTAIRE

1694 — 1778

SUR UN CHRIST HABILLÉ EN JÉSUITE

Admirez l'artifice extrême
De ces moines industrieux;
Ils vous ont habillé comme eux,
Mon Dieu, de peur qu'on ne vous aime.

ON A CHRIST IN JESUIT ROBES

Consider, pray, the artfulness
 Industrious monks like these can show.
My God, they've clothed Thee in their dress,
 Lest men should love Thee here below!

910

SUR SON PORTRAIT ENTRE CEUX
DE LA BEAUMELLE ET DE FRÉRON

Le Jay vient de mettre Voltaire
Entre La Beaumelle et Fréron;
Ce serait vraiment un Calvaire,
S'il s'y trouvait un bon larron.

ON HIS PORTRAIT BETWEEN TWO OTHERS

'Twixt Fréron and La Beaumelle me!
What can Le Jay by this have meant?
It were indeed a Calvary,
Had either thief been penitent.

Translated by J. G. Legge

Here are two of his bitterest epigrams, and they are probably not to be equalled for keen, incisive, cruel wit in all literature. The first is an example of the attacks he indulged in against the Church and its ministers. The second indicates his intolerant contempt for authors he fell foul of; Le Jay, a publisher, had produced a title-page with his portrait between those of two of his pet aversions, Fréron, a leading critic and an estimable man, and La Beaumelle, an old teacher of Voltaire.

J. G. LEGGE
Chanticleer (1935)

ANONYMOUS

SEVENTEENTH CENTURY

CHANSON DE RENAUD

I

Quand Jean Renaud de guerre r'vint,
Tenait ses tripes dans ses mains.
Sa mère à la fenêtre en haut:
"Voici venir mon fils Renaud."

II

"Bonjour, Renaud, bonjour, mon fils,
Ta femme est accouché' d'un fils.
—Ni de ma femm', ni de mon fils
Je ne saurais me réjouir.

III

"Que l'on me fass' vite un lit blanc
Pour que je m'y couche dedans."
Et quand ce vint sur le minuit,
Le beau Renaud rendit l'esprit.

IV

"Dites-moi, ma mère, ma mie,
Qu'est-c' que j'entends pleurer ici?
—C'est un p'tit pag' qu'on a fouetté
Pour un plat d'or qu'est égaré.

V

—Dites-moi, ma mère, ma mie,
Qu'est-c' que j'entends coigner ici?
—Ma fille, ce sont les maçons
Qui raccommodent la maison.

VI

—Dites-moi, ma mère, ma mie,
Qu'est-c' que j'entends sonner ici?
—C'est le p'tit Dauphin nouveau-né
Dont le baptême est retardé.

VII

—Dites-moi, ma mère, ma mie,
Qu'est-c' que j'entends chanter ici?
—Ma fille, c' sont les processions
Qui font le tour de la maison.

VIII

—Dites-moi, ma mère, ma mie,
Quell' robe mettrai-je aujourd'hui?
—Mettez le blanc, mettez le gris,
Mettez le noir pour mieux choisi.

IX

—Dites-moi, ma mère, ma mie,
Qu'est-c' que ce noir-là signifie?
—Tout' femme qui relèv' d'un fils
Du drap de saint Maur doit se vêti.

X

—Dites-moi, ma mère, ma mie,
Irai-je à la messe aujourd'hui?
—Ma fille, attendez à demain,
Et vous irez pour le certain."

XI

Quand ell' fut dans les champs allée,
Trois p'tits garçons s' sont écriés:
"Voilà la femm' de ce seigneur
Qu'on enterra hier à trois heures."

XII

Quand ell' fut dans l'église entrée,
D' l'eau bénite on y a présenté;
Et puis, levant les yeux en haut,
Elle aperçut le grand tombeau.

XIII

"Dites-moi, ma mère, ma mie,
Qu'est-c' que c' tombeau-là signifie?
—Ma fille, je n' puis vous l' cacher,
C'est vot' mari qu'est trépassé.

XIV

"Renaud, Renaud, mon réconfort,
Te voilà donc au rang des morts!
Divin Renaud, mon réconfort,
Te voilà donc au rang des morts!"

XV

Elle se fit dire trois messes,
A la première, ell' se confesse,
A la seconde, ell' communia,
A la troisième, elle expira.

SONG OF RENAUD

I

When Jean Renaud returned from war, he held his bowels in his hands. His mother said at the window above: "Here comes my son, Renaud."

II

"Good day, Renaud, good day, my son, your wife has had a son." "—Neither in my wife, nor in my son can I rejoice."

III

"Let them quickly make a white bed for me to lie in." And when midnight arrived, fair Renaud gave up the ghost.

IV

"Tell me, mother my dear, what is the weeping that I hear?" "—It's a little page who has been whipped for a golden plate that is lost."

V

"Tell me, mother my dear, what is the knocking that I hear?" "—My child, it is the masons repairing the house."

VI

"Tell me, mother my dear, what is the ringing that I hear?" "—It is the little new-born Dauphin, whose baptism is delayed."

VII

"Tell me, mother my dear, what is the singing that I hear?" "—My child, it is the processions that wind about the house."

VIII

"Tell me, mother my dear, what dress shall I wear today?" "—Wear the white, wear the gray, wear the black as a better choice."

IX

"Tell me, mother my dear, what does the black mean?" "—All women who give birth to a son should dress in the drapery of Saint Maur."

X

"Tell me, mother my dear, shall I go to Mass today?" "—My child, wait till tomorrow, and you will surely go."

XI

When she went into the fields, three little boys cried out: "There's the wife of the nobleman who was buried yesterday at three o'clock."

XII

When she entered the church, she was given some holy water; and then, raising her eyes on high, she noticed the great tomb.

XIII

"Tell me, mother my dear, what does that tomb mean?" "—My child, I cannot hide it from you, it is your husband that has passed away."

XIV

"Renaud, Renaud, soul of my soul, you are then among the dead! Divine Renaud, soul of my soul, you are then among the dead!"

XV

She had three Masses said; at the first, she confessed; at the second, she took communion; at the third, she died.

One of the most beautiful inspirations of untutored genius.

ANATOLE FRANCE
La Vie littéraire (1888–92)

HENRY FIELDING

1 7 0 7 — 1 7 5 4

GREATNESS

1. Never to do more mischief to another than was necessary to the effecting his purpose; for that mischief was too precious a thing to be thrown away.

915

2. To know no distinction of men from affection; but to sacrifice all with equal readiness to his interest.

3. Never to communicate more of an affair than was necessary to the person who was to execute it.

4. Not to trust him who hath deceived you, nor who knows he hath been deceived by you.

5. To forgive no enemy; but to be cautious and often dilatory in revenge.

6. To shun poverty and distress, and to ally himself as close as possible to power and riches.

7. To maintain a constant gravity in his countenance and behaviour, and to affect wisdom on all occasions.

8. To foment eternal jealousies in his gang, one of another.

9. Never to reward any one equal to his merit; but always to insinuate that the reward was above it.

10. That all men were knaves or fools, and much the greater number a composition of both.

11. That a good name, like money, must be parted with, or at least greatly risked, in order to bring the owner any advantage.

12. That virtues, like precious stones, were easily counterfeited; that the counterfeits in both cases adorned the wearer equally, and that very few had knowledge or discernment sufficient to distinguish the counterfeit jewel from the real.

13. That many men were undone by not going deep enough in roguery; as in gaming any man may be a loser who doth not play the whole game.

14. That men proclaim their own virtues, as shopkeepers expose their goods, in order to profit by them.

15. That the heart was the proper seat of hatred, and the countenance of affection and friendship.

<div align="right">

The History of The Life of the Late
Mr. Jonathan Wild the Great (1743)

</div>

Jonathan Wild is a personage of undeviating criminality; the beautiful consistency of his life is marred by scarce a single generous deed or decent impulse. From the time of his youthful captaincy over a gang of orchard robbers, when he was invariably "treasurer of the booty, some little part of which he would now and then, with wonderful generosity,

*bestow on those who took it," until his consummation on the scaffold or
"tree of glory," when he found breath to deliver "a hearty curse" upon
the assembled crowd, he showed himself to be "not restrained by any
of those weaknesses which disappoint the views of mean and vulgar
souls, and which are comprehended in one general term of honesty,
which is a corruption of* HONOSTY, *a word derived from what the
Greeks call an ass." From the title-page to the closing sentence there is
an incessant harping on the word "greatness," used in this scheme of
irony to mean material success without moral goodness. And when,
near the end, Fielding reduces the career of his infamous protagonist
to a list of elementary principles of "greatness," behold! that list exactly
defines and delineates the practices by which Fielding saw eminence
achieved in the most respected careers of his own 18th century world.
His purpose is to show how a boot-licking society worshipped prestige
no matter how gained; his method is to draw a grotesque parallel be-
tween the successful man of the great world and the successful criminal
of the underworld, and to signify that the one is as little worthy of
admiration as the other. This catalogue of principles, as applicable to a
Robert Walpole as to a Jonathan Wild, seems to me to be among the
most ingenious and pointed uses of savage irony in English.*

<div align="right">

WILSON FOLLETT
The Modern Novel (1918)

</div>

SAMUEL JOHNSON

1 7 0 9 — 1 7 8 4

THE METAPHYSICAL POETS

Cowley, like other poets who have written with narrow views, and,
instead of tracing intellectual pleasure to its natural sources in the mind
of man, paid their court to temporary prejudices, has been at one time
too much praised, and too much neglected at another.

Wit, like all other things subject their nature to the choice of man,
has its changes and fashions, and at different times takes different forms.
About the beginning of the seventeenth century appeared a race of
writers that may be termed the metaphysical poets; of whom, in a
criticism on the works of Cowley, it is not improper to give some account.

The metaphysical poets were men of learning, and to show their learn-
ing was their whole endeavour; but, unluckily resolving to shew it in
rhyme, instead of writing poetry, they only wrote verses, and very often
such verses as stood the trial of the finger better than of the ear; for

the modulation was so imperfect, that they were only found to be verses by counting the syllables.

If the father of criticism has rightly denominated poetry τέχνη μιμητική, *an imitative art*, these writers will, without great wrong, lose their right to the name of poets; for they cannot be said to have imitated any thing; they neither copied nature nor life; neither painted the forms of matter, nor represented the operations of intellect.

Those, however, who deny them to be poets, allow them to be wits. Dryden confesses of himself and his contemporaries, that they fall below Donne in wit, but maintains that they surpass him in poetry.

If Wit be well described by Pope, as being 'that which has been often thought, but was never before so well expressed,' they certainly never attained, nor ever sought it; for they endeavoured to be singular in their thoughts, and were careless of their diction. But Pope's account of wit is undoubtedly erroneous: he depresses it below its natural dignity, and reduces it from strength of thought to happiness of language.

If by a more noble and more adequate conception that be considered as Wit, which is at once natural and new, that which, though not obvious, is, upon its first production, acknowledged to be just; if it be that, which he that never found it, wonders how he missed; to wit of this kind the metaphysical poets have seldom risen. Their thoughts are often new, but seldom natural; they are not obvious, but neither are they just; and the reader, far from wondering that he missed them, wonders more frequently by what perverseness of industry they were ever found.

But Wit, abstracted from its effects upon the hearer, may be more rigorously and philosophically considered as a kind of *discordia concors;* a combination of dissimilar images, or discovery of occult resemblances in things apparently unlike. Of wit, thus defined, they have more than enough. The most heterogeneous ideas are yoked by violence together; nature and art are ransacked for illustrations, comparisons, and allusions; their learning instructs, and their subtilty surprises; but the reader commonly thinks his improvement dearly bought, and, though he sometimes admires, is seldom pleased.

From this account of their composition it will be readily inferred, that they were not successful in representing or moving the affections. As they were wholly employed on something unexpected and surprising, they had no regard to that uniformity of sentiment which enables us to conceive and to excite the pains and the pleasure of other minds: they never enquired what, on any occasion, they should have said or done; but wrote rather as beholders than partakers of human nature; as Beings looking upon good and evil, impassive and at leisure; as Epicurean deities making remarks on the actions of men, and the vicissitudes of life, without interest and without emotion. Their courtship was void

918

of fondness, and their lamentation of sorrow. Their wish was only to say what they hoped had been never said before.

Nor was the sublime more within their reach than the pathetick; for they never attempted that comprehension and expanse of thought which at once fills the whole mind, and of which the first effect is sudden astonishment, and the second rational admiration. Sublimity is produced by aggregation, and littleness by dispersion. Great thoughts are always general, and consist in positions not limited by exceptions, and in descriptions not descending to minuteness. It is with great propriety that Subtlety, which in its original import means exility of particles, is taken in its metaphorical meaning for nicety of distinction. Those writers who lay on the watch for novelty could have little hope of greatness; for great things cannot have escaped former observation. Their attempts were always analytick; they broke every image into fragments: and could no more represent, by their slender conceits and laboured particularities, the prospects of nature, or the scenes of life, than he, who dissects a sunbeam with a prism, can exhibit the wide effulgence of a summer noon.

What they wanted however of the sublime, they endeavoured to supply by hyperbole; their amplification had no limits; they left not only reason but fancy behind them; and produced combinations of confused magnificence, that not only could not be credited, but could not be imagined.

Yet great labour, directed by great abilities, is never wholly lost: if they frequently threw away their wit upon false conceits, they likewise sometimes struck out unexpected truth: if their conceits were far-fetched, they were often worth the carriage. To write on their plan, it was at least necessary to read and think. No man could be born a metaphysical poet, nor assume the dignity of a writer, by descriptions copied from descriptions, by imitations borrowed from imitations, by traditional imagery, and hereditary similes, by readiness of rhyme, and volubility of syllables.

In perusing the works of this race of authors, the mind is exercised either by recollection or inquiry; either something already learned is to be retrieved, or something new is to be examined. If their greatness seldom elevates, their acuteness often surprises; if the imagination is not always gratified, at least the powers of reflection and comparison are employed; and in the mass of materials which ingenious absurdity has thrown together, genuine wit and useful knowledge may be sometimes found, buried perhaps in grossness of expression, but useful to those who know their value; and such as, when they are expanded to perspicuity, and polished to elegance, may give lustre to works which have more propriety though less copiousness of sentiment.

The Lives of the Poets (1779–81)

919

Johnson's style is not seen in its richness and perfection, nor in its con-
summate ease, until we come to his last and greatest work—the LIVES
OF THE POETS. *That was not begun until he was nearly seventy years of*
age. His time for careful and methodic labour was now past. His opinions
were fixed, and he was not likely to examine or modify them. He was
undisputed literary dictator, and indisposed to bend to others' views. But
all these circumstances contributed to the consummate literary quali-
ties of the book. This is not the place either to impugn or defend the
justice of his literary criticisms. But for vigour and ease and variety
of style, for elasticity of confidence, for keenness of sarcasm, for bright-
ness of humour, the LIVES *hold the first place, absolutely free from com-*
petition, amongst all works of English criticism of similar range. We
may carp at Johnson's judgments, and rail against the prejudice and
injustice of his decrees. We may be disposed to accord to more modern
critics, all the advantages of balanced judgment and sympathetic in-
sight which they may claim; but they must yield to Johnson the palm
for boldness, for wit, for extent of range, and for brilliancy of style.

HENRY CRAIK
English Prose (1895)

SAMUEL JOHNSON

1 7 0 9 — 1 7 8 4

THE PYRAMIDS

"We have now," said Imlac, "gratified our minds with an exact view of the greatest work of man, except the wall of China.

"Of the wall it is very easy to assign the motive. It secured a wealthy and timorous nation from the incursions of barbarians, whose unskil-fulness in arts made it easier for them to supply their wants by rapine than by industry, and who from time to time poured in upon the habi-tations of peaceful commerce as vultures descend upon domestic fowl. Their celerity and fierceness made the wall necessary, and their ignor-ance made it efficacious.

"But for the Pyramids no reason has ever been given, adequate to the cost and labor of the work. The narrowness of the chamber proves that it could afford no retreat from enemies, and treasures might have been reposited at far less expense with equal security. It seems to have been erected only in compliance with that hunger of imagination which preys incessantly upon life, and must be always appeased by some em-ployment. Those who have already all that they can enjoy must enlarge their desires. He that has built for use, till use is supplied, must begin to

build for vanity, and extend his plan to the utmost power of human performance, that he may not be soon reduced to form another wish.

"I consider this mighty structure as a monument of the insufficiency of human enjoyments. A king, whose power is unlimited, and whose treasures surmount all real and imaginary wants, is compelled to solace, by the erection of a pyramid, the satiety of dominion and tastelessness of pleasures, and to amuse the tediousness of declining life, by seeing thousands laboring without end, and one stone for no purpose laid upon another. Whoever thou art, that, not content with a moderate condition, imaginest happiness in royal magnificence, and dreamest that command or riches can feed the appetite of novelty with perpetual gratifications, survey the Pyramids and confess thy folly!"

<div align="right">Rasselas, Prince of Abyssinia (1759)</div>

Perhaps, in all literature, the most magnificent tribute ever paid to the power of Boredom.

<div align="right">

JOSEPH WOOD KRUTCH

Samuel Johnson (1944)

</div>

OLIVER EDWARDS

1 7 1 1 — 1 7 9 1

PHILOSOPHY

'You are a philosopher, Dr. Johnson. I have tried too in my time to be a philosopher; but, I don't know how, cheerfulness was always breaking in.'

<div align="right">Boswell's Life of Johnson (April 17, 1778)</div>

On the Good Friday following the series of dinner-parties Johnson, accompanied by Boswell, followed his usual practice of attending divine service at St. Clement Danes. They had, as usual, talked too long after breakfast and arrived at church late—at the second lesson in fact. But on the return from this service there occurred an encounter that was unusual. It was with Oliver Edwards, who had been an undergraduate with Johnson at Pembroke College, Oxford. It was when they had reached Johnson's house that Mr. Edwards delivered himself of his immortal apologia.

<div align="right">

S. C. ROBERTS

Samuel Johnson (1944)

</div>

THE LIBERTIES OF THOUGHT

Qu'il fasse beau, qu'il fasse laid, c'est mon habitude d'aller sur les cinq heures du soir me promener au Palais-Royal. C'est moi qu'on voit toujours seul, rêvant sur le banc d'Argenson. Je m'entretiens avec moi-même de politique, d'amour, de goût ou de philosophie. J'abandonne mon esprit à tout son libertinage. Je le laisse maître de suivre la première idée sage ou folle qui se présente, comme on voit dans l'allée de Foy nos jeunes dissolus marcher sur les pas d'une courtisane à l'air éventé, au visage riant, à l'œil vif, au nez retroussé, quitter celle-ci pour une autre, les attaquant toutes et ne s'attachant à aucune. Mes pensées, ce sont mes catins.

Rain or shine, it is my custom towards five o'clock in the afternoon to walk in the Palais-Royal. There I may be observed, always alone, musing on the bench by the Hôtel d'Argenson. I am my own interlocutor, and discuss politics, love, taste, and philosophy. I give my mind full fling: I let it follow the first notion that presents itself, be it wise or foolish, even as our wild young rakes in Foy's Alley pursue some courtesan of unchastened mien and welcoming face, of answering eye and tilted nose, and then quit her for another, touching all and cleaving to none. My thoughts are my wantons.

Le Neveu de Rameau (1773)
Translated by Mrs. Wilfrid Jackson

There is no greater precision of expression.

RENÉ DOUMIC
Études sur la littérature française (1896)

THE DEATH OF LE FEVER

Thou hast left this matter short, said my uncle Toby to the corporal, as he was putting him to bed,—and I will tell thee in what, Trim.—In the first place, when thou madest an offer of my services to Le Fever,—

as sickness and travelling are both expensive, and thou knowest he was but a poor lieutenant, with a son to subsist as well as himself out of his pay,—that thou didst not make an offer to him of my purse; because,—had he stood in need, thou knowest, Trim, he had been as welcome to it as myself.—Your honour knows, said the corporal, I had no orders;—True, quoth my uncle Toby,—thou didst very right, Trim, as a soldier,—but certainly very wrong as a man.

In the second place, for which, indeed, thou hast the same excuse, continued my uncle Toby,—when thou offeredst him whatever was in my house,—thou shouldst have offered him my house too:—A sick brother officer should have the best quarters, Trim, and if we had him with us,—we could tend and look to him:—Thou art an excellent nurse thyself, Trim,—and what with thy care of him, and the old woman's, and his boy's, and mine together, we might recruit him again at once, and set him upon his legs.—

—In a fortnight or three weeks, added my uncle Toby, smiling,—he might march.—He will never march, an' please your honour, in this world, said the corporal:—He will march, said my uncle Toby, rising up from the side of the bed, with one shoe off:—An' please your honour, said the corporal, he will never march but to his grave:—He shall march, cried my uncle Toby, marching the foot which had a shoe on, though without advancing an inch,—he shall march to his regiment.—He cannot stand it, said the corporal;—He shall be supported, said my uncle Toby;—He'll drop at last, said the corporal, and what will become of his boy?—He shall not drop, said my uncle Toby, firmly.—A-well-o'-day,—do what we can for him, said Trim, maintaining his point,—the poor soul will die:—He shall not die, by G—, cried my uncle Toby.

—The Accusing Spirit, which flew up to heaven's chancery with the oath, blushed as he gave it in;—and the Recording Angel, as he wrote it down, dropped a tear upon the word, and blotted it out for ever.

—My uncle Toby went to his bureau,—put his purse into his breeches pocket, and having ordered the corporal to go early in the morning for a physician,—he went to bed, and fell asleep.

The sun looked bright the morning after, to every eye in the village but Le Fever's and his afflicted son's; the hand of death pressed heavy upon his eye-lids,—and hardly could the wheel at the cistern turn round its circle,—when my uncle Toby, who had rose up an hour before his wonted time, entered the lieutenant's room, and without preface or apology, sat himself down upon the chair by the bed-side, and, independently of all modes and customs, opened the curtain in the manner an old friend and brother officer would have done it, and asked him how he did,—how he had rested in the night,—what was his complaint,—where was his pain,—and what he could do to help him:—and without giving him time to answer any one of the enquiries, went on, and told

923

him of the little plan which he had been concerting with the corporal the night before for him.—

—You shall go home directly, Le Fever, said my uncle **Toby,** to my house,—and we'll send for a doctor to see what's the matter,—and we'll have an apothecary,—and the corporal shall be your nurse;—and I'll be your servant, Le Fever.

There was a frankness in my uncle Toby,—not the effect of familiarity,—but the cause of it,—which let you at once into his soul, and shewed you the goodness of his nature; to this, there was something in his looks, and voice, and manner, superadded, which eternally beckoned to the unfortunate to come and take shelter under him; so that before my uncle Toby had half finished the kind offers he was making to the father, had the son insensibly pressed up close to his knees, and had taken hold of the breast of his coat, and was pulling it towards him.—The blood and spirits of Le Fever, which were waxing cold and slow within him, and were retreating to their last citadel, the heart—rallied back,—the film forsook his eyes for a moment,—he looked up wishfully in my uncle Toby's face,—then cast a look upon his boy,— and that ligament, fine as it was,—was never broken.——————

Nature instantly ebbed again,—the film returned to its place,—the pulse fluttered—stopped—went on—throbbed—stopped again—moved— stopped—shall I go on?—No.

The Life and Opinions of Tristram Shandy (1760–67)

It is as pure a reflection of mere natural feeling as literature has ever given, or will ever give.

WALTER BAGEHOT
Literary Studies (1878)

WILLIAM SHENSTONE

1 7 1 4 — 1 7 6 3

BLOOM THE JASMINES

If through the garden's flowery tribes I stray,
 Where bloom the jasmines that could once allure,
'Hope not to find delight in us,' they say,
 'For we are spotless, Jessy; we are pure.'

Elegy xxvi

WILLIAM WORDSWORTH

1 7 7 0 — 1 8 5 0

SPRINGTIME WITH ONE LOVE

'Ah, why,' said Ellen, sighing to herself,
'Why do not words, and kiss, and solemn pledge;
And nature that is kind in woman's breast,
And reason that in man is wise and good,
And fear of him who is a righteous judge,—
Why do not these prevail for human life,
To keep two hearts together, that began
Their spring-time with one love, and that have need
Of mutual pity and forgiveness, sweet
To grant, or be received; while that poor bird—
O come and hear him! Thou who hast to me
Been faithless, hear him, though a lowly creature,
One of God's simple children that yet know not
The universal Parent, how he sings
As if he wished the firmament of heaven
Should listen, and give back to him the voice
Of his triumphant constancy and love;
The proclamation that he makes, how far
His darkness doth transcend our fickle light!'

<div align="right">The Excursion (1814), vi</div>

The perfection of both these passages, as far as regards truth and tender-
ness of imagination in the two poets, is quite insuperable.

<div align="right">JOHN RUSKIN
Modern Painters (1856)</div>

THOMAS GRAY

1 7 1 6 — 1 7 7 1

ELEGY WRITTEN IN A
COUNTRY CHURCHYARD

The Curfew tolls the knell of parting day,
The lowing herd wind slowly o'er the lea,
The plowman homeward plods his weary way,
And leaves the world to darkness and to me.

Now fades the glimmering landscape on the sight,
 And all the air a solemn stillness holds,
Save where the beetle wheels his droning flight,
 And drowsy tinklings lull the distant folds;

Save that from yonder ivy-mantled tow'r
 The moping owl does to the moon complain
Of such as, wand'ring near her secret bow'r,
 Molest her ancient solitary reign.

Beneath those rugged elms, that yew-tree's shade,
 Where heaves the turf in many a mould'ring heap,
Each in his narrow cell for ever laid,
 The rude Forefathers of the hamlet sleep.

The breezy call of incense-breathing Morn,
 The swallow twitt'ring from the straw-built shed,
The cock's shrill clarion, or the echoing horn,
 No more shall rouse them from their lowly bed.

For them no more the blazing hearth shall burn,
 Or busy housewife ply her evening care:
No children run to lisp their sire's return,
 Or climb his knees the envied kiss to share.

Oft did the harvest to their sickle yield,
 Their furrow oft the stubborn glebe has broke;
How jocund did they drive their team afield!
 How bow'd the woods beneath their sturdy stroke!

Let not Ambition mock their useful toil,
 Their homely joys, and destiny obscure;
Nor Grandeur hear with a disdainful smile,
 The short and simple annals of the poor.

The boast of heraldry, the pomp of pow'r,
 And all that beauty, all that wealth e'er gave,
Awaits alike th' inevitable hour:
 The paths of glory lead but to the grave.

Nor you, ye Proud, impute to These the fault,
 If Memory o'er their Tomb no Trophies raise,
Where through the long-drawn aisle and fretted vault
 The pealing anthem swells the note of praise.

Can storied urn or animated bust
 Back to its mansion call the fleeting breath?
Can Honour's voice provoke the silent dust,
 Or Flatt'ry soothe the dull cold ear of death?

Perhaps in this neglected spot is laid
 Some heart once pregnant with celestial fire;
Hands, that the rod of empire might have sway'd,
 Or waked to ecstasy the living lyre.

But Knowledge to their eyes her ample page
 Rich with the spoils of time did ne'er unroll;
Chill Penury repress'd their noble rage,
 And froze the genial current of the soul.

Full many a gem of purest ray serene
 The dark unfathom'd caves of ocean bear:
Full many a flower is born to blush unseen,
 And waste its sweetness on the desert air.

Some village Hampden that with dauntless breast
 The little tyrant of his fields withstood,
Some mute inglorious Milton, here may rest,
 Some Cromwell guiltless of his country's blood.

Th' applause of list'ning senates to command,
 The threats of pain and ruin to despise,
To scatter plenty o'er a smiling land,
 And read their history in a nation's eyes,

Their lot forbade: nor circumscribed alone
 Their growing virtues, but their crimes confined;
Forbade to wade through slaughter to a throne,
 And shut the gates of mercy on mankind,

The struggling pangs of conscious truth to hide,
 To quench the blushes of ingenuous shame,
Or heap the shrine of Luxury and Pride
 With incense kindled at the Muse's flame.

Far from the madding crowd's ignoble strife
 Their sober wishes never learn'd to stray;
Along the cool sequester'd vale of life
 They kept the noiseless tenor of their way.

Yet ev'n these bones from insult to protect
 Some frail memorial still erected nigh,
With uncouth rhymes and shapeless sculpture deck'd,
 Implores the passing tribute of a sigh.

Their name, their years, spelt by th' unletter'd muse,
 The place of fame and elegy supply:
And many a holy text around she strews,
 That teach the rustic moralist to die.

For who, to dumb Forgetfulness a prey,
 This pleasing anxious being e'er resign'd,
Left the warm precincts of the cheerful day,
 Nor cast one longing ling'ring look behind?

On some fond breast the parting soul relies,
 Some pious drops the closing eye requires;
E'en from the tomb the voice of Nature cries,
 E'en in our Ashes live their wonted Fires.

For thee, who, mindful of th' unhonour'd dead,
 Dost in these lines their artless tale relate;
If chance, by lonely contemplation led,
 Some kindred spirit shall inquire thy fate,

Haply some hoary-headed Swain may say,
 'Oft have we seen him at the peep of dawn
Brushing with hasty steps the dews away
 To meet the sun upon the upland lawn.

'There at the foot of yonder nodding beech
 That wreathes its old fantastic roots so high,
His listless length at noontide would he stretch,
 And pore upon the brook that babbles by.

'Hard by yon wood, now smiling as in scorn,
 Mutt'ring his wayward fancies he would rove,
Now drooping, woeful wan, like one forlorn,
 Or crazed with care, or cross'd in hopeless love.

'One morn I miss'd him on the custom'd hill,
 Along the heath and near his fav'rite tree;
Another came, nor yet beside the rill,
 Nor up the lawn, nor at the wood was he;

'The next with dirges due in sad array
 Slow through the church-way path we saw him borne.
Approach and read (for thou canst read) the lay
 Graved on the stone beneath yon aged thorn.'

THE EPITAPH

Here rests his head upon the lap of Earth
A Youth to Fortune and to Fame unknown.
Fair Science frown'd not on his humble birth,
And Melancholy mark'd him for her own.

Large was his bounty, and his soul sincere,
Heav'n did a recompense as largely send:
He gave to Mis'ry all he had, a tear,
He gain'd from Heav'n ('twas all he wish'd) a friend.

No farther seek his merits to disclose,
Or draw his frailties from their dread abode,
(There they alike in trembling hope repose,)
The bosom of his Father and his God.

(1750)

For wealth of condensed thought and imagery, fused into one equable
stream of golden song by intense fire of genius, the Editor knows no
poem superior to this ELEGY,—*none quite equal.*

FRANCIS TURNER PALGRAVE
The Children's Treasury of English Song (1875)

THOMAS GRAY

1 7 1 6 — 1 7 7 1

SUPREME DOMINION

Tho' he inherit
Nor the pride, nor ample pinion,
That the Theban Eagle bear
Sailing with supreme dominion
Thro' the azure deep of air.

The Progress of Poesy (1754)

Among the most liquid lines in any language.

ALFRED LORD TENNYSON
Alfred Lord Tennyson: A Memoir by Hallam Tennyson (1897)

929

THE LANGUAGE OF THE AGE

As to matter of stile, I have this to say: The language of the age is
never the language of poetry; except among the French, whose verse,
where the thought or image does not support it, differs in nothing from
prose. Our poetry, on the contrary, has a language peculiar to itself; to
which almost every one, that has written, has added something by
enriching it with foreign idioms and derivatives: Nay sometimes words
of their own composition or invention. Shakespear and Milton have been
great creators this way; and no one more licentious than Pope or
Dryden, who perpetually borrow expressions from the former. Let me
give you some instances from Dryden, whom every body reckons a
great master of our poetical tongue.——Full of *museful mopeings*—
unlike the *trim* of love—a pleasant *beverage*—a *roundelay* of love—stood
silent in his *mood*—with knots and *knares* deformed—his *ireful mood*—
in proud *array*—his *boon* was granted—and *disarray* and shameful rout
—*wayward* but wise—*furbished* for the field—the *foiled dodderd* oaks—
disherited—smouldring flames—*retchless* of laws—*crones* old and ugly—
the *beldam* at his side--the *grandam-hag—villanize* his Father's fame.
——But they are infinite: And our language not being a settled thing
(like the French) has an undoubted right to words of an hundred years
old, provided antiquity have not rendered them unintelligible. In truth,
Shakespear's language is one of his principal beauties; and he has no less
advantage over your Addisons and Rowes in this, than in those other
great excellencies you mention. Every word in him is a picture. Pray
put me the following lines into the tongue of our modern Dramatics:

> But I, that am not shaped for sportive tricks,
> Nor made to court an amorous looking-glass:
> I, that am rudely stampt, and want love's majesty
> To strut before a wanton ambling nymph:
> I, that am curtail'd of this fair proportion,
> Cheated of feature by dissembling nature,
> Deform'd, unfinish'd, sent before my time
> Into this breathing world, scarce half made up—

And what follows. To me they appear untranslatable; and if this be the
case, our language is greatly degenerated.

Correspondence (1742)

*It is impossible for a poet to lay down the rules of his own art with more
insight, soundness, and certainty. Yet at that moment in England there*

was perhaps not one other man, besides Gray, capable of writing the passage just quoted.

<div align="right">

MATTHEW ARNOLD
Essays in Criticism, Second Series (1888)

</div>

HORACE WALPOLE

1 7 1 7 — 1 7 9 7

TO THE REVEREND WILLIAM COLE

<div align="right">

Arlington Street, April 27, 1773

</div>

I had not time this morning to answer your letter by Mr Essex, but I gave him the card you desired. You know, I hope, how happy I am to obey any orders of yours.

In the paper I showed you in answer to Masters, you saw I was apprised of Rastel's *Chronicle,* but pray do not mention my knowing of it, because I draw so much from it, that I lie in wait, hoping that Milles or Masters or some of their fools will produce it against me, and then I shall have another word to say to them which they do not expect, since they think Rastel makes for them.

Mr Gough wants to be introduced to me! Indeed! I would see him as he has been midwife to Masters, but he is so dull that he would only be troublesome—and besides you know I shun authors, and would never have been one myself, if it obliged me to keep such bad company. They are always in earnest, and think their profession serious, and dwell upon trifles, and reverence learning. I laugh at all those things, and write only to laugh at them and divert myself. None of us are authors of any consequence, and it is the most ridiculous of all vanities to be vain of being mediocre. A page in a great author humbles me to the dust, and the conversation of those that are not superior to myself reminds me of what will be thought of myself. I blush to flatter them or to be flattered by them, and should dread letters being published sometime or other, in which they should relate our interviews, and we should appear like those puny conceited witlings in Shenstone's and Hughes's Correspondence, who give themselves airs from being in possession of the soil of Parnassus for the time being, as peers are proud because they enjoy the estates of great men who went before them. Mr Gough is very welcome to see Strawberry Hill, or I would help him to any scraps in my possession that would assist his publications, though he is one of

those industrious who are only reburying the dead—but I cannot be acquainted with him. It is contrary to my system and my humour; and besides I know nothing of barrows, and Danish entrenchments, and Saxon barbarisms, and Phoenician characters—in short I know nothing of those ages that knew nothing—then how should I be of use to modern *literati?* All the Scotch metaphysicians have sent me their works. I did not read one of them, because I do not understand what is not understood by those that write about it, and I did not get acquainted with one of the writers. I should like to be intimate with Mr Anstey, even though he wrote *Lord Buckhorse,* or with the author of the *Heroic Epistle*—I have no thirst to know the rest of my cotemporaries, from the absurd bombast of Dr Johnson down to the silly Dr Goldsmith, though the latter changeling has had bright gleams of parts, and the former had sense till he changed it for words and sold it for a pension. Don't think me scornful. Recollect that I have seen Pope, and lived with Gray. Adieu!

<div align="right">

Yours ever,
H. WALPOLE

</div>

The best letter-writer in the English language.

<div align="right">

SIR WALTER SCOTT
Horace Walpole (1821)

</div>

CHRISTOPHER SMART

1 7 2 2 — 1 7 7 1

A SONG TO DAVID

O thou, that sit'st upon a throne,
With harp of high majestic tone,
 To praise the King of kings:
And voice of heav'n-ascending swell,
Which, while its deeper notes excel,
 Clear, as a clarion, rings:

To bless each valley, grove and coast,
And charm the cherubs to the post
 Of gratitude in throngs;
To keep the days on Zion's mount,
And send the year to his account,
 With dances and with songs:

O Servant of God's holiest charge,
The minister of praise at large,
 Which thou may'st now receive;
From thy blest mansion hail and hear,
From topmost eminence appear
 To this the wreath I weave.

Great, valiant, pious, good, and clean,
Sublime, contemplative, serene,
 Strong, constant, pleasant, wise!
Bright effluence of exceeding grace;
Best man!—the swiftness and the race,
 The peril, and the prize!

Great—from the lustre of his crown,
From Samuel's horn, and God's renown,
 Which is the people's voice;
For all the host, from rear to van,
Applauded and embrac'd the man—
 The man of God's own choice.

Valiant—the word, and up he rose—
The fight—he triumph'd o'er the foes,
 Whom God's just laws abhor;
And arm'd in gallant faith he took
Against the boaster, from the brook,
 The weapons of the war.

Pious—magnificent and grand;
'Twas he the famous temple plann'd:
 (The seraph in his soul)
Foremost to give the Lord his dues,
Foremost to bless the welcome news,
 And foremost to condole.

Good—from Jehudah's genuine vein,
From God's best nature good in grain,
 His aspect and his heart;
To pity, to forgive, to save,
Witness En-gedi's conscious cave,
 And Shimei's blunted dart.

Clean—if perpetual prayer be pure,
And love, which could itself inure
 To fasting and to fear—
Clean in his gestures, hands, and feet,
To smite the lyre, the dance complete,
 To play the sword and spear.

933

Sublime—invention ever young,
Of vast conception, tow'ring tongue,
 To God th' eternal theme;
Notes from yon exaltations caught,
Unrivall'd royalty of thought,
 O'er meaner strains supreme.

Contemplative—On God to fix
His musings, and above the six
 The sabbath-day he blest;
'Twas then his thoughts self-conquest prun'd,
And heavenly melancholy tun'd,
 To bless and bear the rest.

Serene—to sow the seeds of peace,
Rememb'ring, when he watch'd the fleece,
 How sweetly Kidron purl'd—
To further knowledge, silence vice,
And plant perpetual paradise
 When God had calm'd the world.

Strong—in the Lord, who could defy
Satan, and all his powers that lie
 In sempiternal night;
And hell, and horror, and despair
Were as the lion and the bear
 To his undaunted might.

Constant—in love to God THE TRUTH,
Age, manhood, infancy, and youth—
 To Jonathan his friend
Constant, beyond the verge of death;
And Ziba, and Mephibosheth,
 His endless fame attend.

Pleasant—and various as the year;
Man, soul, and angel, without peer,
 Priest, champion, sage and boy;
In armour, or in ephod clad,
His pomp, his piety was glad;
 Majestic was his joy.

Wise—in recovery from his fall,
Whence rose his eminence o'er all,
 Of all the most revil'd;
The light of Israel in his ways,
Wise are his precepts, prayer and praise,
 And counsel to his child.

His muse, bright angel of his verse,
Gives balm for all the thorns that pierce,
 For all the pangs that rage;
Blest light, still gaining on the gloom,
The more than Michal of his bloom,
 Th' Abishag of his age.

He sung of God—the mighty source
Of all things—the stupendous force
 On which all strength depends;
From whose right arm, beneath whose eyes,
All period, pow'r, and enterprise
 Commences, reigns, and ends.

Angels—their ministry and meed,
Which to and fro with blessings speed,
 Or with their citterns wait;
Where Michael with his millions bows,
Where dwells the seraph and his spouse,
 The cherub and her mate.

Of man—the semblance and effect
Of God and Love—the Saint elect
 For infinite applause—
To rule the land, and briny broad,
To be laborious in his laud,
 And heroes in his cause.

The world—the clust'ring spheres he made,
The glorious light, the soothing shade,
 Dale, champaign, grove, and hill;
The multitudinous abyss,
Where secrecy remains in bliss,
 And wisdom hides her skill.

Trees, plants, and flow'rs—of virtuous root;
Gem yielding blossom, yielding fruit,
 Choice gums and precious balm;
Bless ye the nosegay in the vale,
And with the sweet'ners of the gale
 Enrich the thankful psalm.

Of fowl—e'en ev'ry beak and wing
Which cheer the winter, hail the spring,
 That live in peace or prey;
They that make music, or that mock,
The quail, the brave domestic cock,
 The raven, swan, and jay.

Of fishes—ev'ry size and shape,
Which nature frames of light escape,
 Devouring man to shun:
The shells are in the wealthy deep,
The shoals upon the surface leap,
 And love the glancing sun.

Of beasts—the beaver plods his task;
While the sleek tigers roll and bask.
 Nor yet the shades arouse:
Her cave the mining coney scoops;
Where o'er the mead the mountain stoops,
 The kids exult and brouse.

Of gems—their virtue and their price,
Which hid in earth from man's device,
 Their darts of lustre sheathe;
The jasper of the master's stamp,
The topaz blazing like a lamp
 Among the mines beneath.

Blest was the tenderness he felt
When to his graceful harp he knelt,
 And did for audience call;
When satan with his hand he quell'd,
And in serene suspense he held
 The frantic throes of Saul.

His furious foes no more malign'd
As he such melody divin'd,
 And sense and soul detain'd;
Now striking strong, now soothing soft,
He sent the godly sounds aloft,
 Or in delight refrain'd.

When up to heav'n his thoughts he pil'd,
From fervent lips fair Michal smil'd,
 As blush to blush she stood;
And chose herself the queen, and gave
Her utmost from her heart, "so brave,
 "And plays his hymns so good."

The pillars of the Lord are sev'n,
Which stand from earth to topmost heav'n;
 His wisdom drew the plan;
His WORD accomplish'd the design,
From brightest gem to deepest mine,
 From CHRIST enthron'd to man.

Alpha, the cause of causes, first
In station, fountain, whence the burst
 Of light, and blaze of day;
Whence bold attempt, and brave advance,
Have motion, life, and ordinance,
 And heav'n itself its stay.

Gamma supports the glorious arch
On which angelic legions march,
 And is with sapphires pav'd;
Thence the fleet clouds are sent adrift,
And thence the painted folds, that lift
 The crimson veil, are wav'd.

Eta with living sculpture breathes,
With verdant carvings, flow'ry wreathes
 Of never-wasting bloom;
In strong relief his goodly base
All instruments of labour grace,
 The trowel, spade, and loom.

Next Theta stands to the Supreme—
Who form'd, in number, sign, and scheme,
 Th' illustrious lights that are;
And one address'd his saffron robe,
And one clad in a silver globe,
 Held rule with ev'ry star.

Iota's tun'd to choral hymns
Of those that fly, while he that swims
 In thankful safety lurks;
And foot, and chapitre, and niche,
The various histories enrich
 Of God's recorded works.

Sigma presents the social droves,
With him that solitary roves,
 And man of all the chief;
Fair on whose face, and stately frame,
Did God impress His hallow'd name,
 For ocular belief.

OMEGA! GREATEST and the BEST,
Stands sacred to the day of rest,
 For gratitude and thought;
Which bless'd the world upon his pole,
And gave the universe his goal,
 And clos'd th' infernal draught.

O DAVID, scholar of the Lord!
Such is thy science, whence reward,
 And infinite degree;
O strength, O sweetness, lasting ripe!
God's harp thy symbol, and thy type
 The lion and the bee!

There is but One who ne'er rebell'd,
But One by passion unimpell'd,
 By pleasures unentic't;
He from himself his semblance sent,
Grand object of his own content,
 And saw the God in CHRIST.

Tell them, I am, JEHOVAH said
To MOSES; while earth heard in dread,
 And, smitten to the heart,
At once above, beneath, around,
All nature, without voice or sound,
 Replied, O Lord, THOU ART.

Thou art—to give and to confirm,
For each his talent and his term;
 All flesh thy bounties share:
Thou shalt not call thy brother fool;
The porches of the Christian school
 Are meekness, peace, and pray'r.

Open, and naked of offence,
Man's made of mercy, soul, and sense;
 God arm'd the snail and wilk;
Be good to him that pulls thy plough;
Due food and care, due rest, allow
 For her that yields thee milk.

Rise up before the hoary head,
And God's benign commandment dread,
 Which says thou shalt not die:
"Not as I will, but as thou wilt,"
Pray'd He whose conscience knew no guilt;
 With whose bless'd pattern vie.

Use all thy passions!—love is thine,
And joy, and jealousy divine;
 Thine hope's eternal fort,
And care thy leisure to disturb,
With fear concupiscence to curb,
 And rapture to transport.

938

Act simply, as occasion asks;
Put mellow wine in season'd casks;
 Till not with ass and bull:
Remember thy baptismal bond;
Keep from commixtures foul and fond,
 Nor work thy flax with wool.

Distribute: pay the Lord his tithe,
And make the widow's heart-strings blithe;
 Resort with those that weep:
As you from all and each expect,
For all and each thy love direct,
 And render as you reap.

The slander and its bearer spurn,
And propagating praise sojourn
 To make thy welcome last;
Turn from old Adam to the New;
By hope futurity pursue;
 Look upwards to the past.

Control thine eye, salute success,
Honour the wiser, happier bless,
 And for thy neighbour feel;
Grutch not of mammon and his leaven,
Work emulation up to heaven
 By knowledge and by zeal.

O DAVID, highest in the list
Of worthies, on God's ways insist,
 The genuine word repeat.
Vain are the documents of men,
And vain the flourish of the pen
 That keeps the fool's conceit.

PRAISE above all—for praise prevails;
Heap up the measure, load the scales,
 And good to goodness add:
The gen'rous soul her Saviour aids,
But peevish obloquy degrades;
 The Lord is great and glad.

For ADORATION all the ranks
Of angels yield eternal thanks,
 And DAVID in the midst;
With God's good poor, which, last and least
In man's esteem, thou to thy feast,
 O blessed bridegroom, bidst.

For ADORATION seasons change,
And order, truth, and beauty range,
 Adjust, attract, and fill:
The grass the polyanthus cheques;
And polish'd porphyry reflects,
 By the descending rill.

Rich almonds colour to the prime
For ADORATION; tendrils climb,
 And fruit-trees pledge their gems;
And Ivis with her gorgeous vest
Builds for her eggs her cunning nest,
 And bell-flowers bow their stems.

With vinous syrup cedars spout;
From rocks pure honey gushing out,
 For ADORATION springs:
All scenes of painting crowd the map
Of nature; to the mermaid's pap
 The scaléd infant clings.

The spotted ounce and playsome cubs
Run rustling 'mongst the flow'ring shrubs,
 And lizards feed the moss;
For ADORATION beasts embark,
While waves upholding halcyon's ark
 No longer roar and toss.

While Israel sits beneath his fig,
With coral root and amber sprig
 The wean'd advent'rer sports;
Where to the palm the jasmin cleaves,
For ADORATION 'mong the leaves
 The gale his peace reports.

Increasing days their reign exalt,
Nor in the pink and mottled vault
 Th' opposing spirits tilt;
And, by the coasting reader spy'd,
The silverlings and crusions glide
 For ADORATION gilt.

For ADORATION rip'ning canes
And cocoa's purest milk detains
 The western pilgrim's staff;
Where rain in clasping boughs inclos'd,
And vines with oranges dispos'd,
 Embower the social laugh.

Now labour his reward receives,
For ADORATION counts his sheaves
 To peace, her bounteous prince;
The nectarine his strong tint imbibes,
And apples of ten thousand tribes,
 And quick peculiar quince.

The wealthy crops of whit'ning rice
'Mongst thyine woods and groves of spice,
 For ADORATION grow;
And, marshall'd in the fencéd land,
The peaches and pomegranates stand,
 Where wild carnations blow.

The laurels with the winter strive;
The crocus burnishes alive
 Upon the snow-clad earth.
For ADORATION myrtles stay
To keep the garden from dismay,
 And bless the sight from dearth.

The pheasant shews his pompous neck;
And ermine, jealous of a speck,
 With fear eludes offence:
The sable, with his glossy pride,
For ADORATION is descried,
 Where frosts the wave condense.

The cheerful holly, pensive yew,
And holy thorn, their trim renew;
 The squirrel hoards his nuts:
All creatures batten o'er their stores,
And careful nature all her doors
 For ADORATION shuts.

For ADORATION, DAVID'S Psalms
Lift up the heart to deeds of alms;
 And he, who kneels and chants
Prevails his passions to control,
Finds meat and med'cine to the soul,
 Which for translation pants.

For ADORATION, beyond match,
The scholar bulfinch aims to catch
 The soft flute's iv'ry touch;
And, careless on the hazel spray,
The daring redbreast keeps at bay
 The damsel's greedy clutch.

941

For ADORATION, in the skies,
The Lord's philosopher espies
 The Dog, the Ram, and Rose;
The planet's ring, Orion's sword;
Nor is his greatness less ador'd
 In the vile worm that glows.

For ADORATION on the strings
The western breezes work their wings,
 The captive ear to soothe.—
Hark! 'tis a voice—how still, and small—
That makes the cataracts to fall,
 Or bids the sea be smooth.

For ADORATION, incense comes
From bezoar, and Arabian gums;
 And from the civet's furr:
But as for pray'r, or ere it faints,
Far better is the breath of saints
 Than galbanum and myrrh.

For ADORATION, from the down
Of dam'sins to th' anana's crown,
 God sends to tempt the taste;
And while the luscious zest invites,
The sense, that in the scene delights,
 Commands desire be chaste.

For ADORATION, all the paths
Of grace are open, all the baths
 Of purity refresh;
And all the rays of glory beam
To deck the man of God's esteem,
 Who triumphs o'er the flesh.

For ADORATION, in the dome
Of Christ the sparrows find an home;
 And on his olives perch:
The swallow also dwells with thee,
O man of God's humility,
 Within his Saviour's CHURCH.

Sweet is the dew that falls betimes,
And drops upon the leafy limes;
 Sweet Hermon's fragrant air:
Sweet is the lily's silver bell,
And sweet the wakeful tapers smell
 That watch for early pray'r.

Sweet the young nurse with love intense,
Which smiles o'er sleeping innocence;
 Sweet when the lost arrive:
Sweet the musician's ardour beats,
While his vague mind's in quest of sweets,
 The choicest flow'rs to hive.

Sweeter in all the strains of love,
The language of thy turtle dove,
 Pair'd to thy swelling chord;
Sweeter with ev'ry grace endu'd,
The glory of thy gratitude,
 Respir'd unto the Lord.

Strong is the horse upon his speed;
Strong in pursuit the rapid glede,
 Which makes at once his game;
Strong the tall ostrich on the ground;
Strong through the turbulent profound
 Shoots xiphias to his aim.

Strong is the lion—like a coal
His eyeball—like a bastion's mole
 His chest against the foes:
Strong the gier-eagle on his sail,
Strong against tide, th' enormous whale
 Emerges, as he goes.

But stronger still, in earth and air,
And in the sea, the man of pray'r;
 And far beneath the tide;
And in the seat to faith assign'd,
Where ask is have, where seek is find,
 Where knock is open wide.

Beauteous the fleet before the gale;
Beauteous the multitudes in mail,
 Rank'd arms and crested heads:
Beauteous the garden's umbrage mild,
Walk, water, meditated wild,
 And all the bloomy beds.

Beauteous the moon full on the lawn;
And beauteous, when the veil's withdrawn,
 The virgin to her spouse:
Beauteous the temple deck'd and fill'd,
When to the heav'n of heav'ns they build
 Their heart-directed vows.

Beauteous, yea beauteous more than these,
The shepherd king upon his knees,
　　　For his momentous trust;
With wish of infinite conceit,
For man, beast, mute, the small and great,
　　　And prostrate dust to dust.

Precious the bounteous widow's mite;
And precious, for extreme delight,
　　　The largess from the churl:
Precious the ruby's blushing blaze,
And alba's blest imperial rays,
　　　And pure cerulean pearl.

Precious the penitential tear;
And precious is the sigh sincere,
　　　Acceptable to God:
And precious are the winning flow'rs,
In gladsome Israel's feast of bow'rs,
　　　Bound on the hallow'd sod.

More precious that diviner part
Of David, ev'n the Lord's own heart,
　　　Great, beautiful, and new:
In all things where it was intent,
In all extremes, in each event,
　　　Proof—answ'ring true to true.

Glorious the sun in mid career;
Glorious th' assembled fires appear;
　　　Glorious the comet's train:
Glorious the trumpet and alarm;
Glorious th' almighty stretch'd-out arm:
　　　Glorious th' enraptur'd main:

Glorious the northern lights astream;
Glorious the song, when God's the theme;
　　　Glorious the thunder's roar:
Glorious hosanna from the den;
Glorious the catholic amen;
　　　Glorious the martyr's gore:

Glorious—more glorious is the crown
Of Him, that brought salvation down
　　　By meekness, call'd thy Son;

944

Thou at stupendous truth believ'd,
And now the matchless deed's achiev'd,
DETERMIN'D, DAR'D, and DONE.

(1763)

The top-most pinnacles of poetry.

W I L L I A M C L Y D E D E V A N E
A Browning Handbook (1935)

MAURICE MORGANN

1 7 2 6 — 1 8 0 2

SHAKESPEARE

Shakespeare is a name so interesting, that it is excusable to stop a moment, nay it would be indecent to pass him without the tribute of some admiration. He differs essentially from all other writers: Him we may profess rather to feel than to understand; and it is safer to say, on many occasions, that we are possessed by him, than that we possess him. And no wonder;—He scatters the seeds of things, the principles of character and action, with so cunning a hand yet with so careless an air, and, master of our feelings, submits himself so little to our judgment, that every thing seems superior. We discern not his course, we see no connection of cause and effect, we are rapt in ignorant admiration, and claim no kindred with his abilities. All the incidents, all the parts, look like chance, whilst we feel and are sensible that the whole is design. His Characters not only act and speak in strict conformity to nature, but in strict relation to us; just so much is shewn as is requisite, just so much is impressed; he commands every passage to our heads and to our hearts, and moulds us as he pleases, and that with so much ease, that he never betrays his own exertions. We see these Characters act from the mingled motives of passion, reason, interest, habit and complection, in all their proportions, when they are supposed to know it not themselves; and we are made to acknowledge that their actions and sentiments are, from those motives, the necessary result. He at once blends and distinguishes every thing;—every thing is complicated, every thing is plain. I restrain the further expressions of my admiration lest they should not seem applicable to man; but it is really astonishing that a mere human being, a part of humanity only, should so perfectly comprehend the whole; and that he should possess such exquisite art, that

945

whilst every woman and every child shall feel the whole effect, his learned Editors and Commentators should yet so very frequently mistake or seem ignorant of the cause. A sceptre or a straw are in his hands of equal efficacy; he needs no selection; he converts every thing into excellence; nothing is too great, nothing is too base. Is a character efficient like *Richard*, it is every thing we can wish: Is it otherwise, like *Hamlet*, it is productive of equal admiration: Action produces one mode of excellence and inaction another: The Chronicle, the Novel, or the Ballad; the king, or the beggar, the hero, the madman, the sot or the fool; it is all one;—nothing is worse, nothing is better: The same genius pervades and is equally admirable in all. Or, is a character to be shewn in progressive change, and the events of years comprized within the hour;—with what a Magic hand does he prepare and scatter his spells! The Understanding must, in the first place, be subdued; and lo! how the rooted prejudices of the child spring up to confound the man! The Weird sisters rise, and order is extinguished. The laws of nature give way, and leave nothing in our minds but wildness and horror. No pause is allowed us for reflection: Horrid sentiment, furious guilt and compunction, air-drawn daggers, murders, ghosts, and inchantment, shake and *possess us wholly*. In the mean time the *process* is completed. *Macbeth* changes under our eye, *the milk of human kindness is converted to gall; he has supped full of horrors*, and his *May of life is fallen into the sear, the yellow leaf;* whilst we, the fools of amazement, are insensible to the shifting of place and the lapse of time, and till the curtain drops, never once wake to the truth of things, or recognize the laws of existence.—On such an occasion, a fellow, like *Rymer*, waking from his trance, shall lift up his Constable's staff, and charge this great Magician, this daring *practicer of arts inhibited*, in the name of *Aristotle*, to surrender; whilst *Aristotle* himself, disowning his wretched Officer, would fall prostrate at his feet and acknowledge his supremacy. —O supreme of Dramatic excellence! (*might he say*,) not to me be imputed the insolence of fools. The bards of *Greece* were confined within the narrow circle of the Chorus, and hence they found themselves constrained to practice, for the most part, the precision, and copy the details of nature. I followed them, and knew not that a larger circle might be drawn, and the Drama extended to the whole reach of human genius. Convinced, I see that a more compendious *nature* may be obtained; a nature of *effects* only, to which neither the relations of place, or continuity of time, are always essential. Nature, condescending to the faculties and apprehensions of man, has drawn through human life a regular chain of visible causes and effects: But Poetry delights in surprize, conceals her steps, seizes at once upon the heart, and obtains the Sublime of things without betraying the rounds of her ascent: True Poesy is *magic*, not *nature;* an effect from causes hidden or unknown. To the Magician I prescribed no laws; his law and his power are one; his power

946

is his law. Him, who neither imitates, nor is within the reach of imitation, no precedent can or ought to bind, no limits to contain. If his end is obtained, who shall question his course? Means, whether apparent or hidden, are justified in poesy by success; but then most perfect and most admirable when most concealed.

An Essay on the Dramatic Character of Sir John Falstaff (1777)

The passage where he breaks away exultantly from his main subject to write in sheer delight of Shakespeare's essential difference from all other writers and his imperishable gifts, is one of the great things in the whole range of English criticism. There is nothing greater—perhaps nothing so great—in Coleridge or Hazlitt.

<div style="text-align: right">

D. NICHOL SMITH
Shakespeare Criticism (1916)

</div>

EDMUND BURKE

1 7 2 9 — 1 7 9 7

THE PROPOSITION IS PEACE

For that service, for all service, whether of revenue, trade, or empire, my trust is in her interest in the British constitution. My hold of the colonies is in the close affection which grows from common names, from kindred blood, from similar privileges, and equal protection. These are ties, which, though light as air, are strong as links of iron. Let the colonies always keep the idea of their civil rights associated with your government;—they will cling and grapple to you; and no force under heaven will be of power to tear them from their allegiance. But let it be once understood, that your government may be one thing, and their privileges another; that these two things may exist without any mutual relation; the cement is gone; the cohesion is loosened; and every thing hastens to decay and dissolution. As long as you have the wisdom to keep the sovereign authority of this country as the sanctuary of liberty, the sacred temple consecrated to our common faith, wherever the chosen race and sons of England worship freedom, they will turn their faces towards you. The more they multiply, the more friends you will have; the more ardently they love liberty, the more perfect will be their obedience. Slavery they can have any where. It is a weed that grows in every soil. They may have it from Spain, they may have it from Prussia. But until you become lost to all feeling of your true interest and your natural dignity, freedom they can have from none but you. This is the com-

modity of price, of which you have the monopoly. This is the true act of navigation, which binds to you the commerce of the colonies, and through them secures to you the wealth of the world. Deny them this participation of freedom, and you break that sole bond, which originally made, and must still preserve, the unity of the empire. Do not entertain so weak an imagination, as that your registers and your bonds, your affidavits and your sufferances, your cockets and your clearances, are what form the great securities of your commerce. Do not dream that your letters of office, and your instructions, and your suspending clauses, are the things that hold together the great contexture of this mysterious whole. These things do not make your government. Dead instruments, passive tools as they are, it is the spirit of the English communion, that gives all their life and efficacy to them. It is the spirit of the English constitution, which, infused through the mighty mass, pervades, feeds, unites, invigorates, vivifies, every part of the empire, even down to the minutest member.

Is it not the same virtue which does every thing for us here in England? Do you imagine then, that it is the land tax act which raises your revenue? that it is the annual vote in the committee of supply, which gives you your army? or that it is the mutiny bill which inspires it with bravery and discipline? No! Surely no! It is the love of the people; it is their attachment to their government from the sense of the deep stake they have in such a glorious institution, which gives you your army and your navy, and infuses into both that liberal obedience, without which your army would be a base rabble, and your navy nothing but rotten timber.

All this, I know well enough, will sound wild and chimerical to the profane herd of those vulgar and mechanical politicians, who have no place among us; a sort of people who think that nothing exists but what is gross and material; and who therefore, far from being qualified to be directors of the great movement of empire, are not fit to turn a wheel in the machine. But to men truly initiated and rightly taught, these ruling and master principles, which, in the opinion of such men as I have mentioned, have no substantial existence, are in truth every thing, and all in all. Magnanimity in politics is not seldom the truest wisdom; and a great empire and little minds go ill together. If we are conscious of our situation, and glow with zeal to fill our places as becomes our station and ourselves, we ought to auspicate all our public proceedings on America, with the old warning of the church, *Sursum corda!* We ought to elevate our minds to the greatness of that trust to which the order of Providence has called us. By adverting to the dignity of this high calling, our ancestors have turned a savage wilderness into a glorious empire; and have made the most extensive, and the only honorable conquests; not by destroying, but by promoting the wealth, the number, the happiness, of the human race. Let us get an American revenue as we have

got an American empire. English privileges have made it all that it is; English privileges alone will make it all it can be.

In full confidence of this unalterable truth, I now (*quod felix faustumque sit*)—lay the first stone of the temple of peace.

Speech on Moving Resolutions for Conciliation with the Colonies
(March 22, 1775)

If delivered under the conditions of a later period, when it would have been read in every household on the day following, [it] could not but have reacted with power on both House and government. As it is, it remains some compensation to English literature for the dismemberment of the British empire. Whether we reflect on the art with which it is constructed, the skill with which the speaker winds into the heart of his subject and draws from it the material of his splendid peroration on 'the spirit of the English constitution' and its power to unite, invigorate and vivify the British empire in all its diverse members; or reflect on the temper, passionate and moving yet restrained and conciliatory, in which the argument is conducted; or recall simply the greater flights of picturesque eloquence, the description of American industry and enterprise, the imagery in which the speaker clothes his conception of the spirit of the English constitution and the sovereign authority of parliament—the speech takes its own place beside the greatest masterpieces of our literature, the plays of Shakespeare and the poems of Milton.

HERBERT J. C. GRIERSON
Edmund Burke, in The Cambridge History of
English Literature (1914)

WILLIAM COWPER

1731 — 1800

TO THE REV. JOHN NEWTON

March 29, 1784.

My dear Friend,——

It being his Majesty's pleasure that I should yet have another opportunity to write before he dissolves the parliament, I avail myself of it with all possible alacrity. I thank you for your last, which was not the less welcome for coming, like an extraordinary gazette, at a time when it was not expected.

As when the sea is uncommonly agitated, the water finds its way into creeks and holes of rocks, which in its calmer state it never reaches, in

949

like manner the effect of these turbulent times is felt even at Orchard side, where in general we live as undisturbed by the political element, as shrimps or cockles that have been accidentally deposited in some hollow beyond the water mark, by the usual dashing of the waves. We were sitting yesterday after dinner, the two ladies and myself, very composedly, and without the least apprehension of any such intrusion in our snug parlour, one lady knitting, the other netting, and the gentleman winding worsted, when to our unspeakable surprise a mob appeared before the window; a smart rap was heard at the door, the boys haloo'd, and the maid announced Mr. Grenville. Puss * was unfortunately let out of her box, so that the candidate, with all his good friends at his heels, was refused admittance at the grand entry, and referred to the back door, as the only possible way of approach.

Candidates are creatures not very susceptible of affronts, and would rather, I suppose, climb in at a window than be absolutely excluded. In a minute the yard, the kitchen, and the parlour were filled. Mr. Grenville advancing toward me shook me by the hand with a degree of cordiality that was extremely seducing. As soon as he and as many more as could find chairs were seated, he began to open the intent of his visit. I told him I had no vote, for which he readily gave me credit. I assured him I had no influence, which he was not equally inclined to believe, and the less, no doubt, because Mr. Ashburner, the drapier, addressing himself to me at this moment, informed me that I had a great deal. Supposing that I could not be possessed of such a treasure without knowing it, I ventured to confirm my first assertion by saying, that if I had any I was utterly at a loss to imagine where it could be, or wherein it consisted. Thus ended the conference. Mr. Grenville squeezed me by the hand again, kissed the ladies, and withdrew. He kissed likewise the maid in the kitchen, and seemed upon the whole a most loving, kissing, kind-hearted gentleman. He is very young, genteel, and handsome. He has a pair of very good eyes in his head, which not being sufficient as it should seem for the many nice and difficult purposes of a senator, he has a third also, which he wore suspended by a ribband from his buttonhole. The boys haloo'd, the dogs barked, Puss scampered, the hero, with his long train of obsequious followers, withdrew. We made ourselves very merry with the adventure, and in a short time settled into our former tranquillity, never probably to be thus interrupted more. I thought myself, however, happy in being able to affirm truly that I had not that influence for which he sued; and which, had I been possessed of it, with my present views of the dispute between the Crown and the Commons, I must have refused him, for he is on the side of the former. It is comfortable to be of no consequence in a world where one cannot exercise any without disobliging somebody. The town, however, seems

* His tame hare.

to be much at his service, and if he be equally successful throughout the county, he will undoubtedly gain his election. Mr. Ashburner, perhaps, was a little mortified, because it was evident that I owed the honour of this visit to his misrepresentation of my importance. But had he thought proper to assure Mr. Grenville that I had three heads, I should not, I suppose, have been bound to produce them.

Mr. Scott, who you say was so much admired in your pulpit, would be equally admired in his own, at least by all capable judges, were he not so apt to be angry with his congregation. This hurts him, and had he the understanding and eloquence of Paul himself, would still hurt him. He seldom, hardly ever indeed, preaches a gentle, well-tempered sermon, but I hear it highly commended: but warmth of temper, indulged to a degree that may be called scolding, defeats the end of preaching. It is a misapplication of his powers, which it also cripples, and teases away his hearers. But he is a good man, and may perhaps outgrow it.

Many thanks for the worsted, which is excellent. We are as well as a spring hardly less severe than the severest winter will give us leave to be. With our united love, we conclude ourselves yours and Mrs. Newton's affectionate and faithful

<div align="right">

W. C.
M. U.

</div>

The best of English letter-writers.

<div align="right">

ROBERT SOUTHEY
The Life of William Cowper, Esq. (1839)

</div>

JOHN LANGHORNE

1 7 3 5 — 1 7 7 9

POETIC MOMENT

> Where longs to fall that rifted spire,
> *As weary of th' insulting air.*

<div align="right">

Fable vii, The Wall-Flower

</div>

He has in the italicised line a "poetic moment" which is, for its poetic quality, as free of the poetic Jerusalem as "We are such stuff," or the dying words of Cleopatra. He has hit "what it was so easy to miss," the passionate expression, in articulate music, unhit before, never to be poetically hit again save by accident, yet never to perish from the world of poetry. It is only a grain of gold ("fish-scale" gold, even, as the mining

experts call their nearly impalpable specks), but it is gold: something
that you can never degrade to silver, or copper, or pinchbeck.

GEORGE SAINTSBURY
A History of Criticism (1904)

EDWARD GIBBON

1 7 3 7 — 1 7 9 4

GRAVE AND TEMPERATE IRONY

Within these limits the almost invisible and tremulous ball of orthodoxy was allowed securely to vibrate.

When the Arian pestilence approached their frontiers, they were supplied with the seasonable preservative of the Homoousion, by the paternal care of the Roman pontiff.

The prerogatives of the King of Heaven were settled, or changed, or modified, in the cabinet of an earthly monarch.

The *circumincessio* is perhaps the deepest and darkest corner of the whole theological abyss.

Future tyrants were encouraged to believe that the blood which they might shed in a long reign would instantly be washed away in the waters of regeneration.

The Decline and Fall of the Roman Empire (1776–88)

Flaubert could not hunt more nicely for the right word.

OLIVER ELTON
A Survey of English Literature 1730–1780 (1928)

JEAN FRANÇOIS DE LA HARPE

1 7 3 9 — 1 8 0 3

THE PROPHECY OF CAZOTTE

Il me semble que c'était hier, et c'était cependant au commencement de 1788. Nous étions à table chez un de nos confrères à l'académie, grand seigneur et homme d'esprit. La compagnie était nombreuse et de tout état, gens de cour, gens de robe, gens de lettres, académiciens, etc. on avait fait grande chère comme de coutume. Au dessert, les vins de Malvoisie et de Constance ajoutaient à la gaieté de bonne compagnie cette sorte de liberté qui n'en gardait pas toujours le ton: on en était alors venu dans le monde au point où tout est permis pour faire rire. Chamfort nous avait lu de ses contes impies et libertins, et les grandes dames avaient écouté, sans avoir même recours à l'éventail. Delà un déluge de plaisanteries sur la religion: l'un citait une tirade de la Pucelle; l'autre rappelait ces vers *philosophiques* de Diderot,

> Et des boyaux du dernier prêtre,
> Serrez le cou du dernier roi.

et d'applaudir. Un troisième se lève, et tenant son verre plein: *oui, messieurs* (s'écrie-il), *je suis aussi sûr qu'il n'y a pas de Dieu, que je suis sûr qu'Homère est un sot;* et en effet, il était sûr de l'un comme de l'autre; et l'on avait parlé d'Homère et de Dieu; et il y avait là des convives qui avaient dit du bien de l'un et de l'autre. La conversation devient plus sérieuse; on se répand en admiration sur *la révolution* qu'avait faite Voltaire, et l'on convient que c'est là le premier titre de sa gloire. "Il a donné le ton à son siècle, et s'est fait lire dans l'anti-chambre comme dans le sallon." Un des convives nous raconta, en pouffant de rire, que son coëffeur lui avait dit, tout en le poudrant, *voyez-vous, monsieur, quoique je ne sois qu'un misérable carabin, je n'ai pas plus de religion qu'un autre.* On conclut que *la révolution* ne tardera pas à se consommer; qu'il faut absolument *que la superstition et le fanatisme fassent place à la philosophie,* et l'on en est à calculer la probabilité de l'époque, et quels seront ceux de la société qui verront *le règne de la raison.* Les plus vieux se plaignaient de ne pouvoir s'en flatter; les jeunes se réjouissaient d'en avoir une espérance très-vraisemblable; et l'on félicitait sur-tout l'académie d'avoir *préparé le grand-œuvre,* et d'avoir été le chef-lieu, le centre, le mobile de *la liberté de penser.*

Un seul des convives n'avait point pris de part à toute la joie de cette conversation, et avait même laissé tomber tout doucement quelques plaisanteries sur notre bel enthousiasme. C'était Cazotte, homme aimable et original, mais malheureusement infatué des rêveries des illuminés. Il prend la parole et du ton le plus sérieux: "Messieurs (dit-il), soyez

satisfaits, vous verrez tous cette *grande et sublime révolution* que vous desirez tant. Vous savez que je suis un peu prophète; je vous le répète, vous la verrez." On lui répond par le refrein connu, *faut pas être grand sorcier pour ça.*—"Soit, mais peut-être faut-il l'être un peu plus pour ce qui me reste à vous dire. Savez-vous ce qui arrivera de cette *révolution*, ce qui en arrivera pour vous, tout tant que vous êtes ici, et ce qui en sera la suite immédiate, l'effet bien prouvé, la conséquence bien reconnue?—" "Ah! voyons, (dit Condorcet avec son air et son rire sournois et niais), *un philosophe* n'est pas fâché de rencontrer un prophète:—vous, M. de Condorcet, vous expirerez étendu sur le pavé d'un cachot, vous mourrez du poison que vous aurez pris, pour vous dérober au bourreau, du poison que *le bonheur* de ce temps-là vous forcera de porter toujours sur vous."

Grand étonnement d'abord; mais on se rappelle que le bon Cazotte est sujet à rêver tout éveillé, et l'on rit de plus belle.—"M. Cazotte, le conte que vous nous faites ici n'est pas si plaisant que votre *Diable amoureux.* Mais quel diable vous a mis dans la tête ce *cachot* et ce *poison* et ces *bourreaux?* Qu'est-ce que tout cela peut avoir de commun avec la *philosophie* et le *règne de la raison?*—C'est précisément ce que je vous dis: c'est au nom de la philosophie, de l'humanité, de la liberté, c'est sous le règne de la raison qu'il vous arrivera de finir ainsi, et ce sera bien le *règne de la raison;* car alors elle aura des *temples,* et même il n'y aura plus dans toute la France, en ce temps-là, que des *temples de la raison.*"—"Par ma foi (dit Chamfort avec le rire du sarcasme), vous ne serez pas un des prêtres de ces temples-là.—Je l'espère; mais vous, M. de Chamfort, qui en serez un et très-digne de l'être, vous vous couperez les veines de vingt-deux coups de rasoir, et pourtant vous n'en mourrez que quelques mois après." On se regarde et on rit encore. "Vous, M. Vicq-d'Azyr, vous ne vous ouvrirez pas les veines vous-même, mais après vous les ferez ouvrir six fois dans un jour au milieu d'un accès de goutte, pour être plus sûr de votre fait, et vous mourrez dans la nuit. Vous, M. de Nicolaï, vous mourrez sur l'échafaud; vous, M. Bailly, sur l'échafaud; vous, M. de Malesherbes, sur l'échafaud . . .—Ah! Dieu soit béni (dit Roucher) il paraît que monsieur n'en veut qu'à l'académie; il vient d'en faire une terrible exécution; et moi, grâces au ciel. . . .— Vous! vous mourrez aussi sur l'échafaud."—Oh! c'est une gageure (s'écrie-t-on de toute part), il a juré de tout exterminer.—"Non, ce n'est pas moi qui l'ai juré.—Mais nous serons donc subjugués par les Turcs et les Tartares? Encore. . .—Point du tout; je vous l'ai dit: vous serez alors gouvernés par la seule *philosophie,* par la seule *raison.* Ceux qui vous traiteront ainsi seront tous des *philosophes,* auront à tout moment dans la bouche toutes les mêmes phrases que vous débitez depuis une heure, répéteront toutes vos maximes, citeront tout comme vous les vers de Diderot et de la Pucelle . . ."—On se disait à l'oreille, vous voyez bien qu'il est fou; car il gardait toujours le plus grand sérieux.—"Est-ce que

vous ne voyez pas qu'il plaisante; et vous savez qu'il entre toujours du merveilleux dans ses plaisanteries.—Oui (répondit Chamfort), mais son merveilleux n'est pas gai; il est trop patibulaire; et quand tout cela arrivera-t-il?—Six ans ne se passeront pas que tout ce que je vous dis ne soit accompli."

—Voilà bien des miracles; (et cette fois c'était moi-même qui parlais), et vous ne m'y mettez pour rien.—Vous y serez pour un miracle tout au moins aussi extraordinaire: vous serez alors chrétien.

Grandes exclamations.—Ah! (reprit Chamfort) je suis rassuré; si nous ne devons périr que quand la Harpe sera chrétien, nous sommes immortels.

—Pour çà (dit alors M.^me la duchesse de Grammont), nous sommes bien heureuses, nous autres femmes, de n'être pour rien dans les *révolutions*. Quand je dis pour rien, ce n'est pas que nous ne nous en mêlions toujours un peu; mais il est reçu qu'on ne s'en prend pas à nous, et notre sexe . . .—Votre sexe, mesdames, ne vous en défendra pas cette fois; et vous aurez beau ne vous mêler de rien, vous serez traitées tout comme les hommes, sans aucune différence quelconque.—Mais qu'est-ce que vous dites donc là, M. Cazotte? c'est la fin du monde que vous nous prêchez.—Je n'en sais rien; mais, ce que je sais, c'est que vous, madame la duchesse, vous serez conduite à l'échafaud, vous et beaucoup d'autres dames avec vous, dans la charrette du bourreau, et les mains liées derrière le dos.—Ah! j'espère que dans ce cas-là j'aurai du moins un carrosse drapé de noir.—Non, madame; de plus grandes dames que vous iront comme vous en charrette, et les mains liées comme vous.—De plus grandes dames! quoi! les Princesses du sang?—De plus grandes dames encore . . . Ici un mouvement très-sensible dans toute la compagnie, et la figure du maître se rembrunit: on commençait à trouver que la plaisanterie était forte. M.^me de Grammont, pour dissiper le nuage, n'insista pas sur cette dernière réponse, et se contenta de dire du ton le plus léger: *vous verrez qu'il ne me laissera seulement pas un confesseur.*—Non, madame, vous n'en aurez pas, ni vous, ni personne. Le dernier supplicié qui en aura un par grace, sera. . . .

Il s'arrêta un moment.—Eh! bien! quel est donc l'heureux mortel qui aura cette prérogative?—C'est la seule qui lui restera; et ce sera le roi de France.

Le maître de la maison se leva brusquement, et tout le monde avec lui. Il alla vers M. Cazotte, et lui dit avec un ton pénétré: mon cher M. Cazotte, c'est assez faire durer cette facétie lugubre. Vous la poussez trop loin, et jusqu'à compromettre la société où vous êtes et vous-même. Cazotte ne répondit rien, et se disposait à se retirer, quand M.^me de Grammont, qui voulait toujours éviter le sérieux et ramener la gaîté, s'avança vers lui: "Monsieur le prophète, qui nous dites à tous notre bonne aventure, vous ne nous dites rien de la vôtre." Il fut quelque

temps en silence et les yeux baissés.—"Madame, avez-vous lu le siège de Jérusalem, dans Josèphe?—Oh! sans doute. Qu'est-ce qui n'a pas lu çà? Mais faites comme si je ne l'avais pas lu.—Eh! bien, madame, pendant ce siège, un homme fit sept jours de suite le tour des remparts, à la vue des assiégeans et des assiégés, criant incessamment d'une voix sinistre et tonnante: *malheur à Jérusalem;* et le septième jour, il cria: *malheur à Jérusalem, malheur à moi-même!* et dans le moment une pierre énorme lancée par les machines ennemies, l'atteignit et le mit en pièces."

Et après cette réponse, M. Cazotte fit sa révérence, et sortit.

According to La Harpe—testimony, it should be remembered, given many years after the event—a brilliant company were collected, some time in the year 1788, at the house of some unnamed academician, who was also a man of high rank. Among them were assembled Chamfort, La Harpe himself, Condorcet, Bailly, Cazotte, the learned Vicq d'Azyr, Roucher, chief poet of the deplorable descriptive school which Saint-Lambert and Delille had introduced, and many others, with a plentiful admixture of merely fashionable company, and numerous ladies, with Madame de Grammont at their head. The company, if we may trust La Harpe, who had, it must be remembered, become at the time of writing violently orthodox (so that Marie Joseph Chénier contrasted his *feu céleste* with Naigeon's *feu d'enfer*), had been indulging in free feasting and free drinking of the kind recorded in fable of the Holbachians. Chamfort had read "impious and libertine tales," for which the reader of his works will not search in vain. A guest had informed the audience that he did not believe in the existence of God, and that he did believe that Homer was a fool. Another had cited with gusto the remark of his barber, "I am not a gentleman, sir; but I assure you I am not a bit more religious than if I were." Encouraged by these cheering instances, the company begin to forecast the good time coming. Suddenly Cazotte, who was known as an oddity and an *illuminé*, as well as from his admirable tale, the *Diable Amoureux*, breaks in. The good time *will* come, and he can tell them what its fruits will be. Condorcet will die self-poisoned on a prison floor; Chamfort will give himself a score of gashes in the vain hope of escaping from the Golden Age. As each guest, treating the matter at first as a joke, ironically asks for his own fate, the revelations grow more precise. Vicq d'Azyr, Bailly, Roucher have their evil fortunes told. At last the crowning moment of incredulity is reached when the prophet announces the fate of La Harpe. "La Harpe sera chrétien." The company are almost consoled when they think that their own misfortunes depend necessarily upon such an impossible contingency as this. But there is still an unpleasant impression from the gravity and the mystical reputation of the speaker. To dissipate it Madame de

Grammont makes some light remark about the hardship which, by the conventions of society, prevents women from reaping the fruits of the Revolution. Cazotte replies to her promptly. There is no exemption for women in the Golden Age. She herself, her friends, and even her betters will share the fate of Bailly and Roucher. "At least," she cries, "you will give me the consolation of a confessor?" "No," is the answer. "The last victim who will be so attended will die before you, and he will be the King of France." This is too much even for such an assembly, and the host interferes. But the valiant duchess is irrepressible. She asks Cazotte whether he alone is exempted from all these evils, and receives for answer only a gloomy quotation from Josephus, relating to the fate of the madman who at the siege of Jerusalem ended his forebodings by crying, "Woe to myself!" Then Cazotte makes his bow and leaves the room. Before six years had passed every word of his prophecy was fulfilled. Vicq d'Azyr had succeeded, and Chamfort had failed, in their attempts to copy the high Roman fashion. Roucher and Bailly and Madame de Grammont and the rest had looked through the dismal window, and Cazotte himself had been the hero of perhaps the most famous and most pitiful of the revolutionary legends. As for the Christianity of La Harpe, that perhaps is a question of definition.

George Saintsbury

With his PROPHÉTIE DE CAZOTTE *in his hand, he may present himself even to a stubborn generation to whom his* COURS DE LITTÉRATURE *is no longer a living law: they will be satisfied with this single memorable page, and after reading it will salute him.*

C.-A. SAINTE-BEUVE
Causeries du lundi (1851)

JOHANN WOLFGANG VON GOETHE

1 7 4 9 — 1 8 3 2

DAS GÖTTLICHE

Edel sei der Mensch,
Hilfreich und gut!
Denn das allein
Unterscheidet ihn
Von allen Wesen,
Die wir kennen.

Heil den unbekannten
Höhern Wesen,
Die wir ahnen!
Ihnen gleiche der Mensch;
Sein Beispiel lehr' uns
Jene glauben.

Denn unfühlend
Ist die Natur:
Es leuchtet die Sonne
Über Bös' und Gute,
Und dem Verbrecher
Glänzen, wie dem Besten,
Der Mond und die Sterne.

Wind und Ströme,
Donner und Hagel
Rauschen ihren Weg
Und ergreifen,
Vorüber eilend,
Einen um den andern.

Auch so das Glück
Tappt unter die Menge,
Fasst bald des Knaben
Lockige Unschuld,
Bald auch den kahlen
Schuldigen Scheitel.

Nach ewigen, ehrnen,
Grossen Gesetzen
Müssen wir alle
Unseres Daseins
Kreise vollenden.

Nur allein der Mensch
Vermag das Unmögliche:
Er unterscheidet,
Wählet und richtet;
Er kann dem Augenblick
Dauer verleihen.

Er allein darf
Den Guten lohnen,
Den Bösen strafen,
Heilen und retten,
Alles Irrende, Schweifende
Nützlich verbinden.

Und wir verehren
Die Unsterblichen,
Als wären sie Menschen,
Täten im grossen,
Was der Beste im kleinen
Tut oder möchte.

Der edle Mensch
Sei hilfreich und gut!
Unermüdet schaff' er
Das Nützliche, Rechte,
Sei uns ein Vorbild
Jener geahneten Wesen!

THE GODLIKE

Noble be man,
Helpful and good!
For that alone
Distinguisheth him
From all the beings
Unto us known.

Hail to the beings,
Unknown and glorious,
Whom we forebode!
From *his* example
Learn we to know them!

For unfeeling
Nature is ever:
On bad and on good
The sun alike shineth;
And on the wicked,
As on the best,
The moon and stars gleam.

Tempest and torrent,
Thunder and hail,
Roar on their path,
Seizing the while,
As they haste onward,
One after another.

Even so, fortune
Gropes 'mid the throng—
Innocent boyhood's
Curly head seizing,—
Seizing the hoary
Head of the sinner.

After laws mighty,
Brazen, eternal,
Must all we mortals
Finish the circuit
Of our existence.

Man, and man only
Can do the impossible;
He 'tis distinguisheth,
Chooseth and judgeth;
He to the moment
Endurance can lend.

He and he only
The good can reward,
The bad can he punish,
Can heal and can save;
All that wanders and strays
Can usefully blend.

And we pay homage
To the immortals
As though they were men,
And did in the great,
What the best, in the small,
Does or might do.

Be the man that is noble,
Both helpful and good,
Unweariedly forming
The right and the useful,
A type of those beings
Our mind hath foreshadow'd!

(1782)

Translated by Edgar A. Bowring

One of the noblest of all poems.

ALFRED LORD TENNYSON
Alfred Lord Tennyson: A Memoir by Hallam Tennyson (1897)

THE BATTLE OF VALMY

Von hier und heute geht eine neue Epoche der Weltgeschichte aus, und ihr könnt sagen, ihr seid dabei gewesen.

Here and now begins a new epoch of world history, and you, gentlemen, can say that you "were there".

(1792)

No general, no diplomat, let alone the philosophers, ever so directly felt history "becoming". It is the deepest judgment that any man ever uttered about a great historical act in the moment of its accomplishment.

OSWALD SPENGLER
Der Untergang des Abendlandes (1918)
Translated by Charles Francis Atkinson

JOHANN WOLFGANG VON GOETHE

1 7 4 9 — 1 8 3 2

FAUST AND MARGARET

FAUST
Süss Liebchen!

MARGARETE
Lasst einmal!
(*Sie pflückt eine Sternblume und zupft die Blätter ab, eins nach dem andern.*)

FAUST
Was soll das? Einen Strauss?

MARGARETE
Nein, es soll nur ein Spiel.

FAUST
Wie?

MARGARETE
Geht! Ihr lacht mich aus.
(*Sie rupft und murmelt.*)

961

FAUST

Was murmelst du?

MARGARETE (*halblaut*)

Er liebt mich—Liebt mich nicht.

FAUST

Du holdes Himmelsangesicht!

MARGARETE (*fährt fort*)

Liebt mich—Nicht—Liebt mich—Nicht—

(*Das letzte Blatt ausrupfend, mit holder Freude*)

Er liebt mich!

FAUST

Sweet darling!

MARGARET

Wait a moment!

(*She picks a star-flower and plucks the petals one by one*).

FAUST

What is that? A bouquet?

MARGARET

No, it is only a game.

FAUST

What?

MARGARET

Go away! You will laugh at me!

(*She plucks the petals and murmurs.*)

FAUST

What are you murmuring?

MARGARET (*Under her breath*) He loves me—loves me not—

FAUST

Lovely, heavenly vision!

MARGARET (*Continues*)

Loves me—not—loves me—not

(*Plucks the last petal with joy*)

He loves me!

Faust (1808)

The height of lyric eloquence. . . . It was quite out of the question to portray anything more simple or familiar than the young girl who plucks the petals from the daisy and says: He loves me; He loves me not! But no one had availed himself of that theme previous to the days of Goethe. It was the egg of Columbus; and its effect was incalculable. By this addition the field of art was extended.

GEORG BRANDES
Wolfgang Goethe (1924)

JOHANN WOLFGANG VON GOETHE

1 7 4 9 — 1 8 3 2

PRAYER

(In der Mauerhöhle ein Andachtsbild der Mater dolorosa, Blumenkrüge davor.)

GRETCHEN *(steckt frische Blumen in die Krüge)*
Ach neige,
Du Schmerzenreiche,
Dein Antlitz gnädig meiner Not!

Das Schwert im Herzen,
Mit tausend Schmerzen
Blickst auf zu deines Sohnes Tod.

Zum Vater blickst du,
Und Seufzer schickst du
Hinauf um sein' und deine Not.

Wer fühlet,
Wie wühlet
Der Schmerz mir im Gebein?
Was mein armes Herz hier banget,
Was es zittert, was verlanget,
Weisst nur du, nur du allein!

Wohin ich immer gehe,
Wie weh, wie weh, wie wehe
Wird mir im Busen hier!
Ich bin, ach! kaum alleine,
Ich wein', ich wein', ich weine,
Das Herz zerbricht in mir.

(In a niche of the wall a shrine, with an image of the Mater Dolorosa. Pots of flowers before it.)

MARGARET *(putting fresh flowers in the pots).*
Incline, O Maiden,
Thou sorrow-laden,
Thy gracious countenance upon my pain!

The sword Thy heart in,
With anguish smarting,
Thou lookest up to where Thy Son is slain!

Thou seest the Father;
Thy sad sighs gather,
And bear aloft Thy sorrow and His pain!

Ah, past guessing,
Beyond expressing,
The pangs that wring my flesh and bone!
Why this anxious heart so burneth,
Why it trembleth, why it yearneth,
Knowest Thou, and Thou alone!

Where'er I go, what sorrow,
What woe, what woe and sorrow
Within my bosom aches!
Alone, and ah! unsleeping,
I'm weeping, weeping, weeping,
The heart within me breaks.

Faust (1808)
Translated by Bayard Taylor

*Goethe reached the highest height of poetry in Gretchen's appeal to
the Madonna.*

FRANK HARRIS
My Life and Loves (1922–27)

JOHANN WOLFGANG VON GOETHE

1 7 4 9 — 1 8 3 2

WANDRERS NACHTLIED

Über allen Gipfeln
Ist Ruh,
In allen Wipfeln
Spürest du
Kaum einen Hauch;
Die Vögelein schweigen im Walde.
Warte nur, balde
Ruhest du auch.

964

WANDERER'S NIGHT SONG

O'er all the hill-tops
Is quiet now,
In all the tree-tops
Hearest thou
Hardly a breath;
The birds are asleep in the trees:
Wait; soon like these
Thou too shalt rest.

Translated by Henry Wadsworth Longfellow

Most flawless of all lyrics.

JOHN LIVINGSTON LOWES
Convention and Revolt in Poetry (1919)

JOHANN WOLFGANG VON GOETHE

1 7 4 9 — 1 8 3 2

MIGNON

Kennst du das Land, wo die Zitronen blühn,
Im dunkeln Laub die Gold-Orangen glühn,
Ein sanfter Wind vom blauen Himmel weht,
Die Myrte still und hoch der Lorbeer steht?
Kennst du es wohl?—Dahin! Dahin
Möcht' ich mit dir, o mein Geliebter, ziehn.

Kennst du das Haus? Auf Säulen ruht sein Dach,
Es glänzt der Saal, es schimmert das Gemach,
Und Marmorbilder stehn und sehn mich an:
Was hat man dir, du armes Kind, getan?
Kennst du es wohl?—Dahin! Dahin
Möcht' ich mit dir, o mein Beschützer, ziehn.

Kennst du den Berg und seinen Wolkensteg?
Das Maultier sucht im Nebel seinen Weg;
In Höhlen wohnt der Drachen alte Brut;
Es stürzt der Fels und über ihn die Flut.
Kennst du ihn wohl?—Dahin! Dahin
Geht unser Weg! o Vater, lass uns ziehn!

Know'st thou the land where the fair citron blows,
Where the bright orange midst the foliage glows,
Where soft winds greet us from the azure skies,
Where silent myrtles, stately laurels rise,
Know'st thou it well?
 'Tis there, 'tis there,
That I with thee, beloved one, would repair!

Know'st thou the house? On columns rests its pile,
Its halls are gleaming, and its chambers smile,
And marble statues stand and gaze on me:
"Poor child! what sorrow hath befallen thee?"
Know'st thou it well?
 'Tis there, 'tis there,
That I with thee, protector, would repair!

Know'st thou the mountain, and its cloudy bridge?
The mule can scarcely find the misty ridge;
In caverns dwells the dragon's olden brood,
The frowning crag obstructs the raging flood.
Know'st thou it well?
 'Tis there, 'tis there,
Our path lies—Father—thither, oh repair!

Translated by Edgar A. Bowring

Goethe's 'Kennst du das Land' is a perfect poem.
 ALFRED LORD TENNYSON
Alfred Lord Tennyon: A Memoir by Hallam Tennyson (1897)

JOHANN WOLFGANG VON GOETHE

1 7 4 9 — 1 8 3 2

HAMLET

You all know Shakespeare's incomparable 'Hamlet:' our public read-
ing of it at the castle yielded every one of us the greatest satisfaction.
On that occasion we proposed to act the play; and I, not knowing what
I undertook, engaged to play the prince's part. This I conceived that I
was studying, while I began to get by heart the strongest passages, the
soliloquies, and those scenes in which force of soul, vehemence and ele-
vation of feeling, have the freest scope; where the agitated heart is
allowed to display itself with touching expressiveness.

966

I further conceived that I was penetrating quite into the spirit of the character, while I endeavored, as it were, to take upon myself the load of deep melancholy under which my prototype was laboring, and in this humor to pursue him through the strange labyrinths of his caprices and his singularities. Thus learning, thus practising, I doubted not but I should by and by become one person with my hero.

But, the farther I advanced, the more difficult did it become for me to form any image of the whole, in its general bearings; till at last it seemed as if impossible. I next went through the entire piece, without interruption; but here, too, I found much that I could not away with. At one time the characters, at another time the manner of displaying them, seemed inconsistent; and I almost despaired of finding any general tint, in which I might present my whole part with all its shadings and variations. In such devious paths I toiled, and wandered long in vain; till at length a hope arose that I might reach my aim in quite a new way.

I set about investigating every trace of Hamlet's character, as it had shown itself before his father's death: I endeavored to distinguish what in it was independent of this mournful event, independent of the terrible events that followed; and what most probably the young man would have been, had no such thing occurred.

Soft, and from a noble stem, this royal flower had sprung up under the immediate influences of majesty: the idea of moral rectitude with that of princely elevation, the feeling of the good and dignified with the consciousness of high birth, had in him been unfolded simultaneously. He was a prince, by birth a prince; and he wished to reign, only that good men might be good without obstruction. Pleasing in form, polished by nature, courteous from the heart, he was meant to be the pattern of youth and the joy of the world.

Without any prominent passion, his love for Ophelia was a still presentiment of sweet wants. His zeal in knightly accomplishments was not entirely his own: it needed to be quickened and inflamed by praise bestowed on others for excelling in them. Pure in sentiment, he knew the honorable-minded, and could prize the rest which an upright spirit tastes on the bosom of a friend. To a certain degree, he had learned to discern and value the good and the beautiful in arts and sciences; the mean, the vulgar, was offensive to him; and, if hatred could take root in his tender soul, it was only so far as to make him properly despise the false and changeful insects of a court, and play with them in easy scorn. He was calm in his temper, artless in his conduct, neither pleased with idleness, nor too violently eager for employment. The routine of a university he seemed to continue when at court. He possessed more mirth of humor than of heart: he was a good companion, pliant, courteous, discreet, and able to forget and forgive an injury, yet never able

967

to unite himself with those who overstepped the limits of the right, the good, and the becoming.

When we read the piece again, you shall judge whether I am yet on the proper track.

<div align="right">

Wilhelm Meisters Lehrjahre (1796)
Translated by Thomas Carlyle

</div>

We come suddenly upon what we do not hesitate to pronounce the most able, eloquent, and profound exposition of the character of Hamlet, as conceived by our great dramatist, that has ever been given to the world. . . . There is nothing so good as this in any of our own commentators— nothing at once so poetical, so feeling, and so just.

<div align="right">

FRANCIS LORD JEFFREY
Literary Criticism (1825)

</div>

THOMAS CHATTERTON

1 7 5 2 — 1 7 7 0

SONG FROM ÆLLA

O sing unto my roundelay,
O drop the briny tear with me;
Dance no more at holyday,
Like a running river be:
 My love is dead,
 Gone to his death-bed
All under the willow-tree.

Black his cryne as the winter night,
White his rode as the summer snow,
Red his face as the morning light,
Cold he lies in the grave below:
 My love is dead,
 Gone to his death-bed
All under the willow-tree.

Sweet his tongue as the throstle's note,
Quick in dance as thought can be,
Deft his tabor, cudgel stout;
O he lies by the willow-tree!
 My love is dead,
 Gone to his death-bed
All under the willow-tree.

Hark! the raven flaps his wing
In the brier'd dell below;
Hark! the death-owl loud doth sing
To the nightmares, as they go:
 My love is dead,
 Gone to his death-bed
All under the willow-tree.

See! the white moon shines on high;
Whiter is my true-love's shroud:
Whiter than the morning sky,
Whiter than the evening cloud:
 My love is dead,
 Gone to his death-bed
All under the willow-tree.

Here upon my true-love's grave
Shall the barren flowers be laid;
Not one holy saint to save
All the coldness of a maid:
 My love is dead,
 Gone to his death-bed
All under the willow-tree.

With my hands I'll dent the briers
Round his holy corse to gre:
Ouph and fairy, light your fires,
Here my body still shall be:
 My love is dead,
 Gone to his death-bed
All under the willow-tree.

Come, with acorn-cup and thorn,
Drain my heartès blood away;
Life and all its good I scorn,
Dance by night, or feast by day:
 My love is dead,
 Gone to his death-bed
All under the willow-tree.

 (1769)

Few more exquisite specimens of this kind can be found in our language than the Minstrel's song in Ælla.

HENRY CARY
Lives of English Poets (1845)

JOSEPH JOUBERT

1 7 5 4 — 1 8 2 4

THE LAW OF POETRY

Rien de ce qui ne transporte pas n'est poésie. La lyre est, en quelque manière, un instrument ailé.

Nothing that does not transport us is poetry. The lyre is, in some respects, a winged instrument.

<div align="right">Pensées (1842)</div>

The famous, the immortal, ninth "Pensée" of the Poetry section . . . is positively startling. It is, of course, only Longinus, dashed a little with Plato, and transferred from the abstract Sublime to the sublimest part of literature, Poetry. But generations had read and quoted Longinus without making the transfer; and when made it is EN QUELQUE MANIÈRE *(to use the author's judicious limitation, which some people dislike so much), final. Like other winged things, and more than any of them, poetry is itself hard to catch; it is difficult to avoid crushing and maiming it when you think to catch it. But this is as nearly perfect a definition by resultant, by form, as can be got at.*

<div align="right">

GEORGE SAINTSBURY
A History of Criticism (1904)

</div>

WILLIAM BLAKE

1 7 5 7 — 1 8 2 7

SONG

Thou the golden fruit dost bear,
I am clad in flowers fair;
Thy sweet boughs perfume the air,
And the turtle buildeth there.

There she sits and feeds her young,
Sweet I hear her mournful song;
And thy lovely leaves among,
There is love: I hear his tongue.

<div align="right">Poetical Sketches (1783)</div>

As perfect as well can be.

<div align="right">

ALGERNON CHARLES SWINBURNE
William Blake (1866)

</div>

WILLIAM BLAKE

1 7 5 7 — 1 8 2 7

SILENT, SILENT NIGHT

Silent, Silent Night
Quench the holy light
Of thy torches bright.

For possess'd of Day
Thousand spirits stray
That sweet joys betray

Why should joys be sweet
Used with deceit
Nor with sorrows meet?

But an honest joy
Does itself destroy
For a harlot coy.

Poems from the Rossetti Ms. (c. 1793)

Verse more nearly faultless and of a more difficult perfection was never accomplished.

ALGERNON CHARLES SWINBURNE
William Blake (1866)

WILLIAM BLAKE

1 7 5 7 — 1 8 2 7

SUN-FLOWER

Ah, Sun-flower! weary of time.

Songs of Experience (1794)

The most moving and most complete single line in English poetry.

CECIL DAY LEWIS
A Hope for Poetry (1934)

WILLIAM BLAKE

1 7 5 7 — 1 8 2 7

THE ANCIENT TREES

Hear the voice of the Bard!
Who Present, Past, & Future, sees;
Whose ears have heard
The Holy Word
That walk'd among the ancient trees,

Calling the lapsed Soul,
And weeping in the evening dew;
That might controll
The starry pole,
And fallen, fallen light renew!

"O Earth, O Earth, return!
"Arise from out the dewy grass;
"Night is worn,
"And the morn
"Rises from the slumberous mass.

"Turn away no more;
"Why wilt thou turn away?
"The starry floor,
"The wat'ry shore,
"Is giv'n thee till the break of day."

 Songs of Experience (1794)

SONG

Memory, hither come,
 And tune your merry notes;
And, while upon the wind
 Your music floats,
I'll pore upon the stream,
Where sighing lovers dream,
And fish for fancies as they pass
Within the watery glass.

I'll drink of the clear stream,
 And hear the linnet's song;
And there I'll lie and dream
 The day along:

And, when night comes, I'll go
　To places fit for woe,
Walking along the darken'd valley
　With silent Melancholy.

Poetical Sketches (1783)

SEVEN OF MY SWEET LOVES

My Spectre around me night & day
Like a Wild beast guards my way.
My Emanation far within
Weeps incessantly for my Sin.

A Fathomless & boundless deep,
There we wander, there we weep;
On the hungry craving wind
My Spectre follows thee behind.

He scents thy footsteps in the snow,
Wheresoever thou dost go
Thro' the wintry hail & rain.
When wilt thou return again?

Dost thou not in Pride & scorn
Fill with tempests all my morn,
And with jealousies & fears
Fill my pleasant nights with tears?

Seven of my sweet loves thy knife
Has bereaved of their life.
Their marble tombs I built with tears
And with cold & shuddering fears.

Seven more loves weep night & day
Round the tombs where my loves lay,
And seven more loves attend each night
Around my couch with torches bright.

And seven more Loves in my bed
Crown with wine my mournful head,
Pitying & forgiving all
Thy transgressions, great & small.

When wilt thou return & view
My loves, & them to life renew?
When wilt thou return & live?
When wilt thou pity as I forgive?

Poems from the Rossetti Ms. (1800–03)

IN WEARY NIGHT

Tho' thou art Worship'd by the Names Divine
Of Jesus & Jehovah, thou art still
The Son of Morn in weary Night's decline,
The lost Traveller's Dream under the Hill.

<div align="right">The Gates of Paradise (1793)</div>

*For me the most poetical of all poets is Blake. I find his lyrical note as
beautiful as Shakespeare's and more beautiful than anyone else's; and
I call him more poetical than Shakespeare, even though Shakespeare
has so much more poetry, because poetry in him preponderates more
than in Shakespeare over everything else, and instead of being con-
founded in a great river can be drunk pure from a slender channel of
its own. Shakespeare is rich in thought, and his meaning has power of
itself to move us, even if the poetry were not there: Blake's meaning is
often unimportant or virtually non-existent, so that we can listen with
all our hearing to his celestial tune.*

<div align="right">A. E. HOUSMAN
The Name and Nature of Poetry (1933)</div>

ROBERT BURNS

1 7 5 9 — 1 7 9 6

HOLY WILLIE'S PRAYER

O Thou, wha in the Heavens dost dwell,
Wha, as it pleases best thysel',
Sends ane to heaven and ten to hell,
 A' for thy glory,
And no for ony guid or ill
 They've done afore thee!

I bless and praise thy matchless might,
Whan thousands thou hast left in night,
That I am here afore thy sight,
 For gifts an' grace
A burnin' an' a shinin' light,
 To a' this place.

What was I, or my generation,
That I should get sic exaltation?
I, wha deserve most just damnation,
 For broken laws,
Sax thousand years 'fore my creation,
 Thro' Adam's cause.

When frae my mither's womb I fell,
Thou might hae plungèd me in hell,
To gnash my gums, to weep and wail,
 In burnin' lakes,
Where damnèd devils roar and yell,
 Chain'd to their stakes;

Yet I am here a chosen sample,
To show thy grace is great and ample;
I'm here a pillar in thy temple,
 Strong as a rock,
A guide, a buckler, an example
 To a' thy flock.

O Lord, thou kens what zeal I bear,
When drinkers drink, and swearers swear,
And singin' there and dancin' here,
 Wi' great an' sma':
For I am keepit by thy fear
 Free frae them a'.

But yet, O Lord! confess I must
At times I'm fash'd wi' fleshy lust;
An' sometimes too, in warldly trust,
 Vile self gets in;
But thou remembers we are dust,
 Defil'd in sin.

O Lord! yestreen, thou kens, wi' Meg—
Thy pardon I sincerely beg;
O! may't ne'er be a livin' plague
 To my dishonour,
An' I'll ne'er lift a lawless leg
 Again upon her.

Besides I farther maun allow,
Wi' Lizzie's lass, three times I trow—
But, Lord, that Friday I was fou,
 When I cam near her,
Or else thou kens thy servant true
 Wad never steer her.

975

May be thou lets this fleshly thorn
Beset thy servant e'en and morn
Lest he owre high and proud should turn,
 That he's sae gifted;
If sae, thy hand maun e'en be borne,
 Until thou lift it.

Lord, bless thy chosen in this place,
For here thou hast a chosen race;
But God confound their stubborn face,
 And blast their name,
Wha bring thy elders to disgrace
 An' public shame.

Lord, mind Gawn Hamilton's deserts,
He drinks, an' swears, an' plays at cartes,
Yet has sae mony takin' arts
 Wi' grit an' sma',
Frae God's ain priest the people's hearts
 He steals awa'.

An' when we chasten'd him therefor,
Thou kens how he bred sic a splore
As set the warld in a roar
 O' laughin' at us;
Curse thou his basket and his store,
 Kail and potatoes.

Lord, hear my earnest cry an' pray'r,
Against that presbyt'ry o' Ayr;
Thy strong right hand, Lord, make it bare
 Upo' their heads;
Lord, weigh it down, and dinna spare,
 For their misdeeds.

O Lord my God, that glib-tongu'd Aiken,
My very heart and soul are quakin',
To think how we stood sweatin', shakin',
 An' piss'd wi' dread,
While he, wi' hingin' lips and snakin',
 Held up his head.

Lord, in the day of vengeance try him;
Lord, visit them wha did employ him,
And pass not in thy mercy by them,
 Nor hear their pray'r:
But, for thy people's sake, destroy them,
 And dinna spare.

But, Lord, remember me and mine
Wi' mercies temp'ral and divine,
That I for gear and grace may shine
 Excell'd by nane,
And a' the glory shall be thine,
 Amen, Amen!

<div align="right">(1785)</div>

The most perfect bit of satire in English poetry.
<div align="right">HERBERT J. C. GRIERSON and J. C. SMITH
A Critical History of English Poetry (1944)</div>

ROBERT BURNS

1 7 5 9 — 1 7 9 6

TO A MOUNTAIN DAISY

On turning one down with the Plough, in April 1786.

Wee, modest, crimson-tippèd flow'r,
Thou's met me in an evil hour;
For I maun crush amang the stour
 Thy slender stem:
To spare thee now is past my pow'r,
 Thou bonie gem.

Alas! it's no thy neibor sweet,
The bonie lark, companion meet,
Bending thee 'mang the dewy weet,
 Wi' spreckl'd breast!
When upward-springing, blythe, to greet
 The purpling east.

Cauld blew the bitter-biting north
Upon thy early, humble birth;
Yet cheerfully thou glinted forth
 Amid the storm,
Scarce rear'd above the parent-earth
 Thy tender form.

The flaunting flow'rs our gardens yield,
High shelt'ring woods and wa's maun shield;
But thou, beneath the random bield
 O' clod or stane,
Adorns the histie stibble field,
 Unseen, alane.

There, in thy scanty mantle clad,
Thy snawie bosom sun-ward spread,
Thou lifts thy unassuming head
 In humble guise;
But now the share uptears thy bed,
 And low thou lies!

Such is the fate of artless maid,
Sweet flow'ret of the rural shade!
By love's simplicity betray'd,
 And guileless trust;
Till she, like thee, all soil'd, is laid
 Low i' the dust.

Such is the fate of simple bard,
On life's rough ocean luckless starr'd!
Unskilful he to note the card
 Of prudent lore,
Till billows rage, and gales blow hard,
 And whelm him o'er!

Such fate to suffering worth is giv'n,
Who long with wants and woes has striv'n,
By human pride or cunning driv'n,
 To mis'ry's brink;
Till wrench'd of ev'ry stay but Heav'n,
 He, ruin'd, sink!

Ev'n thou who mourn'st the Daisy's fate,
That fate is thine—no distant date;
Stern Ruin's plough-share drives elate,
 Full on thy bloom,
Till crush'd beneath the furrow's weight,
 Shall be thy doom!

There is nothing in all poetry which touches it.
 THEODORE WATTS-DUNTON
 Poetry and the Renascence of Wonder (1914)

ROBERT BURNS

1 7 5 9 — 1 7 9 6

TIME IS SETTING

The wan Moon is setting behind the white wave,
And Time is setting with me, oh.

Open the Door to Me, Oh (1793)

*There are no lines with more melancholy beauty than these by Burns
. . . . and these lines are perfectly symbolical. Take from them the white-
ness of the moon and of the wave, whose relation to the setting of Time
is too subtle for the intellect, and you take from them their beauty.
But, when all are together, moon and wave and whiteness and setting
Time and the last melancholy cry, they evoke an emotion which can-
not be evoked by any other arrangement of colours and sounds and
forms. We may call this metaphorical writing, but it is better to call it
symbolical writing, because metaphors are not profound enough to be
moving, when they are not symbols, and when they are symbols they
are the most perfect of all, because the most subtle, outside of pure
sound, and through them one can the best find out what symbols are.
If one begins the reverie with any beautiful lines that one can remem-
ber, one finds they are like those by Burns.*

W. B. YEATS
Ideas of Good and Evil (1900)

ROBERT BURNS

1 7 5 9 — 1 7 9 6

THE FAREWELL

It was a' for our rightfu' King
We left fair Scotland's strand;
It was a' for our rightfu' King
We e'er saw Irish land,
My dear—
We e'er saw Irish land.

Now a' is done that men can do,
And a' is done in vain;
My love and native land fareweel,
For I maun cross the main,
 My dear—
For I maun cross the main.

He turn'd him right and round about
Upon the Irish shore,
And gae his bridle-reins a shake,
With adieu for evermore,
 My dear—
With adieu for evermore!

The sodger frae the wars returns,
The sailor frae the main;
But I hae parted frae my love
Never to meet again,
 My dear—
Never to meet again.

When day is gane, and night is come,
And a' folk bound to sleep,
I think on him that's far awa
The lee-lang night, and weep,
 My dear—
The lee-lang night, and weep.

 (1794)

The noblest of Burns's, perhaps of all, Jacobite ditties, 'It was a' for our rightfu' king,' one of the great achievements of romantic patriot song in any form of English.

 OLIVER ELTON
 A Survey of English Literature (1920)

FRIEDRICH VON SCHILLER

1 7 5 9 — 1 8 0 5

AN DIE FREUDE

Freude, schöner Götterfunken,
Tochter aus Elysium,
Wir betreten feuertrunken,
Himmlische, dein Heiligtum.

Deine Zauber binden wieder,
Was die Mode streng geteilt,
Alle Menschen werden Brüder,
Wo dein sanfter Flügel weilt.
　　Seid umschlungen, Millionen!
　　Diesen Kuss der ganzen Welt!
　　Brüder—überm Sternenzelt
　　Muss ein lieber Vater wohnen.

Wem der grosse Wurf gelungen,
Eines Freundes Freund zu sein,
Wer ein holdes Weib errungen,
Mische seinen Jubel ein!
Ja—wer auch nur *eine* Seele
Sein nennt auf dem Erdenrund!
Und wer's nie gekonnt, der stehle
Weinend sich aus diesem Bund.
　　Was den grossen Ring bewohnet,
　　Huldige der Sympathie!
　　Zu den Sternen leitet sie,
　　Wo der Unbekannte thronet.

Freude trinken alle Wesen
An den Brüsten der Natur,
Alle Guten, alle Bösen
Folgen ihrer Rosenspur.
Küsse gab sie uns und Reben,
Einen Freund, geprüft im Tod,
Wollust ward dem Wurm gegeben,
Und der Cherub steht vor Gott.
　　Ihr stürzt nieder, Millionen?
　　Ahnest du den Schöpfer, Welt?
　　Such ihn überm Sternenzelt!
　　Über Sternen muss er wohnen.

Freude heisst die starke Feder
In der ewigen Natur.
Freude, Freude treibt die Räder
In der grossen Weltenuhr.
Blumen lockt sie aus den Keimen,
Sonnen aus dem Firmament,
Sphären rollt sie in den Räumen,
Die des Sehers Rohr nicht kennt.
　　Froh, wie seine Sonnen fliegen
　　Durch des Himmels prächt'gen Plan,
　　Wandelt, Brüder, eure Bahn,
　　Freudig wie ein Held zum Siegen.

Aus der Wahrheit Feuerspiegel
Lächelt sie den Forscher an.
Zu der Tugend steilem Hügel
Leitet sie des Dulders Bahn.
Auf des Glaubens Sonnenberge
Sieht man ihre Fahnen wehn,
Durch den Riss gesprengter Särge
Sie im Chor der Engel stehn.
 Duldet mutig, Millionen!
 Duldet für die bessre Welt!
 Droben überm Sternenzelt
 Wird ein grosser Gott belohnen.

ODE TO JOY

Joy, of flame celestial fashioned,
 Daughter of Elysium,
By that holy fire impassioned
 To thy sanctuary we come.
Thine the spells that reunited
 Those estranged by Custom dread,
Every man a brother plighted
 Where thy gentle wings are spread.
 Millions in our arms we gather,
 To the world our kiss be sent!
 Past the starry firmament,
 Brothers, dwells a loving Father.

Who that height of bliss has provèd
 Once a friend of friends to be,
Who has won a maid belovèd
 Join us in our jubilee.
Whoso holds a heart in keeping,
 One—in all the world—his own—
Who has failed, let him with weeping
 From our fellowship begone!
 All the mighty globe containeth
 Homage to Compassion pay!
 To the stars she leads the way
 Where, unknown, the Godhead reigneth.

All drink joy from Mother Nature,
 All she suckled at her breast,
Good or evil, every creature,
 Follows where her foot has pressed.

Love she gave us, passing measure,
 One Who true in death abode,
E'en the worm was granted pleasure,
 Angels see the face of God.
 Fall ye millions, fall before Him,
 Is thy Maker, World, unknown?
 Far above the stars His throne
 Yonder seek Him and adore Him.

Joy, the spring of all contriving,
 In eternal Nature's plan,
Joy set wheels on wheels a-driving
 Since earth's horologe began;
From the bud the blossom winning
 Suns from out the sky she drew,
Spheres through boundless ether spinning
 Worlds no gazer's science knew.
 Gladsome as her suns and glorious
 Through the spacious heavens career,
 Brothers, so your courses steer
 Heroes joyful and victorious.

She from Truth's own mirror shining
 Casts on sages glances gay,
Guides the sufferer unrepining
 Far up Virtue's steepest way;
On the hills of Faith all-glorious
 Mark her sunlit banners fly,
She, in death's despite, victorious,
 Stands with angels in the sky.
 Millions, bravely sorrows bearing,
 Suffer for a better time!
 See, above the starry clime
 God a great reward preparing.

 Translated by Norman Macleod

His poetry was the fruit of reflection—not a simple reaction to experience; and the struggle to obtain an inner harmony and a wide outlook on Nature and Man was accompanied by a struggle for expression, for only with pain and effort did Schiller beat his music out. When he was at last master of his instrument, he attained a rush and sweep of rhythm never before felt in German poetry—not even in Goethe. Schiller was a poet of ideas and ideals, and the philosophies of his time find an expression in his verse. In his "Ode to Joy," we have the noblest rendering of

that enthusiasm for Humanity which heralded, if it did not survive, the French Revolution.

NORMAN MACLEOD
German Lyric Poetry (1930)

FRIEDRICH VON SCHILLER

1 7 5 9 — 1 8 0 5

WHERE MORTALS DWELL

Durch die Strassen der Städte,
Vom Jammer gefolget,
Schreitet das Unglück—
Lauernd umschleicht es
Die Häuser der Menschen,
Heute an dieser
Pforte pocht es,
Morgen an jener,
Aber noch keinen hat es verschont.
Die unerwünschte
Schmerzliche Botschaft
Früher oder später
Bestellt es an jeder
Schwelle, wo ein Lebendiger wohnt.

Through the streets of the city,
By misery followed,
Misfortune strides,
And lurking she creeps
Round the houses of men.
To-day upon this
Portal she knocks,
To-morrow on that.
But none spares she wholly.
Sooner or later,
The dreaded, unwelcome
Message of pain,
She prints upon every
Threshold where mortals dwell.

Die Braut von Messina (1803)
Act iv, Scene iv
Translated by Benjamin W. Wells

In stateliness and dignity of diction, the "Bride of Messina" is perhaps unsurpassed in German, and the true classical irony, "that mixture of jest and earnest which for many is more mysterious and darker than all mysteries," as Schlegel has said, the irony of fate, radically different from that "irony" that was then suffering such abuse at the hands of the romanticists, was represented here with greater strength than ever before or since in Germany.

<div align="right">

BENJAMIN W. WELLS
Modern German Literature (1901)

</div>

FRIEDRICH VON SCHILLER

1 7 5 9 — 1 8 0 5

DAS LIED VON DER GLOCKE

Vivos voco. Mortuos plango. Fulgura frango.

Fest gemauert in der Erden
Steht die Form, aus Lehm gebrannt.
Heute muss die Glocke werden!
Frisch, Gesellen, seid zur Hand!
 Von der Stirne heiss
 Rinnen muss der Schweiss,
Soll das Werk den Meister loben;
Doch der Segen kommt von oben.
Zum Werke, das wir ernst bereiten,
Geziemt sich wohl ein ernstes Wort;
Wenn gute Reden sie begleiten,
Dann fliesst die Arbeit munter fort.
So lasst uns jetzt mit Fleiss betrachten,
Was durch die schwache Kraft entspringt;
Den schlechten Mann muss man verachten,
Der nie bedacht, was er vollbringt.
Das ist's ja, was den Menschen zieret,
Und dazu ward ihm der Verstand,
Dass er im innern Herzen spüret,
Was er erschafft mit seiner Hand.

Nehmet Holz vom Fichtenstamme,
Doch recht trocken lasst es sein,
Dass die eingepresste Flamme

Schlage zu dem Schwalch hinein!
Kocht des Kupfers Brei,
Schnell das Zinn herbei,
Dass die zähe Glockenspeise
Fliesse nach der rechten Weise!

Was in des Dammes tiefer Grube
Die Hand mit Feuers Hilfe baut,
Hoch auf des Turmes Glockenstube,
Da wird es von uns zeugen laut.
Noch dauern wird's in späten Tagen
Und rühren vieler Menschen Ohr
Und wird mit dem Betrübten klagen
Und stimmen zu der Andacht Chor.
Was unten tief dem Erdensohne
Das wechselnde Verhängnis bringt,
Das schlägt an die metallne Krone,
Die es erbaulich weiter klingt.

Weisse Blasen seh' ich springen;
Wohl! die Massen sind im Fluss.
Lasst's mit Aschensalz durchdringen,
Das befördert schnell den Guss.
Auch von Schaume rein
Muss die Mischung sein,
Dass vom reinlichen Metalle
Rein und voll die Stimme schalle.

Denn mit der Freude Feierklange
Begrüsst sie das geliebte Kind
Auf seines Lebens erstem Gange,
Den es in Schlafes Arm beginnt.
Ihm ruhen noch im Zeitenschosse
Die schwarzen und die heitern Lose;
Der Mutterliebe zarte Sorgen
Bewachen seinen goldenen Morgen.—
Die Jahre fliehen pfeilgeschwind.
Vom Mädchen reisst sich stolz der Knabe,
Er stürmt ins Leben wild hinaus,
Durchmisst die Welt am Wanderstabe,
Fremd kehrt er heim ins Vaterhaus.
Und herrlich, in der Jugend Prangen,
Wie ein Gebild aus Himmelshöhn,
Mit züchtigen, verschämten Wangen
Sieht er die Jungfrau vor sich stehn.

Da fasst ein namenloses Sehnen
Des Jünglings Herz, er irrt allein,
Aus seinen Augen brechen Tränen,
Er flieht der Brüder wilden Reihn.
Errötend folgt er ihren Spuren
Und ist von ihrem Gruss beglückt,
Das Schönste sucht er auf den Fluren,
Womit er seine Liebe schmückt.
O zarte Sehnsucht, süsses Hoffen,
Der ersten Liebe goldne Zeit!
Das Auge sieht den Himmel offen,
Es schwelgt das Herz in Seligkeit;
O, dass sie ewig grünen bliebe,
Die schöne Zeit der jungen Liebe!

Wie sich schon die Pfeifen bräunen!
Dieses Stäbchen tauch' ich ein,
Sehn wir's überglast erscheinen,
Wird's zum Gusse zeitig sein.
 Jetzt, Gesellen, frisch!
 Prüft mir das Gemisch,
Ob das Spröde mit dem Weichen
Sich vereint zum guten Zeichen.

Denn wo das Strenge mit dem Zarten,
Wo Starkes sich und Mildes paarten,
Da gibt es einen guten Klang.
Drum prüfe, wer sich ewig bindet,
Ob sich das Herz zum Herzen findet!
Der Wahn ist kurz, die Reu' ist lang.—
Lieblich in der Bräute Locken
Spielt der jungfräuliche Kranz,
Wenn die hellen Kirchenglocken
Laden zu des Festes Glanz.
Ach! des Lebens schönste Feier
Endigt auch den Lebensmai,
Mit dem Gürtel, mit dem Schleier
Reisst der schöne Wahn entzwei.
Die Leidenschaft flieht,
Die Liebe muss bleiben;
Die Blume verblüht,
Die Frucht muss treiben.
Der Mann muss hinaus
Ins feindliche Leben,
Muss wirken und streben

Und pflanzen und schaffen,
Erlisten, erraffen,
Muss wetten und wagen,
Das Glück zu erjagen.
Da strömet herbei die unendliche Gabe,
Es füllt sich der Speicher mit köstlicher Habe,
Die Räume wachsen, es dehnt sich das Haus.
Und drinnen waltet
Die züchtige Hausfrau,
Die Mutter der Kinder,
Und herrschet weise
Im häuslichen Kreise,
Und lehret die Mädchen
Und wehret den Knaben,
Und reget ohn' Ende
Die fleissigen Hände,
Und mehrt den Gewinn
Mit ordnendem Sinn,
Und füllet mit Schätzen die duftenden Laden,
Und dreht um die schnurrende Spindel den Faden,
Und sammelt im reinlich geglätteten Schrein
Die schimmernde Wolle, den schneeichten Lein,
Und füget zum Guten den Glanz und den Schimmer,
Und ruhet nimmer.

Und der Vater mit frohem Blick
Von des Hauses weitschauendem Giebel
Überzählet sein blühend Glück,
Siehet der Pfosten ragende Bäume
Und der Scheunen gefüllte Räume
Und die Speicher, vom Segen gebogen,
Und des Kornes bewegte Wogen,
Rühmt sich mit stolzem Mund:
Fest, wie der Erde Grund,
Gegen des Unglücks Macht
Steht mir des Hauses Pracht!—
Doch mit des Geschickes Mächten
Ist kein ew'ger Bund zu flechten,
Und das Unglück schreitet schnell.

Wohl! nun kann der Guss beginnen,
Schön gezacket ist der Bruch.
Doch bevor wir's lassen rinnen,
Betet einen frommen Spruch!
Stosst den Zapfen aus!
Gott bewahr' das Haus!

Rauchend in des Henkels Bogen
Schiesst's mit feuerbraunen Wogen.

Wohltätig ist des Feuers Macht,
Wenn sie der Mensch bezähmt, bewacht;
Und was er bildet, was er schafft,
Das dankt er dieser Himmelskraft.
Doch furchtbar wird die Himmelskraft,
Wenn sie der Fessel sich entrafft,
Einhertritt auf der eignen Spur,
Die freie Tochter der Natur.
Wehe, wenn sie losgelassen,
Wachsend ohne Widerstand,
Durch die volkbelebten Gassen
Wälzt den ungeheuren Brand!
Denn die Elemente hassen
Das Gebild der Menschenhand.
Aus der Wolke
Quillt der Segen,
Strömt der Regen;
Aus der Wolke, ohne Wahl,
Zuckt der Strahl.
Hört ihr's wimmern hoch vom Turm?
Das ist Sturm!
Rot wie Blut
Ist der Himmel,
Das ist nicht des Tages Glut!
Welch Getümmel
Strassen auf!
Dampf wallt auf!
Flackernd steigt die Feuersäule,
Durch der Strasse lange Zeile
Wächst es fort mit Windeseile;
Kochend wie aus Ofens Rachen
Glühn die Lüfte, Balken krachen,
Pfosten stürzen, Fenster klirren,
Kinder jammern, Mütter irren,
Tiere wimmern
Unter Trümmern;
Alles rennet, rettet, flüchtet,
Taghell ist die Nacht gelichtet.
Durch der Hände lange Kette
Um die Wette
Fliegt der Eimer, hoch im Bogen
Spritzen Quellen Wasserwogen.

Heulend kommt der Sturm geflogen,
Der die Flamme brausend sucht.
Prasselnd in die dürre Frucht
Fällt sie, in des Speichers Räume,
In der Sparren dürre Bäume;
Und als wollte sie im Wehen
Mit sich fort der Erde Wucht
Reissen in gewalt'ger Flucht,
Wächst sie in des Himmels Höhen
Riesengross!
Hoffnungslos
Weicht der Mensch der Götterstärke,
Müssig sieht er seine Werke
Und bewundernd untergehn.

Leergebrannt
Ist die Stätte,
Wilder Stürme rauhes Bette.
In den öden Fensterhöhlen
Wohnt das Grauen,
Und des Himmels Wolken schauen
Hoch hinein.

Einen Blick
Nach dem Grabe
Seiner Habe
Sendet noch der Mensch zurück—
Greift fröhlich dann zum Wanderstabe.
Was Feuers Wut ihm auch geraubt,
Ein süsser Trost ist ihm geblieben:
Er zählt die Häupter seiner Lieben,
Und sieh! ihm fehlt kein teures Haupt.

In die Erd' ist's aufgenommen,
Glücklich ist die Form gefüllt;
Wird's auch schön zu Tage kommen,
Dass es Fleiss und Kunst vergilt?
Wenn der Guss misslang?
Wenn die Form zersprang?
Ach, vielleicht, indem wir hoffen,
Hat uns Unheil schon getroffen.

Dem dunkeln Schoss der heil'gen Erde
Vertrauen wir der Hände Tat,
Vertraut der Sämann seine Saat
Und hofft, dass sie entkeimen werde
Zum Segen nach des Himmels Rat.

Noch köstlicheren Samen bergen
Wir trauernd in der Erde Schoss
Und hoffen, dass er aus den Särgen
Erblühen soll zu schönerm Los.

Von dem Dome,
Schwer und bang,
Tönt die Glocke
Grabgesang.
Ernst begleiten ihre Trauerschläge
Einen Wandrer auf dem letzten Wege.

Ach! die Gattin ist's, die teure,
Ach! es ist die treue Mutter,
Die der schwarze Fürst der Schatten
Wegführt aus dem Arm des Gatten,
Aus der zarten Kinder Schar,
Die sie blühend ihm gebar,
Die sie an der treuen Brust
Wachsen sah mit Mutterlust—
Ach! des Hauses zarte Bande
Sind gelöst auf immerdar;
Denn sie wohnt im Schattenlande,
Die des Hauses Mutter war;
Denn es fehlt ihr treues Walten,
Ihre Sorge wacht nicht mehr;
An verwaister Stätte schalten
Wird die Fremde, liebeleer.

Bis die Glocke sich verkühlet,
Laszt die strenge Arbeit ruhn;
Wie im Laub der Vogel spielet,
Mag sich jeder gütlich tun.
Winkt der Sterne Licht,
Ledig aller Pflicht
Hört der Bursch die Vesper schlagen,
Meister muss sich immer plagen.

Munter fördert seine Schritte
Fern im wilden Forst der Wandrer
Nach der lieben Heimathütte.
Blökend ziehen heim die Schafe,
Und der Rinder
Breitgestirnte, glatte Scharen
Kommen brüllend,
Die gewohnten Ställe füllend.

Schwer herein
Schwankt der Wagen,
Kornbeladen;
Bunt von Farben
Auf den Garben
Liegt der Kranz,
Und das junge Volk der Schnitter
Fliegt zum Tanz.
Markt und Strasse werden stiller;
Um des Lichts gesell'ge Flamme
Sammeln sich die Hausbewohner,
Und das Stadttor schliesst sich knarrend.
Schwarz bedecket
Sich die Erde;
Doch den sichern Bürger schrecket
Nicht die Nacht,
Die den Bösen grässlich wecket;
Denn das Auge des Gesetzes wacht.

Heil'ge Ordnung, segenreiche
Himmelstochter, die das Gleiche
Frei und leicht und freudig bindet,
Die der Städte Bau gegründet,
Die herein von den Gefilden
Rief den ungesell'gen Wilden,
Eintrat in der Menschen Hütten,
Sie gewöhnt zu sanften Sitten
Und das teuerste der Bande
Wob, den Trieb zum Vaterlande!

Tausend fleiss'ge Hände regen,
Helfen sich in munterm Bund,
Und in feurigem Bewegen
Werden alle Kräfte kund.
Meister rührt sich und Geselle
In der Freiheit heil'gem Schutz;
Jeder freut sich seiner Stelle,
Bietet dem Verächter Trutz.
Arbeit ist des Bürgers Zierde,
Segen ist der Mühe Preis;
Ehrt den König seine Würde,
Ehret uns der Hände Fleiss.
Holder Friede,
Süsse Eintracht,
Weilet, weilet
Freundlich über dieser Stadt!

Möge nie der Tag erscheinen,
Wo des rauhen Krieges Horden
Dieses stille Tal durchtoben,
Wo der Himmel,
Den des Abends sanfte Röte
Lieblich malt,
Von der Dörfer, von der Städte
Wildem Brande schrecklich strahlt!

Nun zerbrecht mir das Gebäude,
Seine Absicht hat's erfüllt,
Dass sich Herz und Auge weide
An dem wohlgelungnen Bild.
Schwingt den Hammer, schwingt,
Bis der Mantel springt!
Wenn die Glock' soll auferstehen,
Muss die Form in Stücken gehen.

Der Meister kann die Form zerbrechen
Mit weiser Hand, zur rechten Zeit;
Doch wehe, wenn in Flammenbächen
Das glühnde Erz sich selbst befreit!
Blindwütend, mit des Donners Krachen,
Zersprengt es das geborstne Haus,
Und wie aus offnem Höllenrachen
Speit es Verderben zündend aus.
Wo rohe Kräfte sinnlos walten,
Da kann sich kein Gebild gestalten;
Wenn sich die Völker selbst befrein,
Da kann die Wohlfahrt nicht gedeihn.
Weh, wenn sich in dem Schoss der Städte
Der Feuerzunder still gehäuft,
Das Volk, zerreissend seine Kette,
Zur Eigenhilfe schrecklich greift!
Da zerret an der Glocke Strängen
Der Aufruhr, dass sie heulend schallt
Und, nur geweiht zu Friedensklängen,
Die Losung anstimmt zur Gewalt.

Freiheit und Gleichheit! hört man schallen;
Der ruh'ge Bürger greift zur Wehr,
Die Strassen füllen sich, die Hallen,
Und Würgerbanden ziehn umher.
Da werden Weiber zu Hyänen
Und treiben mit Entsetzen Scherz;
Noch zuckend, mit des Panthers Zähnen,
Zerreissen sie des Feindes Herz.

993

Nichts Heiliges ist mehr, es lösen
Sich alle Bande frommer Scheu;
Der Gute räumt den Platz dem Bösen,
Und alle Laster walten frei.
Gefährlich ist's, den Leu zu wecken,
Verderblich ist des Tigers Zahn;
Jedoch der schrecklichste der Schrecken,
Das ist der Mensch in seinem Wahn.
Weh denen, die dem Ewigblinden
Des Lichtes Himmelsfackel leihn!
Sie strahlt ihm nicht, sie kann nur zünden
Und äschert Städt' und Länder ein.

 Freude hat mir Gott gegeben!
 Sehet! wie ein goldner Stern
 Aus der Hülse, blank und eben,
 Schält sich der metallne Kern.
 Von dem Helm zum Kranz
 Spielt's wie Sonnenglanz,
 Auch des Wappens nette Schilder
 Loben den erfahrnen Bilder.

Herein! herein!
Gesellen alle, schliesst den Reihen,
Dass wir die Glocke taufend weihen!
Concordia soll ihr Name sein.
Zur Eintracht, zu herzinnigem Vereine
Versammle sie die liebende Gemeine.

Und dies sei fortan ihr Beruf,
Wozu der Meister sie erschuf:
Hoch überm niedern Erdenleben
Soll sie im blauen Himmelszelt
Die Nachbarin des Donners schweben
Und grenzen an die Sternenwelt,
Soll eine Stimme sein von oben,
Wie der Gestirne helle Schar,
Die ihren Schöpfer wandelnd loben
Und führen das bekränzte Jahr.
Nur ewigen und ernsten Dingen
Sei ihr metallner Mund geweiht,
Und stündlich mit den schnellen Schwingen
Berühr' im Fluge sie die Zeit.
Dem Schicksal leihe sie die Zunge;
Selbst herzlos, ohne Mitgefühl,
Begleite sie mit ihrem Schwunge
Des Lebens wechselvolles Spiel.

Und wie der Klang im Ohr vergehet,
Der mächtig tönend ihr entschallt,
So lehre sie, dass nichts bestehet,
Dass alles Irdische verhallt.

Jetzo mit der Kraft des Stranges
Wiegt die Glock' mir aus der Gruft,
Dass sie in das Reich des Klanges
Steige, in die Himmelsluft!
 Ziehet, ziehet, hebt!
 Sie bewegt sich, schwebt!
Freude dieser Stadt bedeute,
Friede sei ihr erst Geläute.

SONG OF THE BELL

Fastened deep in firmest earth,
 Stands the mould of well burnt clay.
Now we'll give the bell its birth;
 Quick, my friends, no more delay!
 From the heated brow
 Sweat must freely flow,
If to your master praise be given:
But the blessing comes from Heaven.

To the work we now prepare
 A serious thought is surely due;
And cheerfully the toil we'll share,
 If cheerful words be mingled too.
Then let us still with care observe
 What from our strength, yet weakness, springs:
For he respect can ne'er deserve
 Who hands alone to labor brings.
'Tis only this which honors man;
 His mind with heavenly fire was warmed,
That he with deepest thought might scan
 The work which his own hand has formed.

With splinters of the driest pine
 Now feed the fire below;
Then the rising flame shall shine,
 And the melting ore shall flow.
 Boils the brass within,
 Quickly add the tin;

That the thick metallic mass
Rightly to the mould may pass.

What with the aid of fire's dread power
 We in the dark, deep pit now hide,
Shall, on some lofty, sacred tower,
 Tell of our skill and form our pride.
And it shall last to days remote,
 Shall thrill the ear of many a race;
Shall sound with sorrow's mournful note,
 And call to pure devotion's grace.
Whatever to the sons of earth
 Their changing destiny brings down,
To the deep, solemn clang gives birth,
 That rings from out this metal crown.

See, the boiling surface, whitening,
 Shows the whole is mixing well;
Add the salts, the metal brightening,
 Ere flows out the liquid bell.
 Clear from foam or scum
 Must the mixture come,
That with a rich metallic note
The sound aloft in air may float.

Now with joy and festive mirth
 Salute that loved and lovely child,
Whose earliest moments on the earth
 Are passed in sleep's dominion mild.
While on Time's lap he rests his head,
The fatal sisters spin their thread;
 A mother's love, with softest rays,
 Gilds o'er the morning of his days.—
But years with arrowy haste are fled.
His nursery bonds he proudly spurns;
 He rushes to the world without;
After long wandering, home he turns,
 Arrives a stranger and in doubt.
There, lovely in her beauty's youth,
 A form of heavenly mould he meets,
Of modest air and simple truth;
 The blushing maid he bashful greets.
A nameless feeling seizes strong
 On his young heart. He walks alone;
To his moist eyes emotions throng;

His joy in ruder sports has flown.
He follows, blushing, where she goes;
 And should her smile but welcome him,
The fairest flower, the dewy rose,
 To deck her beauty seems too dim.
O tenderest passion! Sweetest hope!
 The golden hours of earliest love!
Heaven's self to him appears to ope;
 He feels a bliss this earth above.
O, that it could eternal last!
That youthful love were never past!

See how brown the liquid turns!
 Now this rod I thrust within;
If it's glazed before it burns,
 Then the casting may begin.
 Quick, my lads, and steady,
 If the mixture's ready!
When the strong and weaker blend,
Then we hope a happy end:
Whenever strength with softness joins,
When with the rough the mild combines,
 Then all is union sweet and strong.
Consider, ye who join your hands,
If hearts are twined in mutual bands;
 For passion's brief, repentance long.
How lovely in the maiden's hair
The bridal garland plays!
And merry bells invite us there,
Where mingle festive lays.
Alas! that all life's brightest hours
 Are ended with its earliest May!
That from those sacred nuptial bowers
 The dear deceit should pass away!
 Though passion may fly,
 Yet love will endure;
 The flower must die,
 The fruit to insure.
 The man must without,
 Into struggling life;
 With toiling and strife,
 He must plan and contrive;
 Must be prudent to thrive;
 With boldness must dare,
 Good fortune to share.

'Tis by means such as these, that abundance is poured
In a full, endless stream, to increase all his hoard,
 While his house to a palace spreads out.

 Within doors governs
 The modest, careful wife,
 The children's kind mother;
 And wise is the rule
 Of her household school.
 She teaches the girls,
 And she warns the boys;
 She directs all the bands
 Of diligent hands,
 And increases their gain
 By her orderly reign.
And she fills with her treasures her sweet-scented chests;
From the toil of her spinning-wheel scarcely she rests;
And she gathers in order, so cleanly and bright,
The softest of wool, and the linen snow-white:
The useful and pleasant she mingles ever,
 And is slothful never.
The father, cheerful, from the door,
 His wide-extended homestead eyes;
Tells all his smiling fortunes o'er;
The future columns in his trees,
His barn's well furnished stock he sees,
His granaries e'en now o'erflowing,
While yet the waving corn is growing.
 He boasts with swelling pride,
 "Firm as the mountain's side
 Against the shock of fate
 Is now my happy state."
Who can discern futurity?
Who can insure prosperity?
 Quick misfortune's arrow flies.

Now we may begin to cast;
 All is right and well prepared:
Yet, ere the anxious moment's past,
 A pious hope by all be shared.
 Strike the stopper clear!
 God preserve us here!
Sparkling, to the rounded mould
It rushes hot, like liquid gold.

How useful is the power of flame,
If human skill control and tame!
And much of all that man can boast,
Without this child of Heaven, were lost.
But frightful is her changing mien,
When, bursting from her bonds, she's seen
To quit the safe and quiet hearth,
And wander lawless o'er the earth.
Woe to those whom then she meets!
 Against her fury who can stand?
Along the thickly peopled streets
 She madly hurls her fearful brand.
Then the elements, with joy,
Man's best handiwork destroy.
 From the clouds
 Falls amain
 The blessed rain:
 From the clouds alike
 Lightnings strike.
Ringing loud the fearful knell,
 Sounds the bell.
 Dark blood-red
 Are all the skies;
But no dawning light is spread.
 What wild cries
 From the streets arise!
 Smoke dims the eyes.
Flickering mounts the fiery glow
Along the street's extended row,
Fast as fiercest winds can blow.
Bright, as with a furnace flare,
And scorching, is the heated air;
Beams are falling, children crying,
Windows breaking, mothers flying,
Creatures moaning, crushed and dying,—
All is uproar, hurry, flight,
And light as day the dreadful night.
Along the eager living lane,
 Though all in vain,
Speeds the bucket. The engine's power
Sends the artificial shower.
But see, the heavens still threatening lower!
The winds rush roaring to the flame.
Cinders on the store-house frame,

And its drier stores, fall thick;
While kindling, blazing, mounting quick,
As though it would, at one fell sweep,
All that on the earth is found
Scatter wide in ruin round,
Swells the flame to heaven's blue deep,
With giant size.
Hope now dies.
Man must yield to Heaven's decrees.
Submissive, yet appalled, he sees
His fairest works in ashes sleep.

All burnt over
Is the place,
The storm's wild home. How changed its face!
In the empty, ruined wall
Dwells dark horror;
While heaven's clouds in shadow fall
Deep within.

One look,
In memory sad,
Of all he had,
The unhappy sufferer took,—
Then found his heart might yet be glad.
However hard his lot to bear,
His choicest treasures still remain:
He calls for each with anxious pain,
And every loved one's with him there.
To the earth it's now committed.
With success the mould is filled.
To skill and care alone's permitted
A perfect work with toil to build.
Is the casting right?
Is the mould yet tight?
Ah! while now with hope we wait,
Mischance, perhaps, attends its fate.
To the dark lap of mother earth
We now confide what we have made;
As in earth too the seed is laid,
In hope the seasons will give birth
To fruits that soon may be displayed.
And yet more precious seed we sow
With sorrow in the world's wide field;
And hope, though in the grave laid low,

A flower of heavenly hue 't will yield.
 Slow and heavy
 Hear it swell!
 'Tis the solemn
 Passing bell!
Sad we follow, with these sounds of woe,
Those who on this last, long journey go.
 Alas! the wife,—it is the dear one,—
 Ah! it is the faithful mother,
 Whom the shadowy king of fear
 Tears from all that life holds dear;—
 From the husband,—from the young,
 The tender blossoms, that have sprung
 From their mutual, faithful love,
 'Twas hers to nourish, guide, improve.
 Ah! the chain which bound them all
 Is for ever broken now;
 She cannot hear their tender call,
 Nor see them in affliction bow.
 Her true affection guards no more;
 Her watchful care wakes not again:
 O'er all the once loved orphan's store
 The indifferent stranger now must reign.
 Till the bell is safely cold,
 May our heavy labor rest;
 Free as the bird, by none controlled,
 Each may do what pleases best.
 With approaching night,
 Twinkling stars are bright.
 Vespers call the boys to play;
 The master's toils end not with day.

 Cheerful in the forest gloom,
 The wanderer turns his weary steps
 To his loved, though lowly home.
 Bleating flocks draw near the fold;
 And the herds,
 Wide-horned, and smooth, slow-pacing come
 Lowing from the hill,
 The accustomed stall to fill.
 Heavy rolls
 Along the wagon,
 Richly loaded.
 On the sheaves,
 With gayest leaves

1001

They form the wreath;
And the youthful reapers dance
Upon the heath.
Street and market all are quiet,
And round each domestic light
Gathers now a circle fond,
While shuts the creaking city-gate.
Darkness hovers
O'er the earth.
Safety still each sleeper covers
As with light,
That the deeds of crime discovers;
For wakes the law's protecting might.

Holy Order! rich with all
The gifts of Heaven, that best we call,—
Freedom, peace, and equal laws,—
Of common good the happy cause!
She the savage man has taught
What the arts of life have wrought;
Changed the rude hut to comfort, splendor,
And filled fierce hearts with feelings tender
And yet a dearer bond she wove,—
Our home, our country, taught to love.

A thousand active hands, combined
For mutual aid, with zealous heart,
In well apportioned labor find
Their power increasing with their art.
Master and workmen all agree,
Under sweet Freedom's holy care,
And each, content in his degree,
Warns every scorner to beware.
Labor is the poor man's pride,—
Success by toil alone is won.
Kings glory in possessions wide,—
We glory in our work well done.

Gentle peace!
Sweet union!
Linger, linger,
Kindly over this our home!
Never may the day appear,
When the hordes of cruel war
Through this quiet vale shall rush;
When the sky,

With the evening's softened air,
 Blushing red,
Shall reflect the frightful glare
 Of burning towns in ruin dread.

Now break up the useless mould:
 Its only purpose is fulfilled.
May our eyes, well pleased, behold
 A work to prove us not unskilled.
 Wield the hammer, wield,
 Till the frame shall yield!
That the bell to light may rise,
The form in thousand fragments flies.

The master may destroy the mould
 With careful hand, and judgment wise.
But, woe!—in streams of fire, if rolled,
 The glowing metal seek the skies!
Loud bursting with the crash of thunder,
 It throws aloft the broken ground;
Like a volcano rends asunder,
 And spreads in burning ruin round.
When reckless power by force prevails,
 The reign of peace and art is o'er;
And when a mob e'en wrong assails,
 The public welfare is no more.
Alas! when in the peaceful state
 Conspiracies are darkly forming;
The oppressed no longer patient wait;
 With fury every breast is storming.
Then whirls the bell with frequent clang;
 And Uproar, with her howling voice,
Has changed the note, that peaceful rang,
 To wild confusion's dreadful noise.

Freedom and equal rights they call,—
 And peace gives way to sudden war;
The street is crowded, and the hall,—
 And crime is unrestrained by law:
E'en woman, to a fury turning,
 But mocks at every dreadful deed;
Against the hated madly burning,
 With horrid joy she sees them bleed.
Now naught is sacred;—broken lies
 Each holy law of honest worth;
The bad man rules, the good man flies,
 And every vice walks boldly forth.

There's danger in the lion's wrath,
 Destruction in the tiger's jaw;
But worse than death to cross the path
 Of man, when passion is his law.
Woe, woe to those who strive to light
 The torch of truth by passion's fire!
It guides not;—it but glares through night
 To kindle freedom's funeral pyre.

God has given us joy to-night!
 See how, like the golden grain
From the husk, all smooth and bright,
 The shining metal now is ta'en!
 From top to well formed rim,
 Not a spot is dim;
E'en the motto, neatly raised,
Shows a skill may well be praised.

 Around, around,
Companions all, take your ground,
And name the bell with joy profound!
CONCORDIA is the word we've found
Most meet to express the harmonious sound,
That calls to those in friendship bound.

Be this henceforth the destined end
To which the finished work we send
High over every meaner thing,
 In the blue canopy of heaven,
Near to the thunder let it swing,
 A neighbour to the stars be given.
Let its clear voice above proclaim,
 With brightest troops of distant suns,
The praise of our Creator's name,
 While round each circling season runs.
To solemn thoughts of heart-felt power
 Let its deep note full oft invite,
And tell, with every passing hour,
 Of hastening time's unceasing flight.
Still let it mark the course of fate;
 Its cold, unsympathizing voice
Attend on every changing state
 Of human passions, griefs, and joys.
And as the mighty sound it gives
 Dies gently on the listening ear,
We feel how quickly all that lives
 Must change, and fade, and disappear.

Now, lads, join your strength around!
Lift the bell to upper air!
And in the kingdom wide of sound
Once placed, we'll leave it there.
All together! heave!
Its birth-place see it leave!—
Joy to all within its bound!
Peace its first, its latest sound!

Translated by Henry Wadsworth Longfellow

*The "Song of the Bell" is the most wonderful testimony of what consti-
tutes perfect poetic genius. Here, in alternating meters and with pic-
torial vividness of the highest order, by means of few briefly sketched
strokes the total picture is conveyed, embracing all events of human and
social life that spring from every emotion. And all of this is always
symbolically connected with the tolling of the bell, the poem closely
following the purposes the bell serves at various occasions. I do not
know of a poem in any language which, in such condensed form, reveals
such a wide poetic orbit, covering the gamut of all of the deepest human
emotions, and which, entirely in lyric style, depicts life and its most
important phases and events as one epoch surrounded by natural borders.
The poetic clearness is still further intensified by the fact that the visions
conjured up in the distance by the imagination, simultaneously corre-
spond to the actual description of an object, and that the two thus
formed thought columns run parallel side by side toward the same
goal.*

WILHELM VON HUMBOLDT
Briefwechsel zwischen Schiller und Wilhelm v. Humboldt (1830)

RICHARD PORSON

1 7 5 9 — 1 8 0 8

NATURAL PHILOSOPHY

He was in his customary state one night. Wishing to blow out his
candle, and seeing, as is said to be the way of the inebriated, two flames
side by side where there was only one, he three times directed his sway-
ing steps to the wrong image, and three times blew, with no effect, for the
non-existent cannot be extinguished. Whereupon he drew back, bal-
anced himself, and gave verdict: "Damn the nature of things!"

Anecdote

ANDRÉ CHÉNIER

1762 — 1794

NÉÈRE

Mais telle qu'à sa mort, pour la dernière fois,
Un beau cygne soupire, et de sa douce voix,
De sa voix qui bientôt lui doit être ravie,
Chante, avant de partir, ses adieux à la vie:
Ainsi, les yeux remplis de langueur et de mort,
Pâle, elle ouvrit sa bouche en un dernier effort:

"O vous, du Sébethus naïades vagabondes,
Coupez sur mon tombeau vos chevelures blondes.
Adieu, mon Clinias! moi, celle qui te plus,
Moi, celle qui t'aimai, que tu ne verras plus.
O cieux, ô terre, ô mer, prés, montagnes, rivages,
Fleurs, bois mélodieux, vallons, grottes sauvages,
Rappelez-lui souvent, rappelez-lui toujours
Néère tout son bien, Néère ses amours;
Cette Néère, hélas! qu'il nommait sa Néère,
Qui, pour lui criminelle, abandonna sa mère;
Qui, pour lui fugitive, errant de lieux en lieux,
Aux regards des humains n'osa lever les yeux.
Oh! soit que l'astre pur des deux frères d'Hélène
Calme sous ton vaisseau la vague ionienne;
Soit qu'aux bords de Pœstum, sous ta soigneuse main,
Les roses deux fois l'an couronnent ton jardin,
Au coucher du soleil, si ton âme attendrie
Tombe en une muette et molle rêverie,
Alors, mon Clinias, appelle, appelle-moi.
Je viendrai, Clinias; je volerai vers toi.
Mon âme vagabonde, à travers le feuillage,
Frémira; sur les vents ou sur quelque nuage
Tu la verras descendre, ou du sein de la mer,
S'élevant comme un songe, étinceler dans l'air,

1006

Et ma voix, toujours tendre et doucement plaintive,
Caresser, en fuyant, ton oreille attentive."

Ev'n as a lovely swan before he dies,
For the last time, with tender accent sighs,
With a sweet voice, that soon shall cease to be,
Sings, ere he goes, his parting melody:
So, her eyes full of languor and of death,
All pale, she spoke, striving for her last breath:

"Ye wandering naïads of a stream so dear,
Sever your golden locks upon my bier.
Farewell, my Clinias! Thy love was true;
We part for ever; ah! I loved thee too.
O Heaven, Earth, Sea, O mountains, fields and dales,
Flowers, murmuring woods, and savage grots, and vales,
Oft to his mind recall, and still recall
His own Néère, his love, his life, his all;
Néère, alas! whom he called his Néère,
Who, sinful, left her home his lot to share;
Who for him fugitive from place to place,
No more might raise her eyes to human face.
O when the star of Hellen's twins for thee
Beneath thy vessel calm the Ionian sea,
Or when on Pœstum's banks, taught by thy care,
The garden twice a year shall roses bear,
At sunset, if thy heart should gently beat,
Wrapt in a silent reverie and sweet,
Then call, my Clinias, then call on me.
I will come, Clinias; I'll fly to thee.
My errant sprite will sigh the leaves among;
Upon the clouds or breezes borne along,
Descending will appear, or she will seem,
Arising from the ocean, like a dream,
And my voice, ever tender, fleeting near,
Shall, sweetly plaintive, soothe thy listening ear."

Bucoliques, xiii
Translated by Charles Richard Cammell

The simplest and most touching, and one of the most perfectly beautiful poems of the French language.

JOSÉ-MARIA DE HEREDIA
Le Manuscrit des *Bucoliques* (Revue des Deux Mondes, 1905)

ANDRÉ CHÉNIER

1 7 6 2 — 1 7 9 4

LES BELLES FONT AIMER

Jeune fille ton cœur avec nous veut se taire.
Tu fuis, tu ne ris plus; rien ne saurait te plaire.
La soie à tes travaux offre en vain des couleurs;
L'aiguille sous tes doigts n'anime plus des fleurs.
Tu n'aimes qu'à rêver, muette, seule, errante,
Et la rose pâlit sur ta bouche expirante.
Ah! mon œil est savant et depuis plus d'un jour,
Et ce n'est pas à moi qu'on peut cacher l'amour.

Les belles font aimer; elles aiment. Les belles
Nous charment tous. Heureux qui peut être aimé d'elles!
Sois tendre, même faible (on doit l'être un moment),
Fidèle, si tu peux. Mais conte-moi comment,
Quel jeune homme aux yeux bleus, empressé sans audace,
Aux cheveux noirs, au front plein de charme et de grâce . . .
Tu rougis? On dirait que je t'ai dit son nom.
Je le connais pourtant. Autour de ta maison
C'est lui qui va, qui vient; et, laissant ton ouvrage,
Tu vas, sans te montrer, épier son passage.
Il fuit vite; et ton œil, sur sa trace accouru,
Le suit encor longtemps quand il a disparu.
Nul, en ce bois voisin où trois fêtes brillantes
Font voler au printemps nos nymphes triomphantes,
Nul n'a sa noble aisance et son habile main
A soumettre un coursier aux volontés du frein.

BEAUTIES AROUSE LOVE

Young girl, your heart prefers silence with us; you dash away and
laugh no longer; nothing pleases you. Silk vainly offers its colors to your
industrious hands; no longer does the needle bring flowers to life under
your fingers. Your only passion is dreaming, silent, alone, wandering,
and the rose pales on your languishing lips. Ah! my eye is too keen and
too experienced to conceal from me that you are in love. Beauties arouse
love; and they themselves love. Beauties charm us. Happy is he who
can be loved by them! Be tender, even yielding (one should be for a
moment); faithful, if you can. But tell me how, and who, is the young
man with blue eyes, eager but not bold, with black hair, with forehead

1008

full of charm and grace? Are you blushing? One would think I almost named him. I know him, however. It is he who goes and comes around your house, and, abandoning your work, you run without showing yourself to watch for his passing. He goes quickly; and your eye following after his footsteps seeks him long after he has vanished. Doubtless no one in this nearby wood, where three brilliant festivals make our triumphant nymphs carol aloft in springtime, possesses his noble ease and ability of hand to subject a race horse to the will of the bit.

<div align="right">Œuvres posthumes (1819)</div>

It is impossible to portray better and to leave more understood in fewer words. This short fragment comprises a sketch of an entire gracious romance whose continuation is easy to anticipate, a marvellous portrait worthy of a great Greek artist and of his imitator. André Chénier here attains perfection.

<div align="right">

ÉMILE FAGUET
Histoire de la poésie française (1936)

</div>

ANDRÉ CHÉNIER

1762 — 1794

LA JEUNE TARENTINE

Pleurez, doux alcyons! ô vous oiseaux sacrés!
Oiseaux chers à Téthys! doux alcyons, pleurez!

Elle a vécu, Myrto, la jeune Tarentine!
Un vaisseau la portait aux bords de Camarine:
Là, l'hymen, les chansons, les flûtes, lentement
Devaient la reconduire au seuil de son amant.
Une clef vigilante a, pour cette journée,
Dans le cèdre enfermé sa robe d'hyménée,
Et l'or dont au festin ses bras seraient parés,
Et pour ses blonds cheveux les parfums préparés.
Mais, seule sur la proue, invoquant les étoiles,
Le vent impétueux qui soufflait dans les voiles
L'enveloppe: étonnée et loin des matelots,
Elle crie, elle tombe, elle est au sein des flots.

Elle est au sein des flots, la jeune Tarentine!
Son beau corps a roulé sous la vague marine.

Téthys, les yeux en pleurs, dans le creux d'un rocher
Aux monstres dévorants eut soin de le cacher.
Par ses ordres bientôt les belles Néréides
L'élèvent au-dessus des demeures humides,
Le portent au rivage, et dans ce monument
L'ont au cap du Zéphyr déposé mollement;
Puis de loin, à grands cris appelant leurs compagnes,
Et les nymphes des bois, des sources, des montagnes,
Toutes, frappant leur sein et traînant un long deuil,
Répétèrent, hélas! autour de son cercueil:
Hélas! chez ton amant tu n'es point ramenée,
Tu n'as point revêtu ta robe d'hyménée,
L'or autour de tes bras n'a point serré de nœuds,
Les doux parfums n'ont point coulé sur tes cheveux.

THE YOUNG TARENTINE

Weep, gentle halcyons, by the moaning deep,
Loved birds of Tethys, sacred halcyons, weep!
 The young Tarentine, Myrto, is no more!
Myrto who sailed for Camarina's shore,
Where Hymen for her coming, all day long,
Sat waiting, myrtle-crowned, with flute and song
To lift her past the threshold as a bride.
Her wedding-robe lay shining, Tyrian-dyed,
In cedarn chest, and golden bands lay there,
And odorous nard to sprinkle on her hair.
 Charmed by the stars, all heedless of the gale
That rose afar and puffed the bellying sail,
She seaward leans—no sailor at her side—
She shrieks, she falls, she sinks below the tide.
The young Tarentine in the sea is lost,
Her lovely body by the salt waves tossed.
 White Tethys, grieving, in a hollow rock
From dragon jaws and the mad ocean's shock
Hides her away, and ever-weeping bids
The band attendant of her Nereids
Lift her, thus sepulchred, from out the deep
To where a promontory rises steep,
Sacred to Zephyr. Here the golden-tressed
Tarentine virgin lies in lonely rest.
Here all the sister nymphs flock from their fountains,
Fair Dryades and Oreads from the mountains.

In slow procession round her tomb they move,
Mourning her early death and hapless love,
Beating their breasts and crying loud, "Alas!
Alas, that thy brief day so soon should pass!
Thou hast not rested in thy lover's arms,
No hymeneal robe has graced thy charms,
Thy slender wrists no golden circlets wear,
No bridal wreath perfumes thy floating hair."

<div align="right">

Œuvres posthumes (1819)
Translated by William Frederic Giese

</div>

Son of a Greek mother, he was born at Constantinople, traveled in Italy, and stayed three years in London. He read the English and Italian poets in the original. But above everything his contact with Greek poetry is probably the most intimate known to modern man. He is, even more than Ronsard, our great poet-philologer.

<div align="right">

ALBERT THIBAUDET
Histoire de la littérature française (1936)

</div>

ANDRÉ CHÉNIER

1 7 6 2 — 1 7 9 4

TESTAMENT

Il est las de partager la honte de cette foule immense qui en secret abhorre autant que lui, mais qui approuve et encourage, au moins par son silence, des hommes atroces et des actions abominables. La vie ne vaut pas tant d'opprobre. Quand les tréteaux, les tavernes et les lieux de débauche vomissent par milliers des législateurs, des magistrats et des généraux d'armée qui sortent de la boue pour le bien de la patrie, il a, lui, une autre ambition, et il ne croit pas démériter de sa patrie en faisant dire un jour: Ce pays, qui produisit alors tant de prodiges d'imbécillité et de bassesse, produisit aussi un petit nombre d'hommes qui ne renoncèrent ni à leur raison ni à leur conscience; témoins des triomphes du vice, ils restèrent amis de la vertu et ne rougirent point d'être gens de bien. Dans ces temps de violence, ils osèrent parler de justice; dans ces temps de démence, ils osèrent examiner; dans ces temps de la plus abjecte hypocrisie, ils ne feignirent point d'être des scélérats pour acheter leur repos aux dépens de l'innocence opprimée; ils ne cachèrent point leur haine à des bourreaux qui, pour payer leurs amis et punir leurs ennemis, n'épargnaient rien, car il ne leur en coûtait que des crimes;

et un nommé. **A. C.** (*André Chénier*) fut un des cinq ou six que ni la frénésie générale, ni l'avidité, ni la crainte, ne purent engager à ployer le genou devant des assassins couronnés, à toucher des mains souillées de meurtres, et à s'asseoir à la table où l'on boit le sang des hommes.

He is weary of sharing the shame of this immense crowd who secretly abhor as much as he does, but who approve and encourage, at least by their silence, atrocious men and abominable actions. Life is not worth so much opprobrium. When the booths, the taverns and houses of debauchery vomit by the thousand legislators, magistrates and army generals who rise out of the mire for the good of their country, *he* has another ambition, and he does not think himself undeserving of his country, if some day he makes her say: This country, which at that time produced so many prodigies of imbecility and baseness, also produced a small number of men who renounced neither their reason nor their conscience; witnessing the triumphs of vice, they remained friends of virtue and did not blush to be honourable men. In these times of violence they dared to speak of justice; in these times of dementia, they dared to question; in these times of the most abject hypocrisy, they did not feign to be wicked in order to buy their repose at the price of oppressed innocence; they did not conceal their hatred from villains who, to reward their friends and punish their enemies, spared nothing, for it cost them nothing but crimes; and a certain A. C. (*André Chénier*) was among those five or six whom neither the general frenzy, nor avidity, nor fear, could induce to bend the knee before crowned assassins, to touch hands stained by murders, and to sit down to a table where they drink human blood.

Whatever political line a man may follow (and I do not pretend that that followed by André Chénier was strictly speaking the only and the true one), this manner of being and feeling in a time of revolution, especially when it is finally confirmed and consecrated by death, will be ever reputed MORALLY *the most heroic and the most beautiful, the most worthy of all to be proposed to the respect of man.*

<div align="right">

C. - A. SAINTE-BEUVE
Causeries du lundi (1851)
Translated by E. J. Trechmann

</div>

NAPOLEON BONAPARTE

1 7 6 9 — 1 8 2 1

HONOR, GLORY AND WEALTH

Soldats, vous êtes nus, mal nourris; le gouvernement vous doit beau-
coup, il ne peut rien vous donner. Votre patience, le courage que vous
montrez au milieu de ces rochers, sont admirables; mais ils ne vous pro-
curent aucune gloire; aucun éclat ne rejaillit sur vous. Je veux vous con-
duire dans les plus fertiles plaines du monde. De riches provinces, de
grandes villes seront en votre pouvoir; vous y trouverez, honneur, gloire
et richesses. Soldats d'Italie, manquerez-vous de courage ou de con-
stance?

Soldiers, you are naked, poorly fed; the government owes you much,
it can give you nothing. Your patience, the courage that you show in
the midst of these rocks, are admirable, but they bring you no glory; no
renown reflects on you. I want to lead you to the most fertile plains of the
world. Rich provinces, large cities will be in your power; you will find
there honor, glory, and wealth. Soldiers of Italy, will you lack courage
or constancy?

> Proclamation du général en chef, à l'ouverture de la
> campagne, au quartier général à Nice, 28 mars 1796.

*He instinctively discovered the military eloquence of which he is the
model; he invented the form of address suited to French valour and
made to electrify. Henri IV had his flashes of eloquence, happy sallies
of wit which were repeated by Crillon and the nobles; but, here was
wanted an eloquence on the new level of the great operations, adapted
to the measure of those armies risen from the people, the brief, grave,
familiar, monumental address. From the first day, among his means for
waging great war, Napoleon discovered that one.*

> C.-A. SAINTE-BEUVE
> Causeries du lundi (1849)
> *Translated by E. J. Trechmann*

WILLIAM WORDSWORTH

1 7 7 0 — 1 8 5 0

A SENSE SUBLIME

Whose dwelling is the light of setting suns.

<div align="right">

Tintern Abbey (1798)

</div>

The line is almost the grandest in the English language.

<div align="right">

ALFRED LORD TENNYSON
Alfred Lord Tennyson: A Memoir by Hallam Tennyson (1897)

</div>

WILLIAM WORDSWORTH

1 7 7 0 — 1 8 5 0

NATURE'S GIFTS TO LUCY

"The stars of midnight shall be dear
To her; and she shall lean her ear
In many a secret place
Where rivulets dance their wayward round,
And beauty born of murmuring sound
Shall pass into her face."

<div align="right">

Three Years She Grew in
Sun and Shower (1800)

</div>

Take those two last lines, and realize how impossible it would have been for them to have been written by Shakespeare, or Spenser, or Milton, or whomever one may happen to think the greatest of his predecessors; and it will help one to measure the authentic greatness of Wordsworth.

For that great advance of sympathy with nature, the quiet, unadorned purity of style which Wordsworth reached in his happiest moments of inspiration was surely the best. It is so singularly free from mannerism, from that accent of individual self-importance which at other times fell on his work; so pure and unmannered and natural.

At its best his form is so pure that it rises to a style which seems to embrace the highest common factor of other styles.

<div align="right">

LAURENCE HOUSMAN
A Wordsworth Anthology (1946)

</div>

WILLIAM WORDSWORTH

1 7 7 0 — 1 8 5 0

SLEEPLESS SOUL

The sleepless Soul that perished in his pride.
 Resolution and Independence (1802)

I will back that against any of Mr. Arnold's three representative quotations from Homer, from Dante, and from Shakespeare. It is like nothing from any other hand: the unspeakable greatness of its quality is Wordsworth's alone: and I doubt if it would really be as rash as it might seem to maintain that there is not and never will be a greater verse in all the world of song.*

 ALGERNON CHARLES SWINBURNE
 Miscellanies (1886)

WILLIAM WORDSWORTH

1 7 7 0 — 1 8 5 0

THE SOLITARY REAPER

Behold her, single in the field,
Yon solitary Highland Lass!
Reaping and singing by herself;
Stop here, or gently pass!
Alone she cuts and binds the grain,
And sings a melancholy strain;
O listen! for the Vale profound
Is overflowing with the sound.

No Nightingale did ever chaunt
More welcome notes to weary bands
Of travellers in some shady haunt,
Among Arabian sands:
A voice so thrilling ne'er was heard
In spring-time from the Cuckoo-bird,
Breaking the silence of the seas
Among the farthest Hebrides.

* For the Matthew Arnold quotations see Appendix.

Will no one tell me what she sings?—
Perhaps the plaintive numbers flow
For old, unhappy, far-off things,
And battles long ago:
Or is it some more humble lay,
Familiar matter of to-day?
Some natural sorrow, loss, or pain,
That has been, and may be again?

Whate'er the theme, the Maiden sang
As if her song could have no ending;
I saw her singing at her work,
And o'er the sickle bending;—
I listened, motionless and still;
And, as I mounted up the hill
The music in my heart I bore,
Long after it was heard no more.

(1803)

I will give it as my opinion now, that if we were to grant the independence of poetic music or magic, then no poet is so rich in these qualities as Wordsworth. He had the capacity of endowing words of the most commonplace associations with the light or radiant emanation of ideal glory. The most perfect example of this supernal strain is, in my own opinion, the poem called THE SOLITARY REAPER, *which poem I would always send out into the world of letters to represent the quintessence of English poetry.*

HERBERT READ
Phases of English Poetry (1929)

WILLIAM WORDSWORTH

1 7 7 0 — 1 8 5 0

THE BOY'S FEAR AFTER STEALING
A TRAPPED BIRD FROM A SNARE

Low breathings coming after me, and sounds
Of undistinguishable motion, steps
Almost as silent as the turf they trod.

The Prelude (1799–1805), i

1016

HE REMEMBERS THE VISTA
OF A TOWERING PEAK

After I had seen
That spectacle, for many days, my brain
Worked with a dim and undetermined sense
Of unknown modes of being; o'er my thoughts
There hung a darkness, call it solitude
Or blank desertion. No familiar shapes
Remained, no pleasant images of trees,
Of sea or sky, no colours of green fields;
But huge and mighty forms, that do not live
Like living men, moved slowly through the mind
By day, and were a trouble to my dreams.

The Prelude (1799–1805), i

The second passage is an enlargement of the first, and they are both great poetry. The poetic mind is aware of 'low breathings', 'sounds of undistinguishable motion', 'unknown modes of being', 'huge and mighty forms'. It is the pressure of the genius on the outer consciousness.

CHARLES WILLIAMS
The English Poetic Mind (1932)

WILLIAM WORDSWORTH

1 7 7 0 — 1 8 5 0

SOLITUDE

The antechapel where the statue stood
Of Newton with his prism and silent face,
The marble index of a mind for ever
Voyaging through strange seas of Thought, alone.

The Prelude (1799–1805), iii

No finer lines on solitude are found in English.

IRVING BABBITT
Rousseau and Romanticism (1919)

WILLIAM WORDSWORTH

1770 — 1850

TO H. C.

SIX YEARS OLD

O thou! whose fancies from afar are brought;
Who of thy words dost make a mock apparel,
And fittest to unutterable thought
The breeze-like motion and the self-born carol;
Thou faery voyager! that dost float
In such clear water, that thy boat
May rather seem
To brood on air than on an earthly stream;
Suspended in a stream as clear as sky,
Where earth and heaven do make one imagery;
O blessed vision! happy child!
Thou art so exquisitely wild,
I think of thee with many fears
For what may be thy lot in future years.

 I thought of times when Pain might be thy guest,
Lord of thy house and hospitality;
And Grief, uneasy lover! never rest
But when she sate within the touch of thee.
O too industrious folly!
O vain and causeless melancholy!
Nature will either end thee quite;
Or, lengthening out thy season of delight,
Preserve for thee, by individual right,
A young lamb's heart among the full-grown flocks.
What hast thou to do with sorrow,
Or the injuries of to-morrow?
Thou art a dew-drop, which the morn brings forth,
Ill fitted to sustain unkindly shocks,
Or to be trailed along the soiling earth;
A gem that glitters while it lives,
And no forewarning gives;
But, at the touch of wrong, without a strife
Slips in a moment out of life.

(1807)

When Hartley [Coleridge] was six years old, he addressed to him these
verses, perhaps the best ever written on a real and visible child.

WALTER BAGEHOT
Literary Studies (1878)

WILLIAM WORDSWORTH

1 7 7 0 — 1 8 5 0

THE WORLD

Great God! I'd rather be
A Pagan suckled in a creed outworn;
So might I, standing on this pleasant lea,
Have glimpses that would make me less forlorn;
Have sight of Proteus rising from the sea;
Or hear old Triton blow his wreathèd horn.

The World is too Much with Us (1806)

*The most famous expression in English of that longing for the perished
glory of Greek myth which appears in much Romantic poetry.*

A. C. BRADLEY
Oxford Lectures on Poetry (1923)

WILLIAM WORDSWORTH

1 7 7 0 — 1 8 5 0

TO TOUSSAINT L'OUVERTURE

Thou hast left behind
Powers that will work for thee; air, earth, and skies;
There's not a breathing of the common wind
That will forget thee; thou hast great allies;
Thy friends are exultations, agonies,
And love, and man's unconquerable mind.

(1807)

The finest sextet to be found anywhere.

FRANK HARRIS
My Life and Loves (1922–27)

ODE

INTIMATIONS OF IMMORTALITY
FROM RECOLLECTIONS
OF EARLY CHILDHOOD

I

There was a time when meadow, grove, and stream,
The earth, and every common sight,
 To me did seem
 Apparelled in celestial light,
The glory and the freshness of a dream.
It is not now as it hath been of yore;—
 Turn wheresoe'er I may,
 By night or day,
The things which I have seen I now can see no more.

II

 The Rainbow comes and goes,
 And lovely is the Rose,
 The Moon doth with delight
Look round her when the heavens are bare,
 Waters on a starry night
 Are beautiful and fair;
 The sunshine is a glorious birth;
 But yet I know, where'er I go,
That there hath past away a glory from the earth.

III

Now, while the birds thus sing a joyous song,
 And while the young lambs bound
 As to the tabor's sound,
To me alone there came a thought of grief:
A timely utterance gave that thought relief,
 And I again am strong:
The cataracts blow their trumpets from the steep;
No more shall grief of mine the season wrong;
I hear the Echoes through the mountains throng,

The Winds come to me from the fields of sleep,
And all the earth is gay;
Land and sea
Give themselves up to jollity,
And with the heart of May
Doth every Beast keep holiday;—
Thou Child of Joy,
Shout round me, let me hear thy shouts, thou happy
Shepherd-boy!

IV

Ye blessèd Creatures, I have heard the call
Ye to each other make; I see
The heavens laugh with you in your jubilee;
My heart is at your festival,
My head hath its coronal,
The fulness of your bliss, I feel—I feel it all.
Oh evil day! if I were sullen
While Earth herself is adorning,
This sweet May-morning,
And the Children are culling
On every side,
In a thousand valleys far and wide,
Fresh flowers; while the sun shines warm,
And the Babe leaps up on his Mother's arm:—
I hear, I hear, with joy I hear!
—But there's a Tree, of many, one,
A single Field which I have looked upon,
Both of them speak of something that is gone:
The Pansy at my feet
Doth the same tale repeat:
Whither is fled the visionary gleam?
Where is it now, the glory and the dream?

V

Our birth is but a sleep and a forgetting:
The Soul that rises with us, our life's Star,
Hath had elsewhere its setting,
And cometh from afar:
Not in entire forgetfulness,
And not in utter nakedness,
But trailing clouds of glory do we come
From God, who is our home:

1021

Heaven lies about us in our infancy!
Shades of the prison-house begin to close
 Upon the growing Boy,
But He beholds the light, and whence it flows,
 He sees it in his joy;
The youth, who daily farther from the east
 Must travel, still is Nature's Priest,
 And by the vision splendid
 Is on his way attended;
At length the Man perceives it die away,
And fade into the light of common day.

<p style="text-align:center">VI</p>

Earth fills her lap with pleasures of her own;
Yearnings she hath in her own natural kind,
And, even with something of a Mother's mind,
 And no unworthy aim,
 The homely Nurse doth all she can
To make her Foster-child, her Inmate Man,
 Forget the glories he hath known,
And that imperial palace whence he came.

<p style="text-align:center">VII</p>

Behold the Child among his new-born blisses,
A six years' Darling of a pigmy size!
See, where 'mid work of his own hand he lies,
Fretted by sallies of his mother's kisses,
With light upon him from his father's eyes!
See, at his feet, some little plan or chart,
Some fragment from his dream of human life,
Shaped by himself with newly-learned art;
 A wedding or a festival,
 A mourning or a funeral;
 And this hath now his heart,
 And unto this he frames his song:
 Then will he fit his tongue
To dialogues of business, love, or strife;
 But it will not be long
 Ere this be thrown aside,
 And with new joy and pride
The little Actor cons another part;
Filling from time to time his "humorous stage"
With all the Persons, down to palsied Age,
That Life brings with her in her equipage;

<p style="text-align:center">1022</p>

As if his whole vocation
Were endless imitation.

VIII

Thou, whose exterior semblance doth belie
 Thy Soul's immensity;
Thou best Philosopher, who yet dost keep
Thy heritage, thou Eye among the blind,
That, deaf and silent, read'st the eternal deep,
Haunted for ever by the eternal mind,—
 Mighty Prophet! Seer blest!
 On whom those truths do rest,
Which we are toiling all our lives to find,
In darkness lost, the darkness of the grave;
Thou, over whom thy Immortality
Broods like the Day, a Master o'er a Slave,
A Presence which is not to be put by;
Thou little Child, yet glorious in the might
Of heaven-born freedom on thy being's height,
Why with such earnest pains dost thou provoke
The years to bring the inevitable yoke,
Thus blindly with thy blessedness at strife?
Full soon thy Soul shall have her earthly freight,
And custom lie upon thee with a weight,
Heavy as frost, and deep almost as life!

IX

 O joy! that in our embers
 Is something that doth live,
 That nature yet remembers
 What was so fugitive!
The thought of our past years in me doth breed
Perpetual benediction: not indeed
For that which is most worthy to be blest—
Delight and liberty, the simple creed
Of Childhood, whether busy or at rest,
With new-fledged hope still fluttering in his breast:—
 Not for these I raise
 The song of thanks and praise;
 But for those obstinate questionings
 Of sense and outward things,
 Fallings from us, vanishings;
 Blank misgivings of a Creature

1023

Moving about in worlds not realised,
High instincts before which our mortal Nature
Did tremble like a guilty Thing surprised:
 But for those first affections,
 Those shadowy recollections,
 Which, be they what they may,
Are yet the fountain light of all our day,
Are yet a master light of all our seeing;
 Uphold us, cherish, and have power to make
Our noisy years seem moments in the being
Of the eternal Silence: truths that wake,
 To perish never;
Which neither listlessness, nor mad endeavour,
 Nor Man nor Boy,
Nor all that is at enmity with joy,
Can utterly abolish or destroy!
 Hence in a season of calm weather
 Though inland far we be,
Our Souls have sight of that immortal sea
 Which brought us hither,
 Can in a moment travel thither,
And see the Children sport upon the shore,
And hear the mighty waters rolling evermore.

X

Then sing, ye Birds, sing, sing a joyous song!
 And let the young Lambs bound
 As to the tabor's sound!
We in thought will join your throng,
 Ye that pipe and ye that play,
 Ye that through your hearts to-day
 Feel the gladness of the May!
What though the radiance which was once so bright
Be now for ever taken from my sight,
 Though nothing can bring back the hour
Of splendour in the grass, of glory in the flower;
 We will grieve not, rather find
 Strength in what remains behind;
 In the primal sympathy
 Which having been must ever be;
 In the soothing thoughts that spring
 Out of human suffering;
 In the faith that looks through death,
In years that bring the philosophic mind.

And O, ye Fountains, Meadows, Hills, and Groves,
Forebode not any severing of our loves!
Yet in my heart of hearts I feel your might;
I only have relinquished one delight
To live beneath your more habitual sway.
I love the Brooks which down their channels fret,
Even more than when I tripped lightly as they;
The innocent brightness of a new-born Day
 Is lovely yet;
The Clouds that gather round the setting sun
Do take a sober colouring from an eye
That hath kept watch o'er man's mortality;
Another race hath been, and other palms are won.
Thanks to the human heart by which we live,
Thanks to its tenderness, its joys, and fears,
To me the meanest flower that blows can give
Thoughts that do often lie too deep for tears.

(1807)

The Ode remains not merely the greatest, but the one really, dazzlingly, supremely great thing he ever did. Its theory has been scorned or impugned by some; parts of it have even been called nonsense by critics of weight. But, sound or unsound, sense or nonsense, it is poetry, and magnificent poetry, from the first line to the last—poetry than which there is none better in any language, poetry such as there is not perhaps more than a small volume-full in all languages.

GEORGE SAINTSBURY
A History of Nineteenth Century Literature (1896)

FRIEDRICH HÖLDERLIN

1 7 7 0 — 1 8 4 3

DER BLINDE SÄNGER

Ἔλυσεν αἰνὸν ἄχος ἀπ' ὀμμάτων Ἄρης

SOPHOCLES

Wo bist du, Jugendliches! das immer mich
Zur Stunde weckt des Morgens, wo bist du, Licht?
 Das Herz ist wach, doch bannt und hält in
 Heiligem Zauber die Nacht mich immer.

Sonst lauscht' ich um die Dämmerung gern, sonst harrt'
Ich gerne dein am Hügel, und nie umsonst!
 Nie täuschten mich, du Holdes, deine
 Boten, die Lüfte, denn immer kamst du,

Kamst allbeseligend den gewohnten Pfad
Herein in deiner Schöne, wo bist du, Licht!
 Das Herz ist wieder wach, doch bannt und
 Hemmt die unendliche Nacht mich immer.

Mir grünten sonst die Lauben; es leuchteten
Die Blumen, wie die eigenen Augen, mir;
 Nicht ferne war das Angesicht der
 Meinen und leuchtete mir und droben

Und um die Wälder sah ich die Fittige
Des Himmels wandern, da ich ein Jüngling war;
 Nun sitz ich still allein, von einer
 Stunde zur anderen und Gestalten

Aus Lieb und Leid der helleren Tage schafft
Zur eignen Freude nun mein Gedanke sich,
 Und ferne lausch' ich hin, ob nicht ein
 Freundlicher Retter vieleicht mir komme.

Dann hör' ich oft die Stimme des Donnerers
Am Mittag, wenn der eherne nahe kommt,
 Wenn ihm das Haus bebt und der Boden
 Unter ihm dröhnt und der Berg es nachhallt.

Den Retter hör' ich dann in der Nacht, ich hör'
Ihn tödtend, den Befreier, belebend ihn,
 Den Donnerer vom Untergang zum
 Orient eilen, und ihm nach tönt ihr,

Ihm nach, ihr meine Saiten! es lebt mit ihm
Mein Lied, und wie die Quelle dem Strome folgt,
 Wohin er denkt, so muss ich fort und
 Folge dem Sicheren auf der Irrbahn.

Wohin? wohin? ich höre dich da und dort
Du Herrlicher! und rings um die Erde tönts
 Wo endest du? und was, was ist es
 Über den Wolken und o wie wird mir?

Tag! Tag! Du über stürzenden Wolken! sei
Willkommen mir! es blühet mein Auge dir.
 O jugendlicht! o Glück! das alte
 Wieder! doch geistiger rinnst du nieder

Du goldner Quell aus heiligem Kelch! und du,
Du grüner Boden, friedliche Wieg'! und du,
 Haus meiner Väter! und ihr Lieben,
 Die mir begegneten einst, o nahet,

O kommt, dass euer, euer die Freude sei,
Ihr alle, dass euch segne der Sehende!
 O nimmt, dass ichs ertrage, mir das
 Leben, das Göttliche mir vom Herzen.

THE BLIND SINGER

Where are you, ever-youthful, that day by day
Awakened me at morning, where are you, Light?
 My heart's indeed awake, but still in
 Sacred enchantment the Night enchains me.

How gladly once I'd hearken at dawn, or wait,
And never vainly, out on the hill for you:
 Your messengers, dear Light, the breezes,
 Never deceived, for you always came then,

Came all-enkindling down the accustomed path
In all your wonted beauty. Where are you, Light?
 My heart's awake once more, and yet this
 Night that is infinite bans and binds me.

For me the leaves once glittered in green, for me,
Like my own eyes, the flowers were luminous;
 The countenance of those I loved still
 Lightened upon me, and high above me

And round the woods, in days of my youth, I saw
The winged things of heaven go wandering;
 But now I sit alone in silence,
 Hour after hour, with thought still weaving

From love and sorrow gathered in brighter days
The shapes that only serve for its own delight,·
 And hearken lest far off some kindly
 Rescuer be not perchance approaching.

And often then the voice of the Thunderer,
Whose brazen car draws nearer at noon, I hear,
 When all the house will quake, and Earth will
 Rumble below and the hills re-echo:

The Rescuer then I hear in the night, I hear
The Slayer, Liberator, Reviver then,
 The Thund'rer, who from Occident to
 Orient hastens, and you re-echo,

Whom you, my strings, re-echo! With whom my song
Revives, and, ev'n as springs after rivers speed,
 I needs must go where he shall choose, and
 Follow his certainty through the mazes.

But where? But where? I hear you on ev'ry hand,
Whose glory all the earth is resounding with:
 Where will you end? And what, what is it
 Over the clouds there, and, oh, where am I?

Day! Day! arising over the ruining
Of clouds! My eyes, they blossom to welcome you!
 O Light of Youth! O Joy restored, but
 Now a more spiritual essence, pouring

From consecrated chalice your golden stream!
And you, my peaceful cradle, green Earth! And you,
 My fathers' house! and you, my dear ones,
 You that would throng to me once, come hither,

Oh, come, that his delight may be your delight,
And that to-day the Seer may bless you all,
 Oh, come and take, that I may bear it,
 Take from my heart this divine existence!

Translated by J. B. Leishman

Perhaps greater mastery of technique than in any other German poem.
Hölderlin (1944)

FRIEDRICH HÖLDERLIN

1 7 7 0 — 1 8 4 3

THE DEATH OF EMPEDOCLES

 Ihr dürft leben,
solange ihr Odem habt; ich nicht. Es muss
beizeiten weg, durch wen der Geist geredet.
Es offenbart die göttliche Natur
sich göttlich oft durch Menschen, so erkennt
das vielversuchende Geschlecht sie wieder,

1028

doch hat der Sterbliche, dem sie das Herz
mit ihrer Wonne füllten, sie verkündet,
o lasst sie dann zerbrechen das Gefäss,
damit es nicht zu anderm Brauche dien'
und Göttliches zum Menschenwerke werde.
Lasst diese Glücklichen doch sterben, lasst,
eh sie in Eigenmacht und Tand und Schmach
vergehn, die Freien sich bei guter Zeit
den Göttern liebend opfern. Mein ist dies
und wohlbewusst ist mir mein Los und längst
am jugendlichen Tage hab' ich mirs
geweissagt; ehret mirs! Und wenn ihr morgen
mich nimmer findet, sprecht: veralten sollt'
er nicht und Tage zählen, dienen nicht
der Sorge, Krankheit, ungesehen ging
er weg und keines Menschen Hand begrub ihn,
und keines Auge weiss von seiner Asche;
denn anders ziemt es nicht für ihn, vor dem
in todesfroher Stund' am heilgen Tage
das Göttliche den Schleier abgeworfen.

You are permitted to live so long as you have breath; not I. He
through whom the spirit has spoken must depart early. Often the divine
Nature reveals itself divinely through man, and it is, as a consequence,
again recognized by a much-endeavoring generation. However as soon
as Nature has been proclaimed by a mortal, whose heart she filled with
her rapture, let Nature break the vessel, so that it may not serve other
uses and so that the divine may not become the work of man. Let such
happy ones die—let the free offer themselves in good time, lovingly as
a sacrifice for the Gods, before they perish by their arbitrary power and
trifling and shame. This is my lot, and well aware am I of it. Long ago
in the early days of my youth I foretold it myself. Honor me for it! And
if tomorrow you no longer find me, say: to grow old and count the days
was not for him, nor to serve sorrow's illness. He departed unseen, and
no human hand buried him, and no eye knows of his ashes. For any-
thing else would not have been fitting for him before whom on the holy
day, in the joyful hour of death, divinity cast off its veil.

<div align="center">Der Tod des Empedokles (1798–99)</div>

*Never surely did any poet speak so out of his heart, yet in language so
perfect and so glorious.*

<div align="right">MARSHALL MONTGOMERY
Studies in the Age of Goethe (1931)</div>

SIR WALTER SCOTT

1 7 7 1 -- 1 8 3 2

FLODDEN FIELD

But as they left the darkening heath
More desperate grew the strife of death.
The English shafts in volleys hailed,
In headlong charge their horse assailed;
Front, flank, and rear, the squadrons sweep
To break the Scottish circle deep
 That fought around their king.
But yet, though thick the shafts as snow,
Though charging knights like whirlwinds go,
Though billmen ply the ghastly blow,
 Unbroken was the ring;
The stubborn spearmen still made good
Their dark impenetrable wood,
Each stepping where his comrade stood
 The instant that he fell.
No thought was there of dastard flight;
Linked in the serried phalanx tight,
Groom fought like noble, squire like knight,
 As fearlessly and well.
 Marmion, a Tale of Flodden Field (1808), vi

Here, at least, Scott rose to epic heights.
 HERBERT J. C. GRIERSON and J. C. SMITH
 A Critical History of English Poetry (1944)

SIR WALTER SCOTT

1 7 7 1 — 1 8 3 2

MEG MERRILIES

'Ride your ways,' said the gipsy, 'ride your ways, Laird of Ellan-
gowan—ride your ways, Godfrey Bertram! This day have ye quenched
seven smoking hearths—see if the fire in your ain parlour burn the blither
for that. Ye have riven the thack off seven cottar houses—look if your
ain roof-tree stand the faster. Ye may stable your stirks in the shealings
at Derncleugh—see that the hare does not couch on the hearthstone at

Ellangowan. Ride your ways, Godfrey Bertram—what do ye glower after our folk for? There's thirty hearts there that wad hae wanted bread ere ye had wanted sunkets, and spent their life-blood ere ye had scratched your finger. Yes—there's thirty yonder, from the auld wife of an hundred to the babe that was born last week, that ye have turned out o' their bits o' bields, to sleep with the tod and the blackcock in the muirs! Ride your ways, Ellangowan! Our bairns are hinging at our weary backs—look that your braw cradle at hame be the fairer spread up; not that I am wishing ill to little Harry, or to the babe that's yet to be born—God forbid—and make them kind to the poor, and better folk than their father!—And now, ride e'en your ways; for these are the last words ye'll ever hear Meg Merrilies speak, and this is the last reise that I'll ever cut in the bonny woods of Ellangowan.'

So saying, she broke the sapling she held in her hand and flung it into the road.

<div align="right">Guy Mannering (1815)</div>

What wonder if the world sat up to listen! To praise such a composition would be superfluous indeed, and I cite it for no such purpose. A man who could miss or mistake the impression, would be beyond instruction by words. . . . "RIDE YOUR WAYS," *said the gipsy; and in what other tongue could she have condensed her point—luxury, pride, domination, defied and bidden go to their own end—into three such sounds as these?*

Equally remarkable, perhaps even more so, if judged by the prevalent laxity of English rhetoric, is the faultless structure of the speech, the perfect attainment of that symmetry without stiffness which makes a frame organic. . . . Here Scott's craft is supreme, good enough for Racine, Euripides, or the Homer of the Ninth ILIAD.

<div align="right">A. W. VERRALL</div>

<div align="center">Collected Literary Essays, Classical and Modern (1913)</div>

<div align="center">

SAMUEL TAYLOR COLERIDGE

1 7 7 2 — 1 8 3 4

YOUTH AND AGE

</div>

Verse, a breeze mid blossoms straying,
Where Hope clung feeding, like a bee—
Both were mine! Life went a-maying
 With Nature, Hope, and Poesy,
 When I was young!

<div align="center">1031</div>

When I was young? —Ah, woful When!
Ah! for the change 'twixt Now and Then!
This breathing house not built with hands,
This body that does me grievous wrong,
O'er aery cliffs and glittering sands,
How lightly then it flashed along:—
Like those trim skiffs, unknown of yore,
On winding lakes and rivers wide,
That ask no aid of sail or oar,
That fear no spite of wind or tide!
Nought cared this body for wind or weather
When Youth and I lived in't together.

Flowers are lovely; Love is flower-like;
Friendship is a sheltering tree;
O! the joys, that came down shower-like,
Of Friendship, Love, and Liberty,
 Ere I was old!

Ere I was old? Ah woful Ere,
Which tells me, Youth's no longer here!
O Youth! for years so many and sweet,
'Tis known, that Thou and I were one,
I'll think it but a fond conceit—
It cannot be that Thou art gone!
Thy vesper-bell hath not yet tolled:—
And thou wert aye a masker bold!

What strange disguise hast now put on,
To make believe, that thou art gone?
I see these locks in silvery slips,
This drooping gait, this altered size:
But Spring-tide blossoms on thy lips,
And tears take sunshine from thine eyes!
Life is but thought: so think I will
That Youth and I are house-mates still.

Dew-drops are the gems of morning,
But the tears of mournful eve!
Where no hope is, life's a warning
That only serves to make us grieve,
 When we are old:

That only serves to make us grieve
With oft and tedious taking-leave,
Like some poor nigh-related guest,
That may not rudely be dismist;

1032

Yet hath outstayed his welcome while,
And tells the jest without the smile.

(1823–32)

This is one of the most perfect poems, for style, feeling, and everything,
that ever were written.

<div align="right">

JAMES HENRY LEIGH HUNT
Imagination and Fancy (1844)

</div>

SAMUEL TAYLOR COLERIDGE

1 7 7 2 — 1 8 3 4

FRANCE, AN ODE

I

Ye clouds! that far above me float and pause,
 Whose pathless march no mortal may control!
 Ye ocean-waves! that, wheresoe'er ye roll,
Yield homage only to eternal laws!
Ye woods! that listen to the night-birds' singing,
 Midway the smooth and perilous slope reclined,
Save when your own imperious branches swinging,
 Have made a solemn music of the wind!
Where, like a man beloved of God,
Through glooms, which never woodman trod,
 How oft, pursuing fancies holy,
My moonlight way o'er flowering weeds I wound,
 Inspired, beyond the guess of folly,
By each rude shape and wild unconquerable sound!
O ye loud waves! and O ye forests high!
 And O ye clouds that far above me soared!
Thou rising sun! thou blue rejoicing sky!
 Yea, every thing that is and will be free!
 Bear witness for me, wheresoe'er ye be,
 With what deep worship I have still adored
 The spirit of divinest Liberty.

II

When France in wrath her giant-limbs upreared,
 And with that oath, which smote air, earth and sea,
 Stamped her strong foot and said she would be free,
Bear witness for me, how I hoped and feared!

1033

With what a joy my lofty gratulation
 Unawed I sang, amid a slavish band:
And when to whelm the disenchanted nation,
 Like fiends embattled by a wizard's wand,
 The monarchs marched in evil day,
 And Britain join'd the dire array;
 Though dear her shores and circling ocean,
Though many friendships, many youthful loves
 Had swoln the patriot emotion
And flung a magic light o'er all her hills and groves;
Yet still my voice, unaltered, sang defeat
 To all that braved the tyrant-quelling lance,
And shame too long delay'd and vain retreat!
For ne'er, O Liberty! with partial aim
I dimmed thy light or damped thy holy flame;
 But blessed the paeans of delivered France,
And hung my head and wept at Britain's name.

III

'And what,' I said, 'though blasphemy's loud scream
 With that sweet music of deliverance strove!
 Though all the fierce and drunken passions wove
A dance more wild than e'er was maniac's dream!
 Ye storms, that round the dawning east assembled,
The sun was rising, though he hid his light!'
And when, to soothe my soul, that hoped and trembled
The dissonance ceased, and all seemed calm and bright;
 When France her front deep-scarr'd and gory
 Concealed with clustering wreaths of glory;
 When, insupportably advancing,
 Her arm made mockery of the warrior's tramp;
 While timid looks of fury glancing,
 Domestic treason, crushed beneath her fatal stamp,
Writhed like a wounded dragon in his gore;
 Then I reproached my fears that would not flee;
'And soon,' I said, 'shall Wisdom teach her lore
In the low huts of them that toil and groan!
And, conquering by her happiness alone,
 Shall France compel the nations to be free,
Till love and joy look round, and call the earth their own.'

IV

Forgive me, Freedom! O forgive those dreams!
 I hear thy voice, I hear thy loud lament,
 From bleak Helvetia's icy caverns sent—

I hear thy groans upon her blood-stained streams!
 Heroes, that for your peaceful country perished,
And ye that, fleeing, spot your mountain-snows
 With bleeding wounds; forgive me, that I cherished
One thought that ever blessed your cruel foes!
 To scatter rage, and traitorous guilt,
 Where Peace her jealous home had built;
 A patriot-race to disinherit
Of all that made their stormy wilds so dear;
 And with inexpiable spirit
To taint the bloodless freedom of the mountaineer—
O France, that mockest Heaven, adulterous, blind,
 And patriot only in pernicious toils!
Are these thy boasts, champion of human kind?
 To mix with kings in the low lust of sway,
Yell in the hunt, and share the murderous prey;
To insult the shrine of Liberty with spoils
 From freemen torn; to tempt and to betray?

 V

 The sensual and the dark rebel in vain,
Slaves by their own compulsion! In mad game
They burst their manacles and wear the name
 Of Freedom, graven on a heavier chain!
 O Liberty! with profitless endeavour
Have I pursued thee, many a weary hour;
 But thou nor swell'st the victor's strain, nor ever
Didst breathe thy soul in forms of human power.
 Alike from all, howe'er they praise thee,
 (Not prayer, nor boastful name delays thee)
 Alike from priestcraft's harpy minions,
 And factious blasphemy's obscener slaves,
 Thou speedest on thy subtle pinions,
The guide of homeless winds, and playmate of the waves!
And there I felt thee!—on that sea-cliff's verge,
 Whose pines, scarce travelled by the breeze above,
Had made one murmur with the distant surge!
Yes, while I stood and gazed, my temples bare,
And shot my being through earth, sea and air,
 Possessing all things with intensest love,
 O Liberty! my spirit felt thee there.

 (1798)

*The conversation turned after dinner on the lyrical poetry of the day,
and a question arose as to which was the most perfect ode that had been*

produced. Shelley contended for Coleridge's on Switzerland, beginning,
"Ye clouds."

PERCY BYSSHE SHELLEY
in Thomas Medwin's Conversations of Lord Byron (1824)

SAMUEL TAYLOR COLERIDGE

1 7 7 2 — 1 8 3 4

KUBLA KHAN

In Xanadu did Kubla Khan
 A stately pleasure-dome decree:
Where Alph, the sacred river, ran
Through caverns measureless to man
 Down to a sunless sea.
So twice five miles of fertile ground
 With walls and towers were girdled round:
And there were gardens bright with sinuous rills
Where blossom'd many an incense-bearing tree;
And here were forests ancient as the hills,
Enfolding sunny spots of greenery.

But O, that deep romantic chasm which slanted
Down the green hill athwart a cedarn cover!
A savage place! as holy and enchanted
As e'er beneath a waning moon was haunted
By woman wailing for her demon-lover!
And from this chasm, with ceaseless turmoil seething,
As if this earth in fast thick pants were breathing,
A mighty fountain momently was forced;
Amid whose swift half-intermitted burst
Huge fragments vaulted like rebounding hail,
Or chaffy grain beneath the thresher's flail:
And 'mid these dancing rocks at once and ever
It flung up momently the sacred river.
Five miles meandering with a mazy motion
Through wood and dale the sacred river ran,
Then reach'd the caverns measureless to man,
And sank in tumult to a lifeless ocean:
And 'mid this tumult Kubla heard from far
Ancestral voices prophesying war!

The shadow of the dome of pleasure
 Floated midway on the waves;
Where was heard the mingled measure
 From the fountain and the caves.
It was a miracle of rare device,
A sunny pleasure-dome with caves of ice!

A damsel with a dulcimer
 In a vision once I saw:
It was an Abyssinian maid,
 And on her dulcimer she play'd,
Singing of Mount Abora.
Could I revive within me,
 Her symphony and song,
To such a deep delight 'twould win me,
That with music loud and long,
I would build that dome in air,
That sunny dome! those caves of ice!
And all who heard should see them there,
And all should cry, Beware! Beware!
His flashing eyes, his floating hair!
Weave a circle round him thrice,
 And close your eyes with holy dread,
 For he on honey-dew hath fed,
And drunk the milk of Paradise.

(1798)

It is not easy to think of a greater piece of poetry than KUBLA KHAN. *. . . This statement is wont to upset some people terribly. A friend of mine, most right honourable in the literary sense, has said plaintively, "Really, after all, the* ODYSSEY *is a greater poem than* K. K." *Certainly it is—in the sense that the hogshead is a greater health than the nipperkin; but in no other. I once read a very clever paper in which the writer, taking the same side, asked passionately and repeatedly at the end,* "WHY *are we to call* K. K. 'pure poetry'?" *Unluckily he had answered himself a dozen lines before, in the words, "The interest of* K. K. *is to find out how it produces a poetical effect—for it does—* OUT OF SO LITTLE." WE *have found out—by adding to the little, to the almost nothing, of the opium dreams, the pure poetry of verse and diction and atmosphere generally.*

GEORGE SAINTSBURY
A History of English Prosody (1910)

CHRISTABEL

PART THE FIRST

'Tis the middle of night by the castle clock,
And the owls have awakened the crowing cock;
Tu—whit!—Tu—whoo!
And hark, again! the crowing cock
How drowsily it crew.

Sir Leoline, the Baron rich,
Hath a toothless mastiff bitch
From her kennel beneath the rock
Maketh answer to the clock,
Four for the quarters, and twelve for the hour;
Ever and aye, by shine and shower,
Sixteen short howls, not over loud;
Some say, she sees my lady's shroud.

Is the night chilly and dark?
The night is chilly, but not dark.
The thin grey cloud is spread on high,
It covers but not hides the sky.
The moon is behind, and at the full;
And yet she looks both small and dull.
The night is chill, the cloud is grey:
'Tis a month before the month of May,
And the Spring comes slowly up this way.

The lovely lady, Christabel,
Whom her father loves so well,
What makes her in the wood so late,
A furlong from the castle gate?
She had dreams all yesternight
Of her own betrothed knight;
And she in the midnight wood will pray
For the weal of her lover that's far away.

She stole along, she nothing spoke,
The sighs she heaved were soft and low,
And naught was green upon the oak,
But moss and rarest mistletoe:
She kneels beneath the huge oak tree,
And in silence prayeth she.

The lady sprang up suddenly,
The lovely lady, Christabel!
It moaned as near, as near can be,
But what it is, she cannot tell.—
On the other side it seems to be,
Of the huge, broad-breasted, old oak tree.

The night is chill; the forest bare;
Is it the wind that moaneth bleak?
There is not wind enough in the air
To move away the ringlet curl
From the lovely lady's cheek—
There is not wind enough to twirl
The one red leaf, the last of its clan,
That dances as often as dance it can,
Hanging so light, and hanging so high,
On the topmost twig that looks up at the sky.

Hush, beating heart of Christabel!
Jesu, Maria, shield her well!
She folded her arms beneath her cloak,
And stole to the other side of the oak.
 What sees she there?

There she sees a damsel bright,
Drest in a silken robe of white,
That shadowy in the moonlight shone:
The neck that made that white robe wan,
Her stately neck, and arms were bare;
Her blue-veined feet unsandal'd were
And wildly glittered here and there
The gems entangled in her hair.
I guess, 'twas frightful there to see
A lady so richly clad as she—
Beautiful exceedingly!
'Mary mother, save me now!'
(Said Christabel) 'And who art thou?'

The lady strange made answer meet,
And her voice was faint and sweet:—
'Have pity on my sore distress,
I scarce can speak for weariness:
Stretch forth thy hand, and have no fear!'
Said Christabel, 'How camest thou here?'
And the lady, whose voice was faint and sweet,
Did thus pursue her answer meet:—

1039

'My sire is of a noble line,
And my name is Geraldine:
Five warriors seized me yestermorn,
Me, even me, a maid forlorn:
They choked my cries with force and fright,
And tied me on a palfrey white.
The palfrey was as fleet as wind,
And they rode furiously behind.
They spurred amain, their steeds were white;
And once we crossed the shade of night.
As sure as Heaven shall rescue me,
I have no thought what men they be;
Nor do I know how long it is
(For I have lain entranced I wis)
Since one, the tallest of the five,
Took me from the palfrey's back,
A weary woman, scarce alive.
Some muttered words his comrades spoke:
He placed me underneath this oak,
He swore they would return with haste;
Whither they went I cannot tell—
I thought I heard, some minutes past,
Sounds as of a castle-bell.
Stretch forth thy hand' (thus ended she),
'And help a wretched maid to flee.'

Then Christabel stretched forth her hand
And comforted fair Geraldine:
'O well, bright dame! may you command
The service of Sir Leoline;
And gladly our stout chivalry
Will he send forth and friends withal
To guide and guard you safe and free
Home to your noble father's hall.'

She rose: and forth with steps they passed
That strove to be, and were not, fast.
Her gracious stars the lady blest,
And thus spake on sweet Christabel:
'All our household are at rest,
The hall as silent as the cell;
Sir Leoline is weak in health
And may not well awakened be,
But we will move as if in stealth
And I beseech your courtesy,
This night to share your couch with me.'

They crossed the moat, and Christabel
Took the key that fitted well;
A little door she opened straight,
All in the middle of the gate;
The gate that was ironed within and without,
Where an army in battle array had marched out.
The lady sank, belike through pain,
And Christabel with might and main
Lifted her up, a weary weight,
Over the threshold of the gate:
Then the lady rose again,
And moved, as she were not in pain.

So free from danger, free from fear,
They crossed the court: right glad they were.
And Christabel devoutly cried
To the lady by her side,
'Praise we the Virgin all divine
Who hath rescued thee from thy distress!'
'Alas, alas!' said Geraldine,
'I cannot speak for weariness.'
So free from danger, free from fear,
They crossed the court: right glad they were.

Outside her kennel, the mastiff old
Lay fast asleep, in moonshine cold.
The mastiff old did not awake
Yet she an angry moan did make!
And what can ail the mastiff bitch?
Never till now she uttered yell
Beneath the eye of Christabel.
Perhaps it is the owlet's scritch:
For what can ail the mastiff bitch?

They passed the hall, that echoes still,
Pass as lightly as you will!
The brands were flat, the brands were dying,
Amid their own white ashes lying;
But when the lady passed, there came
A tongue of light, a fit of flame;
And Christabel saw the lady's eye,
And nothing else saw she thereby,
Save the boss of the shield of Sir Leoline tall,
Which hung in a murky old niche in the wall.
'O softly tread,' said Christabel,
'My father seldom sleepeth well.'

Sweet Christabel her feet doth bare,
And jealous of the listening air
They steal their way from stair to stair,
Now in glimmer, and now in gloom,
And now they pass the Baron's room,
As still as death, with stifled breath!
And now have reached her chamber door:
And now doth Geraldine press down
The rushes of the chamber floor.

The moon shines dim in the open air,
And not a moonbeam enters here.
But they without its light can see
The chamber carved so curiously,
Carved with figures strange and sweet,
All made out of the carver's brain,
For a lady's chamber meet:
The lamp with twofold silver chain
Is fastened to an angel's feet.
The silver lamp burns dead and dim;
But Christabel the lamp will trim.
She trimmed the lamp, and made it bright,
And left it swinging to and fro,
While Geraldine, in wretched plight,
Sank down upon the floor below.

'O weary lady, Geraldine,
I pray you, drink this cordial wine!
It is a wine of virtuous powers;
My mother made it of wild flowers.'

'And will your mother pity me,
Who am a maiden most forlorn?'
Christabel answered—'Woe is me!
She died the hour that I was born.
I have heard the grey-haired friar tell,
How on her deathbed she did say,
That she should hear the castle-bell
Strike twelve upon my wedding-day.
O mother dear! that thou wert here!"
'I would,' said Geraldine, 'she were!'

But soon with altered voice, said she—
'Off, wandering mother! Peak and pine,
I have power to bid thee flee.'
Alas, what ails poor Geraldine?

Why stares she with unsettled eye?
Can she the bodiless dead espy?
And why with hollow voice cries she,
'Off, woman, off! this hour is mine—
Though thou her guardian spirit be,
Off, woman, off! 'tis given to me.'

Then Christabel knelt by the lady's side,
And raised to heaven her eyes so blue—
'Alas!' said she, 'this ghastly ride—
Dear lady! it hath wildered you!'
The lady wiped her moist cold brow,
And faintly said, ' 'Tis over now!'

Again the wild-flower wine she drank:
Her fair large eyes 'gan glitter bright,
And from the floor whereon she sank,
The lofty lady stood upright;
She was most beautiful to see,
Like a lady of a far countrée.

And thus the lofty lady spake—
'All they who live in the upper sky,
Do love you, holy Christabel!
And you love them, and for their sake
And for the good which me befell,
Even I in my degree will try,
Fair maiden, to requite you well.
But now unrobe yourself; for I
Must pray, ere yet in bed I lie.'

Quoth Christabel, 'So let it be!'
And as the lady bade, did she.
Her gentle limbs did she undress,
And lay down in her loveliness.

But through her brain of weal and woe
So many thoughts moved to and fro,
That vain it were her lids to close;
So half-way from the bed she rose,
And on her elbow did recline
To look at the lady Geraldine.

Beneath the lamp the lady bowed,
And slowly rolled her eyes around;
Then drawing in her breath aloud,
Like one that shuddered, she unbound

The cincture from beneath her breast:
Her silken robe, and inner vest,
Dropt to her feet, and full in view,
Behold! her bosom and half her side—
A sight to dream of, not to tell!
O shield her! shield sweet Christabel!

Yet Geraldine nor speaks nor stirs;
Ah! what a stricken look was hers!
Deep from within she seems half-way
To lift some weight with sick assay,
And eyes the maid and seeks delay;
Then suddenly as one defied
Collects herself in scorn and pride,
And lay down by the Maiden's side!—
And in her arms the maid she took,
 Ah wel-a-day!
And with low voice and doleful look
These words did say:
'In the touch of this bosom there worketh a spell,
Which is lord of thy utterance, Christabel!
Thou knowest to-night, and wilt know to-morrow,
This mark of my shame, this seal of my sorrow;
 But vainly thou warrest,
 For this is alone in
 Thy power to declare,
 That in the dim forest
 Thou heard'st a low moaning,
And found'st a bright lady, surpassingly fair:
And didst bring her home with thee in love and in charity,
To shield her and shelter her from the damp air.'

THE CONCLUSION TO PART THE FIRST

It was a lovely sight to see
The lady Christabel, when she
Was praying at the old oak tree.
 Amid the jagged shadows
 Of mossy leafless boughs,
 Kneeling in the moonlight,
 To make her gentle vows;
Her slender palms together prest,
Heaving sometimes on her breast;
Her face resigned to bliss or bale—
Her face, oh call it fair not pale,

1044

And both blue eyes more bright than clear,
Each about to have a tear.

With open eyes (ah woe is me!)
Asleep, and dreaming fearfully,
Fearfully dreaming, yet I wis,
Dreaming that alone, which is—
O sorrow and shame! Can this be she,
The lady, who knelt at the old oak tree?
And lo! the worker of these harms,
That holds the maiden in her arms,
Seems to slumber still and mild,
As a mother with her child.

A star hath set, a star hath risen,
O Geraldine! since arms of thine
Have been the lovely lady's prison.
O Geraldine! one hour was thine—
Thou'st had thy will! By tairn and rill,
The night-birds all that hour were still.
But now they are jubilant anew,
From cliff and tower, tu—whoo! tu—whoo!
Tu—whoo! tu—whoo! from wood and fell!

And see! the lady Christabel
Gathers herself from out her trance;
Her limbs relax, her countenance
Grows sad and soft; the smooth thin lids
Close o'er her eyes; and tears she sheds—
Large tears that leave the lashes bright!
And oft the while she seems to smile
As infants at a sudden light!

Yea, she doth smile, and she doth weep,
Like a youthful hermitess,
Beauteous in a wilderness,
Who, praying always, prays in sleep.
And, if she move unquietly,
Perchance, 'tis but the blood so free,
Comes back and tingles in her feet.
No doubt, she hath a vision sweet.
What if her guardian spirit 'twere,
What if she knew her mother near?
But this she knows, in joys and woes,
That saints will aid if men will call:
For the blue sky bends over all!

'Each matin bell,' the Baron saith,
'Knells us back to a world of death.'
These words Sir Leoline first said,
When he rose and found his lady dead:
These words Sir Leoline will say,
Many a morn to his dying day!

And hence the custom and law began,
That still at dawn the sacristan,
Who duly pulls the heavy bell,
Five and forty beads must tell
Between each stroke—a warning knell,
Which not a soul can choose but hear
From Bratha Head to Wyndermere.

Saith Bracy the bard, 'So let it knell!
And let the drowsy sacristan
Still count as slowly as he can!
There is no lack of such, I ween
As well fill up the space between.
In Langdale Pike and Witch's Lair,
And Dungeon-ghyll so foully rent,
With ropes of rock and bells of air
Three sinful sextons' ghosts are pent,
Who all give back, one after t'other,
The death-note to their living brother;
And oft too, by the knell offended,
Just as their one! two! three! is ended,
The devil mocks the doleful tale
With a merry peal from Borrowdale.'

The air is still! through mist and cloud
That merry peal comes ringing loud;
And Geraldine shakes off her dread,
And rises lightly from the bed;
Puts on her silken vestments white,
And tricks her hair in lovely plight,
And nothing doubting of her spell
Awakens the lady Christabel.
'Sleep you, sweet lady Christabel?
I trust that you have rested well.'

And Christabel awoke and spied
The same who lay down by her side—

O rather say, the same whom she
Raised up beneath the old oak tree!
Nay, fairer yet! and yet more fair!
For she belike hath drunken deep
Of all the blessedness of sleep!
And while she spake, her looks, her air
Such gentle thankfulness declare,
That (so it seemed) her girded vests
Grew tight beneath her heaving breasts.
'Sure I have sinned!' said Christabel,
'Now heaven be praised if all be well!'
And in low faltering tones, yet sweet,
Did she the lofty lady greet
With such perplexity of mind
As dreams too lively leave behind.

So quickly she rose, and quickly arrayed
Her maiden limbs, and having prayed
That He, who on the cross did groan,
Might wash away her sins unknown,
She forthwith led fair Geraldine
To meet her sire, Sir Leoline.

The lovely maid and the lady tall
Are pacing both into the hall,
And pacing on through page and groom
Enter the Baron's presence-room.

The Baron rose, and while he prest
His gentle daughter to his breast,
With cheerful wonder in his eyes
The lady Geraldine espies,
And gave such welcome to the same,
As might beseem so bright a dame!

But when he heard the lady's tale,
And when she told her father's name,
Why waxed Sir Leoline so pale,
Murmuring o'er the name again,
'Lord Roland de Vaux of Tryermaine?'

Alas! they had been friends in youth;
But whispering tongues can poison truth;
And constancy lives in realms above;
And life is thorny; and youth is vain:
And to be wroth with one we love,
Doth work like madness in the brain.

1047

And thus it chanced, as I divine,
With Roland and Sir Leoline.
Each spake words of high disdain.
And insult to his heart's best brother:
They parted—ne'er to meet again!
But never either found another
To free the hollow heart from paining—
They stood aloof, the scars remaining,
Like cliffs which had been rent asunder;
A dreary sea now flows between.
But neither heat, nor frost, nor thunder,
Shall wholly do away, I ween,
The marks of that which once hath been.

Sir Leoline, a moment's space,
Stood gazing on the damsel's face:
And the youthful Lord of Tryermaine
Came back upon his heart again.

O then the Baron forgot his age,
His noble heart swelled high with rage;
He swore by the wounds in Jesu's side,
He would proclaim it far and wide
With trump and solemn heraldry,
That they, who thus had wronged the dame,
Were base as spotted infamy!
'And if they dare deny the same,
My herald shall appoint a week
And let the recreant traitors seek
My tourney court—that there and then
I may dislodge their reptile souls
From the bodies and forms of men!'
He spake: his eye in lightning rolls!
For the lady was ruthlessly seized; and he kenned
In the beautiful lady the child of his friend!

And now the tears were on his face,
And fondly in his arms he took
Fair Geraldine, who met the embrace,
Prolonging it with joyous look.
Which when she viewed, a vision fell
Upon the soul of Christabel,
The vision of fear, the touch and pain!
She shrunk and shuddered, and saw again—
(Ah, woe is me! Was it for thee,
Thou gentle maid! such sights to see?)

Again she saw that bosom old,
Again she felt that bosom cold,
And drew in her breath with a hissing sound:
Whereat the Knight turned wildly round,
And nothing saw, but his own sweet maid
With eyes upraised, as one that prayed.

The touch, the sight, had passed away,
And in its stead that vision blest,
Which comforted her after-rest,
While in the lady's arms she lay,
Had put a rapture in her breast,
And on her lips and o'er her eyes
Spread smiles like light!
 With new surprise,
'What ails then my beloved child?
The Baron said—His daughter mild
Made answer, 'All will yet be well!'
I ween, she had no power to tell
Aught else: so mighty was the spell.

Yet he, who saw this Geraldine,
Had deemed her such a thing divine.
Such sorrow with such grace she blended,
As if she feared she had offended
Sweet Christabel, that gentle maid!
And with such lowly tones she prayed,
She might be sent without delay
Home to her father's mansion.

 'Nay!
Nay, by my soul!' said Leoline.
'Ho! Bracy the bard, the charge be thine!
Go thou, with music sweet and loud,
And take two steeds with trappings proud,
And take the youth whom thou lov'st best
To bear thy harp, and learn thy song,
And clothe you both in solemn vest,
And over the mountains haste along,
Lest wandering folk, that are abroad,
Detain you on the valley road.
'And when he has crossed the Irthing flood,
My merry bard! he hastes, he hastes
Up Knorren Moor, through Halegarth Wood,
And reaches soon that castle good
Which stands and threatens Scotland's wastes.

1049

'Bard Bracy! bard Bracy! your horses are fleet,
Ye must ride up the hall, your music so sweet,
More loud than your horses' echoing feet!
And loud and loud to Lord Roland call,
"Thy daughter is safe in Langdale hall!
Thy beautiful daughter is safe and free—
Sir Leoline greets thee thus through me.
He bids thee come without delay
With all thy numerous array;
And take thy lovely daughter home:
And he will meet thee on the way
With all his numerous array
White with their panting palfreys' foam":
And by mine honour! I will say,
That I repent me of the day
When I spake words of fierce disdain
To Roland de Vaux of Tryermaine!—
—For since that evil hour hath flown,
Many a summer's sun hath shone;
Yet ne'er found I a friend again
Like Roland de Vaux of Tryermaine.'

The lady fell, and clasped his knees,
Her face upraised, her eyes o'erflowing;
And Bracy replied, with faltering voice,
His gracious hail on all bestowing;—
'Thy words, thou sire of Christabel,
Are sweeter than my harp can tell;
Yet might I gain a boon of thee,
This day my journey should not be,
So strange a dream hath come to me;
That I had vowed with music loud
To clear yon wood from thing unblest,
Warned by a vision in my rest!
For in my sleep I saw that dove,
That gentle bird, whom thou dost love,
And call'st by thy own daughter's name—
Sir Leoline! I saw the same,
Fluttering, and uttering fearful moan,
Among the green herbs in the forest alone.
Which when I saw and when I heard,
I wonder'd what might ail the bird:
For nothing near it could I see,
Saw the grass and green herbs underneath the old tree.

'And in my dream, methought, I went
To search out what might there be found;
And what the sweet bird's trouble meant,
That thus lay fluttering on the ground.
I went and peered, and could descry
No cause for her distressful cry;
But yet for her dear lady's sake
I stooped, methought, the dove to take,
When lo! I saw a bright green snake
Coiled around its wings and neck.
Green as the herbs on which it couched,
Close by the dove's its head it crouched;
And with the dove it heaves and stirs,
Swelling its neck as she swelled hers!
I woke; it was the midnight hour,
The clock was echoing in the tower;
But though my slumber was gone by,
This dream it would not pass away—
It seems to live upon the eye!
And thence I vowed this selfsame day,
With music strong and saintly song
To wander through the forest bare,
Lest aught unholy loiter there.'

Thus Bracy said: the Baron, the while,
Half-listening heard him with a smile;
Then turned to Lady Geraldine,
His eyes made up of wonder and love;
And said in courtly accents fine,
'Sweet maid, Lord Roland's beauteous dove,
With arms more strong than harp or song,
Thy sire and I will crush the snake!'
He kissed her forehead as he spake,
And Geraldine in maiden wise,
Casting down her large bright eyes,
With blushing cheek and courtesy fine
She turned her from Sir Leoline;
Softly gathering up her train,
That o'er her right arm fell again;
And folded her arms across her chest,
And couched her head upon her breast,
And looked askance at Christabel——
Jesu, Maria, shield her well!

A snake's small eye blinks dull and shy,
And the lady's eyes they shrunk in her head,
Each shrunk up to a serpent's eye,
And with somewhat of malice, and more of dread,
At Christabel she looked askance!—
One moment—and the sight was fled!
But Christabel in dizzy trance
Stumbling on the unsteady ground
Shuddered aloud, with a hissing sound;
And Geraldine again turned round,
And like a thing, that sought relief,
Full of wonder and full of grief,
She rolled her large bright eyes divine
Wildly on Sir Leoline.

The maid, alas! her thoughts are gone,
She nothing sees—no sight but one!
The maid, devoid of guile and sin,
I know not how, in fearful wise
So deeply had she drunken in
That look, those shrunken serpent eyes,
That all her features were resigned
To this sole image in her mind:
And passively did imitate
That look of dull and treacherous hate!
And thus she stood, in dizzy trance,
Still picturing that look askance
With forced unconscious sympathy
Full before her father's view—
As far as such a look could be,
In eyes so innocent and blue!

And when the trance was o'er, the maid
Paused awhile, and inly prayed:
Then falling at the Baron's feet,
'By my mother's soul do I entreat
That thou this woman send away!'
She said: and more she could not say:
For what she knew she could not tell,
O'er-mastered by the mighty spell.

Why is thy cheek so wan and wild,
Sir Leoline? Thy only child
Lies at thy feet, thy joy, thy pride,
So fair, so innocent, so mild;
The same, for whom thy lady died!

O by the pangs of her dear mother
Think thou no evil of thy child!
For her, and thee, and for no other,
She prayed the moment ere she died:
Prayed that the babe, for whom she died,
Might prove her dear lord's joy and pride!
 That prayer her deadly pangs beguiled,
 Sir Leoline!
 And wouldst thou wrong thy only child,
 Her child and thine?

Within the Baron's heart and brain
If thoughts like these had any share,
They only swelled his rage and pain,
And did but work confusion there.
His heart was cleft with pain and rage,
His cheeks they quivered, his eyes were wild,
Dishonour'd thus in his old age;
Dishonour'd by his only child,
And all his hospitality
To the insulted daughter of his friend
By more than woman's jealousy
Brought thus to a disgraceful end—
He rolled his eye with stern regard
Upon the gentle minstrel bard,
And said in tones abrupt, austere—
'Why, Bracy! dost thou loiter here?
I bade thee hence!' The bard obeyed;
And turning from his own sweet maid,
The aged knight, Sir Leoline,
Led forth the lady Geraldine!

THE CONCLUSION TO PART THE SECOND

A little child, a limber elf,
Singing, dancing to itself,
A fairy thing with red round cheeks
That always finds, and never seeks,
Makes such a vision to the sight
As fills a father's eyes with light;
And pleasures flow in so thick and fast
Upon his heart, that he at last
Must needs express his love's excess
With words of unmeant bitterness.
Perhaps 'tis pretty to force together
Thoughts so all unlike each other;

To mutter and mock a broken charm,
To dally with wrong that does no harm.
Perhaps 'tis tender too and pretty
At each wild word to feel within
A sweet recoil of love and pity.
And what, if in a world of sin
(O sorrow and shame should this be true!)
Such giddiness of heart and brain
Comes seldom save from rage and pain,
So talks as it's most used to do.

<div align="right">(1797–1801)</div>

In the Edinburgh Review it was assailed with a malignity and a spirit of personal hatred that ought to have injured only the work in which such a tirade appeared: and this review was generally attributed (whether rightly or no I know not) to a man (William Hazlitt), who both in my presence and in my absence has repeatedly pronounced it the finest poem in the language.

<div align="right">WILLIAM HAZLITT

S. T. Coleridge's Biographia Literaria (1817)</div>

SAMUEL TAYLOR COLERIDGE

1 7 7 2 — 1 8 3 4

SYMPTOMS OF POETIC POWER

In the application of these principles to purposes of practical criticism as employed in the appraisal of works more or less imperfect, I have endeavoured to discover what the qualities in a poem are, which may be deemed promises and specific sypmtoms of poetic power, as distinguished from general talent determined to poetic composition by accidental motives, by an act of the will, rather than by the inspiration of a genial and productive nature. In this investigation, I could not, I thought, do better, than keep before me the earliest work of the greatest genius, that perhaps human nature has yet produced, our *myriadminded* Shakspere. I mean the "Venus and Adonis," and the "Lucrece"; works which give at once strong promises of the strength, and yet obvious proofs of the immaturity, of his genius. From these I abstracted the following marks, as characteristics of original poetic genius in general.

1. In the "Venus and Adonis," the first and most obvious excellence is the perfect sweetness of the versification; its adaptation to the subject; and the power displayed in varying the march of the words without passing into a loftier and more majestic rhythm than was demanded by the thoughts, or permitted by the propriety of preserving a sense of melody predominant. The delight in richness and sweetness of sound, even to a faulty excess, if it be evidently original, and not the result of an easily imitable mechanism, I regard as a highly favourable promise in the compositions of a young man. "The man that hath not music in his soul" can indeed never be a genuine poet. Imagery (even taken from nature, much more when transplanted from books, as travels, voyages, and works of natural history); affecting incidents; just thoughts; interesting personal or domestic feelings; and with these the art of their combination or intertexture in the form of a poem; may all by incessant effort be acquired as a trade, by a man of talents and much reading, who, as I once before observed, has mistaken an intense desire of poetic reputation for a natural poetic genius; the love of the arbitrary end for a possession of the peculiar means. But the sense of musical delight, with the power of producing it, is a gift of imagination; and this together with the power of reducing multitude into unity of effect, and modifying a series of thoughts by some one predominant thought or feeling, may be cultivated and improved, but can never be learned. It is in these that *poeta nascitur non fit.*

2. A second promise of genius is the choice of subjects very remote from the private interests and circumstances of the writer himself. At least I have found, that where the subject is taken immediately from the author's personal sensations and experiences, the excellence of a particular poem is but an equivocal mark, and often a fallacious pledge, of genuine poetic power. We may perhaps remember the tale of the statu·ary, who had acquired considerable reputation for the legs of his goddesses, though the rest of the statue accorded but indifferently with ideal beauty; till his wife, elated by her husband's praises, modestly acknowledged that she herself had been his constant model. In the "Venus and Adonis" this proof of poetic power exists even to excess. It is throughout as if a superior spirit more intuitive, more intimately conscious, even than the characters themselves, not only of every outward look and act, but of the flux and reflux of the mind in all its subtlest thoughts and feelings, were placing the whole before our view; himself meanwhile unparticipating in the passions, and actuated only by that pleasureable excitement, which had resulted from the energetic fervor of his own spirit in so vividly exhibiting, what it had so accurately and profoundly contemplated. I think, I should have conjectured from these poems, that even then the great instinct, which impelled the poet to the drama, was secretly working in him, prompting him by a series and never broken chain of imagery, always vivid and, because un-

1055

broken, often minute; by the highest effort of the picturesque in words, of which words are capable, higher perhaps than was ever realized by any other poet, even Dante not excepted; to provide a substitute for that visual language, that constant intervention and running comment by tone, look and gesture, which in his dramatic works he was entitled to expect from the players. His Venus and Adonis seem at once the characters themselves, and the whole representation of those characters by the most consummate actors. You seem to be told nothing, but to see and hear everything. Hence it is, that from the perpetual activity of attention required on the part of the reader; from the rapid flow, the quick change, and the playful nature of the thoughts and images; and above all from the alienation, and, if I may hazard such an expression, the utter *aloofness* of the poet's own feelings, from those of which he is at once the painter and the analyst; that though the very subject cannot but detract from the pleasure of a delicate mind, yet never was poem less dangerous on a moral account. Instead of doing as Ariosto, and as, still more offensively, Wieland has done, instead of degrading and deforming passion into appetite, the trials of love into the struggles of concupiscence; Shakspere has here represented the animal impulse itself, so as to preclude all sympathy with it, by dissipating the reader's notice among the thousand outward images, and now beautiful, now fanciful circumstances, which form its dresses and its scenery; or by diverting our attention from the main subject by those frequent witty or profound reflections, which the poet's ever active mind has deduced from, or connected with, the imagery and the incidents. The reader is forced into too much action to sympathize with the merely passive of our nature. As little can a mind thus roused and awakened be brooded on by mean and indistinct emotion, as the low, lazy mist can creep upon the surface of a lake, while a strong gale is driving it onward in waves and billows.

3. It has been before observed that images, however beautiful, though faithfully copied from nature, and as accurately represented in words, do not of themselves characterize the poet. They become proofs of original genius only as far as they are modified by a predominate passion; or by associated thoughts or images awakened by that passion; or when they have the effect of reducing multitude to unity, or succession to an instant; or lastly, when a human and intellectual life is transferred to them from the poet's own spirit,

> Which shoots its being through earth, sea, and air.

In the two following lines for instance, there is nothing objectionable, nothing which would preclude them from forming, in their proper place, part of a descriptive poem:

> Behold yon row of pines, that shorn and bowed
> Bend from the sea-blast, seen at twilight eve.

But with a small alteration of rhythm, the same words would be equally in their place in a book of topography, or in a descriptive tour. The same image will rise into semblance of poetry if thus conveyed:

> Yon row of bleak and visionary pines,
> By twilight glimpse discerned, mark! how they flee
> From the fierce sea-blast, all their tresses wild
> Streaming before them.

I have given this as an illustration, by no means as an instance, of that particular excellence which I had in view, and in which Shakspere even in his earliest, as in his latest, works surpasses all other poets. It is by this, that he still gives a dignity and a passion to the objects which he presents. Unaided by any previous excitement, they burst upon us at once in life and in power.

> Full many a glorious morning have I seen
> *Flatter* the mountain tops with sovereign eye.
>
> <div align="right">SHAKSPERE, Sonnet 33rd</div>

> Not mine own fears, nor the prophetic soul
> Of the wide world dreaming on things to come—

<div align="center">✦ ✦ ✦ ✦</div>

> The mortal moon hath her eclipse endured,
> And the sad augurs mock their own presage;
> Incertainties now crown themselves assured,
> And Peace proclaims olives of endless age.
> Now with the drops of this most balmy time
> My Love looks fresh, and DEATH to me subscribes!
> Since spite of him, I'll live in this poor rhyme,
> While he insults o'er dull and speechless tribes.
> And thou in this shalt find thy monument,
> When tyrants' crests, and tombs of brass are spent.
>
> <div align="right">Sonnet 107</div>

As of higher worth, so doubtless still more characteristic of poetic genius does the imagery become, when it moulds and colors itself to the circumstances, passion, or character, present and foremost in the mind. For unrivalled instances of this excellence, the reader's own memory will refer him to the LEAR, OTHELLO, in short to which not of the *"great, ever living, dead man's"* dramatic works? *Inopem me copia fecit.* How true it is to nature, he has himself finely expressed in the instance of love in Sonnet 98.

From you have I been absent in the spring,
When proud pied April drest in all its trim
Hath put a spirit of youth in every thing,
That heavy Saturn laughed and leaped with him.
Yet nor the lays of birds, nor the sweet smell
Of different flowers in odour and in hue,
Could make me any summer's story tell,
Or from their proud lap pluck them, where they grew:
Nor did I wonder at the lilies white,
Nor praise the deep vermilion in the rose;
They were, though sweet, but figures of delight,
Drawn after you, you pattern of all those.
Yet seemed it winter still, and, you away,
As with your shadow I with these did play!

Scarcely less sure, or if a less valuable, not less indispensable mark

Γονίμου μὲν ποιητοῦ —
— ὅστις ῥῆμα γενναῖον λάκοι,

will the imagery supply, when, with more than the power of the painter, the poet gives us the liveliest image of succession with the feeling of simultaneousness!

With this, he breaketh from the sweet embrace
Of those fair arms, that held him to her heart,
And homeward through the dark lawns runs apace:
Look! how a bright star shooteth from the sky,
So glides he in the night from Venus' eye.

4. The last character I shall mention, which would prove indeed but little, except as taken conjointly with the former; yet without which the former could scarce exist in a high degree, and (even if this were possible) would give promises only of transitory flashes and a meteoric power; is DEPTH, and ENERGY of THOUGHT. No man was ever yet a great poet, without being at the same time a profound philosopher. For poetry is the blossom and the fragrancy of all human knowledge, human thoughts, human passions, emotions, language. In Shakspere's *poems* the creative power and the intellectual energy wrestle as in a war embrace. Each in its excess of strength seems to threaten the extinction of the other. At length in the DRAMA they were reconciled, and fought each with its shield before the breast of the other. Or like two rapid streams, that, at their first meeting within narrow and rocky banks, mutually strive to repel each other and intermix reluctantly and in tumult; but soon finding a wider channel and more yielding shores blend, and dilate, and flow on in one current and with one voice. The "Venus and Adonis" did not perhaps allow the display of the deeper passions. But the story of Lucretia seems to favor and even demand their

intensest workings. And yet we find in *Shakspere's* management of the tale neither pathos, nor any other *dramatic* quality. There is the same minute and faithful imagery as in the former poem, in the same vivid colors, inspirited by the same impetuous vigor of thought, and diverging and contracting with the same activity of the assimilative and of the modifying faculties; and with a yet larger display, a yet wider range of knowledge and reflection; and lastly, with the same perfect dominion, often *domination,* over the whole world of language. What then shall we say? even this; that Shakspere, no mere child of nature; no automaton of genius; no passive vehicle of inspiration possessed by the spirit, not possessing it; first studied patiently, meditated deeply, understood minutely, till knowledge, become habitual and intuitive, wedded itself to his habitual feelings, and at length gave birth to that stupendous power, by which he stands alone, with no equal or second in his own class; to that power which seated him on one of the two glory-smitten summits of the poetic mountain, with Milton as his compeer, not rival. While the former darts himself forth, and passes into all the forms of human character and passion, the one Proteus of the fire and the flood; the other attracts all forms and things to himself, into the unity of his own IDEAL. All things and modes of action shape themselves anew in the being of MILTON; while SHAKSPERE becomes all things, yet for ever remaining himself. O what great men hast thou not produced, England! my country! truly indeed—

> Must *we* be free or die, who speak the tongue,
> Which SHAKSPERE spake; the faith and morals hold,
> Which MILTON held. In every thing we are sprung
> Of earth's first blood, have titles manifold!

<div align="right">WORDSWORTH</div>

<div align="center">Biographia Literaria (1817), xv</div>

The whole of Chapter XV., for instance, in which the specific elements of "poetic power" are "distinguished from general talent determined to poetic composition by accidental motives," requires a close and sustained effort of the attention, but those who bestow it will find it amply repaid. I know of no dissertation conceived and carried out in terms of the abstract which in the result so triumphantly justifies itself upon application to concrete cases. As regards the question of poetic EXPRESSION, and the laws by which its true form is determined, Coleridge's analysis is, it seems to me, final. I cannot, at least, after the most careful reflection upon it, conceive it as being other than the absolutely last word on the subject.

<div align="right">H. D. TRAILL</div>
<div align="right">Samuel Taylor Coleridge (1902)</div>

ROBERT SOUTHEY

1 7 7 4 — 1 8 4 3

ODE

WRITTEN DURING THE NEGOCIATIONS
WITH BUONAPARTE, IN JANUARY, 1814

1

Who counsels peace at this momentous hour,
When God hath given deliverance to the oppress'd,
And to the injured power?
Who counsels peace, when Vengeance like a flood
Rolls on, no longer now to be repress'd;
When innocent blood
From the four corners of the world cries out
For justice upon one accursed head;
When Freedom hath her holy banner spread
Over all nations, now in one just cause
United; when with one sublime accord
Europe throws off the yoke abhorr'd,
And Loyalty and Faith and Ancient Laws
Follow the avenging sword!

2

Woe, woe to England! woe and endless shame,
If this heroic land,
False to her feelings and unspotted fame,
Hold out the olive to the Tyrant's hand!
Woe to the world, if Buonaparte's throne
Be suffer'd still to stand!
For by what names shall Right and Wrong be known, . .
What new and courtly phrases must we feign
For Falsehood, Murder, and all monstrous crimes,
If that perfidious Corsican maintain
Still his detested reign,
And France, who yearns even now to break her chain,
Beneath his iron rule be left to groan?
No! by the innumerable dead
Whose blood hath for his lust of power been shed,
Death only can for his foul deeds atone;
That peace which Death and Judgment can bestow,
That peace be Buonaparte's . . that alone!

For sooner shall the Ethiop change his skin,
Or from the Leopard shall her spots depart,
Than this man change his old flagitious heart.
Have ye not seen him in the balance weighed,
And there found wanting?—On the stage of blood
Foremost the resolute adventurer stood;
And when, by many a battle won,
He placed upon his brow the crown,
Curbing delirious France beneath his sway,
Then, like Octavius in old time,
Fair name might he have handed down,
Effacing many a stain of former crime.
Fool! should he cast away that bright renown!
Fool! the redemption proffer'd should he lose!
When Heaven such grace vouchsafed him that the way
To Good and Evil lay
Before him, which to choose.

4

But Evil was his Good,
For all too long in blood had he been nurst,
And ne'er was earth with verier tyrant curst.
Bold men and bad,
Remorseless, godless, full of fraud and lies,
And black with murders and with perjuries,
Himself in Hell's whole panoply he clad;
No law but his own headstrong will he knew,
No counsellor but his own wicked heart.
From evil thus portentous strength he drew,
And trampled under foot all human ties,
All holy laws, all natural charities.

5

O France! beneath this fierce Barbarian's sway
Disgraced thou art to all succeeding times;
Rapine, and blood, and fire have mark'd thy way,
All loathsome, all unutterable crimes.
A curse is on thee, France! from far and wide
It hath gone up to Heaven; all lands have cried
For vengeance upon thy detested head;
All nations curse thee, France! for wheresoe'er
In peace or war thy banner hath been spread,

All forms of human woe have follow'd there:
　　　The Living and the Dead
Cry out alike against thee! They who bear,
　Crouching beneath its weight, thine iron yoke,
　　Join in the bitterness of secret prayer
　　The voice of that innumerable throng
Whose slaughtered spirits day and night invoke
　　　The everlasting Judge of right and wrong,
How long, O Lord! Holy and Just, how long!

6

　A merciless oppressor hast thou been,
　Thyself remorselessly oppress'd meantime;
Greedy of war, when all that thou couldst gain
　Was but to dye thy soul with deeper crime,
　And rivet faster round thyself the chain.
　　O blind to honour, and to interest blind,
　　　When thus in abject servitude resign'd
To this barbarian upstart, thou couldst brave
God's justice, and the heart of humankind!
Madly thou thoughtest to enslave the world,
　　Thyself the while a miserable slave;
　Behold the flag of vengeance is unfurl'd!
The dreadful armies of the North advance;
While England, Portugal, and Spain combined
　Give their triumphant banners to the wind,
And stand victorious in the fields of France.

7

One man hath been for ten long wretched years
The cause of all this blood and all these tears;
　One man in this most aweful point of time
Draws on thy danger, as he caused thy crime.
　　Wait not too long the event,
　For now whole Europe comes against thee bent;
His wiles and their own strength the nations know;
　Wise from past wrongs, on future peace intent,
　The People and the Princes, with one mind,
　From all parts move against the general foe:
　　One act of justice, one atoning blow,
　　　One execrable head laid low,
　　Even yet, O France! averts thy punishment:
Open thine eyes! too long hast thou been blind;
Take vengeance for thyself, and for mankind!

France! if thou lov'st thine ancient fame,
 Revenge thy sufferings and thy shame!
By the bones that bleach on Jaffa's beach;
 By the blood which on Domingo's shore
 Hath clogg'd the carrion-birds with gore;
By the flesh that gorged the wolves of Spain,
 Or stiffen'd on the snowy plain
 Of frozen Muscovy;
 By the bodies that lie all open to the sky,
Tracking from Elbe to Rhine the Tyrant's flight;
 By the widow's and the orphan's cry,
 By the childless parent's misery,
 By the lives which he hath shed,
 By the ruin he hath spread,
By the prayers that rise for curses on his head,
 Redeem, O France! thine ancient fame,
 Revenge thy sufferings and thy shame;
Open thine eyes! . . too long hast thou been blind;
Take vengeance for thyself, and for mankind!

 By those horrors which the night
 Witness'd, when the torches' light
 To the assembled murderers show'd
 Where the blood of Condé flow'd;
 By thy murder'd Pichegru's fame;
By murder'd Wright, . . an English name;
 By murder'd Palm's atrocious doom;
 By murder'd Hofer's martyrdom;
Oh! by the virtuous blood thus vilely spilt,
 The Villain's own peculiar private guilt,
Open thine eyes! too long hast thou been blind!
Take vengeance for thyself and for mankind!

Since Milton's immortal imprecation,—

 'Avenge, oh Lord, thy slaughtered Saints whose bones
 Lie scattered on the Alpine mountains cold'

there has been no occasional poem equal to it in grandeur and power.
Nor any indeed equal to it in art.

HENRY TAYLOR
in Ward's The English Poets (1880)

LOCULUS AUREOLUS

I would seriously recommend to the employer of our critics, young and old, that he oblige them to pursue a course of study such as this: that under the superintendence of some respectable student from the university, they first read and examine the contents of the book; a thing greatly more useful in criticism than is generally thought; secondly, that they carefully write them down, number them, and range them under their several heads; thirdly, that they mark every beautiful, every faulty, every ambiguous, every uncommon expression. Which being completed, that they inquire what author, ancient or modern, has treated the same subject; that they compare them, first in smaller, afterward in larger portions, noting every defect in precision and its causes, every excellence and its nature; that they graduate these, fixing *plus* and *minus*, and designating them more accurately and discriminately by means of colours, stronger or paler. For instance, purple might express grandeur and majesty of thought; scarlet, vigour of expression; pink, liveliness; green, elegant and equable composition: these however and others, as might best attract their notice and serve their memory. The same process may be used where authors have not written on the same subject, when those who have are wanting, or have touched it but incidentally. Thus Addison and Fontenelle, not very like, may be compared in the graces of style, in the number and degree of just thoughts and lively fancies: thus the dialogues of Cicero with those of Plato, his ethics with those of Aristoteles, his orations with those of Demosthenes. It matters not if one be found superior to the other in this thing, and inferior in that; the exercise is taken; the qualities of two authors are explored and understood, and their distances laid down, as geographers speak, from accurate survey. The *plus* and *minus* of good and bad and ordinary, will have something of a scale to rest upon; and after a time the degrees of the higher parts in intellectual dynamics may be more nearly attained, though never quite exactly.

Imaginary Conversations, Southey and Porson (1824)

Nowhere, in ancient or modern place, is the education of the critic outlined with greater firmness and accuracy; and those who, by this or that good fortune, have been put through some such a process, may congratulate themselves on having learnt no vulgar art in no vulgar way.

GEORGE SAINTSBURY
A History of Criticism (1904)

LEOFRIC AND GODIVA

GODIVA

There is a dearth in the land, my sweet Leofric! Remember how many weeks of drought we have had, even in the deep pastures of Leicestershire; and how many Sundays we have heard the same prayers for rain, and supplications that it would please the Lord in his mercy to turn aside his anger from the poor pining cattle. You, my dear husband, have imprisoned more than one malefactor for leaving his dead ox in the public way; and other hinds have fled before you out of the traces, in which they and their sons and their daughters, and haply their old fathers and mothers, were dragging the abandoned wain homeward. Although we were accompanied by many brave spearmen and skilful archers, it was perilous to pass the creatures which the farm-yard dogs, driven from the hearth by the poverty of their masters, were tearing and devouring; while others, bitten and lamed, filled the air either with long and deep howls or sharp and quick barkings, as they struggled with hunger and feebleness or were exasperated by heat and pain. Nor could the thyme from the heath, nor the bruised branches of the fir-tree, extinguish or abate the foul odor.

LEOFRIC

And now, Godiva, my darling, thou art afraid we should be eaten up before we enter the gates of Coventry; or perchance that in the gardens there are no roses to greet thee, no sweet herbs for thy mat and pillow.

GODIVA

Leofric, I have no such fears. This is the month of roses: I find them everywhere since my blessed marriage: they, and all other sweet herbs, I know not why, seem to greet me wherever I look at them, as though they knew and expected me. Surely they can not feel that I am fond of them.

LEOFRIC

O light laughing simpleton! But what wouldst thou? I came not hither to pray; and yet if praying would satisfy thee, or remove the drought, I would ride up straightway to Saint Michael's and pray until morning.

GODIVA

I would do the same, O Leofric! but God hath turned away his ear from holier lips than mine. Would my own dear husband hear me, if I implored him for what is easier to accomplish? what he can do like God.

LEOFRIC

How! what is it?

GODIVA

I would not, in the first hurry of your wrath, appeal to you, my loving lord, in behalf of these unhappy men who have offended you.

LEOFRIC

Unhappy! is that all?

GODIVA

Unhappy they must surely be, to have offended you so grievously. What a soft air breathes over us! how quiet and serene and still an evening! how calm are the heavens and the earth! shall none enjoy them? not even we, my Leofric! The sun is ready to set: let it never set, O Leofric, on your anger. These are not my words; they are better than mine; should they lose their virtue from my unworthiness in uttering them!

LEOFRIC

Godiva, wouldst thou plead to me for rebels?

GODIVA

They have then drawn the sword against you! Indeed I knew it not.

LEOFRIC

They have omitted to send me my dues, established by my ancestors, well knowing of our nuptials, and of the charges and festivities they require, and that in a season of such scarcity my own lands are insufficient.

GODIVA

If they were starving as they said they were——

LEOFRIC

Must I starve too? Is it not enough to lose my vassals?

GODIVA

Enough! O God! too much! too much! may you never lose them! Give them life, peace, comfort, contentment. There are those among them who kissed me in my infancy, and who blessed me at the baptismal font. Leofric, Leofric! the first old man I meet I shall think is one of those; and I shall think on the blessing he gave, and (ah me!) on the blessing I bring back to him. My heart will bleed, will burst—and he will weep at it! he will weep, poor soul! for the wife of a cruel lord who denounces vengeance on him, who carries death into his family.

LEOFRIC

We must hold solemn festivals.

GODIVA

We must indeed.

LEOFRIC

Well then.

1066

GODIVA

Is the clamorousness that succeeds the death of God's dumb creatures, are crowded halls, are slaughtered cattle, festivals? are maddening songs and giddy dances, and hireling praises from party-coloured coats? Can the voice of a minstrel tell us better things of ourselves than our own internal one might tell us; or can his breath make our breath softer in sleep? O my beloved! let everything be a joyance to us: it will, if we will. Sad is the day, and worse must follow, when we hear the blackbird in the garden and do not throb with joy. But, Leofric, the high festival is strown by the servant of God upon the heart of man. It is gladness, it is thanksgiving; it is the orphan, the starveling, pressed to the bosom, and bidden as its first command-ment to remember its benefactor. We will hold this festival; the guests are ready: we may keep it up for weeks, and months, and years together, and always be the happier and the richer for it. The beverage of this feast, O Leofric, is sweeter than bee or flower or vine can give us: it flows from heaven; and in heaven will it abundantly be poured out again, to him who pours it out here unsparingly.

LEOFRIC

Thou art wild.

GODIVA

I have indeed lost myself. Some Power, some good kind Power, melts me (body and soul and voice) into tenderness and love. O my hus-band, we must obey it. Look upon me! look upon me! lift your sweet eyes from the ground! I will not cease to supplicate; I dare not.

LEOFRIC

We may think upon it.

GODIVA

Never say that! What! think upon goodness when you can be good? Let not the infants cry for sustenance! The mother of our blessed Lord will hear them; us never, never afterward.

LEOFRIC

Here comes the bishop: we are but one mile from the walls. Why dismountest thou? no bishop can expect it. Godiva! my honour and rank among men are humbled by this: Earl Godwin will hear of it: up! up! the bishop hath seen it: he urgeth his horse onward: dost thou not hear him now upon the solid turf behind thee?

GODIVA

Never, no, never will I rise, O Leofric, until you remit this most impious tax, this tax on hard labour, on hard life.

LEOFRIC

Turn round: look how the fat nag canters, as to the tune of a sinner's psalm, slow and hard-breathing. What reason or right can the people have to complain, while their bishop's steed is so sleek and well ca-parisoned? Inclination to change, desire to abolish old usages.—Up!

1067

up! for shame! They shall smart for it, idlers! Sir bishop, I must blush for my young bride.

GODIVA

My husband, my husband! will you pardon the city?

LEOFRIC

Sir bishop! I could not think you would have seen her in this plight. Will I pardon? yea, Godiva, by the holy rood, will I pardon the city, when thou ridest naked at noontide through the streets.

GODIVA

O my dear cruel Leofric, where is the heart you gave me! It was not so! can mine have hardened it!

BISHOP

Earl, thou abashest thy spouse; she turneth pale and weepeth. Lady Godiva, peace be with thee.

GODIVA

Thanks, holy man! peace will be with me when peace is with your city. Did you hear my lord's cruel word?

BISHOP

I did, lady.

GODIVA

Will you remember it, and pray against it?

BISHOP

Wilt *thou* forget it, daughter?

GODIVA

I am not offended.

BISHOP

Angel of peace and purity!

GODIVA

But treasure it up in your heart: deem it an incense, good only when it is consumed and spent, ascending with prayer and sacrifice. And now what was it?

BISHOP

Christ save us! that he will pardon the city when thou ridest naked through the streets at noon.

GODIVA

Did he not swear an oath?

BISHOP

He sware by the holy rood.

GODIVA

My Redeemer! thou hast heard it! save the city!

LEOFRIC

We are now upon the beginning of the pavement: these are the suburbs: let us think of feasting: we may pray afterward: to-morrow we shall rest.

1068

GODIVA

No judgments then to-morrow, Leofric?

LEOFRIC

None: we will carouse.

GODIVA

The saints of heaven have given me strength and confidence: my prayers are heard: the heart of my beloved is now softened.

LEOFRIC (*aside*)

Ay, ay—they shall smart though.

GODIVA

Say, dearest Leofric, is there indeed no other hope, no other mediation?

LEOFRIC

I have sworn: beside, thou hast made me redden and turn my face away from thee, and all the knaves have seen it: this adds to the city's crime.

GODIVA

I have blushed too, Leofric, and was not rash nor obdurate.

LEOFRIC

But thou, my sweetest, art given to blushing; there is no conquering it in thee. I wish thou hadst not alighted so hastily and roughly: it hath shaken down a sheaf of thy hair: take heed thou sit not upon it, lest it anguish thee. Well done! it mingleth now sweetly with the cloth of gold upon the saddle, running here and there, as if it had life and faculties and business, and were working thereupon some newer and cunninger device. O my beauteous Eve! there is a Paradise about thee! the world is refreshed as thou movest and breathest on it. I can not see or think of evil where thou art. I could throw my arms even here about thee. No signs for me! no shaking of sunbeams! no reproof or frown or wonderment—I *will* say it—now then for worse—I could close with my kisses thy half-open lips, ay, and those lovely and loving eyes, before the people.

GODIVA

To-morrow you shall kiss me, and they shall bless you for it. I shall be very pale, for to-night I must fast and pray.

LEOFRIC

I do not hear thee; the voices of the folk are so loud under this archway.

GODIVA (*to herself*)

God help them! good kind souls! I hope they will not crowd about me so to-morrow. O Leofric! could my name be forgotten! and yours alone remembered! But perhaps my innocence may save me from reproach! and how many as innocent are in fear and famine! No eye will open on me but fresh from tears. What a young mother for so large a family! Shall my youth harm me! Under God's hand it gives

me courage. Ah, when will the morning come! ah, when will the noon be over!

<div align="right">Imaginary Conversations, Leofric and Godiva (1829)</div>

At the finest Landor's is not only the most substantial but also the most musical of styles. No one has written prose so like poetry and yet so unfailingly true to the laws of prose.

<div align="right">HAVELOCK ELLIS
Introduction to Landor's Imaginary Conversations (1886)</div>

WALTER SAVAGE LANDOR

1 7 7 5 — 1 8 6 4

DIRCE

Stand close around, ye Stygian set,
With Dirce in one boat conveyed!
Or Charon, seeing, may forget
That he is old and she a shade.

<div align="right">(1831)</div>

There is nothing in the language comparable.

<div align="right">ALGERNON CHARLES SWINBURNE
Social Verse (1891)</div>

WALTER SAVAGE LANDOR

1 7 7 5 — 1 8 6 4

EPITAPH

LITERARUM QUÆSIVIT GLORIAM,
VIDET DEI.

He sought the glory of literature and now sees the glory of God.

<div align="right">Citation and Examination of
William Shakespeare (1834)</div>

That most perfect of all epitaphs.

<div align="right">JOHN BAILEY
The Continuity of Letters (1923)</div>

CHARLES LAMB

1 7 7 5 — 1 8 3 4

LONDON

Separate from the pleasure of your company, I don't much care if I never see a mountain in my life. I have passed all my days in London, until I have formed as many and intense local attachments, as any of you mountaineers can have done with dead nature. The Lighted shops of the Strand, . . . the innumerable trades, tradesmen and customers, coaches, waggons, playhouses, all the bustle and wickedness round about Covent Garden, the very women of the Town, the Watchmen, drunken scenes, rattles,—life awake, if you awake, at all hours of the night, the impossibility of being dull in Fleet Street, the crowds, the very dirt & mud, the Sun shining upon houses and pavements, the print shops, the old book stalls, parsons cheap'ning books, coffee houses, steams of soups from kitchens, the pantomimes, London itself a panto-mime and a masquerade,—all these things work themselves into my mind and feed me, without a power of satiating me. The wonder of these sights impells me into night-walks about her crowded streets, and I often shed tears in the motley Strand from fulness of joy at so much Life.

<div align="right">Letter to Wordsworth (January 30, 1801)</div>

The most perfect letter-writer in our language.

<div align="right">

WALTER RALEIGH
On Writing and Writers (1926)

</div>

JOSEPH BLANCO WHITE

1 7 7 5 — 1 8 4 1

TO NIGHT

Mysterious Night! when our first parent knew
Thee from report divine, and heard thy name,
Did he not tremble for this lovely frame,
This glorious canopy of light and blue?
Yet 'neath a curtain of translucent dew,
Bathed in the rays of the great setting flame,
Hesperus with the host of heaven came,

And lo! Creation widened in man's view.
Who could have thought such darkness lay concealed
Within thy beams, O sun! or who could find,
Whilst fly and leaf and insect stood revealed,
That to such countless orbs thou mad'st us blind!
Why do we then shun death with anxious strife?
If Light can thus deceive, wherefore not Life?

<div align="right">The Bijou (1828)</div>

*The finest and most graceful sonnet in our language (at least, it is only
in Milton's and Wordsworth's sonnets that I recollect any rival, and this
is not my judgment alone, but that of the man* κατ' ἐξοχὴν φιλόκαλον,
John Hookham Frere).

<div align="right">

SAMUEL TAYLOR COLERIDGE
Letter to White (November 28, 1827)

</div>

JANE AUSTEN

1 7 7 5 — 1 8 1 7

PRIDE AND PREJUDICE

CHAPTER I

It is a truth universally acknowledged, that a single man in possession of
a good fortune, must be in want of a wife.

However little known the feelings or views of such a man may be on
his first entering a neighbourhood, this truth is so well fixed in the minds
of the surrounding families, that he is considered as the rightful property
of some one or other of their daughters.

'My dear Mr. Bennet,' said his lady to him one day, 'have you heard
that Netherfield Park is let at last?'

Mr. Bennet replied that he had not.

'But it is,' returned she; 'for Mrs. Long has just been here, and she
told me all about it.'

Mr. Bennet made no answer.

'Do not you want to know who has taken it?' cried his wife im-
patiently.

'*You* want to tell me, and I have no objection to hearing it.'

This was invitation enough.

'Why, my dear, you must know, Mrs. Long says that Netherfield is

taken by a young man of large fortune from the north of England; that he came down on Monday in a chaise and four to see the place, and was so much delighted with it that he agreed with Mr. Morris immediately; that he is to take possession before Michaelmas, and some of his servants are to be in the house by the end of next week.'

'What is his name?'

'Bingley.'

'Is he married or single?'

'Oh! single, my dear, to be sure! A single man of large fortune; four or five thousand a year. What a fine thing for our girls!'

'How so? how can it affect them?'

'My dear Mr. Bennet,' replied his wife, 'how can you be so tiresome! You must know that I am thinking of his marrying one of them.'

'Is that his design in settling here?'

'Design! nonsense, how can you talk so! But it is very likely that he *may* fall in love with one of them, and therefore you must visit him as soon as he comes.'

'I see no occasion for that. You and the girls may go, or you may send them by themselves, which perhaps will be still better, for as you are as handsome as any of them, Mr. Bingley might like you the best of the party.'

'My dear, you flatter me. I certainly *have* had my share of beauty, but I do not pretend to be any thing extraordinary now. When a woman has five grown up daughters, she ought to give over thinking of her own beauty.'

'In such cases, a woman has not often much beauty to think of.'

'But, my dear, you must indeed go and see Mr. Bingley when he comes into the neighbourhood.'

'It is more than I engage for, I assure you.'

'But consider your daughters. Only think what an establishment it would be for one of them. Sir William and Lady Lucas are determined to go, merely on that account, for in general you know they visit no new comers. Indeed you must go, for it will be impossible for *us* to visit him, if you do not.'

'You are over scrupulous surely. I dare say Mr. Bingley will be very glad to see you; and I will send a few lines by you to assure him of my hearty consent to his marrying which ever he chuses of the girls; though I must throw in a good word for my little Lizzy.'

'I desire you will do no such thing. Lizzy is not a bit better than the others; and I am sure she is not half so handsome as Jane, nor half so good humoured as Lydia. But you are always giving *her* the preference.'

'They have none of them much to recommend them,' replied he; 'they are all silly and ignorant like other girls; but Lizzy has something more of quickness than her sisters.'

'Mr. Bennet, how can you abuse your own children in such a way?

You take delight in vexing me. You have no compassion on my poor nerves.'

'You mistake me, my dear. I have a high respect for your nerves. They are my old friends. I have heard you mention them with consideration these twenty years at least.'

'Ah! you do not know what I suffer.'

'But I hope you will get over it, and live to see many young men of four thousand a year come into the neighbourhood.'

'It will be no use to us, if twenty such should come since you will not visit them.'

'Depend upon it, my dear, that when there are twenty, I will visit them all.'

Mr. Bennet was so odd a mixture of quick parts, sarcastic humour, reserve, and caprice, that the experience of three and twenty years had been insufficient to make his wife understand his character. *Her* mind was less difficult to develop. She was a woman of mean understanding, little information, and uncertain temper. When she was discontented she fancied herself nervous. The business of her life was to get her daughters married; its solace was visiting and news.

(1813)

Possibly the shortest, wittiest, and most workmanlike first chaper in English fiction.

GERALD BULLETT
Readings in English Literature (1945)

ΓHOMAS CAMPBELL

1 7 7 7 -- 1 8 4 4

HOHENLINDEN

On Linden, when the sun was low,
All bloodless lay the untrodden snow,
And dark as winter was the flow
 Of Iser, rolling rapidly.

But Linden saw another sight
When the drum beat at dead of night,
Commanding fires of death to light
 The darkness of her scenery.

By torch and trumpet fast arrayed,
Each horseman drew his battle blade,
And furious every charger neighed
 To join the dreadful revelry.

Then shook the hills with thunder riven,
Then rushed the steed to battle driven,
And louder than the bolts of heaven
 Far flashed the red artillery.

But redder yet that light shall glow
On Linden's hills of stainèd snow,
And bloodier yet the torrent flow
 Of Iser, rolling rapidly.

'Tis morn, but scarce yon level sun
Can pierce the war-clouds, rolling dun,
Where furious Frank and fiery Hun
 Shout in their sulphurous canopy.

The combat deepens. On, ye brave,
Who rush to glory, or the grave!
Wave, Munich! all thy banners wave,
 And charge with all thy chivalry!

Few, few shall part where many meet!
The snow shall be their winding-sheet,
And every turf beneath their feet
 Shall be a soldier's sepulchre.

 (1803)

The BATTLE OF HOHENLINDEN *is of all modern compositions the most
lyrical in spirit and in sound.*

WILLIAM HAZLITT
The Spirit of the Age (1825)

THOMAS MOORE

1 7 7 9 — 1 8 5 2

I WISH I WAS BY THAT DIM LAKE

I wish I was by that dim Lake,
Where sinful souls their farewell take
Of this vain world, and half-way lie
In death's cold shadow, ere they die.

1075

There, there, far from thee,
Deceitful world, my home should be;
Where, come what might of gloom and pain,
False hope should ne'er deceive again.

The lifeless sky, the mournful sound
Of unseen waters falling round;
The dry leaves, quivering o'er my head,
Like man, unquiet even when dead!
These, ay, these shall wean
My soul from life's deluding scene,
And turn each thought, o'ercharged with gloom,
Like willows, downward towards the tomb.

As they, who to their couch at night
Would win repose, first quench the light,
So must the hopes, that keep this breast
Awake, be quenched, ere it can rest.
Cold, cold, this heart must grow,
Unmoved by either joy or woe,
Like freezing founts, where all that's thrown
Within their current turns to stone.

(1824)

It has been the fashion, of late days, to deny Moore imagination, while granting him fancy—a distinction originating with Coleridge—than whom no man more fully comprehended the great powers of Moore. The fact is, that the fancy of this poet so far predominates over all his other faculties, and over the fancy of all other men, as to have induced, very naturally, the idea that he is fanciful ONLY. But never was there a greater mistake. Never was a grosser wrong done the fame of a true poet. In the compass of the English language I can call to mind no poem more profoundly—more weirdly IMAGINATIVE, in the best sense, than the lines commencing—'I would I were by that dim lake'—which are the composition of Thomas Moore. I regret that I am unable to remember them.

EDGAR ALLAN POE
The Poetic Principle (1850)

FRÉTILLON

Francs amis des bonnes filles,
Vous connaissez Frétillon:
Ses charmes aux plus gentilles
Ont fait baisser pavillon.
 Ma Frétillon, (*bis.*)
 Cette fille
 Qui frétille.
N'a pourtant qu'un cotillon.

Deux fois elle eut équipage,
Dentelles et diamants,
Et deux fois mit tout en gage
Pour quelques fripons d'amants.
 Ma Frétillon,
 Cette fille
 Qui frétille,
Reste avec un cotillon.

Point de dame qui la vaille:
Cet hiver, dans son taudis,
Couché presque sur la paille,
Mes sens étaient engourdis;
 Ma Frétillon,
 Cette fille
 Qui frétille,
Mit sur moi son cotillon.

Mais que vient-on de m'apprendre?
Quoi! le peu qui lui restait,
Frétillon a pu le vendre
Pour un fat qui la battait!
 Ma Frétillon,
 Cette fille
 Qui frétille,
A vendu son cotillon.

En chemise, à la croisée,
Il lui faut tendre ses lacs.
A travers la toile usée
Amour lorgne ses appas.

1077

Ma Frétillon,
Cette fille
Qui frétille,
Est si bien sans cotillon.

Seigneurs, banquiers et notaires
La feront encor briller;
Puis encor des mousquetaires
Viendront la déshabiller.
Ma Frétillon,
Cette fille
Qui frétille,
Mourra sans un cotillon.

Hearty friend of good girls, you know Frétillon! Her charms cause the prettiest girls to confess defeat; my Frétillon, my Frétillon, the girl with a frisk, has still but one petticoat. Twice she had a coach, laces and diamonds, and twice she pawned them all for some rascally lovers. My Frétillon, the girl with a frisk, has only one petticoat left. No lady equals her. This winter in her hovel I was lying almost on straw. My senses were numb, but Frétillon, the girl with a frisk, threw her petticoat over me. But what have I just heard? What! the little that remains to her, Frétillon dared to sell for a fop who beat her! My Frétillon, the girl with a frisk, sold her petticoat. She stands in her shift at the window and spreads her snare; love espies her charms through the worn fabric of her shift. My Frétillon, the girl with a frisk, looks so well without a petticoat! Lords, bankers and notaries will make her shine again; then the rough soldiers will come to undress her. My Frétillon, the girl with a frisk, will die without a petticoat!

Frétillon gives us the perfection of the purely wanton spirit. It is the light trifle, the mere nothing, sprightly and free in all its grace.

C.-A. SAINTE-BEUVE
Causeries du lundi (1850)

THOMAS DE QUINCEY

1 7 8 5 — 1 8 5 9

LEVANA AND OUR LADIES OF SORROW

Oftentimes at Oxford I saw Levana in my dreams. I knew her by her Roman symbols. Who is Levana? Readers, that do not pretend to have leisure for very much scholarship, you will not be angry with me

for telling you. Levana was the Roman goddess that performed for the new-born infant the earliest office of ennobling kindness,—typical, by its mode, of that grandeur which belongs to man everywhere, and of that benignity in powers invisible which even in Pagan worlds sometimes descends to sustain it. At the very moment of birth, just as the infant tasted for the first time the atmosphere of our troubled planet, it was laid on the ground. That might bear different interpretations. But immediately, lest so grand a creature should grovel there for more than one instant, either the paternal hand, as proxy for the goddess Levana, or some near kinsman, as proxy for the father, raised it upright, bade it look erect as the king of all this world, and presented its forehead to the stars, saying, perhaps, in his heart, "Behold what is greater than yourselves!" This symbolic act represented the function of Levana. And that mysterious lady, who never revealed her face (except to me in dreams), but always acted by delegation, had her name from the Latin verb (as still it is the Italian verb) levare, to raise aloft.

This is the explanation of Levana. And hence it has arisen that some people have understood by Levana the tutelary power that controls the education of the nursery. She, that would not suffer at his birth even a prefigurative or mimic degradation for her awful ward, far less could be supposed to suffer the real degradation attaching to the non-development of his powers. She therefore watches over human education. Now, the word educo, with the penultimate short, was derived (by a process often exemplified in the crystallization of languages) from the word educo, with the penultimate long. Whatsoever educes, or develops, educates. By the education of Levana, therefore, is meant,—not the poor machinery that moves by spelling-books and grammars, but that mighty system of central forces hidden in the deep bosom of human life, which by passion, by strife, by temptation, by the energies of resistance, works forever upon children,—resting not day or night, any more than the mighty wheel of day and night themselves, whose moments, like restless spokes, are glimmering forever as they revolve.

If, then, these are the ministries by which Levana works, how profoundly must she reverence the agencies of grief! But you, reader! think, —that children generally are not liable to grief such as mine. There are two senses in the word generally,—the sense of Euclid, where it means universally (or in the whole extent of the genus), and a foolish sense of this world, where it means usually. Now, I am far from saying that children universally are capable of grief like mine. But there are more than you ever heard of who die of grief in this island of ours. I will tell you a common case. The rules of Eton require that a boy on the foundation should be there twelve years: he is superannuated at eighteen, consequently he must come at six. Children torn away from mothers and sisters at that age not unfrequently die. I speak of what I know. The complaint is not entered by the registrar as grief; but that it is.

Grief of that sort, and at that age, has killed more than ever have been counted amongst its martyrs.

Therefore it is that Levana often communes with the powers that shake man's heart: therefore it is that she dotes upon grief. "These ladies," said I softly to myself, on seeing the ministers with whom Levana was conversing, "these are the Sorrows; and they are three in number, as the Graces are three, who dress man's life with beauty; the Parcæ are three, who weave the dark arras of man's life in their mysterious loom always with colours sad in part, sometimes angry with tragic crimson and black; the Furies are three, who visit with retributions called from the other side of the grave offences that walk upon this; and once even the Muses were but three, who fit the harp, the trumpet, or the lute, to the great burdens of man's impassioned creations. These are the Sorrows, all three of whom I know." The last words I say now; but in Oxford I said, "one of whom I know, and the others too surely I shall know." For already, in my fervent youth, I saw (dimly relieved upon the dark back-ground of my dreams) the imperfect lineaments of the awful sisters. These sisters—by what name shall we call them?

If I say simply, "The Sorrows," there will be a chance of mistaking the term; it might be understood of individual sorrow,—separate cases of sorrow,—whereas I want a term expressing the mighty abstractions that incarnate themselves in all individual sufferings of man's heart; and I wish to have these abstractions presented as impersonations, that is, as clothed with human attributes of life, and with functions pointing to flesh. Let us call them, therefore, Our Ladies of Sorrow. I know them thoroughly, and have walked in all their kingdoms. Three sisters they are, of one mysterious household; and their paths are wide apart; but of their dominion there is no end. Them I saw often conversing with Levana, and sometimes about myself. Do they talk, then? O, no! Mighty phantoms like these disdain the infirmities of language. They may utter voices through the organs of man when they dwell in human hearts, but amongst themselves is no voice nor sound; eternal silence reigns in their kingdoms. They spoke not, as they talked with Levana; they whispered not; they sang not; though oftentimes methought they might have sung: for I upon earth had heard their mysteries oftentimes deciphered by harp and timbrel, by dulcimer and organ. Like God, whose servants they are, they utter their pleasure not by sounds that perish, or by words that go astray, but by signs in heaven, by changes on earth, by pulses in secret rivers, heraldries painted on darkness, and hieroglyphics written on the tablets of the brain. They wheeled in mazes; I spelled the steps. They telegraphed from afar; I read the signals. They conspired together; and on the mirrors of darkness my eye traced the plots. Theirs were the symbols; mine are the words.

What is it the sisters are? What is it that they do? Let me describe their form, and their presence; if form it were that still fluctuated in its

outline; or presence it were that forever advanced to the front, or forever receded amongst shades.

The eldest of the three is named Mater Lachrymarum, Our Lady of Tears. She it is that night and day raves and moans, calling for vanished faces. She stood, in Rama, where a voice was heard of lamentation,— Rachel weeping for her children, and refused to be comforted. She it was that stood in Bethlehem on the night when Herod's sword swept its nurseries of Innocents, and the little feet were stiffened forever, which, heard at times as they tottered along floors overhead, woke pulses of love in household hearts that were not unmarked in heaven.

Her eyes are sweet and subtile, wild and sleepy, by turns; oftentimes rising to the clouds, oftentimes challenging the heavens. She wears a diadem round her head. And I knew by childish memories that she could go abroad upon the winds, when she heard that sobbing of litanies, or the thundering of organs, and when she beheld the mustering of summer clouds. This sister, the elder, it is that carries keys more than papal at her girdle, which open every cottage and every palace. She, to my knowledge, sat all last summer by the bedside of the blind beggar, him that so often and so gladly I talked with, whose pious daughter, eight years old, with the sunny countenance, resisted the temptations of play and village mirth to travel all day long on dusty roads with her afflicted father. For this did God send her a great reward. In the springtime of the year, and whilst yet her own spring was budding, he recalled her to himself. But her blind father mourns forever over her; still he dreams at midnight that the little guiding hand is locked within his own; and still he wakens to a darkness that is now within a second and a deeper darkness. This Mater Lachrymarum also has been sitting all this winter of 1844-5 within the bedchamber of the Czar, bringing before his eyes a daughter (not less pious) that vanished to God not less suddenly, and left behind her a darkness not less profound. By the power of her keys it is that Our Lady of Tears glides a ghostly intruder into the chambers of sleepless men, sleepless woman, sleepless children, from Ganges to the Nile, from Nile to Mississippi. And her, because she is the first-born of her house, and has the widest empire, let us honour with the title of "Madonna."

The second sister is called Mater Suspiriorum, Our Lady of Sighs. She never scales the clouds nor walks abroad upon the winds. She wears no diadem. And her eyes, if they were ever seen, would be neither sweet nor subtile; no man could read their story; they would be found filled with perishing dreams, and with wrecks of forgotten delirium. But she raises not her eyes; her head, on which sits a dilapidated turban, droops forever, forever fastens on the dust. She weeps not. She groans not. But she sighs inaudibly at intervals. Her sister Madonna is oftentimes stormy and frantic, raging in the highest against heaven, and demanding back her darlings. But Our Lady of Sighs never clamours,

never defies, dreams not of rebellious aspirations. She is humble to abjectness. Hers is the meekness that belongs to the hopeless. Murmur she may, but it is in her sleep. Whisper she may, but it is to herself in the twilight. Mutter she does at times, but it is in solitary places that are desolate as she is desolate, in ruined cities, and when the sun has gone down to his rest. This sister is the visitor of the Pariah, of the Jew, of the bondsman to the oar in the Mediterranean galleys; of the English criminal in Norfolk Island, blotted out from the books of remembrance in sweet far-off England; of the baffled penitent reverting his eyes forever upon a solitary grave, which to him seems the altar overthrown of some past and bloody sacrifice, on which altar no oblations can now be availing, whether towards pardon that he might implore, or towards reparation that he might attempt. Every slave that at noonday looks up to the tropical sun with timid reproach, as he points with one hand to the earth, our general mother, but for him a step-mother,—as he points with the other hand to the Bible, our general teacher, but against him sealed and sequestered; every woman sitting in darkness, without love to shelter her head, or hope to illumine her solitude, because the heaven-born instincts kindling in her nature germs of holy affections, which God implanted in her womanly bosom, having been stifled by social necessities, now burn sullenly to waste, like sepulchral lamps amongst the ancients; every nun defrauded of her unreturning May-time by wicked kinsman, whom God will judge; every captive in every dungeon; all that are betrayed, and all that are rejected; outcasts by traditionary law and children of hereditary disgrace,—all these walk with Our Lady of Sighs. She also carries a key; but she needs it little. For her kingdom is chiefly amongst the tents of Shem, and the houseless vagrant of every clime. Yet in the very highest ranks of man she finds chapels of her own; and even in glorious England there are some that, to the world, carry their heads as proudly as the reindeer, who yet secretly have received her mark upon their foreheads.

But the third sister, who is also the youngest——! Hush! whisper whilst we talk of her! Her kingdom is not large, or else no flesh should live; but within that kingdom all power is hers. Her head, turreted like that of Cybèle, rises almost beyond the reach of sight. She droops not; and her eyes rising so high might be hidden by distance. But, being what they are, they cannot be hidden; through the treble veil of crape which she wears, the fierce light of a blazing misery, that rests not for matins or for vespers, for noon of day or noon of night, for ebbing or for flowing tide, may be read from the very ground. She is the defier of God. She also is the mother of lunacies, and the suggestress of suicides. Deep lie the roots of her power; but narrow is the nation that she rules. For she can approach only those in whom a profound nature has been upheaved by central convulsions; in whom the heart trembles and the brain rocks under conspiracies of tempest from without and tempest from within.

Madonna moves with uncertain steps, fast or slow, but still with tragic grace. Our Lady of Sighs creeps timidly and stealthily. But this youngest sister moves with incalculable motions, bounding, and with a tiger's leaps. She carries no key; for, though coming rarely amongst men, she storms all doors at which she is permitted to enter at all. And her name is Mater Tenebrarum,—Our Lady of Darkness.

These were the Semnai Theai, or Sublime Goddesses, these were the Eumenides, or Gracious Ladies (so called by antiquity in shuddering propitiation) of my Oxford dreams. Madonna spoke. She spoke by her mysterious hand. Touching my head, she beckoned to Our Lady of Sighs; and what she spoke, translated out of the signs which (except in dreams) no man reads, was this:

"Lo! here is he, whom in childhood I dedicated to my altars. This is he that once I made my darling. Him I led astray, him I beguiled, and from heaven I stole away his young heart to mine. Through me did he become idolatrous; and through me it was, by languishing desires, that he worshipped the worm, and prayed to the wormy grave. Holy was the grave to him; lovely was its darkness; saintly its corruption. Him, this young idolator, I have seasoned for thee, dear gentle Sister of Sighs! Do thou take him now to thy heart, and season him for our dreadful sister. And thou,"—turning to the Mater Tenebrarum, she said,— "wicked sister, that temptest and hatest, do thou take him from her. See that thy sceptre lie heavy on his head. Suffer not woman and her tenderness to sit near him in his darkness. Banish the frailties of hope, wither the relenting of love, scorch the fountains of tears, curse him as only thou canst curse. So shall he be accomplished in the furnace, so shall he see the things that ought not to be seen, sights that are abominable, and secrets that are unutterable. So shall he read elder truths, sad truths, grand truths, fearful truths. So shall he rise again before he dies. And so shall our commission be accomplished which from God we had,— to plague his heart until we had unfolded the capacities of his spirit."

Suspiria de Profundis (1845)

A master of English prose, he stands alone.

R. BRIMLEY JOHNSON
in Craik's English Prose (1911)

THOMAS LOVE PEACOCK

1785 — 1866

THE WAR-SONG OF DINAS VAWR

The mountain sheep are sweeter,
But the valley sheep are fatter;
We therefore deemed it meeter
To carry off the latter.
We made an expedition;
We met a host, and quelled it;
We forced a strong position,
And killed the men who held it.

On Dyfed's richest valley,
Where herds of kine were browsing,
We made a mighty sally,
To furnish our carousing.
Fierce warriors rushed to meet us;
We met them, and o'erthrew them:
They struggled hard to beat us;
But we conquered them, and slew them.

As we drove our prize at leisure,
The king marched forth to catch us:
His rage surpassed all measure,
But his people could not match us.
He fled to his hall-pillars;
And, ere our force we led off,
Some sacked his house and cellars,
While others cut his head off.

We there, in strife bewild'ring,
Spilt blood enough to swim in:
We orphaned many children,
And widowed many women.
The eagles and the ravens
We glutted with our foemen;
The heroes and the cravens,
The spearmen and the bowmen.

We brought away from battle,
And much their land bemoaned them,
Two thousand head of cattle,
And the head of him who owned them:

Ednyfed, king of Dyfed,
His head was borne before us;
His wine and beasts supplied our feasts,
And his overthrow, our chorus.

(1829)

*The quintessence of all the war-songs that ever were written, and the
sum and substance of all the appetencies, tendencies, and consequences
of military glory.*

THOMAS LOVE PEACOCK
The Misfortunes of Elphin (1829)

LUDWIG UHLAND

1 7 8 7 — 1 8 6 2

DER GUTE KAMERAD

Ich hatt' einen Kameraden,
Einen bessern findst du nit.
Die Trommel schlug zum Streite,
Er ging an meiner Seite
In gleichem Schritt und Tritt.

Eine Kugel kam geflogen;
Gilt's mir oder gilt es dir?
Ihn hat es weggerissen,
Er liegt mir vor den Füssen,
Als wär's ein Stück von mir.

Will mir die Hand noch reichen,
Derweil ich eben lad':
"Kann dir die Hand nicht geben,
Bleib du im ew'gen Leben
Mein guter Kamerad!"

THE GOOD COMRADE

I had a trusty comrade
No better man you'll see.
We heard the bugles blowing,
To war together going
Still side by side were we.

1085

Then came a bullet flying;
For you, or me alone?
From me it tears him dying.
Now at my feet he's lying,
Oh, part of me is gone!

His hand is held toward me,
But I must load anew;
'Your hand I cannot hold, lad,
But bide you as of old, lad,
In heaven my comrade true!'

Translated by Norman Macleod

Uhland was a great student of earlier German literature and a great master of the narrative ballad, a form in which the folk-singers had not been particularly successful. In the pure lyric style he wrote one masterpiece, "Der gute Kamerad."

NORMAN MACLEOD
German Lyric Poetry (1930)

GEORGE GORDON, LORD BYRON

1 7 8 8 — 1 8 2 4

GRIEF

The all of thine that cannot die
Through dark and dread Eternity
 Returns again to me,
And more thy buried love endears
Than aught except its living years.

And Thou art Dead as
Young and Fair (1812)

I do not know, of its own kind, a more superb monument of grief. . . . Is not this great poetry? I think that it is. There is no falsehood here.

EDITH SITWELL
A Poet's Notebook (1943)

GEORGE GORDON, LORD BYRON

1 7 8 8 — 1 8 2 4

THE DESTRUCTION OF SENNACHERIB

I

The Assyrian came down like the wolf on the fold,
And his cohorts were gleaming in purple and gold;
And the sheen of their spears was like stars on the sea,
When the blue wave rolls nightly on deep Galilee.

II

Like the leaves of the forest when Summer is green,
That host with their banners at sunset were seen:
Like the leaves of the forest when Autumn hath blown,
That host on the morrow lay wither'd and strown.

III

For the Angel of Death spread his wings on the blast,
And breathed in the face of the foe as he pass'd;
And the eyes of the sleepers wax'd deadly and chill,
And their hearts but once heaved, and for ever grew still!

IV

And there lay the steed with his nostril all wide,
But through it there roll'd not the breath of his pride;
And the foam of his gasping lay white on the turf,
And cold as the spray of the rock-beating surf.

V

And there lay the rider distorted and pale,
With the dew on his brow, and the rust on his mail:
And the tents were all silent, the banners alone,
The lances unlifted, the trumpet unblown.

VI

And the widows of Ashur are loud in their wail,
And the idols are broke in the temple of Baal;
And the might of the Gentile, unsmote by the sword,
Hath melted like snow in the glance of the Lord!

(1815)

A faultless poem. Before anyone rises to take up this challenge, I would ask him to be sure that he understands the scope of the poem. It is an artifice, something like the LAYS OF ANCIENT ROME—*a ballad such as a Hebrew might have written at the time if ballads had been allowable (and I am not sure that they were not). It is a short, simple lyrical poem of a tragical time, a great deliverance. Its aim is to give the whole meaning truly, without conceit, without breaking the simple frame.*

W. P. KER
Collected Essays (1925)

GEORGE GORDON, LORD BYRON

1 7 8 8 — 1 8 2 4

THE SHIPWRECK

Then rose from sea to sky the wild farewell—
 Then shriek'd the timid, and stood still the brave—
Then some leap'd overboard with dreadful yell,
 As eager to anticipate their grave;
And the sea yawn'd around her like a hell,
 And down she suck'd with her the whirling wave,
Like one who grapples with his enemy,
And strives to strangle him before he die.

And first one universal shriek there rush'd,
 Louder than the loud ocean, like a crash
Of echoing thunder; and then all was hush'd,
 Save the wild wind and the remorseless dash
Of billows; but at intervals there gush'd,
 Accompanied with a convulsive splash,
A solitary shriek, the bubbling cry
Of some strong swimmer in his agony.

Don Juan (1819–24)

The description of the shipwreck has seldom, if ever, been equalled.

WILLIAM STEBBING
Five Centuries of English Verse (1910)

GEORGE GORDON, LORD BYRON

1 7 8 8 — 1 8 2 4

TRIPLE RHYME

But—Oh! ye lords of ladies intellectual,
Inform us truly, have they not hen-pecked you all?

Don Juan (1819–24)

The happiest triple rhyme, perhaps, that ever was written.

JAMES HENRY LEIGH HUNT
Imagination and Fancy (1845)

GEORGE GORDON, LORD BYRON

1 7 8 8 — 1 8 2 4

WHERE HE GAZED A GLOOM PERVADED

But bringing up the rear of this bright host
A Spirit of a different aspect waved
His wings, like thunder-clouds above some coast
Whose barren beach with frequent wrecks is paved;
His brow was like the deep when tempest-tossed;
Fierce and unfathomable thoughts engraved
Eternal wrath on his immortal face,
And *where* he gazed a gloom pervaded space.

The Vision of Judgment (1821)

I read to him THE VISION OF JUDGMENT. *He enjoyed it like a child, but his criticism went little beyond the exclamatory:* 'TOLL! GAR ZU GROSS! HIMMLISCH! UNÜBERTREFFLICH!' *etc. In general, the most strongly peppered passages pleased the best. . . . The stanza 24 he declared to be sublime.*

JOHANN WOLFGANG VON GOETHE
in Henry Crabb Robinson's On Books and Their Writers,
edited by E. J. Morley (1938)

EDWARD CRAVEN HAWTREY

1789 — 1862

HELEN ON THE WALLS OF TROY
LOOKING FOR HER BROTHERS

"Clearly the rest I behold of the dark-ey'd Sons of Achaia,
Known to me well are the Faces of all; their Names I remember;
Two—two only remain, whom I see not among the Commanders,
Kastor fleet in the Car—Polydeykës brave with the Cestus—
Own dear Brethren of mine—one Parent lov'd us as Infants.
Are they not here in the Host, from the Shores of lov'd Lakedaimon,
Or, tho' they came with the Rest in Ships that bound thro' the Waters,
Dare they not enter the Fight or stand in the Council of Heroes,
All for Fear of the Shame and Taunts my Crime has awaken'd?"
So said she;—long since they in Earth's soft Arms were reposing,
There, in their own dear Land, their Father-Land, Lakedaimon.

Translations of Two Passages of the Iliad (1843)

"νῦν δ' ἄλλους μὲν πάντας ὁρῶ ἑλίκωπας 'Αχαιούς,
οὕς κεν ἐὺ γνοίην καί τ' οὔνομα μυθησαίμην·
δοιὼ δ' οὐ δύναμαι ἰδέειν κοσμήτορε λαῶν,
Κάστορά θ' ἱππόδαμον καὶ πὺξ ἀγαθὸν Πολυδεύκεα,
αὐτοκασιγνήτω, τώ μοι μία γείνατο μήτηρ·
ἢ οὐχ ἑσπέσθην Λακεδαίμονος ἐξ ἐρατεινῆς,
ἢ δεύρω μὲν ἕποντο νέεσσ' ἔνι ποντοπόροισι,
νῦν αὖτ' οὐκ ἐθέλουσι μάχην καταδύμεναι ἀνδρῶν
αἴσχεα δειδιότες καὶ ὀνείδεα πόλλ', ἅ μοί ἐστιν."
ὣς φάτο, τοὺς δ' ἤδη κάτεχεν φυσίζοος αἶα
ἐν Λακεδαίμονι αὖθι, φίλῃ ἐν πατρίδι γαίῃ.

Iliad, iii, 234-44

*The most successful attempt hitherto made at rendering Homer into
English, the attempt in which Homer's general effect has been best
retained, is an attempt made in the hexameter measure. . . . it is the
one version of any part of the* ILIAD *which in some degree reproduces
for me the original effect of Homer: it is the best, and it is in hexameters.*

MATTHEW ARNOLD
On Translating Homer (1861)

HYMNE À LA DOULEUR

Frappe encore, ô Douleur, si tu trouves la place!
Frappe! ce cœur saignant t'abhorre et te rend grâce,
Puissance qui ne sais plaindre ni pardonner!
Quoique mes yeux n'aient plus de pleurs à te donner,
Il est peut-être en moi quelque fibre sonore
Qui peut sous ton regard se torturer encore,
Comme un serpent coupé, sur le chemin gisant,
Dont le tronçon se tord sous le pied du passant,
Quand l'homme, ranimant une rage assouvie,
Cherche encor la douleur où ne bat plus la vie!
Il est peut-être encor dans mon cœur déchiré
Quelque cri plus profond et plus inespéré
Que tu n'as pas encor tiré d'un âme humaine,
Musique ravissante aux transports de ta haine!
Cherche! je m'abandonne à ton regard jaloux,
Car mon cœur n'a plus rien à sauver de tes coups.

Souvent, pour prolonger ma vie et ma souffrance,
Tu visitas mon sein d'un rayon d'espérance,
Comme on aisse reprendre haleine aux voyageurs,
Pour les mener plus loin au sentier des douleurs;
Souvent, dans cette nuit qu'un éclair entrecoupe,
De la félicité tu me tendis la coupe,
Et quand elle écumait sous mes désirs ardents,
Ta main me la brisait pleine contre les dents,
Et tu me déchirais, dans tes cruels caprices,
La lèvre aux bords sanglants du vase des délices!
Et maintenant, triomphe! Il n'est plus dans mon cœur
Une fibre qui n'ait résonné sa douleur;
Pas un cheveu blanchi de ma tête penchée
Qui n'ait été broyé comme une herbe fauchée,
Pas un amour en moi qui n'ait été frappé,
Un espoir, un désir, qui n'ait péri trompé!
Et je cherche une place en mon cœur qui te craigne;
Mais je ne trouve plus en lui rien qui ne saigne!

Et cependant j'hésite, et mon cœur suspendu
Flotte encore incertain sur le nom qui t'est dû!

Ma bouche te maudit; mais n'osant te maudire,
Mon âme en gémissant te respecte et t'admire!
Tu fais l'homme, ô Douleur! oui, l'homme tout entier,
Comme le creuset l'or, et la flamme l'acier;
Comme le grès, noirci des débris qu'il enlève,
En déchirant le fer fait un tranchant au glaive.
Qui ne te connut point ne sait rien d'ici-bas;
Il foule mollement la terre, il n'y vit pas;
Comme sur un nuage il flotte sur la vie;
Rien n'y marque pour lui la route en vain suivie;
La sueur de son front n'y mouille pas sa main,
Son pied n'y heurte pas les cailloux du chemin;
Il n'y sait pas, à l'heure où faiblissent ses armes,
Retremper ses vertus aux flots brûlants des larmes,
Il n'y sait point combattre avec son propre cœur
Ce combat douloureux dont gémit le vainqueur,
Élever vers le ciel un cri qui le supplie,
S'affermir par l'effort sur son genou qui plie,
Et dans ses désespoirs, dont Dieu seul est témoin,
S'appuyer sur l'obstacle et s'élancer plus loin!

Pour moi, je ne sais pas à quoi tu me prépares,
Mais tes mains de leçons ne me sont point avares;
Tu me traites sans doute en favori des cieux,
Car tu n'épargnes pas les larmes à mes yeux.
Eh bien! je les reçois comme tu les envoies:
Tes maux seront mes biens, et tes soupirs mes joies.
Je sens qu'il est en toi, sans avoir combattu,
Une vertu divine au lieu de ma vertu;
Que tu n'es pas la mort de l'âme, mais sa vie;
Que ton bras, en frappant, guérit et vivifie,
Toi donc que ma souffrance a souvent accusé,
Toi, devant qui ce cœur s'est tant de fois brisé,
Reçois, Dieu trois fois saint, cet encens dont tout fume!
Oui, c'est le seul bûcher que la terre t'allume,
C'est le charbon divin dont tu brûles nos sens.
Quand l'autel est souillé, la douleur est l'encens!

HYMN TO SORROW

Strike again, O Sorrow, if you find the place! Strike! My bleeding heart abhors and thanks you, O power incapable of commiseration or forgiveness! Though my eyes have no more tears to give you, there is

in me, perhaps, some responding fiber that under your glance can suffer anew; like a cut serpent, prostrate on the road, whose stump twists under the foot of a passerby. When man, reviving a satiated rage, still seeks to inflict pain where life no longer throbs, there is perhaps still in my grief-torn heart some cry, deeper and more unexpected, that you have not yet drawn from a human soul, ravishing music to the raptures of your hate! Seek! I submit myself to your jealous glance, for my heart has nothing more to save from your blows. Often, to prolong my life and suffering, you visited my breast with a ray of hope, as travelers are allowed to recover their breath, in order to lead them further along the path of sorrow. Often, in the lightning-torn night, you tendered me the cup of happiness, and when it was brimming over with my warm desires, your hand smashed it full against my teeth, and you tore my lips in your cruel caprices, at the bloody rim of the vase of delight! And now, triumph! My heart no longer has a fiber that has not resounded with sorrow; not a whitened hair of my bent head that has not been crushed like cut grass, not one of my loves that has not been shattered, a hope, a desire, that has not perished in deception! And I seek a place in my heart that fears you, but I find nothing in it that does not bleed! Nevertheless, I hesitate, and in my suspense my heart still wavers uncertainly over the name that is due you! My lips curse you, but, not daring to curse you, my moaning soul respects and admires you! You make the man, O sorrow! Yes! the whole man, as the crucible makes the gold, and flame the steel; as the whetstone, blackened by the fragments it rubs off, sharpens the sword by cutting the iron. He who knew you not, knows nothing here below; he treads the earth softly, he does not live there. He drifts over life as on a cloud; nothing marks for him the path vainly followed, the sweat of his brow does not dampen his hand, his feet do not strike against the pebbles of the road. When his vigor flags, he does not know how to strengthen his virtues in the burning waters of tears, he does not know how to fight with his own heart the dolorous fight which makes the winner groan. He does not know how to beseech heaven, how to grow stronger by his own effort on his weakening knee, and in his despair, that God alone witnesses, how to brace himself on obstacles, and bound ahead. As for myself, I do not know for what you prepare me, but your hands are not sparing of lessons to me. You treat me, without doubt, as heaven's favorite, for you do not spare my eyes any tears. So be it! I receive them as you send them; your unhappiness will be my happiness and your sighs my joys. I feel that there is in you, without having fought, a divine virtue in place of my virtue; that you are not the death of the soul, but its life; that your arm, in striking, heals and vivifies. You, whom my suffering often has accused, you before whom this heart has been broken so many times, receive, God thrice-holy, this incense sent up by the world! Yes, it is

the only pyre that the earth kindles for you; it is the divine fuel with which you burn our senses. When the altar is defiled, sorrow is the incense!

The masterpiece of moral poetry and gnomic verse.

<div align="right">

ALBERT THIBAUDET
Histoire de la littérature française (1936)

</div>

ALPHONSE DE LAMARTINE

1 7 9 0 — 1 8 6 9

LE LAC

Ainsi, toujours poussés vers de nouveaux rivages,
Dans la nuit éternelle emportés sans retour,
Ne pourrons-nous jamais sur l'océan des âges
 Jeter l'ancre un seul jour?

O lac! l'année à peine a fini sa carrière,
Et près des flots chéris qu'elle devait revoir,
Regarde! je viens seul m'asseoir sur cette pierre
 Où tu la vis s'asseoir!

Tu mugissais ainsi sous ces roches profondes;
Ainsi tu te brisais sur leurs flancs déchirés:
Ainsi le vent jetait l'écume de tes ondes
 Sur ses pieds adorés.

Un soir, t'en souvient-il? nous voguions en silence;
On n'entendait au loin, sur l'onde et sous les cieux,
Que le bruit des rameurs qui frappaient en cadence
 Tes flots harmonieux.

Tout à coup des accents inconnus à la terre
Du rivage charmé frappèrent les échos;
Le flot fut attentif, et la voix qui m'est chère
 Laissa tomber ces mots:

'O temps, suspends ton vol! et vous, heures propices,
 Suspendez votre cours!
Laissez-nous savourer les rapides délices
 Des plus beaux de nos jours!

<div align="center">1094</div>

'Assez de malheureux ici-bas vous implorent:
 Coulez, coulez pour eux;
Prenez avec leurs jours les soins qui les dévorent;
 Oubliez les heureux.

'Mais je demande en vain quelques moments encore,
 Le temps m'échappe et fuit;
Je dis à cette nuit: "Sois plus lente"; et l'aurore
 Va dissiper la nuit.

'Aimons donc, aimons donc! de l'heure fugitive,
 Hâtons-nous, jouissons!
L'homme n'a point de port, le temps n'a point de rive;
 Il coule, et nous passons!'

Temps jaloux, se peut-il que ces moments d'ivresse,
Où l'amour à longs flots nous verse le bonheur,
S'envolent loin de nous de la même vitesse
 Que les jours de malheur?

Hé quoi! n'en pourrons-nous fixer au moins la trace?
Quoi! passés pour jamais? quoi! tout entiers perdus?
Ce temps qui les donna, ce temps qui les efface,
 Ne nous les rendra plus?

Éternité, néant, passé, sombres abîmes,
Que faites-vous des jours que vous engloutissez?
Parlez: nous rendrez-vous ces extases sublimes
 Que vous nous ravissez?

O lac! rochers muets! grottes! forêt obscure!
Vous que le temps épargne ou qu'il peut rajeunir,
Gardez de cette nuit, gardez, belle nature,
 Au moins le souvenir!

Qu'il soit dans ton repos, qu'il soit dans tes orages,
Beau lac, et dans l'aspect de tes riants coteaux,
Et dans ces noirs sapins, et dans ces rocs sauvages
 Qui pendent sur tes eaux!

Qu'il soit dans le zéphyr qui frémit et qui passe,
Dans les bruits de tes bords par tes bords répétés,
Dans l'astre au front d'argent qui blanchit ta surface
 De ses molles clartés!

Que le vent qui gémit, le roseau qui soupire,
Que les parfums légers de ton air embaumé,
Que tout ce qu'on entend, l'on voit ou l'on respire,
 Tout dise: 'Ils ont aimé!'

THE LAKE

Still tow'rd new shores we wend our unreturning way,
Into th' eternal night borne off before the blast;
May we then never on the ages' ocean cast
 Anchor for one sole day?

The year hath scarce attained its term and now alone,
By thy beloved waves, which she should see again,
O lake, behold, I come to sit upon this stone,
 Where she to sit was fain.

Thou murmurest then as now against thy rocky steep;
As now thou brok'st in foam upon thy sheltered sides;
And at her feet adored the breeze, as now, did sweep
 The spray from off thy tides.

One night, rememberest thou? in silence did we float;
Nought in the water heard or air was far and near,
Except the rowers' stroke, whose oars in cadence smote
 Upon thy waters clear;

When accents, all at once, unknown to mortal ear,
Th' enchanted echoes woke, and earth, air, water, all,
Straight hearkened, as the voice of her I held so dear
 These pregnant words let fall;

"O Time, suspend thy flight; and you, propitious hours,
 Your course a moment stay!
Let us the swift delights taste of this day of ours,
 Of this our fairest day!

Unfortunates enough on earth implore your power;
 For them alone flow yet!
Bear with their days away the cares that them devour
 And happy folk forget.

But I implore in vain a moment of delay;
 Time 'scapes me, still a-flight;
Unto the night I say, "Be slower!" And the day
 Will soon disperse the night.

Let us then love, love still and haste the hour that flees
 Now to enjoy. Alas!
Man hath no port and Time no shore hath its seas;
 It lapses and we pass.

Can't be, O jealous Time, that these our hours so sweet,
Wherein, by long-drawn draughts, Love pours us happiness,
With the same breathless speed away from us do fleet
　　As the days distress?

What! May we not avail at least to fix their trace?
Are they, then, wholly past and lost for evermore?
Will time, that gave them us and doth them now efface,
　　Them ne'er to us restore?

Death, Past, Eternity, ye black abysmal seas,
What do ye with the days ye swallow thus?
Say, will you give us back those rapturous ecstasies
　　That you bear off from us?

O lake, O grottoes dumb, rocks, forests dark and deep,
You that Time spares or young can cause again to be,
Keep off this night of ours, O goodly Nature, keep
　　At least the memory!

Be't in thy stormy days or in thy restful nights,
Fair lake, in the aspect of those thy bright hillsides,
Or in those somber pines or in those wilding heights,
　　That overhang thy tides,

Be't in the breeze that sighs and passes on its way,
In the sounds by thy shores echoed from place to place,
In yonder argent star, that with its dulcet ray
　　Silvers thy smiling face.

Let, let the wind that moans, let, let the reed that sighs,
The perfumes light that float in thine enbalsamed air,
Let all one hears and sees and breathes beneath the skies
　　Still "They have loved!" declare.

Translated by John Payne

Unhoped for perfection.

C.-A. SAINTE-BEUVE
Portraits contemporains (1832)

CHARLES WOLFE

1 7 9 1 — 1 8 2 3

THE BURIAL OF
SIR JOHN MOORE AFTER CORUNNA

Not a drum was heard, not a funeral note,
　As his corse to the rampart we hurried;
Not a soldier discharged his farewell shot
　O'er the grave where our hero we buried.

We buried him darkly at dead of night,
　The sods with our bayonets turning,
By the struggling moonbeam's misty light
　And the lanthorn dimly burning.

No useless coffin enclosed his breast,
　Not in sheet or in shroud we wound him;
But he lay like a warrior taking his rest
　With his martial cloak around him.

Few and short were the prayers we said,
　And we spoke not a word of sorrow;
But we steadfastly gazed on the face that was dead,
　And we bitterly thought of the morrow.

We thought, as we hollow'd his narrow bed
　And smooth'd down his lonely pillow,
That the foe and the stranger would tread o'er his head,
　And we far away on the billow!

Lightly they'll talk of the spirit that's gone,
　And o'er his cold ashes upbraid him—
But little he'll reck, if they let him sleep on
　In the grave where a Briton has laid him.

But half of our heavy task was done
　When the clock struck the hour for retiring;
And we heard the distant and random gun
　That the foe was sullenly firing.

Slowly and sadly we laid him down,
　From the field of his fame fresh and gory;
We carved not a line, and we raised not a stone,
　But we left him alone with his glory.

(1817)

PERCY BYSSHE SHELLEY

1 7 9 2 — 1 8 2 2

SPIRIT OF PLATO

Eagle! why soarest thou above that tomb?
To what sublime and star-ypaven home
　　Floatest thou?—
I am the image of swift Plato's spirit,
Ascending heaven; Athens doth inherit
　　His corpse below.

α.　Αἰετέ, τίπτε βέβηκας ὑπὲρ τάφον; ἢ τίνος, εἰπέ,
　　ἀστερόεντα θεῶν οἶκον ἀποσκοπέεις;
β.　Ψυχῆς εἰμὶ Πλάτωνος ἀποπταμένης ἐς Ὄλυμπον
　　εἰκών· σῶμα δὲ γῆ γηγενὲς Ἀτθὶς ἔχει.

The Greek Anthology, vii, 62

PERCY BYSSHE SHELLEY

1 7 9 2 — 1 8 2 2

LOVE'S PHILOSOPHY

I

The fountains mingle with the river
 And the rivers with the Ocean,
The winds of Heaven mix for ever
 With a sweet emotion;
Nothing in the world is single;
 All things by a law divine
In one spirit meet and mingle.
 Why not I with thine?—

II

See the mountains kiss high Heaven
 And the waves clasp one another;
No sister-flower would be forgiven
 If it disdained its brother;
And the sunlight clasps the earth
 And the moonbeams kiss the sea:
What is all this sweet work worth
 If thou kiss not me?

(1819)

This poem, one of the most beautiful love-songs in our language, is technically miraculous. Those sounds of sparkling waters rippling and falling together are gained in part by the absence of any words beginning with a hard consonant (excepting, in the second verse, the words "brother," "clasp" and "kiss"—these being given to add ecstasy to the sweetness of the music)—partly by the almost invariable use of female rhymes in the first verse—(six out of the eight lines have female endings, the other two have exquisite bright vowels like the light shining through fountains before they reach the ground). The effect is gained, too, by the exquisite and flawless interweaving of two-syllabled words and one-syllabled words.

In the second verse we have the echo—or not so much echo as reinforcement, of the first line in the first verse; the vowel-scheme gives this echo—a little displaced in the line. In the last quatrain of the second verse there are no female endings, and this gives a greater poignancy and

depth than the exquisite lightness of the last quatrain in the first verse,
in which lines A and C are female, lines B and D are not.

E D I T H S I T W E L L
The Pleasures of Poetry, Second Series (1931)

PERCY BYSSHE SHELLEY

1 7 9 2 -- 1 8 2 2

VOICE IN THE AIR, SINGING

Life of Life! thy lips enkindle
 With their love the breath between them;
And thy smiles before they dwindle
 Make the cold air fire; then screen them
In those looks, where whoso gazes
Faints, entangled in their mazes.

Child of Light! thy limbs are burning
 Through the vest which seems to hide them;
As the radiant lines of morning
 Through the clouds ere they divide them;
And this atmosphere divinest
Shrouds thee wheresoe'er thou shinest.

Fair are others; none beholds thee,
 But thy voice sounds low and tender
Like the fairest, for it folds thee
 From the sight, that liquid splendour,
And all feel, yet see thee never,
As I feel now, lost for ever!

Lamp of Earth! where'er thou movest
 Its dim shapes are clad with brightness,
And the souls of whom thou lovest
 Walk upon the winds with lightness,
Till they fail, as I am failing,
Dizzy, lost, yet unbewailing!

Prometheus Unbound (1820)
Act ii, Scene v

This poem is probably the most wonderful example known of magic
wrought by a transcendental vowel-technique. I do not know any poem
where we are so conscious of the different wave-lengths of the changing

and shifting vowels. Shelley's variety, and his incomparable mastery over that variety, is not to be equalled.

<div align="right">

EDITH SITWELL

The Pleasures of Poetry, Second Series (1931)

</div>

PERCY BYSSHE SHELLEY

1 7 9 2 — 1 8 2 2

ADONAIS

I

I weep for Adonais—he is dead!
O, weep for Adonais! though our tears
Thaw not the frost which binds so dear a head!
And thou, sad Hour, selected from all years
To mourn our loss, rouse thy obscure compeers,
And teach them thine own sorrow, say: 'With me
Died Adonais; till the Future dares
Forget the Past, his fate and fame shall be
An echo and a light unto eternity!'

II

Where wert thou, mighty Mother, when he lay,
When thy Son lay, pierced by the shaft which flies
In darkness? where was lorn Urania
When Adonais died? With veilèd eyes,
'Mid listening Echoes, in her Paradise
She sate, while one, with soft enamoured breath,
Rekindled all the fading melodies,
With which, like flowers that mock the corse beneath,
He had adorned and hid the coming bulk of Death.

III

Oh, weep for Adonais—he is dead!
Wake, melancholy Mother, wake and weep!
Yet wherefore? Quench within their burning bed
Thy fiery tears, and let thy loud heart keep
Like his, a mute and uncomplaining sleep;
For he is gone, where all things wise and fair
Descend;—oh, dream not that the amorous Deep
Will yet restore him to the vital air;
Death feeds on his mute voice, and laughs at our despair.

<div align="center">

1102

</div>

IV

Most musical of mourners, weep again!
Lament anew, Urania!—He died,
Who was the Sire of an immortal strain,
Blind, old, and lonely, when his country's pride,
The priest, the slave, and the liberticide,
Trampled and mocked with many a loathèd rite
Of lust and blood; he went, unterrified,
Into the gulf of death; but his clear Sprite
Yet reigns o'er earth; the third among the sons of light.

V

Most musical of mourners, weep anew!
Not all to that bright station dared to climb;
And happier they their happiness who knew,
Whose tapers yet burn through that night of time
In which suns perished; others more sublime,
Struck by the envious wrath of man or God,
Have sunk, extinct in their refulgent prime;
And some yet live, treading the thorny road,
Which leads, through toil and hate, to Fame's serene abode.

VI

But now, thy youngest, dearest one, has perished—
The nursling of thy widowhood, who grew,
Like a pale flower by some sad maiden cherished,
And fed with true-love tears, instead of dew;
Most musical of mourners, weep anew!
Thy extreme hope, the loveliest and the last,
The bloom, whose petals nipped before they blew
Died on the promise of the fruit, is waste;
The broken lily lies—the storm is overpast.

VII

To that high Capital, where kingly Death
Keeps his pale court in beauty and decay,
He came; and bought, with price of purest breath,
A grave among the eternal.—Come away!
Haste, while the vault of blue Italian day
Is yet his fitting charnel-roof! while still
He lies, as if in dewy sleep he lay;
Awake him not! surely he takes his fill
Of deep and liquid rest, forgetful of all ill.

VIII

He will awake no more, oh, never more!—
Within the twilight chamber spreads apace
The shadow of white Death, and at the door
Invisible Corruption waits to trace
His extreme way to her dim dwelling-place;
The eternal Hunger sits, but pity and awe
Soothe her pale rage, nor dares she to deface
So fair a prey, till darkness, and the law
Of change, shall o'er his sleep the mortal curtain draw.

IX

Oh, weep for Adonais!—The quick Dreams,
The passion-wingèd ministers of thought,
Who were his flocks, whom near the living streams
Of his young spirit he fed, and whom he taught
The love which was its music, wander not,—
Wander no more, from kindling brain to brain,
But droop there, whence they sprung; and mourn their lot
Round the cold heart, where, after their sweet pain,
They ne'er will gather strength, or find a home again.

X

And one with trembling hands clasps his cold head,
And fans him with her moonlight wings, and cries;
'Our love, our hope, our sorrow, is not dead;
See, on the silken fringe of his faint eyes,
Like dew upon a sleeping flower, there lies
A tear some Dream has loosened from his brain.'
Lost Angel of a ruined Paradise!
She knew not 'twas her own; as with no stain
She faded, like a cloud which had outwept its rain.

XI

One from a lucid urn of starry dew
Washed his light limbs as if embalming them;
Another clipped her profuse locks, and threw
The wreath upon him, like an anadem,
Which frozen tears instead of pearls begem;
Another in her wilful grief would break
Her bow and wingèd reeds, as if to stem
A greater loss with one which was more weak;
And dull the barbèd fire against his frozen cheek.

XII

Another Splendour on his mouth alit,
That mouth, whence it was wont to draw the breath
Which gave it strength to pierce the guarded wit,
And pass into the panting heart beneath
With lightning and with music: the damp death
Quenched its caress upon his icy lips;
And, as a dying meteor stains a wreath
Of moonlight vapour, which the cold night clips,
It flushed through his pale limbs, and passed to its eclipse.

XIII

And others came . . . Desires and Adorations,
Wingèd Persuasions and veiled Destinies,
Splendours, and Glooms, and glimmering Incarnations
Of hopes and fears, and twilight Phantasies;
And Sorrow, with her family of Sighs,
And Pleasure, blind with tears, led by the gleam
Of her own dying smile instead of eyes,
Came in slow pomp;—the moving pomp might seem
Like pageantry of mist on an autumnal stream.

XIV

All he had loved, and moulded into thought,
From shape, and hue, and odour, and sweet sound,
Lamented Adonais. Morning sought
Her eastern watch-tower, and her hair unbound,
Wet with the tears which should adorn the ground,
Dimmed the aëreal eyes that kindle day;
Afar the melancholy thunder moaned,
Pale Ocean in unquiet slumber lay,
And the wild Winds flew round, sobbing in their dismay.

XV

Lost Echo sits amid the voiceless mountains,
And feeds her grief with his remembered lay,
And will no more reply to winds or fountains,
Or amorous birds perched on the young green spray,
Or herdsman's horn, or bell at closing day;
Since she can mimic not his lips, more dear
Than those for whose disdain she pined away
Into a shadow of all sounds:—a drear
Murmur, between their songs, is all the woodmen hear.

XVI

Grief made the young Spring wild, and she threw down
Her kindling buds, as if she Autumn were,
Or they dead leaves; since her delight is flown,
For whom should she have waked the sullen year?
To Phoebus was not Hyacinth so dear
Nor to himself Narcissus, as to both
Thou, Adonais: wan they stand and sere
Amid the faint companions of their youth,
With dew all turned to tears; odour, to sighing ruth.

XVII

Thy spirit's sister, the lorn nightingale
Mourns not her mate with such melodious pain;
Not so the eagle, who like thee could scale
Heaven, and could nourish in the sun's domain
Her mighty youth with morning, doth complain,
Soaring and screaming round her empty nest,
As Albion wails for thee: the curse of Cain
Light on his head who pierced thy innocent breast,
And scared the angel soul that was its earthly guest!

XVIII

Ah, woe is me! Winter is come and gone,
But grief returns with the revolving year;
The airs and streams renew their joyous tone;
The ants, the bees, the swallows reappear;
Fresh leaves and flowers deck the dead Seasons' bier;
The amorous birds now pair in every brake,
And build their mossy homes in field and brere;
And the green lizard, and the golden snake,
Like unimprisoned flames, out of their trance awake.

XIX

Through wood and stream and field and hill and Ocean
A quickening life from the Earth's heart has burst
As it has ever done, with change and motion,
From the great morning of the world when first
God dawned on Chaos; in its stream immersed,
The lamps of Heaven flash with a softer light;
All baser things pant with life's sacred thirst;
Diffuse themselves; and spend in love's delight,
The beauty and the joy of their renewèd might.

XX

The leprous corpse, touched by this spirit tender,
Exhales itself in flowers of gentle breath;
Like incarnations of the stars, when splendour
Is changed to fragrance, they illumine death
And mock the merry worm that wakes beneath;
Naught we know, dies. Shall that alone which knows
Be as a sword consumed before the sheath
By sightless lightning?—the intense atom glows
A moment, then is quenched in a most cold repose.

XXI

Alas! that all we loved of him should be,
But for our grief, as if it had not been,
And grief itself be mortal! Woe is me!
Whence are we, and why are we? of what scene
The actors or spectators? Great and mean
Meet massed in death, who lends what life must borrow.
As long as skies are blue, and fields are green,
Evening must usher night, night urge the morrow,
Month follow month with woe, and year wake year to sorrow.

XXII

He will awake no more, oh, never more!
'Wake thou,' cried Misery, 'childless Mother, rise
Out of thy sleep, and slake, in thy heart's core,
A wound more fierce than his, with tears and sighs.'
And all the Dreams that watched Urania's eyes,
And all the Echoes whom their sister's song
Had held in holy silence, cried: 'Arise!'
Swift as a Thought by the snake Memory stung,
From her ambrosial rest the fading Splendour sprung.

XXIII

She rose like an autumnal Night, that springs
Out of the East, and follows wild and drear
The golden Day, which, on eternal wings,
Even as a ghost abandoning a bier,
Had left the Earth a corpse. Sorrow and fear
So struck, so roused, so rapped Urania;
So saddened round her like an atmosphere
Of stormy mist; so swept her on her way
Even to the mournful place where Adonais lay.

XXIV

Out of her secret Paradise she sped,
Through camps and cities rough with stone, and steel,
And human hearts, which to her aery tread
Yielding not, wounded the invisible
Palms of her tender feet where'er they fell:
And barbèd tongues, and thoughts more sharp than they,
Rent the soft Form they never could repel,
Whose sacred blood, like the young tears of May,
Paved with eternal flowers that undeserving way.

XXV

In the death-chamber for a moment Death,
Shamed by the presence of that living Might,
Blushed to annihilation, and the breath
Revisited those lips, and Life's pale light
Flashed through those limbs, so late her dear delight.
'Leave me not wild and drear and comfortless,
As silent lightning leaves the starless night!
Leave me not!' cried Urania: her distress
Roused Death: Death rose and smiled, and met her vain caress.

XXVI

'Stay yet awhile! speak to me once again;
Kiss me, so long but as a kiss may live;
And in my heartless breast and burning brain
That word, that kiss, shall all thoughts else survive,
With food of saddest memory kept alive,
Now thou art dead, as if it were a part
Of thee, my Adonais! I would give
All that I am to be as thou now art!
But I am chained to Time, and cannot thence depart!

XXVII

'O gentle child, beautiful as thou wert,
Why didst thou leave the trodden paths of men
Too soon, and with weak hands though mighty heart
Dare the unpastured dragon in his den?
Defenceless as thou wert, oh, where was then
Wisdom the mirrored shield, or scorn the spear?
Or hadst thou waited the full cycle, when
Thy spirit should have filled its crescent sphere,
The monsters of life's waste had fled from thee like deer.

XXVIII

'The herded wolves, bold only to pursue;
The obscene ravens, clamorous o'er the dead;
The vultures to the conqueror's banner true
Who feed where Desolation first has fed,
And whose wings rain contagion;—how they fled,
When, like Apollo, from his golden bow
The Pythian of the age one arrow sped
And smiled!—The spoilers tempt no second blow,
They fawn on the proud feet that spurn them lying low.

XXIX

'The sun comes forth, and many reptiles spawn;
He sets, and each ephemeral insect then
Is gathered into death without a dawn,
And the immortal stars awake again;
So is it in the world of living men:
A godlike mind soars forth, in its delight
Making earth bare and veiling heaven, and when
It sinks, the swarms that dimmed or shared its light
Leave to its kindred lamps the spirit's awful night.'

XXX

Thus ceased she: and the mountain shepherds came,
Their garlands sere, their magic mantles rent;
The Pilgrim of Eternity, whose fame
Over his living head like Heaven is bent,
An early but enduring monument,
Came, veiling all the lightnings of his song
In sorrow; from her wilds Ierne sent
The sweetest lyrist of her saddest wrong,
And Love taught Grief to fall like music from his tongue.

XXXI

Midst others of less note, came one frail Form,
A phantom among men; companionless
As the last cloud of an expiring storm
Whose thunder is its knell; he, as I guess,
Had gazed on Nature's naked loveliness,
Actaeon-like, and now he fled astray
With feeble steps o'er the world's wilderness,
And his own thoughts, along that rugged way,
Pursued, like raging hounds, their father and their prey.

XXXII

A pardlike Spirit beautiful and swift—
A Love in desolation masked;—a Power
Girt round with weakness;—it can scarce uplift
The weight of the superincumbent hour;
It is a dying lamp, a falling shower,
A breaking billow;—even whilst we speak
Is it not broken? On the withering flower
The killing sun smiles brightly: on a cheek
The life can burn in blood, even while the heart may break.

XXXIII

His head was bound with pansies overblown,
And faded violets, white, and pied, and blue;
And a light spear topped with a cypress cone,
Round whose rude shaft dark ivy-tresses grew
Yet dripping with the forest's noonday dew,
Vibrated, as the ever-beating heart
Shook the weak hand that grasped it; of that crew
He came the last, neglected and apart;
A herd-abandoned deer struck by the hunter's dart.

XXXIV

All stood aloof, and at his partial moan
Smiled through their tears; well knew that gentle band
Who in another's fate now wept his own,
As in the accents of an unknown land
He sung new sorrow; sad Urania scanned
The Stranger's mien, and murmured: 'Who art thou?'
He answered not, but with a sudden hand
Made bare his branded and ensanguined brow,
Which was like Cain's or Christ's—oh! that it should be so!

XXXV

What softer voice is hushed over the dead?
Athwart what brow is that dark mantle thrown?
What form leans sadly o'er the white death-bed,
In mockery of monumental stone,
The heavy heart heaving without a moan?
If it be He, who, gentlest of the wise,
Taught, soothed, loved, honoured the departed one,
Let me not vex, with inharmonious sighs,
The silence of that heart's accepted sacrifice.

XXXVI

Our Adonais has drunk poison—oh!
What deaf and viperous murderer could crown
Life's early cup with such a draught of woe?
The nameless worm would now itself disown:
It felt, yet could escape, the magic tone
Whose prelude held all envy, hate, and wrong,
But what was howling in one breast alone,
Silent with expectation of the song,
Whose master's hand is cold, whose silver lyre unstrung.

XXXVII

Live thou, whose infamy is not thy fame!
Live! fear no heavier chastisement from me,
Thou noteless blot on a remembered name!
But be thyself, and know thyself to be!
And ever at thy season be thou free
To spill the venom when thy fangs o'erflow:
Remorse and Self-contempt shall cling to thee;
Hot Shame shall burn upon thy secret brow,
And like a beaten hound tremble thou shalt—as now.

XXXVIII

Nor let us weep that our delight is fled
Far from these carrion kites that scream below;
He wakes or sleeps with the enduring dead;
Thou canst not soar where he is sitting now.—
Dust to the dust! but the pure spirit shall flow
Back to the burning fountain whence it came,
A portion of the Eternal, which must glow
Through time and change, unquenchably the same,
Whilst thy cold embers choke the sordid hearth of shame.

XXXIX

Peace, peace! he is not dead, he doth not sleep—
He hath awakened from the dream of life—
'Tis we, who lost in stormy visions, keep
With phantoms an unprofitable strife,
And in mad trance, strike with our spirit's knife
Invulnerable nothings.—*We* decay
Like corpses in a charnel; fear and grief
Convulse us and consume us day by day,
And cold hopes swarm like worms within our living clay.

1111

XL

He has outsoared the shadow of our night;
Envy and calumny and hate and pain,
And that unrest which men miscall delight,
Can touch him not and torture not again;
From the contagion of the world's slow stain
He is secure, and now can never mourn
A heart grown cold, a head grown gray in vain;
Nor, when the spirit's self has ceased to burn,
With sparkless ashes load an unlamented urn.

XLI

He lives, he wakes—'tis Death is dead, not he;
Mourn not for Adonais.—Thou young Dawn,
Turn all thy dew to splendour, for from thee
The spirit thou lamentest is not gone;
Ye caverns and ye forests, cease to moan!
Cease, ye faint flowers and fountains, and thou Air,
Which like a mourning veil thy scarf hadst thrown
O'er the abandoned Earth, now leave it bare
Even to the joyous stars which smile on its despair!

XLII

He is made one with Nature: there is heard
His voice in all her music, from the moan
Of thunder, to the song of night's sweet bird;
He is a presence to be felt and known
In darkness and in light, from herb and stone,
Spreading itself where'er that Power may move
Which has withdrawn his being to its own;
Which wields the world with never-wearied love,
Sustains it from beneath, and kindles it above.

XLIII

He is a portion of the loveliness
Which once he made more lovely: he doth bear
His part, while the one Spirit's plastic stress
Sweeps through the dull dense world, compelling there,
All new successions to the forms they wear;
Torturing th' unwilling dross that checks its flight
To its own likeness, as each mass may bear;
And bursting in its beauty and its might
From trees and beasts and men into the Heaven's light.

XLIV

The splendours of the firmament of time
May be eclipsed, but are extinguished not;
Like stars to their appointed height they climb,
And death is a low mist which cannot blot
The brightness it may veil. When lofty thought
Lifts a young heart above its mortal lair,
And love and life contend in it, for what
Shall be its earthly doom, the dead live there
And move like winds of light on dark and stormy air.

XLV

The inheritors of unfulfilled renown
Rose from their thrones, built beyond mortal thought,
Far in the Unapparent. Chatterton
Rose pale,—his solemn agony had not
Yet faded from him; Sidney, as he fought
And as he fell and as he lived and loved
Sublimely mild, a Spirit without spot,
Arose; and Lucan, by his death approved:
Oblivion as they rose shrank like a thing reproved.

XLVI

And many more, whose names on Earth are dark,
But whose transmitted effluence cannot die
So long as fire outlives the parent spark,
Rose, robed in dazzling immortality.
'Thou art become as one of us,' they cry,
'It was for thee yon kingless sphere has long
Swung blind in unascended majesty,
Silent alone amid an Heaven of Song.
Assume thy wingèd throne, thou Vesper of our throng!'

XLVII

Who mourns for Adonais? Oh, come forth,
Fond wretch! and know thyself and him aright.
Clasp with thy panting soul the pendulous Earth;
As from a centre, dart thy spirit's light
Beyond all worlds, until its spacious might
Satiate the void circumference: then shrink
Even to a point within our day and night;
And keep thy heart light lest it make thee sink
When hope has kindled hope, and lured thee to the brink.

XLVIII

Or go to Rome, which is the sepulchre,
Oh, not of him, but of our joy: 'tis naught
That ages, empires, and religions there
Lie buried in the ravage they have wrought;
For such as he can lend,—they borrow not
Glory from those who made the world their prey;
And he is gathered to the kings of thought
Who waged contention with their time's decay,
And of the past are all that cannot pass away.

XLIX

Go thou to Rome,—at once the Paradise,
The grave, the city, and the wilderness;
And where its wrecks like shattered mountains rise,
And flowering weeds, and fragrant copses dress
The bones of Desolation's nakedness
Pass, till the spirit of the spot shall lead
Thy footsteps to a slope of green access
Where, like an infant's smile, over the dead
A light of laughing flowers along the grass is spread;

L

And gray walls moulder round, on which dull **Time**
Feeds, like slow fire upon a hoary brand;
And one keen pyramid with wedge sublime,
Pavilioning the dust of him who planned
This refuge for his memory, doth stand
Like flame transformed to marble; and beneath,
A field is spread, on which a newer band
Have pitched in Heaven's smile their camp of death,
Welcoming him we lose with scarce extinguished breath.

LI

Here pause: these graves are all too young as yet
To have outgrown the sorrow which consigned
Its charge to each; and if the seal is set,
Here, on one fountain of a mourning mind,
Break it not thou! too surely shalt thou find
Thine own well full, if thou returnest home,
Of tears and gall. From the world's bitter wind
Seek shelter in the shadow of the tomb.
What Adonais is, why fear we to become?

1114

LII

The One remains, the many change and pass:
Heaven's light forever shines, Earth's shadows fly;
Life, like a dome of many-coloured glass,
Stains the white radiance of Eternity,
Until Death tramples it to fragments.—Die,
If thou wouldst be with that which thou dost seek!
Follow where all is fled!—Rome's azure sky,
Flowers, ruins, statues, music, words, are weak
The glory they transfuse with fitting truth to speak.

LIII

Why linger, why turn back, why shrink, my Heart?
Thy hopes are gone before: from all things here
They have departed; thou shouldst now depart!
A light is passed from the revolving year,
And man, and woman; and what still is dear
Attracts to crush, repels to make thee wither.
The soft sky smiles,—the low wind whispers near:
'Tis Adonais calls! oh, hasten thither,
No more let Life divide what Death can join together.

LIV

That Light whose smile kindles the Universe,
That Beauty in which all things work and move,
That Benediction which the eclipsing Curse
Of birth can quench not, that sustaining Love
Which through the web of being blindly wove
By man and beast and earth and air and sea,
Burns bright or dim, as each are mirrors of
The fire for which all thirst; now beams on me,
Consuming the last clouds of cold mortality.

LV

The breath whose might I have invoked in song
Descends on me; my spirit's bark is driven,
Far from the shore, far from the trembling throng
Whose sails were never to the tempest given;
The massy earth and spherèd skies are riven!
I am borne darkly, fearfully, afar;
Whilst, burning through the inmost veil of Heaven,
The soul of Adonais, like a star,
Beacons from the abode where the Eternal are. (1821)

An elegy only equalled in our language by LYCIDAS,* *and in the point of passionate eloquence even superior to Milton's youthful lament for his friend.*

<div align="right">

JOHN ADDINGTON SYMONDS
Shelley (1879)

</div>

JOHN KEATS

1 7 9 5 — 1 8 2 1

FROM THE SONNET TO HOMER

There is a budding morrow in midnight.

<div align="right">

(1818?)

</div>

One of the finest lines in all poetry.

<div align="right">

DANTE GABRIEL ROSSETTI
Quoted, H. Buxton Forman
The Complete Works of John Keats (1901)

</div>

JOHN KEATS

1 7 9 5 — 1 8 2 1

ARS GRATIA ARTIS

"None can usurp this height," return'd that shade,
"But those to whom the miseries of the world
"Are misery, and will not let them rest.
"All else who find a haven in the world,
"Where they may thoughtless sleep away their days,
"If by a chance into this fane they come,
"Rot on the pavement where thou rotted'st half."

<div align="right">

The Fall of Hyperion: A Dream (1819)

</div>

In the words of Moneta in the VISION, *we find the most searing condemnation of Art for Art's Sake in English literature.*

<div align="right">

ALBERT GUÉRARD
Art for Art's Sake (1936)

</div>

* For *Lycidas,* see page 712.

<div align="center">

1116

</div>

JOHN KEATS

1 7 9 5 — 1 8 2 1

LA BELLE DAME SANS MERCI

I

O what can ail thee, Knight-at-arms,
 Alone and palely loitering?
The sedge has wither'd from the lake,
 And no birds sing!

II

O what can ail thee, Knight-at-arms,
 So haggard, and so woe-begone?
The squirrel's granary is full
 And the harvest's done.

III

I see a lilly on thy brow
 With anguish moist and fever dew;
And on thy cheeks a fading rose
 Fast withereth too.

IV

I met a lady in the meads,
 Full beautiful, a faery's child;
Her hair was long, her foot was light
 And her eyes were wild.

V

I made a garland for her head,
 And bracelets too, and fragrant zone;
She look'd at me as she did love,
 And made sweet moan.

VI

I set her on my pacing steed,
 And nothing else saw all day long;
For sidelong would she bend, and sing
 A faery's song.

She found me roots of relish sweet,
 And honey wild, and manna dew;
And sure in language strange she said,
 I love thee true.

VIII

She took me to her elfin grot,
 And there she wept and sigh'd full sore,
And there I shut her wild wild eyes—
 With kisses four.

IX

And there she lulled me asleep,
 And there I dream'd, Ah woe betide!
The latest dream I ever dreamt
 On the cold hill side.

X

I saw pale kings and princes too,
 Pale warriors, death-pale were they all;
Who cried—"La belle Dame sans merci
 Hath thee in thrall!"

XI

I saw their starv'd lips in the gloam
 With horrid warning gaped wide,
And I awoke, and found me here
 On the cold hill's side.

XII

And this is why I sojourn here
 Alone and palely loitering;
Though the sedge is wither'd from the lake
 And no birds sing.

(1820)

Probably the very finest lyric in the English language.

COVENTRY PATMORE
Principle in Art (1889)

ODE TO A NIGHTINGALE

I

My heart aches, and a drowsy numbness pains
 My sense, as though of hemlock I had drunk,
Or emptied some dull opiate to the drains
 One minute past, and Lethe-wards had sunk:
'Tis not through envy of thy happy lot,
 But being too happy in thine happiness,—
 That thou, light-winged Dryad of the trees,
 In some melodious plot
Of beechen green, and shadows numberless,
 Singest of summer in full-throated ease.

II

O, for a draught of vintage! that hath been
 Cool'd a long age in the deep-delved earth,
Tasting of Flora and the country green,
 Dance, and Provençal song, and sunburnt mirth!
O for a beaker full of the warm South,
 Full of the true, the blushful Hippocrene,
 With beaded bubbles winking at the brim,
 And purple-stained mouth;
That I might drink, and leave the world unseen,
 And with thee fade away into the forest dim:

III

Fade far away, dissolve, and quite forget
 What thou among the leaves hast never known,
The weariness, the fever, and the fret
 Here, where men sit and hear each other groan;
Where palsy shakes a few, sad, last gray hairs,
 Where youth grows pale, and spectre-thin, and dies;
 Where but to think is to be full of sorrow
 And leaden-eyed despairs,
Where beauty cannot keep her lustrous eyes,
 Or new Love pine at them beyond to-morrow.

IV

Away! away! for I will fly to thee,
 Not charioted by Bacchus and his pards,
But on the viewless wings of Poesy,
 Though the dull brain perplexes and retards:
Already with thee! tender is the night,
 And haply the Queen-Moon is on her throne,
 Cluster'd around by all her starry Fays;
 But here there is no light,
Save what from heaven is with the breezes blown
 Through verdurous glooms and winding mossy ways.

V

I cannot see what flowers are at my feet,
 Nor what soft incense hangs upon the boughs,
But, in embalmed darkness, guess each sweet
 Wherewith the seasonable month endows
The grass, the thicket, and the fruit-tree wild;
 White hawthorn, and the pastoral eglantine;
 Fast fading violets cover'd up in leaves;
 And mid-May's eldest child,
The coming musk-rose, full of dewy wine,
 The murmurous haunt of flies on summer eves.

VI

Darkling I listen; and, for many a time
 I have been half in love with easeful Death,
Call'd him soft names in many a mused rhyme,
 To take into the air my quiet breath;
Now more than ever seems it rich to die,
 To cease upon the midnight with no pain,
 While thou art pouring forth thy soul abroad
 In such an ecstasy!
 Still wouldst thou sing, and I have ears in vain—
 To thy high requiem become a sod.

VII

Thou wast not born for death, immortal Bird!
 No hungry generations tread thee down;
The voice I hear this passing night was heard
 In ancient days by emperor and clown:

Perhaps the self-same song that found a path
　　Through the sad heart of Ruth, when, sick for home,
　　　She stood in tears amid the alien corn;
　　　　The same that oft-times hath
　　Charm'd magic casements, opening on the foam
　　Of perilous seas, in faery lands forlorn.

<p style="text-align:center">VIII</p>

Forlorn! the very word is like a bell
　　To toll me back from thee to my sole self!
Adieu! the fancy cannot cheat so well
　　As she is fam'd to do, deceiving elf.
Adieu! adieu! thy plaintive anthem fades
　　Past the near meadows, over the still stream,
　　Up the hill-side; and now 'tis buried deep
　　　　In the next valley-glades:
　　Was it a vision, or a waking dream?
　　Fled is that music:—do I wake or sleep?

<p style="text-align:right">(1820)</p>

One of the final masterpieces of human work in all time and for all ages.
<p style="text-align:right">ALGERNON CHARLES SWINBURNE
Miscellanies (1886)</p>

<p style="text-align:center">*JOHN KEATS*</p>

<p style="text-align:center">1 7 9 5 — 1 8 2 1</p>

<p style="text-align:center">ODE TO PSYCHE</p>

O Goddess! hear these tuneless numbers, wrung
　　By sweet enforcement and remembrance dear,
And pardon that thy secrets should be sung
　　Even into thine own soft-conched ear:
Surely I dreamt to-day, or did I see
　　The winged Psyche with awaken'd eyes?
I wander'd in a forest thoughtlessly,
　　And, on the sudden, fainting with surprise,
Saw two fair creatures, couched side by side
　　In deepest grass, beneath the whisp'ring roof
　　Of leaves and trembled blossoms, where there ran
　　　　A brooklet, scarce espied:

<p style="text-align:center">1121</p>

'Mid hush'd, cool-rooted flowers, fragrant-eyed,
 Blue, silver-white, and budded Tyrian,
They lay calm-breathing on the bedded grass;
 Their arms embraced, and their pinions too;
 Their lips touch'd not, but had not bade adieu,
As if disjoined by soft-handed slumber,
And ready still past kisses to outnumber
 At tender eye-dawn of aurorean love:
 The winged boy I knew;
But who wast thou, O happy, happy dove?
 His Psyche true!

O latest born and loveliest vision far
 Of all Olympus' faded hierarchy!
Fairer than Phœbe's sapphire-region'd star,
 Or Vesper, amorous glow-worm of the sky;
Fairer than these, though temple thou hast none,
 Nor altar heap'd with flowers;
Nor virgin-choir to make delicious moan
 Upon the midnight hours;
No voice, no lute, no pipe, no incense sweet
 From chain-swung censer teeming;
No shrine, no grove, no oracle, no heat
 Of pale-mouth'd prophet dreaming.

O brightest! though too late for antique vows,
 Too, too late for the fond believing lyre,
When holy were the haunted forest boughs,
 Holy the air, the water, and the fire;
Yet even in these days so far retir'd
 From happy pieties, thy lucent fans,
 Fluttering among the faint Olympians,
I see, and sing, by my own eyes inspir'd.
So let me be thy choir, and make a moan
 Upon the midnight hours;
Thy voice, thy lute, thy pipe, thy incense sweet
 From swinged censer teeming;
Thy shrine, thy grove, thy oracle, thy heat
 Of pale-mouth'd prophet dreaming.

Yes, I will be thy priest, and build a fane
 In some untrodden region of my mind,
Where branched thoughts, new grown with pleasant pain,
 Instead of pines shall murmur in the wind:

Far, far around shall those dark-cluster'd trees
 Fledge the wild-ridged mountains steep by steep;
And there by zephyrs, streams, and birds, and bees,
 The moss-lain Dryads shall be lull'd to sleep;
And in the midst of this wide quietness
A rosy sanctuary will I dress
With the wreath'd trellis of a working brain,
 With buds, and bells, and stars without a name,
With all the gardener Fancy e'er could feign,
 Who breeding flowers, will never breed the same:
And there shall be for thee all soft delight
 That shadowy thought can win,
A bright torch, and a casement ope at night,
 To let the warm Love in!

<div align="right">(1820)</div>

ODE ON A GRECIAN URN

I

Thou still unravish'd bride of quietness,
 Thou foster-child of silence and slow time,
Sylvan historian, who canst thus express
 A flowery tale more sweetly than our rhyme:
What leaf-fring'd legend haunts about thy shape
 Of deities or mortals, or of both,
 In Tempe or the dales of Arcady?
 What men or gods are these? What maidens loth?
What mad pursuit? What struggle to escape?
 What pipes and timbrels? What wild ecstasy?

II

Heard melodies are sweet, but those unheard
 Are sweeter; therefore, ye soft pipes, play on;
Not to the sensual ear, but, more endear'd,
 Pipe to the spirit ditties of no tone:
Fair youth, beneath the trees, thou canst not leave
 Thy song, nor ever can those trees be bare;
 Bold Lover, never, never canst thou kiss,
Though winning near the goal—yet, do not grieve;
 She cannot fade, though thou hast not thy bliss,
 For ever wilt thou love, and she be fair!

III

Ah, happy, happy boughs! that cannot shed
 Your leaves, nor ever bid the Spring adieu;
And, happy melodist, unwearied,
 For ever piping songs for ever new;
More happy love! more happy, happy love!
 For ever warm and still to be enjoy'd,
 For ever panting, and for ever young;
All breathing human passion far above,
 That leaves a heart high-sorrowful and cloy'd,
 A burning forehead, and a parching tongue.

IV

Who are these coming to the sacrifice?
 To what green altar, O mysterious priest,
Lead'st thou that heifer lowing at the skies,
 And all her silken flanks with garlands drest?
What little town by river or sea shore,
 Or mountain-built with peaceful citadel,
 Is emptied of this folk, this pious morn?
And, little town, thy streets for evermore
 Will silent be; and not a soul to tell
 Why thou art desolate, can e'er return.

V

O Attic shape! Fair attitude! with brede
 Of marble men and maidens overwrought,
With forest branches and the trodden weed;
 Thou, silent form, dost tease us out of thought
As doth eternity: Cold Pastoral!
 When old age shall this generation waste,
 Thou shalt remain, in midst of other woe
Than ours, a friend to man, to whom thou say'st,
 "Beauty is truth, truth beauty,"—that is all
 Ye know on earth, and all ye need to know.

(1820)

Poems which for perfect apprehension and execution of all attainable in their own sphere would weight down all the world of poetry.
 ALGERNON CHARLES SWINBURNE
 Essays and Studies (1875)

JOHN KEATS

1 7 9 5 — 1 8 2 1

SONNET

*Written on a Blank Page in Shakespeare's Poems,
facing "A Lover's Complaint."*

Bright star, would I were stedfast as thou art—
　　Not in lone splendour hung aloft the night
And watching, with eternal lids apart,
　　Like nature's patient, sleepless Eremite,
The moving waters at their priestlike task
　　Of pure ablution round earth's human shores,
Or gazing on the new soft-fallen mask
　　Of snow upon the mountains and the moors—
No—yet still stedfast, still unchangeable,
　　Pillow'd upon my fair love's ripening breast,
To feel for ever its soft fall and swell,
　　Awake for ever in a sweet unrest,
Still, still to hear her tender-taken breath,
And so live ever—or else swoon to death.

(1820)

Perhaps the most beautiful single sonnet in the English language.
HENRI PEYRE
Writers and Their Critics (1944)

JOHN KEATS

1 7 9 5 — 1 8 2 1

WIDE-SPREADED NIGHT

As men talk in a dream, so Corinth all,
Throughout her palaces imperial,
And all her populous streets and temples lewd,
Mutter'd, like tempest in the distance brew'd,
To the wide-spreaded night above her towers.
Men, women, rich and poor, in the cool hours,

1125

Shuffled their sandals o'er the pavement white,
Companion'd or alone; while many a light
Flared, here and there, from wealthy festivals,
And threw their moving shadows on the walls,
Or found them cluster'd in the corniced shade
Of some arch'd temple door, or dusky colonnade.

<div align="right">Lamia (1820)</div>

*A masterpiece of descriptive imagination scarce to be surpassed in the
whole range of our poetry.*

<div align="right">

SIDNEY COLVIN
John Keats (1920)

</div>

JOHN KEATS

1 7 9 5 — 1 8 2 1

THE EVE OF ST. AGNES

I.

St. Agnes' Eve—Ah, bitter chill it was!
The owl, for all his feathers, was a-cold;
The hare limp'd trembling through the frozen grass,
And silent was the flock in woolly fold:
Numb were the Beadsman's fingers, while he told
His rosary, and while his frosted breath,
Like pious incense from a censer old,
Seem'd taking flight for heaven, without a death,
Past the sweet Virgin's picture, while his prayer he saith.

II.

His prayer he saith, this patient, holy man;
Then takes his lamp, and riseth from his knees,
And back returneth, meagre, barefoot, wan,
Along the chapel aisle by slow degrees:
The sculptur'd dead, on each side, seem to freeze,
Emprison'd in black, purgatorial rails:
Knights, ladies, praying in dumb orat'ries,
He passeth by; and his weak spirit fails
To think how they may ache in icy hoods and mails.

Northward he turneth through a little door,
And scarce three steps, ere Music's golden tongue
Flatter'd to tears this aged man and poor;
But no—already had his deathbell rung;
The joys of all his life were said and sung:
His was harsh penance on St. Agnes' Eve:
Another way he went, and soon among
Rough ashes sat he for his soul's reprieve,
And all night kept awake, for sinners' sake to grieve.

IV.

That ancient Beadsman heard the prelude soft;
And so it chanc'd, for many a door was wide,
From hurry to and fro. Soon, up aloft,
The silver, snarling trumpets 'gan to chide:
The level chambers, ready with their pride,
Were glowing to receive a thousand guests:
The carved angels, ever eager-eyed,
Star'd, where upon their heads the cornice rests,
With hair blown back, and wings put cross-wise on their breasts.

V.

At length burst in the argent revelry,
With plume, tiara, and all rich array,
Numerous as shadows haunting fairily
The brain, new stuff'd, in youth, with triumphs gay
Of old romance. These let us wish away,
And turn, sole-thoughted, to one Lady there,
Whose heart had brooded, all that wintry day,
On love, and wing'd St. Agnes' saintly care,
As she had heard old dames full many times declare.

VI.

They told her how, upon St. Agnes' Eve,
Young virgins might have visions of delight,
And soft adorings from their loves receive
Upon the honey'd middle of the night,
If ceremonies due they did aright;
As, supperless to bed they must retire,
And couch supine their beauties, lily white;
Nor look behind, nor sideways, but require
Of Heaven with upward eyes for all that they desire.

VII.

Full of this whim was thoughtful Madeline:
The music, yearning like a God in pain,
She scarcely heard: her maiden eyes divine,
Fix'd on the floor, saw many a sweeping train
Pass by—she heeded not at all: in vain
Came many a tiptoe, amorous cavalier,
And back retir'd; not cool'd by high disdain,
But she saw not: her heart was otherwhere:
She sigh'd for Agnes' dreams, the sweetest of the year.

VIII.

She danc'd along with vague, regardless eyes,
Anxious her lips, her breathing quick and short:
The hallow'd hour was near at hand: she sighs
Amid the timbrels, and the throng'd resort
Of whisperers in anger, or in sport;
'Mid looks of love, defiance, hate, and scorn,
Hoodwink'd with faery fancy; all amort,
Save to St. Agnes and her lambs unshorn,
And all the bliss to be before to-morrow morn.

IX.

So, purposing each moment to retire,
She linger'd still. Meantime, across the moors,
Had come young Porphyro, with heart on fire
For Madeline. Beside the portal doors,
Buttress'd from moonlight, stands he, and implores
All saints to give him sight of Madeline,
But for one moment in the tedious hours,
That he might gaze and worship all unseen;
Perchance speak, kneel, touch, kiss—in sooth such things have been.

X.

He ventures in: let no buzz'd whisper tell:
All eyes be muffled, or a hundred swords
Will storm his heart, Love's fev'rous citadel:
For him, those chambers held barbarian hordes,
Hyena foemen, and hot-blooded lords,
Whose very dogs would execrations howl
Against his lineage: not one breast affords
Him any mercy, in that mansion foul,
Save one old beldame, weak in body and in soul.

1128

XI.

Ah, happy chance! the aged creature came,
Shuffling along with ivory-headed wand,
To where he stood, hid from the torch's flame,
Behind a broad hall-pillar, far beyond
The sound of merriment and chorus bland:
He startled her; but soon she knew his face,
And grasp'd his fingers in her palsied hand,
Saying, "Mercy, Porphyro! hie thee from this place;
"They are all here to-night, the whole blood-thirsty race!

XII.

"Get hence! get hence! there's dwarfish Hildebrand;
"He had a fever late, and in the fit
"He cursed thee and thine, both house and land:
"Then there's that old Lord Maurice, not a whit
"More tame for his gray hairs—Alas me! flit!
"Flit like a ghost away."—"Ah, Gossip dear,
"We're safe enough; here in this arm-chair sit,
"And tell me how"—"Good Saints! not here, not here;
"Follow me, child, or else these stones will be thy bier."

XIII.

He follow'd through a lowly arched way,
Brushing the cobwebs with his lofty plume,
And as she mutter'd "Well-a—well-a-day!"
He found him in a little moonlight room,
Pale, lattic'd, chill, and silent as a tomb.
"Now tell me where is Madeline," said he,
"O tell me, Angela, by the holy loom
"Which none but secret sisterhood may see,
"When they St. Agnes' wool are weaving piously."

XIV.

"St. Agnes! Ah! it is St. Agnes' Eve—
"Yet men will murder upon holy days:
"Thou must hold water in a witch's sieve,
"And be liege-lord of all the Elves and Fays,
"To venture so: it fills me with amaze
"To see thee, Porphyro!—St. Agnes' Eve!
"God's help! my lady fair the conjuror plays
"This very night: good angels her deceive!
"But let me laugh awhile, I've mickle time to grieve."

XV.

Feebly she laugheth in the languid moon,
While Porphyro upon her face doth look,
Like puzzled urchin on an aged crone
Who keepeth clos'd a wond'rous riddle-book,
As spectacled she sits in chimney nook.
But soon his eyes grew brilliant, when she told
His lady's purpose; and he scarce could brook
Tears, at the thought of those enchantments cold
And Madeline asleep in lap of legends old.

XVI.

Sudden a thought came like a full-blown rose,
Flushing his brow, and in his pained heart
Made purple riot: then doth he propose
A stratagem, that makes the beldame start:
"A cruel man and impious thou art:
"Sweet lady, let her pray, and sleep, and dream
"Alone with her good angels, far apart
"From wicked men like thee. Go, go!—I deem
"Thou canst not surely be the same that thou didst seem."

XVII.

"I will not harm her, by all saints I swear,"
Quoth Porphyro: "O may I ne'er find grace
"When my weak voice shall whisper its last prayer,
"If one of her soft ringlets I displace,
"Or look with ruffian passion in her face:
"Good Angela, believe me by these tears;
"Or I will, even in a moment's space,
"Awake, with horrid shout, my foemen's ears,
"And beard them, though they be more fang'd than wolves and bears."

XVIII.

"Ah! why wilt thou affright a feeble soul?
"A poor, weak, palsy-stricken, churchyard thing,
"Whose passing-bell may ere the midnight toll;
"Whose prayers for thee, each morn and evening,
"Were never miss'd."—Thus plaining, doth she bring
A gentler speech from burning Porphyro;
So woful, and of such deep sorrowing,
That Angela gives promise she will do
Whatever he shall wish, betide her weal or woe.

XIX.

Which was, to lead him, in close secrecy,
Even to Madeline's chamber, and there hide
Him in a closet, of such privacy
That he might see her beauty unespied,
And win perhaps that night a peerless bride,
While legion'd fairies pac'd the coverlet,
And pale enchantment held her sleepy-eyed.
Never on such a night have lovers met,
Since Merlin paid his Demon all the monstrous debt.

XX.

"It shall be as thou wishest," said the Dame:
"All cates and dainties shall be stored there
"Quickly on this feast-night: by the tambour frame
"Her own lute thou wilt see: no time to spare,
"For I am slow and feeble, and scarce dare
"On such a catering trust my dizzy head.
"Wait here, my child, with patience; kneel in prayer
"The while: Ah! thou must needs the lady wed,
"Or may I never leave my grave among the dead."

XXI.

So saying, she hobbled off with busy fear.
The lover's endless minutes slowly pass'd;
The dame return'd, and whisper'd in his ear
To follow her; with aged eyes aghast
From fright of dim espial. Safe at last,
Through many a dusky gallery, they gain
The maiden's chamber, silken, hush'd, and chaste;
Where Porphyro took covert, pleas'd amain.
His poor guide hurried back with agues in her brain.

XXII.

Her falt'ring hand upon the balustrade,
Old Angela was feeling for the stair,
When Madeline, St. Agnes' charmed maid,
Rose, like a mission'd spirit, unaware:
With silver taper's light, and pious care,
She turn'd, and down the aged gossip led
To a safe level matting. Now prepare,
Young Porphyro, for gazing on that bed;
She comes, she comes again, like ring-dove fray'd and fled.

XXIII.

Out went the taper as she hurried in;
Its little smoke, in pallid moonshine, died:
She clos'd the door, she panted, all akin
To spirits of the air, and visions wide:
No uttered syllable, or, woe betide!
But to her heart, her heart was voluble,
Paining with eloquence her balmy side;
As though a tongueless nightingale should swell
Her throat in vain, and die, heart-stifled, in her dell.

XXIV.

A casement high and triple-arch'd there was,
All garlanded with carven imag'ries
Of fruits, and flowers, and bunches of knot-grass,
And diamonded with panes of quaint device,
Innumerable of stains and splendid dyes,
As are the tiger-moth's deep-damask'd wings;
And in the midst, 'mong thousand heraldries,
And twilight saints, and dim emblazonings,
A shielded scutcheon blush'd with blood of queens and kings.

XXV.

Full on this casement shone the wintry moon,
And threw warm gules on Madeline's fair breast,
As down she knelt for heaven's grace and boon;
Rose-bloom fell on her hands, together prest,
And on her silver cross soft amethyst,
And on her hair a glory, like a saint:
She seem'd a splendid angel, newly drest,
Save wings, for heaven:—Porphyro grew faint:
She knelt, so pure a thing, so free from mortal taint.

XXVI.

Anon his heart revives: her vespers done,
Of all its wreathed pearls her hair she frees;
Unclasps her warmed jewels one by one;
Loosens her fragrant boddice; by degrees
Her rich attire creeps rustling to her knees:
Half-hidden, like a mermaid in sea-weed,
Pensive awhile she dreams awake, and sees,
In fancy, fair St. Agnes in her bed,
But dares not look behind, or all the charm is fled.

XXVII.

Soon, trembling in her soft and chilly nest,
In sort of wakeful swoon, perplex'd she lay,
Until the poppied warmth of sleep oppress'd
Her soothed limbs, and soul fatigued away;
Flown, like a thought, until the morrow-day;
Blissfully haven'd both from joy and pain;
Clasp'd like a missal where swart Paynims pray;
Blinded alike from sunshine and from rain,
As though a rose should shut, and be a bud again.

XXVIII.

Stol'n to this paradise, and so entranced,
Porphyro gazed upon her empty dress,
And listen'd to her breathing, if it chanced
To wake into a slumberous tenderness;
Which when he heard, that minute did he bless,
And breath'd himself: then from the closet crept,
Noiseless as fear in a wide wilderness,
And over the hush'd carpet, silent, stept,
And 'tween the curtains peep'd, where, lo!—how fast she slept.

XXIX.

Then by the bed-side, where the faded moon
Made a dim, silver twilight, soft he set
A table, and, half anguish'd, threw thereon
A cloth of woven crimson, gold, and jet:—
O for some drowsy Morphean amulet!
The boisterous, midnight, festive clarion,
The kettle-drum, and far-heard clarionet,
Affray his ears, though but in dying tone:—
The hall door shuts again, and all the noise is gone.

XXX.

And still she slept an azur-lidded sleep,
In blanched linen, smooth, and lavender'd,
While he from forth the closet brought a heap
Of candied apple, quince, and plum, and gourd
With jellies soother than the creamy curd,
And lucent syrops, tinct with cinnamon;
Manna and dates, in argosy transferr'd
From Fez; and spiced dainties, every one,
From silken Samarcand to cedar'd Lebanon.

XXXI.

These delicates he heap'd with glowing hand
On golden dishes and in baskets bright
Of wreathed silver: sumptuous they stand
In the retired quiet of the night,
Filling the chilly room with perfume light.—
"And now, my love, my seraph fair, awake!
"Thou art my heaven, and I thine eremite:
"Open thine eyes, for meek St. Agnes' sake,
"Or I shall drowse beside thee, so my soul doth ache

XXXII.

Thus whispering, his warm, unnerved arm
Sank in her pillow. Shaded was her dream
By the dusk curtains:—'twas a midnight charm
Impossible to melt as iced stream:
The lustrous salvers in the moonlight gleam;
Broad golden fringe upon the carpet lies:
It seem'd he never, never could redeem
From such a stedfast spell his lady's eyes;
So mus'd awhile, entoil'd in woofed phantasies.

XXXIII.

Awakening up, he took her hollow lute,—
Tumultuous,—and, in chords that tenderest be,
He play'd an ancient ditty, long since mute,
In Provence call'd, "La belle dame sans mercy:"
Close to her ear touching the melody;—
Wherewith disturb'd, she utter'd a soft moan:
He ceased—she panted quick—and suddenly
Her blue affrayed eyes wide open shone:
Upon his knees he sank, pale as smooth-sculptured stone.

XXXIV.

Her eyes were open, but she still beheld,
Now wide awake, the vision of her sleep:
There was a painful change, that nigh expell'd
The blisses of her dream so pure and deep
At which fair Madeline began to weep,
And moan forth witless words with many a sigh;
While still her gaze on Porphyro would keep;
Who knelt, with joined hands and piteous eye,
Fearing to move or speak, she look'd so dreamingly.

1134

XXXV.

"Ah, Porphyro!" said she, "but even now
"Thy voice was at sweet tremble in mine ear,
"Made tuneable with every sweetest vow;
"And those sad eyes were spiritual and clear:
"How chang'd thou art! how pallid, chill, and drear!
"Give me that voice again, my Porphyro,
"Those looks immortal, those complainings dear!
"Oh leave me not in this eternal woe,
"For if thou diest, my Love, I know not where to go."

XXXVI.

Beyond a mortal man impassion'd far
At these voluptuous accents, he arose,
Ethereal, flush'd, and like a throbbing star
Seen mid the sapphire heaven's deep repose
Into her dream he melted, as the rose
Blendeth its odour with the violet,—
Solution sweet: meantime the frost-wind blows
Like Love's alarum pattering the sharp sleet
Against the window-panes; St. Agnes' moon hath set.

XXXVII.

'Tis dark: quick pattereth the flaw-blown sleet:
"This is no dream, my bride, my Madeline!"
'Tis dark: the iced gusts still rave and beat:
"No dream, alas! alas! and woe is mine!
"Porphyro will leave me here to fade and pine.—
"Cruel! what traitor could thee hither bring?
"I curse not, for my heart is lost in thine
"Though thou forsakest a deceived thing;—
"A dove forlorn and lost with sick unpruned wing."

XXXVIII.

"My Madeline! sweet dreamer! lovely bride!
"Say, may I be for aye thy vassal blest?
"Thy beauty's shield, heart-shap'd and vermeil dyed?
"Ah, silver shrine, here will I take my rest
"After so many hours of toil and quest,
"A famish'd pilgrim,—saved by miracle.
"Though I have found, I will not rob thy nest
"Saving of thy sweet self; if thou think'st well
"To trust, fair Madeline, to no rude infidel."

XXXIX.

"Hark! 'tis an elfin-storm from faery land,
"Of haggard seeming, but a boon indeed:
"Arise—arise! the morning is at hand;—
"The bloated wassaillers will never heed:—
"Let us away, my love, with happy speed;
"There are no ears to hear, or eyes to see,—
"Drown'd all in Rhenish and the sleepy mead:
"Awake! Arise! my love, and fearless be,
"For o'er the southern moors I have a home for thee."

XL.

She hurried at his words, beset with fears,
For there were sleeping dragons all around,
At glaring watch, perhaps, with ready spears—
Down the wide stairs a darkling way they found.—
In all the house was heard no human sound.
A chain-droop'd lamp was flickering by each door;
The arras, rich with horseman, hawk, and hound,
Flutter'd in the besieging wind's uproar;
And the long carpets rose along the gusty floor.

XLI.

They glide, like phantoms, into the wide hall;
Like phantoms, to the iron porch, they glide;
Where lay the Porter, in uneasy sprawl,
With a huge empty flaggon by his side:
The wakeful bloodhound rose, and shook his hide,
But his sagacious eye an inmate owns:
By one, and one, the bolts full easy slide:—
The chains lie silent on the footworn stones;—
The key turns, and the door upon its hinges groans.

XLII.

And they are gone: ay, ages long ago
These lovers fled away into the storm.
That night the Baron dreamt of many a woe,
And all his warrior-guests, with shade and form
Of witch, and demon, and large coffin-worm,
Were long be-nightmar'd. Angela the old
Died palsy-twitch'd, with meagre face deform;
The Beadsman, after thousand aves told,
For aye unsought for slept among his ashes cold. (1820)

1136

JOHN KEATS

1 7 9 5 — 1 8 2 1

THE KERNEL OF THE GRAVE

She gaz'd into the fresh-thrown mould, as though
 One glance did fully all its secrets tell;
Clearly she saw, as other eyes would know
 Pale limbs at bottom of a crystal well;
Upon the murderous spot she seem'd to grow,
 Like to a native lilly of the dell:
Then with her knife, all sudden, she began
To dig more fervently than misers can.

Soon she turn'd up a soiled glove, whereon
 Her silk had play'd in purple phantasies,
She kiss'd it with a lip more chill than stone,
 And put it in her bosom, where it dries
And freezes utterly unto the bone
 Those dainties made to still an infant's cries:
Then 'gan she work again; nor stay'd her care,
But to throw back at times her veiling hair.

That old nurse stood beside her wondering,
 Until her heart felt pity to the core
At sight of such a dismal labouring,
 And so she kneeled, with her locks all hoar,
And put her lean hands to the horrid thing:
 Three hours they labour'd at this travail sore;
At last they felt the kernel of the grave,
And Isabella did not stamp and rave.

Isabella (1820)

Two Florentines, merchants, discovering that their sister Isabella has placed her affections upon Lorenzo, a young factor in their employ, when they had hopes of procuring for her a noble match, decoy Lorenzo, under pretence of a ride, into a wood, where they suddenly stab and

1137

bury him. . . . Returning to their sister, they delude her with a story of their having sent Lorenzo abroad to look after their merchandises; but the spirit of her lover appears to Isabella in a dream, and discovers how and where he was stabbed, and the spot where they have buried him. To ascertain the truth of the vision, she sets out to the place, accompanied by her old nurse, ignorant as yet of her wild purpose. . . . There is nothing more awfully simple in diction, more nakedly grand and moving in sentiment, in Dante, in Chaucer, or in Spenser.

<div align="right">

CHARLES LAMB
in The New Times (July 19, 1820)

</div>

AUGUST GRAF VON PLATEN

1 7 9 6 — 1 8 3 5

DER PILGRIM VOR ST. JUST

Nacht ist's, und Stürme sausen für und für;
Hispanische Mönche, schliesst mir auf die Tür!

Lasst hier mich ruhn, bis Glockenton mich weckt,
Der zum Gebet euch in die Kirche schreckt!

Bereitet mir, was euer Haus vermag,
Ein Ordenskleid und einen Sarkophag!

Gönnt mir die kleine Zelle, weiht mich ein!
Mehr als die Hälfte dieser Welt war mein.

Das Haupt, das nun der Schere sich bequemt,
Mit mancher Krone ward's bediademt.

Die Schulter, die der Kutte nun sich bückt,
Hat kaiserlicher Hermelin geschmückt.

Nun bin ich vor dem Tod den Toten gleich
Und fall' in Trümmer wie das alte Reich.

THE PILGRIM BEFORE ST. JUST

'Tis night, and tempests roar unceasingly:
O Spanish monks, unlock your gates for me!

Here let me rest, until the pealing bell
Shall drive you chapelwards your beads to tell.

Nought but your Order's common gifts I crave,
A friar's raiment and a friar's grave.

Grant me a cell, receive me at your shrine,
More than the half of all the world was mine.

This head that meekly to the tonsure bows,
Has borne full many a crown upon its brows.

This shoulder, bending low the cowl to don,
Imperial ermine wore in days agone.

Like to the dead am I before death calls,
And fall in ruins as my Empire falls.

Translated by Norman Macleod

*Platen and Eichendorff were both spiritual sons of Goethe, in whom
classical and Romantic influences were uniquely harmonised, and Goethe
had given the watchword "Grace and Dignity," which Platen tried to
exemplify. His contemporaries were quick to detect a coldness and lack
of sympathy in him, and, finding literary life in Germany uncongenial,
he turned to Italy for inspiration. His sonnets are among the most per-
fectly finished in German, and one poem, "The Pilgrim [i.e. the
Emperor Charles V] before the Monastery of St. Just," is in all Ger-
man anthologies.*

NORMAN MACLEOD
German Lyric Poetry (1930)

ALFRED DE VIGNY

1 7 9 7 -- 1 8 6 3

MY TORN HEART

Sur mon cœur déchiré viens poser ta main pure,
Ne me laisse jamais seul avec la Nature;
Car je la connais trop pour n'en pas avoir peur.

Elle me dit: . . .

"Je roule avec dédain, sans voir et sans entendre,
A côté des fourmis les populations;
Je ne distingue pas leur terrier de leur cendre,
J'ignore en les portant les noms des nations.

1139

On me dit une mère, et je suis une tombe.
Mon hiver prend vos morts comme son hécatombe,
Mon printemps ne sent pas vos adorations.

Avant vous, j'étais belle et toujours parfumée,
J'abandonnais au vent mes cheveux tout entiers,
Je suivais dans les cieux ma route accoutumée,
Sur l'axe harmonieux des divins balanciers,
Après vous, traversant l'espace où tout s'élance,
J'irai seule et sereine, en un chaste silence
Je fendrai l'air du front et de mes seins altiers."

On my torn heart come and place thy pure hand, never leave me alone with nature, for I know her too well not to fear her. She says to me: . . . "I whirl round contemptuously, unseeing and unhearing, the peoples of the earth side by side with the ants; I do not distinguish their dwelling from their ashes, and as I carry them I am ignorant of the names of the nations. I am called a mother and I am a tomb. My winter takes your dead as its hecatomb, my spring does not hear your adorations. Before your day I was beautiful and always perfumed, I abandoned to the wind my whole hair, I followed my accustomed way in the heavens on the harmonious axis of the divine scales. After your departure, I shall go on alone and serene, traversing in a chaste silence the space through which all things move; I shall cleave the air with my brow and my haughty breasts."

La Maison du berger (1844)
Translated by A. W. Evans

An expression of a sombre and pathetic philosophy unsurpassed in painful eloquence.

ANATOLE FRANCE
La Vie littéraire (1888–92)

ALFRED DE VIGNY

1797 — 1863

LA COLÈRE DE SAMSON

Le désert est muet, la tente est solitaire.
Quel pasteur courageux la dressa sur la terre
Du sable et des lions?—La nuit n'a pas calmé
La fournaise du jour dont l'air est enflammé.

Un vent léger s'élève à l'horizon et ride
Les flots de la poussière ainsi qu'un lac limpide.
Le lin blanc de la tente est bercé mollement;
L'œuf d'autruche, allumé, veille paisiblement,
Des voyageurs voilés intérieure étoile,
Et jette longuement deux ombres sur la toile.

L'une est grande et superbe, et l'autre est à ses pieds:
C'est Dalila l'esclave, et ses bras sont liés
Aux genoux réunis du maître jeune et grave
Dont la force divine obéit à l'esclave.
Comme un doux léopard, elle est souple et répand
Ses cheveux dénoués aux pieds de son amant.
Ses grands yeux, entr'ouverts comme s'ouvre l'amande,
Sont brûlants du plaisir que son regard demande,
Et jettent, par éclats, leurs mobiles lueurs.

Ses bras fins tout mouillés de tièdes sueurs,
Ses pieds voluptueux qui sont croisés sous elle,
Ses flancs, plus élancés que ceux de la gazelle,
Pressés de bracelets, d'anneaux, de boucles d'or,
Sont bruns, et, comme il sied aux filles de Hatsor,
Ses deux seins, tout chargés d'amulettes anciennes,
Sont chastement pressés d'étoffes syriennes.

Les genoux de Samson fortement sont unis
Comme les deux genoux du colosse Anubis.
Elle s'endort sans force et riante et bercée
Par la puissante main sous sa tête placée.
Lui, murmure le chant funèbre et douloureux
Prononcé dans la gorge avec des mots hébreux.
Elle ne comprend pas la parole étrangère,
Mais le chant verse un somme en sa tête légère.

"Une lutte éternelle en tout temps, en tout lieu,
Se livre sur la terre, en présence de Dieu,
Entre la bonté d'Homme et la ruse de Femme,
Car la femme est un être impur de corps et d'âme.

"L'Homme a toujours besoin de caresse et d'amour;
Sa mère l'en abreuve alors qu'il vient au jour,
Et ce bras le premier l'engourdit, le balance
Et lui donne un désir d'amour et d'indolence.
Troublé dans l'action, troublé dans le dessein,
Il rêvera partout à la chaleur du sein,
Aux chansons de la nuit, aux baisers de l'aurore,
A la lèvre de feu que sa lèvre dévore,

Aux cheveux dénoués qui roulent sur son front,
Et les regrets du lit, en marchant, le suivront.
Il ira dans la ville, et, là, les vierges folles
Le prendront dans leurs lacs aux premières paroles.
Plus fort il sera né, mieux il sera vaincu,
Car plus le fleuve est grand et plus il est ému.
Quand le combat que Dieu fit pour la créature
Et contre son semblable et contre la nature
Force l'Homme à chercher un sein où reposer,
Quand ses yeux sont en pleurs, il lui faut un baiser.
Mais il n'a pas encor fini toute sa tâche:
Vient un autre combat plus secret, traître et lâche;
Sous son bras, sous son cœur se livre celui-là;
Et, plus ou moins, la femme est toujours DALILA.

"Elle rit et triomphe; en sa froideur savante,
Au milieu de ses sœurs elle attend et se vante
De ne rien éprouver des atteintes du feu.
A sa plus belle amie elle en a fait l'aveu:
Elle se fait aimer sans aimer elle-même;
Un Maître lui fait peur. C'est le plaisir qu'elle aime;
L'Homme est rude et le prend sans savoir le donner.
Un sacrifice illustre et fait pour étonner
Rehausse mieux que l'or, aux yeux de ses pareilles,
La beauté qui produit tant d'étranges merveilles
Et d'un sang précieux sait arroser ses pas.
—Donc, ce que j'ai voulu, Seigneur, n'existe pas!—
Celle à qui va l'amour et de qui vient la vie,
Celle-là, par orgueil, se fait notre ennemie.
La Femme est, à présent, pire que dans ces temps
Où, voyant les Humains, Dieu dit: "Je me repens!"
Bientôt, se retirant dans un hideux royaume,
La Femme aura Gomorrhe et l'Homme aura Sodôme;
Et, se jetant, de loin, un regard irrité,
Les deux sexes mourront chacun de son côté.

"Éternel! Dieu des forts! vous savez que mon âme
N'avait pour aliment que l'amour d'une femme,
Puisant dans l'amour seul plus de sainte vigueur
Que mes cheveux divins n'en donnaient à mon cœur.
—Jugez-nous. —La voilà sur mes pieds endormie.
Trois fois elle a vendu mes secrets et ma vie,
Et trois fois a versé des pleurs fallacieux
Qui n'ont pu me cacher la rage de ses yeux;
Honteuse qu'elle était plus encor qu'étonnée
De se voir découverte ensemble et pardonnée,

Car la bonté de l'Homme est forte, et sa douceur
Écrase, en l'absolvant, l'être faible et menteur.

"Mais enfin je suis las. J'ai l'âme si pesante,
Que mon corps gigantesque et ma tête puissante
Qui soutiennent le poids des colonnes d'airain
Ne la peuvent porter avec tout son chagrin.
 Toujours voir serpenter la vipère dorée
Qui se traîne en sa fange et s'y croit ignorée;
Toujours ce compagnon dont le cœur n'est pas sûr,
La Femme, enfant malade et douze fois impur!
Toujours mettre sa force à garder sa colère
Dans son cœur offensé, comme en un sanctuaire
D'où le feu s'échappant irait tout dévorer,
Interdire à ses yeux de voir ou de pleurer,
C'est trop! Dieu, s'il le veut, peut balayer ma cendre.
J'ai donné mon secret, Dalila va le vendre.
Qu'ils seront beaux, les pieds de celui qui viendra
Pour m'annoncer la mort!—Ce qui sera, sera!"

Il dit, et s'endormit près d'elle jusqu'à l'heure
Où les guerriers, tremblants d'être dans sa demeure,
Payant au poids de l'or chacun de ses cheveux,
Attachèrent ses mains et brûlèrent ses yeux,
Le traînèrent sanglant et chargé d'une chaîne
Que douze grands taureaux ne tiraient qu'avec peine,
Le placèrent debout, silencieusement,
Devant Dagon, leur Dieu, qui gémit sourdement
Et deux fois, en tournant, recula sur sa base
Et fit pâlir deux fois ses prêtres en extase,
Allumèrent l'encens, dressèrent un festin
Dont le bruit s'entendait du mont le plus lointain,
Et près de la génisse aux pieds du Dieu tuée
Placèrent Dalila, pâle prostituée,
Couronnée, adorée et reine du repas,
Mais tremblante et disant: IL NE ME VERRA PAS!

————————

Terre et ciel! avez-vous tressailli d'allégresse
Lorsque vous avez vu la menteuse maîtresse
Suivre d'un œil hagard les yeux tachés de sang
Qui cherchaient le soleil d'un regard impuissant?
Et quand enfin Samson, secouant les colonnes
Qui faisaient le soutien des immenses Pylônes,
Écrasa d'un seul coup, sous les débris mortels,
Ses trois mille ennemis, leurs dieux et leurs autels?

1143

Terre et ciel! punissez par de telles justices
La trahison ourdie en des amours factices,
Et la délation du secret de nos cœurs
Arraché dans nos bras par des baisers menteurs!

THE ANGER OF SAMSON

The desert is mute, the tent is solitary. What courageous shepherd pitched it in the land of sand and lions? Night has not stilled the fiery furnace of the day, the air of which is ablaze. A light wind rises on the horizon and ripples the waves of dust like a clear lake. The white linen of the tent sways softly; the lighted ostrich-egg lamp keeps vigil peacefully, like a star within for veiled travelers, and throws two long shadows on the canvas. One shadow is tall and proud, and the other is at its feet: It is the slave, Delilah, and her arms are linked about the knees of the young, grave master whose divine strength yields to the slave. She is lithe as a smooth leopard, and she spreads her unbound hair at the feet of her lover. Her large eyes, half-open like an almond shell, flash brilliantly and restlessly, burning with the pleasure that her glance demands. Her arms are slim and tepidly moist, her voluptuous feet crossed under her, her dark thighs, more slender than those of a gazelle —all covered with bracelets, rings, and golden buckles. As becomes the daughters of Hatsor, her breasts, laden with ancient amulets, are chastely bound with Syrian fabrics. The knees of Samson are firmly joined like the two knees of the colossus Anubis. She falls asleep exhausted, laughing and cradled by the strong hand placed under her head. He murmurs deep in his throat a funereal and mournful Hebrew song. She does not understand the strange tongue, but the chant pours sleep into her light head. "An eternal conflict is fought always and everywhere on earth, in the presence of God, between the goodness of Man and the wiles of Woman, for Woman is a being impure in body and in soul. Man always needs caresses and love; his mother steeps him in them when he comes into the world, and her arm first benumbs him, rocks him and gives him a desire for love and for indolence. Troubled in action, troubled in plans, he will dream always of the warmth of the breast, of the songs of the night, of the kisses of the dawn, of lips of fire which his lips devour, of loosened hair which rolls on his forehead, and longings for the bed will pursue him as he travels. He will go into the town, and there the Foolish Virgins will bind him fast with their first words. The stronger he is at birth the more easily he will be conquered, for the greater the river, the stronger the current. When the conflict that God arranged for his Creature both against his fellow-man and against nature forces Man to search for a breast on which he may repose, when his eyes are filled with tears, he needs a kiss. But he has not completed all his task: Another more secret combat is now

fought, treacherous and cowardly; it is one fought within his arms, in his heart; and, to some extent the woman is always DELILAH. She laughs and exults; in her knowing coldness she waits among her sisters and boasts of feeling nothing from the onslaughts of the fire. To her best friend she confesses it: She wins love without loving herself; a master frightens her. It is pleasure that she loves. Man is coarse and takes love without knowing how to bestow it. In the eyes of her companions, a striking and astonishing sacrifice enhances beauty more than gold, that beauty which produces so many strange marvels, and whose steps are sprinkled with precious blood.—Ultimately, what I desired, Lord, does not exist!—She to whom our love goes and from whom comes life, she, through pride, becomes our enemy. Woman is, today, worse than in times past when, seeing mankind, God said: 'I repent!' Soon, withdrawing into a hideous realm, Woman will have Gomorrah and Man will have Sodom; and casting an irritated glance at each other from afar, the two sexes will die, each on its own side. Eternal God! God of the strong! You know that my soul was only fed by the love of a woman, drawing from love alone more holy vigor than my divine hair gave to my heart.—Judge us.—She is there, asleep at my feet. Three times she has sold my secrets and my life, and three times she has shed false tears which have not been able to hide from me the rage in her eyes; ashamed as she was, even more than astonished, to see herself at once discovered and pardoned. For the goodness of Man is strong, and its gentleness crushes, as it absolves, the weak and false being. But at last I am tired. My heart is so heavy that my gigantic body and my powerful head, which bear the weight of bronze columns, cannot carry it with all its weight of grief. Always to see writhing the gilded viper which drags itself in its slime and believes itself unseen; always this companion whose heart is not true, Woman, sick child and twelve times unclean! Always to put one's strength into guarding one's anger within an injured heart, as in a sanctuary whence, escaping, fire would devour all; to forbid one's eyes to see or cry, it is too much! God, if he wills, may sweep away my ashes. I have given up my secret, Delilah goes to sell it. How beautiful will be the feet of the one who comes to announce my death to me!— What must be, will be!" He finished speaking and fell asleep close to her until the hour when the warriors, trembling at being in his dwelling, paying in weight of gold for each one of the hairs of his head, bound his hands and burnt out his eyes, dragged him bleeding and weighed down with a chain that twelve great bullocks could only drag with diffi- culty, stood him upright, silently, before Dagon, their God, who groaned dully, and twice, in turning, fell back on his pedestal and twice made his priests turn pale in ecstasy. They lighted the incense, prepared a banquet the noise of which was heard as far as the farthest mountain, and, near the heifer killed at the feet of the god they placed the pale prostitute, Delilah, crowned, adored, and queen of the feast, but

trembling and saying: HE WILL NOT SEE ME! Heaven and Earth! Did you quiver with joy when you saw the false mistress follow with a haggard eye the eyes stained with blood which searched for the sun with a helpless look? And when at last Samson, shaking the columns which supported the immense pylons, crushed at one blow his three thousand enemies, their gods and their altars under the mortal debris? Heaven and Earth! Punish by such justice treachery plotted in artificial love, and the betrayal of the secret of our hearts, extorted in our arms by false kisses!

<div align="right">(1839)</div>

Nothing in nineteenth-century verse surpasses it in power.

<div align="right">
E R N E S T D U P U Y

Les Origines Littéraires d'Alfred de Vigny

(Revue d'Histoire Littéraire de la France, 1903)
</div>

ALFRED DE VIGNY

<div align="center">1 7 9 7 — 1 8 6 3</div>

LES DESTINÉES

Depuis le premier jour de la création,
Les pieds lourds et puissants de chaque Destinée
Pesaient sur chaque tête et sur toute action.

Chaque front se courbait et traçait sa journée,
Comme le front d'un bœuf creuse un sillon profond
Sans dépasser la pierre où sa ligne est bornée.

Ces froides déités liaient le joug de plomb
Sur le crâne et les yeux des Hommes leurs esclaves,
Tous errants, sans étoile, en un désert sans fond;

Levant avec effort leurs pieds chargés d'entraves;
Suivant le doigt d'airain dans le cercle fatal,
Le doigt des Volontés inflexibles et graves.

Tristes divinités du monde oriental,
Femmes au voile blanc, immuables statues,
Elles nous écrasaient de leur poids colossal.

Comme un vol de vautours sur le sol abattues,
Dans un ordre éternel, toujours en nombre égal
Aux têtes des mortels sur la terre épandues,

<div align="center">1146</div>

Elles avaient posé leur ongle sans pitié
Sur les cheveux dressés des races éperdues,
Traînant la femme en pleurs et l'homme humilié.

Un soir, il arriva que l'antique planète
Secoua sa poussière.—Il se fit un grand cri:
"Le Sauveur est venu, voici le jeune athlète,

"Il a le front sanglant et le côté meurtri,
"Mais la Fatalité meurt aux pieds du Prophète;
"La Croix monte et s'étend sur nous comme un abri!"

Avant l'heure où, jadis, ces choses arrivèrent,
Tout Homme était courbé, le front pâle et flétri;
Quand ce cri fut jeté, tous ils se relevèrent.

Détachant les nœuds lourds du joug de plomb du Sort,
Toutes les Nations à la fois s'écrièrent:
"O Seigneur! est-il vrai? le Destin est-il mort?"

Et l'on vit remonter vers le ciel, par volées,
Les filles du Destin, ouvrant avec effort
Leurs ongles qui pressaient nos races désolées;

Sous leur robe aux longs plis voilant leurs pieds d'airain,
Leur main inexorable et leur face inflexible;
Montant avec lenteur en innombrable essaim,

D'un vol inaperçu, sans ailes, insensible,
Comme apparaît au soir, vers l'horizon lointain,
D'un nuage orageux l'ascension paisible.

—Un soupir de bonheur sortit du cœur humain;
La Terre frissonna dans son orbite immense,
Comme un cheval frémit délivré de son frein.

Tous les astres émus restèrent en silence,
Attendant avec l'Homme, en la même stupeur,
Le suprême décret de la Toute-Puissance,

Quand ces filles du Ciel, retournant au Seigneur,
Comme ayant retrouvé leurs régions natales,
Autour de Jéhovah se rangèrent en chœur,

D'un mouvement pareil levant leurs mains fatales,
Puis chantant d'une voix leur hymne de douleur,
Et baissant à la fois leurs fronts calmes et pâles:

"Nous venons demander la Loi de l'avenir.
"Nous sommes, ô Seigneur, les froides Destinées
"Dont l'antique pouvoir ne devait point faillir.

1147

"Nous roulions sous nos doigts les jours et les années;
"Devons-nous vivre encore ou devons-nous finir,
"Des Puissances du ciel, nous, les fortes aînées?

"Vous détruisez d'un coup le grand piège du Sort
"Où tombaient tour à tour les races consternées.
"Faut-il combler la fosse et briser le ressort?

"Ne mènerons-nous plus ce troupeau faible et morne,
"Ces hommes d'un moment, ces condamnés à mort,
"Jusqu'au bout du chemin dont nous posions la borne?

"Le moule de la vie était creusé par nous.
"Toutes les passions y répandaient leur lave,
"Et les événements venaient s'y fondre tous.

"Sur les tables d'airain où notre loi se grave,
"Vous effacez le nom de la Fatalité,
"Vous déliez les pieds de l'Homme notre esclave.

"Qui va porter le poids dont s'est épouvanté
"Tout ce qui fut créé? ce poids sur la pensée,
"Dont le nom est en bas: Responsabilité?"

Il se fit un silence, et la Terre affaissée
S'arrêta comme fait la barque sans rameurs
Sur les flots orageux dans la nuit balancée.

Une voix descendit, venant de ces hauteurs
Où s'engendrent sans fin les mondes dans l'espace;
Cette voix de la terre emplit les profondeurs:

"Retournez en mon nom, Reines, je suis la Grâce.
"L'Homme sera toujours un nageur incertain
"Dans les ondes du temps qui se mesure et passe.

"Vous toucherez son front, ô filles du Destin!
"Son bras ouvrira l'eau, qu'elle soit haute ou basse,
"Voulant trouver sa place et deviner sa fin.

"Il sera plus heureux, se croyant maître et libre,
"En luttant contre vous dans un combat mauvais
"Où moi seule d'en haut je tiendrai l'équilibre.

"De moi naîtra son souffle et sa force à jamais.
"Son mérite est le mien, sa loi perpétuelle:
"Faire ce que je veux pour venir où je sais."

1148

Et le chœur descendit vers sa proie éternelle
Afin d'y ressaisir sa domination
Sur la race timide, incomplète et rebelle.

On entendit venir la sombre Légion
Et retomber les pieds des femmes inflexibles,
Comme sur nos caveaux tombe un cercueil de plomb.

Chacune prit chaque homme en ses mains invisibles.
—Mais, plus forte à présent, dans ce sombre duel,
Notre âme en deuil combat ces Esprits impassibles.

Nous soulevons parfois leur doigt faux et cruel.
La Volonté transporte à des hauteurs sublimes
Notre front éclairé par un rayon du ciel.

Cependant sur nos caps, sur nos rocs, sur nos cimes,
Leur doigt rude et fatal se pose devant nous,
Et, d'un coup, nous renverse au fond des noirs abîmes.

Oh! dans quel désespoir nous sommes encor tous!
Vous avez élargi le COLLIER qui nous lie,
Mais qui donc tient la chaîne?—Ah! Dieu juste, est-ce vous?

Arbitre libre et fier des actes de sa vie,
Si notre cœur s'entr'ouvre au parfum des vertus,
S'il s'embrase à l'amour, s'il s'élève au génie,

Que l'ombre des Destins, Seigneur, n'oppose plus
A nos belles ardeurs une immuable entrave,
A nos efforts sans fin des coups inattendus!

O sujet d'épouvante à troubler le plus brave!
Question sans réponse où vos Saints se sont tus!
O mystère! ô tourment de l'âme forte et grave!

Notre mot éternel est-il: C'ÉTAIT ÉCRIT?
SUR LE LIVRE DE DIEU, dit l'Orient esclave;
Et l'Occident répond: SUR LE LIVRE DU CHRIST.

THE FATES

Since the first day of creation, the strong and heavy tread of the
Fates threatened each head and every action. Each head was bowed,
and mapped out its day's work as the ox plows a deep furrow without
going beyond the stone which is its boundary line. These cold deities
bound the yoke of lead on the skull and the eyes of their slaves, Men,
who were all wandering, without a guiding star, in a boundless desert.

With an effort they lifted their shackled feet, and followed the brazen finger in its fatal circle, the finger of the inexorable and grave Fates. Melancholy divinities of the oriental world, white veiled women, unchanging statues, they were crushing us with their colossal weight. Like a flight of vultures brought down to earth in an eternal order, always equal in number to the mortals scattered over the world. They had laid their claws pitilessly on the bristling hair of the distracted races, dragging off tearful Woman and humiliated Man. One evening the ancient planet quaked— It gave a great cry: "The Saviour has come, here is the young athlete, his forehead is bleeding and his side is wounded, but Fate dies at the feet of the Prophet; the Cross ascends and covers us like a shelter!" Before the time in the olden days when these things took place, every man was bowed down, with a pale and wasted face; when this cry was uttered, they all arose. Untying the heavy knots of the leaden yoke of Destiny, all the Nations cried out at once: "Oh Lord! Is it true? Is Destiny dead?" And one saw the daughters of Destiny reascending to Heaven in flocks, opening with an effort their talons which were gripping our disconsolate races. Their feet of brass they concealed under the long folds of their robes; their hands were unrelenting and their faces inflexible. They ascended slowly in an innumerable swarm, gliding imperceptibly, wingless, insensibly, like the peaceful ascent of a thunder cloud on a far horizon at evening. A sigh of happiness issued from the human heart; the Earth shivered in its immense orbit as a horse quivers when released from his bridle. All the stars, deeply moved, kept silence, waiting with Man, in the same stupor, for the supreme decree of the Almighty. When the daughters of Heaven, returning to the Lord, rediscovering the regions of their birth, stood all together around Jehovah, they raised their fatal hands with an identical movement, and sang in unison their hymn of grief, bowing their calm, pale faces: "We have come to ask the Law for the future. Oh Lord, we are the cold Fates whose ancient power was not meant to fail. We made the days and years revolve under our fingers. Are we to live on or are we to end our lives, we who are by far the eldest of the Heavenly powers? You are destroying at a blow the great snare of Fate into which the dismayed races of men fell one after another. Is it necessary to fill in the pit and break the spring of the trap? Will we no longer lead this feeble and dejected flock, these men of a moment, condemned to death, to the end of the road whose boundary stone we fix? The mould of life was hollowed out by us. All the passions poured out their lava in it, and events came there to blend themselves. On the tables of bronze where our law is engraved, you are erasing Fate's name, you unfetter the feet of our slave, Man. Who will bear the burden which has terrified every creature? Who will bear the weight on the conscience whose name is written below: RESPONSIBILITY"? There was a silence, and the Earth, giving way, stopped, as a boat without rowers

1150

rocks on stormy waves in the night. A voice came down from the heights where the worlds are begotten endlessly in space; the voice filled the depths of the earth: "Return in my name, oh Queens, I am the Saving Grace. Man will always be an uncertain swimmer in the seas of time, time which measures itself out and passes on. You will touch him on the forehead, oh daughters of Destiny! Wishing to find his place and foresee his end, his arm will cleave the water, whether the tide is high or low. He will be happier believing himself his own master and free, while struggling against you in a losing battle, where I alone will maintain the balance from on high. From me will spring his strength and his breath forever. His merit is mine; his eternal law: 'Do my will in order that you may come only I know whither.'" And the chorus descended to its eternal prey in order to recapture its domination over the timid, imperfect and rebellious race of men. The dark legion was heard coming, and the feet of those inflexible women were heard falling again with a noise like a leaden coffin dropping down into our burial vaults. Each one of the Fates took a man in her invisible hands.—In the sombre duel, our souls, in mourning but stronger now, combat those impassive spirits. We sometimes lift up their treacherous and cruel fingers. Will transports to sublime heights our brow lighted by a ray from heaven. On capes and rocks and mountain tops, however, the severe finger of Fate appears in front of us and, at one blow, strikes us down into the depths of the black chasms. In what great despair we still live! You have loosened the COLLAR which binds us, but who holds the chain?—Ah, just God, is it you? As free and proud arbiters of the actions of our lives, if our hearts are half opened to the fragrance of virtue, if they are enkindled by love, if they rise to genius, may the shadow of the Fates, oh Lord, no longer oppose an unalterable obstacle to our noble ardors, and deal unforeseen blows to our endless efforts! Oh frightening matters troubling the bravest! Unanswerable question in the face of which even the saints are silent! Mystery! Torment of the strong and earnest soul! Our eternal motto is: IT WAS WRITTEN IN THE BOOK OF GOD, the enslaved Orient says; and the Occident answers: IN THE BOOK OF CHRIST.

(1849)

Nothing in French literature can be compared with the slow, forceful, inexorable movement of these rugged tercets.

ÉMILE LAUVRIÈRE
Alfred de Vigny: Sa vie et son œuvre (1909)

HEINRICH HEINE

1 7 9 7 — 1 8 5 6

GAZELLES

Es hüpfen herbei und lauschen
Die frommen, klugen Gazelln;
Und in der Ferne rauschen
Des heiligen Stromes Welln.

Gazelles come bounding from the brake,
And pause, and look shyly round;
And the waves of the sacred river make
A far-off slumb'rous sound.

Lyrisches Intermezzo (1822–23)
Translated by Sir Theodore Martin

This is an immortal stanza.

GEORG BRANDES
Main Currents in Nineteenth Century Literature (1905)

HEINRICH HEINE

1 7 9 7 — 1 8 5 6

EIN FICHTENBAUM STEHT EINSAM

Ein Fichtenbaum steht einsam
Im Norden auf kahler Höh'.
Ihn schläfert; mit weisser Decke
Umhüllen ihn Eis und Schnee.

Er träumt von einer Palme,
Die fern im Morgenland
Einsam und schweigend trauert
Auf brennender Felsenwand.

A LONELY PINE IS STANDING

A lonely pine is standing
In the North where high winds blow.
He sleeps; and the whitest blanket
Wraps him in ice and snow.

1152

He dreams—dreams of a palm-tree
That far in an Orient land
Languishes, lonely and drooping,
Upon the burning sand.

<div align="right">

Lyrisches Intermezzo (1822–23)
Translated by Louis Untermeyer

</div>

The loveliest poem of eight lines in the literature of the world.

<div align="right">

MICHAEL MONAHAN
Heinrich Heine (1923)

</div>

GIACOMO LEOPARDI

1 7 9 8 — 1 8 3 7

THE INFINITE

Sempre caro mi fu quest' ermo colle,
E questa siepe, che da tanta parte
Dell' ultimo orizzonte il guardo esclude.
Ma sedendo e mirando, interminati
Spazi di la da quella, e sovrumani
Silenzi, e profondissima quiete
Io nel pensier mi fingo, ove per poco
Il cor non si spaura. E come il vento
Odo stormir tra queste piante, io quello
Infinito silenzio e questa voce
Vo comparando, e mi sovvien l' eterno,
E le morte stagioni, e la presente
È viva, e il suon di lei. Così tra questa
Immensita s' annega il pensier mio,
E il naufragar m' è dolce in questo mare.

Dear to me ever was this lonely hill,
This hedge, that from mine eyes shuts off so much
Of the horizon's far immensity.
I sit and gaze, and in my mind are born
Unbounded space, unearthly silences,
And quietness profound, so that my heart
Leaps on the brink of fear. And as the wind

Murmurs among these leaves, this kindly voice
With that eternal silence I compare,
Think on infinity and the dead years,
Until the living present seems more near,
More sweet its sound. Thus are my thoughts submerged
In this immensity, and in this sea
'Tis happiness voluptuously to drown.

Translated by Romilda Rendel

Leopardi's blank verse is the finest in Italian literature.

A History of Italian Literature (1928)

HONORÉ DE BALZAC

1 7 9 9 — 1 8 5 0

THE MAISON VAUQUER

This apartment is in all its lustre at the moment when, toward seven o'clock in the morning, Madame Vauquer's cat precedes his mistress, jumping on the sideboards, smelling at the milk contained in several basins covered with plates, and giving forth his matutinal purr. Presently the widow appears, decked out in her tulle cap, under which hangs a crooked band of false hair; as she walks she drags along her wrinkled slippers. Her little plump elderly face, from the middle of which protrudes a nose like a parrot's beak; her little fat dimpled hands, her whole person, rounded like a church-rat, the waist of her gown, too tight for its contents, which flaps over it, are all in harmony with this room, where misfortune seems to ooze, where speculation lurks in corners, and of which Madame Vauquer inhales the warm, fetid air without being nauseated. Her countenance, fresh as a first autumn frost, her wrinkled eyes, whose expression passes from the smile prescribed to *danseuses* to the acrid scowl of the discounter—her whole person, in short, is an explanation of the boarding-house, as the boarding-house is an implication of her person. . . . Her worsted petticoat, which falls below her outer skirt, made of an old dress, and with the wadding coming out of the slits in the stuff, which is full of them, resumes the parlour, the dining-room, the yard, announces the kitchen, and gives a presentiment of the boarders.

Le Père Goriot (1834)

In this musty and mouldy little boarding-house the Père Goriot is the senior resident. Certain students in law and medicine, from the Quartier Latin, hard by, subscribe to the dinner, where Maman Vauquer glares at them when she watches them cut their slice from the loaf. When the Père Goriot dies horribly, at the end of the tragedy, the kindest thing said of him, as the other boarders unfold their much-crumpled napkins, is, "Well, he won't sit and sniff his bread any more!" and the speaker imitates the old man's favourite gesture. The portrait of the Maison Vauquer and its inmates is one of the most portentous settings of the scene in all the literature of fiction. In this case there is nothing superfluous; there is a profound correspondence between the background and the action.

HENRY JAMES
French Poets and Novelists (1878)

THOMAS HOOD

1 7 9 9 — 1 8 4 5

THE HAUNTED HOUSE

A ROMANCE

Part I

Some dreams we have are nothing else but dreams,
Unnatural, and full of contradictions;
Yet others of our most romantic schemes
Are something more than fictions.

It might be only on enchanted ground;
It might be merely by a thought's expansion;
But in the spirit, or the flesh, I found
An old deserted Mansion.

A residence for woman, child, and man,
A dwelling-place,—and yet no habitation;
A House,—but under some prodigious ban
Of excommunication.

Unhinged the iron gates half open hung,
Jarr'd by the gusty gales of many winters,
That from its crumbled pedestal had flung
One marble globe in splinters.

No dog was at the threshold, great or small;
No pigeon on the roof—no household creature—
No cat demurely dozing on the wall—
Not one domestic feature.

No human figure stirr'd, to go or come,
No face look'd forth from shut or open casement;
No chimney smoked—there was no sign of Home
From parapet to basement.

With shatter'd panes the grassy court was starr'd;
The time-worn coping-stone had tumbled after!
And thro' the ragged roof the sky shone, barr'd
With naked beam and rafter.

O'er all there hung a shadow and a fear;
A sense of mystery the spirit daunted
And said, as plain as whisper in the ear,
The place is Haunted!

The flow'r grew wild and rankly as the weed,
Roses with thistles struggled for espial,
And vagrant plants of parasitic breed
Had overgrown the Dial.

But gay or gloomy, steadfast or infirm,
No heart was there to heed the hour's duration;
All times and tides were lost in one long term
Of stagnant desolation.

The wren had built within the Porch, she found
Its quiet loneliness so sure and thorough;
And on the lawn,—within its turfy mound,—
The rabbit made its burrow.

The rabbit wild and gray, that flitted thro'
The shrubby clumps, and frisk'd, and sat, and vanish'd,
But leisurely and bold, as if he knew
His enemy was banish'd.

The wary crow,—the pheasant from the woods—
Lull'd by the still and everlasting sameness,
Close to the Mansion, like domestic broods,
Fed with a 'shocking tameness.'

The coot was swimming in the reedy pond,
Beside the water-hen, so soon affrighted;
And in the weedy moat the heron, fond
Of solitude, alighted.

The moping heron, motionless and stiff,
That on a stone, as silently and stilly,
Stood, an apparent sentinel, as if
To guard the water-lily.

No sound was heard except, from far away,
The ringing of the Whitwall's shrilly laughter,
Or, now and then, the chatter of the jay,
That Echo murmur'd after.

But Echo never mock'd the human tongue;
Some weighty crime, that Heaven could not pardon,
A secret curse on that old Building hung,
And its deserted Garden.

The beds were all untouch'd by hand or tool;
No footstep mark'd the damp and mossy gravel,
Each walk as green as is the mantled pool,
For want of human travel.

The vine unprun'd, and the neglected peach,
Droop'd from the wall with which they used to grapple;
And on the canker'd tree, in easy reach,
Rotted the golden apple.

But awfully the truant shunn'd the ground,
The vagrant kept aloof, and daring Poacher,
In spite of gaps that thro' the fences round
Invited the encroacher.

For over all there hung a cloud of fear,
A sense of mystery the spirit daunted,
And said, as plain as whisper in the ear,
The place is Haunted!

The pear and quince lay squander'd on the grass:
The mould was purple with unheeded showers
Of bloomy plums—a Wilderness it was
Of fruits, and weeds, and flowers!

The marigold amidst the nettles blew,
The gourd embraced the rose bush in its ramble.
The thistle and the stock together grew,
The holly-hock and bramble.

The bear-bine with the lilac interlaced,
The sturdy bur-dock choked its slender neighbour,
The spicy pink. All tokens were effac'd
Of human care and labour.

The very yew Formality had train'd
To such a rigid pyramidal stature,
For want of trimming had almost regain'd
The raggedness of nature.

The Fountain was a-dry—neglect and time
Had marr'd the work of artisan and mason,
And efts and croaking frogs, begot of slime,
Sprawl'd in the ruin'd bason.

The Statue, fallen from its marble base,
Amidst the refuse leaves, and herbage rotten,
Lay like the Idol of some bygone race,
Its name and rites forgotten.

On ev'ry side the aspect was the same,
All ruin'd, desolate, forlorn, and savage:
No hand or foot within the precinct came
To rectify or ravage.

For over all there hung a cloud of fear,
A sense of mystery the spirit daunted,
And said as plain as whisper in the ear,
The place is Haunted!

Part II

O, very gloomy is the House of Woe,
Where tears are falling while the bell is knelling,
With all the dark solemnities which show
That Death is in the dwelling!

O very, very dreary is the room
Where Love, domestic Love, no longer nestles,
But smitten by the common stroke of doom,
The Corpse lies on the trestles!

But House of Woe, and hearse, and sable pall,
The narrow home of the departed mortal,
Ne'er look'd so gloomy as that Ghostly Hall.
With its deserted portal!

The centipede along the threshold crept,
The cobweb hung across in mazy tangle,
And in its winding-sheet the maggot slept,
At every nook and angle.

The keyhole lodged the earwig and her brood,
The emmets ot the steps had old possession,
And march'd in search of their diurnal food
In undisturbed procession.

As undisturb'd as the prehensile cell
Of moth or maggot, or the spider's tissue,
For never foot upon that threshold fell,
To enter or to issue.

O'er all there hung the shadow of a fear,
A sense of mystery the spirit daunted,
And said, as plain as whisper in the ear,
The place is Haunted!

Howbeit, the door I pushed—or so I dream'd—
Which slowly, slowly gaped,—the hinges creaking
With such a rusty eloquence, it seem'd
That Time himself was speaking.

But Time was dumb within that Mansion old,
Or left his tale to the heraldic banners,
That hung from the corroded walls, and told
Of former men and manners:—

Those tatter'd flags, that with the open'd door,
Seem'd the old wave of battle to remember,
While fallen fragments danced upon the floor,
Like dead leaves in December.

The startled bats flew out—bird after bird—
The screech-owl overhead began to flutter,
And seem'd to mock the cry that she had heard
Some dying victim utter!

A shriek that echo'd from the joisted roof,
And up the stair, and further still and further,
Till in some ringing chamber far aloof
It ceased its tale of murther!

Meanwhile the rusty armour rattled round,
The banner shudder'd, and the ragged streamer:
All things the horrid tenor of the sound
Acknowledged with a tremor.

The antlers, where the helmet hung and belt,
Stirr'd as the tempest stirs the forest branches,
Or as the stag had trembled when he felt
The blood-hound at his haunches.

1159

The window jingled in its crumbled frame,
And thro' its many gaps of destitution
Dolorous moans and hollow sighings came.
Like those of dissolution.

The wood-louse dropped and rolled into a ball,
Touch'd by some impulse occult or mechanic;
And nameless beetles ran along the wall
In universal panic.

The subtle spider, that from overhead
Hung like a spy on human guilt and error,
Suddenly turn'd, and up its slender thread
Ran with a nimble terror.

The very stains and fractures on the wall
Assuming features solemn and terrific,
Hinted some tragedy of that old Hall,
Lock'd up in Hieroglyphic.

Some tale that might, perchance, have solved the doubt,
Wherefore amongst those flags so dull and livid,
The banner of the Bloody Hand shone out
So ominously vivid.

Some key to that inscrutable appeal,
Which made the very frame of Nature quiver;
And every thrilling nerve and fibre feel
So ague-like a shiver.

For over all there hung a cloud of fear,
A sense of mystery the spirit daunted,
And said, as plain as whisper in the ear,
The place is Haunted!

If but a rat had lingered in the house,
To lure the thought into a social channel!
But not a rat remain'd, or tiny mouse,
To squeak behind the panel.

Huge drops roll'd down the walls, as if they wept;
And where the cricket used to chirp so shrilly,
The toad was squatting, and the lizard crept
On that damp hearth and chilly.

For years no cheerful blaze had sparkled there,
Or glanc'd on coat of buff or knightly metal;
The slug was crawling on the vacant chair,—
The snail upon the settle.

The floor was redolent of mould and must,
The fungus in the rotten seams had quicken'd;
While on the oaken table coats of dust
Perennially had thicken'd.

No mark of leathern jack or metal can,
No cup—no horn—no hospitable token—
All social ties between that board and Man
Had long ago been broken.

There was so foul a rumour in the air,
The shadow of a Presence so atrocious;
No human creature could have feasted there,
Even the most ferocious.

For over all there hung a cloud of fear,
A sense of mystery the spirit daunted,
And said, as plain as whisper in the ear,
The place is Haunted!

Part III

'Tis hard for human actions to account,
Whether from reason or from impulse only—
But some internal prompting bade me mount
The gloomy stairs and lonely.

Those gloomy stairs, so dark, and damp, and cold,
With odours as from bones and relics carnal,
Deprived of rite, and consecrated mould,
The chapel vault, or charnel.

Those dreary stairs, where with the sounding stress
Of ev'ry step so many echoes blended,
The mind, with dark misgivings, fear'd to guess
How many feet ascended.

The tempest with its spoils had drifted in,
Till each unwholesome stone was darkly spotted,
As thickly as the leopard's dappled skin,
With leaves that rankly rotted.

The air was thick—and in the upper gloom
The bat—or something in its shape—was winging,
And on the wall, as chilly as a tomb,
The Death's Head moth was clinging.

1161

That mystic moth, which, with a sense profound
Of all unholy presence, augurs truly;
And with a grim significance flits round
The taper burning bluely.

Such omens in the place there seem'd to be,
At ev'ry crooked turn, or on the landing,
The straining eyeball was prepared to see
Some Apparition standing.

For over all there hung a cloud of fear,
A sense of mystery the spirit daunted,
And said, as plain as whisper in the ear,
The place is Haunted!

Yet no portentous Shape the sight amaz'd;
Each object plain, and tangible, and valid;
But from their tarnish'd frames dark Figures gaz'd,
And Faces spectre-pallid.

Not merely with the mimic life that lies
Within the compass of Art's simulation;
Their souls were looking thro' their painted eyes
With awful speculation.

On every lip a speechless horror dwelt;
On ev'ry brow the burthen of affliction;
The old Ancestral Spirits knew and felt
The House's malediction.

Such earnest woe their features overcast,
They might have stirr'd, or sigh'd, or wept, or spoken;
But, save the hollow moaning of the blast,
The stillness was unbroken.

No other sound or stir of life was there,
Except my steps in solitary clamber,
From flight to flight, from humid stair to stair,
From chamber into chamber.

Deserted rooms of luxury and state,
That old magnificence had richly furnish'd
With pictures, cabinets of ancient date,
And carvings gilt and burnish'd.

Rich hangings, storied by the needle's art,
With scripture history, or classic fable;
But all had faded, save one ragged part,
Where Cain was slaying Abel.

The silent waste of mildew and the moth
Had marr'd the tissue with a partial ravage;
But undecaying frown'd upon the cloth
Each feature stern and savage.

The sky was pale; the cloud a thing of doubt;
Some hues were fresh, and some decay'd and duller;
But still the BLOODY HAND shone strangely out
With vehemence of colour!

The BLOODY HAND that with a lurid stain
Shone on the dusty floor, a dismal token,
Projected from the casement's painted pane,
Where all beside was broken.

The BLOODY HAND significant of crime,
That glaring on the old heraldic banner,
Had kept its crimson unimpair'd by time,
In such a wondrous manner!

O'er all there hung the shadow of a fear,
A sense of mystery the spirit daunted,
And said, as plain as whisper in the ear,
The place is Haunted!

The Death Watch tick'd behind the panel'd oak,
Inexplicable tremors shook the arras,
And echoes strange and mystical awoke,
The fancy to embarrass.

Prophetic hints that filled the soul with dread,
But thro' one gloomy entrance pointing mostly,
The while some secret inspiration said
That Chamber is the Ghostly!

Across the door no gossamer festoon
Swung pendulous—no web—no dusty fringes,
No silky chrysalis or white cocoon
About its nooks and hinges.

The spider shunn'd the interdicted room,
The moth, the beetle, and the fly were banish'd,
And where the sunbeam fell athwart the gloom,
The very midge had vanish'd.

One lonely ray that glanc'd upon a Bed,
As if with awful aim direct and certain,
To show the BLOODY HAND in burning red
Embroider'd on the curtain.

And yet no gory stain was on the quilt—
The pillow in its place had slowly rotted;
The floor alone retain'd the trace of guilt,
Those boards obscurely spotted.

Obscurely spotted to the door, and thence
With mazy doubles to the grated casement—
Oh what a tale they told of fear intense,
Of horror and amazement!

What human creature in the dead of night
Had coursed like hunted hare that cruel distance?
Had sought the door, the window in his flight,
Striving for dear existence?

What shrieking Spirit in that bloody room
Its mortal frame had violently quitted?—
Across the sunbeam, with a sudden gloom,
A ghostly Shadow flitted.

Across the sunbeam, and along the wall,
But painted on the air so very dimly,
It hardly veil'd the tapestry at all,
Or portrait frowning grimly.

O'er all there hung the shadow of a fear,
A sense of mystery the spirit daunted,
And said, as plain as whisper in the ear,
The place is Haunted! (1844)

One of the truest poems ever written—one of the TRUEST—*one of the
most unexceptionable—one of the most thoroughly artistic, both in its
theme and in its execution. It is, moreover, powerfully ideal—imagina-
tive.*

<div align="right">

EDGAR ALLAN POE
The Poetic Principle (1850)

</div>

<div align="center">

THOMAS HOOD

1 7 9 9 — 1 8 4 5

RHYMES

</div>

Still, for all slips of hers,
One of Eve's family—
Wipe those poor lips of hers
Oozing so clammily.

<div align="right">

The Bridge of Sighs (1844)

</div>

Hood is one of the great artists in English verse, especially in his serious play with double and treble endings. No one else could have written such a stanza.

ARTHUR SYMONS
The Romantic Movement in English Poetry (1909)

JOHN HENRY NEWMAN

1 8 0 1 — 1 8 9 0

BLESSED VISION OF PEACE

Such were the thoughts concerning the "Blessed Vision of Peace," of one whose long-continued petition had been that the Most Merciful would not despise the work of His own Hands, nor leave him to himself;—while yet his eyes were dim, and his breast laden, and he could but employ Reason in the things of Faith. And now, dear Reader, time is short, eternity is long. Put not from you what you have here found; regard it not as mere matter of present controversy; set not out resolved to refute it, and looking about for the best way of doing so; seduce not yourself with the imagination that it comes of disappointment, or disgust, or restlessness, or wounded feeling, or undue sensibility, or other weakness. Wrap not yourself round in the associations of years past; nor determine that to be truth which you wish to be so, nor make an idol of cherished anticipations. Time is short, eternity is long.

NUNC DIMITTIS SERVUM TUUM, DOMINE,

SECUNDUM VERBUM TUUM IN PACE:

QUIA VIDERUNT OCULI MEI SALUTARE TUUM.

An Essay on the Development
of Christian Doctrine (1845)

It will be remembered as long as the English language endures.

PAUL ELMER MORE
The Drift of Romanticism (1913)

VICTOR HUGO

1 8 0 2 — 1 8 8 5

LIGHT AND LIFE

Oui, ce soleil est beau. Ses rayons,—les derniers!—
Sur le front du Taunus posent une couronne;
Le fleuve luit; le bois de splendeurs s'environne;
Les vitres du hameau, là-bas, sont tout en feu;
Que c'est beau! que c'est grand! que c'est charmant, mon Dieu!
La nature est un flot de vie et de lumière! . . .

> 'Tis true, the sun is beautiful. Its rays—
> The last—do set a crown on Taunus' brow.
> The river gleams, the forests are engirt
> With brilliancy. The windows in yon burg
> Are all on fire. How beautiful it is!
> How grand! how lovely. O Almighty God!
> All nature is a flood of light and life!—

<div align="right">

Les Burgraves, Part i, Scene iii (1843)
Translated by George Burnham Ives

</div>

LOVE

De ma vie, ô mon Dieu! cette heure est la première.
Devant moi tout un monde, un monde de lumière,
Comme ces paradis qu'en songe nous voyons,
S'entr'ouvre en m'inondant de vie et de rayons!
Partout en moi, hors moi, joie, extase et mystère,
Et l'ivresse, et l'orgueil, et ce qui, sur la terre,
Se rapproche le plus de la divinité,
L'amour dans la puissance et dans la majesté!

> In all my life, oh God,
> This hour stands first. Before me is a world,
> A world of light, as if the paradise
> We dream about had open'd wide and fill'd
> My being with new life and brilliancy!
> In me, around me, everywhere is joy,
> Intoxication, mystery, and delight,
> And pride, and that one thing that on the earth
> Approaches most divinity, love—love,
> In majesty and power.

<div align="right">

Ruy Blas, Act iii, Scene iv (1838)
Translated by Mrs. Newton Crosland

</div>

OH, THOU, MY LOVER

Tout s'est éteint, flambeaux et musique de fête;
Rien que la nuit et nous! Félicité parfaite!
Dis, ne le crois-tu pas? sur nous, tout en dormant,
La nature à demi veille amoureusement.
La lune est seule aux cieux, qui comme nous repose,
Et respire avec nous l'air embaumé de rose!
Regarde: plus de feux, plus de bruit. Tout se tait.
La lune tout à l'heure à l'horizon montait;
Tandis que tu parlais, sa lumière qui tremble
Et ta voix, toutes deux m'allaient au cœur ensemble;
Je me sentais joyeuse et calme, ô mon amant!
Et j'aurais bien voulu mourir en ce moment.

 All now is o'er, the torches out,
The music done. Night only is with us.
Felicity most perfect! Think you not
That now while all is still and slumbering,
Nature, half waking, watches us with love?
No cloud is in the sky. All things like us
Are now at rest. Come, breathe with me the air
Perfumed by roses. Look, there is no light,
Nor hear we any noise. Silence prevails.
The moon just now from the horizon rose
E'en while you spoke to me; her trembling light
And thy dear voice together reached my heart.
Joyous and softly calm I felt, oh, thou
My lover! And it seemed that I would then
Most willingly have died.

<div align="right">Hernani, Act v, Scene iii (1830)

Translated by Mrs. Newton Crosland</div>

Drama can rise to the most sublime lyric flights, and as witness of this we need only turn to the plays of Victor Hugo.

<div align="right">THÉODORE DE BANVILLE

Petit Traité de poésie française (1871)</div>

VICTOR HUGO

1 8 0 2 — 1 8 8 5

TRISTESSE D'OLYMPIO

Que peu de temps suffit pour changer toutes choses!
Nature au front serein, comme vous oubliez!
Et comme vous brisez dans vos métamorphoses
Les fils mystérieux où nos cœurs sont liés!

Nos chambres de feuillage en halliers sont changées;
L'arbre où fut notre chiffre est mort ou renversé,
Nos roses dans l'enclos ont été ravagées
Par les petits enfants qui sautent le fossé!

Un mur clôt la fontaine où, par l'heure échauffée,
Folâtre elle buvait en descendant des bois:
Elle prenait de l'eau dans sa main, douce fée,
Et laissait retomber des perles de ses doigts!

On a pavé la route âpre et mal aplanie,
Où, dans le sable pur se dessinant si bien
Et de sa petitesse étalant l'ironie,
Son pied charmant semblait rire à côté du mien!

La borne du chemin, qui vit des jours sans nombre,
Où jadis pour m'attendre elle aimait à s'asseoir,
S'est usée en heurtant, lorsque la route est sombre,
Les grands chars gémissants qui reviennent le soir.

La forêt ici manque et là est agrandie.
De tout ce qui fut nous presque rien n'est vivant;
Et, comme un tas de cendre éteinte et refroidie,
L'amas des souvenirs se disperse à tout vent!

N'existons-nous donc plus? Avons-nous eu notre heure?
Rien ne la rendra-t-il à nos cris superflus?
L'air joue avec la branche au moment où je pleure,
Ma maison me regarde et ne me connaît plus.

D'autres vont maintenant passer où nous passâmes.
Nous y sommes venus, d'autres vont y venir;
Et le songe qu'avaient ébauché nos deux âmes,
Ils le continueront sans pouvoir le finir!

Car personne ici-bas ne termine et n'achève;
Les pires des humains sont comme les meilleurs,
Nous nous réveillons tous au même endroit du rêve:
Tout commence en ce monde et tout finit ailleurs.

Oui, d'autres à leur tour viendront, couples sans tache,
Puiser dans cet asile heureux, calme, enchanté,
Tout ce que la nature à l'amour qui se cache
Mêle de rêverie et de solennité!

D'autres auront nos champs, nos sentiers, nos retraites;
Ton bois, ma bien-aimée, est à des inconnus.
D'autres femmes viendront, baigneuses indiscrètes,
Troubler le flot sacré qu'ont touché tes pieds nus!

Quoi donc! c'est vainement qu'ici nous nous aimâmes!
Rien ne nous restera de ces coteaux fleuris
Où nous fondions notre être en y mêlant nos flammes!
L'impassible nature a déjà tout repris!

Oh! dites-moi, ravins, frais ruisseaux, treilles mûres,
Rameaux chargés de nids, grottes, forêts, buissons,
Est-ce que vous ferez pour d'autres vos murmures?
Est-ce que vous direz à d'autres vos chansons?

Nous vous comprenions tant! doux, attentifs, austères,
Tous nos échos s'ouvraient si bien à votre voix!
Et nous prêtions si bien, sans troubler vos mystères,
L'oreille aux mots profonds que vous dites parfois!

Répondez, vallon pur; répondez, solitude;
O nature abritée en ce désert si beau,
Lorsque nous dormirons tous deux dans l'attitude
Que donne aux morts pensifs la forme du tombeau,

Est-ce que vous serez à ce point insensible
De nous savoir couchés, morts avec nos amours,
Et de continuer votre fête paisible,
Et de toujours sourire et de chanter toujours?

Est-ce que, nous sentant errer dans vos retraites,
Fantômes reconnus par vos monts et vos bois,
Vous ne nous direz pas de ces choses secrètes
Qu'on dit en revoyant des amis d'autrefois?

Est-ce que vous pourrez, sans tristesse et sans plainte,
Voir nos ombres flotter où marchèrent nos pas,
Et la voir m'entraîner, dans une morne étreinte,
Vers quelque source en pleurs qui sanglote tout bas?

Et, s'il est quelque part, dans l'ombre où rien ne veille,
Deux amants sous vos fleurs abritant leurs transports,
Ne leur irez-vous pas murmurer à l'oreille:
—Vous qui vivez, donnez une pensée aux morts!

Dieu nous prête un moment les prés et les fontaines,
Les grands bois frissonnants, les rocs profonds et sourds,
Et les cieux azurés et les lacs et les plaines,
Pour y mettre nos cœurs, nos rêves, nos amours!

Puis il nous les retire; il souffle notre flamme;
Il plonge dans la nuit l'antre où nous rayonnons;
Et dit à la vallée où s'imprima notre âme
D'effacer notre trace et d'oublier nos noms.

Eh bien, oubliez-nous, maison, jardin, ombrages!
Herbe, use notre seuil! ronce, cache nos pas!
Chantez, oiseaux! ruisseaux, coulez! croissez, feuillages!
Ceux que vous oubliez ne vous oublieront pas!

Car vous êtes pour nous l'ombre de l'amour même!
Vous êtes l'oasis qu'on rencontre en chemin!
Vous êtes, ô vallon! la retraite suprême
Où nous avons pleuré nous tenant par la main!

Toutes les passions s'éloignent avec l'âge,
L'une emportant son masque et l'autre son couteau,
Comme un essaim chantant d'histrions en voyage
Dont le groupe décroît derrière le coteau.

Mais toi, rien ne t'efface, Amour, toi qui nous charmes!
Toi qui, torche ou flambeau, luis dans notre brouillard!
Tu nous tiens par la joie et surtout par les larmes!
Jeune homme on te maudit, on t'adore vieillard.

Dans ces jours où la tête au poids des ans s'incline,
Où l'homme, sans projets, sans but, sans visions,
Sent qu'il n'est déjà plus qu'une tombe en ruine
Où gisent ses vertus et ses illusions;

Quand notre âme en rêvant descend dans nos entrailles,
Comptant dans notre cœur, qu'enfin la glace atteint,
Comme on compte les morts sur un champ de bataille,
Chaque douleur tombée et chaque songe éteint;

Comme quelqu'un qui cherche en tenant une lampe,
Loin des objets réels, loin du monde rieur,
Elle arrive à pas lents par une obscure rampe
Jusqu'au fond désolé du gouffre intérieur;

Et là, dans cette nuit qu'aucun rayon n'étoile,
L'âme, en un repli sombre où tout semble finir,
Sent quelque chose encor palpiter sous un voile . . .
C'est toi qui dors dans l'ombre, ô sacré souvenir!

THE SADNESS OF OLYMPIO

How short a time suffices to estrange
 Thy face, calm Nature! How dost thou forget!
How dost thou sever by continual change
 The strings unseen that take us in the net!

The tree that bore our names is felled, or dead;
 Our green-clad bowers are grown to thickets brown;
The little boys who jump the ditch, and tread
 The unwatched close, have torn our roses down.

Where once athirst, descending from the wood,
 Gaily she drank, the little waterfall
Her hands enchaliced, and in fairy mood
 Showered for pearls, is prisoned by a wall.

'Tis metalled now, the rough uneven road,
 Where printing on the sand a clear-cut line,
Her little steps in humorous contrast showed
 Their footmarks laughing by the side of mine.

The immemorial stone beside the way,
 Where she would sit, and wait for me to come,
Is worn by jostlings at the close of day
 From the great carts, that creaked as they went home.

The forest here has shrunk, and there has spread;
 Little survives wherein we had our share;
And like a heap of ashes cold and dead
 Our memories are scattered by the air.

Is all then over? Have we lived our day?
 Is crying unavailing to restore?
Winds, as I grieve, among the tree-tops play;
 My dwelling fronts me, knowing me no more.

Others must now be passing where we passed,
 The paths we traced be traced by others' feet,
The dream of life by our two hearts forecast
 Others perhaps continue—not complete.

For none on earth can fully end or make
 What they would compass, be it worst or best;
Just when the dream seems fairest, we awake;
 Here the beginning—somewhere else the rest.

Yes, other innocent lovers in their bliss
 Will come to taste what Nature's fount supplies
Of awe, of magic in a spot like this
 To love that hides itself from curious eyes.

Leave we to others fields and paths and glades,
 And your own wood by strangers to be trod,
And trampled be by other barefoot maids
 The wave made holy round your feet unshod.

That in this spot we loved was all in vain.
 Nothing to us, who here blent soul with soul,
Of all these flowering hillsides may remain.
 Passionless Nature has resumed the whole.

Tell me O forest, rivulet and brake,
 Nest-laden boughs, caves, thickets, fruits that hang,
Speak ye to others as to us ye spake?
 Sing ye for others as for us ye sang?

We knew your language. Docile, grave, intent,
 Our hearts responded to the tale you told.
We reverenced your mysteries; we lent
 Ears to the deeper secrets you unfold.

Answer chaste valley, and thou solitude,
 Thou Nature shrined within a scene so fair,
When we shall sleep, to that calm form subdued
 Shaped by the tomb for those who slumber there,

Will you be still so mindless as to see
 Us dead together, loving and beloved,
And to continue your mild ecstasy,
 And to smile on, and to sing on, unmoved?

If you then mark us in our wanderings,
 Ghosts by your woods and banks once known so well,
Will you not tell us some of those fond things
 We, when we meet an old acquaintance, tell?

Will you ungrieving, unbewailing see
 Our phantoms flitting where in life we went,
And her with sad embraces drawing me
 Down to some streamlet vocal in lament?

And if some dusky nook, where nothing stirs,
 To hide their bliss two lovers shall have sped,
Will you not go and whisper in their ears
 "Think, you who live, one moment on the dead"?

God for an instant lends us park and brake,
 Tall shivering trees, dark rocks and running streams,
The deep blue sky, the meadow and the lake,
 Wherein to rest our hearts, our hopes, our dreams.

Then He withdraws them; makes the circle dark
 Lit by our tapers; He blows our our flames,
And bids the valley where we set our mark
 Efface our soul-prints, and forget our names.

Be it so, forget us, dwelling, garden, shade!
 Weeds, blur our threshold! Thorns, blot out our trace!
Sing, ye birds; flow, ye rills! Leaves, sprout and fade!
 Those you forget will not forget your face.

You, to our eyes, were love's own counterfeit;
 An oasis amidst our waste of sand;
Thou, O lone valley, wert the last retreat
 Where we shed tears together hand in hand.

Our passions leave us as our feelings grow,
 One with its mask, another with its knife;
Like strolling actors, singing as they go,
 They disappear behind the hills of life.

But thee, O Love, whom every thought endears,
 Our light in darkness, nothing can destroy;
Thou hold'st us by our joys, yea by our tears,
 Idol of age, the torment of the boy.

Now, when the head with weight of years is bent,
 When aimless, nerveless, all our visions fled,
We feel ourselves the ruined monument
 Wherein our hopes and energies lie dead;

When the soul sinks within us, while again
 It numbers, in a heart just touched by frost,
As on a battlefield men count the slain,
 Each out-worn sorrow, each illusion lost;

When even as one searching with a light,
 Far from broad day, far from the world's gay din,
At last it reaches by a winding flight
 The ungarnished basement of the void within;

There, in that night unstarred by any spark,
 Upon some confine of existence, thee
It finds yet stirring, breathing through the dark,
 Veiled and asleep—O sacred memory!

 Les Rayons et les ombres (1840)
 Translated by Sir George Young

VICTOR HUGO

1 8 0 2 — 1 8 8 5

FROM *LES CONTEMPLATIONS*

Une terre au flanc maigre, âpre, avare, inclément,
Où les vivants pensifs travaillent tristement,
Et qui donne à regret à cette race humaine
Un peu de pain pour tant de labeur et de peine;
Des hommes durs, éclos sur ces sillons ingrats;
Des cités d'où s'en vont, en se tordant les bras,
La charité, la paix, la foi, sœurs vénérables;
L'orgueil chez les puissants et chez les misérables;
La haine au cœur de tous; la mort, spectre sans yeux,
Frappant sur les meilleurs des coups mystérieux;
Sur tous les hauts sommets, des brumes répandues;
Deux vierges, la justice et la pudeur, vendues;
Toutes les passions engendrant tous les maux;
Des forêts abritant des loups sous leurs rameaux;
Là le désert torride, ici les froids polaires;
Des océans, émus de subites colères,
Pleins de mâts frissonnants qui sombrent dans la nuit;
Des continents couverts de fumée et de bruit,
Où, deux torches aux mains, rugit la guerre infâme,
Où toujours quelque part fume une ville en flamme,
Où se heurtent sanglants les peuples furieux;—

Et que tout cela fasse un astre dans les cieux!

BRIGHT STARS AND DARK

A meagre soil, arid and harsh and rude,
Furrowed by man with dull solicitude,
Yielding with grudging to the labouring swains
A little bread for all their pangs and pains;

Dour peasants, bending o'er ungrateful lands;
Crammed cities whence depart, wringing their hands,
The sisters grave, Peace, Faith, and Charity;
Pride in the homes of high and low degree,
Hate in all bosoms; Death, an eyeless guest,
Aiming clandestine buffets at the best;
Mists over all the lofty summits rolled;
Two virgins, Modesty and Justice, sold;

Men's passions all, begetters of all woes;
Here the parched desert, there the polar snows;
The forest sheltering wolves beneath its trees;
Lashed into sudden fits of rage, the seas
Shivering with masts that founder in the night;
Continents overspread with smoke and fright,
Where Discord fell, a torch in either hand,
Shrieks, where a flame goes up from land on land,
Where bleeding nations meet in frenzied jar,
—Strange that all this should go to make a star!

(1840)
Translated by Sir George Young

A wholly sublime composition.

CHARLES RENOUVIER
Victor Hugo le poète (1907)

VICTOR HUGO

1 8 0 2 — 1 8 8 5

FROM *PAROLES SUR LA DUNE*

Et je reste parfois couché sans me lever
 Sur l'herbe rare de la dune,
Jusqu'à l'heure où l'on voit apparaître et rêver
 Les yeux sinistres de la lune.

Elle monte, elle jette un long rayon dormant
 A l'espace, au mystère, au gouffre;
Et nous nous regardons tous les deux fixement,
 Elle qui brille et moi qui souffre.

Où donc s'en sont allés mes jours évanouis?
Est-il quelqu'un qui me connaisse?
Ai-je encor quelque chose en mes yeux éblouis,
De la clarté de ma jeunesse?

At times I lie stretched out, and never rise,
Upon the scant grass of the moor,
Until I see the moon's ill-omened eyes,
As in a dream, their glances pour.

Rising, she casts a long and sleepy ray
On space, the deep, and mystery;
And we each other with fixt eyes survey—
She shining bright, and I who sigh.

Where, then, have fled away my vanished years?
My face, is there a soul who knows?
Say, in my eyes if one last glance appears,
Which of my life's glad morning shows?

(1854)
Translated by Henry Carrington

Pure and miraculous poetry.

FERNAND GREGH
Étude sur Victor Hugo (1905)

VICTOR HUGO

1 8 0 2 — 1 8 8 5

BEYOND DREAMS

Il descend, réveillé, l'autre côté du rêve.

Awakened, he descends the far side of dreams.

Ce Que Dit la bouche d'ombre (1855)

This extraordinary line, so weighted with such a beautiful image, so pulsating with both emotion and thought, that you would seek vainly anywhere else than in Hugo for its equal.

ANDRÉ GIDE
Interviews Imaginaires (1943)

VICTOR HUGO

1 8 0 2 — 1 8 8 5

FROM *BOOZ ENDORMI*

Quel dieu, quel moissonneur de l'éternel été
Avait, en s'en allant, négligemment jeté
Cette faucille d'or dans le champ des étoiles.

What God, what harvester of eternal summer, in departing, had negli-
gently thrown that golden sickle into the field of stars.

La Légende des siècles (1857)

There is no art more knowing, nor more exquisite.

ÉMILE FAGUET
Dix-neuvième Siècle: Études littéraires (1887)

VICTOR HUGO

1 8 0 2 — 1 8 8 5

LES ENFANTS PAUVRES

Prenez garde à ce petit être;
Il est bien grand; il contient Dieu.
Les enfants sont, avant de naître,
Des lumières dans le ciel bleu.

Dieu nous les offre en sa largesse;
Ils viennent; Dieu nous en fait don;
Dans leur rire il met sa sagesse
Et dans leur baiser son pardon.

Leur douce clarté nous effleure.
Hélas, le bonheur est leur droit.
S'ils ont faim, le paradis pleure,
Et le ciel tremble, s'ils ont froid.

La misère de l'innocence
Accuse l'homme vicieux.
L'homme tient l'ange en sa puissance.
Oh! quel tonnerre au fond des cieux,

1177

Quand Dieu, cherchant ces êtres frêles
Que dans l'ombre où nous sommeillons
Il nous envoie avec des ailes,
Les retrouve avec des haillons!

THE CHILDREN OF THE POOR

Take heed of this small child of earth;
 He is great: he hath in him God most high.
Children before their fleshly birth
 Are lights alive in the blue sky.

In our light bitter world of wrong
 They come; God gives us them awhile.
His speech is in their stammering tongue,
 And his forgiveness in their smile.

Their sweet light rests upon our eyes.
 Alas! their right to joy is plain.
If they are hungry, Paradise
 Weeps, and, if cold, Heaven thrills with pain.

The want that saps their sinless flower
 Speaks judgment on sin's ministers.
Man holds an angel in his power.
 Ah! deep in Heaven what thunder stirs,

When God seeks out these tender things
 Whom in the shadow where we sleep
He sends us clothed about with wings,
 And finds them ragged babes that weep!
 Translated by Algernon Charles Swinburne

*There is one other poem of even more astonishing power, the five stanzas
about the children of the poor, which Mr. Swinburne's incomparable
rendering has made familiar to all lovers of English poetry. Perhaps
the translator has even surpassed his original, treachery as he would hold
it that we should say so: still, in any case the ineffable tenderness of the
poem is not his, but Hugo's. There is nothing quite like it so far as I
know in all poetry.*

<div align="right">

JOHN C. BAILEY
The Claims of French Poetry (1907)

</div>

VICTOR HUGO

1 8 0 2 · 1 8 8 5

FROM *TOUTE LA LYRE*

Passons, car c'est la loi; nul ne peut s'y soustraire;
Tout penche, et ce grand siècle, avec tous ses rayons,
Entre en cette ombre immense où, pâles, nous fuyons.
Oh! quel farouche bruit font dans le crépuscule
Les chênes qu'on abat pour le bûcher d'Hercule!
Les chevaux de la Mort se mettent à hennir
Et sont joyeux, car l'âge éclatant va finir;
Ce siècle altier, qui sut dompter le vent contraire,
Expire . . . O Gautier! toi, leur égal et leur frère,
Tu pars après Dumas, Lamartine et Musset.
L'onde antique est tarie où l'on rajeunissait;
Comme il n'est plus de Styx, il n'est plus de Jouvence.
Le dur faucheur avec sa large lame avance,
Pensif et pas à pas, vers le reste du blé;
C'est mon tour; et la nuit emplit mon œil troublé
Qui, devinant, hélas! l'avenir des colombes,
Pleure sur des berceaux et sourit à des tombes.

Let us pass on, for it is the law which no one can evade. Everything declines, and our great century, with all its rays of light, enters into that boundless shadow where, pale, we flee. What a savage noise the trees, which are felled for the funeral pyre of Hercules, make as they crash down in the twilight! The horses of Death begin to neigh and are joyful, because the brilliant age is ending; our proud century which knew how to subdue contrary winds, is expiring. . . . You, Gautier, are departing after Dumas, Lamartine and Musset, your equals and brothers. The fountains of the ancient world where one grew young again have run dry; there is no longer a river Styx, nor fountain of youth. The cruel reaper advances with his broad blade, pensively, step by step towards the rest of the wheat. It is my turn; and darkness fills my dimmed eyes, which, guessing, alas, at the future of the doves, weep over cradles and smile at graves.

À Théophile Gautier (1872)

Victor Hugo is the man who wrote the best French verse. No poetry at times is more beautiful or more virile than his. His virtuosity is incomparable.

PAUL VALÉRY
In conversation with Dorothy Bussy
Some Recollections of Paul Valéry (Horizon, May, 1946)

1179

VICTOR HUGO

1802 — 1885

NOUVELLE CHANSON
SUR UN VIEIL AIR

S'il est un charmant gazon
 Que le ciel arrose,
Où brille en toute saison
 Quelque fleur éclose,
Où l'on cueille à pleine main
Lis, chèvrefeuille et jasmin,
J'en veux faire le chemin
 Où ton pied se pose!

S'il est un sein bien aimant
 Dont l'honneur dispose,
Dont le ferme dévouement
 N'ait rien de morose;
Si toujours ce noble sein
Bat pour un digne dessein,
J'en veux faire le coussin
 Où ton front se pose!

S'il est un rêve d'amour,
 Parfumé de rose,
Où l'on trouve chaque jour
 Quelque douce chose,
Un rêve que Dieu bénit,
Où l'âme à l'âme s'unit,
Oh! j'en veux faire le nid
 Où ton cœur se pose!

NEW SONG TO AN OLD AIR

Is there a tuft of grass,
 Nought to deface it,
Where, in their tiny mass,
 Sunny flowers grace it;
Where purple, gold, and red,
Mix in their scented bed?
Under her fairy tread
 Softly I'd place it.

Is there a loving breast,
 Fond as the willow
Watching the stream at rest,
 Pure as its billow;
Filled with great thoughts, and free
From all infirmity?
Sweet, such were meant for thee,
 Meant for thy pillow.

Is there a loving dream,
 Perfumed with roses,
Where every sunny beam
 Fresh charms discloses,
Love-dream which God has blest
Where fond souls meet, and rest?
Then upon such a nest
 Thy heart reposes.

Translated by Harry Curwen

How it sings, every word of it, sets itself to music, and dances to its own tune! There are deeper songs in the world of poetry, songs whose time is beaten for them by the droppings of human tears, and some of them come from Victor Hugo: but where shall we find one in which the delightfulness of love's assurance gets more gracious utterance? Unless indeed it be this which follows it:

AUTRE CHANSON

L'aube naît, et ta porte est close!
Ma belle, pourquoi sommeiller?
A l'heure où s'éveille la rose
Ne vas-tu pas te réveiller?

 O ma charmante!
 Écoute ici
 L'amant qui chante
 Et pleure aussi!

Tout frappe à ta porte bénie;
L'aurore dit: Je suis le jour!
L'oiseau dit: Je suis l'harmonie!
Et mon cœur dit: Je suis l'amour!

1181

O ma charmante!
Écoute ici
L'amant qui chante
Et pleure aussi!

Je t'adore ange et t'aime femme.
Dieu, qui par toi m'a complété,
A fait mon amour pour ton âme
Et mon regard pour ta beauté!

O ma charmante!
Écoute ici
L'amant qui chante
Et pleure aussi!

ANOTHER SONG

Though heaven's gate of light uncloses,
 Thou stirr'st not—thou'rt laid to rest,
Waking are thy sister roses,
 One only dreameth on thy breast.

 Hear me, sweet dreamer!
 Tell me all thy fears,
 Trembling in song,
 But to break in tears.

Lo! to greet thee, spirits pressing,
 Soft music brings the gentle dove,
And fair light falleth like a blessing,
 While my poor heart can bring thee only love.

Worship thee, angels love thee, sweet woman?
 Yes; for that love perfects my soul.
None the less of heaven that my heart is human,
 Blent in one exquisite, harmonious whole.
 Les Chants du crépuscule (1835)
 Translated by H. B. Favnie

Is not the poise and balance of that refrain, as it seems to hang in the air, lingering to enjoy its own delightfulness, one of the greatest triumphs which the art of making music out of human speech has ever achieved?
 JOHN C. BAILEY
 The Claims of French Poetry (1907)

VICTOR HUGO

1 8 0 2 — 1 8 8 5

FROM *CHOSES DU SOIR*

On voit sur la mer des chasse-marées;
Le naufrage guette un mât frissonnant;
Le vent dit: demain! l'eau dit: maintenant!
Les voix qu'on entend sont désespérées. . . .

Le coche qui va d'Avranche à Fougère
Fait claquer son fouet comme un vif éclair;
Voici le moment où flottent dans l'air
Tous ces bruits confus que l'ombre exagère. . . .

Des flaques d'argent tremblent sur les sables;
L'orfraie est au bord des talus crayeux;
Le pâtre, à travers le vent, suit des yeux
Le vol monstrueux et vague des diables. . . .

Un panache gris sort des cheminées;
Le bûcheron passe avec son fardeau;
On entend, parmi le bruit des cours d'eau,
Des frémissements de branches traînées. . . .

La faim fait rêver les grands loups moroses;
La rivière court, le nuage fuit;
Derrière la vitre où la lampe luit,
Les petits enfants ont des têtes roses.

Some coasting vessels can be seen on the ocean; the wreck lies in wait for a shivering mast; the wind says, Tomorrow! the water says, Now! The voices heard are desperate. The coachman on the road from Avranche to Fougère cracks his whip like a vivid flash; this is the moment when all the confused noises that darkness exaggerates float in the air. Silver splashes tremble on the sands, the osprey stands on the chalky slopes; the shepherd, through the wind, follows with his eyes the vague and monstrous flight of devils. A gray plume winds from the chimneys; the woodcutter passes with his burden; one hears, midst the noise of flowing water, the rustle of the dragged branches. Hunger makes the big, morose wolves dream; the river hurries, the cloud passes; behind the window, where the lamp shines, the little children have rosy heads.

L'Art d'être grand-père (1877)

A pure masterpiece.

ÉMILE FAGUET
Dix-neuvième Siècle: Études littéraires (1887)

WHAT IS THIS TRUTH?

Gentlemen, I have ventured to offer you these considerations upon the scholar's place and hope, because I thought that standing, as many of you now do, on the threshold of this College, girt and ready to go and assume tasks, public and private, in your country, you would not be sorry to be admonished of those primary duties of the intellect whereof you will seldom hear from the lips of your new companions. You will hear every day the maxims of a low prudence. You will hear that the first duty is to get land and money, place and name. "What is this Truth you seek? what is this Beauty?" men will ask, with derision. If nevertheless God have called any of you to explore truth and beauty, be bold, be firm, be true. When you shall say, "As others do, so will I: I renounce, I am sorry for it, my early visions; I must eat the good of the land and let learning and romantic expectations go, until a more convenient season;"——then dies the man in you; then once more perish the buds of art, and poetry, and science, as they have died already in a thousand thousand men. The hour of that choice is the crisis of your history, and see that you hold yourself fast by the intellect. It is this domineering temper of the sensual world that creates the extreme need of the priests of science. . . . Be content with a little light, so it be your own. Explore, and explore. Be neither chided nor flattered out of your position of perpetual inquiry. Neither dogmatize, nor accept another's dogmatism. Why should you renounce your right to traverse the star-lit deserts of truth, for the premature comforts of an acre, house, and barn? Truth also has its roof, and bed, and board. Make yourself necessary to the world, and mankind will give you bread, and if not store of it, yet such as shall not take away your property in all men's possessions, in all men's affections, in art, in nature, and in hope.

Literary Ethics (1838)

Every word is still printed on my memory: I can see the left-hand page and read again that divine message: I make no excuse for quoting it almost word for word.

FRANK HARRIS
My Life and Loves (1922–27)

RALPH WALDO EMERSON

1 8 0 3 — 1 8 8 2

ALONE

Every god is there sitting in his sphere. The young mortal enters the hall of the firmament; there is he alone with them alone, they pouring on him benedictions and gifts, and beckoning him up to their thrones. On the instant, and incessantly, fall snowstorms of illusions. He fancies himself in a vast crowd which sways this way and that, and whose movements and doings he must obey; he fancies himself poor, orphaned, insignificant. The mad crowd drives hither and thither, now furiously commanding this thing to be done, now that. What is he that he should resist their will, and think or act for himself? Every moment new changes and new showers of deceptions to baffle and distract him. And when, by and by, for an instant, the air clears and the cloud lifts a little, there are the gods still sitting around him on their thrones—they alone with him alone.

<div align="right">Illusions (1857)</div>

That Emerson had within him the soul of a poet no one will question, but his poems are expressed in prose forms. There are passages in his early addresses which can be matched in English only by bits from Sir Thomas Browne or Milton, or from the great poets. Heine might have written the . . . parable into verse, but it could not have been finer. It comes from the very bottom of Emerson's nature. It is his uttermost. Infancy and manhood and old age, the first and the last of him, speak in it.

<div align="right">JOHN JAY CHAPMAN
Emerson and Other Essays (1898)</div>

THOMAS LOVELL BEDDOES

1 8 0 3 — 1 8 4 9

DIRGE

If thou wilt ease thine heart
Of love and all its smart,
 Then sleep, dear, sleep;

1185

And not a sorrow
　Hang any tear on your eyelashes;
　　Lie still and deep,
　Sad soul, until the sea-wave washes
The rim o' th' sun to-morrow,
　　In eastern sky.
　　　　Death's Jest-Book, Act ii, Scene ii (1833)

DREAM-PEDLARY

If there were dreams to sell,
　What would you buy?
Some cost a passing bell;
　Some a light sigh,
That shakes from Life's fresh crown
Only a roseleaf down.
If there were dreams to sell,
Merry and sad to tell,
And the crier rung the bell,
　What would you buy?
　　　　Poems (1829–44)

This [dirge] is perfect, and when we come to what should be the universally known first stanza of "Dream-Pedlary" what words can possibly do justice to its movement and music? what prosody of the very greatest that we have cited or referred to, in this voyage through the realms of gold, can be held superior to it? The selection of stanza; the arrangement of the rhymes; the framing of single lines to suit their sense; the utter inevitableness of the diction—how shall we acknowledge them rightly? There is nothing for it but to borrow those great and final words for which, even if Hazlitt's many sins were more than they are and his many virtues fewer, he should be canonised as a critic: "It is something worth living for to write, or even read, such poetry as this, or to know that it has been written." And, once more, beyond all question, though not beyond all difference in estimate of proportion, the prosody is a mighty part of this inestimable poetry.

One might quote many more, but this is not an anthology, and after the pair just quoted it is not necessary. Not even in Shelley before, or in Tennyson after, is there anything more significant of the recovered mastery of prosodic music—of the unlocking of the forgotten treasury where the harps and horns of Elfland had hung so long unused.
　　　　GEORGE SAINTSBURY
　　　　A History of English Prosody (1910)

NATHANIEL HAWTHORNE

1 8 0 4 — 1 8 6 4

HESTER PRYNNE

Hester Prynne, gazing steadfastly at the clergyman, felt a dreary influ-
ence come over her, but wherefore or whence she knew not; unless
that he seemed so remote from her own sphere, and utterly beyond her
reach. One glance of recognition, she had imagined, must needs pass
between them. She thought of the dim forest, with its little dell of soli-
tude, and love, and anguish, and the mossy tree-trunk, where, sitting
hand in hand, they had mingled their sad and passionate talk with the
melancholy murmur of the brook. How deeply had they known each
other then! And was this the man? She hardly knew him now! He,
moving proudly past, enveloped, as it were, in the rich music, with the
procession of majestic and venerable fathers; he, so unattainable in his
worldly position, and still more so in that far vista of his unsympathizing
thoughts, through which she now beheld him! Her spirit sank with the
idea that all must have been a delusion, and that, vividly as she had
dreamed it, there could be no real bond betwixt the clergyman and
herself. And thus much of woman was there in Hester, that she could
scarcely forgive him,—least of all now, when the heavy footstep of their
approaching Fate might be heard, nearer, nearer, nearer!—for being
able so completely to withdraw himself from their mutual world; while
she groped darkly, and stretched forth her cold hands, and found
him not.

The Scarlet Letter (1850)

In such a passage as one I have marked for quotation from THE SCARLET
LETTER *there is the stamp of the genius of style.*

HENRY JAMES
Hawthorne (1879)

EDUARD MÖRIKE

1 8 0 4 — 1 8 7 5

DAS VERLASSENE MÄGDLEIN

Früh, wann die Hähne krähn,
Eh' die Sternlein verschwinden,
Muss ich am Herde stehn,
Muss Feuer zünden.

Schön ist der Flammen Schein,
Es springen die Funken;
Ich schaue so drein,
In Leid versunken.

Plötzlich, da kommt es mir,
Treuloser Knabe,
Dass ich die Nacht von dir
Geträumet habe.

Träne auf Träne dann
Stürzet hernieder;
So kommt der Tag heran—
O ging' er wieder!

THE DESERTED MAIDEN

When the cocks craw,
Or the wee stars are gane,
I maun kindle the fire
On the cauld hearthstane.

The sparks flee up,
And the lowe blinks bonnie,
I glower at the licht
Mair waefu' than ony.

Then it comes ower me,
Fause lad! my sorrow!
I did but dream o' ye
A' the nicht thorow.

Fast fa' the tears,
On the hard hearthstane,
And the day's here, but O
Gin it were gane!

Translated by Norman Macleod

One of the great things in German song—recalling folk-poetry, but with greater intensity and higher art.

NORMAN MACLEOD
German Lyric Poetry (1930)

THE BROKEN OAR

Once upon Iceland's solitary strand
 A poet wandered with his book and pen,
 Seeking some final word, some sweet Amen,
 Wherewith to close the volume in his hand.
The billows rolled and plunged upon the sand,
 The circling sea-gulls swept beyond his ken,
 And from the parting cloud-rack now and then
 Flashed the red sunset over sea and land.
Then by the billows at his feet was tossed
 A broken oar; and carved thereon he read:
 "Oft was I weary, when I toiled at thee;"
And like a man, who findeth what was lost,
 He wrote the words, then lifted up his head,
 And flung his useless pen into the sea.

 A Book of Sonnets **(1875)**

This has the gnomic quality of romantic poetry at its best.

 HOWARD MUMFORD JONES
 in American Writers on American Literature (1931)

HENRY WADSWORTH LONGFELLOW

1 8 0 7 — 1 8 8 2

WAIL OF THE FOREST

While from its rocky caverns the deep-voiced, neighboring ocean
Speaks, and in accents disconsolate answers the wail of the forest.

 Evangeline (1847)

*Hexameters, by the way, as sonorous and rhythmical as any in the
language.*

 PAUL ELMER MORE
 Shelburne Essays, Fifth Series (1908)

TO HELEN

Helen, thy beauty is to me
 Like those Nicean barks of yore,
That gently, o'er a perfumed sea,
 The weary, wayworn wanderer bore
 To his own native shore.

On desperate seas long wont to roam,
 Thy hyacinth hair, thy classic face,
Thy Naiad airs have brought me home
 To the glory that was Greece,
And the grandeur that was Rome.

Lo! in yon brilliant window-niche
 How statue-like I see thee stand,
 The agate lamp within thy hand!
Ah, Psyche, from the regions which
 Are Holy Land!

One of the most ripely perfect and spiritually charming poems ever written. . . . The two closing lines of the middle stanza have passed into the body of choice distillations of language reserved for immortality; and there is assuredly nothing more exquisite in its kind in English literature than the last stanza. To have written such verses is to have done a perfect thing.

J. M. ROBERTSON
New Essays Towards a Critical Method (1897)

ABRAHAM LINCOLN

1 8 0 9 — 1 8 6 5

THE GETTYSBURG ADDRESS

Four score and seven years ago our fathers brought forth on this continent, a new nation, conceived in Liberty, and dedicated to the proposition that all men are created equal.

Now we are engaged in a great civil war, testing whether that nation, or any nation so conceived and so dedicated, can long endure. We are

1190

met on a great battlefield of that war. We have come to dedicate a portion of that field, as a final resting place for those who here gave their lives that that nation might live. It is altogether fitting and proper that we should do this.

But, in a larger sense, we can not dedicate—we can not consecrate—we can not hallow—this ground. The brave men, living and dead, who struggled here have consecrated it, far above our poor power to add or detract. The world will little note, nor long remember what we say here, but it can never forget what they did here. It is for us the living, rather, to be dedicated here to the unfinished work which they who fought here have thus far so nobly advanced. It is rather for us to be here dedicated to the great task remaining before us—that from these honored dead we take increased devotion to that cause for which they gave the last full measure of devotion—that we here highly resolve that these dead shall not have died in vain—that this nation, under God, shall have a new birth of freedom—and that government of the people, by the people, for the people, shall not perish from the earth.

(1863)

His brief speech at Gettysburg will not easily be surpassed by words on any recorded occasion.

RALPH WALDO EMERSON
Miscellanies (1878)

EDWARD FITZGERALD

1 8 0 9 — 1 8 8 3

RUBÁIYÁT OF OMAR KHAYYÁM

I.

Wake! For the Sun who scatter'd into flight
The Stars before him from the Field of Night,
 Drives Night along with them from Heav'n, and strikes
The Sultán's Turret with a Shaft of Light.

II.

Before the phantom of False morning died,
Methought a Voice within the Tavern cried,
 "When all the Temple is prepared within,
"Why nods the drowsy Worshipper outside?"

1191

And, as the Cock crew, those who stood before
The Tavern shouted—"Open then the Door!
"You know how little while we have to stay,
"And, once departed, may return no more."

IV.

Now the New Year reviving old Desires,
The thoughtful Soul to Solitude retires,
 Where the WHITE HAND OF MOSES on the Bough
Puts out, and Jesus from the Ground suspires.

V.

Iram indeed is gone with all his Rose,
And Jamshyd's Sev'n-ring'd Cup where no one knows;
 But still a Ruby kindles in the Vine,
And many a Garden by the Water blows.

VI.

And David's lips are lockt; but in divine
High-piping Pehleví, with "Wine! Wine! Wine!
 "Red Wine!"—the Nightingale cries to the Rose
That sallow cheek of her's to' incarnadine.

VII.

Come, fill the Cup, and in the fire of Spring
Your Winter-garment of Repentance fling:
 The Bird of Time has but a little way
To flutter—and the Bird is on the Wing.

VIII.

Whether at Naishápúr or Babylon,
Whether the Cup with sweet or bitter run,
 The Wine of Life keeps oozing drop by drop,
The Leaves of Life keep falling one by one.

IX.

Each Morn a thousand Roses brings, you say;
Yes, but where leaves the Rose of Yesterday?
 And this first Summer month that brings the Rose
Shall take Jamshyd and Kaikobád away.

X.

Well, let it take them! What have we to do
With Kaikobád the Great, or Kaikhosrú?
 Let Zál and Rustum bluster as they will,
Or Hátim call to Supper—heed not you.

XI.

With me along the strip of Herbage strown
That just divides the desert from the sown,
 Where name of Slave and Sultán is forgot—
And Peace to Mahmúd on his golden Throne!

XII.

A Book of Verses underneath the Bough,
A Jug of Wine, a Loaf of Bread—and Thou
 Beside me singing in the Wilderness—
Oh, Wilderness were Paradise enow!

XIII.

Some for the Glories of This World; and some
Sigh for the Prophet's Paradise to come;
 Ah, take the Cash, and let the Credit go,
Nor heed the rumble of a distant Drum!

XIV.

Look to the blowing Rose about us—"Lo,
"Laughing," she says, "into the world I blow,
 "At once the silken tassel of my Purse
"Tear, and its Treasure on the Garden throw."

XV.

And those who husbanded the Golden grain,
And those who flung it to the winds like Rain,
 Alike to no such aureate Earth are turn'd
As, buried once, Men want dug up again.

XVI.

The Worldly Hope men set their Hearts upon
Turns Ashes—or it prospers; and anon,
 Like Snow upon the Desert's dusty Face,
Lighting a little hour or two—was gone.

XVII.

Think, in this batter'd Caravanserai
Whose Portals are alternate Night and Day,
 How Sultán after Sultán with his Pomp
Abode his destin'd Hour, and went his way.

XVIII.

They say the Lion and the Lizard keep
The Courts where Jamshyd gloried and drank deep:
 And Bahrám, that great Hunter—the Wild Ass
Stamps o'er his Head, but cannot break his Sleep.

XIX.

I sometimes think that never blows so red
The Rose as where some buried Cæsar bled;
 That every Hyacinth the Garden wears
Dropt in her Lap from some once lovely Head.

XX.

And this reviving Herb whose tender Green
Fledges the River-Lip on which we lean—
 Ah, lean upon it lightly! for who knows
From what once lovely Lip it springs unseen!

XXI.

Ah, my Belovéd, fill the Cup that clears
To-day of past Regret and future Fears:
 To-morrow!—Why, To-morrow I may be
Myself with Yesterday's Sev'n thousand Years.

XXII.

For some we loved, the loveliest and the best
That from his Vintage rolling Time hath prest,
 Have drunk their Cup a Round or two before,
And one by one crept silently to rest.

XXIII.

And we, that now make merry in the Room
They left, and Summer dresses in new bloom,
 Ourselves must we beneath the Couch of Earth
Descend—ourselves to make a Couch—for whom?

XXIV.

Ah, make the most of what we yet may spend,
Before we too into the Dust descend;
 Dust into Dust, and under Dust, to lie,
Sans Wine, sans Song, sans Singer, and—sans End!

XXV.

Alike for those who for To-DAY prepare,
And those that after some To-MORROW stare,
 A Muezzín from the Tower of Darkness cries,
"Fools! your Reward is neither Here nor There."

XXVI.

Why, all the Saints and Sages who discuss'd
Of the Two Worlds so wisely—they are thrust
 Like foolish Prophets forth; their Words to Scorn
Are scatter'd, and their Mouths are stopt with Dust.

XXVII.

Myself when young did eagerly frequent
Doctor and Saint, and heard great argument
 About it and about: but evermore
Came out by the same door where in I went.

XXVIII.

With them the seed of Wisdom did I sow,
And with mine own hand wrought to make it grow;
 And this was all the Harvest that I reap'd—
"I came like Water, and like Wind I go."

XXIX.

Into this Universe, and *Why* not knowing
Nor *Whence*, like Water willy-nilly flowing;
 And out of it, as Wind along the Waste,
I know not *Whither*, willy-nilly blowing.

XXX.

What, without asking, hither hurried *Whence?*
And, without asking, *Whither* hurried hence!
 Oh, many a Cup of this forbidden Wine
Must drown the memory of that insolence!

XXXI.

Up from Earth's Centre through the Seventh Gate
I rose, and on the Throne of Saturn sate,
 And many a Knot unravel'd by the Road;
But not the Master-knot of Human Fate.

XXXII.

There was the Door to which I found no Key;
There was the Veil through which I might not see:
 Some little talk awhile of ME and THEE
There was—and then no more of THEE and ME.

XXXIII.

Earth could not answer; nor the Seas that mourn
In flowing Purple, of their Lord forlorn;
 Nor rolling Heaven, with all his Signs reveal'd
And hidden by the sleeve of Night and Morn.

XXXIV.

Then of the THEE IN ME who works behind
The Veil, I lifted up my hands to find
 A Lamp amid the Darkness; and I heard,
As from Without—"THE ME WITHIN THEE BLIND!"

XXXV.

Then to the Lip of this poor earthen Urn
I lean'd, the Secret of my Life to learn:
 And Lip to Lip it murmur'd—"While you live,
"Drink!—for, once dead, you never shall return."

XXXVI.

I think the Vessel, that with fugitive
Articulation answer'd, once did live,
 And drink; and Ah! the passive Lip I kiss'd,
How many Kisses might it take—and give!

XXXVII.

For I remember stopping by the way
To watch a Potter thumping his wet Clay:
 And with its all-obliterated Tongue
It murmur'd—"Gently, Brother, gently, pray!"

XXXVIII.

And has not such a Story from of Old
Down Man's successive generations roll'd
 Of such a clod of saturated Earth
Cast by the Maker into Human mould?

XXXIX.

And not a drop that from our Cups we throw
For Earth to drink of, but may steal below
 To quench the fire of Anguish in some Eye
There hidden—far beneath, and long ago.

XL.

As then the Tulip for her morning sup
Of Heav'nly Vintage from the soil looks up,
 Do you devoutly do the like, till Heav'n
To Earth invert you—like an empty Cup.

XLI.

Perplext no more with Human or Divine,
To-morrow's tangle to the winds resign,
 And lose your fingers in the tresses of
The Cypress-slender Minister of Wine.

XLII.

And if the Wine you drink, the Lip you press,
End in what All begins and ends in—Yes;
 Think then you are To-day what YESTERDAY
You were—To-morrow you shall not be less.

XLIII.

So when the Angel of the darker Drink
At last shall find you by the river-brink,
 And, offering his Cup, invite your Soul
Forth to your Lips to quaff—you shall not shrink.

XLIV.

Why, if the Soul can fling the Dust aside,
And naked on the Air of Heaven ride,
 Wer't not a Shame—wer't not a Shame for him
In this clay carcase crippled to abide?

XLV.

'Tis but a Tent where takes his one day's rest
A Sultán to the realm of Death addrest;
 The Sultán rises, and the dark Ferrásh
Strikes, and prepares it for another Guest.

XLVI.

And fear not lest Existence closing your
Account, and mine, should know the like no more;
 The Eternal Sákí from that Bowl has pour'd
Millions of Bubbles like us, and will pour.

XLVII.

When You and I behind the Veil are past,
Oh, but the long, long while the World shall last,
 Which of our Coming and Departure heeds
As the Sea's self should heed a pebble-cast.

XLVIII.

A Moment's Halt—a momentary taste
Of BEING from the Well amid the Waste—
 And Lo!—the phantom Caravan has reacht
The NOTHING it set out from—Oh, make haste!

XLIX.

Would you that spangle of Existence spend
About THE SECRET—quick about it, Friend!
 A Hair perhaps divides the False and True—
And upon what, prithee, does life depend?

L.

A Hair perhaps divides the False and True;
Yes; and a single Alif were the clue—
 Could you but find it—to the Treasure-house,
And peradventure to THE MASTER too;

LI.

Whose secret Presence, through Creation's veins
Running Quicksilver-like eludes your pains;
 Taking all shapes from Máh to Máhi; and
They change and perish all—but He remains;

1198

LII.

A moment guess'd—then back behind the Fold
Immerst of Darkness round the Drama roll'd
 Which, for the Pastime of Eternity,
He doth Himself contrive, enact, behold.

LIII.

But if in vain, down on the stubborn floor
Of Earth, and up to Heav'n's unopening Door,
 You gaze To-DAY, while You are You—how then
To-MORROW, You when shall be You no more?

LIV.

Waste not your Hour, nor in the vain pursuit
Of This and That endeavour and dispute;
 Better be jocund with the fruitful Grape
Than sadden after none, or bitter, Fruit.

LV.

You know, my Friends, with what a brave Carouse
I made a Second Marriage in my house;
 Divorced old barren Reason from my Bed,
And took the Daughter of the Vine to Spouse.

LVI.

For "Is" and "Is-NOT" though with Rule and Line,
And "Up-AND-DOWN" by Logic I define,
 Of all that one should care to fathom, I
Was never deep in anything but—Wine.

LVII.

Ah, but my Computations, People say,
Reduced the Year to better reckoning?—Nay,
 'Twas only striking from the Calendar
Unborn To-morrow, and dead Yesterday.

LVIII.

And lately, by the Tavern Door agape,
Came shining through the Dusk an Angel Shape
 Bearing a Vessel on his Shoulder; and
He bid me taste of it; and 'twas—the Grape!

LIX.

The Grape that can with Logic absolute
The Two-and-Seventy jarring Sects confute:
 The sovereign Alchemist that in a trice
Life's leaden metal into Gold transmute:

LX.

The mighty Mahmúd, Allah-breathing Lord,
That all the misbelieving and black Horde
 Of Fears and Sorrows that infest the Soul
Scatters before him with his whirlwind Sword.

LXI.

Why, be this Juice the growth of God, who dare
Blaspheme the twisted tendril as a Snare?
 A Blessing, we should use it, should we not?
And if a Curse—why, then, Who set it there?

LXII.

I must abjure the Balm of Life, I must,
Scared by some After-reckoning ta'en on trust,
 Or lured with Hope of some Diviner Drink,
To fill the Cup—when crumbled into Dust!

LXIII.

Oh threats of Hell and Hopes of Paradise!
One thing at least is certain—*This* Life flies;
 One thing is certain and the rest is Lies;
The Flower that once has blown for ever dies.

LXIV.

Strange, is it not? that of the myriads who
Before us pass'd the door of Darkness through,
 Not one returns to tell us of the Road,
Which to discover we must travel too.

LXV.

The Revelations of Devout and Learn'd
Who rose before us, and as Prophets burn'd,
 Are all but Stories, which, awoke from Sleep
They told their comrades, and to Sleep return'd.

LXVI.

I sent my Soul through the Invisible,
Some letter of that After-life to spell:
 And by and by my Soul return'd to me,
And answer'd "I Myself am Heav'n and Hell:"

LXVII.

Heav'n but the Vision of fulfill'd Desire,
And Hell the Shadow from a Soul on fire
 Cast on the Darkness into which Ourselves,
So late emerg'd from, shall so soon expire.

LXVIII.

We are no other than a moving row
Of Magic Shadow-shapes that come and go
 Round with the Sun-illumin'd Lantern held
In Midnight by the Master of the Show;

LXIX.

But helpless Pieces of the Game He plays
Upon this Chequer-board of Nights and Days;
 Hither and thither moves, and checks, and slays,
And one by one back in the Closet lays.

LXX.

The Ball no question makes of Ayes and Noes,
But Here or There as strikes the Player goes;
 And He that toss'd you down into the Field,
He knows about it all—ΗΕ knows—HE knows!

LXXI.

The Moving Finger writes; and, having writ,
Moves on: nor all your Piety nor Wit
 Shall lure it back to cancel half a Line,
Nor all your Tears wash out a Word of it.

LXXII.

And that inverted Bowl they call the Sky,
Whereunder crawling coop'd we live and die,
 Lift not your hands to *It* for help—for It
As impotently moves as you or I.

LXXIII.

With Earth's first Clay They did the Last Man knead,
And there of the Last Harvest sow'd the Seed:
　　And the first Morning of Creation wrote
What the Last Dawn of Reckoning shall read.

LXXIV.

Yesterday *This* Day's Madness did prepare;
To-Morrow's Silence, Triumph, or Despair:
　　Drink! for you know not whence you came, nor why:
Drink! for you know not why you go, nor where.

LXXV.

I tell you this—When, started from the Goal,
Over the flaming shoulders of the Foal
　　Of Heav'n Parwín and Mushtarí they flung,
In my predestin'd Plot of Dust and Soul

LXXVI.

The Vine had struck a fibre: which about
If clings my Being—let the Dervish flout;
　　Of my Base metal may be filed a Key,
That shall unlock the Door he howls without.

LXXVII.

And this I know: whether the one True Light
Kindle to Love, or Wrath-consume me quite,
　　One Flash of It within the Tavern caught
Better than in the Temple lost outright.

LXXVIII.

What! out of senseless Nothing to provoke
A conscious Something to resent the yoke
　　Of unpermitted Pleasure, under pain
Of Everlasting Penalties, if broke!

LXXIX.

What! from his helpless Creature be repaid
Pure Gold for what he lent him dross-allay'd—
　　Sue for a Debt we never did contract,
And cannot answer—Oh the sorry trade!

LXXX.

Oh Thou, who didst with pitfall and with gin
Beset the Road I was to wander in,
 Thou wilt not with Predestin'd Evil round
Enmesh, and then impute my Fall to Sin!

LXXXI.

Oh Thou, who Man of baser Earth didst make,
And ev'n with Paradise devise the Snake:
 For all the Sin wherewith the Face of Man
Is blacken'd—Man's forgiveness give—and take!

LXXXII.

As under cover of departing Day
Slunk hunger-stricken Ramazán away,
 Once more within the Potter's house alone
I stood, surrounded by the Shapes of Clay.

LXXXIII.

Shapes of all Sorts and Sizes, great and small,
That stood along the floor and by the wall;
 And some loquacious Vessels were; and some
Listen'd perhaps, but never talk'd at all.

LXXXIV.

Said one among them—"Surely not in vain
My substance of the common Earth was ta'en
 And to this Figure moulded, to be broke,
Or trampled back to shapeless Earth again."

LXXXV.

Then said a Second—"Ne'er a peevish Boy
"Would break the Bowl from which he drank in joy;
 "And He that with his hand the Vessel made
"Will surely not in after Wrath destroy."

LXXXVI.

After a momentary silence spake
Some Vessel of a more ungainly Make;
 "They sneer at me for leaning all awry:
"What! did the Hand then of the Potter shake?"

LXXXVII.

Whereat some one of the loquacious Lot—
I think a Súfi pipkin—waxing hot—
 "All this of Pot and Potter—Tell me then,
"Who is the Potter, pray, and who the Pot?"

LXXXVIII.

"Why," said another, "Some there are who tell
"Of one who threatens he will toss to Hell
 "The luckless Pots he marr'd in making—Pish!
"He's a Good Fellow, and 't will all be well."

LXXXIX.

"Well," murmur'd one, "Let whoso make or buy,
"My Clay with long Oblivion is gone dry:
 "But fill me with the old familiar Juice,
"Methinks I might recover by and by."

XC.

So while the Vessels one by one were speaking,
The little Moon look'd in that all were seeking:
 And then they jogg'd each other, "Brother! Brother!
"Now for the Porter's shoulder-knot a-creaking!"

.

XCI.

Ah, with the Grape my fading Life provide,
And wash the Body whence the Life has died,
 And lay me, shrouded in the living Leaf,
By some not unfrequented Garden-side.

XCII.

That ev'n my buried Ashes such a snare
Of Vintage shall fling up into the Air
 As not a True-believer passing by
But shall be overtaken unaware.

XCIII.

Indeed the Idols I have loved so long
Have done my credit in this World much wrong:
 Have drown'd my Glory in a shallow Cup,
And sold my Reputation for a Song.

XCIV.

Indeed, indeed, Repentance oft before
I swore—but was I sober when I swore?
 And then and then came Spring, and Rose-in-hand
My thread-bare Penitence apieces tore.

XCV.

And much as Wine has play'd the Infidel,
And robb'd me of my Robe of Honour—Well,
 I wonder often what the Vintners buy
One half so precious as the stuff they sell.

XCVI.

Yet Ah, that Spring should vanish with the Rose!
That Youth's sweet-scented manuscript should close!
 The Nightingale that in the branches sang,
Ah whence, and whither flown again, who knows!

XCVII.

Would but the Desert of the Fountain yield
One glimpse—if dimly, yet indeed, reveal'd,
 To which the fainting Traveller might spring,
As springs the trampled herbage of the field!

XCVIII.

Would but some wingéd Angel ere too late
Arrest the yet unfolded Roll of Fate,
 And make the stern Recorder otherwise
Enregister, or quite obliterate!

XCIX.

Ah Love! could you and I with Him conspire
To grasp this sorry Scheme of Things entire,
 Would not we shatter it to bits—and then
Re-mould it nearer to the Heart's Desire!

.

C.

Yon rising Moon that looks for us again—
How oft hereafter will she wax and wane;
 How oft hereafter rising look for us
Through this same Garden—and for *one* in vain!

1205

And when like her, oh Sákí, you shall pass
Among the Guests Star-scatter'd on the Grass,
 And in your joyous errand reach the spot
Where I made One—turn down an empty Glass!

TAMÁM.

(1879)

*Omar's theme, the unconquered mystery of life and death, the flux,
beyond arrest, of human things, the sorrowful and swift flight of beauty
and joy, was a theme old as the world itself. . . . Nor is it likely to lose
its power, so subtly does it render the bitter-sweet of reflective exist-
ence, the thought of beauty that must be loved and yet must be re-
linquished, the uneasy fear, never wholly to be banished from the hearts
of men, that their exile from the joys of conscious being will be without
return, that the only affections they have known can never again be
known. It may well remain, while the language lasts, its most finished
expression of the spirit's darker broodings, its most searching music in
the minor key.*

W. MACNEILE DIXON and H. J. C. GRIERSON
The English Parnassus (1916)

ALFRED LORD TENNYSON

1 8 0 9 — 1 8 9 2

THE VISION OF SIN

I

I had a vision when the night was late:
A youth came riding toward a palace-gate.
He rode a horse with wings, that would have flown,
But that his heavy rider kept him down.
And from the palace came a child of sin,
And took him by the curls, and led him in,
Where sat a company with heated eyes,
Expecting when a fountain should arise:
A sleepy light upon their brows and lips—
As when the sun, a crescent of eclipse,

1206

Dreams over lake and lawn, and isles and capes—
Suffused them, sitting, lying, languid shapes,
By heaps of gourds, and skins of wine, and piles of grapes.

II

Then methought I heard a mellow sound,
Gathering up from all the lower ground;
Narrowing in to where they sat assembled
Low voluptuous music winding trembled,
Wov'n in circles: they that heard it sigh'd,
Panted hand in hand with faces pale,
Swung themselves, and in low tones replied;
Till the fountain spouted, showering wide
Sleet of diamond-drift and pearly hail;
Then the music touch'd the gates and died;
Rose again from where it seem'd to fail,
Storm'd in orbs of song, a growing gale;
Till thronging in and in, to where they waited,
As 'twere a hundred-throated nightingale,
The strong tempestuous treble throbb'd and palpitated;
Ran into its giddiest whirl of sound,
Caught the sparkles, and in circles,
Purple gauzes, golden hazes, liquid mazes,
Flung the torrent rainbow round:
Then they started from their places,
Moved with violence, changed in hue,
Caught each other with wild grimaces,
Half-invisible to the view,
Wheeling with precipitate paces
To the melody, till they flew,
Hair, and eyes, and limbs, and faces,
Twisted hard in fierce embraces,
Like to Furies, like to Graces,
Dash'd together in blinding dew:
Till, kill'd with some luxurious agony,
The nerve-dissolving melody
Flutter'd headlong from the sky.

III

And then I look'd up toward a mountain-tract,
That girt the region with high cliff and lawn:
I saw that every morning, far withdrawn
Beyond the darkness and the cataract,

God made Himself an awful rose of dawn,
Unheeded: and detaching, fold by fold,
From those still heights, and, slowly drawing near,
A vapour heavy, hueless, formless, cold,
Came floating on for many a month and year,
Unheeded: and I thought I would have spoken,
And warn'd that madman ere it grew too late:
But, as in dreams, I could not. Mine was broken,
When that cold vapour touch'd the palace-gate,
And link'd again. I saw within my head
A grey and gap-tooth'd man as lean as death,
Who slowly rode across a wither'd heath,
And lighted at a ruin'd inn, and said:

IV

'Wrinkled ostler, grim and thin!
 Here is custom come your way;
Take my brute, and lead him in,
 Stuff his ribs with mouldy hay.

'Bitter barmaid, waning fast!
 See that sheets are on my bed;
What! the flower of life is past:
 It is long before you wed.

'Slip-shod waiter, lank and sour,
 At the Dragon on the heath!
Let us have a quiet hour,
 Let us hob-and-nob with Death.

'I am old, but let me drink;
 Bring me spices, bring me wine;
I remember, when I think,
 That my youth was half divine.

'Wine is good for shrivell'd lips,
 When a blanket wraps the day,
When the rotten woodland drips,
 And the leaf is stamp'd in clay.

'Sit thee down, and have no shame,
 Cheek by jowl, and knee by knee:
What care I for any name
 What for order or degree?

'Let me screw thee up a peg:
 Let me loose thy tongue with wine:
Callest thou that thing a leg?
 Which is thinnest? thine or mine?

'Thou shalt not be saved by works:
 Thou hast been a sinner too:
Ruin'd trunks on wither'd forks,
 Empty scarecrows, I and you!

'Fill the cup, and fill the can:
 Have a rouse before the morn:
Every moment dies a man,
 Every moment one is born.

'We are men of ruin'd blood;
 Therefore comes it we are wise.
Fish are we that love the mud,
 Rising to no fancy-flies.

'Name and fame! to fly sublime
 Thro' the courts, the camps, the schools,
Is to be the ball of Time,
 Bandied by the hands of fools.

'Friendship!—to be two in one—
 Let the canting liar pack!
Well I know, when I am gone,
 How she mouths behind my back.

'Virtue!—to be good and just—
 Every heart, when sifted well,
Is a clot of warmer dust,
 Mix'd with cunning sparks of hell.

'O! we two as well can look
 Whited thought and cleanly life
As the priest, above his book
 Leering at his neighbour's wife.

'Fill the cup, and fill the can:
 Have a rouse before the morn:
Every moment dies a man,
 Every moment one is born.

'Drink, and let the parties rave:
 They are fill'd with idle spleen;
Rising, falling, like a wave,
 For they know not what they mean.

1209

'He that roars for liberty
 Faster binds a tyrant's power;
And the tyrant's cruel glee
 Forces on the freer hour.

'Fill the can, and fill the cup:
 All the windy ways of men
Are but dust that rises up,
 And is lightly laid again.

'Greet her with applausive breath,
 Freedom, gaily doth she tread;
In her right a civic wreath,
 In her left a human head.

'No, I love not what is new;
 She is of an ancient house:
And I think we know the hue
 Of that cap upon her brows.

'Let her go! her thirst she slakes
 Where the bloody conduit runs:
Then her sweetest meal she makes
 On the first-born of her sons.

'Drink to lofty hopes that cool—
 Visions of a perfect State:
Drink we, last, the public fool,
 Frantic love and frantic hate.

'Chant me now some wicked stave,
 Till thy drooping courage rise,
And the glow-worm of the grave
 Glimmer in thy rheumy eyes.

'Fear not thou to loose thy tongue;
 Set thy hoary fancies free;
What is loathsome to the young
 Savours well to thee and me.

'Change, reverting to the years,
 When thy nerves could understand
What there is in loving tears,
 And the warmth of hand in hand.

'Tell me tales of thy first love—
 April hopes, the fools of chance;
Till the graves begin to move,
 And the dead begin to dance.

'Fill the can, and fill the cup:
 All the windy ways of men
Are but dust that rises up,
 And is lightly laid again.

'Trooping from their mouldy dens
 The chap-fallen circle spreads:
Welcome, fellow-citizens,
 Hollow hearts and empty heads!

'You are bones, and what of that?
 Every face, however full,
Padded round with flesh and fat,
 Is but modell'd on a skull.

'Death is king, and Vivat Rex!
 Tread a measure on the stones,
Madam—if I know your sex,
 From the fashion of your bones.

'No, I cannot praise the fire
 In your eye—nor yet your lip:
All the more do I admire
 Joints of cunning workmanship.

'Lo! God's likeness—the ground-plan—
 Neither modell'd, glazed, or framed:
Buss me, thou rough sketch of man,
 Far too naked to be shamed!

'Drink to Fortune, drink to Chance,
 While we keep a little breath!
Drink to heavy Ignorance!
 Hob-and-nob with brother Death!

'Thou art mazed, the night is long,
 And the longer night is near:
What! I am not all as wrong
 As a bitter jest is dear.

'Youthful hopes, by scores, to all,
 When the locks are crisp and curl'd;
Unto me my maudlin gall
 And my mockeries of the world.

'Fill the cup, and fill the can!
 Mingle madness, mingle scorn!
Dregs of life, and lees of man:
 Yet we will not die forlorn.'

V

The voice grew faint: there came a further change:
Once more uprose the mystic mountain-range:
Below were men and horses pierced with worms,
And slowly quickening into lower forms;
By shards and scurf of salt, and scum of dross,
Old plash of rains, and refuse patch'd with moss.
Then some one spake: 'Behold! It was a crime
Of sense avenged by sense that wore with time.'
Another answer'd 'But a crime of sense?
Give him new nerves with old experience.'
Another said: 'The crime of sense became
The crime of malice, and is equal blame.'
And one: 'He had not wholly quench'd his power;
A little grain of conscience made him sour'
At last I heard a voice upon the slope
Cry to the summit, 'Is there any hope?'
To which an answer peal'd from that high land,
But in a tongue no man could understand;
And on the glimmering limit far withdrawn
God made Himself an awful rose of dawn. (1842)

There are few more prosodically perfect examples in English of what
Johnson calls "the greater ode."

GEORGE SAINTSBURY
A History of English Prosody (1910)

ALFRED LORD TENNYSON

1 8 0 9 — 1 8 9 2

THE DAYS THAT ARE NO MORE

Tears, idle tears, I know not what they mean,
Tears from the depth of some divine despair
Rise in the heart, and gather to the eyes,
In looking on the happy Autumn-fields,
And thinking of the days that are no more.

Fresh as the first beam glittering on a sail,
That brings our friends up from the underworld,
Sad as the last which reddens over one
That sinks with all we love below the verge;
So sad, so fresh, the days that are no more.

Ah, sad and strange as in dark summer dawns
The earliest pipe of half-awaken'd birds
To dying ears, when unto dying eyes
The casement slowly grows a glimmering square;
So sad, so strange, the days that are no more.

Dear as remember'd kisses after death,
And sweet as those by hopeless fancy feign'd
On lips that are for others; deep as love,
Deep as first love, and wild with all regret;
O Death in Life, the days that are no more.

<div align="right">The Princess (1847)</div>

From Alfred Tennyson—although in perfect sincerity I regard him as the noblest poet that ever lived—I have left myself time to cite only a very brief specimen. I call him, and THINK *him the noblest of poets—*NOT *because the impressions he produces are, at* ALL *times, the most profound—*NOT *because the poetical excitement which he induces is, at* ALL *times, the most intense—but because it* IS, *at all times, the most ethereal —in other words, the most elevating and the most pure. No poet is so little of the earth, earthy.*

<div align="right">EDGAR ALLAN POE
The Poetic Principle (1850)</div>

ALFRED LORD TENNYSON

1 8 0 9 — 1 8 9 2

SIR JOHN FRANKLIN

ON THE CENOTAPH IN WESTMINSTER ABBEY

Not here! the white North has thy bones; and thou,
 Heroic sailor-soul,
Art passing on thine happier voyage now
 Toward no earthly pole.

<div align="right">(1877)</div>

The finest [epitaph] that exists in English verse.

<div align="right">JOHN BAILEY
The Continuity of Letters (1923)</div>

ALFRED LORD TENNYSON

1 8 0 9 — 1 8 9 2

EARLY SPRING

I

Once more the Heavenly Power
　Makes all things new,
And domes the red-plow'd hills
　With loving blue;
The blackbirds have their wills,
　The throstles too.

II

Opens a door in Heaven;
　From skies of glass
A Jacob's ladder falls
　On greening grass,
And o'er the mountain-walls
　Young angels pass.

III

Before them fleets the shower,
　And burst the buds,
And shine the level lands,
　And flash the floods;
The stars are from their hands
　Flung thro' the woods,

IV

The woods with living airs
　How softly fann'd,
Light airs from where the deep,
　All down the sand,
Is breathing in his sleep,
　Heard by the land.

V

O follow, leaping blood,
 The season's lure!
O heart, look down and up
 Serene, secure,
Warm as the crocus cup,
 Like snowdrops, pure!

VI

Past, Future glimpse and fade
 Thro' some slight spell,
A gleam from yonder vale,
 Some far blue fell,
And sympathies, how frail,
 In sound and smell!

VII

Till at thy chuckled note,
 Thou twinkling bird,
The fairy fancies range,
 And, lightly stirr'd,
Ring little bells of change
 From word to word.

VIII

For now the Heavenly Power
 Makes all things new,
And thaws the cold, and fills
 The flower with dew;
The blackbirds have their wills,
 The poets too.

(1885)

*If a man who had derived great happiness from the observation of
nature were stricken with blindness or confined for the rest of his life
to a sick-room, and if he were condemned to lose his recollection of all
poets but one, Tennyson's is the poetry he should choose to keep.*

A. C. BRADLEY
A Miscellany (1929)

NAPOLÉON PEYRAT

1 8 0 9 — 1 8 7 9

ROLAND

L'Arabie, en nos champs, des rochers espagnols
S'abattit; le printemps a moins de rossignols
 Et l'été moins d'épis de seigle.
Blonds étaient les chevaux dont le vent soulevait
La crinière argentée, et leur pied grêle avait
 Des poils comme des plumes d'aigle.

Ces Mores mécréants, ces maudits Sarrasins
Buvaient l'eau de nos puits et mangeaient nos raisins
 Et nos figues, et nos grenades,
Suivaient dans les vallons les vierges à l'œil noir
Et leur parlaient d'amour, à la lune, le soir,
 Et leur faisaient des sérénades.

Pour eux, leurs grands yeux noirs, pour eux, leurs beaux seins bruns,
Pour eux, leurs longs baisers, leur bouche aux doux parfums,
 Pour eux, leur belle joue ovale;
Et quand elles pleuraient, criant: "Fils des démons!"
Ils les mettaient en croupe et par-dessus les monts
 Ils faisaient sauter leur cavale.

Arabia swooped down upon our fields from the Spanish rocks; spring
has fewer nightingales and summer fewer blades of rye. Fair were the
horses whose silvered manes were tossed by the wind, and their slender
legs had hairs like an eagle's feathers. These unbelieving Moors, these
cursed Saracens, drank the water of our wells and ate our grapes, and
our figs, and our pomegranates, followed the black-eyed maidens in the
valleys, and spoke to them of love in the evenings by moonlight, and
serenaded them. For them their large eyes were dark, for them their
brown bosoms were fair, for them their kisses were long, the odour of
their mouths was sweet, for them their fair cheeks were rounded; and
when they wept, crying: 'Sons of demons!' they put them on their crup-
pers and galloped across the mountains.

Translated by A. W. Evans

The most beautiful and most finished masterpiece of the art of his age.

ANATOLE FRANCE
La Vie littéraire (1888–92)

ALFRED DE MUSSET

1810 — 1857

CHANSON DE FORTUNIO

Si vous croyez que je vais dire
 Qui j'ose aimer,
Je ne saurais, pour un empire,
 Vous la nommer.

Nous allons chanter à la ronde,
 Si vous voulez,
Que je l'adore et qu'elle est blonde
 Comme les blés.

Je fais ce que sa fantaisie
 Veut m'ordonner,
Et je puis, s'il lui faut ma vie,
 La lui donner.

Du mal qu'une amour ignorée
 Nous fait souffrir,
J'en porte l'âme déchirée
 Jusqu'à mourir.

Mais j'aime trop pour que je die
 Qui j'ose aimer,
Et je veux mourir pour ma mie
 Sans la nommer.

FORTUNIO'S SONG

So sweet my love, her face so fair,
 So pure her fame,
Not for a kingdom would I dare
 To tell her name.

We'll sing our loves, each lover his,
 And I'll sing mine,
How blithe she is, how blond she is,
 How blue her eyne.

Whate'er she asks me, I will give
 Without a sigh;
It is for her alone I live,
 For her I'd die.

1217

Though love that worships unconfessed
 Is grievous woe,
Yet will I hide mine in my breast
 And fain die so.

Too fond am I my love to tell
 Lest I should shame
Her whom I love and love too well
 To breathe her name.

<div align="right">

Le Chandelier (1836), Act ii
Translated by William Frederic Giese

</div>

Some of his lyrics are perfect; the famous song of Fortunio in itself entitles him to a high place among the masters of the language.

<div align="right">

LYTTON STRACHEY
Landmarks in French Literature (1923)

</div>

ALFRED DE MUSSET

1 8 1 0 — 1 8 5 7

À LA MALIBRAN

STANCES

I

Sans doute il est trop tard pour parler encor d'elle;
Depuis qu'elle n'est plus quinze jours sont passés,
Et dans ce pays-ci quinze jours, je le sais,
Font d'une mort récente une vieille nouvelle.
De quelque nom d'ailleurs que le regret s'appelle,
L'homme, par tout pays, en a bien vite assez.

II

O Maria-Félicia! le peintre et le poëte
Laissent, en expirant, d'immortels héritiers;
Jamais l'affreuse nuit ne les prend tout entiers:
A défaut d'action, leur grande âme inquiète
De la mort et du temps entreprend la conquête,
Et, frappés dans la lutte, ils tombent en guerriers.

III

Celui-là sur l'airain a gravé sa pensée;
Dans un rhythme doré l'autre l'a cadencée;
Du moment qu'on l'écoute, on lui devient **ami**
Sur sa toile, en mourant, Raphaël l'a laissée;
Et, pour que le néant ne touche point à lui,
C'est assez d'un enfant sur sa mère endormi.

IV

Comme dans une lampe une flamme fidèle,
Au fond du Parthénon le marbre inhabité
Garde de Phidias la mémoire éternelle,
Et la jeune Vénus, fille de Praxitèle,
Sourit encor, debout dans sa divinité,
Aux siècles impuissants qu'a vaincus sa beauté.

V

Recevant d'âge en âge une nouvelle vie,
Ainsi s'en vont à Dieu les gloires d'autrefois;
Ainsi le vaste écho de la voix du génie
Devient du genre humain l'universelle voix . . .
Et de toi, morte hier, de toi, pauvre Marie,
Au fond d'une chapelle il nous reste une croix!

VI

Une croix! et l'oubli, la nuit et le silence!
Écoutez! c'est le vent, c'est l'Océan immense;
C'est un pêcheur qui chante au bord du grand chemin.
Et de tant de beauté, de gloire et d'espérance,
De tant d'accords si doux d'un instrument divin,
Pas un faible soupir, pas un écho lointain!

VII

Une croix, et ton nom écrit sur une pierre,
Non pas même le tien, mais celui d'un époux,
Voilà ce qu'après toi tu laisses sur la terre;
Et ceux qui t'iront voir à ta maison dernière,
N'y trouvant pas ce nom qui fut aimé de nous,
Ne sauront pour prier ou poser les genoux.

VIII

O Ninette! où sont-ils, belle muse adorée,
Ces accents pleins d'amour, de charme et de terreur,
Qui voltigeaient le soir sur ta lèvre inspirée,
Comme un parfum léger sur l'aubépine en fleur?
Où vibre maintenant cette voix éplorée,
Cette harpe vivante attachée à ton cœur?

IX

N'était-ce pas hier, fille joyeuse et folle,
Que ta verve railleuse animait Corilla,
Et que tu nous lançais avec la Rosina
La roulade amoureuse et l'œillade espagnole?
Ces pleurs sur tes bras nus, quand tu chantais *le Saule*,
N'était-ce pas hier, pâle Desdemona?

X

N'était-ce pas hier qu'à le fleur de ton âge
Tu traversais l'Europe, une lyre à la main;
Dans la mer, en riant, te jetant à la nage,
Chantant la tarentelle au ciel napolitain,
Cœur d'ange et de lion, libre oiseau de passage,
Espiègle enfant ce soir, sainte artiste demain?

XI

N'était-ce pas hier qu'enivrée et bénie
Tu traînais à ton char un peuple transporté,
Et que Londre et Madrid, la France et l'Italie,
Apportaient à tes pieds cet or tant convoité,
Cet or deux fois sacré qui payait ton génie,
Et qu'à tes pieds souvent laissa ta charité?

XII

Qu'as-tu fait pour mourir, ô noble créature,
Belle image de Dieu, qui donnais en chemin
Au riche un peu de joie, au malheureux du pain?
Ah! qui donc frappe ainsi dans la mère nature,
Et quel faucheur aveugle, affamé de pâture,
Sur les meilleurs de nous ose porter la main?

XIII

Ne suffit-il donc pas à l'ange des ténèbres
Qu'à peine de ce temps il nous reste un grand nom?
Que Géricault, Cuvier, Schiller, Gœthe et Byron
Soient endormis d'hier sous les dalles funèbres,
Et que nous ayons vu tant d'autres morts célèbres
Dans l'abîme entr'ouvert suivre Napoléon?

XIV

Nous faut-il perdre encor nos têtes les plus chères,
Et venir en pleurant leur fermer les paupières,
Dès qu'un rayon d'espoir a brillé dans leurs yeux?
Le ciel de ses élus devient-il envieux?
Ou faut-il croire, hélas! ce que disaient nos pères,
Que lorsqu'on meurt si jeune on est aimé des dieux?

XV

Ah! combien, depuis peu, sont partis pleins de vie!
Sous les cyprès anciens que de saules nouveaux!
La cendre de Robert à peine refroidie,
Bellini tombe et meurt!—Une lente agonie
Traîne Carrel sanglant à l'éternel repos.
Le seuil de notre siècle est pavé de tombeaux.

XVI

Que nous restera-t-il si l'ombre insatiable,
Dès que nous bâtissons, vient tout ensevelir?
Nous qui sentons déjà le sol si variable,
Et, sur tant de débris, marchons vers l'avenir,
Si le vent, sous nos pas, balaye ainsi le sable,
De quel deuil le Seigneur veut-il donc nous vêtir?

XVII

Hélas! Marietta, tu nous restais encore.
Lorsque, sur le sillon, l'oiseau chante à l'aurore,
Le laboureur s'arrête, et, le front en sueur,
Aspire dans l'air pur un souffle de bonheur.
Ainsi nous consolait ta voix fraîche et sonore,
Et tes chants dans les cieux emportaient la douleur.

XVIII

Ce qu'il nous faut pleurer sur ta tombe hâtive,
Ce n'est pas l'art divin, ni ses savants secrets;
Quelque autre étudiera cet art que tu créais:
C'est ton âme, Ninette, et ta grandeur naïve,
C'est cette voix du cœur qui seule au cœur arrive,
Que nul autre, après toi, ne nous rendra jamais.

XIX

Ah! tu vivrais encor sans cette âme indomptable.
Ce fut là ton seul mal, et le secret fardeau
Sous lequel ton beau corps plia comme un roseau.
Il en soutint longtemps la lutte inexorable.
C'est le Dieu tout-puissant, c'est la Muse implacable
Qui dans ses bras en feu t'a portée au tombeau.

XX

Que ne l'étouffais-tu, cette flamme brûlante
Que ton sein palpitant ne pouvait contenir!
Tu vivrais, tu verrais te suivre et t'applaudir
De ce public blasé la foule indifférente,
Qui prodigue aujourd'hui sa faveur inconstante
A des gens dont pas un, certes, n'en doit mourir.

XXI

Connaissais-tu si peu l'ingratitude humaine?
Quel rêve as-tu donc fait de te tuer pour eux!
Quelques bouquets de fleurs te rendaient-ils si vaine,
Pour venir nous verser de vrais pleurs sur la scène,
Lorsque tant d'histrions et d'artistes fameux,
Couronnés mille fois, n'en ont pas dans les yeux?

XXII

Que ne détournais-tu la tête pour sourire,
Comme on en use ici quand on feint d'être ému?
Hélas! on t'aimait tant, qu'on n'en aurait rien vu.
Quand tu chantais *le Saule,* au lieu de ce délire,
Que ne t'occupais-tu de bien porter ta lyre?
La Pasta fait ainsi: que ne l'imitais-tu?

XXIII

Ne savais-tu donc pas, comédienne imprudente,
Que ces cris insensés qui te sortaient du cœur
De ta joue amaigrie augmentaient la pâleur?
Ne savais-tu donc pas que, sur ta tempe ardente,
Ta main de jour en jour se posait plus tremblante,
Et que c'est tenter Dieu que d'aimer la douleur?

XXIV

Ne sentais-tu donc pas que ta belle jeunesse
De tes yeux fatigués s'écoulait en ruisseaux,
Et de ton noble cœur s'exhalait en sanglots?
Quand de ceux qui t'aimaient tu voyais la tristesse,
Ne sentais-tu donc pas qu'une fatale ivresse
Berçait ta vie errante à ses derniers rameaux?

XXV

Oui, oui, tu le savais, qu'au sortir du théâtre,
Un soir dans ton linceul il faudrait te coucher.
Lorsqu'on te rapportait plus froide que l'albâtre,
Lorsque le médecin, de ta veine bleuâtre,
Regardait goutte à goutte un sang noir s'épancher,
Tu savais quelle main venait de te toucher.

XXVI

Oui, oui, tu le savais, et que, dans cette vie,
Rien n'est bon que d'aimer, n'est vrai que de souffrir.
Chaque soir dans tes chants tu te sentais pâlir.
Tu connaissais le monde, et la foule et l'envie,
Et, dans ce corps brisé concentrant ton génie,
Tu regardais aussi la Malibran mourir.

XXVII

Meurs donc! ta mort est douce et ta tâche est remplie.
Ce que l'homme ici-bas appelle le génie,
C'est le besoin d'aimer; hors de là tout est vain.
Et, puisque tôt ou tard l'amour humain s'oublie,
Il est d'une grande âme et d'un heureux destin
D'expirer comme toi pour un amour divin!

MALIBRAN

STANZAS

I

It is too late—of her has all been said;
She is no more, and fifteen days are fled;
And in our land a fortnight, I am told,
A recent death but makes an item old.
Whatever means, besides, regret translate,
It soon in every land us men doth sate.

II

O Maria! The painter and the poet high
Leave heirs immortal when at last they die;
Never does frightful night take them entire;
They can not act; but their great souls aspire
Of death, of time, the conquest seek to try,
And in the fight both bard and painter die.

III

The one on **bronze** his thought to grave has sought,
To golden rhythm the other cadence brought;
At first we listen, then become his friend;
To canvas dying Raphael thought would lend;
And, too, that nothingness might come not near,
Enough the child asleep on mother dear.

IV

As in the lamp the faithful flame may shine,
The empty Parthenon, the marble shrine,
Phidias, eternal memory, guards and sees;
Young Venus, daughter of Praxiteles,
Still smiles in her divinity alone,
On feebler ages by her beauty won.

V

From age to age, receiving life anon,
So more toward God the glories all foregone;
So the wide echo of the genius' voice
Is voice of universal human choice.
Of thee, poor Marie, yesterday bereft,
To us a chapel and a cross is left!

VI

A cross, oblivion, silence in the night!
Oh, listen! 'Tis the wind—'tis ocean's night.
A fisher sings upon the grand highway,
Of all that beauty, glory, hope's bright day;
Of sweetest strains of instrument divine,
No feeble sighs, no far-off echoes pine.

VII

A cross! and thy name carved upon a stone,
A husband's name, not even name thy own.
And this is all on earth that thou may'st leave,
And they who go at thy last home to grieve,
Find not that name by all mankind caressed,
And, praying, see no place where knee may rest.

VIII

Ninette, where are they, beauteous muse above,
Those accents full of charm, of dread and love,
Which fluttered with the lip's inspiring power
Like light perfume from out the hawthorn flower?
Where vibrates now the voice's wailing sound,
That living harp to all thy heart-strings bound?

IX

Was it not yesterday, with maddening thrill
Thy mocking rapture quickened fair Corille,
And with Rosina flung at us again
The amorous roulade, sweet leer of Spain?
Those tears upon thy arm when Willow rang,
'Twas yesterday, and Desdemona sang.

X

But yesterday in life's bright flower and fire,
Thou went'st o'er Europe, in thy hand a lyre,
As thou didst swim in seas with laughing cry,
And sing the tarantella 'neath Naples' sky,
Thou angel lion-heart, bird without rest,
At eve a child, the morrow artist blest!

XI

But yesterday elate with happy joy,
Thy charm could the enraptured crowds decoy,
And London, Madrid, France, Italia old,
Brought to thy feet what we men covet—gold;
The gold twice-sacred, need of thy sweet song,
So often charity's, but thine not long.

XII

What hadst thou done to die, O noble heart,
Image of God, who didst while here impart
To rich men some delight, bread to the poor?
Ah, tell, who strikes so in mother nature,
And what blind reaper and his famished hand
Upon the best of us dare to lay their hand?

XIII

Is't not enough for that dark angel wan
To leave us in our day not one great man?
That Géricault, Cuvier, Goethe, Byron,
Sank yesterday beneath the funeral stone;
That we have seen so many dead, well known,
In the abyss succeed Napoleon?

XIV

Is it our fate our dearest ones to lose,
And weeping come, and eyelids for them close,
As soon as hope has sparkled in their eyes?
Of their elect, so jealous are the skies?
Or shall we say the word of ancient seer,
That he who dieth young to God is dear?

XV

How many full of life to death have sprung!
Beneath the ancient cypress, willows young,
The ashes of Robert are hardly cold,
Bellini falls and dies. Slow torture hold
And drag Carrel, bleeding, to his last rest;
The portal of our age with tombs is dressed.

XVI

What shall remain to us but funeral pall!
To-day we build, to-morrow bury all;
We, who can feel the soil already shake,
And o'er the dust onward our passage make;
And if beneath our feet winds sweep the sand,
What mourning wear we at the Lord's command?

XVII

Alas! Maria, thou wast with us still;
When birds on furrows sing Aurora's will,
The plowman stops and wipes his sweaty brow,
Breathes in the air a breath of pleasure now;
Thy voice consoled us; fresh, sonorous strain,
Thy songs to Heaven bore our heavy pain.

XVIII

What we must weep on thy untimely grave,
Is not the art divine the secret wisdom gave;
Some one may read the art thou couldst create;
It is thy soul, Ninette, so simply great;
Heart's voice alone can every heart obtain,
And none shall give it back to us again.

XIX

Thou mightest live without the undaunted soul;
This was thy only ill, the burden whole,
'Neath which thy frame was bending like a reed:
It bore the strife inexorable indeed.
The Muse implacable, all-powerful God,
With arms of fire laid thee beneath the sod.

XX

Thou couldst not stifle that enduring flame
Which throbbing breast of thine could never tame.
Thou might'st be living, hear the plaudits loud
Of hardened public, cool, indifferent crowd,
Which lavishes to-day a fickle boon
On folks of whom not one shall die so soon.

XXI

Knewest thou, so ill, human ingratitude?
What dream was thine to die for things so rude?
What clustering flowers could render thee so vain,
And make thee shed true tears upon our Seine,
When actors, artists of most famous guise,
Though crowned a thousand times, have yet dry eyes?

XXII

Why turned I not my head to smile again,
As we do here when we emotion feign?
Alas! such love as men had never seen.
When singing Willow in that wild, glad mien;
'Twere better hold the lyre in graceful state.
Pasta does so: couldst not her imitate?

XXIII

Didst thou not know, my sweet comedienne,
That all those cries that touched the hearts of men
Increased thy pallor and thy cheeks made thin?
And that upon thy temple's burning skin
From day to day thou laid'st a trembling hand,
That, choosing pain, can we our God withstand?

XXIV

And then didst thou not feel that thy fair youth
From thy tired eyes was flowing, tears of ruth,
And from thy noble heart exhaled in sobs?
And hearing thou thy loved ones' saddened throbs,
Didst thou not feel some fatal, frenzied strife,
Would wear thee out, and still thy wandering life?

XXV

Yes, yes, thou knowest, after triumph sweet,
Some night they'd lay thee in a winding sheet!
They brought thee, like to alabaster cold;
The surgeon would the bluish veinlet hold,
And watch the blood in drops so dark to see;
And well thou knewest what was touching thee.

XXVI

Thou knew'st that in this weary, transient hour,
Naught's good but love, naught true but suffering's power.
Each night amid thy songs thou feltest pale;
The world thou knewest, and foul envy's bale;
Gathering thy genius in a broken frame,
Thou sawest, Malibran, thy dying flame.

XXVII

Die, then! Thy death is sweet, thy task fulfil;
Now, what we men on earth call genius still,
Is need of loving—all beyond is vain,
Since human love is quickly lost again.
It is a great soul's happy destiny
For some high love divine like thee to die.

<div align="right">(1836)

Translated by Marie Agathe Clarke</div>

Perfection.

<div align="right">H E N R Y J A M E S

French Poets and Novelists (1878)</div>

WILLIAM MAKEPEACE THACKERAY

1 8 1 1 — 1 8 6 3

TELMESSUS

There should have been a poet in our company to describe that charming little bay of Glaucus, into which we entered on the 26th of September, in the first steamboat that ever disturbed its beautiful waters. You can't put down in prose that delicious episode of natural poetry; it ought to be done in a symphony, full of sweet melodies and swelling harmonies; or sung in a strain of clear crystal iambics, such as Milnes knows how to write. A mere map, drawn in words, gives the mind no notion of that exquisite nature. What do mountains become in type, or rivers in Mr. Vizetelly's best brevier? Here lies the sweet bay, gleaming peaceful in the rosy sunshine; green islands dip here and there in its waters; purple mountains swell circling round it; and towards them, rising from the bay, stretches a rich green plain, fruitful with herbs and various foliage,

in the midst of which the white houses twinkle. I can see a little minaret, and some spreading palm trees; but, beyond these, the description would answer as well for Bantry Bay as for Makri. You could write so far, nay, much more particularly and grandly, without seeing the place at all, and after reading Beaufort's *Caramania,* which gives you not the least notion of it.

Suppose the great hydrographer of the admiralty himself can't describe it, who surveyed the place; suppose Mr. Fellowes, who discovered it afterwards—suppose, I say, Sir John Fellowes, Knt., can't do it (and I defy any man of imagination to get an impression from his book)—can you, vain man, hope to try? The effect of the artist, as I take it, ought to be, to produce upon his hearer's mind, by his art, an effect something similar to that produced on his own by the sight of the natural object. Only music, or the best poetry, can do this. Keats's *Ode to the Grecian Urn* is the best description I know of that sweet, old, silent ruin of Telmessus. After you have once seen it, the remembrance remains with you, like a tune from Mozart, which he seems to have caught out of heaven, and which rings sweet harmony in your ears for ever after! It's a benefit for all after life! You have but to shut your eyes, and think, and recall it, and the delightful vision comes smiling back to your order! —the divine air—the delicious little pageant, which nature set before you on this lucky day.

Here is the entry made in the note-book on the eventful day;—"In the morning steamed into the bay of Glaucus—landed at Makri—cheerful old desolate village—theatre by the beautiful seashore—great fertility, oleanders—a palm-tree in the midst of the village, spreading out like a Sultan's aigrette—sculptured caverns, or tombs, up the mountain—camels over the bridge."

Perhaps it is best for a man of fancy to make his own landscape out of these materials: to group the couched camels under the plane-trees; the little crowd of wandering, ragged heathens come down to the calm water, to behold the nearing steamer; to fancy a mountain, in the sides of which some scores of tombs are rudely carved; pillars and porticoes, and Doric entablatures. But it is of the little theatre that he must make the most beautiful picture, a charming little place of festival, lying out on the shore, and looking over the sweet bay and the swelling purple islands. No theatre-goer ever looked out on a fairer scene. It encourages poetry, idleness, delicious sensual reverie. O Jones! friend of my heart! would you not like to be a white-robed Greek, lolling languidly on the cool benches here, and pouring compliments in the Ionic dialect into the rosy ears of Neæra? Instead of Jones your name should be Ionides; instead of a silk hat, you should wear a chaplet of roses in your hair: you would not listen to the choruses they were singing on the stage, for the voice of the fair one would be whispering a rendezvous for the *mesonuktiais horais,* and my Ionides would have no ear for aught beside.

Yonder, in the mountain, they would carve a Doric cave temple, to receive your urn when all was done; and you would be accompanied thither by a dirge of the surviving Ionidæ. The caves of the dead are empty now, however, and their place knows them not any more among the festal haunts of the living.

A Journey from Cornhill (1846)

THE ARCH OF DEATH

There came a day when the round of decorous pleasures and solemn gaieties in which Mr. Joseph Sedley's family indulged, was interrupted by an event which happens in most houses. As you ascend the staircase of your house from the drawing towards the bedroom floors, you may have remarked a little arch in the wall right before you which at once gives light to the stair which leads from the second story to the third, where the nursery and servants' chambers commonly are, and serves for another purpose of utility, of which the undertaker's men can give you a notion. They rest the coffins upon that arch, or pass them through it so as not to disturb in any unseemly manner the cold tenant slumbering within the black arch.

That second-floor arch in a London house, looking up and down the well of the staircase, and commanding the main thoroughfare by which the inhabitants are passing; by which the cook lurks down before daylight to scour her pots and pans in the kitchen; by which the young master stealthily ascends, having left his boots in the hall, and let himself in after dawn from a jolly night at the club; down which miss comes rustling in fresh ribbons and spreading muslins, brilliant and beautiful, and prepared for conquest and the ball; or master Tommy slides, preferring the bannisters for a mode of conveyance, and disdaining danger and the stair; down which the mother is fondly carried smiling in her strong husband's arms, as he steps steadily step by step, and followed by the monthly nurse, on the day when the medical man has pronounced that the charming patient may go down-stairs; up which John lurks to bed, yawning with a sputtering tallow candle, and to gather up before sunrise the boots which are awaiting him in the passages;—that stair, up or down which babies are carried, old people are helped, guests are marshalled to the ball, the parson walks to the christening, the doctor to the sickroom, and the undertaker's men to the upper floor; what a memento of life, death, and vanity it is—that arch and stair—if you choose to consider it, and sit on the landing, looking up and down the well! The doctor will come up to us for the last time there, my friend in motley. The nurse will look in at the curtains, and you take no notice; and then she will fling open the windows for a little, and let in the air. Then they will pull down all the front blinds of the house and live in the back

1231

rooms; then they will send for the lawyer and other men in black, etc. Your comedy and mine will have been played then, and we shall be removed, O how far, from the trumpets, and the shouting, and the posture-making. If we are gentlefolks they will put hatchments over our late domicile, with gilt cherubim, and mottoes stating that there is "Quiet in Heaven." Your son will new furnish the house, or perhaps let it, and go into a more modern quarter; your name will be among the "Members Deceased," in the lists of your clubs next year. However much you may be mourned, your widow will like to have her weeds neatly made; the cook will send or come up to ask about dinner; the survivors will soon bear to look at your picture over the mantelpiece, which will presently be deposed from the place of honour, to make way for the portrait of the son who reigns.

<div align="right">Vanity Fair (1847–48)</div>

When I say that I hardly know any master of English prose-rhythm greater, in his way, than Thackeray, and that I certainly do not know any one with so various and pervasive a command, I may seem to provoke the answer, "Oh! you are, if not a maniac, at any rate a MANIAQUE. *The obsession of Titmarsh blinds and deafens you." Nevertheless, I say it; and will maintain it. That he seldom—perhaps never—tried diploma-pieces of the most elaborate kind may, of course, be admitted; the cap-and-bells, which he never wholly laid aside for more than a minute or two, forbade that. Yet the first of the two long passages which I have selected is not in this way far behind—some may think that it is at least on a level with—the most greatly-intending scenes of description that we have had or shall have; and the second, as a piece of reflection, will be hard to beat in sermon or essay, history or tractate, from Raleigh to Newman. But the most remarkable thing about Thackeray, in our connection—a thing impossible fully to illustrate here,—is his mastery of that mixed style "*SHOT *with rhythm" which has been noticed. Even in his earliest and most grotesque extravaganzas you will rarely find a discordant sentence—the very vulgarisms and mis-spellings come like solecisms from a pair of pretty lips and uttered in a musical voice. As there never was a much hastier writer, it is clear that the man thought in rhythm—that the words, as they flowed from his pen, brought the harmony with them.*

<div align="right">GEORGE SAINTSBURY
A History of English Prose Rhythm (1922)</div>

THÉOPHILE GAUTIER

1 8 1 1 — 1 8 7 2

FROM *LE TRIOMPHE DE PÉTRARQUE*

Sur l'autel idéal entretenez la flamme,
Guidez le peuple au bien par le chemin du beau,
Par l'admiration et l'amour de la femme.

Comme un vase d'albâtre où l'on cache un flambeau,
Mettez l'idée au fond de la forme sculptée,
Et d'une lampe ardente éclairez le tombeau.

Que votre douce voix, de Dieu même écoutée,
Au milieu du combat jetant des mots de paix,
Fasse tomber les flots de la foule irritée.

Que votre poésie, aux vers calmes et frais,
Soit pour les cœurs souffrants comme ces cours d'eau vive
Où vont boire les cerfs dans l'ombre des forêts.

Faites de la musique avec la voix plaintive
De la création et de l'humanité,
De l'homme dans la ville et du flot sur la rive.

Puis, comme un beau symbole, un grand peintre vanté
Vous représentera dans une immense toile,
Sur un char triomphal par un peuple escorté:

Et vous aurez au front la couronne et l'étoile!

Let the flame be fed on the altar of the ideal, guide the people to virtue by the path of beauty, by admiration and the love of woman. Like an alabaster vase in which a torch is hidden, place the idea within the sculptured form, and with a burning lamp light up the grave. Let your soft voice, heard by God himself, uttering words of peace in the midst of strife, cause the surge of the angry crowd to subside. Let your poetry, with its calm, fresh lines, be for suffering hearts like running streams, where the deer go to drink in the forest shade. Make music with the plaintive voice of creation and humanity, of man in cities and waves on the shore. Then, like a beautiful symbol, some celebrated painter will depict you on an immense canvas, on a triumphal chariot, escorted by a whole people; and you will have on your forehead the crown and the star.

Poésies diverses (1836)

THÉOPHILE GAUTIER

1 8 1 1 — 1 8 7 2

L'ART

Oui, l'œuvre sort plus belle
D'une forme au travail
 Rebelle,
Vers, marbre, onyx, émail.

Point de contraintes fausses!
Mais que pour marcher droit
 Tu chausses,
Muse, un cothurne étroit.

Fi du rhythme commode,
Comme un soulier trop grand,
 Du mode
Que tout pied quitte et prend!

Statuaire, repousse
L'argile que pétrit
 Le pouce
Quand flotte ailleurs l'esprit.

Lutte avec le carrare,
Avec le paros dur
 Et rare,
Gardiens du contour pur;

Emprunte à Syracuse
Son bronze où fermement
 S'accuse
Le trait fier et charmant;

D'une main délicate
Poursuis dans un filon
 D'agate
Le profil d'Apollon.

1234

Peintre, fuis l'aquarelle,
Et fixe la couleur
 Trop frêle
Au four de l'émailleur.

Fais les sirènes bleues,
Tordant de cent façons
 Leurs queues,
Les monstres des blasons;

Dans son nimbe trilobe
La Vierge et son Jésus,
 Le globe
Avec la croix dessus.

Tout passe.—L'art robuste
Seul a l'éternité.
 Le buste
Survit à la cité,

Et la médaille austère
Que trouve un laboureur
 Sous terre
Révèle un empereur.

Les dieux eux-mêmes meurent,
Mais les vers souverains
 Demeurent
Plus forts que les airains.

Sculpte, lime, cisèle;
Que ton rêve flottant
 Se scelle
Dans le bloc résistant!

ART

All things are doubly fair
If patience fashion them
 And care—
Verse, enamel, marble, gem.

No idle chains endure:
Yet, Muse, to walk aright,
 Lace tight
Thy buskin proud and sure.

Fie on a facile measure,
A shoe where every lout
 At pleasure
Slips his foot in and out!

Sculptor, lay by the clay
On which thy nerveless finger
 May linger,
Thy thoughts flown far away.

Keep to Carrara rare,
Struggle with Paros cold,
 That hold
The subtle line and fair.

Lest haply nature lose
That proud, that perfect line,
 Make thine
The bronze of Syracuse.

And with a tender dread
Upon an agate's face
 Retrace
Apollo's golden head.

Despise a watery hue
And tints that soon expire.
 With fire
Burn thine enamel true.

Twine, twine in artful wise
The blue-green mermaid's arms,
 Mid charms
Of thousand heraldries.

Show in their triple lobe
Virgin and Child, that hold
 Their globe,
Cross-crowned and aureoled.

—All things return to dust
Save beauties fashioned well.
 The bust
Outlasts the citadel.

Oft doth the plowman's heel,
Breaking an ancient clod,
 Reveal
A Cæsar or a god.

The gods, too, die, alas!
But deathless and more strong
 Than brass
Remains the sovereign song.

Chisel and carve and file,
Till thy vague dream imprint
 Its smile
On the unyielding flint.
<div align="right">*Translated by George Santayana*</div>

Singularly perfect.

<div align="right">
H E N R Y J A M E S

French Poets and Novelists (1878)
</div>

<div align="center">

J O H N B R I G H T

1 8 1 1 — 1 8 8 9

THE ANGEL OF DEATH

</div>

I cannot, I say, but notice that an uneasy feeling exists as to the news which may arrive by the very next mail from the East. I do not suppose that your troops are to be beaten in actual conflict with the foe, or that they will be driven into the sea; but I am certain that many homes in England in which there now exists a fond hope that the distant one may return—many such homes may be rendered desolate when the next mail shall arrive. The angel of death has been abroad throughout the land; you may almost hear the beating of his wings. There is no one, as when the first-born were slain of old, to sprinkle with blood the lintel and the two sideposts of our doors, that he may spare and pass on; he takes his victims from the castle of the noble, the mansion of the wealthy, and the cottage of the poor and the lowly, and it is on behalf of all these classes that I make this solemn appeal.
<div align="right">Speech in The House of Commons (February 23, 1855)</div>

Impassioned writing of the highest quality.

<div align="right">
H E R B E R T J. C. G R I E R S O N

Rhetoric and English Composition (1945)
</div>

CHARLES DICKENS

1 8 1 2 — 1 8 7 0

THE MANOR-FARM KITCHEN
ON CHRISTMAS EVE

"How it snows!" said one of the men, in a low tone.

"Snows, does it?" said Wardle.

"Rough, cold night, Sir," replied the man; "and there's a wind got up, that drifts it across the fields, in a thick white cloud."

"What does Jem say?" inquired the old lady. "There a'n't anything the matter, is there?"

"No, no, mother," replied Wardle; "he says there's a snow-drift, and a wind that's piercing cold."

<div align="right">Pickwick Papers (1836–37)</div>

You know this is the introduction to the Tale of Gabriel Grub, an admirable legend which Dickens "farsed" with an obtrusive moral. But I confess that the atmosphere (which to me seems all the wild weather and the wild legend of the north) suggested by those phrases "a thick white cloud," and "a wind that's piercing cold," is in my judgment wholly marvellous.

<div align="right">ARTHUR MACHEN
Hieroglyphics (1923)</div>

CHARLES DICKENS

1 8 1 2 — 1 8 7 0

THE DOVER ROAD

For anything I know, I may have had some wild idea of running all the way to Dover, when I gave up the pursuit of the young man with the donkey-cart, and started for Greenwich. My scattered senses were soon collected as to that point, if I had; for I came to a stop in the Kent Road, at a terrace with a piece of water before it, and a great foolish image in the middle, blowing a dry shell. Here I sat down on a doorstep, quite spent and exhausted with the efforts I had already made, and with hardly breath enough to cry for the loss of my box and half-guinea.

It was by this time dark; I heard the clocks strike ten, as I sat resting. But it was a summer night, fortunately, and fine weather. When I had re-

covered my breath, and had got rid of a stifling sensation in my throat, I rose up and went on. In the midst of my distress, I had no notion of going back. I doubt if I should have had any, though there had been a Swiss snow-drift in the Kent Road.

But my standing possessed of only three-halfpence in the world (and I am sure I wonder how *they* came to be left in my pocket on a Saturday night!) troubled me none the less because I went on. I began to picture to myself, as a scrap of newspaper intelligence, my being found dead in a day or two, under some hedge; and I trudged on miserably, though as fast as I could, until I happened to pass a little shop, where it was written up that ladies' and gentlemen's wardrobes were bought, and that the best price was given for rags, bones, and kitchen-stuff. The master of this shop was sitting at the door in his shirt-sleeves, smoking; and as there were a great many coats and pairs of trousers dangling from the low ceiling, and only two feeble candles burning inside to show what they were, I fancied that he looked like a man of a revengeful disposition, who had hung all his enemies, and was enjoying himself.

My late experiences with Mr. and Mrs. Micawber suggested to me that here might be a means of keeping off the wolf for a little while. I went up the next bye-street, took off my waistcoat, rolled it neatly under my arm, and came back to the shop-door. "If you please, sir," I said, "I am to sell this for a fair price."

Mr. Dolloby—Dolloby was the name over the shop-door, at least—took the waistcoat, stood his pipe on its head against the door-post, went into the shop, followed by me, snuffed the two candles with his fingers, spread the waistcoat on the counter, and looked at it there, held it up against the light, and looked at it there, and ultimately said:

"What do you call a price, now, for this here little weskit?"

"Oh! you know best, sir," I returned modestly.

"I can't be buyer and seller too," said Mr. Dolloby. "Put a price on this here little weskit."

"Would eighteenpence be?"—I hinted, after some hesitation.

Mr. Dolloby rolled it up again, and gave it me back. "I should rob my family," he said, "if I was to offer ninepence for it."

This was a disagreeable way of putting the business; because it imposed upon me, a perfect stranger, the unpleasantness of asking Mr. Dolloby to rob his family on my account. My circumstances being so very pressing, however, I said I would take ninepence for it, if he pleased. Mr. Dolloby, not without some grumbling, gave ninepence. I wished him goodnight, and walked out of the shop, the richer by that sum, and the poorer by a waistcoat. But when I buttoned my jacket, that was not much.

Indeed, I foresaw pretty clearly that my jacket would go next, and that I should have to make the best of my way to Dover in a shirt and a pair of trousers, and might deem myself lucky if I got there even in

1239

that trim. But my mind did not run so much on this as might be supposed. Beyond a general impression of the distance before me, and of the young man with the donkey-cart having used me cruelly, I think I had no very urgent sense of my difficulties when I once again set off with my ninepence in my pocket.

A plan had occurred to me for passing the night, which I was going to carry into execution. This was, to lie behind the wall at the back of my old school, in a corner where there used to be a haystack. I imagined it would be a kind of company to have the boys, and the bedroom where I used to tell the stories, so near me: although the boys would know nothing of my being there, and the bedroom would yield me no shelter.

I had had a hard day's work, and was pretty well jaded when I came climbing out, at last, upon the level of Blackheath. It cost me some trouble to find out Salem House; but I found it, and I found a haystack in the corner, and I lay down by it; having first walked round the wall, and looked up at the windows, and seen that all was dark and silent within. Never shall I forget the lonely sensation of first lying down, without a roof above my head!

Sleep came upon me as it came on many other outcasts, against whom house-doors were locked, and house-dogs barked, that night—and I dreamed of lying on my old school-bed, talking to the boys in my room; and found myself sitting upright, with Steerforth's name upon my lips, looking wildly at the stars that were glistening and glimmering above me. When I remembered where I was at that untimely hour, a feeling stole upon me that made me get up, afraid of I don't know what, and walk about. But the fainter glimmering of the stars, and the pale light in the sky where the day was coming, reassured me: and my eyes being very heavy, I lay down again, and slept—though with a knowledge in my sleep that it was cold—until the warm beams of the sun, and the ringing of the getting-up bell at Salem House, awoke me. If I could have hoped that Steerforth was there, I would have lurked about until he came out alone; but I knew he must have left long since. Traddles still remained, perhaps, but it was very doubtful; and I had not sufficient confidence in his discretion or good luck, however strong my reliance was on his good-nature, to wish to trust him with my situation. So I crept away from the wall as Mr. Creakle's boys were getting up, and struck into the long dusty track which I had first known to be the Dover Road when I was one of them, and when I little expected that any eyes would ever see me the wayfarer I was now, upon it.

What a different Sunday morning from the old Sunday morning at Yarmouth! In due time I heard the church-bells ringing, as I plodded on; and I met people who were going to church; and I passed a church or two where the congregation were inside, and the sound of singing came out into the sunshine, while the beadle sat and cooled himself in the shade of the porch, or stood beneath the yew-tree, with his hand

to his forehead, glowering at me going by. But the peace and rest of the old Sunday morning were on everything, except me. That was the difference. I felt quite wicked in my dirt and dust, with my tangled hair. But for the quiet picture I had conjured up, of my mother in her youth and beauty, weeping by the fire, and my aunt relenting to her, I hardly think I should have had the courage to go on until next day. But it always went before me, and I followed.

I got, that Sunday, through three-and-twenty miles on the straight road, though not very easily, for I was new to that kind of toil. I see myself, as evening closes in, coming over the bridge at Rochester, foot-sore and tired, and eating bread that I had bought for supper. One or two little houses, with the notice, "Lodgings for Travellers," hanging out, had tempted me; but I was afraid of spending the few pence I had, and was even more afraid of the vicious looks of the trampers I had met or overtaken. I sought no shelter, therefore, but the sky; and toiling into Chatham,—which, in the night's aspect, is a mere dream of chalk, and drawbridges, and mastless ships in a muddy river, roofed like Noah's arks,—crept, at last, upon a sort of grass-grown battery overhanging a lane, where a sentry was walking to and fro. Here I lay down, near a cannon; and, happy in the society of the sentry's footsteps, though he knew no more of my being above him than the boys of Salem House had known of my lying by the wall, slept soundly until morning.

Very stiff and sore of foot I was in the morning, and quite dazed by the beating of drums and marching of troops, which seemed to hem me in on every side when I went down towards the long narrow street. Feeling that I could go but a very little way that day, if I were to re-serve any strength for getting to my journey's end, I resolved to make the sale of my jacket its principal business. Accordingly, I took the jacket off, that I might learn to do without it; and carrying it under my arm, began a tour of inspection of the various slop-shops.

It was a likely place to sell a jacket in; for the dealers in second-hand clothes were numerous, and were, generally speaking, on the look-out for customers at their shop-doors. But, as most of them had, hanging up among their stock, an officer's coat or two, epaulettes and all, I was rendered timid by the costly nature of their dealings, and walked about for a long time without offering my merchandise to any one.

This modesty of mine directed my attention to the marine-store shops, and such shops as Mr. Dolloby's, in preference to the regular dealers. At last I found one that I thought looked promising, at the corner of a dirty lane, ending in an inclosure full of stinging-nettles, against the palings of which some second-hand sailors' clothes, that seemed to have overflowed the shop, were fluttering among some cots, and rusty guns, and oilskin hats, and certain trays full of so many old rusty keys of so many sizes that they seemed various enough to open all the doors in the world.

1241

Into this shop, which was low and small, and which was darkened rather than lighted by a little window, overhung with clothes, and was descended into by some steps, I went with a palpitating heart; which was not relieved when an ugly old man, with the lower part of his face all covered with a stubbly grey beard, rushed out of a dirty den behind it, and seized me by the hair of my head. He was a dreadful old man to look at, in a filthy flannel waistcoat, and smelling terribly of rum. His bedstead, covered with a tumbled and ragged piece of patchwork, was in the den he had come from, where another little window showed a prospect of more stinging-nettles, and a lame donkey.

"Oh, what do you want?" grinned this old man, in a fierce, monotonous whine. "Oh, my eyes and limbs, what do you want? Oh, my lungs and liver, what do you want? Oh, goroo, goroo!"

I was so much dismayed by these words, and particularly by the repetition of the last unknown one, which was a kind of rattle in his throat, that I could make no answer; hereupon the old man, still holding me by the hair, repeated:

"Oh, what do you want? Oh, my eyes and limbs, what do you want? Oh, my lungs and liver, what do you want? Oh, goroo!"—which he screwed out of himself, with an energy that made his eyes start in his head.

"I wanted to know," I said, trembling, "if you would buy a jacket?"

"Oh, let's see the jacket!" cried the old man. "Oh, my heart on fire, show the jacket to us! Oh, my eyes and limbs, bring the jacket out!"

With that he took his trembling hands, which were like the claws of a great bird, out of my hair; and put on a pair of spectacles, not at all ornamental to his inflamed eyes.

"Oh, how much for the jacket?" cried the old man, after examining it. "Oh—goroo!—how much for the jacket?"

"Half-a-crown," I answered, recovering myself.

"Oh, my lungs and liver," cried the old man, "no! Oh, my eyes, no! Oh, my limbs, no! Eighteenpence. Goroo!"

Every time he uttered this ejaculation, his eyes seemed to be in danger of starting out; and every sentence he spoke, he delivered in a sort of tune, always exactly the same, and more like a gust of wind, which begins low, mounts up high, and falls again, than any other comparison I can find for it.

"Well," said I, glad to have closed the bargain, "I'll take eighteenpence."

"Oh, my liver!" cried the old man, throwing the jacket on a shelf. "Get out of the shop! Oh, my lungs, get out of the shop! Oh, my eyes and limbs—goroo!—don't ask for money; make it an exchange."

I never was so frightened in my life, before or since; but I told him humbly that I wanted money, and that nothing else was of any use to me, but that I would wait for it, as he desired, outside, and had no wish

1242

to hurry him. So I went outside, and sat down in the shade in a corner. And I sat there so many hours, that the shade became sunlight, and the sunlight shade again, and still I sat there waiting for the money.

There never was such another drunken madman in that line of business, I hope. That he was well known in the neighbourhood, and enjoyed the reputation of having sold himself to the devil, I soon understood from the visits he received from the boys, who continually came skirmishing about the shop, shouting that legend, and calling to him to bring out his gold. "You ain't poor, you know, Charley, as you pretend. Bring out your gold. Bring out some of the gold you sold yourself to the devil for. Come! It's in the lining of the mattress, Charley. Rip it open and let's have some!" This, and many offers to lend his a knife for the purpose, exasperated him to such a degree, that the whole day was a succession of rushes on his part, and flights on the part of the boys. Sometimes in his rage he would take me for one of them, and come at me, mouthing as if he were going to tear me in pieces; then, remembering me just in time, would dive into the shop, and lie upon his bed, as I thought from the sound of his voice, yelling in a frantic way, to his own windy tune, the Death of Nelson; with an Oh! before every line, and innumerable Goroos interspersed. As if this were not bad enough for me, the boys, connecting me with the establishment, on account of the patience and perserverance with which I sat outside, half-dressed, pelted me, and used me very ill all day.

He made many attempts to induce me to consent to an exchange; at one time coming out with a fishing-rod, at another with a fiddle, at another with a cocked hat, at another with a flute. But I resisted all these overtures, and sat there in desperation; each time asking him, with tears in my eyes, for my money or my jacket. At last he began to pay me in half-pence at a time; and was full two hours at getting by easy stages to a shilling.

"Oh, my eyes and limbs!" he then cried, peeping hideously out of the shop, after a long pause, "will you go for twopence more?"

"I can't," I said, "I shall be starved."

"Oh, my lungs and liver, will you go for threepence?"

"I would go for nothing, if I could," I said, "but I want the money badly."

"Oh, go—roo!" (it is really impossible to express how he twisted this ejaculation out of himself, as he peeped round the doorpost at me, showing nothing but his crafty old head); "will you go for fourpence?"

I was so faint and weary that I closed with this offer; and taking the money out of his claw, not without trembling, went away more hungry and thirsty than I had ever been, a little before sunset. But at an expense of threepence I soon refreshed myself completely; and, being in better spirits then, limped seven miles upon my road.

My bed at night was under another haystack where I rested com-

fortably, after having washed my blistered feet in a stream, and dressed them as well as I was able, with some cool leaves. When I took the road again next morning, I found that it lay through a succession of hop-grounds and orchards. It was sufficiently late in the year for the orchards to be ruddy with ripe apples; and in a few places the hop-pickers were already at work. I thought it all extremely beautiful, and made up my mind to sleep among the hops that night; imagining some cheerful companionship in the long perspectives of poles, with the graceful leaves twining round them.

The trampers were worse than ever that day, and inspired me with a dread that is yet quite fresh in my mind. Some of them were most ferocious-looking ruffians, who stared at me as I went by; and stopped, perhaps, and called after me to come back and speak to them, and when I took to my heels, stoned me. I recollect one young fellow—a tinker, I suppose, from his wallet and brazier—who had a woman with him, and who faced about and stared at me thus; and then roared at me in such a tremendous voice to come back, that I halted and looked round.

"Come here, when you're called," said the tinker, "or I'll rip your young body open."

I thought it best to go back. As I drew nearer to them, trying to propitiate the tinker by my looks, I observed that the woman had a black eye.

"Where are you going?" said the tinker, gripping the bosom of my shirt with his blackened hand.

"I am going to Dover," I said.

"Where do you come from?" asked the tinker, giving his hand another turn in my shirt, to hold me more securely.

"I come from London," I said.

"What lay are you upon?" asked the tinker. "Are you a prig?"

"N—— no," I said.

"Ain't you, by G——? If you make a brag of your honesty to me," said the tinker, "I'll knock your brains out."

With his disengaged hand he made a menace of striking me, and then looked at me from head to foot.

"Have you got the price of a pint of beer about you?" said the tinker. "If you have, out with it, afore I take it away!"

I should certainly have produced it, but that I met the woman's look, and saw her very slightly shake her head, and form "No!" with her lips.

"I am very poor," I said, attempting to smile, "and have got no money."

"Why, what do you mean?" said the tinker, looking so sternly at me, that I almost feared he saw the money in my pocket.

"Sir!" I stammered.

"What do you mean," said the tinker, "by wearing my brother's silk

1244

handkerchief! Give it over here!" And he had mine off my neck in a moment, and tossed it to the woman.

The woman burst into a fit of laughter, as if she thought this a joke, and tossed it back to me, nodded once, as slightly as before, and made the word "Go!" with her lips. Before I could obey, however, the tinker seized the handkerchief out of my hand with a roughness that threw me away like a feather, and putting it loosely round his own neck, turned upon the woman with an oath, and knocked her down. I never shall forget seeing her fall backward on the hard road, and lie there with her bonnet tumbled off, and her hair all whitened in the dust; nor, when I looked back from a distance, seeing her sitting on the pathway, which was a bank by the roadside, wiping the blood from her face with a corner of her shawl, while he went on ahead.

This adventure frightened me so, that, afterwards, when I saw any of these people coming, I turned back until I could find a hiding-place, where I remained until they had gone out of sight; which happened so often, that I was very seriously delayed. But under this difficulty, as under all the other difficulties of my journey, I seemed to be sustained and led on by my fanciful picture of my mother in her youth, before I came into the world. It always kept me company. It was there, among the hops, when I lay down to sleep: it was with me on my waking in the morning; it went before me all day. I have associated it, ever since, with the sunny street of Canterbury, dozing as it were in the hot light; and with the sight of its old houses and gateways, and the stately, grey Cathedral, with the rooks sailing round the towers. When I came, at last, upon the bare wide downs near Dover, it relieved the solitary aspect of the scene with hope; and not until I reached that first great aim of my journey, and actually set foot in the town itself, on the sixth day of my flight, did it desert me. But then, strange to say, when I stood with my ragged shoes, and my dusty, sunburnt, half-clothed figure, in the place so long desired, it seemed to vanish like a dream, and to leave me helpless and dispirited.

David Copperfield (1849–50)

As good a piece of narrative prose as can be found in English.

GEORGE GISSING
Charles Dickens (1898)

THE LOST MISTRESS

I

All's over, then: does truth sound bitter
 As one at first believes?
Hark, 'tis the sparrows' good-night twitter
 About your cottage eaves!

II

And the leaf-buds on the vine are woolly,
 I noticed that, to-day;
One day more bursts them open fully
 —You know the red turns grey.

III

To-morrow we meet the same then, dearest?
 May I take your hand in mine?
Mere friends are we,—well, friends the merest
 Keep much that I resign:

IV

For each glance of the eye so bright and black,
 Though I keep with heart's endeavour,—
Your voice, when you wish the snowdrops back,
 Though it stay in my soul forever!—

V

Yet I will but say what mere friends say,
 Or only a thought stronger;
I will hold your hand but as long as all may,
 Or so very little longer!

(1845)

This is one of those love-songs which we cannot but consider among the noblest of such songs in all Love's language.

A R T H U R S Y M O N S
An Introduction to the Study of Browning (1906)

TO DRIVE LIFE INTO A CORNER

I went to the woods because I wished to live deliberately, to front only the essential facts of life, and see if I could not learn what it had to teach, and not, when I came to die, discover that I had not lived. I did not wish to live what was not life, living is so dear; nor did I wish to practise resignation, unless it was quite necessary. I wanted to live deep and suck out all the marrow of life, to live so sturdily and Spartan-like as to put to rout all that was not life, to cut a broad swath and shave close, to drive life into a corner, and reduce it to its lowest terms, and, if it proved to be mean, why then to get the whole and genuine meanness of it, and publish its meanness to the world; or if it were sublime, to know it by experience, and be able to give a true account of it in my next excursion. For most men, it appears to me, are in a strange uncertainty about it, whether it is of the devil or of God, and have *somewhat hastily* concluded that it is the chief end of man here to "glorify God and enjoy him forever."

Walden, or Life in the Woods (1854)

What had proved so heartening to Emerson's contemporaries was his insistence that life for Americans no longer needed to be starved. The most intense expression of that conviction, perhaps the most intense single passage in American writing, is Thoreau's.

F. O. MATTHIESSEN
Henry James: The Major Phase (1944)

TR-R-R-R-OONK

And then the frogs, bullfrogs; they are the more sturdy spirits of ancient wine-bibbers and wassailers, still unrepentant, trying to sing a catch in their Stygian lakes. They would fain keep up the hilarious good fellowship and all the rules of their old round tables, but they have waxed hoarse and solemnly grave and serious their voices, mocking at mirth, and their wine has lost its flavor and is only liquor to distend

their paunches, and never comes sweet intoxication to drown the memory of the past, but mere saturation and water-logged dullness and distension. Still the most aldermanic, and with his chin upon a pad, which answers for a napkin to his drooling chaps, under the eastern shore quaffs a deep draught of the once scorned water, and passes round the cup with the ejaculation *tr-r-r-r-oonk, tr-r-r-r-oonk, tr-r-r-r-oonk*! and straightway comes over the water from some distant cove the selfsame password, where the next in seniority and girth has gulped down to his mark; and when the strain has made the circuit of the shores, then ejaculates the master of ceremonies with satisfaction *tr-r-r-r-oonk*! and each in turn repeats the sound, down to the least distended, leakiest, flabbiest paunched, that there be no mistake; and the bowl goes round again, until the sun dispels the morning mist, and only the patriarch is not under the pond, but vainly bellowing *troonk* from time to time, pausing for a reply.

<div align="right">The Journal (August, 1845)</div>

Where will one turn for a more superbly Rabelaisian picture than this wassail scene of the woods.

<div align="right">PAUL ELMER MORE
Selected Shelburne Essays (1935)</div>

<div align="center">

E M I L Y B R O N T Ë

1 8 1 8 — 1 8 4 8

THE THREE HEADSTONES
BY THE MOOR

</div>

I lingered round them, under that benign sky: watched the moths fluttering among the heath and hare-bells; listened to the soft wind breathing through the grass; and wondered how any one could ever imagine unquiet slumbers for the sleepers in that quiet earth.

<div align="right">Wuthering Heights (1847)</div>

Among the greatest masters of our prose.

<div align="right">HERBERT READ
A Coat of Many Colours (1945)</div>

LECONTE DE LISLE

1818 — 1894

FROM *QAÏN*

Thogorma dans ses yeux vit monter des murailles
De fer d'où s'enroulaient des spirales de tours
Et de palais cerclés d'airain sur des blocs lourds;
Ruche énorme, géhenne aux lugubres entrailles
Où s'engouffraient les Forts, princes des anciens jours.

Ils s'en venaient de la montagne et de la plaine,
Du fond des sombres bois et du désert sans fin,
Plus massifs que le cèdre et plus hauts que le pin,
Suants, échevelés, soufflant leur rude haleine
Avec leur bouche épaisse et rouge, et pleins de faim.

C'est ainsi qu'ils rentraient, l'ours velu des cavernes
A l'épaule, ou le cerf, ou le lion sanglant.
Et les femmes marchaient, géantes, d'un pas lent,
Sous les vases d'airain qu'emplit l'eau des citernes,
Graves, et les bras nus, et les mains sur le flanc.

Elles allaient, dardant leurs prunelles superbes,
Les seins droits, le col haut, dans la sérénité
Terrible de la force et de la liberté,
Et posant tour à tour dans la ronce et les herbes
Leurs pieds fermes et blancs avec tranquillité.

Le vent respectueux, parmi leurs tresses sombres,
Sur leur nuque de marbre errait en frémissant,
Tandis que les parois des rocs couleur de sang,
Comme de grands miroirs suspendus dans les ombres,
De la pourpre du soir baignaient leur dos puissant.

Les ânes de Khamos, les vaches aux mamelles
Pesantes, les boucs noirs, les taureaux vagabonds
Se hâtaient, sous l'épieu, par files et par bonds;
Et de grands chiens mordaient le jarret des chamelles;
Et les portes criaient en tournant sur leurs gonds.

Et les éclats de rire et les chansons féroces
Mêlés aux beuglements lugubres des troupeaux,
Tels que le bruit des rocs secoués par les eaux,
Montaient jusques aux tours où, le poing sur leurs crosses,
Des vieillards regardaient, dans leurs robes de peaux;

Spectres de qui la barbe, inondant leurs poitrines,
De son écume errante argentait leurs bras roux,
Immobiles, de lourds colliers de cuivre aux cous,
Et qui, d'en haut, dardaient, l'orgueil plein les narines,
Sur leur race des yeux profonds comme des trous.

Thogorma in his imagination saw walls of iron arise, from which spiral towers wound upwards, and palaces belted with bronze and resting on heavy blocks; an enormous hive, a gehenna with dismal entrails, where the strong ones, princes of ancient times, were swallowed up as by a chasm. They came from the mountain and from the plain, from the depths of somber forests and from the boundless desert, more massive than the cedar, and taller than pines, sweating, disheveled, blowing their rough breath, with their thick, red mouths, full of hunger. Thus they came home, the shaggy cave-bear on their shoulders, or a deer or a blood-dripping lion. And the gigantic women walked with slow step, under bronze vases filled with cistern water, solemn, with bare arms, and hands on hips. Darting glances from their superb eyes as they walked, firm-breasted, high-necked, with the terrible serenity of strength and freedom, and tranquilly putting down their firm, white feet on briars and grass in turn. The considerate wind, in their somber tresses, wandered tremblingly over their marmoreal napes, while the walls of blood-colored rock, like large mirrors suspended in the shadows, bathed their powerful backs with the purple light of sunset. The asses of Khamos, the cows with heavy udders, the black goats, the wandering bulls hasten, under the goad, single file and leaping, and great dogs bit the she-camel's hocks; and the doors shrieked turning on their hinges. And shouts of laughter and fierce songs mixed with the dismal bellowing of the herds, like the noise of rocks shaken by waters, rose to the towers where, hands on their crooks, old men looked on, in their skin garments. Specters whose beards, flooding over their chests, shed the silver of its wandering foam over their red arms, motionless, with heavy copper necklaces on their necks, and who from on high, with nostrils full of pride, darted over their race glances from eyes deep as holes.

Poèmes barbares (1862)

The most perfect model of what may be conceded to be today the epic style.

THÉODORE DE BANVILLE
Petit Traité de poésie française (1871)

1818 — 1894

LE MANCHY

Sous un nuage frais de claire mousseline,
 Tous les dimanches, au matin,
Tu venais à la ville en manchy de rotin,
 Par les rampes de la colline.

La cloche de l'église alertement tintait;
 Le vent de mer berçait les cannes:
Comme une grêle d'or, aux pointes des savanes,
 Le feu du soleil crépitait.

Le bracelet aux poings, l'anneau sur la cheville,
 Et le mouchoir jaune aux chignons,
Deux Telingas portaient, assidus compagnons,
 Ton lit aux nattes de Manille.

Ployant leur jarret maigre et nerveux, et chantant,
 Souples dans leurs tuniques blanches,
Le bambou sur l'épaule et les mains sur les hanches,
 Ils allaient le long de l'Étang.

Le long de la chaussée et des varangues basses
 Où les vieux créoles fumaient,
Par les groupes joyeux des Noirs, ils s'animaient
 Au bruit des bobres Madécasses.

Dans l'air léger flottait l'odeur des tamarins;
 Sur les houles illuminées
Au large, les oiseaux, en d'immenses traînées,
 Plongeaient dans les brouillards marins.

Et, tandis que ton pied, sorti de la babouche,
 Pendait, rose, au bord du manchy,
A l'ombre des Bois-noirs touffus, et du Letchi
 Aux fruits moins pourprés que ta bouche;

Tandis qu'un papillon, les deux ailes en fleur,
 Teinté d'azur et d'écarlate,
Se posait par instants sur ta peau délicate
 En y laissant de sa couleur;

On voyait, au travers du rideau de batiste,
 Tes boucles dorer l'oreiller;
Et, sous leurs cils mi-clos, feignant de sommeiller,
 Tes beaux yeux de sombre améthyste.

Tu t'en venais ainsi, par ces matins si doux,
 De la montagne à la grand'messe,
Dans ta grâce naïve et ta rose jeunesse,
 Au pas rythmé de tes Hindous.

Maintenant, dans le sable aride de nos grèves,
 Sous les chiendents, au bruit des mers,
Tu reposes parmi les morts qui me sont chers,
 O charme de mes premiers rêves!

THE MANCHY

Clothed in your filmy muslin gown,
 Every Sunday morning, you
 Would come in your manchy of bamboo
Down the footpaths to the town.

The church-bell rang out noisily;
 The salt breeze waved the lofty cane;
 The sun shook out a golden rain
On the savannah's grassy sea.

With rings on wrist and ankle flat,
 And yellow kerchief on the crown,
 Your two telingas carried down
Your litter of Manila mat.

Slim, in tunics white, they sang
 As 'neath the pole of bamboo bent,
 With hands upon their hips, they went
Steadily by the long Etang.

Past banks where Creoles used to come
 To smoke their ancient pipes; past bands
 Of blacks disporting on the sands
To the sound of the Madagascar drum.

The tamarind's breath was on the air;
 Out in the glittering surf the flocks
 Of birds swung through the billow's shocks
And plunged beneath the foaming blare.

While hung—your sandal loosed—the tips
 Of one pink foot at the manchy's side,
 In the shade of the letchi branching wide
With fruit less purple than your lips;

While like a flower, a butterfly
 Of blue and scarlet fluttered on
 Your skin an instant, and was gone,
Leaving his colors in good-by.

We saw between the cambric's mist
 Your earrings on the pillows lain;
 While your long lashes veiled in vain
Your eyes of sombre amethyst.

'Twas thus you came, those mornings sweet,
 With grace so gentle, to High Mass,
 Borne slowly down the mountain pass
By your faithful Hindoos' steady feet.

But now where our dry sand-bar gleams
 Beneath the dog-grass near the sea,
 You rest with dead ones dear to me,
O charm of my first tender dreams!
 Translated by Thomas Walsh

A masterpiece without an equal.

 CHARLES BAUDELAIRE
 Les Poëtes français (1863)

JOHN RUSKIN

1 8 1 9 — 1 9 0 0

MORNING AT VENICE

Between the shafts of the pillars, the morning sky is seen pure and
pale, relieving the grey dome of the church of the Salute; but beside
that vault, and like it, vast thunderclouds heap themselves above the
horizon, catching the light of dawn upon them where they rise, far west-
ward, over the dark roof of the ruined Badia;—but all so massive, that
half-an-hour ago, in the dawn, I scarcely knew the Salute dome and
towers from theirs; while the sea-gulls, rising and falling hither and

thither in clusters above the green water beyond my balcony, tell me
that the south wind is wild on Adria.

<div align="right">Fors Clavigera (November 9, 1876)</div>

*He could not only recover but even better his earlier music; and the
fall of the last ten words is incomparable, quite effacing the faint impres-
sion of metre which is twice left by the preceding clauses—I will leave
the reader to discover where.*

<div align="right">OLIVER ELTON
A Survey of English Literature 1780–1880 (1920)</div>

<div align="center">

WALT WHITMAN

1 8 1 9 — 1 8 9 2

COME SAID THE MUSE

</div>

I am the man, I suffer'd, I was there.

Agonies are one of my changes of garments.

<div align="right">Song of Myself (1881)</div>

Now we have met, we have look'd, we are safe.

<div align="right">Out of the Rolling Ocean the Crowd (1867)</div>

Whoever you are, I fear you are walking the walks of dreams.

<div align="right">To You (1881)</div>

For my enemy is dead, a man divine as myself is dead,
I look where he lies white-faced and still in the coffin—I draw near,
Bend down and touch lightly with my lips the white face in the coffin.

<div align="right">Reconciliation (1881)</div>

Come, I will make the continent indissoluble,
I will make the most splendid race the sun ever shone upon,
I will make divine magnetic lands,
 With the love of comrades,
 With the life-long love of comrades.

<div align="right">For You O Democracy (1881)</div>

When lilacs last in the dooryard bloom'd,
And the great star early dropp'd in the western sky in the night,
I mourn'd, and yet shall mourn with ever-returning spring.

Ever-returning spring, trinity sure to me you bring,
Lilac blooming perennial and drooping star in the west,
And thought of him I love.

<div align="right">When Lilacs Last in the Dooryard Bloom'd (1881)</div>

Come said the Muse,
Sing me a song no poet yet has chanted,
Sing me the universal.

<div align="right">Song of the Universal (1881)</div>

One must admit, too, that only once or twice in the course of a fairly long poem would he reach the high plane of memorable expression, but when he reached it, it was as memorable as that of any poet who ever lived, and in a different way. Sometimes all that was memorable was a line, but the line was pregnant as few single lines ever were. . . . On his highest level, his pregnancy and his lyric potency were both unsurpassable and unique.

<div align="right">MARY M. COLUM
From These Roots (1937)</div>

HERMAN MELVILLE

1819 — 1891

THE GREAT SHROUD OF THE SEA

The harpoon was darted; the stricken whale flew forward; with igniting velocity the line ran through the groove;—ran foul. Ahab stooped to clear it; he did clear it; but the flying turn caught him round the neck, and voicelessly as Turkish mutes bowstring their victim, he was shot out of the boat, ere the crew knew he was gone. Next instant, the heavy eye-splice in the rope's final end flew out of the stark-empty tub, knocked down an oarsman, and smiting the sea, disappeared in its depths.

For an instant, the tranced boat's crew stood still; then turned. 'The ship? Great God, where is the ship?' Soon they through dim, bewildering mediums saw her sidelong fading phantom, as in the gaseous Fata Morgana; only the uppermost masts out of water; while fixed by infatua-

tion, or fidelity, or fate, to their once lofty perches, the pagan harpooners still maintained their sinking lookouts on the sea. And now, concentric circles seized the lone boat itself, and all its crew, and each floating oar, and every lance-pole, and spinning, animate and inanimate, all round and round in one vortex, carried the smallest chip of the Pequod out of sight.

But as the last whelmings intermixingly poured themselves over the sunken head of the Indian at the mainmast, leaving a few inches of the erect spar yet visible, together with long streaming yards of the flag, which calmly undulated, with ironical coincidings, over the destroying billows they almost touched;—at that instant, a red arm and a hammer hovered backwardly uplifted in the open air, in the act of nailing the flag faster and yet faster to the subsiding spar. A sky-hawk that tauntingly had followed the main-truck downwards from its natural home among the stars, pecking at the flag, and incommoding Tashtego there; this bird now chanced to intercept its broad fluttering wing between the hammer and the wood; and simultaneously feeling that etherial thrill, the submerged savage beneath, in his death-gasp, kept his hammer frozen there; and so the bird of heaven, with archangelic shrieks, and his imperial beak thrust upwards, and his whole captive form folded in the flag of Ahab, went down with his ship, which, like Satan, would not sink to hell till she had dragged a living part of heaven along with her, and helmeted herself with it.

Now small fowls flew screaming over the yet yawning gulf; a sullen white surf beat against its steep sides; then all collapsed, and the great shroud of the sea rolled on as it rolled five thousand years ago.

<div align="right">Moby-Dick or The Whale (1851)</div>

The greatest seer and poet of the sea for me is Melville. His vision is more real than Swinburne's, because he doesn't personify the sea, and far sounder than Joseph Conrad's, because Melville doesn't sentimentalize the ocean and the sea's unfortunates.

<div align="right">D. H. LAWRENCE
Studies in Classic American Literature (1924)</div>

CHARLES BAUDELAIRE

1821 — 1867

LE REBELLE

Un Ange furieux fond du ciel comme un aigle,
Du mécréant saisit à plein poing les cheveux,
Et dit, le secouant: "Tu connaîtras la règle!
(Car je suis ton bon Ange, entends-tu?) Je le veux!

Sache qu'il faut aimer, sans faire la grimace,
Le pauvre, le méchant, le tortu, l'hébété,
Pour que tu puisses faire à Jésus, quand il passe,
Un tapis triomphal avec ta charité.

Tel est l'Amour! Avant que ton cœur ne se blase,
A la gloire de Dieu rallume ton extase;
C'est la Volupté vraie aux durables appas!"

Et l'Ange, châtiant autant, ma foi! qu'il aime,
De ses poings de géant torture l'anathème;
Mais le damné répond toujours: "Je ne veux pas!"

THE REBEL

An Angel swoops, like eagle on his prey,
 Grips by the hair the unbelieving wight,
 And furious cries, "O scorner of the right,
 'Tis I, thine angel good, who speaks. Obey!
Know thou shalt love without the least distaste
 The poor, the base, the crooked and the dull;
 So shall the pageant of thy Lord be graced
 With banners by thy love made beautiful.
This is God's love. See that thy soul be fired
 With its pure flame, or e'er thy heart grow tired,
 And thou shalt know the bliss that lasts for aye."
Ah! with what ruthless love that Angel grand
 Tortures and racks the wretch with giant hand!
 But still he answers "Never, till I die."

(1868)

Translated by Cosmo Monkhouse

YEUX DE JAIS

Je te donne ces vers afin que, si mon nom
Aborde heureusement aux époques lointaines
Et fait rêver un soir les cervelles humaines,
Vaisseau favorisé par un grand aquilon,

Ta mémoire, pareille aux fables incertaines,
Fatigue le lecteur ainsi qu'un tympanon,
Et par un fraternel et mystique chaînon
Reste comme pendue à mes rimes hautaines;

Être maudit à qui de l'abîme profond
Jusqu'au plus haut du ciel rien, hors moi, ne répond;
—O toi qui, comme une ombre à la trace éphémère,

Foules d'un pied léger et d'un regard serein
Les stupides mortels qui t'ont jugée amère,
Statue aux yeux de jais, grand ange au front d'airain!

JET EYES

I give you these verses so that, if my name happily reaches distant
times, and causes the human mind to dream some evening, like a ship
favored by a great north wind, your memory, like vague fables, may stun
the reader as a tympanum does, and by a fraternal and mystic link may
remain suspended to my proud rhymes; accursed being to whom, from
the deep abyss to the summit of the sky, nothing answers except myself;
—Oh you who, like a shadow with an ephemeral trace, treads with a
light foot and serene glance, stupid mortals who have judged you bitter,
statue with jet eyes, great angel with forehead of bronze!

(1857)

Masterpieces.

THÉODORE DE BANVILLE
Petit Traité de poésie française (1871)

CHARLES BAUDELAIRE

1 8 2 1 — 1 8 6 7

LES FLEURS DU MAL

Les morts, les pauvres morts ont de grandes douleurs.

The dead, the poor dead, have great sorrows.

<div align="right">Tableaux parisiens (1857)</div>

L'irréparable ronge avec sa dent maudite
Notre âme.

The Irreparable gnaws our soul with his cursed teeth.

<div align="right">L'Irréparable (1857)</div>

La Maladie et la Mort font des cendres
De tout le feu qui pour nous flamboya.

Illness and Death make ashes of all the fire that flamed for us.

<div align="right">Le Portrait (1861)</div>

Ma jeunesse ne fut qu'un ténébreux orage,
Traversé çà et là par de brillants soleils.

My youth was only a tenebrous storm, traversed here and there by brilliant suns.

<div align="right">L'Ennemi (1857)</div>

—O douleur! ô douleur! Le Temps mange la vie,
Et l'obscur Ennemi qui nous ronge le cœur
Du sang que nous perdons croît et se fortifie!

O sorrow, sorrow! Time eats life away, and the obscure Enemy that gnaws our heart, grows and is fortified by the blood we lose.

<div align="right">L'Ennemi (1857)</div>

J'ai plus de souvenirs que si j'avais mille ans.

I have more memories than if I had a thousand years.

<div align="right">Spleen (1857)</div>

Mon triste cerveau.
C'est une pyramide, un immense caveau,
Qui contient plus de morts que la fosse commune.

My sad brain is an immense cave that contains more dead than the potter's field.

<div align="right">Spleen (1857)</div>

Rien n'égale en longueur les boiteuses journées,
Quand sous les lourds flocons des neigeuses années
L'ennui, fruit de la morne incuriosité,
Prend les proportions de l'immortalité.

Nothing equals in length the limping days, when, under the heavy flakes of the snowing years, Ennui, fruit of gloomy incuriosity, takes on the proportions of immortality.

<div align="right">Spleen (1857)

Translated by Mary M. Colum</div>

The Goncourts said that both language and literature had been formed by men who were too healthy and well-balanced to be really representative of humanity. They concluded that the instabilities of the ordinary man, his vagaries, his experiences, his bewilderments, his sins and his suffering, must be expressed in a different style of writing and in a language and syntax susceptible of taking on the coloring of the modern world and the shapes of the many complex human types that compose it.

The Goncourts believed that they themselves were to be the first to accomplish this in prose, for the old Titans of literature had expressed the few and not the many, the uncommon, simple emotions instead of the common, complicated ones. But their contemporary and friend, Baudelaire, was doing it in poetry in their lifetime with a complexity and completeness which no one, either in prose or verse, has since equalled.

<div align="right">MARY M. COLUM
From These Roots (1937)</div>

CHARLES AND EMMA

Quand il rentrait au milieu de la nuit, il n'osait pas la réveiller. La veilleuse de porcelaine arrondissait au plafond une clarté tremblante, et les rideaux fermés du petit berceau faisaient comme une hutte blanche qui se bombait dans l'ombre, au bord du lit. Charles les regardait. Il croyait entendre l'haleine légère de son enfant. Elle allait grandir maintenant; chaque saison, vite, amènerait un progrès; il la voyait déjà revenant de l'école à la tombée du jour, toute rieuse, avec sa brassière tachée d'encre, et portant au bras son panier; puis il faudrait la mettre en pension, cela coûterait beaucoup; comment faire? Alors il réfléchissait. Il pensait à louer une petite ferme aux environs, et qu'il surveillerait lui-même, tous les matins, en allant voir ses malades. Il en économiserait le revenu, il le placerait à la caisse d'épargne; ensuite il achèterait des actions, quelque part, n'importe où; d'ailleurs la clientèle augmenterait; il y comptait, car il voulait que Berthe fût bien élevée, qu'elle eût des talents, qu'elle apprît le piano. Ah! qu'elle serait jolie, plus tard, à quinze ans, quand, ressemblant à sa mère, elle porterait comme elle, dans l'été, de grands chapeaux de paille! On les prendrait de loin pour les deux sœurs. Il se la figurait travaillant le soir auprès d'eux, sous la lumière de la lampe; elle lui broderait des pantoufles; elle s'occuperait du ménage. . . .

Emma ne dormait pas, elle faisait semblant d'être endormie; et, tandis qu'il s'assoupissait à ses côtés, elle se réveillait en d'autres rêves.

Au galop de quatre chevaux, elle était emportée depuis huit jours vers un pays nouveau, d'où ils ne reviendraient plus. Ils allaient, ils allaient, les bras enlacés, sans parler. Souvent, du haut d'une montagne, ils apercevaient tout à coup quelque cité splendide avec des dômes, des ponts, des navires, des forêts de citronniers et des cathédrales de marbre blanc, dont les clochers aigus portaient des nids de cigognes. On marchait au pas à cause des grandes dalles, et il y avait par terre des bouquets de fleurs que vous offraient des femmes habillées en corset rouge. On entendait sonner des cloches, hennir des mulets, avec le murmure des guitares et le bruit des fontaines, dont la vapeur s'envolant rafraîchissait des tas de fruits, disposés en pyramides au pied des statues pâles, qui souriaient sous les jets d'eau. Et puis ils arrivaient, un soir, dans un village de pêcheurs, où des filets bruns séchaient au vent, le long de la falaise et des cabanes. C'est là qu'ils s'arrêteraient pour vivre: ils habiteraient une maison basse à toit plat, ombragée d'un palmier, au fond d'un golfe, au bord de la mer. Ils se promèneraient en gondole, ils se balanceraient en hamac; et leur existence serait facile et large comme

leurs vêtements de soie, toute chaude et étoilée comme les nuits douces qu'ils contempleraient. Cependant, sur l'immensité de cet avenir qu'elle se faisait apparaître, rien de particulier ne surgissait: les jours, tous magnifiques, se ressemblaient comme des flots; et cela se balançait à l'horizon infini, harmonieux, bleuâtre et couvert de soleil. Mais l'enfant se mettait à tousser dans son berceau, ou bien Bovary ronflait plus fort, et Emma ne s'endormait que le matin.

When he came home in the middle of the night, he did not dare to wake her. The porcelain nightlight threw a round trembling gleam upon the ceiling, and the drawn curtains of the little cot formed, as it were, a white hut standing out in the shade, and by the bedside Charles looked at them. He seemed to hear the light breathing of his child. She would grow big now; every season would bring rapid progress. He already saw her coming from school as the day drew in, laughing, with ink-stains on her jacket, and carrying her basket on her arm. Then she would have to be sent to a boarding-school; that would cost much; how was it to be done? Then he reflected. He thought of hiring a small farm in the neighborhood, that he would superintend every morning on his way to his patients. He would save up what he brought in; he would put it in the savings-bank. Then he would buy shares somewhere, no matter where; besides, his practice would increase; he counted upon that, for he wanted Berthe to be well-educated, to be accomplished, to learn to play the piano. Ah! how pretty she would be later on when she was fifteen, when, resembling her mother, she would, like her, wear large straw hats in the summer-time; from a distance they would be taken for two sisters. He pictured her to himself working in the evening by their side beneath the light of the lamp; she would embroider him slippers; she would look after the house. . . .

Emma was not asleep; she pretended to be; and while he dozed off by her side she awakened to other dreams.

To the gallop of four horses she was carried away for a week towards a new land, whence they would return no more. They went on and on, their arms entwined, without a word. Often from the top of a mountain there suddenly glimpsed some splendid city with domes, and bridges, and ships, forests of citron trees, and cathedrals of white marble, on whose pointed steeples were storks' nests. They went at a walking-pace because of the great flag-stones, and on the ground there were bouquets of flowers, offered you by women dressed in red bodices. They heard the chiming of bells, the neighing of mules, together with the murmur of guitars and the noise of fountains, whose rising spray refreshed heaps of fruit arranged like a pyramid at the foot of pale statues that smiled beneath playing waters. And then, one night they came to a fishing village, where brown nets were drying in the wind along the cliffs and in front of the huts. It was there that they would stay; they would live in

a low, flat-roofed house, shaded by a palm-tree, in the heart of a gulf, by the sea. They would row in gondolas, swing in hammocks, and their existence would be easy and large as their silk gowns, warm and star-spangled as the nights they would contemplate. However, in the immensity of this future that she conjured up, nothing special stood forth; the days, all magnificent, resembled each other like waves; and it swayed in the horizon, infinite, harmonized, azure, and bathed in sunshine. But the child began to cough in her cot or Bovary snored more loudly, and Emma did not fall asleep till morning.

<div align="right">

Madame Bovary (1857)
Translation anonymous

</div>

This is indeed writing; this is finding the style suitable to each object, each place, each circumstance, each being; and this is picturing through differences and oppositions of tone the deep and eternal discords which render beings impenetrable to each other, as far away from each other, in the light of the same candle, as if an abyss opened between them. Flaubert is indeed the master of what has been called the artistic style— the style which paints, which engraves, and the style which sings, which whispers and which growls; a style which renders sounds as well as objects and with an equal force of impression.

<div align="right">

ÉMILE FAGUET
Flaubert (1899)
Translated by Mrs. R. L. Devonshire

</div>

<div align="center">

MATTHEW ARNOLD

1 8 2 2 — 1 8 8 8

THYRSIS

</div>

Thus yesterday, to-day, to-morrow come,
They hustle one another and they pass;
But all our hustling morrows only make
The smooth to-day of God.

<div align="right">

From LUCRETIUS
an unpublished Tragedy.

</div>

How changed is here each spot man makes or fills!
In the two Hinkseys nothing keeps the same;
The village-street its haunted mansion lacks,
And from the sign is gone Sibylla's name,
And from the roofs the twisted chimney-stacks;
Are ye too changed, ye hills?

See, 'tis no foot of unfamiliar men
　　To-night from Oxford up your pathway strays:
　　　Here came I often, often, in old days;
　　Thyrsis and I; we still had Thyrsis then.

Runs it not here, the track by Childsworth Farm,
　　Up past the wood, to where the elm-tree crowns
　　　The hill behind whose ridge the sunset flames?
　　The signal-elm, that looks on Ilsley Downs,
　　　The Vale, the three lone weirs, the youthful Thames?—
　　　　This winter-eve is warm,
　　　Humid the air; leafless, yet soft as spring,
　　　The tender purple spray on copse and briers;
　　　And that sweet City with her dreaming spires,
　　She needs not June for beauty's heightening,

Lovely all times she lies, lovely to-night!
　　Only, methinks, some loss of habit's power
　　　Befalls me wandering through this upland dim;
　　Once pass'd I blindfold here, at any hour,
　　　Now seldom come I, since I came with him.
　　　　That single elm-tree bright
　　Against the west—I miss it! is it gone?
　　　We prized it dearly; while it stood, we said,
　　　Our friend, the Scholar-Gipsy, was not dead;
　　While the tree lived, he in these fields lived on.

Too rare, too rare, grow now my visits here!
　　But once I knew each field, each flower, each stick;
　　　And with the country-folk acquaintance made
　　By barn in threshing-time, by new-built rick.
　　　Here, too, our shepherd-pipes we first assay'd.
　　　　Ah me! this many a year
　　My pipe is lost, my shepherd's-holiday!
　　　Needs must I lose them, needs with heavy heart
　　　Into the world and wave of men depart;
　　But Thyrsis of his own will went away.

It irk'd him to be here, he could not rest.
　　He loved each simple joy the country yields,
　　　He loved his mates; but yet he could not keep,
　　For that a shadow lower'd on the fields,
　　　Here with the shepherds and the silly sheep.
　　　　Some life of men unblest

1264

He knew, which made him droop, and fill'd his head.
 He went; his piping took a troubled sound
 Of storms that rage outside our happy ground;
He could not wait their passing, he is dead!

So, some tempestuous morn in early June,
 When the year's primal burst of bloom is o'er,
 Before the roses and the longest day—
 When garden-walks, and all the grassy floor,
 With blossoms, red and white, of fallen May,
 And chestnut-flowers are strewn—
So have I heard the cuckoo's parting cry,
 From the wet field, through the vext garden-trees,
 Come with the volleying rain and tossing breeze:
The bloom is gone, and with the bloom go I.

Too quick despairer, wherefore wilt thou go?
 Soon will the high Midsummer pomps come on,
 Soon will the musk carnations break and swell,
 Soon shall we have gold-dusted snapdragon,
 Sweet-William with its homely cottage-smell,
 And stocks in fragrant blow;
Roses that down the alleys shine afar,
 And open, jasmine-muffled lattices,
 And groups under the dreaming garden-trees,
And the full moon, and the white evening-star.

He hearkens not! light comer, he is flown!
 What matters it? next year he will return,
 And we shall have him in the sweet spring-days,
 With whitening hedges, and uncrumpling fern,
 And blue-bells trembling by the forest-ways,
 And scent of hay new-mown.
But Thyrsis never more we swains shall see!
 See him come back, and cut a smoother reed,
 And blow a strain the world at last shall heed—
For Time, not Corydon, hath conquer'd thee.

Alack, for Corydon no rival now!—
 But when Sicilian shepherds lost a mate,
 Some good survivor with his flute would go,
 Piping a ditty sad for Bion's fate,
 And cross the unpermitted ferry's flow,
 And relax Pluto's brow,

And make leap up with joy the beauteous head
 Of Proserpine, among whose crownèd hair
 Are flowers, first open'd on Sicilian air,
And flute his friend, like Orpheus, from the dead.

O easy access to the hearer's grace
 When Dorian shepherds sang to Proserpine!
 For she herself had trod Sicilian fields,
 She knew the Dorian water's gush divine,
 She knew each lily white which Enna yields,
 Each rose with blushing face;
 She loved the Dorian pipe, the Dorian strain.
 But ah, of our poor Thames she never heard!
 Her foot the Cumner cowslips never stirr'd!
 And we should tease her with our plaint in vain.

Well! wind-dispers'd and vain the words will be,
 Yet, Thyrsis, let me give my grief its hour
 In the old haunt, and find our tree-topp'd hill!
 Who, if not I, for questing here hath power?
 I know the wood which hides the daffodil,
 I know the Fyfield tree,
 I know what white, what purple fritillaries
 The grassy harvest of the river-fields,
 Above by Ensham, down by Sandford, yields,
 And what sedg'd brooks are Thames's tributaries;

I know these slopes; who knows them if not I?—
 But many a dingle on the loved hill-side,
 With thorns once studded, old, white-blossom'd trees,
 Where thick the cowslips grew, and, far descried,
 High tower'd the spikes of purple orchises,
 Hath since our day put by
 The coronals of that forgotten time.
 Down each green bank hath gone the ploughboy's team,
 And only in the hidden brookside gleam
 Primroses, orphans of the flowery prime.

Where is the girl, who, by the boatman's door,
 Above the locks, above the boating throng,
 Unmoor'd our skiff, when, through the Wytham flats,
 Red loosestrife and blond meadow-sweet among,
 And darting swallows, and light water-gnats,
 We track'd the shy Thames shore?

Where are the mowers, who, as the tiny swell
 Of our boat passing heav'd the river-grass,
 Stood with suspended scythe to see us pass?—
They all are gone, and thou art gone as well.

Yes, thou art gone! and round me too the night
 In ever-nearing circle weaves her shade.
 I see her veil draw soft across the day,
 I feel her slowly chilling breath invade
 The cheek grown thin, the brown hair sprent with grey;
 I feel her finger light
 Laid pausefully upon life's headlong train;
 The foot less prompt to meet the morning dew,
 The heart less bounding at emotion new,
 And hope, once crush'd, less quick to spring again.

And long the way appears, which seem'd so short
 To the unpractis'd eye of sanguine youth;
 And high the mountain-tops, in cloudy air,
 The mountain-tops where is the throne of Truth,
 Tops in life's morning-sun so bright and bare!
 Unbreachable the fort
 Of the long-batter'd world uplifts its wall.
 And strange and vain the earthly turmoil grows,
 And near and real the charm of thy repose,
 And night as welcome as a friend would fall.

But hush! the upland hath a sudden loss
 Of quiet;—Look! adown the dusk hill-side,
 A troop of Oxford hunters going home,
 As in old days, jovial and talking, ride!
 From hunting with the Berkshire hounds they come—
 Quick, let me fly, and cross
 Into yon further field!—'Tis done; and see,
 Back'd by the sunset, which doth glorify
 The orange and pale violet evening-sky,
 Bare on its lonely ridge, the Tree! the Tree!

I take the omen! Eve lets down her veil,
 The white fog creeps from bush to bush about,
 The west unflushes, the high stars grow bright,
 And in the scatter'd farms the lights come out.
 I cannot reach the Signal-Tree to-night,
 Yet, happy omen, hail!

Hear it from thy broad lucent Arno vale
　(For there thine earth-forgetting eyelids keep
　The morningless and unawakening sleep
Under the flowery oleanders pale),

Hear it, O Thyrsis, still our Tree is there!—
　Ah, vain! These English fields, this upland dim,
　　These brambles pale with mist engarlanded,
　That lone, sky-pointing tree, are not for him.
　　To a boon southern country he is fled,
　　　And now in happier air,
　Wandering with the great Mother's train divine
　　(And purer or more subtle soul than thee,
　　I trow, the mighty Mother doth not see!)
　Within a folding of the Apennine,

Thou hearest the immortal strains of old.
　Putting his sickle to the perilous grain
　　In the hot cornfield of the Phrygian king,
　For thee the Lityerses song again
　　Young Daphnis with his silver voice doth sing;
　　　Sings his Sicilian fold,
　His sheep, his hapless love, his blinded eyes;
　　And how a call celestial round him rang
　　And heavenward from the fountain-brink he sprang,
　And all the marvel of the golden skies.

There thou art gone, and me thou leavest here
　Sole in these fields; yet will I not despair;
　　Despair I will not, while I yet descry
　'Neath the soft canopy of English air
　　That lonely Tree against the western sky.
　　　Still, still these slopes, 'tis clear,
　Our Gipsy-Scholar haunts, outliving thee!
　　Fields where soft sheep from cages pull the hay,
　　Woods with anemonies in flower till May,
　Know him a wanderer still; then why not me?

A fugitive and gracious light he seeks,
　Shy to illumine; and I seek it too.
　　This does not come with houses or with gold,
　With place, with honour, and a flattering crew;
　　'Tis not in the world's market bought and sold.
　　　But the smooth-slipping weeks

1268

Drop by, and leave its seeker still untired;
 Out of the heed of mortals he is gone,
 He wends unfollow'd, he must house alone;
Yet on he fares, by his own heart inspired.

Thou too, O Thyrsis, on like quest wert bound,
 Thou wanderedst with me for a little hour;
 Men gave thee nothing, but this happy quest,
 If men esteem'd thee feeble, gave thee power,
 If men procured thee trouble, gave thee rest.
 And this rude Cumner ground,
 Its fir-topped Hurst, its farms, its quiet fields,
 Here cam'st thou in thy jocund youthful time,
 Here was thine height of strength, thy golden prime;
And still the haunt beloved a virtue yields.

What though the music of thy rustic flute
 Kept not for long its happy, country tone,
 Lost it too soon, and learnt a stormy note
Of men contention-tost, of men who groan,
 Which task'd thy pipe too sore, and tired thy throat—
 It fail'd, and thou wast mute;
 Yet hadst thou alway visions of our light,
 And long with men of care thou couldst not stay,
 And soon thy foot resumed its wandering way,
Left human haunt, and on alone till night.

Too rare, too rare, grow now my visits here!
 'Mid city-noise, not, as with thee of yore,
 Thyrsis, in reach of sheep-bells is my home!
Then through the great town's harsh, heart-wearying roar,
 Let in thy voice a whisper often come,
 To chase fatigue and fear:
 Why faintest thou? I wander'd till I died.
 Roam on! the light we sought is shining still.
 Dost thou ask proof? Our Tree yet crowns the hill,
Our Scholar travels yet the loved hillside.

 (1866)

ALGERNON CHARLES SWINBURNE

1 8 3 7 — 1 9 0 9

AVE ATQUE VALE

(In memory of Charles Baudelaire)

I

Shall I strew on thee rose or rue or laurel,
 Brother, on this that was the veil of thee?
 Or quiet sea-flower moulded by the sea,
Or simplest growth of meadow-sweet or sorrel,
 Such as the summer-sleepy Dryads weave,
 Waked up by snow-soft sudden rains at eve?
Or wilt thou rather, as on earth before,
 Half-faded fiery blossoms, pale with heat
 And full of bitter summer, but more sweet
To thee than gleanings of a northern shore
 Trod by no tropic feet?

II

For always thee the fervid languid glories
 Allured of heavier suns in mightier skies;
 Thine ears knew all the wandering watery sighs
Where the sea sobs round Lesbian promontories,
 The barren kiss of piteous wave to wave
 That knows not where is that Leucadian grave
Which hides too deep the supreme head of song.
 Ah, salt and sterile as her kisses were,
 The wild sea winds her and the green gulfs bear
Hither and thither, and vex and work her wrong,
 Blind gods that cannot spare.

III

Thou sawest, in thine old singing season, brother,
 Secrets and sorrows unbeheld of us:
 Fierce loves, and lovely leaf-buds poisonous,
Bare to thy subtler eye, but for none other
 Blowing by night in some unbreathed-in clime;
 The hidden harvest of luxurious time,

1270

Sin without shape, and pleasure without speech;
> And where strange dreams in a tumultuous sleep
> Make the shut eyes of stricken spirits weep;
And with each face thou sawest the shadow on each,
> Seeing as men sow men reap.

IV

O sleepless heart and sombre soul unsleeping,
> That were athirst for sleep and no more life
> And no more love, for peace and no more strife!
Now the dim gods of death have in their keeping
> Spirit and body and all the springs of song,
> Is it well now where love can do no wrong,
Where stingless pleasure has no foam or fang
> Behind the unopening closure of her lips?
> Is it not well where soul from body slips
And flesh from bone divides without a pang
> As dew from flower-bell drips?

V

It is enough; the end and the beginning
> Are one thing to thee, who art past the end.
> O hand unclasp'd of unbeholden friend,
For thee no fruits to pluck, no palms for winning,
> No triumph and no labour and no lust,
> Only dead yew-leaves and a little dust.
O quiet eyes wherein the light saith naught,
> Whereto the day is dumb, nor any night
> With obscure finger silences your sight,
Nor in your speech the sudden soul speaks thought,
> Sleep, and have sleep for light.

VI

Now all strange hours and all strange loves are over,
> Dreams and desires and sombre songs and sweet,
> Hast thou found place at the great knees and feet
Of some pale Titan-woman like a lover,
> Such as thy vision here solicited,
> Under the shadow of her fair vast head,

The deep division of prodigious breasts,
 The solemn slope of mighty limbs asleep,
 The weight of awful tresses that still keep
The savour and shade of old-world pine-forests
 Where the wet hill-winds weep?

VII

Hast thou found any likeness for thy vision?
 O gardener of strange flowers, what bud, what bloom,
 Hast thou found sown, what gather'd in the gloom?
What of despair, of rapture, of derision,
 What of life is there, what of ill or good?
 Are the fruits grey like dust or bright like blood?
Does the dim ground grow any seed of ours,
 The faint fields quicken any terrene root,
 In low lands where the sun and moon are mute
And all the stars keep silence? Are there flowers
 At all, or any fruit?

VIII

Alas, but though my flying song flies after,
 O sweet strange elder singer, thy more fleet
 Singing, and footprints of thy fleeter feet,
Some dim derision of mysterious laughter
 From the blind tongueless warders of the dead,
 Some gainless glimpse of Proserpine's veil'd head,
Some little sound of unregarded tears
 Wept by effaced unprofitable eyes,
 And from pale mouths some cadence of dead sighs--
These only, these the hearkening spirit hears,
 Sees only such things rise.

IX

Thou art far too far for wings of words to follow,
 Far too far off for thought or any prayer.
 What ails us with thee, who art wind and air?
What ails us gazing where all seen is hollow?
 Yet with some fancy, yet with some desire,
 Dreams pursue death as winds a flying fire,

Our dreams pursue our dead and do not find.
 Still, and more swift than they, the thin flame flies,
 The low light fails us in elusive skies,
Still the foil'd earnest ear is deaf, and blind
 Are still the eluded eyes.

X

Not thee, O never thee, in all time's changes,
 Not thee, but this the sound of thy sad soul,
 The shadow of thy swift spirit, this shut scroll
I lay my hand on, and not death estranges
 My spirit from communion of thy song—
 These memories and these melodies that throng
Veil'd porches of a Muse funereal—
 These I salute, these touch, these clasp and fold
 As though a hand were in my hand to hold,
Or through mine ears a mourning musical
 Of many mourners roll'd.

XI

I among these, I also, in such station
 As when the pyre was charr'd, and piled the sods.
 And offering to the dead made, and their gods,
The old mourners had, standing to make libation,
 I stand, and to the Gods and to the dead
 Do reverence without prayer or praise, and shed
Offering to these unknown, the gods of gloom,
 And what of honey and spice my seed-lands bear,
 And what I may of fruits in this chill'd air,
And lay, Orestes-like, across the tomb
 A curl of sever'd hair.

XII

But by no hand nor any treason stricken,
 Not like the low-lying head of Him, the King,
 The flame that made of Troy a ruinous thing,
Thou liest, and on this dust no tears could quicken.
 There fall no tears like theirs that all men hear
 Fall tear by sweet imperishable tear

Down the opening leaves of holy poets' pages.
 Thee not Orestes, not Electra mourns;
 But bending us-ward with memorial urns
The most high Muses that fulfil all ages
 Weep, and our God's heart yearns.

XIII

For, sparing of his sacred strength, not often
 Among us darkling here the lord of light
 Makes manifest his music and his might
In hearts that open and in lips that soften
 With the soft flame and heat of songs that shine.
 Thy lips indeed he touch'd with bitter wine,
And nourish'd them indeed with bitter bread;
 Yet surely from his hand thy soul's food came,
 The fire that scarr'd thy spirit at his flame
Was lighted, and thine hungering heart he fed
 Who feeds our hearts with fame.

XIV

Therefore he too now at thy soul's sunsetting,
 God of all suns and songs, he too bends down
 To mix his laurel with thy cypress crown,
And save thy dust from blame and from forgetting.
 Therefore he too, seeing all thou wert and art,
 Compassionate, with sad and sacred heart,
Mourns thee of many his children the last dead,
 And hallows with strange tears and alien sighs
 Thine unmelodious mouth and sunless eyes,
And over thine irrevocable head
 Sheds light from the under skies.

XV

And one weeps with him in the ways Lethean,
 And stains with tears her changing bosom chill;
 That obscure Venus of the hollow hill,
That thing transform'd which was the Cytherean,
 With lips that lost their Grecian laugh divine
 Long since, and face no more call'd Erycine—

A ghost, a bitter and luxurious god.
 Thee also with fair flesh and singing spell
 Did she, a sad and second prey, compel
Into the footless places once more trod,
 And shadows hot from hell.

XVI

And now no sacred staff shall break in blossom,
 No choral salutation lure to light
 A spirit sick with perfume and sweet night
And love's tired eyes and hands and barren bosom.
 There is no help for these things; none to mend,
 And none to mar; not all our songs, O friend,
Will make death clear or make life durable.
 Howbeit with rose and ivy and wild vine
 And with wild notes about this dust of thine
At least I fill the place where white dreams dwell
 And wreathe an unseen shrine.

XVII

Sleep; and if life was bitter to thee, pardon,
 If sweet, give thanks; thou hast no more to live;
 And to give thanks is good, and to forgive.
Out of the mystic and the mournful garden
 Where all day through thine hands in barren braid
 Wove the sick flowers of secrecy and shade,
Green buds of sorrow and sin, and remnants grey,
 Sweet-smelling, pale with poison, sanguine-hearted,
 Passions that sprang from sleep and thoughts that started,
Shall death not bring us all as thee one day
 Among the days departed?

XVIII

For thee, O now a silent soul, my brother,
 Take at my hands this garland, and farewell.
 Thin is the leaf, and chill the wintry smell,
And chill the solemn earth, a fatal mother,
 With sadder than the Niobean womb,
 And in the hollow of her breasts a tomb.

Content thee, howsoe'er, whose days are done;
　　There lies not any troublous thing before,
　　Nor sight nor sound to war against thee more,
For whom all winds are quiet as the sun,
　　All waters as the shore.

<div align="right">Poems and Ballads, Second Series (1878)</div>

Swinburne modestly wrote "There are in the English language three elegiac poems so great that they eclipse and efface all the elegiac poetry we know, all of Italian, all of Greek." He meant LYCIDAS *and* ADONAIS *and* THYRSIS,* *but we make them four, and include "Ave Atque Vale."*

<div align="right">EDMUND GOSSE</div>

<div align="right">The Life of Algernon Charles Swinburne (1917)</div>

WILLIAM ALLINGHAM

1 8 2 4 — 1 8 8 9

A MEMORY

Four ducks on a pond,
A grass-bank beyond,
A blue sky of spring,
White clouds on the wing:
What a little thing
To remember for years—
To remember with tears!

<div align="right">(1854)</div>

As simple an instance of the art of poetry as we could have.

<div align="right">LASCELLES ABERCROMBIE</div>

<div align="right">The Theory of Poetry (1926)</div>

* See pages 712, 1102, 1263.

KINSHIP WITH THE STARS

Cold as a mountain in its star-pitched tent,
Stood high Philosophy, less friend than foe:
Whom self-caged Passion, from its prison-bars,
Is always watching with a wondering hate.
Not till the fire is dying in the grate,
Look we for any kinship with the stars.

<div align="right">Modern Love (1862), iv.</div>

The region of pure poetry.

<div align="right">

GEORGE MACAULAY TREVELYAN
The Poetry and Philosophy of George Meredith (1906)

</div>

GEORGE MEREDITH

1 8 2 8 — 1 9 0 9

THIS LITTLE MOMENT

We saw the swallows gathering in the sky,
And in the osier-isle we heard them noise.
We had not to look back on summer joys,
Or forward to a summer of bright dye:
But in the largeness of the evening earth
Our spirits grew as we went side by side.
The hour became her husband and my bride.
Love, that had robbed us so, thus blessed our dearth!
The pilgrims of the year waxed very loud
In multitudinous chatterings, as the flood
Full brown came from the West, and like pale blood
Expanded to the upper crimson cloud.

Love, that had robbed us of immortal things,
This little moment mercifully gave,
Where I have seen across the twilight wave
The swan sail with her young beneath her wings.
<div align="right">Modern Love (1862), xlvii</div>

A more perfect piece of writing no man alive has ever turned out.
<div align="right">ALGERNON CHARLES SWINBURNE
Letter to The Spectator (June 7, 1862)</div>

GEORGE MEREDITH

1 8 2 8 — 1 9 0 9

DIRGE IN WOODS

A wind sways the pines,
 And below
Not a breath of wild air;
Still as the mosses that glow
On the flooring and over the lines
Of the roots here and there.
The pine-tree drops its dead;
They are quiet, as under the sea.
Overhead, overhead
Rushes life in a race,
As the clouds the clouds chase;
 And we go,
And we drop like the fruits of the tree,
 Even we,
 Even so.
<div align="right">A Reading of Earth (1888)</div>

Certain of his poems will live as long as the language, and there are pages of his novels, such as the love idyll in RICHARD FEVEREL, *which are of the same quality. Here is a short poem almost as fine as Goethe's best; indeed it is almost a rendering of the magical verse beginning: Ueber allen Gipfeln ist Ruh.*
<div align="right">FRANK HARRIS
Contemporary Portraits, First Series (1920)</div>

JENNY

Lazy laughing languid Jenny,
Fond of a kiss and fond of a guinea,
Whose head upon my knee to-night
Rests for a while, as if grown light
With all our dances and the sound
To which the wild tunes spun you round:
Fair Jenny mine, the thoughtless queen
Of kisses which the blush between
Could hardly make much daintier;
Whose eyes are as blue skies, whose hair
Is countless gold incomparable:
Fresh flower, scarce touched with signs that tell
Of Love's exuberant hotbed:—Nay,
Poor flower left torn since yesterday
Until to-morrow leave you bare;
Poor handful of bright spring-water
Flung in the whirlpool's shrieking face;
Poor shameful Jenny, full of grace
Thus with your head upon my knee;—
Whose person or whose purse may be
The lodestar of your reverie?

This room of yours, my Jenny, looks
A change from mine so full of books,
Whose serried ranks hold fast, forsooth,
So many captive hours of youth,—
The hours they thieve from day and night
To make one's cherished work come right,
And leave it wrong for all their theft,
Even as to-night my work was left:
Until I vowed that since my brain
And eyes of dancing seemed so fain,
My feet should have some dancing too:—
And thus it was I met with you.
Well, I suppose 'twas hard to part,
For here I am. And now, sweetheart,
You seem too tired to get to bed.

It was a careless life I led
When rooms like this were scarce so strange
Not long ago. What breeds the change,—
The many aims or the few years?
Because to-night it all appears
Something I do not know again.

The cloud's not danced out of my brain,—
The cloud that made it turn and swim
While hour by hour the books grew dim.
Why, Jenny, as I watch you there,—
For all your wealth of loosened hair,
Your silk ungirdled and unlac'd
And warm sweets open to the waist,
All golden in the lamplight's gleam,—
You know not what a book you seem,
Half-read by lightning in a dream!
How should you know, my Jenny? Nay,
And I should be ashamed to say:—
Poor beauty, so well worth a kiss!
But while my thought runs on like this
With wasteful whims more than enough,
I wonder what you're thinking of.

If of myself you think at all,
What is the thought?—conjectural
On sorry matters best unsolved?—
Or inly is each grace revolved
To fit me with a lure?—or (sad
To think!) perhaps you're merely glad
That I'm not drunk or ruffianly
And let you rest upon my knee.

For sometimes, were the truth confess'd,
You're thankful for a little rest,—
Glad from the crush to rest within,
From the heart-sickness and the din
Where envy's voice at virtue's pitch
Mocks you because your gown is rich;
And from the pale girl's dumb rebuke,
Whose ill-clad grace and toil-worn look
Proclaim the strength that keeps her weak,
And other nights than yours bespeak;
And from the wise unchildish elf,
To schoolmate lesser than himself

1280

Pointing you out, what thing you are:—
Yes, from the daily jeer and jar,
From shame and shame's outbraving too,
Is rest not sometimes sweet to you?—
But most from the hatefulness of man,
Who spares not to end what he began,
Whose acts are ill and his speech ill,
Who, having used you at his will,
Thrusts you aside, as when I dine
I serve the dishes and the wine.

Well, handsome Jenny mine, sit up:
I've filled our glasses, let us sup,
And do not let me think of you,
Lest shame of yours suffice for two.
What, still so tired? Well, well then, keep
Your head there, so you do not sleep;
But that the weariness may pass
And leave you merry, take this glass.
Ah! lazy lily hand, more bless'd
If ne'er in rings it had been dress'd
Nor ever by a glove conceal'd!

Behold the lilies of the field,
They toil not neither do they spin;
(So doth the ancient text begin,—
Not of such rest as one of these
Can share.) Another rest and ease
Along each summer-sated path
From its new lord the garden hath,
Than that whose spring in blessings ran
Which praised the bounteous husbandman,
Ere yet, in days of hankering breath,
The lilies sickened unto death.

What, Jenny, are your lilies dead?
Aye, and the snow-white leaves are spread
Like winter on the garden-bed.
But you had roses left in May,—
They were not gone too. Jenny, nay,
But must your roses die, and those
Their purfled buds that should unclose?
Even so; the leaves are curled apart,
Still red as from the broken heart,
And here's the naked stem of thorns.

1281

Nay, nay, mere words. Here nothing warns
As yet of winter. Sickness here
Or want alone could waken fear,—
Nothing but passion wrings a tear.
Except when there may rise unsought
Haply at times a passing thought
Of the old days which seem to be
Much older than any history
That is written in any book;
When she would lie in fields and look
Along the ground through the blown grass,
And wonder where the city was,
Far out of sight, whose broil and bale
They told her then for a child's tale.

Jenny, you know the city now.
A child can tell the tale there, how
Some things which are not yet enroll'd
In market-lists are bought and sold
Even till the early Sunday light,
When Saturday night is market-night
Everywhere, be it dry or wet,
And market-night in the Haymarket.
Our learned London children know,
Poor Jenny, all your pride and woe;
Have seen your lifted silken skirt
Advertise dainties through the dirt;
Have seen your coach-wheels splash rebuke
On virtue; and have learned your look
When, wealth and health slipped past, you stare
Along the streets alone, and there,
Round the long park, across the bridge,
The cold lamps at the pavement's edge
Wind on together and apart,
A fiery serpent for your heart.

Let the thoughts pass, an empty cloud!
Suppose I were to think aloud,—
What if to her all this were said?
Why, as a volume seldom read
Being opened halfway shuts again,
So might the pages of her brain
Be parted at such words, and thence
Close back upon the dusty sense.

For is there hue or shape defin'd
In Jenny's desecrated mind,
Where all contagious currents meet,
A Lethe of the middle street?
Nay, it reflects not any face,
Nor sound is in its sluggish pace,
But as they coil those eddies clot,
And night and day remember not.

Why, Jenny, you're asleep at last!—
Asleep, poor Jenny, hard and fast,—
So young and soft and tired; so fair,
With chin thus nestled in your hair,
Mouth quiet, eyelids almost blue
As if some sky of dreams shone through!

Just as another woman sleeps!
Enough to throw one's thoughts in heaps
Of doubt and horror,—what to say
Or think,—this awful secret sway,
The potter's power over the clay!
Of the same lump (it has been said)
For honour and dishonour made,
Two sister vessels. Here is one.

My cousin Nell is fond of fun,
And fond of dress, and change, and praise,
So mere a woman in her ways:
And if her sweet eyes rich in youth
Are like her lips that tell the truth,
My cousin Nell is fond of love.
And she's the girl I'm proudest of.
Who does not prize her, guard her well?
The love of change, in cousin Nell,
Shall find the best and hold it dear:
The unconquered mirth turn quieter
Not through her own, through others' woe:
The conscious pride of beauty glow
Beside another's pride in her,
One little part of all they share.
For Love himself shall ripen these
In a kind soil to just increase
Through years of fertilizing peace.

Of the same lump (as it is said)
For honour and dishonour made,
Two sister vessels. Here is one.

It makes a goblin of the sun.

So pure,—so fall'n! How dare to think
Of the first common kindred link?
Yet, Jenny, till the world shall burn
It seems that all things take their turn;
And who shall say but this fair tree
May need, in changes that may be,
Your children's children's charity?
Scorned then, no doubt, as you are scorn'd!
Shall no man hold his pride forewarn'd
Till in the end, the Day of Days,
At Judgment, one of his own race,
As frail and lost as you, shall rise,—
His daughter, with his mother's eyes?

How Jenny's clock ticks on the shelf!
Might not the dial scorn itself
That has such hours to register?
Yet as to me, even so to her
Are golden sun and silver moon,
In daily largesse of earth's boon,
Counted for life-coins to one tune.
And if, as blindfold fates are toss'd,
Through some one man this life be lost,
Shall soul not somehow pay for soul?

Fair shines the gilded aureole
In which our highest painters place
Some living woman's simple face.
And the stilled features thus descried
As Jenny's long throat droops aside,—
The shadows where the cheeks are thin,
And pure wide curve from ear to chin,—
With Raffael's, Leonardo's hand
To show them to men's souls, might stand,
Whole ages long, the whole world through,
For preachings of what God can do.
What has man done here? How atone,
Great God, for this which man has done?

And for the body and soul which by
Man's pitiless doom must now comply
With lifelong hell, what lullaby
Of sweet forgetful second birth
Remains? All dark. No sign on earth
What measure of God's rest endows
The many mansions of his house.

If but a woman's heart might see
Such erring heart unerringly
For once! But that can never be.

Like a rose shut in a book
In which pure women may not look,
For its base pages claim control
To crush the flower within the soul;
Where through each dead rose-leaf that clings,
Pale as transparent Psyche-wings,
To the vile text, are traced such things
As might make the lady's cheek indeed
More than a living rose to read;
So nought save foolish foulness may
Watch with hard eyes the sure decay;
And so the life-blood of this rose,
Puddled with shameful knowledge, flows
Through leaves no chaste hand may unclose:
Yet still it keeps such faded show
Of when 'twas gathered long ago,
That the crushed petals' lovely grain,
The sweetness of the sanguine stain,
Seen of a woman's eyes, must make
Her pitiful heart, so prone to ache,
Love roses better for its sake:—
Only that this can never be:—
Even so unto her sex is she.

Yet, Jenny, looking long at you,
The woman almost fades from view.
A cipher of man's changeless sum
Of lust, past, present, and to come,
Is left. A riddle that one shrinks
To challenge from the scornful sphinx.

Like a toad within a stone
Seated while Time crumbles on;
Which sits there since the earth was curs'd
For Man's transgression at the first;
Which, living through all centuries,
Not once has seen the sun arise;
Whose life, to its cold circle charmed,
The earth's whole summers have not warmed;
Which always—whitherso the stone
Be flung—sits there, deaf, blind, alone,—
Aye, and shall not be driven out
Till that which shuts him round about
Break at the very Master's stroke,
And the dust thereof vanish as smoke,
And the seed of Man vanish as dust:—
Even so within this world is Lust.

Come, come, what use in thoughts like this?
Poor little Jenny, good to kiss,—
You'd not believe by what strange roads
Thought travels, when your beauty goads
A man to-night to think of toads!
Jenny, wake up. . . . Why, there's the dawn!

And there's an early waggon drawn
To market, and some sheep that jog
Bleating before a barking dog;
And the old streets come peering through
Another night that London knew;
And all as ghostlike as the lamps.

So on the wings of day decamps
My last night's frolic. Glooms begin
To shiver off as lights creep in
Past the gauze curtains half drawn-to,
And the lamp's doubled shade grows blue,—
Your lamp, my Jenny, kept alight,
Like a wise virgin's, all one night!
And in the alcove coolly spread
Glimmers with dawn your empty bed;
And yonder your fair face I see
Reflected lying on my knee,
Where teems with first foreshadowings
Your pier-glass scrawled with diamond rings.

And on your bosom all night worn
Yesterday's rose now droops forlorn,
But dies not yet this summer morn.

And now without, as if some word
Had called upon them that they heard,
The London sparrows far and nigh
Clamour together suddenly;
And Jenny's cage-bird grown awake
Here in their song his part must take,
Because here too the day doth break.

And somehow in myself the dawn
Among stirred clouds and veils withdrawn
Strikes greyly on her. Let her sleep.
But will it wake her if I heap
These cushions thus beneath her head
Where my knee was? No,—there's your bed,
My Jenny, while you dream. And there
I lay among your golden hair
Perhaps the subject of your dreams,
These golden coins.
 For still one deems
That Jenny's flattering sleep confers
New magic on the magic purse,—
Grim web, how clogged with shrivelled flies!
Between the threads fine fumes arise
And shape their pictures in the brain.
There roll no streets in glare and rain,
Nor flagrant man-swine whets his tusk;
But delicately sighs in musk
The homage of the dim boudoir;
Or like a palpitating star
Thrilled into song, the opera-night
Breathes faint in the quick pulse of light;
Or at the carriage-window shine
Rich wares for choice; or, free to dine,
Whirls through its hour of health (divine
For her) the concourse of the Park.
And though in the discounted dark
Her functions there and here are one,
Beneath the lamps and in the sun
There reigns at least the acknowledged belle
Apparelled beyond parallel.
Ah Jenny, yes, we know your dreams.

For even the Paphian Venus seems
A goddess o'er the realms of love,
When silver-shrined in shadowy grove:
Aye, or let offerings nicely plac'd
But hide Priapus to the waist,
And whoso looks on him shall see
An eligible deity.

Why, Jenny, waking here alone
May help you to remember one,
Though all the memory's long outworn
Of many a double-pillowed morn.
I think I see you when you wake,
And rub your eyes for me, and shake
My gold, in rising, from your hair,
A Danaë for a moment there.

Jenny, my love rang true! for still
Love at first sight is vague, until
That tinkling makes him audible.

And must I mock you to the last,
Ashamed of my own shame,—aghast
Because some thoughts not born amiss
Rose at a poor fair face like this?
Well, of such thoughts so much I know:
In my life, as in hers, they show,
By a far gleam which I may near,
A dark path I can strive to clear.

Only one kiss. Good-bye, my dear.

The simple sudden sound of that plain line is as great and rare a thing in the way of verse, as final and superb a proof of absolute poetic power upon words, as any man's work can show.

ALGERNON CHARLES SWINBURNE
Essays and Studies (1875)

HENRY KINGSLEY

1 8 3 0 — 1 8 7 6

LANDSCAPE

Down below in the valley, among the meadows, the lanes and the fords, it was nearly as peaceful and quiet as it was aloft on the mountain-tops; and under the darkening shadows of the rapidly leafing elms you could hear—it was so still—the cows grazing and the trout rising in the river.

Stretton (1869)

As word-painter of landscape he is probably unexcelled by any English novelist; as master of the subtle music of prose, as maker of beautiful phrases, he is unrivalled.

MICHAEL SADLEIR
Things Past (1944)

CHRISTINA GEORGINA ROSSETTI

1 8 3 0 — 1 8 9 4

PASSING AWAY

Passing away, saith the World, passing away:
Chances, beauty and youth sapped day by day:
Thy life never continueth in one stay.
Is the eye waxen dim, is the dark hair changing to grey
That hath won neither laurel nor bay?
I shall clothe myself in Spring and bud in May:
Thou, root-stricken, shalt not rebuild thy decay
On my bosom for aye.
Then I answered: Yea.

Passing away, saith my Soul, passing away:
With its burden of fear and hope, of labour and play,
Hearken what the past doth witness and say:
Rust in thy gold, a moth is in thine array,
A canker is in thy bud, thy leaf must decay.
At midnight, at cockcrow, at morning, one certain day
Lo, the Bridegroom shall come and shall not delay:
Watch thou and pray.
Then I answered: Yea.

Passing away, saith my God, passing away:
Winter passeth after the long delay:
New grapes on the vine, new figs on the tender spray
Turtle calleth turtle in Heaven's May.
Though I tarry, wait for Me, trust Me, watch and pray.
Arise, come away, night is past and lo it is day,
My love, My sister, My spouse, thou shalt hear Me say—
Then I answered: Yea.

<div align="right">(1860)</div>

By God! That's one of the finest things ever written!

<div align="right">ALGERNON CHARLES SWINBURNE</div>

And Swinburne, somewhat contrary to his wont, was right. Purer in-
spiration, less troubled by worldly motives, than these verses cannot
be found.

<div align="right">PAUL ELMER MORE
Selected Shelburne Essays (1935)</div>

EMILY DICKINSON

THE CHARIOT

Because I could not stop for Death,
He kindly stopped for me;
The carriage held but just ourselves
And Immortality.

We slowly drove, he knew no haste,
And I had put away
My labor, and my leisure too,
For his civility.

We passed the school where children played
At wrestling in a ring;
We passed the fields of gazing grain,
We passed the setting sun.

We paused before a house that seemed
A swelling of the ground;
The roof was scarcely visible,
The cornice but a mound.

Since then 'tis centuries; but each
Feels shorter than the day
I first surmised the horses' heads
Were toward eternity.

<div align="right">The Poems of Emily Dickinson (1930)</div>

If the word great means anything in poetry, this poem is one of the greatest in the English language; it is flawless to the last detail. The rhythm charges with movement the pattern of suspended action back of the poem. Every image is precise and, moreover, not merely beautiful, but inextricably fused with the central idea. Every image extends and intensifies every other. The third stanza especially shows Miss Dickinson's power to fuse, into a single order of perception, a heterogeneous series: the children, the grain, and the setting sun (time) have the same degree of credibility; the first subtly preparing for the last. The sharp GAZING *before* GRAIN *instils into nature a kind of cold vitality of which the qualitative richness has infinite depth. The content of death in the poem eludes forever any explicit definition. He is a gentleman taking a lady out for a drive. But note the restraint that keeps the poet from carrying this so far that it is ludicrous and incredible; and note the subtly interfused erotic motive, which the idea of death has presented to every romantic poet, love being a symbol interchangeable with death. The terror of death is objectified through this figure of the genteel driver, who is made ironically to serve the end of Immortality. This is the heart of the poem: she has presented a typical Christian theme in all its final irresolution, without making any final statement about it. There is no solution to the problem; there can be only a statement of it in the full context of intellect and feeling. A construction of the human will, elaborated with all the abstracting powers of the mind, is put to the concrete test of experience: the idea of immortality is confronted with the fact of physical disintegration. We are not told what to think; we are told to look at the situation.*

<div align="right">ALLEN TATE</div>
<div align="right">Reactionary Essays On Poetry and Ideas (1936)</div>

WILLIAM MORRIS

1 8 3 4 — 1 8 9 6

GOLDEN WINGS

Midways of a walled garden,
 In the happy poplar land,
 Did an ancient castle stand,
With an old knight for a warden.

Many scarlet bricks there were
 In its walls, and old grey stone;
 Over which red apples shone
At the right time of the year.

On the bricks the green moss grew,
 Yellow lichen on the stone,
 Over which red apples shone;
Little war that castle knew.

Deep green water fill'd the moat,
 Each side had a red-brick lip,
 Green and mossy with the drip
Of dew and rain; there was a boat

Of carven wood, with hangings green
 About the stern; it was great bliss
 For lovers to sit there and kiss
In the hot summer noons, not seen.

Across the moat the fresh west wind
 In very little ripples went;
 The way the heavy aspens bent
Towards it, was a thing to mind.

The painted drawbridge over it
 Went up and down with gilded chains,
 'Twas pleasant in the summer rains
Within the bridge-house there to sit.

There were five swans that ne'er did eat
 The water-weeds, for ladies came
 Each day, and young knights did the same,
And gave them cakes and bread for meat.

They had a house of painted wood,
 A red roof gold-spiked over it,
 Wherein upon their eggs to sit
Week after week; no drop of blood,

Drawn from men's bodies by sword-blows,
 Came over there, or any tear;
 Most certainly from year to year
'Twas pleasant as a Provence rose.

The banners seem'd quite full of ease,
 That over the turret-roofs hung down;
 The battlements could get no frown
From the flower-moulded cornices.

The Defence of Guenevere and Other Poems (1858)

The best description of happiness in the world.

<div align="right">W. B. YEATS
Essays (1924)</div>

W. S. GILBERT

1 8 3 6 — 1 9 1 1

THE FIRST LORD OF THE ADMIRALTY

When I was a lad I served a term
As office boy to an Attorney's firm.
I cleaned the windows and I swept the floor,
And I polished up the handle of the big front door.
 I polished up that handle so carefullee
 That now I am the Ruler of the Queen's Navee!

CHORUS.—He polished, etc.

As office boy I made such a mark
That they gave me the post of a junior clerk.
I served the writs with a smile so bland,
And I copied all the letters in a big round hand—
 I copied all the letters in a hand so free,
 That now I am the Ruler of the Queen's Navee!

CHORUS.—He copied, etc.

In serving writs I made such a name
That an articled clerk I soon became;
I wore clean collars and a brand-new suit
For the pass examination at the Institute,
 And that pass examination did so well for me,
 That now I am the Ruler of the Queen's Navee!

 CHORUS.—And that pass examination, etc.

Of legal knowledge I acquired such a grip
That they took me into the partnership.
And that junior partnership, I ween,
Was the only ship that I ever had seen.
 But that kind of ship so suited me,
 That now I am the Ruler of the Queen's Navee!

 CHORUS.—But that kind, etc.

I grew so rich that I was sent
By a pocket borough into Parliament.
I always voted at my party's call,
And I never thought of thinking for myself at all.
 I thought so little, they rewarded me
 By making me the Ruler of the Queen's Navee!

 CHORUS.—He thought so little, etc.

Now landsmen all, whoever you may be,
If you want to rise to the top of the tree,
If your soul isn't fettered to an office stool,
Be careful to be guided by this golden rule—
 Stick close to your desks and never go to sea,
 And you all may be Rulers of the Queen's Navee!

 CHORUS.—Stick close, etc.

H.M.S. Pinafore (1878)

The very perfection of farce.

THEODORE WATTS-DUNTON
Poetry and the Renascence of Wonder (1914)

ALGERNON CHARLES SWINBURNE

1 8 3 7 — 1 9 0 9

FROM *LAUS VENERIS*

The thunder of the trumpets of the night.
Poems and Ballads (1866)

One of the greatest lines in modern, and English, poetry.
GEORGE SAINTSBURY
A History of English Prosody (1910)

ALGERNON CHARLES SWINBURNE

1 8 3 7 — 1 9 0 9

CHORUSES FROM *ATALANTA IN CALYDON*

When the hounds of spring are on winter's traces,
 The mother of months in meadow or plain
Fills the shadows and windy places
 With lisp of leaves and ripple of rain;
And the brown bright nightingale amorous
Is half assuaged for Itylus,
For the Thracian ships and the foreign faces,
 The tongueless vigil, and all the pain.

Come with bows bent and with emptying of quivers,
 Maiden most perfect, lady of light,
With a noise of winds and many rivers,
 With a clamour of waters, and with might;
Bind on thy sandals, O thou most fleet,
Over the splendour and speed of thy feet;
For the faint east quickens, the wan west shivers,
 Round the feet of the day and the feet of the night.

Where shall we find her, how shall we sing to her,
 Fold our hands round her knees, and cling?
O that man's heart were as fire and could spring to her,
 Fire, or the strength of the streams that spring!

For the stars and the winds are unto her
As raiment, as songs of the harp-player;
For the risen stars and the fallen cling to her,
 And the southwest-wind and the west-wind sing.

For winter's rains and ruins are over,
 And all the season of snows and sins;
The days dividing lover and lover,
 The light that loses, the night that wins;
And time remembered is grief forgotten,
And frosts are slain and flowers begotten,
And in green underwood and cover
 Blossom by blossom the spring begins.

The full streams feed on flower of rushes,
 Ripe grasses trammel a travelling foot,
The faint fresh flame of the young year flushes
 From leaf to flower and flower to fruit;
And fruit and leaf are as gold and fire,
And the oat is heard above the lyre,
And the hoofèd heel of a satyr crushes
 The chestnut-husk at the chestnut-root.

And Pan by noon and Bacchus by night,
 Fleeter of foot than the fleet-foot kid,
Follows with dancing and fills with delight
 The Mænad and the Bassarid:
And soft as lips that laugh and hide
The laughing leaves of the trees divide,
And screen from seeing and leave in sight
 The god pursuing, the maiden hid.

The ivy falls with the Bacchanal's hair
 Over her eyebrows hiding her eyes;
The wild vine slipping down leaves bare
 Her bright breast shortening into sighs;
The wild vine slips with the weight of its leaves,
But the berried ivy catches and cleaves
To the limbs that glitter, the feet that scare
 The wolf that follows, the fawn that flies.

Before the beginning of years
 There came to the making of man
Time, with a gift of tears;
 Grief, with a glass that ran;

Pleasure, with pain for leaven;
 Summer, with flowers that fell;
Remembrance fallen from heaven,
 And madness risen from hell;
Strength without hands to smite;
 Love that endures for a breath;
Night, the shadow of light,
 And life, the shadow of death.

And the high gods took in hand
 Fire, and the falling of tears,
And a measure of sliding sand
 From under the feet of the years;
And froth and drift of the sea;
 And dust of the labouring earth;
And bodies of things to be
 In the houses of death and of birth;
And wrought with weeping and laughter,
 And fashioned with loathing and love,
With life before and after
 And death beneath and above,
For a day and a night and a morrow,
 That his strength might endure for a span
With travail and heavy sorrow,
 The holy spirit of man.

From the winds of the north and the south
 They gathered as unto strife;
They breathed upon his mouth,
 They filled his body with life;
Eyesight and speech they wrought
 For the veils of the soul therein,
A time for labour and thought,
 A time to serve and to sin;
They gave him light in his ways,
 And love, and a space for delight,
And beauty and length of days,
 And night, and sleep in the night.
His speech is a burning fire;
 With his lips he travaileth;
In this heart is a blind desire,
 In his eyes foreknowledge of death;
He weaves, and is clothed with derision;
 Sows, and he shall not reap;
His life is a watch or a vision
 Between a sleep and a sleep.

We have seen thee, O Love, thou art fair; thou art goodly, O Love;
Thy wings make light in the air as the wings of a dove.
Thy feet are as winds that divide the stream of the sea;
Earth is thy covering to hide thee, the garment of thee.
Thou art swift and subtle and blind as a flame of fire;
Before thee the laughter, behind thee the tears of desire;
And twain go forth beside thee, a man with a maid;
Her eyes are the eyes of a bride whom delight makes afraid;
As the breath in the buds that stir is her bridal breath:
But Fate is the name of her; and his name is Death.

 For an evil blossom was born
 Of sea-foam and the frothing of blood,
 Blood-red and bitter of fruit,
 And the seed of it laughter and tears,
 And the leaves of it madness and scorn;
 A bitter flower from the bud,
 Sprung of the sea without root,
 Sprung without graft from the years.

The weft of the world was untorn
 That is woven of the day on the night,
 The hair of the hours was not white
Nor the raiment of time overworn,
 When a wonder, a world's delight,
A perilous goddess was born;
 And the waves of the sea as she came
Clove, and the foam at her feet,
 Fawning, rejoiced to bring forth
A fleshly blossom, a flame
Filling the heavens with heat
 To the cold white ends of the north.

And in air the clamorous birds,
 And men upon earth that hear
Sweet articulate words
 Sweetly divided apart,
 And in shallow and channel and mere
The rapid and footless herds,
 Rejoiced, being foolish of heart.

For all they said upon earth,
 She is fair, she is white like a dove,
 And the life of the world in her breath
Breathes, and is born at her birth;
 For they knew thee for mother of love,
 And knew thee not mother of death.

What hadst thou to do being born,
 Mother, when winds were at ease,
As a flower of the springtime of corn,
 A flower of the foam of the seas?
For bitter thou wast from thy birth,
 Aphrodite, a mother of strife;
For before thee some rest was on earth,
 A little respite from tears,
 A little pleasure of life;
For life was not then as thou art,
 But as one that waxeth in years
 Sweet-spoken, a fruitful wife;
 Earth had no thorn, and desire
No sting, neither death any dart;
 What hadst thou to do amongst these,
 Thou, clothed with a burning fire,
Thou, girt with sorrow of heart,
 Thou, sprung of the seed of the seas
As an ear from a seed of corn,
 As a brand plucked forth of a pyre,
As a ray shed forth of the morn,
 For division of soul and disease,
For a dart and a sting and a thorn?
What ailed thee then to be born?

Was there not evil enough,
 Mother, and anguish on earth
 Born with a man at his birth,
Wastes underfoot, and above
 Storm out of heaven, and dearth
Shaken down from the shining thereof,
 Wrecks from afar overseas
 And peril of shallow and firth,
 And tears that spring and increase
 In the barren places of mirth,
That thou, having wings as a dove,
 Being girt with desire for a girth,
 That thou must come after these,
That thou must lay on him love?

Thou shouldst not so have been born:
 But death should have risen with thee,
 Mother, and visible fear,
 Grief, and the wringing of hands,

1299

And noise of many that mourn;
 The smitten bosom, the knee
 Bowed, and in each man's ear
 A cry as of perishing lands,
A moan as of people in prison,
 A tumult of infinite griefs;
 And thunder of storm on the sands,
 And wailing of wives on the shore;
And under thee newly arisen
 Loud shoals and shipwrecking reefs,
 Fierce air and violent light;
 Sail rent and sundering oar,
 Darkness, and noises of night;
Clashing of streams in the sea,
 Wave against wave as a sword,
 Clamour of currents, and foam;
 Rains making ruin on earth,
 Winds that wax ravenous and roam
As wolves in a wolfish horde;
Fruits growing faint in the tree,
 And blind things dead in their birth;
 Famine, and blighting of corn,
 When thy time was come to be born.

All these we know of; but thee
 Who shall discern or declare?
In the uttermost ends of the sea
 The light of thine eyelids and hair,
 The light of thy bosom as fire
 Between the wheel of the sun
 And the flying flames of the air?
 Wilt thou turn thee not yet nor have pity,
But abide with despair and desire
And the crying of armies undone,
 Lamentation of one with another
 And breaking of city by city;
The dividing of friend against friend,
 The severing of brother and brother;
Wilt thou utterly bring to an end?
 Have mercy, mother!

For against all men from of old
 Thou hast set thine hand as a curse,
 And cast out gods from their places.
 These things are spoken of thee.

Strong kings and goodly with gold
 Thou hast found out arrows to pierce,
 And made their kingdoms and races
 As dust and surf of the sea.
All these, overburdened with woes
 And with length of their days waxen weak,
 Thou slewest; and sentest moreover
 Upon Tyro an evil thing,
Rent hair and a fetter and blows
 Making bloody the flower of the cheek,
 Though she lay by a god as a lover,
 Though fair, and the seed of a king.
For of old, being full of thy fire,
 She endured not longer to wear
 On her bosom a saffron vest,
 On her shoulder an ashwood quiver;
Being mixed and made one through desire
 With Enipeus, and all her hair
 Made moist with his mouth, and her breast
 Filled full of the foam of the river.
 Atalanta in Calydon (1865)

Nothing so swift had been heard in English poetry before as sounded in the almost superhuman choruses of ATALANTA.

<div align="right">

EDMUND GOSSE
The Life of Algernon Charles Swinburne (1917)

</div>

ALGERNON CHARLES SWINBURNE

1 8 3 7 — 1 9 0 9

FROM *HESPERIA*

Sudden and steady the music, as eight hoofs trample and thunder,
 Rings in the ear of the low blind wind of the night as we pass.
 Poems and Ballads (1866)

Never in any land has there been such a master in word-music, such unerring mastership in construction.

<div align="right">

GEORG BRANDES
Creative Spirits of the Nineteenth Century (1923)
Translated by Rasmus B. Anderson

</div>

ALGERNON CHARLES SWINBURNE

1 8 3 7 — 1 9 0 9

SUPER FLUMINA BABYLONIS

By the waters of Babylon we sat down and wept,
 Remembering thee,
That for ages of agony hast endured, and slept,
 And wouldst not see.

By the waters of Babylon we stood up and sang,
 Considering thee,
That a blast of deliverance in the darkness rang,
 To set thee free.

And with trumpets and thunderings and with morning song
 Came up the light;
And thy spirit uplifted thee to forget thy wrong
 As day doth night.

And thy sons were dejected not any more, as then
 When thou wast shamed;
When thy lovers went heavily without heart, as men
 Whose life was maimed.

In the desolate distances, with a great desire,
 For thy love's sake,
With our hearts going back to thee, they were filled with fire,
 Were nigh to break.

It was said to us: 'Verily ye are great of heart,
 But ye shall bend;
Ye are bondmen and bondwomen, to be scourged and smart,
 To toil and tend.'

And with harrows men harrowed us, and subdued with spears,
 And crushed with shame;
And the summer and winter was, and the length of years,
 And no change came.

By the rivers of Italy, by the sacred streams,
 By town, by tower,
There was feasting with revelling, there was sleep with dreams,
 Until thine hour.

And they slept and they rioted on their rose-hung beds,
 With mouths on flame,
And with love-locks vine-chapleted, and with rose-crowned heads
 And robes of shame.

And they knew not their forefathers, nor the hills and streams
 And words of power,
Nor the gods that were good to them, but with songs and dreams
 Filled up their hour.

By the rivers of Italy, by the dry streams' beds,
 When thy time came,
There was casting of crowns from them, from their young men's heads,
 The crowns of shame.

By the horn of Eridanus, by the Tiber mouth,
 As thy day rose,
They arose up and girded them to the north and south,
 By seas, by snows.

As a water in January the frost confines,
 Thy kings bound thee;
As a water in April is, in the new-blown vines,
 Thy sons made free.

And thy lovers that looked for thee, and that mourned from far,
 For thy sake dead,
We rejoiced in the light of thee, in the signal star
 Above thine head.

In thy grief had we followed thee, in thy passion loved,
 Loved in thy loss;
In thy shame we stood fast to thee, with thy pangs were moved,
 Clung to thy cross.

By the hillside of Calvary we beheld thy blood,
 Thy bloodred tears,
As a mother's in bitterness, an unebbing flood,
 Years upon years.

And the north was Gethsemane, without leaf or bloom,
 A garden sealed;
And the south was Aceldama, for a sanguine fume
 Hid all the field.

By the stone of the sepulchre we returned to weep,
 From far, from prison;
And the guards by it keeping it we beheld asleep,
 But thou wast risen.

And an angel's similitude by the unsealed grave,
 And by the stone:
And the voice was angelical, to whose words God gave
 Strength like his own.

'Lo, the graveclothes of Italy that are folded up
 In the grave's gloom!
And the guards as men wrought upon with a charmed cup,
 By the open tomb.

'And her body most beautiful, and her shining head,
 These are not here;
For your mother, for Italy, is not surely dead:
 Have ye no fear.

'As of old time she spake to you, and you hardly heard,
 Hardly took heed,
So now also she saith to you, yet another word,
 Who is risen indeed.

'By my saying she saith to you, in your ears she saith,
 Who hear these things,
Put no trust in men's royalties, nor in great men's breath,
 Nor words of kings.

'For the life of them vanishes and is no more seen,
 Nor no more known;
Nor shall any remember him if a crown hath been,
 Or where a throne.

'Unto each man his handiwork, unto each his crown,
 The just Fate gives;
Whoso takes the world's life on him and his own lays down,
 He, dying so, lives.

'Whoso bears the whole heaviness of the wronged world's weight
 And puts it by,
It is well with him suffering, though he face man's fate;
 How should he die?

'Seeing death has no part in him any more, no power
 Upon his head;
He has bought his eternity with a little hour,
 And is not dead.

'For an hour, if ye look for him, he is no more found,
 For one hour's space;
Then ye lift up your eyes to him and behold him crowned,
 A deathless face.

'On the mountains of memory, by the world's well-springs,
 In all men's eyes,
Where the light of the life of him is on all past things,
 Death only dies.

'Not the light that was quenched for us, nor the deeds that were,
 Nor the ancient days,
Nor the sorrows not sorrowful, nor the face most fair
 Of perfect praise.'

So the angel of Italy's resurrection said,
 So yet he saith;
So the son of her suffering, that from breasts nigh dead
 Drew life, not death.

That the pavement of Golgotha should be white as snow,
 Not red, but white;
That the waters of Babylon should no longer flow,
 And men see light.

<div align="right">Songs Before Sunrise (1871)</div>

*Perhaps the most remarkable case in English literature where a chance
set of words, of quite peculiar rhythm, is taken by a poet, and the rhythm
of those words repeated until it becomes accepted as a perfect and
satisfying pattern, is Swinburne's poem,*

> *By the waters of Babylon we sate down and wept,*
> *Remembering thee,*
> *That for ages of agony hast lain down and slept,*
> *And wouldst not see.*

It is a marvel of metrical skill to produce this effect in English.

<div align="right">GILBERT MURRAY
The Classical Tradition in Poetry (1927)</div>

WALTER PATER

1 8 3 9 — 1 8 9 4

LA GIOCONDA

The presence that thus so strangely rose beside the waters is expressive of what in the ways of a thousand years man had come to desire.
Hers is the head upon which all 'the ends of the world are come,' and
the eyelids are a little weary. It is a beauty wrought out from within
upon the flesh, the deposit, little cell by cell, of strange thoughts and
fantastic reveries and exquisite passions. Set it for a moment beside one
of those white Greek goddesses or beautiful women of antiquity, and
how would they be troubled by this beauty, into which the soul with

all its maladies has passed? All the thoughts and experience of the world have etched and moulded there in that which they have of power to refine and make expressive the outward form, the animalism of Greece, the lust of Rome, the reverie of the middle age with its spiritual ambition and imaginative loves, the return of the Pagan world, the sins of the Borgias. She is older than the rocks among which she sits; like the vampire, she has been dead many times, and learned the secrets of the grave; and has been a diver in deep seas, and keeps their fallen day about her; and trafficked for strange webs with Eastern merchants; and, as Leda, was the mother of Helen of Troy, and, as Saint Anne, the mother of Mary; and all this has been to her but as the sound of lyres and flutes, and lives only in the delicacy with which it has moulded the changing lineaments and tinged the eyelids and the hands.

Studies in the History of the Renaissance (1873)

There is hardly a finer passage in English literature than Pater's page on the Mona Lisa.

<div align="right">

FRANK HARRIS
My Life and Loves (1922–27)

</div>

<div align="center">

THOMAS HARDY

1 8 4 0 — 1 9 2 8

</div>

MICHAEL HENCHARD'S WILL

'That Elizabeth-Jane Farfrae be not told of my death, or made to grieve on account of me.

'& that I be not bury'd in consecrated ground.

'& that no sexton be asked to toll the bell.

'& that nobody is wished to see my dead body.

'& that no murners walk behind me at my funeral.

'& that no flours be planted on my grave.

'& that no man remember me.

'To this I put my name.

<div align="center">

'MICHAEL HENCHARD'
The Mayor of Casterbridge (1886)

</div>

Realistic truth and imaginative power here unite [in] Hardy to achieve their most tremendous effect. The plain words are perfectly in character, just what an uneducated farmer like Henchard might write. But Hardy has managed to charge them with all the emotional grandeur of great

<div align="center">

1306

</div>

STÉPHANE MALLARMÉ

1 8 4 2 — 1 8 9 8

SONNET

O si chère de loin et proche et blanche, si
Délicieusement toi, Mary, que je songe
A quelque baume rare émané par mensonge
Sur aucun bouquetier de cristal obscurci.

Le sais-tu, oui! pour moi voici des ans, voici
Toujours que ton sourire éblouissant prolonge
La même rose avec son bel été qui plonge
Dans autrefois et puis dans le futur aussi.

Mon cœur qui dans les nuits parfois cherche à s'entendre
Ou de quel dernier mot t'appeler le plus tendre
S'exalte en celui rien que chuchoté de sœur

N'était, très grand trésor et tête si petite,
Que tu m'enseignes bien toute une autre douceur
Tout bas par le baiser seul dans tes cheveux dite.

From afar so lov'd and near, so cloudless fair, so
Exquisitely thou, my Mary, that I seem
Breathing rarest balm was never but in dream
From vase-crystal lucent like thee—fain it were so!
Know'st thou? Surely. So all time that I recall, so
Always 'neath thy summer's smile doth bloom for aye
This one rose, its gladness wreathing day to day,
Time past one with now—yea, time that cometh, also!
My heart searching in the night account to render
How—by what last name to call thee—name most tender,
Reacheth but to this but falter'd 'sister mine'—
Thou, such treasure in this little head adwelling,
Teachest me the secret—this caressing name of thine—
That alone my kiss breath'd on thy hair, is telling.

Translated by Arthur Ellis

Mallarmé's sonnet is that miracle, an entire poem consciously organized to such a pitch of artistic perfection that the whole is one single, unflawed piece of "pure poetry." In its unobtrusive way, this is one of the most potent spells ever committed to paper. In what does its magic consist? Partly it is a magic of sound. (Note, incidentally, that the magical sound is not concentrated in single words, or phrases, or lines; it is the sound of the poem as a whole.) But mainly it is a magic of grammar, a syntactical magic of the relations of thought with thought. Consider the sextet; it is a grammatical apocalypse. A whole world of ideas is miraculously concentrated by means of the syntax into what is almost a point.

<div align="right">

ALDOUS HUXLEY
Texts & Pretexts (1933)

</div>

STÉPHANE MALLARMÉ

1 8 4 2 — 1 8 9 8

L'APRÈS-MIDI D'UN FAUNE. ÉGLOGUE

Ces nymphes, je les veux perpétuer.

> *Si clair,*
Leur incarnat léger, qu'il voltige dans l'air
Assoupi de sommeils touffus.

> *Aimai-je un rêve?*

Mon doute, amas de nuit ancienne, s'achève
En maint rameau subtil, qui, demeuré les vrais
Bois mêmes, prouve, hélas! que bien seul je m'offrais
Pour triomphe la faute idéale de roses.
Réfléchissons . . .

> *ou si les femmes dont tu gloses*
Figurent un souhait de tes sens fabuleux!
Faune, l'illusion s'échappe des yeux bleus
Et froids, comme une source en pleurs, de la plus chaste:
Mais, l'autre tout soupirs, dis-tu qu'elle contraste
Comme brise du jour chaude dans ta toison!
Que non! par l'immobile et lasse pâmoison
Suffoquant de chaleurs le matin frais s'il lutte,
Ne murmure point d'eau que ne verse ma flûte

Au bosquet arrosé d'accords; et le seul vent
Hors des deux tuyaux prompt à s'exhaler avant
Qu'il disperse le son dans une pluie aride,
C'est, à l'horizon pas remué d'une ride,
Le visible et serein souffle artificiel
De l'inspiration, qui regagne le ciel.

O bords siciliens d'un calme marécage
Qu'à l'envi des soleils ma vanité saccage,
Tacite sous les fleurs d'étincelles, CONTEZ
'Que je coupais ici les creux roseaux domptés
'Par le talent; quand, sur l'or glauque de lointaines
'Verdures dédiant leur vigne à des fontaines,
'Ondoie une blancheur animale au repos:
'Et qu'au prélude lent où naissent les pipeaux
'Ce vol de cygnes, non! de naïades se sauve
'Ou plonge . . .'

 Inerte, tout brûle dans l'heure fauve
Sans marquer par quel art ensemble détala
Trop d'hymen souhaité de qui cherche le la:
Alors m'éveillerai-je à la ferveur première,
Droit et seul, sous un flot antique de lumière,
Lys! et l'un de vous tous pour l'ingénuité.

Autre que ce doux rien par leur lèvre ébruité,
Le baiser, qui tout bas des perfides assure,
Mon sein, vierge de preuve, atteste une morsure
Mystérieuse, due à quelque auguste dent;

Mais, bast! arcane tel élut pour confident
Le jonc vaste et jumeau dont sous l'azur on joue:
Qui, détournant à soi le trouble de la joue
Rêve, dans un solo long, que nous amusions
La beauté d'alentour par des confusions
Fausses entre elle-même et notre chant crédule;
Et de faire aussi haut que l'amour se module
Evanouir du songe ordinaire de dos
Ou de flanc pur suivis avec mes regards clos,
Une sonore, vaine et monotone ligne.

Tâche donc, instrument des fuites, ô maligne
Syrinx, de refleurir aux lacs où tu m'attends!
Moi, de ma rumeur fier, je vais parler longtemps
Des déesses; et par d'idolâtres peintures,
A leur ombre enlever encore des ceintures:

Ainsi, quand des raisins j'ai sucé la clarté,
Pour bannir un regret par ma feinte écarté,
Rieur, j'élève au ciel d'été la grappe vide
Et, soufflant dans ses peaux lumineuses, avide
D'ivresse, jusqu'au soir je regarde au travers.

O nymphes, regonflons des SOUVENIRS divers.
'Mon œil, trouant les joncs, dardait chaque encolure
'Immortelle, qui noie en l'onde sa brûlure
'Avec un cri de rage au ciel de la forêt;
'Et le splendide bain de cheveux disparaît
'Dans les clartés et les frissons, o pierreries!
'J'accours; quand, à mes pieds, s'entrejoignent (meurtries
'De la langueur goûtée à ce mal d'être deux)
'Des dormeuses parmi leurs seuls bras hasardeux;
'Je les ravis, sans les désenlacer, et vole
'A ce massif, haï par l'ombrage frivole,
'De roses tarissant tout parfum au soleil,
'Où notre ébat au jour consumé soit pareil.'
Je t'adore, courroux des vierges, ô délice
Farouche du sacré fardeau nu qui se glisse
Pour fuir ma lèvre en feu buvant, comme un éclair
Tressaille! la frayeur secrète de la chair:
Des pieds de l'inhumaine au cœur de la timide
Que délaisse à la fois une innocence, humide
De larmes folles ou de moins tristes vapeurs.
'Mon crime, c'est d'avoir, gai de vaincre ces peurs
'Traîtresses, divisé la touffe échevelée
'De baisers que les dieux gardaient si bien mêlée;
'Car, à peine j'allais cacher un rire ardent
'Sous les replis heureux d'une seule (gardant
'Par un doigt simple, afin que sa candeur de plume
'Se teignît à l'émoi de sa sœur qui s'allume,
'La petite, naïve et ne rougissant pas:)
'Que de mes bras, défaits par de vagues trépas,
'Cette proie, à jamais ingrate se délivre
'Sans pitié du sanglot dont j'étais encore ivre.'

Tant pis! vers le bonheur d'autres m'entraîneront
Par leur tresse nouée aux cornes de mon front:
Tu sais, ma passion, que, pourpre et déjà mûre,
Chaque grenade éclate et d'abeilles murmure;
Et notre sang, épris de qui le va saisir,
Coule pour tout l'essaim éternel du désir.

A l'heure où ce bois d'or et de cendres se teinte
Une fête s'exalte en la feuillée éteinte:
Etna! c'est parmi toi visité de Vénus
Sur ta lave posant ses talons ingénus,
Quand tonne un somme triste ou s'épuise la flamme.
Je tiens la reine!

 O sûr châtiment . . .

 Non, mais l'âme

De paroles vacante et ce corps alourdi
Tard succombent au fier silence de midi:
Sans plus il faut dormir en l'oubli du blasphème,
Sur le sable altéré gisant et comme j'aime
Ouvrir ma bouche à l'astre efficace des vins!

Couple, adieu; je vais voir l'ombre que tu devins.

THE AFTERNOON OF A FAUN

I would immortalize these nymphs: so bright
Their sunlit colouring, so airy light,
It floats like drowsing down. Loved I a dream?
My doubts, born of oblivious darkness, seem
A subtle tracery of branches grown
The tree's true self—proving that I have known,
Thinking it love, the blushing of a rose.
But think. These nymphs, their loveliness . . . suppose
They bodied forth your senses' fabulous thirst?
Illusion! which the blue eyes of the first,
As cold and chaste as is the weeping spring,
Beget: the other, sighing, passioning,
Is she the wind, warm in your fleece at noon?
No; through this quiet, when a weary swoon
Crushes and chokes the latest faint essay
Of morning, cool against the encroaching day,
There is no murmuring water, save the gush
Of my clear fluted notes; and in the hush
Blows never a wind, save that which through my reed
Puffs out before the rain of notes can speed
Upon the air, with that calm breath of art
That mounts the unwrinkled zenith visibly,
Where inspiration seeks its native sky.
You fringes of a calm Sicilian lake,
The sun's own mirror which I love to take,

Silent beneath your starry flowers, tell
How here I cut the hollow rushes, well
Tamed by my skill, when on the glaucous gold
Of distant lawns about their fountain cold
A living whiteness stirs like a lazy wave;
And at the first slow notes my panpipes gave
These flocking swans, these naiads, rather, fly
Or dive. Noon burns inert and tawny dry,
Nor marks how clean that Hymen slipped away
From me who seek in song the real A.
Wake, then, to the first ardour and the sight,
O lonely faun, of the old fierce white light,
With, lilies, one of you for innocence.
Other than their lips' delicate pretence,
The light caress that quiets treacherous lovers,
My breast, I know not how to tell, discovers
The bitten print of some immortal's kiss.
But hush! a mystery so great as this
I dare not tell, save to my double reed,
Which, sharer of my every joy and need,
Dreams down its cadenced monologues that we
Falsely confuse the beauties that we see
With the bright palpable shapes our song creates:
My flute, as loud as passion modulates,
Purges the common dream of flank and breast,
Seen through closed eyes and inwardly caressed,
Of every empty and monotonous line.

Bloom then, O Syrinx, in thy flight malign,
A reed once more beside our trysting-lake.
Proud of my music, let me often make
A song of goddesses and see their rape
Profanely done on many a painted shape.
So when the grape's transparent juice I drain,
I quell regret for pleasures past and feign
A new real grape. For holding towards the sky
The empty skin, I blow it tight and lie
Dream-drunk till evening, eyeing it.

 Tell o'er
Remembered joys and plump the grape once more.
Between the reeds I saw their bodies gleam
Who cool no mortal fever in the stream
Crying to the woods the rage of their desire:
And their bright hair went down in jewelled fire

Where crystal broke and dazzled shudderingly.
I check my swift pursuit: for see where lie,
Bruised, being twins in love, by languor sweet,
Two sleeping girls, clasped at my very feet.
I seize and run with them, nor part the pair,
Breaking this covert of frail petals, where
Roses drink scent of the sun and our light play
'Mid tumbled flowers shall match the death of day.
I love that virginal fury—ah, the wild
Thrill when a maiden body shrinks, defiled,
Shuddering like arctic light, from lips that sear
Its nakedness . . . the flesh in secret fear!
Contagiously through my linked pair it flies
Where innocence in either, struggling, dies,
Wet with fond tears or some less piteous dew.
Gay in the conquest of these fears, I grew
So rash that I must needs the sheaf divide
Of ruffled kisses heaven itself had tied.
For as I leaned to stifle in the hair
Of one my passionate laughter (taking care
With a stretched finger, that her innocence
Might stain with her companion's kindling sense
To touch the younger little one, who lay
Child-like unblushing) my ungrateful prey
Slips from me, freed by passion's sudden death,
Nor heeds the frenzy of my sobbing breath.

Let it pass! others of their hair shall twist
A rope to drag me to those joys I missed.
See how the ripe pomegranates bursting red
To quench the thirst of the mumbling bees have bled;
So too our blood, kindled by some chance fire,
Flows for the swarming legions of desire.
At evening, when the woodland green turns gold
And ashen grey, 'mid the quenched leaves, behold!
Red Etna glows, by Venus visited,
Walking the lava with her snowy tread
Whene'er the flames in thunderous slumber die.
I hold the goddess!

Ah, sure penalty!

But the unthinking soul and body swoon
At last beneath the heavy hush of noon.

Forgetful let me lie where summer's drouth
Sifts fine the sand and then with gaping mouth
Dream planet-struck by the grape's round wine-red **star**.

Nymphs, I shall see the shade that now you are.

<div align="right">*Translated by Aldous Huxley*</div>

*It is assuredly the most skilful poem in our language; it is the most
musical and the richest in internal relations.*

<div align="right">P A U L V A L É R Y
Les Nouvelles Littéraires (February 28, 1931)</div>

FROM HÉRODIADE

HÉRODIADE

Oui, c'est pour moi, pour moi, que je fleuris, déserte!
Vous le savez, jardins d'améthyste, enfouis
Sans fin dans de savants abîmes éblouis,
Ors ignorés, gardant votre antique lumière
Sous le sombre sommeil d'une terre première,
Vous pierres où mes yeux comme de purs bijoux
Empruntent leur clarté mélodieuse, et vous
Métaux qui donnez à ma jeune chevelure
Une splendeur fatale et sa massive allure!
Quant à toi, femme née en des siècles malins
Pour la méchanceté des antres sibyllins,
Qui parles d'un mortel! selon qui, des calices
De mes robes, arôme aux farouches délices,
Sortirait le frisson blanc de ma nudité,
Prophétise que si le tiède azur d'été,
Vers lui nativement la femme se dévoile,
Me voit dans ma pudeur grelottante d'étoile,
Je meurs!

J'aime l'horreur d'être vierge et je veux
Vivre parmi l'effroi que me font mes cheveux
Pour, le soir, retirée en ma couche, reptile
Inviolé sentir en la chair inutile
Le froid scintillement de ta pâle clarté
Toi qui te meurs, toi qui brûles de chasteté,
Nuit blanche de glaçons et de neige cruelle!

Et ta sœur solitaire, ô ma sœur éternelle
Mon rêve montera vers toi: telle déjà
Rare limpidité d'un cœur qui le songea,

Je me crois seule en ma monotone patrie
Et tout, autour de moi, vit dans l'idolâtrie
D'un miroir qui reflète en son calme dormant
Hérodiade au clair regard de diamant . . .
O charme dernier, oui! je le sens, je suis seule.

LA NOURRICE
Madame, allez-vous donc mourir?

HÉRODIADE
 Non, pauvre aïeule,
Sois calme et, t'éloignant, pardonne à ce cœur dur
Mais avant, si tu veux, clos les volets, l'azur
Séraphique sourit dans les vitres profondes,
Et je déteste, moi, le bel azur!

 Des ondes
Se bercent et, là-bas, sais-tu pas un pays
Où le sinistre ciel ait les regards haïs
De Vénus qui, le soir, brûle dans le feuillage;
J'y partirais.

 Allume encore, enfantillage
Dis-tu, ces flambeaux où la cire au feu léger
Pleure parmi l'or vain quelque pleur étranger
Et . . .

LA NOURRICE
 Maintenant?

HÉRODIADE
 Adieu.
 Vous mentez, ô fleur nue
De mes lèvres!

 J'attends une chose inconnue
Ou peut-être, ignorant le mystère et vos cris,
Jetez-vous les sanglots suprêmes et meurtris
D'une enfance sentant parmi les rêveries
Se séparer enfin ses froides pierreries.

HÉRODIADE
To mine own self I am a wilderness.
You know it, amethyst gardens numberless
Enfolded in the flaming, subtle deep,
Strange gold, that through the red earth's heavy sleep
Has cherished ancient brightness like a dream,
Stones whence mine eyes, pure jewels, have their gleam

1315

Of icy and melodious radiance, you,
Metals, which into my young tresses drew
A fatal splendour and their manifold grace!
Thou, woman, born into these evil days
Disastrous to the cavern sibylline,
Who speakest, prophesying not of one divine,
But of a mortal, if from that close sheath,
My robes, rustle the wild enchanted breath
In the white quiver of my nakedness,
If the warm air of summer, O prophetess,
(And woman's body obeys that ancient claim)
Behold me in my shivering starry shame,
I die!
The horror of my virginity
Delights me, and I would envelop me
In the terror of my tresses, that, by night,
Inviolate reptile, I might feel the white
And glimmering radiance of thy frozen fire,
Thou that art chaste and diest of desire,
White night of ice and of the cruel snow!
Eternal sister, my lone sister, lo
My dreams uplifted before thee! now, apart,
So rare a crystal is my dreaming heart,
I live in a monotonous land alone,
And all about me lives but in mine own
Image, the idolatrous mirror of my pride,
Mirroring this Hérodiade diamond-eyed.
I am indeed alone, O charm and curse!

NURSE

O lady, would you die then?

HÉRODIADE

No, poor nurse;
Be calm, and leave me; prithee, pardon me,
But, ere thou go, close-to the casement; see
How the seraphical blue in the dim glass smiles,
But I abhor the blue of the sky!
Yet miles
On miles of rocking waves! Know'st not a land
Where, in the pestilent sky, men see the hand
Of Venus, and her shadow in dark leaves?
Thither I go.
Light thou the wax that grieves
In the swift flame, and sheds an alien tear
Over the vain gold; wilt not say in mere
Childishness?

NURSE

Now?

HÉRODIADE

Farewell. You lie, O flower
Of these chill lips!
I wait the unknown hour,
Or, deaf to your crying and that hour supreme,
Utter the lamentation of the dream
Of childhood seeing fall apart in sighs
The icy chaplet of its reveries.

Translated by Arthur Symons

In these two poems [THE AFTERNOON OF A FAUN *and* HÉRODIADE] *I find Mallarmé at the moment when his own desire achieves itself; when he attains Wagner's ideal, that "the most complete work of the poet should be that which, in its final achievement, becomes a perfect music": every word is a jewel, scattering and recapturing sudden fire, every image is a symbol, and the whole poem is visible music.*

ARTHUR SYMONS
Studies in Two Literatures (1924)

JOSÉ-MARIA DE HEREDIA

1 8 4 2 — 1 9 0 5

THE DEATH OF THE EAGLE

Avec un cri sinistre, il tournoie, emporté
Par la trombe, et crispé, buvant d'un trait sublime
La flamme éparse, il plonge au fulgurant abîme.

Heureux qui pour la Gloire ou pour la Liberté,
Dans l'orgueil de la force et l'ivresse du rêve,
Meurt ainsi, d'une mort éblouissante et brève!

A wild scream, and the vortex whirls him down;
 Sublime, he drinks the flames that round him hiss
 And plunges, shriveled, into the abyss.
What joy, for Liberty and Glory's crown,
In pride of might and ecstasy's uplift,
 To die a death so dazzling and so swift!

Les Trophées (1893)
Translated by John Hervey

1317

HENRY JAMES

1 8 4 3 — 1 9 1 6

THE KISS ON THE STAIRS

Facing him, waving him away, she had taken another upward step; but he sprang to the side of the stairs, and brought his hand, above the banister, down hard on her wrist. "Do you mean to tell me that I must marry a woman I hate?"

From her step she looked down into his raised face. "Ah you see it's not true that you're free!" She seemed almost to exult. "It's not true, it's not true!"

He only, at this, like a buffeting swimmer, gave a shake of his head and repeated his question: "Do you mean to tell me I must marry such a woman?"

Fleda gasped too; he held her fast. "No. Anything's better than that."

"Then in God's name what must I do?"

"You must settle that with Mona. You mustn't break faith. Anything's better than that. You must at any rate be utterly sure. She must love you—how can she help it? *I* wouldn't give you up!" said Fleda. She spoke in broken bits, panting out her words. "The great thing is to keep faith. Where's a man if he doesn't? If he doesn't he may be so cruel. So cruel, so cruel, so cruel!" Fleda repeated. "I couldn't have a hand in that, you know: that's my position—that's mine. You offered her marriage. It's a tremendous thing for her." Then looking at him another moment, "*I* wouldn't give you up!" she said again. He still had hold of her arm; she took in his blank dread. With a quick dip of her face she reached his hand with her lips, pressing them to the back of it with a force that doubled the force of her words. "Never, never, never!" she cried; and before he could succeed in seizing her she had turned and, flashing up the stairs, got away from him even faster than she had got away at Ricks.

The Spoils of Poynton (1908)

1318

WILLIAM SHAKESPEARE

1 5 6 4 — 1 6 1 6

A SINGLE FAMISHED KISS

Iniurious time now with a robbers hast,
Crams his ritch theeu'ry vp, hee knowes not how.
As many farewells as be starres in heauen,
With distinct breath, and consign'd kisses to them,
He fumbles vp into a loose adewe:
And skants vs with a single famisht kisse,
Distasted with the salt of broken teares.

Troilus and Cressida (1609)
Act iv, Scene iv

The most famous kisses in literature.

EDITH WHARTON
A Backward Glance (1934)

HENRY JAMES

1 8 4 3 — 1 9 1 6

THE MADONNA OF THE CHAIR

I suffered him at last to lead me directly to the goal of our journey—
the most tenderly fair of Raphael's virgins, the Madonna of the Chair.
Of all the fine pictures of the world, it was to strike me at once as the
work with which criticism has least to do. None betrays less effort, less
of the mechanism of success and of the irrepressible discord between
conception and result that sometimes faintly invalidates noble efforts.
Graceful, human, near to our sympathies as it is, it has nothing of manner,
of method, nothing almost of style; it blooms there in a softness as
rounded and as instinct with harmony as if it were an immediate exhala-
tion of genius. The figure imposes on the spectator a spell of submission
which he scarce knows whether he has given to heavenly purity or to
earthly charm. He is intoxicated with the fragrance of the tenderest
blossom of maternity that ever bloomed among men.

"That's what I call a fine picture," said my companion after we had
gazed a while in silence. "I've a right to say so, for I've copied it so often
and so carefully that I could repeat it now with my eyes shut. Other
works are of Raphael: this is Raphael himself. Others you can praise,
you can qualify, you can measure, explain, account for: this you can
only love and admire. I don't know in what seeming he walked here

1319

below while this divine mood was upon him; but after it surely he could do nothing but die—this world had nothing more to teach him. Think of it a while, my friend, and you'll admit that I'm not raving. Think of his seeing that spotless image not for a moment, for a day, in a happy dream or a restless fever-fit, not as a poet in a five minutes' frenzy—time to snatch his phrase and scribble his immortal stanza; but for days together, while the slow labour of the brush went on, while the foul vapours of life interposed and the fancy ached with tension, fixed, radiant, distinct, as we see it now! What a master, certainly! But ah what a seer!"

"Don't you imagine," I fear I profanely asked, "that he had a model, and that some pretty young woman—"

"As pretty a young woman as you please! It doesn't diminish the miracle. He took his hint of course, and the young woman possibly sat smiling before his canvas. But meanwhile the painter's idea had taken wings. No lovely human outline could charm it to vulgar fact. He saw the fair form made perfect; he rose to the vision without tremor, without effort of wing; he communed with it face to face and resolved into finer and lovelier truth the purity which completes it as the fragrance completes the rose. That's what they call idealism; the word's vastly abused, but the thing's good. It's my own creed at any rate. Lovely Madonna, model at once and muse, I call you to witness that I too am an idealist!"

"An idealist then"—and I really but wanted to draw him further out—"an idealist is a gentleman who says to Nature in the person of a beautiful girl: 'Go to, you're all wrong! Your fine's coarse, your bright's dim, your grace is *gaucherie*. This is the way you should have done it!' Isn't the chance against him?"

He turned on me at first almost angrily—then saw that I was but sowing the false to reap the true. "Look at that picture," he said, "and cease your irreverent mockery! Idealism is *that*! There's no explaining it; one must feel the flame. It says nothing to Nature, or to any beautiful girl, that they won't both forgive. It says to the fair woman: 'Accept me as your artist-friend, lend me your beautiful face, trust me, help me, and your eyes shall be half my masterpiece.' No one so loves and respects the rich realities of nature as the artist whose imagination intensifies them. He knows what a fact may hold—whether Raphael knew, you may judge by his inimitable portrait, behind us there, of Tommaso Inghirami—but his fancy hovers above it as Ariel in the play hovers above the sleeping prince. There's only one Raphael, but an artist may still be an artist. As I said last night, the days of illumination are gone; visions are rare; we've to look long to have them. But in meditation we may still cultivate the ideal; round it, smooth it, perfect it. The result, the result"—here his voice faltered suddenly and he fixed his eyes for a moment on the picture; when they met my own again they were full of tears—"the result may be less than this, but still it may be good, it may

1320

be *great!*" he cried with vehemence. "It may hang somewhere, through all the years, in goodly company, and keep the artist's memory warm. Think of being known to mankind after some such fashion as this; of keeping pace with the restless centuries and the changing world; of living on and on in the cunning of an eye and a hand that belong to the dust of ages, a delight and a law to remote generations; of making beauty more and more a force and purity more and more an example!"

"Heaven forbid," I smiled, "that I should take the wind out of your sails! But doesn't it occur to you that besides being strong in his genius Raphael was happy in a certain good faith of which we've lost the trick? There are people, I know, who deny that his spotless Madonnas are anything more than pretty blondes of that period, enhanced by the Raphaelesque touch, which they declare to be then as calculating and commercial as any other. Be that as it may, people's religious and esthetic needs went arm in arm, and there was, as I may say, a demand for the Blessed Virgin, visible and adorable, which must have given firmness to the artist's hand. I'm afraid there's no demand now."

My friend momentarily stared—he shivered and shook his ears under this bucketful of cold water. But he bravely kept up his high tone. "There's always a demand—that ineffable type is one of the eternal needs of man's heart; only pious souls long for it in silence, almost in shame. Let it appear and their faith grows brave. How *should* it appear in this corrupt generation? It can't be made to order. It could indeed when the order came trumpet-toned from the lips of the Church herself and was addressed to genius panting with inspiration. But it can spring now only from the soil of passionate labour and culture. Do you really fancy that while from time to time a man of complete artistic vision is born into the world such an image can perish? The man who paints it has painted everything. The subject admits of every perfection—form, colour, expression, composition. It can be as simple as you please and yet as rich; as broad and free and yet as full of delicate detail. Think of the chance for flesh in the little naked nestling child, irradiating divinity; of the chance for drapery in the chaste and ample garment of the mother. Think of the great story you compress into that simple theme. Think above all of the mother's face and its ineffable suggestiveness, of the mingled burden of joy and trouble, the tenderness turned to worship and the worship turned to far-seeing pity. Then look at it all in perfect line and lovely colour, breathing truth and beauty and mastery."

The Madonna of the Future (1873)

We should seek English literature vainly for a more beautiful description of Raphael's Madonna, than his VIRGIN OF THE CHAIR.

GEORGE MOORE
Avowals (1926)

CHARLES M. DOUGHTY

1 8 4 3 — 1 9 2 6

ARABIA DESERTA

Now longwhile our black booths had been built upon the sandy stretches, lying before the swelling white Nefûd side: the lofty coast of Irnàn in front, whose cragged breaches, where is any footing for small herbs nourished of this barren atmosphere, are the harbour of wild goats, which never drink. The summer's night at end, the sun stands up as a crown of hostile flames from that huge covert of inhospitable sandstone bergs; the desert day dawns not little and little, but it is noontide in an hour. The sun, entering as a tyrant upon the waste landscape, darts upon us a torment of fiery beams, not to be remitted till the far-off evening.—No matins here of birds; not a rock partridge-cock, calling with blithesome chuckle over the extreme waterless desolation. Grave is that giddy heat upon the crown of the head; the ears tingle with a flickering shrillness, a subtle crepitation it seems, in the glassiness of this sunstricken nature: the hot sand-blink is in the eyes, and there is little refreshment to find in the tents' shelter; the worsted booths leak to this fiery rain of sunny light. Mountains looming like dry bones through the thin air, stand far around about us: the savage flank of Ybba Moghrair, the high spire and ruinous stacks of el-Jebâl, Chebàd, the coast of Helwàn! Herds of the weak nomad camels waver dispersedly, seeking pasture in the midst of this hollow fainting country, where but lately the swarming locusts have fretted every green thing. This silent air burning about us, we endure breathless till the assr: when the dazing Arabs in the tents revive after their heavy hours. The lingering day draws down to the sun-setting; the herdsmen, weary of the sun, come again with the cattle, to taste in their menzils the first sweetness of mirth and repose.—The day is done, and there rises the nightly freshness of this purest mountain air: and then to the cheerful song and the cup at the common fire. The moon rises ruddy from that solemn obscurity of jebel like a mighty beacon:—and the morrow will be as this day, days deadly drowned in the sun of the summer wilderness.

<div align="right">Travels in Arabia Deserta (1888)</div>

This is the achievement of a pure and deliberate art; very little prose of this assured magnificence has been written in our day; and certainly no other book has been maintained on such a level for centuries. ARABIA DESERTA *is incomparable.*

<div align="right">

JOHN MIDDLETON MURRY
Countries of the Mind (1922)

</div>

CHANSON D'AUTOMNE

Les sanglots longs
Des violons
 De l'automne
Blessent mon cœur
D'une langueur
 Monotone.

Tout suffocant
Et blême, quand
 Sonne l'heure,
Je me souviens
Des jours anciens
 Et je pleure.

Et je m'en vais
Au vent mauvais
 Qui m'emporte
Deçà, delà,
Pareil à la
 Feuille morte.

When a sighing begins
In the violins
Of the autumn-song,
My heart is drowned
In the slow sound
Languorous and long.

Pale as with pain,
Breath fails me when
The hour tolls deep.
My thoughts recover
The days that are over,
And I weep.

1323

And I go
Where the winds know,
Broken and brief,
To and fro,
As the winds blow
A dead leaf.

Poèmes saturniens (1867)
Translated by Arthur Symons

The miraculous song.

F R A N Ç O I S P O R C H É
Verlaine tel qu'il fut (1933)

PAUL VERLAINE

1 8 4 4 — 1 8 9 6

CLAIR DE LUNE

Votre âme est un paysage choisi
Que vont charmant masques et bergamasques
Jouant du luth et dansant et quasi
Tristes sous leurs déguisements fantasques.

Tout en chantant sur le mode mineur
L'amour vainqueur et la vie opportune,
Ils n'ont pas l'air de croire à leur bonheur
Et leur chanson se mêle au clair de lune,

Au calme clair de lune triste et beau,
Qui fait rêver les oiseaux dans les arbres
Et sangloter d'extase les jets d'eau,
Les grands jets d'eau sveltes parmi les marbres.

Your soul is a sealed garden, and there go
With masque and bergamasque fair companies
Playing on lutes and dancing and as though
Sad under their fantastic fripperies.

Though they in minor keys go carolling
Of love the conqueror and of life the boon
They seem to doubt the happiness they sing
And the song melts into the light of the moon,

The sad light of the moon, so lovely fair
That all the birds dream in the leafy shade
And the slim fountains sob into the air
Among the marble statues in the glade.

<div align="right">

Fètes galantes (1869)
Translated by Arthur Symons

</div>

As purely decorative writing, however, the FÊTES GALANTES *are in their way unique. What could be better, of its sort?*

<div align="right">

•HAROLD NICOLSON
Paul Verlaine (1921)

</div>

<div align="center">

PAUL VERLAINE

1 8 4 4 — 1 8 9 6

PARSIFAL

</div>

Parsifal a vaincu les Filles, leur gentil
Babil et la luxure amusante—et sa pente
Vers la Chair de garçon vierge que cela tente
D'aimer les seins légers et ce gentil babil;

Il a vaincu la Femme belle, au cœur subtil,
Étalant ses bras frais et sa gorge excitante;
Il a vaincu l'Enfer et rentre sous sa tente
Avec un lourd trophée à son bras puéril,

Avec la lance qui perça le Flanc suprême!
Il a guéri le roi, le voici roi lui-même,
Et prêtre du très saint Trésor essentiel.

En robe d'or il adore, gloire et symbole,
Le vase pur où resplendit le Sang réel,
—Et, ô ces voix d'enfants chantant dans la coupole!

Parsifal has overcome the Lemans,
Their pretty babbling and amusing lusts,
And his own virginal boyhood's fleshly leanings
Teased by their pretty babbling and light breasts;

<div align="center">

1325

</div>

Overcome the Woman, beautiful, subtle-hearted,
Spreading her breast and fresh arms,
Overcome Hell; he strides into the tent
A heavy trophy on his boyish arm;

The lance that pierced the side of the Most High;
He cured the king and now is king himself,
Priest of the Essence, that Most Holy Treasure;

In gold robe, he adores the glory, the sign,
The chalice in which glows the Real Blood,
—Oh, all that children's singing from the Minster!

<div align="right">Amour (1888)

Translated by Denis Devlin</div>

I know of no more perfect thing than this sonnet. The hiatus in the last line was at first a little trying, but I have learned to love it; not in Baudelaire nor even in Poe is there more beautiful poetry to be found.

<div align="right">GEORGE MOORE

Confessions of a Young Man (1888)</div>

ANATOLE FRANCE

1 8 4 4 — 1 9 2 4

GOOD NIGHT, SWEET PRINCE

Vous êtes de tous les temps et de tous les pays. Vous n'avez pas vieilli d'une heure en trois siècles. Votre âme a l'âge de chacune de nos âmes. Nous vivons ensemble, prince Hamlet, et vous êtes ce que nous sommes, un homme au milieu du mal universel. On vous a chicané sur vos paroles et sur vos actions. On a montré que vous n'étiez pas d'accord avec vous-même. Comment saisir cet insaisissable personnage? a-t-on dit. Il pense tour à tour comme un moine du moyen âge et comme un savant de la Renaissance; il a la tête philosophique et pourtant pleine de diableries. Il a horreur du mensonge et sa vie n'est qu'un long mensonge. Il est irrésolu, c'est visible, et pourtant certains critiques l'ont jugé plein de décision, sans qu'on puisse leur donner tout à fait tort. Enfin, on a pré-tendu, mon prince, que vous étiez un magasin de pensées, un amas de contradictions et non pas un être humain. Mais c'est là, au contraire, le signe de votre profonde humanité. Vous êtes prompt et lent, audacieux et timide, bienveillant et cruel, vous croyez et vous doutez, vous êtes

sage et par-dessus tout vous êtes fou. En un mot, vous vivez. Qui de nous ne vous ressemble en quelque chose? Qui de nous pense sans contradiction et agit sans incohérence? Qui de nous n'est fou? Qui de nous ne vous dit avec un mélange de pitié, de sympathie, d'admiration et d'horreur: "Bonne nuit, aimable prince!"

You belong to all times and all countries. You have not aged an hour in three centuries. Your soul is as old as each of our souls. You live with us, Prince Hamlet, and you are what we are, a man in the midst of universal evil. They have cavilled at your words and your actions. They have shown you are inconsistent. How are we to comprehend this incomprehensible character, they said. He thinks alternately like a monk of the Middle Ages and like a scholar of the Renaissance. He has the mind of a philosopher, and yet is full of deviltries. He has a horror of lies but his life is one long lie. He is plainly irresolute, and yet certain critics have judged him full of resolution, without being entirely wrong. Finally, my Prince, they have represented you as a storehouse of thought, a mass of contradictions, and not a human being. But that, on the contrary, is the token of your profound humanity. You are prompt and slow, bold and timid, kind and cruel; you believe and you doubt, you are wise, and above all you are mad. In a word, you live. Who of us does not resemble you in some way? Who of us thinks without contradiction, acts without inconsistency? Who of us is not mad? Who of us may not say to you with a mixture of pity, sympathy, admiration and horror; "Good night, sweet Prince!"

<div align="right">La Vie littéraire (1888–92)</div>

It is just this mystery, emanating maybe from a man long since dust, which sets Hamlet in the timeless and universal theatre of our imagination, which so liberates him from his Elizabethan shell that we forget it altogether and count him a king of infinity. One does not usually look to the Gallic muse for songs in honour of Shakespeare. But I know no better tribute to the eternal Hamlet than a prose apostrophe by Anatole France after an evening at the Comédie-Française.

<div align="right">JOHN DOVER WILSON
Hamlet (1934)</div>

DIE SIEBEN SIEGEL

(Oder: das Ja- und Amen-Lied.)

1

Wenn ich ein Wahrsager bin und voll jenes wahr-
sagerischen Geistes, der auf hohem Joche zwischen
zwei Meeren wandelt,—

zwischen Vergangenem und Zukünftigem als schwere
Wolke wandelt,—schwülen Niederungen feind und Allem,
was müde ist und nicht sterben noch leben kann:

zum Blitze bereit im dunklen Busen und zum erlösenden
Lichtstrahle, schwanger von Blitzen, die Ja! sagen, Ja! lachen,
zu wahrsagerischen Blitzstrahlen:—

—selig aber ist der also Schwangere! Und wahrlich,
lange muss als schweres Wetter am Berge hängen, wer einst
das Licht der Zukunft zünden soll!—

Oh wie sollte ich nicht nach der Ewigkeit brünstig sein
und nach dem hochzeitlichen Ring der Ringe,—dem Ring
der Wiederkunft!

Nie noch fand ich das Weib, von dem ich Kinder mochte,
es sei denn dieses Weib, das ich liebe: denn ich liebe dich,
oh Ewigkeit!

Denn ich liebe dich, oh Ewigkeit!

2

Wenn mein Zorn je Gräber brach, Grenzsteine rückte
und alte Tafeln zerbrochen in steile Tiefen rollte:

Wenn mein Hohn je vermoderte Worte zerblies, und ich
wie ein Besen kam den Kreuzspinnen und als Fegewind
alten verdumpften Grabkammern:

Wenn ich je frohlockend sass, wo alte Götter begraben
liegen, weltsegnend, weltliebend neben den Denkmalen alter
Welt-Verleumder:—

—denn selbst Kirchen und Gottes-Gräber liebe ich, wenn
der Himmel erst reinen Auges durch ihre zerbrochenen
Decken blickt; gern sitze ich gleich Gras und rothem Mohne
auf zerbrochnen Kirchen—

Oh wie sollte ich nicht nach der Ewigkeit brünstig sein
und nach dem hochzeitlichen Ring der Ringe,—dem Ring
der Wiederkunft?

Nie noch fand ich das Weib, von dem ich Kinder mochte,
es sei denn dieses Weib, das ich liebe: denn ich liebe dich,
oh Ewigkeit!

Denn ich liebe dich, oh Ewigkeit!

3

Wenn je ein Hauch zu mir kam vom schöpferischen
Hauche und von jener himmlischen Noth, die noch
Zufälle zwingt, Sternen-Reigen zu tanzen:

Wenn ich je mit dem Lachen des schöpferischen Blitzes
lachte, dem der lange Donner der That grollend, aber ge-
horsam nachfolgt:

Wenn ich je am Göttertisch der Erde mit Göttern Würfel
spielte, dass die Erde bebte und brach und Feuerflüsse her-
aufschnob:—

—denn ein Göttertisch ist die Erde, und zitternd von
schöpferischen neuen Worten und Götter-Würfen:—

Oh wie sollte ich nicht nach der Ewigkeit brünstig sein
und nach dem hochzeitlichen Ring der Ringe,—dem Ring
der Wiederkunft?

Nie noch fand ich das Weib, von dem ich Kinder mochte,
es sei denn dieses Weib, das ich liebe: denn ich liebe dich,
oh Ewigkeit!

Denn ich liebe dich, oh Ewigkeit!

4

Wenn ich je vollen Zuges trank aus jenem schäumen-
den Würz- und Mischkruge, in dem alle Dinge gut
gemischt sind:

Wenn meine Hand je Fernstes zum Nächsten goss, und
Feuer zu Geist und Lust zu Leid und Schlimmstes zum
Gütigsten:

Wenn ich selber ein Korn bin von jenem erlösenden
Salze, welches macht, dass alle Dinge im Mischkruge gut sich
mischen:—

—denn es giebt ein Salz, das Gutes mit Bösem bindet;
und auch das Böseste ist zum Würzen würdig und zum
letzten Ueberschäumen:—

Oh wie sollte ich nicht nach der Ewigkeit brünstig sein
und nach dem hochzeitlichen Ring der Ringe,—dem Ring
der Wiederkunft?

Nie noch fand ich das Weib, von dem ich Kinder mochte,
es sei denn dieses Weib, das ich liebe: denn ich liebe dich,
oh Ewigkeit!
Denn ich liebe dich, oh Ewigkeit!

5

Wenn ich dem Meere hold bin und Allem, was Meeres-
Art ist, und am holdesten noch, wenn es mir zornig
widerspricht:

Wenn jene suchende Lust in mir ist, die nach Unent-
decktem die Segel treibt, wenn eine Seefahrer-Lust in meiner
Lust ist:

Wenn je mein Frohlocken rief: „die Küste schwand—
nun fiel mir die letzte Kette ab—

—das Grenzenlose braust um mich, weit hinaus glänzt
mir Raum und Zeit, wohlan! wohlauf! altes Herz!"—

Oh wie sollte ich nicht nach der Ewigkeit brünstig sein
und nach dem hochzeitlichen Ring der Ringe,—dem Ring
der Wiederkunft?

Nie noch fand ich das Weib, von dem ich Kinder mochte,
es sei denn dieses Weib, das ich liebe: denn ich liebe dich,
oh Ewigkeit!

Denn ich liebe dich, oh Ewigkeit!

6

Wenn meine Tugend eines Tänzers Tugend ist, und
ich oft mit beiden Füssen in gold-smaragdenes Ent-
zücken sprang:

Wenn meine Bosheit eine lachende Bosheit ist, heimisch
unter Rosenhängen und Lilien-Hecken:

—im Lachen nämlich ist alles Böse bei einander, aber
heilig- und losgesprochen durch seine eigne Seligkeit:—

Und wenn Das mein A und O ist, dass alles Schwere
leicht, aller Leib Tänzer, aller Geist Vogel werde: und
wahrlich, Das ist mein A und O!—

Oh wie sollte ich nicht nach der Ewigkeit brünstig sein
und nach dem hochzeitlichen Ring der Ringe,—dem Ring
der Wiederkunft?

Nie noch fand ich das Weib, von dem ich Kinder mochte,
es sei denn dieses Weib, das ich liebe: denn ich liebe dich,
oh Ewigkeit!

Denn ich liebe dich, oh Ewigkeit!

Wenn ich je stille Himmel über mir ausspannte und mit eignen Flügeln in eigne Himmel flog:

Wenn ich spielend in tiefen Licht-Fernen schwamm und meiner Freiheit Vogel-Weisheit kam:—

—so aber spricht Vogel-Weisheit: „Siehe, es giebt kein Oben, kein Unten! Wirf dich umher, hinaus, zurück, du Leichter! Singe! sprich nicht mehr!

—sind alle Worte nicht für die Schweren gemacht? Lügen dem Leichten nicht alle Worte! Singe! sprich nicht mehr!"—

Oh wie sollte ich nicht nach der Ewigkeit brünstig sein und nach dem hochzeitlichen Ring der Ringe.—dem Ring der Wiederkunft?

Nie noch fand ich das Weib, von dem ich Kinder mochte, es sei denn dieses Weib, das ich liebe: denn ich liebe dich, oh Ewigkeit!

Denn ich liebe dich, oh Ewigkeit!

THE SEVEN SEALS

(*Or the Yea and Amen Lay.*)

1

If I be a diviner and full of the divining spirit which wandereth on high mountain-ridges, 'twixt two seas,—

Wandereth 'twixt the past and the future as a heavy cloud—hostile to sultry plains, and to all that is weary and can neither die nor live:

Ready for lightning in its dark bosom, and for the redeeming flash of light, charged with lightnings which say Yea! which laugh Yea! ready for divining flashes of lightning:—

—Blessed, however, is he who is thus charged! And verily, long must he hang like a heavy tempest on the mountain, who shall one day kindle the light of the future!—

Oh, how could I not be ardent for Eternity and for the marriage-ring of rings—the ring of the return?

Never yet have I found the woman by whom I should like to have children, unless it be this woman whom I love: for I love thee, O Eternity!

For I love thee, O Eternity!

2

If ever my wrath hath burst graves, shifted landmarks, or rolled old shattered tables into precipitous depths:

If ever my scorn hath scattered mouldered words to the winds, and if I have come like a besom to cross-spiders, and as a cleansing wind to old charnel-houses:

If ever I have sat rejoicing where old Gods lie buried, world-blessing, world-loving, beside the monuments of old world-maligners:—

—For even churches and Gods'-graves do I love, if only heaven looketh through their ruined roofs with pure eyes; gladly do I sit like grass and red poppies on ruined churches—

Oh, how could I not be ardent for Eternity, and for the marriage-ring of rings—the ring of the return?

Never yet have I found the woman by whom I should like to have children, unless it be this woman whom I love: for I love thee, O Eternity!

For I love thee, O Eternity!

3

If ever a breath hath come to me of the creative breath, and of the heavenly necessity which compelleth even chances to dance star-dances:

If ever I have laughed with the laughter of the creative lightning, to which the long thunder of the deed followeth, grumblingly, but obediently:

If ever I have played dice with the Gods at the divine table of the earth, so that the earth quaked and ruptured, and snorted forth fire-streams:—

—For a divine table is the earth, and trembling with new creative dictums and dice-casts of the Gods:

Oh, how could I not be ardent for Eternity, and for the marriage-ring of rings—the ring of the return?

Never yet have I found the woman by whom I should like to have children, unless it be this woman whom I love: for I love thee, O Eternity!

For I love thee, O Eternity!

4

If ever I have drunk a full draught of the foaming spice- and confection-bowl in which all things are well mixed:

If ever my hand hath mingled the furthest with the nearest, fire with spirit, joy with sorrow, and the harshest with the kindest:

If I myself am a grain of the saving salt which maketh everything in the confection-bowl mix well:—

—For there is a salt which uniteth good with evil; and even the evilest is worthy, as spicing and as final overfoaming:—

Oh, how could I not be ardent for Eternity, and for the marriage-ring of rings—the ring of the return?

Never yet have I found the woman by whom I should like to have children, unless it be this woman whom I love: for I love thee, O Eternity!

For I love thee, O Eternity!

5

If I be fond of the sea, and all that is sealike, and fondest of it when it angrily contradicteth me:

If the exploring delight be in me, which impelleth sails to the undiscovered, if the seafarer's delight be in my delight:

If ever my rejoicing hath called out: "The shore hath vanished,— now hath fallen from me the last chain—

The boundless roareth around me, far away sparkle for me space and time,—well! cheer up! old heart!"—

Oh, how could I not be ardent for Eternity, and for the marriage-ring of rings—the ring of the return?

Never yet have I found the woman by whom I should like to have children, unless it be this woman whom I love: for I love thee, O Eternity!

For I love thee, O Eternity!

6

If my virtue be a dancer's virtue, and if I have often sprung with both feet into golden-emerald rapture:

If my wickedness be a laughing wickedness, at home among rose-banks and hedges of lilies:

—For in laughter is all evil present, but it is sanctified and absolved by its own bliss:—

And if it be my Alpha and Omega that everything heavy shall become light, every body a dancer, and every spirit a bird: and verily, that is my Alpha and Omega!—

Oh, how could I not be ardent for Eternity, and for the marriage-ring of rings—the ring of the return?

Never yet have I found the woman by whom I should like to have children, unless it be this woman whom I love: for I love thee, O Eternity!

For I love thee, O Eternity!

7

If ever I have spread out a tranquil heaven above me, and have flown into mine own heaven with mine own pinions:

If I have swum playfully in profound luminous distances, and if my freedom's avian wisdom hath come to me:—

—Thus however speaketh avian wisdom:—"Lo, there is no above and no below! Throw thyself about,—outward, backward, thou light one! Sing! speak no more!

—Are not all words made for the heavy? Do not all words lie to the light ones? Sing! speak no more!"—

Oh, how could I not be ardent for Eternity, and for the marriage-ring of rings—the ring of the return?

Never yet have I found the woman by whom I should like to have children, unless it be this woman whom I love: for I love thee, O Eternity!

For I love thee, O Eternity!

<div align="right">

Also Sprach Zarathustra (1883–85)

Translated by Thomas Common

</div>

To communicate a state, an inner tension of pathos by means of signs, including the tempo of these signs,—that is the meaning of every style; and in view of the fact that the multiplicity of inner states in me is enormous, I am capable of many kinds of style—in short, the most multifarious art of style that any man has ever had at his disposal. Any style is GOOD *which genuinely communicates an inner condition, which does not blunder over the signs, over the tempo of the signs, or over* MOODS— *all the laws of phrasing are the outcome of representing moods artistically. Good style, in itself, is a piece of sheer foolery, mere idealism, like "beauty in itself," for instance, or "goodness in itself," or "the thing-in-itself." All this takes for granted, of course, that there exist ears that can hear, and such men as are capable and worthy of a like pathos, that those are not wanting unto whom one may communicate one's self. . . . No one has ever existed who has had more novel, more strange, and purposely created art forms to fling to the winds. The fact that such things were possible in the German language still awaited proof; formerly, I myself would have denied most emphatically that it was possible. Before my time people did not know what could be done with the German language—what could be done with language in general. The art of grand rhythm, of grand style in periods, for expressing the tremendous fluctuations of sublime and superhuman passion, was first discovered by me: with the dithyramb entitled "The Seven Seals," which constitutes the last discourse of the third part of Zarathustra, I soared miles above all that which heretofore has been called poetry.*

<div align="right">

FRIEDRICH NIETZSCHE

Ecce Homo (1888)

Translated by Anthony M. Ludovici

</div>

GERARD MANLEY HOPKINS

1 8 4 4 — 1 8 8 9

THE LEADEN ECHO
AND THE GOLDEN ECHO

(Maidens' song from St. Winefred's Well)

THE LEADEN ECHO

How to kéep—is there ány any, is there none such, nowhere
 known some, bow or brooch or braid or brace, láce, latch
 or catch or key to keep
Back beauty, keep it, beauty, beauty, beauty, . . . from vanishing
 away?
Ó is there no frowning of these wrinkles, rankèd wrinkles deep,
Dówn? no waving off of these most mournful messengers, still
 messengers, sad and stealing messengers of grey?
No there's none, there's none, O no there's none,
Nor can you long be, what you now are, called fair,
Do what you may do, what, do what you may,
And wisdom is early to despair:
Be beginning; since, no, nothing can be done
To keep at bay
Age and age's evils, hoar hair,
Ruck and wrinkle, drooping, dying, death's worst, winding
 sheets, tombs and worms and tumbling to decay;
So be beginning, be beginning to despair.
O there's none; no no no there's none:
Be beginning to despair, to despair,
Despair, despair, despair, despair.

THE GOLDEN ECHO

 Spare!
There ís one, yes I have one (Hush there!);
Only not within seeing of the sun,
Not within the singeing of the strong sun,
Tall sun's tingeing, or treacherous the tainting of the earth's air,
Somewhere elsewhere there is ah well where! one,
Óne. Yes I can tell such a key, I do know such a place,
Where whatever's prized and passes of us, everything that's
 fresh and fast flying of us, seems to us sweet of us and
 swiftly away with, done away with, undone,

1335

Undone, done with, soon done with, and yet dearly and
 dangerously sweet
Of us, the wimpled-water-dimpled, not-by-morning-matchèd face,
The flower of beauty, fleece of beauty, too too apt to, ah! to fleet,
Never fleets móre, fastened with the tenderest truth
To its own best being and its loveliness of youth: it is an ever-
 lastingness of, O it is an all youth!
Come then, your ways and airs and looks, locks, maiden gear,
 gallantry and gaiety and grace,
Winning ways, airs innocent, maiden manners, sweet looks,
 loose locks, long locks, lovelocks, gaygear, going gallant,
 girlgrace—
Resign them, sign them, seal them, send them, motion them
 with breath,
And with sighs soaring, soaring síghs deliver
Them; beauty-in-the-ghost, deliver it, early now, long before
 death
Give beauty back, beauty, beauty, beauty, back to God, beauty's
 self and beauty's giver.
See; not a hair is, not an eyelash, not the least lash lost; every hair
Is, hair of the head, numbered.
Nay, what we had lighthanded left in surly the mere mould
Will have waked and have waxed and have walked with the wind
 what while we slept,
This side, that side hurling a heavyheaded hundredfold
What while we, while we slumbered.
O then, weary then whý should we tread? O why are we so
 haggard at the heart, so care-coiled, care-killed, so fagged,
 so fashed, so cogged, so cumbered,
When the thing we freely fórfeit is kept with fonder a care,
Fonder a care kept than we could have kept it, kept
Far with fonder a care (and we, we should have lost it) finer, fonder
A care kept.—Where kept? Do but tell us where kept, where.—
Yonder.—What high as that! We follow, now we follow.—
 Yonder, yes yonder, yonder,
Yonder.

<div align="right">(1882)</div>

The most remarkable technical achievement of Victorian poetry.
<div align="right">C E C I L D A Y L E W I S

A Hope for Poetry (1934)</div>

GERARD MANLEY HOPKINS

1844 — 1889

SONNET

Justus quidem tu es, Domine, si disputem tecum: verumtamen justa loquar ad te: Quare via impiorum prosperatur? &c.

> Thou art indeed just, Lord, if I contend
> With thee; but, sir, so what I plead is just.
> Why do sinners' ways prosper? and why must
> Disappointment all I endeavour end?
>
> Wert thou my enemy, O thou my friend,
> How wouldst thou worse, I wonder, than thou dost
> Defeat, thwart me? Oh, the sots and thralls of lust
> Do in spare hours more thrive than I that spend,
> Sir, life upon thy cause. See, banks and brakes
> Now, leavèd how thick! lacèd they are again
> With fretty chervil, look, and fresh wind shakes
> Them; birds build—but not I build; no, but strain,
> Time's eunuch, and not breed one work that wakes.
> Mine, O thou lord of life, send my roots rain.

(1889)

Never, I think, has the just man's complaint against the universe been put more forcibly, worded more tersely and fiercely than in Hopkins's sonnet.

<div align="right">

ALDOUS HUXLEY
Texts & Pretexts (1933)

</div>

GUY DE MAUPASSANT

1850 — 1893

A WINTER LANDSCAPE
IN THE EARLY MORNING

Un rideau de flocons blancs ininterrompu miroitait sans cesse en descendant vers la terre; il effaçait les formes, poudrait les choses d'une mousse de glace; et l'on n'entendait plus, dans le grand silence de la

ville calme et ensevelie sous l'hiver, que ce froissement vague, innommable et flottant, de la neige qui tombe, plutôt sensation que bruit, entremêlement d'atomes légers qui semblaient emplir l'espace, couvrir le monde.

A curtain of glistening snow-flakes descended towards the earth, veiling every human form and covering inanimate objects with an icy fleece. In the intense stillness of the town, plunged in the deep repose of winter, no sound was audible save that vague, indefinable, fluttering whisper of the falling snow, felt rather than heard, the mingling of airy atoms, which seemed to fill all space and envelop the whole world.

<div align="right">

Boule de Suif (1880)
Translated by Marjorie Laurie

</div>

This sentence . . . seems to me one of the most perfect ever written.

<div align="right">

MAURICE BARING
Have You Anything to Declare? (1936)

</div>

ARTHUR RIMBAUD

1854 — 1891

BATEAU IVRE

Comme je descendais des Fleuves impassibles,
Je ne me sentis plus guidé par les haleurs:
Des Peaux-Rouges criards les avaient pris pour cibles,
Les ayant cloués nus aux poteaux de couleurs.

J'étais insoucieux de tous les équipages,
Porteur de blés flamands ou de cotons anglais.
Quand avec mes haleurs ont fini ces tapages,
Les fleuves m'ont laissé descendre où je voulais.

Dans les clapotements furieux des marées,
Moi, l'autre hiver, plus sourd que les cerveaux d'enfants,
Je courus! et les Péninsules démarrées
N'ont pas subi tohu-bohus plus triomphants.

La tempête a béni mes éveils maritimes.
Plus léger qu'un bouchon j'ai dansé sur les flots
Qu'on appelle rouleurs éternels de victimes,
Dix nuits, sans regretter l'œil niais des falots.

Plus douce qu'aux enfants la chair des pommes sures
L'eau verte pénétra ma coque de sapin
Et des taches de vins bleus et des vomissures
Me lava, dispersant gouvernail et grappin.

Et, dès lors, je me suis baigné dans le poème
De la mer infusé d'astres et lactescent,
Dévorant les azurs verts où, flottaison blême
Et ravie, un noyé pensif, parfois, descend;

Où, teignant tout à coup les bleuités, délires
Et rhythmes lents sous les rutilements du jour,
Plus fortes que l'alcool, plus vastes que vos lyres,
Fermentent les rousseurs amères de l'amour!

Je sais les cieux crevant en éclairs, et les trombes
Et les ressacs et les courants; je sais le soir,
L'aube exaltée ainsi qu'un peuple de colombes,
Et j'ai vu quelquefois ce que l'homme a cru voir.

J'ai vu le soleil bas taché d'horreurs mystiques
Illuminant de longs figements violets,
Pareils à des acteurs de drames très antiques,
Les flots roulant au loin leurs frissons de volets.

J'ai rêvé la nuit verte aux neiges éblouies,
Baisers montant aux yeux des mers avec lenteur,
La circulation des sèves inouïes
Et l'éveil jaune et bleu des phosphores chanteurs.

J'ai suivi, des mois pleins, pareille aux vacheries
Hystériques, la houle à l'assaut des récifs,
Sans songer que les pieds lumineux des Maries
Pussent forcer le muffle aux Océans poussifs.

J'ai heurté, savez-vous? d'incroyables Florides
Mêlant aux fleurs des yeux de panthères aux peaux
D'hommes, des arcs-en-ciel tendus comme des brides,
Sous l'horizon des mers, à de glauques troupeaux.

J'ai vu fermenter les marais, énormes nasses
Où pourrit dans les joncs tout un Léviathan,
Des écroulements d'eaux au milieu des bonaces
Et les lointains vers les gouffres cataractant!

Glaciers, soleils d'argent, flots nacreux, cieux de braises,
Échouages hideux au fond des golfes bruns
Où les serpents géants dévorés des punaises
Choient des arbres tordus avec de noirs parfums!

J'aurais voulu montrer aux enfants ces dorades
Du flot bleu, ces poissons d'or, ces poissons chantants.
Des écumes de fleurs ont béni mes dérades,
Et d'ineffables vents m'ont ailé par instants.

Parfois, martyr lassé des pôles et des zones,
La mer, dont le sanglot faisait mon roulis doux,
Montait vers moi ses fleurs d'ombre aux ventouses jaunes
Et je restais ainsi qu'une femme à genoux,

Presqu'île ballottant sur mes bords les querelles
Et les fientes d'oiseaux clabaudeurs aux yeux blonds,
Et je voguais lorsqu'à travers mes liens frêles
Des noyés descendaient dormir à reculons . . .

Or, moi, bateau perdu sous les cheveux des anses,
Jeté par l'ouragan dans l'éther sans oiseau,
Moi dont les Monitors et les voiliers des Hanses
N'auraient pas repêché la carcasse ivre d'eau,

Libre, fumant, monté de brumes violettes,
Moi qui trouais le ciel rougeoyant comme un mur
Qui porte, confiture exquise aux bons poètes,
Des lichens de soleil et des morves d'azur,

Qui courais taché de lunules électriques,
Planche folle, escorté des hippocampes noirs,
Quand les Juillets faisaient crouler à coups de triques
Les cieux ultramarins aux ardents entonnoirs,

Moi qui tremblais, sentant geindre à cinquante lieues
Le rut des Béhémots et des Maelstroms épais,
Fileur éternel des immobilités bleues,
Je regrette l'Europe aux anciens parapets.

J'ai vu des archipels sidéraux! et des îles
Dont les cieux délirants sont ouverts au vogueur:
Est-ce en ces nuits sans fond que tu dors et t'exiles,
Million d'oiseaux d'or, ô future Vigueur?

Mais, vrai, j'ai trop pleuré. Les aubes sont navrantes,
Toute lune est atroce et tout soleil amer.
L'âcre amour m'a gonflé de torpeurs enivrantes.
Oh! que ma quille éclate! Oh! que j'aille à la mer!

Si je désire une eau d'Europe, c'est la flache
Noire et froide où vers le crépuscule embaumé
Un enfant accroupi, plein de tristesse, lâche
Un bateau frêle comme un papillon de mai.

Je ne puis plus, baigné de vos langueurs, ô lames,
Enlever leur sillage aux porteurs de cotons,
Ni traverser l'orgueil des drapeaux et des flammes,
Ni nager sous les yeux horribles des pontons!

THE DRUNKEN BOAT

As I proceeded down along impassive rivers,
I lost my crew of haulers; they'd been seized by hosts
Of whooping Redskins, who had emptied out their quivers
Against these naked targets, nailed to coloured posts.

Little I cared for any crew I bore, a rover
With Flemish wheat or English cottons in my hold.
When once the tribulations of my crew were over,
The rivers let me go where my own fancy told.

Amid the fury of the loudly chopping tide,
I, just last winter, with a child's insensate brain,
Ah, how I raced! And no Peninsulas untied
Were ever tossed in more triumphant hurricane.

The blessing of the storm on my sea-watch was shed.
More buoyant than a cork I darted for ten nights
Over the waves, those famed old trundlers of the dead,
Nor missed the foolish blink of homely warning lights.

The wash of the green water on my shell of pine,
Sweeter than apples to a child its pungent edge;
It cleansed me of the stains óf vomits and blue wine
And carried off with it the rudder and the kedge.

And afterwards down through the poem of the sea,
A milky foam infused with stars, frantic I dive
Down through green heavens where, descending pensively,
Sometimes the pallid remnants of the drowned arrive;

Where suddenly the bluish tracts dissolve, desires
And rhythmic languors stir beneath the day's full glow.
Stronger than alcohol and vaster than your lyres,
The bitter humours of fermenting passion flow!

I know how lightning splits the skies, the current roves;
I know the surf and waterspouts and evening's fall;
I've seen the dawn arisen like a flock of doves;
Sometimes I've seen what men believe they can recall.

I've seen the low sun blotched with blasphemies sublime,
Projecting vividly long, violet formations
Which, like tragedians in very ancient mime
Bestride the latticed waves, that speed remote vibrations.

My dreams were of green night and its bedazzled snow,
Of kisses slowly mounting up to the sea's eyes,
Of winding courses where unheard-of fluids go,
Flares blue and yellow that from singing phosphors rise.

For whole months at a time I've ridden with the surge
That like mad byres a-toss keeps battering the reefs,
Nor thought that the bright touch of Mary's feet could urge
A muzzle on the seas, muting their wheezy griefs.

And, yes, on Florida's beyond belief I've fetched,
Where flowers and eyes of panthers mingle in confusion,
Panthers with human skin, rainbows like bridles stretched
Controlling glaucous herds beneath the sea's horizon.

I've seen fermenting marshes like huge lobster-traps
Where in the rushes rots a whole Leviathan,
Or in the midst of calm the water's face collapse
And cataracts pour in from all the distant span.

Glaciers, silver suns, pearl waves and skies afire,
Brown gulfs with loathsome strands in whose profundities
Huge serpents, vermin-plagued, drop down into the mire
With black effluvium from the contorted trees!

I longed to show the children how the dolphins sport
In the blue waves, these fish of gold, these fish that sing.
Flowers of foam have blessed my puttings-out from port,
Winds from I know not where at times have lent me wing.

And often, weary martyr of the poles and zones,
Dark blooms with yellow mouths reached towards me from the seas
On which I gently rocked, in time to their soft moans;
And I was left there like a woman on her knees.

Trembling peninsula, upon my decks I tossed
The dung of pale-eyed birds and clacking, angry sound;
And on I sailed while down through my frail cordage crossed
The sleeping, backwards falling bodies of the drowned.

I, lost boat in the hair of estuaries caught,
Hurled by the cyclone to a birdless apogee,
I, whom the Monitors and Hansamen had thought
Nor worth the fishing up—a carcase drunk with sea;

Free, smoking, touched with mists of violet above,
I, who the lurid heavens breached like some rare wall
Which boasts—confection that the goodly poets love—
Lichens of sunlight on a mucoid azure pall;

Who, with electric moons bedaubed, sped on my way,
A plank gone wild, black hippocamps my retinue,
When in July, beneath the cudgels of the day
Down fell the heavens and the craters of the blue;

I, trembling at the mutter, fifty leagues from me,
Of rutting Behemoths, the turbid Maelstrom's threats,
Spinning a motionless and blue eternity
I long for Europe, land of ancient parapets.

Such starry archipelagoes! Many an isle
With heavens fiercely to the wanderer wide-thrown;
Is it these depthless nights that your lone sleep beguile,
A million golden birds, O Vigour not yet known?

And yet, I've wept too much. The dawns are sharp distress,
All moons are baleful and all sunlight harsh to me
Swollen by acrid love, sagging with drunkenness –
Oh, that my keel might rend and give me to the sea!

If there's a water in all Europe that I crave,
It is the cold, black pond where 'neath the scented sky
Of eve a crouching infant, sorrowfully grave,
Launches a boat as frail as a May butterfly.

Soaked in your languors, waves, I can no more go hunting
The cotton-clippers' wake, no more can enterprise
Amid the proud displays of lofty flags and bunting,
Nor swim beneath the convict-hulks' appalling eyes!

(1871)

Translated by Norman Cameron

One of the most remarkable poems in the whole of literature, a completely original poem.

MARY M. COLUM
From These Roots (1938)

FROM A SEASON IN HELL

Je suis esclave de l'Époux infernal, celui qui a perdu les vierges folles. . . .

Je suis veuve . . .–J'étais veuve.–mais oui, j'ai été bien sérieuse jadis, et je ne suis pas née pour devenir squelette! . . .–Lui était presque un enfant . . . Ses délicatesses mystérieuses m'avaient séduite. J'ai oublié tout mon devoir humain pour le suivre. Quelle vie! La vraie vie est absente. Nous ne sommes pas au monde. Je vais où il va, il le faut. Et souvent il s'emporte contre moi, *moi, la pauvre âme*. Le Démon! –C'est un démon, vous savez, *ce n'est pas un homme*. . . .

Je l'écoute faisant de l'infamie une gloire, de la cruauté un charme. . . .

Il avait la pitié d'une mère méchante pour les petits enfants. . . .

A côté de son cher corps endormi, que d'heures des nuits j'ai veillé, cherchant pourquoi il voulait tant s'évader de la réalité. . . . Je reconnaissais,–sans craindre pour lui,–qu'il pouvait être un sérieux danger dans la société.–Il a peut-être des secrets pour *changer la vie?* . . . Hélas! je dépendais bien de lui. Mais que voulait-il avec mon existence terne et lâche? . . .

J'avais de plus en plus faim de sa bonté. . . .

Par instants, j'oublie la pitié où je suis tombée: lui me rendra forte, nous voyagerons, nous chasserons dans les déserts, nous dormirons sur les pavés des villes inconnues, sans soins, sans peines. Ou je me réveillerai, et les lois et les mœurs auront changé,–grâce à son pouvoir magique. . . .

Il m'attaque, il passe des heures à me faire honte de tout ce qui m'a pu toucher au monde, et s'indigne si je pleure. . . .

Hélas! il y avait des jours où tous les hommes agissant lui paraissaient les jouets de délires grotesques; il riait affreusement, longtemps.– Puis, il reprenait ses manières de jeune mère, de sœur aînée. S'il était moins sauvage, nous serions sauvés! Mais sa douceur aussi est mortelle. Je lui suis soumise.–Ah! je suis folle! . . .

Drôle de ménage!

I am the slave of the infernal Spouse, he who ruined the foolish virgins. . . .

I am a widow. . . . I was a widow. . . . Why yes, formerly I was very serious, and not born to become a skeleton! . . . He was almost a child! . . . His mysterious tendernesses seduced me. To follow him I forgot the whole of my human duty. What a life! The true life was absent. We were not in the world. Where he went I followed, for it had

to be so. And often he declaimed against me—*I, the poor soul*. Demon!--
He is a Demon, you know; *he is not a man*. . . .

I listened to him as he converted infamy into a glory and cruelty
into a charm. . . .

For little children he showed the pity of an ill-natured mother. . . .

At the side of his dear, slumbering body, how many nocturnal hours
have I not kept awake, seeking for the reason why he wished so
earnestly to escape from reality. . . . I recognized—but without fear-
ing for him—that he might be a serious danger in society.—Perhaps he
has secret reasons for *changing his life*? . . . Alas! I was indeed sub-
ject to him. But what did he want with my dull and cowardly exist-
ence? . . .

I hungered more and more for his kindness. . . .

At moments I forget the pitiful state into which I have fallen. He will
restore me to strength; we shall travel and hunt in the deserts; we
shall sleep on the stones of unknown cities, unheeded, without vexations.
Or I shall awaken, and laws and morals will have changed,—thanks to
his magic power. . . .

He attacks me; he spends hours making me ashamed of everything
in the world which has had the power to touch me; and he becomes
indignant if I weep. . . .

Alas! he had days when all men of action appeared to him to be
the playthings of grotesque frenzies: he laughed both terribly and long.
—Then he resumed his manners as of a young mother, or beloved sister.
If he were less savage we should be saved. But his gentleness also is
deadly. I am under his power.—Ah! I am insane! . . .

Strange household!

<div style="text-align: right">

Une Saison en enfer (1873)
Translated by George Frederic Lees

</div>

*In all literature it would be difficult to find a more cruel or a more
revelatory piece of writing.*

<div style="text-align: right">

HAROLD NICOLSON
Paul Verlaine (1921)

</div>

ARTHUR RIMBAUD

1 8 5 4 — 1 8 9 1

MEMOIRE

I

L'eau claire; comme le sel des larmes d'enfance;
L'assaut au soleil des blancheurs des corps de femmes;
La soie, en foule et de lys pur, des oriflammes
Sous les murs dont quelque pucelle eut la défense;

L'ébat des anges,—non . . . le courant d'or en marche,
Meut ses bras, noirs et lourds et frais surtout, d'herbe. Elle,
Sombre, ayant le ciel bleu pour ciel de lit, appelle
Pour rideaux l'ombre de la colline et de l'arche.

II

Et l'humide carreau tend ses bouillons limpides!
L'eau meuble d'or pâle et sans fond les couches prêtes.
Les robes vertes et déteintes des fillettes
Font les saules, d'où sautent les oiseaux sans brides.

Plus jaune qu'un louis, pure et chaude paupière,
Le souci d'eau—ta foi conjugale, ô l'Épouse!—
Au midi prompt, de son terne miroir, jalouse
Au ciel gris de chaleur la sphère rose et chère.

III

Madame se tient trop debout dans la prairie
Prochaine où neigent les fils du travail; l'ombrelle
Aux doigts; foulant l'ombrelle; trop fière pour elle
Des enfants lisant dans la verdure fleurie

Leur livre de maroquin rouge. Hélas, Lui, comme
Mille anges blancs qui se séparent sur la route,
S'éloigne par delà la montagne; Elle, toute
Froide et noire, court! après le départ de l'homme!

IV

Regrets des bras épais et jeunes d'herbe pure!
Or des lunes d'avril au cœur du saint lit! joie
Des chantiers riverains à l'abandon, en proie
Aux soirs d'août qui faisaient germer ces pourritures!

Qu'elle pleure à présent sous les remparts; l'haleine
Des peupliers d'en haut est pour la seule brise.
Puis, c'est la nappe, sans reflets, source grise;
Un vieux dragueur, dans sa barque immobile, peine.

V

Jouet de cet œil d'eau morne, je n'y puis prendre,
O canot immobile! ô bras trop courts! ni l'une
Ni l'autre fleur; ni la jaune qui m'importune,
Là; ni la bleue, amis, à l'eau couleur de cendre.

Ah, la poudre des saules qu'une aile secoue!
Les roses des roses dès longtemps dévorées! . .
Mon canot toujours fixe; et sa chaîne tirée
Au fond de cet œil d'eau sans bords—à quelle boue?

MEMORY

I

Clear water; like the salt of childhood tears;
The assault in the sunlight of the whiteness of women's bodies;
The silk of banners, in masses and of pure lily,
Under the walls whose defense a maid held;

The play of angels,—no . . . the golden current in progress,
Moves its arms, black, heavy, and above all cool, of grass. The water,
Dark, having the blue sky for the sky's bed, calls up
For curtains the shadow of the hill and the arch.

II

And the wet stones extend their clear moisture!
The water furnishes the prepared beds with bottomless pale gold.
The green faded dresses of the girls
Are willow trees, out of which hop reinless birds.

More golden than a louis, pure and warm eyelid,
The care of the water—your conjugal faith, O Spouse!—
At prompt noon, from its tarnished mirror, jealous
In the sky grey with heat the rose and precious sphere.

The mother stands too upright in the field
Nearby where the sons of work appear white; the parasol
In her fingers; crushing the flowers too proud for her,
Children reading in the flowered grass

Their book of morocco leather. Alas, he, like
A thousand white angels separating on the road,
Goes off beyond the mountain; she, all
Cold and dark, runs off! after the man's departure!

IV

Regrets of arms thick and young with pure grass!
Gold of April moons in the heart of the holy bed; joy
Of abandoned river lumber yards, a prey
To August nights which caused the rotting to germinate!

Let her weep now under the walls: the breath
Of the poplars above is for the wind alone.
Then, here is the surface, with no reflection, grey water,
An old dredger, in his motionless boat, labors.

V

Toy of this eye of sad water, I can seize,
O motionless boat, O too short arms, neither this
Nor the other flower; neither the yellow one which troubles me,
There; nor the blue one, friends, in the ash colored water.

Ah, the powder of the willows which one wing shakes!
The roses of the reeds devoured long ago!
My boat still fixed; and its chain pulled
In the depths of that rimless watery eye—from what mud?

Translated by Wallace Fowlie

The purest expression in the French language of poetic fervor and beauty.

WALLACE FOWLIE
Rimbaud (1946)

OSCAR WILDE

1 8 5 6 — 1 9 0 0

PARABLE

Christ came from a white plain to a purple city, and as He passed through the first street, He heard voices overhead, and saw a young man lying drunk upon a window-sill, "Why do you waste your soul in drunkenness?" He said. "Lord, I was a leper and You healed me, what else can I do?" A little further through the town He saw a young man following a harlot, and said, "Why do you dissolve your soul in debauchery?" and the young man answered, "Lord, I was blind, and You healed me, what else can I do?" At last in the middle of the city He saw an old man crouching, weeping upon the ground, and when He asked why he wept, the old man answered, "Lord, I was dead, and You raised me into life, what else can I do but weep?"

He has written what he calls the best short story in the world, and will have it that he repeats it to himself on getting out of bed and before every meal. . . . Wilde published that story a little later, but spoiled it with the verbal decoration of his epoch, and I have to repeat it to myself as I first heard it, before I can see its terrible beauty. I no more doubt its sincerity than I doubt that his parade of gloom, all that late rising, and sleeping away his life, that elaborate playing with tragedy, was an attempt to escape from an emotion by its exaggeration.

<div align="right">

WILLIAM BUTLER YEATS
Autobiographies (1926)

</div>

SIR WILLIAM WATSON

1 8 5 8 — 1 9 3 5

HYMN TO THE SEA

I

Grant, O regal in bounty, a subtle and delicate largess;
 Grant an ethereal alms, out of the wealth of thy soul:
Suffer a tarrying minstrel, who finds, not fashions his numbers—
 Who, from the commune of air, cages the volatile song—

Lightly to capture and prison some fugitive breath of thy descant,
 Thine and his own as thy roar lisped on the lips of a shell,
Now while the vernal impulsion makes lyrical all that hath language,
 While, through the veins of the Earth, riots the ichor of spring,
While, amid throes, amid raptures, with loosing of bonds, with
 unsealings—
 Arrowy pangs of delight, piercing the core of the world—
Tremors and coy unfoldings, reluctances, sweet agitations—
 Youth, irrepressibly fair, wakes like a wondering rose.

II

Lover whose vehement kisses on lips irresponsive are squandered,
 Lover that wooest in vain Earth's imperturbable heart;
Athlete mightily frustrate, who pittest thy thews against legions,
 Locked with fantastical hosts, bodiless arms of the sky;
Sea that breakest for ever, that breakest and never art broken,
 Like unto thine, from of old, springeth the spirit of man—
Nature's wooer and fighter, whose years are a suit and a wrestling,
 All their hours, from his birth, hot with desire and with fray;
Amorist agonist man, that, immortally pining and striving,
 Snatches the glory of life only from love and from war;
Man that, rejoicing in conflict, like thee when precipitate tempest,
 Charge after thundering charge, clangs on thy resonant mail,
Seemeth so easy to shatter, and proveth so hard to be cloven;
 Man whom the gods, in his pain, curse with a soul that endures;
Man whose deeds, to the doer, come back as thine own exhalations
 Into thy bosom return, weepings of mountain and vale;
Man with the cosmic fortunes and starry vicissitudes tangled,
 Chained to the wheel of the world, blind with the dust of its speed,
Even as thou, O giant, whom trailed in the wake of her conquests
 Night's sweet despot draws, bound to her ivory car;
Man with inviolate caverns, impregnable holds in his nature,
 Depths no storm can pierce, pierced with a shaft of the sun:
Man that is galled with his confines, and burdened yet more with his
 vastness,
 Born too great for his ends, never at peace with his goal;
Man whom Fate, his victor, magnanimous, clement in triumph,
 Holds as a captive king, mewed in a palace divine:
Many its leagues of pleasance, and ample of purview its windows;
 Airily falls, in its courts, laughter of fountains at play;
Nought, when the harpers are harping, untimely reminds him of
 durance;
 None, as he sits at the feast, utters Captivity's name;

But, would he parley with Silence, withdraw for a while unattended,
　　Forth to the beckoning world 'scape for an hour and be free,
Lo, his adventurous fancy coercing at once and provoking,
　　Rise the unscalable walls, built with a word at the prime;
Lo, in unslumbering watch, and with pitiless faces of iron,
　　Armed at each obstinate gate, stand the impassable guards.

III

Miser whose coffered recesses the spoils of the ages cumber,
　　Spendthrift foaming thy soul wildly in fury away—
We, self-amorous mortals, our own multitudinous image
　　Seeking in all we behold, seek it and find it in thee:
Seek it and find it when o'er us the exquisite fabric of Silence
　　Perilous-turreted hangs, trembles and dulcetly falls;
When the aërial armies engage amid orgies of music,
　　Braying of arrogant brass, whimper of querulous reeds;
When, at his banquet, the Summer is languid and drowsed with
　　　repletion;
　　When, to his anchorite board, taciturn Winter repairs;
When by the tempest are scattered magnificent ashes of Autumn;
　　When, upon orchard and lane, breaks the white foam of the Spring:
When, in extravagant revel, the Dawn, a bacchante up-leaping,
　　Spills, on the tresses of Night, vintages golden and red;
When, as a token at parting, munificent Day, for remembrance,
　　Gives, unto men that forget, Ophirs of fabulous ore;
When irresistibly rushing, in luminous palpitant deluge,
　　Hot from the summits of Life, poured is the lava of noon;
When, as up yonder, thy mistress, at height of her mutable glories,
　　Wise from the magical East, comes like a sorceress pale.
Ah, she comes, she arises—impassive, emotionless, bloodless,
　　Wasted and ashen of cheek, zoning her ruins with pearl.
Once she was warm, she was joyous, desire in her pulses abounding:
　　Surely thou lovedst her well, then, in her conquering youth!
Surely not all unimpassioned, at sound of thy rough serenading,
　　She, from the balconied night, unto her melodist leaned—
Leaned unto thee, her bondsman, who keepest to-day her
　　　commandments,
　　All for the sake of old love, dead at thy heart though it lie.

IV

Yea, it is we, light perverts, that waver, and shift our allegiance;
　　We, whom insurgence of blood dooms to be barren and waste.
Thou, with punctual service, fulfillest thy task, being constant;
　　Thine but to ponder the Law, labour and greatly obey:

Wherefore, with leapings of spirit, thou chantest the chant of the
 faithful;
 Led by the chime of the worlds, linked with the league of the stars;
Thou thyself but a billow, a ripple, a drop of that Ocean,
 Which, labyrinthine of arm, folding us meshed in its coil,
Shall, as to-night, with elations, august exultations and ardours,
 Pour, in unfaltering tide, all its unanimous waves,
When, from this threshold of being, these steps of the Presence, this
 precinct,
 Into the matrix of Life darkly divinely resumed,
Man and his littleness perish, erased like an error and cancelled,
 Man and his greatness survive, lost in the greatness of God.

<div align="right">(1895)</div>

Probably the best hexameters which have been composed in English.
<div align="right">J O H N C H U R T O N C O L L I N S
Ephemera Critica (1901)</div>

J O H N A N D R E W H A M I L T O N,
L O R D S U M N E R O F I B S T O N E

1 8 5 9 — 1 9 3 4

THE LIMITS OF RELIGIOUS TOLERATION

The words, as well as the acts, which tend to endanger society differ
from time to time in proportion as society is stable or insecure in fact, or
is believed by its reasonable members to be open to assault. In the
present day meetings or processions are held lawful which a hundred
and fifty years ago would have been deemed seditious, and this is not
because the law is weaker or has changed, but because, the times hav-
ing changed, society is stronger than before. In the present day reason-
able men do not apprehend the dissolution or the downfall of society
because religion is publicly assailed by methods not scandalous.
Whether it is possible that in the future irreligious attacks, designed
to undermine fundamental institutions of our society, may come to be
criminal in themselves, as constituting a public danger, is a matter that
does not arise. The fact that opinion grounded on experience has moved
one way does not in law preclude the possibility of its moving on fresh
experience in the other; nor does it bind succeeding generations, when
conditions have again changed. After all, the question whether a given
opinion is a danger to society is a question of the times and is a question

of fact. I desire to say nothing that would limit the right of society to protect itself by process of law from the dangers of the moment, whatever that right may be, but only to say that, experience having proved dangers once thought real to be now negligible, and dangers once very possibly imminent to have now passed away, there is nothing in the general rules as to blasphemy and irreligion, as known to the law, which prevents us from varying their application to the particular circumstances of our time in accordance with that experience. If these considerations are right, and the attitude of the law both civil and criminal towards all religions depends fundamentally on the safety of the State and not on the doctrines or metaphysics of those who profess them, it is not necessary to consider whether or why any given body was relieved by the law at one time or frowned on at another, or to analyse creeds and tenets, Christian and other.

<div align="right">Bowman v. Secular Society, Ltd. (1917) A.C. 406</div>

One of the finest pieces of prose to be found in the law reports.

<div align="right">SIR WILLIAM S. HOLDSWORTH
Essays in Law and History (1946)</div>

FRANCIS THOMPSON

1 8 5 9 — 1 9 0 7

THE HOUND OF HEAVEN

I fled Him, down the nights and down the days;
 I fled Him, down the arches of the years;
I fled Him, down the labyrinthine ways
 Of my own mind; and in the mist of tears
I hid from Him, and under running laughter.
 Up vistaed hopes I sped;
 And shot, precipitated,
Adown Titanic glooms of chasmèd fears,
 From those strong Feet that followed, followed after.
 But with unhurrying chase,
 And unperturbèd pace,
 Deliberate speed, majestic instancy,
 They beat—and a Voice beat
 More instant than the Feet—
'All things betray thee, who betrayest Me.'

I pleaded, outlaw-wise,
By many a hearted casement, curtained red,
 Trellised with intertwining charities;
(For, though I knew His love Who followèd,
 Yet was I sore adread
Lest, having Him, I must have naught beside.)
But, if one little casement parted wide,
 The gust of His approach would clash it to:
 Fear wist not to evade, as Love wist to pursue.
Across the margent of the world I fled,
 And troubled the gold gateways of the stars,
 Smiting for shelter on their clangèd bars;
 Fretted to dulcet jars
And silvern chatter the pale ports o' the moon.
I said to Dawn: Be sudden—to Eve: Be soon;
 With thy young skiey blossoms heap me over
 From this tremendous Lover—
Float thy vague veil about me, lest He see!
 I tempted all His servitors, but to find
My own betrayal in their constancy,
In faith to Him their fickleness to me,
 Their traitorous trueness, and their loyal deceit.
To all swift things for swiftness did I sue;
 Clung to the whistling mane of every wind.
 But whether they swept, smoothly fleet,
 The long savannahs of the blue;
 Or whether, Thunder-driven,
 They clanged his chariot 'thwart a heaven,
Plashy with flying lightnings round the spurn o' their feet:—
 Fear wist not to evade as Love wist to pursue.
 Still with unhurrying chase,
 And unperturbèd pace,
 Deliberate speed, majestic instancy,
 Came on the following Feet,
 And a Voice above their beat—
 'Naught shelters thee, who wilt not shelter Me.'

I sought no more that after which I strayed
 In face of man or maid;
But still within the little children's eyes
 Seems something, something that replies,
They at least are for me, surely for me!
I turned me to them very wistfully;
But just as their young eyes grew sudden fair
 With dawning answers there,

1354

Their angel plucked them from me by the hair.
'Come then, ye other children, Nature's—share
With me' (said I) 'your delicate fellowship;
 Let me greet you lip to lip,
 Let me twine with you caresses,
 Wantoning
 With our Lady-Mother's vagrant tresses,
 Banqueting
 With her in her wind-walled palace,
 Underneath her azured daïs,
 Quaffing, as your taintless way is,
 From a chalice
Lucent-weeping out of the dayspring.'
 So it was done:
I in their delicate fellowship was one—
Drew the bolt of Nature's secrecies.
 I knew all the swift importings
 On the wilful face of skies;
 I knew how the clouds arise
 Spumèd of the wild sea-snortings;
 All that's born or dies
 Rose and drooped with; made them shapers
Of mine own moods, or wailful or divine;
 With them joyed and was bereaven.
 I was heavy with the even,
 When she lit her glimmering tapers
 Round the day's dead sanctities.
 I laughed in the morning's eyes.
I triumphed and I saddened with all weather,
 Heaven and I wept together,
And its sweet tears were salt with mortal mine:
Against the red throb of its sunset-heart
 I laid my own to beat,
 And share commingling heat;
But not by that, by that, was eased my human smart.
In vain my tears were wet on Heaven's grey cheek.
For ah! we know not what each other says,
 These things and I; in sound *I* speak—
Their sound is but their stir, they speak by silences.
Nature, poor stepdame, cannot slake my drouth;
 Let her, if she would owe me,
Drop yon blue bosom-veil of sky, and show me
 The breasts o' her tenderness:
Never did any milk of hers once bless
 My thirsting mouth.

Nigh and nigh draws the chase,
With unperturbèd pace,
Deliberate speed, majestic instancy;
And past those noisèd Feet
A voice comes yet more fleet—
'Lo! naught contents thee, who content'st not Me.'

Naked I wait Thy love's uplifted stroke!
My harness piece by piece Thou hast hewn from me,
And smitten me to my knee;
I am defenceless utterly.
I slept, methinks, and woke,
And, slowly gazing, find me stripped in sleep.
In the rash lustihead of my young powers,
I shook the pillaring hours
And pulled my life upon me; grimed with smears,
I stand amid the dust o' the mounded years—
My mangled youth lies dead beneath the heap.
My days have crackled and gone up in smoke,
Have puffed and burst as sun-starts on a stream.
Yea, faileth now even dream
The dreamer, and the lute the lutanist;
Even the linked fantasies, in whose blossomy twist
I swung the earth a trinket at my wrist,
Are yielding; cords of all too weak account
For earth with heavy griefs so overplussed.
Ah! is Thy love indeed
A weed, albeit an amaranthine weed,
Suffering no flowers except its own to mount?
Ah! must—
Designer infinite!—
Ah! must Thou char the wood ere Thou canst limn with it?
My freshness spent its wavering shower i' the dust;
And now my heart is as a broken fount,
Wherein tear-drippings stagnate, spilt down ever
From the dank thoughts that shiver
Upon the sighful branches of my mind.
Such is; what is to be?
The pulp so bitter, how shall taste the rind?
I dimly guess what Time in mists confounds;
Yet ever and anon a trumpet sounds
From the hid battlements of Eternity;
These shaken mists a space unsettle, then
Round the half-glimpsèd turrets slowly wash again.

But not ere him who summoneth
I first have seen, enwound
With glooming robes purpureal, cypress-crowned;
His name I know, and what his trumpet saith.
Whether man's heart or life it be which yields
Thee harvest, must Thy harvest-fields
Be dunged with rotten death?

Now of that long pursuit
Comes on at hand the bruit;
That Voice is round me like a bursting sea:
'And is thy earth so marred,
Shattered in shard on shard?
Lo, all things fly thee, for thou fliest Me!
Strange, piteous, futile thing!
Wherefore should any set thee love apart?
Seeing none but I makes much of naught' (He said),
'And human love needs human meriting:
How hast thou merited—
Of all man's clotted clay the dingiest clot?
Alack, thou knowest not
How little worthy of any love thou art!
Whom wilt thou find to love ignoble thee,
Save Me, save only Me?
All which I took from thee I did but take,
Not for thy harms,
But just that thou might'st seek it in My arms.
All which thy child's mistake
Fancies as lost, I have stored for thee at home:
Rise, clasp My hand, and come!'
Halts by me that footfall:
Is my gloom, after all,
Shade of His hand, outstretched caressingly?
'Ah, fondest, blindest, weakest,
I am He Whom thou seekest!
Thou dravest love from thee, who dravest Me.'

Poems (1893)

The 'Hound of Heaven' has so great and passionate and such a metre-creating motive, that we are carried over all obstructions of the rhythmical current, and are compelled to pronounce it, at the end, one of the very few 'great' odes of which the language can boast.

COVENTRY PATMORE

Francis Thompson, A New Poet (Fortnightly Review, 1894)

LE VASE

Mon marteau lourd sonnait dans l'air léger,
Je voyais la rivière et le verger,
La prairie et jusques au bois
Sous le ciel plus bleu d'heure en heure,
Puis rose et mauve au crépuscule;
Alors je me levais tout droit
Et m'étirais heureux de la tâche des heures,
Gourd de m'être accroupi de l'aube au crépuscule
Devant le bloc de marbre où je taillais les pans
Du vase fruste encor que mon marteau pesant,
Rythmant le matin clair et la bonne journée,
Heurtait, joyeux d'être sonore en l'air léger!

Le vase naissait dans la pierre façonnée.
Svelte et pur il avait grandi
Informe encor en sa sveltesse,
Et j'attendis,
Les mains oisives et inquiètes,
Pendant des jours, tournant la tête
A gauche, à droite, au moindre bruit,
Sans plus polir la panse ou lever le marteau.
L'eau
Coulait de la fontaine comme haletante.
Dans le silence
J'entendais, un à un, aux arbres du verger,
Les fruits tomber de branche en branche,
Je respirais un parfum messager
De fleurs lointaines sur le vent;
Souvent,
Je croyais qu'on avait parlé bas,
Et, un jour que je rêvais—ne dormant pas—
J'entendis par delà les prés et la rivière
Chanter des flûtes . . .

Un jour, encor,
Entre les feuilles d'ocre et d'or
Du bois, je vis, avec ses jambes de poil jaune,
Danser un faune;
Je l'aperçus aussi, une autre fois,
Sortir du bois

Le long de la route et s'asseoir sur une borne
Pour prendre un papillon à l'une de ses cornes.

Une autre fois,
Un centaure passa la rivière à la nage;
L'eau ruisselait sur sa peau d'homme et son pelage;
Il s'avança de quelques pas dans les roseaux,
Flaira le vent, hennit, repassa l'eau;
Le lendemain, j'ai vu l'ongle de ses sabots
Marqué dans l'herbe . . .

Des femmes nues
Passèrent en portant des paniers et des gerbes,
Très loin, tout au bout de la plaine.
Un matin, j'en trouvai trois à la fontaine
Dont l'une me parla. Elle était nue.
Elle me dit: Sculpte la pierre
Selon la forme de mon corps en tes pensées,
Et fais sourire au bloc ma face claire;
Écoute autour de toi les heures dansées
Par mes sœurs dont la ronde se renoue,
Entrelacée,
Et tourne et chante et se dénoue.

Et je sentis sa bouche tiède sur ma joue.

Alors le verger vaste et le bois et la plaine
Tressaillirent d'un bruit étrange, et la fontaine
Coula plus vive avec un rie dans ses eaux;
Les trois Nymphes debout auprès des trois roseaux
Se prirent par la main et dansèrent; du bois
Les faunes roux sortaient par troupes, et des voix
Chantèrent par delà les arbres du verger
Avec des flûtes en éveil dans l'air léger.
La terre retentit du galop des centaures;
Il en venait du fond de l'horizon sonore,
Et l'on voyait, assis sur la croupe qui rue,
Tenant des thyrses tors et des outres ventrues,
Des satyres boiteux piqués par des abeilles,
Et les bouches de crin et les lèvres vermeilles
Se baisaient, et la ronde immense et frénétique,
Sabots lourds, pieds légers, toisons, croupes, tuniques,
Tournait éperdument autour de moi qui, grave,
Au passage, sculptais aux flancs gonflés du vase
Le tourbillonnement des forces de la vie.

1359

Du parfum exhalé de la terre mûrie
Une ivresse montait à travers mes pensées,
Et dans l'odeur des fruits et des grappes pressées,
Dans le choc des sabots et le heurt des talons,
En de fauves odeurs de boucs et d'étalons,
Sous le vent de la ronde et la grêle des rires,
Au marbre je taillais ce que j'entendais bruire;
Et parmi la chair chaude et les effluves tièdes,
Hennissement du mufle ou murmure des lèvres,
Je sentais sur mes mains, amoureux ou farouches,
Des souffles de naseaux ou des baisers de bouches.

Le crépuscule vint et je tournai la tête.

Mon ivresse était morte avec la tâche faite;
Et sur son socle enfin, du pied jusques aux anses,
Le grand Vase se dressait nu dans le silence,
Et, sculptée en spirale à son marbre vivant,
La ronde dispersée et dont un faible vent
Apportait dans l'écho la rumeur disparue,
Tournait avec ses boucs, ses dieux, ses femmes nues,
Ses centaures cabrés et ses faunes adroits,
Silencieusement autour de la paroi,
Tandis que, seul, parmi, à jamais, la nuit sombre,
Je maudissais l'aurore et je pleurais vers l'ombre.

THE VASE

My heavy hammer rang in the light air; I saw the river and the
orchard, the field, and as far as the woods, growing bluer beneath the
sky hour by hour, then rose and mauve in the twilight; then I stood up
straight and stretched myself, happy in the task of the hours, numb with
having crouched from dawn till twilight before the block of marble upon
which I cut out the sides of the vase, still in its shell, that my ponderous
hammer struck, stressing the clear morning and the good day, happy at
being resonant in the light air.

The vase took shape in the worked stone. Slender and pure, it had
grown larger, still unformed in its slenderness, and I waited, with idle
and unquiet hands, for days, turning my head to the left, to the right,
at the slightest sound, without polishing the belly or lifting the hammer.
The water ran from the spring as though breathless. In the silence, I
heard the fruits of the orchard trees falling, one by one, from branch to
branch; I breathed a heralding perfume of distant flowers on the wind;
often I thought that someone spoke low, and one day that I dreamed—

not sleeping—I heard, beyond the fields and the river, the playing of flutes.

Still another day, between the ochre and gold leaves of the woods, I saw a faun with shaggy yellow legs dancing; I caught sight of him also, another time, coming out of the wood, along the road, and sitting down upon a stump to take a butterfly from one of his horns.

Another time, a centaur crossed the river swimming, the water streamed from his man's skin and his horse's coat; he advanced a few steps into the reeds, snuffed the wind, whinneyed, and crossed back over the water; the next day I saw the prints of his hoofs stamped in the grass.

Naked women passed carrying baskets and sheaves, very far off, quite at the other end of the plain. One morning I found three at the spring, and one of them spoke to me. She was naked. She said to me: "Carve the stone after the form of my body in your thoughts, and make my bright face smile in the marble block; listen all round you to the hours danced by my sisters, whose circle winds itself, interlaced, and revolves and sings and unwinds."

And I felt her warm mouth upon my cheek.

Then the vast orchard, and the woods, and the plain, shivered to a strange noise, and the spring ran faster with a laugh in its waters; the three Nymphs standing near the three reeds took one another by the hand and danced; red-haired fauns came out of the wood in troupes, and voices sang beyond the trees of the orchard with flutes awake in the light air. The ground echoed to the galop of centaurs; they came from the depths of the resonant horizon, and one saw lame satyrs, stung by bees, sitting on the rushing cruppers, holding twisted staves and big-bellied leather bottles; hairy mouths and vermillion lips kissed each other, and the immense and frenzied circle—heavy hoofs, light feet, fleeces, cruppers, tunics—turned wildly about me, who, grave while it went on, carved on the rounded side of the vase the whirl of the forces of life.

From the perfume sent out by the ripe earth, an intoxication mounted through my thoughts, and in the smell of fruits and crushed grapes, in the shock of hoofs and the stamping of heels, in the fallow odour of goats and stallions, under the breeze of the circle and the hail of laughter, I carved upon the marble what I heard humming, and amidst the hot flesh and the warm exhalations, neighings of muzzles or murmurings of lips, I felt, loving or savage, upon my hands, the breath of nostrils or the kisses of mouths.

Twilight came and I turned my head.

1361

My intoxication was dead with the accomplished task; and upon its pedestal, at last, from foot to handles, the great vase stood up naked in the silence, and carved in a spiral about its living marble, the dispersed circle, of which a feeble wind brought the echo of the vanished noise, turned, with its goats, its gods, its naked women, its rearing centaurs, and its nimble fauns, silently round the side, while I, alone for ever in the gloomy night, I cursed the dawn and wept toward the darkness.

Translated by Amy Lowell

The most perfect presentation of the creative faculty at work that I know of in any literature.

AMY LOWELL
Six French Poets (1915)

RUDYARD KIPLING

1 8 6 5 — 1 9 3 6

DANNY DEEVER

'What are the bugles blowin' for?' said Files-on-Parade.
'To turn you out, to turn you out,' the Colour-Sergeant said.
'What makes you look so white, so white?' said Files-on-Parade.
'I'm dreadin' what I've got to watch,' the Colour-Sergeant said.
 For they're hangin' Danny Deever, you can hear the Dead March play,
 The Regiment's in 'ollow square—they're hangin' him to-day;
 They've taken of his buttons off an' cut his stripes away,
 An' they're hangin' Danny Deever in the mornin'.

'What makes the rear-rank breathe so 'ard?' said Files-on-Parade.
'It's bitter cold, it's bitter cold,' the Colour-Sergeant said.
'What makes that front-rank man fall down?' said Files-on-Parade.
'A touch o' sun, a touch o' sun,' the Colour-Sergeant said.
 They are hangin' Danny Deever, they are marchin' of 'im round,
 They 'ave 'alted Danny Deever by 'is coffin on the ground;
 An' 'e'll swing in 'arf a minute for a sneakin' shootin' hound—
 O they're hangin' Danny Deever in the mornin'.

' 'Is cot was right-'and cot to mine,' said Files-on-Parade.
' 'E's sleepin' out an' far to-night,' the Colour-Sergeant said.
'I've drunk 'is beer a score o' times,' said Files-on-Parade.
' 'E's drinkin' bitter beer alone,' the Colour-Sergeant said.

1362

They are hangin' Danny Deever, you must mark 'im to 'is place,
For 'e shot a comrade sleepin'—you must look 'im in the face;
Nine 'undred of 'is county an' the Regiment's disgrace,
While they're hangin' Danny Deever in the mornin'.

'What's that so black agin the sun?' said Files-on-Parade.
'It's Danny fightin' 'ard for life,' the Colour-Sergeant said.
'What's that that whimpers over'ead?' said Files-on-Parade.
'It's Danny's soul that's passin' now,' the Colour-Sergeant said.
 For they're done with Danny Deever, you can 'ear the quickstep play,
 The Regiment's in column, an' they're marchin' us away;
 Ho! the young recruits are shakin', an' they'll want their beer to-day,
 After hangin' Danny Deever in the mornin'!

RECESSIONAL

God of our fathers, known of old,
 Lord of our far-flung battle-line,
Beneath whose awful Hand we hold
 Dominion over palm and pine—
Lord God of Hosts, be with us yet,
Lest we forget—lest we forget!

The tumult and the shouting dies;
 The Captains and the Kings depart:
Still stands Thine ancient sacrifice,
 An humble and a contrite heart.
Lord God of Hosts, be with us yet,
Lest we forget—lest we forget!

Far-called, our navies melt away;
 On dune and headland sinks the fire:
Lo, all our pomp of yesterday
 Is one with Nineveh and Tyre!
Judge of the Nations, spare us yet,
Lest we forget—lest we forget!

If, drunk with sight of power, we loose
 Wild tongues that have not Thee in awe,
Such boastings as the Gentiles use,
 Or lesser breeds without the Law—
Lord God of Hosts, be with us yet,
Lest we forget—lest we forget!

For heathen heart that puts her trust
 In reeking tube and iron shard,
All valiant dust that builds on dust,

And guarding, calls not Thee to guard,
For frantic boast and foolish word—
Thy mercy on Thy People, Lord!

<div style="text-align: right">(1897)</div>

EPITAPHS OF THE WAR, 1914-18

AN ONLY SON

I have slain none except my Mother. She
(Blessing her slayer) died of grief for me.

THE COWARD

I could not look on Death, which being known,
Men led me to him, blindfold and alone.

THE BEGINNER

On the first hour of my first day
 In the front trench I fell.
(Children in boxes at a play
 Stand up to watch it well.)

COMMON FORM

If any question why we died,
Tell them, because our fathers lied.

A DEAD STATESMAN

I could not dig: I dared not rob:
Therefore I lied to please the mob.
Now all my lies are proved untrue
And I must face the men I slew.
What tale shall serve me here among
Mine angry and defrauded young?

SALONIKAN GRAVE

I have watched a thousand days
Push out and crawl into night
Slowly as tortoises.
Now I, too, follow these.
It is fever, and not the fight—
Time, not battle,—that slays.

I make no apology for having used the terms 'verse' and 'poetry' in a loose way: so that while I speak of Kipling's work as verse and not as poetry, I am still able to speak of individual compositions as poems, and also to maintain that there is 'poetry' in the 'verse'. Where terminology is loose, where we have not the vocabulary for distinctions which we feel, our only precision is found in being aware of the imperfection of our tools, and of the different senses in which we are using the same words. It should be clear that when I contrast 'verse' with 'poetry' I am not, IN THIS CONTEXT, implying a value judgement. I do not mean, here, by verse, the work of a man who would write poetry if he could: I mean by it something which does what 'poetry' could not do. The difference which would turn Kipling's verse into poetry, does not represent a failure or deficiency: he knew perfectly well what he was doing; and from his point of view more 'poetry' would interfere with his purpose. And I make the claim, that in speaking of Kipling we are entitled to say 'GREAT verse'. What other famous poets should be put into the category of great verse writers is a question which I do not here attempt to answer. That question is complicated by the fact that we should be dealing with matters as imprecise as the shape and size of a cloud or the beginning and end of a wave. But the writer whose work is ALWAYS clearly verse, is not a great verse writer: if a writer is to be that, there must be some of his work of which we cannot say whether it is verse or poetry. And the poet who could not write 'verse' when verse was needed, would be without that sense of structure which is required to make a poem of any length readable. I would suggest also that we too easily assume that what is most valuable is also most rare, and vice versa. I can think of a number of poets who have written great poetry, only of a very few whom I should call great verse writers. And unless I am mistaken, Kipling's position in this class is not only high, but unique.

<div align="right">

T. S. E L I O T
Rudyard Kipling (1941)

</div>

W. B. Y E A T S

1 8 6 5 — 1 9 3 9

DARK UNDER FROTH

Maybe a twelvemonth since
Suddenly I began,
In scorn of this audience,
Imagining a man,

And his sun-freckled face,
And grey Connemara cloth,
Climbing up to a place
Where stone is dark under froth,
And the down-turn of his twist
When the flies drop in the stream;
A man who does not exist,
A man who is but a dream;
And cried, 'Before I am old
I shall have written him one
Poem maybe as cold
And passionate as the dawn.'

<div align="right">The Fisherman (1919)</div>

SALT SEA WIND

I call to the eye of the mind
A well long choked up and dry
And boughs long stripped by the wind,
And I call to the mind's eye
Pallor of an ivory face,
Its lofty dissolute air,
A man climbing up to a place
The salt sea wind has swept bare.

<div align="right">At the Hawk's Well (1921)</div>

FOR MY OWN

To write for my own race
And the reality.

<div align="right">The Fisherman (1919)</div>

DAYS OF MY YOUTH

Through all the lying days of my youth
I swayed my leaves and flowers in the sun;
Now I may wither into the truth.

<div align="right">The Coming of Wisdom with Time (1910)</div>

WATERS OF THE BOYNE

Merchant and scholar who have left me blood
That has not passed through any huckster's loin,
Soldiers that gave, whatever die was cast:
A Butler or an Armstrong that withstood
Beside the brackish waters of the Boyne
James and his Irish when the Dutchman crossed.

<div align="right">Responsibilities (1914)</div>

COURAGE EQUAL TO DESIRE

Why should I blame her that she filled my days
With misery, or that she would of late
Have taught to ignorant men most violent ways,
Or hurled the little streets upon the great,
Had they but courage equal to desire?

<div align="right">No Second Troy (1910)</div>

SO GREAT A SWEETNESS

And what of her that took
All till my youth was gone
With scarce a pitying look?
How could I praise that one?
When day begins to break
I count my good and bad,
Being wakeful for her sake,
Remembering what she had,
What eagle look still shows,
While up from my heart's root
So great a sweetness flows
I shake from head to foot.

<div align="right">Friends (1914)</div>

With the development of this maturer style, it became impossible any longer to regard Yeats merely as one of the best of the English lyric poets of the nineties. The author of "The Lake of Innisfree," which had so delighted Robert Louis Stevenson, had grown, in an interval of ten years during which nobody outside of Ireland had apparently paid

much attention to him, to the unmistakable stature of a master. No other poet writing English in our time has been able to deal with supreme artistic success with such interesting and such varied experience. No other writer has been able to sustain the traditional grand manner of the poet with so little effect of self-consciousness.

EDMUND WILSON
Axel's Castle (1931)

STEPHEN PHILLIPS

1 8 6 8 — 1 9 1 5

THE DEAD

I did not know the dead could have such hair.

Paolo and Francesca, Act iv (1902)

There is little in tragedy more beautiful.

GEORGE GORDON
Airy Nothings Or What You Will (1917)

MARCEL PROUST

1 8 7 1 — 1 9 2 2

MY GRANDMOTHER'S ILLNESS

Cottard, whom we had called in to see my grandmother, and who had infuriated us by asking with a dry smile, the moment we told him that she was ill: "Ill? You're sure it's not what they call a diplomatic illness?" He tried to soothe his patient's restlessness by a milk diet. But incessant bowls of milk soup gave her no relief, because my grandmother sprinkled them liberally with salt (the toxic effects of which were as yet, Widal not having made his discoveries, unknown). For, medicine being a compendium of the successive and contradictory mistakes of medical practitioners, when we summon the wisest of them to our aid, the chances are that we may be relying on a scientific truth the error of which will be recognised in a few years' time. So that to believe in medicine would be the height of folly, if not to believe in it were not

greater folly still, for from this mass of errors there have emerged in the course of time many truths. Cottard had told us to take her temperature. A thermometer was fetched. Throughout almost all its length it was clear of mercury. Scarcely could one make out, crouching at the foot of the tube, in its little cell, the silver salamander. It seemed dead. The glass reed was slipped into my grandmother's mouth. We had no need to leave it there for long; the little sorceress had not been slow in casting her horoscope. We found her motionless, perched half-way up her tower, and declining to move, shewing us with precision the figure that we had asked of her, a figure with which all the most careful examination that my grandmother's mind could have devoted to herself would have been incapable of furnishing her: 101 degrees. For the first time we felt some anxiety. We shook the thermometer well, to erase the ominous line, as though we were able thus to reduce the patient's fever simultaneously with the figure shewn on the scale. Alas, it was only too clear that the little sibyl, unreasoning as she was, had not pronounced judgment arbitrarily, for the next day, scarcely had the thermometer been inserted between my grandmother's lips when almost at once, as though with a single bound, exulting in her certainty and in her intuition of a fact that to us was imperceptible, the little prophetess had come to a halt at the same point, in an implacable immobility, and pointed once again to that figure 101 with the tip of her gleaming wand. Nothing more did she tell us; in vain might we long, seek, pray, she was deaf to our entreaties; it seemed as though this were her final utterance, a warning and a menace. Then, in an attempt to constrain her to modify her response, we had recourse to another creature of the same kingdom, but more potent, which is not content with questioning the body but can command it, a febrifuge of the same order as the modern aspirin, which had not then come into use. We had not shaken the thermometer down below 99.5, and hoped that it would not have to rise from there. We made my grandmother swallow this drug and then replaced the thermometer in her mouth. Like an implacable warder to whom one presents a permit signed by a higher authority whose protecting influence one has sought, and who, finding it to be in order, replies: "Very well; I have nothing to say; if it's like that you may pass," this time the watcher in the tower did not move. But sullenly she seemed to be saying: "What use will that be to you? Since you are friends with quinine, she may give me the order not to go up, once, ten times, twenty times. And then she will grow tired of telling me, I know her; get along with you. This won't last for ever. And then you'll be a lot better off." Thereupon my grandmother felt the presence within her of a creature which knew the human body better than herself, the presence of a contemporary of the races that have vanished from the earth, the presence of earth's first inhabitant—long anterior to the creation of thinking man—she felt that aeonial ally who was

sounding her, a little roughly even, in the head, the heart, the elbow; he found out the weak places, organised everything for the prehistoric combat which began at once to be fought. In a moment a trampled Python, the fever, was vanquished by the potent chemical substance to which my grandmother, across the series of kingdoms, reaching out beyond all animal and vegetable life, would fain have been able to give thanks. And she remained moved by this glimpse which she had caught, through the mists of so many centuries, of a climate anterior to the creation even of plants.

<div style="text-align:right">

Le Côté de Guermantes (1920)
Translated by C. K. Scott Moncrieff

</div>

The picture of the grandmother at death, when the animal and the mineral forces get hold of her, is unequalled in literature.

<div style="text-align:right">

D E N I S S A U R A T
Modern French Literature 1870–1940 (1946)

</div>

PAUL VALÉRY

1 8 7 1 — 1 9 4 5

LA SOIRÉE AVEC MONSIEUR TESTE

<div style="text-align:right">

Vita Cartesii res est simplicissima.
M. de Raey à M. Van Limborch.

</div>

La bêtise n'est pas mon fort. J'ai vu beaucoup d'individus, j'ai visité quelques nations, j'ai pris ma part d'entreprises diverses sans les aimer, j'ai mangé presque tous les jours, j'ai touché à des femmes. Je revois maintenant quelques centaines de visages, deux ou trois grands spectacles, et peut-être la substance de vingt livres. Je n'ai pas retenu le meilleur ni le pire de ces choses: est resté ce qui l'a pu.

Cette arithmétique m'épargne de m'étonner de vieillir. Je pourrais aussi faire le compte des moments victorieux de mon esprit, et les imaginer unis et soudés, composant une vie *heureuse* . . . Mais je crois m'être toujours bien jugé. Je me suis rarement perdu de vue; je me suis détesté, je me suis adoré,—puis nous avons vieilli ensemble.

Souvent, j'ai supposé que tout était fini pour moi, et je me terminais de toutes mes forces, anxieux d'épuiser, d'éclairer quelque situation douloureuse. Cela m'a fait connaître que nous apprécions notre propre pensée beaucoup trop d'après l'*expression* de celle des autres! Dès lors, les milliards de mots qui ont bourdonné à mes oreilles, m'ont rare-

ment ébranlé par ce qu'on voulait leur faire dire; et tous ceux que j'ai moi-même prononcés à autrui, je les ai senti se distinguer toujours de ma pensée,—car ils devenaient *invariables*.

Si j'avais décidé comme la plupart des hommes, non seulement je me serais cru leur supérieur, mais je l'aurais paru. Je me suis préféré. Ce qu'ils nomment un être supérieur est un être qui s'est trompé. Pour s'étonner de lui, il faut le voir,—et pour être vu il faut qu'il se montre. Et il me montre que la niaise manie de son nom le possède. Ainsi, chaque grand homme est taché d'une erreur. Chaque esprit qu'on trouve puissant, commence par la faute qui le fait connaître. En échange du pourboire public, il donne le temps qu'il faut pour se rendre perceptible, l'énergie dissipée à se transmettre et à préparer la satisfaction étrangère. Il va jusqu'à comparer les jeux informes de la gloire, à la joie de se sentir unique—grande volupté particulière.

J'ai rêvé alors que les têtes les plus fortes, les inventeurs les plus sagaces, les connaisseurs le plus exactement de la pensée devaient être des inconnus, des avares, des hommes qui meurent sans avouer. Leur existence m'était révélée par celle même des individus éclatants, un peu moins *solides*.

L'induction était si facile que j'en voyais la formation à chaque instant. Il suffisait d'imaginer les grands hommes ordinaires, purs de leur première erreur, ou de s'appuyer sur cette erreur même pour concevoir un degré de conscience plus élevé, un sentiment de la liberté d'esprit moins grossier. Une opération aussi simple me livrait des étendues curieuses, comme si j'étais descendu dans la mer. Perdus dans l'éclat des découvertes publiées, mais à côté des inventions méconnues que le commerce, la peur, l'ennui, la misère commettent chaque jour, je croyais distinguer des chefs-d'œuvre intérieurs. Je m'amusais à éteindre l'histoire connue sous les annales de l'anonymat.

C'étaient, invisibles dans leurs vies limpides, des solitaires qui savaient avant tout le monde. Ils me semblaient doubler, tripler, multiplier dans l'obscurité chaque personne célèbre,—eux, avec le dédain de livrer leurs chances et leurs résultats particuliers. Ils auraient refusé, à mon sentiment, de se considérer comme autre chose que des choses . . .

Ces idées me venaient pendant l'octobre de 93, dans les instants de loisir où la pensée se joue seulement à exister.

Je commençais de n'y plus songer, quand je fis la connaissance de M. Teste. (Je pense maintenant aux traces qu'un homme laisse dans le petit espace où il se meut chaque jour.) Avant de me lier avec M. Teste, j'étais attiré par ses allures particulières. J'ai étudié ses yeux, ses vêtements, ses moindres paroles sourdes au garçon du café où je le voyais. Je me demandais s'il se sentait observé. Je détournais vivement mon regard du sien, pour surprendre le sien me suivre. Je prenais les journaux qu'il venait de lire, je recommençais mentalement les sobres gestes qui lui échappaient; je notais que personne ne faisait attention à lui.

Je n'avais plus rien de ce genre à apprendre, lorsque nous entrâmes en relation. Je ne l'ai jamais vu que la nuit. Une fois dans une sorte de b . . . ; souvent au théâtre. On m'a dit qu'il vivait de médiocres opérations hebdomadaires à la Bourse. Il prenait ses repas dans un petit restaurant de la rue Vivienne. Là, il mangeait comme on se purge, avec le même entrain. Parfois, il s'accordait ailleurs un repas lent et fin.

M. Teste avait peut-être quarante ans. Sa parole était extraordinairement rapide, et sa voix sourde. Tout s'effaçait en lui, les yeux, les mains. Il avait pourtant les épaules militaires, et le pas d'une régularité qui étonnait. Quand il parlait, il ne levait jamais un bras ni un doigt: il avait *tué la marionnette*. Il ne souriait pas, ne disait ni bonjour ni bonsoir; il semblait ne pas entendre le «Comment allez-vous?»

Sa mémoire me donna beaucoup à penser. Les traits par lesquels j'en pouvais juger, me firent imaginer une gymnastique intellectuelle sans exemple. Ce n'était pas chez lui une faculté excessive,—c'était une faculté éduquée ou transformée. Voici ses propres paroles: «Il y a vingt ans que je n'ai plus de livres. J'ai brûlé mes papiers aussi. Je rature le vif . . . Je retiens ce que je veux. Mais le difficile n'est pas là. *Il est de retenir ce dont je voudrai demain!* . . . J'ai cherché un crible machinal . . .»

A force d'y penser, j'ai fini par croire que M. Teste était arrivé à découvrir des lois de l'esprit que nous ignorons. Sûrement, il avait dû consacrer des années à cette recherche: plus sûrement, des années encore, et beaucoup d'autres années avaient été disposées pour mûrir ses inventions et pour en faire ses instincts. Trouver n'est rien. Le difficile est de s'ajouter ce qu'on trouve.

L'art délicat de la durée, le temps, sa distribution et son régime,—sa dépense à des choses bien choisies, pour les nourrir spécialement,—était une des grandes recherches de M. Teste. Il veillait à la répétition de certaines idées; il les arrosait de nombre. Ceci lui servait à rendre finalement machinale l'application de ses études conscientes. Il cherchait même à résumer ce travail. Il disait souvent: «*Maturare!* . . .»

Certainement sa mémoire singulière devait presque uniquement lui retenir cette partie de nos impressions que notre imagination toute seule est impuissante à construire. Si nous imaginons un voyage en ballon, nous pouvons avec sagacité, avec puissance, *produire* beaucoup de sensations probables d'un aéronaute; mais il restera toujours quelque chose d'individuel à l'ascension réelle, dont la différence avec notre rêverie exprime la valeur des méthodes d'un Edmond Teste.

Cet homme avait connu de bonne heure l'importance de ce qu'on pourrait nommer la *plasticité* humaine. Il en avait cherché les limites et le mécanisme. Combien il avait dû rêver à sa propre malléabilité!

J'entrevoyais des sentiments qui me faisaient frémir, une terrible obstination dans des expériences enivrantes. Il était l'être absorbé dans sa

variation, celui qui devient son système, celui qui se livre tout entier à la discipline effrayante de l'esprit libre, et qui fait tuer ses joies par ses joies, la plus faible par la plus forte,—la plus douce, la temporelle, celle de l'instant et de l'heure commencée, par la fondamentale—par l'espoir de la fondamentale.

Et je sentais qu'il était le maître de sa pensée: j'écris là cette absurdité. L'expression d'un sentiment est toujours absurde.

M. Teste n'avait pas d'opinions. Je crois qu'il se passionnait à son gré, et pour atteindre un but défini. Qu'avait-il fait de sa personnalité? Comment se voyait-il? . . . Jamais il ne riait, jamais un air de malheur sur son visage. Il haïssait la mélancolie.

Il parlait, et on se sentait dans son idée, confondu avec les choses: on se sentait reculé, mêlé aux maisons, aux grandeurs de l'espace, au coloris remué de la rue, aux coins . . . Et les paroles le plus adroitement touchantes,—celles même qui font leur auteur plus près de nous qu'aucun autre homme, celles qui font croire que le mur éternel entre les esprits tombe,—pouvaient venir à lui . . . Il savait admirablement qu'elles auraient ému *tout autre*. Il parlait, et sans pouvoir préciser les motifs ni l'étendue de la proscription, on constatait qu'un grand nombre de mots étaient bannis de son discours. Ceux dont il se servait, étaient parfois si curieusement tenus par sa voix ou éclairés par sa phrase que leur poids était altéré, leur valeur nouvelle. Parfois, ils perdaient tout leur sens, ils paraissaient remplir uniquement une place vide dont le terme destinataire était douteux encore ou imprévu par la langue. Je l'ai entendu désigner un objet matériel par un groupe de mots abstraits et de noms propres.

A ce qu'il disait, il n'y avait rien à répondre. Il tuait l'assentiment poli. On prolongeait les conversations par des bonds qui ne l'étonnaient pas.

Si cet homme avait changé l'objet de ses méditations fermées, s'il eût tourné contre le monde la puissance régulière de son esprit, rien ne lui eût résisté. Je regrette d'en parler comme on parle de ceux dont on fait les statues. Je sens bien qu'entre le «génie» et lui, il y a une quantité de faiblesse. Lui, si véritable! si neuf! si pur de toute duperie et de toutes merveilles, si dur! Mon propre enthousiasme me le gâte . . .

Comment ne pas en ressentir pour celui qui ne disait jamais rien de *vague?* pour celui qui déclarait avec calme: «Je n'apprécie en toute chose que la *facilité* ou la *difficulté* de les connaître, de les accomplir. Je mets un soin extrême à mesurer ces degrés, et à ne pas m'attacher . . . Et que n'importe ce que je sais fort bien?»

Comment ne pas s'abandonner à un être dont l'esprit paraissait transformer pour soi seul tout ce qui est, et qui *opérait* tout ce qui lui était proposé? Je devinais cet esprit maniant et mêlant, faisant varier, mettant en communication, et dans l'étendue du champ de sa connaissance, pouvant couper et dévier, éclairer, glacer ceci, chauffer cela, noyer,

exhausser, nommer ce qui manque de nom, oublier ce qu'il voulait, endormir ou colorer ceci et cela . . .

Je simplifie grossièrement des propriétés impénétrables. Je n'ose pas dire tout ce que mon objet me dit. La logique m'arrête. Mais, en moi-même, toutes les fois que se pose le problème de Teste, apparaissent de curieuses formations.

Il y a des jours où je le retrouve très nettement. Il se représente à mon souvenir, à côté de moi. Je respire la fumée de nos cigares, je l'entends, je me *méfie*. Parfois, la lecture d'un journal me fait me heurter à sa pensée, quand un événement maintenant la justifie. Et je tente encore quelques-unes de ces expériences illusoires qui me délectaient à l'époque de nos soirées. C'est-à-dire que je me le figure faisant ce que je ne lui ai pas vu faire. Que devient M. Teste souffrant?—Amoureux, comment raisonne-t-il?—Peut-il être triste?—De quoi aurait-il peur?—Qu'est-ce qui le ferait trembler?—. . . Je cherchais. Je maintenais entière l'image de l'homme rigoureux, je tâchais de la faire répondre à mes questions . . . Elle s'altérait.

Il aime, il souffre, il s'ennuie. Tout le monde s'imite. Mais, au soupir, au gémissement élémentaire, je veux qu'il mêle les règles et les figures de tout son esprit.

Ce soir, il y a précisément deux ans et trois mois que j'étais avec lui au théâtre, dans une loge prêtée. J'y ai songé tout aujourd'hui.

Je le revois debout avec la colonne d'or de l'Opéra, ensemble.

Il ne regardait que la salle. Il aspirait la grande bouffée brûlante, au bord du trou. Il était rouge.

Une immense fille de cuivre nous séparait d'un groupe murmurant au delà de l'éblouissement. Au fond de la vapeur, brillait un morceau nu de femme, doux comme un caillou. Beaucoup d'éventails indépendants vivaient sur le monde sombre et clair, écumant jusqu'aux feux du haut. Mon regard épelait mille petites figures, tombait sur une tête triste, courait sur des bras, sur les gens, et enfin se brûlait.

Chacun était à sa place, libre d'un petit mouvement. Je goûtais le système de classification, la simplicité presque théorique de l'assemblée, l'ordre social. J'avais la sensation délicieuse que tout ce qui respirait dans ce cube, allait suivre ses lois, flamber de rires par grands cercles, s'émouvoir par plaques, ressentir par *masses* des choses *intimes*,— *uniques*,—des remuements secrets, s'élever à l'inavouable! J'errais sur ces étages d'hommes, de ligne en ligne, par orbites, avec la fantaisie de joindre idéalement entre eux, tous ceux ayant la même maladie, ou la même théorie, ou le même vice . . . Une musique nous touchait tous, abondait, puis devenait toute petite.

Elle disparut. M. Teste murmurait: «On n'est *beau*, on n'est extra-ordinaire que pour les autres! *Ils* sont mangés par les autres!»

Le dernier mot sortit du silence que faisait l'orchestre. Teste respira.

Sa face enflammée où soufflaient la chaleur et la couleur, ses larges épaules, son être noir mordoré par les lumières, la forme de tout son bloc vêtu, étayé par la grosse colonne, me reprirent. Il ne perdait pas un atome de tout ce qui devenait sensible, à chaque instant, dans cette grandeur rouge et or.

Je regardai ce crâne qui faisait connaissance avec les angles du chapiteau, cette main droite qui se rafraîchissait aux dorures; et, dans l'ombre de pourpre, les grands pieds. Des lointains de la salle, ses yeux vinrent vers moi; sa bouche dit: «La discipline n'est pas mauvaise . . . C'est un petit commencement . . .»

Je ne savais répondre. Il dit de sa voix basse et vite: «Qu'ils jouissent et obéissent!»

Il fixa longuement un jeune homme placé en face de nous, puis une dame, puis tout un groupe dans les galeries supérieures,—qui débordait du balcon par cinq ou six visages brûlants,—et puis tout le monde, tout le théâtre, plein comme les cieux, ardent, fasciné par la scène que nous ne voyions pas. La stupidité de tous les autres nous révélait qu'il se passait n'importe quoi de sublime. Nous regardions se mourir le jour que faisaient toutes les figures dans la salle. Et quand il fut très bas, quand la lumière ne rayonna plus, il ne resta que la vaste phosphorescence de ces mille figures. J'éprouvais que ce crépuscule faisait tous ces êtres passifs. Leur attention et l'obscurité croissantes formaient un équilibre continu. J'étais moi-même attentif *forcément,*—à toute cette attention.

M. Teste dit: «Le suprême *les* simplifie. Je parie qu'ils pensent tous, de plus en plus, *vers* la même chose. Ils seront égaux devant la crise ou limite commune. Du reste, la loi n'est pas si simple . . . puisqu'elle me néglige,—et—je suis ici.»

Il ajouta: «L'éclairage les tient.»

Je dis en riant: «Vous aussi?»

Il répondit: «Vous, aussi.»

—«Quel dramaturge vous feriez! lui dis-je, vous semblez surveiller quelque expérience créée aux confins de toutes les sciences! Je voudrais voir un théâtre inspiré de vos méditations . . .»

Il dit: «Personne ne médite.»

L'applaudissement et la lumière complète nous chassèrent. Nous circulâmes, nous descendîmes. Les passants semblaient en liberté. M. Teste se plaignit légèrement de la fraîcheur de minuit. Il fit allusion à d'anciennes douleurs.

Nous marchions, et il lui échappait des phrases presque incohérentes. Malgré mes efforts, je ne suivais ses paroles qu'à grand'peine, me bornant enfin à les retenir. L'incohérence d'un discours dépend de celui qui l'écoute. L'esprit me paraît ainsi fait qu'il ne peut être incohérent pour soi-même. Aussi me suis-je gardé de classer Teste parmi les fous. D'ailleurs, j'apercevais vaguement le lien de ses idées, je n'y remar-

quais aucune contradiction;—et puis, j'aurais redouté une solution trop simple.

Nous allions dans les rues adoucies par la nuit, nous tournions à des angles, dans le vide, trouvant d'instinct notre voie,—plus large, plus étroite, plus large. Son pas militaire se soumettait le mien . . .

—«Pourtant, *répondis-je,* comment se soustraire à une musique si puissante! Et pourquoi? J'y trouve une ivresse particulière, dois-je la dédaigner? J'y trouve l'illusion d'un travail immense, qui, tout à coup me deviendrait possible . . . Elle me donne des *sensations abstraites,* des figures délicieuses de tout ce que j'aime,—du changement, du mouvement, du mélange, du flux, de la transformation . . . Nierez-vous qu'il y ait des choses anesthésiques? Des arbres qui saoulent, des hommes qui donnent de la force, des filles qui paralysent, des ciels qui coupent la parole?

M. Teste reprit assez haut:

—«Eh! Monsieur! que m'importe le «talent» de vos arbres—et des autres! . . . Je suis chez MOI, je parle ma langue, je hais les choses extraordinaires. C'est le besoin des esprits faibles. Croyez-moi à la lettre: le génie est *facile,* la fortune est *facile,* la *divinité* est *facile* . . . Je veux dire simplement—que je sais comment cela se conçoit. C'est *facile.*

«Autrefois,—il y a bien vingt ans,—toute chose au-dessus de l'ordinaire accomplie par un autre homme, m'était une défaite personnelle. Dans le passé, je ne voyais qu'idées volées à moi! Quelle bêtise! . . . Dire que notre propre image ne nous est pas indifférente! Dans les combats imaginaires, nous la traitons *trop bien* ou *trop mal!* . . .»

Il toussa. Il se dit: «Que peut un homme? . . . Que peut un homme! . . .» Il me dit: «Vous connaissez un homme sachant qu'il ne sait ce qui'il dit!»

Nous étions à sa porte. Il me pria de venir fumer un cigare chez lui.

Au haut de la maison, nous entrâmes dans un très petit appartement «garni». Je ne vis pas un livre. Rien n'indiquait le travail traditionnel devant une table, sous une lampe, au milieu de papiers et de plumes. Dans la chambre verdâtre qui sentait la menthe, il n'y avait autour de la bougie que le morne mobilier abstrait,—le lit, la pendule, l'armoire à glace, deux fauteuils—comme des êtres de raison. Sur la cheminée, quelques journaux, une douzaine de cartes de visite couvertes de chiffres, et un flacon pharmaceutique. Je n'ai jamais eu plus fortement l'impression du *quelconque.* C'était le logis quelconque, analogue au point quelconque des théorèmes,—et peut-être aussi utile. Mon hôte existait dans l'intérieur le plus général. Je songeai aux heures qu'il faisait dans ce fauteuil. J'eus peur de l'infinie tristesse possible dans ce

lieu pur et banal. J'ai vécu dans de telles chambres, je n'ai jamais pu les croire définitives, sans horreur.

M. Teste parla de l'argent. Je ne sais pas reproduire son éloquence spéciale: elle me semblait moins précise que d'ordinaire. La fatigue, le silence qui se fortifiait avec l'heure, les cigares amers, l'abandon nocturne semblaient l'atteindre. J'entends sa voix baissée et ralentie qui faisait danser la flamme de l'unique bougie brûlant entre nous, à mesure qu'il citait de très grands nombres avec lassitude. Huit cent dix millions soixante quinze mille cinq cent cinquante . . . J'écoutais cette musique inouïe sans suivre le calcul. Il me communiquait le tremblement de la Bourse, et les longues suites de noms de nombres me prenaient comme une poésie. Il rapprochait les événements, les phénomènes industriels, le goût public et les passions, les chiffres encore, les uns des autres. Il disait: «L'or est comme l'esprit de la société.»

Tout à coup, il se tut. Il souffrit.

J'examinai de nouveau la chambre froide, la nullité du meuble, pour ne pas le regarder. Il prit sa fiole et but. Je me levai pour partir.

—«Restez encore, dit-il, vous ne vous ennuyez pas. Je vais me mettre au lit. Dans peu d'instants, je dormirai. Vous prendrez la bougie pour descendre.»

Il se dévêtit tranquillement. Son corps sec se baigna dans les draps et fit le mort. Ensuite il se tourna, et s'enfonça davantage dans le lit trop court.

Il me dit en souriant: «Je fais la planche. Je flotte! . . . Je sens un roulis imperceptible dessous,—un mouvement immense? Je dors une heure ou deux tout au plus, moi qui adore la navigation de la nuit. Souvent je ne distingue plus ma pensée d'avant le sommeil. Je ne sais pas si j'ai dormi. Autrefois, en m'assoupissant, je pensais à tous ceux qui m'avaient fait plaisir, figures, choses, minutes. Je les faisais venir pour que la pensée fût aussi douce que possible, facile comme le lit . . . Je suis vieux. Je puis vous montrer que je me sens vieux . . . Rappelez-vous!—Quand on est enfant on se *découvre,* on découvre lentement l'espace de son corps, on exprime la particularité de son corps par une série d'efforts, je suppose? On se tord et on se trouve ou on se retrouve, et on s'étonne! on touche son talon, on saisit son pied droit avec sa main gauche, on obtient le pied froid dans la paume chaude! . . . Maintenant, je me sais par cœur. Le cœur aussi. Bah! toute la terre est marquée, tous les pavillons couvrent tous les territoires . . . Reste mon lit. J'aime ce courant de sommeil et de linge: ce linge qui se tend et se plisse, ou se froisse,—qui descend sur moi comme du sable, quand je fais le mort,—qui se caille autour de moi dans le sommeil . . . C'est de la mécanique bien complexe. Dans le sens de la trame ou de la chaîne, une déformation très petite . . . Ah!»

Il souffrit.

« Mais qu'avez-vous? lui dis-je, je puis . . . »

«J'ai, dit-il, . . . pas grand'chose. J'ai . . . un dixième de seconde qui se montre . . . Attendez . . . Il y a des instants où mon corps s'illumine . . . C'est très curieux. J'y vois tout à coup en moi . . . je distingue les profondeurs des couches de ma chair; et je sens des zones de douleur, des anneaux, des pôles, des aigrettes de douleur. Voyez-vous ces figures vives? cette géométrie de ma souffrance? Il y a de ces éclairs qui ressemblent tout à fait à des idées. Ils font comprendre,—d'ici, jusque-là . . . Et pourtant ils me laissent *incertain*. Incertain n'est pas le mot . . . Quand *cela* va venir, je trouve en moi quelque chose de confus ou de diffus. Il se fait dans mon être des endroits . . . brumeux, il y a des étendues qui font leur apparition. Alors, je prends dans ma mémoire une question, un problème quelconque . . . Je m'y enfonce. Je compte des grains de sable . . . et, tant que je les vois . . .—Ma douleur grossissante me force à l'observer. J'y pense!—Je n'attends que mon cri, . . . et dès que je l'ai entendu—l'*objet*, le terrible *objet*, devenant plus petit, et encore plus petit, se dérobe à ma vue intérieure . . .

«Que peut un homme? Je combats tout,—hors la souffrance de mon corps, au delà d'une certaine grandeur. C'est là, pourtant, que je devrais commencer. Car, souffrir, c'est donner à quelque chose une attention suprême, et je suis un peu l'homme de l'attention . . . Sachez que j'avais prévu la maladie future. J'avais songé avec précision à ce dont tout le monde est sûr. Je crois que cette vue sur une portion évidente de l'avenir, devrait faire partie de l'éducation. Oui, j'avais prévu ce qui commence maintenant. C'était, alors, une idée comme les autres. Ainsi, j'ai pu la suivre.»

Il devint calme.

Il se plia sur le côté, baissa les yeux; et, au bout d'une minute, parlait de nouveau. Il commençait à se perdre. Sa voix n'était qu'un murmure dans l'oreiller. Sa main rougissante dormait déjà.

Il disait encore: «Je pense, et cela ne gêne rien. Je suis seul. Que la solitude est confortable! Rien de doux ne me pèse . . . La même rêverie ici, que dans la cabine du navire, la même au café Lambert . . . Les bras d'une Berthe, s'ils prennent de l'importance, je suis volé,—comme par la douleur . . . Celui qui me parle, s'il ne prouve pas,—c'est un ennemi. J'aime mieux l'éclat du moindre fait qui se produit. Je suis étant, et me voyant; me voyant me voir, et ainsi de suite . . . Pensons de tout près. Bah! on s'endort sur n'importe quel sujet . . . Le sommeil continue n'importe quelle idée . . .»

Il ronflait doucement. Un peu plus doucement, je pris la bougie, je sortis à pas de loup.

AN EVENING WITH M. TESTE *

Stupidity is not my strong point. I have seen many persons; I have visited several nations; I have taken part in divers enterprises without liking them; I have eaten nearly every day; I have touched women. I now recall several hundred faces, two or three great events, and perhaps the substance of twenty books. I have not retained the best nor the worst of these things. What could stick, did.

This bit of arithmetic spares me surprise at getting old. I could also add up the victorious moments of my mind, and imagine them joined and soldered, composing a *happy* life. . . . But I think I have always been a good judge of myself. I have rarely lost sight of myself; I have detested, and adored myself—and so, we have grown old together.

Often I have supposed that all was over for me, and I would begin ending with all my strength, anxious to exhaust and clear up some painful situation. This has made me realize that we interpret our own thought too much according to the *expression* of other people's! Since then, the thousands of words that have buzzed in my ears have rarely shaken me with what they were meant to mean. And all those I have myself spoken to others, I could always feel them become distinct from my thought—for they were becoming *invariable*.

If I had gone on as most men do, not only would I have believed myself their superior, but would have seemed so. I have preferred myself. What they call a superior being is one who has deceived himself. To wonder at him, we have to see him—and to be seen, he has to show himself. And he shows me that he has a silly obsession with his own name. Every great man is thus flawed with an error. Every mind considered powerful begins with the fault that makes it known. In exchange for a public fee, it gives the time necessary to make itself knowable, the energy spent in transmitting itself in preparing the alien satisfaction. It even goes so far as to compare the formless games of glory to the joy of feeling unique—the great private pleasure.

And so I have surmised that the strongest heads, the most sagacious inventors, the most exacting connoisseurs of thought, must be unknown men, misers, who die without giving up their secret. Their existence was revealed to me by just those showy, somewhat less *solid* individuals.

This induction was so easy that I could see it taking shape from one moment to the next. It was only necessary to imagine ordinary great men pure of their first error, or to take this error itself as a basis for conceiving a higher degree of consciousness, a fuller sense of the freed mind. Such a simple process opened curious vistas before me, as if I had gone

* Reprinted from *Monsieur Teste* by Paul Valéry, by permission of and special arrangement with Alfred A. Knopf, Inc. Translated from the original French by Jackson Mathews. Copyright 1947 by Alfred A. Knopf, Inc.

down into the sea. I thought that I perceived there, dimmed by the brilliance of published discoveries, but side by side with the unsung inventions recorded every day by business, fear, boredom, and poverty, *many inner masterpieces.* I amused myself with smothering known history beneath the annals of anonymity.

Here they were, solitary figures, invisible in their limpid lives, but knowing beyond anyone in the world. They seemed in their obscurity twice, three times, many times greater than any celebrated person— they, in their disdain for making known their lucky finds and private achievements. I believe they would have refused to consider themselves as anything but things. . . .

These ideas came to me during October of 93, at those moments of leisure when thought practices simply existing.

I was beginning to think no more about them when I made the acquaintance of M. Teste. (I am now thinking of the traces a man leaves in the little space through which he moves each day.) Before I knew M. Teste, I was attracted by his rather special manner. I studied his eyes, his clothes, his slightest low word to the waiter at the café where I used to see him. I wondered whether he felt observed. I would turn my eyes quickly away from his, only to catch my own following me. I would pick up the newspapers he had just been reading, and go over in my mind the sober gestures that rose from him; I noticed that no one paid any attention to him.

I had nothing more of this kind to learn when our relations began. I never saw him except at night. Once in a kind of b—; often at the theater. I heard that he lived on modest weekly speculations at the Bourse. He used to take his meals at a small restaurant on the rue Vivienne. Here, he would eat as if he were taking a purgative, with the same rush. From time to time he would go elsewhere and allow himself a fine, leisurely meal.

M. Teste was perhaps forty years old. His speech was extraordinarily rapid, and his voice quiet. Everything about him was fading, his eyes, his hands. His shoulders, however, were military, and his step had a regularity that was amazing. When he spoke he never raised an arm or a finger: he had *killed his puppet.* He did not smile, and said neither hello nor good-by. He seemed not to hear a "How do you do?"

His memory gave me much to think about. Signs that I could judge by led me to imagine in him unequaled intellectual gymnastics. It was not that this faculty in him was excessive—it was rather trained or transformed. These are his own words: "I have not had a book for twenty years. I have burned my papers also. I scribble in the flesh. . . . I can retain what I wish. That is not the difficulty. *It is rather to retain what I shall want tomorrow!* I have tried to invent a mechanical sieve. . . ."

1380

Thinking about it convinced me that M. Teste had managed to discover laws of the mind we know nothing of. Surely he must have devoted years to this research: even more surely, other years, and many more years, had been given to maturing his findings, making them into instincts. Discovery is nothing. The difficulty is to acquire what we discover.

The delicate art of duration: time, its distribution and regulation—expending it upon well chosen objects, to give them special nourishment—was one of M. Teste's main preoccupations. He watched for the repetition of certain ideas; he watered them with number. This served to make the application of his conscious studies in the end mechanical. He even sought to sum up this whole effort. He often said: "*Maturare!*" . . .

Certainly his singular memory must have retained for him exclusively those impressions which the imagination by itself is powerless to construct. If we imagine an ascent in a balloon, we can, with sagacity and vigor, *produce* many of the probable sensations of an aeronaut; but there will always remain something peculiar to a real ascent, which by contrast with our imagined one shows the value of the methods of an Edmond Teste.

This man had early known the importance of what might be called human *plasticity*. He had tried to find out its limits and its laws. How deeply he must have thought about his own malleability!

In him I sensed feelings that made me shudder, a terrible obstinacy in delirious experience. He was a being absorbed in his own variation, one who becomes his own system, who gives himself up wholly to the frightful discipline of the free mind, and who sets his joys to killing one another, the stronger killing the weaker—the milder, the temporal, the joy of a moment, of an hour just begun, killed by the fundamental—by hope for the fundamental.

And I felt that he was master of his thought: I write down this absurdity here. The expression of a feeling is always absurd.

M. Teste had no opinions. I believe he could become impassioned at will, and to attain a definite end. What had he done with his personality? How did he regard himself? . . . He never laughed, never a look of unhappiness on his face. He hated melancholy.

He spoke, and one felt oneself confounded with *things* in his mind: one felt withdrawn, mingled with houses, with the grandeurs of space, with the shuffled colors of the street, with street corners. . . . And the most cleverly touching words—the very ones that bring their author closer to us than any other man, those that make us believe the eternal wall between minds is falling—could come to him. He knew wonderfully that they would have moved *anyone else*. He spoke, and without being able to tell precisely the motives or the extent of the proscription, one knew that a large number of words had been banished from his discourse. The ones he used were sometimes so curiously held

by his voice or lighted by his phrase that their weight was altered, their value new. Sometimes they would lose all sense, they seemed to serve only to fill an empty place for which the proper term was still in doubt or not provided by the language. I have heard him designate a simple object by a group of abstract words and proper names.

To what he said, there was nothing to reply. He killed polite assent. Conversation was kept going in leaps that were no surprise to him.

If this man had reversed the direction of his inward meditations, if he had turned against the world the regular power of his mind, nothing could have resisted him. I am sorry to speak of him as we speak of those we make statues of. I am well aware that between "genius" and him, there is a quantity of weakness. He, so genuine! So new! So free of all trickery and magic, so hard! My own enthusiasm spoils him for me. . . .

How is it possible not to feel enthusiasm for a man who never said anything *vague*? for a man who calmly declared: "In all things I am interested only in the *facility* or *difficulty* of knowing them, of doing them. I give extreme care to measuring the degree of each quality, and to not getting attached to the problem. . . . What do I care for what I know quite well already?"

How is it possible not to be won over to a being whose mind seemed to transform to its own use all that is, a mind that *performed* everything suggested to it. I imagined this mind managing, mixing, making variations, connections, and throughout the whole field of its knowledge able to intercept and shunt, to guide, to freeze this and warm that, to drown, to raise, to name what has no name, to forget what it wished, to put to sleep or to color this and that. . . .

I am grossly simplifying his impenetrable powers. I do not dare say all my object tells me. Logic stops me. But, within me, every time the problem of Teste arises, curious formations appear.

On certain days I can recover him quite clearly. He reappears in my memory, beside me. I breathe the smoke of our cigars, I listen to him, I am wary. Sometimes, in reading a newspaper I encounter his thought, which some event has just justified. And I try again some of those illusory experiments that used to delight me during our evenings together. That is, I imagine him doing what I have not seen him do. What is M. Teste like when he is sick? How does he reason when he is in love! Is it possible for him to be sad? What would he be afraid of? What could make him tremble? . . . I wondered. I kept before me the complete image of this rigorous man, trying to make it answer my questions. . . . But it kept changing.

He loves, he suffers, he is bored. People all imitate themselves. But he must combine in his sigh, in his elemental moan, the rules and forms of his whole mind.

Exactly two years and three months ago this evening, I was at the theater with him, in a box someone had offered us. I have thought about this all day today.

I can still see him standing with the golden column of the Opera; together.

He looked only at the audience. He was *breathing in* the great blast of brilliance, on the edge of the pit. He was red.

An immense copper girl stood between us and a group murmuring beyond the dazzlement. Deep in the haze shone a naked bit of woman, smooth as a pebble. A number of independent fans were breathing over the crowd, dim and clear, that foamed up to the level of the top lights. My eyes spelled a thousand little faces, settled on a sad head, ran along arms, over people, and finally flickered out.

Each one was in his place, freed by a slight movement. I tasted the system of classification, the almost theoretical simplicity of the audience, the social order. I had the delicious sensation that everything breathing in this cube was going to follow its laws, flare up with laughter in great circles, be moved in rows, feel as a mass *intimate,* even *unique* things, secret urges, be lifted to the unavowable! I strayed over these layers of men, from level to level, in orbits, fancying that I could join ideally together all those with the same illness, or the same theory, or the same vice. . . . One music moved us all, swelled, and then became quite small.

It disappeared. M. Teste was murmuring: "We are *beautiful,* extraordinary, only to others! *We* are eaten by others!"

The last word stood out in the silence created by the orchestra. Teste drew a deep breath.

His fiery face, glowing with heat and color, his broad shoulders, his dark figure bronzed by the lights, the form of the whole clothed mass of him propped by the heavy column, took hold of me again. He lost not an atom of all that at each moment became perceptible in that grandeur of red and gold.

I watched his skull making acquaintance with the angles of the capital, his right hand refreshing itself among the gilt ornaments; and, in the purple shadow, his large feet. From a distant part of the theater his eyes came back to me; his mouth said: "Discipline is not bad. . . . It is at least a beginning. . . ."

I did not know what to answer. He said in his low quick voice: "Let them enjoy and obey!"

He fixed his eyes for a long time on a young man opposite us, then on a lady, then on a whole group in the higher galleries—overflowing the balcony in five or six burning faces—and then on everybody, the whole theater full as the heavens, ardent, held by the stage which we could not see. The stupor they were all in showed us that something or other sublime was going on. We watched the light dying from all the

faces in the audience. And when it was quite low, when the light no longer shone, there remained only the vast phosphorescence of those thousand faces. I saw that this twilight made these beings passive. Their attention and the darkness mounting together formed a continuous equilibrium. I was myself attentive, *necessarily*, to all this attention.

M. Teste said: "The supreme simplifies *them*. I bet they are all thinking, more and more, *toward* the same thing. They will be equal at the crisis, the common limit. Besides, the law is not so simple . . . since it does not include me—and—I am here."

He added: "The lighting is what holds them."

I said, laughing: "You too?"

He replied: "You too."

"What a dramatist you would make," I said to him. "You seem to be watching some experiment going on beyond the limits of all the sciences! I would like to see a theater inspired by your meditations."

He said: "No one meditates."

The applause and the house lights drove us out. We circled, and went down. The passers-by seemed set free. M. Teste complained slightly of the midnight coolness. He alluded to old pains.

As we walked along, almost incoherent phrases sprang from him. Despite my efforts, I could follow his words only with great difficulty, finally deciding merely to remember them. The incoherence of speech depends on the one listening to it. The mind seems to me so made that it cannot be incoherent to itself. For that reason I refused to consider Teste as mad. Anyway, I could vaguely make out the thread of his ideas, and I saw no contradiction in them; also, I would have been wary of too simple a solution.

We went through streets quieted by the night, we turned corners, in the void, by instinct finding our way—wider, narrower, wider. His military step subdued mine. . . .

"Yet, *I replied,* how can we escape a music so powerful! And why should we? I find in it a peculiar excitement. Must I reject this? I find in it the illusion of an immense effort, which suddenly might become possible. . . . It gives me *abstract sensations,* delightful images of everything I love—change, movement, mixture, flux, transformation. . . . Will you deny that certain things are anaesthetic? That there are trees that intoxicate us, men that give us strength, girls that paralyze us, skies that stop our speech?"

M. Teste put in, in a rather loud voice:

". . . But, sir, what is the 'talent' of your trees—or of anyone! . . . to me! I am at home in MYSELF, I speak my language, I hate extraordinary things. Only weak minds need them. Believe me literally: *genius is easy, divinity is easy.* . . . I mean simply—that I know how it is conceived. It is *easy.*

1384

"Long ago—at least twenty years—the least thing out of the ordinary that some other man accomplished was for me a personal defeat. I used to see only ideas stolen from me! What nonsense! . . . Imagine thinking our own image is not indifferent to us! In our imaginary struggles, we treat ourselves *too well* or *too ill!* . . ."

He coughed. He said to himself: "What can a man do? . . . What can a man do? . . ." He said to me: "You know a man who knows that he does not know what he is saying!"

We were at his door. He asked me to come in and smoke a cigar with him.

On the top floor of the house we went into a very small "furnished" apartment. I did not see a book. Nothing indicated the traditional manner of work, at a table, under a lamp, in the midst of papers and pens.

In the greenish bedroom, smelling of mint, there was only a candle and, sitting around it, the dull abstract furniture—the bed, the clock, the wardrobe with a mirror, two armchairs—like rational beings. On the mantel, a few newspapers, a dozen visiting cards covered with figures, and a medicine bottle. I have never had a stronger impression of the *ordinary*. It was *any lodging*, like geometry's *any point*—and perhaps as useful. My host existed in the most general interior. I thought of the hours he had spent in that armchair. I was frightened at the infinite drabness possible in this pure and banal room. I have lived in such rooms. I have never been able to believe them final, without horror.

M. Teste talked of money. I do not know how to reproduce his special eloquence: it seemed less precise than usual. Fatigue, the silence becoming deeper with the late hour, the bitter cigars, the abandon of night seemed to overtake him. I can still hear his voice, lowered and slow, making the flame dance above the single candle that burned between us, as he recited very large numbers, wearily. Eight hundred ten million seventy-five thousand five hundred fifty. . . . I listened to this unheard-of music without following the calculation. He conveyed to me the fever of the Bourse, and these long series of names of numbers gripped me like poetry. He correlated news events, industrial phenomena, public taste and the passions, and still more figures, one with another. He was saying: "Gold is, as it were, the mind of society."

Suddenly he stopped. He was in pain.

I again scanned the cold room, the nullity of the furnishings, to keep from looking at him. He took out his little bottle and drank. I got up to go.

"Stay awhile longer," he said. "You don't mind. I am going to get in bed. In a few moments I'll be asleep. You can take the candle to go down."

He undressed quietly. His gaunt body bathed in the covers, and lay still. Then he turned over and plunged farther down in the bed, too short for him.

He smiled and said to me: "I am like a plank. I am floating! . . . I feel an imperceptible rolling under me—an immense movement? I sleep an hour or two at the very most; I adore navigating the night. Often I can not distinguish thought before from sleep. I do not know whether I have slept. It used to be, when I dozed, I thought of all those who had afforded me pleasure; faces, things, minutes. I would summon them so that my thought might be as sweet as possible, easy as the bed. . . . I am old. I can show you that I feel old. . . . You remember! When we are children we *discover* ourselves, we slowly discover the extent of our bodies, we express the particularity of our bodies by a series of efforts, I suppose? We squirm and discover or recover ourselves, and are surprised! We touch a heel, grasp the right foot with the left hand, take a cold foot in a warm palm! . . . Now I know myself by heart. Even my heart. Bah! the world is all marked off, all the flags are flying over all territories. . . . My bed remains. I love this stream of sleep and linen: this linen that stretches and folds, or crumples—runs over me like sand, when I lie still—curdles around me in sleep. . . . It is a very complex bit of mechanics. In the direction of the woof or the warp, a very slight deviation. . . . Ah!"

He was in pain.

"What is it?" I said. "I can . . ."

"Nothing . . . much," he said. "Nothing but . . . a tenth of a second appearing. . . . Wait. . . . At certain moments my body is illuminated. . . . It is very curious. Suddenly I see into myself . . . I can make out the depth of the layers of my flesh; and I feel zones of pain, rings, poles, plumes of pain. Do you see these living figures, this geometry of my suffering? Some of these flashes are exactly like ideas. They make me understand—from here, to there. . . . And yet they leave me *uncertain*. Uncertain is not the word. . . . When *it* is about to appear, I find in myself something confused or diffused. Areas that are . . . hazy, occur in my being, wide spaces suddenly make their appearance. Then I choose a question from my memory, any problem at all . . . and I plunge into it. I count grains of sand . . . and so long as I can see them . . . My increasing pain forces me to observe it. I think about it! I only await my cry, and as soon as I have heard it—the *object*, the terrible *object*, getting smaller, and still smaller, escapes from my inner sight. . . .

"What is possible, what can a man do? I can withstand anything—except the suffering of my body, beyond a certain intensity. Yet, that is where I ought to begin. For, to suffer is to give supreme attention to something, and I am somewhat a man of attention. You know, I had foreseen my future illness. I had visualized precisely what everybody now knows. I believe the vision of a manifest portion of the future should be part of our education. Yes, I foresaw what is now beginning. At that time, it was just an idea like any other. So, I was able to follow it."

He grew calm.

He turned over on his side, lowered his eyes; and after a moment, was talking again. He was beginning to lose himself. His voice was only a murmur in the pillow. His reddening hand was already asleep.

He was still saying: "I think, and it doesn't bother at all. I am alone. How comfortable solitude is! Not the slightest thing weighs on me. . . . The same reverie here as in the ship's cabin, the same at the Café Lambert. . . . If some Bertha's arms take on importance, I am robbed— as by pain. . . . If anyone says something and doesn't prove it—he's an enemy. I prefer the sound of the least fact, happening. I am being and seeing myself, seeing me see myself, and so forth. . . . Let's think very closely. Bah! you can fall asleep on any subject. . . . Sleep can continue any idea. . . ."

He was snoring softly. A little more softly still, I took the candle, and went out on tiptoe.

(1895)
Translated by Jackson Mathews

*Before retreating into silence, Valéry consented to publish two works, one immediately after the other, in two different reviews—*La Méthode de Léonard de Vinci' *(1894) in* Madame Adam's Nouvelle Revue *and, in* Le Centaure, *at that time edited by Pierre Louys, the astounding* 'Soirée avec M. Teste' *(1895). To that extraordinary creation, unparalleled in any other tongue, to that accomplished and perfect work, each one of us was compelled to do homage. As he had just disclosed his method to us through the medium of Leonardo, Valéry, thanks to this semi-mythical alibi, here revealed his ethic, his attitude towards things, beings, ideas, life. This he maintained and to the end remained faithful—constant to himself, so that a little while before his death he was able to say (I quote his very words), 'The principal themes round which I have grouped my thoughts are still in my mind* unshakeable.' *He spoke this last word strongly, accentuating each syllable.*

ANDRÉ GIDE
Paul Valéry (1945)
Translated by Dorothy Bussy

1 8 7 1 — 1 9 4 5

FROM *LA JEUNE PARQUE*

J'ai de mes bras épais environné mes tempes,
Et longtemps de mon âme attendu les éclairs?
Toute? . . . dans mes doux liens, à mon sang suspendue,
Je me voyais me voir, sinueuse, et dorais
De regards en regards, mes profondes forêts.

J'y suivais un serpent qui venait de me mordre.

. . . . Adieu, pensai-je, MOI, mortelle sœur, mensonge.

I buried my head in my thick arms, and for a long time awaited illumination from my soul. . . . In harmonious oscillation with my blood, in my own soft bonds, I, sinuous, beheld myself contemplating myself, and gilding my own deep inward forests in a succession of glances. I was tracking a snake which had just bitten me. . . . Good-bye, I thought, oh me, oh mortal sister, delusion!

(1917)

Valéry is not only the successful expression of Mallarmé, though that would be enough to make him great; he is, besides, the poetical, orderly, and concise expression of those 'modern' ideas, which Proust was attempting at the same time to put into prose. . . . Here is at last perfect poetry.

DENIS SAURAT
Modern French Literature 1870–1940 (1946)

JAMES JOYCE

1 8 8 2 — 1 9 4 1

DUBLIN WASHERWOMEN SCRUB BESIDE THE RIVER, AND THEIR VOICES FADE INTO THE DUSK

. . . Lord save us! And ho! Hey? What all men. Hot? His tittering daughters of. Whawk?
Can't hear with the waters of. The chittering waters of. Flittering bats, fieldmice bawk talk. Ho! Are you not gone ahome? What Thom

Malone? Can't hear with bawk of bats, all thim liffeying waters of. Ho, talk save us! My foos won't moos. I feel as old as yonder elm. A tale told of Shaun or Shem? All Livia's daughtersons. Dark hawks hear us. Night! Night! My ho head halls. I feel as heavy as yonder stone. Tell me of John or Shaun? Who were Shem and Shaun the living sons or daughters of? Night now! Tell me, tell me, tell me, elm! Night night! Telmetale of stem or stone. Beside the rivering waters of, hitherandthithering waters of. Night!

<div align="right">Finnegans Wake (1939)</div>

The writer who has taken experimentation farthest of all is, of course, Mr. James Joyce.

<div align="right">

BONAMY DOBRÉE
Modern Prose Style (1934)

</div>

SAMUEL JOHNSON

1 7 0 9 – 1 7 8 4

TRIFLES

The greater part of readers, instead of blaming us for passing trifles, will wonder that on mere trifles so much labour is expended, with such importance of debate, and such solemnity of diction. To these I answer with confidence, that they are judging of an art which they do not understand; yet cannot much reproach them with their ignorance, nor promise that they would become in general, by learning criticism, more useful, happier or wiser.

<div align="right">Preface to Shakespeare (1765)</div>

The last word.

<div align="right">R. W. CHAPMAN
The Portrait of a Scholar (1922)</div>

APPENDIX

TOUCHSTONES OF GREAT POETRY

HOMER

DATES UNKNOWN

Ὣς φάτο· τοὺς δ' ἤδη κατέχεν φυσίζοος αἶα
ἐν Λακεδαίμονι αὖθι, φίλῃ ἐν πατρίδι γαίῃ.

So said she;—long since they in Earth's soft Arms were reposing,
There, in their own dear Land, their Father-Land, Lakedaimon.

Iliad, iii, 243–4
Translated by E. C. Hawtrey

Ἆ δειλώ, τί σφῶϊ δόμεν Πηλῆϊ ἄνακτι
θνητῷ, ὑμεῖς δ' ἐστὸν ἀγήρω τ' ἀθανάτω τε!
ἦ ἵνα δυστήνοισι μετ' ἀνδράσιν ἄλγε' ἔχητον;

Ah, unhappy pair, why gave we you to King Peleus, to a mortal? but
ye are without old age, and immortal. Was it that with men born to
misery ye might have sorrow?

Iliad, xvii, 443–5
Translated by Matthew Arnold

Καὶ σὲ γέρον τὸ πρὶν μὲν ἀκούομεν ὄλβιον εἶναι.

Nay, and thou too, old man, in former days wast, as we hear, happy.

Iliad, xxiv, 543
Translated by Matthew Arnold

DANTE ALIGHIERI

1 2 6 5 — 1 3 2 1

Io non piangeva, sí dentro impietrai;
piangevan elli.

I wailed not, so of stone grew I within:—*they* wailed.

Inferno, xxxiii, 49
Translated by Matthew Arnold

Io son fatta da Dio, sua mercè, tale,
che la vostra miseria non mi tange,
nè fiamma d' esto incendio non m' assale.

Of such sort hath God, thanked be His mercy, made me, that your
misery toucheth me not, neither doth the flame of this fire strike me.

Inferno, ii, 91–3
Translated by Matthew Arnold

E la sua volontade è nostra pace.

In His will is our peace.

Paradiso, iii, 85
Translated by Matthew Arnold

WILLIAM SHAKESPEARE

1 5 6 4 — 1 6 1 6

Wilt thou vpon the high and giddy Mast,
Seale vp the ship-boies eies, and rocke his braines,
In cradle of the rude imperious surge.

King Henry the Fourth, Part Two, Act iii, Scene i (1600)

If thou did'st euer hold me in thy hart,
Absent thee from felicity a while,
And in this harsh world drawe thy breath in paine
To tell my storie.

Hamlet, Act v, Scene ii (1604)

JOHN MILTON

1 6 0 8 — 1 6 7 4

Dark'n'd so, yet shon
Above them all th' Arch Angel: but his face
Deep scars of Thunder had intrencht, and care
Sat on his faded cheek.

Paradise Lost, i (1667)

And courage never to submit or yield:
And what is else not to be overcome.

> Paradise Lost, i (1667)

Which cost *Ceres* all that pain
To seek her through the world.

> Paradise Lost, iv (1667)

There can be no more useful help for discovering what poetry belongs to the class of the truly excellent, and can therefore do us most good, than to have always in one's mind lines and expressions of the great masters, and to apply them as a touchstone to other poetry. Of course we are not to require this other poetry to resemble them; it may be very dissimilar. But if we have any tact we shall find them, when we have lodged them well in our minds, an infallible touchstone for detecting the presence or absence of high poetic quality, and also the degree of this quality, in all other poetry which we may place beside them.

MATTHEW ARNOLD
Essays in Criticism, Second Series (1888)

THOMAS WYATT

1 5 0 3 ? — 1 5 4 2

And then may chaunce the to repent
The tyme that thou hast lost and spent
To cause thy lovers sigh and swone;
Then shalt thou knowe beaultie but lent,
And wisshe and want as I have done.

Poems (1528–36)

WILLIAM SHAKESPEARE

1 5 6 4 — 1 6 1 6

That time of yeare thou maist in me behold,
When yellow leaues, or none, or few doe hange
Vpon those boughes which shake against the could,
Bare ruin'd quiers, where late the sweet birds sang.

Sonnets (1609), lxxiii

WILLIAM SHAKESPEARE

1 5 6 4 — 1 6 1 6

And my poore Foole is hang'd: no, no, no life?
Why should a Dog, a Horse, a Rat haue life,
And thou no breath at all? Thou'lt come no more,
Neuer, neuer, neuer, neuer, neuer.
Pray you vndo this Button. Thanke you Sir,
Do you see this? Looke on her? Looke, her lips!
Looke there, looke there.

King Lear, Act v, Scene iii (1623)

1396

THOMAS NASHE

1 5 6 7 — 1 6 0 1

Beauty is but a flowre,
Which wrinckles will deuoure,
Brightnesse falls from the ayre,
Queenes haue died yong and faire,
Dust hath closde *Helens* eye.
I am sick, I must dye:
 Lord, haue mercy on vs.
 Summers Last Will and Testament (1600)

JOHN WEBSTER

1 5 8 0 ? — ? 1 6 2 5

Cover her face: Mine eyes dazell: she di'd yong.
 The Dutchesse of Malfy, Act iv, Scene ii (c.1614)

THOMAS CAREW

1 5 9 5 ? — ? 1 6 4 5

Ask me no more whither doth hast
The Nightingale when May is past:
For in your sweet dividing throat
She winters, and keeps warm her note.
 A Song (1640)

ANDREW MARVELL

1 6 2 1 — 1 6 7 8

'Tis Madness to resist or blame
The force of angry Heavens flame:
 And, if we would speak true,
 Much to the Man is due.

Who, from his private Gardens, where
He liv'd reserved and austere,
 As if his highest plot
 To plant the Bergamot,
Could by industrious Valour climbe
To ruine the great Work of Time,
 And cast the Kingdome old
 Into another Mold.

<div align="right">An Horatian Ode upon Cromwell's
Return from Ireland (1650)</div>

W. B. YEATS

1 8 6 5 — 1 9 3 9

'I am of Ireland
And the Holy Land of Ireland
And time runs on' cried she
'Come out of charity
And dance with me in Ireland'

<div align="right">Words for Music Perhaps
And Other Poems (1932)</div>

T. S. ELIOT

1 8 8 8 —

We have lingered in the chambers of the sea
By sea-girls wreathed with seaweed red and brown
Till human voices wake us, and we drown.

<div align="right">The Love Song of J. Alfred Prufrock (1917)</div>

HART CRANE

1 8 9 9 — 1 9 3 2

O Thou steeled Cognizance whose leap commits
The agile precincts of the lark's return.

<div align="right">The Bridge (1930)</div>

I wish now to introduce other kinds of instance, and to let them stand for us as a sort of Arnoldish touchstones to the perfection that poetic statement has occasionally reached.

ALLEN TATE
Reason in Madness (1941)

GLOSSARY

abrayde, started up
achaat, buying
achátours, buyers
after oon, of uniform quality
alderbest, best of all
alenge, miserable
Algezir, Algeciras
Alisaundre, Alexandria
aller cok, rooster's crow for all
anlaas, dagger
apikèd, trimmed
appele, accuse
arewe, in a row
asterte, escape
astronomye, astrology
áventure, chance

bachelor, young knight
baite, resting-place
baundoun, power
bawdryk, belt
Belmarye, Benmarin
bemès, trumpets
bismótered, stained
bitore, bittern
biwreyè, betray
boote, remedy
bord bigonne, seat of honor
bote, unless
bourde, jest
bracér, arm-guard
briddès, birds
broukè, have the use of
buen, be
bulte it to the bren, sift it to the bran
burdoun, base accompaniment

carl, man
catel, property
ceint, girdle
chapèd, mounted

chaunterie, a job singing daily masses
ches, chose
chevyssaunce, dishonest deals
chyvachie, cavalry raid
cleped, called
clerk, student
coillons, testicles
colpons, bunches
complecciouns, temperaments
conscïence, feelings
contekes, fights
cope, top
coráges, hearts
cote, cottage
coude, knew
countour, auditor
covyne, tricks
coy, modest
croys of latoun, cross of copper and zinc
 alloy
crulle, curled

daunger, control
daungerous, arrogant
dawngerouse, haughty
dees, dice
delyvere, agile
depeint, soiled
despitous, scornful
deye, dairy woman
dissaite, deceit
drecchèd, troubled
drede, doubt
dreynt, drowned

eek, also
embrouded, embroidered
engyned, racked
envynèd, stocked with wine
estatlich, dignified
evene, average
ey, egg

1401

faldyng, coarse wool
faren in londe, gone to the country
farsed, stuffed
fee symple, absolute possession
fen, chapter
fernè, distant
ferrer twynne, go farther
ferthyng, speck
fetisly, precisely
fetys, handsome
feye, stricken
floytynge, fluting
flytt, fled
foo, foe
foond, provided for
for-dronke, very drunk
forneys of a leed, furnace under
 a caldron
forpynèd, wasted by suffering
fors, attention
forslewthen, waste
forthi, for this
forwake, tired out
forward, agreement
fother, load
fredom, generosity
fynch eek koude he pulle, have his own
 concubine
fyne, cease

galle, sore spot
galyngale, a spice
gamed, prospered
gargat, throat
gat-tothèd, teeth widely spaced
gauded, gauds or large beads
Gernade, Grenada
geynest, fairest
gipser, purse
girlès, both sexes
gise, manner
goliardeys, teller of dirty stories
gore, garment
Gretè See, Mediterranean
grope, test
ground, texture
grys, costly gray fur
gypon, tunic

habergeon, coat of mail
halwès, shrines
hap, lot
harre, hinges
haunt, skill
he, she; the knight
hele, conceal
hendy, happy
hente, obtain; took
herberwe, inn
here, their
hett, promised
heu, color
hierde, herdsman
hightè, named
holt, farm
hyre, her

iantilnesse, waywardness
ichabbe, I have
icham, I am
ichot, I wot
in feere, together

janglere, noisy talker
jet, fashion

knarre, stout fellow
kowthe, known

lele, loyal
lemes, flames
lent, turned away
lesynges, lies
lette, prevented
Lettow, Lithuania
letuaries, medicines
levedi, lady
libbe, live
licóur, sap
lith, limb
lode-menage, piloting
loh, laughed
Looth, Lot
losengeour, flatterer
lossom, lovable
love-dayes, arbitration days
lud, voice

Lyeys, Ayas
lyht, has lighted
lymytour, licensed to beg in a limited
 area
lyven, live

make, mate
makeles, matchless
male, bag
mareys, marsh
mede, reward
mekyl, much
mene, pity
mette, dreamed
meynee, followers
middel, waist
moot I thee, may I thrive
moote sterven wood, may die mad
mort, dead
mortreux, stew
morwenynges, mornings
Myda, Midas
myster, craft

narette, blame
narre, nearer
ne, not
nis, is not
nones, occasion
normal, a sore
not-heed, closely cut hair
nyghtertale, nighttime

on, in
ounces, strands
overeste courtepy, upper short coat

paas, walking pace
pace, go; surpass
Palatye, Balat
Parvys, lawyers' meeting place
pers, blue-gray
philosophre, alchemist
pilèd, scanty
pilwè-beer, pillowcase
pistel, word
pocok, peacock

poraille, poor people
poudrè-marchant, a sour seasoning
preevè, experience
prikasour, hunter on horseback
proprè, own
prow, profit
Pruce, Prussia
purchas, money from begging
purtreye, draw
pyned, tortured

rage, play around
rakè-stele, rake handle
raughte, reached
recche, interpret
reed, advice; adviser
remes, realms
rethor, author
reve me, rob me of
reysèd, raided
roun, song
rouncy, a nag
rownèd, whispered
Ruce, Russia

Satalye, Attalia
sautrie, psaltery
sawcèfleem, pimply
scathe, a pity
scoleye, attend school
see, protect
seeke, sick
semlokest, loveliest
senténce, meaning
sette hir aller cappe, fooled them all
sewed, pursued
seynd, broiled
sheeldès, French coins
shentè, harmed
shoope, planned
Significavit, writ of arrest
 for excommunication
siker, certain
sikerly, certainly
sithes, times
so, as
soond, sand
soote, refreshing

sownynge, emphasizing
spicèd, overscrupulous
stape, advanced
stent, stopped
stepe, protruding
sterve, die
stevene, voice
stoor, stock
strondes, shores
stuwe, fishpond
swelte, swooned
swevene, dream
swithe, quickly
swych, such
swynk, work
swynkere, worker
swyre, neck

taille, credit
talen, tell tales
tappestere, barmaid
Tapycer, tapestry weaver
targe, shield
temple, law school
theech, may I thrive
tho, those
tholien whyle sore, to endure for a time
tollen, take toll for grinding
tombesteres, dancing girls
toon, toes
toune, season
toverbyde, outlive
Tramyssene, Tremessen
tretys, neat

undermelès, afternoons
undren, forenoon
unkyndèly, unnaturall

vavasour, squire
vernycle, copy of St. Veronica's hand-
 kerchief bearing the face of Christ
verray, true
vertú, power
vigiliès, religious services

warice, cure
wastel, fine white
Webbe, weaver
wende, turn
wight, person
wlatsom, loathsome
wonges, cheeks
wonyng, dwelling
wonynge, living
wood, crazy
wore, weir
wowyng, wooing
wyter, wise

yeddynges, singing contests
yede, went
yën, eyes
yerne, eagerly
yhent, won
y-lad, drawn
y-lymèd, caught
yore, long
y-purfiled, trimmed
y-yerned, yearned

INDEXES

The names of critics are printed in italics

INDEX OF TITLES

INDEX OF FIRST LINES
OF POEMS AND PLAYS

1458

1472